THE HISTORY
OF
THREE-COLOR PHOTOGRAPHY

by

E. J. WALL, F.C.S., F.R.P.S.

Introductory note by D. A. SPENCER, *Ph.D., D.I.C.,*
F.R.I.C., Hon. F.I.I.P., Hon. Member S.P.S.E.,
Hon. F.R.P.S.

THE FOCAL PRESS
LONDON and NEW YORK

ISBN 0 240 50702 9

First Published in 1925
Reprinted by Focal Press, London
1970

Reproduced and Printed in Great Britain by
Redwood Press Limited, Trowbridge & London
and bound by G. & J. Kitkat Ltd., London.

THE HISTORY
OF
THREE-COLOR PHOTOGRAPHY

CONTENTS

Contents

CHAPTER V

CHAPTER VI

Contents

Contents

Contents

Contents

E DWARD JOHN WALL'S classic "The History of Three-color Photography" was first published in 1925 on the eve of a growing interest in the search for that elusive pot of gold at the foot of the Colour Photographic rainbow.

Typical inventors slid down a wide variety of these spectral rainbows only to land in the mire while their sponsors got a soaking instead of a fortune.

A study of Wall's book would have given such inventors of "New" colour processes food for thought and their backers reason to pause before they embarked on attempts to commercialise colour systems based solely on novel ways of producing the necessary part images and the relative cheapness of the materials involved. Unfortunately for them a successful process of colour photography depends on other, far more important factors as Wall makes abundantly clear.

Since Du Hauron, following up Maxwell's demonstration of its feasibility, indicated the many ways by which colour photography could, in theory, be achieved, many hundreds of attempts have been made to commercialise different methods of colour photography, each of which, in the inventor's laboratory, could be made to produce acceptable results by a variety of chemical or optical conjuring tricks.

The commercially successful processes are however variants or developments of three or four basic inventions which will be found outlined or foreshadowed in Wall and whose subsequent history is recorded in detail in J. S. Friedmann's "History of Colour Photography" which picks up the subject where Wall, perforce, left it.

Wall, who was born at Gravesend, Kent, England, in 1860 developed an early interest in chemistry and photography and at 19 he was making his own plate and paper emulsions.

In his middle 20's he joined the staff of B. J. Edwards & Co. who introduced orthochromatic plates into England and colour photography took the place of Wall's earlier interest in photomicrography as a hobby.

At 29 he compiled a "Dictionary of Photography" and became editor of "Photographic Answers"—a monthly journal of technical photography. Three years later he became the editor of the "Amateur Photographer" which published, as a series, his translation of Vol. III of Eder's "Handbuch" on emulsion making. He also translated Fritz's "Photolithography" and wrote a manual on the carbon process.

At 35 he was elected an F.R.P.S. and a year later he was appointed instructor in three-colour work at the London County Council School of

Photography and editor of "Photographic News".

At 40 he became chemist to the European Blair Camera Co. which manufactured celluloid film base and cine and roll film.

Following an accident he lay on his back for two years during which time, since, as he put it, his "brains were not in his legs", he continued writing for "The British Journal of Photography" and translated Konig's "Natural Colour Photography" into English. At 47 he invented the bromoil process and three years later, in 1910, emigrated to the U.S.A. and made early forms of acetate film base and motion picture film for the Fireproof Film Co. of Rochester. He continued writing, preparing photographic abstracts for "Wilson's Photographic Magazine" and "American Photography" of which he remained an associate editor for the rest of his life.

At 52 he was appointed Professor of Photography at Syracuse University and joined the Technicolor Motion Picture Corpn. of Boston.

Nine years later he became an independent consultant on photographic problems and patents and wrote his "Practical Colour Photography" and "Photographic Facts and Formulas".

Throughout his career his colleagues found him an excellent debater, a born raconteur of good stories and a most interesting companion. He was elected an Honorary F.R.P.S. in 1928.

With such a background it is perhaps not surprising that in 1925, three years before his death, he crowned his life's work with a magnificent history of colour photography. With its references to, and comments on, over 12,000 articles and patents it was, to quote a summary of contemporary reviews, "the most thorough, exhaustive and eminently readable treatment of any photographic subject ever produced in any language".

Many writers have left one book by which they will always be remembered but few technologists have produced a completely documented history of their subject that is still read 40 years later, not only because of intellectual curiosity about the past but because it remains an invaluable reference book to those still working in its field.

<div align="right">D. A. SPENCER</div>

AUTHOR'S PREFACE

T HE collection of material of this work was begun over thirty years ago, but with no idea then of its being published. With the lapse of time the bulk of the notes became so great that it was necessary to boil them down into such form as would make them more readily accessible, with the result that it was finally decided to publish the work, which is but a resume of the literature collected.

The book has not been compiled for the dilettanti who may desire to turn out a few pretty things in color. For such the author's "Practical Color Photography" should provide the necessary pabulum. It is hoped that the work will be useful to the earnest student of color photography, who, desirous of seriously following up any particular line, wants to know what has been done and said by others.

It should be useful also to would-be inventors, as they may learn, if they will, as to previous patents, previous practice and the disclosures of those skilled in the art. There is, of course, a certain class of people and inventors, the latter especially, to whom this work will not be welcome, for in many cases it will prove that their latest ideas and inventions are not original, in fact, in some cases too obviously adoptions, to use a mild term, of other people's ideas and earlier suggestions. But to quote a well-known writer: "in the testimony afforded by an array of mute facts there is neither possibility of collusion nor opening for fraud." The true investigator who starts out, primed with data as to what has been previously said and done in a particular subject, has a very advantageous handicap over him who commences de novo.

The author can at least claim that there is no work in any language which has brought together a history and summary of color photography, comparable to this book. It may as well be pointed out that this is only half the work, as the subjects of the Lippmann, Seebeck and Bleach-out processes have been dealt with in a similar manner. But such are the economic conditions at the present time that this other volume must lie on the shelf till someone is willing to pay for its being published.

In a book of this scope there must necessarily be errors of omission and commission, but extreme care has been taken to verify as far as possible every reference. In a few cases this has been impossible, mostly in the case of some of the early foreign journals, access to which has not been obtained. No attempt has been made to deal with the photomechanical reproduction of color, as this would entail considerable enlargement of the work, which has already attained sufficient bulk. This subject is left for another volume.

Preface

The plan adopted of collecting all the footnotes at the end of each chapter was not decided upon without due deliberation, and while it may be unusual it allows the text to be read in a connected orderly sequence. In order to facilitate the use of the notes the first reference number in each chapter has the number of the footnote page attached in parenthesis. It should be pointed out also that frequently additional information is given in the footnotes.

Some may consider the inclusion of such subjects as the sensitizing of plates and other topics is not justified. But after careful consideration it was decided that the omission of the same would leave gaps, which would entail the writing of other textbooks. The inclusion of many patents, particularly those dealing wtih cinematography in colors, may lead some critic to look upon these as so much padding. It should be pointed out, however, that the author considers all specifications as constituting part of the technical literature, and they stand on the same footing as other publications. To have omitted them would have been an unwarrantable omission, as there is practically no other literature, on color cinematography at least, and would have seriously detracted from the work as a book of reference.

E. J. WALL.

WOLLASTON, MASS.
June, 1925.

CHAPTER I

HISTORICAL AND THEORETICAL DATA

The use of color for graphic purposes dates back to the dim and distant past. Some of the mural paintings of the cave-men were in two colors. The old monkish missals were enriched, particularly as regards the initials, with wonderful coloring; but these were paintings. The Japanese seem to have been the first to print in colors in superposition. But it was not till about 1700 that color printing was introduced into Europe.

J. C. Le Blon[1] (p. 40) tried first to print from copper plates in the seven spectral colors of Newton. Later, in 1722, he came to the conclusion that all colors could be reproduced by means of three plates with the colors red, yellow and blue. The three plates were prepared in mezzotint, one representing all the blue, another all the red and the third all the yellow. He used transparent colors on white paper, the whites of the pictures being scraped out on the plates. A fourth or key plate in black was also used for the deepest shadows and some of the outlines. It is obvious that this process was tedious and costly, and the color rendition entirely dependent on the individual conception of the operator as to the composition of the various colors.

Senefelder's discovery of lithography towards the end of the eighteenth century, and its commercial introduction, about 1812, marks the practical commencement of mechanical superposition of colors in printing. But here again one has the laborious handwork on the stone, and the arbitrary analysis of color by the individual, accompanied by the use of many, that is more than three, stones for printing.

Newton's discovery of the solar spectrum[2] opened up vast fields of research, including the whole field of color photography, and one of the first results was the formulation of the theory of the three primary colors. According to C. Grebe,[3] Antonius de Dominis in his treatise, "De radiis visus et lucis in vitrio perspectivis et iride," published in Venice in 1611, remarked that colors were formed by the absorption of white light; further that red, green and violet were the fundamental colors, from which the rest could be compounded. Aquilonius[4] outlined a color scheme with red, yellow and blue as the primary colors, used half circles of the colors and suggested synthesis by these means. Sir David Brewster[5] enunciated his theory of red, yellow and blue as the fundamental colors.

C. E. Wünsch[6] also propounded the theory of red, green and blue-violet as the basis, though this is always known as the Young-Helmholtz theory. Wünsch's work seems to have been entirely overlooked. It is

1

impossible to deal in detail with this theory, or others in all their ramifications, and reference must be made to the bibliography given at the close of this book for reference works. We are specifically interested in the reproduction of color by photography.

Clerk Maxwell.—Clerk Maxwell[7] was the first to suggest the possibility of reproducing objects in colors by photography. He said: "Young, who made the next great step in the establishment of the theory of light, seems also to have been the first to follow out the necessary consequences of Newton's suggestion on the mixture of colors. He saw that, since this triplicity has no foundation in the theory of light, its cause must be looked for in the constitution of the eye; and, by one of those bold assumptions which sometimes express the result of speculation better than any cautious train of reasoning, he attributed it to the existence of three distinct modes of sensation in the retina, each of which he supposed to be produced in different degrees by the different rays. These three elementary effects, according to his view, corresponded to the three sensations of red, green, and violet, and would separately convey to the sensorium the sensation of a red, a green and a violet picture; so that by the superposition of these pictures, the actual variegated world is represented. In order to fully understand Young's theory, the function which he attributes to each system of nerves must be carefully borne in mind. Each nerve acts, not, as some have thought, by conveying to the mind the knowledge of the length of an undulation of light, or of its periodic time, but simply by being *more* or *less* affected by the rays which fall on it. The sensation of each elementary nerve is capable only of increase and diminution, and of no other change. We must also observe, that the nerves corresponding to the red sensation are affected chiefly by the red rays, but in some degree also by those of every other part of the spectrum; just as red glass transmits red rays freely, but also suffers those of other colors to pass in small quantity.

"This theory of color may be illustrated by a supposed case taken from the art of photography. Let it be required to ascertain the colors of a landscape by means of impressions taken on a preparation equally sensitive to rays of every color. Let a plate of red glass be placed before the camera, and an impression taken. The positive of this will be transparent wherever the red light has been abundant in the landscape, and opaque where it has been wanting. Let it now be put in a magic lantern along with the red glass, and a red picture will be thrown on the screen. Let this operation be repeated with a green and a violet glass, and by means of three magic lanterns let the three images be superimposed on the screen. The color on any point on the screen will then depend on that of the corresponding point of the landscape, and by properly adjusting the intensities of the lights, etc., a complete copy of the landscape, as far as visible color is concerned, will be thrown on the screen. The only

apparent difference will be that the copy will be more subdued, or less pure in tint than the original. Here, however, we have the process performed twice—first on the screen, and then on the retina."

It would seem legitimate to deduce from this passage that Clerk Maxwell had in mind the photographic recording of the colors according to the Young-Helmholtz sensation curves. Therefore, it may be considered as an anticipation of the theory later patented by Ives.

In a subsequent lecture[8] this subject was elaborated and an attempt made to actually reproduce a colored object. Thos. Sutton carried out the photographic work for Clerk Maxwell and gives the following account of the same:[9] "A bow made of ribbon, striped with various colors, was pinned upon a background of black velvet, and copied by photography by means of a portrait lens of full aperture, having various colored fluids placed immediately in front of it, and through which the light from the object had to pass before it reached the lens. The experiments were made out of doors, in a good light, and the results were as follows:— A plate-glass bath, containing the ammoniacal sulfate of copper, which chemists use for the blue solution in the bottles in their windows, was first placed immediately in front of the lens. With an exposure of six seconds a perfect negative was obtained. This exposure was about double that required when the colored solution was removed. 2nd. A similar bath was used, containing a green solution of chloride of copper. With an exposure of twelve minutes not the slightest trace of a negative was obtained, although the image was clearly visible on the ground-glass. It was, therefore, found desirable to dilute the solution considerably; and by doing this, and by making the green tinge of the water very much paler, a tolerable negative was eventually obtained in twelve minutes. 3rd. A sheet of lemon-colored glass was next placed in front of the lens, and a good negative obtained with an exposure of two minutes. 4th. A plate-glass bath, similar to the others, and containing a strong red solution of sulfo-cyanide of iron was next used, and a good negative obtained with an exposure of eight minutes. It is impossible to describe in words the exact shades of color, or intensity of these solutions. The thickness of the fluid through which the light had to pass was about three-quarters of an inch. The collodion was simply iodized, the bath neutral, and the developer pyrogallic acid. The chemicals were in a highly sensitive state, and good working order, producing clean and dense negatives, free from stains and streaks in all cases. The negatives taken in the manner described were printed by the tannin process upon glass, and exhibited as transparencies. The picture taken through the red medium, was at the lecture illuminated by red light—that through the blue medium, by blue light—that through the yellow medium, by yellow light, and that through the green medium, by green light;—and when these different-colored images were superimposed upon a screen, a

sort of photograph of the striped ribbon was produced in the natural colors."

This note is extremely interesting as it proves that Clerk Maxwell did not adhere to the three-color principle in the practical execution of his theory, although the reason is not quite clear, nor is the purpose of the yellow-screened transparency; unless it was to supplement the green picture.

Ducos du Hauron.—The next step that should be recorded is that du Hauron, in 1862, when he was only twenty-five years old, sent to M. Lelut a paper entitled: "Solution physique du problème de la reproduction des couleurs par le photographie."[10] M. Lelut was a friend of du Hauron's family, and he was asked to call the attention of some of his fellow members of the Académie des Sciences, who were physicists, to this work, "confidentiellement communiquée." In this paper the existence of only three simple colors, red, yellow and blue, was assumed, and the suggestion made that it would be possible to separate these photographically and recombine them into one picture. Du Hauron described a photochromoscope for this purpose, an additive method and also the screen-plate process, which are dealt with later. M. Lelut, after consulting one of his fellow members, stated that the paper ought not to be presented, practically because there was no proof of the correctness of the arguments. Although this paper was not brought before the Académie, and was not published till 1897, it is interesting as showing that du Hauron had at that time conceived the idea of an efficient chromoscope and also the screen-plate, which he later elaborated. That there are palpable errors in it also is not a matter of great wonder, but they do not detract from its merits as a whole.

Collen and Ransonnet.—In 1865 H. Collen[11] wrote to the British Journal of Photography as follows: "In a recent conversation the above subject was mentioned, but, although often thought of heretofore, all I could then say on it was that to obtain the natural colors of objects superadded to the practice of photography as it now stands, is by far less an apparent impossibility than the present practice of photography would have been in 1765, if it could even have been dreamed of; that, therefore, it was not to be considered as a hopeless case. It occurred to me, however, this morning that if substances were discovered sensitive only to the primary colors—that is, one substance to each color—it would be possible to obtain photographs with the tints as in nature by some such means as the following:—Obtain a negative sensitive to the blue rays only; obtain a second negative sensitive to the red rays only; and a third sensitive to the yellow rays only. There will thus be three plates obtained for *printing in colors*, each plate having extracted all its own peculiar color from every part of the subject in which it has been combined with the other two colors, and being in a certain degree analagous to the tones

used in chromo-lithography. Now it is evident that if a surface be prepared for a *positive* picture, sensitive to yellow rays only, and that the two negatives sensitive only to blue and red be superimposed either on the other, and be laid on this surface, the action of the light will be to give all the yellow existing in the subject; and if this process be repeated on other surfaces sensitive only to red or blue respectively, there will have been produced three pictures of a colored object, each of which contains a primitive color reflected from that object.

"Now, supposing the first great point achieved, viz., the discovery of substances or preparations, each having sensitiveness to each of the primary colors only, it will not be difficult to imagine that the negatives being received on the surface of a material quite transparent and extremely thin, and that being so obtained are used as above—that is each pair of superimposed negatives to obtain the color of the third—that three *positives* will be obtained, each representing a considerable portion of the *form* of the object, but only one primary of the decomposed color of it. Now, if these three positives be received on the same kind of material as that used for the negatives, and be then laid the one on the other, with true coincidence as to the form, and all laid upon a white surface, it will not be difficult to imagine that the effect would be, not only the representation of the *form* of the object, but that of its color, also, in all its compounds.

Very perfect contrivances would be required to produce true superposition of both negatives and positives, and a considerable difficulty would exist in handling the *extremely thin* material. This, however, as well as all other difficulties, will be easily overcome when the chemist has discovered the three preparations which are each of them sensitive to one of the primary colors only. Although the idea I have endeavored to express in words may be utterly worthless, I am unwilling to let it slip away without notice, as it may, on the other hand, contain a germ which may grow and bear fruit in due season. It is a subject which must have been common to the thought of all intelligent photographers, and there can be no doubt that attempts have been made to solve the problem with certain glimpses of success. The processes I believe have never become public, but if all attempts and thoughts on the subject were made known to all, the desired end of the vista would certainly come into view at an earlier period than it would otherwise do."

Baron Ransonnet, of Vienna, in 1865, appears to have conceived the idea of applying the three-color principle to photo-lithography; but as clearly seen from the following note, without success. Eder[12] stated: "Usually it is assumed as proved that Baron Ransonnet in Vienna and the painter Collen in London, gave the first suggestion, or at least were the first who conceived the idea of this method of photographic color reproduction. With regard to this it should be noted that Herr Kaiserl. Rath

L. Schrank (Phot. Korr, 1869, **5**, 199) remarked that Baron Ransonnet
in the year 1865 conceived the idea of three-color printing and
attempted the same with several photographic experiments, which
were, however, without results. He proposed to isolate the fun-
damental colors by the 'complementary colors' of light filters, and
to print from such negatives, and tried, for instance, to expose behind
yellow liquid cells. But in spite of very long exposures and a wide
aperture apparatus, there showed not the slightest trace of an image.
This and other failures caused the designer not to follow this any fur-
ther (Schrank. loc. cit.)."

After summarizing the publications of du Hauron, Collen and Clerk
Maxwell, Eder says: "Since the work of the Viennese, Baron Ran-
sonnet, especially interested me, I sought for authoritative documents
which would make possible a conclusion whether or when he actually
made successful practical work in the domain of three-color printing.
After Baron Ransonnet's return from his journey to China, which as a
member of the Imperial East Asian expedition he had participated in, he
busied himself, since he was a painter and draughtsman, with the re-
production and multiplication of the sketches of his journey and tried
chalk drawings on stone. In the beginning of the sixtieth decade he
became acquainted with the Viennese lithographer Haupt, who inducted
him into the technique of mezzotint and stump on stone; in this manner
he worked assiduously and executed therewith (without the help of pho-
tography) yellow, red and blue stones, which by superposition gave good
wash drawings. His color stones he handed over to Johann Haupt to
print; as the results did not please him, he superimposed a black wash
key plate and a brown tone plate. The first of Ransonnet's trial prints
is in my possession; it was most kindly handed to me by Herr Haupt.
This is a Chinese temple printed from five plates. In order to determine
accurately the date of the preparation Herr Haupt carefully examined his
ledgers, and the first work of this kind is assignable to August 18, 1875,
since on that date there is booked the bill for 137 examples. Chinese
temple, 5 colors. The illustration is very interesting and boldly executed;
another lithographer might perhaps have required fifteen plates, whilst
Ransonnet, obviously guided by the idea of three-color printing, attained
the same result with three main colors and two correcting plates. It
should be recognized, therefore, that actual, historically authentic proof
of the use of photographic three-color printing can not be here perceived,
since such proofs are not authenticated to him, whilst actually photo-
graphic three-color prints were executed in 1869, and were shown in the
French Society by Ducos du Hauron (see Phot. Korr, 1869, **5**, 199). The
picture of the spectrum, presented by Ducos du Hauron as test, is cer-
tainly far from perfect, yet nevertheless is a confirmation of his con-
tentions."

This would seem an appropriate place to introduce a note relating to a publication by G. Fritsch, of Berlin.[13] He says: "In the text of a diary of a journey, which is exhibited in document, there will be found under the title: 'On Color Photography' the following article, from which extraneous matter has been omitted: 'That which we see in nature as an innumerable number of color tones is composed of a few fundamental colors, which by their common action produce the multiplicity. One may trace these colors, even with not absolute accuracy, as is well known to three, for which colors blue, red and yellow have been assumed as a color triangle, in the middle of which should lie white. This is now, as Helmholtz has shown, not actually the case; the colors do not lie in a triangle, nor in a circle as Newton assumed, but on a curve, and white in the focus of the same. Blue and yellow give no spectral green, and Helmholtz found three other colors that better fitted the requirements, namely a deep red, green and violet, which, however, produce no spectral yellow. If the previously mentioned three colors do not now quite correspond to the natural colors, yet their action is so approximate that we may start from these as a basis. If we illuminate an object with pure yellow light, or if we allow the rays proceeding from it to pass through yellow glass, we obtain an image, in which all tones that contain yellow, appear more or less bright, all the others, however, black. If we illuminate the same object with red light, we obtain red lights, the others are also black; with blue illumination blue and black. In this way I am in a position to separate the fundamental colors and to register an image of each of the same. I obtain in this way then in the collodion film, the places of the bromo-iodide of silver film decomposed by the colored light whilst all the rest appears as shadows and, therefore, transparent. This film, which can be stripped, has first of all the characteristic bluish-grey color of the decomposed bromo-iodized silver, it can, however, be colored in different ways by the action of different salts. . . . For color photography the aim should be so directed that instead of a middle tone, actually the extreme colors should be obtained in as great a purity as possible, which is certainly possible to a much higher degree than now appears to be the case, and one would then be in a position by the aid of this method to obtain three different pictures, in which the yellow lights would appear yellowish, the red lights reddish, and the blue lights bluish. If now I take an object in the ordinary way and so intensify the negative, that in the positive all the lights appear white and only the shadows can be distinctly differentiated, so that the positive, as the photographer says, appears snowed up (chalky). I could transfer the colored collodion films on to the same and thus bring the local tones into the picture; the respective covering of the colors would produce the middle tones."

This note was written in South Africa and was dated Oct. 10, 1863. Fritsch stated that he was not aware of Maxwell's work, and was

prevented from experimenting by the fact that he did not return till 1866, and that then the Austro-Prussian war broke out.

We have now to return to du Hauron. In November, 1868, he applied for a French patent, No. 83,061, entitled "Les Couleurs en Photographie, Solution du Problème." In the following year a series of articles was published in Le Gers, in Auch, under the same title, and a letter was addressed to the Société française de Photographie, which was read at the meeting of May 7, and summarized by A. Davanne.[14] These articles were elaborated and published in book form,[15] and on examination of the arguments it will be found that du Hauron's methods were in close accord with the most successful of present day practice. His idea was to isolate each printing color so that it would, in the final print, properly represent the varying ratios of that color in the subject, and this is quite clear from his definition of the colors of his filters.

Chas. Cros.—At this time Chas. Cros published in Les Mondes, Feb. 25, 1869,[16] an article entitled: "Solution du Problème de la Photographie des Couleurs," which was subsequently printed in pamphlet form. Cros first explained that he had neither the means for carrying out his ideas, nor the desire for commercial exploitation, being content merely with the honor of his discovery. He defined the three elementary colors as red, yellow and blue and suggested the taking of separation negatives, each representing one of these three colors. He outlined two methods of analysis,—successive and simultaneous. The first was to be carried out by the use of three filters, such as glass coated with colored varnishes or cells holding colored liquids. Simultaneous analysis was to be effected by the use of a prism, which should send only red, yellow and blue light into the camera, thus meaning probably the use of a prism in front of or behind the lens, and anticipating the dispersion processes of Drac and others. He also suggested for portraiture and still life the illumination of the subject with colored lights.

For the synthesis he outlined most clearly the optical superposition of the colored images as in the chromoscope (see also p. 109), and also the synthesis by persistence of vision by the aid of the phenakistoscope or zoetrope. He also defined the superposition of colored impressions, and although he first suggested the use of red, green and violet inks, he stated that probably red, yellow and blue would be better.

The Theoretical Basis of Tri-Color Photography.—Whilst du Hauron and Cros did not have all the instrumental advantages that we now have, yet they laid down in somewhat precise terms the fundamental basis of three-color photography by subtractive processes, that is to say, the printing colors should be anti-chromatic to the taking colors. Color curve analysis was merely introduced at a later date, and for some time acted upon the wheels of progress as a drag. Fortunately with better instrumental means and a clearer grasp of the essential

underlying principles, we have now arrived at the strict lines on which to work.

If further progress is to be made in the future, it will be rather in minor details than in fundamentals. We may yet hope to see improvements in the sensitive surfaces; in the obtaining too of printing inks that more nearly conform to the strict theoretical requirements, for here would appear to lie the field of the greatest advance. The improvements in color-sensitizing of the past few years, as exemplified in the discovery of the isocyanins for this purpose, would seem to present but little further chance in this direction. The emulsion maker can and does supply us with all that the most exacting devotee may demand, though possibly the theorist would still require a higher speed than is already obtained with all the advantages of freedom from fog and fineness of grain concomitant with the slower emulsions. Theoretically perfect inks are still a desideratum, though much has been done for us by the ink makers since the first three-color prints were commercially issued about 1889.

Exactly what the fundamental axioms of three-color work are, and how we have arrived at them, may be gathered from the following pages, wherein some attempt has been made to gather the opinions of many, with references, as being preferable to the laying down of mere personal opinion, though this would not differ from the main result.

Ducos du Hauron.—Clerk Maxwell does not appear to have used or suggested the application of his process to the production of subtractive prints or transparencies, contenting himself entirely with the additive method. Du Hauron, on the other hand, clearly outlines the possibility of doing so,[17] and the fullest exposition of his views is to be found in his English patent, in which in defining the particular shades of his filters, he gives the main principles of his method.

H. W. Vogel's Theory.—After describing du Hauron's work, Vogel says: "Another defect of Ducos' process is the comparatively arbitrary choice of the printing inks. The rule that the plate photographed through a colored glass must be printed with a color complementary to that of the colored glass is not sufficiently precise and allows considerable latitude; for statements as to the colors which are complementary to one another are very doubtful. Thus it is said that the complementary color to red is green, which green is not determined. Actually the complementary color to many reds is rather a blue than a green. The author (Vogel) proposes below a modification of the processes which is free from the above described faults. This is as follows:—1. That instead of one optical sensitizer several should be used and actually each with a special plate, thus for instance, a sensitizer for red, one for yellow, one for green, one for blue-green; for blue one is not required as silver bromide is itself sensitive to blue. 2. That the optical sensitizers should be also the printing inks for the plates thus obtained, or if the sensitizers themselves can

not be used as printing inks, one as like spectroscopically as possible should be taken. This last requirement is obvious when it is considered that the printing ink must reflect the color rays which were absorbed by the color-sensitive plate in question, or inversely ought not to reflect the colors which were absorbed by the plate for these particular colors. If we assume a plate dyed with eosin, which by the interposition of a suitable medium (certain chromium glasses are suitable for this, also films dyed with methyl-eosin picrate) before the objective, is only affected by those rays which silver eoside absorbs, the green and the yellow-green would have the strongest action, and would give a plate which, when printed by collotype, must be printed with an ink that does not reflect the said rays. This is eosin itself. The same occurs with cyanin, which is used as optical sensitizer for plates obtained behind the red medium (ruby glass). This gives a collotype plate for an ink which reflects all those rays except those absorbed by the cyanin. This is cyanin itself. The fact that cyanin and other dyes do not actually sensitize for the rays absorbed by the pure hues, but for the neighboring ones lying more towards the red is no objection, as the ink by admixture with media of stronger refractive index (oil, etc.,) can be displaced more towards red and with an approximation so close that the difference is not appreciable to our eyes. Following out this train of thought, we come to the conclusion that every plate, which has been rendered sensitive with any given sensitizer, must be reproduced with the color which was used as the optical sensitizer. Now the light-sensitive cyanin, and still less bromide of silver (which on account of its absorption acts as an optical sensitizer) can not be used as printing inks. But other colored substances can be used which show an equal or similar absorption band."

With reference to the theory outlined above von Hübl[19] pointed out that this must not be taken too literally, nor must it be assumed that the sensitizers, for instance, cyanin, eosin and a yellow pigment should be the actual printing colors, for cyanin and a yellow can never make green. The silver bromide is not sensitized for those rays which the dyes absorb, but for those which correspond to the absorption of the stained silver salt. Silver bromide, dyed with yellowish eosin, is a violet-red color, and the ink used should be of a spectroscopically similar color absorption, thus like rose Bengal. Vogel's theory is, as he says, not theoretically strictly correct; but of practical value and characterizes in an easily grasped form for the laity the connection between the printing inks and the plate sensitizing.

With regard to the printing inks they should, when printed one over the other in saturated tones, give black; and when in half tones give grey, and their absorption bands should be approximately of the same breadth. Transparency is naturally requisite as they are printed in superposition, and if this requirement is not fulfilled the values of the underlying colors

will not come into play. The production of grey is readily seen from the fact that a drawing executed in neutral grey, must under all circumstances, if suitable sensitizers and filters are used, give negatives of equal value; grey places in the colored original will thus be equally dense in all three negatives, and will, therefore, print in all the colors of equal intensity. In order to prove whether the inks will give greys, it is only necessary to print from one negative in all three colors, and then with correctly chosen inks, greys will be the result. It is not easy to fulfill this requirement; if Paris blue, chrome yellow and eosin lake are chosen, a yellowish brown instead of a grey will be formed, because between the absorption bands of the blue and red inks there is a broad gap. Still less satisfactory results are obtained with a bluish eosin lake or alizarin, though none of the present inks is quite satisfactory.

As regards the absorptions of the inks it may be said that each should absorb about one-third of the spectrum and reflect two-thirds. These requirements are met with in a yellow that is neither reddish nor greenish, as in a mean chrome yellow; in a Milori blue or lake of similar shade. A satisfactory red ink is actually wanting, and one must be content with a bluish eosin or alizarin lake.

The plates must be sensitized, in accordance with Vogel's law, for those regions which the printing inks absorb, therefore, the above statement practically determines the sensitizing regions. The plates must not thus be sensitized for one particular region only; but each of them should be sensitive for about two-thirds of the spectrum. The ordinary undyed silver bromide plate does not correspond to this requirement completely, since its sensitiveness for the bright blue is too little. The sensitiveness for the red-printing plate should extend over the yellow-green, green and blue-green. The action of all eosins extends, as is well known, chiefly over the yellow-green and, therefore, such sensitized plates give the blue-greens and blues with too little density. A combination of sensitizers, or one that has not the familiar gap in the blue-green must be used. For the blue-print plate there must be sensitiveness for the orange and red, which can be fairly satisfactorily fulfilled.

Ives' Theory.—F. E. Ives[20] advanced the theory that correct color photographs could only be obtained by utilizing the Maxwell curves as a foundation, and he stated: "My own method is perfectly distinct from Hauron's, in that I do not expose sensitive plates through "orange, green and violet glasses," and from Vogel's, in that I do not make a separate negative for each region of the spectrum but only three, and in such manner as to secure curves of intensity which correspond to the action of light rays upon the sets of nerve fibrils which produce color sensation. This, in fact, is my principle, which is undoubtedly new and true, and is carried out by exposing color-sensitive plates through compound color screens, which have been adjusted by experiment in photographing the

spectrum itself, until they yield negatives having curves of intensity like the curves of a diagram representing the action of the spectrum upon the set of nerve fibrils in the eye." This theory is further elaborated[21] and it is stated that in the making of prints, pigments must be used, which are complementary to those rays of the spectrum, which represent the primary color sensations, and Prussian blue, eosin red and brilliant yellow were recommended.

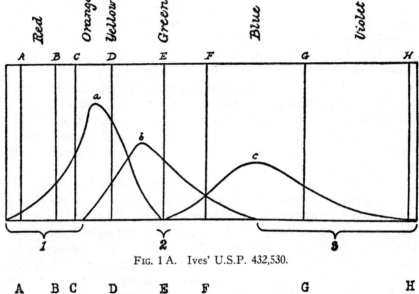

FIG. 1 A. Ives' U.S.P. 432,530.

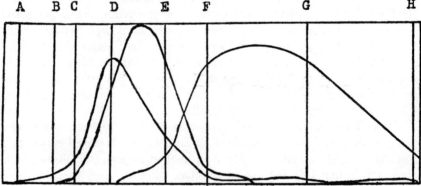

FIG. 1 B. Abney's Color-Sensation Curves.

Ives[22] patented this "new and true" principle and gave the following diagram, Fig. 1 A, of the Maxwell color-sensation curves. The letters *A, B, C,* etc., represent the Fraunhofer lines; and *1, 2* and *3* are spectrum colors which represent the primary color-sensations; *a, b, c* are the curves showing the relative power of spectrum rays to excite the respective primary sensations.

Later Ives[23] discovered that his original contention as to the color-sensation curves would not hold water, as they had been proved not to be color-sensation curves at all, but merely color-mixture curves chosen on a purely arbitrary basis, and he, therefore, modified his statements; but still adhered to the importance of the curves for trichromatic photography.

As a matter of fact the curves, given by Ives, are not correct Maxwell curves, these latter possessing negative values in parts. In Fig. 1 B are given Abney's color-sensation curves, which may be considered typical of those of other investigators. The difference between the two sets of curves is very marked.

A. A. K. Tallent[24] said: "In your issue of Dec. 31, Mr. H. Farmer asks if Mr. Ives can support his claim to the principle that with any trichromatic process the densities of the negative color records must correspond quantitatively with Professor Maxwell's color mixture curves. I venture to say that this claim is unsupportable, and state my reasons below. Maxwell, by empirical methods, found three hues of the spectrum, which when combined in appropriate proportions would counterfeit (approximately) all spectrum hues, white and the purples, in their attributes, hue, luminosity and purity. Synthetically Ives, in his kromskop, employed substantially Maxwell's reproduction colors and adopted the latter curves in the making of the color record negatives. In counterfeiting the spectrum colors by the kromskop the process is substantially a re-performance of Maxwell's experiments, and his curves foretell what colors result from mixtures of his three reproduction hues. Printing. It has been customary to employ Maxwell's curves for the record making in three-color printing, using pigments of complementary or minus (—) hue to those employed by Maxwell. Here, further analogy to the kromskop method ceases, for the colors resulting from pigmentary mixtures are not necessarily those which could be deduced from Maxwell's curves. What colors (in hue, luminosity and purity) actually do result from mixtures of pigments can only be determined by trial under the conditions of actual typographic printing. To secure correct or approximately correct reproduction in colors by three (or more) pigments, Maxwell's curves are not suitable, but in their stead curves derived from actual mixtures of properly chosen pigments, made under the usual working conditions (screen negatives, etc., and typographic printing) should be used. I have no hesitation in saying that to use Maxwell's curves for printing is wrong, both in principle and practice, and I think this incorrect principle is a barrier to progress of this, the most important branch of three-color work, and that it should no longer go unquestioned.

Von Hübl's Views.—A. von Hübl[25] came to the conclusion that the Young-Helmholtz, or Clerk Maxwell, theory had nothing to do with, or at least possessed no importance for three-color work. He pointed out that as every color can be split up into simple spectral colors, it will be

sufficient for the proof of Young's theory if we can form all the spectrum colors by means of three components, which correspond to the three fundamental color-sensations, and which can be called the fundamental or primary colors. This is a physiological problem, that is the formation of the spectral colors, not only as regards hue, but also as regards saturation. If, for instance, two complementary colors, violet and yellow-green are mixed so as to form white, it will be found that much less violet is required than the other. The spectral colors possess varying degrees of saturation; violet is the most saturated, then follow blue, red, orange and yellow. Young chose the most widely separated colors in the spectrum, red, green and violet; but in mixing these colors to produce the intermediate ones the latter could not be made in full saturation. If, for instance, the extreme red be mixed with the green of the E line, a yellow is obtained that agrees with the spectrum yellow in hue, but it is much too white. If a yellower green be used a much better yellow is secured, but its mixture with the blue-violet gives a whitish blue. With the three colors chosen, the intermediate colors can be obtained, but in all cases of insufficient saturation. Therefore, one is forced to the conclusion that the fundamental colors are actually much more saturated than those of the spectrum. These supersaturated colors can not be reproduced, as spectrum colors are the most saturated that we know, and the supersaturated ones can only be numerically calculated.

The fundamental colors, determined by various experimentalists, agree so far, if saturation be excluded, that they may be generally called red, green and violet. Konig and Dieterichi, F. Exner and V. Grünberg have chosen a bluish-green for the fundamental green. Clerk Maxwell and Helmholtz chose a yellowish-green. The primary blue varies from a greenish-blue (Grünberg) to a blue-violet (Maxwell). But there is a fairly unanimous concensus as to the extreme red being called the primary red.

With these primary colors the physiological process of color vision has been explained; but it will be seen that there is no authorization to consider the same as the fundamental colors for three-color photography. If we had only to reproduce the spectrum colors with their peculiar saturation, and had to deal with colors of similar quality, the physiological primary system would be the correct one. Three-color photography has quite another problem to solve. It has to reproduce the colors of natural objects around us and to reproduce them correctly.

Von Hübl utilized the chromatic circle of the spectral colors to explain why the material colors can not be reproduced by the mixture of the physiological colors, and that less saturated ones must be used, which should lie at the corners of an equilateral triangle, of 120 degrees, based on a chromatic circle of relatively impure or less saturated colors. Colored lights or dyes which correspond to the physiological primaries do

not, therefore, equally apply to those material colors, which we have to reproduce by photography. If such primary colors are used in optical synthesis, only very whitish compound colors will be formed, and in subtractive synthesis very black compound colors. From these considerations it ought to be clear that the Young-Helmholtz theory of color vision possesses no importance for the theory of three-color photography, and that it is not correct, therefore, to identify the physiological fundamental colors with those of trichromatic photography.

As a further proof that the fundamental color-sensation curves have nothing to do with three-color work, it may be as well to mention that some have enunciated the law that each of the three taking plates should excite one of the nerve fibrils, and the filters must be so chosen that they transmit the rays of the spectrum in the intensity ratios of the primary sensation curves. If, for instance, König's or Abney's curves are adopted, it will be seen that the red curve is composed principally of yellow, orange and yellowish-green light with less red and green but with some blue-violet. The color of a filter, that would transmit such a curve, would be a brownish-yellow, which can be made by mixing solutions of acridin yellow and naphthol green. But it is obviously absurd to use this for three-color work, even with a perfect panchromatic plate it would give useless results. Exactly in the same way it will be found that the filter corresponding to the primary green sensation curve must transmit chiefly the green, but also some orange, red and pure blue, and it would be a brownish-green. These observations again show that the Young-Helmholtz theory can not be satisfactorily employed in three-color work.

Von Hübl[26] further pointed out that the obvious connection between the filters and the printing inks has been frequently stated, and that Cros and du Hauron started with this. A green or blue or yellow filter was used and the negatives thus obtained printed in red, yellow and blue. And the same principle led K. Hazura and O. Hruza[27] to carry out their researches on the subject.

The expression "complementary" is a little indefinite, as it is possible with a given red to find several greens that are complementary by means of the color top, yet the greens may have totally different spectral characteristics. For instance, it is possible to find a green that absorbs the red and another that reflects only the green of the spectrum. Both are actually of the same color and complementary to red, but if used as filters would give totally different results. The shade plays no part even with complementary colors; one given green is not only complementary to a given red but also to its mixtures with black, thus to brown, and the red would not only give with the pure green, but also with olive, a colorless color-top mixture. The requirement that the filter shall be complementary to the printing ink may perhaps be satisfactory once, but another time it may be false. It is quite another thing, however, if to the

complementary requirement of colorless color-top mixtures there is added the condition that it shall be spectrally complementary. To a given red pigment, which only absorbs the green spectral region, only that green would be complementary, which absorbed all spectrum rays with the exception of this green. Such pigments could be designated "spectroscopic complementaries." Then the absorption band of the printing ink would correspond to the transmission of the filter. Such complementaries can only be determined by the aid of the spectroscope, and this was what Hazura and Hruza tried to do; but this determination is encumbered with unsurmountable difficulties. If it were possible to sensitize plates for particular regions alone, then it would be possible to use them without filters. The axiom that the filter must be spectroscopically complementary to the printing ink agrees with Vogel's principle: printing and sensitizing colors must be spectroscopically the same, but as practically the former is not permissible, Vogel, although both requirements are correct, advanced the easier proposition.

Howard Farmer's Work.—Farmer[28] practically supported von Hübl's view and, after determining the composition of Maxwell's filters and comparing the results obtained with Ives' and other commercial filters both spectroscopically and in the camera, came to the conclusion that the Maxwell curves "as a matter of fact, do not touch the subject, as they can not be usefully dealt with in practice—they have exclusive reference to the use, for synthesis, of three narrow bands of spectrum rays, for the purpose of a scientific verification of the theory of compound colors, and have no known application to tri-color photography." In a later paper[29] the subject was still further elaborated by Farmer, with curves and spectrograms, which prove that the adoption of the Maxwell, or similar curves, as a basis for the production of three-color prints gives a fatal degradation of the colors with black.

Bull and Jolley.—A. J. Bull and C. A. Jolley[30] also dealt with this subject and pointed out that too little attention had been paid to the overlapping of the transmissions of the filters, and that the curve of photographic action never corresponded with the visual effect, so that the range of gradation, which even the best plate will record, is less than the eye can perceive; one effect being that the curve of photographic action was steeper than the visual where the filters absorb; and the dyes used, having abrupt absorptions, any shading off of the limits of the filter records was impossible.

They postulated two fundamental points: first, that since in any photographic process one prints from the parts of the negative where the light has not acted, or there in proportion where the light has not acted, each printing color should consist of white light, minus the colors recorded through the filter. Second:—that the regions where the photographic records overlap should accord in hue with the printing colors of

the red and blue negatives. After explaining how the printing colors are laid down from the negatives, the conclusions arrived at were, that "considered from the point of view of the aforementioned treatment, the tri-color process by negative synthesis would appear to depend only indirectly upon the tri-color theory of vision, for the colors are approximately at least imitated independently of the mechanism of vision. It appears from the foregoing that the region which is recorded through both the green and the red filters is reproduced in the printing color of the violet record, viz., a yellow; and that the region recorded through both the green and violet filters is reproduced by the printing color of the red record, generally a blue.

"Now, as one has, at present, to use reproduction colors which seldom give us what we require, we suggest that the amount which the red and green records fully overlap should be restricted to the region that corresponds most nearly in hue with the printing yellow to be used. Similarly, the completely overlapping region of the green and violet records should be confined to the part most nearly matching the blue or greenish-blue printing color. We consider the overlapping should never exceed this, and, on the other hand, should never fall far short of it. The gradual overlaps required by filters, based upon color-sensation curves, or intended to follow color mixture curves, are seldom or never realized in practice. They are things which are talked about but seldom produced. Mr. Ives is the only person, as far as we know, who claims to have successfully used filters whose records correspond to color mixture curves. We must give deference to Mr. Ives' statements, as he is a practical as well as theoretical worker. But some photochromoscope filters of his which we have examined only give a very crude approximation to color mixture curves, and their excessive overlap is, we have found, fatal to their use for three-color printing.

"There is another point which seems to have been lost sight of altogether, and is, moreover, an objection which has not as much significance if the filters have fairly abrupt absorptions. In all molecular phenomena, i. e., in magnetism and electric response to stimulus to living or non-living bodies, in photographic action, etc., there is a period of ineffective stimulus, e. g., in the case of a photographic plate there is a certain minimum amount of light action below which no deposit of silver occurs. Suppose now that by a certain exposure to the spectrum with suitable filter and plate, one obtained a silver deposit whose density corresponded to, say, the red color mixture curve; if we give any other exposure, then the shape of the curve ought to remain the same (except, perhaps, with great overexposure, when in any case all parts would tend to reach their maximum limit of density). But this would not be so, on reducing the exposure, the less dense parts would lose their density too rapidly and become clear glass while there was still a good deposit in the densest part."

J. Joly.—In describing his linear screen-plate process Joly said:[31] "Maxwell curves are not color-sensation curves (Abney, 'Color Vision, Tyndall Lecture,' 1895) and it is misleading to speak of the foregoing method as effected on color-sensation curves. Maxwell curves represent, in fact, the subjective synthesis of the spectrum out of three chosen wavelengths, a red, a green and a blue-violet." Joly stated that accuracy of the curves was not essential and that he actually followed König's curves.

The particular passage to which Joly referred, runs as follows: "As a matter of fact Clerk Maxwell chose colors which do not best represent the color sensations. The red is too near the yellow, as is also the green. The blue should be nearer the violet end of the spectrum than the position which he chose for it. We may take it, then, that except as a first approximation, Clerk Maxwell's diagram need not be seriously taken into account. The diagram itself shows that the color-sensations are not represented by the colors he chose. Supposing anyone, in whom the sensation of green is absent when examining the spectrum, there would, according to the diagram, be no light in the green at E. Anticipating for a moment what we shall deal with in detail shortly it may be stated that in cases where it is proved that a green sensation is absent, there is no position in any part of the spectrum where there is absence of light. Had he chosen any other green, the same criticism would have been valid. The diagram as it stands is really a diagram of color mixtures, in terms of three arbitrarily chosen colors, and not of color sensations. It merely indicates what proportions were needed of the three colors, which he took as standards, to match the intermediate spectrum colors."

Newton and Bull's Work.—These two experimenters published one of the most important papers[32] on this subject and laid down in such clear language the requirements for practical work, that but little else can be said on the subject. The paper deals with the practical performance of tri-color filters, and included an examination of many recommended at that date, with color prints of the spectrum obtainable with the same.

They stated: "While many think that there are valid theoretical reasons for the use of filter curves, they must suppose at the same time perfect photographic plates with unlimited power to render gradation, that is to say, a straight line law for photographic action, which it can never follow, the plate to be perfectly exposed and the printing to be done in perfect inks; but the spectrum reproductions with graded exposures prove conclusively that the action of a photographic plate is such that they can not be made to follow any definite set of curves, such as have been suggested in various hypotheses of tri-color reproduction. This result was to be expected, if the facts are taken into account when theorizing, for only in the case of very slow plates is there any proportionality between the light stimulus and the opacity produced in the negative, and in this case over a small part of the total range of action. Now slow plates are

useless in all cases where an extended range of gradation has to be rendered, as in oil paintings, for this purpose fast plates have to be employed, and with these there is scarcely any region of proportionality at all, as was proved by Messrs. Hurter & Driffield. Another consideration is that such curve filters, even if possible, would be difficult to make, and we think we are safe in assuming have never yet been made (although approximations have), and if they were, they would certainly break down in use. The fact that the exposure on the lower slopes of a curve will often fall below the minimum of the effective stimulus (so-called photographic inertia) causes those to be lost entirely, restricting the recorded regions to the higher parts of the curve. On the other hand, in practice it is found that they are not necessary, since the spectrum can be tolerably imitated and all natural colors fairly well reproduced by using filters and plates recording three even bands, the blue-violet extending to wave-length 5000, the green record extending from wave-length 4600 to 6000, and the red record from wave-length 5800 to the end. The ultra-violet should be cut out, since it can have no possible utility, and does in certain cases exercise a degrading effect on some colors. Such filters appear to us to give the best results throughout a range of contrast within the limits of the plate.

"The influence of the sensitiveness and the capacity for rendering gradation of the plates is very great, thus no plate records the extreme red, and with some so-called panchromatic plates used for three-color work, even a light red is recorded as black. However, in the case of pinachrom-bathed plates and collodion emulsion dyed with ethyl violet, the red is recorded much further than usual. With regard to gradation it is obvious that with a plate having a fairly steep range, the light tones of the picture will be very fully exposed before the deeper ones have time to fully impress themselves, and this becomes of the utmost importance when the complementary colors are strongly contrasted in the opposite way to the record desired, thus a dark green and a light crimson, a dark blue and light yellow, a deep orange and pale blue; in each of these pairs the dark colors should be more or less recorded and the light ones more or less stopped, but with normal filters and normal exposures on a plate having a steep gradation this is not done, as we have proved in the case of wet collodion and collodion emulsion. The ideal conditions of filter and plate would be that colors should always record evenly throughout, even with the longest exposure, not extending beyond the limits laid down, and even with the shortest, going all the way, though the deposit were less opaque. It should not be forgotten that in an ideal three-color negative the selected colors should be at least as well recorded as white itself, because if there is any less opacity, then it means the subsequent printing there of some part of the antagonistic complementary. Thus, if a white and a pure green do not record equally well through the green filter, then

it means, when printing, the degradation of the green by the addition of some crimson ink because more crimson ink will print on the green than on the white. Needless to say this is not attained in practice, and a possible compromise in the case of subjects having complementary colors, widely antagonistic in contrast, may be found in narrow banded filters, correct in the principal position. The greens are nearly always the trouble, chiefly because they are of low luminosity and do not get recorded on the plate before the complementary colors (minus-green) are recorded.

"To discover the suitability of the filters, it is not necessary to go to the length of reproducing the spectrum in half-tone in the way we have done, as a simple examination of the spectrum negatives, made in the same ratio of exposure as camera exposures, after a little experience will at once enable one to determine if the records are correct or not, and from them to prophesy with practical certainty what color will reproduce well and what badly. Nor need the spectra be reproduced in order to determine whether inks are suitable or not, for after some experience the mere printing of a solid patch, singly, in pairs, and all superposed, will indicate whether inks are suitable or not. We conclude that:—1. It is not possible nor is it desirable for any filter or plate to follow either the color sensation, color mixture, or certain calculated curves. 2. The effect of using plates, having maxima with broad banded weak filters, is to cause a degradation of any pure color occurring in the band of insensibility, therefore, plates showing gaps in the spectrum record should not be used for the green record. 3. Ultra-violet should not be recorded, as it will exercise a disturbing effect where it is reflected by colors other than blues and violets, as is the case with some browns, scarlets and yellows, these reproducing with a distinct bluish tint. 4. As much red should be recorded as possible; ethyl violet in collodion emulsion, or pinachrom-bathed dry plates, at present give the best record of red. 5. There should be no unrecorded gaps in the visible spectrum, for while these may not be important, for certain mixed colors of pale tints, they are fatal to correct rendering of colors whose spectra do not extend beyond the gap. 6. We think that we have proved that the filter records should be even, end abruptly, and overlap each other as follows, the blue-violet and the green from 4600 as far as 5000, and the red and green should overlap from 5800 to 6000.

Bull also published[33] an important paper on the relation of the selective absorption of printing colors to the errors occurring in three-color photography, which should be considered in the original as it is fully illustrated by spectral curves, which space prevents from inclusion. He pointed out that three-color negatives record five color regions; three where the light is recorded through only one filter, which are reproduced by uniform hues of red, green and blue; and two regions where the records

overlap. These latter being each recorded in two negatives and reproduced by a single printing color, that is by the yellow ink where the red and green negatives overlap and the blue-green ink where the blue and green negatives overlap. The spectrum is, therefore, reproduced by five colors only, but in ordinary color work we meet the problem of reproducing common absorption colors, each comprising more or less of the whole of the spectrum. Theory at once defines the reflection spectrum of each printing color; but one is limited by the question of permanence.

Specially selected color patches were used and their spectral reflections measured spectrophotometrically and the reproduction by the normal halftone process measured in the same way. His conclusions are: that given the ideal red and blue printing colors, that is, pigments which shall sharply reflect only one of the primary colors and absorb the other two, perfect reproduction would be possible; the yellow pigments being fairly satisfactory. Certain definite changes of color occur in the course of reproduction, namely, blues become darker and greyer; blue-greens lose their greenish hue; greens become darker and greyer; pinks acquire a yellow hue; mauves become brown; reds lose any bluish tint that they may possess; yellows are lightened without change of hue, while oranges and browns are well reproduced. No change in the character of the reproduction takes place with variation of tone with the colors yellow, blue and green. In the scale of tones between black and white there is a tendency for the middle tones to become reddish. The lightening of the yellows is due to a very light yellow ink being used. The inks are sufficiently transparent for the visual effect of superposed printings to be capable of approximate calculation, and hence the actual reproductions accord fairly well with the calculated result of superposing the component printings. The major errors of the reproductions of the colors would be removed if each ink absorbed one of the three primary regions only. In view of the general characteristics of colors produced by selective absorption, there is little immediate hope of securing printing inks of this theoretical character, therefore, it will be necessary to devise suitable methods of correction as the method of three-color printing is extended into new fields.

Eder[34] made a special study of the absorptions of the filters and reflections of the inks; but it is not necessary to more than refer to this, as the specific nature of the inks he used rather limits the usefulness of his data, and the filter effect is referred to elsewhere.

A. Payne[35] basing his arguments on the correctness of the Maxwell color curves, came to the conclusion that the minus red or blue ink should possess complete and abrupt absorption of the less refrangible rays up to E, wave-length 5270; the minus green or red ink should show abrupt absorption from wave-length 6563 to F½G at 5137, and the minus blue or yellow ink should have complete absorption to E at 5270. But he came to the conclusion that the height of Maxwell's curves, whilst of great

importance in considering the adjustment of light filters, does not influence the character of the reproduction or minus colors.

There is one method of dealing with the reproduction colors or printing inks, which possibly possesses some little merit of novelty, which so far as it has been possible to trace has not been dealt with in this particular form. If we take the spectrum as the subject to be reproduced, and Listing's table[36] of the distribution of the colors as the basis, we can argue out the absorptions of the filters as follows:

Color		Wave-length
	End	8190
Brown	Middle	7680
	End	7230
Red	Middle	6830
	End	6470
Orange	Middle	6140
	End	5850
Yellow	Middle	5590
	End	5340
Green	Middle	5120
	End	4910
Cyan blue	Middle	4730
	End	4550
Indigo	Middle	4390
	End	4240
Violet	Middle	4090
	End	3960
Lavender	Middle	3840
	End	3720

As it is the shadows, or clear parts of the negatives that print, therefore, these must represent the colors with which we print. It is clear that the minus-red, or green filter, should produce more or less clear glass where the red is to print. Therefore, assuming that the indigo and violet are produced by the superposition of some red, the limits of this filter must be those wave-lengths where the red is not printed, and from the above table this will be seen to be from 4550 to 5850. The transmission of the green filter, as defined by Newton and Bull, and which is usually accepted as correct, is from 4600 to 6000. In the case of the yellow, or minus-blue ink, we have another factor to take into consideration, and that is that the red ink is always of a more or less pink or magenta type, that is it reflects some of the blue and violet. To kill this and produce a full red, yellow must be superposed, therefore, the limit of this blue filter should be 4910 to 4000. The usually accepted limits are 5000 to 4000. In the case of the minus-blue or red filter, obviously the limits should be 5340 to the red end, but the region 5340 to 5850 is yellow, and therefore, blue must not print in this region, so that the absorption should be confined to these limits. Unfortunately the luminosity of the region from 5340 to 5850 is so great that it reflects also the region 5340 to 4910, and this would be recorded, hence it must be cut out, so that the absorp-

tion of the red filter should be from 5850. The accepted transmission is from 7000 to 5900.

The Printing Inks.—Although much information has already been given as to the theoretical printing inks in the last section, it has been thought advisable to devote more specific attention to this subject; for the mere statement that the inks must be red, yellow and blue opens up an enormously wide field of conjecture. And there are other factors to be taken into consideration, especially if we have to deal with typographic reproductions, which are independent of the hue of the actual printing inks.

The Superposition Failure.—Von Hübl[37] pointed out that it is not immaterial as regards the final effect whether two transparent colors are mixed together, or whether they are superposed, white paper being assumed ·to be the support. If the colors are absolutely transparent, and in not too thick films, then the same results are obtained; but if these requirements are not perfectly fulfilled then the results are not in accord. As a matter of fact, when two films, either of stained gelatin or printing inks, are superposed, the upper color always predominates. For instance, if a sheet of paper is printed first with a yellow and then with a red dye, there should be formed possibly a yellowish-orange; whereas actually a reddish-orange is seen. To illustrate this, a sheet of paper was printed with chrome yellow, and then with rose Bengal lake, which is very transparent, so that part of the paper was covered only by the yellow, another part only by the pink and the two colors were superimposed in the middle. From this were cut three color-top sectors, one of the superposed colors, and the other two from the pure yellow and pure red. In order to obtain color equilibrium on the top between the compound color and its constituents, it was found necessary to add to the former 30 per cent of white. The compound color was thus the same as that obtained by mixing one part of the chrome yellow with two parts of rose Bengal, instead of equal parts as theory demanded.

The transparency of a film of color depends obviously on its density, and on this and on the saturation of the color depends the amount of the superposition failure. With a saturated red film the incident light-rays will be reflected before they reach the underlying yellow film; whilst with a less saturated red film the underlying yellow color approaches almost its complete value. Thus it will be seen that irregularities of color may be caused, and if a scale of yellow is overprinted with an equal gradation of red, the lower tones will appear of a reddish-orange. Obviously this defect will appear more strongly with three superposed films, so that the lowest film of all will hardly have any visual effect in the deeper tones. This incompleteness of the admixture of superimposed layers of colors is one of the greatest difficulties in three-color printing; and is the reason why we so often have the impression that the three colors do not sufficiently

fuse, and that paucity of coloring exists. Three superposed transparent films, such as anilin-dyed gelatin, are usually free from this defect, and, therefore, we obtain a feeling of greater homogeneity, and frequently a crudeness of coloring that is objectionable.

Color Change by Juxtaposition.—The principle employed in the screen-plate processes, is that of juxtaposition of color elements, wherein light is added to light. In three-color typographic processes, less so in collotype and still less so in photogravure, we have to recognize not only juxtaposition but also superposition. The individual half-tone dots or grains do not in all cases superimpose, but lie closely juxtaposed, and the final color effect in the two cases is by no means the same. For instance, vermilion and ultramarin, when juxtaposed in minute dots, appear reddish-violet; but when superposed they form a reddish-brown. In the same way scarlet-red and green will give the impression of yellow, when contiguous; but an olive-green when superposed. These examples might be multiplied at will, but every worker with screen-plates and superimposed films can find his own examples. In the tri-color half-tone process, we have unfortunately to reckon with both factors, and the result must be different as the one or other method of admixture occurs, and this happens no matter what the spectral composition of the colored inks may be. It applies to broad and narrow banded colors, though naturally the final effect differs. Theoretically one can not have perfect color formation by superposed inks, for with three there must be some black formed. But as von Hübl[38] has pointed out, although we may mix yellow and blue, having chosen two theoretical inks, which lie at 120 degrees from one another on the color circle, there will be formed a green that is not strictly pure, in fact, it may contain as much as 50 per cent black, yet it will give the visual impression of being pure green.

The same result is obtained with an admixture of black and white, and with a mixture of from 10 to 20 per cent black, we are scarcely conscious of the fact, unless we compare it with a standard white. Equal parts of white and black mixed on the color top, appear a light grey and certainly not as lying midway between the two; a mixture of 80 parts of black and 20 parts white appears as a "mean" grey. The effect is, however, different when black and white are juxtaposed, as may be done by means of closely contiguous lines or dots. Then we obtain the impression of a "mean" grey, when the black spaces are equal to the white interspaces.

Obviously there is here the difference between objective brightness and subjective sensation. In observing the lined or dotted surface, a part of the retina is not excited by the black element, therefore, the sensation corresponds to the quantity of white actually existing; whilst to us the differences in luminosity of the homogeneous ground tones appear proportional to their white content. Fechner[39] has clearly laid down the fundamental laws on this point, and the correctness of his law can be proved

by the comparison of lineatures with homogeneous grey mixtures on the color top. For this purpose, a scale of five different luminosities should be prepared by means of black lines on white paper, the lines varying in breadth from 0.05 to 0.40 mm., and by measurement of the breadth of the lines and interspaces the luminosity of the tones can be obtained. Then by means of black and white circles of paper on the color top, the luminosity of the same can be determined, the angles of the white sectors measured and thence the brightness of the homogeneous greys calculated. The lined sheets should be observed at such distance that the lines are still distinctly visible; the surface does not appear homogeneous, but with a little experience and repeated experiment the comparison can be made without difficulty. The objective luminosity of the grey, formed on the color top, is known and the subjective sensation is obtainable from the equal brightness

FIG. 2.

of the lined surfaces. The result should be a straight line at an angle of 45 degrees, but it takes the form of a logarithmic curve, so that the subjective luminosity sensation increases in logarithmic progression to the subjective luminosity. The result is shown in Fig. 2, and it will be seen that a grey consisting, for instance, of 3.5 parts of white and 6.5 parts of black, appears about twice as bright as it ought to, and a mixture of equal parts of black and white appears to have only one-fourth black.

The same phenomenon should appear with colors when mixed with black, but the brightness of the colors alters the law. Yet this is of considerable importance in color mixtures, because only a part of their black

content is perceived, and they appear purer than they actually are. For instance, a green made by the admixture of equal parts of Paris blue and chrome yellow, contains, according to the color law, about three-fourths black, and if our sensation followed the law of color mixture, it would be a greenish grey. Since, however, the presence of 75 per cent black does not give the subjective luminosity of 0.25, but 0.64, the black sensation is so suppressed that the compound green still appears sufficiently pure.

The Theoretical Printing Inks.—If we use the chromatic circle as the starting point of our search for the correct inks we can at once determine the hues, and there should be theoretically any number that one could use. But as one of the fundamental facts is that the colors must be so chosen that they are as far removed from black as possible, and further that they shall include the whole of the spectrum colors, it becomes obvious that they must lie on the periphery of our circle at 120 degrees apart. And as we can not make yellow by the admixture of pigments this gives us our initial starting point, the one fundamental color that is fixed for us. The color that should be chosen for this should be a pure "lemon-yellow chrome" pigment, without any greenish or reddish tinge. The blue at 120 degrees from this is known as peacock blue, and the corresponding red is a crimson, pink or magenta.

F. E. Ives[40] considered that to fulfill his theoretical requirements, the inks must be perfectly transparent, and as specifically anti-chromatic as possible to the respective primary colors in white light. The minus-red, or peacock blue ink, should have a strong absorption from the red end of the spectrum up to the D line and fall off to nothing in the greenish-yellow. The minus-green or crimson, should show a strong and even absorption from over D to F, falling quickly to nothing outside these limits. The minus-blue or yellow ink should have a strong absorption in the violet and blue and fall off gradually between the F and E lines.

C. G. Zander,[41] who was a practical ink maker, stated that good lakes, that is dyes precipitated on an earthy base, such as aluminum hydrate, are the most suitable, as they distribute well, print even and do not clog up the interstices between the dots of the printing block. All the alizarin lakes, the so-called artificial madders, are perfectly permanent, even in tints, and can be produced in all shades from carmin to scarlet and purple. He defined the ideal inks, as regards color, as a "pure red pigment, one that is neither a purple nor an orange, that is it represents as nearly as possible the fundamental red sensation of the spectrum; a pure yellow, not inclined to orange or green, that is about the shade of sulphur, or as artists call it 'lemon-yellow'; the third, a neutral blue, in which neither the violet nor the green predominate. This will be the shade of cobalt blue."

One of the most important attributes of the inks is transparency, for if they are not transparent then the resultant color of a mixture will be that

of the last printed. It is not difficult to find a red that possesses this quality, and madder lake, struck on aluminum hydrate, is perfectly satisfactory and is, moreover, possessed of absolute permanency when exposed to light. The blue is more difficult to produce, the best being a cyanide blue, which can be made of the required hue, and it is transparent but it is not permanent. Ultramarine must be rejected because of its opacity, and anilin blues are much too fugitive. The most serious difficulty presents itself in the case of the yellow, and it is almost hopeless to find one that shall combine permanency, transparency and the requisite shade. It is for this reason that the yellow should always be printed first, and the blue should be laid down last because of its poor luminosity. Another important point, too often neglected by the makers, is that the inks should have the same tinctorial power. If this is not the case, then the picture will show a predominance of that color with the greatest tinctorial power. And this is particularly the case with the reds.

In a later paper[42] Zander dealt more fully with the subject and used the chromatic circle and enclosed triangle as text. He pointed out that within certain limits it is possible to reproduce the colors of nature with the exception of a few vivid hues, such as bright scarlets, orange, emerald green, ultramarine and the brilliant colors of the anilin family. The general conception of the ideal inks was that they should be complementary to the three primary colors recorded by the negatives; but this was correct only in a limited sense. Actually they should be transparent to two-thirds of the spectrum, and show a steep absorption band covering the third part, which corresponds with the main portion of the color sensation curve transmitted by the relative negative. These three absorption bands placed side by side should as nearly as possible cover the whole of the spectrum. The position of the two dividing lines of the three absorption bands should roughly be the D and F lines of the spectrum. The three pigments should *not* transmit only narrow, very luminous bands, as in that case there would be gaps of intermediate hues left, which it would be impossible to reproduce by such dark looking colors. On the other hand, if the absorption bands are too broad the colors will reflect white and approach tints, and it will be impossible to reproduce black with them. It is better, however, to err on the side of the too broad an absorption, as the colors will be of a purer hue.

The qualities of the ideal inks should be: 1. The inks should each absorb one band in the spectrum, in the red, green and violet respectively, and transmit the remainder unaffected, whilst the three absorption bands placed side by side should as nearly as possible cover the whole of the spectrum. 2. The luminosity should be as high as possible. 3. The absorption bands should terminate abruptly, roughly at the D and F lines respectively. If the absorptions terminate abruptly, variation in the quantity of the ink will not cause so much variation in the several impressions.

The theoretic inks are unstable anilin colors, and they have but poor covering power and reflect mostly too much white, that is, they will not give good blacks, and variations in the flow produce great variations in the pulls. For the permanent inks the yellow should be of a slightly greener hue than is generally employed, because the red as a rule contains too much violet. Practically if the position of the red and blue be moved then the yellow must be shifted also. With regard to the permanent inks, both the red and blue lack luminosity and are usually deficient in violet for the red, whilst the blues are deficient in green. Variations in the yellow are more noticeable than in the other colors. The three inks must be of fairly equal working consistency, and when superposed should produce a neutral grey or black. The yellow and red superposed in equal proportions should produce a scarlet, approximating the primary red sensation. The yellow and blue in the same way should give an emerald green approaching the F line, and the red and blue should make a violet midway between ultramarine and methyl violet.

Von Hübl[43] naturally dealt with this subject at some length in his book, but probably the best summary of his views is as follows: The three colors must so behave that mixtures of any two must be of equal purity. These requirements are only satisfied by the colors, yellow, crimson and blue-green, for these give an equally pure vermilion-red, violet-blue and green. The colors chrome yellow, carmin lake and Paris blue give only an impure green, the blackness of which can only be estimated by comparison with a pure green. A blue has been recommended as a printing ink, which approximates to ultramarine, because it was assumed that pure blue, red and yellow must correspond best to theoretical requirements. Pure blue, that is one which excites the blue sensation without the secondary excitation of green or red, is, however, complementary to yellow, and can, therefore, under no conditions be used to form a useful green.

The green present in a painting is never pure, but consists of green and black, and photography decomposes it into its three constituents—blue, yellow and red. Only when the blue and yellow give a pure green will the necessary degree of sadness (or blue blackness) be formed; if, however, the mixture of blue and yellow is already degraded, there will be formed by the subsequent addition of the red only a greenish-grey. For the existing three-color prints the deficiency in the green is characteristic; it is solely to be ascribed to the use of incorrectly chosen fundamental colors, and only to be avoided by the use of blue-green, crimson and yellow as printing inks.

But there are two further reasons in support of the choice of the above-mentioned fundamental colors. The intensity of the three inks must obviously be so chosen that red and yellow, yellow and blue, and blue and red produce the mean sensations orange, green and violet. If we choose, however, such intensities in Paris blue, carmin lake and yellow,

the result when all three colors are mixed together is not black, but brown. In consequence of the ignorance of this fact, it is contended that three-color printing can not produce black and grey, and thence has been deduced the necessity of a neutral grey plate. When using blue-green, crimson and yellow, there is nothing, from a theoretical point of view, that stands in the way of the formation of black or grey.

The third reason why blue-green, crimson and yellow must be chosen as fundamental colors lies in the difficulty or impossibility of splitting up the colors of the original by photographic means into other colors. The negative for the yellow printing should have the blue and red opaque; the yellow, on the other hand, should be clear glass. This requirement is only fulfilled when crimson is chosen as the fundamental color for red, which must reflect the whole of the blue rays, and therefore act on the blue-sensitive plate as white. A pure yellow can never be photographed with red so that the former acts like white and the latter like black, for the red color reflects almost exclusively the orange and red rays; the yellow pigment, on the other hand, reflects the green, yellow, orange and red rays.

We must have a plate which will reproduce the red like white, the yellow like black. Even if one sensitizes for the extreme red, the yellow pigment will still act, for it reflects red rays. This fact can not be gotten over by the most vigorous sensitizer nor by any filter. It is only possible to split up the original colors into three fundamental colors, which show as far as possible striking differences, for only then can the requirements, that each of the three negatives should have two colors opaque and the third transparent, be fulfilled. With the fundamental colors—blue-green, crimson and yellow—this can be easily done. A crimson pigment of the particular hue of dry erythrosin collodion reflects red, violet and blue rays. A yellow dye, however, as already mentioned, reflects green, yellow, orange and red rays. A violet-blue sensitive plate will, therefore reproduce the former like white, the yellow like black, and thus separate the two colors in the desired way. The vermilion-red of the original will then be formed by a mixture of equal parts of yellow and crimson, for it will be quite satisfactory if the vermilion be equally inactive for the yellow and red printing. If, however, one uses for printing a carmin lake then there will always be formed an orange instead of the vermilion.

It will thus be seen how important it is to choose the correct fundamental inks, and that it can not be dismissed with the apodictic statement that "only three stable inks are required." If there are at present no stable suitable inks we must seek for them, and if we can not obtain them we must be content to use the best available and take into account the consequent faults. If pure greens are wanting, if orange replaces vermilion and violet-blue, if we can obtain no black or greys, if the negatives, in spite of correct filters, will not show the correct appearance, we must seek

the fault where it actually lies—in the inks—and not strive after an impossible separation of colors.

Much perplexity has been caused by the shibboleth of the "impurity" of the inks. It is said that correct reproduction of colors is not possible because the inks, in comparison to the spectral colors are "impure." The dinginess of our inks can only have the effect of making compound colors appear dingier than in the original, but on the correctness, that is on the the tone of the color it has no effect. The fact that the colors reflect other rays of the spectrum has also no bearing on the possibility of three-color printing. Colored glass also lets through many rays yet it acts exactly as though it passed naught but pure spectral rays.

The so-called impurity of the colors has nothing to do with the incorrect reproductions in three-color printing, but it has been found a plausible ground for the incompleteness of the process from a want of complete theoretical knowledge.

To match the theoretical colors von Hübl recommended erythrosin, filter yellow and patent blue in the strengths 0.5, 1.0 and 2.0 per square meter.[44]

E. Sanger-Shepherd[45] defined the printing colors as pink or magenta, such as is obtained by admixture of the fundamental red and blue-violet; a pure yellow formed by the admixture of the fundamental green and red, and a bluish-green formed from the fundamental green with the blue-violet. Pink, crimson or magenta are synonymous.

Abney[46] dealt with the subject of printing with transparent inks or colors, and though there is no doubt that he had in mind transparencies produced by superposed films, a brief note as to his conclusions may be worth recording. His whole argument is based on the color sensation curves, as determined by him, and he said: "arguing then from this we find that the inks to be used for printing in transparent colors should be such that their principal intensity, when superposed in pairs, should be near the colors which should be used for the triple projection process, and should end not far from this point in the spectrum. The overlap of the absorptions should be as far as possible, as is consistent with sufficient intensity, if great purity is required. In choosing colors a great point to aim at is that they should, when of full intensity, match the spectrum color (or mixture in the case of purple or pink) with only the smallest addition of white light to this latter. This will indicate that they do not transmit so much of the spectrum as to be harmful. If the intensity of the spectrum colors, when the spectrum is of a certain brightness, matches that of the inks, it may be taken as indicating that the latter are of proper intensity, and finally these intensities of ink when superposed should give a black. If the black is of reddish or greenish cast, it shows that the colors have not been rightly chosen."

A. J. Newton[47] examined the colors used for producing carbon prints,

dyed transparencies and tri-color typographic prints, and proved that none is theoretically correct. Taking as his starting point the negatives with the color records as laid down by him and Bull (see p. 16), he came to the conclusion that the ideal inks should have abrupt absorptions limited by the complementaries of the same; that is to say, the yellow should be the sum of all wave-lengths between 5000 and 7000; the red should be the sum of all colors between 4600 and 4000 plus 6000 and 7000, and the blue the sum of all between 5800 and 4000.

R. J. Wallace[48] accepted the absorptions of the correct filters as red from 7000 to 5900; the green from 6000 to 4900, and the blue from 4000 to 5000. He concluded that the inks must be complementaries to these and advanced proofs in the shape of three superposed films, stained with the correct dyes. L. P. Clerc[49] dealt with this subject at some length, and with the ideal and commercial inks. He set the theoretical colors as a yellow, which can be matched by wave-lengths 5695 to 5700; a red, that does not exist in the spectrum, but which can be matched by rhodamin S or erythrosin solutions, which give a color that is variously termed pink, crimson or magenta; and a blue simulated by wave-lengths 4880 to 4885.

Von Hübl[50] suggested the following apparatus, Fig. 3, for the measurement of the colors of pigments. This may be considered as a modified

Fig. 3. Von Hübl's Colorimeter.

Maxwell color box, or chromoscope. The ink or pigment is placed at *O O*, and illuminated by daylight or artificial light, a standard light. Its image is projected by the lens *m* on to the right-angled prism *e*, thence to the half of the eyepiece *1*. The comparison color is formed by synthesis of the three beams *W, W, W*, passing through the three apertures *B, G, R*, where are placed the three color filters *b, g, r*, which are pure blue, green and vermilion. The light from these filters is reflected from the transparent mirrors *S¹, S², S³* and projected by the lens *L* to the upper half of the

diaphragm *e, e.* Neutral wedges *K* for the pigment to be examined, and *k, k, k* for the standards are used to reduce the light. The eyepiece *1,* focused for the diaphragm, serves for comparison of the two fields.

The filters for this instrument were made as follows: for the red or vermilion tartrazin 2 g., erythrosin 1 g.; for the blue, blue carmin 1 g., acid rhodamin 2 g.; for the green, tartrazin 1.2 g., blue carmin 1 g.; these quantities being per square meter of area. As an example of the analysis of a pigment the following may be taken as typical: a light chamois paper was measured, and found to be matched by 19 per cent blue + 38 per cent green + 47 per cent red. Then as equal parts of the three colors form white, this resolves itself into 19 white + 19 green + 28 per cent red. As equal quantities of red and green make yellow, the final reading becomes 19 white + 19 yellow + 9 per cent red. The amounts of the three colors being obtained by the shifting of the neutral wedges, which are provided with graduated racks and pinions.

L. Geisler[51] suggested the use of the Maxwell color top for ascertaining the intensity of the printing inks, with the view of obtaining blacks and greys, without the predominance of one or the other color. Slotted cards were covered with the inks to be tested in full intensity, and then arranged on the color top, so that they showed equal angles. On rapidly revolving the same, it was at once seen if any color predominated, and the angles of the sectors could be altered till a perfectly neutral grey was obtained. If this could not be done, then the inks were to be rejected. As an example, let it be assumed that the angles of the sectors to obtain a neutral grey were respectively, yellow 120, red 140 and blue 100 degrees. It is at once clear that the yellow and blue are more saturated than the red, and the latter must be taken as the standard. To obtain equilibrium the intensity of the blue and yellow must be reduced by diluting the inks with varnish. Comparing the red, the least saturated, with the others, one can write:

$$\text{for blue } \frac{\text{actual intensity}}{\text{highest intensity}} = \frac{140 \text{ deg.}}{120 \text{ deg.}}$$

$$\text{for yellow } \frac{\text{actual intensity}}{\text{highest intensity}} = \frac{140 \text{ deg.}}{120 \text{ deg.}}$$

One ought then to mix 100 parts of blue ink with 40 parts of varnish, and 120 parts of the yellow with 20 parts of varnish to obtain in each case 140 parts of tint, which should be used.

Clay's Researches.—One of the most important papers on the application of Maxwell's curves to subtractive color work was by R. S. Clay[52] and his reasoning is so complete and detailed that no excuse is needed for dealing with it at some length, particularly as very little attention has been given to it.

He pointed out that Maxwell's curves were derived by adding three monochromatic lights, and are only true of such colors. All colors, including white, can be matched in hue and luminosity by combining the three fundamental colors as lights. Theoretically it is possible to do the same with printing inks, but the result would be a very dark picture of no practical use, as it would have to be examined in full sunlight.

There is a fundamental difference in mixing colored lights and colored pigments. In the first case, if two filters transmit a common color, the result on the screen is a doubling of the amount of the common color. But in printing, if a spectrum color is completely absorbed by one ink, and is also absorbed by another, the total light absorbed by superposition is not twice that removed by the single ink. The law is a geometrical and not an arithmetical one, and if two inks separately transmit one-tenth of the light, the two together would not transmit one-twentieth, but only one-hundredth. This is of extreme importance in "process" work, for there the inks are always printed full strength, and the tint is regulated by the

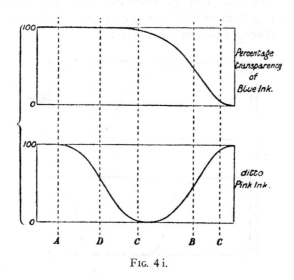

Fig. 4 i.

size of the dots, that is by the percentage area of the paper covered by the ink.

Each color is produced by similar dots, and when the three inks are printed, these dots partly overlap one another. As the dots are very closely spaced it is impossible in ordinary commercial printing to control the extent of the overlap; that is to say, the successive impressions will, owing to minute differences in "registering" the paper, have the dots of the different colors more or less displaced in relation to each other. If, for instance, the blue dots and the pink dots happened each to exactly cover half the area, in one impression they might be exactly superimposed, and in another

they might hardly overlap at all. In the former case half the area will be printed with both pink and blue, and half will be white. In the latter case half the area is printed with blue and half with pink, and there is no white left. If these impressions are to be equally good, the resulting absorptions through the spectrum should be the same in the two cases.

"Let the adjoining curves, Fig. 4 i, represent the percentage transparency of the inks. At *A* both inks are perfectly transparent, and as the color is not absorbed by either, it can of course make no difference to this color if the dots are superimposed or not. At *B* each color absorbs half the light and reflects half the light. When the dots are printed adjacent to one another, half the total light of that color will be reflected. When they coincide, half the paper is left white; this reflects all the light it receives, which is half the total. The blue ink on the other half absorbs half the light which it receives of this color (*B*), and the pink absorbs half of what is left, so that finally a quarter of the light falling on that half of the paper—or one-eighth of the total light of this color—is reflected. Adding this to the white reflected from the white half, we see that *five-eighths* of the total light of this color is now reflected, instead of the one-half which is reflected when they are adjacent.

Fig. 4 ii.

"The color at *C* is entirely absorbed by one ink and is unaffected by the other. The pink ink absorbs the light which falls on its half, and as the blue ink does not affect this color it will not matter whether it is on the pink or adjacent to it. Also at *D*, where one ink is partly transparent and the other completely so, it cannot matter whether the perfectly transparent one is above or adjacent to the other. If one or other of the inks is perfectly transparent at every point, the extent to which the dots overlap is immaterial. If the absorptions of the inks overlap one another, as in Fig. 4 ii at *E*, the results are much worse. This color is entirely

absorbed by each ink. If then the dots are adjacent, the color is absorbed everywhere and none reflected. But when they coincide half the paper is white, and therefore half the total light of that color is reflected. Thus the reflected light of that part of the spectrum where the absorptions overlap will vary from nothing up to half the total light.

"In the case of the pink and blue inks this overlapping would occur at the yellow, where their absorption terminates, the very brightest part of the spectrum. According to Abney's curves the yellow from 5600 to 6000 is about 50 per cent of the whole white light. Thus the addition of one-half of this band of light would be sufficient to entirely spoil the result, and this addition would be produced by a displacement of the dots of about 1/300th of an inch. It is obvious, then, that in process work the absorptions of the inks must not overlap. On the other hand, if we are to be able to produce a black, the absorptions must meet. Thus in process work (in the case of the blue and pink inks at least) the absorptions must just meet without overlapping, and, therefore, they *must end abruptly*. It will not matter so much in the case of the yellow and pink inks, for the part of the spectrum where their absorptions meet is of far inferior luminosity."

After dealing with the differences to be met with in collotype printing, and the differences in the curves of thin and thick layers of inks and the defects arising from the fact that the absorptions of the thin layers are different from those of thick layers, which means that the hues in the high-lights will not be the same in the half-tones or shadows. Clay says: "Assuming now that the absorptions should be abrupt, the next question is, what limits should they have to give the best effects? If one is at

Fig. 5.

A and the other at *B*, Fig. 5—in which equal heights of each color will give white—the yellow and blue inks will be complementary to the color sensations, but they will be very pale, for they reflect large quantities of all three colors. The pink will be very dark, it will reflect only a very small amount of the red sensation, and as the violet is not equal to the red, it will not be complementary to the green sensation. It could be made so by shifting *A* further to the violet, so as to reduce the violet reflected by the

pink ink—in fact, until the areas of the red and violet are equal. It is obvious that this would give absurd inks; the yellow and blue would be so pale as to be mere tints, and the pink so dark as to appear purple. If the absorptions are supposed to end at A' and B', the spectrum will be much more evenly divided between the three colors, each will be slightly pale, but now *neither* will be complementary to the color sensation. For instance, if the yellow ink is to be complementary to the violet sensation, it should absorb either violet or violet and equal amounts of red and green, measured by equal areas on the above curves. But at A' (or at any other line between A and B) the green sensation is evidently in excess. In the same way if the absorption of the blue ink extends from the red end of the spectrum beyond B, green is absorbed as well as red, and the ink can not be complementary to the red sensation. To make this ink complementary, it must have another absorption band somewhere in the violet, and the difficulties we have been considering above will be introduced, for there will then be a part of the spectrum absorbed by more than one ink, namely, by the yellow and the blue, and in places where these inks are printed side by side the absorption of this color will be twice as great as in those where they are on top of one another.

"Thus the blue ink should *not be the complementary* of the red sensation. And in fact the ink will be far from the complementary to the red. I find that by taking the areas of Abney's curves up to B' with a planimeter, that it should very nearly match the green at about 50.3. The yellow ink would be made complementary to the violet by ending the absorptions at A, but it would be very pale, for it would transmit a large amount of white, as there is a large amount of violet beyond A. The result will be an unnecessary amount of white in the final picture. The result will be better if the absorption reaches to A'. Thus this ink also should *not be complementary* to the violet sensation. The pink at the red end of the spectrum transmits red and green, and at the other end chiefly violet and green. If the violet is equal to the red it will be complementary to the green sensation. This can be achieved by moving A towards the violet end, but only at the expense of the yellow, which would be rendered very pale. So this ink also should *not be complementary*."

Clay suggests that the eye is a fairly good judge of the three primary colors—at least, of their hue—so that if the inks be printed in pairs a fair estimate can be made of their correctness. The violet produced by the pink and blue should be almost pure, containing only a very small percentage of white. The green should very closely match the green sensation. But the red will contain some green and should about match wave-length 6740. The only true test is with the spectroscope and then: 1. The inks should each absorb one band of the spectrum in the red, green and violet respectively. 2. Must transmit the remainder unaffected. 3. Must absorb the whole between them. 4. For half-tone work the

absorptions must end abruptly, especially in the case of the pink and blue inks. 5. The limits of the absorptions should be so chosen that the added white may be distributed through the spectrum as nearly as possible proportionally to the luminosity of the spectrum. 6. The luminosity of the resulting colors in matching the spectrum should be as high as possible. 7. The inks will not be complementary to the color sensations. For 3 the absorptions must meet, for 2 they must not overlap; thus 2 and 3 lead to 4.

Four-Color Printing.—Too often tri-color photomechanical prints are by no means satisfactory as regards color rendering, particularly in the greens and blacks, mainly due, as will have been gathered, to the defects of the printing inks employed. These defects can only be remedied by fine etching of one or more of the blocks. To improve this state of things, it has been suggested to use a fourth printing block, especially for the greens.

Eder[53] said: "according to Hering there are four fundamental colors, red, yellow, green and blue. Working according to this theory, all the manipulations necessary for three-color printing may be adapted without

Fig. 6.

difficulty to a four-color system, and a four-color print would be the result, in the production of which there is nothing actually to overcome, and the system ought to give satisfactory results."

Von Hübl[54] explained the theory of the four-color process as follows: For a four-color print, against which there are no theoretical objections,

FIG. 7. Zander's E.P. 27,023, 1895.

the fundamental colors must be so chosen that they are at equal distances on the periphery of a color circle. As all compound colors can then be enclosed in a square, which covers almost the whole of the color circle, it is not necessary to lay such stress on the purity of the colors. Thus, for instance, the stable colors, chrome yellow, alizarin lake, then a green and a blue lake, will be quite satisfactory to reproduce all colors.

Hering's fundamental colors were practically blue, wave-length 4680, yellow at 5730, green at 5100 and a red complementary to the green, a color actually wanting in the spectrum, and which would be usually called a crimson.

C. G. Zander[55] patented a four-color process and proposed magenta red, lemon yellow, emerald green and ultramarine blue; but variation in these colors was permissible. He defined them as for the yellow, any hue between wave-lengths 6000 and 5600; for the green from 5500 to 5000; for the blue from 4900 to 4200; and for the red, that hue complementary to the chosen green; but the wave-lengths of the preferred colors were, 5890, 5220, 4880 and red complementary to the above green.

Whilst this process has produced some good results, it is an open question whether they are better than the best three-color work; and one has the additional chance of error in a fourth negative, a fourth printing block and a fourth registration. In Fig. 6, is shown the position of the colors chosen by Zander in the chromatic circle at the points *1, 2, 3, 4;* whilst the theoretical colors are shown by the triangle *4, 5, 8;* and the usual permanent colors by the points *7, 5, 6.* Zander shows the absorptions of his filters and the corresponding inks with their superposition in Fig. 7.

As complementary colors have been frequently mentioned, it may be useful to give the following simple formulas, suggested by V. Grünberg[56] for finding the wave-length complementary to any given wave-length:

$$\lambda = 559 + \frac{424}{498 - \lambda}$$

And

$$\lambda_1 = 498 - \frac{424}{\lambda - 559}$$

In which λ is the wave-length of the light towards the red end and λ_1 that towards the violet. For instance, suppose it is desired to find the complementaries to 470 and 615, then:

$$\lambda = 559 + \frac{424}{498 - 470} = 559 + \frac{424}{28} = 559 + 15 = 574$$

$$\lambda_1 = 498 - \frac{424}{615 - 559} = 498 - \frac{424}{56} = 498 - 7.5 = 490.5$$

It may be as well to interpolate a note as to the various methods of expressing wave-lengths. The unit of length is the ten-millionth of a millimeter, adopted by Ångstrom, the great Swedish physicist, who first made a fairly complete map of the Fraunhofer lines in the solar spectrum. This is known as the Ångstrom unit, also written A. U. or t. m. and is frequently called a tenth-meter. It is also common to adopt other expressions, and if we select the D_1 line, we may describe this as 0.589616 μ or microns, or 589.616 $\mu\mu$ or millimicrons, also written mμ, or 5896.16 A. U. or t. m., or as 5.89616×10^{-5} cm.

1. Handbuch, 1905, **1**, I, 427; Silbermann, **2**, 393; J. B. Janku, "Der Far-benstich als Vorlaufer des photographischen Dreifarbendrucks," Halle, 1899, 15; Process Photogram, 1896, **3**, 99; C. Grebe, Zeits. Repro. 1900, 2, 130.
Le Blon, also spelt Le Blond and Leblon, published a book "Il Colorito, or the harmony of colouring in painting, reduced to mechanical practice, under easy precepts and infallible rules," London, 1722; also published in French, "L'Harmonie du Colorit dans la peinture reduite à des principles infallibles." A second edition was published by J. Gauthier-Dagoty in 1765. For a sketch of Le Blon's life see H. Schenkan, Penrose's Annual, 1915, **20**, 37. Cf. Goethe's Werke, **54**, Cotta edit. 160.
2. Newton's discovery of the solar spectrum was communicated to the Royal Society in Feb. 1672; but in an accompanying letter to the Secretary, the actual discovery was stated to have been made in 1666. Cf. Newton's "Optics, or a treatise on the reflections, refractions, inflections and colours of light," 1704.
3. Zeits. Repro. 1900, **2**, 130; Handbuch, 1905, **1**, I, 426.
4. "Opticorum libri sex." Antwerp, 1613.
R. Waller, "A Catalogue of simple and mixte Colors," Phil. Trans. 1686 carried out researches on subtractive synthesis.
5. Edin. Trans. 1831, **12**, I, 123; Pogg. Annal. 1831, **23**, 435; Athenæum, 1855, 1156; Report Brit. Assoc. 1855, **2**, 7; "Treatise on Optics."
6. "Versuche u. Beobachtungen über die Farben des Lichtes." 1792. Abst. in J. C. Fischer's "Geschichte der Physik," 1806, 7, 50. Cf. J. Waterhouse, Brit. J. Phot. 1909, **56**, Col. Phot. Supp. 3, 34, who gives a very good sketch of Wünsch's work.
7. Trans. Roy. Soc. Edinburgh, 1857, **21**, 275; Proc. Roy. Soc. 1855, 21. Cf. Howard Farmer, "Clerk Maxwell's Gifts to Photography," Brit. J. Phot. 1902, **49**, 566; Anon. ibid. 64. B. Donath, "Die Grundlage der Farbenphotographie," Brunswick, 1906, 69. L. Vidal, "Traité pratique de Photochromie," Paris, 1903, 53. G. Niewenglowski and A. Ernault, "Les Couleurs et la Photographie," Paris, 1895, 324. Handbuch, 1905, **1**, I, 427.
8. Proc. Roy. Soc. 1859, **60**, 10, 404, 484; Phil. Trans. 1860, 57; Proc. Roy. Inst. 1862, **3**, 370; Brit. J. Phot. 1861, **8**, 272; Phot. News, 1861, **5**, 375; Phot. Notes, 1861, 169; Bull. Soc. franç. Phot. 1897, **44**, 547.
9. Phot. Notes, 1861, 169; Brit. J. Phot. 1861, **8**, 272. Cf. E. J. Wall, Brit. J. Phot. 1921, **68**, Col. Phot. Supp. 14, 47.
Howard Farmer, ibid. 1902, **49**, 566, determined the composition of the three liquid filters by means of a Maxwell color box.
10. This paper appears in "La Triplice Photographique des Couleurs et l'Imprimerie," by Alcide du Hauron, 1897, 448.
F. E. Ives, Traill Taylor Memorial Lecture, Phot. J. 1900, **40**, 99; Phot. News, 1900, **44**, 764; Brit. J. Phot. 1901, **48**, 47, 77, 127, 191, 223; Brit. J. Almanac, 1902, 861, throws considerable doubt, without any justification, on the authenticity of this document. Cf. Photo-Era, 1921; Phot. Ind. 1921; Brit. J. Phot. 1921, **68**, Col. Phot. Supp. **14**, 4.
11. Brit. J. Phot. 1865, **12**, 547, 601. Cf. ibid. 1918, **65**, Col. Phot. Supp. **12**, 16.
The editors prefixed to the first of these communications the following note: "The following speculation concerning the production of photographs in colors by one who, when miniature painter to the Queen, was the first to take a photograph on paper professionally, will, we feel assured, be received by our readers with much interest."
12. Jahrbuch, 1895, **9**, 329.
13. Fritsch delivered four lectures in 1902 and 1903 before the Freien photographischen Vereinigung, of Berlin, which were subsequently printed in pamphlet

form, under the title: "Beiträge zur Dreifarbenphotographie," Halle, 1903. The quoted passage appears p. 1.

14. Bull. Soc. franç, Phot. 1869, **15**, 122, 152; Brit. J. Phot. 1869, **16**, 283; Phot. News, 1869, **13**, 319.

K. Versnæyen gives full translations of du Hauron's and Cros' papers, Phot. News, 1879, **23**, 229, 254. Cf. H. Krone, "Die Darstellung der natürlichen Farben durch Photographie," Weimar, 1894, 80; L. Vidal, "Traité pratique de Photochromie," Paris, 1903, 53; E. Coustet, "La Photographie en Couleurs," Paris; Handbuch, 1905, **1**, I, 430; G. Niewenglowski and A. Ernault, "Les Couleurs et la Photographie," Paris, 1900, 48; Pract. Phot. 1879, **3**, 670; L. Vidal, Bull. Soc. franç. Phot. 1879, **26**, 211; Phila. Phot. 1869, **6**, 414; Penrose's Annual, 1909, **15**, 105; Brit. J. Phot. 1874, **21**, 256, 352, 375, 448, 519; 1875, **22**, 235, 524, 548; 1876, **23**, 377; 1877, **24**, 152, 163, 181, 212, 238, 249, 259; Sci. Amer. 1879, 2781.

15. "Les Couleurs en Photographie, Solution du Problème," Paris, 1869, 39. Cf. Bull. Soc. franç. Phot. 1874, **21**, 136, 163, 298. For a complete list of du Hauron's publications etc., see Phot. Times, 1903, **35**, 207; Bull. Soc. franç. Phot. 1914, **61**, 149. Cf. Brit. J. Phot. 1920, **67**, Col. Phot. Supp. **14**, 38.

16. Phot. News, 1869, **13**, 483; 1879, **23**, 367; Soc. franç. Phys. 1879, 35; reprinted Phot. Coul. 1907, **2**, 24.

It is interesting to note that Cros had deposited with the Académie des Sciences a sealed envelope in 1867, containing his theories; Compt. rend. 1876, **82**, 1514; **83**, 11, 291; **87**, 1026; **88**, 379. A friendly controversy appeared in Cosmos, July, 1869, between Cros and du Hauron, and they both agreed that though working independently, they had deduced the same results from the same principles. Cf. "La Triplice Photographique," Paris, 1897, 172; Bull. Soc. franç. Phot. 1876, **23**, 174; Phot. Mitt. 1892, **29**, 311, 324; "Les Couleurs réelles en Photographie," E. N. Santini, 1899; C. Gravier, Photo-Gaz. 1898, **9**, 26, 54, 84, 207, 229.

17. "Les Couleurs en Photographie, Solution du Problème," 1869, 39; Phot. News, 1880, **23**, 577; F. P. 83, 061, 1868; E. P. 2, 973, 1876. Cf. H. W. Vogel, "Die Photographie farbiger Gegenstände," 1885, 132; E. J. Wall. Phot. J. 1895, **35**, 173. Ives casts ridicule on du Hauron's colored glasses, but refers to his first work, above cited, and totally ignores his two patents, which enter much more fully into the preparation of the filters. Ives himself, Phot. J. 1896, **36**, 315; Brit. J. Phot. 1896, **43**, 764, used colored glasses coated with varnishes.

18. "Die Photographie der farbiger Gegenstände," Berlin, 1885, 136; Vogel's Handbuch, 1894, **2**, 227; Phot. Times, 1885, **15**, 475; Phot. Mitt. 1885, **22**, 85; Phys. Gesell. Verhandl. 1890, **9**, 73. Cf. H. Krone, "Die Darstellung der natürlichen Farben," 1894, 85; Phot. News, 1885, **19**, 434; Ann. Phys. Chem. 1886, **28**, 130; Nature, 1886, **34**, 354. E. J. Wall. Phot. J. 1894, **18**, 292; 1898, **38**, 297.

On the controversy Ives v. Vogel, see Brit. J. Phot. 1892, **39**, 318, 333, 351, 365, 382, 430, 446, 462, 479; Vogel's Handbuch, 1894, **2**, 239; Anthony's Phot. Bull. 1885, **16**, 547; 1891, **22**, 680; Phot. Times, 1885, **15**, 158.

Vogel entered into partnership with H. Ulrich, in Berlin, Brit. J. Phot. 1899, **46**, 20, to exploit his process by collotype printing and some excellent results were published. E. Vogel, the son, formed the Vogel-Kurtz Co., in New York, to use the same process, but in half-tone. Cf. Brit. J. Phot. 1899, **46**, 395; Process Photogram, 1899, **6**, 113 on the Kurtz patent U.S.P. 498,396.

19. Brit. J. Phot. 1898, **45**, 133, 167.

20. J. Frank. Inst. 1888, **125**, 345; 1889, **127**, 54, 140, 339; 1891, **132**, 1; Brit. J. Phot. 1888, **35**, 219, 315, 330, 347, 479, 806; 1889, **36**, 731; 1891, **38**, 56, 103, 118, 137, 425; Phila. Phot. 1888, **25**, 178, 761; Phot. Times, 1888, **18**, 571; 1890, **20**, 79, 91, 103, 112; 1893, 23, 301, 325; Phot. News, 1888, **32**, 789, 802.

W. Kunze, D.R.P. 347,436, 1920, patented the principle that the absorption curves of the taking filters and reproduction colors should be in accord with the fundamental sensations.

21. "A New Principle in Heliochromy," 1889, 3. Cf. J. Soc. Arts, 1893, **41**, 663; 1898, **46**, 548; Brit. J. Phot. 1891, **38**, 56, 103, 118, 137; 1892, **39**, 26, 57, 295, 357; 1893, **40**, 59, 328, 344, 357, Supp. 40, 83; 1895, **42**, 103, 579; 1898, **45**, 35, Supp. 4; Anthony's Phot. Bull. 1891, **22**, 115, 146, 207, 221, 239, 745; Phot. News, 1890, **34**, 153. Technology Quart. 1894, **7**, 317; abst. J. S. C. I. 1895, **14**, 987.

22. U.S.P. 432,530, 1890; Jahrbuch, 1891, **5**, 174; 1892, **6**, 112.

In this patent Ives claims the superposition on a screen of three heliochromic transparencies, although this had been suggested by Clerk Maxwell, and shows three superimposed lanterns. According to G. H. Niewenglowski and A. Ernault, "Les Couleurs et la Photographie," 1895, 353; L. P. Clerc, "La Photographie des

Couleurs," 1899, 159; La Phot. 1895, Feb. G. Lippmann anticipated this: "The lens front of an ordinary camera carried three small lenses, arranged in a straight line, and provided respectively with three cells filled with suitable solutions; for every objective there was a plate orthochromatized for the rays, which the cells transmitted; three positives were printed and placed in the plane of the ground glass and strongly illuminated, and suitably colored glasses were placed in front of the lenses or positives; there was thus obtained on the screen an image of which the size could be varied by interposing a divergent or convergent lens between the screen and the objectives. It was possible to produce, with the same arrangement slightly modified, an aerial image; the object was then seen in colors and relief." L. Vidal, Jahrbuch, 1892, **6**, 303; Bull. Photo-Club, Paris, 1892, pointed out that Cros, in 1869 (see p. 8), and du Hauron (see p. 4), had suggested the superposition of the three images and that he himself had shown three-color transparencies in the same way at the Conservatoire des Arts et Métiers on Feb. 1, 1892, and on Mar. 4, 1892 these were shown before the Société Française de Photographie. A. W. Scott, E.P. 19,402, 1890; abst. Brit. J. Phot. 1907, **54**, Col. Phot. Supp. **1**, 7 used four glasses; Anthony's Phot. Bull. 1891, **22**, 118. For description of A. Miethe's apparatus see Brit. J. Phot. 1905, **52**, 268; Phot. Chron. 1905, **12**, 9; Zeits. wiss. Phot. 1905, **3**, 40; Phot. Korr. 1905, **42**, 21.

23. Traill Taylor Memorial Lecture, Phot. J. 1900, **40**, 100; Brit. J. Phot. 1900, **47**, 743, 757, 773, 788; 1901, **48**, 77, 127, 141, 191, 223, 430, 511; Brit. J. Almanac, 1902, 86; Phot. News, 1900, **44**, 764, 781, 795, 809, 832, 842; J. Soc. Arts, 1892, **40**, 687.

A long controversy ensued between Ives and Howard Farmer, Brit. J. Phot. 1901, **48**, 63, 68, 77, 127, 141, 154, 172, 190, 223, 430, 512, in which the latter contended that Ives' conclusions were wrong and useless for practical work.

24. Brit. J. Phot. 1901, **48**, 15.

25. Brit. J. Phot. 1900, **49**, 23; 1903, **50**, 27; 1906, **53**, 489; 1907, **54**, 315; "Die Dreifarbenphotographie," 1st edit. 1897, 92; 2nd edit. 1902, 102; 3rd edit. 1912, 98; H. Klein's translation, "Three-Color Photography," 1915, 74; Phot. Coul. 1906, **1**, 27; 1907, **2**, 65; Camera Craft, 1903, **6**, 208.

26. Phot. Korr. 1893, **30**, 564; 1894, **31**, 564; Mon. Phot. 1894; Bull. Soc. franç. Phot. 1894, **41**, 166; Brit. J. Phot. 1898, **45**, 133, 310; Amat. Phot. 1894, **19**, 25; Photogram, 1894, **1**, 36; Process Photogram, 1898, **5**, 51, 66; abst. Phot. J. 1894, **34**, 261. Cf. H. Krone, "Die Darstellung der natürlichen Farben," 93; von Hübl, Brit. J. Phot. 1907, **54**, 315.

27. Phot. Korr. 1893, **30**, 374. Cf. O. Hruza, Phot. Korr. 1893, **30**, 277; Jahrbuch, 1894, **8**, 52; H. Krone, loc. cit. L. Pfaundler, Jahrbuch, 1906, **20**, 53.

28. Phot. J. 1901, **41**, 303; Brit. J. Phot. 1901, **48**, Supp. 63, 503, 534; Brit. J. Almanac, 1902, 847.

For controversy Ives v. Farmer see Phot. J. 1901, **41**, 339, 350.

29. Brit. J. Phot. 1902, **49**, 566.

30. Paper read before the Optical Society, Dec. 1903; Brit. J. Phot. 1904, **51**, 47. Bull also read a paper, entitled: "The Principles of Trichromatic Photography" before the Optical Convention; Brit. J. Phot. 1905, **52**, 447, 467; Optician, 1905, **29**, 242; abst. Phot. J. 1905, **45**, 309, which covers the same ground. Cf. Abney "Instruction in Photography," 1900, 10th edit. 352; also papers by him, Phot. J. 1904, **44**, 81; 1899, **39**, 192; 1900, **40**, 121; 1895, **35**, 328; 1905, **45**, 366; 1906, **46**, 298. A. Miethe, "Dreifarbenphotographie nach der Natur," Halle, 1904, 34; Phot. J. 1903, **43**, 214, recommended filters without overlap, but attained the same effect by exposing through two filters for each negative.

31. Brit. J. Phot. 1894, **41**, 458; 1895, **42**, 774. Cf. E. J. Wall, Jahrbuch, 1895, **9**, 34. The passage quoted appears in "Colour Vision, being the Tyndall Lectures delivered in 1894 at the Royal Institution." London, 1895, 47. Cf. Ives v. Joly, Brit. J. Phot. 1894, **41**, 526.

W. Weissenberger, Phot. Korr. 1893, July; Anthony's Phot. Bull. 1893, **24**, 736; Phot. J. 1893, **33**, 42; Phot. Times, 1894, **25**, 10; Annuaire gén. International de Phot. 1894, 59 arbitrarily divided the spectrum into twelve colors, and gave diagrams of the absorptions of the filters and the sensitizing actions of certain plates that he recommended, using von Hübl's ammoniacal collodion emulsion. The final conclusion was that the yellow-printing negative was the most troublesome and can not be correctly prepared, and that retouching must be resorted to. F. Stolze, Phot. Woch. 1888, **4**, 114, 123; Anthony's Phot. Bull. 1888, **19**, 516, 555, 588, 647, 678 starting with the Young-Helmholtz theory, split the spectrum into three regions, which closely corresponded to those now recognized as correct. He ignored actually

all curves and proposed three filters, vermilion to yellow for the red; reddish-yellow to blue for the green, and cyan blue to violet for the blue, with exclusion of the ultra-violet. Carmin red, yellow and blue were to be the printing inks. Cf. H. Thiry, Process Photogram, 1898, **5**, 113 on general theory.

32. Phot. J. 1904, **44**, 263; Brit. J. Phot. 1906, **53**, 248, 410, 910.

33. Phot. J. 1923, **63**, 403; abst. Le Procédé, 1923, **25**, 81; Brit. J. Phot. 1924, **71**, Col. Phot. Supp. **18**, 38, 40, 47.

34. KK. Akad. Wiss. Wien, 1902; Beiträge, 1904, IV; Handbuch, 1903, **3**, 693. Cf. A. Aarland, Phot. J. 1905, **45**, 172; abst. Brit. J. Phot. 1905, **52**, 295.

35. Photography, 1902, May; Brit. J. Phot. 1905, **52**, 13.

36. Pogg. Annal. 1867, **131**, 546. Cf. O. N. Rood, "Textbook of Color," 1913, 21, 27.

G. Baugé, A. Dumez and A. Seauve, D.R.P. 276,645, 1912; Phot. Korr. 1915, **62**, 115; Jahrbuch, 1915, **29**, 551; Phot. Ind. 1914, 957; F.P. 420,349; addit. 13,565, 1914, patented the use of a system of control in making three-color negatives, consisting in the use of a graduated scale of the printing inks and greys which should be recorded on each negative. This idea was published by von Hübl, "Die Dreifarbenphotographie," 1902, 146 and Eder, Handbuch, 1903, **3**, 667.

37. "Die Dreifarbenphotographie," 1902, 2nd edit. 55; 1912, 3rd edit. 59; Klein's translation, "Three-Color Photography," 1915, 49. Cf. Photogram, 1894, **1**, ·6; C. Bonacini, Bull. Soc. Fot. Ital. 1902, **14**, 89; Phot. Times, 1894, **25**, 157; Brit. J. Phot. 1897, **44**, 293, 310; Supp. 12; 1898, **45**, 133, 167.

38. Loc. cit. 77; Das Atel. 1906, **13**, 63, 79.

39. Helmholtz, "Handbuch d. Physiol. Optik, 1911, **2**, 147.

40. J. Frank. Inst. 1902, **153**, 43; Brit. J. Phot. 1902, **49**, 69; Phot. Korr. 1894, **31**, 395. Ives, Amer. Annual Phot. 1895, 244A, stated: "It must also be admitted that what is proved to be true for the photochromoscope process is equally true for three-color printing, not only because the argument works out in the same way when applied to the appropriate 'printing colors' but because the most beautiful and accurate three-color prints yet produced were made from photochromoscope negatives."

41. Phot. J. 1896, **36**, 104.

42. Phot. J. 1904, **44**, 311; abst. Brit. J. Phot. 1904, **51**, 1035; 1905, **52**, 1028. Cf. "Photochromatic Printing" by Zander, Leicester, 1896; Penrose's Annual, 1896, **2**, 63; 1897, **3**, 58; 1899, **5**, 17; 1900, **6**, 61; 1901, **7**, 17; 1902, **8**, 17; Phot. Centrlbl. 1900, **6**, 19.

43. Phot. Korr. 1898; Brit. J. Phot. 1898, **45**, 133. Cf. L. Vidal, Bull. Soc. franç. Phot. 1899, **46**, 306; Brit. J. Phot. 1897, **44**, 293, 310.

44. The quantities of dyes per square meter are dissolved in gelatin solution (see Filters p. 48). Cf. L. P. Clerc, Brit. J. Phot. 1911, **58**, Col. Phot. Supp. **5**, 35.

45. Phot. J. 1897, **37**, 96. Cf. Brit. J. Phot. 1900, **49**, 5.

46. Phot. J. 1899, **39**, 192.

47. Brit. J. Phot. 1906, **53**, 406.

48. Amer. Annual Phot. 1911; Brit. J. Phot. 1911, **58**, Col. Phot. Supp. **5**, 5.

49. "Les Reproductions Photomechaniques Polychromes," Paris, 1919, 263. Cf. "A Handbook of Photography in Colours," London, A. A. K. Tallent based his arguments on the three-color sensation theory and outlined the connection of the theoretical and commercial inks therewith. H. K. Broum, "Die Autotypie u. d. Dreifarbendruck" Halle, 1912, 85 follows von Hübl's practice and arguments. A. J. Bull and C. Jolley, Phot. J. 1915, **55**, 134; abst. Annual Repts. 1916, **1**, 315. C. Bunnin, Phot. J. 1915, **55**, 61.

50. Phys. Zeits. 1917, **18**, 270; Le Procédé, 1920, **22**, 61; Amer. Phot. 1922, **16**, 188. Cf. R. Davis, Phot. J. 1921, **61**, 168; abst. Sci. Tech. Ind. Phot. 1921, **1**, 43. Calmels and Clerc, "Reproductions Photomechaniques Polychromes," 1919, 173; Le Procédé, 1911, **13**, 97; Bull. Soc. franç. Phot. 1911, **58**, 269, suggested the use of neutral wedges with strips of the filters. L. A. Jones, J. Opt. Soc. Amer. 1920, **4**, 420; abst. Sci. Tech. Ind. Phot. 1921, **1**, 59; U.S.P. 1,496,374 described a colorimeter with three colored wedges, red, green and blue with a neutral grey wedge. A. E. Bawtree, Penrose's Annual, 1921, **23**, 38 also described an instrument with three wedges, green, scarlet and blue. Cf. A. J. Bull, E.P. 205,900, 1922.

51. Le Procédé, 1906; Brit. J. Phot. 1906, **53**, 667.

52. Proc. Roy. Soc. 1901, **69**, 26.

53. Schriften d. Vereines z. Verbreitung Kenntnisse, 1896, 255; Phot. Coul. 1907, **2**, 12; Jahrbuch, 1907, 21, 413; Phot. Korr. 1906, **43**, 231, 477. This method

must not be confounded with that in which a black or grey key-plate is used in addition to the three colors.

54. "Die Dreifarbenphotographie," 1897, 1st edit. 77; 1902, 2nd edit, 92; 1912, 3rd edit. 93; Klein's translation, "Three-Color Photography," 1915, 72; Wien. Mitt. 1906, 179; Brit. J. Phot. 1906, **53**, 693.

55. E.P. 27,023, 1895; Brit. J. Phot. 1905, **52**, 1028; 1906, **53**, 15, 371, 397, 719; 1907, **54**, 853; Penrose's Annual, 1905, **11**, 9; 1906, **12**, 17; F.P. 358,448; Le Procédé, 1906, **8**, 60; U.S.P. 884,254; D.R.P. Anm. 4,451, K1, 57b, patent refused; abst. C. A. 1907, **1**, 1647; 1908, **2**, 2340. Cf. C. Gravier, Bull. Soc. franç. Phot. 1906, **63**, 273. Cf. A. E. Bawtree, Penrose's Annual, 1925, **27**, 44.

56. Jahrbuch, 1905, **19**, 83.

A. R. Trist and A. E. Bawtree, E.P. 202,042, 1922; abst. Sci. Ind. Phot. 1924, **4**, 170; Brit. J. Almanac, 1925, 312, proposed to falsify the colors of the original or a screen-plate transparency thereof to a predetermined extent, so as to obtain an accurate copy of the original. A color chart was prepared and photographed in colors and the latter then modified by means of colored celluloid till the reproduction was exact. The original and the color chart then furnished a guide as to the necessary modifications of the colors of the original so as to reproduce correctly. For a landscape, which can not be modified, a transparency was made and modified. G. Jeanne, F.P. 467,909, 1913 proposed to use five colors, instead of three for ordinary polychrome and photo-mechanical work; for instance, a light and dark blue, a light and dark red and a yellow.

As to the use of grey in three-color printing, see F. T. Hollyer, Brit. J. Phot. 1912, **59**, Col. Phot. Supp. **6**, 48; E. G. H. Lucas, ibid. 43, 55; A. J. Newton, ibid. 48, 56.

On the pigment difficulty see C. W. Piper, Brit. J. Phot. 1913, **60**, Col. Phot. Supp. **7**, 5; 1915, **62**, Col. Phot. Supp. **9**, 5, 15; E. H. Gamble, ibid. 1915, **62**, ibid. **9**, 28; P. G. Davidson, ibid. 20.

CHAPTER II

COLOR FILTERS OR COLOR SCREENS

It was but natural that in the early experiments with the spectrum, advantage should be taken of the selective action of colored glasses and fluids. Most of the experiments were to find out the various effects of the rays, that is to say, whether they were, to use the old terms, calorific or chemical in action. To record all such would take up too much space, entail too much work without serving any useful purpose as it is practically outside the scope of our subject.

A prominent experimenter in this field was E. Becquerel, and he seems to have been the first to have suggested the use of filters or screens for the purpose which they are now used. He said:[1] (p. 94) "One may also notice that bright blue objects will appear like white objects, for the one sends almost as many active rays to the sensitive plate as the other; green objects, such as the leaves on trees, on the contrary will appear almost like black. I have suggested that if one were to place in front of the lens of a camera a colored screen of bright green in such a way that all objects would be seen under the same aspect, that is to say, to remove the too active and more refrangible rays, one would increase the exposure in the camera considerably, but one would obtain more of the half-tones of the subject, which are of a yellow or green color."

Becquerel had discovered the absorptive effect of quinin, uranium and yellow glasses on the ultra-violet, and their action, with that of other colored glasses and solutions, on the most refrangible rays in the visible spectrum. He had also pointed out the increased exposure required to obtain chemical action under the same on various salts of silver.

In an editorial article,[2] which was in all probability written by Sir Wm. Crookes, it says, after referring to the sensitiveness of silver iodide to indigo and the ultra-violet, and the greater sensitiveness of silver bromide to blue and green: "another important step is, to destroy the action of the powerful *actinic* rays (including in this term, the violet and lavender, as well as the invisible rays). This is not difficult; a thin layer of solution of sulfate of quinin, between parallel glass plates, interposed between the lens and the object, will effectually cut off all above the indigo; a thin piece of yellow glass employed in the same way will act even more vigorously."

It will thus be seen that the use of filters was recognized in the very earliest days of photography.

Before proceeding to the consideration of the actual manufacture of

filters, it may be as well to record some theoretical data, which are of considerable practical importance.

Theory of Filters.—Von Hübl,[3] who has paid special attention to the manufacture of filters, gives some useful hints, which are summarized in the following notes.

The first point is the change of color with increasing quantity of dye. In Fig. 8 is shown the hypothetical case of a bright yellow dye, which we

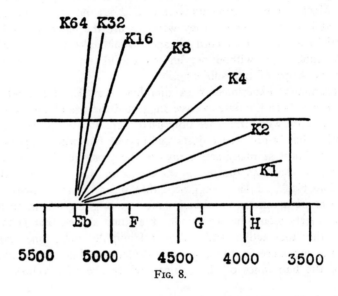

Fig. 8.

may assume to be in separate sheets. With one sheet the absorption may be represented by *K1,* and it will be seen to absorb the violet and blue in decreasing amount till at *E* it is quite transparent, the resultant color will be a pale or whitish yellow. But if we add another film or thickness, the absorption becomes *K2,* and the yellow appears more saturated or deeper, because more violet and blue, which paled the first hue, are absorbed. With four films, as in *K4,* the color deepens still more, as the blue and violet are reduced by the amount shown by the vertical *NM,* and so much so that the eye no longer recognizes their presence. This also applies to eight films, as in *K8,* but the change of color is still less apparent. And with the addition of further films, that is with sixteen to sixty-four, there is no apparent increase of color, though the luminosity may not be so great. Thus at first, with each doubling of the films there is marked color change, which becomes less and less with further increase, and the practical limit of the absorption lies at *E.*

With some dyes, particularly those with rather flat curves, there is, with increase of thickness of the dye film, an increase of the absorption, especially towards the red end, so that the color deepens somewhat and

becomes redder and less luminous, as shown in Fig. 9, in which curve I represents the absorption of a gelatin film containing fast red of a density of 0.1, whilst curve II shows two such films, and III that of four films. It will be seen that there is a slight shift in the red absorption from a to a_1 and a_2; but with increasing concentration, or what comes to the same thing, increasing thicknesses of dyed film, this shift becomes less and less till a point is reached at which there is no longer any further absorption. This point is known as the limiting absorption, and the resultant

Fig. 9.

color as the limiting color. The importance of this is well seen in the making of dark-room screens. Suppose for instance, it is desired to make a screen with a limit of transmission of wave-length 6500. It will at once be seen that it is useless to use such a dye as rose Bengal, which has the absorption limit of 6000; for no matter how much the concentration of the dye be increased this limit will not be overstepped. One must then have recourse to some other dye with an absorption limit further in the red, like one of the violets. In the case of the yellow filter mentioned above, while there is practically no shift of the absorption, the color does change and becomes with increasing depth of filter less greenish, till a pure yellow is obtained.

One of the disadvantages of unduly increasing the thicknesses of the dye is the chance of making the color blackish, that is to say, there are very few dyes of such purity of color that they transmit absolutely unweakened their own particular color. This is specially noticeable with the greens and blues, with which even double the thickness will cause an increase of blackness that is noticeable visually. This naturally means that there is loss of light, which in most cases is that which should not be reduced.

It may also happen that a dye possesses absorption bands that are not contiguous, then the increase of the concentration may so reduce the light at one point more than another, that there is distinct change of color. This occurs with many green and blue dyes, which in somewhat dilute solutions appear blue or green; but in greater concentrations are distinctly red. This is also due to the fact that the absorptions of nearly all dyes increase much more rapidly on the blue side than on the red, therefore, a somewhat weak blue or green transmission band will be much more rapidly

absorbed than a stronger red, with the consequent final appearance of a red transmission only, as is the case with the dark-room green dye, introduced by the Hoechst Farbwerke.

Von Hübl suggested the term "density" of the dye, to express the strength of a solution or dyed film. This convenient unit was introduced to define the quantity of dye, not only in solution but also when coated as a gelatin film. In the former case it is referred to 1000 g. or ccs. of the solvent, and in the latter case to the quantity of dry dye per square meter. This has become fairly general and is very convenient in practice.

One important point in the manufacture of filters of all kinds, though it is of less importance with dark-room screens, is the purity of the dye. Commercial anilin dyes are in many cases advisably broken down by the admixture of inert, as regards color, substances, such as dextrin, sodium sulfate, etc. This must not be looked upon as adulteration, but rather as an intentional and generally accepted legitimate means of weakening a color, and is actually called for by dyers. Purity of the dye, in a chemical sense, is another matter, and it should not be overlooked that the consumption of dyes by the photographic industry is comparatively negligible, when compared with the demands of cloth manufacturers and others of that ilk. On the other hand the photographer is willing to pay well for pure dyes, for the working cost is really very small. Till recently all pure filter dyes were only obtainable from Germany; but since the war other sources have become available.

A still more important matter, too often neglected by the tyro in filter making, is the character of the dye itself. That is to say, its acid or basic nature. By this is not meant that the dyes are acids or bases like hydrochloric acid or sodium carbonate; but in the case of the basic dyes, the actual coloring principle is a base, and most of the commercial dyes of this class are such bases, combined with acids, such as sulfuric, hydrochloric, etc., and the nature of the acid has absolutely no effect on the color of the dye. In the case of acid dyes, the color principle is an acid, and the dye is a compound of these color-acids with a base, such as sodium, calcium, etc. For instance, one may take such a dye as uranin, which is usually a sodium salt of fluorescein, and by the addition of an acid throw down the acid fluorescein, and obtain a colorless solution.

If an acid dye be mixed with a basic in dilute solution, there may be caused a cloudiness of the solution, and a consequent weakening of the absorption. Whilst if the solutions are strong there may be actual precipitation of the compound formed between the color-base and the color-acid, and the solution thus become colorless also. There is no way of finding out whether the dyes are acid or basic, unless through information from the maker, or by actually testing them, and this is not a difficult matter. All basic dyes are precipitated by a mixture of tannin and sodium acetate, and they have little or no affinity for staining gelatin, so that one

may dip a strip of gelatin into a dye solution and at once tell whether it will stain or not, and in the latter case it may be assumed to be basic, and the confirmatory test with tannin may be applied. Or it may be further tried with a collodion film, for basic dyes have a strong affinity for cellulose.

It may happen, of course, that excess of one or other of the dyes will redissolve the precipitate first formed in the above case, but it is hardly worth while to play such tricks, when it is so easy to coat two separate glasses with the dyes. Frequently also the tinctorial power, or the velocity of dyeing gelatin, is increased by the addition of some weak acid, such as acetic; while it may, on the other hand, be markedly decreased by the addition of a base, so as to make the solution alkaline. Basic dyes generally dye more rapidly in a faintly alkaline solution, such as that of borax.

The fugitiveness of a dye is another point, which, however, need practically only be considered in connection with dark-room screens, for the actual exposure of selective or compensating filters is, or should be, reduced merely to the duration of the exposures themselves. Naturally if a careless operator leaves a filter exposed for hours to strong sunlight or even full daylight, it may fade, and also if it be used in front of a powerful arc light, one may expect trouble. Von Hübl's test was to cover half the filter with black paper and expose to bright sunlight and then compare the color of the exposed with the protected part. Those that showed no change after 100 hours exposure were considered fast.

The light-sensitiveness of a dye can only be of interest photographically when examined in the medium in which it is to be used, and as in nearly all cases this is gelatin, this alone should be used in such tests. The addition of glycerol has been recommended, but as pointed out by von Hübl this may act as an energetic sensitizer, especially with basic dyes, and if it be thought desirable to make any addition to render the gelatin more supple a little syrup should be used. It is not without interest to note that the author has used golden syrup for dark-room light screens for more than 20 years, in place of glycerol, as it dries better and has less hygroscopic properties.

Some have advised the use of hard gelatin and others that of soft. As a matter of fact for dark-room screens it is almost immaterial, though the soft is less likely to split under the heat, which is frequently a factor in badly designed lanterns.

Of great importance are the chemical properties of the gelatin, and von Hübl[4] specifically called attention to the presence of sulfites. The gelatin, therefore, should not be looked upon as an inert vehicle. The most striking instance is that of fast red D (echt-rot D), and if a solution of this be added to gelatin, containing sulfites, a brownish-yellow film is obtained; while if the gelatin is pure a purple-red color is formed, which dries a rose-red. Crystal ponceau behaves in the same way; pheno-safranin, naphthol green, filter blue and tartrazin are bleached; filter yellow

becoming darker. The impurity causing this trouble is an unstable substance, as the gelatin improves if allowed to stand in a swollen condition for from 24 to 48 hours. Storage of the dry gelatin also appears to act favorably; and it was found that some sheets, taken from the middle of a packet, had a stronger bleaching action than those from the outside.

Sulfurous acid is frequently used to bleach the raw stock, or to neutralize the last traces of "bleach" when chloride of lime is used.

A radicle means of making such a gelatin fit for use is to add, before incorporating with the dyes, about 0.5 to 1 ccs. of a 1 per cent solution of iodine to every 10 g. of dry gelatin. This proportion is usually enough; but in any case it is easy to test with a little fast red, and if on drying the color is a clear red, the gelatin is fit for use. One may, of course, titrate the iodine in the usual way.

Whilst the various formulas recorded will save any trouble as to the composition of a filter in ordinary practice, the following note by F. Monpillard[5] may be useful, as by its help any given description of filter can be reproduced: the principle of the method is simple. A given weight of the dye is dissolved in a given volume of aqueous gelatin solution. If the same volumes of this be distributed over the same areas, the same weight of the dye will occur per unit area, and the two colors will be identical. In practice the dyed solution is spread on the surface of an optically worked glass, and, after drying the film of gelatin is covered by a glass, also optically worked, and the two cemented with Canada balsam. If plane-parallelism of the filter is necessary, the two outside surfaces are worked.

In the case of preparing a filter to possess certain properties previously decided on—i. e., absorption of certain particular parts of the spectrum—it is necessary to adjust with the greatest precision the weights of the dyes before coating. To avoid the disturbing influences of the gelatin, Canada balsam, etc.—factors which are far from negligible—but also to avoid errors, which arise from differences in the absorptions of the dyes, according as the film is wet or dry, the following method has been devised: Taking first the case of a single dye, the colored gelatin is applied to two glasses, one placed horizontally and the other inclined so as to form an incline of 2 in 100. The volume of solution applied to the first glass having been determined with care, the weight p, of coloring matter per unit surface is known. After drying, the gelatin film has a thickness, e.

The gelatin having been flowed over the inclined surface and dried, the latter is divided into two parts along its length, and to one of these strips a white glass is cemented with balsam. A filter is thus obtained, constructed in the same way as the one required, but with the weights p^1, p^2, p^3 ... of dye per unit area varying in the same proportion as the thicknesses e^1, e^2, e^3 ... of the gelatin film. This filter is then placed in an apparatus by means of which it can be moved in front of the slit of a spectroscope. The latter is illuminated by a narrow beam of light, pro-

jected perpendicularly on to the filter by means of a cylindrical lens, which forms the image of a slit, this being brightly illuminated by the condenser of a projection lantern.

By means of the eyepiece of the spectroscope, that portion of the spectrum for which the filter should show the maximum of absorption is observed, and the filter is slowly displaced until this result is obtained. The portion corresponding to the colored region, which was illuminated at this moment is noted. On the other piece of glass the thickness e^1 is measured. The weights of the dye being proportional to the thicknesses of the films, it is easy to calculate the weight per unit surface required for the depth of color corresponding to that we require:

$$\frac{e}{e^1}=\frac{p}{x} \qquad\qquad x=\frac{e^1+p}{e}$$

When the coloration of the filter comes from two dyes, a plain and graduated filter are prepared from each. These latter are placed in juxtaposition and cemented with balsam, so that the deepest part of one comes next to the lightest part of the other. We thus obtain a filter in which the weights p^1, p^2 of each dye are inversely proportional. Passing this filter over the spectroscope slit, after we have located the region corresponding to the color required, it is not difficult by measuring the thickness of the gelatin on each plate, to find the ratio p^1/p^2.

R. J. Wallace[6] proceeded in somewhat the same fashion, and prepared dye wedges of:

Hard gelatin 25 g.
Distilled water 1000 ccs.
Dye 2.5 g.

Seven cubic centimeters of this at a temperature of 55° C. were flowed on a plane glass strip, 50x250 mm., then laid aside to set in a drying chamber, with one end raised to a height of 5 cm. from the horizontal plane of the support, thus causing the gelatin to flow slowly toward the lower end. When dry a plane cover glass was cemented on with Canada balsam and the edges bound. A centimeter scale was then ruled on the glass with a diamond, and a series of spectrograms made, showing the absorption at every centimeter for constant exposures. From the negatives thus obtained, it was possible to calculate the composition of the required filter. Wallace referred to Monpillard's paper and stated that he found the method unsuitable, and considered that if the thickness of the film on the color-wedge was measured more delicately, say in the interferometer, then a much closer approximation might be arrived at than is possible with a micrometer. By a method of trial and error it was speedily found possible to arrive at an extremely satisfactory duplication. A plate of ordinary glass, of exactly the same size as the desired filter was taken, and flowed with a measured amount of the same solution, as used in

Fig. 10.

Fig. 11.

Fig. 12.

making the wedge. As all dyed filters dry with a slight shift in absorption towards the red, allowance was made for this; therefore, two other glasses were coated with slightly smaller amounts of solution and then dried rapidly with a fan. Exposure to the spectrum was then made through each and any further correction noted.

The Action of a Filter on the Image.—It may be useful to consider the action of a filter on the image. Let *AB*, Fig. 10, represent a plane parallel plate of glass, and *O* an object from which proceeds the light-ray *OC*, incident on the front surface of the glass at *C*. The distance of the point *O* from the plate being *Oa*, then the ray is refracted at the surface of incidence towards the normal and apparently proceeds from *P*. The refracted ray strikes the second surface at *D*, and the distance *DP* is equal to $a\mu+t$; μ being the refractive index of the glass, and *t* its thickness. After refraction by the second surface *B*, the emergent ray appears to proceed from the point *Q*, and the distance *QB* is equal to $a+t/\mu$. As the distance of the point *O* from the second surface is equal to *a* plus *t*, the apparent shift in the direction of the axis and towards the glass is $(a+t)-(a+t/\mu)$ the angle of incidence being assumed to be large. It will thus be seen that the shift is dependent on the thickness *t* of the glass plate and the refractive index, and not on the distance of the point *O* from the plate. The action of a filter in front of a lens is shown in Fig. 11, in which a ray proceeding from the point *O* is refracted by the lens, without a filter, to the point *P*. But if we insert a filter it will, as before, take the dotted path, and the image be formed at *O'*, and the ground glass must be shifted by the amount *S'PP'* from the lens.

If the incident ray is prolonged backwards, as shown by the dotted line, it will cut the axis at *O'*, and the axial shift *S* is equal to *OO'*, in the object space, and is equal to $t(\mu-1)/\mu$, as pointed out above. If the size of the image to the object is called *r*, then the well known ratio is $S:S' :: r^2 : 1$. it naturally follows that $S' : S : r^2$, and the shift of the ground glass as the result of the insertion of the filter in front of the lens is $S'=t\dfrac{\mu-1}{\mu}\times\dfrac{1}{r^2}$.

If we assume the thickness *t* of the filter as being 3 mm. and the refractive index of the glass as 1.5, for we can neglect the thickness of the gelatin and its refractive index, then using the previous formulas we have $(\mu-1)/\mu=\frac{1}{3}$ and $t(\mu-1)/\mu=1$ mm. The shift of the ground glass is $S'=1/\mu^2$ mm. If the ratio of the object to image is large, or in other words, if the distance of the object is great in comparison, then *1 : r* is small and $1/\mu^2$ disappears. It is only when reproducing to a comparatively large size, that is the reduction is small, that we have to take into account the shift of the object in focusing.

If the filter is placed behind the lens, as in Fig. 12, it will be seen that the rays from the point *O* cut the axis at *P* without the filter; but by

refraction through the filter the ray will take the dotted path to P', so that in focusing the ground glass must be removed from the lens by the distance $S'-P'$, and this shift is, from our previous calculations, $=t(\mu\text{-}1)/\mu$, no matter where the object point O is, and from the above the result is $S=1$ mm. Therefore, it is essential always to focus with the filter in its position behind the lens. It is also clear that we actually focus on the point O' that is nearer the lens by S, and from the previously found formula $S=S'$: r^2, so that by the insertion of the filter behind the lens

we shift the plane of maximum sharpness by $S=t\dfrac{\mu\text{-}1}{\mu}\times r^2$ from the

lens, which clearly is of consideration when reproducing objects near at hand.

R. S. Clay[8] called attention to the fact that variation in the size of the three pictures is generally due to the filters, but that it might be due to the lens. In order to differentiate between the effects of the two, it was advised to see first whether the definition was as good with a filter in position as without, and if there was much loss of definition, then the cell, for Clay was writing of liquid cell filters, should be rejected. If on the other hand, the definition remained good, three exposures should be made with the same cell. If there was still a difference in the size of the images, then the lens was at fault and suffered from a slight want of achromatism. If the lens be undercorrected the focal length for the red will be slightly greater than for the violet. Thus if each picture be focused in turn, the red will be the largest, then the green and the violet the smallest of all. It may be possible to maintain the three images of the same size without alteration of the focus; but this will entail a slight loss of definition, and if the blue-printing negative be kept sharp, possibly a slight loss of definition in the yellow-printer may be of no serious matter, but in the case of the red-printer this can not be ignored. The position of the nodal point is not the same for all colors, and as the size of the image for a given position of lens, object and screen depends upon the distance of the object and the screen from their respective nodal points, it is obvious that if the nodal points vary slightly with the colors, the size of the image will vary also.

It is possible sometimes to correct this trouble by slightly altering the separation of the components of the lens system. Two cautions are necessary; to alter the distance appreciably is likely to increase the curvature of the field, or the astigmatism or both. In the second place, rotating a lens will nearly always affect its alinement and centering, therefore, it should always be rotated through a very small angle, say 15 to 20 degrees at most, or through one or more complete revolutions. Thus supposing that there is a difference in the size of the images and focusing is done for each filter, or the stop required to give a good image is too small, then

all that is necessary is to focus some well-defined object, such as a newspaper, with each filter in turn, and make an exposure. Then superpose the negatives in pairs and thus find which is the smallest, and by how many dots in the whole diameter of the plate. It can be easily shown theoretically that a small increase in the distance apart of the components will increase the equivalent focus by a quarter of the increase of the distance apart. In the case of the Cooke process lens, however, this is not the case, and the separation of the front lens shortens the focus very rapidly and also affects the corrections, so that it should never be necessary to unscrew the front lens more than half the amount stated above.

The Extinction Co-Efficient.—Frequently in speaking of filters or dye solutions, the term "extinction co-efficient" is used, and an explanation of the same may not be out of place. The transparency of a solution is defined as $T = \dfrac{I_t}{I_i}$, or in words, the intensity of the light transmitted divided by the incident light is the transparency. And assuming that one thickness of a film or solution reduces the intensity of the transmitted light by a fraction, which we can call $1/a$, then two layers will reduce it $1/a^2$, and three thicknesses $1/a^3$ and so on. If we know the transparency T the number of thicknesses can be easily determined as

$$log\ T = -Z\ log\ a$$

Or

$$Z = \frac{log\ Z}{log\ a} = \frac{log\ T}{log\ 1/a}$$

From this equation it is possible to calculate the number of films of transparency $1/a$, which must be laid over one another in order to obtain a film of transparency T. The transparency of a film may be any unit, but it is generally set so that it allows $1/10$ of the incident light to pass, or $1/a$ equals $1/10$, or $Z = -log\ T$. If this be done the number of the absorbing films is equal to the negative logarithm of the transparency, which is also known as the extinctions co-efficient, and is frequently designated by e, and this can be calculated as follows:

$$T = \frac{I_i}{I_t} \qquad and \quad e = log\ (1/\frac{I_i}{I_t})$$

Supposing, for instance, a solution of rose Bengal be used and a gelatin film stained therewith, if we measure the absorption for every hundred wave-lengths, we should obtain the following table:

λ	T	e
6000	1.00	0.00
5900	0.90	0.05
5800	0.67	0.17
5700	0.34	0.47
5600	0.28	0.55
5500	0.37	0.43
5400	0.54	0.27
5300	0.59	0.23
5200	0.60	0.22
5100	0.70	0.15
5000	0.80	0.10

In which λ = the wave-length, T = the transparency and e = log $(1/I_t)$. In order to find e, therefore, it is only necessary to divide 1 by T and find the logarithm of the quotient. For instance, if we take wave-length 5400 in the table, T = 0.54, then $1/0.54$ = 1.844 and the log of this is 0.266.

The figures in the third column represent the extinction co-efficients for the given wave-lengths, and the height of the ordinates for a chart. As a rule the height of the ordinates is so chosen that that for a 0.1 film corresponds to about one-sixth of the length of the spectrum between C and G. For a complete discussion of these factors, see Kayser's "Handbuch der Spektroscopie," Vol. 3 and S. E. Sheppard's "Photochemistry," 1914, 136.

J. Precht and E. Stenger[9] estimated the actinism of the colors in daylight by the use of additive filters, with the following transmissions: for the red, 7250 to 5700; for the green, 5800 to 5050; for the blue, 4900 to 4100. The ratio of the correct exposures with which should be 1:4:17, for the blue, green and red respectively. Exposures were made in sunlight and in the shade on cloudy days, and the actual exposures to obtain the same densities were as follows: in the sun, B 1 : G 3.2 : R 8.8 and B 1 : G 2.7 : R 8.1 and B 1 : G 3.3 : R 9.0 for three different conditions of light. In the shade and on cloudy days the ratios were B 1 : G 5.6 : R 14 and B 1 : G 4.0 : R 11.7 and B 1 : G 5.1 : R 23.3. It will thus be seen that under equal conditions of exposure in clear and cloudy weather at the same time of day, a strong reduction of the red action takes place. They came to the conclusion that the general assumption that the density is directly proportional to the time of exposure does not hold good in three-color work.

They also directed attention to the influence of the duration of development, and, as was pointed out by H. W. Vogel, the yellowish-green sensitiveness is only correctly rendered with a sufficiently long development. This applies to tri-color work, though not to the same extent; although, on the other hand, the color differences are lessened as the extreme densities are reached.

Turning their attention to arc lights, it was found that the following

densities were obtained with increasing watts, using the same filters as above:

Watts	Blue	Green	Red
400	1.0	1.01	0.84
700	1.0	0.72	0.68
1900	1.0	0.68	0.64

It is obvious from these results that with altered conditions of light the reproduction of colors must suffer considerably, when the exposures given are according to the filter ratios for ordinary daylight.

The Making of Filters.—It may be as well to point out that except under special circumstances, it is hardly worth the average worker attempting to make his own filters, considering especially that gelatin film filters can be obtained at very reasonable prices, and so perfectly and evenly coated, that it is almost hopeless for the amateur operator to try and emulate. For those who want to experiment there are one or two books, that are quite indispensable, unless mere trial and error is adopted. These works are "An Atlas of Absorption Spectra," by H. S. Uhler & R. W. Wood, Washington, 1907, which comprises the absorptions from the red, about 6200, to the ultra-violet, at 2000. But it should not be overlooked that as the authors used a Nernst lamp, and an alloy of cadium and zinc for the ultra-violet, the strong lines of this alloy are recorded, when the normal light of the said wave-lengths would not be transmitted. Nor must one forget that in the average photographic work, one has not only the glass of the lens, but that of the filter also, and these practically cut out the ultra-violet below 3000 at most. C. E. K. Mees has also published "An Atlas of Absorption Spectra," 1909, which shows the absorptions of many dyes in various strengths, from 3500 to 8000. From this work especially it is comparatively easy to determine the dyes necessary to use for any desired filter. An equally valuable work, if not more so to the practical worker, is "Wratten's Light Filters," issued by the Kodak Co., which gives the absorptions of all filters made by this firm, von Hübl's "Die Lichtfilter," 1922, is specially valuable also. For out-of-the-way dyes, that may be rarely used in photography, one should refer to H. Kayser's "Handbuch der Spektroscopie," 1903, Vol. 3, and J. Formanek's "Spectralanalytische Nachweis künstlicher organische Farbstoffe," Berlin, 1900. With reference to the commercial names and chemical terms and makers of dyes, "Farbstofftabellen" by G. Schultz, Berlin, 1923, is excellent, but to be preferred is "Colour Index" by F. M. Rowe, Bradford, 1924.

The use of collodion as the vehicle of the filter dyes is not to be recommended, for it is difficult to obtain an absolutely even film, and it is by no means easy to allot a given amount of dye to a given area. Further than that, one is more limited in the choice of dyes, as obviously they must be soluble in alcohol-ether or like solvents.

In order to avoid striæ, or wavy lines, J. Waterhouse[10] recommended

the use of pyroxylin dissolved in amyl acetate, which dries more slowly than the usual alcohol-ether mixture, and, therefore, does not so readily form these marks. Various depths of color could be obtained by varying the ratio of the dyes as follows:[11]

 I. Pyroxlin 24 g.
 Absolute alcohol 180 ccs.
 Amyl acetate1000 ccs.
 II. Pyroxylin 24 g.
 Aurantia 10 g.
 Amyl acetate1000 ccs.

Dissolve the dye in as small a quantity of alcohol as possible, and add to the collodion. For use take of

A. No. I97.5 No. II 2.5 parts
B. No. I95.0 No. II 5.0 parts
C. No. I90.0 No. II10.0 parts
D. No. I85.0 No. II15.0 parts
E. No. I80.0 No. II20.0 parts

allow 220 ccs. to every 100 qcm.

A. Burchett[12] patented the use of green and yellow filters, the former being placed at the back of the front lens combination, and the latter in front of the rear combination. The inventor claimed that a much truer value of colors was thus obtained in relation to black and white; color-sensitive plates were preferred, but were not actually necessary. In a later patent[13] the staining of the balsam, used to cement the lens components, was claimed, and the dyes used were:

For green: Diamond green70 parts
 Metanil yellow75 parts
 Anilin red 5 parts
For yellow: Safranin45 parts
 Chrysoidin45 parts
 Corallin10 parts

A saturated alcoholic solution of each mixture was made, and a drop or two allowed to fall upon the balsam before working the two lenses together in the usual manner.

F. E. Ives[14] recommended for making one filter the coating of glass with as structureless a collodion as possible, then flowing over it an alcoholic solution of the dye; but when several filters were required, then it was better to stain the collodion in the first place, by using the alcoholic solution of the dye as solvent. A saturated solution of brilliant yellow (Leonhardt) should be made in alcohol and 20 per cent pyroxylin added, when the cotton is saturated, an equal volume of ether should be added, and the mixture allowed to settle. As the collodion was thicker at one end of the glass, where the collodion was drained from, two glasses were cemented together, the thick end of one against the thin end of the other.

The collodion films were varnished to prevent damage during cementing with balsam.

O. Hruza and A. Hazura[15] examined a large number of dyes spectroscopically, and the best summary of this work is given by the former.[16] He stated that for the absorption of the violet the best dyes were picric acid, brilliant yellow S, cotton yellow S; for the blue, orange GRR, alizarin orange; for the green, fast red C, ponceau 4 RB, azofuchsin G, eosin BN, safranin P; for the yellow, pyronin G, rubin R1, fuchsin S, rhodamin S; for the orange, cyanin, ethyl, crystal and methyl violets; for the red, Nile blue and methylen blue. It will be seen that there is no difficulty in absorbing any one color, nor is there when the spectrum is to be divided into three regions for the printing inks, yellow, red and blue. Taking the spectrum, as an example, the whole of the green, yellow and orange must be printed with yellow, therefore, the absorption of the filter for this negative must comprise these regions; and rhodamin S and ethyl violet are the best dyes to use. The result would be unfailingly correct had we plates equally sensitive to the whole of the spectrum; but this is not the case and all plates are more sensitive to blue, therefore the blue and violet rays must be dampened more than the red. Red must be printed over the violet, orange and red, consequently these are the rays to be absorbed, and the best medium is cupric chloride or a mixture of indigo blue and potassium picrate; here too the blue rays must be dampened more than the green and yellow. The blue must print in the violet, blue and green, and spirit eosin and aurantia are the most suitable dyes.

J. McIntosh,[17] in an excellent paper on the making of filters, gave a method distinctly his own, which was as follows: clear sheet gelatin was obtained commercially and soaked in dye solutions for various times, then rinsed and dried. For a light yellow filter suitable for ordinary work, there was used a 1 : 1000 solution of filter yellow K; for medium filters, double that strength; and for deep ones 1 : 250. The method of drying was distinctly novel; when the gelatin had been sufficiently stained, a square of celluloid, larger than the filter to be used, but smaller than the sheet of gelatin, was slipped under the film, and the two laid upon a sheet of cardboard, with the celluloid next the same. The gelatin was smoothed out with a glass rod, and its edges pressed into contact with the card and the whole left to dry. When dry, the gelatin was cut round from the card, the celluloid stripped off, which was effected with the greatest ease, and the film would be smooth and flat. At this stage it was as well to test the color, and the deepest filter should be the same as a 1 : 250 solution in ¼ inch thickness; while the 1 : 500 and 1 : 1000 solutions would serve as guides for the weaker filters, if used in the same cell thickness. McIntosh claimed to have obtained better luminosity rendering with the addition of a methyl blue, or later a Victoria blue, filter;

the depth of color being equal to that of a 1 : 50,000 solution in one-quarter inch thickness. It was necessary to use two films, as the yellow was absorbed much faster than the blue.

It was seldom that these filters were free from surface markings, not dirt, but these disappeared in cementing. To mount the films, they were cut a quarter of an inch larger all round than the glasses. A piece of stout paper, folded double, was pasted on the inner side of the glasses, and the end of the gelatin being clipped in the center of the fold, the edges were lapped over the glass to form a hinge. When the hinge was dry, the glasses could be opened like the leaves of a book, and Canada balsam poured slowly into the joint. Sufficient being used, so that when the glasses were pressed together, it would spread uniformly and exude at the edges. The glasses were then clipped together and allowed to dry at a gentle heat. When the balsam was hard, the edges could be cleaned, excess balsam being scraped off, and bound up.

Gelatin Filters.—The replacement of collodion by gelatin as the vehicle for the dyes, and a more rational system of manufacture as regards the given quantity of dye, has led to a marked improvement in filters, and also placed it in the power of anyone to duplicate a filter that may be recommended.

It is obvious that the mere soaking of a gelatinized glass in a solution of a dye for a given time is one of the loosest instructions that can be given; unless exact data as to the particular gelatin to be used, the exact thickness of the film, the temperature of the solutions and the relative humidity of the gelatin film be given. For on all these factors depends the final color-depth or density of the filter. Equally loose are instructions as to the staining of a filter till, to quote a certain writer, "it appears a pure green, neither yellowish nor bluish." Almost as indefinite are instructions to stain till spectroscopically the filter "shows the required absorption." In the first place, visual examination is useless, and secondly the color of the wet filter may be said to be never the same as that of the dry. In connection with this point, von Hübl[18] gives the following spectrophotometric readings of a wet and dry filter of rose Bengal, to give the same absorption:

Dry filter	Dye density for a For a liquid filter with a solution of	
	1 : 100	1 : 1000
0.5	2.6	6.0
1.0	5.4	10.0
1.5	8.4	15.0
2.0	11.2	20.0
2.5	13.6	25.0
3.0	16.0	30.0
3.5	18.0	35.0
4.0	20.0	40.0

Another matter, that can not be neglected when giving instructions as to filters, is the accurate naming of dyes, and also the names of the makers of the same, as commercially it is no proof that because Brown supplies a dye under the same name as Smith, that the two are identical chemically or in colorimetric qualities. Therefore, if any particular make of dye is specified, it must not be assumed that another make of dye can replace it; it may or may not, and the result may be disaster as regards photographic selection.

J. W. Gifford[19] dealt at some length with the correct values of colors in photography, recommending a cyanin-phosphin N bathed plate. (Phosphin was stated to be synonymous with chrysanilin). The correcting filter suggested was prepared by coating a thin microscopic cover glass with a film of gelatin, stained with picric acid on one side, and collodion stained with aurin on the other; which could be fixed in the diaphragm. Gifford pointed out that the filter might cause a failure in the rendering of the whites and violets of flowers, and this could be remedied by admitting white light through a small aperture in the center, which might be made right through the support, if mica were used.

Protective Screens or Safe-Lights.—In the early collodion days, such was the comparative insensitiveness of the silver halides used, that a bright yellow or orange medium was quite safe; but with the introduction of the gelatin plate, these bright lights were no longer safe, and red media became necessary. While the ordinary plate is not sensitive to orange or red, it must not be overlooked that any and all colors will act upon the sensitive salts, provided sufficient exposure be given. A fact that must not be lost sight of, no matter how "safe" the light may be considered to be.

W. Abney[20] examined spectroscopically many colored glasses and dyes coated on glass, and gave various figures as the illumination, which, however, are hardly worth reproduction. But there is one point on which he laid great stress, and that is the illumination given by a light approaching green. He said: "an object is illuminated better by a very dull light approaching green, than by one illuminated by red.[21] If a red light and a green light of equal luminosity be gradually and equally reduced, the perception of green light will be seen when the luminosity of the red has entirely disappeared. In fact, a green light can be reduced 700 times more than the red before the illumination disappears. Hence, in a room illuminated with faint green light, the dark parts of the room will appear brighter than if the illumination to near objects be red light."

Naturally the use of anilin dyes, dissolved in collodion or gelatin, became general. C. Bardy[22] seems to have been the first to suggest their use, and he proposed chrysoidin, dissolved in gelatin solution, with a little glycerol and chrome alum, or in alcohol and water, in which paper was

to be soaked. But as pointed out by Eder and Tóth[23] this was not so effective as copper ruby glass. H. W. Vogel[24] stated that it transmitted some of the violet about H, and gradually bleached.

Whilst colored glasses have been used for many years, there has been a tendency of late for their replacement by gelatin-coated plates, stained with anilin dyes. These have the advantage that a definite absorption can be obtained, with as a rule, better transmission for that particular region that they transmit. It is extremely easy to make these screens. A rough and ready way is to merely use old fixed-out dry plates, and soak them in solution of the dyes till sufficiently stained. The only disadvantage of this method is that one can not tell exactly how deep to stain, as not only is the absorption of the dyes different when wet than when dry, as has been pointed out before. But to really test any dyed plate it is actually necessary to use a spectrograph, for many dyes, both red and orange, transmit comparatively large quantities of the deep violet and ultra-violet, to which the eye is comparatively insensitive, but to which the silver salts are very sensitive. By far the better plan is to make up solutions of dyes of given strength and coat a given quantity on a given area.

Before dealing with the actual manufacture of screens, it may be as well to call attention to an excellent paper by C. E. K. Mees and J. K. Baker[25] on the efficiency of dark-room screens. They pointed out that it is of importance in dark-room illumination, when other things than the plate itself are to be seen, that diffused light should be used, as a great deal more can be seen with the same intensity falling on the plate, because the whole of the room is lighted instead of the plates only, upon which the direct rays of the light fall. The visual power of the various lights was found by using a large electric bulb, which was not seen directly by the eyes, as the light fell upon a white screen at an angle of 45 degrees, behind the safe-light to be tested. On the face of the screen was placed a cross of black lantern-slide binding, and this image was focused on the ground glass of a camera. In front of the lens of the latter was a calibrated iris diaphragm, the aperture of which could be read. Measurements were made by closing the diaphragm till the image of the black cross disappeared on the ground glass; the amount of light then passing the lens being calculated. The measurements were but roughly approximate only, but sufficient for the purpose. The photographic intensity of the light was measured by means of the usual sector wheel method with an acetylene burner, and the inertia curves plotted after development. All the screens had one sheet of glass coated with gelatin deeply stained with tartrazin, so as to cut out all wave-lengths below 4900 A.U. This was alone used for the yellow lights, and for the others the following were used in addition: for orange, a screen of eosin, cutting all below 5500; for red, a screen of pinatype red (carmin) cutting all below 5900; for deep red, a methyl violet screen, cutting at 6200; for a blue-green

the rays transmitted were from 4900 to 5600; and a naphthol green screen that cut out all but 4900 to 5750.

The following table gives the visual intensities, a sheet of ground glass being used with all colored screens:

1. Ground glass alone..........................200
2. Tartrazin133
3. Tartrazin and eosin.........................80
4. Tartrazin and eosin and red....................28
5. Tartrazin and eosin and red and methyl violet.... 7
6. Tartrazin and blue-green.....................7
7. Tartrazin and naphthol green.................1.60

The efficiency of the lights was determined by multiplying the visual intensity by the safety, that is, the amount of exposure neecssary to produce the same effect in all cases upon the plates for which the screens were designed, as shown in the following table:

Safelight	Intensity	Safety	Efficiency
Tartrazin133		1	133
Tartrazin with tissue paper...	77	1.7	131
Tartrazin with blotting paper.	44	3	132
Eosin	80	14	1120
Eosin with blotting paper....	27	25	675
Eosin with aurin paper......	20	50	1000
Eosin with naphthol green....	1.6	22	35.2
Red	28	6.3	176.4
Red with aurin............	7	25	175
Red with aurin and methyl violet	3.5	100	350
Methyl violet on ordinary plate	7	100	700
Methyl violet on ortho plate..	7	35	385
Methyl violet with aurin.....	1.75	150	262.5
Blue-green	7	1	7
Blue-green with green paper..	0.78	9	7.2
Naphthol green	1.60	2	3.2
Naphthol green with green paper	0.135	64	8.7

The absorption of two sheets of thin tissue paper, measured on the above scale was 1.72, that is, a tartrazin and methyl violet screen had an intensity of 7; if two sheets of white tissue paper were inserted, this must be divided by 1.72, reducing it to 4.1. One sheet of blotting paper divided the intensity by 3. One sheet of aurin paper divided the intensity by 4.1. The addition of one sheet of green paper (acid green was used) reduced the blue-green 9 times, and the naphthol green 12 times.

In conclusion the authors pointed out that increasing the size of the dark-room lamp, with the idea of getting more light is of no avail; that method being based on the assumption that the fog is caused by small amounts of blue light passing the filters. But the results show that with these screens the fog is not due to this, but excess of light of the color which the lamp is intended to transmit.

Houdaille[26] had earlier given somewhat similar tables, but as the particular glasses were not specifically named, they are not so useful. As a measure of the visual effect, he suggested the distance at which a certain sized type could be read, this being about the size of the capital letters used in this work. The author has used the various distances, at which the time can be read on a watch, the latter being held at the usual position, close to the watch pocket.

An exhaustive paper was published by A. P. H. Trivelli[27] which contains probably the best summary of the subject, but most of the information has been collected in these pages. One important point advanced by Trivelli, is that the dyes frequently become light-sensitive, when mixed with gelatin, and this should be taken care of in placing screens in the lantern, and the more stable dye placed next the light-source.

The preparation of the stained gelatin should be as follows: place the gelatin, 6 or 8 g., which ever may be directed, in 100 ccs. of distilled water, and allow to soak for 10 minutes. Then pour off the water into a graduate and note its volume; add this amount of distilled water and soak for another 10 minutes. Again pour off the water and note the quantity and add the same amount, and again pour off. The necessary quantity should be added to make 100 ccs. The temperature should be raised to 60° C., and the dye added in solution, and the glass coated. From 7 to 10 ccs. should be allowed for every 100 qcm. of area, and care should be taken that the gelatin does not set while coating. The glasses should preferably be leveled, the dye gelatin poured into the middle of the glass and coaxed out to the edges with a bent glass rod, allowed to set and then racked to dry. The formulas given by Trivelli are as follows:

No. 1 Yellow:
 Rapid filter yellow...............................0.8 g.

Two glasses, coated with this solution, must be bound up together.

No. 2 Yellow:
 Tartrazin0.8 g.

Two glasses to be bound up.

No. 3 Orange:
 A. Tartrazin, as above.

Bind up with
 B. Rose Bengal0.3 g.

An 8 per cent solution of gelatin, 100 ccs., is to be used with each dye.

No. 4 Red I:
 A. Tartrazin, as No. 3.
 B. Xylene red0.8 g.
Bind together.

No. 5 Red II:
 A. Tartrazin, as above.
 B. Crystal violet, 4 per cent sol.................. 8 ccs.
 Gelatin, 6 per cent sol......................100 ccs.
Bind together.

No. 6. Red III:
 A. Xylene red, as above.
 B. Dark-room red 0.9 g.
 Gelatin, 6 per cent sol......................100 ccs.
Bind together.

No. 7. Red IV:
 A. Rapid filter green II, 6.6 per cent sol.......... 20 ccs.
 Gelatin, 6 per cent sol......................120 ccs.
 B. Xylene red 0.8 g.
 Tartrazin 0.2 g.
 Gelatin, 8 per cent sol......................100 ccs.
Bind together.

No. 8 Grey-Green:
 Dark-room green, 4 per cent sol................. 25 ccs.
 Gelatin, 8 per cent sol......................125 ccs.
Bind two plates together.

No. 9 Grey-Red:
 Dark-room red, as above...................... 25 ccs.
 Gelatin, 6 per cent sol......................125 ccs.
Bind two plates together. All the above dyes are made by the Hoechst
Farbwerke, vorm. Meister, Lucius & Brüning.

 A. J. Newton and A. J. Bull[28] suggested the use of old fixed-out dry
plates, or old negatives freed from the silver images by treatment with
hypo and ferricyanide or potassium cyanide, and staining up in dye solu-
tions. They considered that the better, but less convenient plan, was to
coat a sheet of glass with a given amount of dyed gelatin. They suggested
8 per cent in winter and 10 per cent in summer, and 20 ccs. per qcm. A
soft gelatin should be used and the dyed solution might be filtered through
cotton, while hot. The glass should be leveled and warmed before coat-
ing; a little phenol or thymol might be added to prevent mould whilst
drying, which took a long time. In mounting the glasses it was advisable
to insert a sheet of tissue or papier minérale in between, to diffuse the
light.

A yellow light, suitable for wet plate and bromide papers, could be made by allowing 0.01 g. tartrazin or naphthol yellow, or 0.02 g. auramin per 100 qcm.; brilliant yellow 0.05 g. might be used instead of the tartrazin, but the latter was more convenient, on account of its greater solubility, and its less liability to crystallize out in drying. A red light for ordinary plates might be made with the same quantity of tartrazin, with the addition of 0.05 g. rose Bengal. In place of the latter, the same quantity of fast red, or some scarlet dye might be used. For orthochromatic plates, there should be combined with the above red screen, one coated with 0.05 g. methyl violet. The red screen transmitted from 7000 to 5900, whilst the violet passed from the red to 6500, to which region even the best ortho plate is but feebly sensitive, and the light is sufficient to work comfortably with.

Sometimes it is considered advisable to coat electric bulbs, direct with the filtering medium, although this is not an easy matter, particularly if the bulbs have the usual sealing tip; and it is almost impossible to do this with gelatin. It is somewhat easier with a solution of celluloid, and in this case the spirit-soluble dyes must be used. The author has found the following useful for this work:

Acetyl red O, 51256, 8 per cent alc. sol............75 ccs.
Acetyl yellow, 1039, 8 per cent alc. sol............25 ccs.
Celluloid16 g.
Acetone ..50 ccs.
Amyl acetate50 ccs.

Scrap celluloid, in the shape of old negative films with the gelatin removed with hot water, should be used and allowed to stand in the solvents, with occasional shaking, till completely dissolved. The solution should be allowed to stand for a day or two to clear, and the dye solutions added with 2 per cent of castor oil. The bulb should be completely immersed in the mixture, which is rather thick, removed and turned over and over till the coating is thick enough not to run; then it should be placed in the light socket, the light switched on and left till the bulb is dry. This is not a very satisfactory job at any time, and the celluloid is apt to split in time under the action of the heat. A more satisfactory coating is obtained with cellulose acetate dissolved, in the same strength, in a mixture of 33 parts of methyl alcohol and 66 parts of tetrachlorethane (acetylene tetrachloride). For temporary use, or where a lamp is not much used, this method will answer; but for serious work it can not be recommended.

Von Hübl[30] gave the following formulas for making dark-room screens: for ordinary plates, a screen absorbing all rays below 6000, a mixture of fast red and tartrazin, which he stated was marketed by the Hoechst Farbwerke as "dark-room red," might be used:

Fast red 0.5 g.
Tartrazin 0.5 g.
Gelatin, 8 per cent sol........................100 ccs.

Allow 7 ccs. to every 100 qcm. The illumination through this screen is so bright that at a distance of 1 meter it is possible to read the text of this book, yet it is quite safe. For orthochromatic plates the transmission should be from 6300, and this can be obtained by combining one of the above screens with a violet one made as follows:

Crystal violet0.166 g.
Cupric sulfate0.833 g.
Glacial acetic acid........................ 2 drops
Gelatin, 6 per cent sol.................... 100 ccs.

Allow the same quantity per unit area as above. Half the above quantity of dyes gives a brighter screen, but it is not so safe. Another, which is equally satisfactory, is:

Tartrazin, 4 per cent sol................... 18.5 ccs.
Crystal violet0.156 g.
Glacial acetic acid........................ 2 drops
Gelatin, 8 per cent sol.................... 100 ccs.

Allow the same quantity to the same area.

Liquid Filters.—Cells containing solutions have been frequently recommended; but they possess no particular virtue, are always liable to leak, and the dyes may be precipitated on the walls. In those cases also, in which the bulb is directly immersed in the liquid, one has always to reckon with the heating of the solution and the slow evaporation of the solvent.

Howard Farmer[31] made an exhaustive photometric examination of various glasses and fabrics and finally recommended a 6 per cent solution of potassium dichromate in a thickness of three-eighths of an inch. He stated that this was much safer than the majority of red glasses on the market, and yet gave brilliant illumination; obviously the use of this, except for ordinary plates, would be attended with some danger of fog.

E. Stenger[32] also introduced a liquid cell of bell shape, which would hold 1000 ccs. of solution, as well as the lamp. For collodion plates, bromide paper and lantern slide work, he suggested a 10 per cent solution of potassium dichromate. For fast dry plates, the same solution with the addition of 5 g. fuchsin, or 0.2 g. acid violet 7BN, and for ortho and panchromatic plates 0.5 to 1.0 g. tartrazin with 0.2 to 0.4 g. methyl violet, or the above acid violet.

Green screens have also been used in liquid form and F. Haberkorn[33] recommended the following:

Acid green, 2 per cent sol................... 25 ccs.
Naphthol green, 4 per cent sol............... 1.5 ccs.
Tartrazin, 3 per cent sol.................... 1.2 ccs.
Water800 ccs.

F. Novak[34] found that with continued use the water very rapidly evaporated and, therefore, he suggested the replacement of the same with glycerol, and this was found not to lose in volume in months.

Green Safe-Lights.—Abney (see page 61), called attention to the better illumination given by green light, as compared to red. W. E. Debenham[35] strongly recommended a combination of cathedral green and orange glass as giving a pleasant safe light for ordinary plates. But little attention seems to have been paid to this class of screen, mainly because it was difficult to obtain just the correct shade of glass that would give the greatest safety with the greatest amount of light, and also because of the innate conservatism of photographers generally, and the absurd idea that it was essential to keep on examining the plate to see how development was progressing,[36] and the red light is safer for ordinary plates, if the operator must have a flood of light. Further than that, with the bluish-green glasses it is very easy to obtain one that lets through rather more blue than it should.

But A. Davanne[37] stated that the dry plate factory of Lumière & Sons was lit with green lights only, and this was probably the commencement of the general use of these screens, particularly as with the introduction of red-sensitive and panchromatic plates, the use of red screens was excluded. Further many of these plates show a minimum of sensitiveness in the blue-green, which enables this particular region to be used with greater safety.

It may be pointed out that at first the green light, particularly the deeper kind, seems quite inadequate, and the room will appear quite black. But as the retina becomes more sensitive it will be found that the illumination is really brilliant, and it is easy, after about fifteen or twenty minutes, to see much better than with red light. The author has worked for hours at a stretch in a dark green illuminated room, in the panchromatizing of film, and found it much more pleasant than red light and also much easier to see about the room and much safer.

F. Haberkorn[38] recommended a gelatin safe-light, which was made as follows:—12 g. of gelatin should be allowed to soak in 200 ccs. distilled water for an hour and 3 g. acid green added, then heat applied till the gelatin melts. To this should be added 1.2 ccs. of 3 per cent tartrazin solution, and 2 ccs. of 4 per cent solution of naphthol green, and after thorough mixing the solution filtered. Glass should be well cleaned and given a substratum of 1 : 2000 potassium silicate solution, then after·drying and warming, coated with 7 ccs. of the dyed gelatin for every 100 qcm. When dry the plate should be coated on one side with matt varnish,[39] and two such plates bound together.

E. König specially recommended the use of "dark-room" green, a dye made by the Hoechst Farbwerke, as follows:

> Dark-room green, 4 per cent sol.................100 ccs.
> Gelatin, 6 per cent sol.........................500 ccs.

Allow 7 ccs. per 100 qcm.

Von Hübl[40] recommended a combination of filter blue and naphthol green, as follows:

Filter blue 1 g.
Distilled water 1000 ccs.
Ammonia 1 ccs.

And for the screen use:

Naphthol green 1 g.
Blue sol., as above........................... 4 ccs.
Gelatin, 8 per cent sol........................ 120 ccs.

On every 100 qcm. coat 7 ccs. of this dyed gelatin.

Trivelli[41] gave two formulas, the first of which is better than Haberkorn's, but is less permanent than von Hübl's; but much brighter:

Tartrazin 0.8 g.
Gelatin, 8 per cent sol........................ 100 ccs.

Coat one glass with the above, allowing 7 to 10 ccs. per 100 qcm.

Patent blue, 2 per cent sol.................... 10 ccs.
Filter green-blue, 2 per cent sol.............. 10 ccs.
Gelatin, 8 per cent sol........................ 100 ccs.

Coat another glass in the same ratio, and bind up with the yellow one. The second formula gives a screen that is almost as dark as von Hübl's, is safer but less permanent:

Dark-room red, 4.5 per cent sol............... 25 ccs.
Gelatin, 6 per cent sol........................ 125 ccs.

Coat as above and combine with:

Tartrazin 0.4 g.
Naphthol green 0.6 g.
Gelatin, 6 per cent sol........................ 100 ccs.

Coat as above.

Newton and Bull[42] recommended the use of 0.04 g. brilliant acid green per 100 qcm. and preferably by coating half of the dye on each of two glasses, and binding together with tissue paper in between. This passes approximately from 5000 to 4600.

Any of the green screens already given may be used for screen-plate work; but E. Löwy[43] specially recommended the following, which is so adjusted that the transmissions correspond to the minima of sensitiveness of the Autochrome plate, namely beyond C in the deep red, and between E and F in the blue-green. On every 100 qcm. should be coated

New Bordeaux R, 3 per cent sol................ 1.16 ccs.
Tartrazin, 4 per cent sol...................... 1.38 ccs.
Light green S, 5 per cent sol.................. 1.6 ccs.
Glycerol 0.46 ccs.
Gelatin, 10 per cent sol....................... 4.64 ccs.

Tri-Color Filters.—The correct filter cuts have already been dealt with when treating of the theory.

Eder[44] recommended for the violet filter:

Methyl violet 0.1 g.
Distilled water1000 ccs.

For the green:

New patent blue B, (Bayer) 1 : 1000..............10 ccs.
Ammonium picrate, 0.5 per cent sol...............30 ccs.
Distilled water85 ccs.

For the orange:

Naphthol orange (Orange II, Badische)........ 1.0 g.
Distilled water1000 ccs.

The internal measurement of the cells should be 10 mm., or with 5 mm. thickness, double strength solutions should be used. Ammonio-cupric filters can be used, but they are more transparent for bright blue and transmit a somewhat wider zone, for instance:

Cupric sulfate, cryst........................ 30 g.
Distilled water1000 ccs.
Ammonia q. s.

The copper salt should be dissolved in about half the water and ammonia added till the precipitate first formed is redissolved, and a clear solution obtained, then the total bulk should be made up to 1 liter. This is suitable for wet collodion.

.For the green filter with an orthochromatic, or erythrosin-sensitized plate, Eder[45] recommended:

Ammonium picrate, 0.5 per cent sol............. 40 ccs.
New patent blue B, 0.1 per cent sol............. 15 ccs.
Distilled water1000 ccs.

It is obvious that the absorption of this filter can be altered by varying the ratios of the blue and yellow constituents; for instance, if the plate is more sensitive to green the patent blue solution should be reduced to 10 ccs. If eosin collodion, or ethyl-eosin plates are used the same filter may be employed; with collodion emulsion, sensitized with mono-bromo-fluorescein, the filter should be:

Ammonium picrate, as above....................400 ccs.
Distilled water600 ccs.

Von Hübl[46] recommended for the theoretical printing inks, a liquid filter of new blue (Hoechst) 0.02 per cent solution in a cell of 5 mm. thickness. For the green filter, or red-printing plate, with a silver-eoside bathed plate, a cell of 5 mm. filled with a 0.2 per cent solution of picric acid, or a gelatinized plate, stained to the same depth with naphthol yellow

S. For a neutral solution of silver eoside in ammonia, or Albert's dyes, the above yellow filter should be used. If gelatin plates are employed, then a cell of the same thickness filled with:

Acid green, 0.66 per cent sol.	5 ccs.
Potassium dichromate, 0.5 per cent sol.	150 ccs.

Or a gelatinized plate dyed up in:

Bluish fast green, 0.5 per cent sol.	15 ccs.
Naphthol yellow SL, 0.5 per cent sol.	25 ccs.
Methyl orange, 0.25 per cent sol.	30 ccs.
Alcohol	20 ccs.
Glacial acetic acid	5 drops
Distilled water	100 ccs.

The adjustment of this filter is much facilitated by staining two glasses, one with the green and the other with the yellow dyes.

For the blue filter, with a cyanin-sensitized emulsion, a cell filled with 12.5 per cent solution of potassium chloroplatinite, or 0.1 per cent solution of aurantia. For commercial red-sensitive or panchromatic plates, a cold saturated solution of the platinum salt should be used or a mixture of:

Biebrich scarlet, 0.1 per cent sol.	60 ccs.
Aurantia, 0.1 per cent sol.	100 ccs.

A gelatinized plate should be stained with:

Biebrich scarlet, 0.5 per cent sol.	40 ccs.
Naphthol yellow SL, 0.5 per cent sol.	10 ccs.
Methyl orange, 0.25 per cent sol.	10 ccs.
Alcohol	40 ccs.
Glacial acetic acid	10 drops
Distilled water	200 ccs.

For the stable printing inks, chrome yellow, alizarin lake and Paris blue, with collodion emulsion or a wet plate, no filter should be used for the yellow-printing plate, merely a cell filled with water, or a colorless glass plate. For gelatin plates the use of a 0.01 per cent solution of methyl violet in the usual depth cell may be used, or a plate stained up to the same depth. The same filter should be used with a silver-eoside collodion emulsion, and this shortens the exposure. For the green filter with collodion emulsion, sensitized with eosin-uranin, a 5 mm. cell of 0.10 per cent solution of picric acid, or a dry filter of naphthol yellow S. The same filters can be used with commercial silver-eoside emulsions. For commercial orthochromatic, or erythrosin plate, the liquid filter should be:

Acid green, 0.66 per cent sol.	200 ccs.
Picric acid, 1 per cent sol.	400 ccs.

A suitable dry filter is obtained with:

Bluish fast green, 0.5 per cent sol.	30 ccs.
Naphthol yellow SL, 0.5 per cent sol.	45 ccs.
Glacial acetic acid	10 drops
Alcohol	40 ccs.
Distilled water	200 ccs.

For the red filter with collodion emulsion a rather dark filter of:

Aurantia, 0.1 per cent sol.......................100 ccs.
Biebrich scarlet, 0.01 per cent sol................100 ccs.

should be used. For commercial red-sensitive or panchromatic plates the last or chloroplatinite filters should be used.

Again later[47] other formulas were given by von Hübl, thus for the red filter, a dry one of:

Dianil red 0.4 g.
Filter yellow 2.0 g.
Distilled water200 ccs.

For the blue-green filter:

Patent blue 0.7 g.
Tartrazin 0.7 g.
Distilled water200 ccs.

Of each of these solutions 20 ccs. should be added to 50 ccs. of 8 per cent solution of gelatin, and 7 ccs. allowed for every 100 qcm. For 5 mm. thickness cells there should be allowed:

Red solution, as above......................... 5 ccs.
Distilled water95 ccs.

For the blue-green filter:

Patent blue, 0.2 per cent sol..................... 7 ccs.
Tartrazin, 1 per cent sol......................... 2 ccs.
Distilled water91 ccs.

Howard Farmer and G. Symmons[48] gave the following formulas, which were used for obtaining screen negatives direct on gelatin plates. They stated that the transmissions were practically the same as outlined by Clerk Maxwell, though the ingredients were not the same, as his were unstable. The filters possessed great transparency, consequently the exposures were proportionally short. With the exception of the two dyes, the stock solutions are obviously very stable; but it is as well to keep them in the dark.

<div align="center">Stock solutions.</div>

A. Potassium chromate (yellow).............. 250 g.
Distilled water to1000 ccs.
B. Potassium dichromate (red) 62.5 g.
Distilled water to1000 ccs.
C. Eosin (blue shade) 25 g.
Distilled water to1000 ccs.
D. Methylen blue 1.04 g.
Distilled water to1000 ccs.

All solutions should be filtered several times, or allowed to stand several days and the clear portions decanted.

Filter for yellow-printing negative:

Eosin, solution C............................18.75 ccs.
Distilled water to............................ 1000 ccs.

With this filter the whole of the ultra violet passed by the lens and to which plates are sensitive, is allowed to act, and the eosin subdues the blue-green spectrum. The result is to strongly differentiate the yellow-printing plate from the others. With most subjects the advantages of this extra differentiation more than counterbalances the disadvantages. Should it be preferred to work without the ultra-violet rays, the following should be used:

Eosin, solution C............................ 2.1 ccs.
Potassium chromate, solution A................ 10.5 ccs.
Distilled water to1000 ccs.

If the effect of the blue-green is to be increased the eosin is omitted or reduced in quantity. It will be observed that by increasing or diminishing the quantity of eosin or yellow chromate respectively, the spectrum action can be shifted laterally in either direction, and either concentrated in one band or spread over a considerable area.

Filter for red-printing plate:

Potassium chromate, solution A................31.25 ccs.
Methylen blue, solution D11.50 ccs.
Distilled water to 1000 ccs.

With this filter the aim is to obtain the maximum effect in the greens, combined with equal action in the yellow-greens and blue-greens; this being necessary owing to the general lack of green luminosity in natural objects and pigments. If desired, more or less blue-green can be allowed to pass by weakening the yellow chromate or vice versa. If more or less of the yellow end of the spectrum is desired the methylen blue is weakened or vice versa.

Filter for blue-printing negative:

Potassium dichromate, solution B...............1000 ccs.
Eosin, solution C............................ 26 ccs.
Ammonia, sp. gr. 0.880...................... 26 ccs.

The ammonia is to redissolve the precipitate formed on addition of the eosin to the dichromate solution. With this filter the whole of the spectral red rays act. The other limit is practically at the D line, the action ending abruptly at this point. Should it be preferred to carry the action further towards the green the eosin can be reduced or omitted altogether.

The following formulas were given by Klimsch[49] for use with collodion emulsion (see page 236):

Violet filter:

Methyl violet, 0.5 per cent sol.................. 250 ccs.
Distilled water1000 ccs.

Green filter:

Picric acid, 5:1000 sol....................... 210 ccs.
Carmin blue (Hoechst), 1:1000 sol............. 80 ccs.
Distilled water1000 ccs.

Orange filter:

 Mandarin G, 2:1000 sol...................... 260 ccs.
 Biebrich scarlet, 2:1000 sol................... 210 ccs.
 Distilled water1000 ccs.

These filters were to be used in a cell of 5 mm. internal thickness. For 10 mm. cells an equal volume of water should be added.

For dry filters the following were recommended:

Violet filter:

 Carmin blue 2 g.
 Acid violet 1 g.
 Glacial acetic acid 5 drops
 Warm water50 ccs.

The actual coating solution should be:

 Dye solution 6 ccs.
 Gelatin, 8 per cent sol........................100 ccs.

To every 100 qcm. allow 8 ccs. of the dyed gelatin, and two glasses of each kind should be cemented together.

Green filter:

 Naphthol yellow S........................... 3 g.
 Carmin blue 2 g.
 Naphthol green (Hoechst) 0.5 g.
 Glacial acetic acid 6 drops
 Warm water150 ccs.

The actual coating solution should be:

 Dye solution 5 ccs.
 Gelatin, 8 per cent sol........................100 ccs.

Two glasses to be cemented together.

Orange filter:

 Dianil red (Hoechst) 3 g.
 Tartrazin0.5 g.
 Glacial acetic acid 8 drops
 Warm water100 ccs.

The actual coating solution should be:

 Dye solution 6 ccs.
 Gelatin, 8 per cent sol........................100 ccs

Two glasses should be cemented together.

E. König[50] recommended the following procedure for the making of filters: As the basis of all filters a 6 per cent solution of hard gelatin should be used. This is prepared by allowing hard photographic gelatin to soak in cold distilled water for half an hour, then pouring off the water, adding a little water, melting in a water bath and making up to bulk. As the quantities of the dyes for one or two filters is very small, it is advisable to make stock solutions of the dyes, which will keep perfectly in the dark.

The blue solution is:

Crystal violet 4 g.
Glacial acetic acid 5 drops
Distilled water100 ccs.

To every 100 parts of gelatin solution should be added 7 to 8 parts of this dye solution, and 7 ccs. coated on every 100 qcm. of the glass. Two filters, thus coated, should be bound together.

The green stock solution is:

Patent blue 6 g.
Tartrazin 3 g.
Distilled water330 ccs.

Dissolve by the aid of a gentle heat and add 5 ccs. to every 100 ccs. of gelatin solution. Again two filters should be bound up. This filter transmits the extreme red, and to absorb this one must use naphthol green as well, or:

New filter green I (Hoechst) 4 g.
Distilled water120 ccs.

Add 5 or 6 ccs. to every 100 ccs. of gelatin solution.

The red stock solution:

Dianil red (filter red I)........................ 5 g.
Distilled water200 ccs.

Dissolve by the aid of a gentle heat and add 4 ccs. to every 100 ccs. gelatin solution.

König[51] also suggested the following variants for the green filter:

Filter yellow (flavazin T)........................ 3 g.
Patent blue 6 g.
Green I .. 9 g.

Or

Filter yellow 2.5 g.
Patent blue 6 g.
Naphthol green 4 g.
Hot distilled water330 ccs.

To 100 parts of gelatin solution add 5 parts of the above, and allow 7 ccs. to every 100 qcm. of glass. It should be noted that naphthol green is essential for all filters used with commercial panchromatic plates.

F. Monpillard[52] determined the absorptions of the above filters and found for the red, a transmission of from 5900 to 6800 or from D to B. The first green filter passed from 5000 to 5500, or b½F to D½E, whilst the extreme red from 7000 to 7300 was also transmitted. The naphthol green filter transmitted the same green band, but absorbed the red end. It is obvious that there are one or two gaps in the spectrum, which would lead to these regions being represented in a print by black, or the more or less superposition of all three inks.

A. J. Newton and A. J. Bull[53] dealt very thoroughly with the filters and photographed the absorptions of many that had been recommended, and reference should be made to their paper, as much can be learnt from their various trials, and it is, moreover, illustrated with color reproductions of the spectra through the various filters. The following is but a brief summary of their conclusions: The filter records should be even, end abruptly and overlap. The blue-violet and green should overlap from 4600 to 5000, and the red and green from 5800 to 6000.

Filters prepared on these lines are as follows; in each case the filter is used liquid in a cell of 5 mm. separation:—For use with collodion emulsion, with known sensitizers, e. g., Albert's emulsion with 4 ccs. of 1 : 500 alcoholic solution of pinaverdol per 100 ccs. for the yellow and red printers. And 2 ccs. of 1 : 500 alcoholic solution of ethyl violet per 100 ccs. for the blue printer.

The blue filter contains:

Quinin sulfate	0.5	per cent
Victoria blue	0.1	per cent
Crystal violet	0.005	per cent

The quinin should be dissolved by the addition of a little acetic acid. This cuts out all between 4000 to 5000. This is not stable, and must be freshly made to give this absorption.

The green filter contains:

Naphthol green	0.4	per cent
Naphthol yellow	0.04	per cent

This records from 6000 to 4800.

The red filter contains:

Fast red	0.05	per cent
Tartrazin	0.25	per cent

This records from 5800 to near the end of the spectrum.

For dry plates (indirect method): the blue filter is 0.5 per cent quinin sulfate with an ordinary plate. The red filter is 0.25 per cent Biebrich scarlet, used with a Lumière C plate. Biebrich scarlet is not the best dye to use, owing to its requiring some alcohol to dissolve it. Better is

Fast red	0.5	per cent
Tartrazin	0.25	per cent

This is made up to give exactly the same absorption.

In this set the green filter is acid green 0.05 per cent with quinin sulfate 0.5 per cent, used on a Westendorp & Wehner orthochromatic plate (erythrosin). This green filter was adjusted to a typical erythrosin plate with its band of insensibility in the blue-green, so as to fill up this gap as far as possible, and at the same time to render perfectly the three inks in

printing. This set of filters is interesting in that, while they will reproduce the printing inks perfectly, they fail on other colors.

The same red and blue filters, given above, are used with a green filter made up as follows:

Fast green BS, 1 per cent sol...................	1.5 ccs.
Tartrazin, 1 per cent sol......................	1.5 ccs.
Quinin sulfate, 1 per cent sol..................	100 ccs.
Water to	200 ccs.

This filter was used with the "Spectrum" plate (an obsolete panchromatic plate), and was designed to give an even record throughout the yellow, green, blue and violet of the spectrum, in order to prevent the crimson ink from printing in the blues, since, owing to the want of transparency to some extent of blue printing inks to red, the result obtained by printing these together is often not what it should be—a blue-violet color—but a dark purple.

With these filters the dark blues are somewhat too light with the inks used, but with the usual commercial inks they would be better. The two colors upon which this filter fails are yellow and green, neither being sufficiently recorded in the green negative by the time the whites are fully exposed, the blue and violet recording as well as the green, the result in each case being the printing of too much crimson. Another green filter was designed to record evenly between 5000 and 6000. In this green and the next, the records were fairly even throughout the exposures. The filter was made up of equal parts of naphthol yellow SL, saturated solution in water, and 0.02 per cent of naphthol green, and was used with the Spectrum plate. With this filter one would expect the blues too dark, but the advantage of a narrow green evenly and correctly placed, is that the average greens will be fully recorded in the normally exposed subject. Practically all the colors were fairly well rendered by this, except the dark blues, which were too violet, because they were not sufficiently recorded in the green negatives. The green filter in this case records the yellow, green and blue up to 4600, where it commences to change to violet. The plate used was the Spectrum, a panchromatic, and the composition of the filter was: naphthol yellow 0.03 per cent, naphthol green 0.01 per cent. This filter gave the best rendering of all those tried; the dark greens were rendered as green only with this and the preceding filter.

A. Miethe[54] preferred filters that had no overlap, which were divided sharply at 4800 and 6000; but two filters were used for each record, thus the red and green for the blue-printer and so on, so that the result was practically an overlap. The red filter was:

Rose Bengal, 2 per cent sol....................	7.5 ccs.
Gelatin, 10 per cent sol......................	90 ccs.

And

Tartrazin, 4 per cent sol......................	10 ccs.
Gelatin, as above	90 ccs.

Of each solution 21 ccs. were coated on 100 qcm. and two filters of each color bound together. For the green filter:

Brilliant acid green 6B, 1 per cent sol............ 15 ccs.
Tartrazin, 4 per cent sol......................2.5-5 ccs.
Gelatin, as above............................ 27.5 ccs.

Allow the same quantity as above for one glass and cement on a colorless cover glass. For the blue filter:

New Victoria blue, 0.4 per cent sol.................10 ccs.
Methyl violet, 0.4 per cent sol....................10 ccs.
Gelatin, as above61 ccs.

Allow the same quantity as above and cement on a cover glass coated with

Tartrazin, 4 per cent sol........................ 1 ccs.
Gelatin, as above300 ccs.

Allow the same quantity as above.

A. & L. Lumière[55] recommended the coating of glass with 10 per cent solution of gelatin and, after drying, immersing in the following solutions at 21° C. for 5 minutes, then rinsing and drying. Two filters of each color should be cemented together. The red bath was:

Erythrosin, 0.5 per cent sol.....................450 ccs.
Metanil yellow, sat. sol at 15° C.................500 ccs.

The green solution was:

Methylen blue N, 0.5 per cent sol................100 ccs.
Auramin G, 0.5 per cent sol.....................600 ccs.

The blue-violet solution was:

Methylen blue N, 0.5 per cent sol................500 ccs.
Distilled water500 ccs.

H. Calmels and L. P. Clerc[56] recommended the following for cells of 5 mm. thickness. For the violet:

Crystal violet (Hoechst) 0.2 g.
Aesculin 2.5 g.
Distilled water1000 ccs.

For the green:

Tartrazin (Hoechst)0.105 g.
Carmin blue0.065 g.
Naphthol green0.045 g.
Aesculin2.5 g.
Distilled water 1000 ccs.

For the red:

Dianil red I (Hoechst) 0.20 g.
Aesculin 2.5 g.
Distilled water1000 ccs.

Screen-Plate Filters.—With screen-plates, as with ordinary plates, one has to contend with the overweening blue and violet sensitiveness, and further the color rendering has to be approximated to the visual luminosities. For this purpose a "compensating" filter is inserted between the subject and plate, and whilst the makers of screen-plates issue their

own filters, it may be useful to place on record the various formulas that have been given for the same.

G. Hauberisser[57] suggested staining fixed-out dry plates with a mixture of filter yellow 9 parts and filter red I (Hoechst) so as to correspond with a medium yellow filter. An utterly scientific and hopeless method of working. Von Hübl[58] advised the following:

A. Tartrazin (Hoechst) 1 g.
 Distilled water 500 ccs.
B. Phenosafranin (Hoechst) 0.1 g.
 Distilled water 700 ccs.
C. Gelatin 6 g.
 Distilled water 90 ccs.

For use mix:

C solution 40 ccs.
A solution 10 ccs.
B solution 10 ccs.

And add immediately before use:

Aesculin 0.4 g.
Distilled water 20 ccs.
Ammonia 3 drops.

Allow 8 ccs. to every 100 qcm. of glass. Later the use of phenosafranin was abandoned and the following recommended, because it obviated the use of the aesculin, though there is no difference to be detected in the two filters:[59]

Filter yellow, 1 per cent sol. 6 ccs.
Fast red D, 0.01 per cent sol. 7 ccs.
Gelatin sol. 57 ccs.

For evening and early morning work in which there are great contrasts between the colors of direct sunlight and reflected skylight, which illuminates the shadows, particularly in landscape work, and which then become too blue, G. Winter[60] suggested the use of a more orange filter, which would absorb more of the blue, and using the older dyes the formula was:

Tartrazin sol. 11 ccs.
Phenosafranin sol. 10 ccs.
Gelatin sol. 40 ccs.

With which the above-mentioned aesculin solution should be mixed, and 8 or 9 ccs. allowed to the same area. Using the later formula, the filter yellow should be doubled, that is 12 ccs., allowance being made for this by reducing the quantity of gelatin solution.

E. Wandersleb[61] patented a weak dispersive lens combined with a filter, so that when placed in front of the camera lens it allowed of focusing in the ordinary way, as the dispersive lens increased the focal length of the camera lens slightly, sufficient to compensate for the backward displacement of the sensitive surface due to the exposure through the glass.

C. Wolf-Czapek[62] pointed out that there was always a chance that the filter might be forgotten, or that it might fall off, and proposed that the back of the screen-plate should be coated with a yellow-stained film, which would render any separate filter unnecessary. This method would be of special value with screen-plate films, as the stained coating would act as a non-curling coat.

A. Prilejaeff[63] considered that aurantia extra MP (Agfa) was the best dye to use in conjunction with a little filter yellow, and gave the following formula:

Aurantia, 0.5 per cent sol........................ 4 ccs.
Gelatin, 12 per cent sol..........................66 ccs.

The dye should be dissolved by heat and 7 ccs. of the dyed gelatin allowed for every 100 qcm. This filter was to be combined with one prepared with:

Filter yellow, 0.5 per cent sol.................. 2 ccs.
Gelatin, 12 per cent sol......................... 68 ccs.

The same quantity being allowed for the same area of glass, or the following could be used instead of the filter yellow:

Aesculin0.66 g.
Ammonia 1 ccs.
Gelatin 8 g.
Distilled water 100 ccs.

Only 7 ccs. should be allowed for the same area.

All the above filters were intended for daylight work, but when artificial light is used, which differs in spectral composition in all cases from daylight, then the compensating filter should be altered, and the following were advised by von Hübl[64]:

For Nernst lamps of 220 volts:

A. Gelatin, 10 per cent sol..................... 40 ccs.
Tartrazin, 1:2000 sol....................... 3 ccs.
B. Aesculin0.4 g.
Distilled water 37 ccs.
Ammonia 3 drops

Mix the above and add:

Gelatin, 10 per cent sol....................... 40 ccs.
Patent blue, 1:1000 sol....................... 2 ccs.
Distilled water 38 ccs.

Allow 7 ccs. for 100 qcm. For incandescent gas the same solution may be used, allowing only 5 to 6 ccs. to the same area. For an arc lamp of 20 amperes:

A. Gelatin, 10 per cent sol..................... 40 ccs.
Tartrazin, 1:500 sol....................... 4 ccs.
Phenosafranin, 1:7000 sol.................. 1 ccs.
B. Aesculin0.4 g.
Distilled water 35 ccs.
Ammonia 3 drops

Mix both solutions and allow 7 to 8 ccs. to the same area. The following filter might be used in addition to the commercial filter, issued by the makers of the plates:

Gelatin, 10 per cent sol...........................40 ccs.
Patent blue, 1:1000 sol......................... 6 ccs.
Phenosafranin, 1:7000 sol......................10 ccs.

Allow 7 to 8 ccs. to the same area.

For filters for examination of screen-plates by various lights, von Hübl recommended that the following stock solutions be prepared:

A. Gelatin, 1:15.
B. Patent blue, 1:1000.
C. Rose Bengal, 1:1000.

For oil or gas use:

A solution40 ccs.
B solution 5 ccs.
C solution 3 ccs.
Water ..30 ccs.

For incandescent gas:

A solution40 ccs.
B solution 3 ccs.
C solution 5 ccs.
Water ..30 ccs.

For electric arc light and for projection by the same:

A solution40 ccs.
B solution 4 ccs.
C solution 4 ccs.
Water ..30 ccs.

In each case 5 to 6 ccs. should be allowed for 100 qcm.

For lime light F. Monpillard[65] recommended:

Quinolin yellow (Badische), 1:200 sol........... 0.5 ccs.
Brilliant acid green 6B (Bayer), 1:1000 sol...... 1 ccs.
Gelatin, 10 per cent sol...................... 13 ccs.
Aesculin0.05 g.
Distilled water 25 ccs.

Allow 5 ccs. to 100 qcm. The gelatin solution should contain 2 per cent glycerol.

G. Krebs[66] appears to have been the first to have used magnesium flashlight for Autochrome work in 1908, and prepared special filters for the same. Lumière and Seyewetz[67] recommended a mixture of:

Potassium perchlorate20 parts
Magnesium powder10 parts

And made a special filter for the same. Several firms also made special mixtures and filters for this work, but as the composition of the same was kept secret, no more need be said about them. Eder suggested a mixture of:

Magnesium20 parts
Thorium nitrate, anhyd.......................10 parts

And F. Novak and H. Kessler[68] worked out the following filter as the most suitable for the same:

 Filter yellow, 1:200 sol.......................... 12 ccs.
 Crystal ponceau (Hoechst), 1:800 sol............ 4 ccs.
 Water ... 4 ccs.
 Gelatin, 6 per cent sol..........................100 ccs.
Allow 7 ccs. to 100 qcm.

K. König[69] recommended a filter composed of two solutions, especially for the reproduction of Autochromes on similar plates by magnesium, by the method recommended by Lumière (see p. 545), as this filter required only 3 cm. of ribbon against 16 cm. with Lumière's commercial filter:

 A. Tartrazin, 1:500 sol.................... 4 ccs.
 Phenosafranin, 1:7000 sol.................. 4 ccs.
 Aesculin0.4 g.
 Ammonia 3 drops
 Water 33 ccs.
 Gelatin, 7 per cent sol.................... 40 ccs.

Dissolve the aesculin and ammonia in the water, add to the dyes in the gelatin, allow 8 ccs. to 100 qcm.

 B. Filter yellow, 1:100 sol...................... 2.5 ccs.
 Gelatin, 7 per cent sol.......................100 ccs.
 Water ...17.5 ccs.
Allow 7 ccs. to the same area and bind the two filters together.

 F. Monpillard[70] recommended for flashlight:
 Quinolin yellow, 1:200 sol.......................1.3 ccs.
 Patent blue, 1:1000 sol..........................0.6 ccs.
 Gelatin, 10 per cent sol......................... 10 ccs.

Add the dyes to the gelatin, then add aesculin 0.05 g., dissolved in 6 ccs. hot water and make the total bulk up to 25 ccs.; allow 5 ccs. per 100 qcm.

For Autochrome plates hypersensitized with pinachrom, von Palocsay (see p. 511) recommended a filter prepared from a 15 per cent solution of aesculin in 10 per cent gelatin, allowing 25 ccs. per 100 qcm. But better color rendering was obtained with the following:

 Filter yellow, 1:1000 sol....................... 6 ccs.
 Fast red D, 1:1500 sol.......................... 1 ccs.
 Gelatin, 10 per cent sol........................100 ccs.

G. Simmen also recommended for his hypersensitized plates (see p. 510) a plain aesculin filter:

 Soft gelatin 10 g.
 Ammonia .. 1 ccs.
 Glycerol0.2 ccs.
 Aesculin0.2 g.
 Distilled water100 ccs.

Allow 25 ccs. to the same area; or the following might be used:

Hard gelatin 3 g.
Distilled water100 ccs.
Filter yellow, 1 per cent sol.................... 2.5 ccs.

Allow 10 ccs. per 100 qcm.

L. Gimpel[71] gave the following formula for a filter for reproducing Autochromes on Autochrome plates, by means of a Nernst lamp as illuminant:

A. Gelatin, 1:15 sol...........................40 ccs.
Tartrazin, 1:2500 sol..................... 3 ccs.

And add

Aesculin .. 4 g.
Distilled water37 ccs.
Ammonia 3 drops

Allow 8 ccs. per 100 qcm.

B. Gelatin, as above...........................40 ccs.
Patent blue, 1:1000 sol.................... 2 ccs.
Water38 ccs.

Allow 8 ccs. to the same area and bind the two together.

Chromoscope Filters.—Viewing filters for chromoscopes may be made as follows:[72]

The blue filter:

Crystal violet 3 g.
Methylen blue 1 g.
Glacial acetic acid...........................5–6 drops
Warm water100 ccs.

To every 100 parts of 6 per cent gelatin solution add 2 to 3 parts of above and filter; allow 8 ccs. to every 100 qcm.

The green filter:

Tartrazin 6 g.
Patent blue 1 g.
Naphthol green 2 g.
Warm water180 ccs.

Add 2.5 to 3.5 of the dye to 100 parts of gelatin solution; allow 6 to 12 ccs. to every 100 qcm. The idea is to make five or six filters of different depths of color, as it is generally necessary to use filters of different absorptions to obtain pure white light.

The red filter:

Tartrazin 4 g.
Rose Bengal3.5 g.
Water ..150 ccs.

To 100 parts of gelatin solution add 4.5 parts of the dye; allow 8 ccs. to 100 qcm.

In order to prevent reflection from the back surfaces of the mirrors, the green mirror should be coated with:

Tartrazin .. 0.5 g.
Naphthol green 0.8 g.
Patent blue 1.2 g.
Water ... 100 ccs.

Allow 4 parts of dye solution to 100 parts of gelatin solution and 7.5 ccs. to 100 qcm. The green mirror should be placed under the blue filter and the red under the blue filter.

Filter Patents.—Some patents have been taken out for various filters and are grouped together.

FIG. 13. McDonough's U.S.P. 562,642.

J. A. Smith[73] proposed to insert a lens or lenses between the focus of the camera lens and the plate, thus redirecting the rays into a parallel position. "I also propose to insert or introduce into the camera a diaphragm or opaque screen with small aperture in it for the purpose of intercepting by said diaphragm or screen all or nearly all actinic rays

which do not converge to or pass through the focus aforesaid, and thereby securing so far as may be the actinic efficiency and homogeneous purity of the colors or colored rays proceeding from the object photographed, with the view of producing colored images or photograms of such objects." How this would be done is not clear.

T. C. Roche[74] suggested making the three filters on a circular disk, which was fitted to the lens tube, so that each could be brought in turn into the optical axis. J. W. McDonough[75] patented an adjustable "chromatic balance screen," shown in Fig. 13, which was specially designed for screen-plate work. This consisted of sheets of mica, coated with different colors, which could be brought more or less into the optical axis, thus varying the composition of the light on the plate. The entire sheet *A* in *1*, either of celluloid or mica, was coated with a lemon yellow, and the curved pieces in *2* and *3* were coated with orange dye, and an aperture in the center of the filter could be varied in size, as shown in *5* and *6* in *B'*, *C'*. By varying the size of the aperture, more or less blue rays were passed by the central aperture, and also more or less green, as moving the dyed leaves cut out these colors the more they were moved.

C. F. Uebelacker[76] patented the use of an adjustable filter, composed of one cylinder sliding within another, so that the thickness of a liquid could be varied at will. A small reservoir received the excess liquid, when the glass ends of the cylinders were pressed together. G. Selle[77] would do away with the contraction of collodion, when used for filters, by diluting it with 50 per cent of ether and used a 3 per cent normal collodion. For the blue filter a mixture of gentian blue and fuchsin was used; for the green, emerald green and auramin; for the red, a mixture of fuchsin and safranin. The collodion was poured on glass in the usual manner and excess run off, and the plates dried at about 60° C. The transmissions given as the best were, for the red, from A to beyond C; for the green, from F to D and for the blue from H to F.

W. G. Aarland and A. Bauermeister[78] proposed to make a thin flat cell by cementing to the edges of a sheet of glass, narrow strips of glass, so as to form a shallow trough, and into this was poured a mixture of glycerol, gelatin and dyes of the proper colors. Another sheet of glass was placed on top, and then the whole allowed to cool under pressure. It was claimed that by this means better and larger filters could be prepared without any trouble from distortion of the glasses in drying, and that the mass kept better than others. A typical formula was a 6 per cent solution of gelatin in glycerol, 0.3 per cent of crocein scarlet dissolved in glycerol, with the addition of 0.2 per cent of thymol as an antiseptic.

T. Willsie[79] patented a "ray-filter" consisting of strips of glass or celluloid of different colors cemented to a support, and the edges bevelled to slightly overlap. The inventor claimed that a speed faster than normal was thus attained, and the arrangement of the strips of colored material

was determined by an unique and peculiar theory that has but little truth in it. F. J. Harrison[80] proposed to make filters in the form of long ribbons, as shown in Fig. 14, of celluloid or the like; *a* and *o* are the opaque ends which protected the film, and *c, d, e* the colored sections, which might be of different lengths to compensate for the different sensitiveness of the emulsion. While three colors are specified, only one or more than three, could be used. A motor was suggested as the motive power for moving the ribbon in front of the emulsion, and chrysoidin, malachite green and Hofmann's violet for the dyes.

H. Fritsche[81] patented a roll film with filters attached, as shown in Fig. 15, in which *a* is the opaque support, *c* the sensitive film, and *g, f, e*

Fig. 14. Harrison's U.S.P. 599,670.

the color filters, whilst *b* is a transparent piece of matt celluloid for focusing. J. Thacher Clarke[82] would make tab films for film packs with the filters attached. Fig. 16, *C', C'', C'''* being the usual standard tri-color filters; *F', F'', F'''* the sensitive films, and *P', P'', P'''* the black papers. H. Schmidt[83] provided three filters in rings that fitted into the lens tube, all being mounted on a rod and pulled into position by a string, while the previous filter was released and sprung out of the axis.

C. L. A. Brasseur[84] patented filters with graded coloring from pale to deep, or with one end white. The glasses were provided with scales and rack and pinion, so as to enable them to be set at any desired tint. L. Husson and A. F. Bornot[85] proposed to coat sensitive plates with a solution of wax, spermaceti, or the like in benzol or ether, and polish the

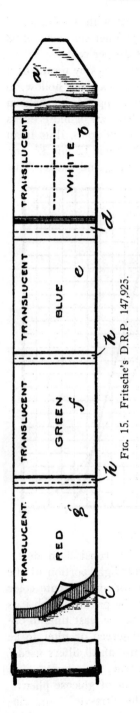

Fig. 15. Fritsche's D.R.P. 147,925.

Fig. 16. Thacher Clarke's E.P. 10,951, 1904.

surface with cotton or chamois leather, and then coat with a solution of dye in glucose or glycerol. A typical formula being 95 per cent alcohol 62 parts, liquid glucose or glycerol 62 parts, anilin dye 0.4 per cent.

F. J. Dukelow[86] proposed to make a cell for fluid filters by means of a ring of glass, side plates and stopper, in the latter being a small hollow, in which any air bubbles were supposed to collect; the stopper being held in position by a spring. W. Hood[87] discovered that when two or more filters are used together their effect is not in sums but in multiples, thus if an 8 times filter be combined with a 4 times, the result is not 12 but 32, and his claim is an exquisite piece of mathematical reasoning, and reads: "The

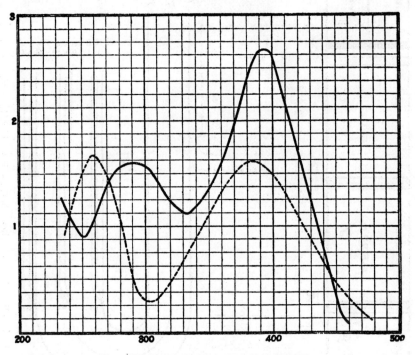

Fig. 17. H. T. Clarke's U.S.P. 1,293,039.

method of correcting photographic exposures, which consists in determining the time of exposure required for the highest light portion of the picture, determining the time of exposure required for approximate color rendering with full detail of the darkest portion of the picture which it is desired to so render, and dividing the greater time by the least time to obtain the exponent of the composite or multiple ray screen or filter to be used, which exponent is the product of the exponents of all filters used." Unfortunately this argument does not happen to be true.

H. T. Clarke[88] patented the use of the sodium salt of glucose phenyl-osazone-p-p′-dicarboxylic acid as an absorbent of the ultra-violet and violet rays, and thus replace the German dye, known as filter yellow K, which

had been almost exclusively used for making yellow filters. In Fig. 17, is shown in continuous line the absorption of the new dye, which is known as Eastman yellow, whilst the dotted line shows that of the older German dye, and it will be seen that the absorption is more abrupt with the former. The strength here used was 1 : 40,000, and in this strength it does not absorb at 4600, and for shorter wave-lengths it is very steep and increases rapidly.

J. Meyer[89] patented a somewhat curious method of obtaining three-color negatives. He first pointed out that the filters must absorb those rays which are not to act on the plate, and that as the organic dyes were used for filters and mineral colors for the inks or pigments, it was extremely difficult to obtain agreement between the two spectra. He, therefore, would paint one side of a prism with the inks, so that only those rays would be reflected which were not absorbed. Thus, if three suitable inks were spectroscopically found, which when superimposed gave black, and it was desired to obtain the red-printing plate, the blue and yellow inks were to be mixed in equal parts and painted on the prism. This was placed in front of the lens, so that the object to be taken was reflected into the camera by the painted side of the prism. It was claimed that only the blue and yellow rays would thus be reflected. The other inks were to be treated in like manner. Instead of the prism, a plane parallel mirror could be used, or glass coated with the pigments and the latter polished.

Hnatek's Filter Formulas.—Probably the most extensive collection of formulas for the manufacture of filters was given by A. Hnatek[90], which may be useful for advanced workers, and those who may wish to make a filter for any special purpose, although it should be pointed that there is no consideration of the permanency of the same.

A. Filters with transmission of about 100 Ångstrom Units.

1.	Hofmann's violet....................3.0 g.	Violet–4900	red from 6800
2.	(a) yellowish eosin................4.0 g.	Violet–4800	red from 7000
	(b) methylen blue 4B................1.0 g.	" "	"
3.	(a) quinolin yellow.................1.0 g.	4500–5600	weak red from 7000
	(b) patent blue.....................2.0 g.		
4.	(a) auramin O......................3.0 g.	4800–5900	
	(b) naphthol green..................1.0 g.		
	light green S.......................1.5 g.		
5.	(a) tartrazin.......................2.0 g.	5200–6400	
	(b) naphthol green..................2.0 g.		
6.	(a) brilliant orange................2.0 g.	5500–6500	
	(b) naphthol green..................2.0 g.		
7.	(a) yellowish eosin.................2.0 g.	5600–6600	
	tartrazin4.0 g.		
	(b) naphthol green..................1.0 g.		
8.	(a) fast red D......................2.0 g.	5900–6900	
	(b) tartrazin2.0 g.		

B. Filters with transmission of from 500 to 900 Å. U.

9.	(a) yellowish eosin................4.0 g.	3900–4500	red from 7000
	(b) methylen blue 4B................1.0 g.	" "	"

10. (a) bluish eosin.........................3.0 g. 3900–4600 " " "
 (b) methylen blue 4B...................1.0 g. " " "
11. (a) filter yellow.......................1.0 g. 4450–5100 weak red from 6800
 (b) alkali blue 6B......................1.0 g. " " " "
12. (a) auramin O..........................2.0 g. 4800–5500 red from 7200
 (b) methylen blue 4B..................0.75g. " " "
13. (a) tartrazin1.0 g. 5100–5700
 naphthol green.....................1.0 g.
 (b) acid green JE......................0.5 g.
14. (a) tartrazin2.0 g. 5600–6300
 naphthol green.....................2.0 g.
 (b) yellowish eosin....................4.0 g.
15. (a) rose Bengal........................2.0 g. 5800–4600
 (b) tartrazin2.0 g.
 naphthol green.....................1.5 g.
16. (a) fast red D.........................2.0 g.
 tartrazin2.0 g.
 (b) naphthol green.....................1.0 g.

C. Filters with transmission of from 200 to 500 Å. U.

17. (a) bluish eosin........................3.0 g. 4250–4650 weak red from 7200
 (b) patent blue A......................4.0 g. " " " "
18. (a) quinolin yellow....................2.0 g. 4600–4800 red from 6500
 (b) gentian violet.....................1.5 g. " " "
19. (a) quinolin yellow....................3.0 g. 4700–4800 fairly dark
 (b) naphthol green.....................2.0 g.
 (c) gentian violet.....................2.0 g. " "
20. (a) naphthol yellow....................2.0 g. 4800–5300 faint red from 6600
 (b) alkali blue 6B.....................1.5 g. " " " " "
21. (a) naphthol yellow....................3.0 g. 4900–5200 " " " 6700
 (b) alkali blue 6B.....................2.0 g. " " "
22. (a) tartrazin2.0 g. 5050–5500 " " " 7100
 (b) patent blue........................3.0 g. " " " "
23. (a) brilliant orange...................2.0 g. 5200–5700
 (b) naphthol green.....................2.0 g.
24. (a) martius yellow.....................1.0 g. 5200–5700 " " " 7000
 (b) patent blue........................1.5 g. " " " "
 Or (a) martius yellow....................1.0 g. " " " "
 (b) brilliant green..................1.0 g.
25. (a) brilliant orange...................1.0 g. 5400–5800
 (b) naphthol green.....................1.0 g.
 patent blue........................1.0 g.
26. (a) new coccin.........................2.0 g. 5700–6000
 (b) naphthol green.....................1.0 g.
 patent blue........................0.5 g.
27. (a) new coccin.........................4.0 g. 5950–6450
 (b) naphthol green.....................1.5 g.
28. (a) bordeaux3.0 g. 6100–6600
 (b) tartrazin2.0 g.
 naphthol green.....................1.0 g.
29. (a) new coccin.........................4.0 g. 6500–6800
 naphthol green.....................0.75g.
 (b) gentian violet.....................0.5 g.
30. (a) new coccin.........................4.0 g. 6500–red
 (b) Hofmann's violet...................1.0 g.
31. (a) fast red D.........................2.0 g. 6750–red
 tartrazin2.0 g.
 (b) methyl green.......................2.0 g.
32. (a) fast red D.........................3.0 g. 6900–red
 tartrazin2.0 g.
 (b) patent blue........................2.0 g.

The dyes can be conveniently made up into solutions of the following strengths: acid green 0.4 per cent; brilliant orange, martius yellow, brilliant green, methyl green, methylen blue, gentian violet, 0.5 per cent; fast red D, Bordeaux, rose Bengal, naphthol yellow, quinolin yellow, filter yellow, auramin O, naphthol green, light green, alkali blue, patent blue, Hofmann's violet, 1.0 per cent; new coccin, eosin, tartrazin, 2 per cent.

The fourth column gives the band of transmission of the filter. The third column the quantity of dry dye in grams per square meter, according to von Hübl, which is called the density of the dye. The last column gives useful data as to the transmission of the red end of the spectrum, which for visual work is negligible; but for panchromatic plates must be taken into consideration.

Filters 9, 29 and 32 are rather dark, that is to say, they exert some absorption of the region that they generally transmit; 10, 17, 28 and 31 are less dark, but still do not transmit to the full the wave-lengths stated. It is obvious that by combination of two or more filters almost monochromatic filters can be obtained, but in all cases the resultant filters will be very dark. The signs (a) and (b) mean that the dyed gelatin must be coated on two separate glasses, and that they can not be mixed. In all cases the dyes should be added to a 12 per cent solution of gelatin.

C. D. Hodgman[91] also gave a useful table of filters, which has been recalculated to the same dye density, that is grams of dry dye per square meter. A 6 per cent solution of gelatin was used as the vehicle, and each filter is composed of two glasses, (a) and (b), each bearing the quantity of dye given. The limits of action with a given plate are for a Mazda C lamp, that is supposed to give an approximation to daylight.

	Filter	Density	Plate	Limits of action
1.	(a) rhodamin B	7.99	pan.	6000–7100
	(b) orange G	6.25		
2.	(a) rose Bengal	0.64	pan.	5800–7100
	(b) orange G	6.25		
3.	(a) erythrosin	0.94	pan.	5700–7100
	(b) orange G	6.25		
4.	(a) ponceau 2R	1.41	pan.	5600–7100
	(b) auramin	0.94		
5.	(a) ponceau 2R	1.128	pan.	5500–7100
	(b) orange G	1.88		
6.	(a) fluorescein	7.332	pan.	5400–7100
	(b) picric acid	1.551		
7.	(a) ponceau 2R	0.47	pan.	5400–7100
	(b) metanil yellow	1.0		
8.	(a) naphthol green	0.282	pan.	4800–6200
	brilliant green	0.141		
	(b) picric acid	5.875		
9.	(a) methylen green	1.875	pan.	4700–6200
	(b) auramin	0.94		
10.	(a) Nacht blau	1.41	pan.	4700–6200
	(b) gentian violet	0.47		
11.	(a) methylen green	0.938	pan.	3700–4900
	(b) gentian violet	0.94		

	Filter	Density	Plate	Limits of action
12. (a)	iodine green	0.94	pan.	3500–7100
(b)	gentian violet	0.39		
13. (a)	picric acid	0.196	ord.	3900–5000
(b)	erythrosin	0.94		
14. (a)	æsculin	0.47	ord.	3900–5000
(b)	erythrosin	0.705		
15. (a)	æsculin	0.47	ord.	3900–5200
(b)	uncoated glass			
16. (a)	gentian violet	0.47	pan.	6400–7100
	orange G	6.25		
(b)	erythrosin	5.875		
17. (a)	fluorescein	5.875	ortho.	5400–6100
(b)	picric acid	1.551		
18. (a)	Nacht blau	1.88	pan.	4600–5100
(b)	picric acid	1.551		
19. (a)	rose Bengal	1.00	ord.	4600–5000
(b)	picric acid	1.287		
20. (a)	picric acid	1.551	pan.	4600–4800
	erythrosin	0.94		
(b)	Nacht blau	1.88		
21. (a)	eosin yellowish	1.306	ord.	4200–4700
(b)	æsculin	1.875		
22. (a)	eosin yellowish	1.316	ord.	3700–4500
(b)	eosin yellowish	1.316		
23. (a)	rose Bengal	1.00	pan.	4600–5000
(b)	picric acid	1.287		5900–7100
24. (a)	erythrosin	0.705	pan.	3900–5100
(b)	æsculin	0.47		5500–7100
25. (a)	picric acid	0.195	pan.	3900–4800
(b)	erythrosin	0.945		5600–7100
26. (a)	eosin yellowish	1.316	pan.	4200–4700
(b)	æsculin	1.875		5600–7100
27. (a)	eosin yellowish	1.316	pan.	3800–4500
(b)	eosin yellowish	1.316		5600–7100

The orange G and fluorescein will not dissolve in water in the proportion stated, and ammonia should be added drop by drop till solution takes place.

Von Hübl[92] gives the following table of filters, which may be useful. The transparency was measured with the colorimeter, shown on page 31, Nos. 1 and 2 are used by W. Ostwald in his system of color. No. 3 is for three-color projection and for the above-mentioned colorimeter. No. 4 is the fundamental red and normal tri-color filter. No. 6 is a subtractive tri-color filter, complementary to 20. No. 8 is the color of the yellow mercury arc spectrum. No. 10 another of Ostwald's filters. No. 11 is the fundamental green or additive three-color filter. No. 14 tri-color projection and for the colorimeter. No. 15 Ostwald's leaf green. No. 16 Ostwald's sea green. No. 18 subtractive fundamental color, complementary to 4. No. 20 complementary to 6. No. 21, 22 fundamental blue-green tri-color filter. No. 23 used for color sensitometer. No. 24 Ostwald's 3a filter. No. 25 subtractive fundamental filter, complementary to 11. No. 26 possesses equal transparency for red and blue. No. 30 used in von Hübl's coloriscope, which looks pure grey by white light, but red or green with the predominance of either of these colors in the light.

No.	Name	Color	Trans.	Max. trans.	Transparency for			Composition of filter
					red	green	blue	
1.	Dark red	deep red	>6400	6560	0.02	acid violet 3.0, tartrazin 2.0.
2.	Monochromatic red	pure red	>6100	6350	0.18	acid rhodamin 3.0, tartrazin 2.0.
3.			>6000	6250	0.33	acid rhodamin 0.8, erythrosin 1.0, tartrazin 2.0.
4.	Spectrum red	yellowish-red	>5900	6150	0.50	0.01	...	rose Bengal 1.5, tartrazin 2.0.
5.	Reddish orange	yellow-red	>5800	6100	0.53	0.04	...	rose Bengal 0.5, erythrosin 1.0, tartrazin 2.0.
6.			>5650	6050	0.52	0.06	...	dianil red 0.8, filter yellow 4.0.
7.	Spectrum orange	dirty orange	5900–6150	6060	0.01	0.005	...	rose Bengal 1.3, naphthol green 1.3, tartrazin 1.3.
8.	Neutral yellow	yellow	>4950	5780	0.96	0.95	...	filter yellow 5.
9.	Reddish yellow	yellow	>5100	5800	0.95	0.65	...	filter yellow 4.
10.	Spectrum yellow	dirty yellow	5600–5850	5780	0.02	0.02	...	sodium monobromofluoresceinate 0.5, patent green 0.5, tartrazin 0.5.
11.	Spectrum green	yellowish-green	5100–5700	5350	...	0.18	...	patent blue 0.7, tartrazin 2.5.
12.	Green, with wide transmission	yellowish-green	4950–5800	5250	0.01	0.20	0.01	patent blue 0.4, filter yellow 5.0, toluidin blue 0.4.
13.	Bluish green	bluish-green	4900–5700	5200	...	0.23	0.02	patent blue 0.7, tartrazin 0.7.
14.	Monochromatic green	pure green	5050–5650	5250	...	0.13	...	patent blue 1.0, tartrazin 1.2.
15.	Yellow-green, spectrum	yellowish-green	5150–5700	6400	0.02	0.11	...	patent blue 0.7, tartrazin 6.0.
16.	Blue-green, spectrum	bluish-green	4900–5400	5050	...	0.05	0.02	patent blue 2.0, filter yellow 3.0.
17.	Spectrum, Eb	dirty-green	5150–5350	5200	...	0.01	...	dark red green 7.0, toluidin blue 0.5.
18.	Minus red	blue-green	<5900	4860	...	0.25	0.50	patent green 0.7, toluidin blue 0.5.
19.	Spectrum, F	dirty blue-green	4700–5150	4860	...	0.01	0.02	patent green 14.0.
20.	Blue, with wide transmission	bright blue	<5650	4900	...	0.13	0.45	patent blue 0.6, toluidin blue 1.0.
21.	Spectrum blue with violet	dark blue	<4850	4550	0.20	acid violet 2.5, toluidin blue 0.2.
22.	Spectrum blue with violet	dark blue	4850–4300	4550	0.20	acid rhodamin 3.0, patent blue 1.0.
23.	Ammonio-sulfate of copper per substitute	pure blue	<4950	4600	0.30	acid violet 1.2, toluidin blue 2.0.
24.	Spectrum violet	dark violet	<4600	4400	crystal violet 5.0, toluidin blue 0.2; or better Uviol glass.
25.	Minus green	purple red	>5060, <5750		0.42	...	0.30	rose Bengal 2.0, eosin 0.2.
26.	Red-blue	red violet	6050–6700, 4200–4700		0.08	...	0.08	acid rhodamin 1.5, sodium dibromofluoresceinate 0.5, toluidin blue 0.3.
27.	Ultra-violet absorbent	colorless	>4200		1.00	1.00	1.00	esculin 2.0 or quinin hydrochloride 10.0.
28.	Ultra-violet transmittent	black	2800–3800		0.00	0.00	0.00	Uviol glass, nitrosodimethylanilin, toluidin blue 0.2.
29.	True grey	grey			...	0.00	1.00	Indian ink, fast red, toluidin blue.
30.	False grey	grey	7100–5900, 4900–5200		...	0.08	...	filter blue 1.0, filter yellow 1.0, toluidin blue 0.1.
31.	False grey	grey	>6500, 5300–5600, <4500		...	0.02	...	sodium dibromofluoresceinate 2.0, patent green 2.0.

1. "La Lumière, ses causes et ses effets," 1868, **2**, 178; Becquerel here refers to Mem. d. savants etrangers d. l'Académie des Sciences, 1840, **8**, 381. He also states that M. Malaguti, Ann. Chim. Phys. 1839 (2), **72**, 5, had used colored screens with silver salts, and Becquerel, ibid. 1842 (3), **9**, 280, pointed out a very probable source of error and described an improvement. Cf. Handbuch, 1912, **1**, III, 333; A. Davanne, "Traité theorique et pratique," 1886, **2**, 363; du Hauron, "La Triplice photographique," 1897, 96.

2. Phot. News, 1858, **1**, 61; 1887, **31**, 97; 1888, **32**, 225. Cf. Gulliver, Phot. J. 1859; Bull. Soc. franç. Phot. 1859.

F. Monpillard, E.P. 23,048, 1907 patented the use of æsculin as an ultra-violet absorbent.

3. "Die photographischen Lichtfilter," Halle, 1910, 16; 2nd. edit. 1922.

Von Hübl, Wien. Mitt. 1913, 160; 1914, 145, 174; abst. C. A. 1913, **7**, 2019; Phot. J. Amer. 1914, **51**, 423, explains in detail the method by which any filter can be made to compensate for any colored illumination. F. Monpillard, Rev. Sci. Phot. 1906, **2**, 226, had suggested the expression of the quantity of the dye in grams per square centimeter; but this gives very inconvenient fractions. Eder, Jahrbuch, 1913, **27**, 280, suggested that this unit, 1 gram per square meter, should be called Hübl's unit, and designated by the letter H.

4. Phot. Rund. 1912, **49**, 9; Brit. J. Phot. 1912, **59**, 195; abst. Jahrbuch, 1912, **26**, 343; Chem. Tech. Rep. 1912, 411; C. A. 1912, **6**, 2040. Cf. E. J. Wall, Brit. J. Phot. 1907, **54**, Col. Phot. Supp. **1**, 9.

5. Compt. rend. 1905, **141**, 31; Brit. J. Phot. 1905, **52**, 587; Camera, 1905, 181; Bull. Soc. franç. Phot. 1905, **52**, 364. Cf. L. P. Clerc, "Les Reproductions Photomechaniques Polychromes," 1919, 182; abst. Phot. J., 1905, **45**, 343. J. Precht & E. Stenger, Zeits. wiss. Phot. 1905, **3**, 27; Brit. J. Phot. 1905, **52**, 226; Phot. Chron. 1905, **12**, 625.

6. Astrophys. J. 1906, **24**, 268; Brit. J. Phot. 1907, **54**, 25; Phot. Coul. 1908, **3**, 144.

7. See also von Hübl, Wien. Mitt. 1914, 203; Phot. J. Amer. 1914, **51**, 379. C. E. K. Mees, Brit. J. Phot. 1906, **53**, 349.

8. Penrose's Annual, 1905, **11**, 13.

Clay also drew attention to the spherical aberration introduced by a flat plate, ibid. 1903, **9**, 60. Also to the shift of the image by the filter, ibid. 1904, **10**, 92. The distortions caused by filters are also discussed mathematically by K. Zaar, Phot. Korr. 1919, **46**, 301; Le Procédé, 1920, **22**, 70; Sci. Tech. Ind. Phot. 1921, **1**, 30. Cf. C. E. K. Mees, Knowledge, 1911, **8**, 155; Brit. J. Phot. 1911, **58**, 69, 330; 1917, **64**, 462; J. Opt. Soc. Amer. 1917, **1**, 22; "Orthochromatic Filters," Wratten & Wainwright, London, 1911, 39. C. Sacco, Red. Acad. Sci. Torino, 1907, **43**, 767, 856; abst. Brit. J. Phot. 1909, **56**, 53.

C. Berthiot, according to Brit. J. Phot. 1897, **44**, 103, was the first to suggest and patent the use of filters with parallel faces, in 1875; Bull. Soc. franç. Phot. 1875, **17**, 119; Fabre, "Traité encycl." 1892, Supp. A, 107.

9. Zeits. wiss. Phot. 1905, **4**, 27; Brit. J. Phot. 1905, **52**, 226; abst. Brit. J. Almanac, 1906, 869; Phot. J. 1905, **45**, 132.

H. C. Vogel, Ber. Berlin Akad. 1880, 801, had compared the luminosity of the sun and skylight with a paraffin lamp with a spectrophotometer. Crova, Compt. rend. 1889, **109**, 493, also investigated the radiation of diffused sky light. E. Köttgen, Wied. Annal. 1894, **53**, 793, compared the relative visual luminosities of various light sources. H. W. Vogel, "Handbuch d. Phot." 1894, 4th edit. **2**, 256, 266: Jahrbuch, 1890, **4**, 197, made numerous experiments on the variability of daylight, using silvereoside plates, under various conditions both at sea level and on mountain tops, and he stated that "without exception the action of the blue diffused sky light appreciably increased after sunset." Cf. K. Schaum. "Photochemie u. Photographie," 1908, 192. A. Rudolph, J. f. Gasbel. 1905, 217. H. C. Vogel, Berlin Monatsber. 1880, 801. L. W. Hartmann, Phys. Zeits. 1903, **5**, 5. W. H. Pickering, Proc. Amer. Acad. 1880, **15**, 236. H. Kayser, "Handbuch d. Spektroscopie," **2**, 126. W. Voege, J. f. Gasbel. 1905, 512. W. Nernst & E. Bose, Phys. Zeits. 1900, **1**, 289. P. Vaillant, Compt. rend. 1906, **142**, 81. C. L. A. Brasseur, Camera Work, 1907; Brit. J. Phot. 1907, **54**, 843.

10. Phot. News, 1889, **33**, 210; Jahrbuch, 1891, **5**, 493.

This was also recommended by L. Vidal, Wilson's Phot. Mag. 1889, **26**, 360; E. Vogel, Phot. Mitt. 1889, **46**, 306; Oesterr-Ungarischen Buchdruckerztg, 1889, 271; Phot. Woch. 1892, **38**, 288; Jahrbuch, 1893, **7**, 405. J. Waterhouse, Brit. J. Phot. 1892, **39**, 510; abst. Phot. Annual, 1893, 116; Brit. J. Almanac, 1893, 761;

Phot. J. 1892, **32**, 88; Phot. News, 1889, **33** recommended the use of a varnish colored with turmeric, annatto and kamala. H. W. Vogel when announcing his discovery of orthochromatism, pointed out the necessity of the yellow filter, and recommended a 3 per cent solution of aurantia in 1.75 per cent collodion. Cf. Anthony's Phot. Bull. 1885, **15**, 359. This was also recommended by O. Litzkow, Phot. News, 1897, **40**, 439.

11. H. Quentin, Photogram, 1894, **1**, 106; Photo-Rev. 1904, **16**, 206; abst. Phot. Annual, 1895, 202; instead of aurantia, picric acid could be used.

On the preparation of pyroxylin for filters, by precipitation, see Brit. J. Phot. 1896, **43**, 722; 1897, **44**, 213, 413. It was also suggested, ibid. 194, to strengthen the collodion by subsequently coating with gelatin and then stripping. E. V. Boissonas, Bull. Soc. franç. Phot. 1889, **36**, 23, used gelatin as more durable than the collodion in the above formula.

12. E.P. 9,926, 1892.

13. E.P. 24,487, 1893; Brit. J. Phot. 1894, **41**, 348, 415; J. Cam. Club, 1894, **8**, 26; Photography, 1894, **6**, 77; Phot. J. 1894, **34**, 211; Phot. News, 1894, **41**, 261; abst. Phot. Annual, 1895, 201; Jahrbuch, 1895, **9**, 382; 1898, **12**, 347. The separate filters increased the exposure about 6 times, and the balsam filter about twice.

According to Phot. Times, 1896, **27**, 119; abst. Jahrbuch, 1897, **11**, 300, C. C. Harrison used yellow glass for one of the lens components. This was first suggested by Gaudin, La Lumière, 1867; Bull. Belge. 1867, 129; Fabre, "Traité encycl." Supp. A, 108. Cf. Kämpfer, Zeits. wiss. Phot. 1899, 25. H. Schmidt, Phot. Mitt. 1902, **39**, 278, also recommended yellow staining of the balsam. Cf. ibid, 341; Jahrbuch, 1903, **16**, 341. Later Burchett, Phot. J. 1895, **35**, 55, introduced a lighter filter. Cf. W. Abney, Phot. J. 1894, **34**, 328; Amat. Phot. 1894, **22**, 42, 73; abst. Phot. Annual, 1896, 182. Burchett, Amat. Phot. 1894, **22**, 117.

W. Abney, Brit. J. Almanac, 1889, 378; 1902, 898; Phot. Times, 1894, **39**; Phot. Rund. 1895, **22**, 120; abst. Jahrbuch, 1896, **10**, 361, fastened microscopic cover glasses to a sheet of glass with a drop of oil, then coated them with collodion stained with turmeric and aurin, or brilliant yellow, and when dry lifted them off and cemented them to the lens diaphragn. T. N. Armstrong, Brit. J. Phot. 1889, **36**, 374; Phot. Times, 1889, **19**, 120, had suggested the use of micro cover glasses in this position. Hupfauf also stripped collodion films and cemented to the diaphragms. O. Lohse, Jahrbuch, 1888, **1**, 361; Jaffé, ibid. 473; M. B. Punnett, Phot. Times, 1896, **41**, 365. Anon. Das Atel. 1896, **3**, 164; abst. Jahrbuch, 1897, **11**, 299. G. T. Harris, Brit. J. Almanac, 1893, 700. J. Waterhouse, ibid, 1888, 457. W. B. Bolton, Brit. J. Phot. 1891, **38**, 502; Phot. J. 1891, **31**, 97 also recommended diaphragm filters. W. Weissenberger, Penrose's Annual, 1898, **4**, 68 strongly recommended the filter close in front of the plate.

14. Phot. J. 1896, **36**, 315; Brit. J. Phot. 1896, **43**, 414; Phot. Chron. 1896, **3**, 328; Anthony's Phot. Bull. 1896, **26**, 573; abst. Phot. Annual, 1897, 211; Jahrbuch, 1897, **11**, 298.

Ives stated that naphthol yellow gave too sharp a cut and that brilliant yellow was more gradual. This dye is sold by Bayer and Grasse; as renol yellow, by Sevoz and Biasson; as paper yellow 3G by Badische; as brilliant yellow Y by Schoelkopff.

15. Phot. Korr. 1893, **30**, 277; 1894, **31**, 21; Phot. Times, 1894, **25**, 213; Photogram, 1894, **1**, 36; Anthony's Phot. Bull. 1894, **25**, 50; abst. Jahrbuch, 1894, **8**, 52. Cf. H. Krone, "Die Darstellung der natürlichen Farben," 1894, 91.

16. Jahrbuch, 1894, **8**, 52.

17. Phot. J. 1907, **47**, 290; 1917, **57**, 2.

C. Bunnin, ibid. 1915, **55**, 61 also dealt with this subject. A. J. Bull, ibid. 1918, **56**, 266; Phot. J. Amer. 1919, **56**, 228, gave directions for making filters.

18. "Die photographischen Lichtfilter," 32.

19. Phot. J. 1895, **35**, 193. This is the first instance of the use of a centrally perforated filter, which was also used by McDonough and Artlett (see p. 85).

For further notes on yellow filters see: W. K. Burton, Phot. Work, 1894, **3**, 122; Phot. Times, 1893; Phot. Woch, 1893, **39**, 367; Phot. J. 1894, **34**, 362; Bull. Soc. franç. Phot. 1893, **40**, 253; Jahrbuch, 1894, **8**, 355; Anthony's Phot. Bull. 1896, **27**, 15. L. Vidal, Brit. J. Phot. 1896, **43**, 199. V. Boissonnas, Photo-Rev. 1904, **16**, 206. H. Quentin, ibid. suggested using fixed-out dry plates. A. Callier, Bull. Belge, 1905, 188; Rev. Sci. Phot. 1906, **2**, 289; abst. Phot. J. 1906, **46**, 169 dealt very fully with the manufacture of filters. F. Novak, Phot. Korr. 1906, **43**, 285; Brit. J. Phot. 1906, **53**, 505. C. Fleck, Mon. Phot. 1897; Brit. J. Phot. 1897, **44**, 167, 710, 722; Pract. Phot. 1897, **8**, 128; abst. Phot. Annual, 1898, 230; Jahrbuch, 1898, **12**, 347.

E. Vogel, Jahrbuch, 1898, **12**, 346; Phot. Annual, 1897, 70. M. Andresen, Jahrbuch, 1901, **15**, 252.

W. Schlichter and F. Leiber, D.R.P. 383,729, 1922 patented a filter so composed of dyes that when used for viewing it should give a colored image with tone gradations, comparable to those obtained on a plate with a filter. Needless to point out that this has been in use for many years.

A. Ames, U.S.P. 1,460,122, patented the use of a yellow filter comparable in size with the macula lutea, combined with neutral tints so as to obtain color rendering as seen by the retina. Cf. U.S.P. 1,482,502; 1,482,503; Amer. Phot. 1924, **18**, 248; Sci. Ind. Phot. 1925, **5**, 28.

G. Lippmann, Bull. Soc. franç. Phot. 1889, **36**, 222, proposed to use first a blue filter, then the green and finally the red, for obtaining correct rendering of colors in monochrome. This was also suggested by C. E. K. Mees, "The Photography of Colored Objects," London, 1909, 29. Cf. Delaurier, Bull. Soc. franç. Phot. 1889, **36**, 225.

20. Phot. News, 1879, **23**, 146; Phot. Korr. 1879, **16**, 83; Brit. J. Phot. 1886, **33**, 304; "Instruction in Photography," 1900, 10th edit. 42; Handbuch, Erganzungsband, 1893, 90.

In this last work Eder implies that Hunt suggested that glass colored yellow with a silver salt was the best for dark-room work, and cited his "Researches on Light," 1854, 311; Dingl. Poly. 1855, **138**, 237; Horn's Phot. J. 1855, **4**, 67. But Hunt does not mention the use of this glass for this purpose, merely stating that it was more efficient in cutting out the blue and violet, and the peculiar dichroic effect of some of these glasses. This was also recommended by H. W. Vogel, Phot. Mitt. 1880, **10**, 267. Ponting, Bull. Soc. franç. Phot. 1858, **5**, 323, stated that silver glass in time lost its power of absorbing the actinic rays, which Eder, loc. cit denied. Some valuable spectroscopic researches on various glasses were carried out by Eder and Valenta, Denkschr. Akad. Wiss. Wien, 1904; Beiträge, 1904, I. 96; Handbuch, 1912, I, III, 334; Jahrbuch, 1894, **9**, 310, particularly as to the absorption of the ultra-violet. A. Claudet, E.P. 9,193, 1841, patented the use of red glass in preparing daguerreotypes.

21. Proc. Roy. Soc. 1891, **69**, 509; Brit. J. Phot. 1891, **38**, 381.

H. Baden Pritchard, Phot. News, 1884, **28**, 17, pointed out that deep, diffused yellow light was quite safe and much more pleasant to the eye than red, and combined an orange and a ground glass; but obviously this was in the early days of dry plates.

22. Bull. Soc. franç. Phot. 1877, **23**, 183; Phot. Archiv. 1877, **18**, 183; Brit. J. Phot. 1877, **24**, 334, 1383; Phot. News, 1877, **21**, 362. Bardy also suggested anilin red and chrysoidin, as well as aurin, but these also bleached. Later, Bull. Soc. franç. Phot. 1879, **25**, 98 he proposed ammonium picrate or chrome yellow rubbed up with varnish. Cf. H. W. Vogel, Brit. J. Phot. 1878, **25**, 64; Eder & Tóth, ibid. 66.

23. Phot. Korr. 1879, **16**, 80; Phot. News, 1879, **23**, 344.

24. Phot. Mitt. 1879, **16**, 19.

E. Breese, Phot. News, 1861, **5**, 298; Horn's Phot. J. 1861, **7**, 24 suggested a saturated infusion of saffron in water, immersing a collodionized plate and superposing two such glasses. F. York, Phot. News, 1875, **19**, 183, proposed a saturated solution of aurin in collodion; this was also proposed by A. J. Brown, ibid. 1881, **25**, 357. Vagner, Phot. Mitt. 1870, **7**, 128 used Brazil wood and gamboge in collodion. Larriston, Phot. News, 1861, **5**, 141; Kreutzer's Zeits. Phot. 1861, **4**, 20; Handbuch, Erganzungsband, 1893, 96 used gamboge alone. Antoine, Kreutzer's Zeits. Phot. 1862, **5**, 138; Handbuch, loc. cit used gamboge, elemi and resin in benzol. Soaking cloth in potassium dichromate and then in lead acetate was also suggested, thus producing lead chromate in the fibers.

25. Phot. J. 1907, **47**, 268; Brit. J. Phot. 1907, **54**, 480. Cf. J. H. Baldock and A. Roods, ibid. 1895, **42**, 805.

26. Bull. Soc. franç. Phot. 1894, **41**, 536; 1895, **42**, 115; Jahrbuch, 1894, **9**, 381.

A. Gaudin, Horn's Phot. J. 1854, **2**, 40, and Hunt, Dingl. Poly. 1854, **136**, 206, coated glass with gelatin or gum and potassium dichromate. Gibbons, Horn's Phot. J. 1865, **23**, 50, saturated muslin with a warm solution of the same. This turns dark brown under the action of light. Gelatin, soaked in potassium permanganate, was also used, Brit. J. Phot. 1876, **33**, 297; this also turns dark brown due to the precipitation of manganese dioxide. Carey Lea, Bühler's "Atelier u. Apparat d. Photographen," 1869, 297, added iodine to ordinary negative varnish; obviously the

iodine would vaporize in time. V. Schumann, Phot. Archiv. 1880, **21**, 111, used brown tissue paper, well oiled, in three thicknesses; this was also used by von Staudenheim, Jahrbuch, 1891, **6**, 267. J. Gædicke, Jahrbuch, 1888, **1**, 89, introduced a sodium lamp. Bardy, Riche and Girard, Bull. Soc. franç. Phot. 1875, **22**, 6; 1883, **30**, 205; 1889, **36**, 33, and T. Stein, "Das Licht," 1877, 96 had anticipated Gædicke. Fleichl, Wied. Annal. 1891, **38**, 675; Chem. Ctrlbl. 1890, 306, suggested sodium bromide for this lamp. E. Vogel, Jahrbuch, 1890, **4**, 199: Phot. Mitt. 1894; Bull. Soc. franç. Phot. 1894, **41**, 212, suggested red pot glass, instead of flashed. He also suggested gelatin screens of rhodamin and aurantia, Jahrbuch, 1891, **5**, 403; 1894, **8**, 301. J. Robitschek, ibid. 1892, **6**, 186 proposed two cylinders of red and yellow glass outside a candle. H. Hinterberger, Jahrbuch, 1898, **12**, 137 tested various glasses and media. Cf. H. Precht, Phot. Ctrlbl. 1897, 177.

A. Miethe, Das Atel. 1902, **9**, 172; Jahrbuch, 1902, **16**, 437, stated that darkroom screens should not transmit below 5800. R. Zsigmondy, Ann. d. Phys. 1901, (4), **60**, 71; abst. Jahrbuch, 1902, **16**, 440, dealt with the absorptions of colored Jena glasses and their composition. Cf. Zeits. f. Instrument. 1901, 4. C. Henry & J. Courtier, La Phot. 1900, 12: Jahrbuch, 1901, **15**, 561 recommended impregnating paper with auramin and aurantia. W. Abney, Phot. 1898; Phot. Woch. 1898, **44**, 371; Jahrbuch, 1899, **13**, 479; Phot. Chron. 1899, **6**, 444, recommended, specially for ortho plates, the soaking of fixed-out dry plates in methyl violet and combining with an orange glass. H. Calmels, Le Photogramme, 1904, 135; Phot. Woch, 1904, **50**, 277; Jahrbuch. 1905, **19**, 298 also recommended bathing plates in 0.3 per cent solution methyl violet and binding up with another glass, soaked in 0.6 per cent tartrazin. These passed only red, close to the A line. A. Miethe, Phot. Korr. 1904, **41**, 224; Jahrbuch, 1904, **18**, 311; 1905, **19**, 298, introduced commercially stiff gelatin films, known as "Flexoid." Cf. Phot. Chron. 1904, **11**, 81. W. Abney, Phot. 1903, 114 suggested pasting orange paper on chromium green glass, using a candle; the light appeared almost white, but was quite safe with ortho plates. Lüppo-Cramer, Phot. Korr. 1904, **45**, 186: Jahrbuch, 1904, **18**, 312, stated that methyl violet and tartrazin screens passed much green the eye could not see, which were likely to fog plates. R. Namias, Il Prog. Foto, 1905, **12**, 67: Jahrbuch, 1906, **20**, 330, recommended soaking paper in a mixture of 1 per cent tartrazin and 0.1 per cent rhodamin. X. Jeannett and E. Mandevillum, E.P. 8,368, 1908; Brit. J. Phot. 1908, **55**, 740; Jahrbuch, 1909, **23**, 237, patented the use of lead chromate in gelatin, with or without orange or violet dyes. L. Castellani, Rev. Phot. 1904, 25; Phot. Chron. 1904, **11**, 605, recommended soaking paper in aurantia and safranin. A. Rousseau, Photo-Rev. 1908, **20**, 202, suggested solution of aurantia in acetone, amyl acetate and pyroxylin. R. Guillemont, Bull. Soc. franç. Phot. 1894, **41**, 298, 533, gave an exhaustive spectrographic examination of various glasses. Cf. A. Nicolle, ibid. 396.

27. Lux, 1911; Bull. Belge, 1911; Brit. J. Phot. 1911, **58**, 474, 494, 533, 628, 777, 872, 951: Jahrbuch, 1912, **26**, 130; abst. C. A. 1912, **6**, 806. The author has found it advisable to warm the glasses before coating, and the gelatin to 65° C. The tip of the finger is excellent for spreading the gelatin.

28. Phot. J. 1905, **45**, 20. These formulas are given every year in Brit. J. Almanac, as standards.

29. These dyes are made by the Schœlkopff Anilin Co., of Buffalo, a branch of the National Anilin & Chemical Co. But any of the spirit-soluble dyes of like character can be used.

30. "Die photographischen Lichtfilter," 1st edit. 1910; 2nd 1922.

31. Phot. J. 1900, **40**, 194; Phot. Rund. 1900, **27**, 143; Phot. Chron. 1901, **8**, 182; Jahrbuch, 1901, **15**, 559; Brit. J. Phot. 1901, **48**, 428.

Instead of dichromate, W. S. Davenport, Brit. J. Phot. 1901, **48**, 504, 590; Jahrbuch, 1902, **16**, 440, recommended mandarin orange. Also, Brit. J. Phot. 1911, **58**, 659, he used flat bottles of 1 in. internal thickness with 0.2 per cent new coccin red. B. N. Wordsley, Phot. 1901, 684; Jahrbuch, 1902, **16**, 440, suggested 0.0125 eosin plus 0.3 per cent metanil yellow, or for a darker screen 0.04 eosin and 0.25 metanil yellow. H. Parzer-Mühlbacker, Phot. Mitt. 1903, **40**, 234, recommended dichromate solution for ordinary work. Cf. A. Popowitsky, Brit. J. Phot. 1899, **46**, 661.

32. Zeits. wiss. Phot. 1905, **3**, 234; Jahrbuch, 1906, **20**, 330; Brit. J. Phot. 1905, **52**, 733; Brit. J. Almanac, 1907, 693.

In Le Procédé, 1907; Brit. J. Phot. 1907, **54**, 72, Stenger's lamp was highly recommended, and the following suggested: tartrazin 0.5 g., violet dahlia BO 0.2 g., water 1000 ccs. This absorbs up to 6500. For extra rapid and panchro plates double the above quantities of dyes should be used, then up to 6900 is absorbed, and with a

10 c. p. electric lamp, no fog is caused. By replacing the larger quantity of tartrazin with naphthol yellow S (Bayer) g. up to 6850 or 6900 is absorbed; the thickness of liquid should be 1 inch.

33. Phot. Korr. 1906, **43**, 345; Jahrbuch, 1907, **21**, 308; Brit. J. Phot. 1906, **53**, 593. Cf. Eder & Tóth, Brit. J. Phot. 1879, **26**, 342.

34. Phot. Korr. 1909, **46**, 591; Jahrbuch, 1910, **24**, 347. This was also given by L. Tschörner, Phot. Korr. 1909; Photo-Rev. 1909, **21**, 160.

For further notes on liquid lamps see: R. J. Sutton, Brit. J. Phot. 1913, **60**, 124; G. F. Greenfield, ibid. 196; Brit. J. Almanac. 1914, *579*. Anon. Brit. J. Phot. 1910, **57**, Col. Phot. Supp. **4**, 14, 18. In Klimsch's Jahrbuch, 1907; Brit. J. Phot. 1907, **54**, Col. Phot. Supp. **1**, 87, was recommended auramin 0.3 g., methylen blue 0.5 g., brilliant green 2 g., water 1000 ccs. in a thickness of 25 mm. K. C. D. Hickman, Brit. J. Phot. 1924, **71**, 731; abst. Sci. Ind. Phot. 1925, **5**, 19.

35. Brit. J. Phot. 1883, **30**, 720; 1884, 31, 441; 1889, **36**, 423; Phot. J. 1891, **31**, 166. Cf. Brit. J. Phot. 1906, **53**, 592.

A yellow-green light was recommended in Phot. Notes, 1861, **6**, 306. Malatier, Phot. Rund. 1894, **31**, 26; Jahrbuch, 1894, **8**, 392, used for daylight, cathedral green glass with ground glass and two yellow screens. Cf. C. de Albouret, Il Corr. Foto. 1917, 305. W. H. Harrison, Brit. J. Phot. 1884, **31**, 520. G. Balagny, Bull. Soc. franç. Phot. 1889, **36**, 80.

36. It seems hopeless to convince photographers that it is useless to watch the plate during development. This can put nothing into nor take anything out of the plate. The exposure alone does this and with proper development the image will be brought out in all its detail.

37. Bull. Soc. franç. Phot. 1894; Jahrbuch, 1894, **8**, 392.

It may be as well to place on record that some ill-directed agitation was gotten up as to the ill-effects of red light on workers in photographic factories. They were stated to be ill-tempered, inclined to quarrel and to gradually become anæmic. This absurd agitation arose from the experiments of Ocoum, of the Finsen Institute, who found that darkness and red light reduced the quantity of blood 3 to 3.5 per cent; therefore, with prolonged stay in the dark-room the 5 liters of blood in the human system would be reduced 15 to 18 ccs. This could be recovered by a 4 hour light bath. Phot. Woch. 1907, **53**, 125; Phot. Korr. 1907, **34**, 356; Jahrbuch, 1908, **21**, 359. Lafont & Heim stated in their work "Recherches sur l'hygiène du travail industriel" that analysis of the blood of dark-room workers proved that they did not become anæmic, but that there was a great increase of the white blood corpuscles, and this they ascribed to absorption of silver salts by the body!

38. Brit. J. Phot. 1906, **53**, 592; Phot. Korr. 1909, **46**, 591; Jahrbuch, 1910, **24**, 347. Also given by L. Tschörner, Photo-Rev. 1909, 160; E. J. Wall, Photo-Era, 1914, **31**, 287; abst. C. A. 1914, **8**, 634.

R. E. Liesegang, Phot. Archiv. 1890, **31**, 122; Phot. Annual, 1891, 74, pointed out that a mixture of 3 parts of green nickel chloride and 1 part red cobalt chloride was colorless, and since the light transmitted by one of these salts was without action on silver compounds, the same will be true of the mixture. Silver paper undergoes no change behind a screen of this kind. To ensure complete absorption of the ultra-violet, one side of the cell should be coated with quinin sulfate in collodion. H. W. Vogel, Phot. Mitt. 1890, **27**, 81; Phot. Annual, 1891, 75, said that the transmitted rays contained a large proportion of those between G and F, therefore, exerted a strong action on plates and bromide papers. A solution of 30 per cent nickel chloride and 10 per cent cobalt chloride absorbs the blue rays entirely, but allows greenish-yellow and yellow rays to pass.

39. "Das Arbeiten mit farbenempfindlichen Platten," Berlin, 1910, 37; Brit. J. Phot. 1906, **53**, 592; Jahrbuch, 1911, **25**, 352.

40. Phot. Mitt. 1910, **57**, 300; Brit. J. Phot. 1910, **57**, 720; "Die photographischen Lichtfilter," 1910, 77; Wien. Mitt. 1910. Cf. Photofreund, 1924, **4**, 267, 285.

Cf. C. E. K. Mees & S. H. Wratten, Brit. J. Phot. 1907, **54**, Col. Phot. Supp. **1**, 64, on rapid filter blue. On dyes in general, E. König, Brit. J. Phot. 1910, **57**, 529.

41. Loc. cit.

For testing dark-room filters, see C. S. Baynton, Photogram, 1900, **7**, 142, 185.

42. Phot. J. 1905, **45**, 20.

Lumière introduced stained papers, called "Virida," for use with Autochrome plates; some were green and others yellow; three or more were to be used according to the candle-power of the light. The Paget Dry Plate Co. also introduced similar papers.

43. Phot. Korr. 1909, **46,** 121; Jahrbuch, 1909, **23,** 304; Brit. J. Phot. 1909, **56,** Col. Phot. Supp. **3,** 37; 1911, **58,** 778.

A. H. Trivelli, ibid. pointed out that there are serious objections to this screen, as the dyes are not chemically pure and the use of glycerol made it difficult to dry, and there was too much gelatin. E. Sanger-Shepherd, Phot. J. 1898, **38,** 347, recommended the use of fixed-out dry plates. One should be soaked in solution of naphthol yellow, another in aurantia. One should be coated with collodion, stained with brilliant green G, the other with fuchsin in collodion. The films should be varnished and bound up together. A screen, which passed more light but was not so safe, could be made by omitting the two collodions and using instead one plate stained with methyl violet 6B; this was intended for panchro plates. Shepherd, Phot. J. 1899, **39,** 114, called attention to the use of invert albumen for substratum and filter work, this having been suggested some years previously by E. Banks. Its aqueous solution flows freely like oil, dries perfectly to a transparent, hard, glossy film, insoluble in water, acids or alcohol. H. Hartridge, J. Physiol. 1915, **50,** 95; abst. C. A. 1916, **10,** 1305; E.P. 17,789, 1914; Brit. J. Phot. 1915, **62,** 593, stated that a safe-light composed of red and green components transmitting from 6800 to 5300 gave a much better visual effect than ordinary red and orange screens, was photographically safe and the colors of objects were only slightly modified. This would only be safe for bromide papers and slow plates.

44. "Rezepte u. Tabellen," Halle, 1908, 7th edit.; Brit. J. Phot. 1904, **51,** 228, 251, 268. For du Hauron's filters see Brit. J. Phot. 1876, **23,** 377, also his patent p.

As to the use of liquid filters see Brit. J. Phot. 1907, **54,** 35.

45. Akad. Wiss. Wien, 1902, **72,** 633; Brit. J. Phot. 1904, **51,** 228, 251, 268; Handbuch, 1903, **3,** 696. In Beiträge, IV, 15, Eder pointed out that the methyl violet filter transmitted ultra-violet; this could be cut out by the addition of 0.05 to 0.1 per cent of æsculin. The addition of the smaller quantity increased exposure about 1.5 times. Instead of the green filter he also suggested, loc. cit. auramin 0.1 per cent solution 100 ccs., Janus green 0.1 per cent solution 100 ccs; there is some damping of the green with this. Cf. K. H. Broum, "Die Autotypie u. der Drei-farbenphotographie," Halle, 1912, 94.

46. "Die Dreifarbenphotographie," 1902, 150; Brit. J. Phot. 1903, **50,** 27; Fabre, "Traité encycl." Supp. D, 356. For information as to the earlier filters and sensitive plates, recommended by von Hübl, see the first edition of said work. Also Brit. J. Phot. 1897, **44,** 311; R. Child Bayley, "Photography in Colors," London, 1904, 86. Cf. F. E. Ives, Amer. Annual Phot. 1894, **25,** 40. E. J. Wall, Brit. J. Phot. 1895, **42,** 375.

47. "Die Dreifarbenphotographie," 3rd edit. 1912, 147; H. O. Klein's translation, "Three-Color Photography," 1915, 102. Cf. L. P. Clerc, "Les Reproductions Photomechaniques Polychromes," Paris, 1919, 169; Phot. Rund. 1912, **49,** 9. P. van Duyse, Phot. Moderne, 1924, 207.

48. Phot. J. 1901, **41,** 294; Brit. J. Almanac, 1902, 847; Handbuch, 1903, **3,** 698.

49. Klimsch's Jahrbuch, 1907; Brit. J. Phot. 1907, **54,** Col. Phot. Supp. **1,** 87.

50. "Die Dreifarbenphotographie," Berlin, 1904, 18; translation by E. J. Wall, London, 1915, 32; Phot. Mitt. 1904, **41,** 67. Cf. H. Quentin, "Photographie en Couleurs," 6; Brit. J. Phot. 1904, **51,** 208, 665; 1905, **52,** 964; 1908, **55,** 111; 1909, **56,** Col. Phot. Supp. **3,** 13; Phot. Coul. 1906, **1,** 26, 38.

K. P., Der Phot. 1922, **32,** 121, stated that filter red I and dianil red I were Congo red, pure, Hoechst. But as this dye was sensitive to acid, a new dye, filter rapid red I, was introduced.

51. Brit. J. Almanac, 1905, 949.

52. Ibid.; Rev. Sci. Phot. 1905, 321; 1906, 225.

53. Phot. J. 1905, **45,** 15; Brit. J. Almanac, 1905, 860: Photographic Annual, 1908, 36; Brit. J. Phot. 1904, **51,** 1068, 1089, 1106; abst. ibid. 1917, **63,** Col. Phot. Supp. **11,** 3. Cf. A. J. Bull, Brit. J. Phot. 1904, **51,** 391.

54. Phot. Woch. 1890, **36,** 143; Der Amat. Phot. 1894, 141; Das Atel. 1891, 173; 1894, 67; 1901, 49; 1903, 6; Phot. J. 1903, **43,** 214; Brit. J. Almanac, 1905, 865; "Photography in Colors," 1907, 87; Brit. J. Phot. 1903, **50,** 203; 1904, **51,** 432; Phot. Motivenschatz, 1909, 158, 198; Photo-Rev. 1903, **14,** 116; Prometheus, 1899, **11,** 49; Mitt. Maler, 1900, **16,** 18; Bayer. Gew. Bl. 1900, 268; Sci. Amer. 1903, 828; Phot. Rund. 1903, **40,** 41; Photogram, 1902, **9,** 235; Le Procédé, 1905, **7,** 98; Fabre, "Traité encycl." Supp. D, 137.

L. Vidal, Bull. Soc. franç. Phot. 1898, **54,** 85, 265; Bull. Phot. Club, 1898; Process Photogram, 1898, **5,** 38; Brit. J. Phot. 1898, **45,** 228; 1899, **46,** 724, stated

that the absorption of the filters should be for the red, from H to E¾D; for the green, from H to b; for the blue, from C to E. These could be obtained by using for the orange filter; yellowish eosin 2 g., naphthol yellow 1 g., water 100 ccs.; for the blue, methylen blue 2 g., Paris violet 2 g., water 100 ccs.; for the green, naphthol green 2 g., naphthol yellow 1 g., water 100 ccs. A. Granger, Mon. Sci. 1897, **49**, 188, 390; abst. Chem. News, 1897, **76**, 182, stated that Americans had been using for some time three-color for advertisements, and the following were used, for the violet filter, concentrated solution of cupric chloride 7 ccs., water 17 ccs., ammonia 3 ccs., after filtration 3 ccs. concentrated methyl violet and 5 ccs. fuchsin were added; for orange, 15 ccs. concentrated solution of cobalt chloride, water 35 ccs., ammonium dichromate 25 ccs., ammonia 2 ccs.; for the green a solution of nickel sulfate. Cells of ⅛ inch thickness were used. C. Wolf-Czapek, Phot. Rund. 1902, **16**, 129; Phot. J. 1902, **42**, 180, proposed to stain up fixed-out dry plates, as follows: for the orange, naphthol yellow 1, methyl orange 1, Biebrich scarlet 4 parts; for the green, bluish-green 1, naphthol yellow 4 parts. The dyes should be dissolved in water, carefully filtered and 2 per cent acetic acid added. The exact amount of water was hard to gauge, and it was stated to be immaterial, the principal point being the ratio of the dyes. The orange solution should have a decided red tinge; the green being saturated at a lighter tint. After staining, the plates were to be rinsed, dried and bound up with a cover glass. The best position was immediately in front of the plate. This seems to be a hash of von Hübl's baths. Cf. Brit. J. Phot. 1895, **43**, 103. J. V. Elsden, ibid. 1897, **44**, 213.

55. Bull Soc. franç. Phot. 1901. Cf. R. Child Bayley, "Photography in Colors," 83. L. Vidal, "Traité pratique de Photochromie, Paris, 1903, 190.

For testing filters by means of colored sectors, see W. Abney, Process Photogram, 1900, **7**, 65, 161. For the use of the tintometer for filter testing see C. F. Townsend, Phot. J. 1897, **37**, 193; Process Photogram, 1897, **4**, 85. Cf. F. E. Ives, J. Frank. Inst. 1907, **164**, 421; Brit. J. Phot. 1908, **55**, Col. Phot. Supp. **2**, 19.

56. "La Reproduction photographique des Couleurs," Paris, 1907, 123; Le Procédé, 1905, **7**, 131; Fabre, "Traité encycl." Supp. D, 106.

G. Naudet, "La Photographie des Couleurs," 1889, 8, suggested staining up gelatinized glass as follows; for the red, bluish eosin 2 g., naphthol yellow 1 g., water 100 ccs.; for the green, sulfo green S 2 g., naphthol yellow 2 g., water 100 ccs.; for the blue, methylen blue 2 g., violet de Paris 2 g., water 100 ccs. T. T. Baker, Phot. J. 1905, **45**, 24, suggested the following dyes, "Which are put into round figures for the sake of convenience": blue, methyl blue 10 parts, naphthol green 1 part; green, patent blue 25 parts, naphthol green 25 parts, tartrazin 31 parts; red, tartrazin 70, Titan scarlet 22 parts. No indication was given as to volume of water, nor how long to stain up. Cf. Brit. J. Phot. 1903, **50**, 987. E. Sanger-Shepherd, Photogram, 1895, **2**, 188; Phot. Annual, 1896, 182, described a cell that he had made. The sides were the best, thin, patent plate, the separation pieces were narrow strips of glass, ¼ inch or greater thickness. The parts were cemented with marine glue. The top piece was not cemented, but was removable for introducing solutions, and was of double depth and longer at its upper part that it might fit well and not fall in. A. J. Henry, Sci. Amer. 1895; Phot. Times, 1895, **26**, 302; Amat. Phot. 1895, **21**, 220; abst. Phot. Annual, 1896, 182, used a narrow glass ring with a flat glass cemented to each side, and a hole in the ring for filling. Cemented cells are commercially obtainable; for temporary or experimental work, a flat ring of rubber or tubing may be clipped between glass plates.

57. Phot. Korr. 1907, **43**, 608; Photographic Annual, 1910, 14; Jahrbuch, 1908, **22**, 395.

58. ·Phot. Rund. 1909, **46**, 1; Jahrbuch, 1909, **23**, 308; Brit. J. Phot. 1909, **56**, Col. Phot. Supp. **3**, 14, 17: Photo-Pratique, 1919, 285; Brit. J. Almanac, 1910, 605; Phot. Rund. 1913, **50**, 79. According to Brit. J. Phot. 1909, **56**, 86, when using an enclosed arc, potassium dichromate 0.02 per cent solution in 1 cm. thickness is the most satisfactory filter.

59. Wien. Mitt. 1910, 568; "Die photographischen Lichtfilter," 1910, 66; Brit. J. Phot. 1911, **56**, Col. Phot. Supp. **5**, 13; Brit. J. Almanac, 1912, 658.

60. Jahrbuch, 1910, **24**, 180.

61. E.P. 23,378, 1907; Brit. J. Phot. 1908, **55**, 625; Brit. J. Almanac, 1909, 647; Phot. Mitt. 1908, **44**, 442; Jahrbuch, 1909, **23**, 237; Photo-Rev. 1908, **20**, 109; Phot. Coul. 1908, **3**, 226; F.P. 393,254; D.R.P. 202,925; 1907, granted to C. Zeiss; U.S.P. 926,523. Cf. F. Dillaye, "Les Nouveautés photographiques," 1912, 104.

62. Phot. Korr. 1907, **43**, 606; Jahrbuch, 1908, **22**, 395.

This idea of dyeing the back coating of roll films for screen-plate work was patented by G. Eastman, U.S.P. 1,028,337, 1912; abst. C. A. 1912, **6**, 2582.

63. Phot. Coul. 1911, **6**, 172, 199; Brit. J. Phot. 1911, **58**, Col. Phot. Supp. **5**, 58, 61; ibid. 1912, **6**, 7; Brit. J. Almanac, 1913, 705; Phot. Mitt. 1911, **48**, 294.

64. Phot. Rund. 1909, **46**, 1, 17; Brit. J. Phot. 1909, **56**, Col. Phot. Supp. **3**, 14, 17; 1913, **60**, ibid. 7, 33; Brit. J. Almanac, 1910, 607; Wien. Mitt. 1909, **49**; Jahrbuch, 1910, **24**, 181. Cf. Johnson & Sons, Brit. J. Phot. 1912, **59**, Col. Phot. Supp. **6**, 12.

65. Bull. Soc. franç. Phot. 1909, **55**, 245; Brit. J. Phot. 1909, **56**, Col. Phot. Supp. **3**, 6; Photo-Rev. 1909, **21**, 39, 194; Photo-Pratique, 1919, 285; Jahrbuch, 1910, **24**, 148.

66. Wien. Mitt. 1909, 336; Jahrbuch, 1910, **24**, 379.

W. Weissermel, Phot. Mitt. 1910, **46**, 6, recommended Kreb's time-light cartridges and stated that a pale yellow filter must be used, made by flowing a fairly thick film of "diamine varnish" over a glass plate, and allowing to drain off. Cf. Brit. J. Phot. 1912, **56**, Col. Phot. Supp. **6**, 36, for filter for use with Agfa flashlight.

67. Brit. J. Phot. 1910, **57**, Col. Phot. Supp. **4**, 74; Phot. Mitt. 1910, **46**, 324; Rev. génér. Chim. pur. appl. 1910, **13**, 284.

F. Thovert, Phot. Coul. 1909, **4**, 94, suggested after sensitizing Autochrome plates with a 1:100,000 solution of erythrosin, that Lumière's flashlight powder should be used with a filter of filter yellow 1 per cent solution 1 part, gelatin 4 per cent solution 20 parts, allowing 5 ccs. per 100 qcm.

68. Phot. Korr. 1907, **43**, 388; 1910, **46**, 142; Jahrbuch, 1911, **25**, 190; Brit. J. Phot. 1911, **58**, Col. Phot. Supp. **2**, 68.

69. Phot. Rund. 1910, **47**, 125; Jahrbuch, 1911, **25**, 350; Brit. J. Phot. 1914, **61**, Col. Phot. Supp. **8**, 67. This was also given by G. Winter, ibid. 75; Wien. Mitt. 1910.

70. Bull. Soc. franç. Phot. 1909, **55**, 203; Brit. J. Phot. 1909, **56**, Col. Phot. Supp. **3**, 51; Brit. J. Almanac, 1911, 609.

F. J. Hargreaves, Photography, 1913, 350; Brit. J. Almanac, 1915, 523, frequently found with hyper-sensitized plates, a general greenish hue, especially in the shadows and neutral tints, and this could be overcome by using a Wratten K1 filter instead of the greenish one supplied by Lumière. For correct rendering of screen-plates by photomicrography, H. Hinterberger, Phot. Rund. 1911, **48**, 81, recommended the use of naphthol orange and filter yellow.

71. Brit. J. Phot. 1910, **57**, Col. Phot. Supp. **4**, 76; Photo-Rev. 1910, 49.

As to the effect of filter thickness see: G. L. Johnson, Phot. J. 1908, **48**, 202; Brit. J. Phot. 1908, **55**, 317. R. E. Havelock, Brit. J. Phot. ibid. 1919, **13**, 22. F. W. Painter, ibid. 1916, **13**, 11. The use of colored filters for different lights was also given by L. Cust, ibid. 1912, **9**, 1, 5; F. Thieme, Phot. Rund. 1912, **49**, 135.

72. "Natural Color-Photography," König & Wall, 1906, 85.

73. E.P. 2,104, 1868.

74. U.S.P. 561,132, 1896. Also patented by A. G. Russell, U.S.P. 766,389, 1903.

75. U.S.P. 562,642, 1896; E.P. 13,895, 1896. Cf. H. E. Rendall, Brit. J. Phot. 1923, **70**, Col. Phot. Supp. **17**, 1.

R. W. Artlett, E.P. 27,373, 1898; Brit. J. Phot. 1899, **46**, 778, patented much the same idea, using two circular disks; one coated with lemon-yellow with a clear central space, the other with red-dyed gelatin or collodion, with a larger central aperture. The filters were cemented together, thus no adjustment of the ratios of the lights was possible. C. L. A. Brasseur, E.P. 4,745, 1908; Brit. J. Phot. 1908, **55**, 514; U.S.P. 1,154,607, 1908, also patented a filter with adjustable sectors. In E.P. 12,235, 1906; Brit. J. Phot. **53**, 934; D.R.P. 176,320, the same inventor patented a graduated filter to compensate for the varying sensitiveness of plates. Brasseur patented a holder by which the filter could be pressed into contact with the plate. Ramstein-Gschwind, D.R.P. 187,427; U.S.P. 970,111, and J. K. Holbrook, U.S.P. 988,710, also patented graduated yellow filters.

76. U.S.P. 612,937, 1898.

M. T. Denne, E. P. 212,390, 1923, also patented a cell with sliding piston, to alter the depth of colored liquids.

77. E.P. 12,515, 1899; Brit. J. Phot. 1900, **47**, 539; D.R.P. 124,624, 1898; Silbermann, **2**, 330; Chem. Crtlbl. 1899, **70**, I, 90; Belg.P. 153,715, 1900.

78. E.P. 4,365, 1902; abst. Brit. J. Phot. 1907, **54**, Col. Phot. Supp. **1**, 79, granted to Bauermeister; D.R.P. 144,661, 1901; Silbermann, **2**, 330 to Aarland; U.S.P. 734,454, 1903, to the two.

79. U.S.P. 727,524, 1903; F.P. 331,760; E.P. 10,240, 1903.
80. U.S.P. 599,670, 1898.
81. D.R.P. 147,925, 1903; Silbermann, **2**, 352; U.S.P. 767,880, 1904; E.P. 4,962, 1903; F.P. 330,023; Belg.P. 170,211, 1903.
82. E.P. 10,951, 1904; Brit. J. Phot. 1905, **52**, 353; D.R.P. 169,018, 1905; F.P. 352,193; Phot. Coul. 1906, **1**, Supp. **4**.
H. Schmidt, E.P. 20,954, 1904; Brit. J. Phot. 1905, **52**, 96; F.P. 346,614, 1904, and J. E. Thornton, E.P. 11,346, 1906; Brit. J. Phot. 1907, **54**, 546, patented the same thing.
83. E.P. 16,659, 1904.
84. D.R.P. 213,773, 1906; E.P. 25,728, 1906; abst. Brit. J. Phot. 1907, **54**, 925; U.S.P. 922,908, 1909. How the wax was removed before development is not stated.
J. A. Scherer, D.R.P. 191,425, 1903, patented an endless band carrying the tri-color filters, which were changed with the change of the film. A. Kolbe and E. Tiedemann, D.R.P. 172,049; 172,050; 172,238, 1904, patented a changing plate-holder, in which the plate and filter were brought into the focal plane by means of frames turning on a central pin.
85. D.R.P. 213,773; E.P. 25,728, 1906; U.S.P. 922,908; Wag. Jahr. 1909, **55**, II, 515; Brit. J. Phot. 1907, **54**, 926.
86. U.S.P. 888,684, 1908; Can.P. 103,761.
J. A. Hatt, U.S.P. 1,013,937, 1912, used a rectangular block of glass with central aperture for the liquid and flat side plates, that were temporarily cemented with wax or paraffin. W. F. Folmer, U.S.P. 1,104,179, 1914, patented a rubber ring with a shoulder, against which the filter disk was pressed, while raised ribs held the same to the lens tube. W. Frey, U.S.P. 1,174,930, 1916; E.P. 22,771, 1914; Brit. J. Phot. 1915, **62**, 386; abst. Phot. J. Amer. 1915, **52**, 407; D.R.P. 200,388, 1907, patented the old idea of placing filters in front of arc lamps. R. John, U.S.P. 1,216,696, 1917, proposed to overcome the disadvantages of sunlight by using colored reflectors behind nitrogen lamps, which should diminish the blue and increase the ratio of the other colors. J. Verfürth, D.R.P. 275,273, 1914, patented a filter holder with centering screws. E. J. Wall, Brit. J. Phot. 1908, **55**, Col. Phot. Supp. **2**, 28, suggested a green arc light, produced by silver and copper in the core of the carbons. Cf. Penrose's Annual, 1907, **13**, 97.
87. U.S.P. 1,182,485, 1919.
88. U.S.P. 1,293,039, 1919; Brit. J. Phot. 1919, **66**, 48; J. Ind. Eng. Chem. 1919, **17**, 454; abst. J. S. C. I. 1919, **38**, 118A, 305A; Annual Reports. 1919, **3**, 513.
J. Owen, E.P. 25,304, 1899; Photography, 1901, 217; Phot. Chron. 1901, **8**, 363; U.S.P. 644,151, 1900, would combine the filters with half-tone screens, either by making the screen by photography and staining the film, or flowing the screen with the dye solution, or cementing the filter to its surface. H. J. Burton, Brit. J. Phot. 1896, 43, 152, gave a method of making a cell for liquid filters at a very reasonable cost. H. Gamble, Austr. P. 1,361-13. U.S.P. 1,102,902; 1,102,903; D.R.P. 322,010; E.P. 6,768; 15,300, 1912; Phot. J. 1914, 54, 359; Brit. J. Phot. 1914, **61**, 861; abst. Phot. J. Amer. 1915, **52**, 61; Can.P. 152,702; F.P. 454,508; Amer. Printer, 1917, 57, would improve the rendering of the red-printing plate by special illumination of the copy whilst making the negative; by first making a negative of the same through the red filter, and projecting this negative by means of an arc light on to the picture whilst the actual working negative was being taken through the green filter. M. Johnson, J. S. C. I. 1921, **40**, 176T; J. C. S. 1921, **120**, 690i; C. A. 1922, **16**, 2993, gave methods of preparing tartrazin and similar dyes of the pyrazolone class; but found that none gave better results, as regards absorption, than tartrazin. O. Will, D.R.P. 309,167, 1917; Wien. Mitt. 1920, 29, Jahrbuch, 1915, **29**, 114, patented a filter for distant photography, composed of two wedges cemented between glasses; the wedges might be of different colors and their slopes in the same or opposite directions. Kopp and Joseph, D.R.P. 253,334, 1911, claimed the use of coumarin derivatives, containing hydroxyl, amino, carboxyl or benzol rings, as ultra-violet absorbents. E. F. Beckwith, E.P. 25,055, 1902, patented a graduated color screen, composed of a prism of colored glass, cemented to a colorless prism of equal angle. In another form the colored glass was made as a concave lens and cemented to a plano-convex to form a parallel plate. W. F. Butcher, E.P. 23,658, 1903, patented a series of filters fitted in the periphery of a wheel on the

lens front, so that each could be brought into the optical axis. O. Oeser, D.R.P. 209,396, 1907; Chem. Ztg. 1909, **33**, 414; Phot. Ind. 1909, 702, patented a coater for filters, either of gelatin or collodion, by means of which it was claimed very even films were obtained. The dyed solution was applied by an endless cloth dipping into a trough of the solution; the plates being passed under the cloth, and thence to a traveling band, that carried reciprocating brushes, which evened the coating. L. Geisler, D.R.P. 246,939, 1910; abst. C. A. 1912, **6**, 2583; E.P. 24,244, 1910, patented the use of collodion or gelatin film held taut by springs at the sides. These could be used as reflectors to prevent doubling of the image. A. B. Klein, E.P. 166,028; 174,747, 1920; Brit. J. Phot. 1921, **68**, Col. Phot. Supp. **15**, 47; ibid. **17**, 12; F.P. 542,938; abst. Sci. Tech. Ind. Phot. 1923, **3**, 50, patented a right-angled constant deviation spectroscope for obtaining spectral illumination. Cf. W. Abney, Brit. J. Almanac, 1888, 287. G. Selle, D.R.P. 154,100, 1903; Silbermann, **2**, 345; Belg.P. 170,747, patented filters set on arms provided with springs and actuated by strings, so that they could be quickly changed in the diaphragm plane; the incoming filter pressing that in position out of the axis. The Société de la Photographie des Couleurs, F.P. 354,127, patented the use of filters in contact with the sensitive surface.

89. D.R.P. 97,247, 1897; Silbermann, **2**, 407.

90. Zeits. wiss. Phot. 1915, **14**, 133, 271; Phot. J. Amer. 1915, **52**, 591; abst. J. S. C. I. 1919, **38**, 963A; Le Procédé, 1921; Brit. J. Phot. 1921, **68**, 95; Sci. Tech. Ind. Phot. 1921, **1**, 34.

Meister, Lucius and Brüning, Brit. J. Phot. 1909, **56**, Col. Phot. Supp. **3**, 79, gave formulas for making filters with filter yellow. This dye was made under E.P. 2,622, 1906. Flavazin L, S, hydrazin yellow, xylene yellow and tartrazin belong to this pyrazolone class; filter yellow was also known as flavazin T. C. L. Leon, Brit. J. Phot. 1909, **56**, 949, gave the same formulas. O. Buss, Phot. Korr. 1896, **53**, 368; abst. Jahrbuch, 1897, **11**, 297; Brit. J. Phot. 1900, **47**, 821; Brit. J. Almanac, 1897, 870, published an exhaustive paper on the absorption of various yellow dyes for the ultra-violet.

For the preparation of filters, transmitting ultra-violet, for the Uviol mercury lamp, see G. Potapenko, Zeits. wiss. Phot. 1919, **18**, 238; abst. J. S. C. I. 1919, **38**, 848A. Cf. C. Blecher and A. Traube, Zeits. Repro. 1909, **4**, 149 on the inks and filters for tri-color. J. Domergue, Rev. d. Phot. 1909, **1**, 57, on making filters with parallel surfaces. M. B. Hodgson and R. B. Wilsey, J. Opt. Soc. Amer. 1917, **1**, 86, gave a compensating filter for spectroscopy. H. Luckiesh, J. Frank. Inst. 1917, **142**, 93, 227 gives several tables of the spectral transmissions of dyes and glasses. Cf. Luckiesh, Brit. J. Phot. 1916, **63**, Col. Phot. Supp. **10**, 31 for filter for spectroscopy.

91. Phys. Rev. 1921 (2), **17**, 246; Brit. J. Phot. 1922, **69**, 6; Bull. Soc. franç. Phot. 1923, **65**, 333.

92. "Die Lichtfilter," von Hübl, 1922, 2nd. edit.

F. Twyman, A. Green and Hilger Ltd., E.P. 196,876, 1922; abst. J. S. C. I. 1923, **42**, 650A; Amer. Phot. 1923, **17**, 687; Sci. Ind. Phot. 1924, **4**, 136, patented a method of obtaining very thin films, which could be used as reflectors. A viscous solution of celluloid or the like was centrifugally coated on a plane surface of rock salt, or other soluble material, and after drying, a metal frame was applied to the filter and the soluble base dissolved with water. R. S. Stoucum, U.S.P. 740,484, 1903, patented two wedge-shaped prisms, one comprizing the less refrangible rays and the other the more refrangible, the division being in the spectral green. These were placed apex to apex and cemented to a colorless bi-prism to form a plane plate. Control of the light was obtained by shifting the dividing line of the colors, as regards the optical axis. H. Blanc, F.P. 552,781; abst. Sci. Tech. Ind. Phot. 1923, **3**, 173, patented the use of orange, green and violet filters for obtaining the constituent negatives. G. Selle, E.P. 12,515, 1903 patented radially-divided circular filters, with apertures covered with three filters and of which the areas were adjustable to accord with the sensitivity of the plates.

H. O. Klein, Penrose's Annual, 1906, **12**, 5; Jahrbuch, 1907, **21**, 88, described the Penrose ratiometer, for obtaining the filter ratios. Cf. F. Stolze, Phot. Chron. 1908, **15**, 379. A. J. Newton and S. M. Furnald, U.S.P. 1,258,636, 1918, also patented a ratiometer. This consisted of a bromide print of full gradation with patches of the minus colors below and a scale of greys. By means of this the print and scale could be shifted to five different positions and an exposure made through any desired filters. From the negatives thus obtained, a good idea of the correctness of the exposures could be obtained. Cf. "Pan Chromo." Brit. J.

Phot. 1915, **62**, Col. Phot. Supp. **9**, 38. A. S. Cory, M. P. News, 1917, **16**, 887 suggested the use of the Bausch & Lomb spectrum projector for testing filters. R. Davis, "A new method for the measurement of photographic filter factors," Bureau of Standards Scientific Paper, No. 409. The Kino-Film Co., D.R.P. 390,897, 1922 patented the making of filters by filling up wire fabric with dyed gelatin.

A. Miethe and E. Stenger, Zeits. wiss. Phot. 1919, **22**, 57; Jahrbuch, 1915, **29**, 111 dealt with the transmission of ultra-violet by some yellow dyes. Cf. Eder, Phot. Korr. 1920, **56**, 34. G. H. Weidhaas, D.R.P. 297,193, 1916; Chem. Ztg. Rep. 1917, 300; Jahrbuch, 1915, **29**, 113 patented a yellow filter with serrated edge for cloud work. Schafer, Jahrbuch, 1915, **29**, 113; Phot. Rund. 1917, **54**, 34 recommended the use of graded filters. Cf. J. Jurz, Phot. Rund, 1918, **55**, 356. C. P. Goerz, D. R. G. M. 634,853; Phot. Ind. 1915, 684; Jahrbuch, 1915, **29**, 114 patented a yellow filter combined with negative lens for screen-plate work. Cf. D. R. G. M. 634,854; Phot. Ind. 1915, 715; Jahrbuch, 1915, **29**, 114 for yellow filter with positive lens. P. R. Kögel, Biochem. Zts. 1918, **98**, 207; Phot. Korr. 1918, **54**, 359; Jahrbuch, 1915, **29**, 114 recommended filters of anthracen and triphenylmethan for absorption of the ultra-violet. Peskoff, Zeits. wiss. Phot. 1919, **22**, 235; Phot. Korr. 1919, **55**, 239; Jahrbuch, 1915, **29**, 115 suggested the use of gaseous chlorine and bromine for isolation of wave-lengths 2460-2500. J. M. Eder, U.S.P. 1,511,874 Amer. Phot. 1925, **19**, 166; D.R.P. 399,699 patented the use of mono-, di- and trisulfonic acids of the naphthol series and their salts as absorbents of ultra-violet, and particularly in the form of the alkaline salts. They might be used as superficial coatings on plates or films, or mixed with fluorescent screens for X-ray work.

W. Frerk, Camera, (Luzerne), 1924, **3**, 66; Amer. Phot. 1925, **19**, 56 gave the following method of making graded filters. Fix out a gelatin dry plate, wash and dry. Then immerse in a 5 per cent solution of filter yellow, till no further absorption takes place. When quite dry clean the glass well and cut off the desired size of filter. Hang this in a 500 ccs. graduate. Water should now be poured into the graduate till it just touches the bottom of the dyed strip. Then more water should be added up to the next graduation and soaked for another 3 minutes. The operation is repeated till about half the length of the strip is covered with water. A. Markus, D.R.P. 404,211, 1924; Phot. Ind. 1925, 124 patented filters of which only the outer glass surfaces were to be optically polished.

Cuenin & Co., D.R.P. 405,551; Phot. Ind. 1925, 423; Phot. Korr. 1925, **61**, 27; E. P. 209,085; F.P. 560,438; addit. 28,868, patented a holder for the reflectors of cameras, consisting of a frame sliding in grooves, in the latter being fixed an elastic strip, such as rubber, against which the frame was pressed by a spring.

For general information on filters see: Anon. Brit. J. Phot. 1904, **51**, 391; 1906, **53**, 489, 627, 693. Von Hübl. E. J. Wall, ibid. 1904, **51**, 666, 685; 1895, **42**, 375; Eder, ibid. 1896, **43**, 660. J. V. Elsden ibid. 391, 438, 569, 710. F. E. Ives, Phot. J. 1896, **36**, 315; Process Photogram, 1896, **3**, 138; C. Smyth, Brit. J. Phot. 1917, **64**, 37. W. Abney, ibid. 1898, **45**, 298, Supp. 35; Sci. Amer. Supp. 1898, 18,750; J. Soc. Arts, 1898. An exhaustive paper by A. V. Potapenko, J. Russ. Phys. Chem. Soc. 1916, **46**, 790; Brit. J. Phot. 1921, **68**, 507, 522, 534; abst. Bull. Soc. franç. Phot. 1923, **65**, 293. C. Zschokke, Phot. Rund. 1912, **26**, 120. T. T. Baker, Phot. Korr. 1906, **43**, 167; Brit. J. Phot. 1906, **53**, 310, 396. H. E. Blackburn, Camera Craft, 1908, **15**, 335. H. Calmels, Bull. Soc. franç. Phot. 1908, **64**, 340. F. Stolze, Phot. Chron. 1904, **16**, 117. F. Dillaye, "Les Nouveautés photographiques," 1910, 112. R. J. Wallace, Amer. Annual Phot. 1910, **25**, 272; Brit. J. Phot. 1911, **58**, Col. Phot. Supp. **5**, 5. H. Bellieni, Bull. Soc. franç. Phot. 1911, **58**, 82. T. T. Baker, Amat. Phot. 1912, **55**, 221; Photo-Era, 1912, **29**, 240. A. Miethe and E. Stenger, Zeits. wiss. Phot. 1919, **19**, 57 for ultra-violet filters. R. M. Fanstone, Brit. J. Phot. 1920, **67**, Col. Phot. Supp. **14**, 17. E. Obernetter, Internat. Annual, 1889, 175.

CHAPTER III

STILL CAMERAS AND CHROMOSCOPES

In the main this chapter is devoted to cameras and chromoscopes[1] (p. 145) in which one or more plates or films are used to receive the color records. But there must obviously be some overlapping with those sections that deal with allied subjects, such as the optical data and cinematography in colors. No hard and fast line can be drawn, as some of the designs may be used for motion picture work.

Cros and du Hauron.—As in so many other branches of color photography we find that Cros and du Hauron anticipated all subsequent workers. The latter, as pointed out elsewhere, sent a paper to M. Lelut, in 1862, with a request that it be read before the Académie des Sciences, and that this paper was rejected. It was reprinted in 1897[2] and du Hauron described a photochromoscope with figure, here reproduced, Fig. 18. It is unnecessary to enter into the construction, suffice it to say, that the three mirrors, shown in continuous lines, are at right angles to one another, and the paths of the rays from the transparencies are shown by the broken lines, as is also the position of the composite image on the extreme right; R, R, R, representing the adjustable mirrors for illuminating the pictures.

Du Hauron suggested that it would be possible to modify the results by varying the color of any positive, locally or entirely. Also that the instrument could be used for stereoscopic transparencies, by merely doubling the length of the apertures. Further, he says, it is possible to use only three single positives, with "less perfection it is true," by arranging for the one eye to see the red and yellow proofs, and the other eye to see the blue; a method, which is physiologically unsound, but which has been subsequently patented by others.

Again in 1869, du Hauron said:[3] "Si l'on projette les images de ces trois épreuves sur une surface blanche au moyen des trois lentilles, placées de telle sorte que les trois images se superposent exactment, on voit apparaitre sur l'écran une image polychrome, qui est le représentation fidèle de la nature. Pour confondre les trois épreuves en une seul tableau, on peut remplacer l'appareil polyoramiques à trois lentilles par un composé de trois glaces sans tain, situées les unes derrière les autres par rapport à l'oeil du spectateur, auquel elles envoient chacune par reflexion une épreuve différente. Pour éviter que l'image de chaque épreuve se dédouble par sa reflexion sur deux faces paralléles de la glace correspondente, il est nécessaire de disposer entre l'épreuve et la glace une lentille convergente, ou verre d'optique, dont le grossissement aura pour effet de placer l'épreuve à une distance telle que ce dedoublement devienne insensible."

This we may translate as follows: if the images of the three proofs are projected on to a white surface by means of three lenses, placed in such a way that the three images will be exactly superposed, there will appear on the screen a polychrome image, which is the faithful representation of nature. To fuse the three proofs into one picture, one may replace the

Fig. 18. Du Hauron's 1862 Chromoscope (Page 105).

polyoramic apparatus with three lenses, by an apparatus composed of three glasses without foil (not silvered) placed one behind the other with respect to the eye of the observer, on which there will be seen by reflection a different picture. To avoid the doubling of each image from the two parallel faces of the corresponding glass, it is necessary to place between

the pictures and the glass a convergent lens or optical glass, the magnification of which should have the effect of placing the picture at such a distance that this doubling becomes unconscious.

No diagram of this instrument was given, but later, after recalling the above remarks[4] du Hauron says: "Here is, moreover, a diagram which, still better than the preceding description, will explain all the simplicity of the construction of which it treats." This is given in Fig. 19 and requires

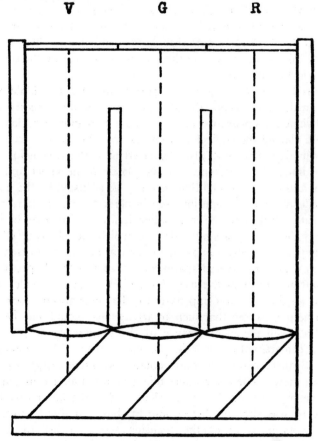

Fig. 19. Du Hauron's 1869 Chromoscope.

no further explanation. In 1874, another camera was patented,[5] which was later embodied in his English patent[6] and the latter says: "The rays coming from the subject to be reproduced are received upon a glass unsilvered with parallel faces inclined 45 degrees, or thereabouts, in respect to the model and in respect to a first lens, towards which it reflects a part of the above-mentioned rays. The greater part of these rays traverse the first glass, and they are received by a second glass equally unsilvered and

with parallel faces also inclined 45 degrees, or thereabouts, in relation to the model and in relation to a second lens towards which it partially reflects the rays it receives. Lastly, the rays that this second glass allows to pass are received by a third lens either direct or by interposing a silvered or metallized glass, which reflects nearly all of them. The distance of this first glass to the first lens is equal, or nearly equal (slight discrepancies do not appreciably alter the results), to the sum of the distance of the first glass to the second, and of this latter to the second lens, and it will be equal also to the sum of the distances of the first glass to the third lens (or if a third glass is made use of it is equal to the sum of the distances of the first glass to the third glass plus that of the third glass to the third lens). In virtue of this arrangement the three images received by the three lenses are geometrically the same."

For reproducing near objects it is pointed out that the doubling of the objects from the thickness of the glasses, can be easily remedied by interposing between the apparatus and the model a magnifying glass, having the effect of placing the subject further back.[7] The use of a concave lens near the sensitive surface is also described to flatten the field. In both patents the unequal sensitiveness of the plates to the violet and green is pointed out and it is suggested that this may be adjusted by the use of two or more reflector glasses superimposed in perfect contact, in front of the sensitive plate. But in the French patent it says: "This may be obtained, moreover, if desired, by a single glass of which the silvering (l'etamage-plating) may be partially removed, in such a way as to present regular alternation of large unsilvered spaces and smaller silvered spaces."[8]

Du Hauron[9] describes the use of three lenses side by side, with diaphragms of unequal size to compensate for the unequal sensitiveness of the plates, but he pointed out that such an arrangement could only be used for objects at a given distance, because of the occurrence of parallax, and proposed a camera with one lens, provided either with a multiplicating slide, or with three plate holders, to obtain successive exposures from the one point of view. The color filters might be fitted almost in contact with the sensitive surfaces, or close to the lens, and in the latter case he stated that the focus was slightly altered, and to allow for this he used a plane uncolored glass in front of the focusing screen whilst focusing. Du Hauron is careful to signalize the necessity of placing the filters outside the lens, where they have no effect upon the focal length. His filters were made by staining up white varnish with anilin dyes, and coated on collodionized glass.

Cros' description of a similar idea is given on page 8, and in a later communication[10] he was more explicit and apparently constructed an instrument: "I distinguish two categories comprised under the word 'color'—the lights and the pigments. The elementary lights, which by their union produce all sorts of proposed tints, are the green light, the

violet, and the orange. The elementary pigments which, by their blending, produce all the proposed tints are the red, the yellow and the blue. To immediately obtain the elementary tints of light and of pigments it suffices to observe through a prism a white bar or line upon a black ground, and a black bar upon a white ground. In the first case an orange, green and violet spectrum is seen; and in the second case a blue, red and yellow spectrum.

"I say that in the first case the orange, the green, and the violet are elementary lights, and in the second case the blue, the red, and the yellow are the same lights combined two and two together. The disunion of the course of the rays of the two images—one of a white bar upon a black ground, and a black bar upon a white ground in the prism—would prove this proposition; but I prefer in this short notice to demonstrate it by the apparatus which I have the honor to present to the Photographic Society of France under the name of 'chromometer.'

FIG. 20. Chas. Cros' Chromometer.

A B C Positive images on glass obtained with different colored rays
a' b' c' Grooves for troughs of colored liquids to be placed in conjunction therewith.
D Ground glass. *E E E* Transparent plate glass screens upon which are projected respectively the images of *A B C*
S Spectator, who sees the three images of different colors coalesced into one image.

"In a box blackened in the interior I arrange three plate glasses, *E E E,* parallel one to the other, and forming angles of 45° with the sides of the box. The three opening, *A B C,* in face of the three diagonally-fixed glasses, and upon which the visual images will on examination appear united in apparently the same place, are furnished with built-up glass-plate troughs filled with the following solutions:—A red solution of chloride of cobalt, to which is added sulfocyanide of potash; a yellow solution of neutral chromate of potash; and a blue solution of nitrate of copper. I make two troughs of each color for the three openings *A B C.* I place before *A* the two troughs of the red solution, before *B* the two troughs of the yellow solution, and before *C* the two troughs of the blue solution. I look

in front of the three diagonal glasses, *E E E,* and I see the three reflec-
tions, which, in combining, give white (if the amount of illumination be
the same for each opening). If I mask *A* by means of an opaque screen
I have only two reflections, blue and yellow, which combine. The result
obtained is white less brightly illuminated. Thus the yellow light and the
blue light combined do not give green. This fact has already been pub-
lished by M. Helmholtz under analogous conditions. If I mask *B* the two
reflections, red and blue, combine in one, and the tint is still white, but
with a feeble trace of violet. In masking *C* white is always obtained with
a rather orange tint.

"When I combine the troughs in couples, yellow and blue, blue and
red, red and yellow, the double media do not pass respectively, but green,
violet and orange. These three combined reflections give white as before;
but if *A B C* are masked successively the appearance changes altogether.
When the green is suppressed the ground assumes a pure red carmin
color, such as is seen in the trichromatic spectra of the black bar upon a
white ground. When the violet is suppressed the ground becomes pure
yellow, such as one sees in the same spectra; when the orange is suppressed
the ground becomes pure blue, similarly as in the same spectra.

"For a more handy presentation before the Photographic Society of
France I have replaced these systems of troughs by glasses colored re-
spectively violet, green and orange by means of collodion tinted with anilin
colors. I have called this instrument a 'Chromometre,' because it can serve
to distinguish the colors one from the other by numerical denomination.
In fact to vary indefinitely the tint resulting from the visible field, it suf-
fices to vary the force or amount of lighting of each opening. I propose
to employ the method of Arago by polarized light, but I cannot afford the
construction of such costly apparatus. I must content myself with the in-
strument that I have already had constructed, and vary the lighting by the
interposition of thicknesses, more or less numerous, of transparent paper.

"One of the most curious applications of the chromometer is the fol-
lowing:—I obtain three negatives reproduced from any colored picture—
the first negative through a green, the second through a violet, and the
third through an orange medium. The media are, again the parallel-sided
troughs of plate glass containing standard colored solutions. I may re-
mark in passing, that the inequality of these different lights is completely
compensated by various organic substances with which I impregnate the
sensitive plates. I obtain the black positives upon glass of reduced silver
like ordinary negatives, and I place each of these positives in the chro-
mometer before the medium of the same color as that which had served to
obtain the corresponding negative. I make the three reflections to coincide,
and the resulting image is that of the colored model picture when the force
of the three illuminations has been properly arranged."

It is evident from the above that we have the fundamental ideas of all

subsequent chromoscopes, and the anticipation of many patented details.

In 1885 du Hauron patented[11] another camera in which "three small mirrors were juxtaposed one against the other, not on the same plane, but in such a manner as to form three facets, differently inclined, but all inclined at 45 degrees with respect to a virtual plane, to which their backs were turned. This virtual plane being built vertically and the three facets being disposed in a triangle, the two facets at the lower part and the facet at the top reflected the same image, the two first into two horizontal cameras where the sensitive plates were, consequently in a vertical position, and the third into a vertical camera where the sensitive surface formed the floor (plafond); the triad of the little mirrors occupied the center of the system and each of them was inclined at 45 degrees with respect to the objective that corresponded to it."

FIG. 21. A. H. Cros'
E.P. 9,012, 1889.

"Si defecteuse et rudimentaire" as the patentee admits this to have been, it gave him satisfactory results. He points out that the three small mirrors should be preferably of plated glass, metal mirrors, or better still glass with a perfectly silvered coating, or they might be three small prisms with silvered hypothenuses. Presumably du Hauron distinguishes between mere "plated" glass, that is ordinary mirrors, and surface-silvered glass, the former being mercury and foil treated.

A. H. Cros[12] patented a camera in which the three plates were not arranged in one plane, but in three planes parallel to the camera front, as shown in Fig. 21, in regular steps from left to right and from back to

front. Behind the lens, and only one was used, was placed a glass wheel, mounted so as to make with the outer lateral sides, from back to front and from left to right, an angle of 45 degrees, which was put into movement by means of a wound-up cord, as for spinning a top. A plane mirror was placed parallel to and opposite the plane of the wheel, which was divided into four sectors, two of which occupied two-sixths of the circle and having their apices opposite and were silvered. The two others, each one-sixth of the circle, were transparent. The wheel was mounted on the optical axis of the lens, and in revolving allowed the light rays to pass direct to C through the transparent sector, and reflected the same to C^1 and C^2 by the silvered sectors. The three images were not reversed as

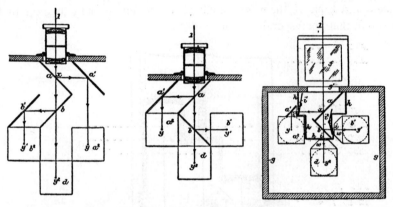

Fig. 22. Ives' U.S.P. 475,084.

that on C was obtained direct, on C^1 by double reflection from one silver sector and the fixed mirror, and on C^2 by reflection from one silver sector to the fixed mirror and thence to the silvered sector opposite the first sector and thence to the fixed mirror and to the plate. The same apparatus might be used to view the results obtained, by placing mirrors outside the planes C^1, C^2, C, and reflecting the light through the positives and setting the wheel in motion, when the image complete in colors would be seen through the lens. Cros called this a "trimonoscope."

A. W. Scott[13] proposed to use four lenses close together and the camera was provided with partitions to isolate each color image. The lenses were fitted with unequal-sized diaphragms to equalize the exposures, filters being placed close in front of the plates. The red filter was to be opaque to all colors but red; the green opaque to blue and violet; the blue opaque to violet, green and yellow; the violet opaque to blue, green and yellow. They might be formed by superposing stained gelatin in films, and as the apertures of the diaphragms of the green, blue and violet were small compared to that for the red, and as the plate was not sensitive to red, the action of the red light transmitted by these filters might be ignored. If,

however, a plate equally sensitive to red were obtainable, it would be necessary to cut out the red light passed by these filters. It is interesting to note that the "green" filter was composed of lemon-yellow and pale orange-yellow. This process was called the "Verak."

F. E. Ives has patented numerous forms of photochromoscopic cameras

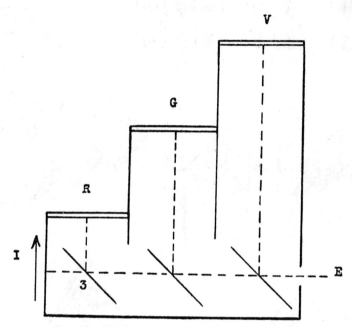

FIG. 23. Zink's Photopolychromskop (Page 114).

and viewing instruments. The first patent[14] shown in Fig. 22, had as will be seen, outside mirrors and three lenses and gave images in trefoil pattern, which requires but little explanation. The main points are that the paths of all the rays are equal, and that a mirror *f* is mounted outside the camera to reflect the image of the object. The apertures in front of the mirrors are inclined slightly in respect to the axial line, as shown in 5 to compensate for unequal reflection from the mirrors *a'* and *b'*. The transparent mirrors might be of glass, either platinized or thinly silvered, colored or uncolored, and when uncolored reflectors are used in front of the lenses, they should be thin, have perfectly parallel surfaces in order that the two reflections, one from each surface of the glass—should be practically coincident for objects at a considerable distance from the camera, and free from doubling of the outlines. When objects were very near, or when plain glasses were used between the condensing lens and sensitive plate, one surface should be slightly inclined in respect to the other in such direction as would make the two reflections practically coincide at the focus of the condensing lens.

9

C. Zink also made a chromoscope, although apparently it was not patented. H. Krone[15] gave the following data of this: "In the spring of 1893, Carl Zink, a photographer of Gotha, without knowing the photo-

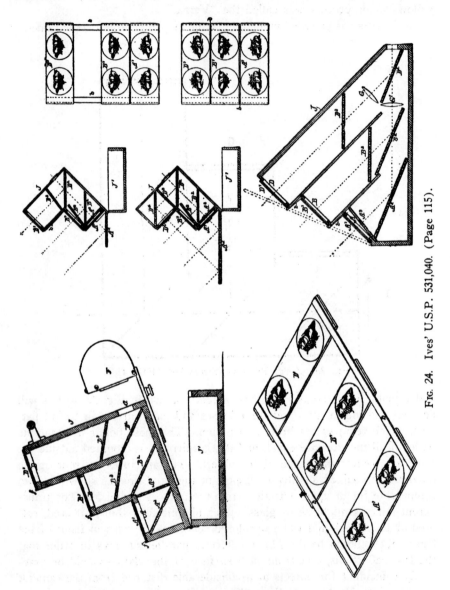

Fig. 24. Ives' U.S.P. 531,040. (Page 115).

or heliochromoscope of Ives, constructed an apparatus which could be used for the same purpose, which he called a 'photopolychromoskop,' and which on account of the greater simplicity in its arrangement appears capable of acting as Ives' apparatus. In the exhibition of the 23rd Convention of

the Deutscher Photographenvereins in August, 1894, at Frankfurt a/M., Zink exhibited for the first time an example of his photopolychromoscope, and after testing, it was awarded the silver medal by the prize committee of the Convention."

FIG. 25. Ives' U.S.P. 546,889, 1895 (Page 117).

It is unnecessary to enter into details of construction, as this is clear from the accompanying diagram, Fig. 23, a copy of that given by Krone. It will be sufficient to say that the filters *V, G, R*, represent the violet, green and red respectively, *3* was a silvered mirror, the other two reflectors being plain glasses; and the eye *E* saw the composite image at *I*. It was also suggested that the instrument might be used as a camera, by inserting dark slides in the three steps, and that the green filter should be replaced by a yellow one. Further, that it might be used for projection by fitting it with three condensers and three small arc lamps. It had the advantage that only one objective was used and that there was no doubling of the outlines.

Ives patented[16] other forms of viewing instruments, as shown in Fig. 24, of three and two-step type, the former being but replicas of Cros' early

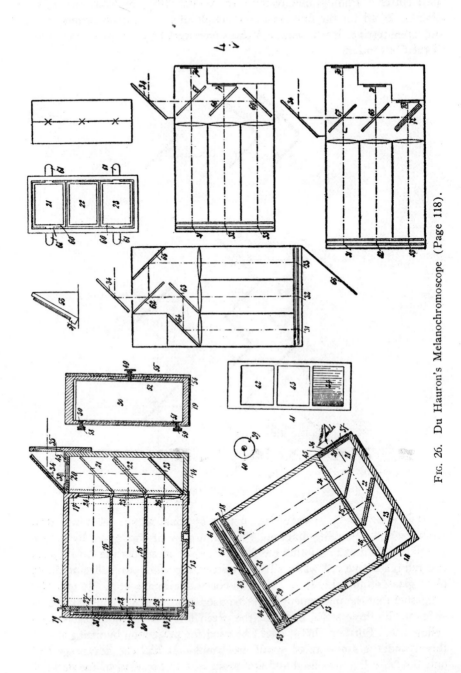

FIG. 26. Du Hauron's Melanochromoscope (Page 118).

FIG. 27. Nachet's F.P. 237,394 (Page 118).

instrument. In these A^3, B^3, D^3 are the filters. An improved form, as shown in Fig. 25 was also devised[17] in which all three images were formed on one plate. Wedge-shaped reflectors were described, but subsequently[18] as these were costly, it was proposed to insert a thick glass plate so inclined as to give the opposite distortion to that of the mirrors.

FIG. 28. Niewenglowski's Chromoscope (Page 118).

Du Hauron[19] also designed another instrument, which was called the "Melanochromoscope," Fig. 26, the details of which are clear. C. Nachet[20] constructed a stereo-photochromoscope, Fig. 27, and two of the positives were placed opposite the lenses, while the third, the green, was placed at the bottom of the instrument, its image being combined with either the red or blue by the platinized mirror M. G. Niewenglowski stated that the idea of this was obtained from the lectures given by L. Vidal at the Conservatoire des Arts et Métiers in 1891. Niewenglowski[21] conceived the idea of increasing the usefulness of Nachet's instrument by fitting it with polarizers and analyzers, Fig. 28, in which P is a pile of glass plates, and N the Nicol prism or another glass pile. Variations of illumination were thus obtainable by merely rotating the Nicol; the date of this instrument must have been 1894 or early 1895.

FIG. 29. Du Hauron's Chromographoscope.

Du Hauron[22] further designed two cameras, one, Fig. 29, was for one plate and was fitted with two transparent reflectors at an angle of 55 degrees to the optical axis, which reflected the rays to the three silvered mirrors M, M, M, and thus gave equal optical paths for the three images. In the other type, Fig. 30, the advantage of the single plate was sacrificed to compactness, and here two transparent mirrors at right angles were used, the first reflecting the rays to the silvered mirror M, thus also equalizing the optical paths. These instruments were called "chromographoscopes," and could be used as cameras as well as for viewing.

B. J. Edwards[23] proposed a two-step, three-plate camera and viewing instrument, which could also be used for projection by placing condensers

FIG. 30. Du Hauron's Chromographoscope.

and arcs outside the three apertures. The specification discloses the use of three separate plates, three mirrors, transparent or semi-transparent, or two quite transparent and the third silvered, placed behind one lens at an angle of 45 degrees; but the construction preferred was that shown

FIG. 31. Edwards' E.P. 3,560, 1899.

in Fig. 31. Filters were, of course, interposed in the correct places and the glass of one might be colored to cut off the reflection from the back. Stereoscopic results might also be obtained by doubling the camera. Each positive might be bound up with a suitable screen and the three combined thus avoiding the use of separate screens, or might be produced by dyed gelatin, as in the Woodburytype process.

Fig. 32. Nachet's Cameras.

C. Nachet[24] made two cameras, Fig. 32, the latter being the simpler, and the mirrors were platinized. W. White[25] adopted practically the same design, Fig. 33, and the mirrors might be plain or colored glass, or thinly platinized or silvered. The instrument could also be used as a camera, for viewing and projection. E. T. Butler[26] patented a two-step camera for single as well as stereo work of practically the same design as Edwards', and in a later patent[27] an improvement was claimed. In this the spectrum was divided into four ordinate colors, two of which combined to act on the retina of one eye to produce half the spectrum, and the other two combined for the other eye. The transparencies were viewed in a similar instrument, which was called a "spectrograph." Presumably it is unnecessary to point out that this method of splitting up the subject into two differently colored stereoscopic pictures will not always result in a picture in colors. The brain ought to make the pictures coalesce; but it refuses to do so sometimes, and all sorts of weird effects are to be obtained, many depending on the idiosyncrasies of the observer's eyes.

Still later[28] Butler patented a one-lens, two-step camera, Fig. 34. C. E. K. Mees[29] speaking of this, pointed out that the three negatives must be taken with one exposure, and there must be no doubling of outlines by double reflection, and all three images must be in focus at once. Further, the ratio of the exposures must be the same and even if a very red-sensitive plate be used for the red, an equally fast green-sensitive plate for the

FIG. 35. Ives' U.S.P. 632,573, 1899 (Page 124).

FIG. 33. White's E.P. 8,663, 1896 (Page 120).

green, and an ordinary plate for the blue, there is yet no means of altering the exposure ratios, which are fixed by the filters. He preferred one kind of plate for all three exposures, and preferably one bathed with pinacyanol, on the ground that this gave more constant results than other or mixed sensitizers. As the beam that passes straight through from the lens suffers no reflections it is the strongest, therefore, this position was chosen for the green-sensation negative, which is the most difficult to obtain. And

the second plate was chosen for the blue, and the first for the red, as shown in Fig. 34.

In order to prevent the doubling of the images from the back surfaces of the reflectors, these must be coated with the minus color of the filter to which they reflect the beam. Therefore, the first reflector should be coated with a minus-red, or blue, film; the second with a minus-blue, or yellow, film. It is also important to secure images of identical size, and this can be secured by altering the position of the filters. If raised the central beam will be shortened, and they must be each adjusted separately, so that the focus of the two reflected images is the same.

It is also extremely important that the path in glass is equal, therefore, the thickness of the filters must be so adjusted that the length of glass

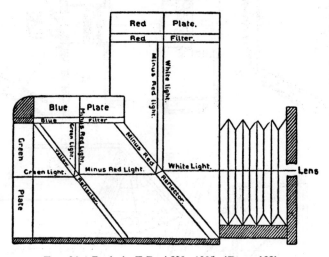

Fig. 34. Butler's E.P. 4,290, 1905 (Page 122).

through which each beam travels is equal. The length of the glass through which the direct beam travels is equal to the thickness of the two reflectors taken at an angle of 45 degrees to the axis of the lens. That is to say, it is 1.41 times the actual thickness of the reflectors. The thickness of the red filter is therefore equal to 1.41 times the thickness of the two reflectors, while the thickness of the blue filter will be 1.41 times the thickness of the yellow reflector.

To adjust the color of the filters so that the correct ratio is obtained, Mees placed pieces of film between the glasses and photographed a black and white chart until equal exposures were obtained with all three filters. The films were finally cemented in the filters.

F. E. Ives[30] divided the light into three beams by means of three prisms, Fig. 35, and equalized the optical paths by the insertion of a lens or block of glass, as seen in *2* and *3*. W. N. L. Davidson[31] proposed to

place the three lenses side by side, and divisions in the camera, using one plate, and exposed simultaneously. In another camera by Ives[32] the images were received on one plate, but the camera was tilted about its optical axis about 45 degrees, by means of a bevelled block, the images being thus formed on the one plate at this angle. To equalize the optical paths Ives also proposed[33] to use blocks of glass or cells filled with liquids, Fig. 36. In yet another chromoscope and camera,[34] Fig. 37, the images from the

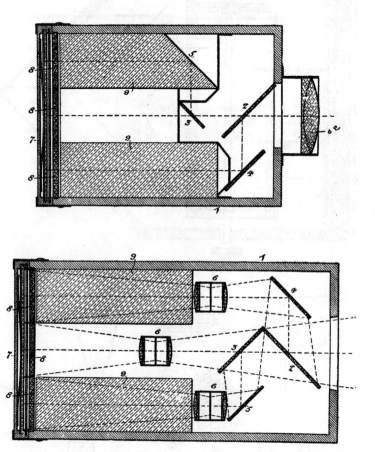

Fig. 36. Ives' U.S.P. 660,442, 1900.

primary reflectors were refracted by prisms. The same inventor also patented[35] compound prisms with silvered surfaces, with part of the silver removed, thus adopting du Hauron's idea, instead of the ordinary glass reflectors, the direction of the light, Fig. 38, being shown in *1* and *2* by *w*, and *x* being the transmitted and reflected rays. The faces of the prisms with the silver or other metal removed being shown in *3, 4* and *5*, whilst in *6* is shown a camera fitted with the prisms.

J. Szczepanik[36] proposed to place two mirrors or a right-angled prism, with the apex to the front, immediately behind the lens, and reflect the two beams thus formed to two other right-angled prisms at the sides, whence the beams were reflected again parallel to the axis of the lens, on to two

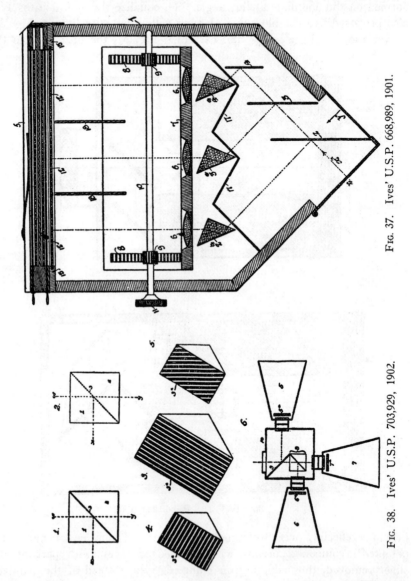

FIG. 37. Ives' U.S.P. 668,989, 1901.

FIG. 38. Ives' U.S.P. 703,929, 1902.

plates or films. This could not only be used as a camera, but also as a chromoscope and for cinematographic work. G. Selle[37] patented the use of four mirrors in his modification of the chromoscope, which could be used for taking and viewing color records. The essential parts, Fig. 39,

being the lens *3*, the transparent mirrors *5* and *12*, the back *6* of the former being colored rose or rose-violet, and the back *13* of the latter being coated with red; *9* and *10* were silvered opaque mirrors, which reflected the images to a^1, b^1, a and b, and the image a^2, b^2 would be formed, as shown by the dotted lines, but the path was shortened by the interposition of the lens *18*.

E. Sanger-Shepherd[38] patented a one-lens camera, Fig. 40, with a sliding carriage *e*, in which were three apertures, as shown in *3*, and be-

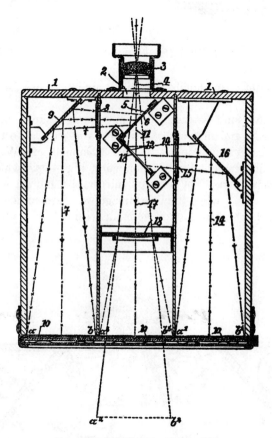

FIG. 39. Selle's E.P. 12,514, 1899.

hind *g* and *i* were mirrors *k*, *l*, which reflected the image respectively to *c* and c^2, in front of which were the filters *d*, *d*. When the aperture *h* was opposite the lens the image would be formed on the plate c^1 through its filter *d*. The carriage was rapidly reciprocated by the cam *m*, which might be controlled with any convenient motive power; *p*, *p* were the partitions forming separate chambers for the plates. If the images were all re-

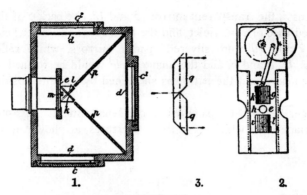

FIG. 40. Sanger-Shepherd's E.P. 21,239, 1900 (Page 125).

quired on one plate, then rhomboidal prisms, as in *2,* were used instead of the mirrors.

W. N. L. Davidson[39] patented three mirrors at an angle of 45 degrees to the optical axis, and in front of the lens, and parallel to one another, forming three images on one plate. H. O'Donnell and W. C. South[40] patented a roll-film camera for tri-color work, Fig. 41, in which the main details are clearly seen. The silvered mirrors *25* and *26* reflecting the two images to *2* and *3,* while the third image was formed direct at *1.* To equalize exposures the diaphragms were cut with oblong apertures of dif-

FIG. 41. O'Donnell & South's E.P. 4,127, 1904.

ferent areas. The filters could be arranged in the planes *27, 27.* A. & L. Lumière[41] patented a one-lens, one-exposure camera, the essential part of which was the divider, shown on the left in Fig. 42, and formed of two sheets of glass *d, b* at right angles to one another and placed behind the lens *o,* as shown on the right. The function of this divider was to direct the image formed by the lens into three directions, so as to permit of the separation of the rays by the filters suitably placed. The sheets of glass were silvered on their surfaces next the lens in parallel bands *a, a,* the width being equal to their distance apart, so that each glass was divided into alternate and equal transparent and reflecting surfaces. On one of these glasses *b* these bands were perpendicular to the intersection of the glasses; on the other *d* they were parallel to the intersection. The divider thus formed was placed behind the lens *o* so that the axis of the lens was perpendicular to the intersection *i* of the two sheets of glass, and so that it formed equal angles with each.

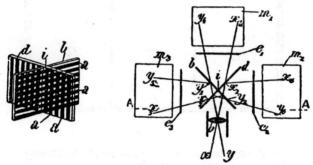

Fig. 42. Lumière's F.P. 350,004, 1904.

W. Abney[42] patented a camera in which three small lenses, or three portions of one lens might be used. The images from the two "side" lenses were deflected by mirrors or prisms so as to fall on the side portions of the camera. While the rays which traversed the central lens passed direct to the central section of the plate, and in their path was placed another lens, preferably adjustable along its focal axis; and between the mirrors and the outer sections of the plate were also lenses. These supplementary lenses enabled the focal length of the rays, passing through the outer lenses to be adjusted to that of the central rays, thus ensuring three pictures of equal size. Obviously the outer lenses might be of fixed focal length and that of the central lens altered. Abney stated that uncorrected lenses might be used, the camera being altered to suit the different focal lengths of the different colors. The arrangement is shown in Fig. 43. Abney stated that he considered one desideratum in making tri-color pictures was the presentment of three negatives taken simultaneously. If separate negatives

were used the difficulty of movement came in. There was no need to have
an elaborately corrected lens. Spectacle lenses were very cheap and gave
excellent results when used with the filters. Meniscus lenses were the best,
but failing this a 6-inch plano-concave lens cemented to a 3-inch plano-
convex made a good combination. But a single lens was of but little use
for color work on account of chromatic aberration. It was possible to

Fig. 43. Abney's E.P. 14,623, 1905.

make a doublet in a special mount by which the separation of the lenses
could be adjusted for each color. Such a mount might consist of three
tubes; in the central one was the diaphragm, while the outer and inner
tubes carried two lenses. With such a tube it was easy to obtain the right
position of the lenses, as regards the diaphragm, for each color in turn,
and permanent mounts could be made from the data thus obtained. With

lenses of the focus given above the components must be 2 in. apart for the green, 1.82 in. for the red and 2.18 in. for the blue.

O. Bauer[44] arranged the sensitive plates or films on three sides of the camera and successively exposed by reflection of the image by means of a revolving mirror. The camera was divided by partitions, and the lens carried by a central tube. Behind the lens was a prism or mirror, which reflected the image through a hole in the central tube at right angles to the plates, the tube being revolved through 90 degrees. The filters were

Fig. 44. Pfenninger's E.P. 26,609, 1910. (Page 131).

placed in front of the plates, and the fourth division of the camera was used for focusing. In a subsequent patent[45] the revolving mirror projected two images to two mirrors at 45 degrees to the optic axis, whence they were projected on to a single plate side by side with the third image, which was formed direct.

Ducos du Hauron and R. Bercegol[46] devised a one-exposure camera with a large front collective lens with three small rear lenses and three

10

adjoining cameras. The use of prisms and mirrors was also indicated. J. S. Chenhall[47] patented a camera with three plate holders carried on a circular disk, the individual plates being automatically brought into the

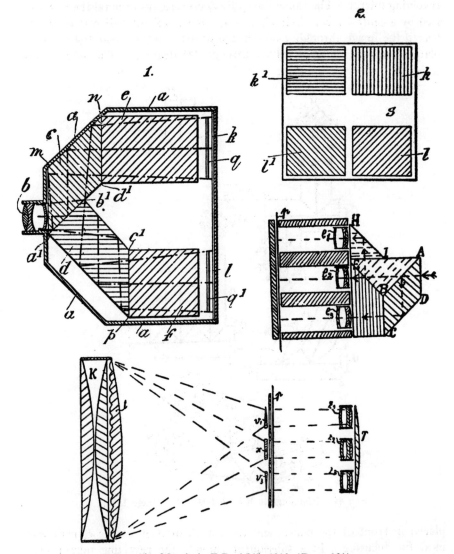

FIG. 45.　Mortier's E.P. 6,565, 1913 (Page 131).

focal plane. Three drop shutters were also provided, which were released by the changing of the slides. E. Bastyns[48] patented a three-lens camera with common shutter. G. Le Saint[49] patented a stereo-chromoscope using mirrors or half lenses and the rays had not the same optical path length.

The Société Anonyme la Photographie des Couleurs[50] used a combination of three right-angled prisms, the front face having a convex and the rear a concave curvature. J. Richard[51] proposed to use two tetrahedral prisms for obtaining reversion of the images for stereoscopic work, and they might also be used for color. A. Cheron[52] used three lenses placed side by side with color filters and a common shutter.

C. Nachet[53] employed an equilateral prism to refract the rays to two mirrors inclined at 60 degrees to the original path of the light, and thence through two objectives. Or two reflecting prisms could be used with two mirrors in front of the two lenses. Or the same arrangement could be used with a large diameter lens in front, and the prisms separated to allow of the interposition of a convex lens to equalize the path of the three beams; or three side by side lenses might be used with reflecting prisms and mirrors in front of the lateral objectives. O. Pfenninger and E. C. Townsend[54] designed a camera that might take one of the several forms, shown in Fig. 44, with what they called a "self-compensating reflector or reflector filter," which was practically a diamond-shaped reflector. M. A. Moriceau[55] patented a chromoscope and camera, in which mirrors were located behind the lens, on the same lines as Nachet's arrangement. The distortion caused by the mirror being rectified by the interposition of a secondary sheet of glass in front of the plate and angled with respect to the same. F. Dogilbert and H. Calmels[56] used a mirror fixed at an angle of 45 degrees above the lens, below which was another like angled mirror, rotating on its center, which projected the images into three cameras placed at angles of 120 degrees to one another.

E. Ventujol and C. Petit[57] patented the use of rhomboidal prisms arranged with a slight separation behind the lens, and the interposition of a supplementary lens in the path of the central beam to equalize the optical paths. L. Geisler[58] proposed a stereochromoscope in which the reflector at 45 degrees was coated on its face with a yellow varnish to prevent double reflection, the reflected colored image being absorbed by a filter in front of one of the plates. P. Mortier[59] patented the use of two prism blocks and two lenses, Fig. 45, for obtaining stereoscopic color records. The filters were arranged in pairs, with the colors of each pair complementary and equidistant on the chromatic circle. The tetrachromatic set could be obtained on one film, either side by side, or in vertical alinement. The necessary sides of the prism blocks were silvered, the remaining sides being of partial reflection only. If the objects were on the same plane it was possible to obtain flat and non-stereoscopic negatives, and in the case of near objects, situated in different planes, exact superposition could be effected by interposing total reflecting prisms of parallelogram cross section, between the subject and the lens, so as to reduce the binocular distance to approximately one-third of its distance. In the diagram, *1* shows the prism block, *2* the four images, and the other figure, which appears in the

French patent, is for a three-color system. To project the three images in superposition, the lowest arrangement was proposed, in which K is the condenser, the front lens of which was provided with parallelopipedal rods, or it could be ground to this form. The light passed unchanged through the central portion of this lens, whilst the upper and side parts acted as prisms and refracted the light downwards, whilst the lower parts refracted it upwards. The small prisms v_1, v_3 destroyed the dispersion of the light, caused by the condenser lens, and the plane block x effected the

Fig. 46. Holbrook's U.S.P. 1,151,786, 1915.

lengthening of the central bundles as much as the prisms. In front of the three objectives 3_1, 3_2, 3_3 was placed a convex lens of long focus.

L. S. Glover[60] patented the use of a two-color stereo camera with separate lenses and filters. J. K. Holbrook[61] proposed to form a segmental lens, Fig. 46, from the usual circular form 4, by grinding it into hexagonals 5, then cutting up as in 6, and assembling as in 7 in a hexagonal tube as in 8; partitions, running back from the lens to the plates. The different segments might be colored or separate filters used. F. E. Ives[62] patented a linear-silvered mirror, which was movable, Fig. 47, in which the light rays are supposed to come from the lens a, and to meet the screen 10, some were reflected upwards to form an image b on 11. The rays passing through the line screen meet the rear one 12 and were thence reflected to form an image c on 13, and those rays passing through 12 form an image on the rear plate 14. The inclined screens 10 and 12 may be colored, or 15, 16, 17 form the filters. The lines 18 were the silvered portions of the screen 10 and 19 the transparent parts, being approximately equal in area and width, about ten to the inch. It is stated that if their number materially exceed this, diffraction phenomena appear. And if too wide spacing be employed there is unequal distribution of light between the transmitted

and reflected images. The screen *10* was moved during the exposure by the handle *22,* which protruded outside the camera, and the inventor stated: "It will be understood that in making the exposures for color-selection negatives, the time of exposure is not brief, but occupies seconds or even minutes. The lens having been adjusted to proper focus and the sensitive films and holders inserted, the lens may be uncapped for the exposure, and the operator will then manually move the handle or pointer *22* through such an arc as is necessary to cause the striped screen's complete move-

Fig. 47. Ives' U.S.P. 1,153,229.

ment. It may, for example, take two such complete turns of the handle *22.* The two turns could be made gradually so as to occupy the whole time of exposure, or could be made rapidly, followed by a reversal to the original position and so on, thus effecting a reciprocation of the striped screen in its own plane." Obviously such an arrangement would be useless for all but still-life or motionless objects.

F. Judge[63] patented a one-plate camera, the plate being carried on a rotating disk, facing the lens, with a spindle and clockwork mechanism to arrest the plate at any previously determined angle; the mechanism being

set in action if required by pneumatic pressure. Four exposures could be made so as to furnish a key plate. T. Klatt[64] would use two concentric mirrors with narrow sectors cut out of the peripheries, which reflected the images to two plates placed on the same side of the camera, but not on the same plane, the one being slightly in advance of the other, so as to equalize the optical paths. S. Procoudin-Gorsky[65] patented a camera that would give the successive exposures through one lens as quickly as possible. The opening and closing of the shutter, the changing of the filters and the film being automatically effected, while the operating speed might be varied within wide limits by the regulation of a tension spring. The shut-

Fig. 48. Brewster's U.S.P. 1,277,040, 1918.

ter disk carried uniformly arranged filters, adapted to rotate, and by means of cam-shaped surfaces on the periphery operated the intermittent film-moving mechanism, which comprised a U-shaped frame having latches, pawls or claws, which engaged in the perforations of the film so that it was drawn forwards one picture space.

P. D. Brewster[66] would immerse a light-splitting device in a liquid cell, Fig. 48, thus obviating, it is claimed, any distortion and complete command over the ratios of reflected to transmitted light. The arrangement shown is for a two-color camera, in which *7* is the light-splitting device, which might be a sheet of glass half-silvered or platinized; *9* and

12 are the color filters, *10, 13* the sensitive plates, *17* the liquid in the cell. By suitable mixtures of various liquids or the use of salts in glycerol and water, the refractive index of the liquid might be so adjusted to that of the glass that the latter would become invisible and without effect on the light rays, whilst the metallized surfaces would still act as reflectors.

J. Dourlen and M. Chretien[67] suggested a one-lens camera in which rotating mirrors were used, the plates being placed on the three sides of a rectangle, the lens occupying the fourth. Any number of plates could be used and the same system might be used for projection. I. Kitsee[68] patented a block of three plates with filters, which were placed in the camera and severally exposed and each swung out of the optical axis. These were printed from on dichromated gelatin and reassembled. F. Barnes and E. Allen[69] suggested a camera with two plates at right angles, and a mirror at 45 degrees, which reflected the image first to one and then to the other plate. A. R. Trist[70] arranged three filters on a rotary disk in front of a lens, the nodal plane of which was situated in the plane of the filters. Each filter was provided with an iris diaphragm to equalize the exposures to the sensitivity ratios of the plates. E. A. Raschke[71] patented a camera for making color separation negatives for photomechanical work. C. E. Bredon[72] patented a single or stereo-chromoscope or camera consisting of a collimator lens with three posterior lenses, fitted with filters; the separation of the beams being effected by two prisms, similar to those suggested by Christensen in F.P. 435,962, 1911 (see p. 206). These prisms being adjustable as to the diaphragms so as to equalize the exposures. G. Vrinat and F. Revet[73] patented a camera with a lens front that could be shifted for each exposure, filters being fitted behind the same. This could be used for stereo work.

T. R. Dallmeyer[74] patented a camera, in which a mirror was placed at an angle of 45 degrees to the optical axis behind the lens, so that it could be rotated in turn to the sides of the camera where the plates were placed. The mirror being revolved from the rear or front of the camera, F. Boucher[75] patented a stereo camera for black and white or color work. A third chamber with lens and prism was attached, so that the object could be viewed at the moment of exposure, the prism being at an angle of 45 degrees to the axis. The fronts of the camera were extended to protect the lens from any light used, such as flashlight. H. E. Liabeuf[76] patented a camera with plates on three sides of a triangle, with filters and rotating shutter, automatically changed with the plates.

G. Russo[77] would form a primary image either on a sheet of ground glass or on a convergent lens and then by the use of three or four supplementary lenses form the secondary images for the constituent records. The images might be in trefoil, or square arrangement and the possibility of using five or seven colors is disclosed. By the use of split condensers

and a light-source behind the transparencies, the same arrangement could be used for viewing or projection. A. J. Tauleigne and E. Mazo[78] would also use three bi-reflectors on the optical axis, thus projecting the three images on one sensitive surface in trefoil pattern. The arrangement was reversible for projection by the aid of split condensers. L. J. Colardeau and J. Richard[79] patented a chromoscope, shown in Fig. 49, in which *I*, *I'*, *I''* are the three pictures and *R*, *R* the reflectors, *M* being a mirror to reflect the light from the open side of the instrument to I. In order to avoid double reflections the reflectors were coated with complementary

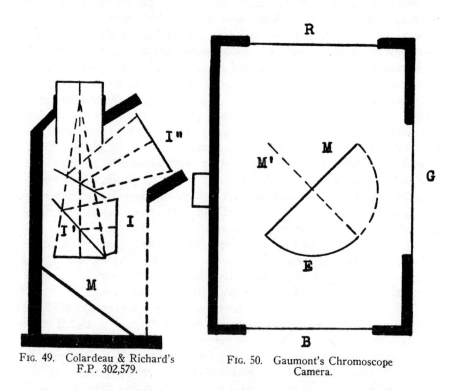

FIG. 49. Colardeau & Richard's FIG. 50. Gaumont's Chromoscope
F.P. 302,579. Camera.

colored varnishes. If the eyepiece were replaced by a lens, the apparatus could be used as a camera.

L. Gaumont & Co.[80] also made a chromoscope camera, shown in Fig. 50. Behind the lens was placed a transparent mirror *M*, which was carried on an axis parallel to the three plates *R*, *G*, *B*, placed on three sides of the camera, the lens occupying the fourth side. In one position the mirror reflected the image to the plate *R*, and simultaneously exposed plate *G*. At the end of this exposure the mirror suddenly assumed the position *M'* and reflected the image to the third plate *B*, and the opaque screen *E* then prevented access of light to *G*. C. Nachet[81] while adhering

to the main idea of right-angled reflectors, modified them by using metallic bars, thus following the idea of Brewster (see p. 189). The Société Cuenin[82] patented a one-exposure camera on the same lines as Nachet and White, with two reflectors at right angles to one another. A. B. Klein & A. Hilger, Ltd.,[83] patented a chromoscope for taking a plurality of sets of slides and means for altering the illumination as by colored light, etc., which was intended for three-color and textile printing. J. Mroz[84] connected the filter carriers with the film so that the latter was automatically and intermittently moved forward; a Maltese cross with spring mechanism was the motive power. In a further patent[85] the lens and filter carriers were so mounted that their relative positions remained unaltered during focusing. The operation of changing the filter automatically adjusted the aperture of the lens to equalize the times of exposure.

Before leaving the subject of chromoscopes, it may be of interest to give E. König's instructions for making such an instrument,[86] which is shown in section and plan in Fig. 51. The box is made in steps with apertures at L, L', L'', for the light filters. In the inside are two transparent mirrors M, M', which are fixed at 45 degrees to the bottom of the box, R is an ordinary white mirror or card, and is used to illuminate the light-filter at L'' through the mirrors M, M''. The picture at L' is reflected by the mirror M' to the eye at O. By means of the mirrors M, M'' the pictures, which lie in a horizontal position at L, L', are seen in an inverted and upright position at L''. The measurements are so adjusted that the mirror images of L and L' combine with L''. As is well known, the mirrored image of an object appears to be as far behind the mirror as the object itself is in front of the mirror. Therefore, LM must equal ML'', and $L'M'$ equal $M'L''$. From this it follows that $LM-L'M'$ equals $ML''-M'L''$, or the distance of the mirrors M and M' from one another must be equal to the distance of L and L'.

The wood may be any well-dried sort, about 1 cm. thick, which will not warp. For 9x12 cm. pictures the measurements should be kept to about the following: AB 285 mm.; CD 165 mm.; BC 265 mm.; AG 135 mm.; HG 125 mm.; CJ 160 mm.; HJ 130 mm. AF, GK, HM, JE are obviously the same as CD. The horizontal surfaces $AGKF$ and $HJEM$ have exactly in the middle an aperture of about 10x13 cm. The vertical surface $CDEJ$ has an aperture of the same size, the upper edge of which is exactly so far from JE as the nearest edge of the aperture $HJEM$ is from JE. One side wall $ABCJHG$ carries a flap, which is provided with hinges and turn-buckles, and is just so large that the mirror, which will be mentioned later, with the boards that carry it, can be conveniently stowed away in the apparatus.

On a board of exactly the same size as the inner bottom surface of the apparatus the two previously mentioned transparent mirrors M, M' are fastened in the following manner: the mirrors, which should measure about

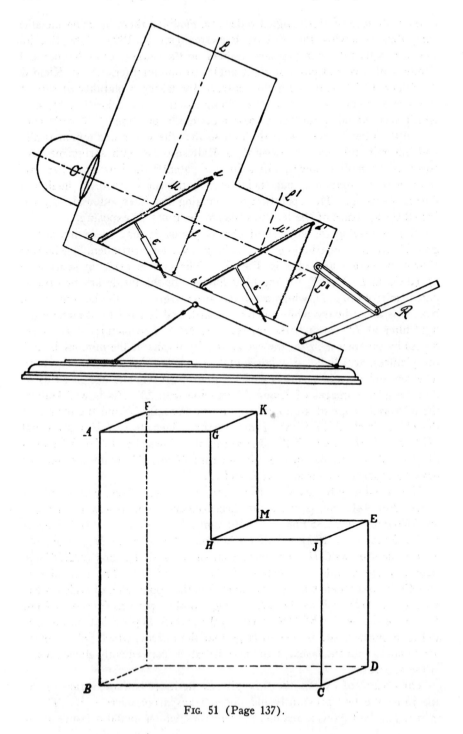

FIG. 51 (Page 137).

135x135 mm. are placed with their lower edges on two metal angle plates *a, a′*, which should be screwed to the board, and the shorter side of which should slant about 5 mm. above the board. The longer side should have a slit about 25 mm. long, through which passes the binding screw. This slit enables one to shift the metal plate if required. The mirror is supported behind by the screws, *C, C′*, by means of which it can be inclined more or less. It is best for these screws to be upright to the surface of the mirror, which is at an angle of 45 degrees, and they should, therefore, form that angle with the bottom of the box. In order to give the mirrors the necessary support, they should have on their upper edge a narrow metal edging *d, d′*, to the ends of which should be soldered a hard brass or steel spring *f, f′*, which may be hooked to small loops fastened for this purpose to the baseboard.

The distance of the two mirrors from one another, as has already been mentioned, is the same as *GH*, 125 mm. The rear mirror should almost touch the back wall *CDEJ* with its metal edging. The image, which is found at *L″* should be illuminated by a mirror, or better still, a sheet of opal glass provided with hinges. The whole apparatus should be fastened to a board by hinges, as at *CD* so that it may be directed to the sky and fixed in any desired position. A piece should be cut out of the front wall *ABF*, and again be fastened in with screws and turn-buckles. In this cut-out piece should be fastened an ordinary bi-convex lens of 35 to 45 cm. focus, so that its optical axis will pass through about the center of the aperture *CDEJ*. This lens need not be achromatic; one of the so-called reading glasses will answer perfectly. As large a lens as possible should be chosen, so that both eyes may be used at once. Above and below the lens should be blocked out with black paper, so that only a horizontal slit remains for the eyes to look through. The inside of the apparatus should be blacked all over. A thin alcoholic solution of shellac with enough lamp-black to give it a dead appearance may be used. For notes as to the making of filters for this apparatus see page 83.

Reflector Modifications.—It is a well-known fact that not only is there double reflection from plane mirrors, but the image is also distorted, and the following patents specifically deal with this subject.

F. E. Ives[87] stated that the inclination of the reflectors, owing to the different angles at which different portions of the light rays enter the same and consequent differences of refraction, causes a distortion of the image formed by the transmitted rays. When the transparent mirrors are inclined at 45 degrees the transmitted image will appear vertically elongated to a slight extent, sufficient to prevent accurate registration with the reflected image. This defect can be corrected by employing glasses, which, instead of having plane surfaces, are slightly wedge-shaped and so disposed that the lowest part of the picture seen through the glass appears optically displaced upward, while the displacement appears less and less

toward the top, where the inclination of the mirror brings it closer and closer to the image. Such wedge-shaped glasses are costly and to overcome this trouble he proposed to distort the reflector by means of springs, Fig. 52, in which *1* represents the spring of brass or other metal; and the application is shown in *2*, whilst a variant was the use of fixed springs, as in *3*.

A. E. Conrady and A. Hamburger[88] also refer to the distortion and state that in the diagram, Fig. 53, *1* shows the main distortion of the trans-

FIG. 52. Ives' U.S.P. 622,480, 1899.

mitted image by the insertion of the reflector, *1*[a] indicates the secondary distortion produced in the transmitted image. In *2* is shown how pressure should be applied to effect the compensating distortion of the filter. A simple form of device for this is shown in *3; 4* is a camera fitted with the same with means for keeping the tilt of the screen appropriate to the focus adjustment of the camera, and *5* shows a camera with plate holders for increasing the size of the image without alteration of the reflector. The

displacement of the rays passing through a filter is shown in *1* and the rays *a*, *b*, *c*, from the optical center *d* of the lens through the filter *e* to the focusing plane *f* are lowered from the point *a'*, *b'*, *c'*, to *a''*, *b''*, *c''*, this effect being greater at the top than at the bottom of the reflector; but by moving the focusing plane further away from the lens center *d* to a posi-

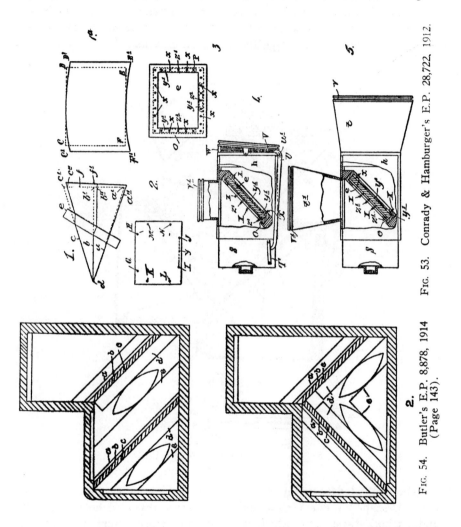

FIG. 53. Conrady & Hamburger's E.P. 28,722. 1912.

FIG. 54. Butler's E.P. 8,878, 1914 (Page 143).

tion *f'* and tilting it in the same sense as the reflector, this distortion can be compensated and this compensation is more than sufficiently accurate in the vertical line of the center line of the rays. The other parts of the focusing plane, however, are affected by a secondary distortion, as shown in *1*[a], which indicates a front view at *CDEF* the true image of a square object while *C' D' E' F'* shows, greatly exaggerated, the actual image. With the

largest practicable field, namely, about 32 degrees in the direction of *CD* and 25 degrees in the direction *DE*, the distance apart of the vertical lines *CF, C'F'* amounts to about 1/25 of the thickness of the transparent reflector. While the curvature of the horizontal lines brings the point *C'* about 1/60th of the thickness of the reflector lower than the ideal point *C*. As a reflector filter may often be required to be a quarter of an inch in thickness the errors of registration between the images obtained by the transmitted and reflected rays respectively become serious.

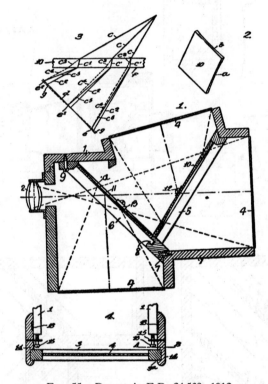

Fɪɢ. 55. Dawson's E.P. 24,538, 1912.

The method adopted by these inventors to cure the troubles was to use a U-shaped frame with a number of screw-threaded holes round it and on both faces, into which spring-faced pressure screws might be inserted. Three rigid but adjustable supporting points with strong springs opposite them were also provided, so as to fix the distance of the reflector from the faces of the frame, and thus pressure might be applied till the transmitted and reflected images were of the same size.

O. Pfenninger[89] patented correction of the distortion by the interposition of another glass at the opposite angle to that of the reflector. E. T.

Butler[90] would alter the curvature of the reflectors by buttresses *a,* in Fig. 54, *b* a liner, *d* a thrust and *e* the supports. The combination of these is shown in a camera in *1,* in which the reflectors were placed parallel to each other at 45 degrees to the optical axis; *2* shows the same with the reflectors at right angles to each ohter. A Dawson[91] dealt with the subject in another manner; Fig. 55 shows a camera fitted with the improved reflectors in *1,* whilst *2* shows the actual form of the reflector; from which it will be seen that it was really a negative cylinder. W. Hillert[92] proposed to obtain regulation of the transmitted and reflected light from reflectors with silvered stripes, by making the same on two glasses and wider at opposite ends, so that by shifting the relative positions of the glasses, more or less transparent spaces were obtained. The same result could be obtained by placing the silvered portions in staggered rectangular areas, which decreased in size from one end of the reflector to the other.

H. E. Rendall[93] stated that hardly any three-color camera would give three mathematically exact images; but the errors are hardly appreciable. The refraction error in the image after passing through a reflector at 45 degrees for a field of 40 degrees was 0.154 *t,* in which *t* was the thickness of the glass. A. Sauve[94] instead of using plane glasses as reflectors, employed two prisms, the contact faces being straight or curved and the outer faces parallel. It is shown that under certain conditions the angles at which the reflectors must be set is 7.5 degrees, and that then the upper faces only acted as reflectors.

Accessory Apparatus.—A few patents have been taken out for accessory apparatus in the shape of dark slides, shutters, etc.

G. Selle[95] patented a sliding back, in which a long dark slide or plate holder was arranged with the three filters in front of the plates, the frame being slid along in front of the aperture in the camera. A. J. B. Legé and W. H. England[96] patented a back in which the plates and filters were changed by gravity, assisted by a spring; the change being effected by pneumatic devices after the firing of the shutter. In a later patent[97] the changes were effected by clockwork. A. Hofmann[98] patented a plate carrier with one or more corners cut off, so as to be able to distinguish the individual color records in the dark, and also a block of the same, in which each carrier fitted into the one in front by means of lugs. J. M. Frachebourg[99] described a folding camera, in which the filters were carried on a rotary disk in front of the camera, and the plates were changed synchronously with the filters by a pneumatic device. J. Joly[100] patented a changing box for screen-plates.

A. Hofmann[101] patented a triangular prism back with the three plates on the sides, with the necessary filters in front of the same. The triangle was set in motion by an outside spring. This had been practically anticipated by V. Matthieu and E. Dery.[102] H. Meyer[103] also patented the same

idea. P. H. Uhlman[104] used what may be described as a compound camera. The image was thrown by means of a lens on to the rear wall of the camera or box, and round this lens were arranged, in the large camera, smaller cameras, the lenses of which threw the image of the rear wall to the sensitive plates. L. Margerie[105] patented a sliding filter frame shifted by the action of the shutter. B. Jumeaux[106] patented a sliding back, as did also W. Bermpohl,[107] and in this arrangement the filters were in front of the plates, and they were changed by pneumatic action. In order to ensure smooth action of such a back, H. Ernemann[108] provided it with a counter-weight.

A. Hofmann[101] patented a triangular prism back with the three plates of his predecessors and made it a quadrilateral figure, on three sides of which were placed the plates and filters, while on the fourth side a focusing screen was added. The Société du Photochrome[110] patented a camera in which the plates and filters, were changed by pressure on a rubber ball or spring. H. Boekholt[111] utilized a magazine back in which plates were changed by means of a roller blind. A. Müller[112] patented a dark slide which held the three plates in sheaths, which also carried the filters. The plates were caused to fall, after exposure, forward into the camera, so as to be out of the field of view. After all three had been exposed they were drawn again into the slide. O. H. Weichel[113] patented practically an identical arrangement. P. Duchenne[114] devised a changing back with two magazine chambers, in one of which the exposed plates were stored; filters were also fitted and could be changed with the plates. H. Brinkman[115] devised a plate or film carrier, comprising a piece of cardboard and a glass plate, which enclosed the film or plate. A corner was to be cut off the film or plate to correspond with a clipped off corner of the carrier, which facilitated loading. The front glass of the carrier might be a yellow filter or a screen-plate. The Société d'Epreuves Photographes en Couleurs[116] patented a changing box with filters in front of each plate.

H. Diernhofer and M. Holfert[117] patented a repeating back in which the plates were stored in carriers and swung out of the focal plane. V. Linhof[118] devised a shutter release that shifted the filters and dark slides. J. Tessier[119] patented a camera back with a focusing screen and three sets of apertures for making the three exposures. Also[120] a plate holder or dark slide for the same, with corresponding sets of apertures and a spring for pressing the sensitive surfaces into register. Also[121] a frame for carrying the filters behind the lenses in the above camera. H. and A. Diernhofer[122] patented a shutter for successive exposures of three plates. B. Zavoda[123] described a rollholder, by means of which one panchromatic film might be exposed behind the three filters, or a film-pack roll, that is, three films rolled up on the supply spool, but separately exposed.

D. F. Comstock[124] patented a photometer in which the visual intensity of various parts of the subject can be compared with a standard light-source; filters, similar to those to be used during exposure, being interposed in the path of the image and the standard light. Tables must be drawn up from actual trials which shall give the correct exposures under the different filters with the different intensities of the light.

J. Trau[125] patented two frames with clamping rims for stretching and retouching color films. G. Selle[126] patented the use of Crooke's radiometer for determining the relative exposures for the constituent negatives. As this instrument is practically dependent on the heat rays, it is obvious that the results would not be reliable. P. Herden[127] patented the use of register marks on the negatives, which should be impressed on each of the constituent prints. W. Deyhle[128] patented a frame in which the constituent negatives were provided with register marks. J. Brinkmann and M. Hoffmann[129] devised a printing frame with rods stretched over the front, carrying pointers, which marked the negatives, so that the marks were reproduced on the positives and serve for registration.

1. The term photochromoscope was first used by J. Francis, E.P. 2,555, 1879; Brit. J. Phot. 1880, **27**, 115, for an instrument that he had devised and exhibited in 1879, for the examination of ordinary lantern slides. It consisted of a tube with enlarging lens, a slot for the slides, a ground glass and a flexible curtain with graded colors for tinting the slides, this curtain being adjustable from the outside.
A summary of the history of chromoscopes was given by E. J. Wall, Brit. J. Phot. 1922, **69**, Col. Phot. Supp. **16**, 13, 18. Cf. O. Pfenninger, Jahrbuch, 1911, **25**, 11. H. E. Rendall, Brit. J. Phot. 1921, **68**, Col. Phot. Supp. **15**, 43; Phot. J. 1924, **64**, 390; Brit. J. Phot. 1924, **71**, 347.
2. "La Triplice Photographique des Couleurs et de l'Imprimerie," Paris, 1897, 448-464.
3. "Les Couleurs en Photographie, Solution du Problème," Paris, 1869, 54. Cf. L. Vidal, Bull. Soc. franç. Phot. 1897, **44**, 225, where he quotes both Cros and du Hauron.
4. "La Triplice Photographique, etc." 354-367.
5. F.P. 105,881, 1874. The full specification is given in the above cited work, 219.
6. E.P. 2,973, 1876; Brit. J. Phot. 1877, **24**, 152, 163, 181, 199, 212, 238, 249, 259; abst. ibid. 1907, **54**, Col. Phot. Supp. **1**, 6.
7. Du Hauron says, loc. cit. 222, that this magnifying glass is nothing more than a magnifier (bonnette d'approche) recently introduced for ordinary work.
8. This is probably the first mention of partially silvered reflectors, later patented by many others, Ives, Lumière, Sanger-Shepherd, Comstock, Brewster, etc. The main idea embodied here has also been repeatedly patented since.
9. See notes 5 and 6.
Parallax has always been the drawback to the use of two or more lenses side by side. The width of the fringe round any object is given by the formula:

$$parallax = \frac{focal\ length\ of\ lens \times lens\ separation}{distance\ of\ object}$$

, H. E. Rendall, Phot. J. 1924, **64**, 390.
10. Compt. rend. 1879, **88**, I, 121; Bull. Soc franç. Phot. 1879, **26**, 23; Phot. Times, 1879, **9**, 186; Brit. J. Phot. 1879, **26**, 29. E. Stebbing, the French correspondent of Phila. Phot. 1879, **16**, 90 gives the same description and diagram. A comparison of this instrument with those of Ives will at once show the great similarity, the latter being obviously modifications of Cros' idea.
11. F.P. 173,101, 1885; "La Triplice, etc." 217.
12. E.P. 9,012, 1889; abst. Brit. J. Phot. 1907, **54**, Col. Phot. Supp. **1**, 7. Chas. Cros was the brother of the patentee; F.P. 193,988.

13. E.P. 19,402, 1890; Brit. J. Phot. 1891, **38**, 24, 325, *729*; 1892, **39**, 345; 1907, **54**, Col. Phot. Supp. **1**, 7; Anthony's Phot. Bull. 1891, **22**, 118; Brit. J. Almanac, 1891, 624; 1892, 553. Cf. Ives v. Scott, Brit. J. Phot. 1892, **39**, 365, 382.

14. U.S.P. 475,084, 1892; E.P. 4,606, 1892; Brit. J. Phot. 1892, **39**, 295, 758; 1893, **40**, 328, 344; 1894, **41**, 26, 790; 1895, **42**, Supp. 80; abst. ibid. 1907, **54**, Col. Phot. Supp. **1**, 15; J. Frank. Inst. 1893, **135**, 35; F.P. 222,121, 1892; Jahrbuch, 1894, **8**, 215. Cf. Traill Taylor Memorial Lecture, p. 40; Bull. Soc. franc. Phot. 1897, **44**, 451; Brit. J. Phot. 1895, **42**, 474; H. W. Vogel, Handbuch, 1894, **2**, 239; Phot. Mitt. 1897, **28**, 294; Phot. Times, 1892, **22**, 533; 1899, **29**, 164; Prof. Amat. Phot. 1900, **5**, 166; Cf. W. Gray, Photogram, 1894, **1**, 140. For controversy Ives v. Pfenninger, see Brit. J. Phot. 1914, **61**, Col. Phot. Supp. **8**, 24, 27.

15. "Die Darstellung d. natürlichen Farben," Weimar, 1894, 113; D. Phot. Ztg. 1893, 67; 1899, 271; Phot. Rund. 1894, **4**, 386; Vie Sci. 1900, **2**, 94; Brit. J. Phot. 1896, **43**, 255; Photogram, 1895, **2**, 111. Cf. A. Berthier, "Manuel de Photochromie Interférentielle," Paris, 1895, 46; Brit. J. Phot. 1895, **42**, 484.

16. U.S.P. 531,040, 1894; E.P. 2,305, 1895; Brit. J. Phot. 1896, **43**, 38, 78; **1897**, **44**, 17, 665; Supp. 4; 1899, **46**, 22, 2, 3, 408; 1907, **54**, Col. Phot. Supp. **1**, 24; Photogram, 1896, **3**, 256. Cf. A. Watkins, Brit. J. Almanac, 1899, 765; Trans. Roy. Scot. Arts, 1898, **14**, 136.

17. U.S.P. 546,889, 1895; E.P. 3,784, 1895; abst. Brit. J. Phot. 1907, **54**, Col. Phot. Supp. **1**, 16; Photogram, 1896, **3**, 234.

A modification of this camera, especially for portraiture, was patented E.P. 3,232, 1897; abst. ibid. 40, in which the filters and plates were synchronously moved by clockwork. For stereo work two reversing prisms were used in front of the lenses. In E.P. 28,082, 1900 Ives patented a lantern with opal glass for illuminating chromoscopes. Cf. Brit. J. Phot. 1909, **56**, Col. Phot. Supp. **3**, 72, 88.

18. U.S.P. 635,253, 1899; Prof. Phot. 1899, **4**, 413; Phot. Times, 1901, **31**, 164. Ives v. Pfenninger see Brit. J. Phot. 1907, **54**, 666, 681.

19. E.P. 15,753, 1899; Brit. J. Phot. 1899, **46**, 8, 822; 1900, **47**, 25; abst. 1907, **54**, Col. Phot. Supp. **1**, 56; F.P. 288,870, 1899; Bull. Soc. franç. Phot. 1898, **45**, 80; 1900, **47**, 58; 1902, **51**, 115; abst. Phot. J. 1900 **40**, 180; Vie Sci. 1900, **1**, 33; Bull. d'Enc. 1899, **98**, 368; Rev. Phot. 1900, 64; Sci. Amer. 1900, **82**, 165; La Nature, 1900, **28**, I, 188; Cosmos, 1900, **42**, 713; U.S.P. 686,897, 1901; Belg.P. 144,181, 1899; 147,211, 1900; Photogram, 1900, **7**, 399; Jahrbuch, 1901, **15**, 257, 461; D.R.P. 117,372. Cf. L. Ruckert, "La Photographie des Couleurs" Paris, 169.

H. de Mare, Belg.P. 149,477, 1900 patented the interposition of a number of reflectors between the lens and plate, so as to obtain images after passage of the rays through filters.

20. F.P. 237,394, 1894; Belg.P. 195,636, 1906; Mon. Phot. 1894, **33**, 135; Brit. J. Phot. 1894, **41**, Supp. 43; 1896, **43**, 125; Phot. Korr. 1894, **31**, 532; Bull. Soc. franç. Phot. 1894, **41**, 197; 1896, **43**, 312; 1897, **44**, 121, 225, 451, 546; 1899, **46**, 103; abst. Brit. J. Phot. 1902, **49**, 340; 1907, **54**, 99; Photo-Gaz. 1907. Cf. L. Ruckert, "La Photographie des Couleurs," Paris, 1900, 121. L. Vidal on Nachet's instruments and Ives, Brit. J. Phot. 1896, **43**, 78, 94, 125; Phot. J. 1897, **37**, 35; Amer. Ann. Phot. 1895, 238; Fabre, "Traité Encycl." Supp. B. 398.

21. "Les Couleurs et la Photographie," by G. H. Niewenglowski and A. Ernault, Paris, 1895, 361; Internat. Annual, 1896, **8**, 221; Jahrbuch, 1896, **10**, 115. Cf. L. Vidal, "Traité pratique de Photochromie," Paris, 1903, 136; "Photographie des Couleurs," 38. L. P. Clerc, "La Photographie des Couleurs," Paris, 164; A. Berthier, "Manuel de Photochromie Interférentielle," Paris, 1895, 51.

22. L. Ruckert, loc. cit. 169; Bull. d'Enc. 1899, **98**, 368; Amer. Annual Phot. 1899, **156**; Brit. J. Phot. 1899, **46**, Supp. 8.

23. E.P. 3,613, 1895 no patent granted on this application; Brit. J. Phot. 1896, **43**, 94; abst. ibid. 1907, **54**, Col. Phot. Supp. **1**, 24; Photogram, 1896, **3**, 233. Ives v. Edwards see Brit. J. Phot. 1896, **43**, 109, 125, 142, 174, 190, 207.

24. Bull. Soc. franç. Phot. 1895, **42**, 564; 1896, **43**, 312; Phot. Coul. 1907, **2**, 5. Cf. D.R.P. 178,999.

25. E.P. 8,663, 1896; Photogram, 1899, **6**, 311; Brit. J. Phot. 1897, **44**, 248; abst. ibid. 1907, **54**, Col. Phot. Supp. **1**, 32. In E.P. 18,875, 1898; Brit. J. Phot. 1899, **46**, 524; abst. ibid. 1907, **54**, Col. Phot. Supp. **1**, 40, an improved, adjustable as to height, instrument was patented by White.

As to a modification of the positions of the filters in this camera see H. E. Rendall, Brit. J. Phot. 1912, **68**, Col. Phot. Supp. **15**, 43. For controversy Ives v.

Butler, Rendall, Wall see ibid. 1921, **68**, 771; 1922, **69**, 27, 58, 103, 206, 286; 1924, **71**, Col. Phot. Supp. **18**, 36.

Cf. L. Geisler, F.P. 383,364, 1908; Photo-Gaz. 1906, **17**, 4, 26; 69. "Lugdunensis," Brit. J. Phot. 1913, **60**, Col. Phot. Supp. **7**, 27, 32.

26. E.P. 29,353, 1897; Brit. J. Phot. 1898, **45**, 842; abst. ibid. 1907, **54**, Col. Phot. Supp. **1**, 40; Jahrbuch, 1899, **13**, 552. Cf. J. Soc. Arts, 1892, **40**, 379, 389, 729.

27. E.P. 9,936, 1900; Brit. J. Phot. 1900, **47**, 636; abst. ibid. 1907, **54**, Col. Phot. Supp. **1**, 64; ibid. 1910, **57**, ibid. **4**, 57; 1919, **66**, ibid. **13**, 36; U.S.P. 708,795, 1902. Cf. E. J. Wall, Brit. J. Phot. 1901, **48**, 231, 244.

Ives v. Butler, Brit. J. Phot. 1922, **69**, 58.

28. E.P. 4,290, 1905; Brit. J. Phot. 1905, **52**, 375, 633; 1906, **53**, 145; 158, 197; 1911, **58**, Col. Phot. Supp. **5**, 14; ibid. **7**, 22; abst. ibid. 1917, **64**, Col. Phot. Supp. **11**, 11; Phot. J. 1905, **45**, 199; Phot. Times, 1906, **38**, 305. Cf. W. Gamble, Phot. J. 1905, **45**, 150; Brit. J. Phot. 1905, **52**, 256.

29. Phot. J. 1908, **48**, 276; Brit. J. Phot. 1908, **55**, 633; Col. Phot. Supp. **2**, 58; abst. ibid. 1917, **64**, ibid. **11**, 11.

30. U.S.P. 632,573, 1899.

Practically the same principle was patented by A. Sauve, E.P. 10,795, 1900; abst. Brit. J. Phot. 1907, **54**, Col. Phot. Supp. **1**, 72; Belg.P. 150,334; 150,335; 150,458, 1900. J. Meyer, E.P. 7,193, 1897; Brit. J. Phot. 1898, **45**, 310; abst. 1907, **54**, Col. Phot. Supp. **1**, 40; D.R.P. 93,951, 1896; Silbermann, **2**, 331; Phot. Chron. 1898, **5**, 40; Phot. Woch. 1898, **44**, 206; Jahrbuch, 1899, **13**, 546 placed three lenses in trefoil with reflecting prisms behind each. The same idea was utilized by E. Rigaut and J. A. Pereire, F.P. 364,883, 1907; abst. Brit. J. Phot. 1907, **54**, Col. Phot. Supp. **1**, 38. Also by B. A. Brigden, U.S.P. 1,187,884, 1916. And B. D. Underhill, U.S.P. 1,340,923, 1920. Also H. Schmidt, Phot. Rund. 1907; Brit. J. Phot. 1907, **54**, 99. Also Soc. Anon. Phot. Coul. Belg.P. 121,552.

31. E.P. 3,560, 1899; Brit. J. Phot. 1900, **49**, 23; abst. 1907, **54**, Col. Phot. Supp. **1**, 48; D.R.P. 125,005, 1899; Silbermann, **2**, 332; Jahrbuch, 1901, **15**, 550; Belg.P. 145,008, 1899. In E.P. 15,444, 1899; Brit. J. Phot. 1900, **47**, 298; 1907, **54**, Col. Phot. Supp. **1**, 64; U.S.P. 653,380, 1900 the same arrangement was used; but the camera was slid along the baseboard so as to expose from the same viewpoint.

A. J. Pollock, E.P. 14,364, 1899; abst. Brit. J. Phot. 1907, **54**, Col. Phot. Supp. **1**, 63 used three lenses in trefoil and practically made three cameras by partitions.

32. U.S.P. 655,712, 1900.

33. U.S.P. 660,442, 1900; E.P. 12,181, 1900; Brit. J. Phot. 1900, **49**, Supp. 71; 1907, **54**, Col. Phot. Supp. **1**, 72.

A lantern chromoscope, or "kromskop" as Ives called these instruments, was also introduced, E.P. 5,800, 1897; 9,025, 1899; Brit. J. Phot. 1897, **44**, 665; Phot. Times, 1895, **25**, 307; Jahrbuch, 1891, **5**, 176; 1893, **7**, 298; 1894, **8**, 215; 1901, **15**, 258; Photography, 1900, 620; Phot. Korr. 1893, **30**, 572; 1894, **31**, 124; D. Phot. Ztg. 1893, 449. Considerable acrimonious controversy occurred, principally between Ives and the French writers, as the latter claimed, and justly, the priority of the chromoscope for du Hauron and Cros. It is not worth while to record all the ink spilt over this subject. Cf. Photo-Rev. 1900, **12**, 14. L. Vidal, Bull. Soc. franç. Phot. 1892, **33**, 207; 1897, **38**, 225; 1898, **40**, 103; "Traité pratique de Photochromie," Paris, 1903, 136; "Photographie des Couleurs," Paris, 38; L. P. Clerc, "La Photographie des Couleurs," Paris, 64.

A. Hofmann, D.R.P. 119,789, 1898; Silbermann, **2**, 408, constructed an instrument in which the filters could be changed, so as to check up the results before printing. R. Krayn, D.R.P. 115,377, 1898; Jahrbuch, 1901, **15**, 544; Silbermann, **2**, 378; E.P. 20,813, 1899; 12,485, 1900; Brit. J. Phot. 1900, **49**, 40 also introduced an instrument in which the strength of the light admitted to each transparency could be regulated by outside mirrors. C. S. Lumley, T. K. Barnard and F. Gowenlock, E.P. 4,164, 1899; Brit. J. Phot. 1899, **46**, 477; abst. 1907, **54**, Col. Phot. Supp. **1**, 48; Photogram, 1899, **6**, 253, also patented a stereochromoscope, which was called the "Kromaz." T. K. Barnard, E.P. 3,476, 1902; abst. ibid. 79; U.S.P. 710,237, 1910; F.P. 322,024; D.R.P. 148,291, 1902; Silbermann, **2**, 337 modified it. Cf. H. Quentin, Brit. J. Phot. 1910, **57**, Col. Phot. Supp. **4**, 20.

34. U.S.P. 668,989, 1901.

F. Lejeune, D.R.P. 335,628 patented a four-color process in which two lenses were used, each beam being split. The positives were to be observed through a similar instrument, each eye seeing two color records.

35. U.S.P. 703,929, 1902.

E. Sanger-Shepherd, E.P. 10,992, 1902; Photogram, 1902, **12,** 254; Zeits. Repro. 1902, **4,** 144; Jahrbuch, 1903, **17,** 587, also patented similar prisms. This system was anticipated by du Hauron (see p. 108).

36. E.P. 17,514, 1899; Brit. J. Phot. 1900, **50,** 56; U.S.P. 733,090, 1903; Belg.P. 175,390, 1904. Cf. E.P. 24,829, 1903; abst. Brit. J. Phot. 1907, **54,** Col. Phot. Supp. **1,** 95; D.R.P. 162,549, 1904; Phot. Chron. 1901, **8,** 58; Silbermann, **2,** 339; F.P. 340,267 in which rhomboidal prisms were used. Cf. also D.R.P. 131,150, 1899; 133,390, 1901.

37. E.P. 12,514, 1903; F.P. 322,840, 1903; Belg.P. 170,720, 1903.

In E.P. 13,666, 1899; Brit. J. Phot. 1900, **47,** 556; 1907, **54,** Col. Phot. Supp. **1,** 63, Selle proposed an instrument very similar to the above in which it was stated a printer could determine the correct printing colors for the records; D.R.P. 120,982, 1899; Jahrbuch, 1901, **15,** 545; Silbermann, **2,** 409. Cf. C. L. Legrand, Belg.P. 251,733.

38. E.P. 21,239, 1900; abst. Brit. J. Phot. 1907, **54,** Col. Phot. Supp. **1,** 72; D.R.P. 131,422, 1901; Silbermann, **2,** 335.

39. E.P. 13,468, 1902.

J. L. Colardeau and J. Richard, Belg.P. 151,306, 1900 patented a stereo-chromoscope. U. R. Evan, Brit. J. Phot. 1912, **59,** Col. Phot. Supp. **6,** 45, 51; 1913, **7,** 4, 12 suggested mirrors at slight angles to one another outside the lens. See C. E. K. Mees, ibid. 1914, **61,** Col. Phot. Supp. **8,** 14 on three-color projection.

40. E.P. 4,127, 1904; abst. Brit. J. Phot. 1907, **54,** Col. Phot. Supp. **1,** 95; U.S.P. 755,235, 1904.

41. F.P. 350,004, 1904; Phot. Coul. 1906, **1,** Supp. 5; abst. Brit. J. Phot. 1906, **53,** 190; Brit. J. Almanac, 1907, 836.

42. E.P. 14,623, 1905; Brit. J. Phot. 1906, **53,** 593; abst. 1909, **56,** Col. Phot. Supp. **3,** 6; Brit. J. Almanac, 1907, 834; Phot. J. 1908, **48,** 331; Jahrbuch, 1909, **23,** 171; Photo-Rev. 1906, **18,** 138.

43. Brit. J. Phot. 1902, **49,** 111.

44. D.R.P. 178,785, 1905; E.P. 25,399, 1906; Brit. J. Phot. 1907, **54,** Col. Phot. Supp. **1,** 31; F.P. 371,261; Phot. Coul. 1907, **2,** Supp. 8; Bull. Soc. franç. Phot. 1904, **45,** 520.

45. D.R.P. 199,447, 1907.

46. F.P. 381,487, 1906; Bull. Soc. franç. Phot. 1906, **47,** 184. Cf. Phot. News, 1906, **50,** 308; O. Pfenninger, Brit. J. Phot. 1906, **53,** 178; E. T. Butler and E. J. Wall, ibid. 105,197. H. Schmidt, Phot. Korr. 1906, **43,** 537, 579.

47. E.P. 22,310, 1906; Brit. J. Phot. 1907, **54,** 830.

Cf. H. J. Comley, ibid. 1907, **54,** 471; Phot. News, 1907, **52,** 31.

48. Belg.P. 208,148, 1908.

49. F.P. 373,524, 1907.

50. E.P. 27,793, 1908; Brit. J. Phot. 1909, **56,** 481; F.P. 408,858, 1909.

51. E.P. 2,142, 1908; Brit. J. Phot. 1908, **55,** 164.

52. F.P. 399,250, 1909. Cf. F.P. 396,040; addit. 10,512; 445,098; Bull. Soc. franç. Phot. 1909, **51,** 117,537; Photo-Gaz. 1909, **19,** 109; Brit. J. Phot. 1909, **56,** Col. Phot. Supp. **3,** 20, 32.

53. F.P. 427,812, 1910. Cf. F.P. 354,781.

54. E.P. 26,609, 1910; Brit. J. Phot. 1912, **59,** 220; U.S.P. 1,066,526, 1913.

55. F.P. 433,187, 1910. Cf. Du Hauron, Ives, Pfenninger, etc.

56. F.P. 437,753, 1911.

57. F.P. 461,532, 1912.

58. U.S.P. 970,322, 1910; F.P. 383,264; E.P. 28,764, 1907; Photo-Gaz. 1906, **16,** 4, 208; Jahrbuch, 1907, **21,** 132; Brit. J. Phot. 1907, **54,** 99; 1909, **56,** 88, 98. Cf. Photo-Gaz. 1898, **8,** 61; Bull. Soc. franç. Phot. 1907, **49,** 271; Phot. 1907, **49,** 271; Phot. News, 1907, **51,** 11.

59. E.P. 6,565, 1913; Brit. J. Phot. 1914, **61,** 633; F.P. 456,203, 1913; addit. 17,513 to 442,976; Phot. Ind. 1913, 127; Belg.P. 266,185, 1913.

For notes on the Verachromoscope see: G. Mareschal, Photo-Gaz. 1912, **22,** 136. F. Mackenstein, Bull. Soc. franç. Phot. 1912, **59,** 40; La Nature, 1912, **40,** Supp. 19.

60. U.S.P. 1,088,412, 1914.

61. U.S.P. 1,151,786, 1915; E.P. 8,447, 1915; Brit. J. Phot. 1915, **62,** 739; F.P. 479,124. Can.P. 173,722, 1916 was granted to D. Plumb for the same device. This was also patented by C. Nachet, F.P. 569,243; E.P. 205,499, 1922 for cinematography; abst. Sci. Ind. Phot. 1924, **4,** 183; Brit. J. Phot. 1925, **72,** 79; Col Phot. Supp. **19,** 8. F.P. 569,243; addit. 28,870.

62. U.S.P. 1,153,229, 1915.

63. E.P. 15,666, 1915; Brit. J. Phot. 1916, **63**, 548; U.S.P. 1,312,694.
64. D.R.P. 342,458, 1916; Phot. Ind. 1921, 1016; Sci. Tech. Ind. Phot. 1922, **2**, 40.
65. E.P. 135,169, 1918; Brit. J. Phot. 1921, **68**, 316; U.S.P. 1,375,175, 1921; F.P. 525,895, 1919; abst. Tech. Ind. Phot. 1922, **2**, 24.
66. U.S.P. 1,277,040, 1918.
67. E.P. 141,368, 1919; Brit. J. Phot. 1921, **68**, 157; F.P. 528,409, 1919; addit. 23,900; abst. Sci. Tech. Ind. Phot. 1921, **2**, 48.
68. U.S.P. 1,325,992, 1919.
69. U.S.P. 1,298,641, 1919.
70. E.P. 164,476, 1920; Brit. J. Phot. 1922, **69**, 8; 1921, **68**, Col. Phot. Supp. **15**, 48; ibid **16**, 3; Penrose's Annual, 1922; F.P. 531,400, 1921; abst. Sci. Tech. Ind. Phot. 1922, **2**, 26; Brit. J. Almanac, 1923, 403; Amer. Phot. 1923, **17**, 184; D.R.P. 359,179; 1921; Phot. Ind. 1923, 226.
71. U.S.P. 1,373,020, 1921.
Cf. Ventujol & Petit, F.P. 469,018. Schneeberger, F.P. 360,794. Ferdinando, F.P. 446,947.
72. F.P. 523,011, 1919; 525,081; 528,649, 1921; Sci. Tech. Ind. Phot. 1922, **2**, 4; E.P. 148,789, 1921; Brit. J. Phot. 1922, **69**, 525; Col. Phot. Supp. **16**, 33; Brit. J. Almanac, 1923, 403; Amer. Phot. 1923, **17**, 184; D.R.P. 380,360; U.S.P. 1,485,956; Phot. Ind. 1924, 170.
73. F.P. 530,224, 1921; abst. Sci. Tech. Ind. Phot. 1922, **2**, 44. See also F.P. 537,479, 1920; abst. ibid. 124 for method of printing the positives for the above.
74. E.P. 22,616, 1898; Brit. J. Phot. 1899, **46**, 762.
75. F.P. 453,484.
76. F.P. 544,923, 1921; Bull. Soc. franç. Phot. 1921, **63**, 167; abst. Sci. Tech. Ind. Phot. 1923, **3**, 67.
This principle was used in an ordinary camera. Cf. Brit. J. Phot. 1892, **39**, 458. Cf. M. Morach, F.P. 320,080, 1902.
77. E.P. 195,663; Brit. J. Phot. 1923, **70**, Col. Phot. Supp. **17**, 23; F.P. 539,600; D.R.P. 375,688.
A. E. Wenzel, F.P. 550,906, 1922 also proposed to obtain color selection negatives from a primary image formed on a ground glass. In addit. 27,425 the image is projected on to an opaque screen and photographed with three cameras, grouped round the projecting objective.
78. F.P. 544,857; abst. Sci. Tech. Ind. Phot. 1923, **3**, 66.
79. F.P. 302,579, 1900; La Phot. 1901, 92; Jahrbuch, 1902, **16**, 540.
80. La Phot. 1902, 13; Jahrbuch, 1902, **16**, 543.
81. Rev. d'optique, 1923; Brit. J. Phot. 1923, **70**, Col. Phot. Supp. **17**, 40. In E.P. 216,162; Brit. J. Phot. 1924, **71**, Col. Phot. Supp. **18**, 40; Brit. J. Almanac, 1925, 309 Nachet patented a reflector pierced with holes. Cf. F.P. 578,446.
82. E.P. 209,085; Brit. J. Phot. 1924, **71**, 344; Col. Phot. Supp. **18**, 24; 1925, **19**, 4; F.P. 560,438; abst. Sci. Tech. Ind. Phot. 1924, **4**, 72; D.R.P. 405,551.
H. Maslenikoff, F.P. 412,164, 1910 proposed to obtain stereo pictures in black and white or colors by means of a twin-lens camera, or Wenham prisms behind the lenses or in front of a single lens. J. B. Torelli-Sereni & V. A. Houssin, F.P. 567,523, 1923, also patented a stereo camera which might be used for either purpose, the filters being pressed out of the optical path at will.
83. E.P. 206,037, 1923; Sci. Ind. Phot. 1924, **4**, 186; U.S.P. 1,519,919.
84. E.P. 176,373; F.P. 548,138; D.R.P. 383,864, 1921; abst. Sci. Tech. Ind. Phot. 1923, **3**, 131; U.S.P. 1,537,868.
85. E.P. 199,037; F.P. 567,183; Brit. J. Phot. 1923, **70**, Col. Phot. Supp. **17**, 40; 1924, **71**, 646; abst. Sci. Tech. Ind. Phot. 1924, **4**, 152.
86. "Die Dreifarbenphotographie," Berlin, 1904, 71; translation by E. J. Wall, "Natural Color Photography," London, 1906, 82. Cf. A. Miethe, Jahrbuch, 1901, **15**, 461.
87. U.S.P. 622,480, 1899.
A. Strauss-Collin, D.R.P. 102,206, 1898; Silbermann, **2**, 376 patented precisely the same thing. E. Sanger-Shepherd, E.P. 10,993, 1902 patented a framework and spring clips for holding the reflectors, which was adjustable from the outside of the camera; though there seems to be no mention of the distortion of the shape of the reflectors.
88. E.P. 28,722, 1912; Brit. J. Phot. 1914, **64**, 106; U.S.P. 1,140,576, 1915; D.R.P. 321, 546, 1913. Cf. O. Pfenninger and the Dover Street Studios, Austr.P.

A9,370, 1913; F.P. 461,165; 437,822; Can.P. 149,857, 1913; Belg.P. 241,001, 1910 for the same thing.
Cf. Ives v. Hamburger, Brit. J. Phot. 1924, **71**, 455, Col. Phot. Supp. **18**, 36.
89. E.P. 25,907, 1906; Brit. J. Phot. 1907, **54**, 581.
Cf. "Bypaths of Colour Photography," by O. Reg.
90. E.P. 8,878, 1914; Brit. J. Phot. 1915, **62**, 291.
91. E.P. 24,538, 1912; Brit. J. Phot. 1914, **61**, 200; Col. Phot. Supp. **8**, 16; U.S.P. 1,214,016, 1917. In U.S.P. 1,299,431, 1919 Dawson proposed cruciform mirrors with plano-concave correctors. Cf. C. H. Honoré, Brit. J. Phot. 1914, **61**, Col. Phot. Supp. **8**, 16.
92. D.R.P. 136,899, 1901; Silbermann, **2**, 334.
93. Phot. J. 1924, **64**, 390.
94. F.P. 301,140; E.P. 11,213, 1900; Jahrbuch, 1902, **16**, 541.
95. E.P. 11,133, 1897; Brit. J. Phot. 1897, **44**, 569; D.R.P. 95,790, 1896; Silbermann, **2**, 353; Belg.P. 127,964, 1897; U.S.P. 604,268.
J. Lambie, E.P. 3,557, 1910 also patented a sliding back with color filters. F. Pascal, F.P. 277,372, 1898 used a sliding back with three plates and a pneumatic arrangement that shifted the plates and filters for stereo work. Cf. C. Ruckert, "La Photographie des Couleurs," 1900, 156. H. R. Eason, E.P. 178,892, 1920 patented a dark slide with springs to press the plates, which were to be accurately ground on the edges, towards one corner, so as to ensure registration in color printing. Cf. J. C. Arch, Brit. J. Phot. 1922, **69**, Col. Phot. Supp. **16**, 21.
96. E.P. 10,318, 1899; abst. Brit. J. Phot. 1907, **54**, Col. Phot. Supp. **1**, 48; U.S.P. 655,789, 1900.
97. E.P. 23,039, 1899; abst. ibid. 56.
98. D.R.P. 120,968, 1899; Silbermann, **2**, 356.
99. E.P. 26,873, 1902; U.S.P. 694,364; Belg.P. 157,207, 1901; F.P. 326,763; addit. 2,146; D.R.P. 155,171, 1902; Silbermann, **2**, 345; Rev. Phot. 1904, 210; Fabre, "Traité Encycl." Supp. D, 356. In a later patent E.P. 5,204, 1904; Brit. J. Phot. 1905, **52**, 153; U.S.P. 827,967, 1906: D.R.P. 176,315, 1905 the filter disk was divided into two segments, so that the camera could be used for black and white work as well. In E.P. 22,077, 1904; F.P. 342,333, 1904 a changing back for three plates and filters was described; Phot. Coul. 1906, **1**, Supp. 2.
100. E.P. 17,632, 1897; abst. Brit. J. Phot. 1898, **45**, 539; 1907, **54**, Col. Phot. Supp. **1**, 40.
101. D.R.P. 120,793, 1898; Silbermann, **2**, 354.
102. F.P. 283,202, 1892; Belg.P. 138,555, 1898. Cf. "La Photographie des Couleurs" by C. Ruckert, 159.
103. D.R.P. 155,614, 1902; Silbermann, **2**, 347.
104. D.R.P. 135,476, 1901; Silbermann, **2**, 333.
105. F.P. 329,581, 1903.
106. E.P. 20,827, 1904; Brit. J. Phot. 1905, **52**, 694.
Cf. W. Schwechten, D.R.P. 185,347, 1906; abst. Brit. J. Phot. 1907, **54**, Col. Phot. Supp. **1**, 94. R. Quellmalz, D.R.P. 176,313, 1906. C. P. Goerz, D.R.P. 327,666 Tauleigne & Mazo, F.P. 410,034; addit. 11,859, 1910. W. N. L. Davidson, E.P. 26,540, 1903; F.P. 319,948, 1902; Austr.P. 11,646, 1903. L. Gaumont, F.P. 373, 643; addit. 7,798; 474,061. F. E. Ives, U.S.P. 1,098,445, 1914. Société Anonyme Photographie des Couleurs, Belg.P. 213,032, 1908.
107. D.R.P. 157,781, 1904; Silbermann, **2**, 350. Cf. E. J. Wall, Brit. J. Phot. 1906, **53**, 105.
108. D.R.P. 167,183, 1904; Silbermann, **2**, 355.
109. D.R.P. 163,193, 1904; Silbermann, **2**, 351.
110. E.P. 4,874, 1905; Brit. J. Phot. 1906, **53**, 174; F.P. 351,907; Belg.P. 183,012, 1905.
Cf. Soc. Phot. Coul. F.P. 449,041; Belg.P. 181,847, 1905.
111. D.R.P. 185,345, 1905. Cf. F. Haberkorn, Phot. Korr. 1906, **43**, 430.
112. E.P. 11,986, 1906; Brit. J. Phot. 1907, **54**, 413.
113. U.S.P. 862,362, 1907.
114. F.P. 372,920; Phot. Coul. 1907, **2**, Supp. 10; Bull. Soc. franc. Phot. 1907, **48**, 121; abst. Brit. J. Phot. 1907, **54**, Col. Phot. Supp. **1**, 23.
115. E.P. 29,823, 1910; Brit. J. Phot. 1911, **58**, 826.
116. F.P. 468,333, 1914.
117. D.R.P. 312,556, 1918.
118. D.R.G.M. 779,800; Phot. Ind. 1921, 688.
119. U.S.P. 1,398,950, 1921.

120. U.S.P. 1,398,951, 1921.
121. U.S.P. 1,398,952, 1921.
122. D.R.P. 355,962, 1921; Phot. Ind. 1922, 961. Cf. D.R.P. 375,037, addit. to above; Phot. Ind. 1923, 162; E.P. 182,814; abst. Sci. Tech. Ind. Phot. 1923, 3, 100. D.R.P. 381,892; F.P. 562,835; U.S.P. 1,507,162.
123. Zeits. Repro. 1909; Brit. J. Phot. 1909, 56, Col. Phot. Supp. 3, 87.
124. U.S.P. 1,437,399, 1922.
125. U.S.P. 1,069,830, 1913.
126. E.P. 12,516, 1899.
127. D.R.P. 253,959, 1912.
128. D.R.P. 238,198, 1911.
129. D.R.P. 368,000, 1921.

F. Donisthorpe, Brit. J. Phot. 1921, 67, Col. Phot. Supp. 14, 11 designed a tri-color camera, the Auto, using film, which was actuated by a cam. The filters formed a part of the shutter mechanism and were mounted in a vertical frame, acting like a drop shutter, so that three exposures could be made in rapid succession. J. C. Deeks, Amer. Phot. 1923, 17, 402 designed a camera in which one plate was used, and rapidly passed behind the lens and shutters, with the filters in front, this also enabling three exposures to be made in rapid succession.

CHAPTER IV

BI-PACKS AND TRI-PACKS

These subjects are so intimately connected that they merge into one another, and a better grasp of the whole is obtained by treating them together.

Dialyte Systems.—Again, as in so many other branches of color photography, we have to commence with the work or writings of Ducos du Hauron. He published an article[1] (p. 165): "La Photographie aux trois Couleurs reduite à deux" in which he suggested that it would be possible to eliminate yellow as one of the printing colors, and said: "During my last researches I have discovered a marvelous law by virtue of which an image, composed of only two monochromes, is capable of producing on the visual organs, under certain conditions, a colored sensation as complete as the trichromatic images, which I have already obtained. The novelty consists in eliminating the yellow monochrome, but taking and superimposing the red and blue monochromes as usual. I do not say that I should use madder lake and Prussian blue, or that under the circumstances they are the best pigments to use; but they give the desired effect, and that should suffice. The phenomenon, that I have suggested, requires one condition and that is that the double image should be examined, not by white light and plenty of it like bright daylight, but rather by weak daylight and just enough to see the subject, or better still by the yellow light of candles or lamps. Viewing the result by daylight is possible, with very great reduction of the light, if the image is produced on a yellow or grey support. It is well known that the sensation of yellow can not be determined when the general coloration is yellow, either through the nature of the illumination or the nature of the support of the print; practically the white parts are reproduced as white, while yellows are reproduced by the yellow. Observers actually believe that they see the three colors where they ought to be, although they know that they are actually absent.

"Apparently this is a physiological equation, the two known terms being red and blue, and the third term, which one may call X, is evolved; that is to say, virtually and actually the appearance of yellow is non-existent. It should be noted that the yellow element, by reason of its brightness, which closely approximates white when it is weakened, produces a gap which is less noticeable than if the red or blue were absent; and it is possible to conceive that a process, which shall fictitiously reconstitute it, may accomplish it in the brain with the same facility as is done with the other two colors."

Du Hauron goes on to describe his anaglyphic process, with which we are not particularly concerned, as it is not a color process, though colors

are used. But we are interested in a further note by him[2] in which he lays down the principle of the bi-pack and tri-pack.

After an exposition of the optical methods, which can be used for obtaining the constituent negatives simultaneously with one lens and a system of mirrors, or with three lenses juxtaposed, he said: "But this triple apparatus with one lens is but a transitional form. Let us go another step, and, without condemning that which has preceded, we arrive at another form, which, this time will be seen to be the extreme limit of simplification. 2. Apparatus with a single dark slide and with a single objective procuring the simultaneous obtainment of the three phototypes; in other words, dialytic selection of the light rays by an alternation of color filters and plates or sensitive films, formed like the leaves of a book or polyfolium, placed in the dark slide. This title contains the abbreviated description of the object designed, and by itself enables one to grasp the importance; this last method appears to me, in fact, to be destined before long to be substituted in practice for the other optical combinations, which we have presented. . . . The general idea having been set forth, let us now enter into the details of the phenomenon, realized by the means which will be presented.

"The beam of the rays transmitted by the lens strikes the back of the sensitive plate, passes through it and arrives at the front, which is covered with an isochromatic film; this film ought to combine two properties, of which one most happily does not exist without the other: (1) a very low sensitiveness compared to ordinary plates; (2) transparency; of such nature are the gelatino-bromide films with very fine grain. (On the manufacture of emulsions of this nature, see the work by M. Berthier, "Manuel de Photochromie Interférentielle," 1898, 30.) [This refers to the manufacture of Lippmann emulsions. E. J. W.]. The blue and violet rays alone act, forming on this film the impression which gives on development the yellow print. The light, continuing its course, meets with a yellow transparent film, placed in contact with the plate already described; this film being extremely thin and colored to saturation, the light penetrates it and is completely deprived of the blue and violet rays, but only of this group of rays. It then traverses the imperceptible thickness of one of the gelatino-bromide films (of celluloid, collodion, etc.) which are found in commerce, and although they are endowed with a sensitiveness for the green very much greater than for the red-orange, and at least equal in sensitiveness to that which the third sensitive surface manifests for the red-orange, which now comes into question. Consequently the second sensitive film, of which we are speaking, will be impressed on its face opposite the objective, by the green light transmitted by the yellow film, and it will give on development, the negative for the red print.

"The light pursuing its path meets the very thin red film, of a moderately intense red, transparent, placed in contact with the preceding

surface; in passing through this red screen, it undergoes a final subtraction of the rays, and is completely deprived of its green element, in such a way that red-orange light alone strikes the third and last sensitive film. This last sensitive film, which we will now describe, is not coated like the second surface on a film, but on a sheet of glass, with this difference, however, that this last film is turned towards the objective. It should be chromatized for the red-orange region. Consequently it will be acted upon by the red-orange rays, and it will give, on development, the negative for the blue print. It will be seen that all the arrangement of the material is confined to the superposition of five elements, the one supple and the others rigid; the two exterior elements, analogous to the two covers of a book, are rigid and compress the three interior elements, which one may compare to the leaves. There is no longer then triple apparatus for the production of a triad of negatives (chromograms), but only the usual camera, and there is only one single difference, that is to say, in the dark slide the sensitive plate is replaced by this new kind of book."

Du Hauron discusses the necessity of obtaining correct exposure, or of correcting the same by development, and points out that excess of sensitiveness of one or other of the plates may be corrected by using a filter on the lens.

The above is a perfectly clear description of a tri-pack system, and obviously anticipates any patent that may have been issued since. Du Hauron then proceeds: "Up to the present, in the manufacture of photographic emulsions, the industry has only been concerned to coat films (pellicules inextensible) with extra rapid emulsions. The day when commerce will provide the three kinds of emulsions coated on films, the dialytic obtainment of our three negatives will be simplified, and if not required for enlarging, not one of the images will require to be reversed, for the three transparent films may each be turned with its back or its front to the lens, and it will be optional to print all in one way or the other. One would then have a book (polyfolium chromodialytique) formed by the alternation of sensitive surfaces and colored films, the whole compressed between two colorless glasses. A very convenient arrangement will consist of three sensitive films (autotendues systeme Planchon), compressed with the filter films, yellow and red, between two glasses slightly smaller than the metallic frames of the three films."

Variation in the size of the images is then discussed, due to their varying distance from the lens, the variation in sharpness of definition and the superior results obtainable if the two first emulsions are absolutely or almost absolutely transparent, and the necessity of sufficient pressure to obtain close contact. Finally he points out the necessity of avoiding halation in the rear plate and the means to avoid this, and winds up the chapter with the footnote: "The industrial making and manufacture of the constituent elements of the polyfolium chromodialytique has been placed

by the inventor under the protection of a French patent, No. 250,862, taken out Sept. 17, 1895."

The following passage is also of interest, because it contains the basic idea of the bi-pack system, although from the point of view of stereoscopy it is unsound: "Particular cases may be seen in which, in place of making the three negatives under the conditions already defined, the purpose to be attained will command the employment of this dialysis only for two negatives, and to create separately, although simultaneously, the third negative. This happens when it is desired to use stereoscopic apparatus with two objectives, the one for taking dialytically two of the negatives, for example that which gives the yellow print and that which gives the red print, and the other to take by itself the third negative, which will be for the blue print."

A. Gurtner[3] patented a somewhat similar idea; but neglected the red, so that his two prints were practically blue and orange. He proposed two plates with their films in contact, the plate nearer the lens being a slow chloride or chloro-bromide as transparent as possible, and sensitive only to blue and violet, and the film was stained a deep orange, the rear plate being sensitive to orange and red. The two plates being placed in contact, "and this double plate can be united into one plate by cementing or pasting the edges with paper strips, or by suitable means," were simultaneously exposed. From the negatives thus obtained, positives could be made on glass or paper, and that from the rear plate was toned blue with one of the usual cyanotype toning mixtures; ferric chloride, ammonium oxalate and potassium ferricyanide being specially mentioned. The positive from the front plate was preferably prepared on stripping collodio-chloride paper, and merely fixed without toning, so that a yellowish tone was obtained, and the two positives were superimposed.

The Chemische Fabrik auf Aktien, vorm. E. Schering,[4] patented the use of positive emulsions on stripping celluloid films for Gurtner's process. J. K. Heuberger[5] proposed to make paper for the same by first coating silver chloride printing-out paper with a rubber film, then with 10 per cent solution of gelatin. After printing, the proof was washed in water for half an hour, and for preference stretched in a frame so as to protect the front, and treated from the back with 25 per cent ammonia; after washing, the gelatin coating was sensitized with ammonio-ferric citrate and potassium ferricyanide, and after drying, printed and washed, and if necessary treated with 1 per cent solution of hydrochloric acid. The treatment of the silver emulsion with ammonia gave the yellow print, and the application from the back prevented any action on the gelatin coat.

A. R. Lawshe[6] patented a process in which a record of the reds was obtained on one negative, and that for the blues and greens on the other. From the red record was printed a blue carbon, which might be dyed up prior to insolation with a mixture of dyes to reduce contrast. A red carbon

was made of the green record and superimposed on the blue print, the latter color being converted into green by dyeing. Local reduction or alteration of the colors was suggested, as also the use of reliefs, subsequently stained up, and the preparation of transparencies on celluloid printed through the back and cementing up. The process was also applicable to cinematography.

W. Finnigan and R. A. Rodgers[7] also patented a two-color process, in which the front member was an ordinary unstained film or plate with a rear panchromatic member, or one specially sensitized. The use of any filter or staining of the front member was specifically disclaimed, it being supposed by the inventors that this would presumably act as a filter for the red-sensitive emulsion. Positives were to be stained or toned pink-red and blue-green respectively, and hermetically sealed together in any way that may be desired, or the blue-green print might be resensitized and printed under the ordinary negative and toned pink-red.

It will be noted that du Hauron omitted the yellow impression, whilst Gurtner omitted the red; but later processes omit the blue-violet, thus following the lead set by G. A. Smith in Kinemacolor, to which reference is made in the section devoted to cinematography. It may be as well to point out the one fact that would seem to be of considerable importance from the theoretical standpoint at least, before we proceed any further.

In the practical execution of the bi-pack and tri-pack systems these points are to a great extent insurmountable, except in the case of "stills," that is to say, of subjects that do not require extremely short exposures in consequence of movement. Theoretically, of course, the image is at one, and only one plane or distance from the lens, and it is, therefore, impossible to obtain critical definition on three sensitive surfaces, separated, as at least one must be, by an appreciable distance from the other. But we know that this image plane is a mathematical one only, and that most lenses, even working at large apertures, possess sufficient depth of focus, and it is possible to obtain sharp definition over a certain interval, small though it is, along the optical axis, therefore, this point may be neglected.

Far more disturbing from a practical point of view, and at present seemingly insurmountable, is the diffusion produced by the grains or complexes of the silver salts themselves. Were it possible to obtain perfectly transparent emulsions answering to the requirements as regards speed for the middle and front elements, then there might be hope of improvement; but such a state of things does not exist. We have no means of making rapid transparent emulsions, for hand in hand with increase of speed goes increase in size of grain. Each individual particle of silver salt not only absorbs some light, but scatters the same diffusely, therefore, a geometrically perfect ray becomes more or less diffused and a confused pencil. For prints, whether large or small, this slight diffusion may be

of little moment; but for projection, particularly on such scale as is met with in cinematography, it is fatal.

It should not be overlooked too that the front element gives the yellow positive, the middle one the red and the rear one the blue impression. It is well known, though but little regarded, that the blue positive gives what the artist calls the "drawing" of the picture. The yellow and red constituents, the former more particularly, may be somewhat diffused without its being very noticeable; but want of critical sharpness in the blue is instantly detected, and this is the sensitive surface which is in the very best position to give the worst definition.

A. F. Cheron[8] would expose two sensitive surfaces preferably on film, in contact, using one lens fitted with a diaphragm, the greater and outer part of which was orange-colored, whilst the inner part was colorless. The sensitive surface nearest the lens was to be sensitive to violet, blue and green; the posterior surface sensitive to yellow, orange and red. In a later patent[9] the front film was to be transparent and sensitive to violet, blue and green and separated from the rear member, which was to be panchromatized. After development, prints were to be made in complementary colors and cemented together in superposition for a single picture; but for cinematography, it would be sufficient to pass them through the projector in contact.

J. F. Shepherd & Colour Photography, Ltd.,[10] proposed to place two plates film to film, that nearer the lens being mainly blue and green-sensitive, the rear one being red-sensitive. The front plate might be dyed yellow or a yellow filter used on the lens. A print was to be made in complementary colors from each negative, and the two negatives were to be superposed and a third positive produced by copying them, and this stained yellow; the three prints were then to be superimposed.

W. Friese-Greene and L. O'Malley[11] patented an improvement in the production of color photographs, whether for transparencies or for mounting on opaque supports. Simultaneous exposures were made on separate or on the same support, as both sides of a film. One of the sensitive surfaces was the ordinary non-color-sensitive emulsion, the other being specially sensitized as described in E.P. 134,238, 1918. In exposing, the surfaces were so arranged that the ordinary emulsion was nearer the lens. This was only affected by the blue and violet rays, while the red, together with some green and blue passed through and acted on the rear films; no filter was used. Colored images could be prepared from the exposed surfaces by toning or staining either the negative images themselves or positives produced from them. The image from the front film was stained or toned red, and that from the rear film blue; the actual colors mentioned being orange-pink and blue-green, but the two chosen colors were those which would give the best color rendering of the subject. This might be applied to cinematography.

L. D. Mannes and L. Godowsky[12] patented the direct superposition of two emulsions, the front one being slow and sensitized for green and bluish-green, with a yellow dye incorporated. The lower emulsion was to be much faster and sensitive for red. This could be used for negative and positive work. The developed image was to be bleached with ferricyanide, washed, dried and then the upper image only developed, preferably with amidol and after washing the film was to be treated with ferrous chloride, which would form the usual cyanotype blue on the lower stratum, but not affect the metallic silver. The upper metallic silver image was then to be toned with copper, uranium or vanadium ferricyanides, thus forming a mordant for basic dyes.

Semi-Dialyte Systems.—Probably the first inventor to utilize this system in which two plates are placed face to face, the third being elsewhere, was J. W. Bennetto,[13] who described a camera with a red glass

Fig. 56. Bennetto's E.P. 28,920, 1897.

reflector at an angle of 45 degrees, behind the lens, which acted as a filter for that plate directly on the optical axis, also as a reflector for the two plates contained in a dark slide at the top of the camera, and parallel to the optic axis. The lower of these two plates was specially sensitive to blue, and the upper to green, a thin greenish-yellow filter being interposed between them. For making positives from the negatives obtained in his camera, Bennetto[14] patented red, yellow and blue pigments, and the usual carbon process was followed, but the prints were transferred to a transparent support, and the two side ones folded over the middle one, thus the lateral inversion of the one print was overcome. Fig. 56 shows Bennetto's camera.

W. N. L. Davidson[15] also patented a semi-dialyte camera, Fig. 57, in which a carrier was used that could be inserted in any dark slide. B^1 represents two plates, the front one being a slow chloride, placed face to face with a yellow and green-sensitive surface, either in contact, or

with a thin yellow or green filter between. *D* is the red glass, which reflected the image as shown by the dotted lines, from the lens to B^1. And *B* was the red-sensitive plate which received the direct image. The position of the plates might be reversed, that is to say, B^1 might be red-sensitive and the blue-sensitive one placed at *B,* in which case *D* should be uncolored glass.

FIG. 57. Davidson's E.P. 10,043, 1901.

F. E. Ives[16] also adopted the semi-dialyte system, and formed a plate-pack, in which the front member was hinged to the other two, so that it could be swung down at right angles, and this might be red-sensitive, and the 45 degrees reflector, *5* in Fig. 58, might be red so as to act as a filter, thus following Davidson's idea. In fact, the principle of the two systems is the same, Ives only making his plate hinged and providing for the dropping down of the one plate by sliding forward the reflector and the supplementary lens *20.* The purpose of this lens, called a "compensating

lens," was to "approximately parallelize the diverging cone of rays from the objective lens 2, and thereby correct or minimize the distortion incident to refraction through an inclined reflector, and also to equalize the color absorption and percentage of reflection from top to bottom of reflector." In this arrangement it is clear that the red-sensitive plate, or that which drops down, must be slightly smaller. A special camera was patented by Ives to carry this system into effect.[17]

Tri-Packs.—J. H. Smith considering the difficulties of obtaining absolute contact between two plates pressed together, unless plate glass be

FIG. 58. Ives' U.S.P. 980,961, 1911.

used as a support, patented[18] the idea of coating two or more layers of emulsion immediately on top of each other, with an insulating film of collodion between. These collodion films could be dyed up as filters if desired. These plates were actually introduced commercially, and after exposure the plate was laid, emulsion up, on a cutting board, which had ledges on two sides, overlapping the edges of the plate about one-eighth of an inch. A cut was made along each of these edges with the point of a knife, the plate was turned round and the other two sides cut in the same manner. It was then placed in a special holder, and the edge of the top film at one end lifted a little way, and a sheet of metal carrying a plate of glass the same size as the film was slid over it. The under side of the glass had been coated with a tacky substance, which caused the film

to adhere. As the glass was slid along, the upper film stripped from the lower and adhered to the new support. The second film was stripped in like manner and the collodion adhering to the two lower films was removed with alcohol-ether and development proceeded with as usual. In the above patent the rear member was red-sensitive; but in a later patent[19] Smith inverted the order and made the middle film red-sensitive, claiming for this particular arrangement that it did away with the necessity of an intervening filter.

F. Stolze[20] claimed that it had not been hitherto observed that the front member of a pack can serve as a filter to the underlying ones, and patented the use of, at least for the two upper films, slow emulsions, which were transparent to red, orange, yellow, yellow-green and blue-green; the middle film being sensitized by a red dye for green, thus forming the only filter necessary. This was a mere variant or particular method of carrying out du Hauron's and Gurtner's process, and it would seem immaterial whether the top film were a pure bromide, or chloro-bromide, as long as it possessed the necessary qualifications of transparency and sensitiveness.

F. Thieme[21] observed that the sensitiveness of the three members of a pack must have their respective sensitivities so arranged that the front one had the least, and that it should act as a filter, and, therefore, he recommended staining it with acridin orange N, which confers increased blue and red sensitiveness. His idea being that red as well as blue should here be recorded. The second member, for which he recommended commercial roll film, should be sensitized with yellowish eosin, but not so deeply as for it to act as a filter for the rear red-sensitive plate; as if this were done, the green would be somewhat suppressed, so that an interposed red filter was advisable.

O. Pfenninger[22] would improve existing ideas of all film packs by doing away with separate filters, and he referred to two plates placed film to film only, obviously for the semi-dialyte system, or Gurtner's. He stained the front plate more or less yellow, claiming to thus obtain a yellow and red record with the yellow-sensitive plate at the back, whilst Gurtner produced yellow and blue records only. The only claim that Pfenninger makes is for "The use of non-color-sensitizing dye or coloring matter for the purpose of making the photographic plate itself a color filter without affecting its color-sensitiveness and also makes the plate anti-halatious."

F. E. Ives[23] claimed a film pack of which the main feature was a "dry superficial and soluble monochrome film acting as a color screen" and except in this it in no wise differs from others that preceded it. He proposed to use as a front member a plate of slow speed, with an exceptionally fine grain and transparency, sensitive chiefly to blue-violet and ultra-violet, such as Lippmann plates, which were suggested by du

Hauron (see p. 153). The color filter was obtained by flowing over an alcoholic solution of a water-soluble dye, which left a superficial film of color, not diffused into the surface and of such tenuity as to add nothing to the material thickness of the plate. The second element was to be a celluloid film, and the third member a red-sensitive glass plate, its surface being coated with an alcoholic solution of a water-soluble dye, red or orange, which formed the filter for this member.

Whether this superficial-filter claim is sound is an open question, for G. Selle[24] said: "The plate to be exposed behind the red needs to be sensitized with a combination of a red and blue coloring substance, although either by itself is sensitive to the red rays. If a red sensitizer only were used most of the red rays would be reflected without being absorbed, thus the formation of a proper image would be prevented; on the other hand, the blue sensitizer alone would be far more sensitive to the purely red rays than the orange, so that incorrect contrasts and values would result; moreover, it presents no obstacle to the property possessed by the red rays of penetrating abundantly a silver plate. By combining the two sensitizers, and, moreover, in such manner that their defects are rendered inactive, which best results if the blue sensitizer be superimposed on the red, a balance is created, which not only ensures the absorption of the total rays within the group but establishes the necessary ratio between the rate of absorption and formation of the image. To achieve my object I use a sensitizing bath, for instance, a solution of 0.002 per cent of cyanin blue and erythrosin in a fluid composed of 60 per cent water and 40 per cent alcohol. By this means the red dye, which is more soluble in the water, is carried into the film while the blue dye, which is more soluble in alcohol, remains substantially on the surface of the plate. But other sensitizers having the same properties or results may be used." Attention should also be drawn to Husson & Bornot's patent for making superficial filters (see p. 86).

Ives claimed the binding together of the edges, although it will have been seen from previous patents that this was also well known. Later[25] he discovered that the best results were only to be obtained by using one batch of plates for all members of the pack, and pinned his faith to a mother emulsion, sensitized in the mass, not by bathing, with one of the fluorescein dyes, eosin for example, and bathing these plates for the red-sensitive member, as he had "made the discovery that the isocyanin red-sensitizing dyes are extremely prepotent over the fluorescein green-sensitizing dyes, so much so in fact that plates made green-sensitive, for example, by the addition of eosin to the emulsion, may afterward be bathed for from under a minute to several minutes in a weak solution of pinachrom or pinacyanol, or a mixture of the two, and are thereby rendered red-sensitive." One of the main contentions of the inventor was that he secured thus the same or substantially identical gradation-giving

and density-giving properties in the plates. Ives ignored entirely the fundamental fact that gradation is dependent on the wave-length of the acting light, as was first pointed out by Chapman Jones,[26] and this had been uniformly recognized by most other workers, and as a matter of fact it would be impossible by the invention to secure the very feature that is claimed. The vaunted "prepotency" is a mere play on words. Eosin does not sensitize for red at all. The isocyanins do and the use of the two was suggested by E. König in 1908 (see p. 281). The use of three plates would make a clumsy pack, and also increase the difficulty of obtaining sharp definition on all three; as a matter of fact, the rear surface would be separated from that of the first plate by approximately 1.5 mm.

This difficulty of separation Ives[27] proposed to overcome by adopting the screen-plate system for one member, the front one. The mosaic should have the secondary colors, yellow and magenta and on this was coated an emulsion sensitive to blue and green, but not to red; the rear member was to be red-sensitive and insensitive to blue and green or from which the three colors were screened off by a thin red filter or superficial red dye or body staining. "By this arrangement the red rays of light, or the red component of the image passes through all parts of the mosaic, and passes without effect through the blue and green-sensitive layer and through the red screen, so as to reach and actinically effect the red-sensitive layer. The green rays will pass through the yellow portions of the mosaic but are excluded by the magenta portions, so that the green light makes an exposure in a mosaic pattern on the sensitive layer to the rear of the mosaic, and is subsequently cut off from reaching the red-sensitive layer to the rear of that. Similarly the blue component of the light passes through the magenta area of the mosaic but is excluded from the yellow areas, thus giving a mosaic exposure on the front sensitive layer, and being cut off by the red screen from the rear sensitive layer."

Another patent[28] by the same inventor deals with "front halation," which may occur when three separate plates are used. This may be neglected as regards the front member as the film is in optical contact with the glass, though the incorporation of a yellow dye may be adopted, and this serves as a filter and takes the place of the superficial one of his previous patents. It was proposed to stain the emulsions, the red-sensitive one being stained with about 0.01 per cent patent blue in water and alcohol, and the middle emulsion with about 0.1 per cent solution of carmoisin M.

J. E. Thornton[29] patented a film pack, composed only of celluloid films. Various and manifold are the methods of manufacture that might be adopted, but the main principles may be gathered from Fig. 59. All the films might be superposed with the filters, or any screen-plate process

adopted. Exactly how these were to be subsequently printed is not clear, but so far as the author is aware they never got beyond the drafting room and the specifications.

H. Hess[30] would apply the film pack system to roll film cartridges by superposing cut films, as Ives did for plates, and stitching them to an opaque band. To keep the films flat and in close contact during exposure, the pack was to be pressed by a resilient member against a sheet of glass. Although this resilient pressure is claimed, it must be pointed out that it is of rather ancient lineage.[31]

Fig. 59. Thornton's E.P. 11,033, 1906 (Page 163).

H. Wolf-Heide[32] proposed to arrange on one support a number of films, each sensitized for a certain color and in suitable order. Color selection was thereby rendered possible, it is said, without the use of filters. In addition to the sensitizers, such as dicyanin and erythrosin, a dye for absorbing the blue rays might be added to the emulsion; the different sensitiveness of the emulsion being thus evened out. It is stated that the exposure required was considerably shorter than with filters and no diffuseness of the images took place. The sequence red, green, blue was the best for cinematography; but for general work other arrangements were better.

E. A. Lage[33] patented the superposition of three films, each sensitized for different spectrum colors, and brought into optical contact by expressing the intervening air by the pressure of rollers. This is exactly on the same lines as the Smith plate, see above.

S. Schapovaloff[34] proposed to coat one layer of emulsion on celluloid-coated glass, then another layer of celluloid and a second emulsion, finally a third celluloid layer and emulsion. The emulsions might be color-sensitized and thin filter coatings interposed. The celluloid layers would easily strip from the under gelatin layers. This also is like Smith's process. The same inventor[35] patented a method of printing from the three negatives, preferably on films and of which at least two were joined together at one edge on to a transparent support coated on both sides. The registered negatives being connected by their edges, bookwise, the bifoliate film was twice the length and breadth of the picture and was coated on one side with ordinary emulsion and carried on the other a non-actinic screen, the film being folded centrally so as to provide in superposition an emulsion layer, support, screen, emulsion, screen, support and emulsion. The negative films were assembled with the bifoliate film by laying on each side and enclosing the third in the fold. The first image was printed on the film carrying only one emulsion. Then this was lifted aside with its negative and covered with black paper. The other two images were then printed in succession, or simultaneously from opposite sides. In this way three positive images already registered were produced on the bifoliate film. In a modification the bifoliate film comprised two emulsions on opposite sides of celluloid to which was connected a white paper carrying the third emulsion, or this might be on a separate support.

C. S. Forbes[36] proposed to use a bi-pack roll film, the opaque backing bearing a sensitive coating in contact with an emulsion on celluloid. The front film was to be sensitive to green and the rear to red and ultra-violet. L. von Tolnay and L. von Kovodsznay[37] patented a tri-pack with interposed filters, the members being pressed into contact under a vacuum. F. Rolan[38] patented a bi-pack with yellow-sensitive front film and blue-sensitive rear film. The two negatives thus obtained were combined to give the third color image.

1. "La Triplice Photographique," Paris, 1897, 214.
Cf. F.P. 216,465; Belg.P. 110,803; U.S.P. 544,666.
2. Ibid. 223; Jahrbuch, 1897, 11, 342; Amat. Phot. 1896, 15; 1903, 86; Monde Phot. 1895; Phot. Archiv. 1896; Rev. Suisse Phot. 1895, 342; Wien. Mitt. Blatt. 1896, 163; Jahrbuch, 1896, 10, 422; "Handbook to Photography in Colours" London, 1900, 10.
3. D.R.P. 146,149; 146,150, 1902; 146,151, 1903; Silbermann, 2, 357, 407; F.P. 330,962; addit. 1,689; 1,702; Belg.P. 169,534; Can.P. 88,484; E.P. 7,924, 1903; U.S.P. 730,454; Phot. Ind. 1903, 497; Phot. Mitt. 1903, 39, 220; Phot. Woch. 1903, 29, 289; Amat. Phot. 1903, 86; Chem. Ztg. 1905, 29, 131; Jahrbuch, 1904, 18, 207; Phot. Chron. 1904, 11, 109; J. S. C. I. 1903, 22, 820; Der Phot. 1924, 34, 13. In his second German patent Gurtner specifically claims the binding together the edges of the plates. Special two-film plates for this process were introduced by

J. H. Smith & Co., of Zurich, F.P. 346,244. Cf. H. E. Rendall, Brit. J. Phot. 1925, 73, Col. Phot. Supp. 19, 1.

4. E.P. 22,725, 1905; Brit. J. Phot. 1906, 53, 825; D.R.P. 169,313; abst. Jahrbuch, 1906, 20, 450; 1907, 21, 412; Phot. Ind. 1905, 408; F.P. 365,314; J. S. C. I. 1906, 25, 953, 1067; Belg.P. 191,507; Phot. Chron. 1906, 13, 429.

5. D.R.P. 174,144, 1905; Phot. Chron. 1907, 14, 20; Jahrbuch, 1907, 21, 418, 587; 1909, 23, 469; Brit. J. Phot. 1906, 53, 705.

6. E.P. 131,319, 1916; Brit. J. Phot. 1920, 67, Col. Phot. Supp. 13, 11; U.S.P. 1,248,139, 1917.

7. E.P. 140,349, 1919; Brit. J. Phot. 1920, 67, 256.

8. F.P. 444,599.

9. F.P.445,098, 1911.

10. E.P. 169,533, 1920; Brit. J. Phot. 1922, 69, 8; Col. Phot. Supp. 16, 3.

11. E.P. 150,819; J. S. C. I. 1920, 39, 734A; Phot. Abst. 1921, 1, 7; Jahrbuch, 1915, 29, 158. Cf. U.S.P. 1,393,460, granted to Friese-Greene; F.P. 504,232; E.P. 134,238.

12. U.S.P. 1,516,824, 1924; Amer. Phot. 1925, 19, 300; Abst. C. A. 1925, 19, 218; J. S. C. I. 1925, 44, B115; F.P. 587,395; U.S.P. 1,538,996.

13. E.P. 28,920, 1897; Brit. J. Phot. 1896, 43, 505,717; 1897, 44, 180; 1898, 45, 737, 776, 782, 814; 1899, 46, 1, 260, 322; Amat. Phot. 1899, 343; "Handbook to Photography in Colour," London, 11; Apollo, 1898, 361; Jahrbuch, 1899, 13, 547; 1900, 14, 563; Phot. Rund. 1899, 9, 219; Photogram, 1896, 3, 273; 1899, 6, 273.

Ives v. Bennetto and Pfenninger, Brit. J. Phot. 1896, 43, 733, 767; 1910, 57, Col. Phot. Supp. 4, 64, 80, 87; 1914, ibid. 8, 27.

14. E.P. 28,920A, 1897.

Cf. R. Moreels, Brit. J. Phot. 1910, 57, 514; 1911, 58, Col. Phot. Supp. 5, 25.

15. E.P. 10,043, 1901; abst. Brit. J. Phot. 1907, 52, Col. Phot. Supp. 1, 72; U.S.P. 701,306, 1902; D.R.P. 145,276; Silbermann, 2, 336; Belg.P. 170,841. In E.P. 15,204, 1904; Brit. J. Phot. 1905, 52, 454; Jahrbuch, 1904, 18, 175, a separate back was patented, see lower diagram in Fig. 57. No patent granted on this application; F.P. 332,868; 354,979; Can.P. 78,571; 95,205.

A. von Arx, F.P. 534,310, 1921; Sci. Tech. Ind. Phot. 1922, 2, 77; patented a semi-dialyte system on very similar lines. A. Gleichmar, D.R.G.M. 751,947; D.R.P. 326,369; F.P. 509,333; Swiss P. 87,394; Phot. Ind. 1921, 19; Hung. appl. G. J. 040, 1918; Chem. Ztg. 1919, 43, 429; used a semi-dialyte system. E. Gilles, Bull. Soc. franç. Phot. 1905, 46, 487.

16. U.S.P. 980,961, 1911; J. S. C. I. 1910, 29, 542; Phot. J. 1910, 50, 261; E.P. 14,243, 1909; Brit. J. Phot. 1910, 57, Col. Phot. Supp. 4, 49; 1911, 58, ibid. 5, 19, 40, 41, 44; 1917, 64, ibid. 11, 12; E.P. 23,058, 1910; Brit. J. Phot. 1911, 58, 440; Can.P. 130,801; F.P. 421,372; D.R.P. 244,942; Amer. Phot. 1910, 4, 413; Camera Craft, 1911, 18, 219; Photo-Era, 1912, 28, 57.

Ives v. Wall, Brit. J. Phot. 1924, 71, 439,455, 603,703, Col. Phot. Supp. 18, 35.

17. U.S.P. 1,287,327, 1918.

18. D.R.P. 165,544, 1903; Silbermann, 2, 358; E.P. 19,940, 1904; Belg.P. 179,515; U.S.P. 781,469; Brit. J. Phot. 1905, 52, 355; 1907, 54, Col. Phot. Supp. 1, 96; Phot. J. 1906, 46, 199.

Smith had previously patented the use of two plates with a film sandwiched between, Swiss P. 29,446, 1903; F.P. 346,244.

19. D.R.P. 185,888, 1903; Swiss P. 33,594, 1905; Phot. News, 1906, 50, 351; U.S.P. 886,883.

20. D.R.P. 179,743, 1905.

21. D.R.P. 163,282, 1903; Phot. Chron. 1906, 13, 429; Jahrbuch, 1907, 21, 411.

22. E.P. 25,906, 1906; abst. Brit. J. Phot. 1907, 54, 581.

23. U.S.P. 927,244, 1909; E.P. 7,932, 1908; Brit. J. Phot. 1910, 57, 29; D.R.P. 244,948; Col. Phot. Supp. 4, 49; 1911, 58, ibid. 5, 19; 1915, 62, ibid. 9, 34; 1917, 64, ibid. 14, 12; Annual Repts. 1916, 1, 304; Camera Craft, 1911, 18, 221; 1916, 23, 3; Phot. Mitt. 1911, 48, 228. Cf. P. L. Anderson, Amer. Annual Phot. 1918, 32, 56. K. Struss, Amer. Phot. 1917, 11, 437; Brit. J. Phot. 1917, 64, Col. Phot. Supp. 11, 33, 37.

24. E.P. 12,516, 1899.

25. U.S.P. 1,173,429, 1916; abst. J. S. C. I. 1916, 35, 490; Annual Repts. 1916, 1, 307; Chem. Ztg. 1916, 40, 332; Camera Craft, 1916, 23, 3; C. A. 1916, 10, 1015.

Cf. U.S.P. 1,261,542, 1918, for a very similar subject, in which the front member is stained yellow, thus following the ideas of Gurtner, Thieme, etc.

26. Phot. J. 1900, 40, 279.

Cf. A. Watkins, Phot. J. 1900, **40,** 286; W. Abney, Proc. Roy. Soc. 1901, 300; W. Hertzsprung, Zeits. wiss. Phot. 1905, **2,** 419; Sheppard & Mees, "Investigations on the Theory of the Photographic Process," 1907, 297,311; A. A. K. Tallent, "Handbook of Photography in Colours," 1900, 255, said "where the aim is to do exact work it is imperative that one kind of plate be used on which to make the three exposures, and again, not only the same kind of plate, but from the same batch, and they must be developed under identical conditions as regards strength and constitution of developer and length of development." This axiom was also laid down by Abney at the Camera Club Conference, Brit. J. Phot. 1897, **44,** 298, and it had become accepted as an axiom by 1900. Cf. R. Lohmeyer, Brit. J. Phot. 1908, **55,** Col. Phot. Supp. **2,** 40.

27. U.S.P. 1,268,847, 1918; abst. J. S. C. I. 1918, **37,** 707A; E.P. 112,769, 1917; F.P. 487,529, granted to Hess-Ives Corp.; abst. Brit. J. Phot. 1919, **66,** Col. Phot. Supp. **13,** 5; Jahrbuch, 1915, **29,** 161.

Cf. Brit. J. Phot. 1915, **62,** Col. Phot. Supp. **9,** 30; ibid. **10,** 40; Amer. Phot. 1916, **10,** 35; G. C. Whidden, Camera Craft, 1916, **23,** 3. H. C. Claudy, Camera, 1920, **24,** 406. H. E. Rendall, Brit. J. Phot.. 1919, **66,** Col. Phot. Supp. **13,** 31.

28. U.S.P. 1,306,904, 1919; J. S. C. I. 1919, **38,** 602A; Annual Repts. 1919, **4,** 512.

29. E.P. 11,033, 1906; Brit. J. Phot. 1907, **54,** 456; F.P. 377,579.

Cf. E.P. 12,003, 1906; Brit. J. Phot. 1907, **54,** 546; E.P. 11,346, 1906; U.S.P. 1,098,535 for similar ideas.

30. U.S.P. 1,330,535, 1920.

31. "A Guide to Photography," by W. H. Thornthwaite, New York, 1856, 21; Handbuch, 1895, **1,** 387; Phot. News, 1862, **3,** 233; R. Krugener, E.P. 18,899, 1892; Hopwood's "Living Pictures," 1913, 57, where the principle of Le Prince's camera is described, and this dates back to 1888; Demeny, F.P. 233,337, 1893; Friese-Greene, E.P. 22,928, 1896.

A. Graby, Mon. Phot. 1900, **39,** 237; Photo-Rev. 1900, 63; "Photographie des Couleurs," Paris, 1901, suggested the use of a two-color system. Cf. R. Moreels, Brit. J. Phot. 1911, **58,** Col. Phot. Supp. **5,** 25. See also section on double-coated films for allied processes by Christensen, Lewy and Hamburger.

32. D.R.P. 345,734, 1920; abst. J. S. C. I. 1922, **41,** 567A; F.P. 539,192; E.P. 168,035; abst. Sci. Tech. Ind. Phot. 1923, 3, 14; Amer. Phot. 1923, **17,** 184. Brit. J. Phot. 1923, **70,** Col. Phot. Supp. **17,** 16, Phot. Ind. 1924, 543.

33. E.P. 183,189, 1921; Brit. J. Phot. 1922, **69,** Col. Phot. Supp. **16,** 40; abst. J. S. C. I. 1922, **41,** 729A; F.P. 538,860; 539,346; abst. Sci. Tech. Ind. Phot. 1923, 3, 13; Amer. Phot. 1923, **17,** 185; Brit. J. Almanac, 1923, 402; 1924, 369; C. A. 1923, **17,** 33; D.R.P. 366,422; U.S.P. 1,499,230.

34. D.R.P. 381,146, 1922; Phot. Ind. 1924, 170; E.P. 205,807; Brit. J. Phot. 1925, **72,** 110; abst. C. A. 1924, **18,** 946. Cf. D.R.P. 395,941; 403,592.

35. E.P. 205,501; D.R.P. 378,661; Phot. Ind. 1924, 196; abst. C. A. 1924, **18,** 946; Brit. J. Phot. 1924, **71,** Col. Phot. Supp. **18,** 8, 34; Sci. Tech. Ind. Phot. 1924, **4,** 154; Brit. J. Almanac, 1925, 310; F.P. 571,384.

36. E.P. 212,674, 1922; Brit. J. Phot. 1924, **71,** 268; Col. Phot. Supp. **18,** 20; abst. Sci. Tech. Ind. Phot. 1924, **4,** 151; U.S.P. 1,508,447. Cf. E.P. 5,641, 1908; 873, 1915; 14,511, 1915; abst. Brit. J. Almanac, 1925, 310; C. A. 1924, **18,** 3557.

37. D.R.P. 397,574, 1922; Phot. Ind. 1924, 970; E.P. 231,717; Brit. J. Phot. 1925, **72,** 340, Col. Phot. Supp. **19,** 22.

38. D.R.P. 406,174, 1923; Phot. Ind. 1925, 476.

CHAPTER V

OPTICAL DATA

Many optical devices for obtaining the constituent negatives, or for projection of positives, will be found scattered throughout other sections. The following have only been isolated because they deal more specifically with the optical parts.

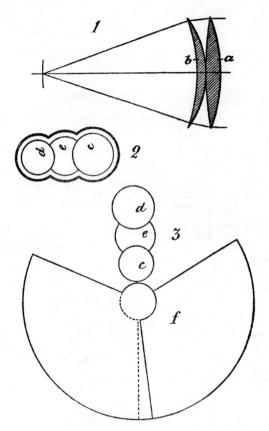

FIG. 60. Christensen's E.P. 7,514, 1908.

C. P. Christensen[1] (p. 206) pointed out that the necessity of short exposures required the largest possible lens apertures, and that as color filters were used, the chromatic aberration was reduced so the lenses need not, therefore, be chromatically corrected. The main feature being that the individual pictures shall be of the same size, and that this is satisfied

if the focal distance of the individual lens systems be of equal length for the particular colored fields. A system of Herschelian lenses would fulfill this condition, such being shown in Fig. 60 in which *1* shows such a lens composed of a double convex *a* with a positive meniscus *b* immediately

Fig. 61. Pfenninger's E.P. 25,908, 1906.

Fig. 62. Sacre's F.P. 460,310.

behind and in optical contact therewith. Such lenses have but little spherical aberration. Parallax, or as Christensen called it "a certain stereoscopic effect," is obviously unavoidable, as with all systems in which more than one lens is used, and the individual pictures will never accurately

coincide. But this is reduced in his system by arranging the lenses, as shown in *2*, in which parts of the lenses are cut off so as to bring their optical axes as close as possible. The arrangement of the shutter is shown in *3*.

Fig. 63. Maurich's E.P. 13,150, 1912. (Page 171).

Fig. 64. Tiverton & Merckel's E.P. 7,756, 1912 (Page 171).

C. Dupuis[2] patented a method of illuminating pictures on an opaque support, such as polished silver or other metallized support, and whilst the method is somewhat worthless from a commercial point of view, his specification is interesting as it deals with the angle of the prisms that

must be used. O. Pfenninger[3] devised a mirror box, which appears somewhat elaborate, but which requires little explanation, Fig. 61. The chief point is the "sawn-off" lenses, as shown in 5 and 7. J. Sacré[4] patented a system of mirrors in front of three lenses, Fig. 62, in which 6, 6 are silvered mirrors and 7 the film. This arrangement could be used for projection also.

M. Maurich[5] proposed to arrange the lenses in trefoil pattern, Fig. 63, in 1, whilst 2 and 3 represent the negative images thus obtained. If the distances between the lens axes be 15 mm., the three sectional pictures would cover a surface that would be about one and a half times the area usually employed. The inventor suggested that, if in this case the pictures were too small, the arrangement shown in 3 might be adopted, and the lenses would then lie at the corners of an isosceles triangle, not in an equilateral one. The three pictures would then take up a space of about 25x38 mm. A special arrangement is shown in 4 with the lenses on an isosceles triangle, and the three pictures would be formed in checker fashion r, g, b and between each two pictures there would be a blank space of about one picture size. To utilize this it was suggested to run the film backwards and rotate the lenses through an angle of 180 degrees, and thus expose the spaces r^1, g^1, b^1.

Viscount Tiverton and E. A. Merckel[6] used an extremely complicated system of annular prisms, Fig. 64, which were constructed to obtain reflection of part of the rays from the internal faces of the prisms. The separation was thus accomplished in a definite manner and the separate components were reproduced in the form of concentric annular beams, corresponding to the three constituent colors, thus obviating the use of filters. The positive printed from the negative could be projected by a similar arrangement but reversed. C. N. Bennett[7] placed, Fig. 65, a mirror c in front of the lens at a suitable angle to receive the image, and two mirrors d, d' which received it from c and reflected the same through the lens in duplicate, one above the other 1, 2 on to the film; F^1, F^2 being the filters. C. Beck and C. N. Bennett[8] patented various forms of prism blocks for breaking up a beam of light into two or more bundles, Fig. 66. The junction surface of b and c was coated with a thin semi-transparent layer of silver or other reflecting material, with or without an opaque reflecting layer, partly removed by ruling lines close together, or by dots or parts scraped away. In 1 f was a block of glass to shorten the path of the reflected ray; the blocks h, h^1 serving the same purpose in 2. In 3, 4 the prisms were placed in front of the lenses.

W. B. Featherstone[9] would use a wide film and three lenses placed side by side, with shutters having crescent-shaped apertures, which exposed and darkened each series in turn, the effect being similar to a dissolving stereopticon. R. Berthon and M. Audibert[10] utilized a distinctly novel principle of obtaining a virtual image by means of an anterior lens and

prisms or mirrors. The various forms of prisms are shown in Fig. 67. The main feature was the use of the anterior lens and the disposition of the prisms thereto, so as to split the image into three beams. In a subsequent patent[11] the shapes of the prisms were altered to correct the aberrations of those first suggested; the chief difference being that all the faces were curved.

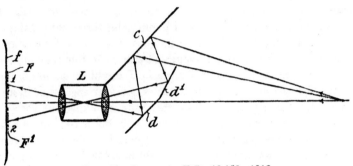

FIG. 65. Bennett's E.P. 10,150, 1912.

FIG. 66. Beck & Bennett's E.P. 24,159, 1912.

C. Urban and the Natural Color Kinematograph Co.[12] patented the use of two mirrors *b*, b^1, Fig. 68, the former being transparent and the latter silvered. A plane parallel plate *x* being placed in the path of the reflected beam to equalize the focus; *e*, e^1 were the filters and *d* the sensitive surface. D. W. Player[13] proposed to use a rotating mirror or reflectors *4*, *5* in *1*, *2*, *3*, Fig. 69. In *1* the films were placed in echelon, as

shown at R, G, B, with the filters r, g, b in front of them. It would be possible to move the mirror 6 and the third image would then be formed at B^2, but this would not be reversed, while the others would be. A side view is shown in 2 and a modification in 3, in which the films are on the three

FIG. 67. Berthon & Audibert's E.P. 24,809, 1911 (Page 172).

sides of a rectangle, the lens occupying the fourth. As in this arrangement it would be impossible to prevent the rays from reaching B, when the mirror 5 followed upon 4, a rotary shutter 8 was to be introduced.

The Société Établissements Gaumont[14] patented three sawn-off lenses, Fig. 70, similar to Pfenninger, and a rotary annular shutter in which the sectors varied from the outside to the center, as shown by the shading, this being necessary as the picture shown through the top lens was also shown through the center and bottom lenses. This plan was also adopted by Lee & Turner (see p. 587). Further patents[15] merely deal with im-

FIG. 68. Urban's E.P. 3,034, 1912. (Page 172).

FIG. 69. Player's E.P. 25,142, 1912. (Page 172).

provements in the lens fittings. P. Ulysee[16] also proposed to use two sawn-off lenses *a, b*, Fig. 71, which were shifted by the cam *j* in *2; 1* shows the arrangement of the pictures on the film.

F. W. Kent and T. P. Middleton[17] used the dialyte system for two or three films, Fig. 72, in which *F1, F2, F3* represent the films; *A1, A2, A3*

the mirrors and *L* the lens. The eccentric mechanism being for the rise
and fall of the mirrors out of the optical path. E. L. Doyen[18] patented
the use of three prisms of small angle, arranged fanwise, Fig. 73, to re-

FIG. 70. Gaumont's E.P. 3,220, 1912 (Page 176).

FIG. 71. Ulysee's E.P. 30,108, 1912.

fract the light to the side filters *4* in projection. H. Blitz[19] used a primary
lens and camera, and focused the image of a subject on a ground glass
or the like, and arranged three juxtaposed lenses horizontally behind this,

which produced the actual constituent images on the intermittently moved film. H. R. Evans[20] used two lenses, one above the other, with a mirror box behind to separate the fields for projection, Fig. 74. Two shutters *20, 21* were used, the former with red and green annular sectors, each of 180 degrees, in one half the red being the outer annulus and in the other, the inner one, thus recalling the Lee and Turner idea.

O. Gergacsevics[21] proposed to use three separate films, Fig. 75, and obtain separation of the images by the use of narrow-angled prisms with their

Fig 72. Kent and Middleton's E.P. 3509, 1913.

apices together, an idea previously used. C. Zeiss[22] patented a novel method of projection, Fig. 76, which dealt particularly with continuously moving films. In this the filters were placed close to the condensing system, which projected their image on to the films. If it was thought desirable to obviate the action of the heat rays on the filters, a second system of condensers might be interposed between the first set and the filters. In *1* is shown one form of the apparatus, in which *a* is the light-source,

close to the collecting lens *c*, and the lens *d* formed a secondary image of it in the incidence pupil *l* of the objective. The filters *f*, *f* in *1, 2* were in the form of a rotary shutter, and their images were projected by the collective lens *c* in the plane of the film *x, x*, the latter being in continuous movement. In *3, 4* another method is diagrammatically shown, *a, a* being

FIG. 73. Doyen's E.P. 11,873, 1913 (Page 179).

FIG. 74. Evans' E.P. 16,867, 1914.

the light-sources. To increase the distance between the light and filters *f*, the condensers k^1, k^2 were used, which projected the image of the light near the collective lens *l*, which threw the image of the condensers in the lens *b*, and this image was projected by *c* on to the film plane *x, x*. Intermediate condensers *d, d* and low angle prisms *m, m* being used to direct and

confine the beams to the individual filters. For two-color work the system, shown in *3* was used. In *5, 6* is shown the tri-color system.

B. A. Brigden patented a continuously-moving film and battery of fifteen lenses (see p. 585) and in a later patent[23] proposed a system of lenses, prisms and mirrors so as to reduce parallax to a minimum, Fig. 77. From

Fig. 75. Gergacsevic's F.P. 465,576.

Fig. 76. Zeiss' D.R.P. 266,061.

this it will be seen that the middle lens was designed for the red rays R, whilst the green and the blue-violet constituents were formed by rays reflected from the mirrors M^2, M^3 at right angles to the total reflecting prisms P^1, P^2, which were placed between the lenses L^3, L^4, L^5, L^6, close to which were the filters S. In *1, 2* the front prisms were located at an angle

to the middle lens, so that the pictures were in cluster and not straight formation. This apparatus was designed both for taking and projection. How the optical paths of the three systems were equalized is not clear.

H. Workman[24] designed a special projector for two- or three-color work, Fig. 78. The main features being the application of cylindrical lenses to alter the shape of the light beam, and the use of split condensers. In a subsequent patent[25] a modification was proposed and prism grids

FIG. 77. Brigden's U.S.P. 1,187,604.

used. A two-color system is shown in Fig. 79. Whilst for three-color systems a sectional grid in the form of a revolving disk with radial strips might be used. Subsequently Workman[26] used a compound prism block, Fig. 80, the internal reflecting faces being coated with a thin partially reflecting and partially transmitting layer, such as silver, platinum or the like; or a totally reflecting layer with removal of narrow lines or small areas.

F. Twyman, J. S. Higham and H. Workman[27] patented a prism block with a reflecting prism at the side, Fig. 81. The compound prism block was made up of two equal right angle prisms cemented together hypothenuse to hypothenuse, with a flat piece of glass added to, or preferably in

FIG. 78. Workman's E.P. 7,659, 1915.

one piece with the rectangular prism, through the face of which the light entered the system. This addition being integral with the reflecting prism, together with a reflecting rectangular prism added to the extended side of the compound block, so that its reflecting surface was parallel to the partially reflecting surface formed at the junction of the prism block;

so that its face, by which the doubly reflected portion of the divided light left it, was parallel to and preferably on the same plane as the back surface of the prism block. This totally reflecting prism being made in one piece or cemented to the side, or made in one piece with the front prism and

Fig. 79. Workman's E.P. 7,659, 1915 (Page 181).

Fig. 80. Workman's E.P. 13,042, 1915 (Page 181).

the flat prism added to it. The partially-reflecting surfaces might be of uniform coating, or with lines or small areas removed. The side lens in this system was optically situated somewhat further from the scene than the direct-image lens, and the former would, if the lenses were accurately

paired, give a smaller image than the direct lens. To remedy this, the
side lens had a greater focal length. Possible alternatives are also indi-
cated. In a later patent[28] the same inventors deal more specially with a
two-color, two-lens camera, in which optically paired lenses were used,
Fig. 82, and the focal length of the side lens was lengthened by the inter-
position of a glass block *I*, or this might be a liquid or plastic material en-
closed in glass. The prism block and reflecting prism were constructed
of glass of refractive index of 1.53, and the glass block *I* of index 1.65.
The thickness, or distance from front to back, of the plane parallel block

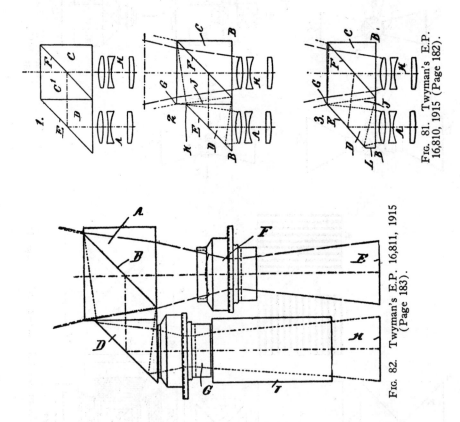

Fig. 81. Twyman's E.P. 16,810, 1915 (Page 182).

Fig. 82. Twyman's E.P. 16,811, 1915 (Page 183).

should be equal, if arrived at by calculation, to $X\dfrac{U}{U\text{-}1}$ wherein X
denotes the distance the direct lens is set nearer to the common focal
plane than the side lens, and U is the refractive index of the glass used.
The refractive index of the block should be preferably that for the aver-
age colored light used to form the image through the side lens.

H. R. Evans[29] patented a supplementary lens between the condensers
and the objective so as to cause the crossing point of the light rays to fall

outside the objective, and at this point was placed the shutter, so that the period of obscuration should be as short as possible. The additional lens might be placed between the condenser and the film, or between the film and the objective.

W. B. Wescott[30] reverted to the old mirror system, but made the front one partly reflecting and partly transmitting thus by a second reflection obtained records with two picture spaces between, Fig. 83. For instance, G^1 and R^1 were simultaneously exposed. The film was then shifted two spaces and G^2, R^2 exposed, thus filling up the blanks. F. E. Ives[31] patented various systems, which whilst shown for projection were stated to be also suitable for negative making. In *1, 3* and *6,* Fig. 84, are

Fig. 83. Wescott's E.P. 101,972, 1915.

shown two-color systems, while *4* shows three-color systems. In a subsequent patent[32] Ives claimed the use of a dichroic reflector, which could be made by flowing a sheet of glass with a solution of eosin in alcohol and drying. It was also suggested that thin films of gold, which are dichroic, might be used, particularly in the formation of compound prisms.

W. H. Doherty[33] patented a system for two or three plates or cinematography, in which prisms were moved in and out of the fields, thus exposing the sensitive surfaces behind the filters and correcting lenses. O. J. Cooper[34] proposed to minimize parallax, or to correct the focal diffusion or divergence, which occurs in planes beyond that of the principal object, by means of three telephoto lenses, vertically juxtaposed with refracting

FIG. 84. Ives' U.S.P. 1,169,161 (Page 185).

FIG. 85. Comstock's U.S.P. 1,231,710.

FIG. 86. Kunz's U.S.P. 1,319,292.

prisms behind the two outer lenses, parallel with the central image. The three images would thus be disposed one above the other on the film, which must be run horizontally and not vertically.

D. F. Comstock[35] patented a particular form of grid or reflecting surface, consisting of polygonal forms irregularly distributed, Fig. 85. In *1* is shown the lens with the compound prism block, composed of the prisms p^1, p^2, p^3 and the block p^4; f being the film and I, I' the gates; T^1, T^2, T^3 are the totally reflecting surfaces and the grid G is placed on the plane g. By this means the optical path of the two beams is equal. In *2* the device is shown for observing the superposed images. The grid shapes are shown enlarged in *3,* in which r represents the polygonal reflecting shapes, which might take other forms, and s the transmitting portions; *4* is merely a section through the grid. In *5* is shown the familiar result of a diffraction grating giving the central image and the spectra on each side, the appearance of the central white beam being shown in *II,* the object being a spot. If a slit be used then *III* is seen, and the inventor claimed that by this particular form and distribution of the grid elements the appearance as in *IV* was obtained. Subsequently[36] the composite prism block and lens were patented, the whole being termed the composite component and lens component of a lens system. Constructional details are given in the specification for both. The lens is obviously nothing more than a Tessar lens[37] modified. Curvature of the last faces of the prisms was indicated to partially correct the aberrations, and a correcting positive lens element might be placed in front of the camera lens, which obviated the curving of the prism faces. In the additive projection of polychromatic pictures there is always great liability of non-registration of the individual color constituents due to machine defects, or more often to unequal expansion and contraction of the film base. To faciliate registration Comstock[38] patented the idea of including a target in every picture.

W. H. Kunz[39] patented various forms of prisms, Fig. 86. In which is given the perspective diagram of a camera arranged to take simultaneous three-color records. One mirror and two prisms were used in *2,* and *11* interposed to give the reflected beam the same refraction as the direct ray passing through *2.* All-prism sets are shown in *3, 4, 5.* The filters might be cemented at any convenient plane and the varying lengths of the glass blocks *35, 36* in the last three diagrams were due to the refractive indices of the glasses employed. The inventor stated that he had found that a partially reflecting surface or mirror does not reflect a cone of light alike throughout its surface; but from the part nearer the lens less light was reflected than from that part further away, giving rise to unequal exposure. This is due to the light striking the oblique surface more nearly vertical upon the part near the lens, while the angle with the farther part of the surface is more acute; for the more nearly acute the angle is, the more the glass surface acts as a mirror; while the more nearly at right angles the

FIG. 87. Kunz's U.S.P. 1,320,625 (Page 193).

less the reflecting power. To correct this the reflecting surface was applied in a thinner coating farther away from the lens, as shown in 6. With

FIG. 88. Parker's E.P. 156,980, 1919 (Page 195).

FIG. 89. Miller's U.S.P. 1,346,234, 1920 (Page 195).

all the above prisms the path of the sensitive surface was parallel to the optical axis of the lens. As an improvement Kunz patented other forms,[40]

Fig. 90. Brewster's E.P. 100,082, 1915 (Page 195).

shown in Fig. 87. In *1* the images would be formed in a plane parallel to the top face of the grouped prisms; *2* is a plan view of the same, *3* a section of the same through the lens. In *4* the triplicate pictures would appear on the film right side up, *4a* is a plan view of the same. Whilst *5* is similar in construction with mirrors substituted for some of the prismatic reflectors. Another modification is shown in *6*, and *7* shows the linear reflecting surfaces used in *1* and *2*. In these the oblique prism *4* has its

FIG. 91. Furman's U.S.P. 1,371,970 (Page 195).

surface *5* made partly reflecting in stripes, they must be offset as regards the stripes in prism *1*, and must also be narrower by approximately one half, in order that the light-rays which pass between the stripes, on the surface *2*, may partially pass between the stripes on the prism *4*. The stripes on *2* should be substantially one third the width of the spaces between them, so that approximately one third of the light shall be diverted and two thirds transmitted. By altering these ratios the difference in sensitiveness of the film might be compensated for. An oblique quadrilat-

eral prism is shown in *7*. In *8* only two of the triplicate images are on the same surface; and in *9* three separate surfaces must be used, as is also the case in *10*. In *11* the pictures were on the same surface, but in triangular formation, and in *12* the sensitive surface was above the prisms, *13* being a perspective view.

E. C. S. Parker[41] patented some elaborate arrangements in which cylindrical lenses were used to deform the images on the film, and the same

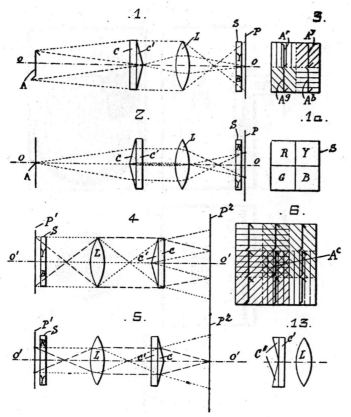

Fig. 92. Furman's U.S.P. 1,371,969 (Page 195).

arrangements were used to project them in their proper form. This system was applicable for two or three-color work. An enlarged diagram of part of the system is shown in Fig. 88. H. N. Miller[42] also invented a prism set for two-color work, Fig. 89, which gave contiguous images. In *1* it is shown complete and in *2* dissembled; *d* is a quadrilateral prism with the bottom face forming an opaque reflecting surface. The upper face *5* is half-silvered and this prism was mounted in an inclined position, so that

the light-rays passed from the lens *1* through the transparent surface *4* and impinged on the face *5*. The block *b* lies flush with the surface *6* of the prism, and it is preferably cemented thereto. The rear surface *S* has a red filter cemented to it; *a* is another block, slightly separated from *b;* the prism *c* is cemented to the face *5* of the prism *d,* and preferably its lower edge has a flat surface *13* which rests on the block *b*.

P. D. Brewster[43] patented a perforated reflecting and transmitting surface, Fig. 90, either with bars, holes or a solid sheet of metal perforated;

Fig. 93. Kamei's E.P. 143,597, 1919 (Page 196).

the holes being flared back to permit of the unobstructed passage of the rays. In *1* is shown the application to two sensitive surfaces at right angles to one another, and in *3* to double-coated stock. A. P. Furman[44] also patented various prism sets, Fig. 91; equality of the optical paths was again secured by the use of glass blocks. In another patent[45] bi-prisms were used. The course of the light is shown in Fig. 92, *1, 2*. The compound

prism *C C* deflected the light, coming from the object *a*, to left and right and up and down, and these deflected rays passed through four quadrants of a lens and the filters *S*, so that four separate images A^r, A^g, A^y, A^b were formed on the sensitive surface. This four-fold image was to be projected through similar prisms and filters, as in *4, 5*, with the result that sixteen different colored images would be thrown on the screen in red,

Fig. 94. Isensee's D.R.P. 334,776 (Page 196).

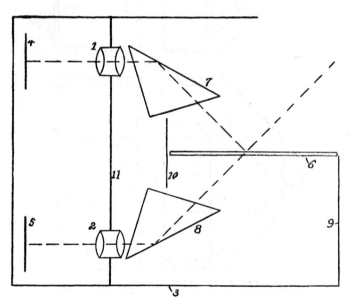

Fig. 95. Ives' U.S.P. 1,383,543 (Page 196).

green, blue and yellow. It is stated that these reproduced the colors of nature, and the central image, A^c in *6*, received twice the amount of light than any of the others, and these latter might be advantageously cut out.

N. E. Luboshey[46] patented the use of a bi-prism placed between the lens combinations. E. Kamei[47] proposed to use a square prism, practically a Lummer-Brodhun rhomb, Fig. 93, between the lens and the sensitive

surface. H. Isensee[48] patented a cell filled with cinnamic ether, which has
a very high refractive index, so that the different colored rays were totally
reflected from the separating glass plates through the ether prisms to the
film, Fig. 94, which must obviously run at an angle to the optical axis of
the lens. F. E. Ives[49] patented an arrangement of mirrors, lenses and
prisms, by means of which two images could be simultaneously obtained,
one of them being reversed. In Fig. 95, *1* and *2* are the lenses, *4* and *5*

Fig. 96. Mortier's F.P. 442,976.

the film and *6* a transmitting reflector, either plain, colored or dichroic;
while *7, 8* are total reflecting prisms that bend the rays to the lenses; *10,
11* are merely casing shields or parts of the camera, *9* also serving for the
same purpose.

P. Mortier[50] patented a prism block for cinematography or color work
generally. The block, Fig. 96, was composed of five prisms, cemented to-
gether with Canada balsam, and with some of the faces partly silvered.

In the upper figure it will be seen that lenses, either of air or glass of lower refractive index, were introduced in the paths of the reflected rays, and the posterior faces were concave, while that of the glass in the direct ray was convex. By this means the three images were all formed on one

FIG. 97. Pathé's F.P. 461,248, 1913.

FIG. 98. Procoudin-Gorsky's E.P. 185,161.

plane. Pathé Frères[51] also proposed various forms of prism blocks, Fig. 97. The main features of which are the equalization of the optical paths by the varying thickness of the glass and by variation of the foci of the lenses, also the use of a convergent or divergent lens giving an aerial image

at the plane of the arrow. There was claimed for this system complete annulment of parallax and perfect superposition of the three images.

M. S. Procoudin-Gorsky[52] patented a series of rhomboidal prisms, Fig. 98, from which it will be seen that either one or three staggered films might be used. The lower face of the first prism was provided with silver bars twice the width of the interspaces, and the lower face of the second prism with bars and spaces of equal width, thus ensuring equal distribution of the light. The Rathenower Optische Industrie-Anstalt, vorm. Busch,[53] arranged three lenses in trefoil pattern, the front combinations being at right angles to the optical axes, and mirrors at 45 degrees reflecting the three images to three separate plates, the mirrors being between the combinations.

E. Belin[54] patented a continuously moving film with moving prisms or reflecting mirrors for successively forming or projecting the three-color images. Either a single film or three juxtaposed films might be used. T. R. Dallmeyer[55] apparently considered the making of a camera. He proposed to take the requisite number, three or four as the case may be, of identical images on one plate, projecting them through four lenses, not necessarily those with which they were taken, the axes of the lenses being parallel. The multiple images were brought into coincidence by one of two methods; the first by placing an achromatic combination of lenses that covered the front combinations of the three or four projecting lenses of focus equal to about that of the distance of the screen. The second, by applying three or four achromatic prisms of very small convergence in front of said lenses. Another, and pretty method was the application of prisms to a multiple diaphragm. If a diaphragm with a number of apertures be inserted in a lens, and the focus of the lens taken, only one image is formed. But in the proposed invention the various cones of rays were not permitted to meet at one focus, by inserting in each aperture a prism, which threw three or four distinct images on one plate. This, of course, necessitated the employment of the lens with which the negatives were taken for the projector.

B. Björnson[56] patented the idea of altering the foci of projecting lenses by variation of the separation of the components for the different sizes of the constituent pictures. A. Köhler[57] proposed to use rotating sectional mirrors in front of three objectives, fitted to three cameras or projectors, working in synchronism with the film. C. Zeiss[58] patented an optical system comprising two or more reflectors and objectives, by which a corresponding number of images from the same point of view might be obtained; a collective lens was placed in front of the mirrors. The front focal point of the lens was located approximately in the object, so that the images would be of the same size on the film. Dumez, Baugé and Sauve[59] patented three side by side lenses, the central one fixed and the lateral ones adjustable, so as to simultaneously focus on the same point. Or three equi-

lateral prisms might be used, the rays from the object falling on one prism and being thence refracted to two others, placed at each side and slightly

FIG. 99. Comstock's U.S.P. 1,460,706.

FIG. 100. Comstock & Ball's U.S.P. 1,451,325.

behind the first one, and by these prisms the light was again refracted into four beams, one of which was suppressed, the other three being received by films in three separate cameras.

A. Polack[60] patented the use of lenses, corrected for astigmatism, spherical aberration and roundness of field, but not for achromatism. One surface of the lens might be parabolic and the other spherical, or supplementary parabolic lenses might be used. The focusing was to be effected by the red rays, the other rays dispersing in the image and forming by their combination with the sharp outlines of the red image, mixtures of different kinds of light, which, without impairing the sharpness of these outlines, produced the most favorable color and contrast effects. C. W. Campbell and F. G. Roberts[61] described a battery of lenses on an endless sprocketed chain, with a large rear lens to form the images on the film.

L. F. Douglass[62] patented a prism fitted in front of a lens for obtaining two stereoscopic images with a separation of 2½ inches between the centers of the prisms. It is stated to be particularly suitable for cinematography in colors; but the inventor does not state how coincidence of the outlines could be obtained, and this is an impossibility. In a later patent[63] the same inventor proposed the use of two mirrors, slightly angled, in front of the lens. The essential idea in this is the old stereoscopic transmitter of T. Brown.[64] Later still[65] Douglass proposed to use a bi-prism of about 12 degrees angle, in front of the lens; though this would seem to be rather for the production of multiple images in one picture space, not for color work. J. Byron[66] patented an objective comprizing two achromatic lenses for reducing the images to the desired size and a central ray interceptor. R. Eberhard[67] patented the combination of filters and prisms, or colored glass prisms, and a lens, so that the reflected rays coincided with one or more planes in front of the lens.

L. Horst[68] used three rhomboidal prisms, arranged at angles of 90 degrees to one another behind the lens, and later[69] the ends of the prisms near the lens were cut off straight and three movable mirrors placed in between. In this case double rhomboidal prisms were used, so that the three images were formed side by side. The same inventor[70] also used one large mirror at an angle of 45 degrees to the subject and three small mirrors parallel to the large one; the small mirrors being staggered so as to reflect three images to the film or plate. A. Lassally[71] patented a double apparatus, one for the warm half of the spectrum and the other for the cold half. Pairs of pictures were combined in projection and observers were provided with spectacles, as in du Hauron's anaglyphic process, to enable the pictures to be seen stereoscopically and in colors. J. A. Perrey[72] would also use light-splitting prisms behind the lens, so as to produce images on two films, which were simultaneously advanced by a Geneva gear movement. F. R. Bouffartigue[73] would use three lenses in trefoil, so that three small pictures were obtained; or one lens could be used, behind which were placed three total reflecting prisms, which produced the same effect.

D. F. Comstock[74] patented various prismatic systems, Fig. 99, for obtaining two or three complemental images. In conjunction with J. A. Ball[75] the obtaining of head to foot images by means of prisms, Fig. 100, was claimed. L. Albert[76] proposed to use a single lens with three mirrors arranged on the optical axis at angles of 45 degrees, one behind the other and from which the images were reflected to another set of mirrors, which reflected them to the sensitive surface, this being situated on the base of a triangle, erected on the optical axis of the lens, Fig. 101. It is obvious that one may consider this arrangement as similar in principle to the use of three rhomboidal prisms with the glass omitted.

Fig. 101. Albert's F.P. 554,056.

F. Janovjak[77] proposed an extraordinary system of illumination, in which white light was split up into a spectrum and the colors of the latter projected on the screen. It is stated that Lippmann pictures or screen-plates might be used. The apparatus is very complicated and there are eighteen continuously-driven semi-circular mirrors. J. K. Holbrook and M. de Francisco[78] patented a light-splitting mirror in the form of a silvered checker board. It being claimed that the reflection from the back surface of the glass was prevented from forming a double image by the disposition of the silvered squares, this being determined by the thickness of the glass, its refractive index and the angle to the optic axis. This was

specially designed for cinematographic work. It is not quite clear how the inventors take care of the rays impinging on the glass at varying angles, which must be the case with a divergent beam. In the specification drawing the rays are shown as proceeding from the lens as a parallel beam. L. Horst[79] patented an arrangement of mirrors to obtain equalization of the optical paths, Fig. 102, by the use of the three reflecting mirrors and the path of the rays is shown by the arrows. The three images being formed on the film by the lenses. In a later patent[80] three mirrors, each smaller

FIG. 102. Horst's D.G.M. 757,468.

than the other, were used in conjunction with a larger mirror that reflected the image to the smaller mirrors.

O. and A. Pilny[81] proposed to use a front lens forming an image on a plane; this being re-imaged by two bi-convex lenses cemented to a plano-convex lens. This is but a modification of the system of Blitz and Audibert. E. Belin[82] proposed to use a large anterior lens, composed of a bi-convex separated from a bi-concave, which was to render the rays from the object parallel, and a number of smaller lenses behind the same. T. A. Willard[83] patented two mirrors at right angles to one another, but not in the same plane. These were moved by a slide so as to reflect the images to sensitive surfaces placed opposite one another and parallel to the optical

axis, while the third image was obtained direct on a sensitive surface on the optic axis. J. Blicharski[84] used a single lens with rotating mirrors behind, the peripheries of the latter being cut out into reflecting and transparent sectors so as to divert the beams to two side films and also allow the light to proceed to one film placed on the lens axis. F. E. Hoffman[85] would obtain stereo and color effects with a single lens, by placing in contact with the front member of the same an opaque bar, so as to divide the lens into two active portions. A shutter with two peripheral sectors was used.

Fig. 103. Douglass' U.S.P. 1,509,936. (Page 205).

C. H. Nolte[86] arranged two reflectors at right angles to one another behind the lens and thus obtain images at the sides and one direct image, side by side on normal width film, sensitized for three colors in longitudinal strips. E. Mors[87] proposed to use two circular mirrors at right angles to one another, revolving on their axes, and with transparent and silvered sectors, the latter reflecting two partial images to two films facing one another on opposite sides of the optical axis, while the third image

was obtained direct through the transparent sectors. Or three mirrors might be arranged behind one another and three or four images obtained. C. Zeiss[88] patented an optical system composed of two separated prisms placed behind a three-lens projection system so that parallel beams of colored light passed through their respective filters and objectives. Or a series of small prisms might take the place of one of the prisms. H. N. Cox[89] used four-color component records, which were obtained by refracting prisms behind the lens. H. May[90] also proposed to use various prisms behind the lens, forming four images of the subject. This might be used for stills or cinematographic work. L. F. Douglass[91] patented a Swan cube behind the lens, in the contiguous faces of which were cut separated, triangular depressions *5* in Fig. 103, with intermediate reflecting surfaces *4*. This was for two films *7, 9,* the filters being *6, 10.*

C. A. Steinheil Söhne[92] patented a block of three prisms in front of the lenses, one prism being right-angled and to this were cemented two rhomboidal prisms. The faces of the prisms next the lenses being in step form,

Fɪɢ. 104. Steinheil's D.R.P. 399,196.

so that the latter could be placed closer together and the prisms made smaller. A mirror *S*, Fig. 104, might be placed in front of the entrant surface. L. Ross and K. Pokorny[93] placed a pair of mirrors at right angles to one another, in front of a central objective, which formed a direct image; while the reflected beams were received on two mirrors at 45 degrees in front of the side lenses. The mirrors were comb-shaped, and fitted together with intervening gaps, which permitted the transmission of the central image. A. D. Lang and D. C. L. Syndicate[94] would use a camera with twin lenses, juxtaposed with narrow segments cut off, so as to permit of less separation and obtaining the images side by side. This being specially designed for two-color cinematography. C. Zeiss[95] patented the use of reflectors parallel to one another and 45 degrees to the optic axis, in front of two or three lenses. In front of one reflector was placed

a collective lens of such focal length that its front focal plane fell approximately in the subject, thus forming a virtual image lying in the far distance. It being necessary to have several collective lenses of different focal length in order to select that suitable for the object to be taken. G. Griffiths[96] would use two continuously moving films, side by side with spaced lenses, the images being reflected from right-angled prisms and a crown of revolving mirrors. Stereoscopic or two or three-color cine results might be thus obtained.

The Lenses for Color Work.—Not the least important part of the color worker's outfit, especially in cinematography in colors, when naturally there is great enlargement of the resultant images, is the lens. The ordinary lens is achromatized for only two colors, as a rule, the visual and the blue rays. But in three-color work we have three regions to reckon with, and even in two-color systems when the blue is more or less neglected, the green rays are used. This subject has not, of course, been overlooked by opticians and experimenters, and although we have not many papers on the subject, it may be as well to sum up what has been said on the matter.

Kaempfer[97] pointed out that frequently there was a difference in the focus of the red rays and consequently the negative taken through the red filter would be larger than the others, and would not coincide. The remedies suggested were: 1, the use of a spherical filter which would correct the focal difference; 2, alteration of the aberration of the red by a small change in the separation of the lens combinations, as can be done in the Cooke lens; 3, the use of the spherical zones of the individual colors. The zones for each color should be found and those which gave the same focal length used, and the others cut out by ring diaphragms. It is clear that while the first proposition is easily carried out, the second can only be done with those lenses in which uncemented combinations are used, and which primarily depend on the separation of the individual elements for correction, as is the case with the Cooke lens, and some others of uncemented type.

Eder[98] pointed out that it is fairly easy to find out for what spectral regions the lens should be corrected for, by determining the transmissions of the filters. He suggested that it is necessary to correct for the red filter for the characteristic lithium line at wave-length 6100, or the hydrogen, Fraunhofer's C line, at 6560.

For blue-violet the achromatism may be somewhat wide. The particular sensitiveness of silver bromide extends from 4600 to 4250, with a glass apparatus and generous exposure it extends from 4800 to H and K in the extreme violet. So that the optician may choose from 4500 to 4400, or from F, 4860, to K, H3960 to 3930, or the G′ line at 4340 or h at 4100. The latter corresponds to the requirements of wet collodion with silver iodide, the maximum action on which begins at 4370 and includes 4230 and

4100, and which is specially suitable for half-tone work, on account of its good gradation and sharpness of the lines.

For ordinary achromatized lenses, which are almost always used with gelatino-bromide plates, it is practically immaterial whether the focus of the D lines, 5893, coincides with the blue hydrogen line G', 4340, or with the violet calcium line, g4230, or h4100. For reproduction photography with wet collodion, correction for the mean violet ray, g4230, is the best.

All opticians do not correct for the same rays, as is obvious from the accompanying table, the details of which were supplied by the firms in question:

Ordinary lens, Steinheil D5893 g4230
Trichromatic lens, Steinheil. C6560 F4860
Astrographic lens, Steinheil. g4230 3890
Ordinary lens, Voightländer. D5893 G'4340
Ordinary lens, Zeiss. D5893 G'4340

To correct for the chemical rays only Voightländer recommended:

Apochromat, Voightländer $\begin{cases} \text{F4860} & \text{4340 and h4100} \\ \text{C6560} & \text{F4860} \end{cases}$

Double anastigmat, Ser. III, Goerz.D5893 G'4340
Double anastigmat, Ser. IV, Goerz.D5893 G'4340

For the green filter the principal action is represented by the magnesium line 5170, and the apochromats should be corrected for this ray. Opticians do not specially correct for this green ray, but for orange and blue, and assume that the correction for the green will be satisfactory. For blue-violet filters, or when using plates that are sensitive only to these rays, the following considerations are worth taking into account: if collodion plates without a filter are used, excellent negatives of the blue-violet region may be obtained with the Steinheil achromatism for 4230, which corresponds with the middle of the principal action of the ordinary violet filter, with which the printing plate for yellow is prepared.

The apochromat for three-color work should be corrected for:

Orange at the Fraunhofer line. C6560
Orange at the lithium line. 6100
Green at the Fraunhofer line. $b_1$5170
Violet at the Fraunhofer line. g4230

Unfortunately the region from 6560 to 4230, which is of importance in tri-color work, is too great to be altogether corrected, even if glasses are used, which diminish the secondary spectrum; therefore the narrow correction from the orange line to the blue at 4340 must be applied. This should extend from 6100 to 4340. A better correction would be from 6560 to 4230; but practically if it extends to 4860 it is sufficient.

Two excellent process lenses were tested, by focusing for each color midway between the axis and the margin, and the aberration from the focus of the D line estimated. Both gave the same amount of aberration, but one was much worse in the red than in the violet, the other equally

as bad in the violet as the other was in the red. Practical experiments with three-color prints showed that the latter objective, which was better in the red than the violet, gave unquestionably more precise three-color prints, than that which was worse in the red than the violet, which gave a marked fuzziness of the prints.

This result will not be a matter of surprise to the expert in color-printing, for the yellow-printing plate, produced by the violet rays, is printed first and is more generally a coloration film; whilst the blue-printing plate, produced by the orange-red rays, which is printed last, gives, according to the color printer, not only the contour, but the drawing of the picture. Therefore, it is of less moment if the yellow-printing plate is less sharp if only the red and blue-printing plates are sharp and superimpose well.

The ordinary method of testing a lens for chromatic aberration by merely focusing objects at varying distances, as in the old Claudet focimeter, is not delicate enough for this work. A. Hofmann[99] suggested a scale of white lines drawn on black paper. The lines should be at least an inch long and about 1/12 of an inch wide. This test object should be pinned up at right angles to the optical axis, making the image rather large, that is very nearly full size. Focusing should be effected with the full aperture and with the red filter in position. Naturally great care must be taken to see that the copy and the camera are exactly parallel, and the camera back upright. The test object should now be covered, as to two-thirds of the length of the lines with a strip of black velvet, and an exposure made. Then the blue filter should be put into position, in place of the red, and another section of the lines covered, whilst the first should be uncovered, then the second exposure should be made; and a third with the green filter, the same operations having been gone through.

On development there will be seen a reproduction of the lines, which when examined with an eyepiece should give a very good idea of the performance of the lens, for obviously if the equivalent planes and image sizes are not the same for all three colors, one or more of the sets of lines will be fuzzy and displaced. It is clear that this assumes perfect optical filters, and it was suggested[100] that a more satisfactory method would be to make a negative of the test lines and illuminate this from behind with the three filters, as this would exclude any aberrations of the filters themselves.

Hofmann used a red filter of Tolan red and tartrazin that isolated from 5850 to 6900, with maximum visual transmission from 6100 to 6300. The green filter was acid green and naphthol green with auramin, and transmitted from 4700 to 5800, with visual maximum from 5200 to 5400. The blue was toluidin blue and the transmission from 3900 to 5100, and the maximum 4500 to 4700. The ratio of image to object was 1 : 1, that is the same size. An apochromat was tested against an anastigmat, and exposures were made through plain water, and the color filters. The dif-

ference in the focal length for the anastigmat was practically 0.45 mm., the focal length being 440 mm. In the case of the apochromat, the difference was only 0.08 mm., the focal length being 460 mm. A reproduction of the test negative is given and the apochromatic image is much superior even with the water filter, the lines being sharper, and this is particularly noticeable at 30 degrees from the axis.

A. J. Newton and A. J. Bull[101] described a camera and tests, specially designed for color work. The main points of the same are that the camera could be rotated about the second equivalent point of the lens, the plate moving with the lens. A removable bellows was fitted and the lens held in a pair of large iris diaphragms, so that any lens could be centered. The carriage, bearing the mounts, could be rotated independently of the camera, which allowed of convenient adjustment of the equivalent point to the axis of rotation. The back of the camera carried an indicator which read the focal length on a millimeter scale. The plates used were 24x2 inches. The test object was a series of pinholes, which were respectively white, red, green, blue and red. But later it was found that a slit covered with the same colors was more convenient. Chromatic differences of magnification might be obscured by oblique aberrations in lenses, that are not well corrected, but for color work the definition must be good for all colors, and then this error can be measured, as for this class of work this is an important aberration. It may be assumed that this defect is due to the lens having its second equivalent points in slightly different positions for different colors, not merely that the focal length varies with the color, then it may be expressed as d/D, where d is the separation of the red and blue light, and D the distance from the center of the image. Where this ratio is as high as 0.0001, as the error is proportioned to the size of the picture, the want of register will soon be noticed.

1. E.P. 7,514, 1908; Brit. J. Phot. 1908, **55**, 740; D.R.P. 203,110, 1907; F.P. 439,373; U.S.P. 979,129; Jahrbuch, 1910, **24**, 329.
 In F.P. 435,962, 1911, Christensen patented a projector fitted with mirrors or erecting prisms close to a double or triple image positive, successively taken, with three objectives. Mauclaire, Breon and Randabel, F.P. 453,754, 1913, also used two lenses vertically juxtaposed with an arc cut off each, so that the centers would be closer together.
 Cf. G. Poirée, Bull. Soc. franc. Phot. 1907, **49**, 61; Brit. J. Phot. 1907, **54**, Col. Phot. Supp. **1**, 21.
 2. E.P. 13,458, 1909; Brit. J. Phot. 1909, **56**, 879; F.P. 395,506; Austr.P. 37,042.
 3. E.P. 25,908, 1906; Brit. J. Phot., 1907, **54**, 582.
 4. F.P. 460,310, 1913; Phot. Coul. 1914, **9**, 90; Belg.P. 246,294, 1912.
 5. E.P. 13,510, 1912; Brit. J. Phot. 1913, **60**, 520; F.P. 444,232; D.R.P. 264,085; Phot. Ind. 1911, 1727; 1913, 1645; Jahrbuch, 1912, **26**, 241; 1914, **28**, 524.
 Cf. Société Anonyme Photographie des Couleurs, D.R.P. 215,683, 1908; Austr.P. A378; F.P. 406,049, 1909; Belg.P. 246,347, 1912.
 6. E.P. 7,756, 1912; Brit. J. Phot. 1913, **60**, 426.
 7. E.P. 10,150, 1912; Brit. J. Phot. 1913, **60**, 182; Jahrbuch, 1913, **27**, 145. In E.P. 27,207, 1912; Brit. J. Phot. 1914, **61**, 86, Bennett proposed to use two prisms with their apices together behind the lenses for projection.
 8. E.P. 24,159, 1912; Brit. J. Phot. 1913, **60**, 897; F.P. 457,192; U.S.P. 1,121,739 also shows arrangements *3* and *4* in connection with images spaced apart on the film; D.R.P. 320,718; Phot. Ind. 1920, 466; Abst. Bull. 1921, **7**, 135.

Cf. G. A. Smith, Brit. J. Phot. 1924, **71,** Col. Phot. Supp. **18,** 5; Brit. J. Almanac, 1925, 321, for a very similar arrangement. This method was called Cinechrome. Cf. C. N. Bennett and F. E. Ives, ibid. **18,** 12, 16.

9. U.S.P. 1,034,006, 1912.

10. E.P. 24,809, 1911; Brit. J. Phot. 1912, **59,** 202; F.P. 434,002; addit. 15,006; 15,048; 15,191; D.R.P. 248,188, 1910; 253,903; 253,904, 1911; U.S.P. 1,126,689; Jahrbuch, 1912, **26,** 244; 1913, **27,** 142; Bioscope, 1912, 597; Phot. Ind. 1912, 1020, 1372. Cf. C. Forch, "Der Kinematograph," Vienna, 1913, 128; Rivista Intern. Illus. 1913, 69; Phot. Korr. 1913, **50,** 391; Phot. Rund. 1913, **50,** 231. This instrument was called the Kineidochrome.

M. Audibert, E.P. 17,023, 1913; Brit. J. Phot. 1914, **61,** 106; D.R.P. 324,547; patented an improvement on the above, by replacing the prismatic element by a dividing system composed of three lenses arranged adjacent to one another. In F.P. 458,040, 1912; addit. 18,980; U.S.P. 1,124,253; Bull. Soc. franç. Phot. 1923, **65,** 169; Sci. Tech. Ind. Phot. 1923, **3,** 140; Amer. Phot. 1923, **17,** 689, Audibert proposed to use a negative front lens forming a virtual image and three positive lenses with filters, in rear of the same to form coplanar images. T. Thorier, Photo-Rev. 1920, **32,** 49; Rev. Opt. 1924, **3,** 80; Sci. Tech. Ind. Phot. 1924, **4,** 79, stated that this arrangement considerably reduced parallax, because the virtual image, taken up by the positive lenses, has but little depth of field. If f is the focus of the divergent lens all the field included between a distance d and infinity is compressed into a space practically equal to f^2/d. And calling F the foci of the posterior lenses, R the ratio of the final image to the aerial image, the distance D of the nearest point which can be satisfactorily taken is found from f/F $(2 + R + 1/R)$. The ratio system of the complete system is $1/n$ $(R + 1)$, in which $1/n$ represents the ratio aperture of the posterior lenses. It is easy by making $R < 1$ to increase the luminosity of the lenses.

11. E.P. 27,389, 1912; Brit. J. Phot. 1912, **59, 220**; F.P. 443,100, 1911; Jahrbuch, 1912, **26,** 245; 1913, **27, 147.**

12. E.P. 3,034, 1912; Brit. J. Phot. 1913, **60,** 290; F.P. 450,413; M. P. News, 1917, 295; Jahrbuch, 1914, **28,** 521. Austr. P.A. 378–12.

13. E.P. 25,142, 1912; Brit. J. Phot. 1913, **60,** 763; Jahrbuch, 1914, **28,** 523; U.S.P. 1,253,883; F.P. 464,267. Cf. E.P. 20,928, 1913 for somewhat similar arrangement.

14. E.P. 3,220, 1912; Brit. J. Phot. 1913, **60,** 69; Jahrbuch, 1914, **28,** 523; U.S.P. 1,213,184; F.P. 437,173, 1911; addit. 16,442; 18,095; 18,622; 19,355; 19,951; 384,796, 1907; D.R.P. 261,264; 274,670, 1912. F.P. 525,067; 527,132; addit. 23,941, 1919, refer to electric adjustment of the lenses from the operating booth. Cf. U.S.P. 1,454,850. In F.P. 384,795 red-orange, green and violet color sector shutters were used for projecting. In F.P. 471,474; addit. 19,364 the use of multiple arcs on a common support and cooling of the carbons was claimed.

15. E.P. 24,873; 25,161, 1912; 26,265, 1913; Brit. J. Phot. 1913, **60,** 407; 1914, **61,** 106; U.S.P. 1,223,381; 1,233,772; Bull. Soc. franç. Phot. 1919, **56,** 366; Photo-Rev. 1919, **31,** 185; F.P. 421,004; 474,061; Le Procédé, 1911, **9,** 73; Jahrbuch, 1912, **26,** 241.

16. E.P. 30,108, 1912; Brit. J. Phot. 1914, **61,** 143; D.R.P. 259,163, 1910; abst. C. A. 1913, **7,** 3087. Cf. F.P. 523,553, 1920. In F.P. 459,669, 1912, the same inventor proposed to obtain the three negatives on one film with three objectives or three mirrors with one lens, the images being side by side. Positives were toned, re-emulsified and toned or iodized and stained up with basic dyes.

17. E.P. 3,509, 1913; Brit. J. Phot. 1914, **61,** 309.

18. E.P. 11,873, 1913; ibid. 1913, **60,** 881; F.P. 444,119, 1912; Jahrbuch, 1914, **28,** 522.

19. E.P. 25,600, 1913; ibid. 1915, **62,** 518.

20. E.P. 16,867, 1914; ibid. 484; D.R.P. 321,549; F.P. 479,764; U.S.P. 1,261,800. In U.S.P. 1,304,466, 1919, two Wenham prisms were used instead of mirrors. Cf. E.P. 7,699, 1915.

21. F.P. 465,756, 1913.

22. D.R.P. 266,061, 1912; E.P. 22,796; 22,965, 1913; F.P. 463,588; Cf. F.P. 460,866; addit. 23,243, 1920. A similar design in part was granted to J. Lehmann, U.S.P. 1,214,798, 1917; 1,399,567, 1921. Cf. A. Köhler, U.S.P. 1,143,287, 1915.

23. U.S.P. 1,187,604, 1916. Cf. U.S.P. 1,143,608.

24. E.P. 7,659, 1915; Brit. J. Phot. 1916, **63,** 548. Modifications of this system were also patented in E.P. 14,722, 1915; ibid. 1916, **63,** 692.

F. S. Soudet, F.P. 466,089, 1913, also patented split and multiple condensers.

Berthon, Theurier & Gambs, F.P. 382,719, patented simultaneous projection of multiplex images by affixing to the plane posterior surface of a double plano-convex condenser, supplementary plano-convex lenses, and reflecting the outer images by mirrors and prisms to the central axis.

25. E.P. 7,660, 1915; Brit. J. Phot. 1916, **63**, 692.

J. K. Holbrook, U.S.P. 1,151,787, 1915, also used deflecting prisms near the condensers and in front of the lens.

26. E.P. 13,042, 1915.

27. E.P. 16,810, 1915; Brit. J. Phot. 1916, **63**, 236; U.S.P. 1 304,517.

28. E.P. 16,811; 1915; ibid. In E.P. 16,812, 1915; ibid. U.S.P. 1,312,088 details for the adjustment of the lenses were patented; F.P. 483,538; 483,539; 483,540, 1916.

29. E.P. 11,099, 1915; Brit. J. Phot. 1916, **63**, 601.

30. E.P. 101,972, 1915; Brit. J. Phot. 1917, **64**, 608; U.S.P. 1,454,418; F.P. 483,303, 1917, granted to Technicolor M. P. Corp.

R. Killick and H. Stewart, E.P. 173,571, 1920; Brit. J. Phot. 1922, **69**, 174; U.S.P. 1,427,131; F.P. 546,865; abst. Sci. Tech. Ind. Phot. 1923, **3**, 146, patented the same thing. Cf. E.P. 184,205 and C. Zeiss, F.P. 527,497, 1920, for a very similar idea with a front collecting lens and a lens behind the mirrors.

Separation of simultaneously taken pictures with subsequent exposure of the unexposed spaces was patented by Mazo & Tauleigne, F.P. 431,967, 1910.

31. U.S.P. 1,169,161, 1916.

32. U.S.P. 1,238,775, 1917; E.P. 110,089; F.P. 484,660, granted to Hess-Ives Corp.; Brit. J. Phot. 1918, **65**, Col. Phot. Supp. **12**, 9; abst. J. S. C. I. 1917, **36**, 1195; Annual Repts. 1917, **2**, 500; Jahrbuch, 1915, **29**, 162.

It should be pointed out that although the inventor gives the transmission and reflection figures for half-silvered glass, the percentage of the same may be altered by increasing or decreasing the thickness of the silver films to any extent, and that in thin films silver is dichroic. L. G. Morris, U.S.P. 1,216,835, 1917 had patented a gold-plated mirror for obtaining a mellow light in projection.

33. U.S.P. 1,207,513, 1916; E.P. 110,595, 1916; Brit. J. Phot. 1918, **65**, 196. Cf. E. Ventujol and L. Petit, E.P. 11,415, 1914.

34. U.S.P. 1,269,391, 1918; F.P. 533,585; abst. Sci. Tech. Ind. Phot. 1922, **2**, 76; D.R.P. 372,909.

35. U.S.P. 1,231,710, 1917; F.P. 485,249 granted to Technicolor M. P. Corp.; E.P. 127,308; Brit. J. Phot. 1917, **64**, Col. Phot. Supp. **11**, 41; Annual Repts. 1917, **2**, 501; M. P. News, 1919, 2606.

36. U.S.P. 1,280,667, 1918; F.P. 491,615; E.P. 131,422; Brit. J. Phot. 1920, **67**, 348; Col. Phot. Supp. **13**, 21. On comparison of this prism block with the mirror arrangement of Wescott (see p. 183), it will be seen that the prism is obtained by filling in the air spaces with glass.

37. P. Rudolph, D.R.P. 142,924, 1902; P. Rudolph and E. Wandersleb, Zeits. f. Instrument. 1907, 78; A. Gleichen "Theorie der modernen optischen Instrumente," Stuttgart, 1911, 275; Handbuch, 1911, **1**, IV, 133.

38. U.S.P. 1,232,504, 1917; F.P. 483,595, 1916. The incessant recurrence of these target images in every picture very soon became most irritating, as they had obviously nothing whatever to do with the picture. In *a, a'* are shown parallel glasses used for registration of the images, E.P. 104,162, 1916; U.S.P. 1,208,490. This device was used by du Hauron, F.P. 288,870, 1899.

39. U.S.P. 1,319,292, 1918; F.P. 484,012, 1917; Can.P. 183,749; M. P. News, 1917, 4060. Kunz's process was called Cinechrome.

40. U.S.P. 1,320,625, 1919.

41. U.S.P. 1,328,291; 1,328,292; 1,328,293; 1,328,294; E.P. 156,980, 1919; Brit. J. Phot. 1921, **68**, 389; Col. Phot. Supp. **14**, 25; F.P. 507,724; abst. Sci. Tech. Ind. Phot. 1921, **1**, 7; Can.P. 216,397. Cf. U.S.P. 1,341,338.

Cf. L. Horst, D.R.P. 381,531 for a very similar system; abst. Sci. Ind. Phot. 1925, **5**, 51.

42. U.S.P. 1,346,234, 1920.

43. E.P. 100,082, 1915; Brit. J. Phot. 1916, **63**, 389; Col. Phot. Supp. 1916, **12**, 21; Sci. Amer. 1916, **114**, 471, 495; F.P. 483,761; U.S.P. 1,253,138. This was also applicable to still cameras.

44. U.S.P. 1,371,970, 1921.

45. U.S.P. 1,371,969, 1921; abst. Sci. Tech. Ind. Phot. 1921, **2**, 88.

46. U.S.P. 1,351,430, 1920.

47. E.P. 143,597, 1919; Brit. J. Phot. 1920, **67**, 409; Col. Phot. Supp. **13**, 27; F.P. 498,113; U.S.P. 1,493,549.

48. D.R.P. 334,776, 1920; abst. Phot. Abst. 1921, **1**, 125; Phot. Ind. 1921, 624; Sci. Tech. Ind. Phot. 1922, **2**, 15; Amer. Phot. 1922, **16**, 529. In D.R.P. 365,787; Brit. J. Phot. 1909, **56**, Col. Phot. Supp. **3**, 72; Jahrbuch, 1910, **24**, 340 H. Isensee patented a single objective with three prisms behind so as to obtain the three images on one plane, the optical paths being equalized by blocks of glass.
49. U.S.P. 1,383,543, 1921; abst. Sci. Tech. Ind. Phot. 1922, **2**, 40.
50. F.P. 442,976, 1912; Belg.P. 254,659. Cf. E.P. 6,565, 1913, p. 000.
51. F.P. 461,248, 1913.
52. E.P. 185,161, 1921; Brit. J. Phot. 1922, **69**, Col. Phot. Supp. **16**, 4, 42; abst. Amer. Phot. 1922, **16**, 727; Conquest, 1922, **3**, 52; U.S.P. 1,456,427; abst. Sci. Tech. Ind. Phot. 1923, **3**, 146; Brit. J. Almanac, 1924, 385; F.P. 551,758.
53. D.R.P. 167,478, 1904; Silbermann, **2**, 334. Cf. Soc. Anon. Phot. Coul. Belg.P. 121,553.
54. E.P. 157,196, 1914; Brit. J. Phot. 1922, **69**, Col. Phot. Supp. **16**, 46; D.R.P. 339,480; U.S.P. 1,492,503.
55. E.P. 2,880, 1891; Brit. J. Phot. 1891, **38**, 433.
56. D.R.P. 342,310, 1915; Phot. Ind. 1921, 925; abst. Sci. Tech. Ind. Phot. 1922, **2**, 40.
57. F.P. 477,181, 1914.
58. E.P. 153,325; abst. Sci. Tech. Ind. Phot. 1921, **1**, 27.
59. F.P. 424,215, 1910.
60. F.P. 474,816, 1914; E.P. 16,487, 1914; Brit. J. Phot. 1917, **64**, 439; Belg.P. 258,408, 1913; D.R.P. 326,709; abst. Sci. Tech. Ind. Phot. 1921, **1**, 28.
61. E.P. 16,200; 16,201; 16,202, 1915; Brit. J. Phot. 1917, **64**, 223; U.S.P. 1,427,578; 1,440,004; abst. Sci. Tech. Ind. Phot. 1924, **4**, 16.
62. U.S.P. 1,429,495, 1922.
63. U.S.P. 1,424,886, 1922.
64. Brit. J. Phot. 1895, **42**, 273. Cf. S. Gill and H. Newton, E.P. 2,903, 1857.
65. U.S.P. 1,410,557, 1922.
66. U.S.P. 1,154,232, 1912.
67. D.R.P. 348,314, 1917.
68. D.R.P. 350,959, 1919.
B. Underhill, U.S.P. 1,490,751, 1924 patented the use of two, three or four rhomboidal or Wenham prisms with curved faces to fit the posterior surface of a lens, and curved faces to the posterior faces of the prisms. The constituent images were obtained side by side on one plate.
69. D.R.P. 351,305, 1920.
70. D.R.P. 359,178, 1920; Phot. Ind. 1921, 252; 1923, 226; abst. Sci. Tech. Ind. Phot. 1921, **1**, 55; F.P. 552,371.
71. D.R.P. 330,896, 1918; Phot. Ind. 1921, 373.
72. F.P. 510,260; Abst. Bull. 1921, **7**, 130. In F.P. 512,298, 1920 this inventor proposed to insert a helicoidal reflector on a helical worm behind the lens, this acting as a continuously moving mirror in synchronism with the film.
73. F.P. 549,841, 1922; abst. Sci. Tech. Ind. Phot. 1923, **3**, 144.
74. U.S.P. 1,460,706; F.P. 564,693; E.P. 212,134. Cf. E.P. 194,971; Sci. Tech. Ind. Phot. 1924, **4**, 102, 116; 1925, **5**, 28; U.S.P. 1,497,356; 1,497,357; Brit. J. Phot. 1924, **71**, 344; Col. Phot. Supp. **18**, 23; Phot. Ind. 1924, 544, 945.
75. U.S.P. 1,451,325; F.P. 557,750; D.R.P. 394,570.
76. F.P. 554,056, 1922; abst. Sci. Tech. Ind. Phot. 1923, **3**, 191; E.P. 222,948; Brit. J. Phot. 1925, **72**, 79; Col. Phot. Supp. **19**, 8; D.R.P. 393,673.
77. U.S.P. 1,458,826, 1923; abst. Sci. Ind. Phot. 1925, **5**, 28.
78. U.S.P. 1,451,774, 1923.
79. D.G.M. 757,468; Phot. Ind. 1921, 252; abst. Sci. Tech. Ind. Phot. 1921, **1**, 55.
80. D.R.P. 367,014, 1921; abst. Sci. Tech. Ind. Phot. 1923, **3**, 148; E.P. 204,745; Brit. J. Phot. 1924, **71**, Col. Phot. Supp. **18**, 15; F.P. 552,371. For notes on an exhibition by this method see Phot. Ind. 1923, 596; 1924, 340.
81. E.P. 204,636, 1922; F.P. 561,457; D.R.P. 389,448; Brit. J. Phot. 1924, **71**, Col. Phot. Supp. **18**, 15; abst. Sci. Tech. Ind. Phot. 1924, **4**, 82; Phot. Ind. 1924, 340; abst. Brit. J. Almanac, 1925, 323.
82. E.P. 209,041, 1923; F.P. 571,793; abst. Sci. Ind. Phot. 1924, **4**, 199; Brit. J. Phot. 1924, **71**, 600; Col. Phot. Supp. **18**, 40; Brit. J. Almanac, 1925, 310; Can.P. 246,015.
A. Wojcik, E.P. 202,046 patented a camera formed into separate compartments, with one lens that could be shifted as desired. D. S. Plumb, E.P. 13,038,

15

1915 patented a projection apparatus with three lenses in trefoil and low angle prisms in front of one lens for registration. E. G. Caille, F.P. 462,987, 1912 proposed to use a condenser in front of three lenses both to take and project the three images; the secondary lenses might be either horizontally superposed or in trefoil.

 83. U.S.P. 1,467,466.
 84. D.R.P. 376,988.
 85. E.P. 198,859, 1922.
 J. A. Barbe, F.P. 564,651 proposed two right-angled prisms, which were rocked to and fro behind the lens, so as to obtain stereo results in black and white or colors.
 86. E.P. 199,044, 1922; Brit. J. Phot. 1923, 70, 201; Col. Phot. Supp. 17, 47; abst. Sci. Tech. Ind. Phot. 1924, 4, 152R. Cf. E.P. 206,820; 206,821, 1923; Brit. J. Phot. 1924, 71, Col. Phot. Supp. 18, 8; F.P. 571,258; abst. Brit. J. Almanac, 1925, 320.
 87. F.P. 564,465; abst. Sci. Tech. Ind. Phot. 1924, 4, 116.
 W. M. Thomas, U.S.P. 1,313,615 patented a mechanism for varying the diaphragm apertures for each color-filter exposure. G. Ranlet, L. Ardouin and H. Vanry, F.P. 452,392 used two juxtaposed lenses with movable prisms.
 88. E.P. 162,656; 170,267, 1920. Cf. W. Bauersfeld, U.S.P. 1,519,105, 1924.
 89. F.P. 565,899; abst. Sci. Tech. Ind. Phot. 1924, 4, 146; E.P. 219,737; Brit. J. Phot. 1924, 71, 600; Col. Phot. Supp. 18, 37; Phot. Ind. 1924, 971; D.R.P. 408,560.
 90. F.P. 578,713; E.P. 211,147; abst. Sci. Ind. Phot. 1925, 5, 26.
 91. U.S.P. 1,509,936; Amer. Phot. 1925, 19, 229. This is somewhat on the lines of Brewster's patent (see p. 642).
 92. D.R.P. 399,196, 1921; abst. Amer. Phot. 1925, 19, 229.
 93. E.P. 220,328, 1923; F.P. 584,391.
 94. D.R.P. 397,654; Phot. Ind. 1924, 917. For use of sawn-off lenses see Christensen and Pfenninger. E.P. 220, 702.
 95. E.P. 153,325, 1918.
 96. U.S.P. 1,513,984, 1924.
 97. Jahrbuch, 1900, 14, 469. Cf. R. S. Clay, p. 54.
 98. Beiträge, 1904, IV, 27; Brit. J. Phot. 1904, 51, 229; Phot. Coul. 1907, 2, 126.
 99. Jahrbuch, 1905, 19, 230.
 100. Brit. J. Phot. 1907, 54, Col. Phot. Supp. 1, 42.
 101. Phot. J. 1912, 52, 91. Cf. A. S. Cory, M. P. News, 1917, 2536.

CHAPTER VI

COLOR-SENSITIVE PLATES

Early History.—It must be recognized that the photographic plate is actually sensitive to all spectrum rays and, therefore, to all colors; but the preponderating action lies in the ultra-violet, violet and blue, and so much so that, in ordinary work and under normal conditions, the plate sees only the violets and blues, and is, in common parlance, color blind to the other rays.

There is one fundamental law that applies to all chemical light changes, and this is known as the Grotthus-Draper law, and may be stated as follows: only those rays of light, which are absorbed can produce chemical action. Grotthus[1] (p. 238) was the first to announce this axiom, but it was independently stated by J. W. Draper.[2] It would take us too far afield to collate all the researches on the action of light on the silver salts, and one must be content with but a comparatively brief summary.

In 1873, H. W. Vogel[3] discovered the sensitizing action of the anilin dyes on the silver salts, and his account is given verbatim: "In the year 1873 I made photographic studies of the solar spectrum on chloride, bromide and iodide of silver films, and tested among others commercial English so-called dry plates, the films of which, in order to prevent reflection in the glass (halation), were colored yellow with a dye unknown to me. These plates showed not the slightest difference from ordinary photographic plates, when photographing colored objects; they reproduced the blue bright, the yellow and red dark. Their behavior was quite different, however, in the solar spectrum. Whilst the sensitiveness of silver bromide to the solar spectrum decreased quite gradually from blue to green, the said plates also showed a decrease, then, however, an increase in the green itself. Starting with a train of thought developed from the above, I came immediately to the conclusion that the dye, which had been mixed with the emulsion, had acted, and that the absorption of the same for the green light played a part. If a flask filled with anilin red, for instance, be placed in the path of the solar rays which fall on a prism, the yellow-green rays will be cut off by the colored solution. In consequence there is formed in the region of the yellow-green a dark stripe between the D and E lines, called an absorption band. If now, as I assumed, this absorption of light by the dye in the above mentioned experiment had any influence, it must disappear when the dye was removed. As a matter of fact, a plate from which I washed out the dye with alcohol, did not show any abnormal behavior in the solar spectrum.

"I now tried whether other dyes behaved similarly, that is to say, made

211

the silver bromide sensitive to those rays, which they absorbed. I first tested corallin. A dilute solution of this gives in the spectroscope, like anilin red, an absorption stripe between D and E, that is to say, it absorbs yellow and yellowish-green light; the blue, on the other hand, is transmitted to a considerable degree. If one allows sunlight, therefore, to pass through the corallin solution before it passes through the prism, there is wanting in the spectrum, which is thus produced, the yellow and the green. I now dissolved corallin in alcohol and added the same to my bromized collodion, so that it was colored a vigorous red. With this collodion dry plates were prepared, which were distinctly red, and which, exposed in the spectrum, confirmed my assumption, that is to say, the plates showed themselves sensitive to indigo, and from there the sensitiveness gradually decreased towards the bright blue, became weak at F, then increased again and showed themselves to be almost as vigorous in the yellow as in the indigo. Thus was found a means of preparing silver bromide plates, which were as strongly affected by a color, namely yellow, which up to this time had been considered chemically inactive, as by the indigo which had hitherto been held to be the most chemically active spectrum color.

"After this experiment I dared to hope that perhaps another substance, which vigorously absorbed the red, would also increase the sensitiveness of silver bromide for red. Such a substance I found amongst the green anilin dyes. This strongly absorbed the red rays between the lines D and C; the absorption extended with greater concentration further towards D; yellow, green and blue were transmitted almost undamped. A collodion colored with this green, proved to be, as a matter of fact, sensitive right into the red. The sensitiveness gradually decreased from the indigo towards yellow, was almost nothing in the orange, then increased and at the same place, where the above mentioned absorption band appeared, there showed a strong action in the red. From these experiments I believe we ought to conclude with tolerable certainty, that we are in a position to make silver bromide light-sensitive for any desired color, or to increase its existing sensitiveness for certain colors; it is only necessary to add a substance which will accelerate the chemical decomposition of the silver bromide, that will absorb the color in question and not the others. The existing troublesome photographic inactivity of certain colors ought then to be overcome."

Vogel proceeded to test his discovery practically, using as a test object a blue band on a yellow ground, and found a great improvement with his corallin plates, as compared with the unsensitized. But the blue still acted too strongly, and to cut down its action he inserted a sheet of yellow glass which absorbed the blue, thus obtaining a fairly correct rendering of the colors in black and white. Further experiments were carried out to determine the most favorable conditions of working. He discovered that beyond a certain strength the dye did not increase the color sensitiveness,

but actually decreased it; this being due, as we now know, to the screening action of the dye (see p. 216). Vogel also discovered that not all dyes would sensitize for the rays they absorbed, and that some dyes depressed the characteristic sensitiveness of the silver salt itself.[4] Vogel's results were confirmed by E. Becquerel[5] and J. Waterhouse,[6] who later discovered the sensitizing action of eosin.

Vogel[7] drew a distinction between "optical" and "chemical" sensitizing and thus explained the same: "A remarkable fact noted by the author (Vogel) in 1876[8] is that the absorbing dyes in question do not act on silver bromide collodion, which has been prepared with an excess of bromide. If one dips the plate, however, in a very dilute solution of silver nitrate, or in a solution of tannin or morphin, the action of the dye becomes clearly marked. Naphthalen red is, therefore, not capable by itself of making a silver bromide collodion sensitive to yellow; another substance is necessary which reacts readily with free iodine or bromine. Cyanin behaves in the same way. One is, therefore, obliged to distinguish between those substances which make silver bromide sensitive for certain rays of the spectrum, on account of their absorption bands, and the ordinary sensitizers, which produce their effect by reacting chemically with iodine or bromine. These latter sensitize the plate directly, provided they do not weaken the optical absorption of a substance which reacts with iodine or bromine. The author, therefore, named the dyes in question *optical sensitizers,* to distinguish them from the *chemical* ones. It is quite conceivable that a substance may be both an optical and a chemical sensitizer, and a careful study will undoubtedly bring to light such substances.

"It is just as conceivable that dyes may not always show the desired action in the presence of a chemical sensitizer, especially if the dye tends to decompose the sensitizer. The action of the dyes is extraordinarily different with different kinds of plates, even though the silver halide be the same. The effect is strongest with dry silver bromide collodion plates. All the experiments referred to were made with dry silver bromide collodion. Many dyes, such as methyl violet and cyanin, work admirably with dry silver bromide; but have little or no action on wet silver bromide films moistened with silver nitrate solution. Entirely different is the action on the modern gelatin plates. In these the silver bromide is quite different in nature, and its behavior is correspondingly different. Gelatin itself ranks as a weak chemical sensitizer whose presence is just as necessary for the action of the optical sensitizer as is silver nitrate or morphin, in the case of the silver bromide, which is sensitive to the violet. Here also it is surprizing that methyl violet and fuchsin have only a very slight action on silver bromide gelatin, whereas they are very effective in making a silver bromide collodion plate sensitive to the yellow. With all these optical sensitizers the effect was in complete harmony with the theory given, that they made the photographic film, and especially the silver bromide

one, sensitive to those rays which they themselves absorbed. In connection with this, the author (Vogel) has noticed that many dyes not only increase the sensitiveness for the rays they absorb, but they also decrease the sensitiveness for the more refrangible rays. This is marked with fuchsin.

"Here the yellow sensitiveness of silver bromide dyed with it is distinctly greater than the sensitiveness for the blue, which is ordinarily much the greater. The sensitiveness of the dyed plate to the blue is less than that of the undyed plate. With the other dyes the increased sensitiveness for the absorbed rays also goes hand in hand with a decrease in the sensitiveness of the adjacent more refrangible rays. Thus silver bromide, dyed with naphthalen red, is much more sensitive to the blue-green, lying next to it in the spectrum, than is pure silver bromide. A similar result is to be noted with rosanilin picrate and aldehyde green[9]. Further investigations by the author (Vogel) established the fact that all three halides were themselves slightly sensitive to the less refrangible rays. This had not been noticed before, because people had exposed the plates for much too short a time. With long exposures, however, the sensitiveness of these substances extends into the red of the solar spectrum, with silver bromide even beyond that and into the invisible infra-red, so that the author was able to photograph the infra-red rays.[10] Consequently the addition of the dyes really *increases* the color-sensitiveness of the photographic film instead of causing it."

Eder has paid considerable attention to this particular subject[11] it being only possible to sum up the main conclusions of his work, and his views may be considered as practically accepted at the present time. The conclusions arrived at are:

1. The dye must stain the silver halide grain;

2. Dyes which vigorously sensitize are all so-called substantive dyes, that is to say, they color substances direct, and probably by molecular attraction. Staining of the silver halide grain is no proof of color-sensitizing;

3. A dye sensitizes for those rays which it absorbs, or more correctly for those rays which the dyed silver halide absorbs;

4. The maximum of sensitiveness lies about the same position as the maximum absorption of the dye, with a general shift towards the red. More correctly stated the maximum sensitiveness agrees with the maximum absorption of the dyed halide;

5. Dyes with narrow, intense absorption bands generally give narrow, intense sensitizing bands, and those with broad, ill-defined bands give broad, ill-defined stretches of sensitiveness;

6. The brilliancy of color of the dye has no special influence;

7. Neither the fugitive character of the dye, nor its fluorescence, have any action on the color-sensitizing properties.

Theoretical Considerations.—Von Hübl[12] dealt with the behavior of dyes with silver bromide and stated that if an aqueous solution of silver nitrate was precipitated with excess of soluble bromide, and part of the silver bromide be washed with silver nitrate, two kinds of salts were obtained, which he termed respectively *Br* and *Ag*, the latter being that treated with silver nitrate, the former that precipitated with excess of bromide. If these were washed with eosin solution, it would be found that the *Ag* compound would be intensely colored, while the other appeared undyed, if the salts were repeatedly washed with alcohol or water to remove excess dye. Solution of silver eoside stained both, and this coloration was removed by treatment with a soluble bromide. The presence of free bromide, therefore, prevents the staining of silver bromide with eosin. If eosin be added to a collodion emulsion, containing free bromide, and it be exposed damp to the spectrum, there will be found no sensitiveness in the yellow-green, whilst this immediately appears if the excess of bromide is removed with silver nitrate.

If the two kinds of silver bromide are washed with alcoholic solution of cyanin, the *Ag* variety turns an intense grey-blue, while the *Br* becomes a bright rose-red. If a solution of a bromide or silver nitrate be applied, the blue *Ag* is decolorized. These facts are in agreement with the known facts of cyanin-sensitizing. Collodion emulsions, which contain *Br* silver bromide, can not be sensitized with the cyanin in the presence of chemical sensitizers; but if a trace of silver nitrate be added the orange sensitiveness appears; but if a small excess of silver nitrate be present then the color-sensitiveness disappears. A similar behavior is found with quinolin red. Dry gelatin, and perhaps dry collodion emulsion, films behave differently in this respect for cyanin, for then it sensitizes in the presence of the *Br*. The conclusions to be drawn from these facts are: 1, that for a dye to act as a sensitizer, it must stain the silver bromide grain, or be in intimate solid connection therewith, the presence of the dye in the vehicle is not sufficient; 2, the compound of the dye with the silver bromide ought in most cases to be ascribed to molecular attraction.

Von Hübl[13] also recalled Eder's early statement that for a dye to sensitize, it must stain the silver salt itself, and experimentally proved that this was correct; but his results were questioned by Lüppo-Cramer, therefore, the subject was again examined. Silver bromide was precipitated with excess of bromide and stained up with dyes, then the dyes used in the same ratios for collodion emulsion, and their sensitiveness ratios for the less refrangible rays compared to that for the blue-violet. It was found that alcoholic solutions of dyes had but little effect; the addition of water increased this. In the presence of silver nitrate a high ratio was obtained, and ammonia completely destroyed any color-sensitiveness. Soluble bromides enormously reduced it and chlorides had less action. The suggestion was advanced that the different action of the dyes might

be accounted for on the modern theory of dyeing, that is the formation of solid solutions of the dyes in the silver bromide. It was proved that there is some intimate connection between the power of a dye to stain silver bromide and its color-sensitizing, and that all circumstances that altered the staining intensity also influenced the sensitizing.

A. and L. Lumière[14] called attention to several matters that are often neglected in the examination of dyes for their sensitizing properties. Dyes are often sold under the same name, though differing entirely in composition; and that they are frequently impure, containing some of the reagents used in their preparation, together with isomeric substances, which may exert unexpected action. Further that they may contain indifferent substances, such as dextrin, sodium sulfate, etc., which are added to increase weight or to bring them to a given colorimetric power. The action is dependent, too, on the composition of the sensitive film, that is to say, the ratio of silver bromide to iodide, and the molecular condition of the silver salt. There may also be free bromide in the film, or other additions that affect the result. In examining over one thousand dyes, all these factors were taken into account in the endeavor to obtain some general law as to the action.

They first observed, as was well known, that too concentrated solutions of the dyes acted as screens by staining the vehicle. It was also known that some dyes have great tinctorial power, while others have less; for instance, ethyl violet sensitizes in a strength of 1 : 500,000; whilst the phthalein dyes require a much stronger solution. The sensitizing action does not correspond with the absorption, but it appears to more nearly coincide with the absorption of the dyed silver salt. This difference may be accounted for by the fact that the dye acts as a filter, and this physical action is the reverse of the local sensitizing action, which may be ascribed to chemical action or a combination of the dye with the silver compounds. According to the concentration of the dye, it is easy to see that these two opposing actions may give very different results. It is, therefore, of importance to use only such sensitizers as act in very small quantities. These have the advantage that they do not lower the general sensitivity and it is only possible by the use of such dyes to use different ones for the same emulsion to complement the individual action.

Most of the dyes used in orthochromasy are commercial dyes, designed primarily for dyeing materials and to give stable colors, that can be washed, etc. These requirements play no part in color-sensitizing. There are a great number of dyes that are useless for ordinary dyeing, and are, therefore, not obtainable commercially, which have not been tested. It was found that dyes obtained by the condensation of the organic acids with resorcin in the form of their chloride, bromide, iodide, succinate, benzoate, tartrate, citrate, oxalate and other salts, or the dyes obtained with the condensation of the same substances with m-aminophenol and its homo-

logues, dihydroxy- and aminophenols, substituted in the meta position, gave excellent results.

A survey of the results did not prove that there was any particular connection between their chemical constitution and their sensitizing power. In spite of all experiments it was not found possible to find a sensitizer for the blue-green rays, and this might be explained by assuming that the sensitizing action corresponds to the absorption of the dyed silver salt, and it is possible that as the silver combines with the dye and confers on the compound its characteristic properties, that it is not possible to find an orange-colored silver salt which is complementary to blue-green.

Von Hübl[15] reviewed the older methods of sensitizing and considered that ethyl violet was a great advance. It was specially interesting because of its great light-stability, which proved that the fugitiveness of a dye plays no part, but the dye and silver compound is the factor. The newer isocyanins are all fugitive dyes and sensitize for those colors which are complementary to the dyed silver salts and to the adjacent regions. Thus a purple-red dye sensitizes not only for green, but also for the yellow- and blue-green. So far dyes have not been discovered that will sensitize for the whole stretch from blue to red, and choice must be made between those that sensitize from blue-green to orange and those from green to red.

Von Hübl[16] also examined the absorption and sensitizing spectra of the old and new cyanins and came to the conclusions: 1, that aqueous and alcoholic solutions contain the dyes in different form. They can be distinguished by their color, as the aqueous solutions are always more reddish than the alcoholic, and the former will run almost colorless through a paper filter. The different color is not due to the difference in dispersion of the solvent, for both show the same absorption bands, but their intensities are different. The difference is noticeable when the dyes are in solid media, and one can thus tell whether an aqueous or alcoholic solution was used. 2, The sensitizing power corresponds to the absorption spectra in the solid state. With gelatin plates the alpha band predominates, the minimum between this and the individual sensitiveness of the plate is smaller than with collodion. The displacement of the two bands, by about 100 Ångstrom units, can be explained by the screening action, or one must assume that the dye reacts chemically with the silver salt, and that a colored substance with another absorption spectrum is formed. 3, The disappearance or lag in sensitiveness, corresponding to the alpha band appears to be connected with the absorption of the dye adhering to the silver bromide. It was found that in aqueous solutions the cyanins showed the strongest absorption band at 5600, and this he called the beta band; whilst in alcohol the strongest lies about 5800, and this he called the alpha band.

Probably the close connection between absorption and sensitizing properties is best shown by some curves given by Meggers & Stimson[17], Fig. 105, for if the transmission curves be inverted and shifted towards the

red, they will be found to almost coincide with the sensitiveness curves.

An examination of the dyes that have been found to be sensitizers will at once prove that they belong to many families, and it would be not only interesting but valuable from a practical point of view, if one could find some connecting link between them, or some particular grouping of elements to which one might ascribe the sensitizing properties, and although little work has been done on this question, except with the isocyanins, to

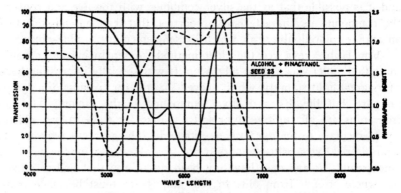

Spectral transmission and photo-sensitizing of pinacyanol.

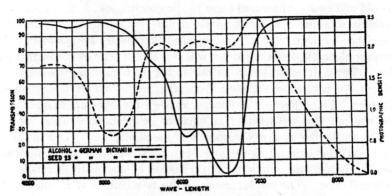

Spectral transmission and photo-sensitizing of German dicyanin.

Fig. 105.

which reference will be found under that heading, it would seem, according to A. & L. Lumière and A. Seyewetz[18] there are "sensitizing groups" in each class of dyes; but not one common to all. These experimenters pointed out that the active dyes belong to practically six families. Of course, it will be understood that this applied to 1898, the date of their paper. It must be admitted that there is one group that confers the sensitizing power, and it will be found that the one common to each family is the so-called "chromophoric group."

Eder had stated that the maximum effect of the color-sensitizer although not coincident with the maximum absorption of the dye itself, did correspond with that of the dyed silver salt. J. J. Acworth's experiments[19] led to the conclusion that this was not correct, but von Hübl[20] proved that Eder's view was sound and that the seemingly contradictory results by others were due to the screening effect of excess of the dye, which reduced the sensitiveness and altered the curves.

W. Abney[21] contended that oxidation of the dye was an important factor. But C. H. Bothamley[22] found that the less refrangible rays would produce an image on color-sensitized plates even when they were immersed in powerfully reducing solutions, such as pyrogallol and sodium sulfite, during exposure. This held good for cyanin, the eosin dyes, rhodamin and quinolin red, whether the dyes were added to the emulsion or applied as a bath. It is, therefore, impossible to attribute the sensitizing effect to any intermediate oxidation of the dye. Other experiments seem to show that the chemical nature of the latent image produced by the less refrangible rays on the specially sensitized plates was precisely the same as that on the unsensitized ones. The order of the fading of the dyes, when exposed by themselves, did not correspond with the sensitizing effect.[23] Eder painted a plate with cyanin solution[24] that had been exposed to light for a year and was presumably fully oxidized, as it was quite brown, and found no action.

E. Stenger[25] examined the color-sensitiveness and the connection with the thickness of the film, and came to the following conclusions: 1, the characteristic sensitiveness of gelatin plates is practically independent of film thickness; 2, color rendering is hardly influenced by the thickness; 3, with increasing film thickness the color sensitiveness increases, compared to the characteristic sensitiveness; 4, thick films in conjunction with prolonged development do not, as is generally assumed, compensate for underexposure; 5, thin and thick films work softer than normal ones; 6, thin films solarize faster than thick ones; 7, the possibility of producing practically useful thick films is limited by the time of drying in manufacture.

G. Eberhard[26] dealt with sensitizing with mixtures of dyes and pointed out that it was important that the dyes do not chemically act upon one another, in the form of simultaneous decomposition and decolorization, nor act physically and mutually precipitate, nor must they cause fog. Further that they must give practically equal sensitiveness to the different regions of the spectrum, and the absorption curve of the one must not coincide with the sensitiveness curve of the other.

To elucidate the question of the quantity of the dye V. Schumann[27] added ammoniacal erythrosin solution from 1 : 170,000 to 1 : 3,500 and found that with the lowest concentration the ratio of the blue to yellow sensitiveness was as 1 : 2.5, whilst with the strongest it was 1 : 5, so

that increase of dye increased the total and yellow sensitiveness, particularly the latter, which was obviously due to the screening action.

E. Stenger[28] made a long series of experiments as to the continued heating of panchromatic plates and concluded that panchro plates of medium speed increase in sensitiveness 2.5 times by heating for 24 hours to 42° C. The increase extends over the whole spectrum. The sensitiveness for green and orange increased more than for blue, therefore, there was better filter ratio. The increase is permanent within practical limits, and is not dependent on whether the plate is exposed warm or cold, or whether the development is done at once or deferred.

The Addition of Alcohol to the Dye Bath.—H. W. Vogel[29] was probably the first to suggest a comparatively large quantity, 30 per cent, of alcohol in the dye bath. G. Selle[30] recommended 40 per cent. O. Ruh[31] suggested 20 per cent of ethyl alcohol with the eosin dyes. The Farbwerke, vorm. Meister, Lucius & Brüning,[32] advised the addition of alcohol in large proportions to isocyanin solutions, as the plates dried quicker and were freer from spots and stains.

Incidentally it may be mentioned here that these particular dyes do not form true solutions in water, only colloidal suspensions[33] and exhibit, therefore, a great tendency to flock out in the baths, though this is more noticeable with sensitol red (pinacyanol), pinachrom and sensitol violet. In fact if an aqueous solution of these dyes be passed through an ordinary filter paper or pledget of absorbent cotton, the solution will run through practically colorless, and the whole of the dye will be found on the filtering medium. This explains, therefore, the tendency of these dyes to give streaks and other marks, as they flock out on the surface of the plates, giving rise to localized fog, streaks, etc. There is, however, a very serious drawback to the use of large ratios of alcohol, as the color-sensitiveness is appreciably diminished. S. E. Sheppard[34] found that the addition of 25 per cent of alcohol, in the case of pinacyanol, reduced the sensitivity to less than one-half.

E. Valenta[35] stated that plates bathed with the isocyanins in equal parts of water and alcohol would dry in a warm place in 10 to 15 minutes; but unfortunately such plates showed less color-sensitivity and the minima were more marked. The quantity of alcohol should not exceed 40 per cent. Methyl is better than ethyl alcohol, and acetone is the best and may amount to 50 per cent of the bath.

Von Hübl[36] summed up the various methods of bathing plates. All the panchromatic sensitizers, the isocyanins, can be used in aqueous solutions, though with pinachrom violet the addition of 20 to 30 per cent of alcohol is advisable. König[37] recommended that plates sensitized in aqueous baths be washed for 2 minutes in running or frequently changed water, but the film of dye that separates out on the film surface, and which is the cause of fog and spots, is completely insoluble in water, and can not be removed

by water, and numerous experiments have proved that the washing may be omitted. The red sensitizers absolutely require about 30 to 50 per cent of alcohol in the baths. Stock solutions of the dyes should be made 1 : 1000 in alcohol and these will keep indefinitely in the dark. For panchromatizing the following quantities of the stock solutions should be added to 1000 ccs. of water or 334 ccs. alcohol and 666 ccs. water, homocol, ethyl red, orthochrom T, pinachrom and pinachrom violet 20 ccs.; pina-verdol and isocol 30 ccs. For the red sensitizers, pinacyanol 13.3 ccs., water 666 ccs., alcohol 334 ccs.; pinachrom blue 13.3 ccs., water 600 ccs., alcohol 400 ccs.; pinacyanol blue 13.3 ccs., water 500 ccs., alcohol 500 ccs.; dicyanin 30 ccs., water 566 ccs., alcohol 434 ccs. To every liter of bath should be added 10 ccs. of cold saturated solution of borax or 16 drops of ammonia. In the case of erythrosin 66.5 ccs., water 1000 ccs., ammonia 16 drops.

According to König 1 liter can be used for 6000 qcm. with the aqueous baths; but with the alcoholic baths from 7200 to 9000 qcm. may be sensitized with the same quantity and the bath can be strengthened by the addition of more dye. The precipitation of the dye may be completely overcome by immersing the plates after bathing in 90 per cent alcohol for one minute and then drying. König[38] also recommended a process of bathing without alcohol, based on a method suggested by W. E. Debenham in 1894. The plate is first bathed in an alcoholic solution of the dye, which may be carried out in red light, as no sensitization takes place, the plate is then dried and placed for a short time in water, which induces color-sensitiveness. A 5 per cent solution of the stock dye solution should be used for this and the time of alcoholic bathing need be but a minute or so. The plates dry in 5 minutes. This process is only applicable with the panchromatizers, soluble in water. Pinachrom gave a sensitiveness of $v=0.25$. The red sensitizers do not act well, pinachrom violet giving $v=0.07$ and pinachrom blue $v=0.03$; pinacyanol is an exception; this gave $v=0.17$.

Weissenberger's method of decolorizing the dye baths with acetic acid may be used and has the advantage that the color sensitivity is not produced till the plates are dry, or the acid has evaporated. From 20 to 30 ccs. of the stock dye solution with 3 drops of acetic acid should be added to 1000 ccs. of water. This process gives very clean plates, but care must be taken as the plates dry very quickly, becoming then color-sensitive.

In a later paper von Hübl[39] gave some figures as to the color sensitiveness obtained with various additions of alcohol.

50 per cent alcohol...........................$v=0.07$
25 per cent alcohol...........................$v=0.23$
10 per cent alcohol...........................$v=0.23$
No alcohol$v=0.26$

These results were with pinachrom, ethyl red, pinaverdol and pina-chrom violet. With pinacyanol 25 per cent of alcohol gave $v=0.33$, without alcohol $v=0.12$. With erythrosin alcohol lowered the color-sensitiveness.

P. Thieme[40] considered treatment of plates with alcohol dye baths and was of the opinion that whilst long washing was advantageous, the gelatin absorbed so much water that it took too long to dry. He recommended, therefore, the rinsing of the plate with alcohol, after bathing; this removed surface water and cleared the gelatin from surface dye. The plates thus dried quickly and the addition of alcohol to the bath is unnecessary. Plates thus treated dry in about an hour and a half. For many dyes the period of drying can not be curtailed, as in the case of wool black, which requires that the plates remain moist for about 6 hours for the full effect of the dye. Comparative experiments were made with plates sensitized for 2 minutes in an aqueous bath and immersed in an alcohol bath for 5 minutes, as to one half, the other half being merely rinsed with alcohol. Both halves were exposed together and in the half soaked in alcohol there was distinctly less action. In another case half the plate was rinsed in alcohol and the other allowed to remain 30 minutes and then deprived of its water, no difference was discoverable. The conclusions come to were that the best process is to use aqueous dye baths, and rinse with alcohol, using two baths, the first for removal of the excess dye, the second for removal of the drops of the dye solution. For special quick drying, an aqueous bath should be used, the plate allowed to remain moist for 30 minutes, then bathed in alcohol for about 5 minutes.

The Addition of Ammonia to the Dye Bath.—Probably the majority of baths recommended contain more or less ammonia, and the action of this has always been a moot point. It is an open question whether this is added to give increase of general or color-sensitiveness. Certainly its use is frequently accompanied with increase of fog, above all with a lower keeping power, and it has not been proved, except in individual cases, that there is actual increased color-sensitiveness. It is advisable to omit the same unless the plates are to be used at once. Naturally if extreme sensitivity is required, then, assuming that one can use the plates at once, it is permissible to employ any means to attain the desired end. The author carried out a long series of experiments with various dyes, in various strengths, with and without ammonia, and found that where there was so-called increased color-sensitiveness, there was also increased general sensitivity, and that if the ratio of the blue to the color-sensitiveness was taken into account, there was practically no increase in the same. In these experiments this ratio was determined by the methods outlined by Sheppard & Mees[41] using selective filters and the Hurter & Driffield sector wheel. These experiments proved that there was an increase of chem-

ical fog noticeable in two days, and that while this increase was at first slow, it rapidly increased with time. In some cases, with the isocyanins especially, in less than two weeks the initial fog of the bathed plate had increased from 0.17 to 0.43, and in one month to 0.98, in six weeks to 2.1. In these tests the sensitized material was kept in an airtight receptacle at about 5° C.

Lüppo-Cramer[42] used for some experiments on this subject fast erythrosin plates and found that there was actual increase of speed when ammonia was used; but the test object was a color chart and no numerical results could be given. To prove that it was not merely the alkalinity of the bath, analogous experiments were made using potassium carbonate and in this case, neither with erythrosin, which is an acid dye, nor with pinachrom violet, which is basic, was any increase of speed detected. In fact, there was reduction of sensitiveness and Lüppo-Cramer came to the conclusion that the increase of color-sensitiveness was due to the solvent action of the ammonia on the silver halide, without actual ripening, quâ ripening, taking place.

As bearing on this point von Hübl[43] pointed out that as a rule ammonia is quite superfluous, and in any considerable ratios is prejudicial as it induced fog. The isocyanins are very sensitive to acids and then one or two drops of ammonia to 100 ccs. is permissible. The following figures prove the little action of ammonia:

Orthochrom, without ammonia.....................$v=0.30$
Orthochrom, with ammonia......................$v=0.33$
Pinaverdol, without ammonia....................$v=0.32$
Pinaverdol, with ammonia.......................$v=0.26$
Pinacyanol, without ammonia...................$v=0.33$
Pinacyanol, with ammonia......................$v=0.32$

Instead of ammonia it is far better to use a little borax, about 1 per cent of a cold saturated solution. This neutralizes any acidity and does not cause fog.

G. Eberhard[44] explained the action of ammonia as due to the solvent action. He stated that in order to save time he prepared a number of glycin red plates in a dish containing 300 ccs. of dye solution, in pairs. The first two plates were clean, but the others were flat and foggy; the same result was obtained with eosin. Further trials were made with chloro-bromide and chloride plates, and some of the silver salts were found to dissolve. From this he concluded that the greater sensitiveness was due to the solvent action of the ammonia. It is not quite legitimate to argue from the action of ammonia on the chloride emulsions, as this salt is notably soluble in ammonia.

Lüppo-Cramer would assume an etching effect on the silver halide grain surface, which would produce a greater tendency to absorption of the dye, and there might also be on the grain surface an "intergranular

ripening" with inclusion of the dye. To prove whether the solvent action did play any part, experiments were carried out with sodium sulfite and potassium sulfocyanide, which are solvents of silver halides, and these were found to prevent color-sensitizing. On the other hand K. Kieser[45] stated that the addition of comparatively large quantities of ammonia prevented the sensitizing with acid dyes, and their action only appeared with very low concentrations and keeping the dye ratio constant.

When it comes to deal with the isocyanins, we have other conditions to consider. These dyes are extremely sensitive to acids, and are more or less instantly decolorized by the same. So sensitive are they that they will be decolorized by the small amount of carbonic acid in distilled water. But even in this case the quantity of ammonia should be restricted to the lowest possible amount, not more than 2 drops to 100 ccs. of the bath. Borax is much better than ammonia, as it affects the keeping qualities of the plates less. This can be used in the ratio of 0.2 per cent. Equally as effective is anilin water, made by shaking anilin in distilled water till saturated. The solubility of anilin is about 3.25 per cent, and of this solution about 20 per cent should be used in the bath. Renwick and Bloch recommended quinolin.

The Wet Collodion Process.—Ducos du Hauron[46] employed first of all the wet collodion process, sensitizing the plate for the red filter with chlorophyll, obtained from ivy leaves; that for the green filter being sensitized with 0.4 per cent aurin in the collodion, which was a pure bromized, 3 per cent cadmium bromide, with a 20 per cent silver bath. The green-sensitive plate was also washed, then immersed in a preservative of 0.5 per cent solution of gelatin plus the same quantity of sodium carbonate and a little aurin. The plate for the violet filter was either used plain, or the aurin collodion might be used. Later,[47] after Waterhouse's discovery of the action of eosin, he employed this. This had the advantage that the dyed collodion could be used for all three plates, and it was immaterial whether the plates were wet or dry, that is, if treated with some hygroscopic substance, they would keep one or two days. The eosin collodion was made as follows:

Cadmium bromide 30 g.
Pyroxylin 10 g.
Ether 62°600 ccs.
Alcohol 62°400 ccs.
Yellowish eosin 1.5 g.

The eosin was powdered, added to the collodion, well shaken and filtered, as there was always a precipitate, or it could be allowed to stand for some days. The silver bath was a 20 to 24 per cent solution, acidulated with nitric acid, the quantity of this latter being determined by the temperature. The collodion was coated rather thickly and sensitized **for**

from 4 to 8 minutes. If the plate was used soon after silvering, that is within 2 or 3 hours in winter, or 15 minutes in summer, it was washed with a 1 to 2 per cent solution of silver nitrate. After exposure the plates were well washed to free them from excess silver and developed with an alkaline developer, with preferably immersion in a 30 per cent solution of potassium bromide, saturated with silver bromide[48] after which the plates were rinsed. After drying the negatives were washed with alcohol to remove the eosin, thus rendering printing easier. If the plates were thoroughly washed after sensitizing, then treated with tannin, they might be used as a dry plate.

Chas. Cros[49] also dealt with this subject, but whether ever more than theoretically has not been determined. His work, begun in 1869, was directed to finding sensitizers. He tried chlorophyll, tincture of black currants preserved in brandy, aqueous extract of marsh mallow flowers, alcoholic tincture of carthamin, also curcuma, and an aqueous extract of bullock's blood.[50]

H. W. Vogel[51] suggested the following method: the glass should be substratumed with a 3 per cent solution of gelatin plus 0.04 per cent of chrome alum. When dry collodionized with:

Pyroxylin 15 g.
Alcohol-ether 750 ccs.

To which was added after solution:

Cadmium bromide 16.6 g.
Alcohol 250 ccs.

Or if a thicker film, which was sometimes advantageous, was desired then the cadmium should be increased to 20 g., and the pyroxylin to 19 g. To the above should be added:

Yellowish or bluish eosin...................... 0.16 g.
Alcohol 55 ccs.

The mixture allowed to stand for an hour or two and then filtered. The silver bath was:

Silver nitrate 100 g.
Distilled water 1000 ccs.
Calcium iodide, 1 per cent sol............... 26 ccs.
Glacial acetic acid 12 drops
Alcohol 30 ccs.

Only enough acid should be used to make the bath faintly acid, as too much threw down the bromofluorescein, which does not sensitize so strongly as the eosin. The further treatment of the plate did not differ from ordinary practice.

Vogel[52] pointed out that in consequence of the silver bath becoming loaded with organic matter from the dye, the plates were very likely to show crescent-shaped markings near the edges; but these could be avoided by vigorous movement of the plate in the bath; but the addition of 2 to 3 per cent of alcohol was of great assistance, as these markings were caused

16

by the stained collodion repelling the bath more decidedly than usual. The best remedy was a second bath after exposure, which he called the "development bath," this was:

Silver nitrate 100 g.
Calcium iodide, 1 per cent sol................ 26 ccs.
Ammonium nitrate 200 g.
Water1000 ccs.
Nitric acid, sp. gr. 1.22......................8–10 drops

The plate should be moved up and down in this for from 5 to 10 minutes, then well washed free from silver and developed. Vogel[53] also used silver eoside, which was discovered by Bayer[53] and with this no yellow filter was required. To make the eoside, 1 g. yellow eosin should be dissolved in 360 ccs. alcohol and 1 g. eosin in 300 ccs. collodion, containing 2 per cent pyroxylin, and the two solutions allowed to stand in the dark to settle. Cadmium bromide 2 g. should be dissolved in 30 ccs. of the alcoholic eosin solution and added to 90 ccs. of the eosin collodion, this should be kept in the dark. After coating, the plate was sensitized in a bath of:

Silver nitrate 137 g.
Alcohol 41 ccs.
Turpentine 0.14 ccs.
Distilled water1000 ccs.

For 6 to 7 minutes, then drained and immersed in a bath of 6.85 per cent silver nitrate, slightly acidulated with nitric acid.

Eder[54] gave the following method:

Yellowish eosin1.72 g.
Cadmium bromide3.43 g.
Alcohol 400 ccs.

Shake well, filter and add to:

Collodion, 2 per cent.........................600 ccs.

The plate was to be edged with rubber, sensitized in a 20 per cent silver solution, acidified with nitric acid, for 5 to 7 minutes, then immersed in a 2 per cent solution of silver nitrate for 2 minutes, which washed off the impure bath, and prevented crystallization of the silver on the film during exposure. The exposure was about eight times longer than with the normal wet plate. Ferrous sulfate was the developer used. Erythrosin was also used by Eder;[55] 0.03 to 0.1 g. erythrosin, 0.5 g. ammonium bromide and 1.5 g. cadmium bromide were dissolved in 30 ccs. alcohol and added to 4 times the volume of 2 per cent collodion. The silver bath contained 20 per cent nitrate and alcohol, with nitric or acetic acid. After exposure the plate was dipped into 10 per cent solution of silver nitrate, slightly acidified with nitric acid, then developed as usual. This process was said to obviate the use of a yellow filter.

W. T. Wilkinson[56] proposed the use of a 2 per cent celloidin collodion, containing 1 per cent zinc bromide, allowing to stand for a week, then decanting. A neutral 2 per cent silver bath was to be used, the plate

drained and immersed for 2 or 3 minutes in a 0.25 per cent solution of erythrosin plus 2 per cent ammonia. The plate should be washed before development. Later he suggested 3.33 per cent of zinc bromide, and sensitizing with 15 per cent of silver, acidified with nitric acid. The plate was then washed and immersed in:

Erythrosin	1 g.
Cyanin	0.25 g.
Ammonia	1 ccs.
Distilled water	1000 ccs.

For 3 minutes and developed immediately after exposure with any alkaline developer. He also suggested the addition of 17 ccs. of a 1 : 1000 solution of orthochrom T.

H. Calmels and L. P. Clerc[59] gave the following process:

Alcohol, 96 per cent	100 ccs.
Cadmium bromide	20 g.
Eosin, 5 per cent alc. sol.	25 ccs.

Dissolve and add:

Alcohol	300 ccs.
Ether	535 ccs.
Pyroxylin, high temperature	14 g.

Or add to

Ether	175 ccs.
Collodion, 20 per cent	700 ccs.

The plate should be edged with rubber and sensitized in 16 per cent silver solution, containing 3 per cent alcohol and a few drops of acetic acid. After exposure and before development the plate should be immersed in a 1.2 per cent solution of silver nitrate, acidified with nitric acid, for 3 minutes, then be developed and fixed as usual.

A. Payne[60] proposed what is actually an emulsion process. The glass should be substratumed, then collodionized with a 0.2 per cent bromide salt, sensitized in 16.7 per cent silver solution for 5 to 10 minutes, till a rich creamy film was obtained. After removal from this bath the plates were immersed in distilled water for at least 5 minutes, and this washing repeated five times, the plate being left in the washing tank till required for use. Sensitizing might be effected with any of the usual dyes, preferably a 1 : 50,000 alcoholic solution being used. For the minus-yellow negative a 0.5 per cent silver solution might be flowed over. For the minus-red plate it should be flowed over with a solution of:

Yellowish eosin, 1 per cent alc. sol.	50 ccs.
Silver nitrate, 2 per cent sol.	50 ccs.
Alcohol	1000 ccs.

A precipitate of silver eoside would form, and this should be dissolved by the careful addition of ammonia.[61] Plates must be washed after exposure, prior to development.[62] For the blue-printer an alcoholic solution of pinacyanol should be flowed over the plate, and the dyed plate washed

under the tap for 2 or 3 minutes before exposure. Any developer, suitable for collodio-bromide emulsion, might be used, but that found very suitable was:

Hydroquinon 50 g.
Sodium sulfite, dry........................ 50 g.
Potassium carbonate 100 g.
Potassium bromide 25 g.
Distilled water1000 ccs.

For use mix 1 part with 4 parts water.

Color-Sensitive Emulsion.—Collodion emulsion still finds some adherents for tri-color work, especially for photomechanical purposes. Whether there is any advantage in its use in the face of the excellent gelatin plates now obtainable, is an open question. Certainly for those who have had no experience in its working it can not be recommended, as there are many pitfalls. Absolute cleanliness is essential, and freedom from dust, which is one of the chief bugbears, as this causes spots which are difficult to eradicate. The film is also very tender, and the novice is very apt to damage the same.

As regards illumination of the dark room the same precautions must be observed as when working color-sensitive gelatin plates.

The making of a collodion emulsion is not a difficult matter, if the following directions are carefully followed. They are those given by von Hübl[63] as his method has been found to be the simplest and most reliable. It is not advisable to attempt to manufacture the pyroxylin. It is a delicate process and not worth the trouble in the face of the excellent commercial articles obtainable. The so-called high temperature pyroxylin should be used, though the most satisfactory are those specially purified forms, such as necol, celloidin, etc., sent out in shred form. Whatever pyroxylin is used it is important to see that it gives a collodion of the proper viscosity, which should be about 1.60. This can be determined by a simple viscosimeter, devised by von Hübl, which consists of a glass tube about 15 cm. long, with 3 cm. internal bore. About 1 cm. from one end should be made a diamond mark, large enough to be easily seen, and the other end should be drawn out to a point with a hole of about 1 mm. aperture.

To use this, the small hole should be closed with the finger, the tube filled with water at 18° C., and with a stop watch the time noted that the water takes to run out; the mean of six runs should be taken. The tube should then be thoroughly dried, filled with the collodion up to the diamond scratch, and the time for this to run out taken. Then by dividing the time taken by the collodion by that taken by the water will give the viscosity. For instance, with a given collodion, the time was 190 seconds and the time for water was 87 seconds, then 190/87 gives 2.18, the viscosity for that particular sample.

If an ordinary collodion be used, it is important to see that there are no

suspended particles, therefore, it is better to make up a stock, more than is ordinarily required, and allow to stand to settle, a week not being too long. Then the upper part should be carefully decanted. Filtration of collodion is not an easily performed task.

Many formulas have been given, but we shall be content with two; the one a pure bromide, the other a chloro-bromide, which is specially recommended for color work, as it gives better rendering than the pure bromide. The bromide emulsion is:

Pyroxylin24–30 g.
Alcohol 300 ccs.
Ether 300 ccs.

The quantity of pyroxylin is determined by the viscosity. The above ingredients should be placed in a flask capable of holding at least 1500 ccs. A silver solution should be made by dissolving:

Silver nitrate50 g.
Distilled water50 ccs.
Ammonia q. s.

As soon as the silver has dissolved in the water, add strong ammonia till the precipitate first formed is redissolved, and a perfectly clear solution obtained, then add:

Absolute alcohol25 ccs.

This solution should be cooled down to 18° C. and added to the collodion gradually, with constant shaking. Some of the pyroxylin may be thrown out, but this may be disregarded, as it will soon redissolve on vigorously shaking. Some of the silver may also separate out in fine crystals, which can also be ignored. To this silvered collodion should be added in the dark room, the following:

Ammonium bromide32 g.
Distilled water35 ccs.
Alcohol50 ccs.

Warm till perfect solution is obtained, and whilst warm add to the collodion. The flask should be well shaken for 5 minutes, then distilled water added in small doses, with constant and vigorous shaking. Although it is some little trouble, it will be found to pay to add not more than 5 ccs. of water at a time, and the emulsion will be gradually precipitated as a fine sandy powder, when about 200 ccs. of water have been added. The exact amount of water that it is advisable to add in this way is easily determined, as the emulsion begins to flock out or no longer run smoothly on the sides of the flask. It should then be poured into 5 liters of warm water, about 40° C., with constant stirring, and allowed to settle to the bottom of the vessel. The supernatant liquid should be syphoned off, the vessel filled up again with water, the emulsion shreds being stirred up for about 5 minutes, again allowed to settle, and this operation repeated five times.

The shreds should be collected on a sheet of well-washed linen, an old handkerchief is excellent, and some distilled water poured over them about five times, when they will be washed enough. The ends of the cloth should then be gathered together and twisted round and round so as to squeeze out as much water as possible. The emulsion shreds should then be added to about 400 ccs. of alcohol, or this quantity may be poured gradually over the shreds in a funnel, while still in the cloth, the shreds being well stirred to bring them as much as possible into contact with the alcohol; the idea being to free them from as much water as possible. This alcohol may be used two or three times, and finally as much as possible pressed out. The damp emulsion should be collected, placed in a flask and 250 ccs. absolute alcohol added, then well shaken for 5 minutes and allowed to stand for 24 hours. After that time 150 ccs. of the liquid should be run off, 150 ccs. of absolute alcohol added, in which 0.5 g. of narcotin has been dissolved, then 250 ccs. ether added, and the mixture allowed to stand 3 days with occasional shaking. The emulsion should be filtered through a pad of absorbent cotton, that has been well wetted with absolute alcohol. It is necessary to use a filter pump for this, otherwise the filtration is too slow and the loss of solvents considerable. Finally should be added 500 ccs. alcohol-ether, and the emulsion is ready for use.

Chloro-Bromide Emulsion.—Prepare 700 ccs. of plain collodion, as advised above, and add the following:

Silver nitrate ...50 g.
Ammonia ...50 ccs.

Shake well till a perfectly clear solution is obtained, then add:

Alcohol, 95 per cent100 ccs.

If any silver crystallizes out, add a few drops of water. To this must be added the chloro-bromide solution, as follows:

Ammonium bromide27 g.
Distilled water40 ccs.

Heat gently till dissolved and add:

Alcohol ...100 ccs.

Then add:

Lithium chloride, 10 per cent sol.................15 ccs.

This chloride solution is made by dissolving 10 g. lithium chloride in 10 ccs. distilled water and adding 90 ccs. alcohol. The chloro-bromide solution should be gently warmed before adding to the collodion, and the addition should be made in small lots with constant agitation. Allow the emulsion to stand from 2 to 4 hours, and place a drop or two on a sheet of glass and examine by transmitted light; it should appear a fine orange-red color. The emulsion is then precipitated and washed as described above for the bromide, and the shreds finally dissolved in:

Alcohol ...350 ccs.
Ether ...350 ccs.

If the foregoing instructions are carefully followed the result will be an emulsion that will answer every requirement.

Eder[64] gave the following method:

Silver nitrate30 g.
Distilled water24 ccs.

Dissolve and add:

Alcohol, 95 per cent..........................180 ccs.

Then

Collodion, 4 per cent.........................300 ccs.

To this should be added the following bromized collodion:

Cadmium bromide, cryst.......................30 g.

Dissolved in

Yellowish eosin, 1:800 alc. sol...............14 ccs.

And added to

Collodion, 4 per cent.........................300 ccs.

The admixture should be made in small quantities and when there are from 5 to 10 ccs. of the bromized collodion left, the emulsion should be tested for free silver nitrate by putting a drop or two on a sheet of glass and adding a drop of potassium chromate solution, on stirring a crimson color should make its appearance, if not a few drops of silver nitrate solution should be added, as it is essential for good color rendering that there should be a slight excess of silver. The plates may be coated at once, but it is better to allow the emulsion to ripen for 12 to 24 hours. After coating the plates should be placed in water till greasy marks no longer show. They should be exposed while still damp, as they are less sensitive when dry.

E. Sanger-Shepherd[65] suggested the following, with erythrosin as the sensitizer, but obviously it can be used with other dyes:

Silver nitrate62.5 g.
Distilled water39 ccs.
Alcohol300 ccs.

Dissolve by heat if necessary, and add:

Pyroxylin, high temperature..................12.5 g.

Shake well, add:

Ether ..360 ccs.

To this should be added in small quantities:

Zinc bromide50 g.
Alcohol300 ccs.

And finally

Erythrosin, 4 per cent sol....................2.5 ccs.

After coating the plate should be well washed.

A. Jonas[66] described the preparation of an emulsion with ammonium picrate, which would obviate the necessity of a yellow filter, but the mother

emulsion, without this, can be used for color work. The method of preparation is as follows:

Ammonium bromide	64 g.
Distilled water	80 ccs.
Absolute alcohol	800 ccs.
Collodion, 4 per cent	1,500 ccs.
Acetic acid	65 ccs.

Dissolve the bromide in the water with a gentle heat, add the alcohol, then the collodion and the acid. To this should be added:

Silver nitrate	80 g.
Distilled water	50 ccs.

Dissolve by heat and add ammonia till a clear solution is formed, about 72 to 75 ccs. will be required, then add:

Alcohol	800 ccs.

This silver solution should be added gradually with constant shaking and when all has been added the emulsion should be tested with litmus paper, if not acid a few drops of acetic acid should be added. The emulsion should be well shaken for 15 minutes, allowed to stand for an hour, then precipitated with water, as described for von Hübl's emulsions, and washed by hanging the shreds in a cloth bag in running water for 2 hours, or obviously it may be washed as stated above. The shreds should be collected and dried on a pad of thick blotting paper. For use 60 g. should be allowed to 400 ccs. alcohol and 600 ccs. ether to form the actual working emulsion.

The eoside of silver emulsion was made with the following solutions:

A. Eosin, cryst.	4 g.
Distilled water	50 ccs.
Alcohol, 96 per cent	450 ccs.
B. Silver nitrate	3.4 g.
Distilled water	50 ccs.

Mix and add enough strong ammonia to form a clear solution; make the volume up to 200 ccs. with 96 per cent alcohol.

C. Picric acid	3 g.
Distilled water	10 ccs.

This should be exactly neutralized with strong ammonia, and the bulk made up to 300 ccs. with alcohol. For use the following proportions were taken:

Solution A	75 ccs.
Solution B	30 ccs.
Solution C	30 ccs.
Glycerol	20 ccs.
Alcohol, 96 per cent	45 ccs.

This should be allowed to stand for one or two days, then filtered and 20 ccs. added to every 100 ccs. of the mother emulsion. Erythrosin might be used instead of the eosin, a stock solution being made in the same way. The working solution was:

Erythrosin solution 75 ccs.
Solution B 30 ccs.
Solution C 30 ccs.
Glycerol 25 ccs.
Alcohol 120 ccs.
Distilled water 20 ccs.

This should be allowed to stand for 15 minutes and then strong ammonia added till a perfectly clear solution is formed, then allowed to stand for one or two days, and mixed in the same proportion as the eosin to the emulsion. The dyed emulsions should be well shaken and could be used after filtering twice. They will not keep more than a day or two, though the raw emulsion will keep indefinitely. The eosin emulsion gives soft negatives, whilst the erythrosin gives rather harder results.

J. Waterhouse[67] tested Jonas' method and generally confirmed his statements. The difficulty of keeping the color-sensitized emulsion might ·be obviated by coating the plates with the plain emulsion, washing, then flowing them over with a solution of:

Erythrosin 1 g.
Silver nitrate 1 g.
Picric acid 1 g.
Ammonia 30 ccs.
Alcohol 500 ccs.
Water 500 ccs.

Ferrous oxalate, hydroquinon and paraminophenol, particularly this last, seemed very suitable as developers.

E. Albert[68] had used collodion emulsion for some time for the copying of oil paintings, but only in 1888 did he publish his method, which was the addition of silver eoside in 10 per cent solution with addition of ammonium picrate to act as a filter. H. W. and E. Vogel[69] stated that the colored emulsion was not more sensitive than an ordinary one, and that the extreme green and yellow-green sensitiveness was due entirely to the silver eoside. They recommended:

A. Erythrosin 1 g.
 Methyl alcohol 200 ccs.
B. Silver nitrate 4 g.
 Water 4 ccs.
 Alcohol 95 ccs.

For use 10 ccs. of this mixture plus 1 ccs. of the silver solution and 4 ccs. alcoholic ammonia were added to 10 times the volume of emulsion.

Von Hübl[70] had first used Warnerke's unwashed zinc bromide emulsion, mixed with eosin, and neutralized the aqua regia with sodium salicylate; but as this had to be used damp he adopted washed emulsions with the addition of silver eoside.

The plain emulsions can be sensitized with eosin or erythrosin for the yellowish-green, and panchromatized with cyanin, etc.; but the best results are obtained with ethyl violet or the newer isocyanins. Ethyl

violet, hexa-ethyl-p-rosanilin hydrochloride, was. first suggested by Valenta[71] and the sensitiveness extends from beyond B to beyond D$\frac{1}{2}$E, with a maximum rising sharply towards C and reaching a peak at C1/5D. The method recommended was to add 25 ccs. of a 1 : 500 alcoholic solution to 1 liter of emulsion, and after coating to immerse the plates in a 0.2 to 0.3 per cent silver nitrate solution. Before development the plates should be well washed.

As regards the isocyanins the most extensive experiments were made by von Hübl,[72] and he stated that if pinaverdol, pinachrom and pinachrom violet are added to collodion emulsions the color sensitivity does not exceed four or five times that of a dry plate; but other dyes increase it from fifteen to twenty times. The most interesting of these dyes are pinacyanol, pinachrom blue, pinacyanol blue, dicyanin and ethyl violet.

To 100 parts of the mother emulsion should be added 8 parts of a 1 : 1000 solution of the first-named dyes, and 2 parts of a similar strength solution of the second class of dyes. After the plate has been coated and the film set it should be washed to remove excess dye, and it is during this process that the color-sensitiveness is attained. An unwashed emulsion gives very clean negatives but the color sensitivity is low.

The sensitizing action is not alone traceable in the less refrangible rays, the red and green; but the sensitiveness to blue is actually better than that of the mother emulsion. The red sensitizers are particularly energetic; with pinachrom blue, for instance, the white light sensitiveness is more than doubled, and relatively the red and green sensitiveness is greater than that of a gelatin emulsion with the same dye.

G. Winter determined the sensitiveness of emulsions prepared according to von Hübl's chloro-bromide formula, under various filters, using as a light-source an electric lamp, adjusted as to spectral light emission by a special filter so as to approximate daylight:

Sensitizing dye	Relative sensitivity of the dyed emulsion to the colors				Ratio of sensitiveness $\frac{Red}{Green}$
	Green	Red	Yellow	White	
Pinaverdol2.3		0.3	2.6	4.4	0.14
Orthochrom T2.0		0.3	2.3	4.0	0.18
Isocol1.4		0.4	1.8	3.5	0.30
Pinachrom1.6		0.5	2.1	3.7	0.33
Pinachrom violet1.1		1.1	2.2	3.5	1.00
Pinacyanol1.3		2.8	4.1	5.0	2.10
Pinachrom blue2.5		5.2	7.7	9.0	2.10
Pinacyanol blue0.8		4.2	5.0	6.3	5.00
Dicyanin1.0		4.5	5.5	6.6	4.50
Ethyl violet0.5		0.6	1.1	3.0	1.20

It is quite probable that these results are clear; but to obviate any mistake let us consider the pinachrom-sensitized emulsion. The sensitiveness

to green is 1.6 times the initial sensitiveness to blue, and to red one-half the initial sensitivity; but as the red plus the green gives by admixture the sensitivensss to yellow, which is slightly more, 2.1 times that for the initial for blue, the actual sensitiveness to white light being 3.7 times the sensitiveness to blue before dyeing, therefore, the sensitiveness of the stained emulsion to blue is the difference between that to white light and that to yellow, or 3.7—2.1=1.6, the sensitiveness to green.

Various tests proved that pinachrom blue was the best sensitizer, the ratios being—blue 1, green 2.3, red 4.8. It would seem preferable, therefore, to manipulate such plates in a blue light. Emulsion sensitized with pinachrom violet, ought to be considered as a truly isochromatic film; that is to say, equally sensitive to all colors, for the ratios are—blue 1.0, green 0.9, red 0.9.

Von Hübl[73] stated that the white transparent spots frequently met with in color-sensitized emulsions, were due to particles of ammonium bromide, which is insoluble in the menstruum, and the formation of these could be partially prevented by careful filtration. But a better remedy was to add eosin to the emulsion and then immerse the plate in a 0.5 per cent solution of silver nitrate, containing 1 per cent of glycerol. Or the plates might be sensitized with silver eoside, acidified with acetic acid. Rose Bengal, tetra-iodo-dichlor-fluorescein, was recommended by von Hübl[74] as it gave a lower sensitiveness to green and a relatively high sensitiveness to yellow and orange.

Valenta[75] found that pinacyanol was an excellent sensitizer for collodion emulsion and gave a vigorous band with maximum from B to C$\frac{1}{2}$D. The best formula was 4 to 5 ccs. of 1 : 1000 alcoholic solution to the liter, and after allowing to stand for some hours, filtering. A. J. Newton[76] compared pinacyanol with ethyl violet, and found that it was much more sensitive. This was denied by Valenta,[77] although pinacyanol had the advantage of higher red sensitiveness; but when used correctly ethyl violet gave more vigorous negatives with greater freedom from fog, which is a great advantage for half-tone work.

Mallmann and Scolik[78] dissolved 3.5 g. ammonium bromide in as little water as possible, added 40 ccs. hot alcohol, and 40 ccs. of 4 per cent collodion. To this was added 5 g. silver nitrate, dissolved in 6 ccs. water and alcoholic ammonia added till a clear solution was obtained, the solution was then warmed and added to 40 ccs. of collodion of the same strength. It was then tested to see that there was excess of bromide, allowed to stand 2 or 3 hours, then precipitated in the usual manner and dried. The dried emulsion was dissolved in as much alcohol-ether, as would give a film that when coated would just allow the flame of the dark room lantern to be discerned through the coated plate; it being impossible to give more explicit data as the proportions varied with the pyroxylin. To dye the emulsion the following was used: eosin 1 g. was

precipitated with excess silver nitrate and the precipitate washed till the water became deep red; then dilute eosin solution was poured over the precipitate to convert any possible trace of silver nitrate, it was again washed twice with water, and finally dissolved in alcohol to which ammonia had been added, and enough was added to make the emulsion a deep rose-red color.

Klimsch[79] suggested Albert's emulsions should be used for tri-color work, for the filters (see p. 73), for the violet and green the mixture should be:

Eos emulsion1000 ccs.
Sensitizer A 70 ccs.
Sensitizer GG 50 ccs.

Allow to remain a few minutes before coating, wash the plate well before development. For the orange filter the following should be used:

Ethyl violet, Hoechst, 2 : 1000 alc............... 25 ccs.
Acridin orange NO, 2 : 1000 alc............... 30 ccs.
Alcohol 45 ccs.
Emulsion1000 ccs.

Shake well, filter and allow to stand a day before use. When the coated plates have set they should be immersed in:

Gum ... 25 g.
Glycerol 90 ccs.
Tannin, 1 : 1000 alc. sol. 5 ccs.
Water1100 ccs.

The plates should be well washed before development.

Abney[80] published a method of making a red-sensitive emulsion without the use of dyes. His initial idea was to make an emulsion that should be transparent for the shorter wave-lengths and opaque to the longer, or in other words, sensitive to the longer. His first results made by the addition of resins were not successful and he then adopted the following method: "A normal collodion is first made according to the formula:— pyroxylin (any ordinary kind) 16 grains; ether, sp. gr. 0.725, 4 ozs.; alcohol, sp. gr. 0.820, 2 ozs. This is mixed some days before use, and any undissolved particles are allowed to settle, and the top portion decanted off; 350 grains of pure zinc bromide are dissolved in ½ to 1 oz. of alcohol (0.820) together with 1 drachm of nitric acid. This is added to 3 ozs. of the above normal solution, which is subsequently filtered. Then 509 grains of silver nitrate are dissolved in the smallest quantity of hot distilled water, and 1 oz. of boiling alcohol added. This solution is poured into the bromized collodion, stirring briskly while the addition is made. Silver bromide is now suspended in a fine state of division in the collodion, and if a drop of the fluid be examined by transmitted light it will be found to be of an orange color. Besides the suspended silver bromide, the collodion contains zinc nitrate and nitric acid and these have to be eliminated. The collodion emulsion is turned out into a glass flask

and the solvents carefully distilled over with the aid of a water bath, stopping the operation when the whole of the solids deposit at the bottom of the flask. Any liquid remaining is carefully drained off, and the flask filled with distilled water. After remaining a quarter of an hour the contents of the flask are poured into a well-washed linen bag, and the solids squeezed as dry as possible. The bag with the solids is again immersed in water, all lumps being previously crushed, and after half an hour the squeezing is repeated. This operation is repeated till the wash water contains no trace of acid when tested by litmus paper. The squeezed solids are then immersed in alcohol (0.820) for half an hour to eliminate almost every trace of water, when after wringing out as much as possible of the alcohol the contents of the bag are transferred to a bottle, and 8 ozs. of ether (0.720) and 2 ozs. alcohol (0.805) are added. This dissolves the pyroxylin and leaves an emulsion of silver bromide, which when viewed in a film is essentially blue by transmitted light. All these operations must be conducted in a very weak red light—such a light, for instance, as is thrown by a candle at a distance of 20 feet. It is most important that the final washing should be conducted almost in darkness. It is also essential to eliminate all traces of nitric acid, as it retards the action of light on the bromide, and may destroy it if present in any appreciable quantity. To prepare the plate with this silver bromide emulsion all that is necessary is to pour it over a clean glass plate, as in ordinary photographic processes, and allow it to dry in a dark cupboard. (It has been found advantageous to coat the plate in red light, and then wash the plate and immerse it in a dish of dilute hydrochloric acid, and again wash and finally dry. These last operations can be done in dishes in absolute darkness; the hydrochloric acid gets rid of any silver subbromide which may have been formed by the action of the red light). For development after exposure I recommend what is known as the ferrous oxalate developer."

In a later treatise[81] Abney slightly modified his procedure and said: "I find the addition of nitric acid is not necessary to be present whilst the emulsion is being formed, though in the subsequent washings it is convenient to use it. This may be avoided, however, by washing first with water, and using a dilute solution of iodine to eliminate the veil which is nearly always present when the emulsion is boiled. To the boiled emulsion when prepared I add about 1 per cent of good soluble cotton. A very sensitive gelatin emulsion plate is coated with the collodion emulsion, washed, and then allowed to dry in a warm chamber. The washing causes a minute portion of the underlying gelatin to mingle with the collodion film surrounding the silver salt, and to protect it from premature reduction by the ferrous oxalate."

The sensitiveness of these plates was extraordinary as regards the infra-red, extending to wave-length 20,000, or nearly twice as far as has

been attained by dyes. And so delicate was this sensitiveness that they would record the infra-red rays from boiling mercury, and from a black kettle filled with boiling water.

W. Ritz[82] made a special study of Abney's emulsion, and found that either zinc or ammonium bromide could be used; that the ether-alcohol mixture could be replaced by methyl alcohol or acetone. The transformation of the silver bromide was purely physical, and the increase of sensitiveness was always accompanied by increase in size of grain. Many failures were due to the pyroxylin, and the quantity of silver bromide suspended, on the viscosity of the collodion, Abney's emulsion was characterized by the high concentration of the salts and the low content of pyroxylin. Using a low-nitrated cotton, Ritz used 1.5 times the weight of the silver nitrate, thus about ten times that employed by Abney. Ritz advised chilling the residue left after distilling, again adding the distillate and redistilling. By this successive heating the solutions might be two or three times more dilute than used by Abney, with better chances of homogeneous emulsions. The sensitiveness increases irrespective of whether the silver or bromide be in excess, but the ripening is more rapid with excess silver, and it takes place partially in the cold when the silver excess is considerable, that is about 1 g. to 5 g. silver bromide. Ritz found that a gelatin emulsion behaved like the collodion in that the heat, the salt and gelatin content might be varied. He concluded that the same phenomenon took place, and that the only difference was quantitative. He proved experimentally that a precipitated silver bromide, obtained in alcohol or water, then washed and heated in gelatin with subsequent heating, gave greater sensitiveness than Abney's collodion emulsion. The blue color by transmitted light immediately appeared when the emulsion was cold. After 5 minutes' exposure to the spectrum of a Nernst lamp, which is infinitely less rich in infra-red rays than sunlight, which Abney always used, Ritz obtained action decreasing regularly from the blue to wavelength 14,400, without any maxima or minima, so frequently shown by dye-sensitizing.

1. Ostwald's Klassiker, **152, 94.** Cf. Slater, Phil. Mag. 1853, (4), **5,** 67; Draper, "Scientific Memoirs," 1878, 412. Goldberg, Zeits. wiss. Phot. 1906, **4,** 99.
The best summary of photographic action is given by W. D. Bancroft, "Electro-Chemistry of Light," J. Phys. Chem. 1908, **12,** 209, 318, 417; 1909, **13,** 1, 181, 269, 449, 538, 292; and in his treatise on the "Photographic Plate," ibid. 1910, **14,** 12, 97, 201, 620.
2. Phil. Mag. 1841 (3), **19,** 195; Chem. Zentr. 1851, 705; 1873, 241; Handbuch, 1906, I, **1,** 41; Amer. J. Sci. 1873; Brit. J. Phot. 1873, **29,** 363. Draper said: "That so far from chemical influences being restricted to the more refrangible rays, every part of the spectrum, visible and invisible, can give rise to chemical changes or modify the molecular arrangement of bodies. That the ray effective in producing chemical or molecular changes in any special substance is determined by the absorptive property of that substance."
3. Ber. 1873, **6,** 1302; 1874, **7,** 544; Ann. Phys. Chem. 1874, **153,** 218; 1885, **26,** 527; Phot. Mitt. 1873, **9,** 236; 1875, **11,** 55, 75, 110; Bull. Soc. franç. Phot. 1874, **20,** 42, 191; 1876, **22,** 219; Pogg. Ann. 1873, **150,** 453; 1874, **153,** 233; J. Phys. 1873, **3,** 324; Phot. News, 1873, **17,** 582, 589, 617; 1874, **18,** 253, 451; 1875, **19,**

76, 85, 265; Bull. Soc. franç. Phot. 1874, **16**, 42; Brit. J. Phot. 1874, **21**, 29, 198, 363, 617; 1876, **23**, 28; Arch. f. Pharm. 1875, 180; Amer. J. Pharm. 1875, **47**, 326. Cf. H. W. Vogel, "Die Photographie farbiger Gegenstände in den richtigen Tonverhältnissen," Berlin, 1885; "La Photographie des Objets colorés avec leur Valeur réelle," Paris, 1887; this is a translation of Vogel's work; Vogel's Handbuch, 1894, **2**, 145; Fabre, "Traité Encycl." 1890, **1**, 315; Eder, "The Chemical Effect of the Spectrum," London, 1883; Handbuch, 1896, **2**, 443; **3**, 148. E. J. Wall, Phot. J. 1895, **35**, 170; Phila. Phot. 1874, **11**, 25, 154, 250; 1876, **13**, 77, 177; 1878, **15**, 212; W. Abney, Phot. News, 1876, **20**, 307, 323; 1878, **22**, 319; 1884, **28**, 500; 1887, **31**, 178; Anthony's Phot. Bull. 1876, **7**, 138; L. Vidal, Brit. J. Phot. 1875, **22**, 101; T. Sutton, ibid. 1874, **21**, 45, 249, 271, 333, 375, 379, 441, 503; Schultz-Sellack, ibid. 1874, **21**, 25; J. Spiller, 1874, **21**, 255; Phot. News, 1874, **18**, 253; E. Becquerel, Brit. J. Phot. 1874, **21**, 398; Waterhouse, 1875, **22**, 450, 474, 594; 1876, **23**, 233, 305; Phot. Times, 1875, **5**, 269; Internat. Annual, 1894, **6**, 143.

To prevent halation Carey Lea, Brit. J. Phot. 1868; 1870, **17**, 237, 266 used red litmus. W. Blair, ibid. suggested staining the film with turmeric. Anilin red was used by Aitken and Cooper, Phot. Mitt. 1875, **11**, 18. Waterhouse, Brit. J. Phot. 1875, **22**, 450 used rosein. L. Scotellari, Phot. Mitt. 1878, **14**, 208 used methyl violet; M. Sanders, Kreutzer's Zeits. Phot. 1881, **3**, 106 also used turmeric.

4. Pogg. Ann. 1874, **153**, 233; Ber. 1874, **7**, 276; Phot. Mitt. 1876, **12**, 286. Vogel added about 10 drops of saturated solution of naphthalen red to 100 ccs. of cadmium bromide collodion and exposed in the spectrograph. On increasing the dye to 20 drops the plates were markedly insensitive to blue and less also to the less refrangible rays. The sensitiveness increased with decrease of the dye, and 10 drops gave the best results; whilst reduction below this did not give increased sensitiveness. Later he found that equally good results could be obtained by bathing the plates in solution of the dye.

5. Ber. 1875, **8**, 1636; Bull. Soc. franç. Phot. 1874, **20**, 233; Phila. Phot. 1874, **11**, 336, 378; 1879, **16**, 109.

E. Becquerel, Compt. rend. 1874, **79**, (3), 185; Brit. J. Phot. 1874, **21**, 398; Phot. News, 1874, **18**, 508, discovered the sensitizing action of chlorophyll. This was confirmed by C. Cros, Compt. rend. 1879, **88**, 119; Brit. J. Phot. 1879, **26**, 136. Cf. T. Geymet, "Traité elémentaire de Photographie," 1875; Fabre, "Traité Encycl." 1890, **2**, 315.

Carey Lea, Brit. J. Phot. 1874, **21**, 111, 121, 230; 1875, **22**, 245; 1876, **23**, 287, 303; Bull. Soc. franç. Phot. 1874, **20**, 130, 187; Anthony's Phot. Bull. 1876, **7**, 207, was not inclined to accept Vogel's conclusions, but as he photographed pieces of colored paper, the results were hardly comparable. It is interesting to note that Lea found some colorless substances enhanced the spectral sensitiveness of the silver salts, particularly salicin, which he stated sensitized through the green, yellow and orange into the red. Cf. Carey Lea, Amer. J. Sci. 1876, **12**, 48, 459; 1877, **14**, 96. D. van Monckhoven, Brit. J. Phot. 1874, **21**, 292, 363.

6. Brit. J. Phot. 1875, **22**, 450; 1876, **23**, 233, 304; Phot. News, 1876, **20**, 302; Phot. Mitt. 1875, **12**, 196, 247; 1876, **13**, 17; Anthony's Phot. Bull. 1876, **7**, 183; Phot. Times, 1875, **5**, 269.

As to the sensitizing power of eosin see Phot. J. 1876, **16**, 135; Brit. J. Phot. 1875, **22**, 595; 1876, **23**, 305; 1877, **24**, 341, 412. Cf. Carey Lea, Brit. J. Phot. 1874, **21**, 316, 405; 1876, **23**, 303; W. J. Stillman, Phot. News, 1879, **16**, 41. In a later paper, Brit. J. Phot. 1889, **36**, 685, Waterhouse gave full details of his experiments with various dyes, but as he used commercial dyes, some as used for household purposes, it is not worth while recording these at length. He used bromized plates, without any preservative, well washed and dried. In some cases the dyes were added to the collodion, in others applied in aqueous solutions to the plates after washing. Amongst other interesting facts recorded was that uncolored silver bromide was at least as sensitive to the red rays as any dyed films as regards the extent of action, but not as regards intensity. In nearly all cases of long exposures of stained and unstained plates, the spectrum was reversed in the blue and violet between H and F, and in many cases the lines came out with great distinctness reversed. This effect Waterhouse ascribed as partly due to the alkaline developer, and it was more marked on plates stained with certain dyes than others. A reversed action had been noticed on rosein-stained plates, when they were slightly fogged, and it was also found on others. That this action was not due to the dyes was determined in that it was found that preliminary exposure to white light caused it. The fact was recalled that Sir J. Herschel, Draper, Fizeau and Claudet had observed a similar reversing action on daguerreotype plates, and

• he found that with stained plates a short preliminary exposure, prior to that in the spectrograph, showed strong bleaching action in the red, and after development the plate showed a reversal of the whole spectrum from above H to below A, with a minimum action about F. This action had not been previously noted on collodion plates.

7. Handbuch, 1890, 4th edit. 1, 204.

8. Ber. 1876, 9, 667.

9. As to the screening action of dyes (see p. 216).

10. Ber. 1875, 8, 1636.

11. This passage is quoted from an article by the author, Brit. J. Phot. 1907, 54, 365, 386, 406, 464. Reference should be made to the original articles by Eder, Monatsheft, 1884, 90, II, 1131; 1885, 92, II, 1359; "The Chemical Effect of the Spectrum," Phot. J. 1881; 1882; published separately in 1883; Jahrbuch, 1896, 10, 166; Sitzungsber. Akad. Wiss. Wien. 1884, 11, 1885; 1886; Handbuch, 1903, 3, 142-198; Beiträge, 1904, III; Phot. Korr. 1884, 21, 137; 1885, 22, 359; 1891, 28, 313; 1894, 31, 457; 1895, 32, 92; Phot. News, 1885, 29, 145, 162, 227, 355, 420, 452. Carey Lea, Anthony's Phot. Bull. 1885; Brit. J. Phot. 1885, 32, 56, also pointed out that the dye must combine with the silver salt. J. Stark, Phys. Zeits. 1907, 8, 248; Brit. J. Phot. 1907, 54, Col. Phot. Supp. 1, 44 considered that latent ultra-violet fluorescence was a predominating factor. For comment see E. J. Wall, Brit. J. Phot. 1907, 54, Col. Phot. Supp. 1, 45.

12. "Die Collodium-Emulsion," Halle, 1894; Jahrbuch, 1894, 5, 189.

13. Jahrbuch, 1903, 17, 128.

14. Mon. Phot. 1895; Congres d. Sociétés Savantes, 1895; Résumé d. Travaux, 1896, 41.

15. Das Atel. 1906, 13, 6, 14; abst. Brit. J. Almanac, 1907, 743. Further details are given but these are summarized later.

16. Jahrbuch, 1905, 19, 188; abst. Brit. J. Almanac, 1906, 772. A further paper appeared Das Atel. 1906; Zeits. wiss. Phot. 1904, 2, 272; Phot. J. 1906, 46, 133.
J. Precht and E. Stenger, Zeits. Repro. 1905, 7, 98; Brit. J. Phot. 1905, 52, 969; abst. Brit. J. Almanac, 1907, 741 examined the absorption and sensitive maxima of ethyl red, pinachrom, homocol, orthochrom T, and pericol and proved that the two do not correspond, but that the sensitizing maxima were shifted towards the red by about 20 wave-lengths, thus agreeing with the older sensitizers.

17. J. Opt. Soc. Amer. 1920, 4, 91.

18. Résumé d. Travaux 1906, 75.

19. Wied. Ann. 1891, 42, 371; Phot. Quarterly, 1890, 2, 197; Anthony's Phot. Bull. 1891, 22, 198; 1893, 24, 148, 180, 206.

20. Phot. Korr. 1895, 32, 549; Jahrbuch, 1896, 10, 289; Brit. J. Phot. 1896, 43, 519. Cf. Jahrbuch, 1897, 11, 71; Phot. Rund. 1896, 10, 42, 76; Phot. Annual, 1897, 201.
Eder had already pointed out that the maximum sensitiveness of silver chloride varied in spectrographs, according to whether prisms or diffraction gratings were used, in consequence of the absorption of the ultra-violet by the glass of the prism. Wentzel, Zeits. wiss. Phot. 1909, 7, 113; Compt. rend. 1909, 1, 1456, disputed this, but as was pointed out by Eder, Zeits. wiss. Phot. 1909, 7, 253; Chem. Zentr. 1909, II, 411; Jahrbuch, 1910, 24, 375 his conclusions were wrong. Chapman Jones, Phot. J. 1909, 49, 110 also showed that the position of the maxima shifted according to the instrument used.

21. "Chemical Effect of the Spectrum," 1883, 39.

22. Brit. J. Phot. 1895, 43, 727; Brit. Assoc. Repts. 1895, 66; Phot. Annual, 1896, 168; Chem. News. 1895, 72, 187; Jahrbuch, 1896, 10, 167. Cf. E. J. Wall, Brit. J. Phot. 1907, 54, 407.

23. Beiträge, III, 100.

24. Brit. J. Phot. 1888, 35, 499.

25. Zeits. Repro. 1907, 9, 9; Jahrbuch, 1908, 22, 384; Brit. J. Phot. 1907, 54, 932.

26. Jahrbuch, 1900, 14, 251.

27. Phot. Korr. 1889; Jahrbuch, 1890, 4, 308. Cf. C. Scolik, Brit. J. Phot. 1885, 32, 58.
E. Zettnow, Jahrbuch, 1890, 4, 170; 1891, 5, 303 considered in detail the use of silver erythrosin plates, both by bathing and addition of the salt to the emulsion, giving various methods for making the emulsion and the dye solution. He pointed out that although such plates gave the highest possible color-sensitiveness, they

would not keep. ⸂To remove the persistent color of the dye from the negatives, he recommended the use of a fixing bath, acidulated with sodium bisulfite and subsequent treatment with common salt solution.

Lüppo-Cramer, Jahrbuch, 1901, **15**, 623, found that silver bromide dyed with erythrosin was decolorized by potassium bromide, as was first pointed out by von Hübl, Jahrbuch, 1894, **8**, 189, but it was unaffected by sulfates and carbonates. On the other hand, barium sulfate dyed with the same dye was not decolorized with halides or carbonates, but only by sulfates; calcium carbonate, dyed up, was only decolorized by carbonates. This peculiarity was only confined to the eosin group. In Phot. Korr. 1900, **31**, 686; Jahrbuch, 1901, **15**, 623, Lüppo-Cramer remarked that even with the most favorable sensitizing, fast silver bromide was always far more sensitive to blue; with grainless emulsions the opposite might easily occur, and the sensitiveness to the less refrangible rays might be so great that blue or green filters might be required to obtain correct color rendering.

28. Jahrbuch, 1911, **25**, 50; Phot. Rund. 1911, **48**; abst. C. A. 1912, **6**, 2519. Cf. "Xtensis," Brit. J. Phot. 1915, **62**, Col. Phot. Supp. **9**, 33. O. Masaki, Japan, J. Phys. 1923, **2**, 163; abst. J. S. C. I. 1925, **44**, 27B; Sci. Ind. Phot. 1925, **5**, 31; Amer. Phot. 1925, **19**, 494.

29. Phot. Mitt. 1887, **24**, 87. Cf. J. B. Obernetter, ibid. 1886, **23**, 167, 186, 228, 275.

30. E.P. 12,516, 1899.

31. Jahrbuch, 1899, **13**, 480; Phot. Korr. 1898, **35**, 243; Beiträge, III, 118.

32. Jahrbuch, 1907, **21**, 399.

33. S. E. Sheppard, Phot. J. 1908, **48**, 300. Von Hübl, "Die orthochromatische Photographie," 1920, 69; Phot. Coul. 1908, **3**, 248.

34. Loc. cit.

35. Phot. Korr. 1907, **44**, 449; Brit. J. Phot. 1907, **54**, 751; abst. Brit. J. Almanac, 1908, 619. It should be pointed out that neither methyl alcohol nor acetone are safe to use in such quantities for celluloid films, as they soften the celluloid.

36. Das Atel. 1920, **27**, 98; Phot. J. Amer. 1920, **57**, 180.

37. Phot. Rund. 1917, **54**, 257; Phot. Korr. 1918, **55**, 22; Zeits. Repro. 1918, **20**, 7.

38. Ibid.

39. Phot. Chron. 1920, **27**, 41; Phot. J. Amer. 1920, **57**, 188; Le Procédé, 1920, **22**, 91.

40. Phot. Mitt. 1908; Brit. J. Phot. 1908, **55**, Col. Phot. Supp. **2**, 29.

O. Pfenninger, Penrose's Annual, 1916, **21**, 37, stated that he had found that the addition of from 15 to 20 per cent of alcohol to eosin and isocyanin baths gave the best results, and did not lower the speed. A bath of the commercial stock solutions (1:1000) of pinachrom and pinacyanol, in the ratio of 20 ccs. to the liter with 0.2 per cent ammonia enabled him to bathe 1880 sq. ins. of plate surface. The plates would keep for a year, while films only kept two months. Pure bromide plates should alone be used especially with erythrosin. It should be noted that such plates are not commercial articles, except as very slow transparency plates. He also made the curious statement, which had but little truth in it, "Nearly all English dry-plate makers add carbonate of ammonia and such like chemicals to the emulsion before coating, in the belief that the plates will be more rapid and softer working, all such plates are of no use whatsoever for color workers, who have to, or desire to, sensitize dry plates for colors, and plates with an acid chrome alum substratum destroy the sensitizing dyes."

41. "Investigations on the Theory of the Photographic Process," London, 1907, 308.

42. Phot. Ind. 1916, 79, 111.

43. "Die orthochromatische Photographie," 1920, 59; Phot. Chron. 1920, **27**, 41; Phot. J. Amer. 1920, ɔ7, 186. Cf. von Hübl, Jahrbuch, 1903, **17**, 128.

44. Jahrbuch, 1903, **17**, 55.

It should also be pointed out that Eder, Handbuch, **3**, 12 stated that silver bromide is soluble in concentrated ammonia, about 1 in 1000, and this was also pointed out by Rammelsberg, Liebig and Jarry. Obviously, however, in such dilute solutions as used for sensitizing, the solvent action would be less, but even so it might account for the action.

45. Beiträge, 1904, 66, 94.

R. Namias, Il. Prog. Foto. 1916, **40**; Phot. J. Amer. 1920, **57**, 188 stated that when using pinachrom and pinacyanol, it is extremely difficult to prevent fog,

and advised the addition of 0.1 to 0.2 per cent of boric acid, which stabilizes the solutions and prevents fog, without affecting the color-sensitiveness, although the general sensitiveness is lowered. From actual trial the author found that both dyes were readily decolorized by boric acid, and although König has stated that the decolorized dyes sensitize as well it is not the author's experience.

46. "L'Héliochromie, Decouvertes, Constations et Ameliorations Importantes," Agens. 1874; Phot. News, 1875, **19**, 482; Phila. Phot. 1874, **11**, 240; Brit. J. Phot. 1874, **21**, 352, 375; 1876, **22**, 377.

47. "L'Héliochromie, Nouvelles Recherches sur les Négatifs héliochromiques," Agens. 1875; F.P. 119,457, 1877, "Productions des trois clichés générateur d'une épreuve positive héliochromique. Nouvelle mèthode fondée sur les propriétés de l'eosine avec interposition de milieux colorés"; E.P. 2,973, 1876; Brit. J. Phot. 1877, **24**, 199; "Traité pratique de Photographie des Couleurs," Paris, 1878; Phot. Archiv. 1878, **29**, 109; Phot. News, 1878, **22**, 115, 148; Phila. Phot. 1876, **13**, 179; Phot. Times, 1876, **6**, 3; 1884, **14**, 364; Mon. Phot. 1898, **17**, 137; Jahrbuch, 1891, **5**, 191; Handbuch, 1896, **2**, 448. Cf. E. Dumoulin, "Les Couleurs reproduites en Photographie," Paris, 1876.

48. Removal of all free silver was essential because the alkaline developer would reduce the same all over the plate. The bromide bath would also remove any possible traces, although possibly its use was really to increase density.

49. Compt. rend. 1879, **88**, 379; Phot. Korr. 1879, **16**, 107; Brit. J. Phot. 1879, **26**, 136; Bull. Soc. franç. Phot. 1879, **21**, 185; Phila. Phot. 1879, **16**, 213.

50. It is interesting to note that Eder, Sitzungsber. Akad. Wiss. Wien, 1913, 122; abst. Jahrbuch, 1913, **27**, 188; Phot. J. Amer. 1913, **50**, 357 proved that hæmatoporphyrin, a coloring matter obtained from horse's blood, sensitizes energetically from the red, wave-length 6300, to the green.

51. Phot. Mitt. 1884, **20**; Brit. J. Phot. 1884, **31**, 345, 360.

52. Phot. Mitt. 1886, **22**, 286; Phot. News, 1886, **30**, 130; Vogel's Handbuch, 1894, **3**, 170.

53. Liebig's Ann. 1876, **182**, 45; Phot. Mitt. 1885, **21**, 47; Vogel's Handbuch, 1894, **2**, 172.

54. Handbuch, 1896, **2**, 456; Jahrbuch, 1888, **2**, 126; 1889, **3**, 409; Phot. Korr. 1888; Brit. J. Phot. 1888, **35**, 524; Phot. News, 1888, **32**, 388.

Max Jaffé, Phot. Woch. 1890, **36**, 314; Phot. Annual, 1891, 91 used alcohol 250, eosin 2.2, cadmium bromide 45, ether 250, plain collodion, 2 per cent 1000 parts and sensitized in a 16.5 per cent silver bath, slightly acidulated with nitric acid.

55. Jahrbuch, 1888, **2**, 126; Phot. Rund. 1888, **2**, 249.

56. Brit. J. Phot. 1903, **50**, 467.

57. Penrose's Annual, 1903, **9**, 84.

58. Brit. J. Phot. 1913, **60**, 424; Le Procédé, 1913, **15**, 131; Jahrbuch, 1914, **28**, 329.

59. "Les Procédés au Collodion Humide" 1905; Brit. J. Phot. 1905, **52**, 34; Brit. J. Almanac, 1906, 779.

60. Penrose's Annual, 1907, **13**, 118.

61. It is advisable to add the silver to the eosin solution, then cautiously add ammonia till the silver eoside is redissolved, and dilute with alcohol. If the solutions are diluted, it takes much longer to dissolve the precipitate and there is greater danger of excess of ammonia.

62. Payne's advice as to washing out the free silver is sound; but it is safer to immerse the plate in 1 per cent solution of potassium bromide. This in no wise affects the color rendering or development; but possibly in the face of the large ratio of bromide in his developer, this preliminary bath may be unnecessary.

63. "Die Collodium-Emulsion," 1894; Process Photogram, 1904, **1**, 54; Phot. Rund. 1892, **6**, 2; Phot. J. 1892, **32**, 221; Phot. News, 1893, **37**, 310; Jahrbuch, 1892, **6**, 273; 1893, **7**, 403; 1894, **8**, 391; 1904, **18**, 3. Cf. G. Eberhard, ibid. 1895, **9**, 250; H. Klein, "Collodion Emulsion," London, 1905; Penrose's Annual, 1905, **10**, 67; Brit. J. Phot. 1904, **51**, 66, 107, 846. G. R. Mayer, Amer. Photo-Engraver, 1924, **16**, 748.

64. Bull. Soc. franç. Phot. 1888, **35**, 246; Bull. Belg. 1888; Handbuch, 1897, **2**, 443; Brit. J. Phot. 1888, **35**, 359, 370, 466; Phot. Times, 1888, **18**, 399.

65. Photogram, 1895, **2**, 127.

66. Phot. Korr. 1891, **28**, 372; Phot. Mitt. 1892, **28**, 155, 172, 185; Jahrbuch, 1892, **6**, 35; Handbuch, 1897, **2**, 458; Amat. Phot. 1891, **14**, 46; Phot. J. 1891, **31**, 65; Phot. Annual, 1892, 109; Fabre, "Traité Encycl." Supp. A. 210.

67. Brit. J. Phot. 1892, **39**, 167, 182, 271, 281, 404, 411; Phot. News, 1892, **36**,

151, 163, 179; Phot. Times, 1892, **22**, 24; Phot. Mitt. 1892, **29**, 208; 1893, **30**, 71; Phot. Annual, 1893, 116; Bull. Soc. franç. Phot. 1892, **39**, 400; 1893, **40**, 252; J. Phot. Soc. India. 1892.

68. Jahrbuch, 1889, **3**, 402; Phot. Mitt. 1889, **25**, 149, 153, 183; 1891, **27**, 108. Albert also introduced, Zeits. Repro. 1907, **9**, 74; Brit. J. Phot. 1907, **54**, Col. Phot. Supp. **1**, 55; abst. Brit. J. Almanac, 1908, 620, emulsions with the filter dyes incorporated so that separate filters were unnecessary.

69. Jahrbuch, 1889, **3**, 406; Bull. Soc. franç. Phot. 1889, **31**, 34.

70. Jahrbuch, 1889, **3**, 407; Phot. Times, 1892, **22**, 193. Cf. J. Birfelder, Jahrbuch, 1891, **5**, 180; von Hübl, ibid. 459; Phot. Korr. 1890, **37**, 388.

F. Tarsulat, E.P. 14,073, 1903 patented the use of di-iodo-fluorescein, either alone or with other dyes for collodion emulsion.

71. Jahrbuch, 1901, **15**, 624; 1906, **20**, 412; Phot. Korr. 1901, **38**, 37; 1904, **41**, 125. Cf. L. Tschörner, Jahrbuch, 1907, **21**, 405.

72. Zeits. Repro. 1920, **22**, 10; abst. Phot. J. Amer. 1920, **57**, 355; Le Procédé, 1920, **22**, 41. Cf. H. O. Klein, Penrose's Annual, 1905, **11**, 67. W. T. Wilkinson, Process Eng. Monthly, 1914, **21**, 275; 1915, **22**, 14.

73. Phot. Korr. 1892, **29**, 587; Phot. Rund. 1893, **7**, 3; Phot. News, 1893, 37, 90; Phot. Annual, 1893, 115; 1894, 96.

74. Phot. Korr. 1893, **30**, 216; Phot. Annual, 1894, 97.

C. H. Bothamley, Phot. News, 1887, **32**, 510; Jahrbuch, 1888, **2**, 215; Phot. Annual, 1894, 97 recommended the same dye for gelatin plates for the same reason.

75. Phot. Korr. 1906, **43**, 132; Jahrbuch, 1906, **20**, 411.

76. Brit. J. Phot. 1905, **52**, 830; Jahrbuch, 1906, **20**, 411. Cf. E. Stenger and H. Heller, Zeits. Repro. 1908; Brit. J. Phot. 1908, **55**, 418.

77. Loc. Cit.

78. Jahrbuch, 1889, **3**, 407; Bull. Soc. franç. Phot. 1888, **35**, 18; Phot. Woch. 1888; Brit. J. Phot. 1888, **35**, 332.

79. Klimsch's Jahrbuch, 1907; Brit. J. Phot. 1907, **54**, Col. Phot. Supp. **1**, 87.

80. Phil. Trans. 1880, **171**, II, 653; Monthly Notices, 1878, **36**, 348; Phil. Mag. 1878, (5), **6**, 154; Compt. rend. 1880, **90**, 182; Nature, 1881, **25**, 162, 167, 187; 1882, **27**, 15; Mon. Phot. 1881; Bull. Soc. franç. Phot. 1882, **38**, 36; Anthony's Phot. Bull. 1878, **9**, 267; Phot. News, 1882, **26**, 684; Brit. J. Phot. 1876, **23**, 139, 222; 1878, **25**, 243, 256; 1880, **27**, 571, 583. Cf. Nature 1876, **13**, 432.

81. Phil. Trans. 1886, **177**, II, 457. Cf. W. Abney and E. R. Festing, Phil. Trans. 1881, **172**, III, 887; Proc. Roy. Soc. 1883, **35**, 328.

H. Kayser, "Handbuch d. Spectroscopie," 1900, **1**, 618 says that Abney told him verbally that he had later improved his emulsion by boiling it in a soda water bottle for 6 hours at 105° C. The English soda water bottle is made of very thick glass and will stand considerable pressure with safety.

82. Compt. rend. 1906, **143**, 167; Brit. J. Phot. 1906, **53**, 726; Jahrbuch, 1907, **21**, 393.

The best summary of photography in the infra-red is given by M. A. Chanoz in "La Photographie des Radiations Invisibles," Paris, 1917. Cf. W. H. Pickering, Brit. J. Phot. 1885, **32**, 682.

L. Tschörner, Jahrbuch, 1908, **22**, 200 gave a resume of his trials with commercial emulsions and color-sensitizers. Von Hübl, Jahrbuch, 1897, **11**, 168 recommended the addition of 3 ccs. of 1:500 alcoholic solution of the old cyanin to 100 ccs. of a chloro-bromide emulsion, and after the film had set, immersing in 1 part of saturated solution of borax and 3 parts water till the greasy marks disappeared, then slightly draining and exposing. For further notes on collodion emulsion Cf. P. C. Duchochois, Phot. Times, 1887, **17**, 142; Mallmann and Scolik, ibid. 1888, **18**, 20. Anon, Brit. J. Phot. 1896, **43**, 642. F. E. Ives, Brit. J. Phot. 1886, **33**, 355; Phot. Woch. 1887, **33**, 21; Phot. News, 1888, **32**, 385; Phot. Times, 1887, **17**, 245; 1888, **28**, 292; J. Frank. Inst. 1888, **125**, 479 used collodion emulsions and after coating, flowed the plates with an alcoholic solution of chlorophyll and then immersed them in 0.625 per cent solution of eosin. In Brit. J. Phot. 1896, **43**, 351; Jahrbuch, 1897, **11**, 382, Ives stated that the best results were obtained with chlorophyll in collodion emulsion if there was no free silver; after the plates had set they should be flowed over two or three times with alcoholic chlorophyll solution and then immersed in water to precipitate the chlorophyll. Cf. Brit. J. Phot. 1888, **35**, 330, 347; 1886, **33**, 447. H. W. Vogel, Phot. News, 1885, **29**, 35; Phot. Mitt. 1888, **25**, 115. W. Friese-Greene, Phot. News, 1889, **33**, 310; Brit. J. Phot. 1889, **36**, 255 recommended silver nitrate, decoction of horse chestnut bark and cyanide. Chlorophyll was also used by du Hauron (see p. 224) and Cros (p. 225).

Ives, Pract. Phot. 1879, **16**, 365; Bull. Soc. franç. Phot. 1880, **27**, 82; 1888, **35**, 200; Phot. Mitt. 1886, **23**, 274; 1884, **21**, 315; J. Frank. Inst. 1888, **125**, 479; Brit. J. Phot. 1885, **32**, 313, 371, 486, 527, 761; 1886, **33**, 417, 483, 651 used blue myrtle leaves and claimed that the results were superior to cyanin. J. Bartlett, Amer. J. Phot. 1896; Brit. J. Phot. 1896, **43**, 692 used the seed vessels of Datura Stramonium. Eder, Sitzungsber. Akad. Wiss. Wien, 1915, IIa, **124**, 16; abst. Chem. Zentr. 1916, I, 886; C. A. 1917, **11**, 1796 tried ivy, spinach, wild vine, xanthophyll, carotin, blue grapes, beetroot, red phlox flowers, whortle berries, black elder, turmeric and red fly agaric. J. J. Acworth, Wied. Ann. 1891, **42**, 371; Phot. Quarterly, 1890, used tincture of Jaborandi. E. Guignet, Compt. rend. 1885, **100**, 433; Jahr. Chem. 1885, **38**, 1794; Ber. 1885, **18**, 196; J. C. S. 1885, **48**, 551; Phot. Woch. 1886, **34**, 355; Jahrbuch, 1888, **2**, 467; Bull. Soc. franç. Phot. 1885, **36**, 164; Phot. Times, 1886, **16**, 522 gave a method of preparing sodium chlorophyllate. Wollheim, Phot. Mitt. 1888, **25**, 113; Jahrbuch, 1889, **3**, 401 also tested with good results alkaline chlorophyll solution and especially zinc oxide phyllocyanin with gelatin plates, and obtained spectral action to A. Cf. Vogel's Handbuch, 1894, **2**, 178. V. W. Zenger, "Meterologie der Sonne"; Phot. Woch. 1886, **32**, 340; Jahrbuch, 1888, **2**, 467; Brit. J. Phot. 1886, **33**, 732 used chlorophyll for solar work. Cf. Gautier, Phot. News, 1880, **24**, 47 on the use of chlorophyll and soda. Schenck, Anthony's Phot. Bull. 1894, **24**, 131; abst. Phot. J. 1894, **34**, 175 proposed a method of making pure chlorophyll from sodium chlorophyllate. Cf. Brit. J. Phot. 1886, **33**, 286.

CHAPTER VII

COLOR-SENSITIVE GELATIN PLATES

With the great advances made of late years in emulsion making and the color-sensitizing of the same, there is but little temptation for the average worker to sensitize his own plates; but probably for those who decide to do this enough information will be found in the following notes to enable the same to be satisfactorily performed. The treatment of the subject has been to isolate as far as possible notes on the various dyes recommended for this purpose.

Cyanin.—H. W. Vogel[1] (p. 277) discovered the sensitizing powers of the old cyanin for the red, and it was for years, practically till the discovery of the newer isocyanins, the only general red-sensitizer; but its proneness to fog and spots militated much against its use except under exceptional circumstances, and many other dyes were tried instead.

To overcome these troubles numerous methods were suggested as improvements on the original process, which was with a preliminary ammoniacal bath followed by an ammoniacal dye bath. W. Weissenberger[2] proposed the use of cyanin decolorized with acetic acid, without any preliminary bath, and as the dye was for the time destroyed, there was no red sensitiveness, till on drying when the dye was regenerated. W. E. Debenham[3] suggested bathing the plates in an alcoholic, 1 : 1920, solution, then immersing after a few minutes in water and exposing while damp. These methods were critically examined by H. Hinterberger[4] and he found Schumann's method with ammoniacal baths gave very foggy plates; while Weissenberger's method gave a very clean plate, but with only a narrow band between D and C. Debenham's process, on the other hand, not only gave fairly clean plates, but the sensitivity extended over practically the whole of the spectrum, with a minimum at a and in the green between E and F. Hinterberger found that by the addition of quinolin red, and using Debenham's method, equally good results were obtainable and the plates could be exposed dry.

W. Weissenberger[5] returned to the subject and suggested a method, which has not received the attention it deserves. He pointed out the sensitiveness of cyanin to acids, and the fogging power of ammonia, and suggested the replacement of the latter by anilin or codein, which act in the same way as ammonia. His bath was:

Cyanin, 1 : 1000 alc. sol.	6 ccs.
Codein, 1 per cent alc. sol.	34 ccs.
Water	1000 ccs.

Or 5 drops of pure anilin could be used instead of the codein. The plates

should be bathed for 2 minutes, washed for 2 minutes in a 4 per cent solution of alcohol and dried. Absolute alcohol should be used for dissolving the codein and the dye. Von Hübl[6] suggested the following bath:

 Cyanin, 1 : 500 alc. sol......................... 5.5 ccs.
 Borax, sat. sol.36.5 ccs.
 Dextrin, 10 per cent sol........................ 727 ccs.
 Alcohol .. 273 ccs.

Bathe the plates for 5 minutes and dry in the dark.

The use of anilin or borax is a great improvement over ammonia, even with the old dye, and is certainly so with the isocyanins. The idea of using dextrin was probably based on its colloidal character, which would prevent the precipitation of the dye.

A. Miethe[7] recommended the following mixture for panchromatizing plates, and it gave a sensitiveness ranging from B½C to the ultra-violet and worked very cleanly. Three stock solutions should be prepared by dissolving 1 g. of cyanin, quinolin red and glycin red (Kinzelberger) each in 500 ccs. water; a few drops of ammonia should be added to the cyanin solution. After filtration the solutions should be mixed as follows:

 Glycin red sol................................. 20 ccs.
 Quinolin red sol.............................. 20 ccs.
 Water ..100 ccs.
 Alcohol, 93 per cent......................... 50 ccs.

Reaction takes place, some gas is given off, and some brown scales are formed. After 2 hours the mixture should be filtered, then there be added to it:

 Cyanin solution1 ccs.

And

 Water ..200 ccs.
 Alcohol 50 ccs.

Then

 Cyanin solution1 ccs.

And finally

 Ammonia3 ccs.

After bathing, the plates should be washed under the tap for 2 minutes and dried as rapidly as possible.

J. W. Gifford[8] recommended a mixture of cyanin and phosphin N, which was stated to be the same as chrysanilin. Two stock solutions should be prepared 1 : 1000 alcohol. The bath was:

 Cyanin solution 83.5 ccs.
 Phosphin solution 83.5 ccs.
 Distilled water1000 ccs.

The plates should be immersed for 3 minutes, rocking the dish all the time, then rinsed under the tap, washed for 2 minutes with water made alkaline with ammonia, 1 : 1430, again well rinsed and dried.

J. B. Burbank[9] recommended a somewhat tedious method, but with which he was able to photograph as far as wave-length 9000 in the infrared, with a grating spectrograph. One gram of cyanin was gently heated in a water bath with 30 g. of chloral hydrate and 120 ccs. water for about 45 minutes with continual stirring. While this was going on 8 g. of quinin sulfate should be dissolved in a few ounces of alcohol by heat. 30 ccs. of strong ammonia should now be added to the cyanin mixture. Strong ebullition at once occurs, chloroform being evolved, and the cyanin being deposited on the sides of the vessel. The mixture should be allowed to settle for a few minutes, the supernatant fluid decanted, and 90 to 120 ccs. of alcohol added to dissolve the cyanin. The quinin solution should then be added and the bulk made up to 270 ccs. with alcohol. This stock solution must be kept in the dark. The actual bath was:

Cyanin solution 6.25 ccs.
Ammonia 6.25 ccs.
Water1000 ccs.

The plates should be bathed 4 minutes. This method was actually first given by J. B. B. Wellington.[10]

V. Schumann[11] stated that plates bathed in ammoniacal solution of cyanin were far more sensitive than when the dye was added to the emulsion, and the same applied to cyanin plus silver nitrate; but unfortunately the latter plates were always foggy and streaky, and were, therefore, not advisable for ordinary work; but the latter method with erythrosin and eosin gave good results. The difference being due to the fact that cyanin did not combine with the silver salt, whereas the phthalein dyes did. As a matter of fact, the reaction was between the silver and the iodide of the dye with the formation and precipitation of silver iodide, the nitrate of the dye being formed.

Eder[12] stated that ordinary cyanin was an iodide and better results could be obtained by powdering it, placing in a porcelain dish, covering repeatedly with hydrochloric acid, and repeatedly evaporating to dryness. The resultant dye, said to be the chloride, should then be dissolved in alcohol and used like the ordinary dye. E. König[13] stated that this treatment had no effect on the dye itself, though it might remove impurities. And the only way, as pointed out by von Hübl[14] to convert the iodo-cyanin into chlor-cyanin was to treat it with damp silver chloride. The chloride compound acts no better than the iodide.

W. Eckhardt[15] tested the comparative sensitizing powers of cyanin, coerulin and nigrosin for red and used a modified process. The plates were first immersed in an ammoniacal bath, then in alcohol. In the case of nigrosin the quantity of dye had an important effect; the plates were immersed in the aqueous bath for 3 to 4 minutes, drained and immersed in alcohol for the same time. Cyanin applied by Weissenberger's method, or when borax was used, reduced the general sensitiveness to a marked

degree, and a similar effect was noted with nigrosin and coerulin, but to a less degree. When tested behind tri-color filters, very different results were obtained with different illuminants.

The Phthalein Dyes.—To this family belong many dyes, some of which have been more widely used than others. Eosin was at first generally adopted, and was specially commended by V. Schumann and Eder[16] for gelatin plates, which were to be bathed in a 1 : 30,000 to 50,000 solution for 2 or 3 minutes, with or without the addition of ammonia, 2 or 3 ccs. Schumann was the first to record that bathed plates were more sensitive to the respective colors, than those in which the dye had been added to the emulsion before coating. His remarks applied mainly to eosin, and this was confirmed for azalin by H. W. Vogel. The method adopted by the former was to bathe plates, without silver iodide content, in a preliminary ammoniacal bath of from 2.0 to 0.25 per cent, which softened the gelatin and after draining they were immersed in:

Eosin, 0.2 per cent alc. sol....................20– 50 ccs.
Ammonia10– 20 ccs.
Alcohol50–100 ccs.
Water 1000 ccs.

Time of bathing 2 to 4 minutes.

H. W. Vogel[17] found that silver eoside gave ten times greater sensitiveness than eosin alone, and that it sensitized further towards the red. Further it was not necessary to use a yellow filter. In developing these plates[18] the parts that had been acted upon by the blue rays were at first much denser than those affected by the yellow, but after continued development, the reverse was the case. This showed that the blue rays acted chiefly on the surface, whilst the yellow penetrated more deeply.

Erythrosin, a more bluish dye than the eosins, was found to give greater general color-sensitiveness, especially for the yellow and the beginning of the orange. This dye is generally used for commercial iso- or orthochromatic plates, being added to the emulsion during manufacture. Usually it is mixed with the bromized gelatin, when obviously the silver halide is precipitated in the presence of the dye, becoming more intimately mixed with the same. It is possible to add the dye to the silver solution, if the ammonia process be adopted, as otherwise insoluble silver erythrosinate is precipitated, and this can be dissolved by ammonia. The quantity of dye used naturally varies with the particular ideas of the emulsion maker, but 0.1 g. of dye to 100 g. silver nitrate is about the general ratio; although the quantity may be varied within very wide limits without any apparent variation in color-sensitiveness. The only point to be considered is that with larger ratios there is always considerable staining of the gelatin itself; and this is not entirely removed in washing, so that there may be some screening action.

C. H. Bothamley[19] gave a very good sketch of the subject of color-

sensitizing generally, dealing specially with the composition of the dyes and their optical behavior. In a later paper[20] he specially treated of bathing and examined three points, viz., the necessity of the preliminary bath, the influence of alcohol in the bath, and the necessity of washing. Erythrosin was the dye used, and the conclusions he came to were: (1) alcohol up to 10 per cent has no influence whatever, and may be dispensed with in all cases where the dye is soluble in water; alcohol in larger proportions produces a distinct decrease in sensitiveness; (2) with a concentration of dye up to 1 : 5000 the washing after bathing was quite unnecessary; (3) the preliminary bath might be omitted. It should be further noted that there was no advantage in increasing the bath from 1 : 10,000 to 1 : 5000. However, with plates that have been prepared with very hard gelatin, or which have been treated with chrome alum, it is advisable to use the stronger bath, or increase the time of immersion. Ives' method consists in flooding the plate with an alcoholic solution of the dye, 0.052 per cent, allowing the alcohol to evaporate, and then washing with water. It was not easy to see why this method should give better results than simply immersing the plate in an aqueous dye solution. Photometric experiments confirmed this supposition. They also confirm Ives' statement that if the plate be treated with strong alcoholic solution and not washed there is no color-sensitiveness, doubtless because the alcoholic solution does not penetrate the gelatin.

F. Mylius and F. Foerster[21] recommended the following method of purifying commercial erythrosin: Dissolve the dye in hydrated ether, that is ether saturated with water, and add dilute solution of sodium carbonate, shake thoroughly and separate the two liquids, and treat the aqueous solution of the dye with a strong solution of sodium carbonate, saturated is best, when the dye will be precipitated and should be filtered out, washed with alcohol and then recrystallized from hot alcohol. Von Hübl[22] dissolved eosin in water, precipitated the bromofluorescein with dilute sulfuric acid and after thorough washing dried it and used instead of the commercial dye.

E. Vogel[23] made experiments on the relation of the chemical constitution of the eosin dyes, their sensitiveness to light and the sensitizing effect, and concluded (1), that all dyes of the eosin group sensitize; (2), the silver salts have a greater effect than the ordinary alkaline salts, the action extending further into the red, the relative sensitiveness to blue and violet being lower; (3), derivatives in which a halogen is substituted in the resorcinol residue are better sensitizers than those in which substitution had been effected in both residues; (4), derivatives in which substitution takes place in the resorcinol residues are better sensitizers than when it is in the phthalic residue; (5), iodine derivatives are better than bromine ones, the best being erythrosin (tetra-iodo-fluorescein) and di-iodo-fluorescein; (6), the sensitizing is greater the more sensitive the dye is to light;

(7), sensitizing decreases as fluorescence decreases. The fading of the dye is a photochemical process. Vogel also said[24] that the common statement that silver eoside was a better sensitizer than erythrosin was not correct with collodion or gelatin emulsions, and the error had probably arisen from the fact that eosin was frequently mixed with other dyes of the same class. Silver eoside does, however give softer results than erythrosin silver and a mixture of the two is desirable. As pure erythrosin has no fluorescence Vogel's seventh statement is not correct.[25]

J. Waterhouse[26] reviewed the various methods of bathing and gave preference to Mallmann & Scolik's given above, slightly modified: 0.05 g. erythrosin should be dissolved in 50 ccs. distilled water and heated on a water bath, and silver nitrate added as long as a precipitate is formed. This must be done by artificial light, as the silver erythrosinate is sensitive to light. The precipitate should be washed with distilled water till the washings no longer show milkiness with hydrochloric acid. At this point the dye begins to dissolve, but the purer the dye the less soluble the silver compound. Then ammonia, 2 to 4 ccs., should be diluted with 20 ccs. water and passed repeatedly through the filter till the dye dissolved, then the filter should be washed with distilled water to make 200 to 300 ccs. in all, and the solution used for bathing.

J. Gaedicke[27] pointed out that the order of mixing erythrosin with silver nitrate was not unimportant, and that when silver is added to the dye, 20 parts of the latter combine with 8.5 parts of silver; whereas if the order is reversed, then twice the quantity of silver is required. As it is important to obtain as much silver as possible, the best way to make the compound is to dissolve 17 parts of silver, add 20 of erythrosin, then 17 more silver, allow to settle for two hours, after which a few drops of dye should be added.

W. H. Hyslop[28] adopted a rather curious method of forming erythrosin-silver and his method is interesting historically as the forerunner of Monpillard's method for screen-plates (see p. 512). Silver nitrate 3.6 g. were precipitated as chloride with hydrochloric acid, washed and dissolved in ammonia and the volume brought up to 10 ccs. with water: 5.4 g. erythrosin were dissolved in 3.6 ccs. ammonia and 172 ccs. alcohol. For bathing plates the bath was: silver solution 1.85, dye solution 6.3, water 1000 parts.

Eder and Valenta[29] also recommended rose Bengal and stated that it gave a maximum near D to $D\frac{1}{2}C$, thus was useful as an orange sensitizer, although the general sensitiveness was not so great as with erythrosin. Ordinary rhodamin is similar in action to erythrosin but not so good; but rhodamin 3B, the ethyl ester of tetra-ethyl-rhodamin, was more powerful and gave greater sensitiveness to greenish-yellow, yellow and orange, the maximum being at $E\frac{1}{4}D$, extending to $D\frac{1}{2}C$. Tetra-chlor-tetra-ethyl-rhodamin acted still more strongly, the maximum being at D and extend-

ing to D$\frac{1}{2}$C. The corresponding methyl ester extends the action to D$\frac{3}{4}$C. The hydrochloride of di-phenyl-rhodamin and the sodium salt of the sulfonic acid had but little sensitizing effect. Nitrilo-rhodamin sensitizes still further into the red, although the action is not so strong as with cyanin, the plates were cleaner and with a suitable filter B and C could easily be photographed.

W. Weissenberger[30] examined the action of pyronin dealing with the constitution of the pyronin dyes and eosin, and proved that the former was a sensitizer. H. Vollenbruch[31] stated that erythrosin silver did not give plates that would keep, but by the use of silver citrate, tartrate or acetate this trouble could be gotten over. He also stained his film with ammonium picrate to obviate the use of the yellow filter. M. Trautz[32] experimented with silver salts and proved that certain chemical actions could be delayed by light, and put forward the theory that this might explain the non-coincidence of the absorption of dyes and the sensitizing property. It was assumed that the rays absorbed acted as retarders instead of accelerators of the light action, and would then extinguish that light which formed the latent image.

Lüppo-Cramer[33] stated that with the addition of erythrosin to a silver bromide hydrosol and an electrolyte, such as a sulfate or nitrate, there was no immediate precipitation of the dye. The same results were obtained if the mixture was boiled. Hence the dye acted as a strong protective colloid. This should, therefore, be of value for making grainless emulsions. F. Monpillard[34] in testing some antihalation plates with an underlying substratum of dyed gelatin, found a color-sensitizing effect, and this was due to the dye used, congo red, and he brought this forward as new; but the action of this dye had been described by Eder.[35] W. Abney[36] in a general treatise on orthochromasy, stated that coating a gelatin plate with dyed collodion gave color-sensitiveness, mere contact of the surfaces sufficing. J. B. B. Wellington, W. Bedford, and A. Pringle,[37] H. W. Vogel[38] and Eder[39] were unable to confirm this statement.

F. Kropff[40] examined the color-sensitiveness of various silver salts in emulsion form, either with the spectrograph, or when the sensitivity was too low, with the color patches of the Chapman Jones plate-tester. Silver chloride was found to be sensitive to the whole spectrum, and more so to the less refrangible rays than the bromide. Sulfite, cyanate, thiocyanate, ferrocyanide, bromate, iodate, periodate, phosphate, pyrophosphate, arsenite, arsenate, chromate, dichromate, citrate and tartrate were chiefly sensitive to the shorter wave-lengths; although there was considerable variation in the spectral sensitiveness, no relation between this and the color of the salt could be observed. Sensitizing with dyes gave no noteworthy results.

F. E. Ives[41] detailed experiments with ordinary plates and concluded that with properly selected filters, they were capable of giving good mono-

chromatic rendering of colored objects, and that the results were more correct than those obtained with commercial plates with the ordinary yellow filters. This was confirmed by Chapman Jones,[42] who recommended the flame spectrum of the double carbonate of sodium and potassium as a convenient test for the two ends of the spectrum. E. Stenger[43] also tested ordinary plates for tri-color work and found that the results alleged to be quite as good as those on color-sensitive plates could be obtained with exposures of 1 : 750 : 9000 for the blue, green and red, respectively. Obviously this is utterly impracticable for ordinary work. Eder also pointed out that from tests of 130 different kinds of plates, all negative emulsions were sensitive to red and yellow as long as sufficient exposure was given, and only in the case of transparency emulsions was this found practicable.

Sensitizers for Special Spectral Regions.—It is possible to find among commercial plates some that will answer to nearly all requirements of the average worker, and it is only when one has to deal with special spectral regions that one need sensitize one's own plates.

Green Sensitizers.—Till quite recently there were practically no actual green sensitizers, with the exception of auracin G and acridin orange NO, which have, however, been but little used. The former sensitizes from D$\frac{1}{2}$E to F in a concentration of 1 : 25,000, and in 1 : 8,500 strongly depresses the blue through screening action, it can be used with the phthalein dyes and should be useful. Acridin orange is not very soluble in water and a saturated solution in alcohol should be used. This unfortunately stains gelatin very deeply and can only be removed by an alcohol bath.[44]

It is an open question whether an actual green sensitizer, or green-blue, is required in practical work, because all green objects reflect yellow and blue and will be more or less recorded by plates sensitized with the phthalein dyes. On the other hand, for tri-color work an actual green sensitizer may be more useful. Such a dye is pinaflavol, introduced by Meister, Lucius and Brüning[45] which was said to belong to an entirely new class of basic dyes, characterized by their yellow color and specific sensitizing action for the green.

Eder[46] stated that it had a maximum about E, 5300, falling sharply at D and extending without gaps to F, thus not exhibiting the minimum of the eosins in the blue-green. The rapid fall of the action at D is of special interest, and in photographing a color chart with a medium yellow filter, the yellow-green was reproduced stronger than the yellow. For tri-color work this would be of great value, as it reduces the exposure considerably under the green filter, and actually the green filter may be done away with and a yellow one used instead. The importance of this is easily seen from the fact that all green filters are comparatively dark, that is to say, they absorb a considerable quantity of green light, and this

want of transparency has always been a handicap. The use of a yellow filter will enable the exposure to be cut in half.

Pinaflavol is used in the same way as the isocyanins, and the bath may be:

Pinaflavol, 1 : 1000 aqueous sol. 20 ccs.
Water 1000 ccs.

The time of bathing should be about 2 minutes and the plates be drained and rapidly dried. The addition of alcohol reduces the sensitiveness.

To combine this with the isocyanins to obtain panchromatism König[47] stated the plate should be bathed for 2 minutes in:

Pinacyanol, 1 : 10,000 alc. sol. 30 ccs.
Water 1000 ccs.

Briefly rinsed and immersed in:

Pinaflavol, 1 : 1000 sol. 7.5 ccs.
Water 1000 ccs.

And dried without washing. Plates thus treated only require half the exposure through the green filter, as compared with pinachrom-bathed plates. It may also be used for collodion emulsion, and about 20 ccs. per liter, the strength of the dye as above.

W. H. Mills and W. J. Pope[48] described the preparation of 2-p-dimethylaminostyrylpyridin methiodide from α-picolin ethiodide, p-dimethylaminobenzaldehyde and piperidine. The dye is obtained in bright red prisms with blue reflex, giving an orange-colored solution that shows an absorption band at about 4750 and 4600. Plates bathed in 1 : 30,000 to 40,000 solution show almost uniform sensitiveness to all wave-lengths from the blue to 5600. There is no gap in the blue green. A number of sensitizing dyes may be prepared by replacing picolin by its derivatives.

The Eosin Group.—Copious notes have already been given as to these dyes in general. They are chiefly used for commercial plates and nearly all give the characteristic gap in the blue-green, which is the more pronounced the bluer the shade of the dye. Erythrosin[49] a bluish-red dye, is generally used and is a tetra-iodo-fluorescein compound of sodium or potassium, $C_{20}H_6O_5I_4K_2$ or Na, and a normal bath is a 0.06 g. in 1000 ccs. with the addition of a little ammonia if the emulsion be acid. The addition of very small traces of silver nitrate increases the sensitiveness but the plates will not keep, and there is great tendency to fog. The addition of alcohol von Hübl[50] said reduces considerably the speed.

Quinolin red is the only other green sensitizer used and actually only with other dyes, usually the isocyanins. It can not be used with the eosins as the latter are acid dyes and the former basic. The use of this with the isocyanins is dealt with under the isocyanins.

Red Sensitizers.—Notes on the old, amyl cyanin have already been given, and as it has fallen into complete disuse the matter may be left.

Alizarin Blue.—Although Eder had tested this dye he had not

detected its strong action for the red. This was first noted by J. Waterhouse[51] who used a 1 : 10,000 solution with 1 per cent ammonia and photographed to A, wave-length 7600. This action was confirmed by Lord Rayleigh[52]. G Higgs[53] was able to reach to 8400 with it, and suggested the following method of operation: 10 parts of the dye paste, alizarin blue S (Badische) should be triturated with 10 parts of saturated solution of sodium bisulfite and 10 parts water in a mortar, and allowed to stand 5 or 6 weeks with daily agitation, except for the last 10 days. The liquid should be decanted and alcohol added to precipitate the bisulfite, which should be filtered out. Then 50 parts of water should be added and sufficient salt to form a saturated solution and the whole set aside for about 10 days. The dye crystallizes out with the calcium salts and the latter should be removed by filtration, after solution in water. The final purification should be effected by crystallization from strong alcohol. A solution of the dye 1 : 10,000 in water plus 1 per cent ammonia gave excellent results.

Gargam de Moncetz[54] used a mixture of:

Alizarin blue bisulfite, 1 :500.................... 30 ccs.
Ammonia 10 ccs.

Mix and add

Alcohol 420 ccs.
Nigrosin B, 1 : 500........................... 20 ccs.
Pinacyanol, 1 : 1000 12 ccs.

The plates were bathed for 2½ minutes and after drying kept for a day. The sodium line at 8160 and the calcium line at 8680 were thus obtained. The alizarin must be used immediately after making; the ammonia could be replaced by 5 per cent potassium carbonate solution.

G. Michaud and J. F. Tristran[55] detailed experiments with the infra-red rays and suggested their application to telephotography, as very fine details are rendered by this region with suitable plates. Alizarin blue plus a little silver nitrate was used. W. A. Scoble[56] also reported on Higgs' method and stated that it sensitized well up to 8300, and that he had obtained lines up to 8900. The plates were first immersed in 1 per cent ammonia for 3 minutes then in 1 : 10,000 solution of dye plus 1 per cent ammonia, washed and exposed wet. Scoble gave some interesting notes on this dye, which seems rather capricious in behavior. When the dye is dissolved in water the solution has a reddish-brown color, turning to blue after a few days. If ammonia be added to the strong solution, 1 : 500, the blue appears at once; a weaker solution, 1 : 10,000 becomes purple changing to blue in a day; occasionally the weak solution turns only green, but more frequently greenish-blue and this is more likely to occur if the ammonia is added to the water before the dye. After a few days the dye flocks out; the solution must be green to act well. The final procedure was to add 1 of dye to 500 alcohol and 10 parts ammonia. This should be filtered and used soon.

G. Eberhard[57] also found later that good results could be obtained with an admixture of:

Alizarin blue S, 1 : 500..................... 30 ccs.
Rose des Alpes, 1 : 200................... 20 ccs.
Ammonia 10 ccs.
Silver nitrate, 2.5 per cent..................40-60 drops
Water 1000 ccs.

The action of the nigrosins and acridin orange NO was reported on. Indulins, nigrosins, alizarin blues, oranges and reds were tested and there was found with a comparatively wide slit some red action, whereas with a narrow slit this could not be seen. He also strongly recommended alizarin blue bisulfite and stated that there was strong action from C to A with maximum between B and C. The general sensitiveness was not appreciably reduced, and with a small addition of silver nitrate the action extended further into the red.

J. B. B. Wellington[59] proposed to heat nearly to boiling 1 g. methyl violet, potassium dichromate 22 g, and 280 ccs. water, collecting the precipitate and dissolving in 360 ccs. alcohol with the addition of 12 g. quinin; this mixture was mixed with 6.6 ccs. ammonia and 1000 ccs. water. According to Eder this did not give good results. U. Yoshida[60] bathed plates in 1 : 20,000 solution of methyl violet in 50 per cent alcohol, the bath being cooled by ice. The maximum sensitiveness was at 6400, and no better results were obtained than with Wratten panchromatic plates. Bathing an orthochromatic plate in this solution gave sensitiveness to 6600, with a minimum at 5300.

L. Vidal[61] recommended a mixture of malachite green and naphthalen blue. To prepare the former, 1 part was dissolved in 200 ccs. water and heated to 70° C., and 10 parts of a hot 10 per cent solution of potassium dichromate added. The mixture was then heated to 70° to 80° C. for 30 minutes, filtered and the precipitate well washed with water and dissolved in alcohol, containing 6 to 8 parts quinin sulfate. One part of naphthalen (indophenol) blue should be dissolved in 5000 alcohol. The plates should be bathed for 2 minutes in:

Naphthalen blue sol......................... 6.6 ccs.
Malachite green sol......................... 6.6 ccs.
Water 1000 ccs.

These plates were sensitive to green, yellow and red and the blue sensitiveness was reduced.

E. Valenta[62] announced his first trials with ethyl violet for gelatin plates as failures because he used too strong a solution, as it has enormous tinctorial power. He finally found that 1 : 250,000 with a little ammonia gave a strong band from C to D with a weaker one from D to E. This minimum could be filled up with monobromofluorescein. The actual bath was:

Ethyl violet, 1 : 5,000 .100 ccs.
Erythrosin, 1 : 500 . 20 ccs.
Monobromofluorescein, 1 : 500 30 ccs.

And of this stock solution 30 parts should be added to 1000 water and 4 parts ammonia. Time of bathing 3 minutes and the plates should be washed in a similar solution much diluted and dried at a moderate heat.

The Isocyanins.—W. H. Mills and Sir W. J. Pope[63] gave an extremely interesting paper on the isocyanins, in which they pointed out that up to 1903 there were practically two classes of sensitizers; the first consisted of a large number of dye stuffs, more or less studied by Vogel, Eder and others, whilst the second comprised the fluorescein derivatives, which were first examined through the discovery of the effect of eosin by Waterhouse.

Greville Williams[64] proved that a blue dye, which was named cyanin, could be prepared from the amyl iodide of the substituted quinolin, lepidin, by the action of an alkali. Lepidin can be obtained by distilling cinchonin with potash, but was subsequently separated from the quinolin bases in coal tar, and quinolin blue or cyanin was produced commercially.[65] Vogel recognized its sensitizing power, but it was very prone to give fog. It is still of interest from a chemical point of view, and some clew to its chemical nature was obtained by the syntheses of Skraup & Döbner, and von Müller had facilitated work in the quinolin series. Hoogewerf & van Dorp[66] and Spalteholz[67] showed that cyanin and its analogues were formed by the condensation of a molecule of quinolinium alkyliodide with one of a lepidinium alkyliodide. They discovered independently a similar series of salts by the condensation of quinolinium alkyliodide and quinaldinium alkyliodide, and these are called the isocyanins. These dyes give solutions that are reddish-purple by transmitted light, whilst those of the cyanins are blue. The isocyanins attracted but little attention till Miethe & Traube's discovery of the sensitizing properties of ethyl red, and this was rapidly followed by the dyes of Meister, Lucius & Brüning, and Bayer.

This paper dealt primarily with the molecular constitution, the relation between the chemical constitution and sensitizing action and the preparation of the new dyes that should be an improvement on existing ones. Reference should be made to the original, which is illustrated with spectrograms and deals fully with the manufacture of the dyes. In a later paper[68] the same investigators treated of what they called the "carbocyanins," that class to which pinacyanol, or sensitol red belongs. This paper is also fully illustrated.

Ethyl Red.—This was the first of the isocyanins and was introduced by A. Miethe and A. Traube.[69] G. E. Brown[70] stated that the dye should be used in the ratio of 1 : 50,000 with 0.3 to 0.5 per cent ammonia. The fresh bath gave fog, but after standing a day or two in the dark lost

this defect, and then gave clean plates. The plates should be bathed 2 minutes, washed for 3 minutes and then rapidly dried.

A. Miethe[71] introduced "irisine," the nitrate or sulfate of ethyl red, and which was, therefore, the corresponding salt to orthochrom T, which had been patented by Meister, Lucius & Brüning. E. König pointed out that the acid radicle had no influence on the sensitizing power of the dye. Miethe[72] also found that the addition of quinolin red, as first pointed out by H. W. Vogel, lessened the fog with the isocyanins, and recommended five or six times that of the isocyanin; eosin might be used, but it did not give such an even spectrum. A typical formula was:

 Isocyanin dye, 1 : 1000...................... 20 ccs.
 Quinolin red, 1 : 1000...................... 100 ccs.
 Ammonia 3 ccs.
 Water1000 ccs.

This addition has been found of considerable practical value, as is also the addition of glycin red.

Homocol.—This was one of the Bayer dyes and the following was recommended:

 Homocol, 1 : 1000 alc. sol....................10-20 ccs.
 Ammonia, sp. gr. 0.91...................... 50 ccs.
 Water 1000 ccs.

The plates, which should not be of the extra rapid class, should be bathed for 2 minutes, allowing 50 ccs. of bath per 100 qcm. of surface. Then washed for 3 minutes in running water and dried at 20 to 26° C in not more than 2 hours. They might be dried by alcohol, but the color-sensitiveness was lowered.

A. J. Newton, C. E. K. Mees and S. E. Sheppard[74] tested homocol, using Eder's method with blue and yellow filters, and found the ratio of blue to yellow to be 1 : 1.1 to 1.4, this value being unaffected by washing the plates with alcohol. The same plates with pinaverdol gave 1 : 2.1, with pinachrom 1 : 1.1. Other plates gave different ratios, probably due to variation in washing.

Isocol.—Another Bayer dye. The bath recommended was:

 Isocol, 1 : 1000 alc. sol........................ 25 ccs.
 Alcohol, 90 per cent........................ 350 ccs.
 Ammonia, sp. gr. 0.90...................... 10 ccs.
 Water1000 ccs.

Time of bathing 4 minutes, washing and drying as usual. The sensitiveness extended to wave-length 7200.[75]

A. J. Newton and A. J. Bull[76] examined many commercial and also bathed plates, and their results with a spectrograph are given. The experiments included mainly ortho- and panchromatic plates and the isocyanin dyes. The papers are well worth study, though they are somewhat too long for inclusion here.

Orthochrom T.—This was the first of the Hoechst dyes and is p-toluquinaldin-quinolinmethylcyanin bromide, and like ethyl red sensitizes to about 6200. A stock solution of the dye should be made by dissolving 1 g. of the dye in 100 ccs. warm alcohol, then adding 400 ccs. cold alcohol and 500 ccs. water. For bathing:

Stock solution 20 ccs.
Ammonia 10 ccs.
Water 1000 ccs.

Time of bathing 3 or 4 minutes, with constant rocking of the dish, then washing in running water for 2 or 3 minutes and rapidly drying.[77]

Pinaverdol.—Another of the Hoechst dyes, which is p-toluquinaldin-quinolin-methyl-cyanin bromide, may be looked upon practically as a green and yellow sensitizer,[78] which unlike the later isocyanins does not give such a marked minimum in the blue-green. Its chief use would seem to be as addition to the red-sensitizers to fill up the before mentioned gap.

The recent discovery of other dyes (see p. 252), as green sensitizers would seem to supplement the action of this dye or replace it. W. T. Braunholz and W. H. Mills[79] described the formation and action of a new series of dyes from one quinolin and one benzothiazol nucleus, and to which they gave the name of thioisocyanins. They are all bright red compounds, which crystallize well from alcohol. Their orange-red solutions show a pair of overlapping absorption bands of unequal intensity in the green and blue-green. The crest of the deeper band lies near 5000 to 5100; that of the less intense about 1200 to 1500 wave-lengths shorter. The absorption spectra are much akin to those of the isocyanins, but the bands of the former lie nearer the blue end of the spectrum, the difference being about 500 wave-lengths, reaching to 5800. As with other isocyanins their aqueous solutions are decolorized by acids. They are all powerful sensitizers for green.

Pinachrom.—A Hoechst isocyanin which sensitizes further into the red than pinaverdol, up to 6500 approximately. It is p-ethoxyquinaldin-p-methoxyquinolinethylcyanin bromide. It is distinctly bluer in shade than orthochrom or pinaverdol.

E. König[80] pointed out that plates bathed with this dye were more sensitive than those prepared with the dye in the emulsion, and that this can not be due to the deeper stain of the former on the gelatin, for those bathed long enough to stain right through still showed superior speed. And plates coated with a pinachrom emulsion, and then bathed show the same sensitiveness as the undyed emulsion when bathed. Ammonia is frequently added to the bath, and with some of the old dyes it is essential, but with the new dyes it is not, and it sooner or later causes fog. The sensitiveness of plates bathed in neutral solutions was for practical work, equal for the green and blue and four-fifths for the red. The actual bath suggested was a 0.015 to 0.02 per cent solution used as for pinaverdol, etc. Another

advantage of the omission of ammonia was that tap water might be used, there being no precipitation of lime salts. The washing was not to remove the dye, as this is impossible even with the most soluble of the dyes, the sole purpose was to remove surface dye solution, which might otherwise do harm. If a bath containing much alcohol be used, the washing must be continued till the so-called greasy marks disappear. König stated that it was not generally known that if methyl instead of ethyl alcohol were used these greasy marks were not formed. A bath with 1 per cent of potassium carbonate gave better red sensitiveness than a neutral one. Isocyanin solutions are decolorized by sodium or ammonium chloride and and the color restored by ammonia. Plates bathed with solutions containing 1 per cent ammonium or sodium chloride showed better red sensitiveness than plain ones. He contended that a spectrogram prepared with a given dye does not of itself give any measure of the value of the dye for practical work.

R. Namias[81] considered that commercial plates did not give such good results as bathed ones, and came to the conclusion that the omission of alcohol and acetone gave better results. He advised bathing for 15 minutes in total darkness, then rinsing under the tap, immersion in alcohol, 95 per cent, for 1 minute and drying in a box with calcium chloride, when they will dry in 2 to 3 hours. The alcohol can be repeatedly used, though it becomes highly colored. Ethyl violet and pinachrom were tried, and the latter gave shorter exposures with better results. The former on the other hand, required less care and was not so prone to fog. The ethyl violet was made up in a stock solution:

Ethyl violet 1 g.
Erythrosin 0.5 g.
Alcohol, 95 per cent......................... 500 ccs.
Water 500 ccs.

For use 2 per cent plus 0.5 per cent ammonia was mixed. For pinachrom a 1 : 1000 solution in equal volumes of water and alcohol was made and of this 2 per cent was used for 268 qcm. The addition of 0.5 per cent ammonia increased the speed and fog.

Pinacyanol.—This is not a true isocyanin and was introduced by the Hoechst Farbwerke. It gives a marked gap in the blue-green, but sensitizes further into the red than the other dyes.

F. Monpillard[82] stated that it absorbed the orange, yellow and part of the green, the strength of the dye being 0.0005 g. to 1000 ccs., with two strong bands, one in the green from 5400 to 5600 and the other much stronger at 6000. The sensitiveness curves were displaced towards the red and were at 5900 and 6380, the sensitiveness extending to 6900, with a minimum at 5100 to 5300. A number of experiments proved that the best concentration was 0.005 to 0.001 g. per liter, and the smaller quantity gave invariable success. This dilute solution required no washing of the

plates; increase of the dye did not increase fog. Several comparative experiments with ammonia showed that a rapid and constant increase of sensitiveness is obtained, which is most marked in the orange, less in the yellow and still less, though noticeable in the blue-violet. There was no sensible increase in fog; but when the quantity of ammonia exceeded 0.01 per cent, the gelatin had an increasing tendency to become yellow. The bath recommended was:

Decimal ammonia	60 ccs.
Distilled water	940 ccs.
Pinacyanol, 1 : 1000 alc. sol....................	5 ccs.

Time of bathing 3 minutes, drain and dry without washing. The decimal ammonia should contain 1.7 gaseous NH_3 per liter, and can be made by diluting 8 ccs. ammonia solution, sp. gr. 0.9241 at 22° C. to 1000 ccs. In order to fill up the gap in the green, Monpillard recommended the addition of 5 ccs. of 1 : 1000 alcoholic solution of homocol to the above bath.

Eder[83] stated that this dye was not so sensitive to acids as pinachrom, sensitized further into the red, but did not sensitize for green. Gelatin plates should be bathed in a 0.0015 per cent solution for 3 minutes, washed for the same time in running water and rapidly dried. For collodion emulsion 5 to 10 ccs. of a 1 : 1000 alcoholic solution should be added to 1 liter. G. C. Laws[84] stated that for three-color half-tone work a 0.002 solution in equal volumes of alcohol and water should be used.

Dicyanin and Other Dyes.—This dye contains two lepidin rings and no quinolin. It was examined by von Hübl[85] but it was afterwards found that the dye was impure. In a later paper[86] he stated that the action extended from almost A to Eb, with three maxima at B, C$\frac{1}{2}$D and behind D. Mees & Wratten[87] found, contrary to Monpillard that it did not depress general sensitiveness if used in the right ratio, which is rather less than 1 : 100,000. It is important that the plates be rapidly dried, as the dye appears to fade out during drying. The dyed plates keep their color-sensitiveness for months. There is complete absence of action from 5200 to 6000, it is not a minimum but a gap. The maximum was at 7000, and while the plates have great sensitivity from 6800 to 7200, the sensitiveness at 7300 is so small that a pinacyanol plate will require a shorter exposure at 7500. Practically the use of this dye may be said to be limited to photography of the little *a* line, 6280, which is of great importance in sunspot work.

F. Monpillard[88] recommended the same strength bath as for pinacyanol, see above, also drying without washing. The sensitiveness extended from 7420 with maxima at 6900 and 6300, with a minimum between 5100 and 5200. Combined with homocol, the same quantity of the latter being used, an almost even band from 7100 to the ultra-violet was obtained, but the general sensitiveness was lowered.

The Bureau of Standards, Washington, D. C. in their circular, state:

"the solid dicyanin should be bronze-green in color. If it is not, particularly if it appears brownish, the dye has deteriorated and should not be used. If the crystals are not kept cool and dry, they not only rapidly lose their sensitizing power, but the bath made from them diminishes the natural sensitivity of the plate so much as to make it useless. A freshly mixed staining bath of fresh or healthy dicyanin is bright snappy blue-green in color. As soon as the dye deteriorates, owing to oxidation, the green color fades considerably, the solution appears dull and in addition shows transmission bands in the red. Such a bath should not be used."

Eder[89] dealt with the action of dicyanin A, pinachrom blue and pinacyanol blue. The addition of ammonia, 0.3 to 1.0 per cent, to dicyanin A, dicyanin and pinachrom violet makes the aqueous solutions bluish-violet, but they soon become muddy. Pinacyanol blue is soon decomposed by ammonia separating out in flocks, while pinachrom blue remains blue longer but also gradually decomposes. Alcoholic baths are to be preferred because the plates dry quicker, and, therefore, work cleaner. A typical bath is:

Dye solution, 1 : 1000 alc..................... 20 ccs.
Alcohol333 ccs.
Water ..666 ccs.

This can be filtered through glass wool. Time of bathing 4 minutes in the dark, drying should be as rapid as possible. The addition of 1 ccs. ammonia to the above increases the total sensitiveness two or three times; but there is great danger of fog, and this is dependent on the dye and the plate. The sensitivity with dicyanin extends from the infra-red to the green, with a maximum from A to D, 7600 to 6000, and with an orange filter with longer exposures it extends into the infra-red to Z, X, X_2 and X_3 and fairly vigorous to 6400, with weaker action on to 8400. The addition of ammonia increases the red sensitivity four or five times, and especially that to the infra-red; but as pointed out with increase of fog, and it is advisable to dry the plates within 20 minutes and use them within 24 hours.

Dicyanin A is a greenish-blue dye, an ethoxylated dicyanin, it sensitizes further into the red, 7800 to 6300 and with long exposure extends to 8900 and 6800, but the band is narrower than with dicyanin and the minimum ranges through the orange-yellow and green. The plates possess but little keeping power.

Pinachrom Blue gives a broader band than dicyanin A and the minimum in the green is less and the general sensitivity greater. Addition of ammonia is not necessary, but it doubles the general speed. The maximum does not reach quite so far in the infra-red, beginning about A, or with shorter exposures at *a*, and extends, with a small minimum in the orange, into the yellow-green to D½E, about 5400. With longer exposure it extends beyond A and the minimum in the green is not so marked.

Pinacyanol Blue gives a maximum between B and C with a fainter

one at C$\frac{1}{2}$D to D, and a broad minimum in the green. It will not stand the addition of ammonia, and presents no particular advantage.

Pinachrom Violet[90] which is a true isocyanin, was discovered by E. Staehlin of Meister, Lucius & Brüning, and can be combined with pinaverdol and pinachrom much better than pinacyanol, and then gives greater sensitiveness in the red. It is very sensitive to acids, and when diluted with water is bleached by carbonic acid. It can be used in exactly the same way as pinacyanol in a bath of:

Pinachrom violet, 1 : 1000 alc.................... 10 ccs.
Orthochrom T, 1 : 1000 alc...................... 10 ccs.
Or pinaverdol, 1 : 1000 alc...................... 10 ccs.
Or pinachrom, 1 : 1000 alc...................... 10 ccs.
Alcohol ...333 ccs.
Water ...666 ccs.

To make the stock solution of this dye 1 g. should be dissolved in 100 ccs. hot alcohol and 600 ccs. cold alcohol added and 300 ccs. distilled water.

Sensitol Violet, issued by the Ilford Co., England, is a similar dye, and should be, according to the makers, dissolved in the ratio of 1 : 1000 warm alcohol and then diluted with cold alcohol to 5000. For red-sensitive plates the following should be used:

Alcohol .. 333 ccs.
Stock dye sol................................13.5 ccs.
Water ... 666 ccs.

Time of bathing 3 minutes; dry without washing in current of dry air. It is stated that this bath keeps in good condition and may be strengthened after use. For the best rendering of green at the same time as orange and red, sensitol green should be also used, in the ratio of 1 violet to 2 green. Sensitol violet sensitizes feebly from 5000 to 5200, therefore, this should be the transmission of a safe light for these plates.

C. E. K. Mees and A. Gutekunst[91] described the preparation and sensitizing powers of naphthocyanole, acetaminocyanole and kryptocyanin. The first sensitizing for red with a marked gap in the green. The second shows a range to 7600, but only seems suitable for addition to emulsion, and not for bathing in consequence of the hydrolysis of the dye. Kryptocyanin in 1 : 500,000 without ammonia or alcohol sensitizes to 7700, with a very wide gap in the green, and is only suitable for infra-red and astronomical work.

A. and L. Lumière and H. Barbier[92] gave the spectral curves obtainable with cyanin A, prepared from di-methyl-amino-quinolin and iodo-ethyl-tolu-quinaldin which sensitizes to 6800. And cyanin B, from iodo-ethylate of dimethyl-amino-quinolin and di-methyl-amino-quinaldin, sensitizing to 7000. Also pantochrome prepared like the last but with dimethyl-amino-benzaldehyde, which sensitizes to 7000, but without the marked minimum in the blue-green of the former dye. These dyes differ from the older

isocyanins in that they contain one or two auxochrome groups of diethyl-or di-methyl-amino and are prepared from the above bases by the condensing action of piperidin.

V. P. Lubovich and E. M. Pearen[93] examined the absorptions of various filters and alcoholic solutions of dicyanin, dicyanin A, pinacyanol, nigrosin SS blue shade, and alizarin blue S and found that the use of a proper mixture of dyes may prove useful in photographing beyond 9000, and that although not so popular nigrosin and alizarin blue may be more useful for certain spectral regions than the dicyanins.

Mixed Isocyanins.—With the idea of obtaining more even sensitiveness, and filling up the minimum that occurs with red-sensitizers, numerous workers have suggested admixtures of various isocyanins and some curious formulas have been arrived at obviously largely by empirical methods.

If one considers the sensitizing action of the different dyes, as evidenced in their spectrograms, it is at once clear that it is of no advantage to add two red sensitizers to what we may call a green-sensitizer. For instance, let us take for granted that we want as high green sensitiveness as possible, and for this use sensitol green, orthochrom or a similar dye, and that these sensitize fairly evenly to 6250, that is right into the orange between D and C. But this is not far enough for tri-color work, nor for the correct rendering of reds in the copying of pictures. We, therefore, decide to add on red-sensitiveness, and our choice would naturally lie between sensitol red or sensitol violet. Till these were introduced pinachrom alone was available, and this practically sensitizes to about 6600, whilst sensitol red reaches to 6750 and the violet to 7000 or 7250. There is obviously not the slightest advantage in combining pinachrom, sensitol violet and one of the green sensitizers, as the pinachrom sensitizing band is overlapped by that of the violet and the sensitol red. And with such complex substances there is far more likelihood of deposition when such mixtures are used. In any case sensitol red, or pinacyanol, not being a true isocyanin, does not stand up so well in admixture with other dyes as the true isocyanins, pinachrom or sensitol violet. This has been proved by experience. Probably the best mixture is orthochrom, or sensitol green with sensitol violet.

Numerous formulas and curves of the results obtained therewith have been given; but the main trouble with these is that they are, unless taken as sign posts, quite misleading. From a fairly wide experience in sensitizing with the isocyanins the author would lay down almost as an axiom that the sensitiveness obtainable with a given mixture, or a single dye, is dependent on so many factors, that exact duplication of the results can never be obtained—except under the exact conditions of the original experiments.

The factors that may and do vary the results are: (a), the plate used; (b), the temperature of the bath; (c), the duration of bathing; (d), the

time and temperature of washing, and the composition of the water; (e), the rate and temperature of drying; (f), the method of bathing and composition of the bath.

To consider these factors in detail. First, the character of the plate. Some can be better sensitized than others, when the final results are considered. In all cases a plate that is at all inclined to be foggy, will have its fog increased. The faster the plate the less likely it is to keep after bathing, that is to keep free from fog, and with the original added color-sensitiveness. Very fast plates in many cases are so cooked in the manufacture of the emulsion that they are on the verge of incipient breakdown, and are, therefore, extremely sensitive to outside influences. There may be, of course, exceptional circumstances when speed is absolutely essential, and then one must sacrifice something to attain this. But it may be taken as an axiom that a medium speed plate, which assumes that it is perfectly clean-working under normal conditions, will give better results than a fast one, and it will have a longer life.

All plates will not give the same results, because there are probably no two commercial plates by different makers that are made exactly alike or by the same process, even if they are of the same composition. On this point we are unfortunately much in the dark. It has always been assumed from the very earliest days of bathing plates, that those containing much iodide are unsuitable.[94] To decide this question recourse would have to be made to a long series of experiments, or information obtained from the manufacturers, and they are, as a class, the least likely to give any information on this point, as it is considered by them the most holy of holy secrets as to the manufacture of their plates, and even the slightest and really trivial facts are guarded like the secrets of freemasonry. It is thus generally assumed that 5 per cent of silver iodide is the highest that can be used, and 2 or 1 per cent is better. On the other hand, one of the best orthochromatic plates on the market contains nearly 10 per cent. Again it is stated that a boiled emulsion gives better results than one made with ammonia, against which practical experience could be brought forward. To the average worker the best advice is to use the plate that is generally used in ordinary work.

The temperature of the bath plays a very important part, for, as everyone knows, the higher the temperature the more easily is the gelatin penetrated by a solution and the softer it becomes. Practically it may be considered that temperature and time of bathing are interchangeable. Still the best temperature is from 18° to 20° C.

The duration of bathing is a moot point; writers have differed much on this. Von Hübl[95] recommended about 3 minutes. Sheppard and Mees[96] stated: "provided the plate is bathed long enough the time of bathing is of no importance; 3 minutes is long enough." Others again have recommended 5 minutes. But this is dependent also on the strength of the

bath and the method of use, and it would be as well to consider the method of bathing.

There are two methods available, either to bathe in a flat dish or to use a grooved trough, and one may merely allow the plates to soak in the solution, or the solution may be rocked all the time. At first sight it would appear that letting the solution lie quiescent would have the same final effect, given time enough, as agitating it. But the results are not the same, either because the solution is locally exhausted, or as the author is inclined to think, there is local deposition of the dye on the gelatin surface, which prevents further penetration into the depths of the film. A bathed plate nearly always shows a darker color on the surface of the film than it does at the back, and it has been possible to pick out bathed plates by this sign from those in which the emulsion was dyed before coating.

The following figures, taken from a working note book, are somewhat interesting: (A), plate immersed in bath without agitation for 3, 6, 9, 12 minutes gave a red speed of 152, 160, 169, 180. (B), plate immersed in similar bath and rocked all the time gave 240, 240, 245, 247. These are two examples from a very large number of trials, and when the characteristic curves were plotted, it was found that there were quite inexplicable variations in the A batch; whilst those of B were practically constant throughout the trials. In some cases with A there was an extraordinary variation in the red and green speeds, and the curves obtained under the usual tri-color filters, presented all sorts of anomalies. Sometimes being parallel and at others crossing, and this at different densities. It would seem as though want of agitation must either cause slower penetration of the dye, or the latter was locally exhausted, or it happened that one dye was locally deposited on the surface, though under the particular composition of the bath this was extremely unlikely.

The effect of washing is again a moot point. Sheppard and Mees[97] stated that in the case of pinacyanol no washing gave a red speed of 1.7, after 40 seconds wash the speed was 6.6, after 10 and 40 minutes 26, so that 10 minutes would be sufficient. E. König[98] stated that washing is practically useless, as all the isocyanins are basic dyes and they can not be washed out of the gelatin. Procoudin-Gorsky[99] stated that thorough washing was very important as regards keeping properties. Prolonged washing did not injure the gelatin in any way. Testing the plates visually in the spectroscope showed no difference between those washed for 3 minutes and those washed for half an hour, but there was a marked difference when the washing was prolonged 3 hours. The dyes used were ethyl red and orthochrom with pinachrom in an ammoniacal bath. Distilled water at about 10° C, was used for washing, which was carried out in grooved troughs with running water. An idea of the keeping properties of the plates thus prepared may be gained from the fact that a dozen plates were simultaneously bathed in the same sensitizer; six being washed 3 minutes

and six for 3 hours. When starting for the Caucasus, these plates were left behind with others in St. Petersburg. A month after they were sent on, but failed to reach Gorsky and followed him for a year, when they were tested. Those washed for the longer time were perfectly preserved; whilst those washed for 3 minutes only were strongly fogged and so insensitive as to be useless. Both kinds had the same kind of packing. Drying should be effected within an hour and a half.

These seemingly contradictory statements as to washing may be to some extent explained by the fact that the same dyes were not used in every case, and also on the composition of the water used. In the author's experience there is but little advantage by prolonged washing; but it should be sufficient to remove surface dye. When the washing is very prolonged, as in Gorsky's case, it is quite possible that one may have decolorization of the dye by the carbonic acid in the water, and the air dissolved therein, which would certainly remove the dye retained by the gelatin before that absorbed by the silver halide grain, on the assumption that the latter enters into some sort of chemical combination or solid solution with the dye. It is not, of course, permissible to wash in acidulated water, which certainly assists in the removal of the dye, as this is completely decolorized; but better results, or less staining of the gelatin, are obtained by the use of weak borax baths, and slightly higher color-sensitiveness thus obtained, but whether this be due to the general removal of the dye or the alkaline action of the borax was not determined.

The quantity of dye, judging from published formulas, is still a matter of doubt. Sheppard and Mees,[100] tested baths of pinacyanol: 1, 2, 4, 8 parts per 100,000 and with a time of bathing of 5 minutes and 10 minutes washing. The speeds obtained were practically 11, 27, 19 and 13 respectively whence it is seen that 2 : 100,000 with 3 minutes bathing and 10 minutes washing gave the best results.

The temperature and rate of drying certainly play some part in the resultant sensitiveness. The temperature of the air used for drying has some influence, but it is very difficult to differentiate between this and the rate of drying, as it is extremely difficult to so hold the balance between the two that the rate of drying in cool air is the same as in warm. Some experiments carried out by the author, which were admittedly rather rough, proved that a higher temperature is more favorable even when the time of drying with cooler air was approximately the same. Rapid drying has a marked influence on the general and color-sensitiveness, and the more rapid the drying the better, as it conduces to better keeping qualities.

If one has not a special drying cupboard, in which there is rapid circulation of warm air, the most efficient substitute is one of the small electric hot-air dryers, as used by hairdressers, and with one of these installed, and preferably enclosed in a tunnel, which may be merely a box with the ends knocked out, it is possible to dry plates in 30 minutes. But care should be

taken to place the plates parallel with the air current, and at such distance that the temperature of the air does not strike the thoroughly wet plates higher than 32° to 38° C. If many plates are to be sensitized two or three racks should be used, and as soon as the first plates are washed they should be thoroughly wiped on the back, so as to prevent local drops of water, which locally cool the plates and cause spots by slower drying. The film should also be wiped. This may seem a somewhat risky matter; but it is quite easy to carry out without making any scratches or marks by using a fairly large swab of absorbent cotton, that has been thoroughly wetted with distilled water and then wrung out. If this be folded so as to leave the fold free, and it be held by the ends, it is possible to pass it two or three times over the surface of the gelatin without the slightest chance of scratching, and the film will appear completely surface dry and free from all blobs of dye solution. Naturally great pressure is not required, in fact the swab should be rather allowed to drag over the surface. The plates after this treatment should be placed at the end of the tunnel away from the hot-air fan, and when the next lot are ready, the first rack may be pushed a little nearer the fan. By repeating this the wettest plates are always furthest from the source of heat, and as they dry will be nearer and nearer, and there will not be the slightest chance of the gelatin melting, for when half dry it is astonishing the heat the plates will stand without harm.

There is one caution, which it is as well to note carefully—the vessel used for sensitizing must be absolutely clean. It is, in fact as well to use a new one altogether. If but a few plates are to be sensitized a flat dish can be used, but for a dozen a grooved trough may be used, though more solution will be wasted in this way. A dish or trough that has been used for developing should never be used with the dyes, if made of stoneware or porcelain; it is very rare for the enamel of these to be perfect, as in use they soon acquire cracks into which solutions penetrate, so that when dyeing some of the old solutions are withdrawn and all sorts of curious happenings may ensue. Glass dishes are not liable to this trouble; but they should be cleaned by allowing them to soak for a short time in the usual cleansing mixture of potassium dichromate and sulfuric acid. In no case should metal troughs be used, these may lead to bitter troubles. It is a curious fact that the plain dye solutions may remain in contact with metal for days and the only trouble seems to be a slight deposition of the dye here and there. But if it is attempted to sensitize in the same, there will appear sooner or later an extraordinary increase of fog. Undoubtedly this is due to electrolytic action of minute traces of something extracted from the emulsion. This phenomenon is not due to the metal container having been used for other purposes, nor is it due to dirt on new metal.

It has been recommended to strengthen the bath after using for a certain number of plates, by the addition of more dye. This may be done if a single dye is used; but with a mixture of dyes it is courting disaster,

that is assuming that a like color-sensitiveness is desired in the first and the last batch of plates. It has never been determined in exactly what ratio the dyes are absorbed; and it is impossible to tell without chemical or spectrographic analysis, the content of a mixture of dyes after bathing plates therein. That the dyes are used up in different ratios the author has determined and also that a once-used bath does not give the same color-sensitiveness.

When the isocyanins are used it is advisable to make the total quantity of bath up for the batch of plates, and having determined how many plates are to be treated at once to use the requisite proportion and after use to bottle it and start with a fresh supply for the next batch. If much work is done it will pay to determine in what respect the bath wants replenishing, which can be done by spectrograms of the used bath. But for amateur work, it is preferable to discard the bath after once using, for the cost of the dyes, though at first sight heavy, is really very little per plate. It should be understood that the bath should only be made up as wanted, for the dilute solutions will not keep even in the dark. On the other hand the concentrated alcoholic solutions will keep indefinitely.

W. F. Meggers and F. J. Stimson[101] summarized the conditions and technique of sensitizing and gave the following method: a stock solution of the dye should be prepared by dissolving 1 part in 1000 or 2000 parts of ethyl alcohol, and 6 ccs. of this should be added to a mixture of 60 ccs. alcohol and 85 ccs. water, to which 6 ccs. strong ammonia should be finally added. The time of bathing should be from 5 to 6 minutes, and the plates briefly rinsed in alcohol and rapidly dried. The use of water and alcohol, they remark, is a compromise between the conflicting requirements of the sensitizing bath. While water, by softening the gelatin, aids penetration of the dye, it retards drying, and rapid drying is essential. Again, in a water solution, containing ammonia, the dyes flocculate easily, producing a worthless bath. The presence of alcohol tends to prevent this flocculation and also hastens drying; but at the same time it hardens the film and tends to prevent the penetration of the dye. Because of these conflicting conditions the use of a water-alcohol bath first, followed by an alcohol rinse has been found to give the best results. Ammonia plays an important part in the dyeing process to obtain greater sensitiveness, and investigations have shown that the sensitiveness of commercial panchromatic plates can be considerably increased by bathing in dilute solution of ammonia in water and alcohol. It has also been found that the baths are more permanently useful if free from ammonia, so that an excellent procedure is to bathe the plates first in a water-alcohol solution of the dye and then in a separate solution of ammonia.

R. J. Wallace[102] carried out a series of sensitometric tests with the isocyanins, which were used singly and in combination. His baths are unnecesssarily complicated, but reference should be made to the original

paper. G. F. Greenfield[103] strongly advocated the home-sensitizing of plates. Some sort of drying cupboard is essential and a simple form is sketched with gas burner below with the flue running along the bottom and side, with an outlet at the top, thus giving a current of warm air. Using a large dish was found to lead to air-bells and other troubles when seven or eight plates were manipulated at once. A grooved trough was, therefore adopted, and as it was found inadvisable to use the bath more than twice, it became necessary to find the dilution that could be used. It was determined that, taking 500 ccs. of a 1 : 50,000 solution as the standard for 470 sq. ins. of plate area, the bath might be:

Pinachrom, 1 : 1000 alc. 3 ccs.
Pinacyanol, 1 : 1000 alc. 2 ccs.
Water .1000 ccs.

The quantity to fill a 5x7 developing tank being 1600 ccs. The plates should be placed in the tank and allowed to soak for 18 minutes, then washed under the tap for 5 minutes and dried. Such plates were found to keep good for a month.

George[104] recommended for panchromatizing plates up to 6200 the following:

Pinaverdol, 1 : 2000 alc. .13.75 ccs.
Homocol, 1 : 2000 alc. 9.0 ccs.
Pinacyanol, 1 : 2000 alc. 11.5 ccs.
Ammonia .68.75 ccs.
Alcohol, 90 per cent. 376 ccs.
Water to. 1000 ccs.

For infra-red from 6000 to 9000:

Pinaverdol sol. 9 ccs.
Homocol sol. 9 ccs.
Dicyanin, 1 : 2000 alc. 13 ccs.
Pinacyanol sol. 11.5 ccs.
Ammonia . 11.5 ccs.
Alcohol . 376 ccs.
Water to. 1000 ccs.

F. Monpillard[105] in order to obtain more even sensitiveness than was possible with a single dye, tried mixtures of pinacyanol and dicyanin. The actual bath was:

Pinacyanol or dicyanin, 1 : 1000 alc. 5 ccs.
Homocol, 1 : 1000 alc. 5 ccs.
Ammonia . 0.1 ccs.
Water .1000 ccs.

With dicyanin the sensitiveness extended to 7500, with pinacyanol to 6800.

The following instructions are given as a standard method:[106] The dye solution should be prepared in a measure, the plates dusted and laid in a flat porcelain dish, which is large enough to hold nearly twice the number of plates it is desired to sensitize at one time. These are put at one end of the dish; the dish is then tilted, and the dye solution poured into

the other (empty) end, then the dish is tilted back; so that the solution sweeps over the plates in one even flow free from air-bells. The dish should be now gently rocked for 3 minutes, then the plates removed, washed in a good stream of running water for at least another 3 minutes. Their sensitiveness and keeping quality will probably be somewhat greater if they are washed for 10 minutes, but they will remain good for months, after 3 minutes thorough washing. The water tap should be fitted with one of the small anti-splash filters, the fine wire gauze in which retains any solid particles that may be in the water. After washing, the plate should be well swabbed with a wad of absorbent cotton, and then placed in a drying cupboard. The quicker the drying takes place the better, so that if a current of warm, filtered air, free from fumes, can be sent through the cupboard it is an advantage, though the absence of this need not deter anyone from sensitizing plates. Drying can be hastened by placing a dish of dry calcium chloride at the top of the cupboard.

One most important point is that the room in which sensitizing is carried out, should not have been used for development and fixing. It is impossible to obtain clean results, for any air current will carry traces of developers and fixing bath on to the damp gelatin with disastrous results. This is of paramount importance.

P. E. Dhein[107] stated that for spectrographic work, he was able to obtain far more red-sensitive plates by the use of the following than commercial plates; but that after keeping two days they were no better than Wratten & Wainwright commercial plates:

Pinaverdol, 1 : 2000 alc...................... 8.8 ccs.
Homocol, 1 : 1000 alc........................ 8.8 ccs.
Dicyanin, 1 : 1000 alc.......................12.6 ccs.
Pinacyanol, 1 : 1000 alc.....................11.35 ccs.
Ammonia 21.0 ccs.
Alcohol 400 ccs.
Water to 1000 ccs.

E. Stenger[108] recommended a mixture of pinaverdol and dicyanin as giving a color-sensitiveness, similar to the luminosity curve of the eye, and suggested the name "ophthalmochromatic" for the plates. Later[109] he gave the following, which is without the familar gap in the green:

Pinachrom violet 10 ccs.
Pinaverdol 10 ccs.
Alcohol 333 ccs.
Water to1000 ccs.

The dyes were used in stock solutions 1 : 1000. Clean-working plates should be bathed for 3 minutes in the dark and dried without washing. The sensitiveness extended to 7000 with very little damping in the minimum.

P. Richard and M. Abribat[110] pointed out that solutions of the isocyanins have very little penetrative power as regards gelatin and that neutral

or alkaline solutions of pinaverdol and pinacyanol deposit a film of dye. They recommended the use of acidulated solutions for bathing plates or films, with subsequent treatment with ammonia. Particular stress was laid on the freshness of the stock solutions of the dyes, and these should not be more than eight days old, and have been kept in the dark. The water should be free from lime and preferably distilled and must not be acid. The dyes were decolorized with acetic acid:

> Pinachrom, 2 : 1000 alc...................... 40 ccs.
> Distilled water1000 ccs.
> Dilute acetic acid............................ q. s.

Add the dye to the water and just enough acid to decolorize it, then add:

> Pinacyanol, 2 : 1000 alc........................6.6 ccs.

And decolorize in the same way. After addition of the pinacyanol the mixture should be well shaken and will probably require more acid as it is difficult to completely decolorize. Time of bathing 5 minutes, and red light may be used. Washing for 5 minutes in the dark should be followed by bathing in 1.5 per cent solution of ammonia for 5 minutes, followed by another 5 minutes wash and drying at 25° to 30° C. Richard and M. Labori[111] stated that spectrograms on plates thus sensitized showed an almost even sensitivity throughout the spectrum and that the acid solutions kept for 3 weeks had lost none of their sensitizing power.

Hyper-Sensitizing Plates.—S. M. Burka[112] carried out experiments on the hyper-sensitizing of plates with ammonia, mainly with the idea of finding whether any substantial increase of speed was obtainable for aerial photography. The bath adopted was, except in a few cases:

> Ammonia 35 ccs.
> Alcohol250 ccs.
> Water750 ccs.

And it was found that there was practically no difference with 2, 4 or 6 minutes bathing, as long as the plates were thoroughly soaked, and 4 minutes was adopted as the standard. Some plates thus treated showed marked increase of fog in a week, whilst others were unusable in three or four days. Plates thus treated were much more susceptible to fog in development and should be used within a few hours of bathing. Practically there was found no increase of speed with ordinary plates, nor with orthochromatic plates; but with panchromatic plates there was in every case a marked increase, particularly in color-sensitiveness.

Summarizing the results it was found that the difference between the various plates showed that the sensitivity increase was not that observed by Eder, which is due to ripening, but it was an action associated with the dyestuff. The effect was to increase the sensitivity to the incident light and not to increase the developability of the latent image, as a plate bathed after exposure and before development showed no increase in speed. The action was not due to the alkalinity, as was proved by comparative trials

with sodium hydroxide. If panchromatic plates were bathed for 4 minutes at 18° C. and rapidly dried, the speed to white light was increased 100 per cent in nearly all cases. The red-sensitivity was extended about 100 Ångstrom units, and the red speed was increased in some cases about 400 per cent. If the alcohol was omitted, the speed was increased still more, but the plates should be used immediately after bathing.

In a circular, issued by the Bureau of Standards, the following procedure is advised for panchromatic plates, and it would seem of value in that stale plates may be thus rejuvenated. Bathe the plates for 4 minutes in 3 parts of the strongest ammonia (20 per cent), 25 parts of 95 per cent alcohol and 75 parts water, then rapidly dry in front of a fan. The increase of speed to white light may be from one-half to twice and even five times for the red. Greater speed can be obtained with a 3.5 per cent solution of the ammonia, without the alcohol. These plates fogged badly in development; but this could be ignored in some cases, particularly if development was not pushed too far. If the alcohol be omitted the plates must be used a few hours after treatment. See also the ultra-sensitizing of screen-plates with ammoniacal silver chloride solutions (p. 512), which is also applicable to ordinary plates. F. M. Walter and R. Davis[113] also confirmed the improvement in speed by washing panchromatic films and plates, ascribing this to the loss of free bromide and chrome alum. The increase in speed was about 33 per cent, although the fog was doubled.

The Keeping Properties of Color-Sensitive Plates.—This has been a moot point ever since the introduction of orthochromatic plates, and very contradictory statements have been made, which it is not worth while to record. The differences are due, of course, to the different methods of manufacture and conditions of keeping. But it may be accepted as an established fact that color-sensitive plates will keep as well as ordinary under like conditions.

With the introduction of the isocyanins and the more general use of bathing methods, this question has become of great importance. E. König[114] stated that at the commencement of 1906 different kinds of German and French plates were sensitized with pinachrom and pinacyanol in a semi-aqueous bath with ammonia, and that after 2 months the whole were good; but at the end of 10 months nearly all were foggy and some utterly useless. Those treated with pinachrom still had full color-sensitiveness; but the pinacyanol-bathed plates had lost a good deal of the same.

H. Lüppo-Cramer[115] stated that whilst bathed plates do not keep so well as those in which the dye is added to the emulsion, yet the degree of color-sensitivity was higher in the former. He had already showed that the color-sensitiveness could be increased by washing in water and drying.[116] This it was stated to be due to the loss of soluble bromide by diffusion from the film, which occurs when the latter is bathed in water or in a bromide-free solution. By adding a small percentage of potassium bro-

mide, this being found by trial, to the dye solution, a compromise between good-keeping qualities and high color-sensitiveness may be obtained. The author, from a long series of experiments, found that while the keeping properties could be thus increased, it was at the expense of color-sensitiveness and consequent speed under filters. And that, at any rate for cinematographic work in colors, is the most important.

Sensitizing With Mineral Salts.—J. G. Capstaff and E. R. Bullock[117] published the fact that bathing a film or plate in sodium bisulfite solution and then washing conferred panchromatic qualities. The following treatment was found to give sensitiveness to 8000, and probably further: bathing in 5 per cent solution of sodium bisulfite for 10 minutes, washing for 5 minutes, treatment with N/10 sodium carbonate solution for 10 minutes and washing for 5 minutes. Later it was found that treatment with 0.2 per cent solution of potassium carbonate in distilled water, free from chlorides and neutral to litmus gave better results. Extremely small percentages of soluble bromides or chlorides in the washing water or carbonate bath diminished the color-sensitiveness, and 0.004 per cent of bromide or 0.2 per cent of sodium chloride completely prevented it. No restraining action occurs if these are present in the bisulfite. Sodium sulfite as a preliminary bath has no action but sulfurous acid has, and the addition of a little sulfuric acid to the bisulfite increases the action.

Almost simultaneously F. F. Renwick[118] stated that a weak solution of potassium iodide, 1 : 20,000, after from 15 to 60 seconds action, gave orange and red sensitiveness. Sodium or potassium cyanide from 1 : 2000 to 1 : 10,000 also had the same effect. Renwick[119] considered that it was impossible to assume that it can be due merely to the formation of a new colored silver salt (iodide, cyanide or sulfite) whose absorption by the silver bromide grains could render them color-sensitive, because of the apparent identity in the character of the effect (at least in two cases found) in spite of the widely different color of the salts. Moreover none of these silver salts is known to exist in a form having a strong absorption in the yellow, orange or red of the spectrum. For this reason it seems clear that the conferred color-sensitiveness must be due to a change within the halide grains rather than to anything akin to dyestuff absorption. Capstaff and Bullock had suggested that colloidal silver was formed; but this Renwick considered inadequate and he would assume that the extremely minute grains of colloidal silver, which he postulated[120] as present in the ripened silver bromide, change in size as a result of the salt baths with a consequent change of color from a yellow to a greyer or bluer modification, and this caused the effect.

The author called attention to[121] Carey Lea's researches on the color-sensitiveness of the silver halides and gave a resumé of the same which showed that silver iodide was more sensitive to the less refrangible rays than the bromide.[122] R. Bruce Archey[123] gave some interesting data as to

the red-sensitiveness of cinematograph positive emulsion with an accidental overdose of iodide, added at the moment of mixing, with comparative spectrograms, that conclusively proved that silver iodide, or a bromo-iodide emulsion can be distinctly red-sensitive.

As the author pointed out it would seem reasonable to suppose in the face of these facts that the increase of red-sensitiveness of the iodide-treated emulsion is easily explicable on the assumption of a mere external skin of silver iodide, and there is no need to assume the existence of colloidal silver, because Carey Lea's salts were formed without a vehicle and without ripening. This would not explain the phenomenon in the case of the bisulfite and cyanide, but as both cyanide and sulfite are solvents of silver halides, it would seem as legitimate to assume some solvent action or formation of a double salt in each case.

That this method of panchromatizing is likely to be of any practical value is an open question, but it raises the important point, already once referred to, as to the kind of emulsions suitable for color-sensitizing. For if the presence of iodide confers color-sensitiveness one would imagine that such should be the best for this work.

S. E. Sheppard[124] investigated the peculiar action of iodides and cyanides and found that it was specific, that is to say, it was confined to those emulsions, which per se showed red-sensitiveness. He suggested that the orienting effect of the iodide ion in the silver halide lattice is responsible, rather than mechanical rearrangement of colloid silver nuclei. The paper is very instructive, fully illustrated with spectrograms and should be consulted in the original.

Screened Plates.—As all color-sensitized plates still possess an overweening sensitiveness to blue and violet and require the use of a yellow filter to give satisfactory color rendering, L. Vidal[125] suggested the incorporation of a yellow dye, which would act as a filter, in the emulsion itself, and used for this purpose ammonium picrate.

J. H. Smith & Co.[126] were the first to commercially introduce such plates and in 1902, Perutz, of Munich, brought forward the Perxanto plate of like character and the Kodak Co. introduced the Kodoid film[127]; these were followed by the Flavin plate of Hauff, Schleussner's Viridin plate and others. A. Miethe[128] recommended making the addition of some tartrazin to an erythrosin bath. E. König[129] recommended a bath of:

Filter yellow 5.5 g.
Erythrosin0.11 g.
Distilled water 667 ccs.
Alcohol 333 ccs.

Bathing for 2 to 3 minutes and drying without washing. A. Cararra[130] suggested a panchromatic plate with reduced blue sensitiveness by bathing for 3 minutes in:

Filter yellow, 10 per cent sol. .55.5 ccs
Erythrosin, 1 per cent sol. .11.1 ccs.
Pinacyanol, 1 : 1000 alc. 6.6 ccs.
Distilled water . 600 ccs.
Alcohol . 333 ccs.

The plates were dried without washing. As they were found weak in the green, the addition of pinaverdol was tried and finally the best results were obtained by replacing half the above quantity of pinacyanol by an equal volume of pinaverdol, 1 : 1000, and omitting the alcohol altogether, to which streaks and marking were due. This reduced the sensitiveness of plates to about one-half for daylight.

E. Stenger[131] submitted commercial screened plates to spectrographic examination, giving curves and readings of his results, and after trying various superimposed films, such as gelatin, albumen and collodion, and glycerol, stained with filter yellow, adopted a 6 per cent solution of gum arabic with 0.75 per cent filter yellow for weak filters and double that quantity for deeper filters, and better results were thus obtained.

Sensitizing Patents.—There are not many patents, exclusive of those relating to the isocyanins.

P. A. Attout, called Tailfer, and J. Clayton obtained a patent for the use of eosin and allied dyes dissolved in ammonia and added to gelatin emulsions[132], at the moment of formation, or already coated plates might be flowed over with ammoniacal eosin solution to which alcohol had been added, then washed. The term eosin was used inclusively and other alkalis than ammonia might be used.

H. W. Vogel[133] patented the use of quinolin red and quinolin blue or cyanin, mixed as a sensitizer. He also claimed all the red and violet dyes that had been discovered by Jacobsen[134]. These dyes were formed by the action of benzol trichloride on quinolin and pyridin. Vogel also indicated their admixture with other dyes and either as addition to the emulsion or as a bath for coated plates. Later Vogel[135] patented the use of silver eoside with other sensitizers. Ordinary plates were to be bathed in a solution of a soluble salt of silver and then in the dye solution or silver eoside might be formed and added to the emulsion. Cyanin, quinolin red, etc., which do not combine with silver, might be added to increase the sensitiveness.

The Aktien-Gesellschaft f. Anilin-Fabrikation[136] patented the use of two baths, a typical example being the use first of an ammoniacal solution of erythrosin, then washing followed by an aqueous solution of acridin orange, which will not stand the action of ammonia. For panchromatism a mixture of carbid black and glycin red was used for the first bath, followed by acridin orange.

G. Selle[137] proposed to sensitize plates both for red and green by the use of a mixture of erythrosin and cyanin, dissolved in 60 per cent water

and 40 per cent alcohol, and stated "by this means the red dye, which is more soluble in water, is carried into the film, while the blue dye, which is more soluble in alcohol, remains substantially on the surface of the plate." In a later patent[138] Selle claimed the use of dyes, which are insoluble or not readily soluble in water, but dissolved by the aid of alkali or acid, then immersing the plate in baths of the opposite character so as to regenerate the dye. As an example is given the use of cyanin in acidulated solution, and the after treatment of the bathed plate in an alkaline solution.

A. Miethe and A. Traube[139] patented the use of ethyl red. The Farbenfabrik vorm. Bayer[140] patented the use of the dye formed by the action of diethyl sulfate on quinaldin. This being also patented by E. Berendes.[141] Later the use of tolu-quinaldin, the homologue of quinaldin was claimed, and this yielded isocol.[142] Also the use of additional products of quinaldin and the corresponding quinolin derivatives which gave homocol.[143] The Compagnie Paris Couleur d'Aniline[144] patented the formation of basic red and violet dyes from dinitro-pyridin or cyan-pyridin, but apparently these were not introduced as sensitizers. The Aktien-Gesellschaft f. Anilin-Fabrikation patented[145] dyes form α-naphthol-alkyl-quinaldins. Also the production of dyes by the action of oxidizing agents, such as ferricyanides, persulfates, etc., on quinolin, quinaldin and similar bases.[146].

H. Schmidt[147] pointed out that it had not been possible to obtain real red sensitiveness even with ethyl violet and that a mixture of dyes, such as erythrosin and cyanin did not give good results, as the former acted best in alkaline and the latter in acid baths, followed by alkaline baths. He proposed to use first an acid cyanin bath and then an alkaline erythrosin bath. F. Tarsulat[148] claimed the use of di-iodo-fluorescein either alone or with other dyes, for sensitizing collodion emulsion.

Farbwerke vorm. Meister, Lucius and Brüning[149] patented the various isocyanin dyes[150, 151, 152, 153, 154, 155, 156].

F. F. Renwick and A. Bloch[157] patented the use of auramin with the isocyanins and claimed increased sensitiveness for red and green, together with cleaner plates and better keeping properties. For bathing the mixture might be used in 1 : 50,000 with an equal quantity of isocyanin; time of bathing 3 to 4 minutes. If the dyes were to be mixed with the emulsion from 0.005 to 0.025 g. of each dye should be added to 1 liter. If a self-screened plate were desired then 1 g. : 50,000 should be used for bathing and 0.25 g. added to 1 liter of emulsion.

The author[158] called attention to the following note by J. W. Gifford:[159] "I wish to make the following communication that photographic gelatin films, bathed in a solution of auramin and erythrosin, the latter in small proportion, give an approximation to correct color values without the use of any screen or light filter, and are sensitive to all colors, including red. N.B. there are other dyes than auramin which besides sensitizing the silver salt stain the gelatin film, which then plays the role of a light

filter." Renwick and Bloch[160] contend that Gifford's use of auramin was as a filter dye only, and that erythrosin confers red sensitiveness. A conclusion that is open to very great question.

E. Q. Adams and L. E. Wise[161] patented the preparation of dicyanin A nitrate and in later patents the preparation of kryptocyanin and other infra-red sensitizers.[162] S. Palkin[163] patented an improved method of making dicyanin A.

E. J. Wall[164] patented the recovery of the isocyanins from sensitizing baths by shaking with benzol, chloroform, ether, carbon tetrachloride or other volatile solvents; or precipitating the dye with colloidal hydroxides or barium sulfate; or by absorption with hydrocellulose, oxycellulose, etc., and recovery of the dye by suitable means.

A. Cobenzl[165] patented the preparation of an emulsion, which was claimed to be nearly perfectly panchromatic, although no dyes were used. K. Kieser[166] proposed to precipitate silver bromide by adding the nitrate to hydrobromic acid, washing and sensitizing with dyes and washing till the waters were colorless, then emulsifying in gelatin. The advantage claimed being that the vehicle was not stained. E. Albert[167] patented the sensitizing of collodion emulsions for the several spectrum regions so that they could be used without filters; but he claimed the use of a filter to absorb the ultra-violet. Fritzsche[168] patented a dye, called katachrome, about which nothing can be learned. W. Friese-Greene and F. Garrett[169] patented for a bi-pack system a sensitizing bath of:

Pinacyanol	0.0032 g.
Pinaverdol	0.0096 g.
Pinachrom	0.0032 g.
Flavasin	0.0064 g.
Ammonia	3 ccs.
Water	1000 ccs.

Time of bathing 5 minutes, and rapid drying at 24° C. The flavasin is one of the pyrazolon dyes, and either tartrazin or filter yellow.

1. Ber. 1875, **8**, 1635; "Die Photographie der farbiger Gegenstände," 11.
Eder and Schumann, Sitzungsber. Akad. Wiss. Wien. 1884; Beiträge, III, 13; Phot. News, 1886, **30**, 195; Phot. Mitt. 1885, **22**, 240; Anthony's Phot. Bull. 1886, **17**, 343, 588, 632, 654, 752; Phot. Times, 1885, **15**, 120; 1889, **19**, 329, 449; Brit. J. Phot. 1885, **32**, 58, specially studied the action of cyanin with gelatin plates.
2. Phot. Korr. 1886, **23**, 591; Beiträge, III, 95.
3. Phot. Rund. 1904, **14**, 279.
Cf. P. G. Nutting, Nature, 1902, **66**, 416; abst. Phot. J. 1902, **42**, 197 as to the action of light on cyanin.
4. Phot. Korr. 1896, **33**, 131; Beiträge, III, 95; Phot. Annual, 1897, 200.
5. Penrose's Annual, 1897, **4**, 89; Anthony's Phot. Bull. 1900, **31**, 84; Phot. Chron. 1900. This was also commended by Valenta, Brit. J. Phot. 1900, **47**, 392.
6. Das Atel. 1899, **6**, 5; Phot. Rund. 1899, **9**, 170; Brit. J. Phot. 1899, **46**, 38, 410. Also recommended by "Phenol," Process Photogram, 1900, **7**, 10.
7. Das Atel. 1901, **8**, 9; Zeits. Repro. 1900; Jahrbuch, 1901, **15**, 626; Brit. J. Phot. 1900, **47**, 122. Cf. T. T. Baker, Penrose's Annual, 1903, **9**, 28. W. Bedford, Phot. J. 1888; Phot. News, 1888, **32**, 230; Brit. J. Phot. 1888, **35**, 232, 778 recommended a mixture of erythrosin, methyl violet and cyanin.
8. Phot. J. 1895, **35**, 193; Brit. J. Phot. 1895, **39**, 230, 243; Phot. News, 1895, **36**, 230. Cf. H. W. Vogel, Brit. J. Phot. 1886, **33**, 22 on the use of chrysanilin.

9. Phil. Mag. 1888, (5), **26**, 391; Kayser's "Handbuch d. Spectroscopie," 1900, **1**, 612; Amer. J. Phot. 1888; Phot. News, 1888, **32**, 791; Phot. Archiv. 1889, **30**, 61; Jahrbuch, 1890, **4**, 309.

10. Phot. News, 1887, **31**, 710. Cf. J. Waterhouse, ibid. 1889, **33**, 71; Brit. J. Phot. 1887, **34**, 21, 710, 722; Phot. Times, 1887, **17**, 631.

11. Phot. Rund. 1889, **1**, 143, 207; Brit. J. Phot. 1889, **33**, 505; Jahrbuch, 1890, **4**, 308.

12. Phot. Korr. 1891, **27**, 313; Phot. Annual, 1892, 108; Jahrbuch, 1892, **6**, 391; Bull. Soc. franç. Phot. 1891, **33**, 265.

13. Jahrbuch, 1903, **17**, 9.

14. Das Atel. 1899, **6**, 5.

15. Phot. Korr. 1897, **34**, 124; Brit. J. Phot. 1897, **44**, 166, 407; Phot. Annual, 1898, 219; Process Photogram, 1897, **4**, 139.

16. Phot. Woch. 1885, **31**, 395; 1886, **32**, 49; Phot. News, 1884, **28**, 416; 1885, **29**, 724. Cf. Brit. J. Phot. 1884, **31**, 354. H. Lohse, ibid. 1884, 31, 445, 450, 636. H. Ruh, ibid. 1898, **45**, 326.

17. Phot. Mitt. 1890, **26**, 280; Phot. Annual, 1891, 90; E.P. 15,532, 1886; Brit. J. Phot. 1888, **35**, 326; Phot. News, 1884, **28**, 325, 405. Cf. Lüppo-Cramer, Phot. Rund. 1915, **52**, 225; 1920, **57**, 129.

18. Phot. Mitt. 1891, **27**, 63; Brit. J. Phot. 1890, **37**, 506.

19. Phot. News, 1886, **32**, 571; 1887, **33**, 65, 116, 146, 193, 211, 452, 505, 539, 548, 566, 693, 707; 1895, **42**, 499; Phot. Times, 1887, **17**, 568; J. S. C. I. 1887, **6**, 427; Phot. Mitt. 1888, **25**, 135; Brit. J. Phot. 1888, **35**, 499; 1889, **36**, 571, 641; Bull. Soc. franç. Phot. 1887, **29**, 267; 1888, **31**, 253; 1889, **32**, 193, 235; Jahrbuch, 1889, **3**, 211, 399.

20. Phot. News, 1889, **33**, 565; Jahrbuch, 1890, **4**, 57; Phot. Mitt. 1890, **27**, 244; Phot. Times, 1889, **19**, 472, 484.
On the preparation and composition of erythrosin see M. Gemberg and D. L. Tabern, J. Ind. Eng. Chem. 1922, **14**, 1115.

21. Brit. J. Almanac, 1893, 705; Phot. Times, 1892, **22**, 93.
On the reciprocal behavior of silver halides and acidic and basic dyes Cf. O. Hassel, Kolloid Zeits. 1924, **34**, 304; abst. C. A. 1924, **18**, 641, 2828.

22. Phot. Korr. 1892, **29**, 588; Jahrbuch, 1893, 7, 404.

23. Phot. Mitt. 1891, **28**, 140, 153, 166; Phot. Annual, 1892, 108; Phot. Times, 1892, **22**, 395.

24. Phot. Mitt. 1897, **34**, 217; Phot. Annual, 1898, 218.
Free silver nitrate is apparently without action on the sensitizing powers of rhodamin, Amat. Phot. 1891, **13**, 390; Phot. Annual, 1892, 108. H. W. Vogel, Phot. Times, 1884, **14**, 151; Phot. J. 1884, **24**, 151; Phot. News, 1884, **28**, 493 stated that R. Amory, Amer. Acad. Sci. 1878, had used pure silver eoside in Jan. 1878 and obtained action in the spectrum from D to F.

25. Phot. Korr. 1886, **23**, 589; Jahrbuch, 1887, **1**, 312; Phot. News, 1886, **30**, 312, 329; Brit. J. Phot. 1886, **33**, 372.

26. Brit. J. Almanac, 1888, 454.

27. Ibid. 1892, 747.

28. Phot. News, 1887, **20**, 107; Brit. J. Phot. 1887, **34**, 88, 126, 159; Bull. Belg. 1887, 266; Jahrbuch, 1888, **2**, 473.
E. Obernetter, Jahrbuch, 1889, **3**, 139 used equal quantities of silver nitrate and erythrosin, dissolved in ammonia, flowed over the plate after it had been well washed under the tap, it being then dried without further washing. W. Abney, Phot. News, 1884, **28**, 500 suggested the addition of a silver eoside emulsion to an ordinary, non-color sensitive, emulsion. J. B. B. Wellington, Brit. J. Phot. 1887, **34**, 21; Phot. News, 1887, **31**, 29 recommended erythrosin-silver dissolved in ammonium carbonate.

29. Phot. Korr. 1894, **31**, 227; Jahrbuch, 1895, **9**, 431.

30. Jahrbuch, 1894, **8**, 513.

31. D. Phot. Ztg. 1897; Brit. J. Phot. 1897, **44**, 265.

32. Phys. Zeits. 1907, 907; abst. Brit. J. Almanac, 1908, 618.

33. Zeits. Chem. Ind. Kolloide, 1897, 227; Brit. J. Phot. 1907, **54**, Col. Phot. Supp. **1**, 501; abst. Brit. J. Almanac, 1908, 619.

34. Bull. Soc. franç. Phot. 1905, **47**, 88; Jahrbuch, 1906, **20**, 418.

35. Phot. Korr. 1886, **23**, 295, 576; 1905, **42**, 311; Handbuch, 1905, **3**, 161, 183, 274; Beiträge, III, 48. Cf. C. Mallmann, Brit. J. Phot. 1886, **33**, 373 on the use of erythrosin.

36. Phot. News, 1878, **22**, 400; 1888, **32**, 708; 1889, **33**, 114; Jahrbuch, 1889, **3**, 400; Anthony's Phot. Bull. 1878, **9**, 234.

37. Phot. News, 1888, **32**, 301, 415.
38. Phot. Mitt. 1886, **25**, 117; 1890, **27**, 72.
39. Jahrbuch, 1889, **3**, 400.
40. Phot. Korr. 1919, **56**, 33; Chem. Zentr. 1919, **90**, IV, 168; abst. J. S. C. I. 1919, **38**, 697A; Annual Repts. 1919, **4**, 511; Brit. J. Phot. 1920, **67**, Col. Phot. Supp. **14**, 36.
41. J. Frank. Inst. 1886, **122**, 123; Brit. J. Phot. 1886, **33**, 447; 1895, **42**. 517; Phot. J. 1896, **36**, 216; Phot. Annual, 1897, 201; Phot. Times, 1895, **25**, 180; Phot. Korr. 1895, **32**, 494; Jahrbuch, 1896, **10**, 449; Brit. J. Almanac, 1896, 836.
42. Chapman Jones, Phot. J. 1896, **36**, 216.
43. Zeits. Repro. 1905, **7**, 86; Brit. J. Almanac, 1906, 860.
44. Beiträge, III, 154.
45. Phot. Rund. 1921, **58**, 80, 193; Brit. J. Phot. 1921, **68**, Col. Phot. Supp. **14**, 16; Phot. Korr. 1921, **58**, 20; Le Procédé, 1921, **23**, 34; Camera Craft, 1921, **28**, 203; abst. J. S. C. I. 1921, **40**, 324A; Amer. Phot. 1922, **16**, 119; Sci. Tech. Ind. Phot. 1921, **1**, 37, 41; D. Camera Almanach, 1921, 124; D.R.P. 395,666, 1922; Phot. Ind. 1924, **768** claims the use of dyes formed by the condensation of pyridin-ammonium bases in the presence of catalysers with dialkylaminobenzaldehyde; abst. J. S. C. I. 1924, **43**, B813. Cf. D.R.P. 394,744; abst. J. S. C. I. 1925, **44**, B5.
46. Phot. Korr. 1921, **58**, 29; Phot. Rund. 1921, **57**, 87; Amer. Phot. 1922, **16**, 119; Sci. Tech. Ind. Phot. 1921, **1**, 41.
47. Phot. Rund. 1921, **57**, 193; abst. Sci. Tech. Ind. Phot. 1921, **1**, 78; Amer. Phot. 1922, **16**, 119.
48. J. C. S. 1922, **121**, 946; abst. Sci. Tech. Ind. Phot. 1922, **2**, 86; Amer. Phot. 1922, **16**, 727.
49. Commercial erythrosins differ greatly and care must be used in selection of the dye. Cf. Brit. J. Phot. 1887, **34**, 81, 114, 145, 163. J. Bartlett, ibid. 344. J. B. B. Wellington, ibid. 21, 27. H. Ehrmann, ibid. 8. J. Dixon, ibid. 56. C. Ehrmann, Phot. Times, 1884, **14**, 291; 1887, **17**, 164, 238, 249, 261, 307, 403.
50. "Die orthochromatische Photographie," 1920, 60.
51. Phot. News, 1889, **33**, 315, 645; Brit. J. Phot. 1889, **36**, 255, 685; Phot. Times, 1889, **19**, 504; Phot. Woch. 1889, **35**, 211; Jahrbuch, 1890, **4**, 309; Brit. J. Almanac, 1888, 454.
An excellent account of his experiments with red-sensitizers is given by Waterhouse, Phot. J. 1904, **44**, 165, and this includes notes on early experiments with eosin and other dyes. He confirmed Carey Lea's statement that colorless substances, such as salicin and æsculin sensitized, both giving a band between D and C. Aqueous solutions of annatto, either with or without ammonia, sensitized for the whole spectrum with collodion emulsion, and with a green screen it was possible to photograph below A. With gelatin this was found only to increase density. Ammoniacal carmin also gave good results, and certain resins, sandarac and bitumen apparently gave red-sensitiveness. Milton B. Punnett, Phot. Times, 1897, **27**, 283 recommended the mixture of rose des Alpes and alizarin blue.
52. Proc. Roy. Soc. 1891; Brit. J. Phot. 1891, **38**, 229; Phot. Woch. 1891, **37**, 149; Jahrbuch, 1892, **6**, 392.
53. Proc. Roy. Soc. 1891, **49**, 345; Chem. News, 1891, **63**, 157; Beibl. Ann. Phys. Chem. 1891, 518; Jahrbuch, 1892, **6**, 392; Phot. Annual, 1892, 108; Process Photogram, 1897, **4**, 146.
54. Compt. rend. 1909, **149**, 851; Jahrbuch, 1910, **24**, 374.
55. Sci. Amer. 1914, 521, 531; Brit. J. Phot. 1915, **62**, 56; Annual Repts. 1916, **1**, 314.
E. Bierstadt, Phot. Times, 1904, **36**, 165 recommended a preliminary bath of 1 per cent ammonia and then 1½ minutes bathing in 0.0125 per cent saccharin plus 2 per cent ammonia.
56. Phot. J. 1906, **46**, 190; Brit. J. Almanac, 1907, 742.
57. Phot. Korr. 1896, **33**, 116; Jahrbuch, 1897, **11**, 69, 165; Phot. Annual, 1897, 201; Brit. J. Almanac, 1897, 850; Brit. J. Phot. 1896, **43**, 407.
58. Phot. Korr. 1895, **32**, 375; Jahrbuch, 1896, **10**, 447; Phot. Annual, 1896, 169.
59. Phot. News, 1887, **31**, 693; Phot. Mitt. 1887, **24**, 238; Jahrbuch, 1889, **3**, 400.
60. Mem. Coll. Sci. Kyoto. Imp. Univ. 1918, **3**, 69; abst. J. S. C. I. 1919, **38**, 28A.
61. Phot. Korr. 1890, **27**, 351; Phot. Times, 1890, **20**, 303; Phot. Annual, 1891, 91; Jahrbuch, 1891, **5**, 456.

G. Millochau, Compt. rend. 1907; Brit. J. Phot. 1907, **54**, 364 soaked plates for 10 minutes in distilled water, slightly acidulated with acetic acid, then immersed them in a saturated alcoholic solution of malachite green, rinsed, dried and found the sensitiveness extended to 9500. T. T. Baker, Brit. J. Phot. 1904, **51**, 867, 1066, 289; Brit. J. Almanac, 1906, 767 repeated Miethe's experiments with glycin red and cyanin and Valenta's with wool black, aurantia, thiazol yellow, uranin and auracin. In Phot. J. 1907, **47**, 207; Brit. J. Phot. 1907, **54**, 245; Phot. Coul. 1907, **2**, 13 ; abst. Jahrbuch, 1907, **21**, 403 Baker detailed trials with diazo black BHN and benzo green in conjunction with silver nitrate and said they sensitized to about 9800. These were first tested by Valenta.

62. Liesegang's Phot. Almanach. 1905, 59; abst. Brit. J. Phot. 1905, **52**, 89; Brit. J. Almanac, 1906, 769.

63. Phot. J. 1920, **60**, 183; abst. J. S. C. I. 1920, **39**, 369R, 468A; Annual Repts. 1920, **4**, 511. Cf. J. W. Pope, Manchester Lit. Phil. Soc. 1919, **64**, (2), 28; abst. Nature, 1919, **104**, 346.

E. König, Phot. Korr. 1920, **57**, 312, commenting on above stated that pinachrom contained two ethoxy groups.

64. Chem. News, 1856, II, 219; 1859, I, 15.

65. Proc. Roy. Soc. 1863, **12**, 410; Jahresber. 1862, 351. Cf. Nadler and Merz, ibid. 1867, 512.

66. Rec. trav. Chim. 1863, **2**, 28, 41.

67. Ber. 1883, **16**, 1847.

68. Phot. J. 1920, **60**, 253; abst. J. S. C. I. 1920, **39**, 802A; Annual Repts. 1920, **4**, 511; Sci. Tech. Ind. Phot. 1921, 1, 6; 1922, 2, 86.

69. "Die Dreifarbenphotographie nach der Natur," Halle, 1904; Chem. Ind. 1903; Jahrbuch, 1903, **16**, 437; Phot. Korr. 1903, **40**, 173. Cf. G. E. Brown, Brit. J. Phot. 1902, **49**, 281, 1002; 1903, **50**, 203; 1904, **51**, 489; Sci. Amer. 1903, 828. C. Kaiserling, ibid. 282. E. König, Phot. Korr. 1903, **40**, 311; Jahrbuch, 1903, **16**, 438. On the constitution of ethyl red cf. E. Kaufmann, Chem. Ztg. 1911, 409.

70. Brit. J. Almanac, 1905, 865; Brit. J. Phot. 1904, **51**, 489.

71. Jahrbuch, 1905, **19**, 334; Brit. J. Phot. 1904, **51**, 708.

72. Zeits. wiss. Phot. 1904, **2**, 272; Phot. Woch. 1904, **50**, 246; Jahrbuch, 1905, **19**, 336.

73. Brit. J. Phot. 1905, **52**, 391; Brit. J. Almanac, 1906, 768.

74. Phot. J. 1905, **45**, 264; Brit. J. Phot. 1905, **52**, 568; abst. Brit. J. Almanac, 1906, 768. Cf. T. T. Baker, Photography, 1904, 373. J. Ive, Phot. Woch. 1904, **50**, 329.

According to E. König, "Photochemie," 1906, 329 homocol is a mixture of isoquinolin red with an isocyanin, and this is readily seen if some acetic acid be added to the solution, as the isocyanin is at once decolorized, leaving the quinolin red.

75. W. Gummelt, Jahrbuch, 1911, **25**, 368.

Rost, Franz and Heise, Fortschritte Gebiete Röntgentechnik, 1910 had obtained the absorption spectra of blood with such plates.

76. Phot. J. 1903, **43**, 262.

77. Maker's instructions. Cf. Brit. J. Phot. 1903, **50**, 694. A. Callier, Bull. Belg. 1904, 42; abst. Jahrbuch, 1903, **16**, 438. A. J. Newton, Photogram, 1903, **10**, 302; abst. Jahrbuch, 1904, **18**, 386. E. Valenta, Phot. Korr. 1903, **40**, 359.

The same method was advised for pinachrom and the ratio of exposures with orthochrom with König's subtractive filters, was 1:3:6 for the blue, green and red respectively. With pinachrom it was 1:2½:2½. Cf. Photography, 1903, **40**, 310, 366, 479; 1904, **41**, 116, 172, 281; Jahrbuch, 1904, **18**, 386. W. A. Scoble, Phot. J. 1907, **47**, 195; abst. Jahrbuch, 1907, **21**, 403.

78. Von Hübl, Jahrbuch, 1905, **18**, 183; Brit. J. Phot. 1906, **53**, 147; Phot. Korr. 1906, **43**, 157.

79. J. C. S. 1922, **121**, 2004; abst. Amer. Phot. 1923, **17**, 312; J. S. C. I. 1922, **41**, 997A; C. A. 1923, **17**, 108.

80. Phot. Korr. 1904, **41**, 108, 116; 1905, **42**, 406; abst. Brit. J. Almanac, 1906, 770; Jahrbuch, 1906, **20**, 410; 1907, **21**, 309; Brit. J. Phot. 1904, **51**, 306; 1905, **52**, 69; Phot. Mitt. 1905, **42**, 325. Cf. "Photochemie," 1906, 329. E. Valenta, Phot. Korr. 1906, **53**, 132. J. E. Greene, Amer. Annual Phot. 1912, **26**, 207.

81. Penrose's Annual, 1901, **15**, 129.

82. Bull. Soc. franç. Phot. 1906, **48**, 132; abst. Phot. J. 1906, **46**, 260. Instructions for using sensitol green and sensitol red, the English made pinaverdol and pinacyanol, marketed by Ilford, Ltd. Brit. J. Phot. 1917, **64**, Col. Phot. Supp. 11, 7.

83. Jahrbuch, 1907, **21**, 399.
84. Penrose's Annual, 1908, **14**, 206.
85. Jahrbuch, 1905, **42**, 188; abst. Brit. J. Almanac, 1906, 773.
86. Das Atel. 1906, **13**, 14; Brit. J. Phot. 1906, **53**, 147; abst. Brit. J. Almanac, 1907, 743.
87. Phot. J. 1908, **48**, 25.
88. Phot. Korr. 1915, **52**, 271; Brit. J. Phot. 1917, **64**, Col. Phot. Supp., 11, 8; Annual Repts. 1917, **2**, 508. Cf. Meissner, Ann. d. Phys. 1916, **50**, 713; Sci. abst. 1917, 97, who used dicyanin A for line spectrograms of metals.
89. Bull. Soc. franç. Phot. 1906, **48**, 132; abst. Phot. J. 1906, **46**, 260; Brit. J. Phot. 1917, **64**, Col. Phot. Supp. 11, 25; Camera Craft, 1917, **24**, 254; Fabre, "Traité Encycl." Supp. D. 208.
90. Phot. Rund. 1914, **24**, 49; Jahrbuch, 1914, **28**, 220; Brit. J. Phot. 1914, **61**, Col. Phot. Supp. **8**, 13; Camera Craft, 1914, **21**, 243.
91. J. Ind. Eng. Chem. 1922, **14**, 1060; Brit. J. Phot. 1922, **69**, 474; abst. Bull. Soc. franç. Phot. 1922, **64**, 234; Sci. Tech. Ind. Phot. 1922, **2**, 93; J. S. C. I. 1922, **41**, 689A; U.S.P. 1,532,814; C.A. 1925, **19**, 1668.
92. Bull. Soc. Chim. Franç. 1920, (4), **27**, 427; Bull. Soc. franç. Phot. 1920, **62**, 182; Brit. J. Phot. 1921, **68**, 77; abst. Sci. Tech. Ind. Phot. 1921, **1**, 2; J. S. C. I. 1921, **40**, 27A; J. C. S. Annual Repts. 1920, **17**, 122; Phot. Abst. 1921, **1**, 568; F.P. 508,091; 508,092, 1919.
E. König, Phot. Korr. 1920, **57**, 312 commenting on the above stated that many attempts had been made at Hoechst to find useful dyes amongst the di-ethyl or di-methylamins, and that pinachrom violet belonged to this class.
93. Trans. Roy. Soc. Can. 1922, **16**, (3), 195; abst. C. A. 1923, **17**, 3834.
94. Handbuch, 1903, **3**, 154.
95. "Die orthochromatische Photographie," 81.
96. "Investigations on the theory of the photographic process," 327.
97. Ibid.
98. "Photochemie," 331.
99. Bull. Mens. Soc. Foto. Ital. 1906, **18**, 161; abst. Phot. J. 1906, **46**, 304.
100. Loc. cit. 327.
101. J. Opt. Soc. Amer. 1920, **4**, 91.
102. Astrophys. J. 1907, **26**, 299; Brit. J. Phot. 1908, **56**, 101, 119; abst. Brit. J. Almanac, 1909, 591.
103. Brit. J. Phot. 1912, **59**, 591; abst. ibid. 1916, **63**, 505.
104. Zeits. wiss. Phot. 1913, **12**, 238; Jahrbuch, 1914, **28**, 220.
105. Bull. Soc. franç. Phot. 1906, **48**, 132; Le Procédé, 1906, **8**, 20; abst. Brit. J. Almanac, 1907, 742; Phot. J. 1906, **46**, 260.
106. Given annually in Brit. J. Almanac.
107. Zeits. wiss. Phot. 1912, **10**, 323; Jahrbuch, 1913, **27**, 290.
108. Das Atel. 1909, **16**, 98; Jahrbuch, 1910, **24**, 375.
109. Zeits. Repro. 1915, **17**, 23; abst. C. A. 1915, **9**, 2627; Phot. J. Amer. 1915, **52**, 305. G. Daur, Brit. J. Phot. 1909, **56**, 572, 610, 630, 649 gave an exhaustive paper with tables and curves of sensitizing with dye mixtures.
110. Bull. Soc. franç. Phot. 1923, **65**, 283; Rev. franç. Phot. 1923, **4**, 267; abst. Sci. Tech. Ind. Phot. 1923, **3A**, 113; Amer. Phot. 1924, **18**, 570; J. S. C. I. 1924, **43**, B77. Cf. von Hübl, "Die orthochromatische Photographie," 1920, 83.
111. Bull. Soc. franç. Phot. 1924, **66**, 345; Rev. franç. Phot. 1923, **4**, 291; Amer. Phot. 1924, **18**, 570.
112. J. Frank. Inst. 1920, **189**, 25; Brit. J. Phot. 1920, **67**, 479, 496, 514; abst. J. S. C. I. 1920, **39**, 207A; Sci. Tech. Ind. Phot. 1921, **1**, 1; Annual Repts. 1920, **5**, 512.
113. Scientific Paper, No. 442, Bureau of Standards, Washington, D. C.; Brit. J. Phot. 1922, **69**, 416; abst. Sci. Tech. Ind. Phot. 1922, **2**, 93; Le Procédé, 1922, **24**, 41; J. S. C. I. 1922, **41**, 689A.
114. Phot. Mitt. 1907, **44**, 68; abst. Brit. J. Almanac, 1908, 619; Brit. J. Phot. 1907, **54**, Col. Phot. Supp. **1**, 23.
E. Stenger, Zeits. wiss. Phot. 1922, **21**, 246; abst. Amer. Phot. 1922, **16**, 727; Phot. Ind. 1922, 835, 859, 979, 899 also reported on the keeping power of emulsion-dyed and bathed plates.
115. Phot. Ind. 1917, 657; abst. Abst. Bull. 1920, **6**, 400.
116. Phot. Ind. 1916, 79, 111.
117. Brit. J. Phot. 1920, **67**, 719; abst. Phot. J. Amer. 1920, **57**, 460; Sci. Tech. Ind. Phot. 1921, **1**, 7.

118. Phot. J. 1921, **61**, 12; Brit. J. Phot. 1921, **68**, 34; abst. J. S. C. I. 1921. **40**, 99A; Phot. Absts. 1921, **1**, 62.
119. Brit. J. Phot. 1920, **67**, 743.
120. J. S. C. I. 1920, **39**, 156T; Brit. J. Phot. 1920, **67**, 447, 463.
121. Brit. J. Phot. 1921, **68**, 129.
122. Brit. J. Phot. 1875, **22**, 256; Bull. Soc. franç. Phot. 1875, **17**, 236.
123. Phot. J. 1921, **61**, 235; abst. J. S. C. I. 1921, **40**, 413A.

T. Bolas, Brit. J. Phot. 1920, **67**, 759 called attention to the inherent color-sensitiveness of the silver salts in the Seebeck process, and the reversal of the latent image by iodide. Bolas added that he had found nothing better as a color-sensitizer than the old cyanin, provided care was taken in its purification, possibly associated with quinolin or glycin red or phosphin; the former as recommended by Vogel and Miethe and the last by Gifford.

124. Phot. J. 1922, **62**, 88.
125. Mon. Phot. 1891, 163; Bull. Soc. franç. Phot. 1891, **33**, 163; Phot. Nach. 1891, **3**, 170; Jahrbuch, 1892, **6**, 393. This was also given by P. C. Duchochois, Phot. Work, 1893; Jahrbuch, 1895, **9**, 437.
126. Jahrbuch, 1897, **11**, 379. Cf. G. T. Harris, Brit. J. Almanac, 1895, 617.
127. Jahrbuch, 1903, **17**, 437.
128. Phot. Woch. 1906, **52**, 89; Jahrbuch, 1906, **20**, 419.

E. E. Burnett, E.P. 13,561, 1906; abst. Brit. J. Phot. 1907, **54**, 468; Jahrbuch, 1908, **22**, 382 patented the addition of 0.16 per cent of naphthol yellow to the emulsion. T. MacWalter, E.P. 17,453, 1907; abst. Brit. J. Phot. 1908, **55**, 666; Jahrbuch, 1909, **23**, 293 patented the addition of 0.075 per cent of tartrazin. In E.P. 17,452, 1907 he claimed the use of filter yellow. R. Namias, Il. Prog. Foto, 1908; Brit. J. Phot. 1908, **55**, Col. Phot. Supp. **2**, 55; Brit. J. Almanac, 1909, 571; Phot. Coul. 1908, **3**, 135 suggested a bath of erythrosin 1, naphthol yellow 50, tartrazin 50, water 1000 ccs. and stated that he obtained good even spectra with excellent green rendering.

129. Phot. Korr. 1908, **45**, 23; Jahrbuch, 1908, **22**, 380; "Das Arbeiten mit farbenempfindlichen Platten," Berlin, 1909, 28. Cf. R. Namias, Brit. J. Phot. 1908, **55**, Col. Phot. Supp. **2**, 52.

König also recommended, Phot. Korr. 1908, **45**, 570; Brit. J. Phot. 1907, **54**, 786; abst. Brit. J. Almanac, 1909, 570; Phot. Coul. 1907, **2**, 174 the addition of pinacyanol, 1:1000, 6 ccs. to the erythrosin bath; but failed to get good results with pinachrom though later, Phot. Mitt. 1910, **57**, 121; Jahrbuch, 1910, **24**, 376; 1911, **25**, 367; Brit. J. Phot. 1910, **57**, Col. Phot. Supp. **4**, 3; Penrose's Annual, 1909, **15**, 73 he introduced pinorthol I and II, the former containing pinachrom, erythrosin and filter yellow and the latter pinacyanol. As erythrosin is an acid dye and the pinachrom basic, the latter is precipitated, but this can be overcome if the former is considerably in excess. In Stolze's Phot. Notizenkalender, 1913, 250 there is reversion to the old ammonium picrate used by Vidal and Jonas.

130. Brit. J. Phot. 1907, **54**, Col. Phot. Supp. **1**, 89; 1908, **2**, 7; abst. Brit. J. Almanac, 1908, 571.
131. Zeits. Repro. 1915, **17**, 68, 88, 100, 125, 146.
132. E.P. 101, 1883; Brit. J. Phot. 1883, **30**, 516; 1888, **35**, 191; F.P. 152,645, 1882; Jahrbuch, 1887, **1**, 308.

According to B. J. Edwards, Brit. J. Phot. 1888, **35**, 485 the term isochromatic, frequently applied to these plates, was first suggested by Prof. E. Bert. F. C. Lambert, ibid. 1887, **34**, 181 suggested the term kairolamprotic. Cf. J. Waterhouse, Brit. J. Phot. 1887, **34**, 126.

133. D.R.P. 39,779, 1886; Silbermann, **1**, 37; Phot. Mitt. 1887, **24**, 87; E.P. 7,963, 1886; Brit. J. Phot. 1884, **31**, 477; 1886, **33**, 543; 1887, **34**, 188, 412; Phot. News, 1889, **33**, 83.

Vogel commercially introduced such plates under the name "azalin," and the dye solution was sold separately; the old cyanin was the dye used. Mallmann and Scolik, Phot. Korr. 1886, **23**, 335; Jahrbuch, 1887, **1**, 310; Phot. Times, 1886, **16**, 410, 422, 431, 437 analyzed azalin and stated that it was a mixture of 10 parts of quinolin red with 1 part cyanin dissolved in alcohol. Cf. C. H. Bothamley, Phot. News, 1889, **33**, 180. Eder, Jahrbuch, 1888, **2**, 124. W. Abney, Phot. J. 1888; Phot. Mitt. 1888, **25**, 255; Phot. Times, 1884, **14**, 489; 1886, **16**, 129; 1887, **17**, 116.

134. D.R.P. 19,306, 1882.
135. E.P. 15,532, 1886; Brit. J. Phot. 1887, **34**, 122; 1888, **35**, 412; Phot. News, 1887, **31**, 124; Phot. Korr. 1916, **53**, 20.

Apparently there was no corresponding German patent.

136. D.R.P. 127,771, 1901; Silbermann, 1, 37; E.P. 11,719, 1901; Phot. Chron. 1902, 9, 165; Jahrbuch, 1902, 16, 530.

137. E.P. 12,516, 1899; Belg.P. 153,714; 170,721.

138. E.P. 12,513, 1903; F.P. 332,875.
The use of cyanin decolorized with acid was suggested by W. Weissenberger, Phot. Korr. 1886, 43, 591; Beiträge, III, 95, 101, 106 (see p. 245). Cf. Mallmann and Scolik, Phot. Times, 1887, 17, 7.

139. D.R.P. 142,926, 1902; Silbermann, 1, 38; E.P. 27,177, 1902; Fabre, "Traité Encycl." Supp. D. 208; Can.P. 81,403, 1903.

140. D.R.P. 158,078, 1903.

141. U.S.P. 752,323, 1904; F.P. 336,298.

142. D.R.P. 170,048; 170,049, 1903; Phot. Chron. 1906, 13, 273; Jahrbuch, 1907, 21, 400; Chem. Crtlbl. 1905, I, 486.

143. D.R.P. 158,080, 1903; Fabre, "Traité Encycl." Supp. D. 207.

144. F.P. 338,780; D.R.P. 218,904, 1908.

145. F.P. 342,656, 1904; Phot. Ind. 1904, 1062; Jahrbuch, 1905, 19, 338; E.P. 9,456, 1904.

146. D.R.P. 155,541, 1903.
On the use of dyes from brom- and chlorcyanpyridin cf. K. Kieser, Zeits. wiss. Phot. 1905; Brit. J. Phot. 1905, 52, 189.

147. D.R.P. 161,196, 1904; Silbermann, 1, 41.
In La Phot. 1902, 43 it is stated that F. Monpillard, recommended this method, Bull. Soc. franç. Phot. 1893, 40, 243; but Monpillard merely suggested the use of ammoniacal baths of erythrosin, followed by an ammoniacal cyanin bath.

148. E.P. 14,073, 1903.

149. D.R.P. 154,448, 1903. Claims the use of quinolin ethylates with caustic alkalis.

150. D.R.P. 154,475, 1903; Silbermann, 1, 39; Fabre, "Traité Encycl." Supp. D. 207. Claims compounds of p-toluquinaldin with p-toluquinolin and p-methoxyquinolin. The methylated dye was pinaverdol and the ethylated orthochrom T.

151. D.R.P. 172,118, 1905; U.S.P. 844,804; E.P. 16,227, 1905; Brit. J. Phot. 1906, 53, 293; Brit. J. Almanac, 1907, 742; abst. J. S. C. I. 1906, 25, 368; Fabre, "Traité Encycl." Supp. D. 208. The patent for pinacyanol from the same compounds with caustic soda and formaldehyde.

152. D.R.P. 175,034, 1906. Claims the use of tolu-sulfonates.

153. D.R.P. 189,942, 1906. Claims the use of sodium glycolate.

154. D.R.P. 178,688, 1906. Treatment of the bases with sulfites and formaldehydes.

155. D.R.P. 200,207, 1907. Claims the addition of chloroform, bromoform and iodoform and other alkalis than soda.

156. D.R.P. 167,159, 1903; E.P. 9,598, 1903; J. S. C. I. 1904, 23, 384. The treatment of the tolu- bases with caustic alkalis. To this class belong pinaverdol, or sensitol green.
Cf. E. Wise, E. Q. Adams, J. K. Stewart and C. H. Lund, J. Ind. Eng. Chem. 1919, 11, 460.

157. E.P. 133,769; 133,770, 1919; Brit. J. Phot. 1919, 66, 699; abst. J. S. C. I. 1919, 38, 926A; Annual Repts. 1919, 4, 511; U.S.P. 1,372,548; 1,320,176, 1919; D.R.P. 328,557; 328,558; Phot. Ind. 1921, 159; F.P. 498,810; 498,811; Bull. Soc. franç. Phot. 1921, 63, 31. Cf. Phot. J. 1920, 60, 145; Brit. J. Phot. 1920, 67, 304; Phot. J. Amer. 1920, 57, 332.

158. Brit. J. Phot. 1920, 67, 563.

159. Phot. J. 1895, 35, 37; Phot. Annual, 1896, 170.

160. Brit. J. Phot. 1920, 67, 579.

161. U.S.P. 1,338,346; 1,338,349, 1920.

162. U.S.P. 1,374,871; 1,374,872, 1921; abst. J. S. C. I. 1921, 40, 413; C. A. 1921, 15, 2799; Sci. Tech. Ind. Phot. 1921, 1, 96.

163. U.S.P. 1,437,674, 1922; J. Ind. Eng. Chem. 1923, 15, 379.

164. U.S.P. 1,297,046; 1,303,426; 1,337,673, 1920.

165. E.P. 20,069, 1902; U.S.P. 718,312; D.R.P. 147,876, 1901; Silbermann, 1, 42.

166. U.S.P. 785,219, 1905; D.R.P. 151,996, 1902; Silbermann, 1, 40.

167. D.R.P. 199,535, 1907.

168. Jahrbuch, 1905, 19, 76.

169. E.P. 134,238, 1918; Brit. J. Phot. 1919, **66**, 728; abst. J. S. C. I. 1919, **38**, 963A; F.P. 504,232; U.S.P. 1,383,620; 1,391,310; Can.P. 219,070.

Sir W. J. Pope, Brit. J. Phot. 1917, **64**, 22; J. S. C. I. 1917, **39**, 163; Annual Repts. 1917, **2**, 496; Phot. J. Amer. 1917, **54**, 419, announced that the isocyanins were being made at Cambridge University, England.

Cf. On the carbocyanins, W. H. Mills and F. L. M. Hamer, J. C. S. 1920, **117**, 1550; abst. J. S. C. I. 1921, **40**, 41A. On the quinocyanins see O. Fischer and G. Scheibe, J. prakt. Chem. 1919, **100**, 86; abst. J. S. C. I. 1921, **40**, 41A; C. A. 1922, **16**, 4213; F. M. Hamer, J. C. S. 1921, **119**, 1432; abst. J. S. C. I. 1921, **40**, 41A. W. König and O. Treichel, J. prakt. Chem. 1921, **102**, 63; abst. J. S. C. I. 1921, **119**, 1, 738; C. A. 1922, **16**, 563. L. A. Mikeska, J. K. Stewart and L. E. Wise, I. Ind. Eng. Chem. 1919, **11**, 456; abst. J. S. C. I. 1919, **38**, 456A, describe the preparation of quinolin. W. H. Mills and F. M. Hamer, J. C. S. 1922, **121**, 2008; abst. C. A. 1923, **17**, 109 describe the quarternary salts of quinaldinic acid. On the preparation of quinaldin see Chemische Fabrik a. Aktien, vorm. Schering, D.R.P. 24,317, 1882. C. H. Lund and L. E. Wise, J. Ind. Eng. Chem. 1919, **11**, 458 gave instructions for making quinolin ethiodide etc. W. H. Mills and P. E. Evans, J. C. S. 1920, **117**, 1035 gave the preparation of o-aminocinnamylidenequinaldin methiodide. W. H. Mills and R. S. Wishart, J. C. S. 1920, **117**, 579 on the constitution of the isocyanins. Cf. Miethe and Booke, Ber. 1904, **37**, 2008; Brit. J. Phot. 1905, **52**, 146; and contra S. Friedlander, Ber. 1904, **37**, 2821; W. König, J. prakt. Chem. 1906, **73**, 100; 1912, **86**, 166; Vongerichten and Höfchen, Ber. 1908, **41**, 3054; Kaufmann and Vonderwahl, Ber. 1912, **45**, 1404. J. A. Gardner and M. Williams, E.P. 198,462, 1922 patented the use of chloropicrin as the oxidizing agent for making quinolin and derivatives. W. König and K. Seifert, Ber. 1923, **56B**, 1853 deal with the preparation of quinolin. W. H. Mills and W. K. Braunholz, J. C. S. 1923, **123**, 2804; abst. J. S. C. I. 1924, **43**, B155; C. A. 1924, **18**, 398; Sci. Tech. Ind. Phot. 1924, **4**, 21 dealt with the formation of the carbocyanins and constitution of the thioisocyanins and kryptocyanin. A. Adam, Chem. Zentr. 1923, i, 1591; Wiss. Ind. 1923, **2**, 2; abst. J. C. S. 1923, **123**, 1129 treated of the anhydro base of 2-methylquinolin. Knoll & Co. D.R.P. 363,582; 363,583; J. S. C. I. 1923, **42**, 628A, patented the preparation of quinaldin. J. L. B. Smith, J. C. S. 1923, **123**, 2288; abst. J. S. C. I. 1923, **42**, 1120A; abst. C. A. 1924, **18**, 264; Sci. Tech. Ind. Phot. 1924, **4**, 5 studied the effects of various substituents on the sensitizing power of methylthiazol and methylbenzothiazol dyes. F. M. Hamer, J. C. S. 1923, **123**, 2333; abst. J. S. C. I. 1923, **42**, 1103A; C. A. 1924, **18**, 85 dealt with the preparation of carbocyanin and failed to confirm the results of Mees and Gutekunst. S. H. R. Edge, J. C. S. 1923, **123**, 2330; abst. C. A. 1924, **18**, 83 dealt with the benzothiazoles. F. M. Hamer, J. C. S. 1924, **125**, 1348; abst. J. S. C. I. 1924, **43**, 667 dealt with the synthesis of the azocyanins. On the isocyanins generally see J. S. Ellingsworth, Chem. Age, 1923, 251, 302; Chim. Ind. 1924, **11**, 1154. E. Rosenhauer, A. Schmidt and W. Schleifenbaum, J. prakt. Chem. 1924, **107**, 232. W. König, Ber. 1924, **57B**, 685; abst. C. A. 1924, **18**, 2897; described the indolenino- or indocyanins, which are sensitizers. W. Harrison and S. E. Bottomley, J. Soc. Dyers & Col. 1917, **33**, 88; abst. C. A. 1917, **11**, 2863; J. S. C. I. 1917, **36**, 163 gave a method for making ethyl iodide, quinaldin, toluquinolin and orthochrom, which they called tolucyanin. Cf. W. H. Harrison, Color Trade J. 1917, **2**, 229; J. Soc. Dyers & Col. 1917, **33**, 179; J. S. C. I. 1917, **36**, 179 gave a summary of the dyestuffs of the pyridin and quinolin series, ethyl red, quinolin red, etc. Cf. Döbner and Müller, Ber. 1883, **16**, 2465. Skraup, Monats Chem. 1881, **2**, 158. C. H. Lund and L. E. Wise, J. Ind. Eng. Chem. 1919, **11**, 458; abst. J. S. C. I. 1919, **38**, 456A; Bull. Soc. franç. Phot. 1921, **63**, 179; L. E. Wise, E. Q. Adams and C. H. Lund, J. Ind. Eng. Chem. 1919, **11**, 460; Brit. J. Phot. 1919, **66**, Col. Phot. Supp. **13**, 34; abst. J. S. C. I. 1919, **38**, 456A; Bull. Soc. franç. Phot. 1921, **63**, 179 gave details of preparation of pinaverdol, or sensitol green and pinacyanol or sensitol red. E. T. Wherry and E. Q. Adams, J. Wash. Acad. Sci. 1919, **9**, 369; abst. J. S. C. I. 1919, **38**, 756; J. C. S. 1919, i. 496 dealt with the crystallography of pinaverdol. W. H. Mills, J. C. S. 1922, **121**, 455; abst. C. A. 1922, **16**, 1924; J. S. C. I. 1922, **41**, 524A, reported on cyanin dyes of the benzothiazol series and proposed the name of carbothiocyanins for the same. Some of these are powerful sensitizers for the orange and red, while others sensitize silver chloride well for bright blue. W. Braunholz, J. C. S. 1922, **121**, 169; abst. J. S. C. I. 1922, **41**, 198; Sci. Tech. Ind. Phot. 1922, **2**, 146 gave comparisons of three isomeric carbocyanins, which apparently offer no marked improvement on those in use. F. M. Hamer, Phot. J. 1922, **62**, 8; abst. J. S. C. I. 1922, **41**, 120a;

C. A. 1922, **16**, 2085 dealt with the constitution and sensitizing of the isocyanins. S. Palkin and M. Harris, J. Ind. Eng. Chem. 1922, **14**, 704; abst. J. C. S. 1922, **121**, 951 described the preparation of the intermediates used in making isocyanins. Cf. S. Palkin, U.S.P. 1,437,674, 1922. J. E. Harris and W. J. Pope, J. C. S. 1922, **121**, 1029; abst. C. A. 1922, **16**, 2645; Sci. Tech. Ind. Phot. 1922, **2**, 86 described the preparation of isoquinolin and isoquinolin reds, and methyl- and ethyl-isoquinolin red, which are also sensitizers, but not very soluble in water. R. Bing, "Ueber einige neue Isocyanine und deren Einwirkung auf Bromsilbergelatine," Berlin, 1914; Phot. Ind. 1914, 1050; Phot. J. Amer. described the preparation of bases and isocyanins, most of which had already been prepared by Meister, Lucius and Brüning. Cf. K. Kieser, Zeits. wiss. Phot. 1905, **3**, 6. W. König, Ber. 1922, **55**, 3923; abst. J. S. C. I. 1922, **41**, 934A; J. C. S. 1922, **121**, 1188 confirmed the structure of the pinacyanols as given by Mills and Hamer. Cf. W. H. Mills and J. L. B. Smith, J. C. S. 1922, **121**, 2725, on the reactivity of methyl groups with the isocyanins. J. M. Hamer, J. C. S. 1923, **123**, 246; abst. C. A. 1923, **17**, 1642 dealt with some derivatives of the methylenedi-quinaldins and their relation to the carbocyanins. As to the constitution of pinacyanol see O. Fischer, J. prakt. Chem. 1918, ii, **98**, 204; Wise, Adams and Stewart, J. Ind. Eng. Chem. 1919, **11**, 460; W. H. Mills and R. S. Wishart, J. C. S. 1920, **117**, 579. W. H. Mills, J. Harris and H. Lambourne, J. C. S. 1922, **121**, 1509 treated of the preparation of quinaldin. W. H. Mills and K. Braunholz, J. C. S. 1922, **121**, 1489 treated of the virtual tautomerism of the thiocyanins. K. L. Moudgill, J. C. S. 1922, **121**, 1509 treated on brominated isocyanins, and showed that the introduction of the bromine molecule lowers the sensitizing power. M. Giua, Gazetta, 1922, **52**, i, 349; abst. J. C. S. 1922, **121**, 681; C. A. 1922, **16**, 2690 described a new red quinolin dye, but gave no data as to sensitizing. S. Palkin, J. Ind. Eng. Chem. 1923, **15**, 379; abst. J. C. S. 1923, **123**, i, 591; C. A. 1923, **17**, 1889, described the preparation of dicyanin A. E. Q. Adams and H. L. Haller, J. Amer. Chem. Soc. 1920, **42**, 2389; abst. J. S. C. I. 1920, **40**, 75A; J. C. S. 1921, **119**, 53 gave the method of making isocyanin dyes from 4-methyl-quinolin, etc. by treatment with hot strong alcoholic alkalis. L. A. Mikeska, J. Amer. Chem. Soc. 1920, **42**, 2396; abst. J. C. S. 1921, **119**, 54; J. S. C. I. 1921, **40**, 75A detailed the preparation of 4-methyl-quinolin. Cf. O. Fischer, G. Scheibe, P. Merkel and R. Müller, J. prakt. Chem. 1919, (ii) 91; abst. J. C. S. 1921, **119**, 55. L. A. Mikeska and E. Q. Adams, J. Amer. Chem. Soc. 1920, **42**, 2394; abst. J. C. S. 1921, **119**, 54 gave methods for the preparation of dicyanin A nitrate and iodide. E. Q. Adams and H. L. Haller, J. Amer. Chem. Soc. 1920, **42**, 2661; abst. J. C. S. 1921, **119**, 129; J. S. C. I. 1920, **40**, 75A gave the manufacture of kryptocyanin. Cf. U.S.P. 1,374,871; 1,374,872; abst. J. S. C. I. 1921, **40**, 413A; C. A. 1921, **15**, 2799; Sci. Tech. Ind. Phot. 1921, **1**, 96. A. G. Scheibe and E. Rossner, Ber. 1921, **54**, (B) 786; abst. J. C. S. 1921, **119**, 457 described quin-olylmethane, the isocyanins and quinolin red. W. H. Mills and R. C. Odams, J. C. S. 1924, **125**, 1913; abst. Sci. Ind. Phot. 1924, **4**, 190, dealt with the synthesis of 2:4'-carbocyanins. J. H. Hewitt, "Synthetic coloring matters; dyestuffs derived from pyridine, quinoline, acridine and zanthene," London, 1922. C. Hollins, "The synthesis of nitrogen ring compounds," London, 1924. F. M. Hamer, on the reduc-tion of the carbocyanins, J. C. S. 1925, **127**, 271; Abstracts 1925, 1305. O. Fischer, E. Diepolder & E. Wölfel, J. prakt. Chem. 1925 (ii), **109**, 59, 69; abst. C. A. 1925, **19**, 1279; J. S. C. I. 1925, **44**, 1438 deal with 4-aminoquinolins. O. Fischer, A. Müller & A. Vilsmeier, J. prakt. Chem. 1925 (ii), **109**, 69 deal with the synthesis of 4-chlor-oisoquino-cyanins.

The following deal with the use of color-sensitive plates or sensitizing gen-erally: W. Abney, Brit. J. Phot. 1887, **34**, 196, 214, 225. T. Armstrong, ibid. 1889, **36**, 345, 394, 411; edit. ibid. 1890, **37**, 162. J. V. Elsden, ibid. 1896, **43**, 711. Eder, ibid. 1884, **31**, 813; 1885, **32**, 8. J. S. Gibson, Phot. Times, 1897, **27**, 101; Anthony's Phot. Bull. 1896, **27**, 184. C. A. Swinton, Anthony's Phot. Bull. 1885, **16**, 194, 226; Phot. Times, 1884, **14**, 200. J. Carbutt, Phot. Times, 1891, **21**, 373. G. Cramer, ibid. 1891, **21**, 384. P. C. Duchochois, ibid. 1894, **24**, 6, 41, 55, 75, 86, 104, 119. L. Tranchant, ibid. 1894, **25**, 233. C. Scolik, Phot. Times, 1885, **15**, 613, 656, 705; edit. ibid. 609. V. Schumann, ibid. 1886, **16**, 109, 121, 130, 145, 208, 398. C. Ehrmann, Phot. Times, 1886, **16**, 673. C. Sturenburg, ibid. 1887, **17**, 16, 29, 48. J. Schnauss, ibid. 1888, **18**, 616. W. J. Harrison, ibid. 1890, **20**, 210, 269, 368, 384. R. Namias, Il Prog. Foto. 1917, **1**, 33, 65, 97, 135, 158, 190, 254. A. S. Cory, M. P. News, 1917, 3642, 3812, 3968, 4131. E. Valenta, Brit. J. Phot. 1901, **47**, 133. J. Husnik, Jahrbuch, 1901, **15**, 56; Phot. J. 1901, **41**, 364. Lüppo-Cramer, Brit. J. Phot. 1901, **48**, 675. T. T. Baker, ibid. 1904, **51**, 289, 342, 867; Amat. Phot. 1906;

Jahrbuch, 1906, **20**, 418; Phot. J. 1907, **47**, 207. K. Franck, Phot. Korr. 1916, **53**, 303 on the action of the spectrum on various sensitive surfaces. E. A. Salt, Brit. J. Phot. 1916, **63**, Col. Phot. Supp. **10**, 1. W. F. Meggers, Bull. Bureau Standards, 1918, **14**, 376 for dyes for infra-red. Von Hübl, Das Atel. 1906, **13**, 14; Jahrbuch, 1906, **20**, 413 examined the action of ethyl violet, pinachrom, pinacyanol, etc. S. Procoudin-Gorsky. Phot. Korr. 1906; Jahrbuch, 1906, **20**, 414 tested ethyl red, pinachrom and orthochrom T in weak ammoniacal baths and strongly recommended washing for 3 hours. K. Kieser, "Beiträge z. Chemie d. optischen Sensibilisation v. Silbersalzen," Frieburg, 1904, dealing with the action of various dyes on silver halides and other salts; cf. abst. Brit. J. Phot. 1907, **54**, 365. E. J. Wall, Brit. J. Phot. 1904, **51**, 544, 565 dealt with sensitizing generally; ibid. 1907, **54**, 365, 386, 406, 464 a complete summary of the subject. F. Wenzel, "Beiträge z. optischen Sensibilisation d. Chlorsilbergelatine," Berlin, 1908; abst. Brit. J. Phot. 1909, **61**, 5, 22, 41, 64, the most complete summary of sensitizing silver chloride with the phthaleins and isocyanins. Fabre, "Traité Encycl." Supp. A. 245; Supp. B. 284; Supp. C. 247; Supp. D. 206.

CHAPTER VIII

TESTING COLOR-SENSITIVE PLATES

Various methods have been suggested for testing color-sensitive plates and very contradictory opinions are held on this subject. Some workers pin their faith to color charts, with others the spectrum alone can be relied upon; whilst yet again the use of broad-banded filters, that divide the spectrum into definite regions, have been adopted. There is something to be said for each method, for each has its good and weak points. In testing dyes for their sensitizing powers undoubtedly the best method is with the spectrograph. But here also opinions differ, for one may use the prismatic or diffraction spectrum. The advantage of the former is that the red end is always cramped together, so that it apparently gives a stronger action here than in the more extended blue regions. Yet, on the other hand, this very advantage may be misleading, as when the dye is proved in actual practice the sensitiveness may be so low as to be practically valueless. A combination of methods is after all the most satisfactory.

Von Hübl[1] (p. 293) gave a simple method of converting the readings of the prismatic spectrum into that of the diffraction spectrum. Calling the extension of action in the former a with an intensity m, and the intensity in the diffraction spectrum n and its intensity b, the latter must always be weaker than m because it extends over a greater region; then

$am = bn$, and $n = \dfrac{a}{b} m$. Naturally if one has a photometer the densities can be measured.

S. E. Sheppard and C. E. K. Mees[2] gave an excellent sketch of the various methods in use, and the first method[3] was spectroscopic examination and visual estimation of the densities, plotting against wave-length. Later this method was improved, and several plates were exposed one by one in a patch of monochromatic light of differing spectral color and developed together. On noting the sensitiveness for different wave-lengths, a curve could be plotted showing the color-sensitiveness.[4] In 1888 Abney impressed on one plate the spectrum and a series of densities from a white light, and after measuring the opacities of the spectral exposures, interpolated them between those of the white light exposures, thus obtaining a curve of equivalent intensities, a method which has the advantage of being independent of the development of the plate.[5] Sheppard and Mees justly pointed out that pigment sensitometers, that is color charts, reflect a large amount of white light, and while it is true that this occurs in practical photography, this is not what one should measure.

287

Abney[6] used a sensitometer in which squares of white, blue, green, yellow and red glasses were used, and all brought to the same luminosity by means of a rotating sector wheel; though omission of the blue glass was later advised. For the best form of chart probably that by Abney,[7] in which disks of colored paper were used, deserves attention; but the objection to this was that it gave only one tone.

Eder[8] divided the spectrum into two parts, using a blue filter to isolate the characteristic sensitiveness of the silver salts, and a yellow one to isolate the added color sensitiveness. The blue filter was composed of cupric sulfate, crystals, 25 g. dissolved in some water, with enough ammonia added to form a clear solution and the total volume brought up to 1000 ccs. The yellow filter was a 4 per cent solution of potassium chromate. Both were used in a cell of 10 mm. internal thickness. Later Eder[9] used an orange filter, composed of 0.2 per cent of naphthol orange II (Badische). The author[10] used Eder's blue and orange filters and a red one of 1 : 4000 solution of tolan red, to determine the red sensitiveness. Sheppard & Mees[11] used Eder's blue screen and a green screen, which was the same as Eder's yellow plus a saturated solution of cupric acetate to cut out the red. Their red screen was at first Eder's yellow plus potassium permanganate, but this was given up for a tartrazin and rose Bengal filter, which was suggested by A. J. Newton.

One must differentiate between the purely theoretical and the practical methods of testing. In the former one may say that what is required is a numerical estimation of the added color-sensitivity for particular regions of the spectrum, that is to say, one wants to know the added value for the green and red rays. While in the latter case one only needs the increase of exposure with the taking filters. Naturally if the first be determined, the latter can be easily estimated. But a practical test that is quite reliable, is the determination of the inertias of the plate behind the filters to be used, by the Hurter & Driffield system, which gives at once that information, which can be calculated from the spectrum curves, or the purely theoretical determination of the added sensitiveness for particular spectral regions. In the former case one would have to lay down the particular boundaries of the colors, and theoretically one ought to use sharp-cutting filters, that transmit nothing but pure red, pure green and pure violet. But one must recognize that nearly all reds reflect some yellowish-green, and nearly all greens some blue, and in the case of an intermediate color, such as yellow, we have reflection both of the red and green, therefore, yellow should be represented in both filter actions. This is clearly seen in the case of a non-color-sensitive film; this was found to have a speed of 252 to white light. With the standard tri-color green filter the speed was found to be 79, or practically one-third. This film, when bathed with the isocyanins had a white light speed of 240, a green speed under the same filter as before, of 230. The initial red speed under the standard red filter

was nil; after bathing it was 230. So that in this case there was added in the case of green the difference between 79 and 230, whereas in the case of the red the increase was 230.

Sheppard & Mees proposed to define the ratio between the blue and yellow inertias by χ (chroma = a color), and the yellow inertia was divided by the blue inertia, or the blue sensitiveness divided by that of the yellow, was thus termed, and this term has been generally adopted.

Von Hübl[12] gave the following composition of the filters suitable for estimating the sensitiveness of plates:

For the red:

Rose Bengal	1.5 g.
Tartrazin	2.0 g.

For the green:

Patent blue	0.4 g.
Filter yellow	5.0 g.
Toluidin blue	0.4 g.

For the blue:

Toluidin blue	2.0 g.
Acid violet	1.2 g.

The quantities are grammes per square meter of filter surface. These can be prepared in the same way as described for the taking filters, and they may be used with the sector wheel or tube photometer, in which light is admitted to the plates through short tubes, the front end of which is pierced with varying number of holes of the same diameter. Von Hübl also suggested the use of Goldberg's neutral grey wedge; and Eder[13] has introduced such a sensitometer commercially. This not only gives the speed to white light, but also to colors, as part of the wedge is covered by dyed strips of gelatin, yellow, blue, green and red. The wedge is provided with an opaque scale of numbers, which are impressed on the plates, and the relative speeds are estimated by the last number visible, which is not the most satisfactory method nor really reliable, but probably is sufficiently so in this case.

H. O. Klein[14] constructed a ratiometer, consisting of a frame to hold the three filters in front of a roller shutter with a narrow slit in it, which passed before the sensitive plates, giving five exposures of different durations to each. The plates were then developed together and the densities being marked with their exposures, the three of equal density in the three negatives were read off. S. M. Furnald and A. J. Newton[15] proposed the copying of a transparency behind the filters, with a grey scale on bromide paper, placed under the same and the reproduction of this scale was compared in the negatives.

An extremely important matter in the testing of color-sensitive plates is the nature of the light employed, which naturally should be daylight,

or, if as is sometimes the case, arc lights are alone used as in a studio, then the arc should be used. As typical of the different results obtained with various lights, the following table, given by Eder[16] is instructive:

KIND OF PLATE	SPEED		RELATIVE SENSITIVITY		Blue/Yellow
	Benzin lamp 1 m. distant	Daylight equal to ordinary AgBr plate. Scheiner degrees	Benzin lamp 0.3 m. distant, directly incident	Reflected from white paper	
				Diffuse daylight	Magnesium ribbon
Commercial ortho erythrosin, no filter	19°	11–12°	$\frac{1}{4.7}$ $\frac{1}{5.5}$	$\frac{2.7}{1}$	$\frac{1.3–1.6}{1}$
Ditto b.........	13°	11–12°	$\frac{1}{1.3}$	$\frac{6–7}{1}$	$\frac{4.3–5.0}{1}$
Ditto c.........	14°	9–10°	⅛	$\frac{2.8}{1}$	$\frac{1.35}{1}$
Ditto d......... Strongly screened	14°	7–8°	⅛	$\frac{1.2–1.3}{1}$
Poor orange sensitive	10°	7°	$\frac{2.1–2.4}{1}$	$\frac{60}{1}$	$\frac{20}{1}$
Average panchro, emulsion dyed.	17°	10–11°	$\frac{1}{2.1}$	$\frac{7.1}{1}$
Good panchro, orthrochrom, ethyl red, pinachrom	18–19°	11°	¼–⅛	1–2	1–2

Sheppard and Mees adopted[17] an acetylene light, with an interposed filter to reduce the spectral composition of the light to daylight; this filter being first in the form of liquid cells and later a dyed gelatin film. R. J. Wallace[18] did not agree with the use of screened acetylene, and suggested daylight diffused by ground glass, taken from a point at an angle of 25° with the plane of the horizon. The objection to this is that at no time can one depend on the spectral intensity nor spectral composition of daylight.

Probably the most complete summary of the various methods adopted by different workers for spectrometric testing was that by H. Ewest[19] and this is given practically in full. H. T. Simon[20] was the first to study absorptions in the ultra-violet by photographic means, and equated isolated narrow bands of two contiguous spectra by steadily reducing the brighter of the two. During the operation a plate was driven steadily across the slots, which were used to isolate any particular region of the spectrum, so that the relative intensities of the original spectra could be calculated from the positions of equal density on the two records. E. Belin[21] rotated a sector wheel with sinusoidal sector close in front of the slit, so that the height of the curve at any point varied with the light intensity. E. Callier[22]

used the same method, but substituted the later form of the Scheiner disk with cut out steps. Both Belin and Callier were dependent on the constancy of the light, the validity of the Bunsen-Roscoe and Talbot laws, and uniform illumination of the slit, as well as uniformity of the plate. Simon's method allows of comparison being made at the contiguous borders of the two spectra and, therefore, avoids the necessity for uniform illumination except near the center of the slit, and also the troubles due to the want of uniformity of the plates. E. Herzsprung[23] photographed the spectra in succession on different plates with geometrically increasing exposures, and printed on paper, which was then cut into strips, and the positions of equal density determined. This method is dependent on constancy of the light-source and uniformity of the plates and papers; but is able to avoid errors due to uneven illumination of the slit images. Defregger[24] exposed in the same way as Herzsprung, but obtained his curves by connecting up the positions of just visible blackening on the spectrograms. V. Henri[25] avoided the errors due to plate variations by alternately photographing on one plate the normal spectrum with constant exposure, and the comparison spectrum with increasing times of exposure. His method is less dependent on the gradual changes of the light, but is more affected by the uneven illumination of the slit. P. G. Nutting[26] and J. Königsberger[27] employed polarized light, giving a series of equal exposures with various known positions of the Nicol prism, and noting the appearance of the Savart bands. Luther and Forbes photographed the Marten's double wedge of a König-Martens spectrophotometer, co-ordinating the positions of Nicol and negative and finally narrowing down the range till equal illumination of the two fields was obtained. J. Hartmann[28] photographed two spectra on different plates in succession, systematically changing the slit width and calculated the relative intensities from the resulting densities. Glatzel[29] employed an adjustable slit, but avoided the inconstancy of the light and the variability of the plates by the use of a Vierordt double slit, thus getting the images side by side. The method of varying the slit aperture only gives good results with a continuous spectrum; it is inapplicable to monochromatic lights and narrow band absorptions, since it leads to increase of width and not intensity of the images. P. P. Koch[30] used a glow lamp as light-source and varied the intensity by regulating the current consumption. The effect of these changes was determined by comparisons made in the visible spectrum, on Talbot's principle with another constant lamp source. He used adjustable stops in the path of the rays, so placed that they were filled with uniform light. J. Stark[31] used the stops of his camera objective for varying the intensity of the incident light. Since the rays of different refrangibility do not in general pass through the stop aperture as a uniform beam, he calibrated the apertures by ocular measurements in the visible spectrum by changing the distance from a white surface, which was used to illuminate the slit.

Since the inverse law is not valid for extended objects, the calibration was effected photometrically on Talbot's principle and since the spectral composition is unaffected, it holds good also for the ultra-violet. C. E. K. Mees[33] placed a wedge of neutral glass in front of the slit and thus obtained a steadily decreasing density for each wave-length.

The method used by Ewest resembled those of Belin, Defregger and Mees, inasmuch as he used the limit curve of isopaques. Two comparative exposures were made in succession on two different plates and the required relation between the intensities was calculated from the difference in height of the isopaques. Belin and Defregger obtained the limit curves by varying the times of exposure, and Mees by means of the slit wedge. Ewest kept the time of exposure constant and used a wedge placed immediately in front of the plate. During exposure the plate and wedge were driven at a uniform rate past a slot situated in the plane of the image, in a direction parallel to the spectral lines and at right angles to the edge of the wedge. Mees' method requires an accurately made wedge, because only a very small area of it is projected over the whole spectrum. It must be in good optical and mechanical contact with the slit, otherwise its gradation will not be similar to that of the slit images, owing to want of focus. Neither of these requirements are so stringent in Ewest's method, and Mees' method requires uniform illumination and parallel straight jaws to the slit, and since the wedge must necessarily be small and steep in gradation and the quantitative results depend on the measurement of differences between two narrow spectrograms, small errors in reading off the positions of the isopaques will introduce large percentage errors.

In Ewest's method the wedge, in intimate contact with the plate, glides vertically over the slot, which isolates a horizontal strip of the spectrum. Every point of the image, therefore, receives light from every part of the slit and irregularities in the character of the slit are eliminated. The gradation of the wedge can be shallower, because the required intensity range is distributed over the whole length of the plate, instead of over the slit. Lastly in Mees' method the height of the spectrum is not independent of the wave-length and, therefore, there is no common measure of the isopaques. A slot for limiting the images can not be applied and the evaluation of the isopaques is difficult. This error is likewise avoided by placing the wedge at the plate, for since the illumination is only weakened on arriving there, it is possible to work with isolated portions of the slit image. The derivation of the absorption values from the measurements is based on the assumption that the densities of the wedge increase linearly and that equal densities of image, when resulting from equal times of exposure, depend on the light intensities. It is necessary to determine the gradation constant of the wedge for every wave-length; this being done it is only necessary to multiply the appropriate constants by the difference in height of corresponding isopaques in the two spectrograms to

obtain the extinction for every wave-length. To fix the exact outline of the limit curve, a piece of fine-meshed black gauze netting was placed in front of the wedge during exposure, and the places where the same was just visible were determined in the following manner: upon a large sheet of black paper was pasted a small piece of glossy white paper, having a black dot in the center. The negative, film side down, was moved parallel to the spectral lines and the long axis of the white paper by means of a suitable device, until the just visible image of the gauze touched the black spot. This position of the plate was marked by a fine prick upon a sheet of paper, fastened under the black sheet, and, therefore, in fixed relation to the black spot, by operating a pricker firmly attached to the plate. Several estimations were made and an average limit curve was then drawn by eye estimation among the individual readings. Reference should be made to the original paper for further details.

1. "Die Dreifarbenphotographie," 2nd edit. 1902, 20.
R. J. Wallace, Astrophys. J. 1907, **25**, 116; Brit. J. Phot. 1907, **54**, 368, 388, 408, 427, 578 did not consider this formula satisfactory and gives curves to prove that it was not correct. What was wanted was a formula that would take into account the loss of luminosity by absorption and the shift due to the prism glass.
2. "Investigations on the Theory of the photographic Process" 1907, 308.
3. W. Abney, Phot. J. 1882, **22**, 154.
4. Bakerian Lecture, Proc. Roy. Soc. 1880; Phot. J. 1881.
5. Phot. J. 1888, **28**, Nov.
M. Seddig, Brit. J. Phot. 1906, **53**, 629 suggested the projection of the three fundamental colors in superposition on a screen in triangular form, utilizing the half shadow principle, obtained by three diaphragms in front of the condenser. This could be used for testing the sensitiveness of plates.
6. Phot. J. 1895, **35**, 328.
Abney's sensitometer was also used by J. Cadett, Phot. J. 1896, **36**, 161, and Sanger-Shepherd, ibid. 1898, **38**, 346, also E. Senior, Brit. J. Phot. 1904, **51**, 504, and A. A. K. Tallent, "Photography in Colors," 1900, 217. The same idea is used in Chapman Jones' plate tester, Phot. J. 1901, **41**, 246; Jahrbuch, 1902, **16**, 491; Handbuch, 1912, **1**, III, 222; Phot. Korr. 1901, **38**, 430. L. Vidal, "Manuel pratique d'Orthochromatisme," Paris 1891 had used the same idea without bringing the colors to the same luminosity. Cf. Eder, Sitzungsber. Akad. Wiss. Wien, 1919, **128**, Apr.; Phot. Korr. 1919, **36**, 141; "Ein neues Graukeil-Photometer" Halle, used a neutral wedge with color filters.
7. Phot. J. 1900, **40**, 121.
Color charts were also used by H. W. Vogel, "Handbuch d. Photographie"; Cassell's Popular Educator; Brit. J. Phot. 1895, **42**, 23; Hay, Process Photogram; J. C. Warburg, Penrose's Annual, 1899, **5**, 13; Sanger-Shepherd ibid; Von Hübl, "Die Dreifarbenphotographie"; Klein's translation of the same; Fischer and Wittick, Jahrbuch, 1896, **10**, 587; J. Mayer, ibid. E. Kreutzer, ibid; Prang. ibid. 1899, **13**, 616; Cellarius, ibid. 1897, **14**, 484; Steinheil, Harber, Schulz, ibid.
E. König, Photochemie, 186 said: "with spectral exposures mixtures of dyes generally act more favorably so that it is not difficult to attain an even sensitizing band. The practical worker should, however, beware of placing great value on these spectrograms. For practice there is only one certain means for testing color-sensitive plates, exposures on a color chart with or without the interposition of a light filter." Von Hübl, loc. cit. 39 stated that König's chart, which was published by the Hoechst works, contained colors of incomplete saturation and contaminated with plenty of black.
8. Sitzungsber. Akad. Wiss. Wien. 1901; Jahrbuch, 1902, **16**, 482; Phot. Korr. 1901; Handbuch, 1912, **3**, 664; Beiträge, III, 163.
9. Phot. Korr. 1903, **40**, 426; Beiträge, III, 163.
10. Photography, 1904, 368; Brit. J. Phot. 1904, **51**, 926, 949, 968.
11. Loc. cit. 322. This filter probably contained tartrazin 0.1 g., rose Bengal 0.05 per 100 qcm; Phot. J. 1906, **46**, 110.

12. Loc. cit. 41.

For descriptions of tube photometers see Taylor, Phot. News, 1869, **13**, 19; Phot. Mitt. 1869, **5**, 284; 1882, **18**, 267; Mucklow and Spurge, E.P. 5,368, 1881; Brit. J. Phot. 1882, **29**, 493; Phot. J. 1881, **21**, 44; Eder, Phot. Korr. 1903, **40**, 426; Handbuch, 1912, **1**, III, 182; A. Miethe, Zeits. Repro. 1901, **3**, 187; H. W. Vogel, "Handbuch d. Phot." 1894, II, 48; Brit. J. Phot. 1882, **29**, 448, 459.

13. Phot. Korr. 1919, **56**, 244; Mitt. Oesterr. Techn. Versuchsamst. 1919 published separately as pamphlet. "Ein neues Graukeil-Photometer," 1920. The filter cuts in the above are, for the red, to 5630; for the green, 4620 to 5440 and for the blue-violet 5100 to end, with a weak transmission at 6500. Wratten and Wainwright's 23A, 75 and 48 or 48A practically correspond to these. The yellow filter cuts at 4720 and a Wratten K3 would take its place. Cf. F. Monpillard, Rev. Sci. Phot. 1906; Brit. J. Phot. 1906, **53**, 970.

14. Penrose's Annual, 1906, **12**, 5.

15. Brit. J. Phot. 1916, **63**, Col. Prot. Supp. **10**, 9.

16. Beiträge, II, 161; Handbuch, 1912, **1**, III, 215; Sheppard & Mees, loc. cit. 319.

17. Loc. cit. 314. The liquid filter was composed of gentian violet, 0.02 g., acid green 0.01 g., mandarin orange 0.01 g., rose Bengal 0.004 g., water 1000 ccs. used in a cell of 10 mm. thickness with another cell of like thickness, filled with a 2.5 per cent solution of cupric acetate. The dyes had a great tendency to precipitate and the dry gelatin filter, which has a different composition, supplied by Wratten & Wainwright, is far preferable.

18. Astrophys. J. 1907, **25**, 116; Brit. J. Phot. 1907, **54**, 368, 388, 408, 427, 578.

S. E. Sheppard, ibid. 425 pointed out the unreliability of daylight and criticized Wallace's method. A. Callier, Phot. J. 1913, **53**, 242; Brit. J. Phot. 1913, **60**, 951, 972, described an excellent spectrophotometric condenser, which can be used with any spectroscope. Cf. E. Belin, ibid. 1906, **53**, 630.

19. "Beiträge z. quantitaven Spektralphotographie," condensed by F. F. Renwick, Phot. J. 1914, **54**, 99.

20. Ann. d. Phys. 1896, **59**, 61; Jahrbuch, 1897, **11**, 36.

21. Brit. J. Phot. 1906, **53**, 630; Bull. Soc. franç. Phot. 1906, **48**, 25.

22. Phot. J. 1913, **53**, 242; Brit. J. Phot. 1913, **60**, 951, 972.

23. Zeits. wiss. Phot. 1905, **3**, 15; Jahrbuch, 1905, **19**, 328.

24. Phot. Rund. 1912, **48**, 5.

25. Phys. Zeits. 1913, **14**, 515.

26. Ibid. 1903, **4**, 201.

27. Ibid., 345.

28. Jahrbuch, 1910, **14**, 175.

29. Phys. Zeits. 1900, **1**.

30. Ann. d. Phys. 1909, **30**.

31. Ibid. 1911, **35**.

32. Ibid.

33. "Atlas of Absorption Spectra," London, 1909; Brit. J. Phot. 1907, **54**, 384; 1909, **56**, 685.

For general notes on testing plates cf. Houdaille, Bull. Soc. franç. Phot. 1894, **41**, 314. P. Hanneke, Phot. Mitt. 1909, **39**, 233. G. Ewing, Phot. News, 1895, **39**, 147. J. Carbutt, ibid. 1893, **37**, 558, 564. J. H. Baldock, Brit. J. Phot. 1899, **46**, 86. J. Cadett, ibid. 344, Supp. 85. G. T. Harris, ibid. 1904, **51**, 482. A. Payne, ibid. 487. E. V. Boissonnas, Bull. Soc. franç. Phot. 1889, **36**, 154. A. and L. Lumière, ibid. 1894, **41**, 308. J. Vallot, ibid. 313.

CHAPTER IX

DESENSITIZING PLATES

Whilst this process can hardly be considered as strictly belonging to the domain of color photography, it has been considered justifiable to include the same, as so many methods of development depend upon somewhat critical examination of the image in its first appearance. Further, it may be of considerable practical value to the color worker, as it enables one to use a dark room illumination, which would otherwise be unsafe.

Many suggestions have been put forward with the idea of destroying the color sensitiveness of the emulsion before development. C. Simmen[1] (p. 303) suggested that Autochrome plates should be immersed in a strong solution of sodium bisulfite, and used the acid amidol developer with the same idea. He used a 10 per cent solution of bisulfite for 2 minutes. Le Roy[2] recommended a 10 per cent solution of sodium hydrosulfite, $Na_2S_2O_4$. H. G. Brockman[3] bathed his plates in 3 per cent solution of potassium metabisulfite for 30 seconds, washed in running water for 1 minute and developed in the normal way by the light of a No. 1 Bray gas burner, behind two thicknesses of canary medium. R. Krayn[4] patented the use of a preliminary bath of sulfuric acid and development with amidol or ferrous oxalate.

E. Stenger[5] tested the action of the acid amidol developer and found that there was no reduction of color sensitiveness of panchromatic plates, in fact rather the reverse. E. Valenta[6] was the first to point out that many of the red sensitizers, such as wool black, dianil black, etc., were destroyed by an acid bath, and confirmed this for cyanin and the isocyanins, and with one of the latter the Autochrome plate is sensitized. Actually W. Weissenberger[8] was the first to utilize this idea, as he bathed plates with an acidified solution of cyanin, which gave no red sensitiveness, but this latter appeared as the acid evaporated. C. E. K. Mees and J. K. Baker[9] tried the effects of treating plates with metol-hydroquinon, ferrous oxalate and hydroquinon and found but slight reduction of the panchromatic properties, but in this case only the ferrous oxalate was acid.

W. J. Pope[10] patented the use of a bath of potassium nitrite, acetic acid and water, or a dilute solution of sulfurous acid for desensitizing. N. Sulzberger[11] patented the use of potassium ferrocyanide for reducing or destroying the sensitivity of silver bromide or chloride left in plates or papers after development, a more permanent image being thus obtained. In a later patent[12] the use of palladium ammonio-chloride was claimed. Sir W. N. Hartley[13] worked out a modified formula of the Balagny acid

amidol developer for panchromatic plates, that were required to be kept some time between exposure and development.

In 1898 P. Mercier[14] patented the use of oxidized developing agents, such as amidol, or pyrogallol and eserin and apomorphin, and the first-named was found to be the best, to overcome the effects of extreme over-exposure. And 0.1 g. oxidized amidol or 1.5 g. oxidized pyrogallol per liter, were used as a preliminary bath before exposure. Valenta[15] tested this process and found that a 0.02 per cent amidol solution, used before or after exposure, was very effective, and also pointed out that a bath of 0.1 per cent of m-phenylendiamin was even more efficacious, and reduced the speed of the plates to approximately one-fourth.

Lüppo-Cramer[16] found that soaking a plate after exposure in hydroquinon or adurol (chlor- or bromhydroquinon) had no effect, but that ferrous oxalate, pyrogallol, paraminophenol, glycin and amidol did reduce the sensitiveness so that a much brighter light could be used. Lumière and Seyewetz[17] confirmed these results, and stated that mere wetting of the plates reduced the sensitiveness. Lüppo-Cramer[18] again took up the subject and found that the greatest depression of sensitiveness was caused by plain aqueous solutions of amidol, triaminophenol, triaminobenzol and triaminotoluol in the form of their hydrochlorides. With a 0.05 per cent solution of these compounds it was found that the greatest effect was obtained with triaminotoluol hydrochloride, which reduced the sensitiveness to one six-hundredth, with amidol it was one two-hundredth. Consequently it was possible to develop very rapid plates, after treatment with these solutions, in a bright yellow light.

Continuing the research[19] it was found that the yellow dye, phenosafranin, when used as a preliminary bath before development for about 1 minute, a 0.05 per cent solution being the best, desensitized very strongly. R. E. Crowther[20] pointed out that there is here no screening action, as a gelatinized plate stained in the above solution, transmits the whole of the spectrum, excepting a small gap in the blue-green; it is a real desensitizing action. This action is extremely valuable and considerably facilitates working with panchromatic plates, and the use of the dye has the further advantage that it eliminates most of the chemical fog, that is sometimes prevalent with color-sensitive emulsions.

A. and L. Lumière and A. Seyewetz[21] examined the desensitizing properties of various dyes, to determine whether this was peculiar to all substances derived from the phenazin group, if they alone desensitize, and whether the action was the same for panchromatic as well as ordinary plates; further whether the action was chemical, physical or a physico-chemical one. Fast plates were bathed for 2 minutes in various strength solutions, 1 : 100 to 1 : 2000, and were exposed under similar conditions behind a Chapman Jones plate-tester, and were then developed at a distance of 1.5 meters from a candle with the light reflected directly on

to the plate. The intermediate compounds, which precede the formation of phenosafranin, phenyl blue, Bindschedler green, toluylen blue, phenazin, toluylen red and neutral violet were examined, and were found without action, except toluylen red, which acts very much like phenosafranin; paraphenylendiamin was also found to have slight desensitizing action. It appears that the presence of the phenazin group, and the substitution of amino groups in the benzol nucleus are essential.

Of the various dyes, it was found that the following acted the same as phenosafranin: dimethyl-phenosafranin, tetra-ethyl-phenosafranin (amethyst violet), dimethyl-benzo-xylylsafranin (giroflè), tolusafranin (ordinary safranin), methyl-tolusafranin (safranin MN) and pheno-naphtho and creso-safranin; whilst ethyl-dimethyl-ethosafranin (fast neutral violet D), tolu-naphtho-etho-safranin (indulin scarlet), tetra-methyl-phenosafranin were slightly inferior. Safranone, amidosafranon, homosafranin (azo-carmin X) were much inferior. Dimethyl-amino-phenyl-dimethyl-benzo-safranin (indazin M), a diazo derivative of phenosafranin, and the α-naphthol derivative (indoine blue R) were also much inferior and attacked the image. Acetyl-phenosafranin and safranol were without action. Of the above dyes, comparable with phenosafranin, the creso-safranin has the advantage of being more readily washed out of the gelatin. The indulins, fast blue R, soluble indulin blue B, paraphenylen blue R, metaphenylen blue 2B, azin green and azin green S, Bale blue R, milling blue and Coupier's blue had no action, neither did Lauth's violet, Nile blue 2B, nor resorufin, the first being a thiazin and the others oxazin or oxazon dyes of constitution approximating the safranins. Picric acid, aurantia, Indian yellow and chrysoidin were found to be desensitizers.

There is apparently no well defined relation between the constitution of the dye and the desensitizing properties. A large number of nitrogenous substances, especially the alkaloids, were also tested, and apomorphin hydrochloride was alone found to be active; its solution after turning blue by exposure to the air, seems to be more active than that freshly prepared.

To test the action on panchromatic plates, a particular kind, sensitive to wave-length 7000, was exposed in the spectrograph, then immersed in the dark for 1 minute in the following solutions: phenosafranin and other safranins and chrysoidin 1 : 2000; aurantia, toluylen red and apomorphin, 1 : 1000; picric acid and diaminophenol, 1 : 100; neutral potassium chromate and Indian yellow, 2 : 100. Afterwards the plates were developed for $1\frac{1}{2}$ minutes in the dark with normal amidol developer, and then for 2 minutes at a distance of from 18 to 48 inches from a 16 cp. incandescent bulb, screened with tartrazin paper, and examined four times, for 3 seconds each time, by transmitted light. Under these conditions, the plates treated with the various safranins, toluylen red and aurantia gave only very slight fog; whilst all others were strongly fogged.

If a weaker light was used with a bright yellow screen, the results were the same, and only the safranins, toluylen red and aurantia gave images free from fog.

Further experiments as to the desensitizing action on different regions of the spectrum, proved that phenosafranin reduced the blue sensitiveness, at about wave-length 4250, to 1/750 to 1/800, and destroyed the sensitiveness for all other parts of the spectrum. Toluylen red reduced 1/400 for the blue, 1/300 to 1/4000 for other rays. Apomorphin about 1/200 for the blue and destroyed the sensitiveness for all other rays, except for red for which it was about 1/10,000, and there was slight chemical fog. Aurantia reduced the blue to 1/750 to 1/800, maximum at 4250, and 1/400 for other rays. Picric acid, 1/200 for the blue, maximum 4850, about 1/120 for the blue at 4750 and 1/200 for other rays. Indian yellow about 1/50 in the blue-green, blue and violet, almost without action for the rest. Chrysoidin, practically uniform effect, about 1/100 throughout the spectrum. Potassium chromate also practically uniform, about 1/40.

The absorption spectra of the desensitizers prove that the action is not merely that of a light filter, and if the plates, treated with phenosafranin, were washed the sensitiveness slowly reappeared as the dye was washed out, and was completely restored when the dye was completely removed. This applied to all spectrum rays, therefore, it may be assumed that the emulsion forms an adsorption complex of much lower light-sensitiveness, and that this complex is gradually removed by washing.

C. Adrien[22] stated that the safranin desensitizing process was applicable to Autochrome plates, as the dye was removed in the acid permanganate bath, and the underlying screen elements were not affected. There was a small retardation of development, which could be compensated for by an increase of the exposure by one-third.

Lüppo-Cramer[23] stated that X-ray plates have their sensitiveness to light much more reduced than to the X-rays, and this was explained by the fact that light-action only occurs on the surface of the silver grains, which is protected by deposition of the dye, while the action of the X-rays takes place throughout the whole grain, the interior of which is not protected. After treatment with pheno-safranin, 1 : 20,000, measurements by E. Mauz showed a reduction of X-ray sensitiveness of 25 to 30 per cent in the neighborhood of the threshold values, but practically no reduction in the more exposed parts, while the reduction of the light-sensitiveness permitted development by a strong light. Sosna and Biedebach[24] patented the addition of red coloring matters to X-ray emulsion to reduce the sensitiveness to ordinary light.

Lüppo-Cramer[25] suggested that the desensitizing action was an oxidizing one on the latent image, which is bleached if exposed to light in the presence of certain of the dyes. Plates, which were uniformly exposed, then dyed and exposed gave reversed images, showing definite sensitive-

ness. If silver bromide transparency plates were exposed, converted into iodide and then stained, the silver iodide complex was strongly color-sensitive. E. König and Lüppo-Cramer[26] stated that other dyes, such as chrysoidin, containing several amino groups were somewhat active as desensitizers; those with only one amino group, like congo red, are quite without action. The replacement of the hydrogen of the amino group by methyl has no action on the desensitizing power.

Lüppo-Cramer[27] found that the addition of pheno-safranin to an ordinary caustic alkali hydroquinon developer, up to a strength of 1 : 20,000, produced a developer resembling metol-hydroquinon, and nearly though not quite so rapid in action. A further increase of the dye was not essential and had no effect on the development speed. Where the most rapid development is not essential, this developer was recommended on account of its cheapness, while it has the additional advantage of allowing development in bright light.

J. G. Druce[28] examined the desensitizing action of spent developers, and prepared oxidized amidol by warming 500 ccs. of ordinary amidol developer with 6 g. freshly prepared silver bromide, which had been freed from other salts, and exposed to daylight. The undecomposed silver bromide and metallic silver were filtered out. Plates immersed in the oxidized amidol at 21° C. for 10 minutes were thoroughly desensitized. It is obvious that the amidol was used in much greater strength than the safranin. Lüppo-Cramer ascribed the desensitizing property to the amino group. Paraphenylendiamin and paraminophenol, which may be regarded as homologues of amidol, yield quinon when oxidized, and this is also the oxidation product of hydroquinon. Paraminophenol when carefully oxidized yielded first quinon chloro-imide, $C_6H_4O.NH.Cl$, and this appears to be the desensitizer with oxidized rodinal, and this is not in agreement with Lüppo-Cramer's amino group theory. But till the oxidized product of amidol is accurately determined, this does not disprove the theory.

O. Mente pointed out that some orthochromatic plates were not desensitized by safranin, and Lüppo-Cramer[29] ascribed this to the use of erythrosin as the orthochromatizing dye. The same was found to occur with some non-filter plates, and bathing the plates in a 5 per cent solution of potassium carbonate was found to be the remedy, or the safranin might be made alkaline. Probably one has here the precipitation of the basic safranin by the acid erythrosin and non-filter dye.

A. and L. Lumière and A. Seyewetz[30] carried out an investigation as to the desensitizing of Autochrome plates, for which the use of any desensitizer, such as safranin, which stains the gelatin, is obviously unsuitable, as the stain would alter the color rendering. They recommended aurantia, which was found comparable with phenosafranin. Aurantia is very readily washed out, so that alteration of the relative value of the colors does not ensue. A bath of 1 : 1000 was recommended and

immersion for from 30 to 60 seconds. Picric acid was also efficient as regards the blue, but not so for the green and red, therefore, it is not so advisable as aurantia. Lüppo-Cramer[31] tested aurantia and found it useless except for slow plates, like the Autochrome; but he used the bath twenty times weaker than prescribed.

The Hoechst Farbwerke[32] introduced safranin JIV, under the name of pinasafrol, which does not stain gelatin so badly. This is tetra-methyl-safranin, as tried out by Lumière and Seyewetz. Funger[33] stated that acid green and corallin desensitized and did not stain; but this was denied by Lüppo-Cramer.[34]

To remove the persistent stain of the safranins E. König[35] suggested immersion of the negative in a nitrous acid bath:

Sodium nitrite 1 g.
Hydrochloric acid 10 ccs.
Water 1000 ccs.

And Lüppo-Cramer[36] proposed a mixture of equal parts of 2 per cent alum solution with 5 per cent hydrochloric acid. An anonymous writer[37] suggested that the stain might be removed by treatment with:

Potassium permanganate 2 g.
Hydrochloric acid 10 ccs.
Water 1000 ccs.

This bleaches the image and any brown stain might be removed by treatment with 1 per cent solution of sodium bisulfite, then after washing the negative might be redeveloped.

H. G. Cleveland[38] stated that the following method of preparing the dye bath practically eliminates all stain, what little stain that occurs being removed in the washing:

Stock solution A.
Phenosafranin 5.2 g.
Water 1000 ccs.
Stock solution B.
Formaldehyde 27.5 ccs.
Sodium sulfate, dry......................... 110 g.
Water to 1000 ccs.

For use add 1 part A to 9 parts B. This should be used as a separate bath, and the plates immersed for 1 or 2 minutes prior to development, then shortly rinsed and developed as usual. Lüppo-Cramer[39] stated that a 5 per cent solution of sodium hydrosulfite immediately decolorizes all desensitizing dyes.

Several desensitizers have been introduced commercially. R. E. Crowther[40] stated that the red backing used for all Kodak plates, except panchromatic, was a powerful desensitizer, the sensitiveness being reduced to 1/200th of its original value. The Imperial Dry Plate Co. also introduced, 1922, plates with desensitizing backing. The Goerz Photochemische Werke[41] and K. Wiebking[42] patented a similar backing. H. Schreiber[43]

proposed to treat plates before development with an alcoholic solution of phenosafranin, which on drying forms a thin film on the surface, and on contact with water this reacts with the silver salt. The same inventor[44] proposed to coat first an emulsion, the sensitiveness of which had been lowered by desensitizers, on glass or celluloid, and then on top another high speed emulsion. The combination must be exposed and the upper film developed without the lower one being affected. From the negative thus formed, a positive was to be produced in the lower coating by a second exposure, and the two films separated.

H. K. Broum[45] found that desensitizing is equally efficient with panchromatic collodion emulsion. A 1 : 2000 solution being used as a preliminary bath, or 10 per cent of the solution being added to the developer.

H. Bossel[46] described a desensitizing process in which safranin and some anilin dye, the sodium salt of naphthionic acid and beta-naphthol, are mixed with the developer. The plate was to be immersed in this under a black cloth, and after about 1 minute the development might be watched in daylight.

E. König[47] announced the discovery of a whole series of new desensitizers, one of which was introduced as pinakryptol green, which is a mixture of two substances, the composition of which has not been announced. This is used in the same way as the safranins, and while equally as efficient, washes out of the gelatin much easier. The only disadvantage seems to be that the narcosis of the film takes a little longer, therefore, more time must be allowed for the preliminary soaking. R. E. Crowther[48] dealt with these new compounds, and found that the desensitizing effect was about the same order as with the safranins. The action on the latent image was investigated and there was no destruction of the same even with prolonged action. It is only necessary to prolong development by about 25 to 30 per cent to obtain the same threshold value.

J. Desalme[49] suggested the use of sodium picramate in 1 per cent solution, but his experiments were incomplete and it has only been tested for ordinary and orthochromatic plates. C. Bonacini[50] exposed panchromatic plates desensitized with phenosafranin in the spectrograph and concluded that the action is uniform throughout the spectrum, being stronger in the regions for which the plate is color-sensitized. Placing the negatives stained with safranin before the slit of the spectrograph, showed that any screening action was limited to the green, the absorption place of the dye. The fact that the red-sensitiveness is sometimes less strongly reduced than for the other rays, suggests that a blue-green light should be better than an orange.

E. Stenger and H. Stammreich[51] dealt with this subject and considered that the desensitizing power is best measured by determining the ratio of the amounts of light necessary to give equal densities on the treated plate and on a normal one. This density is not immaterial unless the

gradation curves of two plates run parallel. It is best to measure the "Schwellenwerth," or least visible exposure, for the two plates. A very sensitive bromide paper was used in the experiments. Pronounced desensitizers are found only in the quinonoid dyes, that is especially with the triphenylmethans, azins and oxazins. All the thiazins are strong desensitizers, but generally give fog. The pure quinones are weak desensitizers. Lüppo-Cramer's view that the amino group is the active agent is discredited; mere removal of the amino groups gives greatly increased desensitization. Flavindulin, neutral red and indulin scarlet are much stronger than phenosafranin. Contrary to Lüppo-Cramer's views some oxazins, especially Nile blue, are strong desensitizers. Quinon-imines and quinondi-imines are the strongest desensitizers the less they are substituted in the nucleus and the retarding influence of substituents increases in the direction of basicity to acidity; this rule does not explain the action of the thiobenzyl dyes. Regarding the influence of the concentration of the desensitizer, it was found that if the concentration forms a geometrical progression the corresponding desensitizations form an exponential series. For constant It, using Nile blue 2B, the action increases rapidly from a certain point, to become constant again, as I is increased; t has no influence. Desensitization is independent of the wave-length of the light; only in the ultra-violet is there stronger decrease in action.

A. von Hübl[52] stated that a new preparation, pinacryptol or pinacryptol yellow, was the best desensitizer, particularly for panchromatic plates. But that in the presence of sodium sulfite it lost most of its power. It can, however, be used as a preliminary bath, 1 : 1,500, for 3 minutes and the plates transferred to a developer containing 0.25 per cent of pinacryptol green. The best developer was metol-hydroquinon with only 8 g. potassium carbonate to the liter.

The Pathé Research Laboratory[53] announced the desensitizing action of basic scarlet N (ecarlate basique N) made by the Compagnie des Matières Colorantes, the composition of which was not known; but which appears to belong to the azin dyes, like safranin. It has the advantage of not staining gelatin or the skin, and is completely washed out in the subsequent treatments. Neither does it give rise to chemical fog. The best strength is 1 : 10,000 as a preliminary bath, or it may be added to the developer.

It was pointed out by the same investigators that there are several known desensitizers, which unfortunately have the disadvantage of causing strong fog, thus precluding their general use. It has been found, however, that other dyes possess the remarkable property of preventing this fog. This protective action is not possessed by all dyes, but seems to be particular to certain couples, and the optimum dose of the protector varies with the various dyes. The fogging dyes are methylen blue, malachite green, Victoria blue, indulin, flavanilin, the rhodulins and Janus

yellow. Acridin yellow, auramin, auracin, benzoflavin, etc., are the protective dyes. An excellent desensitizer is:

Rhodulin violet 0.06 g.
Acridin yellow 0.01 g.
Water 1000 ccs.

Methylen blue 1 : 1,000,000 gives intense fog, but if mixed with acridin yellow works perfectly clean; a suitable strength being:

Methylen blue 0.005 g.
Acridin yellow 0.02 g.
Water 1000 ccs.

The above concentrations must be strictly adhered to, as variations cause fog.

1. Phot. Coul. 1908, **2**, 1; Brit. J. Phot. 1908, **55**, Col. Phot. Supp. **2**, 9; Bull. Soc. franç. Phot. 1908, **50**, 36; Jahrbuch, 1910, **24**, 376. Also recommended by G. Balagny, Bull. Soc. franç. Phot. 1908, **50**, 55; Anon, Phot. Chron. 1916, **23**, 228; abst. C. A. 1917, **11**, 1093, stated that the fact that panchromatic plates can be developed by red light in an acid amidol developer is attributable to a considerable general reduction of sensitiveness, and not to destruction of the sensitizer.
2. Bull. Soc. franç. Phot. 1908, **54**, 258; Photo-Rev. 1908, **20**, 104; Brit. J. Phot. 1908, **55**, Col. Phot. Supp. **2**, 53; Brit. J. Almanac, 1909, 652; Phot. Coul. 1908, **3**, 191.
3. Brit. J. Phot. 1908, **55**, Col. Phot. Supp. **2**, 80; Photography, 1909, 272.
4. D.R.P. 209,937, 1908; Phot. Ind. 1909, 845; Chem. Ztg. Rep. 1909, 348; Brit. J. Phot. 1909, **56**, 546; Jahrbuch, 1910, **24**, 375.
 H. W. Vogel had pointed out that cyanin was destroyed by an acid ferrous oxalate developer.
5. Phot. Chron. 1908, **15**, 383; Das Atel. 1910, **12**, 1; Brit. J. Phot. 1908, **55**, 617; 1910, **57**, 61; Brit. J. Almanac, 1909, 572; Photo-Rev. 1908, **20**, 165; Phot. Coul. 1908, **3**, 256. Cf. E. Stenger and F. Leiber, Das Atel, 1909, **11**, 19; Jahrbuch, 1910, **24**, 376.
6. Phot. Korr. 1902, **48**, 214.
7. Phot. Korr. 1903, **49**, 359; Beiträge, III, 162. Cf. E. J. Wall, Phot. J. 1907, **47**, 283.
 F. Dillaye, Bull. Soc. franç. Phot. 1912, **54**, 68; abst. C. A. 1912, **6**, 1102 suggested immersing Autochrome plates for 2 minutes in a 1 per cent solution of potassium bromide plus 2 per cent acid sulfite lye, then rinsing and developing as usual.
8. Jahrbuch, 1897, **11**, 379.
9. Phot. J. 1907, **47**, 284.
10. E.P. 28,598, 1911; Brit. J. Phot. 1913, **60**, 30; Jahrbuch, 1913, **27**, 290; abst. C. A. 1913, **7**, 1847.
11. U.S.P. 1,356,236, 1920; abst. C. A. 1921, **15**, 35; Phot. Absts. 1921, **1**, 74. The use of potassium ferrocyanide for this purpose was described by R. Hunt in 1844.
12. U.S.P. 1,361,352, 1920; abst. C. A. 1921, **15**, 477.
13. Brit. J. Phot. 1913, **60**, 224; abst. ibid. 1916, **63**, 506.
14. E.P. 11,420, 1898; Brit. J. Phot. 1898, **45**, 599; 1899, **46**, 347; abst. J. S. C. I. 1898, **17**, 632; 1899, **18**, 548, 608; D.R.P. 111,463; Silbermann, **1**, 48; Chem. Zentr. 1900, **71**, II, 605; Chem. Ztg. 1900, **24**, 445; Jahr. Chem. 1900, **53**, 60; Mon. Sci. 1901, 101; Compt. rend. 1898, **126**, 1500; Bull. Soc. franç. Phot. 1898, **40**, 429, 521; Wien. Mitt. 1898; Jahrbuch, 1899, **13**, 320.
15. Jahrbuch, 1899, **13**, 320.
16. Phot. Korr. 1901, **47**, 422; 1902, **48**, 9; Phot. Almanach, 1902, 76; Handbuch, 1905, **3**, 455; Jahrbuch, 1902, **16**, 440.
 G. Mareschal, Phot. Rund. 1910, **46**, 27, pointed out that the lowering of the sensitiveness was not caused by the chemicals of the developer, since an unexposed Autochrome plate, which had been by accident treated for 1½ minutes with a metolhydroquinon developer, and then washed and dried had retained its original sensitiveness.
17. Bull. Soc. franç. Phot. 1907, **49**, 264; Phot. Rund. 1907, **43**, 220; Jahrbuch, 1908, **22**, 494; Brit. J. Phot. 1907, **54**, 632.

18. Phot. Ind. 1920, 378, 505, 664; abst. J. S. C. I. 1921, **40**, 28A; Brit. J. Phot. 1921, **68**, 232; C. A. 1921, **15**, 2797; Phot. Korr. 1920, **57**, 274; Zeits. ang. Chem. 1922, **35**, 69.

19. Der Phot. 1920, 379; abst. J. S. C. I. 1921, **40**, 99a; Phot. J. Amer. 1921, **58**, 84; Phot. Ind. 1925, 56.

20. Brit. J. Phot. 1921, **68**, 7; Phot. J. Amer. 1921, **58**, 249; Phot. J. 1921, **61**, 146.

21. Brit. J. Phot. 1921, **68**, 370; abst. J. S. C. I., 1921, **40**, 529A.

J. Pike, Brit. J. Phot. 1893, **40**, 361, pointed out that picric acid and ammonium picrate desensitized plates; but made no use of the fact.

22. Bull. Soc. franç. Phot. 1921, **63**, 110; abst. J. S. C. I. 1921, **40**, 289A.

23. Phot. Korr. 1921, **58**, 40; abst. J. S. C. I. 1921, **40**, 324A; Phot. Ind. 1921, 259; C. A. 1921, **15**, 2798; Sci. Tech. Ind. Phot. 1921, **1**, 29.

24. F.P. 512,546, 1915; abst. Sci. Tech. Ind. Phot. 1921, **1**, 30.

25. Phot. Ind. 1921, 259; abst. J. S. C. I. 1921, **40**, 325A.

26. Phot. Rund. 1921, **57**, 37; abst. J. S. C. I. 1921, **40**, 325A.

27. Der Phot. 1921, **31**, 65; abst. J. S. C. I. 1921, **40**, 280A. Cf. Brit. J. Phot. 1921, **68**, 261.

28. Brit. J. Phot. 1922, **69**, 296.

29. Phot. Ind. 1921, 912; abst. Amer. Phot. 1922, **16**, 256; Sci. Tech. Ind. Phot. 1922, **2**, 1.

30. Brit. J. Phot. 1921, **68**, 351,370, Col. Phot. Supp. **14**, 29; Photo-Era, 1921, **27**, 297; abst. Camera Craft, 1921, **28**, 307.

Cf. On desensitizing Autochrome plates, 'Anon' Brit. J. Phot. 1921, **68**, 418. J. Carteron, ibid. 1922, **69**, Col. Phot. Supp. **16**, 23. E. Muller ibid. 44. H. Bäckström ibid. 2.

31. Phot. Korr. 1921, **57**, 257; Amer. Phot. 1922, **16**, 256.

32. O. Mente, D. Camera Almanach, 1922, 99.

33. Phot. Chron. 1921, **28**, 245; Amer. Phot. 1922, **16**, 256.

34. Der Phot. 1921, **31**, 303; Sci. Tech. Ind. Phot. 1921, **1**, 101; Amer. Phot. 1922, **16**, 256.

35. Phot. Rund. 1921, **57**, 40; Amer. Phot. 1921, **15**, 658; Brit. J. Phot. 1921, **68**, 3; Brit. J. Almanac, 1922, 370.

36. "Negativ-Entwicklung bei hellem Lichte," Leipzig, 1921; 2nd edit. 1922.

37. Il Prog. Foto. 1921, **28**, 96; Amer. Phot. 1922, **16**, 120.

38. Amer. Phot. 1922, **16**, 756.

39. Phot. Ind. 1922, 774; Amer. Phot. 1922, **16**, 756.

40. Brit. J. Phot. 1921, **68**, 231; abst. Brit. J. Almanac, 1922, 369; Sci. Tech. Ind. Phot. 1921, **1**, 46.

41. D.R.G.M. 820,565; 820,566.

42. D.R.P. 354,432, 1921; abst. J. S. C. I. 1922, **41**, 730A; F.P. 175,296, 1921; Brit. J. Phot. 1923, **70**, 356.

43. D.R.P. 350,658, 1921.

A. Gerling, Bull. Soc. franç. Phot. 1923, **65**, 105, stated that the stain of phenosafranin could be readily removed by adding to the washing water 2 or 3 drops of perhydrol, hydrogen peroxide conc. 100 vol. The stain disappears in from 20 to 30 seconds.

44. D.R.P. 350,659, 1921.

45. Phot. Korr. 1921, **58**, 128.

46. Phot. Ind. 1922, 72; Amer. Phot. 1922, **16**, 465.

47. Phot. Rund. 1922, **59**, 89; Amer. Phot. 1922, **16**, 598. Cf. D.R.P. 396,402. J. S. C. I. 1924, **43**, B902. B. Homolka, Phot. Ind. 1925, 347.

48. Brit. J. Phot. 1922, **69**, 351.

49. Ibid. 1921, **68**, 700.

50. Il Prog. Foto, 1921, **28**, 210; abst. Sci. Tech. Ind. Phot. 1921, **1**, 91; Amer. Phot. 1922, **16**, 528.

For summary of desensitizing processes see E. J. Wall, Amer. Phot. 1921, **15**, 651.

51. Zeits. wiss. Phot. 1924, **23**, 11; abst. J. S. C. I. 1924, **43**, B655; Amer. Phot. 1924, **18**, 755.

52. Phot. Rund. 1924, **61**, 143; 1925, **62**, 71, 114; abst. Amer. Phot. 1925, **19**, 112, 165.

C. H. Nolte, E.P. 206,820, 1923, proposed to avoid difficulties arising from the fact that colored, shiny surfaces are not faithfully reproduced, or not reproduced in tone with other deep colors, by using a film comprising a mixture of two or more

emulsions of differently matured grains, or by treating a coated surface with a desensitizing bath of an alcoholic or alcoholic-aqueous nature, so that more sensitive zones or points alternate with less sensitive ones. C. L. Case, E.P. 211,643, patented the application of a desensitizer, mixed with glycerol, to roll films in the camera, immediately after exposure; abst. Amer. Phot. 1925, 19, 52; Sci. Ind. Phot. 1925, 5, 27.

53. Bull. Soc. franç. Phot. 1925, 66, 239; Rev. franç. Phot. 1924, 5, 286; 1925, 6, 33; Brit. J. Phot. 1924, 71, 699; 1925, 72, 107; abst. Sci. Ind. Phot. 1924, 4, 190; Amer. Phot. 1925, 19, 165; Phot. Chron. 1924, 31, 431. Cf. E. Marriage, Brit. J. Phot. 1924, 71, 575. E. W. Reid, ibid. 1925, 72, 10. F. E. Ross, ibid. 5, 19; abst. Amer. Phot. 1925, 19, 366. Von Hübl, Phot. Ind. 1925, 14; Amer. Phot. 1925, 19, 112; C. A. 1925, 19, 217. J. A. Hall, Brit. J. Phot. 1925, 72, 132. R. Namias, Photo-Rev. 1924, 36, 153, 163. J. G. F. Druce, Sci. News, 1924, 1, 2. E. W. Reid, Brit. J. Phot. 1925, 72, Col. Phot. Supp. 19, 10; abst. C. A. 1925, 19, 786. Lüppo-Cramer, Phot. Ind. 1925, 187; abst. Amer. Phot. 1925, 19, 165. Pathé, Bull. Soc. franç. Phot. 1925, 67, 28; abst. J. S. C. I. 1925, 44, B266.

CHAPTER X

COLOR-SENSITIVE PHOTOMETRIC PAPERS. SENSITIZING DYES

M. Andresen[1] (p. 316) in a paper read before the Congress of Applied Chemistry in 1898, announced that bromide as well as printing-out papers could be color-sensitized by the addition of dyes. This may be of considerable importance, as the normal Bunsen-Roscoe silver chloride paper is only sensitive to violet and blue.

The dyes found efficient were chlorophyll for the red, rhodamin B or rose Bengal for yellow, erythrosin or eosin for green and auramin for bright blue. The method of preparation was as follows: raw photographic paper should be bathed for 5 minutes in a 6.1 per cent solution of potassium bromide and dried by hanging up in the air. Then by red light it should be floated on a 12 per cent solution of silver nitrate for 2 minutes. In this condition the sensitivity lies between F and G. The paper should then be washed, without allowing it to dry, to free it from all soluble salts and then immersed in a bath of:

Sodium nitrite	30 g.
Rhodamin B, 0.5 per cent alc. sol	40 ccs.
Water	1000 ccs.

For 5 minutes and hung up to dry. The maximum sensitivity now lies close to the D lines. The other dyes can be used in the same way, with the exception of the chlorophyll, in which case the paper should be immersed in an alcoholic solution of the same and then in the nitrite bath.

To make the chlorophyll Andresen used old deep green leaves, cut them up into small pieces, about 1 to 3 mm., and digested at room temperature for a day or two and filtered, using the solution undiluted.

With the exception of the chlorophyll paper, which shows initial action in the blue and only with long exposure the second maximum in the red, the other papers show a marked principal action in the region of the absorption of the dye, although there was always initial action a little nearer the red. For the rhodamin paper the interposition of a filter of auramin, either in liquid cell or as glass coated with collodion stained therewith, was advisable to attain the dominating action in the yellow. The sensitivity of the normal color-sensitized paper was considerable, for instance, with rhodamin it was about twenty-five times that of the undyed paper.

A. Wingen[2] used this method in his determination of the necessary illumination in schools and patented a photometer with yellow filters.[3] Ruzicka used Andresen's paper but coated the auramin stained collodion

direct on the paper, using it for the same purpose as Wingen. Eder[4] tested Andresen's papers in the spectrograph and found that with rhodamin the maximum sensitivity was at D, from 5870 to 5890. With longer exposure it extended from 5710 to 6080, with faint action to 6210 on the orange side, and 5150 in the blue-green. There was a minimum at 4770 to 4620, but in the bright blue from 4400 to 4500 there appeared the characteristic sensitiveness of the silver bromide, which, however, was weaker than the rhodamin maximum in the yellow. With still longer exposure the action extended faintly to 6250 and 6800 in the red. Experiments with silver chloride papers, prepared in the same way, proved that it was much less sensitive and not so satisfactory in practice and the yellow sensitivity was not so great. By the use of Andresen's paper a much better estimation of the brightness of the visual rays can be obtained than with ordinary photometer papers.

K. Kieser[5] also dealt with the sensitizing of development papers, and found that erythrosin was the best sensitizer for bromide, and eosin for chloride or gaslight paper. In a dilution of 1 : 20,000 with the addition of 0.5 per cent of ammonia, bathing time 2½ minutes, the sensitivity was increased for daylight and arc light three times, with incandescent gas twenty-five, for incandescent electric and oil twenty-nine times. Tested in the spectrograph, the yellow appeared in 1 minute and the first traces of the blue in 8 minutes, and after 30 minutes exposure the density in the yellow was about 8 times that in the blue. The curve of sensitiveness fell sharply towards the red, which is advantageous as it enables a bright red light to be used.

Erythrosin acts less strongly than eosin; homocol, however, more strongly and the sensitivity with the latter was increased for oil lamps fifty times. Methyl- and ethyl-eosin do not sensitize markedly; rhodamin B, sodium fluorescinate and quinolin red do not act so strongly as eosin, and the latter, like acridin orange, stains the paper very much. The pure silver salts of the above three dyes acted better than ammoniacal solutions on paper carefully freed from soluble halides. If increasing quantities of potassium chloride were added to the baths, the sensitizing action was prevented; on the other hand, paper already sensitized appeared to withstand the action of the chloride. Eosin and erythrosin sensitize as well in very dilute baths, given long enough, as in strong ones, and the same action was obtained with a concentration of 1 : 500,000 in 30 minutes as in 2½ minutes with 1 : 20,000; even with a concentration of 1 : 10,000,000 the action was obtained in 3 hours. The same tones were attained on the sensitized as on the plain paper, and the sensitivity is only attained when the paper is dry, and it is lost as soon as it is placed in the developer, so that there is little danger from fog.

Eder[6] also dealt further with the preparation of these photometric papers and suggested bathing them in a 5 per cent solution of nitrite or 1

per cent solution of resorcin, plus 5 to 10 per cent of glycerol, for 3 minutes, then drying spontaneously. Papers thus prepared were constant in use. He also suggested sensitizing them with the leuco, or colorless bases of some dyes. A 1 per cent solution of leuco brilliant green (Hoechst) was prepared by dissolving it in ether, mixing with twice its volume of 2 per cent collodion. This was coated on glossy gelatinized paper, litho transfer, and dried in the dark. This was about eight times more sensitive behind a red filter than behind a blue and thirty times more sensitive behind a green filter. For a green-sensitive paper, leuco-rhodamin should be used, and preferably that from rhodamin 6G, which is mainly sensitive to green. Rhodamin B may be used, but is sensitive to green and yellow and the beginning of the orange. The leuco-rhodamin can be prepared by dissolving 1 g. of the dye in 50 ccs. water, shaking well and adding 7 to 10 g. zinc dust and 2 ccs. glacial acetic acid. Then adding 75 ccs. ether, shaking well and allowing to stand till the ether is colorless. Should the red tint not disappear a little more zinc and acid should be added. When colorless the ether should be decanted and added to an equal volume of 2 per cent collodion and coated on paper. Unfortunately neither of these papers will keep. The dye being regenerated, even in the dark, within about 16 hours.

Sensitizing Dyes.—The following list includes all, or nearly all, dyes that have been tested at various times, and which have not been already dealt with.[7]

The abbreviations used are: Max.=maximum. Min.=minimum. (A)=Aktien-Gesellschaft f. Anilinfabrikation. (Bad)=Badische Anilin u. Sodafabrik. (Bas)=Gesellschaft f. Chemische Industrie, Basel. (By)=Bayer. (Ber.)=Berlin Aktien-Gesellschaft f. Anilinfabrikation. (Cas)=Casella. (Cl)=Clayton. (D)=Dehl. (G)=Geigy. (H)=Holliday. (K)=Kalle. (L)=Leonhardt. (M)=Meister, Lucius & Brüning. (Mo)=Monnet. (Mühl)=Mühlheim. (O)=Oehler. (Re)=Remy. (S)=Sandoz. (Sch)=Schuchardt. (W)=Walter.

Dye	Sensitizing Action	Remarks
Acid chrome black RH (By)	D¼-¾C, C-C½B	Medium
Acid green	D-B	
Acid orange (G)	E-D	
Acid orange (K)	E-C	Weak
Acid violet	D-C	
Acid violet 5B (By)	D-C	
Acid violet R (By)	D-C	
Acid violet 4BG (By)	D-C	
Acid violet 2R, 3R (By)	E½D-D¾C	Strong
Acid violet PW (Bad)	D-C	Weak
Acridin orange	F-D	Strong
Acridin yellow (L)	H-D½E	Strong
Akme brown (L)	E⅔D-B	Foggy
Alizarin astrol B (By)	D⅓C-a	
Alizarin black (Bad)	D-C	Weak
Alizarin blue S		See p. 253

Dye	Sensitizing Action	Remarks
Alizarin acid blue black 3B (M).		Even band with long exposure to B
Alizarin cyanin green E (By)....	D⅔-B	
Alizarin blue black 3B (By).....	D-B	Fairly strong, Max. B
Alizarin emeraldol G (By)......	a-A	Strong, with long exposure, narrow, Max. D⅓C
Alizarin granat R (M).........	D½E-C	Weak
Alizarin green S (By)..........	D¼C-¾A	Fresh sol. must be used with NH₃
Alizarin irisol (By)............	D½C-B	Weak
Alizarin pure blue B (By).......	D¾C-B	Fairly strong
Alizarin sapirol B (By)........		Increases blue. With long exposure, E-A
Alizarin yellow GGW & N (M)..		Increases blue
Alizarin viridin (By)...........	D½C-B	Strong. Max. C
Alkali dark brown (D)	D-C	
Alkali dark brown V (D).......	E-C	Max. D½E
Alkali fast green B (By)........	E-E	Narrow band at C
Alkali fast green 3B (By).......	E-B	Narrow band at A
Alkali granat (D)..............	E-B	Max. D
Alkali red brown GR (D)......	E-C	Max. D
Alkali violet extra (Bad).......	D¼C-C	Strong
Amidobenzol-azo-benzol HCl.....	F-D	Violet and UV reduced
Amidoazol G, 2G & 4G (H).....	F-A	Weak
Amidoazol 6G (H).............	F-A	Strong. Max. E⅗D
Amidonaphthol red G, 2B, 6B (M)	E⅔E-D½C	Strong
Anilin red.....................	E-D½C	Max. D⅔E
Anisol red....................	E-D	Weak
Anthracen blue SWX (Bad).....	E-B	Weak
Anthracen blue WGG (Bad).....	E⅓D-C	Weak
Anthraquinon black (Bad).......	F-B	Weak
Arnika (G)....................	C-B	Weak blue action
Astazin red B (Bad)...........	D-C	Medium
Auracin G (By)................	F-D½C	Strong blue-green sensitizer. Can be used with eosin
Auramin		See p. 276
Aureosin		See Fluorescein
Auroflavin KR (M)............	D-E	With long exposure C-D. Strong green sensitizer. Max. E
Azalin		See p. 275
Azarin S (M)..................	D½E-C	Weak
Azindon blue..................		Weak red sensitizer
Azocarmin (K)................	D-a	Good results with eosin
Azo acid violet BAL (By).......	D¾C-C	Weak
Azo blue (M)..................	F½E-D	Weak
Azo eosin (By)................	F-a	Weak
Azo green (Bad)...............		Weak general
Azo grenadin (By).............	E¼D-D¾C	Weak
Azo mauve (O)................	E-A	Max. C-B
Azos red 6B (M)..............	D¾C-C	To A with long exposure
Benzal green..................		Weak. Max. C
Benzoflavin II (O).............	(G-D)	Max. E-F
Benzo red SG (Bad)...........	E¼D-B	Strong. Max D½C
Benzo-nitro dark brown (By)....	D½C-E¼D	Strong
Benzo-nitro brown (By)........	E-C½D	Max. D½E
Benzo-olive (By)..............	D½C-C	Weak
Benzo brown RC (By).........	D-B	Weak
Benzo Chrome brown 5G (By)..	E¾D-C	Weak
Benzo dark green B (By).......	C-B	Weak
Benzo purpurin 4B (S)........	E-C	Weak
Benzyl rosanilin...............	E-C	Max. D½C
Biebrich Indigo B (K).........	E½D-C	
Biebrich scarlet	E-D	Weak

Dye	Sensitizing Action	Remarks
Brilliant geranin B (By)........	F-a	Weak. Shifts blue. Max. to F
Bordeaux extra (S).............	E-C	Acts better with NH₃
Brilliant green	D-C	
Brilliant pure blue G, 5G (By)...	D¾C-C	Weak
Brilliant rhodulin violet (By)....	H-a	Strong but spotty
Brilliant wool blue (By).........	D⅔C-B	Weak
Brilliant yellow		Weak sensitizer for UV
Blue Coupier...................	E-C	Weak. Max. D½E, D½C
Canary yellow (H)..............	H-E½D.D-C	Strong
Carbid black (Bas).............	E-A	E-B strong. Max. C-B
Cashmir green B (By)...........	D-C	Weak
Ceresotin yellow G & R (By)....	F-b	Increases blue
Chicago blue B (Bad)...........	D½E-a	Weak
Chicago brown G (By)..........	D½E-a	Weak
Chicago orange (G)............	D½E-a	Weak. Increases blue
Chloramin yellow G & M (By)..	F-E	Weak
Chlorophyll		See p. 224
Chromanil brown 2G (a)........	E¼D-D	Strong
Chromotrope blue A (M).......	D½E-C	Weak
Chrome black F & B (M).......	D⅕E-C	Faint Max. d⅓C
Chrysanilin (Sch)..............	E-D	See p. 246
Chrysolin		See fluorescein
Coerulin S.....................	A	
Columbia black (A)............	C½D-A	Strong
Columbia blue G (A)...........	D¼C-B	Strong
Columbia brown R (A).........	C¾D-B	Weak
Columbia fast scarlet 4B (A)....	E¼D-D½C	Weak
Columbia green (A)............	D-A	Strong. Max. B Increases blue
Congo (S)	D½E-C	Strong
Congo orange G & R (By)......	D¼E-D½C	Weak
Congo red	E-D	
Congo rubin (Ber).............	E⅓D-C	
Cotton black B (Cas)	D¼C-B	Max. D⅔C
Cotton black B (Bad)	D-a	Max. B½C
Cotton scarlet extra (Bad)......		Weak. Max. C
Cotton yellow II (H)...........	H-E½D	Strong
Cotton yellow 5G (Bad)........		Increases blue
Coupier's toluol red............	E-D	Max. E⅔D. Violet and UV reduced
Cressyl blue 2BS (1)............		Strong. Max. C½B
Cressyl violet BBA (Muhl)......	D¾C-C	Weak
Crocein 3BX (K)...............	E-C	Weak
Crocein orange (K).............	E-C	Weak
Crocein scarlet (G).............	E-D	
Crystal violet P (By)...........	D½E-B	Strong
Cyanin		See p. 245
Cyanol (Cas)...................	E⅔D-C½B	
Cyanosin		See fluorescein
Cyclamen	E-D½C	
Dahlia	E	Green generally
Delfin blue B (By).............	F-A	Increases blue; shifts Max. to F¾b
Diamin deep black (Cas)........	E-C½B	Strong
Diamin blue Cr (Cas)..........	E½D-C½B	Strong
Diamin pure blue FF (Cas).....	E¼D-C¾B	Weak
Diamin blue FR (Cas)..........	E¼D-D⅘C	Strong
Diamineral blue (Cas)..........	E-C½D	Strong
Diamond black FB (By)........	D¼C-a	Strong. Max. C½B
Diamond black FR (Bad).......	D-A	Max. B½C
Diamond blue black (By).......	D¾C-C	Long exposure to A. Max. C½B
Diamond deep black SS (Cas)...	D¼C-a	Strong
Diamond green (By)............		Long exposure C-A

Dye	Sensitizing Action	Remarks
Diamond yellow G (By)........		Increases blue. Faint orange action
Dianil black G (M).............	E¼D-C¼D	Max. D
Dianil black N (M).............	E-B	Max. D¼C. Long exposure A to Z. One of the strongest red sensitizers
Dianil black R (M).............	E-C	Max. D¼C
Dianil blue B (M).............	E⅔D-D⅓C	Weak
Dianil blue 2R (M).............	D¼C¾D¾C	Weak
Dianil blue R (M).............	D¼C-D¾C	Weaker
Dianil fast scarlet 8BJ (M).....	D¼C-D¾C	
Dianil granat B & G (M)......	F-B	Weak
Diazo-amidobenzol (S)..........	E-D½C	HC1 compound
Diazo black (By)	E¾D-B	
Diazo black 3B (Bad)..........	E¼D-B	Strong
Diazo brilliant scarlet (By).....	C-D	Only with long exposure
Diazo granat B & G (M)........	F-B	Weak
Diazoresorufin	E-D¾C	Max. 5600-6140
Diphenyl blue black (G).........	D¼C-B½C	Strong
Diphenyl blue (G)...............		Max. D. Increases blue
Diphenyl brown (G).............	D⅕C-D⅘C	Increases blue
Diphenyl fast black (G).........	D-a	Strong. Max. C
Diphenyl green (G).............	F-C	Max. C½B. Increases blue
Diphenyl Indigo blue (G).......	E⅔D-B	Max. C. Increases blue
Diphenyl orange (G)............	D¼C-B	Increases blue
Direct black V (S)..............	F-B	Strong
Direct blue black 2B (Bad).....	E½D-a	Weak
Direct bronze brown (By).......	D-B	Max. D½C. Inclined to fog
Direct indon blue R (S).........	D-B	Strong. Max. C½B
Domingo chrome black M (L)...	D½C-a	Max. C½B
Double ponceau R, 2R & 3R (By)	E½D-D¼C	Very weak
Eboli blue R....................	F-B	Weak
Eboli green F (L)..............	E⅘D-a	Weak continuous. Lengthens spectrum
Eosin, yellowish	E-D	Strong. Known as Eosin J, pyronin J, yellowish erythrosin
Eosin, bromo	E-D	
Eosin, B	E-D	
Erie blue B (A)................	C-a	Weak
Eriocyanin (G).................	D¾C-B	
Erioglaucin (G)................	B⅓C-a	
Ethyl eosin		See fluorescein
Ethyl green	E¾D-B	Weak. Max. C
Fast acid green BB (M)........	D¼C-B	Narrow band with long exposure
Fast blue R, 3R (M)...........	E-D	
Fast brown 3B (A).............	E-D	
Fast chrome black (H).........	D½C-a	Max. B with NH₃
Fast chrome green	C-a	With NH₃
Fast dark blue R (M).........	D¼C-C	Strong
Fast light yellow 3B (By).......	E-C	Max. D½C. Weak
Fast red	E-D	Weak
Fast wool blue R (A)...........	C	Weak
Fluorescein	E-D	Max. E½D, Min. E-F. All the eosin and fluorescein dyes sensitize for practically the same region. The bluer the dye the more marked the gap in the blue-green.
Fluorescein Benzyl		
Fluorescein dinitro		
Fluorescein tetra-nitro		
Fluorescein nitrobenzyl		
Fluorescein monobromo		
Fluorescein monochloro		
Fluorescein octo-iodo		
Fluorescein bromo-naphtho		

Dye	Sensitizing Action	Remarks
Formyl violet S, 4B (C).........	E¼D-C	Strong. Same as violet 6B (G) and acid violet 4B (By). Highly recommended by Valenta
Fuchsin G (W).................	E-C	
Gallein		General weak
Gentian violet	E½D-C	Weak
Gentian violet BR..............	E½D-C	Weak
Geranin BB, G (By)............	F-a	Act strongly in blue
Glycin red (Kin)................		See p. 246
Glycin corinth (Kin)...........	E-B½C	Strong
Grenadin (Bad).................	E-D	Strong
Guinea green B (A)............	C⅓D	Narrow strong band with long exposure
Guinea violet 4B (A)...........	E¼D-C	Causes red fog
Half wool black (Cas)	D-C	Max. D½C
Half wool black (By)	D-B	Weak
Heliathin (G)...................	F¼E-D¾C	Weak
Helio fast blue BL (By)........		Long exposure two bands weak Max. D⅓C strong Max. C¼B
Helio fast blue SL (By)........		Acts better than BL
Helio fast violet AL (By).......	D-C	Weak. Max. D⅓C
Helio purpurin B (By)..........	D-E	
Hofman's violet................	E½D-C	Weak
Hydrolein	C-C¾D	
Immedial blue C (C)...........	H-A	Inclined to fog
Immedial brown (C)............	H-A	
Immedial brown B, V (C).......	E-A	
Indon blue 2B, 2R (By)........	D-B	Max. C
Indulin and BWS (G)..........	E-A	Weak
Ingrain black B (H)...........	D-B	Max. D⅝C
Intensive blue (By).............	D¼C-B	Max. D. Shifts blue Max. to F
Iodine green....................	E-C	Weak
Iris blue (Bad).................	D⅔C-D	Strong
Isodiphenyl black R (G)........		Max. C, increases blue
Jasmin (G).....................	E-D¾C	Max. E½D
Katigen Indigo (By)............	F-A	Weak. Foggy
Kreosotin yellow G & R (By)...	F-b	Strong
Kryogen blue (Bad)............	E⅓D-B	Weak
Kryogen brown (Bad)..........		Increases blue
Lanacyl blue BB (C)............	C-B	
Lanacyl violet (C)..............	D-B	
Leaf green (A).................	D⅘C-C½B	Narrow, strong band with long exposure
Light green SL (Bad)...........		Weak. narrow band. Max. D½C
Magdala red.....................	D	Weak. Known also as naphthalin red
Malachite green.................	E-C	Weak. See p. 255
Mandarin G extra and RL.......	D-a	
Melogen blue BH (S)..........	D-B	Strong. Max. D⅘C
Methyl eosin		See fluorescein. Known also as methylerythrin
Methyl green	F½E-D	Weak
Methyl violet	F½E-D	Weak
Methyl violet (Bad)	D-C	Strong
Methyl violet 6B	D-C	Strong
Mikado brown 2B and M (L)...		Weak, continuous

Dye	Sensitizing Action	Remarks
Mikado orange G (By)	D¼E-D½C	Increases blue
Mikado orange GO and RO (L)		Increases blue
Mikado yellow (By)	D¼E-D½C	Increases blue
Naphthol fluorescein (By)	E-C	Max. D
Naphthol blue (S)	E-a	
Naphthol blue	E-A	Max. C
Naphthol red (S)	E-D	
Naphthyl blue (K)	D-a	
Naphthyl blue 2B (Bad)	E-D	Weak
Naphthyl violet (K)	D-C½B	Weak
Naphthylamin black 4B (C)	D½C-a	Weak
Naphthylamin black 4BN, 6BN (By)		Even action only with long exposure to beyond C
Naphthylamin black 10BN (By)		
Naphthylamin blue (K)	D-B	Strong
Naphthylamin blue B (K)	D-B	Strong
Naphthylamin blue 2B (K)	D-C	Strong
Naphthylamin blue 3R (K)	E⅓D-C	Max. D½E
Neptune green S (Bad)	E-C	Max. C
Neutral blue R, 2R (M)	D-C	Strong
Neutral violet (Gans)	F-B	Weak
New blue O (M)	D⅘C-C⅓B	Strong
New red (K)	E-D	Weak
New toluylen brown M (By)	E¼D-B	Strong
Nigrosin B (By)	E-B	Weak
Nigrosin WS (G)	E-B	Weak
Nigrosin WG (Bad)	D½C-a	
Nitrophenin yellow (CI)	h-D	Strong without NH₃. Highly recommended
Oxamin black MD, MB (R)	E½D-C	Strong
Oxamin black BR (R)	E-C	Strong. Max. E¾D, D¾C
Oxamin blue B (Bad)	D-B	Weak
Oxamin blue 3R (By)	E½D-C	Strong. Max. D⅓C
Oxamin blue MD (Re)	E½D-C	Strong. Max. D-C
Oxamin copper blue RR (Bad)		Broad band. Max. D¾C. Weak
Oxamin heliotrope B (Re)	E-D½C	Max. D¼E, C½D
Oxamin maroon (Bad)	D½E-B	Weak
Oxamin orange G (Re)	F¾b-D¾C	
Oxamin red MF (Re)	D-D¾E & C¾D	
Oxamin red B (Re)	D-C	Max. D
Oxamin scarlet B (Re)	E-C	Max. D½E, D⅘C-C
Oxamin violet GRF (Re)	D-C	Weak
Oxamin violet MD (Re)	D¼E-C	Max. D¾C-C½D
Oxamin violet GR (Re)	E-D	Strong. Max. D
Orange R (S)	E-D	Strong
Orange R (G)	E-D	
Orange TA (L)	E-C	Strong. Max. E⅘D
Orange (W)	D-C	Weak
Orseilline	E-D	Strong
Palatin black 4B	D-A	Max. a-B
Patent dianil black EE, 7EF (M)	D-A	Strong broad band with medium exposure. E-b most active
Pegu brown G (L)	D-B	Weak. Foggy
Phenol ponceau	E-D	Weak
Phloxin		See fluorescein
Phosphin		Same as chrysanilin, see p. 246
Pluto black G, R (By)	E¼D-B	Strong
Pluto black BS, (Bad)	D-a	Strong with long exposure
Pluto black PG (By)	D-a	Strong
Polyphenol black B (G)		Max. C. Increases blue

Dye	Sensitizing Action	Remarks
Ponceau 3R (K)................	E-C	Weak
Primula	E-C	
Pyramin orange G, R (Bad)....		Increases blue
Quinolin red..................		See p. 246
Resorcin blue.................	E-D	
Rhodamin	E-D	Strong
Rhodamin 3B (Basel)..........	E¾D-C	Strong
Rhodamin ponceau G extra (M).	C-B	Weak
Rhodamin tetra-ethyl-tetra-chlor..	E-D½C	Strong
Rhodulin pure blue BB (By)....	C-B	Strong, especially with AgNO₃
Rosazurin G, B (By)...........	E-C	Max. D
Rosazurin B (By)..............	E-A	Max. D½C
Rose Bengal	F½E-D¾C	Strong
Rose des Alpes................		See p. 255
Rosanilin (Bad)...............	D¼C-C	Strong. Tetramethyl-phenyl-p-rosanilin. Dibenzyl compound acts similarly
Rosanilin acetate	E-D	Max. F-E
Rosanilin hydrochloride	E-D	Max. F-E
Rosindulin (K)................	D-D½E	
Saccherein (Mo)..............	E¾D-D¼C	Strong, this is the diethyl-m-aminophenol; sulfurein, the sulfate of same
Saccharoeosin (Mo)...........	E¾D-D¼C	
Sulferein (Mo)................	E¾D-D¼C	
Safranin	E-D	See p. 297
Safrosin		See p. 297
Sensito green.................	E-C	Max. D-C. Not to be confounded with sensitol green
Solid green	E½D-B	
Solid green J.................	E½D-B	
Swiss red (S).................	E-D	Strong
Thiazin red G (Bad)..........	D½C	Weak
Thiazin red R (Bad)..........	E-B	Strong. Max. D⅕C
Thiazoindigo blue M (Bad).....	E-a	
Thiazol yellow (By)...........	F-D¼C	Strong with NH₃. Highly recommended
Thiocarmin R (C).............	B-A	
Thionin blue GO (M)..........	C-B	Fogs
Titan scarlet B, D, G, S (H)....	F-D	Weak
Titan scarlet S (H)...........	E⅕D-B½C	Strong, very good with AgNO₃
Titan black (H)...............	D¼C-a	Max. B with NH₃
Titan yellow (H)..............	H-D	
Toledo blue V (L).............		Continuous, increases blue
Toluylen red (C).............	F-C	See p. 297
p-Triphenyl carbinol (Bad)......	D¼C-A	Works well with eosin
Trisulfon blue B, R (S).........	C½D-B	Weak
Trisulfon brown B (S).........	C½D-B	Weak
Trisulfon violet B (S).........	D-C	Weak
Typophor AR (Bad)............	C½D-B	Strong, narrow band Max. D½C
Typophor blue (Bad)..........		Weak. Max. C
Typophor violet (Bad).........	D½E-C	Weak. Max. D¾C
Violet	E-D½C	Obtained from acid fuchsin and benzyl chloride
Violet F, DP (Basel)..........	E½D-B	Max. D-B
Violet R (Basel)..............	E¾D-B	Max. C-B
Violet de Paris...............	E¾D-B	
Walk blue 2R extra (M)........		Narrow band with long exposure. Max. D⅔C
Walk brown B, G (L)..........	F-C	Increases blue
Wool black 4B, 6B (A)........	D-A	Strong

Dye	Sensitizing Action	Remarks
Wool fast blue RL (By)........	D	Weak
Wool blue N (Bad).............	C	Strong narrow band, general sensitiveness depressed
Wool print blue (Bad)..........	E⅓D-C	Max. C⅔D
Wool yellow (Bad).............		Increases blue
Xylidin ponceau................	E-D	Weak
Zambesi blue B (Ber)...........	E⅘D-A	Max. A
Zambesi brown 2G (A).........	E⅓D-A	Strong

The following dyes are either not sensitizers or sensitize so faintly as to be of no practical value for gelatin plates.

Acid black
Acid black 4B1, LD
Algol blue B
Algol green B
Aloe extract
Aloe purple
Alizarin black SNP, acid
Alizarin blue SN, acid
Alizarin red G, acid
Alizarin yellow RC, acid
Alizarin yellow 5G, KR
Alizarincyanin black
Alizarin-rubinol R
Alkali blue
Amidoazol Gambier
Amidoazol cachou
Amidoazol green B
Amidoazol grey B
Anthracen green
Anthracen red G
Astazin red G extra
Azindon blue G, R
Azo blue
Azo acid blue 2B
Azo acid red B

Benzo brown
Benzo fast yellow
Benzo brown D, 3G
Benzo fast blue BN
Benzo fast red L
Benzo fast scarlet
Benzol dark green GG
Berlin blue, soluble
Brasilin
Brilliant carmin L
Brilliant fast blue B
Brilliant yellow
Brune pure

Capri blue
Carbon black
Carbon black II
Carbon black GAT
Carmin
Carminogen
Cashmir blue FG
Cashmir black TN
Chlornaphthalin acid
Chlorophenin OR

Chrome blue B, acid
Chrome yellow D, R
Chromoglaucin BMG
Chromotrope 3B, 6B
Chromotrope DW
Chrysoidin
Chrysophanic acid
Coelestin blue
Cressyl violet
Crocein AZ
Curcephenin yellow

Delphin blue
Diamidobenzol
Diamin blue
Diamin steel blue
Diamin green
Diamin orange
Diamin rose
Diamin yellow
Diaminogen blue
Diamond blue-black R
Diamond falvin G
Diamond yellow
Dianil chrome brown G
Dianil deep black BT, Conc. T
Dianil dark green B
Dianil fast scarlet BJ
Diazo brilliant orange
Dimethyl orange
Disulfin blue

Eclipse black
Erica 2B
Ethyl blue RS, BS new
Ethyl blue BF
Ethylen blue
Ethylen blue, extra -p-

Fast chrome blue
Fast acid violet, RGE, RDE, ED
Fast azo granat, base
Fast brown G
Fast light orange
Fluorescein, dinitro
Fluorescein, tetranitro
Firn blue
Fustic extract

Gallamin blue

Hæmatoxylin
Hydrol blue

Indanthren S
Indophenol
Indulin reddish

Janus blue
Janus brown
Janus green

Katigen brown black N
Katigen violet B

Lack Bordeaux B
Lanafuchsin SB
Lanaglaucin N, paste
Lauth's violet
Leather yellow base 3BO, OB

Martius yellow
Melanogen blue BG
Metanil red 3B
Methylindon blue B
Muscarin green

Naphthindon blue, 2B
Naphthol green
Naphthylamin black 4B, 4BK
Nerol
Neutral violet
Night blue
Nigrosin C, G, M
Nile blue
m-Nitro-anilin
o-Nitro-anilin
p-Nitro-anilin
Nitro-benzyl fluorescein
Nitrophenin
o-Nitrophenol
Nitroso-dimethylanilin
Nyanza black

Orange RO
Oxamin blue GN

Palatin red A
Palatin scarlet, A, Sr, 4R
Para blue extra
Patent blue
Phenanthroquinon
Phenol black
Phenyl blue black N
Philochromin B, G

Phosphin G, new
Picraminic acid
Pigment yellow fast G
Pluto black B
Pluto brown NB, GG, R
Poirrier's blue
Pt. blue

Quercitrin
Quinin sulfate
Quinolin yellow

Rhodulin blue GG
Rhodulin heliotrope
Rosaflavin
Rosanilin, mono-phenyl
Rosanilin, penta-methyl-p-
Rosanilin, tetra-methyl-diphenyl-p-
Rosanilin, triethyl-phenyl-p-
Rosophenin 4B

Safranin, dimethyl
Salmon red
Sulfo-acid blue
Sulfon cyanin black B
Sulfon yellow R, 5G

Thiogen black BB, BR, M
Thiogen black 4B, M conc.
Thiogen blue BD, R, RR
Thiogen brown G, GG, GR
Thiogen cyanin O, G
Thiogen dark blue B
Thiogen dark red R
Thiogen diamond black B, V
Thiogen green B, GG, GL, GLD
Thiogen heliotrope O
Thiogen katechin R
Thiogen marine blue R
Thiogen orange GG, RG, RR
Thiogen purple O, OD
Thiogen violet, B
Thiogen yellow G, GG
Tolan red
Trona red 3B
Trona violet B
Tropæolin OO
Tropæolin J
Turmeric

Victoria blue
Violet 4R, acid

Wool green

1. Phot. Korr. 1898, **35**, 504; Handbuch, 1903, **3**, 764; Jahrbuch, 1899, **13**, 147; Brit. J. Phot. 1898, **45**, 693.

Eder, Jahrbuch, 1896, **10**, 436, first suggested the use of the nitrites with silver bromide papers for photometric work. The darkening of ordinary bromide paper is very slight, and the presence of nitrites or metabisulfites, which are also frequently used, causes vigorous darkening.

2. Das Schulhaus, 1901, **3**, 1.
3. D. Phot. Ztg. 1902, 223; Jahrbuch, 1902, 16, 499; D.R.P. 109, 897, 1900.
4. Wien. klinische Wochenschr. 1902, 687; Handbuch, 1903, **3**, 767; Sitzungsber. Akad. Wiss. Wien. 1902.

5. Jahrbuch, 1910, **24**, 116. This work was founded on Kieser's dissertation, "Beiträge z. optischen Sensibilisation der Chlorsilbergelatine," Berlin, 1908; Brit. J. Phot. 1910, **57**, 493, 513.

On the application of pinaflavol to photometric papers cf. J. M. Eder, Sitzungsber. Akad. Wiss. Wien. 1922, 131, Nov.; Sci. Tech. Ind. Phot. 1923, **3**, 43.

6. Phot. Korr. 1919, **56**, 141; "Ein neues Graukeilphotometer," Halle, 1920; Sitzungsber. Akad. Wiss. Wien. 1919, **128**, Abt. IIa; Jahrbuch, 1915, **29**, 215.

7. These lists have been compiled from Eder's Handbuch, 1903, **3**, 141-198; Beiträge, III; Jahrbuch, 1887-1920.

Lüppo-Cramer, Jahrbuch, 1902, **16**, 54, tested the following yellow dyes for sensitizing powers and found no action: Mandarin G extra, Philadelphia yellow, naphthol yellow, chrysoidin, acid yellow G and OO, conc. and D extra S, resorcin yellow, ammonium picrate, martius yellow, methyl orange, auramin O and aurantia. Also the following natural coloring matters: curcuma, saffron and aesculin. No effect was obtained in the spectograph or camera, and the only ones to stain silver bromide were Philadelphia, metanil, olive, acid OO yellows, auramin and saffron. It should be pointed out that some of these dyes actually increase the sensitiveness for blue and it is only possible to gauge the same by the Hurter & Driffield method. Cf. E. Valenta, Phot. Korr. 1902, **49**, 155; 1903, **50**, 483; Beiträge, III, 155, 163, where it is shown that some of these sensitize very strongly for the blue, violet and ultra-violet.

CHAPTER XI

SUBTRACTIVE PROCESSES—I

Color prints are the chief aim of the average worker, and undoubtedly a process that would give results, measurable in facility of preparation as the ordinary black and white print, would completely solve the problem. This, however, is too much to expect at present. Various methods have been suggested and a summary is given in the following pages. They all belong naturally to the subtractive class, that is to say, the color is formed by the absorptive action of dyestuffs, etc., on white light reflected from the support.

The Carbon Process.—The first photographs in color were made by the carbon process, and du Hauron was again the pioneer[1] (p. 339), and the following passage is not only interesting historically, but also valuable in the face of certain patent claims:[2] "Je me sers de trois feuilles de mica, ou bien de trois pellicules de collodion, recouvertes toutes les trois d'une couche de gélatine bichromatée; sur la première feuille ou pellicule, cette couche de gélatine est enduite d'une matière colorante rouge; sur la seconde, d'une matière colorante jaune; sur la troisième, d'une matière colorante bleue. Les trois matières colorantes doivent être insolubles dans l'eau. J'impressione sous un cliché différente chacun de ces trois pellicules à la lumière blanche, savoir: la pellicule rouge sous le cliché obtenu par le verre de couleur verte. La pellicule jaune sous le cliché obtenu par le verre violet, et le pellicule bleu sous le cliché obtenu par le verre orange. Cette impression se fait par le verso de la pellicule, c'est à dire, par le côte non préparé." This we may translate as follows: I use three sheets of mica, or indeed three films of collodion, all three covered with a film of dichromated gelatin; on the first sheet or film, this film of gelatin is coated with a red coloring matter; on the second, a yellow coloring matter; on the third, a blue coloring matter. The three coloring matters should be insoluble in water. I print each one of the three pellicles in white light under a different negative, that is: the red film under the negative obtained through the green glass, the yellow pellicle under the negative obtained through the violet glass and the blue pellicle under the negative through the orange glass. This printing is done through the back, that is to say, through the uncoated side.

Before leaving these historical facts it would seem well to translate another passage, which is also interesting in view of certain patent claims. Du Hauron[3] said at a much later date: "Une autre chose à noter comme faisant exception aux conditions habituelle de la photographie dite au charbon, se rattache à la production du *monochrome bleu*. La couche

318

mixtionnée bleu est, en effet, beaucoup plus permeable à la lumière que les couches teintées par d'autres pigments. S'agirait-il des pigments les plus usuels, noir ou brun foncé, on peut constater que la coloration jaune temporairement communiquée à toute l'épaisseur d'une couche colloide par le bain bichromate ne s'y dépose pas en quantité assez intense pour faire toujours obstacle independement de la couleur stable incorporée dans ia mixtion, à une trop rapide et trop profonde pénétration des rayons actiniques, et, par conséquent, à une insolubilité tendant a dépasser les justes limites : l'inconvénient de ce travail exagéré de la lumière est encore plus à craindre lorsque l'insolubilisation se trouve, comme il arrive à Alger, activée par l'élévation habituelle de la température. L'idée me vint, il y a un dizaine d'années, de combattre cette cause d'insuccès en introduisant soit dans la mixtion colloide bichromatée, soit dans le bain sensibilisateur de bichromate, une substance colorante fortement antiphotogénique qui, au lieu d'être par elle même insoluble dans l'eau comme la couleur minérale du monochrome bleu, s'éliminerait complètement par les bains de dépouillement et du lavage. Je fis choix d'une couleur d'aniline soluble dans l'eau additionée d'un peu d'alcohol ; c'etait la *fuchsine jaune*, à l'état de pureté, designée egalement sous le nom *coralline jaune* et de jaune d'or d'aniline. Cette substance, et il en existe d'analogues s'acquitta à merveille du rôle que je lui confai ; elle favorisa à souhait, sous un autre rapport, la venue de mes photocopies au charbon, et particulièrement du monochrome bleu, en ce qu'elle permettait d'abaiser, même bien au-dessous des proportions indiquées par les auteurs, la dose du bichromate ; tant et si bien que nonobstant la forte chaleur de la saison ou j'experimentais, la lumière ne fouillait jamais trop protordément de celle-ci que ce qui devait être insolubilise. En presence de cette réussite, il me parut de bonne guerre, étant donnée la grande vogue dont jouissant encore, à cette epoque, les phototirages aux mixtions bichromatées, de donner une date certaine à cette trouvaille par le prise d'un brevet. Je le pris le 17 Decembre 1885 (sous le nombre 173,012), et le lassai du reste tomber, peu de temps après, dans le domaine public."

Anglicized this reads: Another thing to be noted as being an exception to the usual conditions of working photography with the carbon process, is connected with the production of the blue monochrome. The blue tissue is in fact more permeable to light than the films colored with other pigments. If the more usual pigments are in question, blacks and dark browns, it can be proved that the yellow color temporarily communicated throughout the thickness of a colloid film by the dichromate bath is not deposited in sufficiently intense quantity to always form an obstacle, independently of the stable color incorporated in the mixture, to a too rapid and too deep penetration of the actinic rays, and consequently to an insolubility tending to pass the correct limits; the inconvenience of this work exaggerated by the light, is still more to be feared as the insolubilization

takes place, when it arrives at Algers, actuated by the habitual high temperature. The idea occurred to me, about a decade ago, to combat this source of ill success by introducing, either in the dichromated colloid mixture, or in the dichromate sensitizing bath, a substance of strong non-actinic color, which, instead of being itself insoluble in water, like the mineral color of the blue monochrome, would be completely eliminated by the development and washing baths. I chose an anilin color, soluble in water with the addition of a little alcohol; it was *fuchsin yellow*, in a pure state, also known under the name of *yellow corallin* or anilin gold yellow. This substance, and analagous ones exist, marvellously discharged the role which I entrusted to it. It assisted as desired, in another respect, the advent of my prints in carbon, and particularly of the blue monochrome, in that it permitted the reduction of the strength of the dichromate, even below the proportions indicated by the makers; to such a degree and so well that notwithstanding the great heat when I experimented, the light never penetrated too deeply into the film and did not insolubilize that which should be soluble. In the face of this success, it appeared to me to be but fair, given the great vogue which printing with dichromated mixtures would still play at this time, to give a definite date to this work by taking out a patent. I took it out December 18, 1885, under No. 173,012 and it was allowed, moreover, to fall a short time after into public domain.[5]

The use of a non-actinic, light-restraining dye as here suggested by du Hauron, was later patented by F. E. Ives (see p. 334), and he claimed[6] to have been the first to thus use dyes for this particular purpose, with a colorless relief. It would seem that the application of this to various processes is of minor count, and that the main principle, that of "light-restraining" should alone be taken into consideration, when dealing with the originality or patentability of the same. A few notes on this subject have, therefore, been collated.

L. Garchey[7] in his patent for tri-color ceramics said: "I add alcohol and a small quantity of anti-photogenic colouring matter. . . . The anti-photogenic colouring matter introduced is intended to prevent the soft effects of the interference of the rays which sometimes present themselves on proofs on glass, opal or the like." Although the wording is somewhat ambiguous there is no doubt that he intended the use of the light-restraining dye, as outlined by du Hauron. Nor is it an injustice in presuming that he borrowed the idea from his countryman, for both were Frenchmen. In this case a fusible flux was incorporated in the reliefs.

MM. Lumière[8] (see p. 322) also used a non-actinic dye. In this case for the formation of colorless reliefs. And they stated: "The sensitive film is very deeply penetrated by the light, which gives monochromes with very high relief, which is an obstacle to the subsequent convenient superposition of the three elementary images. We have remedied this fault by introducing into the gelatin preparations a non-actinic coloring

matter preventing the penetration of the light rays into the thickness of the film. This coloring matter ought, however, to present the following qualities: it ought to be easily eliminated by washing; after development it ought not to be fixed on the ordinary or chromated gelatin; it ought, moreover, to be without action on the alkaline dichromates. After having tried several hundred colors, we have found to fulfil these conditions cochineal red made by the action of naphthionic acid on a naphthol disulfonic acid."

O. Pfenninger[9] used acid yellow in the printing of the blue constituent carbon image, which obviously is not a colorless relief. E. Sanger-Shepherd and O. M. Bartlett[10] (see p. 345) also disclosed the use of coloring matter in the formation of colorless reliefs.

Ives also later[11] claimed to be the first to use a light-restraining dye in conjunction with a silver salt. But this claim can not be upheld. O. Fischer[12] had suggested the incorporation of such a dye in a silver emulsion in connection with developed silver images. Hernandez-Mejia[13] used a yellow dye to restrain the light from penetrating through the base of double-coated stock. This was also patented by Gaumont[14] (see p. 648) for the same purpose and by J. E. Thornton[15] (see p. 648). A. Gurtner[16] in his patent for a bi-pack proposed to stain the front member a deep orange. J. H. Smith[17] also disclosed staining the front film for the same process. As did P. Thieme[18] and O. Pfenninger.[19]

It is legitimate also to recall the use of light-restraining dyes with self-screened orthochromatic plates (see p. 274). This was first suggested by L. Vidal in 1891; G. T. Harris, 1895; J. H. Smith & Co., 1897; Kodak Co., 1903; Hauff, Schleussner, Miethe and König in 1906 and Cararra in 1907. In all these cited cases anilin, non-actinic, light-restraining dyes were used.

L. Vidal[20] patented the use of the carbon process, with or without a lithographic basis, and was always a warm adherent of the same, producing some excellent results as early as 1873. H. C. Bond[21] patented a three-color process using either collotype or photolithography for prints, and he said: "These colored pictures may also be printed in gelatin tissue, stained to the required colors after development with anilin dyes or other dyes, and the three skins superimposed, for the Magic Lantern slides." E. Dumoulin[22] described the preparation of carbon prints and transparencies, and suggested after exposure, that the prints should be collodionized and squeegeed to waxed glass for development, but the collodion was dissolved from the prints prior to superposition.

In 1895 A. and L. Lumière[23] patented the use of dichromated glue for three-color work, and as the glue alone did not give good half tones, they recommended the addition of from 5 to 10 per cent of silver bromide to the same. The constituent prints were obtained on glass or paper, each being insulated by coating with collodion or rubber before the application of the succeeding sensitive film. In the Paris Exhibition of 1900 A. and

L. Lumière[24] showed some magnificent three-color prints that were characterized by a richness of coloring and luminosity that far exceeded all previous work. The principles used were the old ones with the red, green and violet filters, and specially sensitized plates made commercially by them. As the negative process in no wise differs from present practice it is unnecessary to dilate on the same. But the preparation of the paper was unique, and they pointed out that it was attended with some difficulties, particularly as regards the evenness of the sensitive coat, its expansion in water and perfect regularity in drying the same.

Their method was as follows: a sheet of glass was rubbed over with talc powder, then polished till not a trace of powder was to be seen. The edges were then painted with a 1.5 per cent solution of rubber in benzol, to the width of a few millimeters. When this was dry the plate was coated with a collodion composed of:

Pyroxylin 10 g.
Castor oil2.5 ccs.
Ether ..500 ccs.
Alcohol500 ccs.

Then allowed to dry and placed in a dish containing a 7 per cent solution of gelatin at 50° C. A sheet of baryta paper the same size as the glass should also be immersed in the gelatin solution and brought with its baryta-coated side into contact with the collodionized glass, the two lifted out together, and after thorough squeegeeing allowed to dry. The paper should then be painted on the back with shellac varnish and allowed to dry for 12 hours at room heat. It was then ready for the sensitive film, which was prepared as follows:

Gelatin 120 g.
Coignet's hard glue.......................... 120 g.
Ammonium dichromate 60 g.
Neutral potassium citrate 10 g.
Cochineal red (anilin) 1 g.
Alcohol 200 ccs.
Water1000 ccs.

The gelatin and glue should be soaked in the water for 12 hours, then dissolved in a water bath at 50° to 60° C., and the solution cooled to 35° C., then the dichromate, citrate and dye added and finally the alcohol in small quantities with constant stirring.

The mixture should then be filtered through a fine cloth and coated on the paper, prepared as above. About 65 ccs. should be allowed for every 1000 qcm., and the plates placed on a leveling stand to set, then dried at not over 20° C.; but the drying should not take over 12 hours. The drying was of great importance as if uneven, unequal sensitiveness was caused that gave local changes in color. When dry the paper should be stripped from the glass plate and exposed under the negatives, and as no image was visible it was necessary to use an actinometer. After printing

the tissue was transferred to a support for development, and this should be a sheet of glass prepared as above, that is talced and collodionized, then coated with a 0.75 per cent solution of rubber. The image-bearing paper and the glass should both be immersed in ice-cold water for from 15 to 20 seconds, then brought into contact and thoroughly squeegeed. They should then be pressed between two glass plates for 5 minutes and placed in cold water for 2 hours to ensure complete swelling of the gelatin.

The print on its glass should then be placed in water at 38° C. for half an hour, when the paper support can be easily stripped, and the picture will develop in the usual way in about 15 minutes. When all the soluble colloids have washed away there remains on the glass a colorless relief. The plate should then be washed in cold water, immersed in alcohol for 5 minutes and dried. The reliefs should be dyed up with the following baths:

For red:

 Erythrosin J, 3 per cent sol. 25 ccs.
 Water ..1000 ccs.

For blue:

 Diamin blue F pure, 3 per cent sol. 50 ccs.
 Hard glue, 15 per cent sol. 70 ccs.
 Water ..1000 ccs.

For yellow:

 Chrysophenin G............................ 4 g.
 Water ..1000 ccs.

Dissolve at 70° C. and add

 Alcohol 200 ccs.

The dyeing takes approximately 12 hours at normal temperatures. It is as well to examine the prints in superposition to see whether they are correctly stained, and for this purpose they may be temporarily super-imposed on a large sheet of glass, raised up on two blocks of wood, or other convenient support, and great care must be taken that the images are not damaged in this process.

Correction can be made, and either local coloring applied with a brush, or generally by immersion in one or other of the baths. If the whole tone of the picture is too green, then the red impression should be dyed up further. The prints can be reduced in the case of the red and yellow by mere soaking in water. But the blue will resist cold and hot water, acids and organic solvents, and the only remedy is to soak the plate in a weak solution of hard gelatin or glue, about 0.5 to 1 per cent.

When the result is satisfactory, the red and blue images should be immersed in 5 per cent solution of cupric sulfate, rinsed and dried; but this treatment is not necessary for the yellow. The prints should be thoroughly dried and coated with a 1.5 per cent solution of rubber in benzol, and after this is dry with a 1 per cent collodion. To mount the

prints, the yellow image should be cemented to a sheet of paper, prepared as above, with a 15 per cent solution of hard glue, and when thoroughly dry stripped. The blue monochrome should now be applied, using as cement a 12 per cent solution of hard gelatin containing 5 per cent of glycerol. This warmed solution should be placed in a dish, the blue monochrome on its glass slipped into the same and the yellow print also immersed, the two brought into exact superposition and excess of solution removed with a squeegee. The two prints should then be allowed to dry thoroughly and be stripped from the glass and the red monochrome superposed in the same way, then stripped when dry. If thought fit the final print can be easily transferred to glass as the yellow print being only cemented with the glue is easily stripped from the paper with a little warm water, the three monochromes forming the finished picture being cemented to glass by aid of the gelatin and glycerol mixture above described.

The special points in these two processes of the Lumière Brothers are, first the use of the inert silver halide and the use of the red anilin dye, both of which had the purpose of reducing the relief, the dye also preventing the too deep penetration of the light into the tissues.

Von Hübl[25] also recommended the use of celluloid and printing through the back, and the incorporation of silver halides in the dichromated gelatin. L. Vidal[26] suggested the use of Eastman roll films and printing through the support, and this was also recommended by Goddé,[27] C. Wolf-Czapek[28] and von Hübl. The clearing of the film being effected after exposure with hypo and ferricyanide. L. Wulff[29] suggested coating each monochrome with 2 per cent collodion and then rubber solution. Dugardin[30] also used the carbon process. V. Matthieu and F. Dery[31] patented a method which was supposed to do away with the necessity of using an actinometer, especially for tri-color tissues, in which the colors are relatively transparent, by first sensitizing the paper with silver nitrate and then coating with the pigmented gelatin. The difficulty of the expansion of the paper in superposition of colored images was well known, and F. Thuringer[32] proposed to use transfer paper, or unsized paper, coated on one side with starch, albumen and gum solution, then with collodion and varnish and when dry a further coat of gelatin was given.

A. Hoffmann[33] patented the use of silver salts in the carbon tissue support, as a substitute for an actinometer. The paper was lightly albumenized with chlorides or bromides, then silvered, dried and coated with dichromated gelatin. It is obvious that in this case there would be in all probability some free silver present in the paper, and this would have a tendency to wander into the gelatin film, and would at least combine with the dichromate whilst warm.

G. Selle[34] proposed to use one support for three monochromes and to recoat with an insulating film in between. He proposed the use of a sheet

of glass, larger than the final print, and giving this an edging of 10 per cent solution of gelatin. To this a sheet of paper, one side of which at least should be provided with a waterproof material, was squeegeed with the waterproof side up; or if non-waterproof paper was used, then it should be cut slightly smaller than the glass and allowed to soak in water for a short time. When quite dry the paper was coated with a layer of impervious material, such as collodion, and on this a thin film of dichromated gelatin. When dry, printing was effected under one of the constituent negatives, and treated with cold water, so that obviously there was no relief. This was then dyed up, again coated with collodion and dichromated gelatin, again printed and stained up, and the operation repeated for the third time. The dyes suggested were methyl blue, fuchsin red and helianthin yellow. The paper was finally cut round the edges and stripped from the glass. A modification[35] was also suggested by the same inventor. In this case the collodion and dichromated films being produced direct on glass, a sheet of transfer paper being squeegeed to each constituent image and superposed, gelatin being used as cement.

This process was further elaborated[36] and there is here claimed that the exposed gelatin acted as a mordant. The particular strength of gelatin solution recommended was "one between 5 per cent and 7 per cent, preferably 6 per cent, when poured upon a rigid surface such as glass or suitably mounted paper and the excess allowed to drain off, there will result a film of about 0.0015 millimeter in thickness." The strength of the dichromate sensitizer should be 2.5 to 3 per cent and the draining and drying should take place between 40 and 60° C.

E. R. Clarke[37] obtained protection for various processes. If paper was to be used as the support, it should be rendered non-stretching in any well-known way, and baryta paper served well. Opal glass or celluloid could also be used; but in no case must the support have a smooth surface, as a rough or matt surface was the main object. The support was to be varnished with celluloid or other varnish that is impervious to water, and should then be coated with the dichromated colloid. This might be gelatin, though if this were used enough chloral hydrate should be added to reduce its melting point to 21° C., or fish glue might be used. The support was coated by means of a whirler and dried, and after printing and washing the relief was stained up, rinsed, dried and varnished with the same varnish as before, then recoated with the colloid and the other operations repeated for the second and third impressions. It was suggested that to strengthen any monochrome the whole operations should be repeated, and the inventor preferred to print the blue monochrome faintly and put on a fourth print in blue. A roundabout way of control was suggested, in which positives were to be made on celluloid films, stained and superposed and reduced to obtain the best results, and a second set of negatives made from the same.

Before entering on the next phase of the subject, which practically deals with the use of celluloid or other flexible support and printing through the back, thus avoiding the trouble of transfer with the increased chances of expansion and consequent non-registration, it may be as well to deal with the particular point of printing through the support, as this has been advanced as a special claim in some patents.

Unless the carbon tissue is transferred before development, when it has been printed from the front, the half tones and more delicate details will wash away, as they are obviously on the surface of the gelatin more or less, and lack any insolubilized support. This defect was one of the very earliest troubles in carbon printing, and was common to the processes of Poitevin, Garnier and Salmon, and Pouncy. The cause was clearly pointed out by Abbé Laborde,[38] although actually speaking of a particular process that he had discovered, based on the action of light on linseed oil and lead oxide, in which the oil lost its solubility in ether under the action of light. He said: "One must assume two different surfaces in the sensitive film, thin as it is, an outer and an inner, the latter in contact with the paper. The light-action begins at the upper surface but does not continue in the half tones right to the inner surface; in washing, therefore, the half tones lose their hold on the paper and are washed away."

J. C. Burnett[39] suggested as the remedy, exposing through the back, that is the paper, and W. Blair[40] proposed the use of wax paper, as this did not show the grain of the paper so strongly, nor did it turn brown like ordinary paper soaked in the dichromate and, therefore, did not prolong printing so much. Placet and Despaquis[41] suggested coating the pigmented gelatin with collodion and printing through that, and we have seen that du Hauron also suggested the same idea.

Risler[42] proposed the use of mica, and this was also patented by Raphael[43] and O. Moh[44] and was also suggested by Despaquis. But the interesting point in connection with the note recording M. Raphael's patent is that it says: "man schlagt an Stelle des Glimmers das regelmässigere Celluloid vor"; that is, the more regular celluloid has been proposed in place of mica. R. Krayn[45] patented the use of celluloid as a support and printing through the same and pointed out that Monckhoven had called attention to the advantage of printing carbon tissue through the back; but this had to be done in the solar camera, as the tissue was supported on glass.[46] H. Schmidt[47] recalled O. Volkmer's account of his visit to Hanfstängl's factory at Munich, where carbon tissues and prints were made. Volkmer said:[48] "For this ingenious process the pigment paper is the most important article. After Hanfstängl had tried the pigment paper of all manufacturers and found them unsatisfactory for his work, he started commercial production himself. The endless paper receives first, by means of specially constructed machinery, a thin coating of rubber. On the day that the paper is to be used, it receives the light-sensitive film of chromium

salts, color and gelatin." Volkmer did not state how the tissue was printed, but in a footnote, L. Schrank, the editor of the journal, said: "The preparation of pigment paper with rubber substratum is a far-reaching improvement in carbon printing as it only requires that the insolation should be not from the side of the light-sensitive gelatin, but through the paper, that is from the back." An anonymous writer, "f", who was undoubtedly Friedlein, of Munich,[49] commenting on this, pointed out that the yellowish rubber and the grain of the paper would be serious drawbacks, and said: "The only conceivable possibility would be to use celluloid sheets instead of paper, which should be thin enough so as not to produce marked want of sharpness."

It is abundantly clear from the above that printing through the support, either with collodion or celluloid as base, is not of recent origin, and whilst this applies to the carbon process, the general principle is established.

R. Krayn's patent[50] is for the production of "pigment foils," which were celluloid of from 0.05 to 0.25 mm. thickness. This was given a preliminary coating of rubber, wax, or rubber and collodion, or wax and collodion. Colloids soluble in cold water, such as gum arabic, starch, dextrin or the like might be used instead of gelatin. The Aktien-Gesellschaft für Anilin-Fabrikation[51] patented the printing of carbon tissue on celluloid through the back, then hardening after development with formaldehyde and transferring to paper, and soaking the print in a solution that would soften the celluloid without dissolving it, such liquids being ethyl and methyl alcohol, benzol, etc., and the celluloid could then be stripped. The same inventors later[52] patented the manufacture of a special celluloid for carbon work, and claimed thus to obtain an easily strippable film. This was attained by the addition of castor oil, nitrobenzol, naphthalin, rubber in benzol, anilin, wax, resins or hydrocarbons of high boiling point.

A. Hesekiel[53] proposed to obtain a readily stripping product by giving the paper support a coating of rubber and collodion. M. and H. M. Miley[54] patented the ordinary three-color process, but prepared the temporary support first with a solution of wax and resin, thus following the normal procedure, and then coated with collodion, and suggested the use of celluloid as a temporary support. After drying, the prints were stripped, their surface rubbed with a mixture of equal parts of ether and alcohol, to remove the wax and collodion, and then cemented with gelatin and chrome alum solution.

H. Schmidt[55] suggested that the manufacture of stripping celluloid was difficult and proposed to overcome this by sensitizing the tissue in the usual way, then whilst it was still wet, squeegeeing it to a sheet of celluloid, mica, collodion or the like, and after drying, printing through this "carrier," the adhesion of which might be reduced by preliminary treatment with talc, wax, oil, rubber, etc. C. L. Brasseur[56] patented a tissue for three-

color work, in which the colored gelatin was supported on a soluble layer of gum, wax, albumen, varnish, etc., or gelatin might be used, which had been rendered insoluble by Poitevin's method with ferric chloride and tartaric acid, which becomes soluble under the action of light. The pigment-gelatin was preferably flowed on to plate glass, and then the support squeegeed thereto. One of the chief advantages of this process was said to be that after one print had been made, the second and third could be produced in superposition because the tissue could be applied cold.

A. Davies[57] proposed to overcome the irregular expansion of the transfer paper for tri-color prints by hardening it as a whole, the development of the individual prints on collodionized glass, and the use of picric acid in the blue tissue so as to obtain a blue-green image, which harmonized better with the red and yellow. The glass plates were first talced, then collodionized and when set placed in water. The exposed tissues were squeegeed to the plates and developed in the usual way. The yellow print was squeegeed to double transfer paper, which could be first soaked in 10 per cent solution of alum for a few minutes, or a weak solution of formaldehyde. When dry the paper was stripped from the glass, bearing the yellow print with it; to this the red and blue impressions were successively transferred from their glass plates, using size and isinglass as cement.

E. Clifton and A. Wells[58] proposed to use the ordinary tri-color carbon process, but temporarily superpose the results to see whether any modification was required. This could be effected by using indulin blue, Lyon's blue or Hofman's violet (blue shade) for the blue impression; naphthol yellow or berberin for the yellow and chrysoidin and aurin for orange, which might also be used for both the red and yellow prints; and alizarin, ammoniacal carmin or Magdala red for the red print. The same inventors[59] proposed to add to the tissue, particularly the blue, a temporary dye or pigment, which should be removed in the subsequent operations, or with a suitable solvent. Manganese peroxide was suggested and its removal with sulfurous acid. L. Garchey[60] patented the manufacture of dichromated gelatin that could be repeatedly washed without damage to the film, by the incorporation of a reinforcing body, such as collodion. Coloring matters might be mixed with the emulsion to "impart clear definition." Before each new print, the image was coated with gum or gelatin solution.

J. W. Bennetto[61] patented a web of paper with three parallel bands of red, yellow and blue carbon tissue side by side, for use with negatives obtained in his semi-dialyte camera, E.P. 28,920 (see p. 158), so that the side prints might be folded over the central one. A. Gleichmar[62] proposed to make prints from three separate negatives, taken side by side on one support, on one thin film of celluloid, or like material, which had three color fields side by side. Before printing, which was done through the support, the film was creased twice along lines corresponding to the nega-

tive. After development, correct registration was automatically obtained by folding along the creases. B. Bichtler[63] in order to obviate the difficulties of registration would print in carbon on a transparent support, then recoat and print from the front, again recoat and print again from the front.

A. Blachorovitsch[64] patented the use of superimposed carbons on glass or celluloid and stated that they could be exposed in the camera. A silver bromide emulsion was to be incorporated with Prussian blue, yellow ochre or cadmium yellow and carmin respectively. The plates were to be exposed in the camera with the back open, or a mirror behind the plates, so that light might act on both sides at once. Color filters were used to isolate the different regions. The plates were to be developed with pyroammonia and after fixation the images bleached with mercuric chloride. F. Haderer[65] proposed the use of dichromated gelatin with subsequent hand coloring. A. Sebé[66] proposed to use yellow corallin, carmin and Prussian blue as the pigments. L. C. Lesage[67] would make three separation negatives and carbon prints therefrom with a half-tone screen for metal printing.

J. Sury and E. Bastyns[68] would obtain more harmonious coloring of three superposed monochromes by perforating the same before superposition. A roller or rolling mill with points was used to perforate the prints, and the compound picture was compressed in a press, so that the colors passed through the perforations, and the whole rendered more homogeneous. Practically this would be a compromise between the additive and subtractive processes, and the color rendering, therefore, be false. The same inventors[69] also patented a process in which one colloid film was resensitized for each constituent image. The interposition of a screen[70] during printing was also patented. This being also patented by the Société Anonyme Photographie des Couleurs,[71] which was formed, it is believed, to work the Sury-Bastyn patents. This company also patented[72] the use of lead chromate as the yellow pigment. Sury & Bastyns[73] patented the production of color prints by any process, as long as the results were in polychrome. They also patented[74] carbon printing in colors, and the addition of dextrin[75] to the cyanotype sensitizer to prevent the image from sinking into paper, for color work.

W. E. Brewerton[76] sensitized double transfer paper with cyanotype and superposed red and yellow carbon prints. O. Pfenninger and E. C. Townsend[77] proposed additional components to be combined with the three-color prints, where the colors required modification, and these components were to be made from prints from combinations of two or more of the constituent negatives. For example, it may be desirable that the greens be a little lighter and that red and dark objects receive more printing color. The red component should accordingly receive more red, and for this purpose, the red and yellow printing negatives were to be superposed

and a fourth print obtained from the combination, which accentuated the red only. The original red print was to be printed mellow and light so that the other colors, but especially the greens were over printed or affected as far as was desirable. Other combinations could be used.

The commercial introduction of tri-color carbon tissues, especially on celluloid and stripping supports, led to some little literature, which requires but little comment, except in a few points, which deal rather with general procedure. The author[78] suggested the use of H. W. Vogel's substratum[79] as a cementing medium, the advantage being that it would keep a long time and was more efficient than the usual plain gelatin solution. This is prepared as follows:

> A. Gelatin...................................... 4 g.
> Glacial acetic acid.............................20 ccs.

Allow to soak for 10 minutes and dissolve in a water bath.

> B. Chrome alum................................ 1 g.
> Distilled water................................20 ccs.

For use mix

> Alcohol400 ccs.
> Distilled water..............................160 ccs.
> Solution A................................... 20 ccs.
> Solution B................................... 8 ccs.

At first some of the gelatin may be thrown out, if solution A be not added very gradually with constant stirring, if so addition of a few drops of acetic acid and heat will at once dissolve it. Another cement was also given by the same[80] but this requires heating before use:

> Gelatin 10 g.
> Glacial acetic acid........................... 10 ccs.
> Distilled water...............................240 ccs.
> Denatured alcohol............................750 ccs.

Allow the gelatin to soak for a short time in the acid and water, melt to, 65° C., then add the alcohol carefully and slowly with constant stirring. There should be no precipitation of the gelatin, or at most a few fine shreds, which rapidly redissolve. This solution should be painted over the print, and left for a few minutes for most of the alcohol to evaporate. In the same article it was suggested that a spirit sensitizer should be used and painted on the tissue:

> Ammonium dichromate........................ 15 g.
> Hot water...................................100 ccs.

And add an equal volume of alcohol. This will not keep well, especially in the light. The tissue should be pinned to a board and the sensitizer painted freely over the gelatin surface till the film is well saturated and then excess blotted off. The advantage of this is the rapid drying of the tissue.

E. Grills[81] using the tri-color tissues, preferred to sensitize in a 4 per cent solution of potassium dichromate, blot off superfluous moisture, then

immerse in alcohol, when the sheets dried in a warm place in 10 minutes. For the temporary support he used sheet celluloid, 10/1000 inch thick, well rubbed with a 4 per cent solution of wax in benzol. S. Manners[82] patented a process for a special temporary support. The paper was to be floated on a warm solution:

Soft gelatin.................................. 50 g.
Hard gelatin................................. 50 g.
Sugar or glycerol............................ 50 g.
Water1000 ccs.

In using this paper it was soaked in cold water till limp, then squeegeed on to one of the prints, which were supposed to be on glass, and allowed to become perfectly dry, then stripped with hydrofluoric acid, washed and applied to the second print, this stripped as before and the third print treated in the same way. The temporary support, bearing the complete print, was while wet squeegeed to the final support, which might be paper, coated with insoluble gelatin. When thoroughly dry, the whole should be placed in warm water for a short time and the temporary support stripped. So far there does not seem to be much novelty, but now comes the important point. In practice it is found that the paper treated with the gelatin solution as described, when soaked in water, stretches more in one direction than another, in the direction at right angles, and does not return to its original dimensions when dried, so that each print applied to the temporary support will not register so well in one direction as the other with the next print. To obviate this it was advisable to cut the prepared paper so that when wet its longer stretch was across the narrowest part of the print to which it was to be applied.

For those who like to prepare their own materials, the following instructions by J. C. Arch[83] may be useful. The colors required are chrome yellow, alizarin crimson, Prussian blue and ultramarin blue. Reeve's powder colors were used, but probably those supplied by artists' colormen would answer. Three 2 ounce bottles are also required. Into one place 40 grains of chrome yellow, into another 18 grains of alizarin carmin, into the third 4 grains of Prussian blue and 6 grains of ultramarin blue, taking care that there are no lumps. Add to each color 1 ounce of water, a little at a time, shaking well all the time and put on one side for several hours, giving an occasional shake. Then prepare the following:

Soft gelatin.................................... $\frac{1}{2}$ oz.
Glycerol60 minims
Water .. 4 oz.

Mix the glycerol thoroughly and allow to stand till the gelatin is soft, then add the liquid colors, stir well and place in hot water till the gelatin melts. It is, of course, understood that the above quantity is used for each color. When the gelatin has melted, filter through fine muslin and add enough water to make 5 fluid ounces in all. This will not keep longer than three

days. A smooth surface is best for the support, and it should be cut about half an inch longer each way than the picture. The same paper must be used for all three colors. The cut sheets should be soaked for at least 15 minutes in cold water, then squeegeed to glass, the surface dried with blotting paper and the glass placed on a leveling stand. The color emulsions should be heated so that they are thoroughly liquefied, but not too hot. Allow 1660 minims, practically $3\frac{1}{2}$ oz. to every 100 sq. ins. of surface. Pour into the center of the paper and guide to the edges with the finger; any air bubbles can be broken in the same way. When the gelatin has set, pin the sheets to the edge of a shelf to dry, trim to size and put under gentle pressure till required.

Sensitize in the usual way, and it is important to sensitize all three colors in the same bath, so that all receive the same time of immersion, and the sets should be marked on the back. Printing is carried out as usual, and is complete when the details of the negative can be seen in the yellow print. It is as well to expose all three colors together and to remove the red and blue frames when the other is examined, so that they do not print longer. The prints should be soaked for at least 10 minutes in cold water, squeegeed down to thin sheets of celluloid, previously waxed, and development carried out as usual. Further operations call for no comment.

W. T. Wilkinson[84] considered that it was impossible to make tri-color carbons on plain gelatin, as the light strikes right through the tissue to the paper. He suggested the use of manganese dioxide as an inert pigment for the red and blue tissues, and lampblack in small proportion for the yellow, and as this was not removed, it formed a delicate range of greys, which he considered essential for successful work. Practically this is tantamount to the grey key of the process printer. The manganese dioxide was to be dissolved by weak sulfurous acid.

E. Deyhle[85] patented a frame into which the three constituent films could be fastened in superposition, and marked with a pointer so as to facilitate their subsequent registration, either for photomechanical, transparency or other work. P. Herden[86] patented the provision of the constituent negatives with registration marks, which should appear on all three negatives.

G. Baugé, A. Dumez and A. de Sauve[87] entered somewhat fully into the manufacture of the tissues and recommended for the red, a madder lake, using 8.5 g. per qm. of paper surface. For the yellow 12.8 g. of cadmium sulfide was to be used for the same area. For the blue, Prussian blue, made by precipitating an 11.85 per cent solution of ferrous bromide with a 21 per cent solution of potassium ferrocyanide. These colors were suspended in gelatin solution and coated on vegetable parchment, that is paper that had been "sulfurised" by dipping twice into a mixture of sulfuric and nitric acids. The paper was dipped twice into a

solution of gum-lac in ethanol (presumably ethyl alcohol), so as to obtain a non-expanding paper, which if necessary must be printed through the back. Celluloid coated with gum-lac might also be used. Sensitizing was to be effected with a mixture of the dichromates of potassium and ammonium, and then centrifuged. Printing of all three negatives should be effected at the same time, and the insolation considered complete when the details in the yellow print were visible.

The patents of F. E. Ives have been collected together, although somewhat disturbing the chronological order, not only because of their number, but also of their similitude. In 1894,[88] he described the preparation of lantern slides by the carbon process, thus: "dichromated gelatin films on clear celluloid were exposed from the back by electric light, developed as carbon prints, the images cut apart and each dyed to a suitable depth by immersion in a solution of the proper printing color A great degree of precision is necessary to secure the correct proportionate depth of coloring in the three prints." He discovered, however,[89] that the above process was not as practical as was desired, for the following reasons: "1. Celluloid films thick enough to be satisfactorily coated with the necessary thickness for the process were objectionable because of the color and of the shrinkage and tendency to buckle through general evaporation or solution of contained camphor, and because when the prints were used as lantern slides the effect of heat in the lantern upon the celluloid was liable to destroy or seriously damage the pictures. 2. The dichromated gelatin films must be of such thickness that detail may be retained in the prints from both ends of the scale of gradation from black to white of the negative, and owing to the small percentage of dichromate salt that can be incorporated with gelatin without crystallization in drying, the gelatin film must be so thick as to make the process of development in warm water tediously slow, and the resulting print difficult to color up correctly, since the color bath proved to have been too strong for the subject, washing to reduce the strength acted relatively too fast upon the thin parts, and strengthening by the use of a stronger bath, also acted relatively too fast upon the thin parts. 3. The finished color prints were seldom as sharp as desirable, and the relief was too great so that it became necessary, in order to obtain satisfactory results with lantern slides, to seal the prints together with Canada balsam."

These difficulties were to be overcome by the use of a film of amyl acetate collodion, instead of celluloid, and a coating of fish glue instead of gelatin. The amyl acetate film containing no camphor, is said to have been unaffected by water, and the use of the fish glue allowed the incorporation of sufficient dichromate without crystallization, and a much thinner coating was possible. The collodion was coated on glass, dried, then coated with the fish glue by means of a whirler, being dried by heat, then stripped and exposed through the back. Development was effected in

cold water, leaving a relief which could be stained up in neptune green for the peacock blue print, rhodamin and eosin for the crimson and brilliant yellow for the yellow impression. The prints were superposed by transfer of one to paper and cementing the others on to the same; starch paste, gelatin or glue were suggested as the cements.

Amyl acetate-acetone collodion might be used or even celluloid when the print was not to be subjected to heat, and "rotted" gelatin might be used instead of fish glue. In the following year a still further improvement was patented[90] which was the treatment of the reliefs with a 4 per cent solution of chromic acid, which "contracts, sharpens up and hardens the relief print, so that very sharply defined and exceedingly low relief prints may be made and dyed to the desired depth of color." Ives claimed the incorporation of a silver halide and a non-actinic dye in the sensitive film, both features having been, as previously recorded, used by Lumiére, and Sanger-Shepherd. Another patent[91] still further modified the procedure, the main feature now being the use of a cyanotype image on paper for the blue constituent with superposed celluloid reliefs, retained on their supports and cemented together. The three monochromes were registered and fastened together like the leaves of a book, and the use of amyl acetate collodion, containing camphor, which sufficiently attacks the celluloid surfaces to hold them permanently together; too much softening of the film being avoided by applying heavy roller pressure so as to expel excess of cement. It should be noted here that both in the Lumiére and Sanger-Shepherd processes of 1902, a bromide print toned with a cyanotype mixture was utilized, and it was common practice to use this both for prints and transparencies.

W. C. South[92] proposed to use fish glue with a red pigment as the first layer on paper, and after printing and development to coat with a cyanotype mixture with glue and after development to coat with the yellow dichromated glue. In a subsequent patent[93] the production of paper coated with fish glue and natural or artificial rose madder was claimed.

A. R. Lawshe[94] proposed to use the dialyte system for two-color work, and specifically preferred the use of an orthochromatic plate with its film in contact with a panchromatic plate, using a deep yellow or orange filter in front of the lens. At the same time he preferred to stain the film of the ortho plate to about one-third of its depth with a mixture of yellow and red dyes. The image after having its excess blue light cut off by the lens-filter would record the greens and blues upon the undyed two-thirds, whilst the dyed third would act as a filter for the reds on the underlying panchromatic plate. To obviate the use of the lens-filter the back of the ortho plate might be coated with gelatin dyes, yellow or orange. After development the dye was removed from the plate by an alkaline solution. Two negatives would be thus obtained; the one recording all the blues and greens, whilst the other, the rear plate, would record the reds. From the

front plate a positive was to be made in red carbon tissue; and from the rear one a blue carbon. Control of printing could be obtained by dyeing the tissues and the colors might be altered by action of acids or alkalis. This process was applicable to motion pictures by using two films face to face in the camera, making positives from these in complementary colors and uniting the celluloid sides of the two positives by passing them through a celluloid solvent and press with rubber rollers. Or they might be used for simultaneous projection with two machines.

W. Vobach[95] obtained a relief with dichromated gelatin, this film being exposed simultaneously as one sensitized with the ordinary cyanotype sensitizer, and the insolation was stopped as soon as the blue print was dark enough. L. Didier[96] proposed to obtain gelatin reliefs by exposing gelatino-chloride printing-out paper till a deep chocolate color, then immersing in a chloride bath to convert excess silver into chloride and sensitizing in 2 per cent dichromate solution and exposing under the constituent negatives, developing with warm water and transferring to glass. The dark silver was removed by hypo and ferricyanide, and the colorless reliefs stained up with auramin, Prussian blue and rhodamin. The idea of using the silver was to obtain a coloring matter which would enable the progress of printing to be seen, and which could yet be easily removed.

R. Fuelgen[97] stated that he had secured non-distorted carbon prints by using glass instead of celluloid or paper as the support. For the temporary support, glass was coated with a solution of rubber in benzol. The carbon plate was soaked in cold water for 2 or 3 minutes, and then the rubber-coated plate brought into contact therewith under water, avoiding airbells. To secure contact small bottles, filled with shot or the like, might be placed on top; about 1.5 kilos being allowed for a 9x12 cm. plate, and the two plates should be allowed to remain in contact for 30 minutes. Then if placed in warm water the still soluble gelatin will dissolve and the plates can be slid apart. Ordinary glass may be used and although uneven, contact is ensured by the swelling of the gelatin after the plates are left in contact. Because being brought together under water, the inequalities between the surfaces are filled with water. This means a reasonable quantity of gelatin on the glass, and 0.8 g. for 9x12 cm. is about right. To avoid too great relief the use of a non-actinic dye, as suggested by Lumière, is advisable and that recommended is pinatype red F (this is natural carmin) and a 4 per cent solution should be made and after filtration 20 per cent should be added to 10 per cent gelatin solution and 8 ccs. should be coated on 9x12 cm. This color can be discharged with 4 per cent solution of potassium dichromate, acidified with glacial acetic acid.

A. Wohler[98] patented a process in which the red and yellow images were produced on the same support by the carbon process and the blue constituent by the cyanotype method. H. J. C. Deeks[99] utilized dyes, dissolved in alcoholic solution of sandarac, then atomized into a hot chamber so as to

obtain them in powder form, as the pigments for the carbon process. The dyed particles were suspended in gelatin and after sensitizing were exposed through the back. It is suggested that the gelatin should be coated in separate layers with the lowest layer containing the least pigment, on the ground that the finer details would be thus better rendered. The celluloid was stretched taut in a metal frame during exposure and development,[100] and tangent screws at the two ends of the frames were provided which considerably facilitated registration of the prints. This process was called Raylo.

C. S. Forbes[101] proposed to use a carbon print for the red and superimpose a green-toned bromide print by transfer. E. A. Burchardt[102] suggested a method of using dichromated "size," which was nothing more than home-made carbon tissue:

Sugar 152 g.
Water1000 ccs.

Dissolve and add

Hard gelatin42 g.

Allow to swell and melt in a water bath. This forms the size. For the blue pigment was used:

French blue...................................23.5 g.
Aureoline15.7 g.
Ammonium dichromate.......................15.7 g.
Glycerol 62 ccs.

Mix thoroughly and add

Above size to..............................1000 ccs.

For the yellow impression was used:

Aureoline15.7 g.
Aurora yellow.............................. 5.25 g.

For the red was used:

Alizarin crimson............................5.25 g.
French blue...................................1.75 g.

The dichromate, glycerol and size were added as above. The powders used were Winsor & Newton's fine powder colors. The blue mixture should be heated in a water bath at 27° C., but kept as low as possible consistent with good coating. Spread quickly on paper with a brush with lengthwise strokes, followed by cross strokes for evening up. Dry and expose, using two tints of a Wynne meter. Place the prints face down on water at 32° C., and at once brush the surface to remove air bubbles. It should be developed in 3 or 4 minutes or the brush may be gently used and the temperature raised if necessary. Hang up to dry. Paint with the following:

Above size....................................666 ccs.
Water ..334 ccs.
Ammonium dichromate........................ 11 g.

This should be about 35 to 38° C, and it prevents the peeling of the subsequent coats. The yellow mixture should be heated to 32 to 35° C. and brushed over the print, dried and exposed. The exposure will be longer than for the blue. The blue-yellow print is again coated with the dichromated size and the red mixture applied. H. J. Comley[103] stated that the following was an improvement as it obviates the use of glycerol:

Sugar .. 152 g.
Soft gelatin................................. 38 g.
Water ..1000 ccs.

This develops readily between 25 and 32° C.

L. Dufay[104] proposed to resensitize the gelatin film of a primary silver image with dichromate for the second and third images.

Carbon Prints by Chemical Transfer.—It is not within the province of this work to deal with all the processes that have been suggested for obtaining carbon prints by transfer of a chemical action, nor with the processes of bromoil and oil-printing, for whilst color prints may be obtained with such processes they are produced by the application of the colors by hand, and, therefore, from the author's point of view fall into the domain of coloring prints, with which no connection has been attempted, though the primary image is obtained by photography. We must be content with the various steps that have led up to the one now in use.

A. Marion[105] described a process, in which dichromated gelatin paper was pressed, after exposure, into contact with pigmented tissue, that had not been exposed, and the two were left in contact for 8 to 10 hours, then developed in warm water. The light-image on the dichromated gelatin was transferred to the pigmented tissue and hardened the same, and the colored pigment adhered to the primary image. This process was demonstrated before the Royal Photographic Society, London, and was called "Mariotype by contact." Little practical use was made of this process.

T. Manly[106] introduced "ozotype" and the name arose from the fact that the inventor assumed that ozone was generated from the sensitive mixture of dichromate and manganese sulfate. Paper was sensitized with potassium dichromate and the manganese salt, exposed under a negative, the print washed in water and immersed in an acidulated solution of ferrous sulfate and squeegeed to pigment tissue also immersed in the same, and the two left for some time, then the print was developed. Various modifications were suggested, such as the use of hydroquinon, instead of the iron salt and reference should be made to the various journals, as given in the footnote. Later Manly introduced the "ozobrome" process, in which a silver image was treated with a mixture of ferricyanide and dichromate, and squeegeed to pigment tissue. The products of the action on the silver were transferred to the tissue, rendering this insoluble, and the carbon print could be developed in warm water.

The following is a sketch of the method: A bromide print is first required, and either direct or enlarged prints may be used, it should be immersed in a 5 per cent solution of formaldehyde for 5 minutes, then washed and dried or used at once. If the print be dried, it must be immersed in water till limp. A sheet of pigment tissue should be immersed in the pigmenting solution, which may be:

Potassium dichromate	6.6 g.
Potassium ferricyanide	6.6 g.
Potassium bromide	6.6 g.
Alum	3.3 g.
Citric acid	1.0 g.
Water	1000 ccs.

The citric acid hastens the action and the alum prevents too great swelling of the gelatin. The print and plaster are left in contact for about half an hour, and then one of two courses may be adopted. Either the two papers may be treated as ordinary tissue, or they may be stripped apart, and the tissue treated alone, when the bromide print can, after washing, be redeveloped. If the first plan be adopted then the print with the adherent plaster or tissue should be immersed in water about 42° C., and after a short time the pigment will ooze out from the edge of the paper, and this can be stripped and thrown away, and development completed as with any ordinary carbon tissue. If the bromide print is stripped then the tissue should be squeegeed to single transfer paper, and the normal carbon procedure followed.

If the bromide print is the support, one has the color of the underlying silver image modifying that of the tissue. If this latter be dark it will be of no moment; but with lighter pigments it may cause trouble, and the silver can be dissolved with any solvent, such as Farmer's reducer. Early three-color prints were made by this process, but little seems to have been done with it, though the author did some experimenting with materials supplied by Manly.

The Raydex Process.—This is undoubtedly founded on the Manly processes, and is capable of excellent results. The three constituent negatives are obtained in the usual manner, and from the same bromide prints made on a special paper, which is important, as this is specially prepared to obviate the unequal stretching that occurs with ordinary bromide paper. The three prints should be developed together and transferred, without washing, to an acid fixing bath for at least 10 minutes, and after washing allowed to dry thoroughly. Celluloid sheets are to be waxed at least 30 minutes before use. The bromide prints should be immersed in water till thoroughly limp. At the same time the color-pigmented paper should also be soaked in water and hung up to allow surplus water to drain off, and immersed in the special sensitizing solution. It is advisable to immerse all three sheets together, and they should be left for 2 minutes, air bells

being removed with the finger tip only. The bromide sheets should be smaller than the color sheets, and should be squeegeed to the color tissue, so as to exclude all air bells, and allowed to remain in contact for 15 minutes.

The print should then be stripped, and the color sheet, which now bears an invisible image of insolubilized gelatin, should be squeegeed to waxed transparent celluloid, and allowed to remain for 10 minutes. It should then be immersed in water at 43 to 47° C. and after 2 or 3 minutes the backing paper can be pulled off and thrown away, as in the ordinary carbon process. The prints should be gently moved about in the warm water, occasionally being held up to allow the soluble gelatin to drain off, then immersed in clean water at about 38° C., and hung up to dry. The bromide print can be redeveloped and used again if required. To assemble the color prints, the special single transfer paper and the yellow image, which need not be dry, should be immersed in cold water, and the two brought into contact, lifted out and squeegeed and set aside to dry.

The blue and red impression should be brushed over with the cementing solution. When the yellow impression is quite dry it can be stripped from the temporary support, and the surface gently rubbed with benzol to remove all traces of the waxing solution. The blue positive, which should be dry, should be soaked in water for a few minutes, together with the yellow print and the two brought into contact under the surface of the water, and lightly squeegeed with a piece of doubled felt, then brought into register, placed aside for a few minutes and rolled into intimate contact with a roller squeegee, allowed to dry and then stripped. The red impression is treated in the same way. This reverses the prints as regards left and right, and to avoid this the color sheets may be squeegeed to glass, coated with insoluble gelatin, and the color impressions developed on this, superimposed and stripped with hydrofluoric acid when dry. It is obvious that enlargements may be made in the same way.

The method of obtaining prints by the transfer of chemical action has also been introduced by the Autotype Co., under the name of Carbro. F. G. Tutton[108] suggested the old method of intensifying three-color Carbro prints with anilin dyes.

1. Bull. Soc. franç. Phot. 1869, 11, 122, 144, 155, 177; 1870, 12, 68; Phot. News, 1869; Phot. Korr. 1869, 6, 169; Handbuch, 1917, 4, II, 205; "Les Couleurs en Photographie et en particulier l'Héliochromie au Charbon," Paris, 1870; L'Héliochromie. Méthode perfectionée pour la formation et la superposition des trois monochromes constitutifs des héliochromes à la gelatine." Agen. 1875, "Traité pratique de Photographie des Couleurs," Paris, 1878, 61.

2. "La Photographie des Couleurs, Solution du Problème," Paris, 1869, 37.

Eder, Handbuch, 1917, 4, II, 204, states that du Hauron exhibited some carbon prints in the Palais de l'Industrie in Paris in 1877, in which, however, the outlines did not exactly coincide and the individual prints did not fit well. In 1878 he published his method with some further improvements in a special pamphlet, which was reprinted in Phot. Archiv. 1878, 19, 109, 124. Possibly this was "Traité pratique de Photographie des Couleurs," Paris, 1878. Carmin, Berlin blue and gold yellow were the colors used. These three colored images were superposed; it was, however, very difficult to make them fit, as the three pigment papers expanded differently in water,

in spite of all precautions. The best thing was soaking the carbon papers in 90 per cent alcohol for 3 hours, as this contained enough water to soften the tissues. The glass plates, on which the tissues were squeegeed, were previously coated with a thin film of boiled linseed oil, diluted with ten times its volume of benzol, and dried for 24 hours, as this favored the adhesion. Then each of the colored tissues was developed separately, then superposed. Du Hauron prepared not only paper prints but transparencies by this process.

3. "La Triplice photographique des Couleurs et l'Imprimerie," by Alcide Ducos du Hauron, Paris, 1897, 261.

Alcide was the brother of Louis Ducos du Hauron, and he says in a footnote to his preface of the above work: "Dans l'expose des méthodes et plus encores dans les dissertations qui s'y rattachant, la clarté du discours exige assez souvent l'emploi de la première personne; faire parler le Professeur, c'est le mieux. Il importe, à ce sujet, que toute equivoque soit evitée; ce sera constamment mon frère, jamais moi qui, dans tout le cours de ce Traité, parlera ainsi à la première personne; c'est à lui seul qui s'appliquent les expressions l'inventeur, l'Auteur, fréquemment employées."

4. F.P. 173,012, 1885, "Nouveau modes de papiers mixtionées ou produits analogues pour la photographie dite au charbon, caracterisé par l'incorporation provisoire d'une teinture."

5. For description of du Hauron's methods of preparing his tissues, see E. Lacan, Phot. News, 1875, **19**, 212.

M. Pacini, Brit. J. Phot. 1906, **53**, 11, recommended as stable colors for tri-color carbons, picric acid, carmin and Prussian blue.

6. Brit. J. Phot. 1921, **68**, 48. For controversy Ives v. Wall. ibid. **69**, 27, 119, 206, 286.

7. E.P. 19,843, 1899; Brit. J. Phot. 1900, **49**, 572; U.S.P. 679,501.

8. E.P. 7,188, 1895; F.P. 245,948, 1895. The passage quoted is from Bull. Soc. franç. Phot. 1901, **48**, 204, 303, 411; Brit. J. Phot. 1922, **69**, 27.

9. Jahrbuch, 1909, **23**, 45.

10. E.P. 24,234, 1902; U.S.P. 728,310, 1903.

11. U.S.P. 1,186,000, 1916.

12. E.P. 15,055, 1912; Brit. J. Phot. 1913, **60**, 595.

13. U.S.P. 1,174,144, 1916; application date June, 1912.

14. F.P. 420,163, 1909.

15. E.P. 9,324, 1912; U.S.P. 1,250,713.

16. E.P. 7,924, 1903; U.S.P. 730,454.

17. D.R.P. 185,888, 1903.

18. D.R.P. 163,282, 1903.

19. E.P. 25,906, 1906.

20. F.P. 97,446, 1872; 102,415, 1874; U.S.P. 178,210, 1876; Brit. J. Phot. 1873, **20**, 385, 464, 488, 521; 1877, **24**, 6; 1878, **25**, 84.

Eder, Handbuch, 1917, **4**, II, 204, states that Vidal turned out some very fine work, examples of which are in the Graphischen Lehr-u. Versuchanstalt, Vienna, but that he used a grey carbon key print over chromolithographs. In Brit. J. Phot. 1873, **20**, 385, 467, 487, T. Sutton speaks enthusiastically of Vidal's carbons, and there is no doubt that they were pure carbons. For Vidal's methods of making his tissues see Brit. J. Phot. 1902, **49**, 1002; Mon. Phot. 1902, also "La Photographie des Couleurs par Impressions pigmentaires superposées," Paris, 1894, (?); also Bull. Soc. franç. Phot. 1902, **44**, 200.

21. E.P. 13,301, 1888; Phot. News, 1889, **33**, 543; Brit. J. Phot. 1889, **36**, 544.

Bond's process was used by Waterlow & Sons, London, and an example in collotype was issued with the Photographic Quarterly, 1900, **1**. The color filters proposed by Bond were a green solution, preferably chlorophyll, that transmits no red, an orange solution of ferric sulfocyanide and a purple or puce-colored anilin dye solution. According to Eder, "The chemical effect of the spectrum," a translation by W. Abney of "Chemische Wirkungen des Lichtes," and reprinted from Phot. J. 1881, 1882, J. Husnik brought out a new process, Phot. News, 1870, in which he proposed to print in superposition colored collotypes. E. Albert also experimented with the same process, Kunst. u. Gewerbe, 1877; Phot. Korr. 1878, **14**, 1; Handbuch, 1905, **1**, I, 432; Albert's "Die verschiedenen Methoden des Lichtdruckes," Halle, 1900; H. Krone, "Die Darstellung der natürlichen Farben," Weimar, 1894, 81; E. J. Wall, Phot. J. 1895, **35**, 171.

23. Compt. rend. 1895, **120**, 875; E.P. 7,188, 1895; F.P. 245,948, 1895; "Résumé des Travaux," 1906, 39. In the analagous D.R.P. 94,052; Silbermann, **2**, 368, the use of silver chloride or iodide or lead iodide is indicated as the insoluble

matter; Brit. J. Phot. 1896, **43**, 183; 1898, **45**, 386; Brit. J. Almanac, 1897, 827; Photogram, 1898, **5**, 316; Jahrbuch, 1896, **10**, 160; Phot. Rund. 1898, **12**, 210; Bull. Soc. franç. Phot. 1896, **33**, 312; 1898, **35**, 316; Phot. Mitt. 1898, **35**, 83; Phot. J. 1899, **39**, 173; Anthony's Phot. Bull. 1895, **26**, 203; Fabre, "Traité encycl," Supp. B398.

The cochineal red used by Lumière was an anilin dye, prepared by the action of naphthionic acid on a naphthol-disulfonic acid, and was sold by several firms under various names, crocein scarlet 4BX, brilliant scarlet and S, brilliant ponceau 4R and 5R, ponceau LR, new coccin C, scarlet OOOO, see Schultz, "Farbstofftabellen," 1914, 62.

24. "La Photographie des Couleurs," Lyons, 1901; Bull. Soc. franç. Phot. 1901, **43**, 204, 303, 441; Photo-Rev. 1901, 121, 170, 182; Phot. Times, 1902, **34**, 544; Brit. J. Phot. 1901, **48**, 472, 644; 1902, **49**, 52; J. S. C. I. 1902, **21**, 275; Phot. Woch. 1901, **47**, 147; Phot. Mitt. 1901, **38**, 201, 247, 331, 344, 381; 1902, **39**, 44; Handbuch, 1903, **3**, 702; Phot. News, 1901, **45**, 794; Jahrbuch, 1902, **16**, 647; Fabre, "Traité encycl." Supp. C, 397.

25. "Die Dreifarbenphotographie," 1897, 137; 1902, 2nd edit. 165; 1912, 3rd edit. 196; Phot. Rund. 1899, **9**, 167; Brit. J. Phot. 1899, **46**, 470, 357; Jahrbuch, 1900, **14**, ·562; 1901, **15**, 272,545; 1902, **16**, 533.

26. Bull. Soc. franç. Phot. 1899, **41**, 306, 486, 538; Mon. Phot. 1889.

Sanger-Shepherd & Co. and the Lumière North American Co., London, introduced commercially such celluloid films with silver halide and dye content; the silver salts were removed with hypo and ferricyanide, then stained up and superimposed, Brit. J. Phot. 1902, **49**, 814. A. Hesekiel, Jahrbuch, 1901, **15**, 272; Phot. Korr. 1902, **49**, 485; Phot. Chron. 1900, **7**, 63, also placed such films on the market.

27. Bull. Soc. franç. Phot. 1905, **47**, 296.

28. Phot. Rund. 1902, **12**, 130; Phot. Mitt. 1902, **36**, 46; Phot. J. 1902, **42**, 181.

29. Photo-Rev. 1899, **11**, 52. Cf. C. Kaiserling, Phot. Mitt. 1901, **38**, 8, 26. H. Hinterberger, ibid. 1902, **39**, 53, 65.

30. La Nature, 1898, **26**, II, 170.

31. U.S.P. 624,837, 1899; Belg.P. 138,556; 138,557; 138,558; 138,559, 1898; E.P. 17,758, 1894; Photogram, 1896, **3**, 173; Brit. J. Phot. 1895, **42**, 526.

32. D.R.P. 61,051, 1891; Silbermann, 1, 237.

33. D.R.P. 113,982, 1898; Bull. Soc. franç. Phot. 1901, **43**, 371; Jahrbuch, 1900, **14**, 562; 1901, **15**, 287; Silbermann, 2, 231; Prometheus, 1899, 49; Phot. Rund. 1899, **10**, 365; Brit. J. Phot. 1900, **49**, 389. Cf. "Die Praxis der Farbenphotographie nach dem Dreifarbenphotographie."

34. E.P. 7,104, 1895; U.S.P. 604,269; Phot. Times, 1898, **30**, 336; Phot. Mitt. 1895, **32**, 162, 360, 389; Brit. J. Phot. 1896, **43**, 182; 1898, **45**, 625; F.P. 246,517, 1895; Brit. J. Almanac, 1897, 832; D.R.P. 101,132.

35. E.P. 4,290, 1899; Brit. J. Phot. 1900, **47**, Supp. 23; D.R.P. 117,134, 1898; Silbermann, 2, 370; U.S.P. 654,766, 1900; Photogram, 1900, **7**, 86; Phot. Rund. 1899, **10**, 92; Jahrbuch, 1900, **14**, 562.

36. E.P. 12,517, 1899; Brit. J. Phot. 1900, **47**, 540. It is an open question as to how far the reduced chromium compound acted as a mordant, and it is also further pointed out by E. König, "Die Dreifarbenphotographie," 1912, 198; König & Wall, "Natural-Color Photography," London, 1906, 57, that the great difficulty was to find dyes that would be thus mordanted.

37. E.P. 9,184, 1902.

38. Bull. Soc. franç. Phot. 1858, **1**, 213. R. E. Liesegang, "Der Kohledruck," 1884, 8; Handbuch, 1917, **4**, II, 57.

39. Phot. J. 1858, **5**, 84.

40. Phot. Notes, 1859, **4**, 331.

V. Blanchard, Jahrbuch, 1896, **10**, 531; 1897, **11**, 444, suggested the use of paraffin or vaselin to make the paper more transparent. W. Hall, Photography, 1909, 380; Jahrbuch, 1910, **24**, 536, also suggested printing through the paper and because of the darkening of the dichromated paper, advised painting the gelatin with the sensitizer. The Autotype Co. obtained D.R.P. 157,218, 1904; Phot. Mitt. 1905, **41**, 57; Jahrbuch, 1905, **19**, 455, for practically the same.

41. Bull. Soc. franç. Phot. 1867, **13**, 170, 227.

42. Ibid. 1864, **10**, 271; E.P. 2,954, 1863.

43. D.R.P. 66,730, 1891; Jahrbuch, 1892, **6**, 454; 1893, 7, 552; Phot. Woch. 1891, **37**, 406; Handbuch, 1917, **4**, II, 194; E.P. 18,827, 1891; Brit. J. Phot. 1892, **39**, 59.

44. D.R.P. 61,236, 1890; Silbermann, 1, 70. In this case the claim is for mica for gelatino-bromide films also, or light-sensitive films generally.

45. E.P. 13,093, 1902; F.P. 321,841. The Neue Phot. Gesellsch., Berlin, obtained D.R.P. 152,797, 1901; E.P. 925, 1904, for the same process, Krayn being in their employment; Phot. Korr. 1903, 40, 651, 680; Phot. Chron. 1905, 12, 20; Jahrbuch, 1905, 19, 454; Phot. News, 1906, 50, 1040; Brit. J. Phot. 1906, 53, 467; J. S. C. I., 1903, 22, 923.

J. Thacher Clarke, E.P. 11,254, 1893; Brit. J. Phot. 1893, 40, 332, also patented celluloid as a support for carbon tissue and printing through the back.

46. Phot. Korr. 1879, 25, 31.
Cf. Phot. News, 1881, 25, 259.

47. Jahrbuch, 1909, 23, 46.

48. Phot. Korr. 1889, 35, 406.

49. Ibid. 1893, 17, 173.

50. E.P. 13,093, 1902; D.R.P. 152,797, 1901; Silbermann, 1, 235; abst. Brit. J. Phot. 1907, 54, Col. Phot. Supp. 1, 80; J. S. C. I. 1903, 22, 923; Handbuch, 1917, 4, II, 195; Phot. News, 1906, 50, 1040; Belg.P. 150,329, 1900; Phot. Coul. 1908, 3, 124.

Similar films were introduced by the Rotary Phot. Co., London. Cf. E. J. Wall, Phot. J. 1906, 46, 144; Brit. J. Phot. 1906, 53, 195; 1907, 54, Col. Phot. Supp. 1, 9; E. Grills, ibid. 17. Also by the Neue Phot. Gesellsch., Berlin. H. O. Klein, Brit. J. Phot. 1905, 52, 768; Phot. Korr. 1905, 42, 518, 568. A. C. Braham, Phot. J. 1906, 46, 178; Brit. J. Phot. 1906, 53, 106, 566. R. Namias, VI Congress Internat. Chim. Applic. 1906, 6, 36; abst. Camera Craft, 1907, 14, 110; Brit. J. Phot. 1906, 53, 469; Phot. Kunst. 1906, 4, 345.

51. D.R.P. 154,539, 1903; Silbermann, 1, 236; F.P. 339,654.

52. E.P. 925, 1904; D.R.P. 160,665, 1903; Silbermann, 1, 237.

Rigaut & Pereire, F.P. 364,883, patented the superposition of constituent prints suitably dyed, obtained by the use of stripping silver emulsion films.

53. D.R.P. 162,807, 1904; Silbermann, 1, 238.

Hesekiel considered that one of the difficulties of stripping carbon tissue was due to the light penetrating right through the pigmented gelatin, thus rendering that in contact with the support insoluble; therefore, he patented the idea of giving the paper a preliminary coat of a non-actinic layer of gelatin, gum or the like.

54. U.S.P. 711,875, 1902; E.P. 17,485, 1902; F.P. 324,813; Can.P. 79,192; Belg.P. 165,082, 1902.

55. E.P. 17,610, 1904; Brit. J. Phot. 1906, 53, 469; Phot. Ind. 1904, 1062; Jahrbuch, 1905, 19, 455; Handbuch, 1917, 4, II, 195; J. S. C. I. 1904, 23, 998; F.P. 346,614.

56. E.P. 21,208, 1904; Brit. J. Phot. 1905, 52, 694; U.S.P. 778,947.

A. Carrara, Brit. J. Phot. 1914, 61, Col. Phot. Supp. 8, 48; Camera Craft, 1914, 21, 293, proposed a semi-alcoholic sensitizer for carbon tissue.

57. E.P. 18,741, 1906; Brit. J. Phot. 1907, 54, 603; D.R.P. 203,979, 1907; Chem. Ztg. Rep. 1908, 636; Jahrbuch, 1909, 23, 294; U.S.P. 879,445, 1908; Can.P. 105,737; F.P. 375,548; Belg.P. 198,467.

58. E.P. 23,615, 1907; Brit. J. Phot. 1909, 56, 163; U.S.P. 923,019; abst. C. A. 1909, 3, 1966; Belg.P. 213,633; F.P. 412,043. Cf. F.P. 400,581.

59. E.P. 23,273, 1908; Brit. J. Phot. 1910, 57, 163; Belg.P. 222,773.

60. E.P. 19,843, 1899; Brit. J. Phot. 1900, 47, 572; Belg.P. 145,210.

61. E.P. 28,920A, 1897; Brit. J. Phot. 1896, 43, 505,602; 1898, 45, 635,776, 783, 799; 1899, 46, 114, 190, 226, 290, 322; 1900, 47, 143, 159, 175; Phot. Rund. 1899, 10, 219; Jahrbuch, 1900, 14, 561; Nature, 1897, 44, 661.

62. E.P. 148,737, 1920; J. S. C. I. 1921, 40, 718A; Brit. J. Phot. 1920, 67, Col. Phot. Supp. 14, 44; Jahrbuch, 1915, 29, 162; Dan.P. 27,784.

63. D.R.P. 272,666, 1913; Phot. Ind. 1914; Phot. Chron. 1915, 22, 40; Phot. Korr. 1916, 53, 36; Jahrbuch, 1915, 29, 189.

Cf. K. Kamei, Jap.P. 38,113; abst. C. A. 1922, 16, 1915, for four-color process with dichromated gelatin with successive coatings.

64. F.P. 353,420; 355,385, 1905.

65. F.P. 460,362, 1913.

66. F.P. 361,976, 1905.

67. F.P. 326,298, 1902.

68. E.P. 21,281, 1909; Brit. J. Phot. 1910, 57, 310; Belg.P. 211,112, 1908. Cf. F. de Mare, Phot. Coul. 1911, 6, 246.

69. Belg.P. 209,468, 1908.

70. Belg.P. 212,155, 1908; Can.P. 130,292.

71. Belg.P. 215,338, 1909; Austr.P. 46,656, 1910; Jahrbuch, 1911, **25**, 632; 1912, **26**, 610.

72. Belg.P. 215,339, 1909.

73. Belg.P. 223, 732, 1910.

74. Belg.P. 224,641,1910.

75. Belg.P. 246,084, 1912.

76. Phot. Mitt. 1901, **34**, 468.

77. E.P. 26,608, 1910; Brit. J. Phot. 1911, **58**, 979. No patent granted.

78. Phot. News, 1906, **50**, 491.
Cf. H. Schmidt, Brit. J. Phot. 1906, **53**, 469. H. O. Klein, ibid. 1905, **52**, 768; Phot. Times, 1906, **38**, 125.

79. "Das photographisches Pigmentverfahren," 1892, 69; Phot. Mitt. 1891, **28**, 40; Handbuch, 1917, **4**, II, 177.

80. Brit. J. Phot. 1907, **54**, Col. Phot. Supp. **1**, 9, 35. The denatured alcohol or "methylated spirit" as it was called, was ethyl alcohol with 10 per cent methyl alcohol.

81. Ibid. 17.
J. Baumgartner, D.R.P. 20,966; Silbermann, **1**, 233, patented the superposition of two or more color pigmented films.

82. E.P. 25,646, 1910; Brit. J. Phot. 1911, **58**, Col Phot. Supp. **5**, 46; abst. 1917, **64**, Col. Phot. Supp. **17**, 18.

83. Brit. J. Phot. 1920, **67**, Col. Phot. Supp. **13**, 33.

84. Phot. J. 1917, **57**, 231; Brit. J. Phot, 1916, 63, Col. Phot. Supp. **10**, 26; Camera Craft, 1918, **25**, 157.
O. Muck and P. Gödrich, D.R.P. 396,611, 1923, also patented the use of a grey key print.

85. D.R.P. 238,198, 1911; Jahrbuch, 1912, **26**, 610.

86. D.R.P. 253,959, 1912.

87. E.P. 20,251, 1911; Brit. J. Phot. 1912, **59**, 979; abst. C. A. 1913, **6**, 966; F.P. 420,349, 1910; Belg.P. 231,668.

88. J. Cam. Club, London, 1894, **9**, 63.

89. U.S.P. 960,939, 1910; E.P. 21,410, 1909; Brit. J. Phot. 1911, **58**, 483; abst. J. S. C. I. 1910, **29**, 542.

90. U.S.P. 980,962, 1911.

91. E.P. 17,799, 1913; Brit. J. Phot. 1914, **61**, 679, Col. Phot. Supp. **7**, 32; ibid. **8**, 8; Phot. J. Amer. 1914, **50**, 499; U.S.P. 1,122,935; Can.P. 160,581; F.P. 461,078, granted to Hess-Ives Corp. U.S.P. 1,145,143; D.R.P. 305,752; Can.P. 160,273 is for the same, one patent being for the process and the other the result; Camera, 1915, **20**, 725.

92. E.P. 128, 1903; Brit. J. Phot. 1904, **51**, 1063; 1905, **52**, 902; 1906, **53**, 88, 853; U.S.P. 769,773, 1904; F.P. 328,228; Can.P. 85,455; Belg.P. 167,672.

93. U.S.P. 827,188, 1906; Jahrbuch, 1907, **21**, 436; Phot. Ind. 1906, 1191.

94. E.P. 131,319, 1916; Brit. J. Phot. 1920, **67**, 144, Col. Phot. Supp. **13**, 11; U.S.P. 1,248,139; abst. J. S. C. I. 1918, **37**, 75A; Jahrbuch, 1915, **29**, 169.

95. D.R.P. 360,633, 1921; Phot. Ind. 1923, 250. In D.R.P. 361,679 the use of a non-extensible support for each positive is claimed.

96. Photo-Rev. 1900, **12**, 73.

97. Zeits. wiss. Phot. 1923, **21**, 98; Brit. J. Phot. 1923, **70**, Col. Phot. Supp. **17**, 13; abst. Brit. J. Almanac, 1924, 376.

98. D.R.P. 367,928; abst. Phot. Ind. 1923, 180; Amer. Phot. 1923, **17**, 559.

99. E.P. 189,844; Brit. J. Phot. 1923, **70**, Col. Phot. Supp. **17**, 6, 29; Amer. Phot. 1923, **17**, 402; Sci. Tech. Ind. Phot. 1923, **3**, 194; Brit. J. Almanac, 1924, 372. Cf. A. H. Beardsley, Photo-Era, 1923, **51**, 30. J. W. Gannon, Camera Craft, 1923, **30**, 305; F.P. 552,630.

100. E.P. 190,424. Cf. U.S.P. 1,430,059; 1,430,060; 1,430,061; F.P. 533,633; D.R.P. 378,960; Brit. J. Phot. 1923, **70**, Col. Phot. Supp. **17**, 31; abst. Brit. J. Almanac, 1924, 369.

101. E.P. 198,745.

102. Brit. J. Phot. 1907, **54**, Col. Phot. Supp. **1**, 25; ibid. 1912, **59**, Col. Phot. Supp. **6**, 26.

103. Ibid. 1907, **54**, Col. Phot. Supp. **1**, 46.

104. F.P. 571,111, 1922; abst. Sci. Ind. Phot. 1924, **4**, 198.

105. Phot. J. 1873; Brit. J. Phot. 1873, **20**, 242; 1900, **47**, 709; Phot. Korr. 1873, **10**, 98; Jahrbuch, 1901, **15**, 682; Handbuch, 1917, **4**, II, 250.

106. E.P. 10,026, 1898; Brit. J. Phot. 1899, **46**, 198; Jahrbuch, 1900, **14**, 50; Phot. J. 1899, **39**, 218; 1903, **43**, 301; D.R.P. 117,829; Silbermann, **1**, 211; Amat. Phot. 1902, **39**, 218; "Ozotype," London, 1900; "Lessons in Ozotype," 1901; Jahrbuch, 1901, **15**, 235, 679; 1903, **17**, 533, 555; A. von Hübl, "Die Ozotypie," 1903. H. Quentin, "Le Procédé Ozotype," Paris, 1903. H. Hauberisser, Phot. Rund. 1901, **11**, 200. H. Kressler, Jahrbuch, 1901, **15**, 238. R. Blackmore, Brit. J. Phot. 1900, **47**, 777; Amat. Phot. 1902, **39**, 520; 1904, **44**, 177. For gum-ozotype see Manly, Amat. Phot. 1904, **44**, 177; Phot. Chron. 1903, **10**, 642. E. W. Foxlee, Phot. News, 1900, **37**, 814; Phot. Chron. 1903, **9**, 170; Jahrbuch, 1903, **17**, 560; Handbuch, 1917, **4**, II, 259. For notes on Ozobrome and three-color, Brit. J. Phot. 1906, **53**, 581. Cf. E. Engelken, "Ozo-Pinatype," Brit. J. Phot. 1909, **56**, Col. Phot. Supp. **3**, 36. On three-color bromoil transfers, G. Böhm, Photofreund, 1925, **5**, 59; Brit. J. Phot. 1925, **72**, Col. Phot. Supp. **19**, 21.

107. Phot. J. 1915, **55**, 266; 1919, **59**, 238; Brit. J. Phot. 1913, **60**, Col. Phot. Supp. **7**, 16; ibid. 1914, **61**, 13, 17: 1920, **67**, 740; abst. C. A. 1914, **8**, 1923. Cf. Brit. J. Phot. 1923, **70**, Col. Phot. Supp. **17**, 21.

For descriptions of working the Raydex process see: J. Brand, Brit. J. Phot. 1914, **61**, Col. Phot. Supp. **8**, 9; C. W. Piper, ibid. 5; W. Watmough, ibid. 8; H. W. Wright, ibid. 1; H. E. Rendall, ibid. 1917, **64**, ibid. **11**, 13; 1921, **15**, 21; Rendall and S. H. Manners, ibid. 1923, **17**, 25; abst. Brit. J. Phot. 1924, 370; V. P. Davis, Brit. J. Phot. 1915, **62**, Col. Phot. Supp. **9**, 1; 1917, ibid. **11**, 17, 25; H. J. Campbell, ibid. **16**, 1. J. C. Arch, Brit. J. Phot. 1924, **71**, Col. Phot. Supp. **18**, 8; abst. Brit. J. Almanac, 1925, 311.

108. Amer. Annual Phot. 1925, **39**, 92.

CHAPTER XII

SUBTRACTIVE PROCESSES—II

Various methods have been suggested for obtaining reliefs in colorless gelatin, which might be stained up for use as print-plates or matrices for transfer of dye to other surfaces, or for direct superposition, and these are grouped together.

Carbon Reliefs.—E. Sanger-Shepherd and O. M. Bartlett[1] (p. 360) produced reliefs by what is known as the carbon process, that is the insolubilizing of dichromated gelatin by light-action, and their specification is given in full: "Our invention relates to photographic printing and chiefly to the production of multi-color prints upon plain paper or surface. We have found by experiment that when a hardened gelatin relief or film with a selective absorption is stained with an anilin or other suitable dyestuff and placed in contact with a dampened surface of gelatin softer than that of the relief or film, the coloring matter will be absorbed by the softer gelatin, the color forming a perfect image of the colored gradations.

"In a suitable method of applying this discovery to the production of color prints upon paper from three color record negatives we prepare a positive from each negative as follows, that is to say, we coat a sheet of thin celluloid or other suitable support with a film of gelatin sensitized with a dichromate salt after the manner well known in producing carbon prints. The dried film is exposed to light under the negative through the support and subsequently developed with warm water. In order to keep the relief as low as possible it is desirable to add a coloring matter or preferably bromide of silver to the gelatin solution, as the latter may be easily removed after printing, by a solution of hyposulfite of sodium.

"The resulting low reliefs in soluble gelatin are next stained up in dye-baths of greenish-blue, pink and yellow respectively. In order to combine the colored impressions corresponding to the reliefs upon one surface such as a sheet of paper, opal, glass or the like, the said surface, previously coated with a film of soft gelatin, is wetted and the reliefs are successively laid upon it in proper register, each relief being allowed to remain for sufficient time for the color to be absorbed by the softer gelatin. It is to be understood that the reliefs may be repeatedly re-dyed according to the number of prints to be produced. Instead of transferring a greenish-blue dye to the surface of a print, the desired greenish-blue color may be produced by any of the ferroprussiate processes and the pink and yellow prints laid down upon the support by the method above described. It will be clear that our process is applicable, not only to multi-color prints

or reproductions as above described, but also to monochrome reproductions."

It will be noted that the inventors claim the exposure of the film through the support, and disclose the use of a non-actinic dye, or silver bromide, as additions to keep the relief as low as possible. The former having been used by du Hauron, and both the dye and silver halide by Lumière. In practice a cyanotype image was used for the blue constituent image.

J. H. Smith and W. Merckens[2] applied the principle of the wandering of dyes to the production of prints; but used a carbon relief as the dye carrier, the final support being coated with collodion to which the dyes transferred.

F. E. Ives[3] also patented a carbon relief process for imbibition, with exposure through the support, the incorporation of a non-actinic dye in the dichromated gelatin, and he specifically claims the use of mordanted paper, that is paper coated with gelatin insoluble in boiling water. He further preferred to apply the dye carrier to the final support with both in a dry condition, and then to apply moisture by means of blotting paper saturated with water, and pressure. A later patent[4] was also granted for the print thus produced. Another patent[5] was for imbibition with an acid dye, having no special affinity for gelatin and transferring the dye to a mordanted gelatin coating. The control of the quantity of dye absorbed by the relief was also claimed by the addition of potassium citrate with acetic acid to the dye solution; though the nature of the control salt varied with the nature of the dye, potassium ferrocyanide, sodium acetate or bicarbonate being mentioned. A temporarily separating means might be used to prevent the smearing of the dye during registration of the images, and this might be a film of acidulated water, or a film of non-absorbent collodion; this latter recalling the thin celluloid used for the same purpose in the pinatype process. It was finally claimed to varnish the pictures with amyl acetate collodion.

F. J. Ventujol[6] patented the incorporation of inert powders, such as carbon, chalk, etc. in dichromated gelatin for relief plates, claiming thus to obtain far better transfer of the dyes.

Relief Processes—Dichromate.—The production of reliefs by the action of light upon dichromated gelatin and subsequent treatment with hot water has already been dealt with, and in this section it is proposed to deal with those chemical processes for obtaining the same results, and in which light plays no part as the relief-producing agent.

E. Howard Farmer[7] proposed to treat developed silver images with dichromate, which he had discovered acted upon the gelatin in situ with the silver, and hardened it just as though light had reduced the dichromate. Later he ascribed this action to the catalytic action of the finely divided silver in the presence of gelatin and a soluble dichromate. The dichromate is

reduced and the gelatin by combination with the reduced salt is converted into the insoluble chromated form. The silver itself does not undergo any change. The simplest manner, he suggested, of observing this action "is to immerse a plate or film with a silver image in a dichromate solution, when if the strength be fairly concentrated, about 20 per cent, the action is practically instantaneous. A more convenient means consists in preparing gelatino-bromide plates, in which the gelatin is retained in a soluble form, and developing the images with ferrous oxalate.[8] On placing the plates for a few seconds into a 20 per cent solution of ammonium dichromate, the gelatin, where it is in contact with the reduced silver, becomes insoluble, and the image after washing presents the same relief as exposed carbon prints do when immersed in water. The chromated images obtained in this way exhibit the same properties as chromated images formed by the action of light upon dichromated gelatin. Thus, after drying and rewetting can be squeegeed to insoluble surfaces and developed with hot water, as is customary with carbon or Woodburytype reliefs, and the results have the well-defined sharpness so characteristic of the latter process. Further by heating the films, as is customary in the collotype process, similarly reticulated surfaces are obtained on immersion in cold water. These examples are sufficient to show that in the reaction I have just described we are afforded the means of obtaining for the chromium process the high degree of sensitiveness hitherto only obtainable with the gelatino-bromide process."

Eder[9] considered that the catalytic explanation was not satisfactory, as the metallic silver is changed for the most part, as chromic acid and dichromates convert it into chromate, the acid and the salt being converted into chromium oxide, and he gave the following equation as explanatory:

$$6Ag + 5CrO_3 + 3H_2O = 3Ag_2CrO_4 + Cr_2(OH)_6$$

This equation is only schematic, and in the presence of dichromate the reaction may be represented as follows:

$$6Ag + 5K_2Cr_2O_7 + 3H_2O = 3Ag_2CrO_4 + Cr_2(OH)_6 + 5K_2CrO_4$$

in both cases the metallic silver is attacked and the chromic acid converted into the tanning chromium oxide, which in the presence of further chromic acid passes into the chromate of chromium, $Cr_2O_3.CrO_3$.

This explanation can not be accepted as representative, for although dichromate disassociates into chromic acid, there does not seem to be any marked action with a pure dichromate solution on the silver. If the silver were converted into chromate, it should be markedly changed and probably soluble in excess of the salt, which is not the case.

Eder stated that this principle is involved in all tanning processes, even with ferricyanides and cupric chloride and chromates, as in bromoil, ozobrome, etc. It is immaterial whether the dichromate is applied to the silver image before or after fixing, and the image almost disappears in these

chromic acid baths. This certainly is not the case with plain dichromate baths.

A much more feasible explanation was given by R. Namias.[10] The insolubilization of the gelatin may be produced by the substitution of compounds for the metallic silver, or by the secondary reactions that accompany that change. Thus, in the conversion to the silver chromate or ferrocyanide, particularly with the deposition of other metallic ferrocyanides, uranium, iron, copper, etc., in situ with the silver, the copper ferrocyanide tans the gelatin the most. The best method of tanning the gelatin is to produce a secondary reaction, as by reducing chromic acid to a lower oxide of chromium, and the simplest way is to allow chromic acid to act on silver, when silver chromate is formed and hydrogen set free, according to the equation:

$$6Ag + 3H_2CrO_4 = 3Ag_2CrO_4 + 6H$$

The hydrogen reduces the excess of acid to chromium oxide, which in the presence of chromic acid, becomes chromate of chromium, and it is this salt that is the active agent in producing insolubilization:

$$3H + 2H_2CrO_4 = 5H_2O + Cr_2O_3$$

The disadvantage of using chromic acid is that it not only suffers reduction locally, but also generally, so that the gelatin not in contact with the silver may become hardened, even if only to a small extent. Namias positively states that the chromic acid in combination with the dichromate can not attack the silver.

It is unnecessary to enter into the experiments in detail, but Namias came to the conclusion that the best insolubilizer was a 0.5 per cent solution of chromic acid, to which 2 per cent of potassium bromide was added. The dichromate does not produce the same effect as the acid, for it has no tendency to decompose into chromic acid and neutral chromate. Namias ignores here obviously any disassociation. If a solution of dichromate and bromide is only faintly acidulated with sulfuric acid, the action is the same as if free chromic acid were used, and the silver image is rapidly bleached:

$$6Ag + 5H_2CrO_4 + 6KBr = 6AgBr + 3K_2CrO_4 + 5H_2O$$

The gelatin in situ with the silver is then so hardened that the film may be placed in boiling water without any harm, and the image will withstand a fairly energetic friction.

The effect with a sulfide-toned image is greater still, because the sulfide is first converted into sulfate and then into bromide and there would be a greater quantity of chromium oxide set free:

$$3Ag_2S + 8H_2CrO_4 = 3Ag_2SO_4 + 4Cr_2O_3 + 8H_2O$$

For years this valuable property of the dichromates appears to have lain dormant, and so far as the author is aware no practical application of

Farmer's own patent was made. W. Riebensahm and Posseldt[11] after re-
ferring to Farmer's work, which as they say gives no pigment images,
merely the relief, proposed to incorporate the pigment itself with the
gelatino-bromide emulsion. The paper was to be exposed like bromide
paper and developed in the usual way, then fixed or unfixed, immersed for
10 or 15 minutes in a 5 per cent solution of potassium dichromate, then
repeatedly washed and the last traces of dichromate removed by ammonia
or soda, and the print then treated as an ordinary carbon print, that is, it
was transferred to another support and developed with warm water. As
the presence of the black silver gave but dark colors it could be removed by
any solvent. The inventors stated: "Das Verfahren ist auch verwendbar
zur Herstellung von Bildern in natürlichen Farben, indem nach dem Prin-
zip des Dreifarbendrucks Bilder in den drei Grundfarben herstellt und bei
der zweiten Uebertragung aufeinanderklebt." Anglicized: the process
is also applicable to the preparation of pictures in natural colors, as, accord-
ing to the principle of three-color printing, pictures in the three funda-
mental colors are prepared and superposed in the second transfer.

The same inventors[12] pointed out that in the above process the sensi-
tiveness of the bromide emulsion was considerably lowered, presumably by
the screening action of the pigment, therefore, they proposed to overcome
this difficulty by color-sensitizing the mixture with eosin, erythrosin and
other dyes.

The Neue Photographische Gesellschaft[13] claimed the addition of a
hardening agent, such as aluminum chloride, to the dichromate bath. The
Plastographische Gesellschaft Pietzner & Co.[14] referred to Pretsch's early
work and patent, and the use of silver salts to shorten the exposure with
dichromated gelatin, and stated that a slight alteration increased the speed
from 10 to 20 times, and this was apparently obtained by ripening the silver
salt. A similar paper was introduced in England by the Rotary Photo-
graphic Co. under the name "Carbograph," although so far as the author
is aware tri-color paper was not introduced.[15]

J. Mezaros[16] patented a process for preparing pictures in monochrome,
polychrome or natural colors. Printing plates with a silver salt, or an
emulsion of the same, were treated according to Farmer's process. Ordi-
nary silver chloride or bromide emulsion could be used, and the positives
made in the usual way, great stress being laid on thorough washing after
development and fixation. The chromate necessary for the preparation
of the pigment images was added afterward to the gelatin, and not used as
a sensitizer. The silver image was immersed in a solution of alkaline
dichromate, or other salt for 3 to 5 minutes. It being necessary to fix the
chromic acid in the film, which had been absorbed by the film, in propor-
tion to the shadows of the image, the plate was immersed in a solution
which could dissolve the metal of the image, whilst at the same time the
chromic acid precipitated the metal in the form of an insoluble chromate.

For this purpose the plate was immersed after the chromic acid bath in a 2 or 3 per cent solution of nitric acid, or these might be mixed.

F. E. Ives[17] patented a method of producing multi-color pictures by "desolubilizing" gelatin in situ with silver, utilizing the action of chromic acid. A normal silver transparency on a transparent support, such as glass or celluloid, was used and the emulsion predyed with a yellow dye, such as tartrazin, to prevent the too deep penetration of the light.[18] The exposure was made through the support, as would obviously be necessary, otherwise one would have precisely the same condition of affairs as in the early days of the carbon process, and the loss of the half tones. A non-tanning developer was recommended and the positive treated with:

Ammonium dichromate.......................... 6.8 g.
Potassium bromide............................. 6.8 g.
Sulfuric acid................................. 6.5 g.
Water1000 ccs.

The acid was said to be an advantage as the desolubilizing was seen to be accompanied by a bleaching of the image. The film was then treated with hot water, as in the carbon process so as to form a relief which contained silver bromide that could be dissolved. The particular dyes recommended for staining up the reliefs were: Bayer's alizarin blue AS; equal parts Bayer's alizarin rubinol R and rubinol 3G, and Bayer's sulphon yellow. To make a paper print the blue constituent was made on bromide paper and converted into a cyanotype image as usual, then fixed in an alkaline hypo bath, rinsed and placed in a strong oxalic acid bath and the other reliefs superimposed.

It may be noted here that this particular tanning bath gives rather strong contrasts, and has a tendency to eat out the finest details, and Namias' bath has in the author's hands given better results.

There are, of course, all possible variations to be rung on this bath, and it will be found that slight variations of contrast are thus possible; a few experiments will soon show these. It should be noted, however, that Ives' bath on standing, particularly in the light, develops free bromine and that this may have a prejudicial effect, as it tans gelatin. It is obvious that another halide, such as salt may be used, then this subsidiary action is not to be so much feared, or the solutions can be mixed just before use.

W. Braun[19] patented the production of a positive gelatin relief by treating a negative with a bromoil bleach, which as is well known consists of a mixture of ferricyanide, dichromate and copper sulfate. After this treatment the still soluble gelatin, that where there was no silver, was to be dissolved with hot water.

P. Schrott[20] patented a method of transforming a silver image into a tanned gelatin one by hardening the gelatin in situ with the silver by first treating with cupric bromide or chloride, or a ferricyanide, to obtain a

metallic image, which acts as a reducing agent for the dichromate, and then the latter was applied. A yellow image should be formed, indicative that the tanning was complete. The metallic image could be dissolved out by acid, leaving a clear tanned gelatin image, which can be dyed up or a greasy coloring matter applied and printed from.

T. P. Middleton[21] patented a transfer process in which a developed silver image was transferred and treated with a bromoil bleach, then developed with warm water. Later[22] he proposed to coat baryta paper with a soluble film of soft gelatin and sugar and on this a halide emulsion. After development the gelatin was hardened in situ with the silver by chromic acid and bromide and the print treated like carbon tissue.

Relief Processes—Developed.—Probably the inception of the idea of obtaining relief images by development is contained in J. W. Swan's patent[23] for producing photo-relief plates, in which development preferably with pyro-ammonia was described, and the plate placed in warm water, when the parts unacted upon by light, swelled up.

But L. Warnerke[24] protected a process for "the production of negatives and transparencies where the parts unacted upon by light and development are dissolved away." For the film, colloids like gelatin or dextrin might be used and could be supported on paper, etc. The sensitive salt might be produced by the emulsion or bath process and exposure be in the camera or otherwise. The developer was pyro-ammonia; the images might be fixed or not; but in the whole treatment care must be taken that no substances, such as alum, are used that would produce general insolubility of the film. When dry the picture was placed in contact with glass, and plunged into warm water, when that part of the film bearing no image was dissolved. The image would be reversed, but that could be overcome by transfer paper. Enlargements might be produced on paper, canvas, etc., and insoluble pigments might be added to the emulsion if desired.

It will be noted that Warnerke's developer contained no sulfite, and the reason for this was that he desired to obtain the full effect of the tanning of the oxidized pyrogallol. This naturally leads to the conclusion that if the oxidation of the developing agent is more or less prevented, then we shall have a lower or higher relief. Silbermann[25] pointed this out and said: "It is well known that in the development of negatives there appears a more or less marked relief formation, which among other things depends upon the developer. Pyrogallol, eikonogen, hydroquinon and amidol give a strong relief; metol and di-aminophenol a low one and glycin and rodinal practically none. Even if in the constitution of the developing agents there is to be found no regularity it can be determined that p-aminophenol is not suitable for relief formation, and it may be stated that the acid developers especially, and their oxidation products can exert to a different degree a tanning action on gelatin. That the insolubility of the gelatin is dependent on an oxidation process is also clear in that the

presence of sulfite is prejudicial to the formation of the relief." Obviously then we have in the use of more or less sulfite the power to control the relief.

From the author's experiments it seems immaterial whether ammonia or one of the fixed alkalis be used, though the latter are preferable for color work, as they give more uniform results than the volatile ammonia. The actual composition of the developing solution seems also to be of no particular moment, only such good results have never been obtained with any reducing agent as with pyrogallol.

There are one or two points to which attention should be directed. One is that the total omission of sulfite is apt to give a superficial skin of insolubilized gelatin, that may later give a little trouble. The second and more important point is the absence of fog. Fog is metallic silver, and as the deposition of silver is accompanied by insolubilization of the gelatin, it is clear that a foggy result will not develop into so good a relief as a plate that is clean. Therefore, it is advisable to use a fair amount of bromide in the developer and to allow for this in the exposure, as it is well known that bromide slows the plate, to use a current phrase.

In this process we again meet with the old trouble of loss of half tone if the exposure is made from the front, therefore, exposure must be made through the support, or by projection printing. Films are preferable for this work and then contact printing through the back does not as a rule give sufficient want of sharpness to be troublesome. If the relief must be kept very low, then the old expedient of staining the emulsion with a dye can be used, and tartrazin, naphthol yellow or similar acid dye can be adopted; basic dyes are of no value as they are not absorbed by gelatin. Some dyes act as desensitizers or even slightly increase the sensitiveness, but the above two and thiazol yellow are very suitable. In the choice of the dye it must be borne in mind that its ready washing-out from the relief is advantageous, though but little trouble need be anticipated from this, as even if it does not wash out the only effect will be to make the blues a little more greenish and the red slightly more orange, which is an advantage in many cases. If glass plates are used one has to contend with the thickness of the glass and one ought to print by parallel light, which entails the rigging up of a light-source at the equivalent focus of a lens, or a Mazda lamp behind an opal glass may be used to ensure even illumination.

When using films as the positive material there is little trouble with small work, and the simplest arrangement is to place the lamp at the bottom of a box, about 4 feet deep, or of convenient height, and to limit the light to a round disk of opal glass of about 1 inch diameter. This answers perfectly without any parallelizer, but for anything over quarter plate or 4x5, a parallel light is better.

It is the author's experience that it is better to develop the relief before

fixing the plate. It should be rapidly rinsed with water to stop development and immediately plunged into water at about 40° C., and the soluble gelatin and bromide will be seen to wash away. The fact that the film has not been fixed enables one to judge of the progress of development of the relief, and this can be stopped as soon as all the details in the high lights are seen. It should be noted that it is very easy to carry the process too far and lose detail, as this is often so fine that there is not sufficient tanning of the gelatin to enable it to withstand rough treatment with hot water. As soon as the relief is sufficiently developed the film can be immersed in a plain or acid fixing bath; but chrome alum baths occasionally give rise to a little trouble in the subsequent dyeing up. The dyes to be used require but little comment, as one would naturally use those generally employed in color work.

There is one point in connection with the staining up which has received but little attention, and yet it is by no means unimportant, and that is the limiting absorption of the dye. There is, as has been pointed out when dealing with filters, a certain point beyond which no increase of dye will give increase of absorption. Many writers and patentees have laid great stress on keeping the reliefs low, totally disregarding this law. The height of the relief may be so great that one comes to the limiting absorption of the dye, and this is best seen with H and D strips. Supposing, for instance, that one has a strip showing all nine sectors clearly and a gamma of about 1.5, then in printing one may have all these showing in the silver image. But in the relief, though one may be able to detect these, in dyeing it will be seen that only six can be differentiated, the three highest being all the same depth of color visually, and no amount of staining will show more. This effect varies with the dye, and it is impossible to state which dye will and which will not show this effect, and one must experiment till the result is correct. In the face of this fact the actual increase of the height of the reliefs is not of such moment, nor is it in practical work so important a defect, because as a rule if the dyes are properly chosen, the dye absorption is sufficient to give correct color rendering.

Frequently it may be found that whilst the high lights and half tones are perfect in coloring, the deep shadows, which should be black, are more or less tinged with color, and the most common fault is for them to be more or less violet or reddish. This is not the fault of the process, but of the dye selection and is generally due to two of the dyes, the red and the blue being unsuitable, both having a band of transmission in the red or violet or both. This defect does not makes its appearance so much with three-color as with two-color work, and then other dyes must be tested, or a mixture used so as to fill up this gap.

R. E. Liesegang[26] reported that a gelatino-bromide plate exposed for a short time and developed with pyro-soda, without sulfite, showed a well-marked relief and grain both as regards the reduced silver and the accom-

panying precipitated organic matter. Similar plates not underexposed and developed in the same way showed a very fine grain, and it seemed probable that the granularity was the result of the prolonged action of the alkali during the slow development.

A. Haddon and J. Grundy[27] found that pyro solution had no tanning action on gelatin, but when the pyro was oxidized and had become brown, it exerted a marked tanning action, and the gelatin became quite insoluble in hot water. After exposure to air glycin and rodinal (paraminophenol) did not affect the temperature at which gelatin dissolved in water; metol and paraminophenol raised the temperature; pyrogallol, hydroquinon, eikonogen and amidol made the gelatin insoluble in boiling water. It was found that glycin and rodinal were oxidized by bromine or some other agents and the products tanned gelatin thoroughly, and the conclusion was that glycin and rodinal were not oxidized by air. When large proportions of sulfite are used in the developer the organic compound is very little oxidized, the gelatin is left soluble and the relief of the image is very small. An image in high relief is only formed under conditions which permit of the oxidation of the developer at the points at which it reduces the silver bromide, the tanning being effected by the oxidation products.

J. H. Christensen[28] would produce hardened reliefs by preventing the gelatin soaking up liquid and swelling to any important degree during development, by the addition of large quantities of substances, which counteract swelling, such as alcohol or large quantities of salts of the polybasic acids, like the carbonates and silicates. These were added to the developer in such large quantities that the leathery consistence of the gelatin was preserved during development. Typical formulas are the following:

Pyrocatechin 5 g.
Potassium carbonate 20 g.
Alcohol 750 ccs.
Water 250 ccs.

Or the alcohol might be omitted and then the carbonate must be increased to 400 or 500 g. A good developer for fine grain plates is:

Pyrocatechin 10 g.
Potassium carbonate 500 g.
Alcohol 200 ccs.
Potassium bromide 30 g.
Water 1000 ccs.

After development the plate must be fixed and it was said that it behaved like a dichromate-hardened plate, that is to say, the non-hardened parts might be washed away with hot water. Chlorobromide plates are specially suitable for this purpose, and are adapted for printing plates for tri-color work, and a colored transparency might be made from an Autochrome by means of three plates, sensitized with pinachrom, etc. Films might be used and have perforations for registration. It would seem that the real essence of this patent lies in the use of a small quantity of reducing

agent, without sulfite, which is, therefore, thoroughly oxidized during the slow development caused by the additions, which would prevent the rapid diffusion of the solution into the gelatin.

G. Koppmann[29] patented the use of pyrocatechin without sulfite, and subsequent treatment with hot water to obtain a relief; the positive being exposed through the support. Or the first exposed image might be developed with a non-tanning developer, and then the unreduced silver halide exposed and developed with a tanning developer. On treatment with hot water the primary image and gelatin would be dissolved. The use of a non-actinic dye is indicated to prevent over-exposure. Films coated with emulsion poor in silver were stated to give the best results. The reliefs might be used for transparencies or the imbibition process.

The Aktiengesellschaft für Anilinfabrikation[30] patented the formation of reliefs by the tanning action of developers, such as pyrocatechin, adurol, pyro and pyro-metol without or with sulfite. R. John[31] patented the use of a relief, obtained by development with a tanning developer, composed of pyro-metol with a small quantity of sulfite, as a print-plate. The so-called neutralizing action of the sulfite is claimed and the removal of the unhardened gelatin with hot water. "The most important of the novel characteristics is a printing or reducing surface comprising granules or great numbers of photographically formed, extremely minute, individual protuberances which are distributed and grouped irregularly to represent photographic lights and shades." It is needless to point out that this description would apply to any relief obtained by development, as the "individual protuberances" are merely the particles of hardened gelatin. The same inventor[32] patented the production of a non-reticulated printing plate by the use of a gelatin film, treated with formaldehyde and sensitized with dichromate. A light-restraining dye, such as erythrosin, was indicated. After exposure and washing, the plate was to be treated to an alcoholic bath, then heated to approximately 205° C. This was stated to give a non-reticulated film, which can be used for offset, etc., by the use of a dot image.

The Daylight Film Corporation[33] also patented the same developer as John, and there is disclosed the use of a bleach and fixing bath composed of:

Cupric sulfate 125 g.
Ammonia 100 ccs.
Water1000 ccs.

Which was to be mixed with three volumes of 12.5 per cent solution of hypo. Hardening of the gelatin by means of dichromate acidified with sulfuric acid, is also disclosed, and various chlorizing and bromizing baths of well-known composition. The use of a dye in the emulsion to restrain the height of the reliefs, or the use of a light complementary to the natural color of the emulsion, thus a methyl violet filter, is pointed out.

The solvent action of solutions of cupric hyposulfite on silver images was pointed out by Carey Lea[34] and the use of an ammoniacal solution by Howard Farmer[35]. It was also well known in France, where it is termed eau Celeste[36]. It was also dealt with by W. J. Smith[37] who recommended it for photo-mechanical work in lieu of potassium ferricyanide and hypo during the war, because of the high price of ferricyanide. Welborne Piper[38] also wrote on its use.

The use of acidified dichromate baths has already been dealt with. The same inventors patented[39] the addition of 0.5 to 2.5 per cent of potassium iodide to the developer to obtain soft results.

The use of a soluble iodide in the developer was first suggested by Carey Lea[40] and he pointed out that the image was flatter. This was confirmed by J. Szekely,[41] F. Wilde,[42] F. Cousin,[43] A. Lainer,[44] von Hübl,[45] and Lüppo-Cramer.[46]

F. C. Rockwell[47] patented a film with relief images which might be produced by hand, moulding or a photographic process and which might be colored. L. T. Troland[48] patented a developer of the following composition:

Pyrogallol	8.2 g.
Citric acid	0.2 g.
Potassium bromide	4.0 g.
Sodium hydroxide	3.4 g.
Ammonium chloride	1.7 g.
Water	1000 ccs.

The caustic soda and ammonium chloride reacted to form ammonia and sodium chloride. It was stated that this had no tendency to general hardening of the film and the relief was much firmer and more sharply defined than with a sulfite-containing ordinary pyro-ammonia developer. Obviously this is nothing more than Warnerke's original developer when it acts. The setting free of ammonia from a halide by a caustic alkali has been known for many years, probably 30 or 40.[49]

Relief Processes—Etching.— R. E. Liesegang[50] stated that a concentrated solution of ammonium persulfate so acted upon gelatin, in which finely divided silver was imbedded, that the gelatin was subsequently soluble in hot water, but the process was a little uncertain in action. This action was observed with both gelatino-bromide and chloride prints and bleaching took place, and on placing the prints in warm water and passing the hand over them the exposed parts were eaten away, and there was thus formed a relief. J. Waterhouse[51] informed Liesegang that he had made repeated trials of this process and failed, and the latter had the same experience also. It was found that a fresh solution was useless and it was preferable to allow a saturated solution to ripen in the air for a fortnight. If too old the whole film might dissolve. The negative must not be intensified and better results were obtained from under-exposed plates developed with a non-staining developer. Liesegang recommended the use of paper

negatives for this purpose and stated that the reliefs could be stained up for making color pictures.

M. Andresen[52] improved on this method by using hydrogen peroxide, and he pointed out the shadow-reducing action of this liquid, and said "by the action of hydrogen peroxide on the silver image produced in gelatin, the densest parts are attacked first, and in such a way that from the surface of the film there appears a gradual dissolving of the silver with the gelatin in which the silver particles are imbedded." It was pointed out that images thus treated showed a marked relief, and that a 3 per cent solution of peroxide plus 2 per cent of hydrochloric acid should be used. If there were somewhat large surfaces with great density it was advisable to harden the plate by preliminary soaking in alum solution.

E. Coustet[53] recommended developing with ferrous oxalate and treatment of the negative with ammonium or potassium persulfate till the image bleached, then gentle friction with a brush would remove the gelatin and immersion in an alum bath and drying, with subsequent immersion in a dye bath and the transfer of the dye to gelatinized paper. H. Schnauss[54] called attention to Coustet's process and stated that plates exposed in the camera might be thus at once converted into printing plates for color photography. The process was based on the well-known action of hydrogen peroxide, of the persulfates and other oxidizers of attacking the densest parts of the image, while the unreduced parts were unaffected. There was thus obtained a relief in which the high lights were etched and the shadows in relief. Coustet discovered a method of effecting this in a few minutes and called the solution "Bioxhydre." The relief image was bathed in dye solution, and the gelatin absorbed the dye according to its thickness, and yielded the dye to gelatinized paper. According to Valenta[55] the solution used was hydrogen peroxide.

The author experimented with this process in 1910 and found better results were obtainable with the addition of small quantities of cupric chloride. In the meantime, however, E. Belin and C. Drouillard[56] applied for a patent, which was published in 1911, in which they recite the prior state of the art and the difficulties that had been met with, and that the action of the peroxide varied with the temperature. They assumed that better results would be secured if a rise in temperature could be induced in the molecule itself by the oxidation of the silver, and the solution they adopted was:

Hydrogen peroxide 12.5 ccs.
Cupric sulfate 50 g.
Nitric acid 0.06 ccs.
Potassium bromide 0.02 g.
Water ..1000 ccs.

Any developer could be used, provided that the oxidation products did not tan gelatin in the reduced parts. It was suggested that the reliefs

thus obtained might be used for printing by various photomechanical processes and for tri-color photogravure.

H. Lüppo-Cramer[57] dealt with this subject and called attention to the fact that the silver itself was not attacked when hydrogen peroxide alone was used. The addition of bromine or iodine salts considerably hastened the action and in such a way that a practical use of the reaction could be produced for the formation of reliefs. As the action between silver and the peroxide was examined it was found that the silver acted catalytically, in exactly the same way as iron or cupric chloride. According to Lüppo-Cramer's ideas, there is formed in the decomposition of the peroxide, oxygen in a highly disperse form, and because of this and the protective action of the finely divided silver, it had an unusually strong oxidizing action on the gelatin. The catalytic action is adversely influenced if the silver goes into solution at the limiting surfaces of the gelatin, even if only in traces. This solution of the silver is prevented by the halogen ions and these are indirectly the cause of assisting the velocity of the catalytic liquefaction of the gelatin.

Strips of glass plates were coated with colloidal silver-gelatin, and immersed in test tubes filled with the following solutions: (a) 20 ccs. of 3 per cent peroxide solution plus 1 ccs. of 50 per cent sulfuric acid; (b) the same solution with a few drops of 10 per cent silver nitrate; (c) solution (a) mixed with a few drops of 10 per cent potassium bromide. While the addition of the silver nitrate produced a strong acceleration of the dissolution of the silver and decoloration; in (c) the decoloration of the brown silver-gelatin did not take place at first; but there appeared in approximately 5 minutes a liquefaction of the gelatin so that not only the plate but the whole solution became brown. Only after the film was dissolved did there appear a conversion of the yellow silver into white silver bromide. This experiment shows that the addition of bromide retards solution of the silver, but accelerates that of the gelatin.

The author's experiments with this process shows that it is one well worth the attention of color workers. It is, of course, obvious that, as with all other relief processes, great changes may be rung on the composition of the etch to suit individual requirements. But it must be recognized that Lüppo-Cramer's deductions hold good, and, therefore, the acceleration of the etching is easily under control. It is clearly an inverse process, that is to say, as it is the dense parts that are etched, one must use a negative to obtain a positive relief. For this very reason the process seems to be more suitable for the amateur, who desires to make either superimposed film pictures or imbibition prints. The dense parts of the image being eaten away there is left a relief that corresponds to the negative, in that it is a positive in gelatin, which will take dye in exact ratio to the quantity of gelatin present. This dye image can be used as one of

the constituent images of superposed transparencies or it may be used as a print-plate from which any number of proofs can be pulled. Thus actually, if one wishes to use the original negative, it does away with the trouble of making a transparency and print-plate, as in the pinatype process. It may be advanced, and rightly, that one thus destroys the original negative, and it might be thought that this limits the process; but as a matter of fact, if one has dyed up the original negative, it can be used for making other negatives, if they are wanted, by copying in the camera through a complementary color filter.

The gelatin being dissolved where there was silver one has a relief which is never quite free from silver halide, and the plate or film should be fixed in a chrome alum fixing bath, and after washing, treated with a 5 per cent solution of formaldehyde and dried. This treatment removes the last trace of silver and leaves a colorless relief that would be invisible were it not for the slight turbidity of the gelatin. As each individual grain or particle of the image is surrounded by gelatin there is left a pitted film, each small particle of silver leaving a little crater or hollow, but these are of no moment either in superposed prints or imbibition.

It may happen that reticulation of the gelatin will make its appearance, though this is only occasionally noticeable and usually disappears after the relief has been treated with formaldehyde and dried. This last treatment is not actually necessary, but it hardens the gelatin and certainly in some cases conduces to better dyeing up. The main trouble, and this only appears when working with glass plates, is that with the greater densities, the film may strip, and this is obviously due to the silver deposit being so close to the glass that the etching action loosens the adherence of the gelatin, but this can be overcome by the use of an alum bath prior to etching. There is, as will have been gathered, no hot water treatment, with films there is, therefore, much less chance of distortion through expansion and contraction of the base, so that superposition of the constituent images is as easy as with glass.

Riebensahm and Posseldt[58] applied the peroxide etch process to silver-pigment printing. They coated the compound emulsion on paper or celluloid; in the latter case it might be exposed through the support. Development was effected in the usual way and the prints fixed in a hypo bath, with bisulfite. After washing the proofs were immersed in a saturated solution of alum for 5 minutes and then treated with peroxide. The silver emulsion should contain about 7 per cent of gelatin and 5 per cent of silver bromide. The pigment emulsion should contain, for instance, dry alizarin lake, rubbed up with about double its weight of glycerol, and some gum arabic; and of this paste about 100 g. should be mixed with 130 g. of gelatin and dissolved in four times the quantity of water. To this fluid mixture should be added 2000 g. of silver bromide emulsion. A variation of this process was to develop the exposed paper, remove the

metallic silver by known means, then expose the remaining silver bromide, develop and treat with peroxide or persulfate.

The Mimosa Aktiengesellschaft and E. Loening[59] patented the production of laterally reversed images and after the usual development, etching the image with acidulated persulfate or peroxide, then converting the unexposed, undeveloped salts into silver sulfide or dyeing up. This process has no novelty though they disclose the use of an emulsion with small silver halide content.

1. E.P. 24,234, 1902; U.S.P. 728,310, 1903; F.P. 329,526; D.R.P. 161,519; J. Cam. Club, 1903, 18; Brit. J. Phot. 1902, 49, 1004, 1015; 1903, 50, 50, 115; 1906, 53, 259, 278; 1908, 55, Col. Phot. Supp. 2, 20; Handbuch, 1917, 4, II, 319; Phot. Woch. 1903, 20, 28; Jahrbuch, 1903, 16, 451; 1906, 20, 588; Amat. Phot. 1903, 310; Silbermann, 2, 371; Phot. Chron. 1901, 8, 29; 1905, 12, 571; Phot. Times, 1901, 33, 104; Phot. News, 1902, 46, 829; 1907, 51, 505; Camera Craft, 1903, 6, 169; Photo-Gaz. 1906, 16, 96.

L. Vidal, Mon. Phot. 1903, 42, 6; Brit. J. Phot. 1903, 50, 22, 298 recalled Cros' hydrotype method and pointed out the similarity. Cf. A. Pumphrey, Brit. J. Phot. 1903, 50, 176, 198, 218; E. J. Wall, ibid. 189, 236. Amat. Phot. 1897, 26, 66; 1902, 488; 1898, 434, 454. "Triplice," Brit. J. Phot. 1903, 50, 257.

2. E.P. 7,217, 1907; Brit. J. Phot. 1907, 54, 772; Phot. Coul. 1907, 2, Supp. 46; Phot. Woch. 1907, 24, 447; Handbuch, 1917, 4, II, 326; D.R.P. 209,444; abst. Chem. Ztg. Rep. 1909, 33, 296; F.P. 376,062; abst. J. S. C. I. 1907, 36, 1029; Jahrbuch, 1908, 22, 420; U.S.P. 885,066.

3. U.S.P. 1,106,816, 1914; E.P. 15,823, 1914; Brit. J. Phot. 1914, 61, 653; F.P. 463,737, 1913; abst. J. S. C. I. 1914, 36, 441; Annual Repts. 1916, 1, 307, granted to Hess-Ives Corp.; C. A. 1914, 8, 274; Can.P. 158,870; Belg.P. 259,001; 261,589.

The use of a non-actinic dye was also patented by J. Timar and F. Fuchs, D.R.P. 229,552, 1902; abst. C. A. 1911, 5, 42. Also R. Widmann, D.R.P. 228,967, 1907; abst. ibid. E.P. 13,666, 1909.

4. U.S.P. 1,160,288, 1915; Jahrbuch, 1915, 29, 166.

5. U.S.P. 1,121,187, 1914; D.R.P. 308,030, 1919; Phot. Korr. 1919, 56, 131; Phot. Rund. 1919, 29, 46; Jahrbuch, 1915, 29, 167; abst. C. A. 1914, 8, 274.

The action of acids and salts for the control of the absorption of dyes by gelatin was outlined by von Hübl, in 1899 (see p. 442).

6. F.P. 558,698; Brit. J. Phot. 1923, 70, Col. Phot. Supp. 17, 43; abst. Sci. Ind. Phot. 1924, 4, 27.

This was also patented by W. Vobach, D.R.P. 379,377, 1922; Phot. Ind. 1924, 221; E.P. 195,056, granted to A. Gleichmar and W. Vobach; abst. Sci. Ind. Phot. 1924, 4, 102; Brit. J. Phot. 1924, 71, Col. Phot. Supp. 18, 28; J. S. C. I. 1924, 43, B619.

P. A. Schœlz and C. W. Wœhler, E.P. 204,420, 1922; abst. Sci. Ind. Phot. 1924, 4, 170 patented the preparation of high relief plates by exposing dichromated gelatin, washing in cold water, partly drying and inking up with a greasy ink. On to such a surface a mixture of gum arabic, resin and zinc oxide was cast, which was only absorbed by those parts not protected by the ink. On heating the plate a high relief was obtained.

7. E.P. 17,773, 1889; Phot. J. 1892, 32, 30; Brit. J. Phot. 1894, 41, 742; Phot. Annual, 1895, 221; Anthony's Phot. Bull. 1893, 24, 138; Bull. Soc. franç. Phot. 1893, 40, 27. Cf. W. B. Bolton, Brit. J. Phot. 1894, 41, 742, 770, 821; R. E. Liesegang, Collegium, 1923, 351.

It is quite possible that when using such concentrated solutions of the dichromates some softening of the gelatin, not in contact with the silver, might take place, as strong dichromate solutions are good solvents of gelatin in the cold. This property was utilized by J. Husnik in his Leimtype process, E.P. 73, 1887; 8,496, 1889; D.R.P. 40,766, 1887; 42,158, 1901; Jahrbuch, 1888, 3, 751; Handbuch, 1917, 4, II, 215; Silbermann, 2, 185.

8. The use of ferrous oxalate is based on its non-tanning properties. Cf. A. Payne, E.P. 28,415, 1907; 18,775, 1908; Brit. J. Phot. 1909, 56, 198, 785; 1910, 57, 47, 68.

9. Handbuch, 1917, 4, II, 279.

10. Jahrbuch, 1911, **25**, 140; 1912, **26**, 167; abst. C. A. 1913, **7**, 1681; Brit. J. Phot. 1913, **60**, 141. Cf. T. Manly, Jahrbuch, 1912, **26**, 98. R. E. Liesegang, Collegium, 1923, 351; abst. Amer. Phot. 1924, **18**, 755.

11. E.P. 808, 1904, granted to Riebensahm and G. Koppmann; Brit. J. Phot. 1904, **51**, 1007; D.R.P. 153,439, 1902, granted to Riebensahm and Posseldt; Jahrbuch, 1905, **19**, 456; Silbermann, **1**, 241; Phot. Chron. 1904, **11**, 548; Handbuch, 1917, **4**, II, 280; 1922, **4**, III, 308; F.P. 338,170; Belg.P. 174,793; Austr.P. 21,214.

12. E.P. 24,290, 1904; abst. Brit. J. Phot. 1905, **52**, 365, 873; D.R.P. 158,517; Silbermann, **1**, 280.

13. D.R.P. 196,962; Handbuch, 1917, **4**, II, 282.

14. D.R.P. 117,530, 1900; 196,769, 1907; Silbermann, **1**, 231; F.P. 363,584; Phot. Mitt. 1907; Das Atel. 1908, **15**, 65; Jahrbuch, 1908, **22**, 261, 538; Handbuch, 1917, **4**, 280; 1922, **4**, III, 308; H. W. Vogel, "Das Pigmentverfahren," 5th edit. 85. Cf. P. Pretsch, E.P. 2,373, 1854; U.S.P. 18,056, 1857.

15. Brit. J. Phot. 1907, **54**, 139, 860, 879; 1908, **55**, 30, 200, 236; Phot. J. 1908, **48**, 232.

16. F.P. 352,815, 1905; Brit. J. Phot. 1906, **53**, 434; Phot. News, 1906, **50**, 574.

17. U.S.P. 1,186,000, 1916; Jahrbuch, 1915, **29**, 166; E.P. 15,823, 1913; Brit. J. Phot. 1914, **61**, 653; an acidulated dichromate solution was suggested by Namias, see foot note 10.

18. The use of non-actinic dye as light-restraining agent has already been dealt with.

19. D.R.P. 354,494; 357,486; Phot. Ind. 1922, 987; Amer. Phot. 1923, **17** 368; Sci. Tech. Ind. Phot. 1923, **3**, 84.

20. E.P. 175,988, 1922; abst. C. A. 1922, **16**, 2,086; Sci. Tech. Ind. Phot. 1922, **2**, 128; D.R.P. 303,136; 353,835, 1921; Austr.P. 72,450, 1914; Handbuch, 1922, **4**, III, 135; Phot. Korr. 1918, **55**, 101, 278.

21. E.P. 127,953, 1918.
Cf. E.P. 1,436, 1881; 28,415, 1907; 20,555, 1912. E. Stenger and A. Herz on imbibition with chemical solutions, Brit. J. Phot. 1924, **71**, 75; Amer. Phot. 1924, **18**, 573.

22. E.P. 190,501, 1922; abst. C.A. 1923, **17**, 2,397. No patent granted.

23. E.P. 2,969, 1879; Brit. J. Phot., 1880, **27**, 212; 1892, **39**, 737. Cf. R. E. Liesegang, Collegium, 1923, 351. M. C. Cochran, U.S.P. 875,505, 1908.

24. E.P. 1,436, 1881; D.R.P. 16,357; Silbermann, **1**, 173; **2**, 141; Phot. J. 1881, **21**, 266; Phot. News, 1881, **25**, 217, 229, 248, 261, 286; Brit. J. Phot. 1881, **28**, 241, 247, 266, 330, 613; Mon. Phot. 1881, **20**, 93, 109; Phila. Phot. 1881, **18**, 187, 214, 218, 246; Phot. Mitt. 1881, **18**, 65, 98, 235; 1884, **21**, 288; Handbuch, 1903, **3**, 106-110; 1917, **4**, II, 278; Phot. Archiv. 1881, **22**, 85, 1195. Cf. L. Vidal. Mon. Phot. 1881, **20**, 93; Phot. Woch. 1884, **28**, 347.
Demonstrations of his process as applied to photo-engraving were also given later by Warnerke, Phot. J. 1894, **34**, 94; Phot. Annual, 1895, 222; Process Photogram, 1895, **2**, 15; Bull. Belg. 1898; Bull. Soc. franç. Phot. 1898, **35**, 301; Phot. Woch. 1898; Jahrbuch, 1899, **13**, 587. Warnerke's tissue with colored pigments incorporated was introduced commercially, Brit. J. Phot. 1881, **28**, 266; advertised 1884. Warnerke also suggested that the reliefs might be treated with "soluble liquids and stains." Cf. E. W. Foxlee, Brit. J. Phot. 1897, **44**, 42. R. E. Liesegang, D.R.P. 102,968; Silbermann, **2**, 106. A. Payne, Penrose's Annual, 1910, **16**, 97; Jahrbuch, 1911, **25**, 590. O. Pustet, Jahrbuch, 1891, **5**, 195; Handbuch, **4**, III, 137. Procoudin-Gorsky, Brit. J. Phot. 1925, **72**, 33; Bull. Soc. franç. Phot. 1925, **66**, 262. T. E. Bullen, ibid. 54; Le Procédé, 1925, **26**, 89. P. Schumacher, U.S.P. 1,042,827, 1912.

25. Silbermann, **2**, 141. Cf. Handbuch, 1903, **3**, 109.

26. Phot. Archiv. 1892, **33**, 294; 1894, **35**, 273; 1896, **37**, 183; Phot. Annual, 1895, 221; 1897, 189; Brit. J. Phot. 1897, **44**, 774; 1898, **45**, 2; Process Photogram, 1900, **7**, 61; Phot. Korr. 1898, **25**, 198; Jahrbuch, 1899, **13**, 587; 1900, **14**, 639; Camera Obscura, 1899, 445; "Photochemische Studien," 1895, **2**, 20; Handbuch, 1922, **4**, III, 304.

27. Brit. J. Phot. 1896, **43**, 356; Phot. Annual. 1897, 189; Phot. Rund. 1896, **6**, 313; Phot. Crbl. 1896, 269; Jahrbuch, 1897, **11**, 40, 402, 511: Phot. Archiv. 1892, **33**, 295. Cf. Lumière and Seyewetz, Brit. J. Phot. 1906, **53**, 245, 285; Jahrbuch, 1906, **20**, 500; Phot. Woch. 1906, **52**, 233.

28. E.P. 135,477, 1918; Brit. J. Phot. 1920, **67**, 320; U.S.P. 1,472,048.

29. D.R.P. 309,193, 1916; 310,037, 1917; 310,038; 358,093; 358,165; 358,166; 358,167; 358,149; 395,805; 358,193; Phot. Ind. 1922, 893; Amer. Phot. 1923, **17**, 122;

C. A. 1923, **17**, 2,397; Sci. Tech. Ind. Phot. 1923, **3**, 84; Phot. Rund. 1922, **59**, 144.

This process was introduced commercially as the Jos-Pe, Phot. Chron. 1924, **31**, 148, 156; Phot. Ind. 1924, 435, 705; Brit. J. Phot. 1924, **71**, Col. Phot. Supp. **18**, 35; D. Phot. Ztg. 1924, **48**, 83, 132; Cf. D.R.P. 395,805; Phot. Ind. 1924, 678. In D.R.P. 400,663; Phot. Ind. 1924, 1,074, Koppmann patented the development of a silver image, coating generally with an ink or color, in a medium insoluble in water, then etching with peroxide or persulphate. The silver might then be fixed out or not from the relief. Cf. O. Mente, Camera (Luzerne) 1925, **3**, 157, 186; Brit. J. Phot. 1925, **72**, Col. Phot. Supp. **19**, 13.

30. E.P. 172,342, 1920; Brit J. Phot. 1922, **69**, 82; F.P. 518,526; abst. Sci. Tech. Ind. Phot. 1921, **1**, 85. U.S.P. 1,453,258; Sci. Ind. Phot. 1924, **4**, 188; Dan.P. 29,368; Swiss P. 85,587.

31. U.S.P. 1,374,853, 1921; 1,417,328, 1922. Cf. U.S.P. 1,482,611; 1,482,612; 1,482,613; 1,482,614; 1,482,615; 1,482,616; 1,484,029.

32. U.S.P. 1,453,259, 1923; abst. C. A. 1923, **17**, 2,088; J. S. C. I. 1923, **43**, 631A. Cf. M. C. Cochran, U.S.P. 878,505, 1908.

33. E.P. 187,638, 1921; Brit. J. Phot. 1922, **69**, 741; F.P. 539,828; abst. Sci. Tech. Ind. Phot. 1923, **3**, 14; Can.P. 244,376. Cf. U.S.P. 1,482,612; 1,482,613; 1,484,029. The Comptroller of English patents directs attention to E.P. 1,436, 1881; 17,773, 1889; 27,957, 1908; 18,965, 1911; 20,555, 1912; 5,100, 1915; 127,953; 135,477, 172,342.

34. Brit. J. Phot. 1865, **12**, 197.

35. Ibid. 1883, **30**, 119. Cf. F. C. Beach, ibid. 1887, **34**, 523.

36. Photo-Gaz. 1892, 98; Fabre, "Traité encycl." Phot. 1897, Supp. B, 279.

G. E. Brown, Photogram, 1899, **6**, 340; 1900, **7**, 188 quotes this reducer as Pramer and Mathet's. Cf. E. Valenta, Phot. Rund. 1917, **27**, 110.

37. Brit. J. Phot. 1916, **68**, 574; Brit. J. Almanac, 1917, 358.

38. Brit. J. Phot. 1916, **68**, 634; Brit. J. Almanac, 1918, 302.

39. E.P. 187,932. Cf. E.P. 187,933.

40. Brit. J. Phot. 1881, **27**, 304.

41. Ibid. 1882, **28**, 322; Phot. Korr. 1882, **19**, 111.

42. Brit. J. Phot. 1883, **29**, 333; Handbuch, 1903, **4**, 472; Bull. Soc. franç. Phot. 1890, **37**, 175. Cf. M. Vetenver, ibid. 1892, **39**, 93.

43. Brit. J. Phot. 1897, **44**, 347.

44. Phot. Korr. 1891, **28**, 475; Handbuch, 1905, **3**, 463. Cf. E. Cousin, Jahrbuch, 1898, **12**, 480. B. L. Williams, U.S.P. 838,488, 1896, patented the addition of iodine to a developer for prints, to prevent abrasion marks and obtain softness.

45. Phot. Rund. 1897, **7**, 229; Photo-Rev. 1911, **2**, 136; "Die Entwicklung bei zweifelhaft richtiger Exposition" 1898, 22; 1907, 27.

46. Phot. Korr. 1912, **59**, 40, 262, 310, 356, 440, 503; 1913, **60**, 17, 61.

47. U.S.P. 1,444,388, 1923.

48. E.P. 204,034, 1922; Brit. J. Phot. 1924, **71**, 402; abst. J. S. C. I. 1924, **43**, B655; Sci. Ind. Phot. 1924, **4**, 171, 185; Amer. Phot. 1925, **19**, 54; F.P. 570,076; D.R.P. 400,951. Cf. Troland, U.S.P. 1,535,700.

49. It has not been thought worth while to find the first mention of this first reaction; but the statement is made in Cassell's Cyclopædia of Photography, 1912, 25, under "ammonium bromide."

50. Phot. Archiv. 1897, **32**, 161; Brit. J. Phot. 1897, **44**, 774, 814; 1898, **45**, 2, 646; Phot. Annual, 1898, 315; Jahrbuch, 1898, **12**, 457; 1899, **13**, 538; Phot. Korr. 1898, **35**, 562; Anthony's Phot. Bull. 1898, **29**, 351; Process Photogram, 1898, **5**, 1; Phot. Woch. 1898, **44**, 388. Cf. J. Gædicke Phot. Woch. 1898, **44**, 333; D. Nyblin, Das Atel. 1900; Brit. J. Phot. 1900, **47**, 470.

51. Brit. J. Almanac, 1899, 935.

52. D.R.P. 103,516, 1898, granted to Aktiengesell. f. Anilinfabrik. Silbermann, **1**, 145; Jahrbuch, 1899, **13**, 538; 1900, **14**, 582; 1901, **15**, 685; Phot. J. 1899, **39**, 329; Phot. Korr. 1899, **36**, 260; Phot. Chron. 1900; Brit. J. Phot. 1899, **46**, 308.

Houzel, Photography, 1902, 813; Phot. Woch. 1902, **48**, 386 accidentally found a process by which gelatino-bromide images could be converted into carbon images. A number of prints, which showed green fog, were placed in solution of hydrogen peroxide and left overnight. The next morning the images had completely disappeared, but it was seen that the whites were covered with gelatin, while in the deep shadows there was none. The whole surface of the print was then painted with Chinese ink and dried. Then it was treated with warm water, in which the gelatin dissolved and carried the ink with it, while the shadows remained black; there was

thus developed a correct carbon image. The process was found applicable to most papers.

53. Mon. Phot. 1903, **42**, 251; Phot. J. Amer. 1916, **53**, 389; Photo-Gaz. 1905; Brit. J. Almanac, 1906, 802; Fabre, Traité Encycl. Phot. 1906, Supp. D, 244.

54. Phot. Rund. 1903, **13**, 282; Jahrbuch, 1904, **18**, 408.

55. "Photographische Chemie," 1921, **1**, 12.

56. F.P. 423,150, 1910; Le Procédé, 1911, **13**, 141; Jahrbuch, 1912, **26**, 488; D.R.P. 230,386, 1909; Jahrbuch, 1911, **25**, 631; 1912, **26**, 580; Phot. Chron. 1911, **18**, 438; Chem. Ztg. Rep. 1911, 88; Handbuch, 1922, **4**, III, 305.

57. Phot. Korr. 1911, **48**, 466, 608; Jahrbuch, 1912, **26**, 487; abst. C. A. 1912, **6**, 37. L. E. Taylor, U.S.P. 1,518,945; 1,518,946, 1924, would use the peroxide etching process for making matrices for imbibition for cine films, using a modification of Belin and Drouillard's solution.

58. D.R.P. 144,554, 1901; Silbermann, **1**, 240; Phot. Ind. 1903, 498; Jahrbuch, 1904, **18**, 209; 1905, **19**, 456.

59. E.P. 204,101, 1922; F.P. 553,127.

A summary of these relief processes was given by the author, Brit. J. Phot. 1921, **68**, Col. Phot. Supp. 14, 30, 34. Cf. T. P. Middleton, ibid. 1923, **70**, 735.

CHAPTER XIII

SUBTRACTIVE PROCESSES. III

Mordanting Processes.—Under this term are included all processes in which some substance acts as a fixative agent for the dyestuff, forming either a permanent or temporary lake, as for instance, silver iodide, cuprous and iron ferrocyanides, etc. The use of such substances in dyeing must date back to the early ages, and no attempt has been made to collate any information on this point, except where it may have direct bearing on some photographic process. The inclusion of some of the early methods may seem far-fetched, but the underlying idea has been to give as far as possible a complete sketch of certain principles so that the reader may see the connection between these early, and in some cases incomplete and abortive processes, with those of the present day.

Chromium Mordants.—Testud de Beauregard[1] (p. 385) presented some pictures to the Société française de Photographie, in various colors, some yellow, some blue and others black. The first were made with the chromates and the others with iron. He stated that the yellow one could be converted into black without the use of silver salts, and that if each image, which had been printed on paper saturated with dichromate, was washed and then immersed in ferrous sulfate solution every trace of the image disappeared, but if then immersed in gallic acid a blue-black image appeared; obviously through the formation of a gallate ink. He also stated that a color similar to Chinese ink, could be secured by immersion of the washed image in a decoction of logwood.

E. Kopp[2] also stated that the chromium salt, obtained by the action of light on ammonio-potassium chromate acted as a mordant for tannin, logwood, Brazil wood, alizarin and purpurin. Rousseau and Masson[3] pointed out that better results were obtained when albumen was mixed with the dichromate. A Teissonière[4] patented a process in which a sheet of paper, albumenized with sodium or ammonium chloride, was sensitized with dichromate, and after exposure treated with a solution of tannin, washed and treated with ferrous sulfate, and finally washed and varnished. The interesting point about this is that the inventor stated that while the dichromate, combined with the organic matter, becomes insoluble by the action of light, the unaffected parts remain soluble and on washing, the paper was left in its primitive condition. When the tannin was applied the sodium or ammonium chloride acted as a mordant and formed peroxide of iron. Clearly the inventor's chemistry was a little weak; the halides would be washed away and the hardened albumen would not absorb the coloring matter.

Carey Lea[5] suggested the use of murexide, acid ammonium purpurate, for dye intensification of negatives, using an image bleached with mercuric chloride as mordant. He said: "The purple color is fixed only in the shadows and the quantity of the murexide taken up is in proportion to the density of the respective portions of the film, so that the gradations of shade are preserved. The color is a very pleasing one. It is probable that other coloring matters might be fixed upon collodion negatives. All that is necessary is to find some suitable mordant which is capable of being also combined with the silver upon the negative, either directly or indirectly. There is here a considerable field open for ingenuity. One of the substances, however, which would be particularly available—chromic acid —cannot be employed because of the solubility of the chromate of silver. It is true that this last named compound is but sparingly soluble in water; still it is quite enough as to interfere with proper washing." It will be noted that Lea suggested the idea of the general use of mordants, though he had in mind merely intensification.

G. Richard[6] also suggested the conversion of the silver image into one of dyes. He proposed to make color records, according to the principle of du Hauron, and print three positives on gelatino-bromide of silver. Unfortunately he did not give details of his method. But he pointed out that the three constituent images might be obtained by the chemical transformation of the silver image into a salt capable of fixing the color that one wished to employ. The positive thus mordanted would retain the colors in those parts, which were previously metallic silver and in proportion to the intensities of the same. Or by the transformation of the silver into a salt capable of reacting on the anilin derivatives so as to form the artificial coloring matters.

A. Villain[7] also presented to the Société française de Photographie in 1892, some proofs on paper and materials, which had been obtained by the action of light on a mixture of dichromate and ammonium vanadate. After exposure the print was well washed and treated with alizarin and other dyestuffs, which combine with chromium oxide, such as alizarin, isopurpurin, alizarin blue, black, green and orange, and anthracen brown. The whites of the prints, if tinted, could be cleared with weak sodium carbonate solution. It is an open question whether the vanadium salt was actually affected by light in this case; but there is no question that it played an important part in the coloring.

R. E. Liesegang[8] stated that ammonium vanadate with organic acids was light-sensitive on unsized paper, though only faintly so, but insensitive on sized paper. On the other hand, it is quite possible that some slight action would ensue with the dichromate-vanadium mixture, or that enough vanadate might be retained by the image as to form a mordant, and it is well known that very small quantities of vanadium act very powerfully, as in the formation of anilin black, in which about 1 : 1,000,000 is sufficient.

G. Selle[9] also claimed the use of the reduced chromium salts as mordants for three-color work. But it is doubtful whether there is any actual mordanting action in this case, or whether the dyes are merely absorbed by the hardened gelatin. E. König[10] said: "Selle's process does not depend like all other printing methods on the property of dichromated gelatin becoming insoluble in light, but on the property of the dichromate being reduced by the action of light, in the presence of organic matter, to chromium oxide. Therefore, Selle's method is not a mere variation of well known methods, but a really original process, which takes a special place among the various printing methods of three-color photography. The difficulty of the process lies in the finding suitable dyes, which will stain only the chromium-oxide-holding gelatin and leave the whites clean."

Von Hübl[11] said: "The oxide of chromium formed should act as a mordant and hold fast the dye. After drying the collodion skins carrying the colored pictures are stripped from the glass, and bound together by a sticky material. The process is especially simple, and makes the formation of pictures of absolutely identical size, so that the images at once coincide. It appears, however, that vigorously printed proofs are very difficult to obtain in this way, because the behavior of the exposed and unexposed chromate gelatin differs so slightly towards dyes. It is also questionable whether this difference in behavior of the exposed and unexposed places towards the dye solution can actually be ascribed to the action of the oxide of chromium. We understand by mordants in dyeing, materials that possess the power of combining with the dye, of taking up the dye and forming with it an insoluble compound. Cotton or linen fibers can not be dyed by immersion in solutions of dyes; therefore, they are mordanted —that is, they are impregnated with iron, aluminum or chromium oxide; thus bodies are placed in the fibers, which combine with the dyes to form the so-called lakes.

"But gelatin does not require a mordant in this sense; it takes up most of the dyes without any hesitation, and can itself also, like albumen, be used as a mordant. From some experiments made in order to clear up this behavior, it appears that the possibility of Selle's process is to be ascribed not to the mordant action of chromium oxide, but to the difference in the swelling power of exposed and of unaltered gelatin. The unexposed gelatin is, to a certain extent, permeable by liquids, whilst the gelatin tanned by light, which has lost its power of absorbing aqueous solutions, will not permit of the penetration of liquids. If dry gelatin films are treated with solutions of dyes, the film tanned by the oxide of chromium will be colored more slowly, because the liquid only penetrates slowly. If, however, the untreated film has been allowed to previously swell in water, it takes the dye slower than the tanned film, because the absorbed water prevents the penetration of the solution. If

the colored films are then treated with water, the unchanged gelatin gives up its dye more quickly than that exposed with the chromate, because the latter can scarcely be penetrated by the water." This passage is given in full because it may explain the action of some later processes.

A. and L. Lumière[12] found that gelatin impregnated with vanadic acid or pentoxide in hydrochloric acid yielded a faint print, which could be rendered more intense by treatment with amines. J. Helouis and C. de Saint-Père patented a process for obtaining prints on fabrics by the use of the chromates, -ic iron, uranium, copper and lead salts, which gave -ous salts under the action of light. The tissue, after printing, was first washed in water, then in sulfurous acid, or weak hydrochloric acid for the chromates, by which the brown chromium oxide was converted into a green salt, which acted as mordant for cochineal, alizarin, logwood, tannins, anthracen and other dyes.

The Aktiengesellschaft für Anilinfabrikation[14] patented the use of the reduced chromium salt as mordant for organic compounds of the aromatic series, such as p-phenylendiamin and its derivatives, aminophenol and derivatives, anilin and like substances. In a later patent[15] the mixture of developing substances was claimed for obtaining different tones.

Robert Hunt had suggested a printing process with cupric sulfate and dichromate, and various methods were based on this, though not with the idea of using the reduced salts as mordants. A. Thiebaut[16] suggested a method, however, for obtaining prints in colors, based on this method. It might be applicable for transparencies as well as prints, for which it was proposed. Gelatinized paper was treated with a mixture of:

Potassium dichromate	90 g.
Cupric sulfate	50 g.
Water	1000 ccs.

This had been suggested by W. C. Benham. Or the following might be used, as suggested by F. Dillaye:

Potassium dichromate	43 g.
Ammonium dichromate	50 g.
Cupric sulfate	47 g.
Water	1000 ccs.

Or the following given by Thiebaut:

Ammonium dichromate	90 g.
Cupric sulfate	45 g.
Manganese sulfate	10 g.
Water	1000 ccs.

Or

Potassium dichromate	100 g.
Cobalt chloride	80 g.
Manganese sulfate	20 g.
Water	1000 ccs.

The paper was to be floated on one of these solutions, dried, exposed under a negative and washed. By immersion in 5 per cent solution of

anilin hydrochloride, slightly acidulated with sulfuric acid, a green color was produced, which might be altered into a blue by cobalt chloride. Or the images might be treated with a phenol, phenylamin, a cresol or naphthol, and there was combination of the metal with the aromatic compound with simultaneous formation of a lake.

It is a little difficult to obtain pure whites with this process, but acidulation of the developer is of great assistance. Pyrogallol, paraminophenol (base), paraphenyendiamin (base) gave various colors and the addition of gallic acid altered the same. The exposure should only be sufficient to show the details in the highest lights. The print should be washed in hot or cold water till the whites are clean; preliminary immersion in alum or salt solution facilitates washing. The developer should be applied for about a minute and the print well washed for 10 minutes. To remove any fog in the whites, the print should be floated face down on a 5 per cent solution of eau de Javelle, and after a few minutes the whites will become slimy, and gentle friction with a soft sponge or swab will remove the fog. The print should then be washed in cold water, or immersed in alum and acetic acid solution. While explicit directions are not given for obtaining tri-color prints, the process is worth noting as a possibility, and because of the obvious connection with the mordanting processes.

A. B. Clark[17] made an investigation into the mordanting action of various metallic ferri- and ferrocyanides, and suspensions of these salts of the following metals were tried: cuprous and cupric, silver, zinc, cadmium, mercurous and mercuric, cerous and ceric, thorium, stannous and stannic, lead, vanadium, uranyl, manganous, ferrous and ferric, cobaltous and nickelous, with the silver halides for comparison. The dyes used were: the sodium salt of sulfanilic acid-azo-Neville and Winther acid, oxyazo; tartrazin, fuchsin, crystal violet, rose Bengal, acridin orange NO, alizarin red S, tannin heliotrope, Capri blue GON, methylen blue and quinolin yellow. In many cases the precipitates were dyed to the color of the dye, but some, for example, mercuric ferricyanide, completely decolorized the solutions, and others darkened to a muddy unsaturated color. The silver halogens were found to have very little mordanting power, compared to the ferri- and ferrocyanides; their action being in the descending order iodide, bromide, chloride. This, it was suggested, may be due to their low molecular weights compared to those of the complex cyanogen compounds. Manganese, cobalt, iron, nickel and the silver halides have practically no mordanting action, except on alizarin. Cadmium, cuprous, stannous and stannic, cerous, cupric, lead, vanadium, bismuth, uranyl and ceric form intermediate classes. The heavier metals, silver, mercury and thorium are the strongest mordants. Zinc is abnormal as it was the strongest, which is probably due to the state of subdivision, as the dye might be carried down by the semi-colloidal particles. An

attempt to connect the mordanting power with the molecular weight was only partially successful, since the physical state of the division is a factor. The general mordanting power of the metals, averaging the effect of all dyes, corresponds roughly to the following figures: copper 6; zinc 30; vanadium 5; tin 6; manganese 2; iron 2; nickel 2; cobalt 2; silver 8; cadmium 2; mercury 8; lead 5; bismuth 7; thorium 10; uranium 6.. If these numbers are placed in the periodic classification of the metals in the place of the atomic weights, the relation between the mordanting powers is roughly the same as that between the atomic weights, that is, the mordanting powers radiate from thorium like the leaves of a fan.

Clark drew three conclusions from the results: (1) all ferricyanides mordant basic dyes better than acid dyes in the presence of a slight excess of the ferricyanide ion; (2) all ferrocyanides with the exception of thorium and lead, mordant basic dyes better than acid dyes in the presence of excess of the ferrocyanide ion; (3) ferricyanides mordant better than ferrocyanides. The work indicates that the mordanting power in the presence of slight excess of the cyanogen compounds is primarily a function of the atomic weight of the mordant. It is probable that the nature of the absorption compound varies with the ionic concentration of the solutions.

E. R. Bullock[18] stated that whilst dye-mordanting applied to photography had not been found to conform precisely to any simple theory, yet when the disturbing effect of gelatin is sufficiently reduced the results of experiment agree very fairly with the principle of the mutual precipitation of oppositely charged colloids. It is found that any image of a pronounced negative character is a mordant for basic dyes, and vice versa. For example, the deposition of methyl violet on a silver iodide image as an instance of the fixing of a basic dye, and conversely the retention of acid dyes by gelatin containing aluminum hydroxide. The influence of the gelatin may be so great as to reverse this tendency, but the effect may be minimized in practice.

Lead and Copper Mordants.—R. Namias[19] attempted to use some metallic compounds other than silver as mordants, especially the lead salts. He also tried copper and cobalt, using known methods of toning with the ferricyanides; but the results were not satisfactory in the case of the copper compounds and altogether negative in the case of cobalt. The lead compounds were, therefore, tried out further and basic dyes found to be the best. A transparency was bleached with a mixture of 5 per cent solution of lead acetate, acidulated with acetic acid, and potassium ferricyanide. As soon as bleached the image was washed for 30 minutes, till free from yellow stain. As gelatin obstinately retains traces of lead salts, treatment for about 10 minutes with a 10 per cent solution of nitric acid was beneficial. Immersion in 10 per cent hypo removed the silver ferrocyanide, leaving the lead compound. The lead ferrocyanide was also

converted into sulfate by immersion in a 5 per cent solution of sodium sulfate with 0.5 per cent sulfuric acid. Satisfactory results were obtained with auramin, safranin and methyl blue, used in 1 per cent solutions. At the end of a few hours the images were sufficiently stained and the plates washed to remove excess dye. In order to obtain perfectly transparent images, the lead sulfate was removed with a bath of strong hypo with the addition of 7 per cent of boric acid; but prior to this treatment the image was subjected to a bath of 1 per cent copper sulfate to fix the dye. By treatment of the lead ferrocyanide image with 1 per cent of caustic potash lead hydroxide was formed and this was found to fix the dyes from an acetic solution; this gave better results in some cases, as the hydroxide was more transparent than the sulfate.

In a later communication Namias[20] practically repeated the previous information, but considered it was unnecessary to convert the ferrocyanide into other compounds and proposed to fix in a bath of:

Hypo ... 100 g.
Sodium acetate, cryst. 50 g.
Glacial acetic acid 5 ccs.
Water 1000 ccs.

After washing, the plates were immersed in 5 per cent alum solution containing 0.5 per cent cupric sulfate.

A. Traube[21] patented the use of copper ferrocyanide early in 1916. He pointed out that any basic dye might be used and that the red-brown color of the copper ferrocyanide was suppressed by the majority of dyes, the color of the latter prevailing. In consequence of the abnormal capacity of the copper salt for being dyed, the silver image must be kept quite soft and thin for projection. The dyeing may be completed in about 5 minutes in a 1 : 1000 dye solution, and the copper image necessary for obtaining a powerful dye image is so thin that the removal of the copper compound is unnecessary; at the same time the definition of the silver image is preserved.

The transparency of the copper image is very high, but the removal of the silver ferrocyanide, which is more opaque, may be effected by a weak solution of hypo that does not affect the copper salt. When the silver image is removed greater transparency is secured by varnishing the picture, for example, with dammar varnish. In a later patent[22] the use of basic dyes with a benzol ring, such as thiobenzyl dyes for the yellow, thiazins for the blue, pyronins for the red and the safranins, oxazins and acridins is claimed. Later[23] the use of a bath of from one-fourth to one-third the usual strength was claimed, and it was stated that the pictures had a varnished appearance and were very transparent. Traube's process is known as Uvachrome.

J. I. Crabtree[24] also patented the use of copper ferrocyanide and treated the image with:

Cupric sulfate	12 g.
Potassium ferricyanide	12 g.
Potassium citrate	57 g.
Ammonium carbonate	6 g.
Water	1000 ccs.

The film was then rinsed to free it from excess bleaching solution and immersed in a solution of a basic dye, such as tannin heliotrope, rhodamin 6G, thioflavin, methyl green, Victoria green or methylen blue, about 0.1 to 0.2 per cent with the addition of 0.1 per cent of acetic acid. The film was then washed either in plain water or acidulated with acetic acid and dried. To enhance the transparency of the colors the silver ferrocyanide might be dissolved with hypo to which was added 0.25 per cent of tannin and the same ratio of sodium acetate.

F. E. Ives[25] also proposed copper ferrocyanide, using:

A. Potassium ferricyanide	5.7 g.
Potassium citrate	27.68 g.
Water	1000 ccs.
B. Cupric sulfate	7.14 g.
Potassium citrate	27.68 g.
Water	1000 ccs.

Equal parts were mixed together. Ives recommended a mixture:

Fuchsin	0.026 g.
Auramin	0.052 g.
Acetic acid	1.6 ccs.
Water	1000 ccs.

The silver salt might be dissolved before or after dyeing, leaving the dyed copper image.

It will be seen that in these processes the old copper toning methods, as used for bromide prints, are substantially followed, and any of such baths may be used for this purpose with success; there being but little variation in the final results, except that with the ammoniacal baths there are obtained clearer whites. The copper ferrocyanide image may be removed with a weak solution of caustic soda, about 2 per cent, leaving nothing but the dye image. Some basic dyes bleed rather badly under this treatment and then the addition of tannin and sodium acetate is advisable, or a preliminary treatment with this.

F. J. Ventujol[26] patented the formation of cuprous ferrocyanide as a mordant by the use of two successive baths, instead of mixing them, which is by no means a novel idea. E. Lehmann[27] analyzed copper-toned images and found that they are composed of the ferrocyanides of copper and silver. He stated that the essential mordant is the silver ferrocyanide, and that the copper salt plays but a subsidiary role. The mordanting action is lost to a great extent if the silver ferrocyanide is converted into a halide. The different behavior, according to whether the baths contained an excess of ferricyanide or excess of cupric sulfate is, therefore, based on the action of the silver ferrocyanide on the potassium ferrocyanide formed.

This statement is not correct, it has been proved by the author that silver ferrocyanide has but little mordanting power, compared to the copper salt, and Lehmann's treatment of the image with a halide would convert the copper ferrocyanide into a halide also as well as the silver.

Iron Mordants.—The mordanting action of the iron salts to obtain prints in colors was apparently first employed by J. Mercer[28] as pointed out by W. H. Harrison. The salt he generally used was ferric oxalate, and his blue image was decomposed by a solution of lime or other alkali into ferric hydroxide, which acts as a mordant for a large number of vegetable and other dyes. In dyeing with madder Mercer preferred not to alter his blue images, thus obtaining purple colors. Many of his prints were exhibited at the British Association meeting at Leeds in 1858.

Iron salts as mordants were also used by J. Perry[29] and A. Baudesson and P. Houzeau.[30] Stewart J. Carter[31] also used iron and sensitized fabrics with a mixture of 37.5 per cent solution of ferric-ammonio-citrate and 37.5 per cent solution of potassium ferricyanide in equal volumes. After well washing, the prints were treated with caustic soda, thus precipitating ferric hydroxide, then treated with hot water, and a hot, 77° C., solution of sodium phosphate, the purpose of this last bath being to give more brilliancy to the colors. After further washing the fabric was immersed in a bath of:

Resorcin green	3-5 g.
Glue size	5 ccs.
Water	1000 ccs.

The object of the glue was to preserve the whites. The water was heated to about 71° C., the glue added then the dye and the temperature gradually raised to 82° C., and the fabric immersed. When sufficiently dyed, the print was removed, well washed in boiling water to remove excess dye, then rinsed in a neutral soap bath at 71° C., then in hot and cold water, dried and ironed. Other dyes could be used; gallocyanin gave blue and violet shades; alizarin, purple; alizarin brown and sepia shades, and natural dyes, such as logwood could also be used.

F. Dommer[32] preferred to use sodium nitroprusside as the sensitive salt, on the ground that purer whites were obtained. The fabric was sensitized with a 3 per cent solution, and well washed after printing. The dye bath was preferably a 0.1 to 0.2 per cent solution of a 20 per cent dye paste plus a little acetic acid. The dyes enumerated were alizarin SX, anthracen brown SW, coerulein SW, alizarin orange, alizarin blue or gambine. Tartaric or oxalic acids might be added to the sensitizer to increase its rapidity. It will be seen that here the greenish-blue cyanotype image was used and not converted into hydroxide. The prints were finally treated with a hot soap bath to improve the shades; here possibly the hydroxide was formed.

A. F. Hargreaves[33] also patented the use of a ferro-prussiate print as a mordant for dyes, preferably madder, alizarin, purpurin or logwood.

J. Ephraim[34] proposed to use iron, manganese, chromium, aluminum, mercury and lead salts. The Société de Hélioteinture[35] patented the use of the nitroprussides with cobalt and nickel salts and the fixation of alizarin and other mordanting dyes. J. Lewisohn[36] patented the use of a ferroprussiate print, and claimed the blue color as one of the constituent images. Though this process was apparently a painting process, as an orthochromatic plate was used, and after printing on cyanotype paper, eosin red and aurantia were locally applied, and where blue was not wanted silver nitrate was applied, which would form silver ferrocyanide and basic ferric nitrate. In a later patent[37] the process was varied in that three constituent negatives were obtained. The blue print was washed with aurantia, dried and immersed in silver nitrate. After washing the print was sensitized with a cyanotype mixture, printed under the red negative, washed and dyed with a red dye, such as eosin. Then again washed, resensitized as before and exposed under the third negative.

J. I. Crabtree[38] patented a variation of the above, obtaining a silver image first and bleaching this in:

Potassium ferricyanide........................ 20 g.
Potassium permanganate...................... 20 g.
Water1000 ccs.

At a temperature of 21° C., which converted the silver into ferricyanide. Or the following could be used:

Potassium ferricyanide, 10 per cent sol.........5 volumes.
Chromic acid, 10 per cent sol.................2 volumes.

Then washed for a brief time and converted into the usual cyanotype image by treatment with:

Ferrous sulfate.............................. 50 g.
Hydrochloric acid........................... 50 ccs.
Water1000 ccs.

And after rinsing the image was immersed in a 35 per cent solution of hypo for 1 minute, which dissolved the silver chloride formed in the last bath. The image was then immersed in a 1 per cent solution of sodium carbonate or potassium hydroxide, which converted the image into ferric hydroxide. This was then to be toned with an alizarin dye containing either ammonia or acetic acid. A pure dye image might be obtained by removing the ferric hydroxide with oxalic acid. Alternate methods are given for obtaining the hydroxide by well known toning methods. L. F. Douglass[39] also patented the use of ferric hydroxide produced by treatment of a cyanotype-toned silver image with a caustic alkali, and the use of basic dyes.

Various Mordants.—E. R. Bullock[40] would take advantage of metallic salts in the -ic state as mordants or oxidizers of organic compounds forming colored substances, whilst they themselves are reduced to the -ous state and a soluble form. It is assumed that a silver image will be

used and the bath, which acts as a bleach, might consist of ferricyanide and permanganate or chromic acid. For the former 4 parts of a 10 per cent solution of potassium ferricyanide were mixed with 1 part of 1 per cent solution of potassium permanganate. The image was converted into the pale orange or yellow silver ferricyanide in about 1 minute, then may be washed, or if any brown stains were formed from the manganous salts, it might be treated with 5 per cent solution of oxalic acid and washed. As an alternative might be used 5 parts of 10 per cent solution of ferricyanide with 2 parts of 10 per cent of chromic anhydride, CrO_3. This acts quickly, in about 2 minutes; but it has the disadvantage that it requires rather long washing to remove the chromate stain. It is important that the washing waters should contain not more than a trace of chlorides, as these would change some of the ferricyanide into silver chloride.

The toning baths, or those in which the colors were developed were as follows: (1) benzidin, which gives a strong blue; (2) o-tolidin, that gives green; (3) p-phenylendiamin, purple; (4) alpha-naphthylamin, a reddish-purple; (5) dianisidin hydrochloride, a strong green. These are typical of the reactions utilized. Weak baths were used and the images washed for about 5 minutes, then fixed to remove the silver salt. For the permanganate-treated images a hypo bath with the addition of 1 per cent of potassium chromate was used, there being in this case a tendency to reduction of the colored images, which was not so with the chromate ones. It was also suggested that the silver ferricyanide image might be treated with manganous bromide, and silver bromide and manganous ferricyanide would be obtained, and on treatment with benzidin and its compounds a colored compound would be formed, the manganic salt being at the same time reduced to the -ous state. The silver might be dissolved, as it takes no part in the formation of the colored benzidin compounds, the manganous salt alone acting in this respect.

F. E. Ives[41] recommended a chromic acid and ferricyanide bleach, thus infringing Bullock's patent, 1.5 per cent of each salt being employed. In a later communication[42] the strength of the bath was reduced to 1.4 per cent ferricyanide and 3 per cent chromic acid. The positives were to be thin, obtained by full exposure and short development, and fixed in acid hypo. Dye baths of from 0.25 to 0.75 per cent, with the addition of some acetic acid, were to be used. Methylen blue, fuchsin and chrysoidin were said to give the best results; though safranin, aurantia and malachite green could be used with weaker acid content. Blacks could be obtained by admixture of the three dyes. Later still[43] another formula was put forward and it became:

Potassium ferricyanide...................... 1.39 g.
Chromic acid................................. 0.35 g.
Glacial acetic acid.......................... 50 ccs.
Water1000 ccs.

Or ammonium dichromate, in equal weight, might replace the ferricyanide.

A remarkable pink-toning process was patented by W. Friese-Greene, J. N. Thompson and Colour Photography, Ltd.[44] Two formulas were recommended:

Potassium ferricyanide	12.5 g.
Uranium nitrate	12.5 g.
Rose Bengal	0.013 g.
Naphthol yellow	0.013 g.
Iodine	0.013 g.
Glacial acetic acid	12.5 ccs.
Water	1000 ccs.

Or the same bath with the addition of 0.013 g. sensitol red. The particular value of the sensitol red is not clear as it would be at once decolorized by the acid.

J. Schweitzer[45] proposed to make color prints by the use of dyestuffs which are destroyed by oxidizing agents, which in turn are destroyed by the action of light and silver. In particular, if a sheet of glass be coated with manganese oxalate and exposed under a negative and placed in a dye solution, the image will become colored where there was light action, obviously the manganous salt acting as mordant. Similarly if the silver image be converted into chromate, the whole immersed in a dye and subsequently given a weak acid bath, the dye would be destroyed only in contact with the silver chromate, and a positive dye image would remain. Suitable dyes were said to be tartrazin, anilin green, orchil, safranin, methyl blue and violet.

J. M. Blaney[46] proposed to use a salt of tin. The film, and the invention was primarily intended for motion picture work, was immersed in a weak bath of:

Hydrochloric acid, sp. gr. 1.19	2 ccs.
Glycerol	75 ccs.
Water	1000 ccs.

The purpose of this was to prevent hydrolysis of the tin salt. Then it was immersed in:

Oxalic acid	4.7 g.
Ammonium nitrate	2 g.
Glycerol	50 ccs.
Stannic chloride sol. sp. gr. 1.5	13.9 ccs.
Potassium ferricyanide	3.5 g.
Water	1000 ccs.

The image at this stage would consist of stannic and silver ferrocyanide, and the latter was eliminated with:

Sodium pyrosulfite	6.2 g.
Hypo	31 g.
Ammonium chloride	13.4 g.
Water	1000 ccs.

To which enough hydrochloric acid was added to set free sulfurous acid. The image was then well washed and dyed.

W. V. D. Kelley[47] patented a process, which possesses some points of novelty and permits of the use of acid or azo dyes. The positive is developed and fixed in the usual way, then treated with 10 per cent solution of formaldehyde, washed and then with:

Potassium dichromate.........................4.75 g.
Potassium bromide............................ 9.5 g.
Cupric sulfate................................ 14 g.
Hydrochloric acid............................ 10 ccs.
Water 1000 ccs.

Nitric or acetic acid might be used instead of the hydrochloric. The temperature of the bath might be from 38 to 43° C. The inventor states that the action of this bath is to deposit a transparent salt of copper or chromium or a mixture of the two, as the image has a brown color, possibly due to silver oxide, which entirely disappears in a subsequent fixing bath, while the transparent copper or chromium image does not lose its mordanting power. Acid and azo dyes, fast reds, blues and greens, acid fuchsin and yellows are the dyes recommended, preferably about 0.5 per cent at a temperature of 43 to 45° C.

This process has been included in this section because the inventor claims it as a mordanting one. But the chemistry of the specification is very weak. Certainly silver oxide would not be formed, nor is any mordanting transparent copper-chromium salt. It would appear much more reasonable to ascribe the results to the differential staining of the gelatin, hardened in situ with the silver by the bleaching bath. Practically the same action is present here as in the Kodachrome and bromoil processes. The dyes are absorbed by the whole of the gelatin, and in the subsequent washing the unhardened gelatin, that is those parts which did not contain silver, give them up more readily than the hardened.

Kelley[48] modified this process by producing the one image at the bottom of the emulsion, by printing through the support, the emulsion being stained with a light-restraining dye. The gelatin was then hardened with formaldehyde and the image treated with dichromate, copper sulfate and bromide, which converted it into a compound, which is stated to be transparent and barely visible by reflected light. The emulsion, which was not fixed, was resensitized by immersion in a bath of chromic acid and bromide, washed and dried, and the second image imprinted on the top of the emulsion, that is on the side away from the support, development and fixing being as usual. It is stated that the first-impressed image is practically silver free, but capable of absorbing acid or azo dyes. After dyeing this up, the metallic silver image was toned to the complementary color.

A. Hamburger[49] proposed to apply both a yellow and red dye to one picture, and a blue and green dye to the other and then bleach the image, claiming pure gradations from yellow through orange to red and from pure

green through blue-green to blue in the other. It was stated that the silver image possessed an esoteric power which caused the proper colors to be deposited at the correct places, a contention which is obviously farcical. The dyes were to be mordanted either with a mixture of chromic acid and ferricyanide, as in Bullock's method, plus some thiocarbamid, which was suggested by Christensen, and the use of two dyes, which though claimed by Ives, was suggested as early as 1897 by von Hübl.

The Aktiengesellschaft für Anilinfabrikation[50] patented the use of quinon with silver images to form compounds that would act as mordants for basic dyes. But the validity of this is open to grave doubt, as A. and L. Lumière[51] had published the use of quinon and bromide for bleaching silver images in 1910.

M. Robach[52] suggested the use of silver sulfide as a mordant, a bright yellowish sepia being first obtained in the following:

Ammonium dichromate...................... 2.6 g.
Sodium chloride............................. 5.2 g.
Hydrochloric acid........................... 5.2 ccs.
Water1000 ccs.

Rinse and immerse in a clearing bath of 3 per cent sodium sulfite, bisulfite must not be used. Sulfiding might be effected in either of the following:

A. Sodium sulfide, 1 per cent solution;
B. Potassium sulfurata.................... 1.5 g.
 Hypo0.3-0.75 g.
 Water 1000 ccs.
C. Sodium sulfantimoniate................0.75-1.5 g.
 Ammonia 0.3 ccs.
 Water 1000 ccs.

The temperature should not be higher than 21° C. Wash for about 5 minutes after sulfiding and dry. The following was given as a typical bath for red:

Rhodamin B............................... 5.6 g.
Chrysoidin Y extra........................0.93 g.
Auramin 9.3 g.
Oxalic acid.............................. 3 g.
Glacial acetic acid........................ 50 ccs.
Water1000 ccs.

Although so far as the author is aware, the following process of the Neue Photographische Gesellschaft[53] has not been brought forward as a possible mordanting method for color photography, yet it warrants inclusion because it is capable of giving dye images, and as the possible forerunner of later processes. It is a modification of the original catatype process. O. Gros pointed out that the manganese salts were the best to use, but were very unstable, the phosphate alone being reasonably so. It was possible to make stable solutions by adding a manganic salt to potassium permanganate and dissolving the precipitate thus formed in an

organic acid, such as tartaric, and then rendering the solution permanently alkaline by the addition of caustic alkali. Practically this amounted to dissolving manganic hydroxide in the alkaline tartrate. The following was suggested among other solutions:

Potassium ferricyanide, 0.5 per cent sol.......... 3.7 ccs.
Manganese sulfate, 2 per cent sol................ 3.0 ccs.
Potassium bromide, 10 per cent sol.............. 11 ccs.
Water 1000 ccs.

The silver image was bleached in this and then treated with:
Potassium ferricyanide....................... 18 g.
Caustic soda................................. 1 g.
Water 1000 ccs.

In which a brown image was formed, which mordanted dyes or formed dyes with anilin, naphthylamin, toluidin, etc.

Iodide Mordanting or Diachrome Process.—This process, based on the mordanting action of silver iodide for basic dyes, was patented by A. Traube[54] and it seems as though he must be considered as the first inventor, though as is apparent from a note by A. Tauleigne[55] that the idea was in the air. E. Mazo presented to the Société française de Photographie some examples of Tauleigne's work in three colors, and E. Coustet, who reported the meeting, questioned the novelty of process, which was mordanting with iodide, and referred to Traube's work. Tauleigne wrote a protest and stated that he had made his first experiments in 1897, and that his first essays were with ferricyanide, particularly for the red constituent. He said: "if a proof, bleached with ferricyanide of potassium, be plunged into a solution of certain anilin colors, it will be seen that the color immediately mordants on the silver ferricyanide. The whites tint also, but with subsequent washing they become quite white, and fixing in hypo makes the silver disappear, leaving a monochrome stained a very pure color. Thus obtained, the color, it is true, is not stable. It was soon discovered in continuing these experiments that several silver salts were capable of precipitating certain anilin colors, and amongst them, the chloride, iodide, ferricyanide, chromate and others." It should be pointed out that if the venerable Abbé actually treated his silver images with ferricyanide, he would obtain an image in ferrocyanide and not the ferri as he stated.

The chloride and ferrocyanide gave but feeble images, and the iodide behaved the best, and finally a mordant was found that was satisfactory. There still remained the difficulty of fixing the color and at the same time removing the mordanting silver salt, and a means was finally found in potassium iodide, or a double bath of hypo or cyanide, preceded by a precipitant bath for the color. Pictures by this method were exhibited at the Exposition at Auxerre in 1908, and attracted much attention. Unfortunately Tauleigne did not publish his method till his French patent[56] was

issued, and from this it will be seen that he used not only silver iodide but cuprous iodide as a simultaneous mordant.

Traube points out in his patent that the silver print, obtained in the ordinary way, is transformed by double decomposition with the corresponding salts in the presence of an oxidizing agent into a print composed of silver iodide or bromide, chloride, ferrocyanide, double compounds of silver and copper, or of silver and mercury and other compounds. After coloring, the pictures must be fixed. Quinolin red is the only color actually cited as suitable; but it is pointed out that only basic dyes could thus be used. Stripping celluloid films could be used and the fixing bath should contain some tannin, which is well known as a precipitant for basic dyes. Of the acid dyes, eosin and other tri-phenyl-methane dyes could be used, and these required a fixing bath containing certain metallic salts. When all three prints were dyed up they might be immersed in weak gelatin solution and transferred in superposition.

Tauleigne & Mazo proposed to immerse the positives in a 5 per cent solution of cupric chloride, and after washing in a 1 or 2 per cent solution of potassium iodide, and stated: "in this bath the color of the image, which was a browny white, is changed into a greenish white, and the positive image is completely transformed into iodide of silver." This statement is open to question, because in the copper bath there would be formed a mixture of silver and cuprous chlorides, probably a complex, and on immersion in iodide would be transformed into the corresponding iodides, and there is no proof that the cuprous salt would be dissolved. From experiments carried out by the author, this certainly would not dissolve and the mixture of the two iodides not only gives greater absorption of the dye, but the presence of the copper can be at once detected by the action of ammonia.

To remove the silver salt, which degrades the color of the image, one method was to harden the film in alum solution, and then immerse in a 20 per cent solution of potassium iodide, and the inventors stated: "the iodide commences to completely dissolve the iodide of silver which is rendered completely transparent, without, however, being removed. This renders the color pure but without allowing it to diffuse or come out of the gelatin since it is retained by the iodide of silver which becomes invisible." If this statement is correct, there would be formed the silver hydrosol, which is the subject of Miller's patent. F. F. Renwick[57] stated that 100 ccs. of 30 per cent solution of potassium iodide will dissolve about 3 g. of silver iodide. Consequently it is not difficult to fix a plate in 20 per cent solution of alkaline iodide. He also pointed out that such strong solutions caused a softening or even melting of the gelatin film, unless the latter had been well hardened first with formaldehyde or the like. Renwick also pointed out that exposed plates, fixed in iodide solutions, could be developed with a physical developer of silver sulfite and p-phenylen-

diamin. It may, therefore, well happen that in the Tauleigne-Mazo process, although the plate was apparently fixed, nuclei or germs were still existent in the film, which would act as mordants for basic dyes, thus indirectly anticipating Miller's process.

H. Miller[58] claimed the use of silver iodide hydrosol for mordanting basic dyes. Two baths were suggested, one without acid:

Iodine	1 g.
Potassium iodide............................	50 g.
Water	1000 ccs.

And an acid bath of:

Iodine	1-5 g.
Potassium iodide...........................	50 g.
Acetic acid, 3 per cent sol...................	50-150 ccs.
Water	1000 ccs.

Potassium dichromate, permanganate or persulfate or the corresponding cerium salt might be used, and it is disclosed that the hydrosols of chromate, ferrocyanide and ferricyanide might also be used. Considerable variation of the ratios of the iodine and iodide are permissible, but the ratio of the former should be from 1 to 4 per cent of the iodide, if the latter falls below 1 per cent the details in the high lights are lost.

It may seem a curious fact, yet fact it is that more intense color images are thus obtained than with the more opaque silver iodide, for if the bleach bath is properly compounded the silver image is quite invisible, unless washed too long, in which case it reappears as a faint yellow stain, rather than a definite image, and is, even in this condition very transparent. To avoid the long washing, the positive may be immersed in sodium bisulfite solution, which instantly removes the somewhat deep stain of the free iodine in the gelatin, then a brief wash will make the print ready for staining up.

Various changes have been rung on the iodide bath. H. D'Arcy Power[59] suggested the use of potassium ferricyanide and iodide in the ratio of 40 : 20 : 1000 water. In this the transparency should be left for 10 minutes, washed and dyed up, and before fixing should be immersed in 10 per cent solution of tannin to which a few drops of formaldehyde has been added as a preservative. A. Cohen[60] tried this process for direct positives. Bromide paper was fully exposed in the camera, developed, exposed to white light till the whites were tinted, the image iodized and after washing immersed in solution of nigrosin. The negative portion of the image was then seen in relief, whereas the other part was sunken in, insolubilization of the positive image taking place. It was then fixed in a hot hypo bath, when the negative image dissolved with the gelatin, leaving a positive behind in pure dye, which was very intense but lacked half tone, and it would seem as though the process was suitable for line work.

C. Wolf-Czapek[61] suggested after the iodizing bath the use of 1 per

cent solution of brilliant green, with 2 per cent sulfuric acid, or as quicker
working a compound bath of:

Potassium ferricyanide	2 g.
Potassium iodide	3.5 g.
Ethyl green, 2 per cent sol	15 ccs.
Sulfuric acid, 10 per cent sol	1 ccs.
Water	1000 ccs.

The following basic dyes were suitable for this process: auramin, chrys-
oidin, vesuvin, fuchsin, methyl violet, safranin, rhodamin, thionin blue,
methylen blue, malachite green and Victoria blue. These should be used
in 0.05 per cent solution with an equal volume of ammonia. The fol-
lowing acid dyes could be used also, tartrazin, Victoria yellow, ponceau,
brilliant orange, naphthalin blue, acid violet, acid fuchsin, eosin, erythrosin,
rose Bengal in 0.1 per cent solution with half the weight of citric acid.

The author has found that the positives for this process should be of
rather a soft character and absolutely free from fog, which causes a super-
ficial veil of color. Fixation of the plates should be effected in a chrome
alum fixing bath, and after washing immersion in a 25 per cent solution
of formaldehyde for 15 minutes and drying without washing, gives the
best results. The strength of the dye solutions should not exceed 0.25
per cent, and with the addition of 5 per cent of glacial acetic acid, which
keeps the whites much purer, and facilitates after-washing. Frequent
failures may be met with, and this is often traceable to want of acid in
the iodizing and dyeing baths, therefore, if the baths are in repeated use
a little acid should be added occasionally.

A. S. Cory[62] suggested as an iodizing bath:

Potassium iodide	40 g.
Iodine	19 g.
Water	1000 ccs.

When the image is bleached, wash for 30 minutes and immerse in the dye
bath, which should be from 1 : 2000 to 1 : 5000, for about 15 minutes,
then wash in running water, or in 5 per cent solution of glacial acetic acid,
then fix in 10 per cent hypo solution containing 5 per cent of tannin and
the same weight of sodium acetate.

J. H. Christensen[63] proposed some methods which are rather compli-
cated, the main idea being apparently to use emulsions weak in silver salts.
Very thin negatives were to be obtained by the use of diluted emulsions,
such as would be quite useless for ordinary printing. The image was to
be converted into a dye-absorbing compound, such as silver iodide, silver
sulfocyanide or colorless cuprous iodide or sulfocyanide. A typical solu-
tion would be:

Potassium citrate	55.5 g.
Cupric sulfate	41.75 g.
Potassium thiocarbamid	20 g.
Acetic acid	25 ccs.
Water	1000 ccs.

After bleaching the plate should be washed and dyed with a basic dye, such as rhodamin, fast green, etc., then again washed. The plate might also be bleached with cupric sulfate and potassium bromide, whereby the image would be converted into silver and cuprous bromide, which have no dye-absorptive power; but if the plate was treated with:

Potassium citrate	71.5 g.
Potassium iodide	143 g.
Water	1000 ccs.

In which was dissolved a little dye, the plate would be cleared and at the same time the dye deposited. Thiocarbamid will produce dye-absorbent compounds and if a silver bromide or other halide be treated with the following, it will absorb dye:

Potassium metabisulfite	7.8 g.
Thiocarbamid	6 g.
Potassium iodide	3.1 g.
Potassium sulfocyanide	15.5 g.
Water	1000 ccs.

Such plates are very transparent and may be used for superposition. In producing two-color pictures, the two differently sensitized emulsions may be arranged on each side of the same film.

A. Seyewetz[64] dealt generally with these mordanting processes and gave the preference to Christensen's though a modified formula is given:

Cupric sulfate	40 g.
Potassium sulfocyanide	20 g.
Potassium citrate	60 g.
Glacial acetic acid	30 ccs.
Water	1000 ccs.

This bleaches fairly slowly but takes dyes well.

Seyewetz also stated that the double ferrocyanides of silver and iron or uranium are good mordants, these being formed preferably by using potassium ferricyanide and oxalic acid plus iron nitrate or citrate or the corresponding uranium salts. And notwithstanding the fact that these compound salts are rather deep in color, with some dyes this is not very noticeable, particularly if the plates are well washed. He also stated that high transparency was conferred on positives mordanted with chrome salts, as in Bullock's process, if the plates were treated with a bath of:

Hypo	78 g.
Cupric sulfate	32 g.
Acetic acid, 30 per cent	31 ccs.
Water	1000 ccs.

The cupric sulfate prevents the diffusion of the dye.

Dealing with other methods of mordanting Seyewetz pointed out that quinon and an alkaline bromide convert the silver image into a brown one, which will absorb dyes; but the final color is different to that of the dye due to the brown primary image. Toluquinon behaves in the same way, but quinon sulfonic acid, whilst acting as a mordant, stains the high lights.

Various dyes were tested in 0.5 per cent solution, acidified with 1 per cent acetic acid. The positives were immersed long enough to stain the gelatin strongly and were then washed for a long time in running water. It was found that the dyes gave results of three kinds:

(a) The clear gelatin-covered edges containing no silver deposit remain colorless or faintly tinted, the image remaining stained; (b) the edges and the image lose their stain simultaneously; (c) neither the edges nor the image are freed from stain even by prolonged washing. Dyes which give results of the first type are alone considered as fixing on the mordant, those of the third type staining image and film indiscriminately. The table on the next page gives those dyes proved to be efficient in dyeing the mordants:

Seyewetz considered that the theory of dyeing of silver images was not quite clear. Probably the process is analagous to that of dyeing of fibers by means of metallic mordants; but with this difference that, in the case of fibers, it is insoluble oxides which combine with acid dyes to give actual lakes, and that, in order to be able to form these lakes, the dyes must possess certain chromatic groupings, such as hydroxyl and carboxyl groups, or two hydroxyl groups in the ortho position. In the case in question, the lake is apparently formed with compounds such as ferrocyanide, sulfocyanides, chromates, the acids of which are capable of forming insoluble compounds with certain basic dyes, although it is not possible to trace any definite color-forming groups. However , except for the triphenylmethane dyes and certain azo varieties, all these dyes, such as the thiazins, eurhodins, safranins, indulins, acridins and phenyl-acridins contain, like indamin, a diphenylamin residue, having the two nuclei joined in the ortho position by sulfur or nitrogen.

M. Martinez[65] proposed a very complicated process, which might be classified under various headings. Practically it consisted in emulsifying colored compounds, such as dyes, silver, ferric, mercuric or mercurous and uranium salts, or "organates," by which was meant any organic compound. Three or more colors, either additive or subtractive, might be used. The specification is extremely complicated, but apparently silver salts were to be stained with various dyes, then emulsified and converted into silver iodide by treatment with methyl iodide, and ripened by exposure to light of their own color. The different colored emulsions were to be mixed, coated on various supports, exposed, developed and fixed, either with hypo or an alkaline iodide; this latter converting the unexposed parts into silver iodide. Or borax powder might be strewed over the surface, then on immersion in an acid bath, this was supposed to absorb the bromine and chlorine, present in the image and fix it. The silver image might be etched out with its contiguous gelatin, with peroxide. When positives were to be made, the silver image was to be converted into a white compound by treatment with ferricyanide and potassium oxalate, or a salt of zinc,

Dyes.	With Silver Copper Sulphocyanide mordant.	With Silver Copper Ferrocyanide mordant.	With Quinochrome mordant.	With Silver Ferrocyanide and Chromic Oxide mordant.
BASIC AZO DYES.				
Chrysoidin	Brown *a*	Brown *a*	Brown *a*	Weak brown.
Bismarck brown	Yellow brown *c*	Yellow brown *a*	Yellow brown *c*	Weak brown.
New Phosphin	Yellow brown *a*	Yellow *a*	Yellow brown *c*	Weak brown.
DI- AND TRI-PHENYLMETHANE DYES.				
Auramin	Pure yellow *a*	Feeble tint only	Yellowish brown *a*	No tint.
Pyronin G	Red *a*	Red *a*	Red *a*	Red *c*.
Red acridin 3B	Red *a*	Red *a*	Red *a*	Feeble tint.
Pyronin orange	Orange *a*	Orange *a*	Orange *a*	Feeble red tint.
Malachite green	Green *a*	Feeble tint only	Green *a*	No tint.
Ethyl green	Green *a*	Green *b*	Green *a*	No tint.
Fuchsin	Red *a*	Red *a*	Red *a*	Feeble tint.
Methyl violet	Violet *a*	Violet *c*	Violet *a*	Violet *c*.
Ethyl violet	Violet *a*	Violet *c*	Violet *a*	Weakly mordanted.
Hoffman violet	Violet *c*	Violet *c*	Violet *c*	Weakly mordanted.
Rodamin S	Red *a*	Red *a*	Red *c*	Red *a*.
Anisoline	Red *a*	Feeble red tint	Red *a*	No tint.
Eosin	Faint tint only	Red *b*	Feeble tint *b*	No tint.
Erythrosin	Red *c*	Red *c*	Feeble tint *b*	Feeble tint.
Fuchsin M.L.B.	Red *c*	Red *c*	Red *c*	Feeble tint.
THIAZINE DYES.				
Methylen blue	Blue *a*	Blue *a*	Green *a*	Feeble tint.
Methylen green	Blue *a*	Blue-green *a*	Green *a*	Feeble tint.
Capri blue	Blue *a*	Blue *a*	Greenish blue *a*	Blue.
Nile blue 2B	Blue *a*	Blue *a*	Blue *c*	
EURHODINE DYES.				
Toluylen red	Red *a*	Red *a*	Reddish *c*	No tint.
SAFRANINE DYES.				
Phenosafranin	Red *a*	Red *a*	Red *c*	No tint.
Indulin scarlet	Red *a*	Red *a*	Red *a*	No tint.
INDULIN DYES.				
Metaphenylen blue 2B	Blue *c*	Blue *c*	Blue *c*	Feeble tint.
Bale blue	Feeble tint	Blue violet *a*	Mauve *a*	Blue *a*.
QUINOLINE AND ACRIDINE DYES.				
Quinolin yellow	Yellow *a*	Yellow *b*	Yellow *a*	No tint.
Acridin orange	Orange yellow *a*	Orange *c*	Yellow brown *a*	Orange *c*.
Phosphin	Orange yellow *a*	Yellow brown *a*	Yellow brown *a*	Feeble tint.
Brilliant phosphin 5A	Yellow *a*	Yellow *a*	Yellow brown *a*	No tint.
Acridin yellow A	Yellow *a*	Yellow *a*	Yellow brown *a*	No tint.
THIOBENZENE DYES.				
Thioflavin T	Yellow *a*	Yellow *a*	Yellow brown *a*	No tint.

mercury, barium or lead. The color particles were said not to be affected and would slightly bleed or diffuse, so as to destroy any grainy effect. Gum arabic, tragacanth, collodion, etc., might be used as vehicles and salicylate or benzoate compounds of iron as the sensitive material. It would seem as though the specification were so worded as to really hide rather than disclose the process.

R. Luther and K. von Holleben[66] patented a process, which they call a modification of the bleach-out process; but which apparently necessitated the incorporation of dyestuffs with a silver emulsion, and destroying them by the action of an "inductor," such as vanadium ferricyanide, and treating the compound thus obtained with chromic or hydrobromic acids. Or silver bromate or lead chromate might be formed; cobalt, lead and manganese compounds, which on treatment with acids would destroy the dyes, might be used. Or the insoluble dyes might be locally converted into soluble compounds. This process was stated to be suitable for obtaining positives in the camera.

1. Bull. Soc. franç. Phot. 1855.
These early notes are abstracted in part from Eder's Handbuch, 1899, **4**, IV, 271.
2. Chem. News, 1864, **9**, 296; 1865, **10**, 28; 1886, **11**, 16; Poly. Crbl. 1865, 187; Chem. Zentr. 1865, 383; D. Industrieztg. 1865; Dingl. Poly. 1865, **172**, 249; Jahr. Chem. 1864, **17**, 821; Phot. Mitt. 1864, **1**, 35; Phot. News, 1878, **22**, 466. Kopp said: "On peut utiliser les propiétés oxydantes de cette substance brune en faisant réagir sur elle un corps qui, en oxydant, donne des composés colorés insolubles; c'est le cas avec certains acides pyrogénés, plusieurs combinaisons d'aniline et de naphtaline, soit même avec composes minéraux, par exemples les sels ferreux."
For notes on chromium oxide as a mordant for dyes cf. Schnauss, Phot. Lexicon, 1864, 393; Lemling, Der Forscher, 1867, 83, 127, 148; Heinlein's Photographicon, 1864, 296; Dingl. Poly, 1864, **220**, 192.
3. Bull. Soc. franç. Phot. 1856, **3**, 343; Kreutzer's Jahrber, Phot. 1856, 39. Cf. Selle, ibid. 1857, 62; Perry, ibid. 53; Lemling, "Der praktische Photographie," 1862, 77. Schnauss reports, Phot. Lexicon, 1882, 469, that Graw used albumen and chromate. In all these processes the print was immersed in gallic acid or pyrogallol solution and then in ferrous sulfate or vice versa. E. Edwards, E.P. 1,362, 1875 (see p. 390), imbibition process, used mordants for the imbibed image. Hannaford, Brit. J. Phot. 1860, **7**, 100, used ammonio-ferric-citrate, albumen and dichromate and immersed the washed print in gallic acid or first in gold chloride and then in gallic acid.
4. E.P. 185, 1863.
5. Brit. J. Phot. 1865, **12**, 162; 1924, **71**, 45; Phot. Archiv. 1865, **6**, 184.
6. Compt. rend. 1896, **122**, 609. According to L. P. Clerc, "La Photographie des Couleurs," 1899, 147, Richard used azo dyes.
Eder gives a summary of the mordanting of dyes, Camera (Luzerne), 1924, **2**, 133, 153, 178, 201. Cf. Brit. J. Phot. 1908, **55**, 110; abst. C. A. 1924, **18**, 3557.
7. Bull. Soc. franç. Phot. 1892, **39**, 336; 1919, **56**, 263; Phot. Annual, 1893, 112; Brit. J. Phot. 1892, **39**, 421; Fabre, "Traité Encycl." Supp. A, 287.
Villain published his methods in "De la Photo-Teinture," Boulogne, 1893; Amer. Annual Phot. 1895, 235; Brit. J. Almanac, 1899, 929; Phot. Times, 1892, **22**, 421; Paris-Photographe, 1892, 293; Photogram, 1899, **6**, 335; Jahrbuch, 1893, **7**, 485; 1894, **8**, 442. A. Soret, Brit. J. Phot. 1900, **47**, 474; Bull. Soc. Havraise Phot. 1900, is reported to have described Villain's work and stated that Persoz, in L'Année Scientifique, 1858 had described some experiments to utilize the greenish chromium oxide produced by the action of light on potassium or ammonium dichromate, as a mordant for logwood, sumac, Brazil, alkanet, quercitrin, etc. Villain used Kopp's process and immersed paper, etc., in a mixture of potassium dichromate 50, ammonium vanadate 5, water 1000 parts, and after exposure washed and immersed in the dye solutions. Cf. P. C. Duchochois, Phot. News, 1895, **39**, 167; Jahrbuch, 1915, **29**, 174. P. van Duyse, Phot. Moderne, 1924, **2**, 125. Villain gave a good sketch of all

these processes, Bull. Assoc. génér. d. Chimistes de l'Industrie textile, 1914, 15; abst. American Textile, 1917, **28,** 21; Amer. Phot. 1925, **19,** 406.

Barreswill & Davanne, "Chimie photographique," 1861, 3rd edit. 362, commenting on Poitevin's carbon process, stated that "Doubtless one could also use for coloring, the new colors obtained from coal tar, which take directly on albumen." Persoz, in 1858 in his course on dyeing at the Conservatoire des Arts et Metièrs; Année Sci. 1859, **1,** 250, pointed out the sensitiveness of potassium dichromate and suggested impregnating fabrics with the same, and printing under stencils. He stated that chromium oxide was formed, which would act as a mordant for madder and logwood. E. Höttenroth, D.R.P. 168,771, 1904, suggested the painting of fabrics with a colloid, dichromate, and coloring matters and exposing to light with subsequent washing to remove the unaltered salt. W. Willis, E.P. 2,800, 1864; Phot. Archiv. 1865, **6,** 177; Handbuch, 1899, **4,** 275, in his anilin process used not only dichromate, but cupric dichromate and phosphate. Cf. E. J. Reynolds, Phot. Archiv, 1865, **6,** 299; La Blanchère, Rep. encycl. Phot. **6,** 204. T. Dawson, Phot. Archiv., 1866, **7,** 105; La Blanchère, Rep. encycl. Phot. **6,** 204; Handbuch, 1899, **4,** 275. H. W. Vogel, Phot. Mitt. 1866, **2,** 138; 1867, **3,** 15.

8. Phot. Archiv. 1895, **37,** 209; Phot. Mitt. 1898, **35,** 230; Brit. J. Phot. 1898, **45,** 613; Jahrbuch, 1894, **8,** 50.

9. D.R.P. 117,134, 1898; E.P. 12,517, 1899.

10. "Die Dreifarbenphotographie," 1904, 54. This was confirmed also in a private letter to the author. Cf. König & Wall, "Natural-Color Photography," 1906, 66.

11. Phot. Rund. 1899; Brit. J. Phot. 1899, **46,** 538.

12. Bull. Soc. franç. Phot. 1895, **42,** 108; 1898, **45,** 17; Phot. Annual, 1895, 164. H. Endemann, J. Amer. Chem. Soc. 1886, **8,** 189, Handbuch, 1889, **4,** 279, used dichromate and sodium vanadate, and after exposure exposed the paper to the vapor of anilin, thus following Willis' anilin process, E.P. 2,800, 1864. W. J. Gottlieb, U.S.P. 306,481, 1884, also used vanadates and dichromate as sensitizer.

13. F.P. 247,065, 1895; addit. Jun. 1895; Brit. J. Phot. 1895, **42,** 824; Mon. Sci. 1896, 45; Sci. Amer. 1895; Mon. d. l. Teinture, 1895; Textile Colourist, 1895; Jahrbuch, 1912, **26,** 419; L'Industrie Textile, 1895, May 1. In a subsequent patent, ibid. Mar. 15, 1896, the use of tannin as a mordant and a soap bath with an ammoniacal bath of peroxide, for clearing the whites was claimed.

14. E.P. 12,313, 1900; Brit. J. Phot. 1900, **47,** 820; D.R.P. 116,177, 1899; Silbermann, **1,** 212; F.P. 302,019, 1909.

15. E.P. 5,879, 1901; Brit. J. Phot. 1901, **48,** 98; D.R.P. 123,292; Silbermann, **1,** 212.

16. La Phot. 1908, 227; Jahrbuch, 1909, **23,** 408; Handbuch, 1917, **4,** II, 43; Schweizer Phot. Ztg. 1908; "Les épreuves au Bichromate par Teinture Directe," Paris, 1912; Brit. J. Phot. 1908, **55,** 738; Phot. Coul. 1908, **3,** 227. Benham's copper process is described, Photogram, 1899, **6,** 24. Phillipe, F.P. 112,072, 1896, used dichromate of copper and ammonia as sensitive salt, and immersed the print, after treatment with cyanide in anilin oxalate.

17. "Abridged Scientific Publications from the Kodak Research Laboratory," 1915; 1916, **2,** 130; Jahrbuch, 1915, **29,** 177. Cf. E. J. Wall, Brit. J. Phot. 1925, **72,** 207.

18. Abst. Chem. News, 1923, **126,** 351; Brit. J. Phot. 1923, **70,** 352; Amer. Phot. 1923, **17,** 756; Trans. Faraday Soc. 1923, 327; abst. J. S. C. I. 1924, **43,** B997.

19. Brit. J. Phot. 1909, **56,** Col. Phot. Supp. 3, 68; abst. Jahrbuch, 1910, **24,** 545; C. A. 1910, **4,** 1136.

20. Phot. Coul. 1909, **4,** 195; Photo-Rev. 1909, **21,** 170; Brit. J. Phot. 1909, **56,** Col. Phot. Supp. 3, 91. Namias, Bull. Soc. franç. Phot. 1919, **56,** 332, stated that he had also indicated the use of lead and copper ferrocyanides at the Photographic Congress at Rome in 1911. For historical notes cf. R. Namias, Il. Prog. Foto. 1924, **31,** 289.

21. E.P. 147,005, 1916; Brit. J. Phot. 1921, **68,** 328; Col. Phot. Supp. **14,** 23; 1922, **69,** ibid. 15, 28; F.P. 491,927; Can.P. 231,070; abst. Phot. Korr. 1920, **57,** 303; Jahrbuch, 1915, **29,** 174; Sci. Tech. Ind. Phot. 1921, **1,** 8; Lux. 1918, 90; Sci. Amer. 1921, **125,** 225. Traube's D.R.P. applic. T20,656, which was his first for the use of copper ferrocyanide as mordant, has been refused by the German Patent office, on the ground that the process was previously described by Namias. Phot. Ind. 1923, 637; 1924, 9, 80, 210, 212, 267, 285; Sci. Ind. Phot. 1924, **5,** 2; Amer. Phot. 1924, **18,** 573.

22. E.P. 147,103. As no basic dye can possibly be formed without a benzol ring, the validity of this patent is dubious. Cf. Phot. Ind. 1924, 80.

23. E.P. 163,337; abst. J. S. C. I. 1921, **40**, 903A; 1922, **41**, 120A; F.P. 520,111, 1918; abst. Sci. Tech. Ind. Phot. 1922, **2**, 15; D.R.P. 403,428. In this patent excess of ferricyanide is claimed, but this has been quite general in copper toning formulas. Cf. L. Preiss, D.R.P. 406,707; 406,708; Phot. Ind. 1925, 98; Amer. Phot. 1925, **19**, 540.

24. U.S.P. 1,305,962, 1919, applic. date Jan. 25, 1917; abst. J. S. C. I. 1919, **38**, 602A; Annual Repts. 1919, **4**, 511; M. P. News, 1918, 1104, 1276. It is stated here that although the process was patented it was open to all users of Eastman film; Photo-Rev. 1920, **32**, 54; Jahrbuch, 1915, **29**, 176.

The Naturfarben-Film G.m.b.H., D.R.P. 393,790; Phot. Ind. 1924, 846; J. S. C. I. 1924, **43**, B813, also patented the use of separate baths of ferricyanide and cupric chloride for toning

25. U.S.P. 1,278,667; 1,300,616, 1919; applic. date Feb. 20, 1917; abst. J. S. C. I. 1918, **37**, 607A; 1919, **38**, 479A; E.P. 113,617; 113,618, 1917, granted to Hess-Ives Corp.; Brit. J. Phot. 1919, **66**, Col. Phot. Supp. **13**, 2; F.P. 488,955, 1915; 490,750, 1918; Jahrbuch, 1915, **29**, 152. Cf. E.P. 119,254, 1917. This copper mordanting process was used for a two-color process, Brit. J. Phot. 1921, **68**, Col. Phot. Supp. **15**, 16; Camera Craft, 1921, **28**, 202.

26. F.P. 558,699; abst. Sci. Ind. Phot. 1924, **4**, 27.

27. Phot. Ind. 1924, 526; abst. C. A. 1925, **19**, 218.

28. Brit. J. Phot. 1895, **42**, 557. The best account of the life and researches of Mercer will be found in "The Life and Letters of John Mercer," London, 1886, by E. A. Parnell. According to Villain, loc. cit. Smith, of Brackford (? Bradford) used iron and chromium salts as mordants, obtaining pictures on fabrics by photography; La Lumière, 1854.

29. E.P. 1,983, 1856.

30. E.P. 2,526, 1864; La Blanchère, Rep. encycl. Phot. 1864, **6**, 18.

31. J. S. C. I. 1898; Brit. J. Phot. 1898, **45**, 445, 499, 806; Jahrbuch, 1899, **13**, 568; 1907, **21**, 527; Handbuch, 1899, **4**, II, 246; Amer. Phot. 1922, **16**, 463; Photo-Rev. 1906, 48; Phot. Woch. 1906, **52**, 406; La Phot. 1899, 57.

32. D.R.P. 114,923, 1899; Silbermann, **1**, 208; Jahrbuch, 1902, **16**, 597; 1912, **26**, 419; Phot. Chron. 1901, **8**, 197; F.P. 281,659.

West & Wedmore, D.R.P. 281,659, 1899; La Phot. 1899, 135, used ammonium nitroprussiate as the sensitive salt, with or without zinc and magnesium salts. Cf. A. J. Jarman, Bull. Soc. franç. Phot. 1913, for the use of ammonio-citrate of iron and silver with dyes.

33. E.P. 25,043, 1898; Brit. J. Phot. 1899, **46**, 790; Photogram, 1900, **7**, 87.

34. D.R.P. 166,837, 1902; Jahrbuch, 1907, **21**, 573.

35. F.P. 303,700; abst. Jahrbuch, 1912, **26**, 419.

36. U.S.P. 1,071,559, 1913; Can.P. 160,056.

37. E.P. 2,474, 1915; Brit. J. Phot. 1916, **63**, 548; U.S.P. 1,126,495; abst. C. A. 1913, **7**, 3722; J. S. C. I. 1916, **38**, 754; Annual Repts. 1916, **1**, 306; F.P. 477,751, 1914; D.R.P. 293,478; Can.P. 160,056; Jahrbuch, 1915, **29**, 168.

Cf. W. Gamble, Brit. J. Phot. 1922, **69**. Col. Phot. Supp. **16**, 7.

38. U.S.P. 1,389,742, 1921; abst. Sci. Tech. Ind. Phot. 1922, **2**, 40; Amer. Phot. 1922, **16**, 463.

39. F.P. 450,412, 1923; abst. Amer. Phot. 1923, **17**, 184; U.S.P. 1,450,,412, abst. J. S. C I. 1923, **42**, 522A; C. A. 1923, **17**, 1927; Sci. Ind. Phot. 1924, **4**, 172.

40. U.S.P. 1,279,248, 1918; Jahrbuch, 1915, **29**, 170.

Cf. R. J. Carnotel, La Photo pour Tous, 1925, **2**, 275.

41. M. P. News, 1918, 3941; J. Frank. Inst. 1918, **163**, 755; abst. Abstract Bull. 1919, **5**, 30; U.S.P. 1,376,940; E.P. 193,069, 1921; Brit. J. Phot. 1919, **66**, Col. Phot. Supp. **12**, 3, abst. J. S. C. I. 1919, **38**, 56; Annual Repts. 1919, **4**, 511; Jahrbuch, 1915, **29**, 175; Sci. Tech. Ind. Phot. 1921, **1**, 5, 18; Phot. Korr. 1920, **57**, 103; 1921, **58**, 63; Handbuch, 1922, **4**, III, 308. Cf. Clark, footnote 17. Ives v. Wall, Brit. J. Phot. 1925, **72**, 55, 131, 207.

42. Brit. J. Phot. 1920, **67**, Col. Phot. Supp. **13**, 24, 43; abst. Abst. Bull. 1920, **6**, 225.

43. Brit. J. Phot. 1921, **68**, Col. Phot. Supp. **14**, 3.

Ives recommended the above bleach followed by a mixture of Victoria green, 0.17, safranin 0.34, glacial acetic acid 8.5, water 1000 parts for intensifying negatives.

44. E.P. 160,540, 1919; Brit. J. Phot. 1921, **68**, Col. Phot. Supp. **14**, 23; abst. Sci. Tech. Ind. Phot. 1921, **1**, 95.

45. F.P. 476,213, 1915; abst. J. S. C. I. 1916, **35**, 73; Annual Repts. 1916, **1**, 307.
46. U.S.P. 1,331,092, 1920; abst. Sci. Tech. Ind. Phot. 1921, **1**, 28.
47. U.S.P., 1,411,968, 1922; Amer. Phot. 1922, **16**, 662; E.P. 160,137, 1921; Brit. J. Phot. 1922, **69**, 539; D.R.P. 378,959; Phot. Ind. 1924, 221; Sci. Tech. Ind. Phot. 1921, **1**, 95; 1923, **4**, 14; F.P. 539,936; 540,191; 540,192.
48. E.P. 193,069; Brit. J. Phot. 1923, **70**, Col. Phot. Supp. **17**, 17; Brit. J. Almanac, 1924, 387; D.R.P. 369,403; abst. J. S. C. I. 1923, **42**, 377A. Cf. E.P. 193,362; 193,363; 193,364; Phot. Ind. 1924, 221; Sci. Ind. Phot. 1924, **4**, 84.
49. E.P. 203,358, 1922; Brit. J. Phot. 1922, **69**, Col. Phot. Supp. **16**, 23; 1923, **70**, ibid. **17**, 42; Amer. Phot. 1924, **18**, 380; 1925, **19**, 56; F.P. 563,381. This method was applied to cinematography and called the Verachrome process, Kine. Weekly, 1924, **91**, No. 907, 82; Sci. Ind. Phot. 1924, **4**, 171; D.R.P. 388,345.
50. D.R.P. 354,434; E.P. 180,292; Brit. J. Phot. 1923, **70**, 133, 143; F.P. 133,143. Cf. U.S.P. 1,473,568 granted to W. Lenger.
51. E.P. 25,751, 1910; Brit. J. Phot. 1911, **58**, 460. Cf. W. Lenger, Phot. Ind. 1925, 162.
52. Brit. J. Phot. 1923, **70**, 363; 1924, **71**, 183; abst. Amer. Phot. 1924, **18**, 381; C. A. 1924, **18**, 1794.
53. D.R.P. 157,411; 180,947; 180,948; Phot. Ind. 1905, 146, 215; Jahrbuch, 1905, **19**, 451; 1907, **21**, 525; Silbermann, **1**, 189; E.P. 21,584, 1906; Brit. J. Phot 1907, **54**, 201, 202, 275. Cf. E.P. 10,898, 1904.
54. D.R.P. 187,289, 1905; 188,164, 1906 in this the use of tannin is claimed as mordant; E.P. 10,258, 1907; Brit. J. Phot. 1906, **53**, 942, 944; 1907, **54**, 196; Col. Phot. Supp. **1**, 26; 1908, **55**, 435, 446, 855; 1911, **59**, 607, 857; 1919, **66**, 598; Brit. J. Almanac 1908, 701; Phot. News, 1906, **50**, 983; Das Atel. 1907, **14**, 23, 35; Jahrbuch, 1907, **21**, 103, 416; 1908, **22**, 414; M. P. News, 1917, 3488; F.P. 376,051; Bull. Soc. franç. Phot. 1919, **50**, 263; Phot. Korr. 1898; U.S.P. 1,093,503; abst. C. A. 1914, **8**, 1924; Phot. Coul. 1907, **2**, 8, 70, 176; 1908, **3**, 168; Photo-Gaz. 1908, **18**, 197; 1912, **22**, 110; Phot. Kunst. 1916, **15**, 9.
A. Mori, Photo-Rev. 1920, **32**, 54 stated that he had been in the habit of daily altering the colors obtained by the use of uranium toning for motion picture films by the use of basic dyes.
55. Phot. Coul. 1910, **5**, 37; Brit. J. Phot. 1910, **57**, Col. Phot. Supp. **4**, 16, 22, 51.
56. E.P. 27,818, 1909; Brit. J. Phot. 1910, **57**, Col. Phot. Supp. **4**, 22, 51; 1911, **58**, 221; Phot. Coul. 1910, **5**, 37, 130; F.P. 420,584; 420,585; U.S.P. 1,059,917; abst. Jahrbuch, 1911, **25**, 365; Phot. Mitt. 1910, **57**, 369; Le Procédé, 1911, **3**, 77; J. S. C. I. 1911, **30**, 308,447; 1913, **32**, 551; C. A. 1911, **7**, 2021. Cf. E. J. Wall, Brit. J. Phot. 1911, **56**, 607. F. Lefebre, Bull. Nord France, 1911; Brit. J. Phot. 1911, **58**, 857; Jahrbuch, 1912, **26**, 686.
57. Phot. J. 1921, **61**, 12; Brit. J. Phot. 1921, **68**, 34; J. S. C. I. 1920, **39**, 156T.
58. U.S.P. 1,214,940; E.P. 100,098, 1915; Brit. J. Phot. 1917, **64**, 303; abst. J. S. C. I. 1917, **36**, 403; Annual Repts. 1917, **2**, 502; C. A. 1916, **10**, 1095; Jahrbuch, 1915, **29**, 175; F.P. 483,764; D.R.P. 405,962.
59. Brit. J. Phot. 1912, **59**, 41.
60. Ibid. 150.
61. Phot. Ind. 1912, 609.
F. Kropff, Phot. Ind. 1924, 1143; Brit. J. Phot. 1924, **71**, 774; Amer. Phot. 1925, **19**, 365; Sci. Ind. Phot. 1925, **5**, 18, suggested the addition of a dye to a cupric bromide bleacher, so that the dye was precipitated as the image bleached. F. E. Ives, Brit. J. Phot. 1925, **72**, 55 claimed to have been the first to combine the dye with a bleacher (ibid. 1921, **68**, 186). This combination was patented by W. Friese-Greene et al. E.P. 160,540, 1919 and by H. Shorrocks, E.P. 111,054, 1917; U.S.P. 1,303,506 prior to Ives. Cf. E. J. Wall, Brit. J. Phot. 1925, **72**, 131, A. Hamburger, ibid. 70. Ives, ibid. 131.
62. M. P. News, 1916, 3488.
63. E.P. 132,846; Brit. J. Phot. 1919, **66**, 639; abst. J. S. C. I. 1919, **39**, 878A; D.R.P. 319,459; 319,477; 334,277; Sci. Tech. Ind. Phot. 1921, **1**, 100; Phot. Korr. 1919, **56**, 274; Jahrbuch, 1915, **29**, 173, 179. Cf. E.P. 135,477; F.P. 506,205; 491,927; U.S.P. 1,447,759; C. A. 1923, **17**, 1598. E. Granaug, Phot. Korr. 1924, **60**, 7; abst. Amer. Phot. 1925, **19**, 365; Phot. Ind. 1925, 103.
64. Brit. J. Phot. 1924, **71**, 609; Amer. Phot. 1924, **18**, 445; Rev. Franç. Phot. 1923, **4**, 288; Chim. Ind. 1924, sp. No. 472; abst. C. A. 1924, **18**, 3326; J. S. C. I. 1924, **43**, B812; La Phot. 1924, **11**, 257. Cf. G. Schweitzer, Photo-Rev. 1924, **36**, 43, 59; C. A. 1925, **19**, 217.

R. E. Marker and N. E. Gordon, Ind. Eng. Chem. 1924, **16**, 1186 dealt with the absorption of dyes by inorganic gels and the effect of the hydrogen ion concentration. Their conclusions may have considerable bearing on the question of the absorption of dyes in color photography. They used ferric oxide, silica and alumina gels and proved inter alia that definite crystalline compounds were formed between the mordants and the dyes. Magnesium, nickel, lead, strontium, mercury, calcium and manganese mordants were thus tested.

On the light-sensitiveness of manganese salts and the formation of colored images, see A. and L. Lumière, Bull. Soc. franç. Phot. 1892, **34**, 218, 278, 332; 1893, **35**, 104; Jahrbuch, 1893, **7**, 40; Handbuch, 1899, **4**, 546; Phot. Annual, 1894, 92. Cf. R. E. Liesegang, Phot. Archiv. 1893, **34**, 133. R. Child Bayley, Phot. J. 1893, **33**, 130.

On tungsten and molybdenum salts, see R. E. Liesegang, La Blanchère, Rep. Encycl. Phot. 1864, **5**, 146. Schoen, Soc. indust, Mulhouse, 1893, **4**, Dec. 15, Niewenglowski, Bull. Soc. Amat. Phot. 1894. A. Villain, Paris-Photographe, 1894, Mar. 30.

On the use of vanadium salts see R. E. Liesegang, Phot. Archiv. 1893, **34**, 180, 209; Jahrbuch, 1894, **8**, 50; Handbuch, 1899, **4**, 557. A. and L. Lumière, Jahrbuch, 1895, **9**, 65; Handbuch, 1899, **4**, 557; Compt. rend. 1877; 1893.

On the use of cobalt salts see Anon. Brit. J. Phot. 1898, **45**, 291, 483, 532, 627, 659; Phot. Korr. 1898, **35**, 590; Der Phot. 1898, **8**, 148; Handbuch, 1899, **4**, 552. 65. E.P. 222,523; Brit. J. Phot. 1924, **71**, 736, Col. Phot. Supp. **18**, 45; abst. J. S. C. I. 1924, **43**, B997; Amer. Phot. 1925, **19**, 165; Phot. Ind. 1925, 14; F.P. 581,144. Cf. W. Eissfeldt, Phot. Ind. 1925, 109; abst. C. A. 1925, **19**, 1382. 66. D.R.P. 396,485; abst. J. S. C. I. 1924, **43**, B813; Amer. Phot. 1925, **19**, 166; Phot. Ind. 1924, 1206.

SUBTRACTIVE PROCESSES. IV

Hydrotype or Imbibition Process.—E. Edwards[1] (p. 414) was practically the first to use this process, as he stated: "my invention consists in producing impressions with colors known as dyes, as distinguished from printing inks, from plates consisting of gelatin, gum, albumen, fibrin or analagous substances which are absorbent of water; the parts which are not required to print having been rendered non-absorbent of water, or otherwise suitably prevented from printing." And he used the action of light on dichromated colloids, or hardening agents, such as chrome alum or tannin. The use of mordants, such as stannic and stannous chlorides are also indicated and likewise the use of an opaque or matt varnish, to prevent the transfer of the dyes.

C. Cros[2] seems to have independently discovered this process, and gave it the name of "hydrotypie," usually called in English hydrotype, though imbibition is more generally used. L. Vidal[3] in describing Cros' process said: "a sheet of dichromated gelatin, free or on a support, receives the impression of the light under a positive; after washing out the undecomposed dichromate and drying, it is immersed in an aqueous solution. The gelatin only swells up in those parts not attacked by the light, and it absorbs, in these places only, the colored solution. The result is the formation of a colored image, positive from a positive, a negative from a negative. M. Cros deduces the following applications: (1) printing in aqueous inks of monochrome proofs; this is hydrotype, properly called. The gelatin is soaked in a communicable colored solution, then applied with light pressure to a sheet of paper; the gelatin having absorbed a certain quantity of the solution, it follows that one may print a set of proofs without reimbibing. This printing may be effected on continuous paper and in rolls, if the gelatin plate has been stripped from its support and applied to a cylinder. The proof is printed by a sort of rolling. This method of printing permits the obtaining of monochrome proofs in every kind of tint, it may be applied to photographic polychrome prints formed of three colors, red, yellow and blue. (2) Printing of the gelatin itself, and this consists in producing by imbibition in the gelatin itself. In this case one has a transparent image, and which may be utilized for the effect of stained glass windows (vitraux). If the first image is printed in red, and covered by an insulating film, then one prints in the same way the blue, then the yellow image, all three superimposed, a polychrome result will be obtained similar to that above, but forming a transparency and reproducing pretty near the colors of the subject. Here are the solutions tried up to the present: red, ammoniacal carmin, fuchsin, eosin; yellow, berberis, picric

acid and soluble picrates; blue, the double bath of iron and prussiate, giving Prussian blue, anilin blue and indigo. This process may be applied to making reversed negatives."

The author has drawn a distinction between this process, that is to say, the printing from a plate in which the whole of the original gelatin remains, and those processes in which a pure relief is printed. This division may seem somewhat meticulous, but it makes the subject easier to deal with and, it is hoped, clearer to the reader.

The next process is that known as pinatype, and was the invention of L. Didier[4] and was patented in England by Farbwerke vorm. Meister, Lucius & Brüning.[5] They pointed out that dyes show a marked difference in their behavior to hardened and unhardened gelatin; some are taken up by this one and some by the other, while yet again others are absorbed almost indifferently by both. The mikado dyes, obtained from p-nitro-toluene-sulfonic acid, the soluble azo dyes from dehydro-thio-toluidin, primulin or their homologues and substitution products, natural carmin, the sulfonic acids of indulin and nigrosin, naphthazin blue and some of the diamin colors, like diamin pure blue, dianil blue, yellow and garnet. Of the anthraquinon dyes, the alkyl-sulfonic acids and their derivatives are absorbed by unhardened gelatin alone. The process was capable of giving excellent results, but might justly be termed "zeitraubend," that is rather tedious, as one has to make three constituent negatives, three transparencies from the same, and three print-plates from the latter. Of course, having once obtained the print-plates any number of pulls could be made, and the process was applicable to enlarged positives also.

It is unnecessary to enter into the production of the negatives, it being sufficient to point out that with this, as all other color processes, harsh, under-exposed or over-developed negatives or véry flat ones will not give the best results; though there is considerable prospect of improving matters in the making of the transparencies, which also should not be hard. It is advisable, of course, to mark the positives or negatives, so that one may know at starting with which color to dye them.

The print-plates are made by coating glass with dichromated gelatin, or what is better still, with plain gelatin and to sensitize afterwards, as in this way it is possible with very little trouble to coat in an evening a large stock of glass, which can then be sensitized as wanted. Good hard gelatin should be used, preferably emulsion gelatin, and the actual formula is:

Hard gelatin.................................... 50 g.
Ammonium dichromate........................ 20 g.
Water ..1000 ccs.

The gelatin should be soaked in the water for about 30 minutes, then melted in a water bath about 60° C., the salt added and the solution filtered through swansdown or Canton flannel, previously well washed and rinsed in distilled water.

A leveling stand is necessary to ensure that the coating sets level, otherwise unequal results will be obtained. Should it be desired to coat with plain gelatin, the salt will be omitted. The quantity of gelatin should be measured out, not guessed, and it is advisable to keep the graduate in hot water when not in use, otherwise there is a chance for it to chill and cause streaks. The glass should be perfectly clean and to every 100 qcm. should be allowed 5 ccs. of gelatin solution. The coating should be carried out by weak daylight or artificial light. As soon as the liquid is poured on the glass it should be coaxed out to the edges with a glass rod or the finger tip. When set the plates may be reared up to dry, and as a rule, if coating is done at night they will be quite dry in the morning, even without the aid of extra heat, though a proper drying cupboard is a great convenience. If the plain gelatin solution be used the plates must be sensitized and the best solution is a 2 per cent solution of ammonium dichromate, in which they should be immersed, the dish rocked for about 3 minutes and then dried.

Printing takes about as long as in the carbon process, and although it is possible to see the image distinctly as dark brown on the yellow color of the gelatin, it is better to use an actinometer. Some little practice will be required to gauge the depth of printing, but this is soon learnt when the plates are dyed up, as if the whites are tinted, the printing time was too short; on the other hand if the details in the high lights are wanting, then printing was too long. After printing the plates should be washed in running water till all traces of undecomposed dichromate are removed, which can be easily seen by allowing the plate to drain from one corner on to white paper.

Although it is a little extra trouble it is advisable to wash, particularly with the yellow plate, in distilled water, as the particular yellow dye, issued by the makers soon becomes thick and ropy from the calcium salts in ordinary water. The plates may be dyed up at once, or allowed to dry, it is quite immaterial. The blue dye solution should be 3 per cent and plenty should be made up, and the cost need not be considered, as the bath may be used hundreds of times, or till exhausted, or takes too long. The red solution is made from natural carmin, the best Nacarat, if it can be obtained, 4 g. should be rubbed into a paste with a little water and from 3 to 4 ccs. strong ammonia added, just enough should be used as will dissolve the carmin, then the bulk should be made up to 100 ccs. with distilled water. The yellow dye only requires a 3 per cent solution made with hot distilled water.

The print-plates take rather a long time to dye up the first time, probably not less than 15 minutes; but afterwards, only about 10 minutes. As soon as a plate is sufficiently stained it should be rinsed and can be used for printing.

Actually it is immaterial in which order the plates are pulled, but it will

be found much easier to obtain register if either the red or blue be printed first. If the yellow print be obtained first it is extremely difficult to sharply distinguish the contours of objects from the white paper, whereas if the blue be pulled first either the red or yellow may be pulled on top and the two are then easily superimposed.

The paper used for the final support may be either glossy or matt, the so-called "velvet" surface giving excellent results. Almost any bromide or development (gaslight) paper may be used, naturally being freed from silver salts first. Special papers were issued by the makers, but if a gelatinized paper be soaked in 5 per cent solution of formaldehyde for 5 minutes and then dried, without washing, it will give excellent results. Before bringing the paper and plate into contact, the former should be soaked in water for 10 minutes to allow it to absorb some water, then allowed to lie flat on a table for 2 or 3 minutes, then the dyed-up plate brought into contact. It may be found easier at first to bring the plate and paper into contact under water, but this does not give such good pulls as the above.

As soon as the two are in contact they should be well squeegeed, and a flat squeegee is better than the roller variety. The two should then be laid, with the paper up, on a thick pile of blotting paper, or any old book answers admirably; the main idea is to have a fairly firm but resilient pad. The paper may be left in contact for about 15 minutes under light pressure, the time varying somewhat, but one can easily judge of the progress of the transfer of the dye by carefully lifting one corner of the paper, and examining the image; if it is not dark enough the paper should be rubbed into contact again and a little longer time allowed.

Naturally while the first print-plate is in contact with the paper the others can be dyeing up, and assuming that the blue was the first pull, and the red is to be the next, this plate should be rinsed in water and brought into contact with the blue print. With a little practice this will be found very easy and register can be so quickly effected, particularly with a magnifying glass, that there will be no time for any bleeding of the red on those places where it should not be. But at first it is advisable to insert between the plate and the print a sheet of thin celluloid, which should be larger than the print so as to allow of its being taken hold of, and yet should not completely cover the paper at one edge, as this enables one, when correct register has been attained, to temporarily clip the plate and paper together and slip the celluloid out without shift. The third plate is applied in the same way.

For successive printings the plates must be dyed up afresh, but they will only take about 5 minutes to stain up sufficiently. In course of time, with repeated dyeing of the plates they will become rather deeply stained even in the whites, but the only disadvantage of this is that it becomes rather difficult to see the underlying images so as to obtain good register. They absorb the dyes even in the hardened parts of the gelatin, but even

then good pulls may be obtained, as this dye in the wrong place has very little tendency to transfer. To decolorize the plates one of the best things is[6] the following:

Potassium permanganate...................... 2 g.
Sulfuric acid................................ 0.6 ccs.
Water1000 ccs.

Wash well as soon as the dye is bleached, or treat with a 5 per cent solution of sodium bisulfite. A prolonged soaking of the plates in water to which some glue has been added, about 5 per cent, will also decolorize, but this takes a long time.

Although pinatype prints are very permanent it is just as well to give them a bath of cupric sulfate, about 3 per cent, for 5 minutes, then rinse and dry. This renders them much more permanent. Unfortunately this gives the carmin a slight violet tinge, so that unless the print is to be unduly exposed to light the bath may be omitted. On the other hand this slight alteration of tint is only noticeable with strong illumination, and is quite invisible by artificial light.

L. Vidal[8] suggested a modification of the pinatype process, which gave much more brilliant prints than the original. This was by superimposed printing on one glass and then stripping. The details of the method are as follows: a sheet of glass, rather larger than the final print is to be, is coated with dichromated gelatin, having first been cleaned, polished with talc and coated with 2 per cent solution of collodion, and allowed to dry before being coated with the gelatin, which should be used in the same ratio as above. This should then be printed with the red or blue impression and after exposure, washed and treated with sodium bisulfite to free the whites from the reduced chromium salt, then washed and dried before dyeing up. It should be again coated with the gelatin mixture, dried and the same procedure gone through, and this repeated for the third print. The composite picture should then be coated with 3 per cent gelatin solution, and allowed to thoroughly set. A sheet of gelatinized paper should be soaked in water, brought into contact, well squeegeed and allowed to dry. When thoroughly dry the edges may be cut round with a sharp knife and the print stripped. If plate glass be used a very high polish is secured, but with ground glass a matt surface.

E. Grills[9] followed the original procedure or sensitized in an ammoniacal solution of the dichromates of potassium and ammonium. And the ratio of exposures he found was for the blue print 2, for the red 3 and for the yellow 1½, using an actinometer with printing-out paper. As an alternative he also suggested making the blue impression on bromide paper and toning with the well-known cyanotype mixture. Also for those subjects in which there was a preponderance of greys, an extra negative was made on a panchromatic plate, and from this a weak grey print made on bromide paper and the three color impressions pulled on to the same as usual.

L. Didier[10] suggested a simplification which reduced the nine steps of the original process to six, by using the transparencies themselves as print-plates. The transparencies might be made on any plates and should be fairly dense with clean whites, and it was important to use a developer that would not tan the gelatin, and that for the yellow pull should be somewhat denser than the others. The yellow transparency should be sensitized in:

Ammonium dichromate........................ 12.5 g.
Ammonia 100 ccs.
Water1000 ccs.

And the blue and red in a 2 per cent solution of the dichromate with 20 per cent ammonia.

The backs of the plates should be thoroughly cleaned and the plates placed in a printing frame, gelatin inside and a sheet of printing-out paper placed in contact and exposed. The paper acted as an actinometer, and the exposure should be stopped as soon as the details appear in the shadows, naturally this paper image would be negative. The yellow plate required about double the exposure of the others. The plates should be well washed and to shorten the time might be immersed in a 5 per cent solution of ammonia. They were then ready for staining up, but as the presence of the silver image was troublesome in superposing, it should be removed with weak ferricyanide and hypo. This method of procedure presents the advantage of cutting out the making of the print-plates, and the exposure can be very easily determined. The plates are very hard and will stand all the subsequent treatment without damage, and in consequence of the feeble relief the prints show a most delicate detail, and the successive prints are very regular, owing to the soluble superficial film being backed up by the insoluble film caused by exposure through the back, and they absorbed at each staining exactly the same amount of dye.

G. Engelken[11] proposed a combination of ozotype and pinatype for which the three negatives should preferably be on films, as it was difficult to obtain perfect contact with plates. The film negatives should be immersed in the ozobrome solution (see p. 338), and brought under water in contact with a glass plate coated with a plain solution of gelatin. Or if a glass negative be used then a film might be used for making the print-plate, and this can be a fixed-out and unexposed film. But the simplest method was to bleach the original negative in the ozobrome solution, wash and when dry stain up like an ordinary print-plate. E. König[12] suggested that celluloid films should be used for print-plates, exposure being through the back.

F. W. Donisthorpe[13] would take advantage of the hardening properties of certain chemical sustances, particularly the ferricyanides and use the original negatives, thus avoiding the making of the intermediate positives. After fixing and washing the negative was immersed in:

A. Uranium nitrate 20 g.
 Potassium ferricyanide 20 g.
 Water1000 ccs.

For 10 minutes and then in 2 per cent solution of ferric chloride with a few drops of glycerol added. Or the following might be used:

 Vanadium chloride 2 g.
 Potassium ferricyanide 2 g.
 Ferric oxalate 1 g.
 Ferric chloride 1 g.
 Oxalic acid 125 g.
 Glycerola few drops
 Water1000 ccs.

Or the negative might be immersed in a bath of lead ferricyanide, so that the image was converted into a mixture of lead and silver ferrocyanides, and this in turn into the sulfides. After washing the negatives were either dyed up at once or dried and subsequently stained by immersion in the dye for about 10 minutes. They were then rinsed and brought into into contact with gelatinized paper, which had been previously soaked in water for about a minute and squeegeed together and left for about 10 minutes, keeping the same moist all the time.

The negative could be used several times, and the later times of dyeing were only a few minutes. The application of this to three-color prints and transparencies is described, but in this latter case the negative images were dissolved, leaving the dye images which were superimposed. To make the three-color transparencies by this method one of the negatives should be reversed in the camera, another on a film, so that when finished the two pictures taken on plates might be placed face to face with the film in between them.

E. S. Donisthorpe[14] claimed the use of an opaque support for the emulsion, such as black paper, etc., for the hydrotype process, particularly the above. It was necessary in working this process that the negatives should be rather thin and as free from fog as possible, as in the last case any general fog would cause the gelatin to become hardened and there might be difficulties in the absorption of the dyes. When flexible supports were used for the negatives, three-color transparencies could be made on gelatinized glass by transfer of the dyes, as perfect contact was readily obtained.

F. W. Donisthorpe[15] also in a later patent disclosed an improvement on the above process by which the penetration of the dye into the negative was facilitated, and by which cheap printing paper could be used. The paper might be coated with gelatin hardened by exposure with dichromate or by alum, formaldehyde or the like. A preparing bath was used composed of a mixture of vanadium oxalate, oxalic acid and potassium ferricyanide. In this the negative was to be immersed and then dyed up and used for imbibition.

L. Lemaire[16] published an extremely useful paper as to the dyes applicable for the imbibition process. It was found that there was a connection between the composition of the dyes and their behavior towards gelatin hardened by light in the presence of dichromate. F. Curtis and P. Lemoult[17] had found that the more sulfo groups the dyes contained the better they took and this appears to be the case here also, while those that took badly were the nitrated dyes, such as rhodamin and auramin. On the other hand, this was not a law, as it was found that the fluorescein group, eosin, erythrosin, etc., were readily absorbed by the hardened gelatin, and it might be that this was due to the presence of iodine or bromine in the molecule. It was found that when exposed to the air the dyes faded much more quickly than when protected by a glass, and that treatment with cupric sulfate or chrome alum increased the permanency. The actual dyes recommended by Lemaire were: for red, lanafuchsin 6B, brilliant lanafuchsin SL (Casella); for blue, alizarin cyanol BF (Casella); for yellow, paper yellow M (Hoechst); solid yellow 2GL and quinolin yellow; for bluish-black, amino black 4B, 10B, S4B (Agfa); for violet-black, naphthol black (Casella); for green, naphthol green and brilliant alizarin green; for violet, lanacyl violet B (Casella). Practically Lemaire used the modified pinatype process, suggested by Didier, with 1 per cent solutions of the dyes and these were brushed on or applied with a swab irrespective of the image, as the dyes only took in the proper places.

J. H. Christensen[18] patented a novel variation of the hydrotype process, based on the observation that a specially prepared collodion emulsion film, after it had been exposed and developed, became permeable to certain substances, to which it was not previously permeable, in those parts where the metallic silver image was. A precipitated collodion emulsion was dissolved in amyl acetate and iso-butyl alcohol and coated on a gelatinized glass. The collodion prevented access of the dye to the gelatin, but if the plate were exposed and developed with a caustic developer, not a carbonate, dye would penetrate where the image was. Or the gelatin might be stained with an acid dye, coated with the above emulsion, exposed and developed, the dye only passed through the collodion where there was silver, thus forming a print-plate.

Later[19] the same inventor modified the process and the porosity was produced by subsequent treatment of the unexposed silver salt so that it formed a pore-filling substance. This was actually silver sulfide, and every process advised for sulfur or sepia-toning was patented.

The Rotophot Co.[20] patented the preliminary hardening of films for pinatype, hydrotype and kindred processes. The dichromated gelatin being first hardened, so that it would not dissolve in hot water, and yet absorb dyes in those parts where there was no light action. B. Lincke and R. Kaufhold[21] patented a print-plate produced by exposure of a plate through the back and hardening the gelatin in situ with the silver by means

of a bromoil bleach, and developing with hot water and hardening the relief with alum or formaldehyde.

H. J. C. Deeks[22] patented a distinct novelty. The coloring matter was prepared by staining up alcoholic solutions of sandarac; rhodamin for the red, auramin for the yellow and a mixture of methylen blue and brilliant green for the blue. These solutions were atomized into a hot chamber, where they were precipitated as a fine powder. These colored powders were suspended in dichromated gelatin, coated on celluloid, printed under the respective negatives through the support and then developed in warm water and dried. The celluloid sheets were held taut during exposure in a frame, thus obviating expansion and contraction. After drying, the color prints were successively brought into contact with collodion, before the solvents had completely evaporated, with the result that the alcohol attacked the stained resinous particles and extracted the dyes, which wandered into the collodion film.

E. T. Butler[23] patented the use of a Prussian blue or cyanotype image, produced from a silver positive on a glass or stripping-film plate, in combination with two pinatype components, the blue image forming the last superposed image. Alternatively the blue image might be used with a yellow component obtained by fixing an ordinary printed-out silver print without toning. And one or two pinatypes might be interposed between the yellow and blue images for a three- or four-color print. The Rotophot Co.[24] patented the transfer of an exposed chromated gelatin film on to a rigid support and development with hot water for forming reliefs for hydrotype.

H. G. Lucas[25] patented a process of obtaining greasy ink impressions from bromide prints. The print was first treated with formaldehyde, then bleached in a bromoil bath, fixed, washed and heated in an oven to 24° C. for about 15 minutes till a relief was formed. It was then pressed into contact with a pad coated with greasy ink and pressed into contact with paper. Later[26] the print was to be made translucent with copal varnish and treated to an etching bath of salt, ammonia and glycerol. The production of printing plates[27] on celluloid by the above methods, especially for offset printing is claimed.

Toning Processes.—The use of colored metallic compounds for tricolor work has rather gone out of fashion, due to the fact that they are as a rule somewhat too opaque for transparencies, and in many cases give muddy prints with stained whites; but occasionally a process crops up and it may be as well, therefore, to collect what little has appeared about the same.

One of the earliest and most complete researches on the obtaining of colored prints by these methods, not for three-color work, however, was made by C. R. Woods[28] who described methods of toning silver images with copper ferrocyanide, molybdenum and iron; by the formation of silver

ferricyanide, and chromate and also sulfide toning. In a later paper[29] uranium, iron, lead, silver iodide, Schlippe's salt, mercury and tin salts were dealt with.

R. Namias[30] also dealt with this subject, but it will be sufficient to merely record this particular communication, and give somewhat fuller details of a later paper,[31] which presents some special points of novelty, and which had the specific purpose of obtaining three-color images, either by the direct action of light, or the substitution of colored images for the black silver deposit. A mixture of lead acetate and potassium ferricyanide was mixed with 5 per cent of lactic acid, but better results were obtained by using a saturated solution of lead lactate with 10 per cent of ferricyanide added. Coated on paper this was found to be very sensitive, and after exposure was washed and treated with a chromate or dichromate, which converted the lead ferrocyanide into yellow lead chromate. It was found that a blue image could be produced on the same image by the usual cyanotype process, without any alteration of the yellow image. The red image gave the most trouble and was never quite satisfactory. A 15 per cent solution of copper lactate was prepared by dissolving freshly precipitated copper carbonate in excess of lactic acid, and to this 10 per cent of potassium ferricyanide was added. There was formed a precipitate of copper ferrocyanide, which was but slightly soluble. And this insolubility was the cause of the trouble, as it rendered it difficult to obtain an even coating and to fix after exposure. The use of ammonia was not permissible, because it weakened the cuprous ferrocyanide formed by the action of light.

On exposure to light the mixture of lactate of copper and ferricyanide was rapidly affected and the image became pink, turning red on treatment with water. It was not found possible to completely fix the images, or remove the copper ferricyanide, although ammonium carbonate was of some assistance, but even this attacked the image. The red copper image should be made after the blue one, as otherwise the former was attacked by the cyanotype solution. Finally it was found possible to indirectly obtain a red image, by treating the lead ferrocyanide image either with copper sulfate or acetate, acidified with acetic acid. There was formed a good red-chalk color, as the copper replaced the lead. But for tri-color work this red was not satisfactory, but it might be used in some cases.

The lead ferrocyanide image might be treated with various other salts and other colors obtained. Uranium gave deep reds, vanadium salts yellow and cobalt gave greenish tones. Namias claims to have been the first to point out toning with iron and copper, but obviously he was ignorant of Wood's work cited above. All metals, capable of giving insoluble ferrocyanides, may be used for toning silver images, thus zinc, manganese, iron, nickel, lead, cobalt, mercury, copper, uranium and vanadium. A neutral solution of potassium ferricyanide acts but slowly on silver, but the addi-

tion of a little ammonia, about 10 per cent, quickens the action very much, and the image is converted into white silver ferrocyanide. This image can be immersed in a 1 or 2 per cent solution of the metallic chloride, containing at least 5 per cent of hydrochloric acid. The image rapidly tones and becomes more opaque as the metallic ferrocyanide and silver chloride are formed. Various tones can be obtained by treatment with two metallic salts in succession. The silver chloride in the image gradually darkens and the best means of removing the same is a 5 per cent solution of hypo and boric acid, which dissolves it without attacking the ferrocyanide.

Whilst it is impossible to enter into the question of toning by chemical changes as a whole, it may be worth while to draw attention to the use of vanadium for obtaining green tones, requisite in two-color processes, as worked out by the author, as the results are far superior to anything obtainable by any other process.[32] Abandoning the use of vanadium chloride, which always forms opaque silver chloride, the employment of sulfate or oxalate was advised, and the latter can be prepared from ammonium vanadate: place 100 g. in a beaker with 460 g. of pure oxalic acid, adding 500 ccs. distilled water, and heat. The thick white cream gradually becomes thinner, as the acid goes into solution, and turns first orange and then a dirty green; but on further heating and the addition of more water, a brilliant blue solution is obtained. The total bulk should be made up to 1477 ccs., when the result will be a 20 per cent solution of vanadium oxalate, with a very small excess of oxalic acid. The sulfate may be made in the same way, by adding ammonium vanadate to 200 ccs. distilled water and adding gradually with constant stirring, 197 ccs. pure sulfuric acid. The heat generated on addition of the acid may be enough to form a perfect solution, but heat should be applied till the solution turns bright blue. The total bulk should be made up to the above stated quantity. This will give the same strength in vanadium as the oxalate. The actual toning bath is composed of:

Vanadium oxalate or sulfate sol.	50 ccs.
Oxalic acid, sat. sol. .	50 ccs.
Ammonium alum, sat. sol. .	50 ccs.
Ferric oxalate, 20 per cent sol.	q.s.
Glycerol .	50 ccs.
Potassium ferricyanide, 10 per cent sol.	10 ccs.
Water .	1000 ccs.

Add the oxalic acid to the vanadium and half the water, then add the alum and the ferric oxalate. The quantity of the iron oxalate is dependent on the color required, and the more iron added the bluer becomes the tone. The ferricyanide should be mixed with the glycerol and the remainder of the water and then added to the other solution. The result should be a bright green, clear solution that will not deposit while toning, though after use and by standing in white light it deposits a deep blue precipitate. There is no necessity to fix the transparencies as a rule, but it is advisable to

immerse them for 5 minutes in a 10 per cent solution of sodium sulfate, which quickly removes the ferricyanide stain.

F. Leiber[33] stated that he had obtained very successful results for transparencies by the following chemical toning methods; but there must be some danger of the images being heavy and wanting in transparency. Four solutions were required, which must be kept in the dark: (1) an 8 per cent solution of potassium ferricyanide; (2) 8 per cent of lead nitrate; (3) 25 per cent green ammonio-citrate of iron; (4) 2.5 per cent potassium dichromate. The yellow image was obtained by the process recommended by Namias, the image being treated with lead ferricyanide and then after washing with 1 per cent dichromate, again washed and cleared with 1 per cent sulfuric acid, or better still was treatment of the bleached image with a mixture of dichromate, ammonia and potassium iodide, or the black image might be toned in a mixture of 1000 ccs. No. 1, 11.5 ccs. No. 2, with a few drops of glacial acetic acid. After thorough washing it should be immersed in equal parts of No. 4 and water, then thoroughly washed. The blue image was Prussian blue, obtained by equal parts of Nos. 1 and 3, this being used as a sensitizer for a film, which was printed under the red-filter negative. If a black image was to be toned, a mixture of 60 ccs. No. 1, 20 ccs. No. 3, acetic acid 50 ccs., water 1000 ccs. should be used. The red image was obtained by transfer imbibition of a red pinatype image.

A. Hamburger[34] would utilize a mixture of silver and mercury iodides for the yellow impression. The silver print was bleached till but a faint grey image remained, in a mixture of equal parts of 5 per cent solution of potassium ferricyanide and bromide, or:

Lead nitrate, 5 per cent sol.	256 ccs.
Potassium ferricyanide, 10 per cent sol.	86 ccs.
Aluminum nitrate, 10 per cent sol.	86 ccs.
Nitric acid	9 ccs.
Acetic acid	128 ccs.
Water to	1000 ccs.

After washing the print was immersed in:

Mercuric chloride, 6 per cent sol.	400 ccs.
Potassium iodide, 8 per cent sol.	600 ccs.

The yellow tone continues to develop during washing, but it can be arrested by immersion in an acid bath.

The inventor stated that "the resultant photograph is of particular brilliance and accuracy in color reproduction. This is apparently due to the fact that the print obtained from the negative corresponding to the yellow color is more or less panchromatic and that the yellow toning method above described produces the yellow tone irrespective of the faint panchromatic grey image, which remains as a key or foundation to the print."

This process was worked commercially in London, and known as the Polychromide.

In a lecture before the Royal Photographic Society[35] Hamburger stated with reference to this process that the yellow image was on bromide paper, "with the introduction of a few novelties in the composition of the emulsion," and bleached in chromic acid, thoroughly washed, then converted into a complex of silver, iodine, chromium and mercury. The red image was an alizarin lake, containing a silver salt and was used as carbon paper; and the blue monochrome was a silver image toned with the usual cyanotype bath. It will be seen that there is here a slight variation from the method of the patent.

H. E. Rendall[36] suggested bleaching the silver image with 2.3 per cent solution of dichromate plus 1.25 per cent hydrochloric acid, then washing and treating with a solution of mercuric iodide, made by adding a 2 per cent solution of mercuric chloride to 12.5 per cent potassium iodide as long as the precipitate was dissolved.

E. C. G. Caille[37] proposed to use mercuric chloride in printing from screen-plates. The silver image was treated with mercuric and cupric chlorides, thus converting the black image into a white one. Later[38] he proposed to print on a slow gelatino-bromide emulsion, coated on glass or celluloid, preferably behind a screen, a minus-blue negative and wash without fixing. The image thus obtained was to be toned with ferricyanide, iron and vanadium, and the minus-yellow negative printed in register and developed with a developer without alkali, so as not to affect the blue image. This image was then toned yellow by conversion into silver iodide, treated with tartar emetic and toned with mercuric chloride. The gelatin was then to be sensitized with dichromate and printed under the minus-red negative and stained with pinatype red.

S. M. Procoudin-Gorsky[39] patented the production of a neutral grey key for color work, by intensely developing the positive then bleaching in 1 per cent solution of ferricyanide and ammonia, the action being stopped before all the silver was converted. It was then immersed in a ferrous salt solution, washed, dipped in hypo solution and then into sulfuric acid. The blue positive was selected for this treatment, the reason being that as it was taken through an orange filter with a panchromatic plate, correct monochromatic rendering was obtained.

J. F. Shepherd and Colour Photography, Ltd.,[40] proposed to tone one image with the usual cyanotype mixture. The yellow one was obtained with mercuric iodide plus ferricyanide and bromide. The red being a magenta carbon print. This process was introduced commercially as Triadochrome. The Societa Anonima per la Fotografia Autopanchromatica[41] patented, after printing the first image, the temporary application of the paper to be used for the final support to a non-extensible material, such as glass, metal, celluloid or the like. E. A. Lage[42] proposed to convert

the image of a bromide print into lead chromate, then resensitize the film with the usual cyanotype mixture for the blue print, and again sensitize with dichromate and obtain the red image with a greasy ink.

T. Truchelut and A. A. Rochereau[43] would use red mercuric iodide, yellow silver ferrocyanide, and anilin blue or Prussian blue with lead sulfate for pigments for originals and after obtaining one negative treat the picture with chemicals so as to make a color disappear. Obviously this process was to do away with all panchromatic plates and filters, and it is a pity that it could not be applied to natural objects, landscapes and fair sitters generally, though possibly some dainty maidens might object not alone to the baths, but to the final results on their looks.

W. Reichel[44] would rely upon chemical toning entirely for the three monochromes. He proposed to use stripping paper with silver halides, especially printing-out paper. The yellow was obtained by treating the image with lead ferricyanide, then with chromates or vanadates; for the blue, a Prussian blue was obtained; whilst the red was formed by the action of gold sulfocyanide, sodium iodide and potassium carbonate. The prints were transferred to glass for examination and then to paper.

F. W. Kent[45] while dealing with a transfer process, which is referred to under cinematography in colors, pointed out the method of obtaining the yellow monochrome by means of a long exposure of silver chloride and development with a suitable developer, and the cementing material for the constituents was a distinctly alkaline solution of sodium or potassium silicate with albumen.

R. Isenmann[46] immersed a printed-out image in "Lemon juice and potassium ferricyanide and then the landscape portion of the picture was treated to ferrous sulfate when it turned various shades of green, red and yellow, whilst the sky having been washed turned blue." S. Vathis[47] proposed to tone collodio-chloride prints with acidified solution of gold chloride and then obtain local colors by heat. C. P. Plachaire[48] would take advantage of the sensibility of mercuric iodide to heat so as to obtain different colors on different parts of the print. E. J. Browne[49] patented the use of colors obtained by the action of heat on gold-toned and lead prints for the red, in conjunction with lead chromate for the yellow and cyanotype toning for the blue.

F. E. Ives[50] patented the conversion of a silver image into a cyanotype blue by treatment with a bath containing a bromide, the silver image lying in a colloid film containing silver bromide. The bath suggested was:

Oxalic acid 4.25 g.
Potassium ferricyanide 1.75 g.
Sodium chloride 4.25 g.
Potassium bromide 0.35 g.
U. S. P. ferric chloride sol.................. 1.0 ccs.
Water 1000 ccs.

After toning the print was washed and preferably redeveloped after the second exposure with an acid amidol developer which would not affect the cyanotype image. Obviously this is for a two-color process with subsequent formation of the second image in the unexposed bromide, as was utilized by Fox and Kelley.

The use of a bromide in the cyanotype bath is not new. It was recommended by E. Sedlaczek,[51] A. Mebes[52] and M. Barenthin.[53] Caille (see p. 402), had suggested the development of a second image with a developer without alkali, so that a previously formed cyanotype image should not be destroyed.

Developed Color Images.—It has been a well-known fact ever since the introduction of the gelatin plate that the color of the image obtained with pyrogallol was not the same as that with iron oxalate. And, of course, in more recent times the difference in the color of images with the newer phenolic developers has also been noticed.

R. E. Liesegang[54] called particular attention to this and proved by bleaching a negative with cupric bromide that the color was due to the deposition in situ with the silver of the oxidized pyrogallol. Nor was this oxidation due to the action of the silver halide, as silver nitrate precipitated by pyrogallol gave the brownish color, and this experiment proved that the coloring matter was precipitated on the silver itself and not on the vehicle.[55] He also found that amidol, when rendered alkaline, gave a colored image, but in this case it was red or reddish brown. Very similar observations were made by A. Watkins[56] and he exhibited H and D strips, which, after development with pyrogallol without sulfite, were bleached with cupric bromide and fixed and showed a series of gradations in the characteristic or orange-yellow stain. He found that this image was not removable with acid, alum, thiocarbamid, hydrogen peroxide or acidified sodium sulfite. He contended that the yellow stain imparted to the gelatin generally was different to the said stain, as the former was removable, to some extent at least. It is quite possible that in the case of the image-stain some particular form of lake was formed, which even silver solvents would not decompose. It can hardly be thought that this color-image was of any practical value from the point of view of color workers, it being looked upon in most cases as a general nuisance.

Here the matter seems to have remained for some years, but little attention being directed to it as the newer developers ousted, from general amateur practice at any rate, the use of pyrogallol. H. Lüppo-Cramer[57] proved that the developed image was not composed of pure silver, but probably contained an organic compound also. B. Homolka[58] in some experiments on the nature of the latent image, pointed out that there are many substances which are very readily oxidized, but that the choice is narrowed down by the fact that the product of oxidation ought to be

easily examined and that, therefore, it should be colored. The leuco bases of the di-phenyl- and tri-phenyl-methanes and the di-phenyl-amin series give oxidation products, which are brilliant anilin dyes. But as they contain two or more oxy- or amino- groups, or the two together, in combination with the benzol ring, they might be suspected of themselves acting as developers, and leuco-indamin and leuco-indophenol will develop alone. It is desirable also that the oxidation products should remain at the place of their formation and be insoluble in water.

Indoxyl and thio-indoxyl were found to answer all requirements, and with these colored images were obtained. Indoxyl is the intermediate product in the formation of indigo from indol, and it exists in two forms, the normal or β-indoxyl and the pseudo form. It dissolves freely in water and is completely oxidized into indigo by the mildest agent. Thio-indoxyl, or its pseudo form, is but slightly soluble in water, but readily so in alkalis and in such solutions is readily oxidized into red thio-indigo. Both were found to possess developing power, and the following were recommended:

```
Sodium sulfite, 6 per cent sol. ..................  100  ccs.
Potassium  bromide  .........................    6 g.
Indoxyl  ...................................15-20  ccs.
Water ...................................... 1000  ccs.
```

In this the plate will be perfectly developed in from 5 to 8 minutes. It should then be rinsed in water and fixed in an acid bath. For thio-indoxyl the following may be used:

```
Normal soda lye (27 per cent sol.) ..............  100  ccs.
Sodium sulfite, 6 per cent sol. ..................  100  ccs.
Thio-indoxyl  ..............................   15  g.
Water ......................................1000  ccs.
```

And the negative treated as the other.

Examined by daylight the indoxyl-developed image appears green, that with thio-indoxyl orange-yellow, and both show a strong metallic luster by reflected light. Both images can be easily separated, thus the silver may in both cases be dissolved with cyanide after the plate has been treated with alum. Pure blue and red images remain behind. If the plates are immersed in a weak solution of sodium hydrosulfite, $Na_2S_2O_4$, about 4 per cent, the dye images are dissolved, leaving the silver image, and this appears brown by transmitted light, but white, with metallic luster, similarly to the physically developed image of a wet plate. Both give beautiful transparencies.

Later Homolka[59] returned to the subject of the formation of the compound images and found that the mono-ethyl- or mono-methyl-ether of a-naphthhydroquinon[60] possessed developing powers and the image was a blue-black, the solution used being:

Sodium sulfite, cryst.......................... 100 g.
Sodium hydrate, 5 per cent sol. 50 ccs.
Potassium bromide 10 g.
Naphthhydroquinon compound 10 g.
Water ..1000 ccs.

As before the silver image can be removed by a solvent leaving a per-
fectly blank plate; but if this be immersed in solution of cyanide and
ferricyanide or Farmer's reducer, the image appears of a brilliant blue.
It will be seen that this differs from the previous cases, in which the dye
is deposited as dye, here it is in the leuco form and it is necessary to
form the dye by subsequent oxidation. A further paper[61] by Homolka sug-
gested the use of 4-oxy-iso-carbostyril (1 : 4 di-oxy-iso-quinolin) which
was discovered by Gabriel and Colman,[62] which has some similarity in
structure with indoxyl and thio-indoxyl. The negative treated with Farm-
er's reducer gave an image of fine yellow-orange color.

R. Fischer[63] patented the practical application of Homolka's work,
and gave the terms "color development" and "color formers" to the process
and substances used. These included indoxyl, thio-indoxyl, hydroquinon
and alpha-naphthol, paraminophenol and xylenol, paraminophenol and
alpha-naphthol, dimethylparaphenylendiamin and alpha-naphthol and
other diphenylamin derivatives, which not only act as developers, but also
precipitate in situ with the silver image colored compounds. The black
silver image could be removed with a reducer. Fischer[64] also suggested
converting positive images into silver halides, then redeveloping with some
of the above substances. Also later[65] the addition of substances to de-
velopers, which form colored precipitates with the oxidation products of
the reducing agent, such as tri-chlornaphthol and paraphenylendiamin,
thymol and paramino-phenylen-piperidin hydrochloride, alpha-naphthol
and dimethyl-p-phenylendiamin, thio-indoxyl-carboxylic acid, etc. R.
Fischer and H. Siegrist[66] dealt with the same subject from the theoretical
standpoint and considerably enlarged the list of substances that can be
used. W. F. Ermen[67] independently discovered the color-forming action
of dimethyl-p-phenylendiamin and alpha-naphthol.

The Neue Photographische Gesellschaft[68] patented the use of color
developers for making additive as well as subtractive pictures. Screen-
plates were made by exposing a gelatino-bromide film under a black and
white matrix with the transparent spaces one-third the width of the
opaque. The film was then bathed in a substance which would give blue,
for instance, indoxyl. The film was again exposed under the matrix
and bathed in thio-indoxyl, or other red-producing agent, and then the
whole surface was exposed without the matrix, so that the previously
unexposed parts were exposed. This was then bathed in chlor-indoxyl,
which gave green. The silver was removed leaving the three colors. For
subtractive work, the three constituent positives were developed with color

developers and superimposed. The dye-forming substances could be added to the emulsions, and then these coated on top of one another and exposed under the three negatives with suitable filters. Or the three emulsions might be tanned so that on mixing, they would not form a homogeneous emulsion.

Although not strictly a color-developed process, the following would seem to fall in this class. J. H. Christensen discovered that finely divided silver acted as a catalytic agent in the reduction of certain substances on some dyes, which without this catalyser were only reduced at high temperatures, and advantage was taken of this fact to produce colored images. If, for instance, a plate dyed with oxamin rosa (Badische) be exposed in the camera, an ordinary black image on colored gelatin is obtained after the usual treatment. But with subsequent action of sodium hydrosulfite or stannous chloride, etc., the dye is bleached in situ with the silver, and the degree of bleaching is dependent on the quantity of silver present. A 1 to 3 per cent solution of hydrosulfite might be used. When the bleaching is completed, the silver can be removed with a reducer, so that a clear color picture remains. The developing and bleaching might be effected in one solution, such as:

Sodium hydrosulfite 20 g.
Potassium bromide 20 g.
Water 1000 ccs.

Then the removal of the silver and fixing might be effected in one operation with Farmer's reducer.

With some dyes, aurophenin, for instance, amidol acts as a bleaching agent when allowed to act for a long time, but it is preferable to use the hydrosulfite. Other dyes might be used, for instance, oxamin blue, aurophenin, congo pure blue. Most of the suitable dyes appear to belong to the dianil group. Some dyes give better results when the metallic silver is toned first, as Chicago blue 6B, especially if converted into a cyanotype image, and the hydrosulfite is made alkaline. By arranging two or more films on top of one another or on opposite sides of a film, it is possible by direct exposure to produce a picture in more than one color at once, but if two emulsions are immediately superposed, there should be an insulating porous film in between, such as collodion and glycerol. Some of the dyes need mordanting after this treatment, but others, like Chicago blue, give better results when mordanted with a metallic salt, such as cupric sulfate with the addition of chrome alum.

The Kodachrome and Allied Processes.—These processes are based on the selective action of dyes for hardened and unhardened gelatin, these two states being produced by a chemical action on the finely divided silver of the image, thus being closely allied with the dichromate process of Howard Farmer, and ozobrome.

Possibly G. Engelken (see p. 395) should be considered as the first

to suggest the basis of these methods, that is the use of ozobrome bleaches for hardening gelatin. W. Weissermel[70] had attempted unsuccessfully in 1911 to use this particular reaction in a combination process, based on ozobrome and pinatype. Subsequently he described a method[71] which he stated was entirely successful, but as this was entitled: "A process for the production of enlarged negatives, etc.," it appears to have escaped notice in its applicability to color work.

Either negatives or positives might be used, and it could be applied to the production of prints as in the pinatype method. The avoidance of tanning developers and too great contrasts were advised in the making of the plates, and after fixing and washing they were to be treated with:

Potassium dichromate	10 g.
Potassium ferricyanide	20 g.
Sodium chloride	53 g.
Alum (iron-free)	10 g.
Glacial acetic acid	7-14 ccs.
Water	1000 ccs.

Potassium or ammonium chloride or citric acid might be used in lieu of those stated. Old negatives required long soaking in water to ensure equal bleaching action, as their gelatin became hardened in time. Constant rocking of the dish being also necessary for the same purpose. The washing was not to be longer than 1 minute after bleaching, otherwise the dye subsequently took uniformly, and it was preferable to decolorize in a 10 per cent solution of sodium sulfite. The plates were to be fixed in an acid bath, and should then exhibit but a faint brown image. They were then to be well washed and stained up with pinatype dyes.

For reducing over-dyed plates a weak solution of potassium permanganate, acidified with sulfuric acid, was advised, and a stronger solution for the complete decolorization of the dye. Too long tanning caused the dye to take with difficulty, and it could then be completely decolorized with acid sulfite, rinsed and immersed in a 1 per cent ammonia bath, washed and dried. Special stress was laid on drying the plates after the various operations, since, after washing, the film as a rule was too much swollen and took the dye in places which should be clear.

The applications of the process are detailed and the production of enlarged negatives outlined, thus the making of an enlarged transparency and the conversion into a negative dye image. Still finer results were said to be obtainable if the small negative was made reversed, and then the transparency was grainless, almost structureless and the details most perfectly reproduced, and could be enlarged to almost any extent. The use of these plates for direct pulls on paper in the pinatype fashion was pointed out; but as there was a slight color veil in the high lights, it was advisable to clear this off with the permanganate bath.

Finally the theory of the process is dealt with and it was assumed

that the ferricyanide formed silver ferrocyanide, and the alkaline halide converted this into the silver halide. The potassium ferrocyanide, thus formed, then reacted with the dichromate, reforming ferricyanide and chromium oxide, which was the tanning agent. The finely divided silver was assumed to be the chief factor and the action purely catalytic. The ferricyanide and chloride or bromide would then only play the part of converting the silver into the halide, though the formation of the ferrocyanide might also take part, although it might be dispensed with. For if the plate be treated with dichromate and acetic acid then after thorough washing, the silver was converted into a bromide or chloride, the same result was obtained as in the combined bath.

The ferricyanide might be dispensed with altogether and other halogenizing agents used, such as:

Potassium dichromate	10 g.
Potassium bromide	20 g.
Cupric sulfate	20 g.
Alum	6.5 g.
Glacial acetic acid	26.5 ccs.
Water	1000 ccs.

The action of this differs in no way from that of the previous bath; though it is difficult to obtain plates which are perfectly clear after fixing. The plates are turbid, but dye up perfectly.[72]

The Kodachrome process was patented by J. G. Capstaff[73] and, as it will be seen on comparison, bears a very striking similarity to the above. It is a two-color process, primarily intended for portraiture.

Two negatives were obtained through the usual green and red filters, either simultaneously or successively, and a special system of lighting with Mazda lamps was devised. The negatives should be of rather soft character, and it was important to give correct exposure, or at least not to over-expose; a metol-hydroquinon developer was recommended. After development the negatives should be washed for 2 minutes before removing the backing and then a further 8 minutes washing in white light might ensue.

There were then two courses open to the operator; either immediate fixing of the negatives, washing and further treatment, or they might be bleached at once. The bleaching solution recommended was:

A. Potassium ferricyanide	37.5 g.
Potassium bromide	56.25 g.
Potassium dichromate	37.5 g.
Acetic acid	10 ccs.
Water	1000 ccs.

B. Potassium alum, 5 per cent solution.

For use these were mixed in equal volumes and might be diluted with water. The plates were then fixed and it was important that the bath

should not contain alum or other hardener, and that specially commended was:

A. Hypo 250 g.
 Water1000 ccs.
B. Sodium bisulfite 400 g.
 Water1000 ccs.

For use add one volume of B to 20 of A. This could be repeatedly used. After fixing the plates should be washed for 20 minutes, then rocked in a bath of 5 per cent ammonia for 3 minutes and again washed for 5 minutes. Surface water should be removed by mopping with a clean cloth, the back dried and then the plates dried. The drying was important and should be as even as possible, an electric fan being used for preference; any sudden change of conditions of drying affecting the absorption of the dyes later. The humidity of the film had also considerable bearing on the results; the drier the film the cleaner the high lights, and the greater the contrasts. The drying could be pushed to the limit, even by dessication in an oven, after having been dried by the fan. If the latter course was followed, the plates required longer development than if they were not completely dessicated, and if not dyed up after the usual time of drying more contrasty results were secured, so that it was important to adhere to a uniform time of drying.

The dyes were salts of sulfonic acids, the names and composition never having been published, and were an orange-red and a blue-green. For the red dye a 1.2 per cent solution in water was used; for the green a 3 per cent solution. Each dye should be disssolved in a little hot water, then diluted to the required volume and filtered through fine cotton or paper; with the green dye there was a slight residue, that could be thrown away. The solutions might be repeatedly used, but should be kept up to strength approximately by the addition of fresh dye and frequently filtered. The plates were immersed in the baths, naturally that taken through the green filter in the red dye and that through the red filter in the green dye. As in all other processes it was at this point that the individual judgment came into play, but as the plates could be rinsed and examined by the light by which they were to be finally viewed, considerable control was secured. It may be noted that the best results were visible by artificial light, and practically only by this light. As soon as the plates were sufficiently stained they were to be rinsed in 1 per cent solution of glacial acetic acid. The green dye was absorbed rather more slowly than the red, but the dyeing should be complete in 10 minutes. If it took longer, more concentrated baths should be used and the temperature kept up, since cold solutions caused slow dyeing and bad color balance.

To superimpose, the green plate should be placed on top of the red, register obtained, and the plates clipped together and the edges temporarily bound together with small strips of tape, about one inch long. The

cover glass should then be attached and binding completed. Masking could be effected by placing the mask between the green plate and the cover glass. If it was thought undesirable to use the original negatives, then transparencies and duplicate negatives could be made in the usual way. Should any error be made in dyeing, the plates could be entirely bleached with:

Potassium permanganate	2 g.
Sulfuric acid	2.5 ccs.
Water	1000 ccs.

During bleaching the dye image was replaced by a dirty negative image of manganese oxide, but the progress of bleaching could be estimated by the shadows. When thoroughly bleached the plates should be immersed in the fixing bath till clear, washed and dried as before.

A modification of this process[74] was also patented by Capstaff. The two negatives were obtained as before and positives made and the latter without fixing immersed in a bleach of:

Ferric chloride	100 g.
Tartaric acid	30 g.
Water	1000 ccs.

Besides bleaching the image, this softened the gelatin immediately adjacent to each particle of silver, so that the high lights where there was no silver were relatively harder than the shadows and half tones. The plates were then fixed in hypo and washed. The result was obviously a plate, which was the reverse of the Kodachrome plates, that is to say the portions where there had been silver were softer than the rest and consequently more absorbent of dyes, and presumably the same dyes were used as in the former case.

If but one color picture was required, the original negatives might be bleached, and washed with hot water, which would dissolve the gelatin leaving a relief that could be dyed up. In connection with this modification, reference should be made to the notes on reliefs (see p. 346). An alternative bleaching bath was:

Potassium permanganate	2 g.
Sulfuric acid	10 ccs.
Water	1000 ccs.

Or the acid might be omitted. It is unnecessary to enter more fully into details as the procedure was exactly the same as above. The inventor does claim, however, the application of this process to three-color work, and the suggestion is made that the third film should be stripped and transferred to the others, so as to avoid too great separation of the images. The advantage of this process was that as positives alone were used, as many sets of positives could be obtained from a set of master negatives, therefore, the loss of quality due to making the master positives was avoided and the dyes were absorbed by the soft gelatin and did not have to penetrate a hardened upper layer.

A patent that is of decided interest in connection with this subject is that of B. Jumeaux and W. N. L. Davidson.[75] In this the inventors stated: "The essential novelty of the process consists in the use of gelatin capable of absorbing the dye and retaining the same by automatic selection, only in those parts exposed to light under the negative in proportion to the intensity of the light transmitted, thus obviating the washing away of any portion of the gelatin base." Gelatin supported on glass, celluloid or free, was sensitized with dichromate, exposed under the negative. Chromates, chromic acid or an acidified dichromate being specified, though whether there was any particular virtue in the acid solution is not quite clear. With chromic acid the action was said to be much more energetic, but the gelatin not exposed remains much more soluble; the addition of an acid forms a trichromate, which acts like chromic acid[76] and the plain dichromate solutions partly dissociate into chromic acid and monochromate.[77] After exposure the gelatin was immersed in the dye and allowed to remain therein till completely saturated in every part, even the most exposed parts and no image was visible. The film was then washed and the dye removed from the softer parts more rapidly than from the harder and exposed parts, and the inventors claimed that the staining was much more accurate and delicate in tone, also much simpler and easier to obtain.

Referring to the Kodachrome process it may be pointed out that presumably the hardening action is produced by the dichromate alone, the ferricyanide taking no part therein, this merely assisting in the bleaching of the image. This statement is based on C. Sedlaczek's research[78] for he contends that the ferricyanide has no tanning action per se, and the hardening effect, so well known in the uranium and iron toning processes, is really due to the metallic ferricyanide. On the other hand, as there must be initial reduction of the ferricyanide to the ferrous salt with simultaneous formation of silver bromide, there may be hardening in situ with the silver; the alum, as Sedlaczek points out, keeps the whites clear. The action of dichromates on gelatin containing silver was pointed out by Howard Farmer (see p. 346). The selective absorption of dyes by hardened and unhardened gelatin is also the basis of the imbibition process.

With regard to Capstaff's second patent, in which ferric chloride and tartaric acid, were used, this is the application of A. L. Poitevin's process[79] in which to obtain a permanent image, paper was sensitized with this mixture, printed under a positive and a developing bath of casein or albumen used; or a film of gelatin with the addition of the above plus coloring matter could be used. The dried film was insoluble in water and became soluble under the action of light.

J. E. Thornton[80] also suggested the selective action of hardened and unhardened gelatin for color results. The developed and fixed prints might

be treated to an oxidizing bath, which also bleached and rendered the image transparent and the gelatin insoluble in direct proportion to the amount of metallic silver. He gave as suitable baths, mixtures of dichromate, or cupric bromide and dichromate. After bleaching the image was to be fixed and then treated with different dyes, according to whether a negative or positive was required; that is to say, with dyes which took on the hardened or unhardened gelatin. From the bleach bath composition it would appear as though the fundamental idea had been in this particular case borrowed from the ozobrome or similar processes.

A. E. Latelle and F. Billing[81] patented the use of dichromated gelatin, printed under a positive and stained up, as "the parts of the film not hardened by the exposure to light, absorb or take up the dye and produce a photographic picture in the color of the dye used." It was also suggested that ferric chloride and tartaric acid might be used and that then the exposure must be under a negative.

The particular reactions involved in this ferric chloride process were clearly laid down by E. Coustet[82] and on the same was based a simplified collotype process. He pointed out that ferric chloride renders gelatin insoluble in warm water and partially impermeable to cold, whilst ferrous chloride does not affect its usual properties. And ferric salts being reduced not only by light, but also by other means, it is possible to produce collotype plates without the direct aid of light, namely, by simple contact with a photographic image. The process, in short, consisted in saturating an ordinary negative with ferric chloride. The finely divided silver, forming the image, reduced the ferric to the ferrous chloride, the gelatin in those parts remaining permeable. In the transparent portions the ferric salt left unaffected, rendered the gelatin impermeable. This was also pointed out by R. E. Liesegang.[83]

It is obvious that the process of W. V. D. Kelley (see p. 376), which is included amongst mordanting methods, belongs to this class and is identical with the second alternative method suggested by Weissermel.

Bullock[84] considered that the alum in the Kodachrome bleach may be dismissed as playing but a minor part in the process, and that the bromide, ferricyanide and chromic acid, the latter being formed from the acid and dichromate, alone act. From analysis of the bleached compound, both in gelatin and in vitro, it was found to be silver bromide and the normal chromic salt of ortho-chromic acid, which suffers hydrolysis on washing, leaving chromic hydroxide. In somewhat similar bleaches, as used in the bromoil and similar processes, which contain cupric sulfate, the copper acts in the same way as the ferricyanide, as a catalyst.

In dealing with the mordanting of dyes Bullock[85] would ascribe it to the mutual flocculation of the respective colloid particles of opposite electrical character. And in the case of copper ferrocyanide, the mordanting is due to the complex anion. With aluminum hydroxide precipitated

in gelatin it was found that basic dyes were not retained so long by this as by plain gelatin; whilst an acid dye was retained longer. T. Slater Price[86] in commenting on this paper, pointed out that the formation of the complex anion in the case of cuprous ferrocyanide does not explain why this mordants, while the silver ferrocyanide does not, yet the complex anion is the same in both cases. With regard to the precipitated aluminum hydroxide, this could have been foretold, as the gelatin was thus on the alkaline side of the isoelectric point, and as Loeb has shown, basic dyes are retained by gelatin under such circumstances, the gelatin acting as an acid towards the color base. If part of the acidity of the gelatin is already accounted for by the basic aluminum hydroxide, it follows that the basic dyes will not be retained as readily as when it is absent. Loeb also showed that an acid dye is not retained by gelatin on the alkaline side of the isoelectric point. If this gelatin contains aluminum hydroxide, this, as a base, will retain the acid dye, which will, therefore, not be washed out as readily as from plain gelatin.

J. G. Capstaff[87] patented the obtaining of positives with different gammas by varying the development time, like Comstock and Brewster.

1. E.P. 1,362, 1875; Anthony's Phot. Bull. 1876, 7, 259; U.S.P. 150,946, 1874.
This patent received under the above number, provisional protection only; but was later patented by H. J. Hadden, as a communication from E. Edwards, as 3,453, 1875. In E.P. 2,799, 1871, Edwards claimed the addition of dyes or colors to the water used in damping prepared gelatinous plates, used for printing from with greasy inks, thus obtaining two-color effects. He also proposed to use stopped out negatives for as many colors as were required. His other patents were E.P. 2,201, 1868; 3,543, 1869; 2,485, 1870; 73, 1892, all of which dealt with the use of dichromated gelatin plates.
2. F.P. 139,396, 1880; addit. Jun. 25, 1881; Mon. Phot. 1881, 20, 67; Phot. Woch. 1881, 8, 176; Handbuch, 1917, 4, II, 321; Phot. News, 1887, 25, 222; Brit. J. Phot. 1882, 29, 281; J. de Phys. 1881, 8, 233; Mon. Ind. Belge, 1881, 8, 220; Pract. Phot. 1881, 18, 214.
Chas. Cros and J. Carpentier, Compt. rend. 1881, 92, 1504; Bull. Soc. franç. Phot. 1882, 29, 78, reported that a collodion film containing cadmium bromide when saturated with albumen and immersed in ammonium dichromate behaved in the same way. P. Liesegang, Phot. Archiv. 1865; Handbuch, 1919, 4, II, 321, stated that if a sheet of albumen paper was floated face up on a solution of ammonium dichromate, dried and exposed under a positive and then immersed in a weak alcoholic solution of fuchsin, that the impression became converted into a positive with deep red shadows and greenish high lights. Eder considers this to be the forerunner of Cros' process, but except for the use of the dichromate there is but little similarity.
3. L. Vidal, "Photographie des Couleurs," Paris, 1897, 58; Rev. Phot. 1898, 10, 219.
P. C. Duchochois, Phot. News, 1892; Fabre, "Traité Encycl." Supp. B. 401; Phot. Woch. 1893, 20, 13 described the hydrotype process and called it Tegeotype. Sobacchi, Brit. J. Phot. 1897, 44, 452; Phot. Rund. 1897, 7, 282; Bull. Soc. franç. Phot. 1897, 44, 408, described what he called "photopolygraphy," in which a sheet of smooth paper was repeatedly soaked with a 5 per cent solution of gelatin and then sensitized with 3 to 5 per cent dichromate, dried and exposed under a positive till the image was seen in brown. It was then well washed and brushed with a solution of methyl violet to which a small quantity of glycerol was added, and the excess removed with blotting paper. A sheet of white paper was laid on the print and lightly pressed and an impression was obtained. Obviously this may be considered as nothing more than a variation of the ordinary hektograph process on a supple support. See also P. Kraft, Belge P. 252,400, "appareil multiplicateur au policopiste pour des épreuves en deux ou en plus nombreuses couleurs."

4. F.P. 337,054, 1903; abst. J. S. C. I. 1904, **23**, 455; 1906, **25**, 198; U.S.P. 885,453, 1908.

M. Skladanowsky D.R.P. 145,284, 1903, claimed the use of dilute sulfuric acid to remove the reduced chromium salts from pinatype print plates.

5. E.P. 7,557, 1905; Brit. J. Phot. 1905, **52**, 182, 721, 749; 1906, **53**, 110, 195, 246; F.P. 337,054; D.R.P. 176,693; abst. Brit. J. Phot. 1907, **54**, 855, Col. Phot. Supp. **1**, 2, 23, 46; Jahrbuch, 1907, **21**, 434; Phot. Chron. 1907, **14**, 397; Chem. Crlbl. 1907, **1**, 439; C. A. 1912, **6**, 719. Cf. H. Festenberg, Phot. Rund. 1916, **16**, 25; F. Monpillard, Bull. Soc. franç. Phot. 1905, **52**, 302. R. Wagner, Phot. Rund. 1920, **57**, 330; Photo-Era, 1921, **46**, 297. P. Van Duyse, Phot. Moderne, 1925, **3**, 21.

6. Kerotype Co. Brit. J. Phot. 1916, **64**, 475.

B. Jumeaux and W. N. L. Davidson, E.P. 3,730, 1903, also suggested the use of their plates for the imbibition process.

7. V. Selb, Brit J. Phot. 1907, **54**, Col. Phot. Supp. **1**, 23, stated that he had left a print in carmin red exposed to daylight in a window for nine months without any change being noticeable, and that the copper bath gave a slight mauve tint to the same.

8. Brit. J. Phot. 1906, **53**, 390; 1907, **54**, Col. Phot. Supp. **1**, 9; Chem. Zentr. 1907, **1**, 438; Jahrbuch, 1907, **21**, 434; Camera Craft, 1906, **13**, 447; 1907, **14**, 273, 515. Cf. W. A. Sims, Phot. J. 1907, **47**, 4. H. Minuth, Phot. Rund. 1921, **58**, 324.

9. Brit. J. Phot. 1907, **54**, Col. Phot. Supp. **1**, 2.

10. Brit. J. Phot. 1907, **54**, Col. Phot. Supp. **1**, 43; Phot. Mitt. 1906, **43**, 36, 133; Phot. Coul. 1907, **2**, 77; Jahrbuch, 1905, **19**, 343; Phot. Rund. 1905, **42**, 125.

11. Phot. Mitt. 1909, **43**, 133; Brit. J. Phot. 1909, **56**, Col. Phot. Supp. **3**, 36; Jahrbuch, 1906, **21**, 453.

12. Phot. Rund. 1913, **50**, 325; Brit. J. Phot. 1914, **61**, Col. Phot. Supp. **8**, 20; ibid. 1917, **11**, 16.

C. S. Forbes, E.P. 17,015, 1911; Brit. J. Phot. 1912, **59**, 370; abst. C. A. 1913, **7**, 311, proposed to recoat each color pull with isinglass or similar medium so as to provide a more receptive surface.

13. E.P. 13,874, 1907; Brit. J. Phot. 1907, **55**, Col. Phot. Supp. **1**, 54; 1908, **56**, 29, 242, 280; Phot. J. 1908, **48**, 253; Phot. Rund. 1908, **45**, 245; Jahrbuch, 1909, **23**, 324; U.S.P. 923,030; Phot. Coul. 1908, **3**, 119, 192.

14. E.P. 5,641, 1908; Brit. J. Phot. 1909, **56**, 310; J. S. C. I. 1909, **28**, 491; D.R.P. 219,188. Cf. E.P. 7,087, 1908; Brit. J. Phot. 1909, **56**, 348, granted to F. W. Donisthorpe for the same subject.

15. E.P. 158,021, 1919; Brit. J. Phot. 1920, **67**, 63; 1921, **68**, 127; Amat. Phot. 1920, 220; Phot. J. 1920, **60**, 119; abst. C. A. 1925, **19**, 219; J. S. C. I. 1921, **41**, 196A; Sci. Tech. Ind. Phot. 1921, **1**, 44; Can.P. 209,090; D.R.P. 360,550; F.P. 518,229; SwissP. 97,435; U.S.P. 1,517,200. Donisthorpe's process was introduced commercially under the name of D. I. P. or Dye Impression Process.

16. Bull. Nord. Franç. 1911; Phot. Coul. 1911, **6**, 191; Brit. J. Phot. 1911, **58**, 969; abst. C. A. 1912, **6**, 719.

17. Compt. rend. 1905; Soc. de Biol. 1905, "Sur l'affinité des matières colorantés sur le tissu conjonctif."

18. E.P. 25,419, 1913; Brit. J. Phot. 1914, **61**, 922; F.P. 481,149; abst. J. S. C. I. 1917, **36**, 164; C. A. 1915, **9**, 1,282; D.R.P. 289,629; abst. Phot. J. Amer. 1916, **53**, 221; Jahrbuch, 1915, **29**, 163; E.P. 13,260, 1914; addit. to above; Brit. J. Phot. 1915, **62**, 90; Phot. Korr. 1916, **53**, 113; D.R.P. 306,206; Handbuch, 1922, **4**, III, 309.

19. E.P. 103,890, 1916; Brit. J. Phot. 1917, **64**, 251; D.R.P. 289,629, 1913; 334,277; Phot. Rund. 1921, 543; U.S.P. 1,256,981. Cf. H. Festenberg, Phot. Rund. 1916, **53**, 25.

20. D.R.P. 284,805; Phot. Rund. 1915, **52**, 205; abst. Phot. J. Amer. 1916, **56**, 35; C. A. 1917, **11**, 1,797. In D.R.P. 397,984, 1923; Phot. Ind. 1925, 21 the use of a carbon relief on a metal support is claimed.

21. D.R.P. 336,041, 1920; Phot. Ind. 1921, 624; J. S. C. I. 1921, **40**, 562A; Sci. Tech. Ind. Phot. 1922, **2**, 15.

22. U.S.P. 1,430,059; 1,430,060; 1,430,061, 1922; abst. Amer. Phot. 1923, **17**, 184; J. S. C. I. 1922, **41**, 899A; E.P. 189,844; 190,424, 1921; Brit. J. Phot. 1923, **70**, 67; Col. Phot. Supp. **17**, 6; Phot. Ind. 1923, 129; C. A. 1923, **17**, 2,397; Can.P. 245,818 granted to L. Varney.

23. E.P. 1,937, 1911; Brit. J. Phot. 1912, **57**, 29. Cf. A. Le Mée, Phot. J. Amer. 1917, **54**, 154. Cf. J. W. Grün, Phot. Coul. 1906, **1**, 6.

24. D.R.P. 284,805, 1914.
W. Vobach, D.R.P. 358,308, 1920 also patented the use of a metal support for the matrix.
25. E.P. 27,957, 1908; Brit. J. Phot. 1910, **57**, 68.
26. E.P. 18,965, 1911; Brit. J. Phot. 1912, **59**, 829.
27. E.P. 11,120, 1912; Brit. J. Phot. 1913, **60**, 785; Jahrbuch, 1914, **28**, 394; Phot. Ind. 1913, 609; Handbuch, 1922, **4**, III, 306.
W. V. D. Kelley, U.S.P. 1,505,787, 1924; abst. C. A. 1924, **18**, 3,827, patented the imbibition process on a black key positive.
28. Phot. J. 1881; Brit. J. Phot. 1881, **28**, 675.
29. Phot. J. 1882; Brit. J. Phot. 1882, **29**, 248.
30. Il Prog. Foto. 1894; Phot. Korr. 1894, **51**, 323; Jahrbuch, 1895, **9**, 486.
The author dealt with the toning of prints with lead ferricyanide and the various colors obtained with different salts, Phot. Quarterly, 1893, **3**, 240; Phot. Annual, 1894, 90; but the results were too often muddy and the tones unsatisfactory. Cf. Loescher, Phot. Mitt. 1893, **30**, 284.
31. Jahrbuch, 1901, **15**, 172; Anthony's Phot. Bull. 1900, 31, 90, 126; Bull. Soc. franç. Phot. 1899, **46**, 565.
32. Phot. J. Amer. 1921, **68**, 96; Brit. J. Almanac, 1922, 395; Amer. Phot. 1922, **16**, 396.
R. Namias, Il Prog. Foto. 1924, **31**, 36; Rev. franç. Phot. 1924, **5**, 76; Sci. Ind. Phot. 1924, **4**, 75 suggested also the use of vanadium oxalate, but preferred to treat with this salt first, and then with a citric acid solution of iron alum, as the toning can be arrested at any moment.
33. Phot. Rund. 1907, **27**, 189; Brit. J. Phot. 1907, **54**, Col. Phot. Supp. **1**, 84; Phot. News, 1907, **52**, 231. A further description with slight modifications was given by F. Leiber, Phot. Rund. 1911, **48**, 200; Jahrbuch, 1913, **26**, 36; Brit. J. Phot. 1912, **59**, Col. Phot. Supp. **6**, 3. Cf. A. Le Mée, ibid. 1910, **57**, ibid. **4**, 41; 1913, **60**, ibid. **7**, 19.
A. Le Mée, Phot. Coul. 1913, **8**, 30; Brit. J. Phot. 1913, **60**, Col. Phot. Supp. **7**, 19, used a lead-toned yellow image with pinatype red and blue.
34. E.P. 20,880, 1911; Brit. J. Phot. 1911, **58**, Col. Phot. Supp. **6**, 39; 1912, **59**, 828; U.S.P. 1,059,867; F.P. 448,565; Can.P. 143,392; abst. C. A. 1912, **6**, 2,021; D.R.P. 329,273.
Cf. O. Pfenninger v. Hamburger, Brit. J. Phot. 1915, **62**, Col. Phot. Supp. **9**, 3.
35. Phot. J. 1914, **54**, 288; abst. Annual Repts. 1916, **1**, 304; Brit. J. Phot. 1914, **61**, Col. Phot. Supp. **8**, 8, 45; 1915, **62**, ibid. **9**, 4; Amat. Phot. 1914, **60**, 419; Phot. J. Amer. 1913, **50**, 572; Camera Craft, 1915, **22**, 82; Brit. J. Almanac, 1915, 516. In the E.P. an alternative bleach of lead ferricyanide and aluminum nitrate is given.
36. Brit. J. Phot. 1923, **70**, 167.
Hamburger, Brit. J. Phot. 1923, **70**, 183 claimed to be the originator of mercuric iodide toning for color work and generally, E. J. Wall, ibid. 262; Amer. Phot. 1923, **17**, 556, pointed out that Woods (see p. 398) had suggested this salt for the same purpose. And that G. Brunel, "La Photographie en Couleurs," 1891 (?), 108 had suggested lead ferricyanide, followed by mercury-potassium-iodide. Also that C. Glissenti, or Brissenti, Les Progrés photographique, 1887; Phot. Times, 1887, **17**, 68, 91, had proposed cupric iodide followed by mercuric iodide for toning. Hamburger replied, Brit. J. Phot. 1923, **70**, 278.
37. E.P. 15,050, 1908; Brit. J. Phot. 1909, **56**, 634; F.P. 463,062, 1912; addit. 18,917; 19,579, 1913; abst. J. S. C. I. 1914, **36**, 440; 1915, **37**, 1,118; Annual Repts. 1916, **1**, 306.
38. D.R.P. 335,088, 1914; Phot. Ind. 1921, 526; Sci. Tech. Ind. Phot. 1921, **1**, 112.
39. E.P. 178,981, 1921; abst. J. S. C. I. 1922, **41**, 484A; Amer. Phot. 1923, **17**, 184.
40. E.P. 175,003, 1920; Brit. J. Phot. 1921, **68**, Col. Phot. Supp. **15**, 20; 1922, **69**, 202, ibid. **16**, 8, 15; abst. C. A. 1922, **16**, 2,086; Amer. Phot. 1922, **16**, 465; Sci. Tech. Ind. Phot. 1922, **2**, 32; J. S. C. I. 1920, **39**, 772A.
41. E.P. 161,578, 1920, Void, F.P. 534,080. According to abst. Sci. Tech. Ind. Phot. 1921, **1**, 112, this was used by Hauberrisser, Phot. Rund. 1900. And has been used by Thornton and others.
42. E.P. 188,692, 1921; Brit. J. Phot. 1923, **70**, Col. Phot. Supp. **17**, 30; abst. J. S. C. I. 1923, **42**, 73A; D.R.P. 372,814; Brit. J. Almanac, 1924, 376.

43. E.P. 23,826, 1899; Brit. J. Phot. 1901, **48**, 98; Phot. Woch. 1901, **41**, 69; D.R.P. 122,617; Silbermann, **2**, 361; Jahrbuch, 1901, **15**, 634; U.S.P. 667,349.
A. Dufait, F.P. 573,484, 1923; abst. Sci. Ind. Phot. 1925, **5**, 23, proposed to make line drawings, maps, etc., with aqueous solutions of rhodamin B, naphthol yellow and toluidin green, to facilitate tricolor selection.

44. E.P. 6,356, 1903; Brit. J. Phot. 1898, **45**, 406; Brit. J. Almanac, 1906, 866; Photography, 1904, 69; Phot. Ind. 1903, 567; Jahrbuch, 1904, **18**, 410; Chem. Ztg. Rep. 1904, 348; D.R.P. 163,326; Silbermann, **2**, 374; Phot. Chron. 1904, **11**, 668; 1906, **13**, 405; Jahrbuch, 1907, **21**, 405; F.P. 333,372; Phot. Kunst. 1904, **3**, 393.

45. E.P. 20,556, 1912; Brit. J. Phot. 1913, **60**, 845.

46. U.S.P. 807,932, 1905; Camera Craft, 1905, **10**, 167.

47. U.S.P. 809,651, 1906; F.P. 317,524; E.P. 579, 1902. This process was called "Pyrochromographie."

48. E.P. 318, 1911; Brit. J. Phot. 1912, **59**, 352. Cf. A. M. Dessoye, F.P. 52,635, 1862.

49. E.P. 22,580, 1905.

50. U.S.P. 1,499,930, 1,538,816; abst. J. S. C. I. 1924, **43**, B770; Amer. Phot. 1925, **19**, 53. The U.S.P. solution of ferric chloride contains 29 per cent of anhydrous ferric chloride. Cf. E. J. Wall, Brit. J. Phot. 1925, **72**, 69.

51. "Die Tonungsverfahren von Entwickelungspapieren," 1906, 135.

52. "Der Bromsilber-u. Gaslichtpapier-Druck," 1913, 452, 453.

53. Brit. J. Phot. 1913, **60**, 838.

54. Phot. Archiv. 1895, **36**, 115; Phot. Korr. 1896, **33**, 6; Jahrbuch, 1896, **10**, 11; Phot. Annual, 1897, 189.

55. "Photochemische Studien," 1895, **2**, 28.

56. Phot. J. 1896, **36**, 245; Phot. Annual, 1897, 189.

57. Phot. Korr. 1905, **42**, 319; 1906, **43**, 242; Jahrbuch, 1906, **20**, 237.

58. Brit. J. Phot. 1907, **54**, 136, 196, 216; Phot. Korr. 1907, **44**, 55; Phot. Chron. 1907, **14**, 206.
The Aktiengesell. f. Anilinfabrik. F.P. 457,079, 1913 patented the use of indoxyl.

59. Phot. Korr. 1914, **51**, 256, 471.

60. J. prakt. Chem. **62**, 53.

61. Jahrbuch, 1914, **28**, 22.

62. Ber. **33**, 985.

63. E.P. 15,055, 1912; Brit. J. Phot. 1913, **60**, 595; D.R.P. 257,167, 1911; U.S.P. 1,055,155; abst. C. A. 1913, **7**, 27, 149, 944, 1,449; 1914, **8**, 27, 2,657, 2,986; Phot. J. Amer. 1912, **49**, 436.

64. U.S.P. 1,079,756, 1913; abst. C. A. 1914, **8**, 470, 2,986; Austr.P. 8,572, 1911; E.P. 5,602, 1913; Brit. J. Phot. 1913, **60**, 712.

65. U.S.P. 1,102,028, 1914; D.R.P. 253,335, 1912; E.P. 2,562, 1913; Brit. J. Phot. 1914, **61**, 329; M. P. News, 1917, 2,216; abst. C. A. 1914, **8**, 2,657.

66. Phot. Korr. 1914, **51**, 16; Photo-Woche, 1914, 8; abst. C. A. 1914, **8**, 1,710; Phot. J. Amer. 1914, **51**, 137; Bull. Soc. franç. Phot. 1922, **69**, 247; J. S. C. I. 1922, **41**, 383A.

67. Brit. J. Phot. 1923, **70**, 47. Cf. E. J. Wall, ibid. 262, and Ermen ibid.

68. D.R.P. 257,160, 1911; Jahrbuch, 1913, **27**, 414; Phot. Ind. 1913, 698; F.P. 454,792; Austr.P. A8,572, 1911.

69. E.P. 133,034, 1918; Brit. J. Phot. 1921, **68**, 96; F.P. 503,954; D.R.P. 327,591; abst. Jahrbuch, 1915, **29**, 164; J. S. C. I. 1921, **41**, 164A; Sci. Tech. Ind. Phot. 1921, **1**, 28; U.S.P. 1,517,049; C. A. 1925, **19**, 446.

70. Phot. Rund. 1911; Brit. J. Phot. 1912, **59**, 727.
Cf. E. J. Wall, Brit. J. Phot. 1915, **62**, Col. Phot. Supp. **9**, 29.

71. Phot. Rund. 1912, **49**, 264; 1914, **51**, 72; Brit. J. Phot. 1912, **59**, 727.
Cf. A. Boer, Amer. Phot. 1924, **18**, 672; Der Phot. 1924, **34**, 333; Phot. Ind. 1924, 482; Brit. J. Phot. 1924, **71**, 726, described a similar process. R. von Arx, Phot. Ind. 1924, 830.

72. The turbidity is dependent on the different structure of the hard and unhardened gelatin, and is noticeable in nearly all similar processes.

73. E.P. 13,429, 1915; Brit. J. Phot. 1915, **62**, Col. Phot. Supp. **9**, 17, 1916, **63**, 434; Col. Phot. Supp. **10**, 30; Brit. J. Almanac, 1917, 408; Phot. J. 1915, **55**, 40, 141; Sci. Amer. 1915, **112**, 350; Camera Craft, 1915, **22**, 248; abst. J. S. C. I. 1916, **38**, 868, 907; Annual Repts. 1916, **1**, 304; C. A. 1916, **10**, 922, 2,853; U.S.P. 1,196,080; F.P. 479,796; 479,797; D.R.P. 279,802; Phot. Ind. 1917, 307.
In U.S.P. 1,273,457, 1918; abst. J. S. C. I. 1918, **37**, 607A, Capstaff patented a film in which an opaque or light-resisting screen or layer of finely comminuted

silver was to be interposed between the support and the sensitive emulsion, this layer being removed by the subsequent treatment, which presumably might be for this process.

Cf. G. H. Croughton, Brit. J. Phot. 1915, **62**, Col. Phot. Supp. **9**, 4. S. Allan, Bull. Phot. 1915, **16**, 654. C. E. K. Mees, Amer. Annual Phot. 1915, **30**, 9; Bull. Phot. 1916, **18**, 101. E. J. Wall, Brit. J. Phot. 1915, **62**, Col. Phot. Supp. **9**, 29.

74. U.S.P. 1,315,464, 1919; abst. J. S. C. I. 1919, **38**, 848A.

J. Joe, Phot. Woch. 1913; Brit. J. Phot. 1913, **60**, 250 used the old Poitevin method with ferric chloride and citric acid and dyed up in baths containing gelatin to keep the whites clean.

75. E.P. 3,730, 1903; U.S.P. 814,215.

76. Eder, "Reaktionen der Chromsäure auf organische Substanzen," 1878; reprinted from J. prakt. Chem. 1879, **14**, 294; Handbuch, 1917, **4**, III, 103; Brit. J. Phot. 1878, **25**, 150, 161, 197, 526, 461, 520, 545, 582, 616, 656; 1879, **26**, 140, 209, 271, 292, 318, 353, 378, 436, 461, 473.

77. R. Abegg and Cox, Zts. phys. Chem. 1904, **48**, 725; R. Abegg, Jahrbuch, 1905, **19**, 108.

78. "Die Tonungsverfahren von Entwickelungspapieren," Halle, 1906, 22. H. Lüppo-Cramer, "Kolloidchemie u. Photographie," Dresden, 1908, 144.

79. E.P. 586, 1863.

80. E.P. 25,084, 1912; Brit. J. Phot. 1913, **60**, 979.

81. E.P. 8,518, 1888; Phot. News, 1888, **33**, 413; Brit. J. Phot. 1889, **37**, 320.

82. Photo-Rev. 1905; 1907; Brit. J. Phot. 1912, **59**, 424.

83. Kolloid Zeits. 1914, **15**, 18; Zeits. Repro. 1919, **21**, 77; Photographie, 1920, **25**, Nos. 2, 3; Phot. Korr. 1919; abst. "Kolloide in der Technik," Liesegang, 1923, 140; Jahrbuch, 1915, **29**, 368.

84. Brit. J. Phot. 1923, **70**, 491; abst. Sci. Tech. Ind. Phot. 1923, **3**, 152; Amer. Phot. 1923, **17**, 756.

85. Trans. Faraday Soc. 1923, **19**, 396. This paper was read at a general discussion and all the papers were reprinted in full under the title: "The Physical Chemistry of the Photographic Process." Cf. J. Phys. Chem. 1924, **28**, 179; abst. J. S. C. I. 1924, **43**, B729, 997B.

86. Loc. cit. 401.

87. U.S.P. 1,469,811.

CHAPTER XV

SUBTRACTIVE PROCESSES. V

The Askau Process.—Under this name J. Rieder[1] (p. 437) invented a printing process, based on the action of light on ASphalt and KAUtschuk (rubber), hence the name. In a previous patent[2] he described the use of a light-sensitive film of asphalt and tacky resins, chiefly rubber, which after exposure was dusted with a fine powder, which only adhered to the unexposed parts, thus recalling the old powder process with dichromated colloids. In the new process the asphalt was dissolved with rubber, the solution poured on a support and dried. The inventor claimed that the asphalt formed a solid solution which was destroyed by the exposure. At the same time the thin films became permeable to alcohol, and similar substances, as well as to solutions of alcohol and water. Dyes, which are soluble in such solvents penetrate there through, and if a support be used which could be stained, a picture would be obtained in all its details.

A positive was thus obtained from a positive, whilst by the previous dusting-on process, according to D.R.P. 211,329, a negative was obtained from a negative. For this later diffusion process it was more convenient to replace the rubber entirely or partially with guttapercha, or similar bodies as the tacky properties were of no value. The process worked best when the light-sensitive film was underlaid by collodion and so on, in which basic dyes principally are absorbed. Gelatin and similar substances might be used, but then water-soluble dyes must be used.

Another variant was to produce the dyes in the substratum by treating with ferric chloride and then with tannin. Finally the image might be produced by gasses, which would give dyes with agents incorporated in the lower film.

For tri-color work, the constituent images might be combined from three separate prints, for instance, the blue print might be produced on paper, coated with collodion and then washed and recoated and the yellow printed.

The Universal Color Co.[3] patented the use of the resinates, either of the metals, alkaline earths, or the alkalis or their halogen derivatives. Magnesium and silver abietates were found the most sensitive, although some organic salts, such as quinin abietate could be used. These could be used as resists for etching, or anilin or other colors could be incorporated and, after exposure, treatment with benzol dissolved the unexposed parts.

J. North[4] patented the use of salts of guaiacum with anilin colors for etching. Müller-Jacobs[5] described a process, though not directly for color work. This was based on the light-sensitiveness of the double resin soaps

of some of the anilin color bases and magnesia. These resinate colors, after exposure, resist more or less perfectly the solvent action of oil of turpentin, so that if such a film be exposed under a negative or positive, washed in turpentin, there would be obtained a negative from a negative, and the resinate gave a grain to the picture. J. L. de Bancels[6] suggested treating resin with soda or potash lye, forming a resinate and adding a dye, then a zinc or magnesium salt to precipitate the colored resinate, which after exposure to light was insoluble in benzol, toluene-xylol, but soluble in methyl or ethyl alcohol.

The Diazotype Processes.—These have been but little used for tri-color work, though they merit attention as it is possible to obtain a great variety of colors with the same.

Feertype.—A. Feer[7] based his process on the fact that although the diazo-sulfonic compounds form no coloring matters with phenols and amins, yet on exposure to light the diazo compound is liberated and is able to exert its azo-color-forming properties. Paper was sensitized with a dilute molecular mixture of a diazo-sulfonic salt of anilin, amino-azo-benzol, benzidin and their homologues, or the chlorides or free amins, anilin, naphthylamin, phenylendiamin, etc., or phenolates of the alkalis, phenol, resorcin α- and β-naphthol, dried in the dark and exposed for about 5 minutes to sunlight or the arc.

There was formed on the exposed parts the insoluble azo dyes, whilst on the unexposed parts colorlessness and solubility remained. The image was developed, after washing either with water or weak hydrochloric acid. The developers recommended were:

<div style="margin-left:2em">

Sodium toluol-diazo-sulfonate 25 g.
α-naphthol 25 g.
Caustic soda 8 g.
Water1000 ccs.

</div>

or

<div style="margin-left:2em">

Sodium ditolyl-tetrazo-sulfonate 25 g.
m-phenylendiamin 25 g.
Water1000 ccs.

</div>

Or

<div style="margin-left:2em">

Sodium ditolyl-tetrazo-sulfonate 25 g.
Resorcin 22 g.
Caustic soda 16 g.
Water1000 ccs.

</div>

The Primulin Process.—A. G. Green, C. F. Cross and E. J. Bevan[8] patented printing with primulin, which was based on Green's discovery of primulin, a compound of sulfur and p-toluidin, which dyes cotton, linen and similar fabrics without a mordant. If the primulin be treated with dilute nitrous acid, it forms diazo-primulin, which has the power of forming a variety of coloring matters with various phenols and amins. It is very sensitive to light in contact with vegetable and animal matters, and

on exposure is decomposed and loses its dye-forming power. If, therefore, a surface dyed with primulin is diazotized and exposed behind a transparency and is afterwards treated with a phenol or amin a colored image is obtained.

The material, cotton, linen, silk, paper, wood, gelatin, celluloid, etc., is dyed in a hot solution of primulin, washed and diazotized in a dilute solution (0.25 per cent) of sodium nitrite acidified with hydrochloric acid. It is again washed and dried in the dark. The sensitized material will keep for sometime and should be exposed to daylight or an arc, the duration of exposure being determined by simultaneous exposure of a strip, and as soon as the latter gives a color with the developer that is to be used, the insolation should be stopped. The printed material is then treated at once, or after some time, with a dilute solution of the desired developer, 0.25 per cent. An alkaline solution of α-naphthol gives red; a similar solution of the corresponding sulfonic compound gives maroon; yellow is obtained with an alkaline solution of phenol; orange with alkaline resorcin; brown with a slightly alkaline solution of pyrogallol, or phenylendiamin hydrochloride; for purple a solution of α-naphthylamin hydrochloride and for blue a slightly acid solution of eikonogen. Primulin might be replaced by its homologues, and for silk dehydro-thio-toluidin-sulfonic acid might be used.

M. Andresen[9] found that all diazo compounds were more or less sensitive to light, and especially the tetrazo compounds of benzidin, tolidin, dianisidin, diamino-stilbene, and were thus better than the primulins and gave better whites.

An example of making these compounds is as follows: 9.2 g. of pure benzidin are dissolved in 200 ccs. boiling water and 15 g. strong sulfuric acid and 15 g. water added, the mixture allowed to cool and chilled with ice to 5 to 10° C. A solution of 7.2 g. sodium nitrite in 20 ccs. water should then be slowly added with constant stirring and the benzidin sulfate is diazotized and goes into solution. As soon as the reaction is ended, which can be tested with starch-iodide paper, the solution should be filtered into five times its volume of alcohol, which separates out the diazo compound in a very pure form. This should then be filtered out, washed with alcohol, *but not dried, as when dry it is very explosive,* then dissolved in 400 ccs. water and cooled to 5° C. The paper or other material should be floated on this for 2 minutes and dried in the dark. Exposure should be under a positive and development effected with a 2 per cent solution of amino-naphthol-sulfonic acid—5, or the corresponding 9 compound, dissolved in an equal weight of calcined soda.

M. Schoen[10] patented the use of diazo-o-amino-salicylic acid, formed by dissolving the amino acid in hydrochloric acid and diazotizing with sodium nitrite in chilled solution. The color of the compound is yellow; it is but slightly soluble in water or alcohol, but readily soluble in alkalis

and the action of light is to form a red dye. To use this it is preferable to dissolve it in ammonia or sodium carbonate, and after impregnation of the material to dry in the dark, then expose under a negative. The unexposed parts remain yellow and can be removed by washing with water. The tones can be modified by the use of lead acetate, cobalt nitrate, ferric chloride, or lime or baryta water.

T. Valette and R. Feret[11] patented a process for obtaining colored prints by the use of a light-sensitive emulsion of a phenol and a diazo compound in sodium bisulfite solution, and the dyes must contain no free sulfonic or carboxyl group. The images were developed with anilin and phenol for yellow; p-nitranilin and α-naphthol for red and toluidin and α-naphthol or amino-α-naphthol for blue.

A. and L. Lumière[12] tried to apply Feertype to the production of subtractive prints, but were unable to find a blue that was satisfactory, and, therefore, used a silver image and toned it blue with ferricyanide, followed after washing with ferric chloride. After removal of the silver chloride by fixing, then washing and drying, the print was coated with collodion containing tetrazo-tolylsulfite of sodium and hydrochlorate of α-naphthylamin ether, or tetrazo-anisidin sulfite with the naphthylamin compound. After fixing, prolonged washing and drying the same operations were repeated to obtain the yellow impression, using sodium diazo-o-toluidin and m-aminophenol (base) or resorcin. Very satisfactory results were thus obtained.

G. Kogel and H. Neuenhaus[13] patented the use of the diazoanhydrides, preferably the halogen or nitro derivatives of the sulfo acids of naphthalene -1-2. The compound was destroyed by light, and no longer coupled with azo colors to form dyes. Alkaline resorcinol was used for red; or resorcinol, phloroglucinol or methylphenyl-pyrazolon might be incorporated with a small quantity of citric or tartaric acid with the diazo compound. The use of nickel, copper or other suitable salts is indicated to obtain greater fastness to light.

Pinachromy.—This process was introduced commercially by Meister, Lucius and Brüning[14] in 1904, and was based on the use of the leuco dyes; but as the results were not stable in light, it was soon withdrawn from the market.

E. König pointed out that it was well known that some of the leuco bases of many dyes were extremely unstable, for instance, leuco-safranin, which is so readily oxidizable that it is impossible to isolate the same, yet there are many others, leuco-malachite green, for instance, which are relatively stable in air. Gros had stated that the leuco bases of the fluoresceins and their substitution products especially were all readily oxidizable on exposure to light. The leuco bases can not be used alone for obtaining images and are useless if imbedded in acetyl cellulose or gelatin. On the other hand, oxidation rapidly took place if collodion be used as the

vehicle, since oxidation takes place at the cost of the nitro group. Mixtures of the leuco bases were found to be much more sensitive with the nitric esters of glycerol, glucose or mannite, and the sensitiveness of the nitro-cellulose-leuco mixture was considerably increased by nitro-mannite, and similar but weaker action was shown by nitrosamin, quinolin and its homologues. The action here was purely catalytic. Turpentin and anethol were without action, while urea and antipyrin were restrainers. To fix the prints it was necessary to dissolve the unchanged bases, and this was partially effected by mineral acids, benzol, toluol, ether, chloroform; acetic, di- and tri-chloracetic acids were useless, and the best fixer was mono-chloracetic acid.

The best leuco bases were, for blue: o-chloro-tetra-ethyl-diamino-tri-phenyl methane; for green, leuco-malachite green, m-nitro-tetra-ethyl-diamino-triphenyl methane; for red, p-leucoanilin, leuco-rhodamin; for violet, hexa-methyl-p-leuco-anilin; for yellow, leuco-fluorescein and leuco-flavanilin. Gros had pointed out that the leuco bases were least affected by light of the same color, and most strongly by that of the complementary color. The sensitive paper had to be prepared shortly before use, as even in the dark, slow oxidation to the dye took place. For making three-color prints, each color was exposed by itself. First the blue collodion film was coated, and after exposure treated with monochloracetic acid, washed and then given a protective coating of gelatin. Then coated with the film for the red, a second treatment with acid and gelatin and finally the third coat for the yellow.

L. Didier[15] also patented a process, which apparently is the same as the above, except that it is suggested to use negatives of complementary colors, such as Autochrome plates, though Gros had already given this procedure. A film or several superposed films, containing three reagents, which in the presence of suitable adjuncts, become colored by light, respectively in blue, red and yellow, each under the complementary colors was to be used. Each reagent ought not to nullify the action of the others, and each color formed should not act on the sensitizers forming the other colors, and the same fixing agent should be used for all.

The yellow might, for example, be obtained by the action of a mixture of an alkaline diazosulfite of an aromatic amin or of a phenol; and the red and the blue by the leuco derivatives of dyes. A mixture of the three leuco derivatives in a single film, does not permit, by reason of the optical sensitizing, an exact reproduction of the colors, but certain reactions of the leuco bases and diazo-sulfites are independent optically and chemically, and may then be used in the same vehicle. One could then use two films of collodion, separated by an insulating film of gelatin with the addition of certain neutral salts, which prevent the migration of one film into the other in which the leuco-base reagents could be mixed, the one should have the leuco-base and the other the leuco-base and the diazo-

sulfite. The paper was said to keep well if dry. Fixation was to be effected with a solution of monochloracetic acid with the addition of stannous chloride.

W. Eissfeldt[16] proposed to divide a gelatin emulsion into four parts, and sensitize three for red, yellow and green, respectively, and add a yellow screening dye also. Leuco bases of red, yellow, green and blue dyes, insoluble in water, were to be dissolved in alcohol and added to the different lots of the emulsions; the yellow leuco-base being added to the non-color-sensitive one, the red leuco-base to the green-sensitive, the green to the red-sensitive and the blue to the yellow-sensitive. The bases would thus be suspended in the emulsions and the alcohol driven off. The emulsions were then to be mixed, hardened and re-emulsified in fresh gelatin, or allowed to set, their melting points determined and then emulsified in gelatin of lower melting point. Exposure was to be effected in the camera behind a yellow filter, and development, but not fixation, carried out as usual. The silver image was then to be converted into an iodide or a copper-silver ferrocyanide complex, the leuco-bases oxidized to dyes, which were supposed to be immediately absorbed by the iodide or copper complex. Those particles of the leuco compounds, which were now distributed as free dyes in the gelatin, were to be dissolved and those adhering to the iodide and copper salts hardened or mordanted.

Tri-Color Bi-Gum.—Under the name of bi-gum is known a process in which gum arabic is used as the colloid instead of gelatin or glue, its correct title being, of course, gum bichromate. The feature of this process is that no transfer is required, the prints being developed from the front with cold water.[17] The inception of this process was by A. L. Poitevin, in 1855, who was followed by J. Pouncy, in 1858, Mariot 1885, Artigue 1889, Rouillé-Ladévèze 1894, Maskell and Demachy 1894 and others.

The first three-color gum prints were made by H. Watzek,[18] who saturated paper with a 2 per cent solution of shellac and then coated with the three solutions with the red, blue and yellow pigments. P. von Schoeller[19] employed Paris blue, gamboge for the yellow and alizarin lake for the red. H. Scheidemantel[20] described the method adopted by Nicola Perscheid and pointed out that one of the most important matters was the non-expansion of the paper support, so that the outlines of the three-constituent prints should coincide. The raw paper was, therefore, soaked in water for 24 hours, which caused it to expand considerably; it was then hung up to dry, and, although it contracted, it obtained sufficient stability from this soaking, not to unduly expand again.

It was then coated with about a 5 per cent solution of gelatin, to which was added about 1.5 per cent of chrome alum, and again dried. The actual colors used were kept secret, but the method of preparing the surface was as follows: rice starch 5 g. was dissolved in 150 ccs. water by

heat and 50 ccs. fish glue added; the mixture was rubbed up with 50 g. gum arabic, adding a little glycerol and phenol to preserve it. The sensitizer was a 12 to 15 per cent solution of ammonium dichromate. The paper was cut rather larger than the negative to be printed from, and then 2 parts of the colloid with an equal volume of sensitizer and 1 part of blue pigment were intimately mixed in a mortar, and painted on with a soft brush. The exposure was about 10 minutes in sunlight. The print was then floated face downwards on cold water, so that the undecomposed dichromate dissolved out and in about 15 minutes the print was developed. After drying, the print was coated with the yellow pigment, mixed like the blue, only rather more yellow pigment being used, on account of its lesser covering power. The use of an alum bath was suggested between coatings and the addition of a few drops of hydrochloric acid to the developing water to clear the prints if necessary; the red impression was obtained in the same way.

A. Miethe, E. Lehmann and Nybom[21] used a cyanotype blue image as the basis of their work. A rough surface paper was first coated with an 8 per cent solution of gelatin, then soaked in a 40 per cent solution of formaldehyde and dried. This was sensitized with equal volumes of 8.3 per cent solution of green ammonio-citrate of iron and 3 per cent solution of potassium ferricyanide. After exposure, and the print should not be too deep, it was developed in cold water, with three changes, and then immersed in 0.2 per cent of hydrochloric acid for a short time. The yellow mixture was prepared by mixing 1 part of dark citron chrome-yellow, water-color in tubes, with 2 parts of water, and of this mixture 1 part was rubbed up with 1 part of a 50 per cent solution of gum arabic and 1 part of a cold saturated solution of potassium dichromate. The red pigment was alizarin lake water-color mixed in the same way.

J. Moeller[22] also used the gum process with enlarged paper negatives made translucent with castor oil. Zander, Whatman and Allongé papers were used and prepared with 25 per cent of gelatin treated with 5 per cent formaldehyde. Cadmium yellow, gamboge, madder lake and Paris blue were the pigments used. After exposure the print was immersed in water at 18° C, then developed with a spray and locally treated with a brush, and finally immersed in 10 per cent alum solution.

F. Leiber[23] proposed to use gaslight or bromide prints as the base, and converted the image into lead and silver ferrocyanide, washed and dried. This yellow print was then immersed in solution of ammonio-citrate of iron, exposed and immersed in solution of potassium ferricyanide, briefly washed and immersed in solution of a dichromate by which lead chromate was formed. The blue print sunk into the paper, and it was frequently necessary to superimpose a blue impression by the gum process. The red constituent was prepared by the gum process, using first bright alizarin lake and then a dark red of the same pigment.

The Powder Process in Colors.—This process is again one of the early uses of the properties of colloids and dichromates, and is based on the fact that after exposure to light gum loses more or less its hygroscopic character, and consequently the power of holding powder colors; therefore, as a rule some hygroscopic substance, such as glycerol, glucose, treacle, etc., was mixed therewith.

A. Miethe and A. Lehmann[24] applied this principle to three-color work. After thoroughly cleaning a sheet of plate glass, it was coated with the following mixture:

Gelatin	6 g.
Grape sugar	200 g.
Potassium dichromate	60 g.
Water	1000 ccs.

And dried at 60 to 70° C. Printing was effected as usual under a positive for about 2 minutes, and a faint image appeared. Development was effected with a very broad, soft brush, and the colors used were Berger and Wirth's dark alizarin red, the normal tri-color yellow and the normal tri-color blue. They were gently rubbed up in a mortar, then sifted through bolting silk on to the prints, and after a few minutes slowly moved over the surfaces. After about 5 minutes the image began to appear, and the brushing was continued till all details were visible. Care must be taken to keep the plate during this operation from the breath and undue moisture. Excess color was removed with a brush, and the print coated with 2 per cent collodion, dried and again collodionized and the film cut round the edges, and immersed in cold water, when it soon began to strip from the glass. The water was renewed twice or three times till colorless, this being to remove the dichromate. Then the water should be replaced with 1 per cent solution of gelatin, lukewarm. A card should then be slipped under the print in the gelatin solution and the two brought into contact, the collodion side down and gently squeegeed into flat contact. The red and blue impressions were obtained in the same way and superimposed on the yellow.

The powder process is not one that should be chosen for three-color work, as it is by no means easy to obtain just the correct ratio of colors, and there is always some trouble to be expected if the exposure is not correct, as in the case of under-exposure the color will take generally, and with over-exposure the details in the high lights will be wanting. The powders must be in a very fine state of comminution, otherwise a coarse, granular appearance is caused, which also appears with under-exposure.

J. Sury[25] patented the incorporation of a temporary coloring matter, aluminum and sodium silicates and pentasulfide of sodium, which is probably artificial ultramarin, in a colloidal coating with barium sulfate or kaolin. This coating was to be sensitized with dichromate, the image developed with hot or cold water and treated with hydrochloric acid, which

decolorized the added coloring matter with the evolution of gas, which made the colloid spongy. This might be dusted with a powdered pigment and the image transferred to a tacky paper or fixed on its original support. The process might be used for three-color work.

Preparation of the Paper Support.—One of the troubles met with in making prints on paper is the unequal expansion of the same when wet and dry. Were this but regular it could be easily overcome, but not only does it vary with the period of immersion in the necessary baths, but it is unfortunately not the same in the paper web itself, that is to say, the paper has a tendency to stretch more in one direction than another, due to the lie of the fibers in the paper machine. This trouble was known before color photography became as it were the sport of the general and was well known in the early days of plain and albumenized papers. Much can be done by cutting the paper always the same way of the web, by soaking for some time till maximum expansion has set in, and in taking care to subject all papers to exactly the same treatment; it is also, of course, more under control of the worker who prepares as far as possible his own raw materials.

C. Fleck[26] proposed to use pure linen paper, stretch it in a frame, then coat with the following:

Celluloid scraps	35 g.
Absolute alcohol	400 ccs.
Ether	600 ccs.
Castor oil	15 ccs.

When dry the paper was passed through a calendar two or three times with constantly increasing pressure, then moistened with:

Ether	50 ccs.
Alcohol	50 ccs.
Water	1000 ccs.

And again passed through the press till dry. This does not expand then if the raw stock was good.

Obviously this is not a process that the amateur can adopt, but it is possible to prepare the paper so that it will not stretch much, if at all, by soaking a sheet for some time in cold water, and while thoroughly wet squeegeeing down to a sheet of glass, the edges of which have been previously coated for about half an inch with gelatin solution, containing a little chrome alum, and then allowing to dry. The glass should be rather larger than the paper, and the main idea is to stretch the paper as taut as possible while wet, so that on drying it shrinks and becomes as tight as a drum. When dry the paper should be freely coated with the celluloid solution, though there is no need to use absolute alcohol, methyl alcohol and ether being preferable, and the strength should not exceed more than one-third of that given above. Two coats should be given if the paper is very porous, but in no case should there be any tendency to glaze; if

there is, the ratio of celluloid must be reduced. When the solvents have evaporated, the surface may be painted with a solution of gelatin in glacial acetic acid and alcohol with chrome alum (see p. 330), on the lines given for the cement, and one or two coats may be given. As a rule the final transfer papers, as issued commercially for carbon work, are quite satisfactory and save all trouble.

J. Sury and E. Bastyns,[27] referring principally to plain papers on which a cyanotype image is first produced, pointed out that it expands differently after the application of the gum solution, as used in superposed film prints. They proposed to immerse the paper in a solution of formaldehyde, or tannin, and dry, and then coat the back with gum, dextrin, sugar or glucose.

G. Selle[28] considering the paper support always shows through superimposed monochromes, proposed to make a special white surface, so that the colors should not be affected. This was an emulsion of oxide of zinc in collodion. When dry this was coated with plain gelatin solution and when this was dry varnished with celluloid varnish. A. Nefgen[29] proposed to prevent the distortion of carbon tissue support by soaking the paper before or after exposure in a weak solution of wax in benzol, which renders it proof against liquids, without affecting its developing properties. P. Glaser[30] patented the preparation of paper supports for color photography, by coating with colloids with the addition of tanning agents, and the use of two or three layers with the incorporation of oily or waxy substances in the paper mass, to prevent expansion in aqueous solutions.

Photo-Ceramics in Three Colors.—P. C. Duchochois[31] suggested the use of the powder process for obtaining three-color ceramics. The following was the sensitive mixture:

Glucose 85 ccs.
Gum arabic 40 g.
Ammonium dichromate, sat. sol. 200 ccs.
Water to1000 ccs.

The glass, porcelain or faience should be flowed over with this, drained in a vertical position for a few seconds and then the lower edge wiped free from excess liquid. The plate should then be placed in a level position over a lamp or in an oven, and the temperature should not exceed 35° C. The plate should be exposed under the three transparencies, which must be rather thin with clear shadows, for from 3 to 4 minutes in diffused light and left in a shallow box for 2 minutes to absorb moisture. The vitrifiable color, ground into an impalpable powder—and this is important—should be dusted over it with a pepper pot. Then the powder should be gently rubbed all over the plate, describing small circles, afterwards allowing the film to absorb more moisture before further operations.

On the first application of the powder only the deep shadows and half tones appear. If the powder adheres in the half tones and delicate details,

the picture is under exposed. Then it is better to wash it off and commence afresh. If the details hang back, or if after about 10 minutes the development does not proceed any more the picture has been over-exposed and it should be washed off. Local breathing through a tube on to the parts may bring out high lights without intensifying the shadows. When all the details are developed the plate should be heated to remove the moisture it has absorbed, and the superfluous powder dusted off carefully. The dichromate has to be removed, but it is first necessary to fix the picture, which is done with the following:

> Fused borax, powdered........................ 11 g.
> Alcohol750 ccs.
> Water250 ccs.

Dissolve the borax in the water by heat, add the alcohol and filter when cold. Immerse the plate until the yellow color of the film disappears, then apply fresh solution, and dry.

The vitrifiable colors should be transparent, and can be obtained commercially, but usually not in fine enough powder for this work. In selecting the colors, yellow, carmin red and blue, they should be appropriate to the material on which they are to be burnt in. Those prepared for porcelain and faience are too tender for enamel plates on account of their great fusibility, while the same would be too hard—not sufficiently fusible —to be employed on glass. Hence one should be careful to select the colors according to the material to be decorated.

` **Pseudo-Color Processes.**—Photography in natural colors has for so long been the goal of many that it is not surprising to find that it should also provide a field for those ingenious people that believe there are always others ready to swallow a gilded pill. Consequently we have had some processes brought forward, of which one can but say that they are ingenious if not ingenuous.

In 1897 a process, called Radiotint, burst forth and being fathered by men in high standing, it created for a time quite a sensation, but the bubble soon burst. J. A. Michel-Dansac and L. Chassagne[32] invented this process, which when critically examined proved to be nothing more than local painting with anilin colors. The patent specification is a real curiosity and deserves rescuing from oblivion. Five products were required:—albumen for shadows, albumen for reliefs, blue, green and red pigments. The albumen solutions were 20 per cent solutions of dried blood albumen; and that for shadows contained, according to the specification, the chlorides of platinum, sodium, palladium, ammonium, iron, chromium, cobalt, gold, tin, barium, nickel, strontium, cadmium, silver and cocain. That for reliefs, by which was probably meant the high lights, contained chromic and formic acids, sodium, and platinum chlorides and casein. The blue pigment was composed of the albumen solution plus indigo carmin and oxalic acid; the green pigment was albumen and a further lot of the

chlorides of nickel, chromium and copper plus the sulfate and nitrate of copper, picric acid and indigo carmin. The red pigment included albumen plus mercury sulfide, iron chloride and sulfate, uranium acetate and ammonium sulfocyanide. The mixtures were to be allowed to stand at least 8 days, but the best results were only obtainable after 3 or 4 months. The print was first painted with the albumen for shadows, and then the colors locally applied, and the whole process was no more than painting with anilin colors. One of the main contentions of the inventors was that the photographic image automatically selected the appropriate colors, and that it was immaterial whether the picture was developed silver, or printed out, or platinum. A somewhat amusing incident occurred at a demonstration of this process, for the author tore a half-tone illustration from a dealer's catalog and presented this for trial. The operator actually began to treat this till stopped by his compatriot, for neither could speak English, with a short expression in French, which stopped the work. Obviously if a proof in printer's ink could select the colors, the claim for the selective action of the image was a little doubtful.

Multico Paper.—The idea of making carbon tissue with several superposed layers of different colors, seems to have been repeatedly invented in the hopes of obtaining color prints. The obvious reasoning being that as the colors in nature acted in some sort of given order from the most refrangible rays to the red end of the spectrum, it would be sufficient to provide multiple layers of colored pigments in order to obtain colored results. Obviously the results would be not only dependent on the sensitiveness of the plates, but also on the exposure both of the plates and tissue. Some weird and wonderful results could be obtained by this process, but by no stretch of imagination could they be called photographs in natural colors.

E. R. Hewitt[33] was the first to patent this process, and as many layers of colored gelatin were applied to paper, glass or celluloid as were required in the finished picture. All of the seven colors of the spectrum, or only three primary ones, could be used, or only flesh tints for the skin and darker ones for the clothes. V. Vaucamp[34] proposed to use only red, yellow and blue pigments. One peculiarity of the process was that the unnecessary colors might be removed with a grindstone! In the above patents the colored films were allowed to dry before the next one was applied, but C. Gitchell[35] went one better, and in order to produce nice gradations of color or tints, he proposed to coat successive layers, one on top of the other, before the underlying ones had time to set and dry, so that they would blend into one another.

A. Hesekiel[36] also patented the same process, and preferred to arrange the colors according to the subject for which they were to be used. For landscape work, the blue was placed uppermost, then yellow, then a green, below that red and finally black; and every layer was to be some-

what more dense than the upper one. In order to prevent the films from blending intermediate films were suggested and then the order was to be, counting from the top, blue, pink or crimson, yellow, red, green and black.

E. N. White[37] also patented this process. H. Kuhn[38] patented the waterproofing of mounts by the aid of soap with alum, with a supplementary thick coat of celluloid varnish, followed by a thick coat of barium sulfate suspended in gelatin. To this support was applied collodio-chloride printing-out emulsions, each protected by an insulating coat, and dyed up with anilin colors; "for landscape work, three or more colors may be employed according to taste, or as the subject may require."

The Mars-Star Color Process.—This was the invention of W. Lascelles-Davidson, and only one negative was required[39] in which white should be opaque, green of middle density the same as yellow, red should be of faint density and black clear glass. Three prints had to be made by any known process and superimposed on a grey key print.

Yet another process[40] was described by the same inventor though so far as can be traced, it was not patented. The main feature being that only one negative was required, and that "no special apparatus, color screens or difficult color processes are required, and that a bromide print in colors can be produced and finished within 10 minutes." Apparently it was a chemical toning process and a bromide print was first bleached with a certain solution, then a red-developing compound applied, by which only the red and yellow deposits were affected. Then the blue-developer was used. No details were ever published as to the composition of the solutions, but it was stated that it was only during the redevelopment that the bromide print showed power to select or repel the colors. Further the process was very simple "and the merest tyro in photography can at once produce prints in colors that a three-color worker would envy."

There have been, of course, innumerable reports in the daily papers and other journals as to wonderful discoveries, many of which have been no further heard of. To this class belonged an American process, invented by A. H. Verril[41] and which was kept so secret that no information has ever leaked out. R. Luther[42] announced that B. Loundin, spelt also Lundin, had discovered a process that was cheaper than the Autochrome, was not a screen-plate nor interference method, and that he had seen some results rather over-exposed but very good. Later[43] it was reported that Loudine, another spelling, had been established in a laboratory in Munich, and that he produced negatives in complementary colors, from which any number of positives, either on film or paper, could be prepared.

J. Germeuil-Bonnaud[44] patented a dusting-on process, which in no wise differed from any similar powder process. But it was claimed that natural colors were produced. C. V. Boys[45] said: "The colors do not appear indiscriminately, but to fall into their proper places as if directed by an

unseen hand. For instance, in a landscape that I saw copied by this process the blue powder was first dusted on and then a suitable shade of green. On examination it was found that the sky was blue and the leaves of the nearer trees green, while the more distant trees were of a slightly different shade, giving the effect of distance perfectly."

The same inventor[46] also briefly described a process of obtaining color prints, which is a little indefinite. He proposed to mix colored pigments with some substance capable of forming with silver nitrate, a color salt sensitive to light according to the activity of each color. Apparently canvas was used as the support and it was exposed under a negative and treated like an ordinary print. The prints came from the toning baths colored.

Another glorious discovery was credited to C. Gilbert of Chicago[47] who discovered that agencies, other than interference, were required to produce a translating medium. This was a new anilin color pigment, so sensitive that every trace of color can be made to disappear when subjected to a ray of light passed through a closely contracted diaphragm in one-hundredth of a second. A specially prepared printing paper was coated with three primary pigments, arranged side by side as microscopic lines, in the order of their position in the spectrum. The entire surface had a grey appearance. No plates were used. The decomposition of the white light transmitted by the lens was accomplished with a triangular prism, which was made up of a number of small parallel ones. The entire arrangement had the appearance of a fluting. Upon entering the rays were decomposed by the smaller prisms and affected the pigment paper in varying degrees. Thus by interference selective areas were subjected to rays of variable lengths and the differently colored lines were bleached simultaneously to a greater or less degree, according to the character and density of the color areas. The duration of exposure was about one-thousandth of a second. The paper was developed with rodinal and the picture was immediately tonal in value, but negative in position, as though viewed in a looking glass.

J. Hero[48] proposed a curious method of obtaining colors direct. Plates were to be prepared with a mixture of gelatin, alum, ferrous sulfate, asphalt, ferricyanide, uranium nitrate, paraffin and gum arabic. Ordinary silver bromide plates might be immersed in this mixture, exposed as usual, developed with paraminophenol and fixed. Prints were to be made on ordinary paper, treated with a combined bath and then immersed in a mixture of barium sulfate, ferrous sulfate, paraffin, asphalt, alum, ferricyanide, ferrocyanide and gum.

Theoretical Processes.—K. Schinzel[49] proposed a one-plate process, which he called "Katachromie," in which a plate was to be coated with a number of films of gelatino-bromide of silver, separated by plain gelatin films. The individual films were so colored that a part of the incident

light was absorbed in each film, and by suitable sensitizers, the absorption was made as perfect as possible. For example, the top film would be colored orange and be sensitive to violet; the middle one would be blue-green and sensitive to orange-red; while the bottom one would be colored red and be sensitive to yellowish-green. If such a plate be exposed to a colored subject, a part of the rays would be absorbed by each film and after development and fixing there would be three separate images. If the negative were immersed in hydrogen peroxide, the latter would be decomposed where there was silver, and oxygen set free, and if dyes had been used that are easily oxidized into colorless compounds, then they would be bleached at those places, and after removal of the silver a colored picture would be the result. Or the dyes might be rendered soluble in water by the action of the liberated oxygen. The result would be, not a complementary colored negative, but a positive in the true colors.

In a later paper[50] Schinzel proposed various catalytic methods which are chiefly theoretical and of doubtful practical value. The first process was based on the preparation of a mixture of grains of silver bromide dyed with complementary-colored sensitizers, or by dyeing separate lots of emulsion. These emulsions were to be mixed to form a neutral grey, in fact the process is a theoretical screen-plate method with silver bromide as the screen elements. On exposure it was supposed that each individual grain would only be acted upon by one particular colored light, and the negative could be converted into the complementary colors by treatment with dichromate, which would tan the gelatin, and the dye could be removed from the unhardened parts. The image was then to be converted into the correct colors by a somewhat similar process.

Another method was to sensitize the individual grains of silver salt, and provide them with an envelope of stained gelatin that would act as a filter for the light, and limit the action to practically one color. For this purpose the sensitive salt was precipitated in the form of a sandy powder in alcoholic media, then dyed with the correct dyes, which must not be soluble in water nor attacked by the developer and other solutions. This dyed matter was then emulsified in a 1 per cent solution of gelatin. The colored image was to be obtained by treating the negative with dichromate and decolorizing the unhardened parts with weak acids. As an alternative the emulsion was to be pressed through fine apertures and the threads thus obtained combined into a thick bundle and cut into thin films, and presumably exposed in this condition and treated with dichromate. The superposition of three emulsion films, separated by colorless gelatin films was also suggested, somewhat on the lines of Smith's tri-pack, each layer acting as a filter for the underlying one. Preliminary exposure through a line screen might be adopted, or the plate might be subjected to pressure by a comb of needles and the developed silver, produced by the pressure, removed by permanganate.

29

Yet another method was the admixture of the emulsion with colorless substances which would afterwards give rise to dye formation. The formation of reliefs by the peroxide or dichromate methods was also outlined. Finally Schinzel proposed some methods of screen-plate formation, which are rather curiosities than of any practical value.

F. Sforza[51] also suggested some methods very similar in principle to Schinzel's. The main idea seems to have been to sensitize each silver bromide grain to the required colors and to so exalt the sensitivity by the admixture of coloring matters, as to render the same completely insensitive to other colors. This having been attained it would be possible to emulsify the individually sensitive grains and after exposure and development, it being assumed that the solutions would have no effect on the coloring matters, the silver might be bleached by mercuric chloride or the like, and the plate immersed in a mordant, which would fix the colors, and also by immersion in a solvent which should dissolve the colors wherever the silver was dissolved; thus leaving a negative in colors, from which it should be possible to print on paper, prepared in the same way. In a subsequent paper[52] the same idea was elaborated.

Possibly the following note should belong to the bleach-out process; but as it is purely theoretical it has been thought better to include it here. Sforza[53] is again the author, and he suggested that a glass plate or film should be coated with three emulsions of silver bromide, the gelatin in each case being dyed with one of the primary colors. This dyeing of the gelatin should effect the chromatic selection on the haloid salt, of which it was the vehicle, that is to say, the film dyed red would be identical with the record obtained with a panchromatic plate and a red filter. Obviously each emulsion coating should be sensitized for that region of the spectrum that it is to record. The dyes were to be mordanted on the emulsion, so as to be neither attacked nor dissolved by the solutions. But they should be capable of being decolorized or destroyed in the operation of development, where the silver is reduced to the metallic state. It would be necessary to find a developer which would permit the bromine liberated to destroy the dye. A plate coated with three films would be exposed and developed and would then consist of three separate images. By oxidizing or reconverting the silver into the halide and then removing by hypo, there would be a negative in colors, formed of dye exclusively, held in the gelatin. This would be negative only as regards color, but positive as regards light and shade, for in the case of a green object, for example, only the red film would be left unaffected, and red, therefore, would be the only color left at the final stage. For the same reason blacks would be blacks and greys grey. The negative would not be a mosaic of colors as in screen-plates, but would resemble stained glass with the colors uniform, and the results would be visible either by transmitted or reflected light. Such a negative would allow of infinite reproduction.

R. Luther[54] quite independently arrived at possible processes, which are very similar to Sforza's, and it is not worth while, therefore, to summarize the same.

F. Kropff[55] had been making experiments for some time on the lines laid down by Luther, that is to say, using the absorptive capacity of the silver salts for dyes. Both the bromide and sulfocyanide were tried, and the latter found to be the more satisfactory. A solution of 20 g. gelatin in 130 ccs. water was made and 8 g. potassium bromide, or 6 g. potassium sulfocyanide added. To each solution was then added 10 ccs. of guinea green (Agfa) solution and finally in the dark room 10 g. silver nitrate in 60 ccs. water. The silver salts were precipitated and carried down the dye. After setting and washing the emulsion, the washing waters were quite colorless. The bright green emulsion was coated on plates and paper, exposed under a transparency for some hours (printed out ?). The bromide emulsion showed but a faint image, but the sulfocyanide gave a vigorous one, which could be intensified with metol-hydroquinon. The developer did not become colored, probably because there was formed a colorless compound of the dye. The silver image was removed with Farmer's reducer and the result was a green positive image.

E. Klein[56] apparently worked on the same lines, and he stated that Vollenbruch was the originator of this process, although it has not been possible to verify this statement. The latter laid down the necessary qualities of the dyes as follows: on mixing with the silver halide, iodide, bromide or chloride, it should unite with these and be completely precipitated so as to leave the solvent colorless; the silver compounds should not give up any dye in the washing of the emulsion. Hypo must completely dissolve the silver-dye compound left unreduced by the developer, but the reduced silver should retain the coloring matter, both in the hypo bath and washing waters. Klein found that the dyed silver bromide, which was the halide he used, possessed quite different properties from ordinary silver bromide. Starting from a brief note of Vollenbruch's he prepared the following stock solutions:

A. Ammonium bromide 65 g.
 Potassium iodide 2.5 g.
 Water 250 ccs.

B. Silver nitrate 100 g.
 Water 250 ccs.

C. Auramin (Hoechst) 2 g.
 Water 500 ccs.

From these colored emulsions could be prepared in either of two ways. In a small flask a mixture was made by red light as follows:

Solution C 40 ccs.
Solution A 30 ccs.
Water 100 ccs.

To this was added a drop at a time, with vigorous shaking, 30 ccs. of solution B, the whole was then well shaken and poured into a liter of water. It was then well stirred, and a little of the water brought out into daylight; it should be completely colorless. And a test of the precipitated emulsion, when examined in daylight, should be an intense yellow color. The wash water was renewed three or four times, and finally as much as possible decanted, so that the quantity left behind did not measure more than 250 ccs. The vessel was now to be placed in hot water at about 30° C. Then in another vessel 20 g. of soft gelatin should be soaked in water and excess pressed out, then the gelatin liquefied and mixed with the dyed silver halide and by vigorous shaking a fine-grained emulsion would be obtained. This was filtered through wash leather, coated on baryta paper, and dried in the dark. This paper is referred to as *A*.

In a second experiment exactly the same procedure was followed, only without the dye solution in the precipitation of the silver bromide. After the silver salt had settled the greater part of the liquid was poured off, 80 ccs. of solution C were poured over the residue, then vigorously shaken for a few minutes, and again allowed to stand. The supernatant liquid was decanted and the silver salt washed several times by stirring in water, with frequent changes. Finally it was emulsified, as described above, filtered and coated on paper. This was called *B*.

Exposed in the spectrograph, *A* showed a strong maximum in the blue, with a faint action extending to beyond H on the one hand and to E on the other. The paper coated with *B*, treated in exactly the same way, showed a maximum sensitiveness toward G and H, with strong visible action up to K on the one side, and to D on the other. Thus *A* emulsion was chiefly sensitive to blue, whilst *B* was chiefly violet-sensitive with a very strong action in the ultra-violet and extending to red. If *A* was exposed under a negative, developed and fixed, a black image on a yellowish-white ground would be obtained. The yellow color of the silver bromide completely disappeared in the parts not exposed; the hypo and the first wash water showed a yellow color. Emulsion *B*, treated in the same way, showed more yellow in the high lights; in this case also the hypo was colored yellow, much dye being left in the high lights. Both plates were then placed in a 5 per cent solution of ammonium dichromate for 10 minutes, and to every 100 ccs. was then added 5 drops of ordinary hydrochloric acid and 25 ccs. of solution A. The black image commenced to bleach and became invisible in about 2 minutes. In the case of the *B* plate, the original image was no longer visible, whilst the *A* plate on the other hand, showed an image of a yellow color, which became more distinct after dissolving the silver chloride and washing.

These experiments proved the correctness of Vollenbruch's theory that a silver halide precipitated in the presence of a dye, is capable of retaining certain coloring matters throughout development, fixing and

washing. Klein suggested that it would be possible to utilize the sensitiveness of the silver halides in the bleach-out process, and pointed out that there are several dyes, which, when compounded with silver salts, acquire the property of bleaching in light; this bleaching effect, when once initiated, progressed in the dark by the aid of sodium sulfite or bisulfite baths. He cited as example orthochrom T, and stated that there were also blue, yellow and green dyes with similar properties.

M. Schneider[57] reported a rather curious experience. Having prepared in a test tube a mixture of collodion, eosin, methylen blue and auramin, all Hoechst dyes, a considerable quantity of thiosinamin was added with a few drops of sulfuric acid, and the mixture, which had a blackish color, became gradually green and then yellow. As the yellow did not disappear, a new mixture was made without the auramin, and when treated in the same way became colorless. This was coated on baryta paper, exposed for 30 seconds to sunlight under a colored transparency, and the outlines of the red and blue colors were visible after exposure. The prints were then developed with hot ammoniacal water, the blues, the reds and violets were perfectly reproduced and the rest of the image remained white. The action of light, therefore, had destroyed the complementary colors and retained those corresponding to the original. It was not found possible to obtain a yellow that would answer to this treatment. J. Gaedicke, the editor of the Photographisches Wochenblatt, in which this note appeared, stated that another experimenter, who desired to remain anonymous, had tried this process without results.

1. D.R.P. 227,129; 309,376; 388,512; 390,163; 390,165, 1909; Handbuch, **4**, III, 383; Jahrbuch, 1909, **23**, 416; 1910, **14**, 166, 542, 613; 1911, **25**, 545; Phot. Rund. 1909, **23**, 157, 257; 1910, **24**, 151, 613; Phot. Korr. 1907, **44**, 74; Phot. Chron. 1910, **17**, 46, 59, 493; abst. C. A. 1909, **3**, 2,911; 1910, **4**, 1,137, 2,240; E.P. 7,932, 1909; Brit. J. Phot. 1910, **57**, 28; "Die Praxis des Askaudrucks," 1910. In D.R.P. 312,657, 1918; abst. J. S. C. I. 1919, **38**, 878A, alcohol and acetone were added to the developer.
Cf. R. T. Wall, E.P. 775, 1882; Phot. News, 1909, **53**, 589; Jahrbuch, 1909, **23**, 417. P. van Duyse, Phot. Moderne, 1925, **3**, 28.
2. D.R.P. 211,329, 1908; abst. C. A. 1910, **4**, 2,419; Jahrbuch, 1910, **24**, 613; 1911, **25**, 543; Phot. Chron. 1910, **17**, 59. Cf. D.R.P. 390,163, 1922; abst. Phot. Ind. 1924, 500.
3. D.R.P. 40,774, 1887; Silbermann, **1**, 219.
4. D.R.P. 62,662, 1891; Silbermann, **1**, 220.
5. Zts. ang. Chem. 1890, **3**, 451; Phot. Annual, 1891, 158.
6. Compt. rend. 1912, **155**, 280; Brit. J. Phot. 1912, **59**, 731; abst. C. A. 1912, **6**, 3,371.
7. D.R.P. 53,455, 1889; Silbermann, **1**, 216; Phot. Mitt. 1890, **17**, 187; 1891, **18**, 187; Phot. News, 1891, **36**, 98; Phot. Annual, 1891, 98; Jahrbuch, 1891, **5**, 529; Handbuch, 1899, **4**, IV, 562; Bull. Soc. Ind. Mulhouse, 1890, **60**, 307; Fabre, "Traité Encycl." Supp. A. 286.
K. Noack, Phot. Korr. 1898, **35**, 633; Jahrbuch, 1900, **14**, 215; Liesegang's Phot. Almanach, 1899, **20**, 17; Brit. J. Phot. 1898, **45**, 822 used Feertype for the red print, with lead chromate for the yellow and cyanotype for the blue.
8. E.P. 7,453, 1890; Brit. J. Phot. 1890, **37**, 657, 686; 1891, **38**, 57, 71, 331, 453, 456; Brit. J. Almanac, 1892, 535; Phot. News, 1890, **34**, 701, 707; abst. J. S. C. I. 1890, **9**, 1001; Phot. Annual, 1891, 98; D.R.P. 56,606, 1890; Silbermann, **1**, 216; Jahrbuch, 1892, **6**, 458; Handbuch, 1899, **4**, IV, 563; Phot. Times, 1890, **20**, 568, 1891, **21**, 30; Bull. Soc. franç. Phot. 1891, **38**, 24, 107; F.P. 207,963;

Phot. Woch. 1890, **36**, 345, 356; Phot. Archiv. 1890, **31**, 321; Fabre, "Traité Encycl." Supp. A. 286. Cf. O. N. Witt, Jahrbuch, 1891, **5**, 529.

9. D.R.P. 82,239, 1894; Silbermann, **1**, 217; F.P. 239,022, 1894; Jahrbuch, 1896, **10**, 260; Handbuch, 1899, **4**, IV, 565; Phot. Korr. 1895, **32**, 284; Brit. J. Phot. 1895, **43**, 428; Phot. Annual, 1896, 166; Phot. Mitt. 1895, **32**, 215.

10. D.R.P. 111,416, 1899; Mon. Sci. 1901, **57**, 101; Silbermann, **1**, 218; Bull. Soc. franç. Phot. 1901, **48**, 370; Chem. Centr. 1901, **71**, II, 605; Jahr. Chem. 1900, 1,554; F.P. 296,569; La Phot. 1900, 166; Plon's Annuaire Phot. 1893, 127. M. Leroy exhibited some prints at the Congress of photographic Societies, Lille, 1896; Bull. Congrès Phot. 1896, Feb. 7.

11. F.P. 457,446, 1913; addit. 18,376; abst. C.A. 1914, **8**, 2,658; Jahrbuch, 1915, **29**, 170; Brit. J. Phot. 1914, **61**, Col. Phot. Supp. **8**, 7; 1917, **64**, ibid. **11**, 4.

12. Rev. Gén. Sci. 1895, **6**, 1034; "Résumé d. Travaux," 1906, 51; Bull. Soc. franç. Phot. 1896, **43**, 195; Rev. Phot. 1895, **7**, 168; Fabre, "Traité Encycl." 1897, Supp. B, 397; Phot. Mitt. 1897, **33**, 60.

F. J. Farrell and E. Bentz, E.P. 17,735, 1899; Brit. J. Phot. 1900, **47**, 684; Photogram, 1900, **7**, 323, patented the use of diazotized silk and development after exposure with various agents for obtaining colored prints; Rev. d. Matières colorantes, 1906, 117. H. Damianovich and H. Guglialmetti, Rev. gen. d Matières colorantes, 1909, 163 proposed to apply the above process to albumen. Cf. Baudisch, ibid. 1912, 43; Chem. Ztg. 1911, used a salt of ammonia and α-nitrosonaphthylamin on wool or silk and obtained a red image on exposure.

13. U.S.P. 1,444,469, 1923; D.R.P. 302,786; 371,385; 376,385; 386,433; 383,510; 386,434; Can.P. 247,155 granted to Kalle & Co. In D.R.P. 379,998; abst. J. S. C. I. 1923, **42**, 1,248A, alkali was added to the diazo-anhydrides; D.R.P. 381,551 is for exposing the print to diffused light; cf. D.R.P. 383,510; Phot. Ind. 1924, 196; F.P. 558,465; abst. Sci. Ind. Phot. 1924, **4**, 27, 155, 187; E.P. 210,862; J. S. C. I. 1924, **43**, B356. Cf. K. H. Broum, Phot. Korr. 1924, **60**, 10.

14. Oesterr. Chem. Ztg. 1904; Phot. Mitt. 1904, **40**, 321; Jahrbuch, 1905, **19**, 342; 1906, **20**, 591; 1907, **27**, 591; E. König, "Photochemie," 1906, 59; "Natural-Color Photography," König and Wall, 1906, 68; E.P. 4,994, 1904; Brit. J. Phot. 1904, **51**, 886,908; 1905, **52**, 73; Brit. J. Almanac, 1906, 865; D.R.P. 160,772, 1904; Silbermann, **2**, 375; D.R.P. 171,671; 175,459; F.P. 349,060; Phot. Times, 1905, **37**, 65; Phot. Chron. 1904, **11**, 591; Phot. Korr. 1904, **41**, 521; Photo-Gaz. 1904, **15**, 13; Phot. Kunst. 1904, **3**, 108; Photo-Era, 1905, **14**, 46; Rev. Sci. 1906. Cf. O. Gros, F.P. 310,084, 1901. A. Ruff and V. Stein, Ber. 1901, 1,668; La Phot. Franç. 1903.

15. F.P. 524,143, 1919; abst. Sci. Tech. Ind. Phot. 1922, **2**, 12; Brit. J. Phot. 1922, **69**, 16; Amer. Phot. 1922, **16**, 463; Chim. Ind. 1922, **7**, 1,170. Cf. F. J. Farrell, Brit. J. Phot. 1906, **53**, 167. E. J. Wall, ibid. 1922, **69**, 146.

16. D.R.P. 400,350, 1923; Phot. Ind. 1924, 896; Amer. Phot. 1925, **19**, 229.

17. Full information as to the working of the gum dichromate process will be found in the following treatises: F. Behrens, "Der Gummidruck," Berlin, 1898, 2nd edit. 1903; 3rd edit. 1912. F. Bollmann, "Das photographische Kohlebild," Berlin, 1863. J. Gaedicke, "Der Gummidruck," Berlin, 1898; 2nd edit. 1903. T. Hofmeister, "Der Gummidruck," Halle, 1898; 2nd edit. 1907. H. C. Kosel, "Der Gummidruck," Vienna, 1900; "Die Technik des Kombinations-Gummidruck u. d. Drei-farben-Gummidrucks," Vienna, 1906. W. Kosters, "Der Gummidruck," Halle, 1904. A. Maskell and R. Demachy, "Le Procédé à la Gomme-Bichromatée ou Photo-Aquatinte," Paris, 1898; 2nd edit. 1905. Also English translation, "Photo-Aquatint or the Gum-bichromate Process," London, 1897. J. C. Richards, "Practical Gum-bichromate," London, 1905. Rouillé-Ladevèze, "Sepia-photo et Sanguine-photo," Paris, 1894. L. Rouyer, "La Gomme bichromatée," Paris, 1904. H. Silberer, "Anleitung z. Gummidruck," Vienna, 1903. W. J. Warren, "Handbook to the Gum-bichromate Process," London, 1898. H. Emery, "Le Procédé à la Gomme bichromatée," Paris, 1900. C. Puyo, "La Procédé à la Gomme bichromatée," Paris, 1904. H. Renger-Patzsch, "Der Eiweiss-Gummidruck," Dresden, 1904. R. Demachy and C. Puyo, "Les procédés d'Art en Photographie," Paris, 1906. H. Wilmer, Phot. News, 1897, **41**, 808; Phot. Rund. 1898, **10**, 55 proposed the name "Photo-mezzotint" for this process.

18. Wien Phot. Blatt, 1897, 33; Jahrbuch, 1898, **12**, 457; Handbuch, 1917, **4**, 248. Cf. R. Rapp. Wien. Phot. Blatt, 1898. Noack, Phot. Korr. 1898, **35**, 633. According to a note in Phot. Korr. 1899, **36**, 144, L. Schrank first suggested the use of the gum-bichromate process. Cf. E. Wallon, Photo-Gaz. 1899; Photogram, 1899, **6**, 170.

19. Jahrbuch', 1899, **13**, 553; 1900, **14**, 562; Brit. J. Phot. 1897, **44**, 281; Brit. J. Almanac, 1898, 863; Handbuch, 1917, **4**, 248. Cf. C. Pepper, Camera, 1911, **6**, 45; Phot. Korr. 1898, **35**, 144; 1899, **36**, 325; Anon. Brit. J. Phot. 1906, **53**, 388.

20. "Nicola Perscheid's Photographie in natürlichen Farben," Leipzig, 1904.

21. A. Miethe, "Dreifarbenphotographie nach der Natur," Halle, 1904, 68; Das Atel. 1904, **11**, 29, 33; Jahrbuch, 1904, **18**, 408.

W. Zimmermann, Photominiature, No. 113, 1910; Brit. J. Phot. 1911, **58**, 72, proposed to expose gum prints in the usual way, then to immerse in water and place face down on wet blotting paper till the print was developed and then strip.

22. Brit. J. Almanac, 1907, 644; Phot. Coul. 1907, **2**, 22.

23. Phot. Rund. 1912, **22**, 39; Jahrbuch, 1912, **2**, 526; Handbuch, 1917, **4**, II, 248.

The Soc. Anon. Phot. Coul. and Sury and Bastyns, E.P. 27,686, 1908; Can.P. 128,684, patented the preparation of a mixture of coloring matter 20, gum arabic 2, sugar 1, potassium dichromate 4, all in powder form, and dissolving 1 part in 2 of water just before use. Cf. R. Hiecke, Phot. Korr. 1906, **43**, 170; Phot. Woch. 1906, **52**, 224; Brit. J. Phot. 1906, **53**, 305. J. Barker, Brit. J. Phot. 1905, **52**, 946 used a cyanotype print, then applied the red and yellow gum prints by successive coatings. Gamboge and crimson lake moist colors were used.

24. Das Atel. 1903; A. Miethe, "Dreifarbenphotographie nach der Natur," 1904, 64; Jahrbuch, 1904, **18**, 409; Brit. J. Almanac, 1907, 646; Photo-Rev. 1903, **15**, 39, 111; Mon. Phot. 1903; Amat. Phot. 1903. Cf. Bachmann, Jahrbuch f. phot. Kunst. 1907; Jahrbuch, 1907, **22**, 536. E. Quedenfeldt, Phot. Rund. 1907, **17**, 201; Handbuch, 1917, **4**, II, 249; Jahrbuch, 1908, **22**, 587; Phot. Chron. 1907, **14**, 496; Phot. Coul. 1907, **2**, 19. Cf. L. Dufay, Can.P. 245,049.

25. E.P. 216,860, 1924; abst. C. A. 1925, **19**, 18; D.R.P. 405,494; F.P. 580,888; Brit. J. Phot. 1925, **72**, 219; Amer. Phot. 1924, **18**, 308; Das Atel. 1923, **30**, 88; Phot. Moderne, 1923, **1**, 165; abst. J. S. C. I. 1925, **44**, B267. Cf. C. Duvivier, Sci. Ind. Phot. 1923, **3**, 110.

26. Phot. Chron. 1898; Brit. J. Phot. 1898, **45**, 584; Photogram, 1899, **6**, 101.

F. Rousseau, F.P. 431,866; 436,100; addit. 15,116 patented a method of making the supports permeable to actinic rays.

27. E.P. 27,687, 1908; Brit. J. Phot. 1910, **57**, 48; D.R.P. 226,292; Belg.P. 211,107; Mon. Sci. 1916, **44**; U.S.P. 1,010,200; abst. C. A. 1912, **6**, 329. Similar patents F.P. 406,521; Can.P. 127,644; D.R.P. 221,917; Austr.P. 6,642; Phot. Korr. 1921, **58**, 186; Belg.P. 223,348; Dan.P. 13,979 were granted to Soc. Anon. Phot. Couleurs.

28. E.P. 8,498, 1903; D.R.P. 148,932, 1902; Silbermann, **2**, 370; Phot. Ind. 1904, 114; Jahrbuch, 1904, **18**, 405; Can.P. 85,882; F.P. 331,178.

For the preparation of stripping plates see Procoudin-Gorsky F.P. 576,879, 1924.

29. D.R.P. 266,165, 1913; abst. C. A. 1915, **9**, 876; E.P. 800, 1915; Brit. J. Phot. 1916, **63**, 535.

30. D.R.P. 195,449, 1903; Jahrbuch, 1908, **22**, 547.

31. Anthony's Phot. Bull. 1897, **28**, 326, 362; Brit. J. Phot. 1897, **44**, 824; Process Photogram, 1897, **4**, 164; 1898, **5**, 23.

Duchochois recommended filters for the negatives cutting from the ultra-violet to E¾D for the blue; from A to C¾D for the red and E to D¼C for the yellow. Cf. E. Lemling, Neues Erfind. 1879, **6**, 168. E. L. Garchey, E.P. 19,843, 1899; Brit. J. Phot. 1900, **47**, 572.

32. F.P. 248,234, 1895; E.P. 18,131, 1896; Nature, 1897, **44**, 95, 223, 318, 447; Brit. J. Phot. 1897, **44**, 81, 85, 102, 118, 146, 151, 226, 267, 285, 390, 395, 447, 613, 639, 661; Phot. News, 1897, **41**, 89, 103; Phot. J. 1897, **37**, 153; J. Soc. Arts, 1897, **45**, 158, 278; The Times, Jan. 30, 1897; Phot. Korr. 1897, **34**, 504; Jahrbuch, 1898, **12**, 430, 451; Phot. Times, 1897, **27**, 202; Anthony's Phot. Bull. 1897, **28**, 133, 140, 230, 270; Photogram, 1897, **4**, 69, 147.

E. Vogel, Phot. Mitt. 1898, **35**, 89, 93; Jahrbuch, 1899, **13**, 579; Photogram, 1898, **5**, 388; Brit. J. Phot. 1897, **44**, 472 stated that exactly the same results could be obtained by the use of ammonium picrate for the yellow, safranin G for the red and methylen blue for the blue, though actually indigo, eosin and Bayer's blue with picric acid were used.

33. U.S.P. 549,790, 1895.

J. R. Sawyer, Brit. J. Phot. 1877, **24**, 295 had suggested the use of four different colors, but this was not for color photography.

34. F.P. 252,207, 1895; E.P. 20,898, 1896; Brit. J. Phot. 1897, **44**, 712;

U.S.P. 608,934; D.R.P. 103,063; Silbermann, **1**, 234; Photo-Rev. 1900, 90; Austr.P. 47,542; Bull. Soc. franç. Phot. 1904, **51**, 86.

35. U.S.P. 611,409, 1898; F.P. 317,214.

36. D.R.P. 163,194, 1904; Silbermann, **2**, 372; E.P. 4,941, 1904; Brit. J. Phot. 1905, **52**, 73; U.S.P. 791,904; U.S.P. 791,829, 1905; Camera Craft, 1905, **10**, 295, 379; Photo-Era, 1904, **13**, 165 granted to J. von Slawik is for the same process and was assigned to Hesekiel, and in Germany the two names were coupled together to describe the process, which met with a by no means friendly reception; Phot. Woch. 1904, **50**, 1; Phot. Korr. 1904, **25**, 132; Phot. Rund. 1904, **14**, 21; D. Phot. Ztg. 1904, **28**, 118; 1905, **29**, 92; Phot. Mitt. 1904, **40**, 90; Jahrbuch, 1904, **18**, 417; 1905, **19**, 457. A somewhat similar process was described by J. Husnik, "Die Heliographie," 1878, 145.

37. E.P. 10,892, 1910; Brit. J. Phot. 1911, **58**, 501; F.P. 417,003; Can.P. 133,186; Belg.P. 225,159.

38. E.P. 6,921, 1891; Brit. J. Phot. 1891, **38**, 42; abst. ibid. 1907, **54**, Col. Phot. Supp. **1**, 7; U.S.P. 450,963.

39. E.P. 16,104, 1905; Brit. J. Phot. 1906, **53**, 711; 1916, **66**, Col. Phot. Supp. **12**, 4; Brit. J. Almanac, 1907, 857; Penrose's Annual, 1905, **11**, 85.

40. Penrose's Annual, 1906, **12**, 71.

41. Wilson's Phot. Mag. 1902, **39**, 124; Phot. Times, 1902, **34**, 224; Brit. J. Phot. 1902, **49**, 349.

42. Phot. Rund. 1909, **23**, 118; 1910, **24**, 214; Chem. Ztg. Rep. 1910, 572; Phot. Ind. 1910, 922.

43. Phot. Ind. 1921, 533; Amer. Phot. 1922, **15**, 188; Brit. J. Phot. 1921, **68**, Col. Phot. Supp. **15**, 40.

44. E.P. 4,537, 1888; D.R.P. 54,715; Silbermann, **1**, 234; Phot. Annual, 1897, 64.

45. Phot. News, 1889, **30**, 458.

46. Bull. Soc. franç. Phot. 1879, **26**, 321; Truth, 1879, No. 108; Sci. Amer. 1881, **42**, 33; Pract. Phot. 1879, **3**, 549.

47. Phot. Times, 1907; Brit. J. Phot. 1907, **54**, Col. Phot. Supp. **1**, 53.

48. F.P. 342,037, 1904.

49. Phot. Woch. 1905; Brit. J. Phot. 1905, **52**, 608; Austr.P. 42,478, 1908.

R. Neuhauss, Phot. Rund. 1905, **19**, 239 pointed out that the process was impracticable, as the dyes would bleach out entirely, and not only where there was silver. Schinzel admitted that this was a failure for the very reason advanced by Neuhauss, see following note.

50. Chem. Ztg. 1908, **32**, 665; Brit. J. Phot. 1908, **55**, Col. Phot. Supp. **2**, 61.

51. Phot. Coul. 1909, **4**, 23; Wien. Mitt. 1910, 535.

52. Phot. Coul. 1909, **4**, 101; Brit. J. Phot. 1909, **56**, Col. Phot. Supp. **3**, 64.

53. Phot. Coul. 1910, **5**, 209; Brit. J. Phot. 1910, **57**, Col. Phot. Supp. **3**, 65.

54. Phot. Rund. 1911, **25**, 1; Jahrbuch, 1911, **25**, 225; Brit. J. Phot. 1911, **58**, Col. Phot. Supp. **5**, 17.

55. Phot. Rund. 1911, **25**, 58; Chem. Ztg. Rep. 1911, 196; Jahrbuch, 1911, **25**, 390.

56. D. Phot. Ztg. 1911; Brit. J. Phot. 1911, **58**, Col. Phot. Supp. **5**, 49.

57. Phot. Woch. 1913; Phot. Coul. 1913, **8**, 163.

For notes on three-color bromoil see: C. Donaldson, Brit. J. Phot. 1916, **63**, Col. Phot. Supp. **10**, 25, 33. C. H. Hewitt, ibid. 29. A. B. Warburg, ibid. 1918, **65**, ibid. **12**, 37. For three-color oil prints see: J. Switkowski, Wien. Mitt. 1911; Brit. J. Phot. 1911, **58**, Col. Phot. Supp. **5**, 12.

E. Rolffs, E.P. 1,583, 1903, patented the use of engraved rollers with photographically obtained images for making colored impressions on fabrics, with the colors in solution.

CHAPTER XVI

THREE-COLOR TRANSPARENCIES AND LANTERN SLIDES

Undoubtedly the lantern slide is one of the most popular methods of entertainment of a number of people simultaneously and naturally the use of color pictures should also find its place. It is proposed here to deal with some of the methods that have been proposed for making the same by subtractive processes, which hold the premier place, as they can be shown in any lantern.

Ducos du Hauron and Chas. Cros outlined the possibilities of this method of working, and many of the processes that have already been outlined for the making of prints are also applicable to transparency work, the sole requisite being the use of as transparent colors and supports as possible, and therefore the chapters dealing with subtractive processes should be referred to.

The most popular process seems to be the carbon and naturally, because the image obtained with dichromated gelatin is practically colorless, particularly when exhibited by artificial light. As early as 1867 the carbon process was recommended by Despaquis[1] (p. 452), who suggested its use for making window decorations.

L. Vidal[2] printed by the carbon process, using mica or celluloid as the support and stained the images with anilin yellow or picric acid for the yellow, carmin or anilin red for the red, and the third in blue and projected them in superposition. F. E. Ives[3] used dichromated gelatin on celluloid and printed through the back and after developing in hot water, stained with dyes, superposed and cemented together. A. and L. Lumière[4] used the glue process, which has already been described (see p. 322). G. Selle[5] superposed the three images on collodion skins.

Possibly the most complete description of slides was given by von Hübl[6] and a few extracts from his paper may not be out of place. Celluloid, collodion or mica may be used as support, but the latter is extremely brittle, and can not be obtained in large pieces sufficiently clear and free from cracks or streaks of color. Uncolored dichromated gelatin, as used by Vidal and later by Ives, has the disadvantage that the prints show a very high relief, and, therefore, hardly reproduce the details in the shadows.[7] This defect can be gotten over by adding to the gelatin an inert powder, which stops the too deep penetration of the light and silver bromide is the best thing to use, as this can be readily removed subsequently with hypo.

Paper should be coated with ordinary silver bromide emulsion allowing

for every 1000 qcm. about 0.5 g. of gelatin and 0.4 g. of silver bromide. The proportion of bromide to gelatin affects the character of the prints. For plucky negatives it is advisable to increase the silver bromide so as to prevent the formation of a high relief, whilst for thin negatives the bromide should be reduced. Any existing formula for an emulsion can be used and it should be made as usual, then coated on the raw paper as used in the carbon process. The preparation and coating of the paper can be carried out in daylight, as the silver salt has only to act as a pigment, and any discoloration, caused by light, is of no moment.

Sensitizing, printing and development is effected precisely as in the carbon process. Only in order to have pictures of equal size, the following must be observed: the pieces of paper must be cut out of the sheet in the same direction, as the expansion caused by damp is different in the length and breadth of the sheet. Further the prints must not as usual, be soaked in cold water before squeegeeing on to the glass plate, but must be painted over on the film side with a broad brush with water, and then quickly squeegeed down to the sheet of glass. In this way it is possible to obtain pictures that will register everywhere, assuming that only small pictures are to be made. After development the silver bromide can be dissolved with hypo or Farmer's reducer, then after a good washing the picture is ready for coloring.

The coloration which gelatin assumes in solutions of dyes is not, as generally believed, produced by absorption, but must be ascribed to a chemical combination, if a loose one, with the dye. All dyes, therefore, are not suitable for staining gelatin, and as in dyeing materials, certain dyes must be used in an acid and others in an alkaline solution. For instance, gelatin is not stained at all by iodine green in an acid solution, whilst neublau will stain only from an acid and not from an alkaline solution. Gelatin thus plays the role of an acid sometimes and at others that of a base, and combines with the dye bases or acids to form colored compounds of the character of salts. As a rule, however, it will take acid dyes more readily, therefore, these dyes are preferable for staining the gelatin images. The eosins, rhodamins and all the sulfonic acid dyes are excellent stains for gelatin. As the commercial dyes are potassium or sodium salts of these acids, the addition of a little acetic acid causes a decomposition of the salts and renders the dyeing process considerably easier, whilst the presence of a strong alkali quite stops their dyeing powers.

The combination of the dye with the gelatin is only very loose and even continuous treatment with water is sufficient to produce gradual decoloration. It is possible, therefore, to wash the colored gelatin images with acidulated water, without altering their color; by treatment with pure water the color is weakened, and with dilute ammonia the pictures may be entirely decolorized.

The following dyes, with the addition of a little acetic acid are specially suitable for dyeing gelatin: xylidin ponceau or Biebrich scarlet stain a scarlet red, corresponding to the spectral color between B and C. Methyl orange stains a yellowish-orange corresponding to the spectral color at D. Naphthol yellow SL stains a pure yellow. Acid green stains green with a faint bluish tinge. This color is complementary to that produced by xyliden ponceau. Bluish fast green produces a tone midway between blue and green, which corresponds to about b$\frac{1}{2}$F. Methylen blue stains a pure blue with a faint greenish shade, which is complementary to the orange of the D line, and it also corresponds to Paris blue. Hoechst neublau stains a purer blue, which almost corresponds to ultramarine yet it has a slight greenish tinge. The various dyes of the eosin group produce bluish-red .tones and can be used in neutral solutions. Yellowish eosin stains a pure red, similar to carmin, whilst erythrosin gives a more bluish red.

The color imparted to gelatin nearly always alters in drying, the reds become bluer and the blues greener. Thus a film stained with bluish fast green whilst wet is a peacock blue, corresponding to the F line, but on drying it is a greenish blue, matching about midway between b and F. Almost all dyes exhibit the peculiarity that with decreasing concentration they appear to be mixed with red, thus a gelatin picture appears almost pure red in the shadows, whilst the high lights shade off to purple. With a blue picture the shadows show less of a greenish tinge, and a yellow picture shows the deepest shadows orange. For these reasons the deep shadows appear reddish in transparent three-color pictures; a dark blue drapery shows reddish-brown in the folds instead of black. This fault is only noticeable with intense illumination.

For dyeing up colorless gelatin images von Hübl recommended the following baths:

For the red:

Erythrosin	0.25	g.
Alcohol	300	ccs.
Water to	1000	ccs.

For the blue:

Bluish fast green	0.75	g.
Methylen blue	0.75	g.
Glacial acetic acid	6	ccs.
Alcohol	300	ccs.
Water to	1000	ccs.

For the yellow:

Naphthol yellow SL	0.5	g.
Methyl orange	0.5	g.
Glacial acetic acid	6	ccs.
Alcohol	300	ccs.
Water to	1000	ccs.

The picture should be placed in the solution and left till saturated which takes about 30 minutes. It should then be well drained and immersed in the following which removes the dye combined with the gelatin without weakening the stained parts:

Alcohol .. 444 ccs.
Glacial acetic acid 20 ccs.
Water to 1000 ccs.

If celluloid films are used 10 per cent of glycerol should be added to keep the films supple. In this bath the pictures should be left for about 2 minutes, then washed in plain water for a minute or two and dried. If the high lights which should appear white, are tinted they may be cleared by washing with water till quite white; they should then be immersed in the above bath, which stops the action of the water. Complete decolorization or reduction of the color may be effected by adding a few drops of ammonia to the water; and it is obvious that by alternate treatment with the alkaline water and the acid bath great variations may be effected.

If the negatives are too dense or printed too long, it is not easy to obtain sufficiently modelled shadows. Then the picture should be left in the dye for a long time, then washed with water till the lighter half tones are decolorized and again dyed up for a short time. For cementing the pictures together the best cement is a solution of Canada balsam in benzol 1 : 1. The blue picture should be placed on a sheet of glass, the edges fastened down with a strip of paper, and the balsam painted over it with a brush and the yellow print laid down after it also has been painted with the balsam. Registration should be obtained with the aid of a magnifying eyepiece, then strips of paper should be fastened down on the edges of the yellow picture and the red superimposed in the same way. After some hours the edges should be cut and the combined picture placed on a sheet of glass, a cover glass applied and the whole bound up.

Later[8] von Hübl slightly altered the staining baths and recommended for the red:

Erythrosin 0.5 g.
Alcohol 100 ccs.
Water 1000 ccs.

For the blue:

Bluish fast green 1 g.
Alcohol 100 ccs.
Glacial acetic acid 6 ccs.
Water 1000 ccs.

For the yellow:

Naphthol yellow SL 0.5 g.
Alcohol 100 ccs.
Glacial acetic acid 6 ccs.
Chrome alum, sat. sol...................... 50 ccs.
Water 1000 ccs.

Concentrated solutions flatten the pictures though they act quickly; whilst very dilute solutions give more brilliant pictures though they take a long time. Weak borax solution may be used instead of ammonia to reduce the color.

Ducos du Hauron[9] also recommended gelatino-bromide films for making the positives, using for his colors, for the blue:

Indigo carmin 60 g.
Water1000 ccs.

For the red:

Nacarat red, anilin 30 g.
Water1000 ccs.

For the yellow a saturated solution of picric acid.

R. Krayn[10] in order to obtain extreme sharpness, made one of the constituent images on a stripping plate, and after completion of the dyeing, stripped the film and sandwiched it between the other two pictures, which were on glass plates. The stripping plate was obtained by fixing an ordinary silver emulsion stripping plate and dichromating. This plate with its image was cemented with gelatin in register with one of the other pictures and the two allowed to dry, though how this was to happen with glass on both sides is not quite clear. When dry the glass was stripped.

A. and L. Lumière[11] used the following dyes for staining:

For the red:

Erythrosin J, 3 per cent sol................... 25 ccs.
Water1000 ccs.

For the blue:

Diamin blue pure FF, 3 per cent sol............. 417 ccs.
Glue solution, 15 per cent sol. to...............1000 ccs.

For the yellow:

Chrysophenin G 4 g.
Alcohol 167 ccs.
Water to1000 ccs.

Dissolve the yellow dye at 70° C. and add the alcohol.

E. Sanger-Shepherd[12] described the method, which he had introduced commercially, in which celluloid, coated with gelatin containing silver bromide, was exposed through the back, after sensitizing with dichromate, and stained as usual. He suggested the use of a blue cyanotype-toned lantern slide for the blue impression, as this acted as a cover glass; the three films were cemented together with Canada balsam.

C. Wolf-Czapek,[13] E. Goddé,[14] L. Desmarres[15] all recommended the use of Eastman roll film, sensitized with dichromate and printed through the back with subsequent dyeing. Desmarres used a 1 per cent solution of dianil yellow; and fuchsin 0.4 and eosin 0.4 per cent for the red, and the same strength of methylen blue and methyl green for the blue.

E. T. Butler[16] preferred to use dyes that would not be decomposed by dichromate, and stain up before exposure, claiming that this enabled the

progress of development to be better observed. Separate plates could be used, or one plate, and the individual color films being each protected with an insulating coat of Canada balsam, before recoating with gelatin. H. Schmidt[17] proposed to make a silver transparency and tone as usual with cyanotype, then coat with dichromated gelatin and print under the green-filter negative, stain with red and repeat the operation for the yellow. He claimed that the water dissociated the dichromate into chromium oxide and chromic acid, and that the dyes formed lakes with the same, obviously agreeing with Selle.

A. E. Bawtree[18] published a very complete paper on the preparation of colored transparencies, that, although it does not primarily deal with tri-color work, is worthy of somewhat full condensation. The colloid he used was fish glue, which whilst it had been much used in photo-mechanical processes, had not been much employed in color work. Like gelatin and other colloids, it possesses the property of becoming insoluble by the action of light in the presence of dichromates. The novelty of the process lies in the fact that although some dyes have but little affinity for gelatin, yet they have a strong affinity for each other, and, therefore, by first staining up, though but faintly with one dye, the subsequent application of a second dye gives a very strong colored image. It should be noted here that J. H. Powrie[19] had not only used fish glue, but also the very principle that Bawtree claimed as novel, namely, the mordanting action of basic dyes for acid, and vice versa.

Either of the following might be used for the sensitive coat, though Bawtree preferred the latter:

A. Le Page's fish glue......................... 500 ccs.
 Water 500 ccs.
B. Dried albumen 60 g.
 Water 1000 ccs.

When dissolved add

 Ammonium dichromate, 10 per cent sol. 400 ccs.

To make *A* put the water into a graduate and add the viscous fish glue, which should be the special clarified kind, up to the 1000 ccs. mark; this obviates measuring the glue in a separate vessel, stir well till completely mixed and add *B,* filter through absorbent cotton. This solution must be kept in the dark. The preparation and the coating of this mixture must be done by artificial light. The second formula was:

Fish glue 570 ccs.
Water .. 285 ccs.
Ammonium dichromate, 10 per cent sol. 145 ccs.

Both solutions would keep well in the dark for about 2 months, and then the sensitiveness doubled.

Whilst Bawtree recommended line negatives only, there is no doubt that the process is applicable to half tone, if the film is printed through the back, and he suggested that old negatives should be freed from their

gelatin with hydrofluoric acid, then the glass scrubbed and polished with a paste of tripoli 1 part, whitening 10, and 2 per cent caustic soda solution, and then dried. Hot water would be quite as efficient as the acid for cleaning the glass.

The plates should be coated on a whirler at about 400 revolutions per minute. The scoured plate should be attached to the whirler, rinsed under the tap and given a whirl to free it from water, and a small pool of the sensitive mixture poured on to the middle of the plate, guided to the edges and the plate drained and a second lot of fish glue poured on and then the plate whirled. It should then be removed from the whirler, the back cleaned and dried before a hot fire or over a gas burner, but in the latter case the film must be held away from the flame or the fumes of the burnt gas would fog the plate. If rapidly dried at about 27° C., the plate was about twice as sensitive as when dried at half that temperature. The plate should be warmed before exposure, which varied from about 1 minute in the middle of the day in June to 6 minutes in December in full sunlight. An arc could be used and the exposure to an enclosed arc, 200 volts, 4.5 amperes, alternating, was 12 minutes at 12 inches distance.

Development was effected by soaking in cold water for about 30 seconds, then rinsing under a tap or strong spray. A fairly complete list of dyes and the colors obtainable therewith are given, but as many are of no interest to the color worker, the following are selected for trial: for deep blue, soluble blue 1 and methyl violet 3, then malachite green 5; for blue, soluble blue 5 and oxalic acid 1; for peacock blue, soluble blue 5 and naphthol green 5, then malachite green 5; for blue-green, naphthol green 1, then malachite green 5; for lemon yellow, aurantia 2 and auramin 0.3; for orange-red, rose Bengal 10, then auramin 0.3; for scarlet, rose Bengal 10 then auramin 0.3, then rose Bengal 10; for deep red, dye scarlet as in the last case and then with chrysoidin 2; for pink, rose Bengal 10. The numbers after the names of the dyes refer to the strength of the solutions in percentages. The solutions should be applied in succession and this is indicated by the word "then."

For obtaining superposed images in colors Bawtree preferred to use ordinary cyclist's rubber solution thinned down with benzol or coal tar naphtha to the consistency of cream, and poured a small pool on the plate at one corner and after coaxing it over the plate, whirled at about 120 revolutions per minute in front of a hot fire, and allowed to remain there for about an hour. Then he applied a coat of enamel collodion, and when this was dry, again coated with fish glue and treated for the subsequent impressions.

C. K. Teamer and E. E. Miller[20] proposed to use Kodak film, and presumably sheet and not roll film, as nothing was said about the back coating of gelatin. This may be manipulated in daylight, as the silver

bromide is not actually used. It should be sensitized in a 2 per cent solution of potassium dichromate to which sufficient ammonia should be added to make it a lemon-yellow color and give a faint smell; 5 minutes at 18° C. should be the time for sensitizing. The back of the film should be wiped dry and it should then be hung up to dry. The time of exposure to daylight is about that for Solio printing-out paper to tint in the highest lights under the red negative. Use as small a printing frame as possible, and build up to about the height of 6 inches, a wall of black cardboard to prevent all but direct light from access to the negative.

The temperature of the water for development should be from 38 to 44° C., not higher, or cockling of the celluloid will make its appearance. Development should be continued till the drainings from one corner show no trace of bromide, then rinse in cold water, fix and wash, then dry. The staining baths were:

For the blue:

Methylen blue	2	g.
Sodium carbonate	1	g.
Water	1000	ccs.

For the red:

Basic fuchsin	2	g.
Sodium carbonate	1	g.
Water	1000	ccs.

For the yellow:

Tartrazin	3	g.
Glacial acetic acid	10	ccs.
Water	1000	ccs.

The dyes should be carefully dissolved in a little hot water and filtered into the rest of the water. The pictures should be suspended in the solutions till sufficiently stained. Rinsing in water will remove excess dye, and with the red picture the addition of a little borax will clear the film up. Care must be exercised with the yellow, as the tartrazin is very soluble in water and has a great tendency to bleed, but it can be fixed with an acetic acid wash. For mounting dissolve some scrap celluloid in acetone or amyl acetate, till about the consistency of syrup, and apply this to the corners of the positives in superposition and bind up.

The pinatype process has been dealt with (see p. 391), but to complete this section the actual preparation of transparencies by this process will be described. A sheet of glass should be coated with 5 per cent solution of hard gelatin, containing 2 per cent of ammonium dichromate, and there should be allowed 5 ccs. for every 100 qcm. The transparency from the green-filter negative should be printed first, washed in water, stained up in red and thoroughly dried. Then another coating of the sensitive gelatin should be applied and this printed under the red-filter

negative, exact register being, of course, obtained. This should be stained up in blue. The exposure for this will be about two and one-half times that for the first impression, as the gelatin penetrates the red picture, so that the light-sensitiveness is reduced. An increase in dichromate is not advisable, nor is an insulating medium necessary. In the same way the yellow impression is obtained. The yellow print may be made on a separate glass from a reversed transparency and will then form the cover glass. Obviously the pinatype principle may be applied to celluloid films, that is the use of the particular dyes that will stain up hardened gelatin.

L. Errera[21] patented the production of lantern slides by printing with transparent inks in superposition on a flexible support, either by collotype, or the half-tone process. Gelatin, celluloid, mica or specially prepared glass might be used as support. B. Ludwig[22] patented the use of color prints on flexible transparent supports for demonstration purposes, the supports being fastened together by a stud at one corner.

F. G. Tutton[23] suggested the combination of chemical toning and imbibition processes for making transparencies. From the minus-blue negative a silver transparency was to be made in the usual way. After fixation and washing this was to be toned in:

Ammonium ferric oxalate.................... 4.75 g.
Potassium ferricyanide 4.75 g.
Glacial acetic acid........................... 5 ccs.
Water ..1000 ccs.

As soon as toned through it should be rapidly washed and immersed for a short time in an acid fixing bath, so as to remove the silver ferrocyanide. After well washing it should be immersed for 1 or 2 minutes in a 1 or 2 per cent solution of hydrochloric acid, which converts the blue into a brilliant greenish-blue. Then it should be washed in repeated changes of distilled water and dried.

To produce the yellow image a positive transparency from the blue-filter negative should be printed on a film and immersed in:

A. Potassium ferricyanide 13.5 g.
 Water1000 ccs.
B. Lead nitrate 73.5 g.
 Water1000 ccs.

For use mix 9 parts A with 1 part B and add a few drops of acetic acid. As soon as the image is completely bleached through, wash until all traces of yellow stain have disappeared, then place in the following for a few seconds:

Potassium dichromate 1.1 g.
Water ..1000 ccs.

Again wash till all traces of yellow stain disappear and dry. If this be varnished with one of the commercial varnishes, such as crystal varnish, it will become more transparent.

The red transparency is obtained by using old and useless films fixed out with hypo and ferricyanide, well washed and dried. They should be immersed in the following at 15° C. for 2 minutes:

Ammonium dichromate 26.5 g.
Sulfuric acid 6 drops
Water 1000 ccs.

Rinse in clean water and dry in the dark. Printing should be carried out in daylight, till the image is seen in a brownish color, then the film should be well washed for 30 minutes in cold water and immersed in:

Magenta red dye 8.35 g.
Acetic acid 5 ccs.
Water 1000 ccs.

For about 20 minutes. Then rinse in water, made acid with acetic acid, till the high lights are clear from dye. The three transparencies should be superimposed and the edges cemented with seccotine or other cement and a cover glass put on.

F. E. Ives[24] proposed to cyanotype-tone a silver transparency and then superpose photomechanical prints on celluloid. T. Bentzen[25] used commercial roll film dichromated and stained for the blue with methylen blue N 4 g., methyl green 4 g., water 1000 ccs.; for the yellow, diamant yellow 10 g., water 1000 ccs.; for the red, fuchsin 4 g., eosin 4 g., water 1000 ccs. F. Ganichot[26] suggested merely washing dichromated gelatin after exposure then staining up with carmin and ammonia for the red, Prussian blue and oxalic acid for the blue and gamboge and saffron for the yellow.

It may be a convenience to indicate how even the thinnest celluloid or paper may be kept flat for coating with warm liquids, which is not an easy matter without a proper coating machine; but by the following plan no trouble will be encountered. Clean some old negative glasses, or preferably pieces of plate glass and level them carefully. Prepare the following mixture:

Gelatin 53 g.
Golden syrup 53 g.
Glycerol 65 ccs.
Chrome alum 1 g.
Water 1000 ccs.

Soak the gelatin in about 750 ccs. of the water with the syrup and glycerol for half an hour, then melt at a temperature of 50° C., add the chrome alum dissolved in 100 ccs. water and make up to bulk. Coat 65 ccs. of this mixture on every 645 qcm. (100 sq. ins.), allow to dry, this may take 24 hours, and one should not be misled by the feel, as the film remains tacky and never dries out. This gives a tacky film that will hold any sheet of celluloid or paper quite flat when squeegeed down, so that it can be easily coated. To remove the celluloid, a bone paper knife should be passed under one edge and the sheet pulled off with a steady

even pull. These tacky sheets may be used repeatedly, four or five dozen times without harm.

To prepare a suitable sensitive film the following may be used:

Carpenter's fine glue........................ 55 g.
Water1000 ccs.

This glue is the finest and palest glue that can be obtained and it should be allowed to soak in the water for 12 hours. The correct method of working is to weigh the jar or beaker empty, then weigh in the glue and measure the water. At the expiration of the soaking pour off the water and add enough water to make the weight 660 g. and add:

Gelatin 55 g.

Allow to soak for 30 minutes, then raise to 50° C., stir till dissolved and add:

Alcohol 40 ccs.

To this should be added some emulsion of silver bromide, and this can be made as follows:

Gelatin 10 g.
Potassium bromide 6 g.
Water100 ccs.

Allow the gelatin to soak for 10 minutes, melt at 50° C., and add slowly with constant stirring:

Silver nitrate 5 g.
Water50 ccs.

This can be made by artificial light, as the silver salt merely plays the part of an inert pigment, and prevents too high a relief; its light-sensitiveness is not used.

Keep the emulsion at the above temperature for about 15 minutes, then pour out to set in a flat dish, and leave all night, preferably on ice. Next morning score the emulsion with a *silver* fork lengthwise and then across, so as to break it up into little lumps. Place these in a clean cloth and suspend in water. The water should be changed six times in half an hour, giving the bag a squeeze after each change. Leave to drain for an hour and melt at the above temperature and add 75 ccs. alcohol. This should then be mixed with the warm gelatin-glue mixture and should give about 1000 ccs. of a milky emulsion.

This may be sensitized by the addition of:

Ammonium dichromate 30 g.
Potassium dichromate 10 g.

And immediately coated. Or the plain emulsion, that is without the dichromate, may be used, and the plates sensitized as required. The plates coated with the sensitized emulsion will not keep more than two or three days, while the plain ones will keep indefinitely.

F. G. Tutton[27] described a method of intensifying three-color transparencies and prints by subsequent bathing in dye solutions. The dyes recommended by von Hübl were found to be the best, naphthol yellow and auramin for the yellow; erythrosin for the red and fast greenish-blue

for the blue. These should be preferably made up in 1 per cent stock solutions and about 3 per cent acetic acid added, except for the red dye, which is decomposed. The prints or transparencies should be immersed for some time, being examined about every half hour. When sufficiently intense they should be rinsed in water, acidulated with acetic acid, till the high lights are colorless.

R. Fuelgen[28] would obtain accurate registration for additive projection, by providing the plate holders with a special rebate so that the plates occupied a definite position as regards the camera, and the printing frame and lantern slide carrier were also provided with a similar rebate. S. Procoudin-Gorsky[29] patented a frame by means of which the three constituent positives might be printed in register. P. D. Brewster[30] patented the use of a mixture of potassium carbonate, glycerol and formaldehyde for the stripping of the constituent images from glass plates, and the use of caustic soda and formaldehyde, followed by an acid with glycerol, for stripping films for transparencies.

H. Diernhofer[31] also patented a frame for holding three-color component transparencies for simultaneous projection. The middle one was fixed and the outer ones adjustable, so as to secure registration. Farbenfabriken vorm. Bayer[32] patented the use of a film, coated with a light-sensitive emulsion, the back of the film carrying a film of gelatin capable of absorbing dyes or pigments. This was for transparency or reproduction purposes generally. E. F. Grün[33] stated that the ordinary lantern plate, opal or bromide print might be used for the primary image and after fixing and washing the image converted into a cyanotype blue and the gelatin sensitized with dichromate for the red and yellow impressions. A. Nefgen[34] proposed to make a transparency of an original and paint with the three fundamental colors and from this make negatives with suitable filters. H. A. Rogers[35] proposed to combine the parallax system with color results by using a colored screen in conjunction with colored, black and white or neutral tinted pictures. The lines of the screen might be opaque, translucent or transparent. The lines forming the picture might be consecutively in different colors, red, yellow and blue, or each line might itself comprise more than one color. Or the picture might be printed by an ordinary three-color process.

1. Bull. Soc. franç. Phot. 1867, 14, 124; Handbuch, 1917, 4, II, 187.
2. J. Camera Club. 1891, 6, 135; Phot. Nachr. 1891, 3, 582; Jahrbuch, 1892, 6, 454.
In Bull. Soc. franç. Phot. 1898, 45, 265, 306, L. Vidal used roll films (Eastman) coated with emulsion, sensitized with 2 per cent ammonium dichromate and used for dyes, erythrosin, ammonium picrate and methylen blue. In Bull. Photo-Club, 1898, 724 he suggested methyl green for the blue, erythrosin plus eosin yellow for the red. E. Dunmore, Brit. J. Phot. 1894, 41, 504 also suggested the use of stained gelatin films superposed. "G. L." Phot. Coul. 1906, 1, 23 also used roll films.
3. St. Louis Phot. 1895; Jahrbuch, 1895, 9, 418; Handbuch, 1917, 4, II, 207.
4. Jahrbuch, 1896, 10, 160; Bull. Soc. franç. Phot. 1898, 45, 316.
5. D.R.P. 101,132, 1895; Silbermann, 2, 369; Phot. Rund. 1895, 9, 217; E.P. 7,104, 1895; Brit. J. Phot. 1896, 43, 39, 78; Jahrbuch, 1896, 10, 240.

Marguery, Brit. J. Phot. 1896, **43**, 709; 1897, **44**, 86; Brit. J. Almanac, 1898, 906 used ammoniacal solution of carmin, saturated solution of picric acid and methylen blue.

6. Phot. Rund. 1899; Brit. J. Phot. 1899, **46**, 409, 470, 537; Brit. J. Almanac, 1900, 813; Bull. Soc. franç. Phot. 1899, **46**, 511, 587; 1900, **47**, 31; "Die Dreifarben-photographie," 1st edit. 1897; Anthony's Phot. Bull. 1897, **28**, 26. Cr. A. Watkins, Brit. J. Almanac, 1902, 750; Fabre, "Traité Encycl." Supp. C. 400.

7. The author can not agree with this statement, the want of detail in the shadows is often due to the limiting absorption of the dye, not to the thickness of the gelatin; at least in many cases this last plays a secondary part.

8. "Die Dreifarbenphotographie," 2nd edit. 1902, 170; 3rd edit. 1912, 198; Brit. J. Phot. 1903, **50**, 27; H. O. Klein's translation, "Three-Color Photography," 1915, 132.

9. Photo-Rev. 1900, **12**, 282; "La Photographie indirecte des Couleurs," Paris, 1900, 26.

10. D.R.P. 123,016, 1899; Silbermann, **2**, 371; E.P. 10,003, 1900.

11. Brit. J. Phot. 1902, **49**, 913.

T. T. Baker, ibid. 1904, **51**, 707 recommended auracin G for the yellow, erythrosin for the red and methylen blue for the blue.

12. Phot. J. 1900, **40**, 95; Brit. J. Phot. 1899, **46**, 583; 1900, **47**, Supp. 5; 1906, **53**, 506; J. Soc. Arts, 1900, **49**, 758, 769, 781, 793; Phot. Mitt. 1903, **40**, 14, 28; Anthony's Phot. Bull. 1899, **30**, 371. Cf. A. Norman, Phot. J. 1903, **43**, 68. S. A. Acland, Brit. J. Phot. 1905, **52**, 456.

13. Phot. Rund. 1902, **13**, 129; Amat. Phot. 1902, **36**, 46.

14. Bull. Soc. franç. Phot. 1902, **49**, 296.

15. Phot. News, 1902, **46**, 563; Phot. Rund. 1902, **13**, 221; Jahrbuch, 1903, **17**, 452.

16. E.P. 8,260, 1903; Jahrbuch, 1904, **1**, 406. Cf. V. A. Vaucamps, Le Procédé, 1913; Brit. J. Phot. 1913, **60**, Col. Phot. Supp. **7**, 8 for making carbon printing by a pre-dyeing method.

17. Jahrbuch, 1905, **19**, 349.

18. Brit. J. Phot. 1913, **60**, Col. Phot. Supp. **7**, 41, 45; abst. Phot. J. Amer. 1913, **50**, 36; C. A. 1914, **8**, 1923; Amat. Phot. 1913, **58**, 430.

19. E.P. 20,662, 1905; Brit. J. Phot. 1906, **53**, 454; D.R.P. 225,004; Phot. Ind. 1910, **1**, 187; U.S.P. 802,471.

20. Camera, 1921, **25**, 14; Brit. J. Phot. 1921, **68**, Col. Phot. Supp. **14**, 13; Amer. Phot. 1922, **16**, 597.

For instructions for making transparencies by the pinatype process see Brit. J. Phot. 1906, **53**, 6.

21. E.P. 20,660, 1898; Belg.P. 138,091.

22. U.S.P. 799,609, 1904.

23. Club Phot. 1922, **3**, 122; Brit. J. Phot. 1922, **69**, Col. Phot. Supp. **16**, 41; abst. Amer. Phot. 1922, **16**, 310; C. A. 1923, 17, 2,087; Brit. J. Almanac, 1924, 375.

24. U.S.P. 725,566, 1903.

25. Phot. Mitt. 1903, **40**, 191.

26. Anthony's Phot. Bull. 1894, **25**, 163.

27. Phot. J. 1923, **63**, 325; Brit. J. Phot. 1923, **70**, Col. Phot. Supp. **17**, 26; abst. Brit. J. Almanac, 1924, 375; Sci. Tech. Ind. Phot. 1923, **3**, 137; Amer. Phot. 1924, **18**, 310.

28. D.R.P. 371,653, 1922.

29. U.S.P. 1,413,878; F.P. 503,376.

30. U.S.P. 1,224,442, 1917. This mixture was practically the same as that given in Cassell's Cyclopædia of Photography, 1912, 247.

31. D.R.P. 356,474; E.P. 182,476; abst. Sci. Tech. Ind. Phot. 1923, **3**, 99; Brit. J. Phot. 1924, **71**, 267, Col. Phot. Supp. **18**, 20; F.P. 576,051; abst. Brit. J. Almanac, 1925, 312.

32. D.R.P. 374,596, 1921.

33. Penrose's Annual, 1905, **11**, 118; Brit. J. Phot. 1905, **52**, 1,030.

34. D.R.P. 392,753, 1922; Phot. Ind. 1924, 475. Cf. D.R.P. 394,085.

35. E.P. 178,150.

On the preparation of transparencies see E. König, Brit. J. Phot. 1907, **54**, Col. Phot. Supp. **1**, 13. General notes, "Anon." Brit. J. Phot. 1907, **54**, Col. Phot. Supp. **1**, 71. J. Rheinberg, ibid. 1910, **57**, Col. Phot. Supp. **4**, 24. For making photomicrographs in colors: C. E. K. Mees, J. Frank. Inst. 1917, **184**, 311; Brit. J. Phot. 1918, **65**, Col. Phot. Supp. **12**, 1; Amer. Phot. 1917, **11**, 448; Mining and Scientific Press, 1917, **115**, 610.

SCREEN-PLATES—HISTORICAL AND THEORETICAL DATA

In the ordinary tri-color processes it is necessary to use three separate plates for the constituent negatives. L. Ducos du Hauron[1] (p. 473) conceived the idea of applying the principle of a particular school of French painters, known as the "pointillistes," and this was the laying-down of juxtaposed minute dots of color, instead of superposing three films. It is obvious that this is essentially an additive process and not subtractive, as to make violet, minute dots of red and blue were placed side by side, and to make yellow minute dots of green and red.

Du Hauron, in his French patent said: "Enfin, il existe une dernière méthode par laquelle la triple opération se fait sur une seule surface. Le tamisage des trois couleurs simples s'accomplit non plus moyens de verres colores, mais *au moyen d'une feuille translucide recouverte mecaniquement d'un grain de trois couleurs.*" Which may be thus translated: Finally there is another method by means of which the triple operation may be effected on one surface. The separation of the three elementary colors may be effected no longer by three colored glasses, but *by means of one translucid sheet covered mechanically by a grain of the three colors.*

In a series of articles published in the following year[2] the process is more fully described and speaking of his dot method he says: "Assume that we have the surface of a paper entirely covered with the alternating lines of red, yellow and blue, as fine as possible, of equal size and without interspaces. If this paper be viewed at a short distance, one can distinguish the three colored lines; but at a distance they will fuse into a uniform tint, which will be white if viewed by transmitted light, but grey if examined by reflected light (assuming at least the relative luminosities of the three kinds of rays are so combined that not one of them dominates).[3] And if the camera image is received on this paper, the image, viewed at a distance, will appear the same as though the paper was actually white. Such a paper gives the possibility, either by artistic hand work with a black crayon, or by means of light with the aid of the direct or indirect processes of ordinary photography, of obtaining a picture, in which the colors of nature will be represented with a certain degree of truth. Supposing, for instance, that it is desired to produce on this paper, which when examined at a distance, is a uniform grey tint, a red color; it will be sufficient to cover with hatchings with a dark pencil the yellow and blue lines. If it is desired to obtain violet, it will be sufficient to cover in the same way the yellow lines, and if it is considered necessary to lower the luminosity of the

violet, which may be too great from the action of the two rays, then one need only lightly shade with a crayon the red and blue lines. To produce grey, the luminosity of all the lines must be reduced, and black will naturally be produced by obliteration of all three. That which may be done by an expert hand may all be done by natural forces. In fact, assume that the surface of this paper, on the side covered by the lines, is coated with a preparation which will give direct a positive print by the action of light, and that on the back, that is on the side not covered by the lines, is formed the image of the camera; the result will be that the three simple colors will be separated in passing through the paper, and each would form its positive imprint, that is to say, its impression in light on the lines of the corresponding color; and the three impressions will be formed with the same rapidity, in spite of the unequal degree of the actinism of the three simple colors, if care be taken to give each of the three lines a transparency in inverse ratio to the photogenic power of these same colors on the preparation used. This unequal transparency may be produced by dark lines previously formed on the back of the sheet, and the most simple means to obtain these lines consists in negatively sensitizing, by means of silver chloride, for instance, the back of the sheet, and exposing through the front to diffused light, so that there is formed by the unequal action in passing through the different kinds of lines, dark lines possessing the required degree of purity. To make this method of three lines practical, it would be preferable to employ as auxiliaries, the indirect processes of photography. One might have a single film, such as a sheet of mica, covered on one side with red, yellow and blue lines of an intense color, and on the other the lines of unequal opacity. Such a film would then serve to obtain other surfaces (paper, glass, etc.) brought in contact with negatives in silver bromide. Each of the negatives would then furnish in turn positives, in black or carbon, a film, glass or mica, etc., and all that would be required would be to apply one of these positives to an opaque or transparent surface, mechanically covered with red, yellow and blue lines, each corresponding in position to the lines of the film, which was used as a filter for the lines of the simple colors. The lines might be produced either by pure mechanical means, such as chromo-lithography, or by photography itself, by means of black and white screens, reduced in the camera, and through which preparations of gelatin, or gum or albumen, etc., dichromated and colored might be exposed. The three lines, instead of being printed on one sheet, might be made on three separate sheets, which might then be superposed to produce juxtaposition of the lines. The yellow lines ought to be replaced on the filter by greenish-yellow lines, as I have already pointed out."

In a later work[4] occurs the following passage, which is given in its entirety, because of its historical importance, and because it conclusively proves that no patent can be valid for any particular form of screen

element, merely for the method of producing the same: "The colored lines can be produced either by purely mechanical means, or by photography itself. As regards the mechanical means, the method most to be recommended consists in passing the transparent tissue over three grooved cylinders, each of which, of very narrow diameter and very close to one another, receives an inkage of one of the three colors by contact of its ridges with a corresponding inking roller. As regards the use of photography itself for the formation of the colored screens, this will chiefly find its application in those cases where one requires to have a screen of extreme fineness. Preliminary to the description of this process, I ought to point out that it is a matter of absolute indifference, for the optical results obtained, whether the screens be composed of straight lines or constantly parallel, or of some geometrical divisions, provided that in a given area, the division of each of the three colors reproduces the same amount of surface for each of them. This being granted, let us assume that a dichromated colloid, colored red-orange, is spread over the tissue, and that this surface is exposed to light through the back under a very transparent screen, composed only of opaque and transparent lines, whether mechanically drawn or obtained by photographic reduction, the opaque lines having double the width of the transparent ones. The development bath will cause a series of parallel, red, lines to appear, visible with the magnifying glass, and with colorless transparent interspaces, the latter occupying two-thirds of the surface. If after having hardened this surface and rendered it impermeable by any well known means (the latest and most satisfactory is hardening with formaldehyde) the screen is coated with a second dichromated mixture, this in turn dyed green, and if this be exposed to light, not through the first line screen, but through one made in a similar manner in which the black lines are of equal width to the transparent; and if, moreover, this screen be turned in such fashion that the lines take a direction at right angles to the red lines already formed, the light will be intercepted not only by each black line, but also where the red lines extend over the spaces between the black lines. The second development will then cause the green lines to appear, which the red lines will divide into small rectangular pieces; these pieces leave between them colorless transparent spaces of the same shape and area. Finally, if after having hardened and rendered impermeable this second coating, the screen thus transformed, is covered with a third and final dichromated mixture, dyed this time in blue-violet, and it is exposed through the back to light, but now without the interposition of any black-line screen, the light will act on the rectangular spaces not covered by the red and green lines; these two lines act as non-actinic filters for the dichromated preparation which they cover. On development, at the same time as the red and green lines disengage themselves from the blue-violet film uniformly coated over them, one will see all the blue-violet areas show themselves in turn, and the final result will

be a kind of checker or chess board, in which the light should be controlled by the close juxtaposition of the colored divisions, however minute they may be. The work should be, moreover, the finer the thinner the film, the more deeply it was colored, the more dichromate it contained, and when the light rays acted more perpendicularly."

A chronological arrangement of the various patents would seem at first sight to be the most natural to adopt, but far easier of grasp will be found their classification into groups, based on the methods of manufacture. C. E. K. Mees and J. H. Pledge[5] adopted this plan; but F. Limmer[6] suggested a somewhat more elaborate classification, and this has been adopted: (1) linear systems; (2) dusting-on methods; (3) cut screens; (4) printed screens; (5) resist screens; (6) dichromated colloids; (7) woven screens; (8) other processes, not included in the above.

The Theory of Screen-Plates.—Before entering upon the subject of particular screen-plates it may be as well to consider what may be termed the fundamental bases of all screen-plate manufacture, and these have been exhaustively laid down by C. E. K. Mees[7] and again by him in conjunction with J. H. Pledge[8] and full use has been made of these papers.

All screen-plate processes are additive processes, that is the colors are formed by the admixture of colored lights and not by the subtraction of light from a white surface, like white paper, as is the case with colored prints. For an additive process, the color filters for taking the negatives should overlap in the green and red, and in the blue and green, and they should be sharp-cutting, as has already been pointed out when dealing with filters. Whilst for viewing and projecting, the filters should be comparatively narrow-banded and not overlapping.

Abney[9] pointed out that the viewing colors should be those of the three fundamental color sensations, and that the purest green sensation, that is, green unmixed with any sensation but white, is found in the spectrum where the red and green sensation curves cut one another; but the proportion of white to green is so large that the color mixtures would be pale; this point is about wave-length 5150. If some other green much less diluted with white, such as that nearer the yellow-green, were chosen, the mixture would be less pale, but not quite so accurate in hue, since it would contain a larger proportion of red than it should. For this reason it is well to choose a green, somewhere about E, wave-length 5270, which is not too red, and in which the white light existing is small. The red that ought theoretically be used is below the lithium line, wave-length 6710, for there we have only one sensation stimulated, but it is very feeble; so that in practice a red near C, wave-length 6560, is chosen, which is fairly bright, although the red sensation is slightly contaminated with green. Blue is at all times of feeble intensity, but as that near the blue lithium line, wave-length 4600, is strongest and fairly pure, it is chosen.

J. Joly[10] dealt with this subject when describing his screen-plate, and

basing his statements on König's curves, after rejecting Clerk Maxwell's, suggested that a color a little to the right of the E line, about wave-length 5500, was the best for the green sensation; and for the red about D$\frac{1}{6}$C, which would be about 6000, and that for the blue about 4550. These were the dominant wave-lengths for the taking screens; other colors were chosen for the viewing screens (see p. 475).

C. Kaiserling[11] stated that the transmissions of the Joly negative screens were for the red, from 6700 to 5500 with maximum at 6000 to 5800; for the green, from 5700 to 4700 with maximum at 5300 to 5150; for the blue, 5200 to 4300 with maximum at 4800 to 4600.

Mees[12] pointed out that as in this process the negatives are frequently reversed and viewed as positives, a compromise between the taking and viewing filters must be made, and, therefore, the filter zones should touch but not overlap. The reason for this is that the eye is extremely sensitive to changes of color, or wave-length, where the overlap of the filters should occur, as stated by P. G. Nutting[13] and it is important, therefore, that there should be no great gaps between the transmissions of the filters.

Mees and Pledge[14] stated: "But if it is of importance that the taking filters should overlap, or at least touch, it is of equal importance that the viewing filters for the additive process should be as pure as possible, especially if the taking filters already show an overlap. Consequently the best practical compromise will probably be three filters transmitting red from 5900 upwards; green, from 5900 to 4900; blue, from 5000 downwards. It may be remarked that the higher the lower limit of the red filter is, the better will be the color of the pure reds, and the greater the difficulty of distinguishing between yellow-greens and pure greens. Similarly if the lower limit of the green filter is too far into the blue, there will be difficulty in obtaining bright yellows, if not far enough, blue-greens will be too blue."

That white should be rendered as white and without color, it is important that the screen-plate shall be of a neutral tint, or free from color, which Mees described as the "first black condition," and ascribed it to McDonough[15] but as will be seen from page 454 this requirement was fully recognized by Ducos du Hauron. To fulfill this condition, the area of the units must be altered, and not their depth of color, the latter being determined by the necessary filter cuts.

The size of the screen elements is determined by their invisibility, the thickness of the medium necessary to obtain sufficient depth of color, and the irradiation occurring in the emulsion film.

The Pattern of the Screen Elements.—In the manufacture of screen-plates, it is obvious that the pattern of the elements plays no unimportant part, and this subject was very fully treated by Welborne Piper.[16] In making the screen-plates by methods which involve the application of dyes to a film, trouble may be caused by the overlapping of the margins, or the

dyes diffusing from one element to the next. If such happens, there must be either black or secondary colors formed, which if present in any large quantity must influence the color rendering prejudicially. It is, therefore, desirable to reduce the element boundaries to a minimum. It is clear that the lines must be reduced in length, as the size of the elements increases, but they may also be reduced by the use of a particular form without alteration of size. That is to say, as the periphery of a hexagon is less than that of a square of the same area, the total length of the boundaries must be smaller in the regular hexagon mosaic than in a square mosaic, containing the same number of units.

Fig. 106 Fig. 107 Fig. 108

Fig. 109 Fig. 110 Fig. 111

If it be assumed that the width of a colored line be 1 mm., Fig. 106, and the area of the plate measure 10x12 mm.; it will be covered by thirty lines 10 mm. long, and the total length of these lines will be 300 mm. It may also be covered by ten lines at right angles to the others, in which case the total length of the lines is still 300 mm. And if both lines are used, the plate will be divided into a mosaic of 300 units, each 1 mm. square, Fig. 108, and the total division of the lines will be 600 mm. If, however, only one set of lines is crossed, Fig. 107, then the length of this set will be halved, and the total will only be 450 mm. The total length of the dividing lines can, however, be arrived at more easily, by measuring the total length of the several lines bounding one unit, and multiplying by half the total number of units, and this method is applicable to every pattern. Thus, in the line screen, if the lines run the long way of the plate,

there are ten units, each having two boundaries 30 mm. long, and multiplying this by half the units, or by 5, the result is the same, 300 mm. If one line be crossed the total of the boundaries is 4×150, or 600 mm., as before. If the lines of an alternating line and mosaic plate run the short way of the plate, then there are fifteen line units, each with boundaries of 20 mm., thus 15×10, or 150 square units, each with a periphery of 4 mm.; the total is, therefore, 20×7½ added to 4×75, which equals 150+300, or 450 mm.

In the case of an equilateral triangle mosaic, Fig. 109, assuming that each triangle is equal in area to one of the squares before considered, there are then 300 units. But as the periphery of each triangle is 4.56 mm., the total length of the boundaries is greater, that is 684, instead of 600 mm. If there are 300 hexagons, Fig. 110, then as the periphery of the hexagon is only 3.72 mm., the total of the boundaries is reduced to 558 mm. If the area of the units be increased, or diminished, other results will

Fig. 112 Fig. 113 Fig. 114

obviously be obtained. Taking the square first, then if the sides of the square are doubled, that is 2 mm., instead of 1, the periphery is doubled and the area quadrupled, which reduces the total number to one-fourth; therefore, there are 75 squares, each with a periphery of 8 mm., so that the total of the boundaries is 300, instead of 600 mm., as before. If the sides are halved the peripheries are halved and the area reduced to one-fourth, and the total number quadrupled, with the result that there are 1200 squares of 2 mm. periphery, so that the total is 1200 mm. From this it is clear that the smaller the unit the greater the length of the dividing lines.

In considering the diaper pattern screens, in which one color unit forms the ground on which two other color units are in the form of quite separate units, larger results are obtained. Assume the blue units to be merged together so as to form a blue ground, and the other units are uniformly distributed thereover, Fig. 109, the total boundary of the lines is equal to the periphery of each of these units, 200 multiplied, therefore, for the square pattern the total is 800, instead of 600 mm., as before. If the squares are changed to circles, Fig. 112, the periphery of each unit is only 3.54 mm., and the length of the dividing lines is reduced to 708 mm. With a diaper of triangles, Fig. 114, it would be necessary to nearly

double the area of the triangle to reduce the length of the boundaries to that of the hexagons, Fig. 113. The various results may be summed up in the following table, which shows in millimeters the length of the dividing lines on a plate measuring 10x30 mm., the width of the lines being 1 mm., while the smaller units are all equal to 1qmm. :

Line screens:

 Single line screens, Fig. 106........................ 300
 Alternate lines and squares, Fig. 107................ 450

Mosaic screens:

 Hexagons, Fig. 110................................ 558
 Squares, Fig. 108................................. 600
 Triangles, Fig. 109............................... 684

Diaper screens:

 Circles, Fig. 112................................. 708
 Hexagons, Fig. 113................................ 744
 Squares, Fig. 111................................. 800
 Triangles, Fig. 114.............................. 912

FIG. 115

W. Scheffer[17] dealt with the subject from the point of view of the visibility of the screen elements, when seen in projection or direct viewing, and based his remarks on the "screen period" and the characteristics of the human eye, and considered the most favorable degree of fineness of the screen in particular cases.

In the first place, it is desirable to select a measure for the finest details which the eye can separately recognize under given conditions. And it is as well to express this value as a fraction of the distance of the object from the eye. If we have a system of black and white lines, and gradually remove this to a greater and greater distance from the eye, it is found that at a certain distance the separate lines or elements cease to be visible. In making a test of this kind it is a good plan to employ the idea of the "object period," which means the distance between two like points in a portion of the screen which is repeated at regular intervals. For example, in Fig. 115 the distance P will be the object period. From experiments with screens of varying degrees of fineness, it was determined that a degree of fineness in the structure of an object, which is 1/1000

of the distance at which the object is viewed, can be fairly well differentiated.

The author pointed out[18] that Scheffer's arguments were based on the use of black and white screens, and that the same might not apply to colored units. The following experiments were made: cinematograph film was slit lengthwise and stained red, green and blue, so that the absorptions were approximately the same as in screen-plates. Strips of the dyed film were stuck on gelatinized glass to form a linear screen, and this placed against a window covered with tissue paper. The plate was first placed with the lines running horizontally, then so that they were at an angle of 45 degrees. Seven observers and the author then determined quite independently at what distance the lines became invisible, with the following results:

Observer	=	45°	M
Ba.	38,400	30,480	25,300
O.*	20,420	15,545	16,460
F.	38,400	26,820	26,820
K.	24,690	27,430	16,150
Bu.	34,440	34,440	19,810
Y.	38,400	27,430	27,430
M.	33,530	25,910	21,030
W.	38,400	30,840	19,810

*Suffered from red blindness.

The second column gives the distance in millimeters at which the horizontal lines became indistinguishable; the third column the distances for the lines at 45 degrees, and the fourth for a mosaic screen. This was made as follows: strips of the same dyed film were cut into small rectangles 13x17.4 mm. These were placed alternately in rows with their longer axes vertical, and so that under every red there was a blue, and so on, the result being that rectangles of the same color were at an angle of approximately 37 degrees.

Scheffer has shown that the resolving power of the eye is of such an order that it will see lines as separate, if their "period" (twice their separating distance for lines equal in width to the spaces) is one-thousandth of their distance from the eye. From the above it is clear that the units of the above linear screen should have become invisible at 52,000 mm. when the lines were horizontal and at an angle of 45 degrees. In the case of the mosaic screen a rectangle was taken that would include four units and the diagonal measured, this was 41 mm.; therefore the units of this screen should have become invisible at 123,000 mm. The following table shows the difference between theory and practice:

	=	45°	M
Theory	52,000	52,200	123,000
Practical mean	30,834	27,692	21,000

It is apparent from this that one can not apply the arguments of a black and white screen to colors. It very soon became apparent in the

trials that the distance of blending (Verschmelzungspunkt) was not the same for all three colors; the blue and green tended, in the majority of cases, to blend before the red; in two cases the red was visible long after the others had blended into a uniform tint. This difficulty of blending of the reds may account in part for the apparent predominance of the red units in some screen-plates. In connection with this subject it should not be overlooked that the eye is not achromatic, and one must also take into account the Purkinje phenomenon.

Mees and Pledge[19] pointed out that taking 20 cms. as the viewing distance, the screen period will be 0.2 mm., that is the separate units of the screen will be invisible if they are 0.66 mm. in diameter. This is assuming that regular screens are used, but with irregular units one has to take into consideration the clumping of grains of the same color. This effect may be due to improper mixing, but it is inevitable by the law of probability.

The thickness of the screen element necessary to obtain the requisite depth of color also settles the diameter, in consequence of parallax. If the thickness is equal to the diameter of the element, or to the width of one line, then any light ray entering the screen-plate at an angle above 10 degrees will be subject to considerable parallax error, as it will have passed not only through the element through which it ought to pass, but also diagonally through a portion of the adjacent unit before passing into the proper screen element; so that a green ray, for instance, would pass through the top surface of a red unit, and suffer considerable absorption before passing through the green element.

With gelatin as a medium of the color this is of great importance, as it is difficult to obtain a sufficiently deep screen with less gelatin than 1 ccm. of a 5 per cent solution per 20 qcm.; and the thickness of this coating, whilst wet, will be 0.5 mm., but when dry only 0.025 mm., which gives 40 lines of square section to 1 mm., or the limiting fineness of the lines is 1000 to the inch.[20] If irradiation occurs in the emulsion the effect will be to reproduce all over-exposed sections of the plate as white, and an increase of exposure of 4 times is sufficient to dilute a color with an equal amount of white, an effect which would require at least 40 times the normal to produce by penetration of the screen elements.

As regards the emulsion, this must be of reasonably fine grain; but it need not necessarily be slow. It must be sensitive to the whole of the spectrum, and the sensitiveness must be so adjusted that the deposit beneath the red and green filters is equal in intensity. But this, and the effect of the blue, can be adjusted by the compensating filter, so that if greys are photographed, greys will be reproduced on the plate, and this is an excellent method of testing as to the compensation correctness. This, Mees signalized[21] as "the second black condition."

Summing up the necessary adjustment of factors in the construction

of a screen-plate, Mees and Pledge[22] stated that the following must be taken into account, and that each must be considered separately, and the necessary conditions fulfilled. All can be tested without taking pictures at all, and if they are not fulfilled the color will be wrong:

1. The size of the units. For regular screens, these should not be larger than 1/300 of an inch, nor smaller than 1/600. For irregular screens not larger than 1/900, nor smaller than 1/2000 of an inch. It is quite needless to strive for exceedingly small units.

2. The interstices. If these exist at all, they must be filled in; white interstices are fatal, even if they only occupy one-twentieth of the area of the screen-plate.

3. The colors of the units. These must be primary red, green and blue-violet, and conform to the conditions explained.

4. The relative area occupied by each color. This must be adjusted to fulfill the first black condition.

5. The emulsion. This must be coated, for which purpose the varnishes will have to be selected, as they must not act upon it. Turpentin and ether, especially the former, are inadmissible as solvents; resin varnishes are suspect.

6. The sensitizing. This must be performed so that the actions under the red and green filters are equal.

7. The compensator. This must finally be adjusted to fulfill the second black condition.

The following notes apply to Autochrome plates, for these alone were for some time the only plates available commercially.

With reference to the fineness of the screen elements, it may be of interest to summarize, as far as possible, available data, and Mees and Pledge gave some interesting figures. The Joly line plate was ruled with lines 0.12 mm. in width, while the McDonough plate lines were 0.08 mm. These plates are no longer available. The Autochrome plate is covered with starch grains, and numerous measurements have been made of these. The author[23] found that they varied from 0.006 to 0.025 mm., which gives as a mean 0.015 mm. and this was confirmed by Mees and Pledge.[24] L. Benoist[25] found that the finest grains were 0.008, the medium 0.0105 and the coarsest 0.0132, which gives as a mean 0.0106 mm.

With regards to the distribution of the grains, theoretically this should be uniform, as the stained starch grains are mixed to satisfy the first black condition as far as possible, but as pointed out by Mees and Pledge, according to the law of probability, there will always be clumping of the grains of one or all colors. If, for instance, counters of three different colors are placed in a bag and two are withdrawn, then the chances that those two counters will be of the same color are 1 in 3; the chances that three counters will be the same color are 1 in 9; four, 1 in 27; the chances that twelve will be the same color being about 1 in 120,000. In

the Autochrome plate there are about 4,000,000 starch grains to the square inch, so that the probability of clumping of twelve grains of the same color in a square inch will be 4,000,000/120,000 or 33.3. Therefore, in a square inch we may, if the grains are perfectly mixed and distributed at random, expect to find 33 clumps of twelve grains or over; 11 of thirteen grains or over; 4 of fourteen grains or over, and 1 of fifteen grains or over. There will probably be only 1 clump of seventeen grains in a quarter plate, while a clump of twenty grains should occur about twice in a dozen whole plates. In order to determine the extent to which this calculation applied, the said investigators examined one hundred fields of the plate, each containing about 400 grains, and they found 1 clump of seventeen grains, 1 of sixteen, 3 of fourteen, 5 of twelve, 11 of eleven, 21 of ten and 29 of nine. Numerous counts of other workers practically confirm this statement.

Fig. 116. Red

C. Wolf-Czapek[26] found clumps of from three to fifteen grains, and the ratios red 28, green 45, blue 27 per cent. A. Haddon[27] found within two given areas red 127 and 116; green 170 and 155; blue 129 and 108, which roughly correspond to 40, 30 and 30 per cent. Ferran[28] found 46, 31 and 30 per cent. E. Valenta[29] also found 40, 30 and 30. According to A. Seyewetz,[30] the grains were not mixed in any definite proportions, but empirically so that no one color predominated, (see also p. 467). In connection with this point Mees and Pledge stated that as the makers were unable to adjust for the fulfillment of the first black condition by the variation of the size of the units, they probably increased the number of the green grains.

The distribution of the starch grains is well shown in Figs. 116, 117,

118 from photomicrographs, taken by the author[31] and the preponderance of the green and also the clumping is evident.

Von Hübl[32] found that the substratum that holds the grains was completely soluble in benzol, which goes to show that it is rubber. Treatment of the plate with alcohol dissolves the film of varnish over the grains, and water dissolves the dye from the red and green grains, but leaves the blue untouched. Jung[33] found that alcohol, ether, chloroform and oil of cloves very quickly decolorized the grains, but water only slowly and he considered the dyes to be safranin, iodine green and methylen blue. He also considered that the starch was maize and not potato. F. M. Duncan[34] said it was wheat starch because it did not show the familiar hilum and black cross by polarized light. J. H. Pledge[35] and W. Scheffer[36] proved

Fig. 117. Violet Fig. 118. Green

that this observation was erroneous. The latter also stated that by prolonged soaking in xylol, the rubber substratum was so softened that the film of colored grains and the gelatin could be stripped from the glass, although it took a long time, as the xylol had to find its way in from the edges.[37]

Some discussion arose at first as to the actual medium used for the emulsion, probably from its character differing so much from that of the ordinary plate. C. Wolf-Czapek[38] and R. Neuhauss[39] considered it to be collodion. A. Haddon[40] thought it was some starch or feculose preparation. J. Gaedicke[41] stated that a gelatin emulsion was used and its thickness was 0.005 mm. Lumière and Seyewetz[42] definitely stated that nothing but a gelatino-bromide emulsion had ever been used, in accordance with the patent specification.

E. Ventujol[48] gave some very interesting details as to the manufacture of the Autochrome plate. In the first place the starch grains were sifted by means of a sieve made from sheet copper 0.01 mm. thick, which was sensitized with asphalt and exposed under a negative of a black and white screen with clear spaces of 16 microns. The back of the copper plate was varnished and the plate etched with ferric chloride till perforation took place at the holes protected from light. Unfortunately it was found that these holes clogged up, and a system of centrifugal separation was tried without satisfactory results. Finally a system of elutriation was adopted.

The particular method of dyeing was not stated, though the triphenylamin dyes were found to be the best. A colorimeter was designed in which a sector shutter with 60 degree sectors, was used and the sectors were covered with glasses coated with each of the colored grains. By comparison of the resultant light on revolution, with a neutral grey, obtained by various thicknesses of black gauze, the sectors were altered till a complete match was obtained and the angles of the sectors gave the respective quantities of the colored grains. Very finely powdered charcoal was found to be the best filling for the interstices between the grains, and a special machine had to be devised, which would apply this to the plates, without filling the air with powder, which might give rise to spots on the plates. A machine was made which applied the charcoal to the interstices without attaching it to the grains.

The plates were examined daily with the microscope and one day great astonishment was created by the greater transparency. This was found to be due to the crushing of the grains by the roller. Therefore, this crushing was adopted as part of the daily routine, and at first the plates were compressed between a thin sheet of steel and a rubber blanket with 5,000 kilos pressure per square centimeter; but this did not prove a success, and finally a roller of 1.5 mm. diameter with tangential lines was used, and with this the pressure might be adjusted up to the crushing point of the glass. Considerable trouble was found in selecting a suitable insulating medium for the colored stratum, as it must have a refractive index akin to the starch, be not readily fusible because of the heat in projection and the solvents must not attack the dyes. A special machine was built to apply this varnish. The grains run about 6,000 to 7,000 per qmm., or about 140,000,000 to a 5x7 inch plate. The thickness of the tri-color elements is about 15 microns. The emulsion had to have a special character and be of very fine grain, approximately 6 microns, and it must be rich in silver bromide and poor in gelatin.

As regards the sensitiveness of the Autochrome plate and other screen-plate emulsions, Mees and Pledge stated that it seemed characteristic that they showed a deep gap in the blue-green, probably due to the fact that

slow emulsions were generally used, and the normal sensitiveness of the emulsion does not extend into this region, and consequently when sensitized there is this gap between the added and the original sensitiveness. E. Stenger[44] found three maxima, one at 5300, another from 5600 to 5700 and the third from 6100 to 6200. The curve of sensitiveness was very similar to that of isocol. With short exposures the action extended to 6400, and with longer to 6900. Under given conditions plates were under-exposed in from 5 to 200 seconds, correctly exposed in from 400 to 800, and over-exposed from 1000 to 1400 seconds. With these exposures the orange-red appeared first from 6000 to 6250, and then with increase of exposure this region was prolonged to 6500 with a whitish-red; the green showed first at 5500, and blue at 4400 to 5750, after a long exposure the yellow turned to a whitish-yellow. The maximum sensitiveness of the emulsion was at 4250.

Von Hübl[45] placed the maxima at 4500, 5500 and the sensitiveness extended to 6500. Mees[46] said that the sensitiveness was very similar to a collodion emulsion, and that the sensitizer might be orthochrom T. R .J. Wallace made[47] a careful examination of the Autochrome plate. He found the diameter of the grains to accord with the author's estimate, and the number of grains found to be in the ratio stated by others. On treatment with hot water, the blue dye was found to be the most soluble, then the red and lastly the green; but on treatment with cold water the green was the most soluble. Ether dissolved the varnish of the starch layer, so that isolated grains could be observed, but it had no influence on the colors. In alcohol the green dye was discharged slowly, and the color film frilled away from the support in one continuous film. Dilute ammonia discharged the colors slowly in the order of red, green and blue and in acid permanganate the colors were equally but slowly discharged. The thickness of the starch layer was 0.01524 mm., and that of the emulsion only 0.004 mm.; for comparison the thickness of that of the ordinary plate may be put at 0.031 mm. The sensitiveness of the emulsion was found to correspond practically with the results of Stenger. On exposing to the spectrum through the screen elements, without the compensating filter, it was found that with under-exposures the first visible action was at 4100, which gave a bright blue; with increased exposure, the green at 5270 was the next color to show, followed almost immediately afterwards by 5850, which appeared of a deep red, instead of bright yellow. With increased exposure, the blue-violet, from 4300 to 3900, became diluted with white; while the green and red regions extended and whitened. The ultra-violet was shown throughout as a bright blue.

Mees and Pledge dealt with the examination of the screen as a whole, and stated that the Autochrome, when examined by daylight showed a distinct pink tint, as did also the Omnicolore, whilst the Dioptichrome was greenish, and the Krayn film fulfilled the first black condition best.

The best experimental method for this subject would be the use of a modification of Ives' colorimeter.[48]

They stated that if the plate is to render colored objects in their relative intensities as they appear to the eye it is necessary that the curve of the effect produced upon the emulsion by exposure to the spectrum through the screen and the compensating filter shall correspond to the luminosity curve as seen by the eye after correction for the relative luminosity to the eye of the color producing each portion of the curve.

The total visual absorption is of very considerable importance, as it largely affects exposure. At the same time, however, a low visual absorption may point to filters which are too weak, and which transmit too wide regions of the spectrum or even white light. Roughly speaking, the green conditions the maximum possible transparency. Probably even in gelatin no tricolor filter can transmit more than one-third of the green light falling on it. Under the best conditions for the other filters green might occupy half the area of the plate. Also in order to fulfill the first black condition the green area must transmit about two-thirds of all the light transmitted by the plate. Consequently, half the plate will transmit two-thirds of the light, and this will not be more than one-third of the incident green light or two-ninths of the incident white light. So that half of the plate can transmit two-ninths of the light, and the other half one-ninth, giving for the plate as an average, one-sixth. This, then, is the maximum which a plate with correct filters can transmit. Measurements of the absorptions are readily made with a photometer. The results obtained were:[49] the Autochrome transmits 7.5 per cent of the incident light; the Thames plate 12 per cent; the Omnicolore 10 per cent and the Dufay 21 per cent.

E. Stenger[50] stated that the Autochrome plate transmitted only 10 per cent of the incident light; the Warner-Powrie 11.5, the line screen of the Deutsche Raster-Gesellschaft only 5.4, the Omnicolore 15 per cent. C. Wolf-Czapek[51] stated that this last only passed 12.5 per cent. According to von Hübl[52] the Thames plate passed 12.5 and H. Quentin[53] estimated the Omnicolore at 15 per cent.

According to von Hübl[54] the ideal red, green and blue dyes can only transmit each one-third of the spectrum, so that the ideal screen-plate can do no more. On the other hand, it would be found that the red transmitted 0.8 per cent, while the green let through only 0.5 and the blue about 0.6. From this can be easily calculated in what ratio the elements must be mixed in order to produce a neutral grey. They must be in the ratios of 1.25 : 2 : 1.66 for red, green and blue, or for every six red, there must be about ten green and eight blue, which will be seen to agree very well with the actual percentages of the Autochrome. The total quantity of red, green and blue light will be about half, and, therefore, the luminosity of the white light will be restricted to $\frac{1}{2} \times \frac{1}{3} = \frac{1}{6}$ or 0.17. The trans-

parency of the screen elements, measured with a spectrophotometer, was found to be: for wave length 7070, 0.15; for 6520, 0.15; for 5720, 0.09; for 5180, 0.16; for 4880, 0.11; for 4550, 0.11 and for 4200, 0.10.

It is obvious that the total effective speed of a screen-plate depends on the speed of the emulsion, the multiplying factor of the compensating filter, and the screen element factor, and Mees and Pledge[55] gave the following very interesting table on this point:

	Auto-chrome	Thames	Omni-colore	Dufay
Emulsion speed, Watkins	35	120	22	13
Screen factor	12	8	7	5
Compensation factor	2	1$\frac{1}{2}$	1$\frac{1}{4}$	1$\frac{1}{2}$
Effective speed	1$\frac{1}{2}$	10	2$\frac{1}{2}$	2

Whilst the formation of the colors in a screen-plate picture is fairly obvious to anyone at all acquainted with the principles of three-color photography, the following condensation of a note by von Hübl[56] may make the matter clear to all. Let it be assumed that we have a glass plate, as in Fig. 119, covered with the three screens, either in lines or dots or other pattern, in such ratio that the same looks grey by transmitted light. Then the formation of color is merely due to the blocking out of one or more of the color elements by the deposit of metallic silver. In the case of 1 the red is blocked out and the light transmitted is a blue-green that is a blue plus green, as we are assuming that we have a negative, the normal result of exposure and development. If we reverse the negative as usual by dissolving the silver, and then expose the previously unaffected silver salts and develope, we should obtain on the underlying silver salts the complementary color to the blue-green, which is red; and the negative image is shown in *a*, whilst the positive, either obtained by reversal or by contact printing on another plate, is shown in *b*, when obviously the only color to reach the eye will be red. In *c* the red elements are completely covered and the blue partly so, and the result will be a color between blue-green and blue, lowered in luminosity by the deposit over these two lines.

If all the lines are covered, the plate will be opaque or black; if they are only partially covered, then it will be grey; if only one or two lines are covered incompletely, whitish colors are obtained. It is obvious from the above that by complete or partial covering of one or more color lines all possible color tones, with their saddened or lightened tints, can be formed, and the result is free from all the irregularities and faults which appear in the admixture of pigments. Also the spectral composition of the dyes used for the lines does not play any important part, for rays of similar appearance give similar mixtures.

It is obvious that the covering of the lines is automatically effected by photography. For the lines of the taking filters, vermilion, yellow-green

and blue are chosen, so that each line acts as an individual filter, and the same screen-plate serves as a reproduction filter. In 1, Fig. 119, the vermilion lines are covered and the spot appears blue-green, 2 appears purple-red, 3 yellow, 4 blue and so on, 11 shows a blackish and 12 a whitish blue-green, shades which are complementary to yellow-orange, but have a negative character.

If such a linear screen-plate is placed on a plate, equally sensitive to all colors, the rays reflected from a vermilion colored object will pass through a red line, but not through a green or a blue, so that only under this red line will the silver bromide be affected and blackened by subsequent development. If Fig. 119 represents a section through the two plates and "r," "gr" and "bl," the section through the red, green and blue lines, only the parts behind the red lines will be black after development and fixation, whilst those behind the green and blue will be clear glass. In a similar way with incident yellow-green and blue rays, only the silver bromide under the similarly colored lines will be affected and appear opaque in the negative. If yellow light, formed of a mixture of red and green rays, falls on the lines, the blackening will only take place under the red and green lines, for the blue absorbs the complementary rays before they can affect the silver salts. In 5 and 6 will be seen the action of the blue-green and reddish-violet rays reflected from the object.

White light penetrates equally all three lines, and causes an equal density, whilst under the black parts of the image the sensitive film will remain unchanged. The weakened white light from a grey object will as shown in 9, only produce partial blackening. If the color of the original does not correspond to any line of the screen and is not complementary to any, it will penetrate two colored fields with different intensity and cause different deposits. Yellowish-orange, for instance, as will be seen from 10, causes a deposit under the red and green lines. A whitish yellow-orange, as shown by 11, acts through all three lines, whilst a saddened yellow-orange or brown, causes only slight deposits under two lines, as shown in 12. Thus the light incident on the plate is split up by the closely contiguous linear filters into three parts, and the deposit under the same represents the red, green and blue parts of the same. If a plate thus exposed is developed, fixed, and placed in contact with a similarly colored plate, so that the red, green and blue lines will fall in the same places, we shall see a negative or complementary colored picture. If, however, from this negative a transparency is made, and this covered with the linear color plate, a positive picture in the colors of the original must be formed, which can be easily understood by considering that Fig. 119 is looked through, and that the opaque parts are transparent and the transparent opaque. The opaque parts in the negative are now transparent, and therefore colored, and the quantity or the brilliancy of the colors is in ratio to the deposit on the negative.

The theory of this three-color screen process may therefore be explained as follows: the rays which fall on the photographic film consist of red, green and blue light; they penetrate corresponding to the rest of

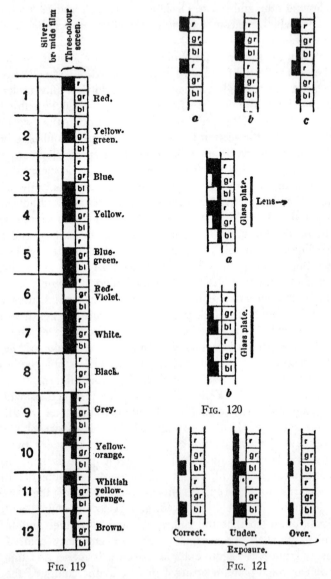

Fig. 119

Fig. 120

Fig. 121

these three constituents, the three analogously colored lines, and produce a proportional deposit. This deposit will then, by means of the transparency in combination with the line screen, decompose in proportionate ratio the three colors, and there is formed a color picture similar to the original.

Fig. 120 shows the production of a whitish orange, the upper diagram

representing the negative and the lower the positive, that is the negative reversed. Fig. 121 shows the effects of correct, under and over-exposure in the positive.

A. Förster[57] considered that the whites in an Autochrome were not formed by contrast action, but by subjective changes of the silver bromide film caused by exposure. Photometric comparison of the unchanged screen with a white place showed that although the white appeared whiter than the unchanged screen places, yet the latter transmitted more light. By microscopic examination of the whites, there was seen a fine deposit of silver, and this produced the whites of the picture, in comparison to the reddish grey of the unchanged parts. A. Schüller[58] thought that Förster's phenomenon could be easily explained from the different power of diffusion of the red, green and blue elements. It was found that the red units were the strongest diffusers, and the green the weakest. It was further determined that this difference disappeared as soon as a strong light diffuser was brought into contact with the film.

1. F.P. 83,061, 1868; Recueil des Brevets d'Invention, **104**, ser. XVII, Arts Industriels, fasc. 3, 8. Cf. E. J. Wall, Photographic Annual, 1910, 9; Photo-Rev. 1907, **19**, 41, 491; 1905, **17**, 189. H. Snowden Ward, Phot. J. 1900, **40**, 142.

2. Le Gers, 1869, March, 11, 15, 20, 25, April, 1, 6. These articles were subsequently published in book form under the title, "Les Couleurs en Photographie. Solution du Problème," Paris, 1869. The passage cited occurs on p. 54 of this book.

3. Special attention is called to this remark, as this principle, the so-called "black condition" has been ascribed to others.

4. "La Triplice photographique et l'Imprimerie," Paris, 1897, 336. Cf. E. J. Wall, Photographic Annual, 1910, 10; A. Mebes, "Die Dreifarbenphotographie mit Farbrasterplatten," Bunzlau, 1911, 10.

5. Phot. J. 1910, **50**, 197; Phot. Coul. 1910, **5**, 171; Brit. J. Phot. 1910, **57**, Col. Phot. Supp. **4**, 45, 52, 62, 68; abst. ibid. 1917, **11**, 24.

6. Phot. Ind. 1911, 929, 956, 998; Jahrbuch, 1912, **26**, 272.

7. J. Soc. Arts, 1908, **56**, 195; Brit. J. Phot. 1908, **55**, 41; Col. Phot. Supp. **2**, 12; abst. Brit. J. Almanac, 1909, 638.

8. "On some experimental methods employed in the examination of screen-plates," Phot. J. 1910, **50**, 197; Brit. J. Phot. 1911, **58**, Col. Phot. Supp. **5**, 45, 52, 62, 68; abst. Brit. J. Almanac, 1911, 613; Jahrbuch, 1911, **25**, 223.

9. "The Scientific Requirements of Colour Photography," London, 1897, 6; abst. Brit. J. Phot. 1897, **44**, Supp. 6.

10. Brit. J. Phot. 1895, **42**, 774.
F. E. Ives, Amer. Annual Phot. 1895, 24 commenting on Joly's statement said that König's curves are compressed at the violet end and are misleading. As a matter of fact, the curves given by Joly, were drawn on the diffraction spectrum scale, and therefore would actually give correct curves in accordance with the wave-lengths, and would not be compressed. Obviously Ives was ignorant of the diffraction spectrum. He also said: "Now, however, comes the suggestion from one who is no less than a F. R. S., that, since König's curves are more nearly 'correct' than Maxwell's, with which the writer succeeded, therefore, there is great latitude in the selection of color screens for this work. The inference is that as good, or better results should be obtained with screens proved according to König's curves König's curves do not represent mixtures of three spectral colors, but mixtures of red and violet, with a fundamental sensation which nothing in the spectrum represents, and which, therefore, cannot be optically mixed with other colors, as required in composite heliochromy."

11. Phot. Mitt. 1898, **35**, 273; 1899, **36**, 8, 14, 35, 46, 65.

12. Mees, loc. cit. 199.

13. "The Luminous Equivalent of Radiation," taken from O. Steindler, Wien. Sitzber. 1906, **115**, II a. Cf. P. G. Nutting, "Outlines of Applied Optics," Philadelphia, 1912, 129, 141.

14. Loc. cit. 212.
On the isolation of the filter cuts, see F. F. Renwick, Brit. J. Phot. 1909, **56**, Col. Phot. Supp. **3**, 95.
15. J. W. McDonough, E.P. 5,597, 1892; Brit. J. Phot. 1892, **39**, 651; abst. ibid. 1907, **54**, Col. Phot. Supp. **1**, 16; U.S.P. 471,186; 471,187, 1892.
16. Brit. J. Phot. 1909, **56**, Col. Phot. Supp. **3**, 84.
17. Phot. Rund. 1909; Brit. J. Phot. 1909, **56**, Col. Phot. Supp. **3**, 62, 70; Phot. Korr. 1910, **47**, 588.
18. Brit. J. Phot. 1914, **61**, Col. Phot. Supp. **8**, 4.
19. Brit. J. Phot. 1909, **56**, 100.
20. Mees, loc. cit. 200; Mees and Pledge, loc. cit. 215.
21. Loc. cit. 201; Mees and Pledge, loc. cit. 218.
22. Loc. cit. 218.
23. Brit. J. Phot. 1907, **54**, Col. Phot. Supp. **1**, 57.
24. Loc. cit. Cf. Von Hübl, "Die Theorie u. Praxis d. Farbenphotographie mit Autochromplatten," Halle, 1909, 2nd edit. 16. E. Valenta, "Die Photographie in natürlichen Farben," Halle, 1912, 2nd edit. 119; Jahrbuch, 1908, **22**, 134.
25. Brit. J. Phot. 1911, **58**, Col. Phot. Supp. **5**, 65; Bull. Soc. franç. Phot. 1911.
26. Phot. Ind. 1907, 907; Phot. Korr. 1907, **34**, 46.
27. Photography, 1907, 119; Phot. Korr. 1907.
28. Ibid.
29. Phot. Korr. 1908, **35**, 390; Jahrbuch, 1908, **22**, 390.
30. Phot. Mitt. 1909, **46**, 296.
31. Brit. J. Phot. 1907, **54**, Col. Phot. Supp. **1**, 57.
32. "Die Theorie u. Praxis der Farbenphotographie mit Autochromplatten."
33. Phot. Korr. 1907, **34**, 597.
34. Brit. J. Phot. 1907, **56**, Col. Phot. Supp. **1**, 6.
35. Ibid. 721.
36. Ibid. 25, 96; Jahrbuch, 1908, **22**, 96, 388.
37. Phot. Rund. 1906, **16**, 103; Jahrbuch, 1909, **23**, 299; Brit. J. Phot. 1908, **55**, Col. Phot. Supp. **2**, 87.
38. Phot. Korr. 1907, **34**, 461.
39. Phot. Rund. 1907, **17**, 210.
40. Photography, 1907, 119.
41. Phot. Woch. 1907, **34**, 261; Jahrbuch, 1908, **22**, 391.
42. A private communication to E. König, "Die Autochrom-Photographie," Berlin, 1902, 10.
43. Rev. Franç. Phot. 1923, **4**, 80; Amer. Phot. 1924, **18**, 384.
44. Zeits. wiss. Phot. 1907, **5**, 372. Cf. Valenta, loc. cit. 121.
45. "Theorie u. Praxis, etc." 27; Brit. J. Phot. 1908, **55**, Col. Phot. Supp. **2**, 5, 30, 82; Phot. Korr. 1908, **45**, 446, 496.
46. J. Soc. Arts, 1908, **56**, 201.
47. Popular Astronomy, 1908, **16**, 83; Brit. J. Phot. 1908, **55**, Col. Phot. Supp. **2**, 21; Jahrbuch, 1908, **22**, 395.
48. Brit. J. Phot. 1908, **55**, Col. Phot. Supp. **2**, 19; J. Frank. Inst. 1908.
49. Phot. J. loc. cit.; Phot. Korr. 1911, **5**, 237; Prometheus, 1910, 34; Jahrbuch, 1911, **25**, 377.
50. Jahrbuch, 1911, **25**, 371; Phot. Chron. 1908, **15**, 193.
51. Phot. Ind. 1909, 178.
52. Wien. Mitt. 1908, 121.
53. Der Phot. 1910, **20**, 73; Phot. Chron. 1910, **17**, 370; Jahrbuch, 1911, **25**, 371.
54. Wien. Mitt. 1912, 163; Jahrbuch, 1912, **26**, 270; Brit. J. Phot. 1908, **55**, Col. Phot. Supp. **2**, 30, 83.
55. Loc. cit. Cf. E. J. Wall, Brit. J. Phot. 1908, **55**, Col. Phot. Supp. **2**, 56.
56. Wien. Mitt. 1907, 387; 1908, 232; Brit. J. Phot. 1908, **55**, Col. Phot. Supp. **2**, 6. Cf. A. E. Salt, ibid. 55; Phot. Coul. 1907, **2**, 164; 1908, **3**, 294.
57. Zeits. wiss. Phot. 1911, **9**, 291; abst. Chem. Zentr. 1911, I, 1674; C. A. 1911, **5**, 3203. Cf. Brit. J. Phot. 1907, **54**, 761. E. Stenger, ibid. 1911, **58**, 247; A. von Hübl, ibid. 1912, **59**, Col. Phot. Supp. **6**, 13.
58. Zeits. wiss. Phot. 1912, **10**, 368; abst. C. A. 1913, **7**, 1681.

CHAPTER XVIII

SCREEN-PLATE PATENTS

Linear Screen-Plates.—The honor of making the first line screen, as outlined by du Hauron, may be fairly divided between J. Joly and J. W. McDonough. The former[1] (page 507) suggested the use of the color sensation curves (see p. 457). He also ruled plates with diagonal or other lines forming a filter screen that was placed in front of and in contact with a color-sensitive plate. Various pigments or dyes could be used, chrysoidin orange for the red; a mixture of ethyl green and chrysoidin for the green and water blue for the blue-violet. From the negative obtained in the camera, an ordinary black and white positive was made and bound up with a viewing screen, ruled in like manner but not with the same colors. In this case the colors were like the lithium line in the red, a green like the E line and a lapiz-lazuli blue. The lines should be 200 to the inch, and it was suggested that the same screen could be used for taking and viewing and then the emulsion might be coated on the top of the lines.

McDonough[2] also patented the same idea and disclosed the use of glass, mica or celluloid as the support, and various patterns of lines and mosaics, as shown in Fig. 122, in which the letters R, G, B stand respectively for red, green and blue-violet, and he proposed to provide the plate with registering patterns, marked T and O. Later he proposed to use various patterns, and also more than three colors, as shown in the letters R, O, Y, G, B, I, Fig. 123, which obviously mean the seven colors of the spectrum.

Macfarlane Anderson[3] proposed to use a frame carrying a number of parallel wires with interspaces half the diameter of the wires, the color filters were placed in front of the lens, and after an exposure with one filter, it was changed and the wire frame shifted so as to cover the exposed part and this operation repeated with each color filter. This method was primarily intended for photomechanical work. F. J. Harrison[4] proposed to use a "color ribbon," that is a length of celluloid uniformly stained and ruled with opaque lines, Fig. 124, in staggered pattern, twice the width of the interspaces. This was moved by clockwork in front of the sensitive surface in parallel with the lines and the result would be as though the lines had been ruled in juxtaposition on one surface.

C. L. A. Brasseur and S. P. Sampolo[5] patented the use of a black and white screen in front of a tri-color linear screen, the black lines being twice the width of the interspaces, and this screen was shifted between the exposures. F. Faupel[6] patented a process for obtaining linear and other patterned plates by coating a surface with a colloid and then ruling with a

roller saturated with a hardening liquid, such as formaldehyde or chrome alum. Or the colloid might be mixed with certain substances, such as hypo and ferricyanide of potassium and the ruling roller be made of copper, when cuprous ferrocyanide would be formed and tan the colloid. If iron were used for the roller, then Berlin blue would be formed and this might be used as one of the colors of the screen-plate.

Fig. 122. McDonough's U.S.P. 561,686 (Page 475).

F. E. Ives[7] proposed to obviate the difficulty of ruling linear screens by making negative records through a black and white screen, and shifting the same for each exposure, the latter being made through color filters, thus following Anderson and Brasseur & Sampolo. For viewing the resultant transparencies, it was suggested to use prismatic plates, as shown in Fig. 125, with three differently colored light sources, so placed that the lines over the red, green and blue elements refracted or transmitted to the eye, only the corresponding colored light. The best theoretical conditions for carrying out this idea involved three separate but sufficiently powerful light sources, with a separation equal to about 3 degrees of arc from the observer, and at sufficient distance to make all the utilized rays approxi-

mately parallel, as they struck the viewing screen. In Fig. 125, *l* represents the light source *A*, which was shielded on three sides by a screen

FIG. 123. McDonough's E.P. 12,645, 1896 (Page 475).

FIG. 124. Harrison's U.S.P. 578,147 (Page 475).

having blue, green and red sides, *B, G, R*, so that the rays were colored. Diagonal mirrors *E, F* reflected the red and blue rays. The prismatic

screen x was provided with plane surfaces g, flanked by prismatic surfaces r and b, the green rays being incident perpendicularly on the plane surfaces, whilst the red and blue were refracted. In order to render the rays parallel, the condenser w might be used and y to converge the light passing through the linear transparency i. Other suggested forms of prismatic surfaces are shown in *2, 3, 4.*

M. Petzold[8] patented a process in which cold saturated solutions of azo or acid dyes were made in 1 per cent solution of an alkaline chromate, and lines ruled therewith on gelatinized glass; the red and green lines thus produced were dried and the plate bathed in a concentrated solution of rosanilin blue, which only dyed the interspaces. For the red, Bordeaux, orange scarlet or ponceau were used and acid green for the green. L. Horst[9] patented a system of forming an image on a line screen and then reducing the two on to a film.

FIG. 125. Ives' U.S.P. 648,784 (Page 476).

Dusting-on Methods.—The production of irregular mosaics by the dusting-on of particles seems to have found considerable favor with inventors, though the Autochrome and Agfa plates are the only ones that survive.

J. W. McDonough[10] was the first to patent this method. He proposed to coat the plates with varnish or like material, that would dry tacky, then dust over the plate a mixture of colors composed of fine or powdery particles, containing the desired colors. Powdered glass, transparent pigments, gelatin, resin or shellac, stained with anilin dyes were suggested; and in the case of glass the particles might be afterwards fused into the body of the support. The preparation with shellac is rather fully dealt with; it was proposed to dissolve the same in alcohol, white shellac being used, and anilin colors were added. The red, formed of yellow and red, was to cut off as much green as possible, in fact to be a pure red. The

green was to be as pure a green as possible, the blue being cut off by admixture of yellow. If the mixture thus formed did not give a bright yellow, then a yellow, as near spectrum yellow as possible might be added. Another lot was colored blue. After drying, grinding and sifting, the powders were to be mixed so as to form black. The mass dusted on glass would reflect or transmit all the colors, and the result would be white, in proportion to the purity of the color, and quantity of light transmitted or reflected. This is the first black condition to which reference has already been made, and which was outlined by du Hauron.

The plate thus prepared will show small interstices between the particles and to fill these up the plate was to be heated till the edges met. This plate was to be coated with panchromatic emulsion, or as an alternative it was suggested that an ortho plate be rendered tacky and the colored particles dusted on its surface. The picture might be used as a negative, or be backed with a black surface so as to be viewed by reflected light, as the old ambrotype. The plate might be exposed through the back and the gelatin and silver not acted upon by the pyrogallol developer removed by hot water. It will be gathered from the above that McDonough recognized the process as an additive one, hence his terms "pure red," etc.

The Société Anonyme des Plaques et Papiers A. Lumière et ses Fils[11] patented a dusting-on method, and the plates are commercially available as the Autochrome plates. The colored elements might be grains of starch, ferments, yeasts, bacilli, pulverized enamels or other transparent powdered matter. These were to be colored red, yellow and blue, then mixed in such proportions that they do not show any appreciable color. The glass was to be rendered tacky and the colored units spread over the same so as not to overlap. Then a second coat of tacky matter was to be used and a second coat of elements, and a varnish was then to be applied. It is pointed out that this varnish must have a refractive index, similar to the color units, so as to prevent diffusion of the light. And the superposition of the above named colors would produce red, green and violet, though where they did not superpose the simple colors would be seen. After the insulating varnish, the emulsion was to be coated and reversion of the negative image was disclosed. This double coating is not disclosed in the U. S. P., but is in the German, and the latter is more specific in that potato starch is taken as the particular grain. Later[12] the same inventors found that two superimposed layers of color elements were not actually necessary but that the same results could be obtained by the six colors, red, orange, yellow, green, blue and violet, but also by any given number of colors, distributed in a single layer, and that the powdering might be commenced with large particles and finished up with smaller ones to fill in the interstices, or even black might be used. And it appears[13] that the first powdering might be done with two colors and the third applied subsequently. Further patents[14] also claimed the perfect continuity of the

screens by softening and crushing the colored elements; but whether this particular method was ever adopted is not known, but certainly commercially no one has ever reported the occurrence of Autochrome plates without the black filling.

H. Clement[15] would replace the starch grains by corpuscles infinitely small, rigorously of the same size, ultratransparent and yet capable of being stained by the absorption of colors when alive, these corpuscles being the spores of champignons, algae, mosses and the like, of which the growth is arrested at the desired moment. E. Gistl[16] while recognizing that fine glass particles had been suggested, pointed out that in melting the same to make them adhere to the glass, they would assume a more or less spherical form and would then act as refractive elements, therefore, he proposed to grind and polish them flat, after firing.

The Aktien Gesellschaft f. Anilinfabrikation, usually known as "Agfa," introduced[17] a screen-plate that was prepared from gum arabic; this being colored, broken up and then deposited on glass, and by suitable treatment pressed flat, so that there were no interstices. The margins of the elements frequently overlapped so that there were black outlines. As the gum would be attacked by aqueous solutions, the film was provided with an insulating varnish, which was zapon or celluloid varnish, about 0.02 mm. thick. For further notes on this plate see page 578.

J. Bamber[18] proposed to use gelatin as the color carrier, and sheet gelatin was stained up and dried, then immersed in a 15 per cent solution of formaldehyde and dried. This last treatment made it very hard and brittle in water, in which it was then soaked and allowed to expand to its fullest extent; excess water was removed and it was ground up to a fine granular state. Grinding should be effected under 75° C. and the powder allowed to dry, then further grinding carried out. The powder, thus obtained was of various sizes and elutriated in petroleum spirit, about sp. gr. 0.680, or some other spirit that it did not absorb. By this process it was possible to select grains in equal batches of from 1/300 to 1/3000 of an inch. Transparent celluloid was then coated with a solution of celluloid and a resinous gum that remained tacky, and the colored powders, suitably mixed, sifted on, having been previously dried at 100° C. The screen thus formed was exposed in a room under normal conditions, so that the gelatin grains expanded by absorption of moisture from the air, and there would be interlocking of the grains, so that no white light passed, or a warm solution of gelatin might be sprayed on for the same purpose. After expansion the screen was passed through polished pressure rolls, slightly heated; there was thus obtained a perfectly even surface, which after being varnished with celluloid, might be again passed through the rolls slightly heated and be coated with panchromatic emulsion. Glass plates might be used and be coated with pale gold size to form a tacky surface.

In a subsequent patent[19] Bamber proposed to avoid the use of the com-

pensating filter by a colored substratum below his filter elements, gamboge with a little red being specified. He claimed that this did not slow the plate nor interfere with the optical adjustment of the lens. With the latter claim there can be no dispute, but as to the former, it is, of course, immaterial where the filter be interposed, the effect on exposure must be the same. Gelatin, as the color carrier, was later[20] abandoned by Bamber and he used sandarac and castor oil, dissolved in alcohol, stained up and allowed to evaporate and powdered. The support was to be coated with a mixture of sandarac, castor oil, oil of lavender and alcohol, and the dry powder dusted thereover; the castor oil being to prevent the grains cracking. After superfluous grains had been dusted off, the screen was submitted to the vapor of alcohol, wood naphtha, acetone, etc., and the grains already softened by absorption of some of the essential and fixed oils were quickly liquefied by the vapor, and capillary attraction between the grains is said to have drawn the liquid colors into the smallest spaces, leaving the screen gapless and transparent.

H. W. H. Palmer[21] proposed to make the color grains by spraying colored solutions into an elongated chamber, and catching the small particles thus formed. The solution might be gelatin, gum arabic, tragacanth or the like, hardened with formaldehyde; or celluloid or colloids; or dammar, mastic, lac or the like might be dissolved in amyl acetate, benzol, alcohol or other spirit and the particles after application to the support might be flattened out. It is also disclosed that liquid colored glass might be blown into fine particles and subsequently fired to make a mosaic. The celluloid or colloids mentioned might be blown on to celluloid film during manufacture, while the latter was still plastic and passed through polished steel rollers, or the colored particles made of materials having no affinity for the components of the liquid celluloid mass, might be incorporated therewith, and so form part of the film in the making.

F. L. Dyer[22] proposed to make the colored particles by atomizing a solution of celluloid in amyl acetate, into an electrically polarized atmospheric field, produced by the convective passage through the air of a current of high tension[23] and the fibers thus formed were to be subjected to intense cold, such as liquid air, and then powdered. R. Ruth[24] also suggested producing the color elements by atomizing gelatin solutions, resins or colloids, and allowing the particles to settle on to a tacky surface; the height of the atomizing chamber being so adjusted that they would be dry when they settled. In a later patent[25] Ruth proposed to add colors to a panchromatic emulsion and atomize the mixture in the same way.

C. L. A. Brasseur[26] suggested cutting blocks of celluloid of the desired size, or sheets, threads or filaments of artificial silk, after coloring, and then to roll the small particles between disks or plates till they assumed a spherical form, either with or without heat. A sheet of paper was stretched on a flat board, etc., and coated with a tacky material and allowed to dry,

32

so that the celluloid spheres would roll thereon. As soon as the surface was completely covered it was subjected to heat, moisture or spray so that the spheres adhered. The paper was transferred face down to celluloid cast on a flat surface and heat and pressure applied, so that the spheres flattened out, the paper being stripped. If there were interstices, they might be "daubed over" with dichromated gelatin and exposed to light through the back. Black and white screens might also be made by this method. Subsequently[27] the same inventor proposed to print on paper coated with an adhesive, with a copper plate, using some liquid that would render the coating adhesive, then applying the grains, again printing with a moistener and repeating for the other two colors. The colors would be thus symmetrically arranged and could be transferred to glass or celluloid.

C. F. Bleecker[28] proposed to make spherical granules from glass, silica or borax, especially low-melting colored lead glass, grinding and sifting the particles till all of the same size, then allowing them to fall through a gas jet, burning under a pressure of about 20 pounds per square inch, which fused them into spheres, and blew them into a cooling bin. The particles might be again sifted and dusted on to a support. C. Schleussner[29] suggested sifting colloid particles on to surfaces coated with glycerol and glacial acetic acid, evaporating the acid and then applying steam till the particles joined up.

I. Kitsee[30] would coat paper with gum solution, dry and coat with celluloid in amyl acetate or other solvents, but not in alcohol-ether, dry and then cut the celluloid by the same machinery as used for half-tone screens, into squares; it being an easy matter to make cuts every five-hundredths of an inch, and it is possible to go as high as eight hundred, thereby making individual pieces small enough to require more than half a million to the square inch. After the film had been cut, the support was soaked in water, so that the gum was dissolved and the small pieces released. The different colored pieces were then well mixed and applied to their final support. The same inventor[31] would dissolve soluble cellulose or gelatin, and spray into a large and high compartment, collect the particles and apply by spray to a tacky support.

M. Wieland[32] proposed a phenol-formaldehyde condensation product, a suitable coloring matter being added. An intimate mixture of such globules was dusted on to a prepared plate, excess removed and the plate so heated that the globules softened and coalesced, and the hardening process was completed by pressure and heat. A final coat of colorless condensation product was to be applied.

H. W. H. Palmer[33] proposed to use casein or gum, which can be rendered insoluble in water after dyeing, to grind and mix the powders till the first black condition was satisfied and then apply to glass. On standing the grains absorbed moisture and could be flattened out by pressure, thus filling the interstices. Later Palmer[34] proposed to use ceramic colors,

or chemically stained fluxes and fuse on to glass. A. Montagna and G. Ascoli[35] also patented the use of glass which contained a trace of arsenic acid, and this was powdered with a mixture of blue and crimson, or violet or green, low-smelting grains, then fired in with a yellow mass. The previously prepared side was then coated with a silver chloride emulsion, the plate exposed through the back and the unreduced silver chloride dissolved and the plate again heated. Obviously the silver emulsion was to give the familiar yellow-flashed glass. Wieland, Hamm and Mohr[36] also proposed glass globules having different melting points so as to form an even surface without interspaces, or mixed colors when fired. It was pointed out[37] that McDonough and Palmer had proposed to use glass elements.

F. M. Duncan[38] patented the use of particles of gum tragacanth or allied gums and also the use of dichromated fish glue. A. Borrel and P. E. Pinoy[39] would use microbes, staphylococcus, etc., killed by heat and stained. Later[40] they claimed yeast cells, though this had been patented by the Lumières. The Chemische Fabrik B. T. Silbermann[41] proposed the use of stained particles of calcined magnesia. The Farbenfabrik vorm. Bayer[42] suggested a multi-color screen of irregular pattern, in which a bottom layer was covered with particles, and in any interstices the layer was stained, this last color depending on the tint which the screen as a whole should have.

A. Wiebking[43] proposed to spray dissolved resinous or colloid substances into a liquid that should coagulate them; for instance, in the case of gelatin, ferric chloride, chrome alum, tannin, etc., might be used; and in the case of alcoholic solutions of resins, water. E. Fenske[44] introduced the "Aurora" plate, which was prepared by sifting fine particles of dyed materials on to a tacky surface. The particles were rather unequal in size and there was a deficiency in green. A black filling was used to fill interstices. P. H. Uhlmann[45] provided a negative with a grainless matt layer of slightly adhesive material, to which color particles would adhere, and the use of a tacky matter was also claimed.[46]

Dichromate Processes.—The hardening action of light on dichromated gelatin and the ready absorption of dyes by the latter would naturally lead to its use for making screen-plates, particularly as extremely thin films can thus be obtained. Ducos du Hauron (see p. 456) was the first to suggest this and C. L. A. Brasseur[47] seems to have been the first to copy him. A suitable support was substratumed, flowed with colored gelatin, or this might be colored afterwards, sensitized with dichromate and exposed with a black and white screen as suggested by du Hauron. After printing an insulating varnish or coat of colorless gelatin might be applied and a second coat of colored gelatin be applied, sensitized, printed and again insulated and the third applied. It was stated that screens having over 500 lines to the inch had been thus prepared. The necessity of using a compensating

filter is pointed out and this the inventor would obviate by coating both viewing and taking screens with a thin gelatinous film stained to the correct color.

J. H. Powrie[48] also used the dichromate process, but preferred fish glue as the colloid, though gelatin and albumen were disclosed. The dichromated fish glue was coated on glass, whirled so as to obtain a thin and even coating, and rapidly dried by heat, then exposed under a black and white screen, the transparent lines of which were half the width of the black. Development was effected with cold water, and the insolubilized lines dyed up. It is here that Powrie utilized what was at that time a new principle, namely the application of an acid dye and then mordanting with a basic.[49] For instance, aurophenin, an acid yellow dye was first applied and absorbed by the insolubilized colloid, then a basic dye, such as brilliant green, for the green, safranin for the red, or thiazin red might be used for the latter. The acid dyes, in consequence of the extremely thin film, gave but a faint coloration, but the basic being precipitated or mordanted, gave quite a deep color, which could not be obtained by a single color (see also Bawtree, p. 446). This process has also the advantage that the dye compound is insoluble, there being no tendency for it to bleed, and moreover, it enables the necessary absorptions to be obtained much more readily. The dyed lines were insolubilized further by treatment with tannin or formaldehyde, and the former would again tend to stabilize the dye, as tannin is well known as a mordant for basic dyes.

The surface was again coated with dichromated colloid and exposed under the matrix screen so that the previously obtained lines were covered by the opaque lines. This was effected in a very ingenious manner, for the matrix screen was shifted till the colored lines suddenly disappeared. No care was taken to see that the edge of the matrix screen was contiguous to the colored line, merely that the latter was covered, thus the lines might and would not exactly juxtapose. As a matter of fact the finished screen showed red, blue, green, blue lines and the width of the two blue lines was not the same. Powrie disclosed the use of Victoria green, emerald green and auramin in acetic solution for the green; thiazin red R and safranin for the red, and acid blue, soluble blue, methyl blue or methyl violet for the blue lines, and obviously others could be used; violamin R being an excellent mordant for the blue also. The inventor admitted knowledge of du Hauron's process. Obviously it is possible to make mosaic screens by this process, as was subsequently done by the inventor, by placing the matrix screen in the second exposure at right angles to the first impressed lines. It was also pointed out that the colors being insoluble there was no necessity for an insulating varnish. Further notes on this process will be found on page 574.

C. L. Finlay[50] also used dichromated colloids and employed as matrix screen, one with circular dots. Stripping or transfer paper was coated

with soft gelatin, holding in suspension a silver halide and when dry was printed in one of the three colors, and, after moving the position of the matrix, another color was printed. The coating was now transferred to its support, and the temporary support removed. Hot water being used for development the soluble gelatin above each color patch was dissolved, the progress being visible by the washing away of the silver halide, which also prevented the too great swelling of the gelatin, this being the principle utilized by Lumières. Two colors were printed as circles, the red and green, and the interspaces stained up in blue. Such a screen could be coated with panchromatic emulsion, or used as a separate screen.

O. S. Dawson and C. L. Finlay[51] proposed an improvement on the above, in that the matrix screen was prepared by the use of the ordinary half-tone screen with a circular diaphragm, circles being thus obtained on a plate, occupying about one-third of the area. From this a positive was made and used as a matrix for printing on to dichromated colloid. After dyeing a second sensitizing was effected, the matrix shifted and a second series of circles printed and stained, the third color being obtained by dyeing the interspaces. O. S. and H. E. Dawson[52] adopted the same method, only varying the shape of the elements, one being a circle, another an oval and the interspaces being of diabolos form.

C. E. K. Mees and Wratten & Wainwright[53] patented the production of a screen composed of a single coating, differentially stained up, and which could be made in one operation. One method of carrying this into effect was to use a colloid, sensitized with dichromate and dyed up, or after-dyed with, for instance, patent blue. This was exposed under a matrix of graduated opacity and conveniently composed of lines in sets, each set comprising a black or opaque line, a semi-opaque and a clear line. This might be made in various ways. After printing under this matrix the plate was washed till the dye was completely removed from under the opaque line, or where it had not been exposed, and partially washed out from those lines of semi-opacity. The result would be a deep blue line, one more bluish-green, partially washed out and the third colorless. The plate was then to be soaked in a yellow dye, that would only take in soft gelatin, as a result the blue line of hardened colloid would be unaffected, the half-hard and half-soft line would be pure green, owing to the addition of the yellow on the bluish-green, and the clear colloid would be yellow. By subsequently dyeing with a red dye that only takes on soft gelatin, this yellow line would be turned scarlet.

F. Faupel[54] whilst using dichromated colloids, did not develop the same but used their differential absorption for different dyes. Azorubin and crystal ponceau 6R were used for the hardened colloid, and methyl blue, brilliant wool blue G and brilliant azurin for the soft. The two-color screen thus obtained was again sensitized and exposed under a matrix with the lines running at an angle to the first and the plate was immersed in a

yellow, such as fast chrome yellow G, and the untanned rectangles of the blue-dyed colloid were stained green. In a subsequent patent[55] Faupel proposed to immerse the exposed colloid in a mixture of naphthol green and crystal ponceau. After some time the hardened lines would be stained red and the unhardened green. The film was again sensitized, the dichromate being taken up only by the soft green lines, and then on exposure the uncovered green lines would be hardened. The film was then immersed in a mixture of alcohol and water which decolorized the untanned fields and it was then immersed in brilliant azurin solution, which only took on the colorless parts without affecting those previously dyed.

E. Sanger-Shepherd[56] adopted du Hauron's method exactly. A. Löwy[57] also probably used the dichromate method as a colloid film was used, figures impressed by light and the dye partly retained or partly washed out or bleached. Then a fresh sensitizing which only took on the unhardened parts, fresh exposure and this repeated for the third time. C. Späth[58] patented a process which is almost identical with that of Faupel, using ponceau BO and brilliant azurin for the red and blue lines and flavazin for the yellow dye, and the alternative of washing out the dye with alcohol and water and the use of the same dyes is disclosed. The ways of authorities of patent offices are above the understanding of most laymen, and it will be seen that this is not the only instance in which practically or actually identical processes are protected.

J. M. Child[59] patented a process of making hexagonal elements by ruling parallel line screens and combining them in three layers with the lines crossing at 60 degrees, to form clear hexagons on a black ground, and printing from the combined film to form a matrix, a special frame[60] being used in the dichromated colloid printing. Berthon and Gambs[61] printed on dichromated colloid, dyed up with red dye, which was soluble in water, and the plate washed till the dye was removed from the unhardened lines. The plate was then immersed in a blue dye, which only took on the uncolored lines. The plate was then varnished, coated with dichromated colloid dyed yellow. Exposure was made with the matrix lines at 45 degrees to the first lines, and after washing was dyed up in blue. The plate thus showed blue lines with yellow interspaces, but by superposition with the first screen they were crossed by the red and blue and thus gave green and violet.

J. M. Borrel[62] utilized this common idea, and the plate was stained in red, which took on the exposed parts, the chromium salt being said to act as mordant. It was then stained blue which took only on the unexposed and after again sensitizing and printing with the matrix lines at right angles to the first it was stained yellow. The result was orange lines with green and blue rectangles, and immersion in a red dye, which acted only on the blue, formed violet. R. Goldschmidt[63] and F. M. Duncan[64] also used the dichromate method. B. Bichtler[65] coated both sides of a support with

dichromated colloid, printed under a matrix and then only one side was again coated, exposed and dyed up.

Cut Screen-Plates.—Under this section are included those methods in which sections or slices of superimposed sheets of colored celluloid are made. O. N. Witt[66] appears to have been the first to patent this method, and he pointed out the difficulties of avoiding black lines through the marginal superposition of ruled elements. This he proposed to overcome by superposing sheets of thin celluloid, colored suitably, with a cementing

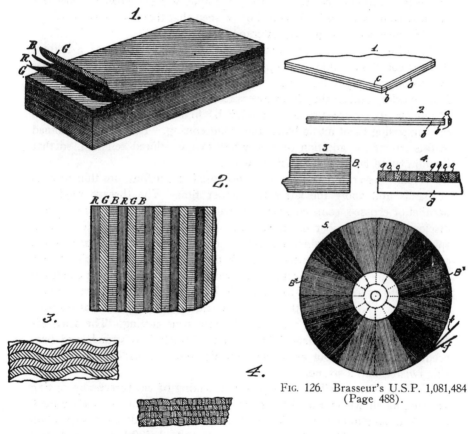

FIG. 126. Brasseur's U.S.P. 1,081,484 (Page 488).

FIG. 127. Fifield's U.S.P. 990,247 (Page 488).

solution of celluloid to make them adhere. A block was thus made of the requisite height to give the breadth of the desired screen. Or instead of this, sheets of greater thickness might be made and rolled out to the requisite thickness as in the manufacture of ivory celluloid. The use of gelatin sheets in the same way was suggested. This patent was never completed, but Witt had proved by actual experiment that the idea was feasible, and the patent was abandoned on May 8, 1899, in consequence of non-payment of fees.

A month earlier, R. E. Liesegang[67] had also applied for a patent, and stated[68] that screens in which black lines gradually merged into white or one color into another could also be made by this process (Witt's). With such black and white screens it would be possible to obtain half-tone negatives in the camera, without any separation between the screen and sensitive surface. Further it would be possible to print on copper with the interposition of a screen. Dot-form screens could also be made by cutting blocks made as above at right angles to the direction of the lines. Instead of sheets, solution of celluloid or the like might be cast, allowed to dry and the next coating poured. It will thus be seen that there is a clear description of processes subsequently patented.

R. Krayn[69] patented this process and suggested the use of a bottom sheet of colorless celluloid as support. In a subsequent patent[70] each sheet was to be cast separately, then cemented into blocks. By making cylindrical blocks[71] and cutting thin veneers long lengths of film were obtainable. Mosaic screens were also to be made[72] by first cutting veneers and then superimposing them into a block and again cutting. There is also claimed in this patent the addition of zinc white to the colored celluloid, so that the film could be used for positive work.

W. C. Masser and W. Hudson[73] proposed to cut film into thin threads or bands and apply the latter to another film. The threads might be parallel or crossed, some colorless or opaque. Various modifications were disclosed and a number of films might be clamped to form a disk on a spindle and rotated against a knife, applied at the circumference of the disk. The Vereinigte Kunstseidefabriken[74] proposed to make color sheets from 0.125 to 0.15 mm. thickness, and whilst they were in a soft condition to press into a block and cut the same. F. Fritz[75] thought the above methods troublesome and proposed the use of materials woven of artificial threads, then combining these into a block and subsequent cutting. The same effect was also[76] to be obtained by spinning threads into strands and proceeding as before. Dot or mosaic screens could be made from artificial silk, twisted into a strand.

C. L. A. Brasseur[77] also patented the making of cut screens by cutting veneers, as shown in Fig. 126, in which *1* shows the three sheets united, and *2* the same in end and side views, and *3* a block made by superposition of many sheets. The width of the line was to be 1/520th of an inch, and the thickness not more than 1/2500, and with some colors even 1/4000 of an inch. It was proposed to grind down the sheets, as shown in *4*, as it was impossible to cut such thin veneers. The formation of a long screen is shown in *5*. F. A. Fifield[78] would adopt the same method precisely. Fig. 127 shows the various forms of the finished screens.

M. Obergassner[79] would make line or mosaic screens by coating a glass plate with gelatin solution, colored with the requisite color, and cutting lines in the same with a plane, then again coating, again ruling lines and

coating a third time. This would produce a film with the three colored lines or mosaic, but there would also be superposition of the colored gelatins and the film was to be planed down till only three colors showed.

H. Snowden Ward,[80] when speaking of the McDonough-Joly process, said: "Dr. Joly patented a method of making such screens (or light-filters) by laying dyed silk across a glass support; and he made a still more interesting and promising suggestion. This was to take a great number of sheets of colored gelatin, alternating red, green and violet, and

FIG. 128. Smith's E.P. 6,881, 1906 (Page 490).

lay them down in a great pile, like the leaves of a book, until the edges of the sheets should cover an area equal to that of the desired screen. Then by cutting sections across the edges (at right angles to the surfaces of the sheets) it would be possible to make a great number of thin films each consisting of the desired colored lines." The author has not been able to verify this statement, but it would look as though Joly was the first to suggest, possibly simultaneously with Witt, this method of making screen-plates.

Photomechanically Printed Screen-Plates.—This class is a somewhat small one, probably due to the difficulty of making the original printing plates with fine enough elements and secondly to the difficulty of the transfer of the colors.

J. H. Smith[81] would employ unit areas regularly distributed, such as equilateral triangles, and their combinations to regular hexagons and rhombuses, which lend themselves to the purpose without overlapping.

Fig. 129. Szczepanik's E.P. 6,098, 1907.

Six elementary colors could also be used. This regular distribution was obtained by arranging round every central point where the unit areas met, all the colors employed in the screen. In Fig. 128 are shown some of the units that might be employed; *1* shows equilateral triangles; *5* the three colors grouped round every point where the hexagonals meet.

J. H. Smith, W. Merckens and H. B. Manissadjian[82] pointed out the difficulties of obtaining good results by ordinary photomechanical printing and would use intaglio steel or copper plate printing. Soft paper, with

very little sizing, was coated with gum arabic or other water-soluble matter, then with a coating of soft pyxroxylin, the screen printed on this and transferred to glass or other support, and stripping the paper. There is also disclosed three transfers. J. S. Szczepanik[83] would print fine lines so as to cross. The several phases in the production of such a screen are shown in Fig. 129. It will be seen that not only are there black but white areas as well, and the results in the positives from such plates must be degraded in color.

H. W. H. Palmer[84] would arrange the elements in a "key" pattern, and after printing one color, shift the block and print in the second and then the third in the same way. The three stages in the process being shown in Fig. 130. Metal type could be used, or etched plates, or dichromated colloids, and the print photographed down. Printing from rubber or celluloid or the offset process might be adopted and the process was

Fig. 130. Palmer's E.P. 8,761, 1910.

said to be particularly suited for cinematographic films by using rollers. Paper coated with such a screen-pattern could be sensitized with print-out emulsion, and thus the commercial production of color prints would be rendered possible.

G. Valensi[85] would form the elements with contiguous hexagons about 0.001 mm. These might be produced by photographing on a reduced scale, designs in black and white. The elements were to be produced on both sides of a film, the red on one side, the yellow on the other; the blue being obtained by resensitizing and printing through the existing elements. This was stated to be particularly suitable for cinematography.

C. L. A. Brasseur[86] also proposed to print regular screens from a copper plate. I. Kitsee[87] patented the formation of screen-plates by photographing the patterns on to rollers, etching and printing. A. Nodon[88] would use a transparent and flexible support with greasy litho or typographic ink lines in two colors horizontally and others angled so that in a square there

would be four elementary colors, blue and orange as one pair, red and green as the other, each pair being complementary and forming white.

Screen-Plates with Resists.—It is frequently easier to prevent the deposition or absorption of a color, than it is to remove the same after it has been absorbed and, therefore, the use of resists to protect the supports of possible screen-plates has received considerable attention.

A. Baumgartner[89] first printed a red grain on gelatin-coated celluloid in an oil color by lithography. Then dipped it into a blue-green dye solution which only took on the unoiled parts. A grain of yellow might then be printed and, as there would be partial covering of the red and blue, orange and green would be formed. Or celluloid might be printed in red and yellow, so that they overlapped, then a coat of dichromated gelatin dyed blue might be applied and exposed through the back, when the light would not act through the red and yellow and on washing the blue would

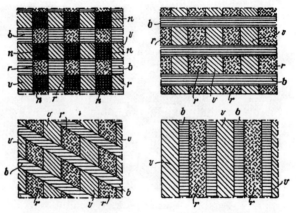

Fig. 131. Du Hauron & Bercegol's E.P. 194, 1907.

be left in full depth on the unprotected parts, and as a little action would take place through the yellow, some of the blue would adhere and form green.

L. Ducos du Hauron and R. Bercegol[90] used a greasy resist of one or more colors applied with a ruling pen. Thus, a sheet of glass or celluloid was coated with gelatin, a coat of varnish colored green applied and lines drawn in parallel through the varnish and the sheet dipped into an aqueous solution of orange dye, which would soak into the gelatin through the fine lines. A third color was provided by coating again with varnish, colorless and impermeable to water, and fresh lines were drawn through this, rather deeper than the first ones, so as to expose the lower layers of gelatin that the first lines did not reach. These lines might be parallel, oblique or at right angles to the first. The sheet was then to be dipped into a violet bath, which would take on the gelatin. Celluloid superficially

colored green might be used, and the lines drawn sufficiently deep to lay bare the colorless base, and if a protective coating of gelatin had been used the dye might be applied with acetone or other celluloid solvent. Then the deeper lines might be ruled as above, and the third color applied in the same way. Lines might be drawn on copper, zinc or litho stones and the resist ink applied by the same. To produce films rollers might be used. The support might be colored to act as a compensating screen. Fig. 131 shows some of the possible variants.

Fig. 132. Krayn's E.P. 26,911, 1909 (Page 494).

G. S. Whitfield[91] dyed a film of collodion, then applied a resist of rubber, bitumen or wax by means of a spray, and the color was removed from the exposed parts by washing out, or bleaching with chlorine, or an acid or alkali, and the colorless parts dyed up with a second color. Another set of resist spots was applied and the operations repeated for the third color. R. Krayn[92] used a resist and mordant for the dyes. A gelatin-coated surface was impressed with greasy lines and the unprotected parts treated

with cinnabar scarlet (von Beyer & Kegel). This penetrated the gelatin and was fixed with ferric chloride. The resist was removed, fresh lines impressed at an angle to the former and methyl blue for silk (Hoechst) was then used and mordanted with ferric chloride. The greasy ink was removed and the uncovered parts treated with a mixture of patent blue A (Hoechst) and yellow F, this being also fixed with the iron salt. The result was six or seven red lines to the millimeter with green and blue units arranged at 45 degrees in between as rhomboids. The colors transmitted by the filters were, for the red down to 5600; the green from 5700 to 4800 and the blue from 4900 to the ultra-violet. The various stages are shown in Fig. 132.

C. Späth[93] used rubber as a resist for the two sides of celluloid and a series of lines were ruled on one side so as to expose the celluloid and a 2 per cent solution of Victoria blue in absolute alcohol was used. The protective layer was again ruled at right angles to the first lines and the uncovered base stained up with a mixture of auramin and ethyl green in 80 per cent alcohol. The resist was then removed, the uncolored parts were stained up with rubin and auramin in 60 per cent alcohol. In a subsequent patent[94] Späth proposed to soften the surface of celluloid so that it would receive a colloid. Acetone and alcohol were used in varying ratios and the base stained up in quinolin yellow, then mordanted with tannin. Greasy resists could be used but the essence of the patent is the use of basic dyes, which are absorbed by celluloid.

L. Dufay[95] exposed a dichromated colloid under a matrix line screen, or other patterns could be used. After washing the soluble parts were stained and then a greasy resist applied, which only adhered to the exposed parts. Pulls were then made on to a gelatin coated surface and the dyes were transferred. Before complete drying of the resist the plate was coated with an alcoholic varnish, and as soon as this was dry the resist was removed, leaving the dyed elements covered with varnish. Then another transfer was made from another plate as before and the plate would thus bear two colored elements. The uncolored places were dyed up by contact with a gelatin pad saturated with color.

In a subsequent patent[96] the method of applying the resist by means of a spray or copper plate was disclosed. Fig. 133 shows the various stages: *1* and *2* show the first stage in end view and plan, that is the application of the resists *c* with the interstices *d,* and *3* represents the result of the dyeing. *4* the layer of varnish, whilst *5* and *6* show the removal of the varnish. *7* shows half the surface covered with resist, *8* the result of the second dyeing and *9* the finished plate. The colors are indicated by the letters, *w* for violet, *o* for orange and *v* for green; *10* to *15* show various patterns that could be produced.

Another patent[97] was taken out by Dufay; a resist was applied and lines cut there through to varying depths and stained in various colors;

but the disadvantage of this was that the elements did not lie in one plane. To overcome this trouble and some manufacturing difficulties it was proposed[98] that the recesses should be filled up to the level of the upstanding parts of the support with a colored filling. Fig. 134 shows the various stages and effects obtainable and calls for no comment. In yet another

FIG. 133. Dufay's E.P. 18,744, 1908.

FIG. 134. Dufay's E.P. 15,027, 1908.

patent[99] the celluloid was to be grooved on one face only and, instead of packing the grooves with a greasy homogeneous matter, it was mixed with perfectly transparent elements, but of slightly smaller diameter than the width of the grooves, and these elements were dyed before mixing and were introduced into the recesses. The film then showed two transparent

colors and it was only necessary to dye the uncolored spaces with the third color. By this method six or nine colors might be used.

The Vereinigte Kunstseide-Fabriken[100] impressed celluloid with fine lines and applied greasy resists to the raised bands, and by immersion in an alcoholic solution of the dye the depressions were dyed. The resist was removed, the depressions were again formed at right angles to the first and the prior operation repeated. After removal of the resist the raised parts were coated with dichromated gelatin, rendered insoluble by light, then dyed up and the sheet flattened by heat and pressure. In an improvement[101] the same inventors would utilize the non-absorption of a dye by a previously colored area, during short immersion in a second solution.

The Société Anonyme des Plaques et Papiers A. Lumière et ses Fils[102] applied a resist to gelatin dyed with one of the colors in a pattern and then destroyed the dye by some chemical agent. A second series of lines was imprinted at right angles to the former and the same operation gone through. The same inventors[103] would utilize the principle of basic dyes precipitating acid dyes, as first employed by Powrie. A gelatin-coated support was given a resist as to two-thirds of its surface and the exposed parts dyed orange with eosin scarlet, and the resist removed. A further series of resists were imprinted and the sheet immersed in metanil yellow S, and cyanin V, to which was added some iron salt. This mixture dyed the free parts green, and the iron salt prevented any action on the eosin scarlet. The resist was removed, the remaining parts dyed with methyl violet, and the precipitation of this last dye by the eosin and green dye prevented the penetration of the parts already dyed. As to the use of iron salts see Krayn, page 494.

J. Rheinberg[104] proposed to use a colloid as a resist, and sensitized with uranium and iron salts. The colloid used depended on the nature of the underlying film, which acted as a vehicle for the dyes. The governing condition was that both should be permeable to the solvent used for extracting the dye from the underlying film through the upper, or dyeing the lower through the upper. A specific example was: a support was coated with collodion dyed red, then coated with albumen containing 7.5 per cent of ammonio-citrate of iron and an equal quantity of uranium nitrate. This was exposed under a matrix with 200 opaque and 200 clear lines to the inch, the lines being of equal width. The plate was then immersed in acidified alcohol which extracted the red dye from those parts of the collodion film corresponding to the clear lines of the matrix. The plate was then immersed in a green dye, which stained the cleared parts. The plate was washed in water, the resist sensitized as before, and exposed under a matrix with the same number of rulings, but with the opaque lines twice the width of the clear, placed at right angles to the first screen lines, during exposure. After immersion in acidified alcohol to extract the dyes, the violet dye was applied.

R. de Bercegol[105] proposed to use a resist of soft consistency, such as wax, tallow, etc., and coat celluloid with one dye, dissolved in alcohol, and after this had been allowed to act, it was washed off then coated with the resist and lines ruled through it and the superficial color film, thus laying bare the colorless celluloid, which was then stained up with the second color also dissolved in alcohol. The operations were repeated for the third color, with the ruling at right angles.

R. Nishimo[106] patented a rather curious process in which he claimed that the various colors produced in the image a distribution of the grains varying with the wave-length, but the effect was masked by the silver grains superposed in a haphazard manner. The solution of these grains would leave an image in colors. K. Schinzel[107] patented a screen in which the elements were formed by derivatives or other conversion products of lycopodium or other pollens. E. Scherpel[108] proposed to apply a colorless substratum to a support, spray on a resist, then bathe in a solution of a blue dye, which adhered between the particles of the resist. This latter was then removed and a red dye applied to those places where the resist had been. A yellow dye was then sprayed on, which formed green and orange spots on the blue and red dyes, thus giving a four-color screen. F. May[109] patented the use of a fatty resist and ruling this while hot. The dyes were to be fixed with ferric chloride, aluminum acetate or formaldehyde.

Woven and Allied Screen-Plates.—J. Joly[110] suggested the use of silk fibers, either natural or artificial, dyed to the required colors, applied side by side to a tacky surface. He further disclosed the weaving of the filaments into a fabric to be applied to the support, the colored threads forming the warp and the weft consisting only of a sufficient number of colorless threads to cause the threads of the warp to retain their relative positions until secured on the support.

R. Berthon and J. Gambs[111] would use woven fabric, or linear filaments alternately colored in the proper colors might be stuck to one another or imbedded in a homogeneous material. The latter means permitted not only colored negatives being obtained, but also positives by printing from the negatives. The threads were to be placed parallel to the longer side of the plates for the negatives; this arrangement automatically assuring the superposition of the dyes of the same color at the point of intersection of the filaments. The refraction of the light in the monochrome filaments, when each filament was exposed within the exact limits set by those of complementary colors, caused the silver to be affected over the whole length exposed. The filaments of single thread or ply were received on conical rollers, which by rotating and sliding the threads along the generating line, brought them into contact; and this was made more perfect by moistening them with a viscous mass and causing them to travel over a polished cylinder, the tangential velocity of which was greater than the velocity of the threads. Capillarity then ensured contact, without overlapping.

33

R. J. Cajal[112] described a somewhat theoretical method in which colored fibers were imbedded in celloidin and then sections cut with a microtome. The threads were first stained up in anilin dyes, which must not be soluble in 36 deg. alcohol. After staining the fibers were to be left for about 34 hours in syrupy celloidin, with which was incorporated some opaque powder, then withdrawn and compressed into a mass by a circular compressor, and plunged into 36 deg. alcohol for coagulation. The best sections were 0.025 to 0.03 mm. in thickness; in all cases the thickness had to be adjusted to the colors. The colored particles were homogeneous, cylindrical and produced a uniform effect. The celloidin between the particles stopped the least trace of white light, through the opaque particles, which were metallic silver made by adding silver nitrate with pyrogallol and ammonia to the celloidin. The definition of the image depended upon the regularity and fineness of the sections; when using silk fibers the diameter of the disks did not exceed 5 to 8 microns.

M. Ratignier and H. Pervilhac[113] would let colored fibers into celluloid as it was cast. The threads were wound on bobbins and passed through combs, which distributed them on the cylinder, about one-fifth of the circumference from the hopper, which contained the dope. Artificial silk was preferred and after dyeing arranged in sets of three, and the teeth of the combs were so arranged that the fibers touched one another, and became part and parcel of the film. Woven cloth might be used and then mosaic screens would be formed.

F. Fritz[114] pointed out that it was well known to use colored fibers for woven fabrics for screens, but that these had the disadvantage that white light passed through the interstices. This he proposed to overcome by using threads of artificial celluloid which could be softened by heat. Fabric was woven in the usual way, then pressed between hot plates, so that the fibers softened and filled up the interstices. In a later patent[115] he proposed to imbed a fabric in a plane and plastic layer, which was stained with a color complementary to the warp threads, which were made of cellulose acetate, that is soluble in chloroform, glacial acetic acid and acetylen tetrachloride, but not in alcohol, ether or benzol. The weft threads were nitrocellulose and the imbedding layer gelatin. After drying, the weft was dissolved by alcohol-ether, which did not affect the acetate threads, and the colorless gelatin, not covered by the dyed threads, was dyed up with a dye that did not affect the acetate threads.

A. J. Jorelle[116] proposed to use natural or degummed silk, artificial silk or spun glass, either singly or spun into threads and cemented to celluloid with collodion. A. N. Pierman[117] also patented the use of spun glass or silk woven into a fabric, using a weft of fibrous character but colorless, the strands being placed so close together that white light would not pass. E. B. Smith[118] followed on the lines of Ratignier and Pervilhac and guided threads of celluloid or the like through combs, but in this case the base was

already in band form. The threads could be guided on to glass, led along a glass table, gelatin being used to cause adherence. The provision of a wide band along one edge for registration was disclosed. F. de Mare[119] also proposed woven threads and later colored threads[120] were to be merely juxtaposed. Schmelik[121] proposed to repeatedly card the fibers and thus obtain a more intimate mixture, and the individual fleeces were then to be saturated with a filling material, like colored collodion or rubber solution, then combined by pressure and cut.

Various Processes.—The first method to be dealt with is that of J. H. Christensen[122] who would apply emulsified particles to a support. Solutions of gum arabic and dextrin were dyed up, emulsified in gum dammar solution, then thinned with turpentine which removed most of the resin, and the particles were allowed to settle down. They were then suspended separately in benzine to which was added carbon tetrachloride, kerosene and asphalt. The solutions were then mixed and poured over a support coated with rubber; this latter swelled and held the lower globules and excess ran off, if the support was held in a slanting position. Later[123] emulsification of dextrin or resin solutions in dammar solution in turpentine was proposed, and the globules were repeatedly washed with turpentine, and finally suspended in petroleum spirit. Later still[124] Christensen coated the globules with a tanning substance that would not act on the support. It was also suggested by the same inventor[125] in order to avoid loss of brilliancy by mordanting dye particles, to mix basic dyes with alcoholic solutions of tannin, thus preventing the precipitation. Or tungstic, molybdic or phospho-tungstic acids rendered basic with ammonia might be used. The mixtures were to be atomized or emulsified and the particles applied to a suitable support, and the tannate particles thus mordanted, while in the case of acid particles an acid might be used. For holding the particles, collodion with a small proportion of sodium oleate was to be used.

The Aktiengesellschaft f. Anilinfabrikation[126] proposed to atomize solutions of dextrin by compressed air, saturated with aqueous vapor into a chamber. The particles were allowed to fall on to a layer of turpentin flowing over an inclined plane. The three dyed emulsions were sprayed over a tacky support. S. E. Sheppard[127] would use cellulose nitrate or other ester, with or without camphor as latent solvent, dye the same with basic dyes, then emulsify in a colloid. For the dyes it was advisable to use the oil-soluble kinds, known as Sudan, for instance, for red, spirit-soluble red OG, and malachite green. Various methods might be adopted to convert water-soluble dyes into spirit-soluble ones, as by the precipitation of a basic dye with tannin, and the tannate thus formed might be prevented from insolubilizing gelatin by treatment with tartar emetic or other antimony salt. Ethyl and methyl alcohols should be used to dissolve the tannated dyes and in the case of cellulose acetate the alcoholic solution

might be added and the greater part of the alcohol distilled off. If nitro-cellulose were used the dye might be added in acetone-methyl alcohol solution, the colored mass thrown into water, and the cellulose dried. The nitrocellulose might be dissolved, in amyl acetate, or any solvent normally insoluble in water, in which gelatin was dissolved and then emulsified in gelatin. Turkey red oil (sulfonated castor oil) might be added to facilitate emulsification which could be effected in various ways. The emulsion being obtained, it was curdled by chilling, or adding excess of a strong electrolyte, such as saturated solution of sodium carbonate or sulfate. The curds would settle and could be washed. The mass was then melted and applied to a support generally or in patterns, and it was disclosed that the emulsion might be mixed with a sensitive one.

J. Camiller and A. Hay[128] proposed to mix colored particles into a paste with a tacky material, which should not impair the colors, and with this glass or suitable support was coated, this being capable of being colored but of such a nature as would resist any dye that might be applied to the tacky material. For a two-color screen, for example, the particles would be all of one color, mixed with a colloid that would not dissolve the grains, this colloid being dyed another color. Three-color screens might be made by using other particles. The grains might be a gum, such as sandarac in alcohol, dyed and evaporated. In a later patent[129] the same inventors proposed to use a gum as before and suspend the grains in a colloid stained to another color, and apply the paste to a support.

J. Szczepanik[130] would take advantage of the wandering of dyes, that is three lots of gelatin were to be stained with three basic dyes, ground to a fine powder and sifted on to a collodion surface, into which the dyes wandered. Or blocks of piled up gelatin leaves might be made and these used as a printing surface. K. Hollborn[131] also patented the same prin-ciple. A screen-plate made on these processes, the Szczepanik-Hollborn "Veracolor" was introduced, but the screen elements were very diffuse as to their edges and the plates generally very unsatisfactory. J. H. Smith and W. Merckens[132] also used this principle, making a gelatin relief, staining up with basic dyes, which were transferred to a collodion surface.

E. H. Tarlton[133] patented a method of making a two-color screen, in which one side of a thin transparent support was coated with a layer of colored, transparent particles, for instance red. These were applied in such a manner that they left interstices having approximately the same area as the grains. The layer was varnished and then coated with an emulsion sensitive to green and blue rays only. An exposure was made to white light so that the light passed through the base carrying the grains before reaching the emulsion. A metallic silver image was thus formed in those places corresponding to the interstices, there being no action be-hind the red grains. The silver image was toned to a blue-green color.

The process might be varied by using blue-green grains and toning the silver red.

J. Marchand[134] obtained a somewhat confused patent, which apparently starts with a bleach-out process, then utilizes a screen-plate method in which black is formed by a mixture of three colors and yet light is supposed to traverse the "molecules" and act on a panchromatic plate. And two images were projected in superposition by two lenses. R. Demoulins de Riols[135] proposed to use red, blue and yellow flashed glasses and to prepare the constituent images as resists and etch the glass and superimpose. L. Paris and G. Piard[136] would substitute phosphorescent grains of zinc sulfide for the starch grains of the Autochrome plate. They were successively treated with alum and ammonia solutions and the gelatinous alumina stained up.

W. R. B. Larsen[137] proposed screens with portions of the lines transparent, in order to secure a varying effect in the high lights and half tones. Transparent or translucent color flakes were superposed on the transparent parts on the cover glass of the screen, so that when the two glasses were placed together the light openings were covered by the flakes. R. Lehner[138] patented a process for incorporating dyes with celluloid by grinding it with semi-alcoholic solutions, and when the mass was homogeneous, the water was driven off by heat and the celluloid worked into films.

L. Gimpel[139] patented a screen composed of parallel lines photographed on an ordinary plate, and after development the image was toned a primary color, as red. The film was then coated with sensitive emulsion and the screen photographed again but with the lines at right angles to those of the first time, this second lot of lines was toned blue-green. The plate was again coated and exposed through the lines already formed and this image toned yellow. F. Faulstich[140] proposed to spray a base with dyes, then immerse the film in others. This immersion might affect those parts already sprayed or the sprayed parts might act as a resist, and subsequent to immersion in another colored bath might be washed away, and all colors thus produced.

The Compagnie Générale Établissements Pathé[141] gave constructional details of an apparatus for the manufacture of dust-like particles from colored resins or other colloid solutions. H. N. Holmes and D. H. Cameron[142] disclosed the application of an emulsion of gum dammar and dyed gelatin. A. Gleichmar[143] colored the film support with areas so that there would be no error from shrinkage of the film differing from that of the elements. M. Jeanson[144] proposed to expose a Lippmann plate in the usual way in contact with mercury, the plate being sensitized with dichromate. This was to be used instead of the usual colored element plate.

K. E. Stuart[145] patented the use of bands of orange overlapping red, blue and violet, so that red, green and violet would be formed. Or lines tion of blacks. This is essentially the principle used in the Dufay patent

tion of blacks. This is essentially the principle used in the Dufay patent (see p. 494).

C. Späth[146] proposed to make ruling machines for fine line work by alternating on a steel rod, pieces of triangular steel 0.05 mm. thick and 18 mm. wide, with celluloid triangles of the same dimensions. These were tightly clamped together, the edges brought into coincidence and the celluloid partly dissolved, leaving the steel as sharp ruling pens or planes. J. H. Powrie[147] patented a method of obtaining fine line screens without overlapping of the edges. A matrix screen with registering bands on two opposite edges was used. These registering marks were opaque and transparent lines, and an opaque and transparent band were termed the margin interval. It is claimed that this method permits of ocular registration without the use of a microscope.

W. C. Huebner and C. Bleistein patented[148] various cameras, in which screen patterns were formed immediately in front of the sensitive surfaces by altering the shapes of apertures ruled in compound screens of black and white. A. W. Carpenter[149] patented the use of a pulverisable material, such as soft paraffin wax, reducing this after dyeing to an impalpable powder by liquefying and atomizing synchronously into a congealing chamber. The spherical particles thus produced were to be compressed into blocks and cut by means of a microtome into thin laminæ and these transferred to a suitable support. The Naturfarben-Film G.m.b.H[150] proposed to coat a transparent support with a thin silver emulsion, expose under a matrix screen and develop right through to the support. Then treat the image with an agent that would harden the gelatin in situ with the silver and bleach or dissolve the latter, then wash out the unhardened parts with hot water and dye up the hardened parts. H. Butschowitz[151] patented a method of making the color elements on the emulsion and hardening the same by development, so that the parts removed left the screen.

J. H. Christensen[152] further patented the emulsification of dyed lac solutions in thick rubber solution, or in this plus dammar. The main part of the rubber was removed by washing with benzol, etc. The colored particles were then suspended in a liquid and after mixing in suitable proportions applied to the carrier. K. Fröhlich[153] proposed to emulsify dyes in a resinous or oily medium and spray on to a gelatin-coated support, when the dyes were absorbed by the gelatin, through the thin skin of the emulsifying agent.

1. E.P. 14,161, 1894; Brit. J. Phot. 1894, **41**, 458, 730; 1896, **43**, 553, Supp. 39; 1895, **42**, 774; 1897, **44**, 85; Supp. 84; 1898, **45**, 215; Supp. 29; 1899, **46**, 264, 380, 774; abst. 1907, **54**, Col. Phot. Supp. 1, 16; Photography, 1897, 68; Trans. Dublin Roy. Soc. **6**, (2), 127; F.P. 240,933; D.R.P. 94,051; Silbermann, **2**, 380; Can.P. 51,125; Nature, 1898, **53**, 91; Phot. Times, 1894, **24**, 337; 1895, **25**, 292; 1897, **27**, 531; Phot. Chron. 1895, **12**, 115; Phot. Woch. 1895; Jahrbuch, 1895, **9**, 213, 512; 1896, **10**, 419; Phot. News, 1895, **39**, 419, 485; Phot. Mitt. 1895, **32**, 14, 125, 278; 1898, **35**, 273, 289; Photogram, 1896, **3**, 31; 1899, **6**, 205; Process Photogram, 1896, **3**, 103. Cf. R. Neuhauss, Phot. Rund. 1895, **9**, 380; 1898, **12**, 155. A. Hesekiel, D. Phot. Ztg. 1898, **22**, 356. J. S. Gibson, Eng. News, 1898, **39**, 298;

Amer. Annual Phot. 1899, 84. J. M. Eder, Phot. Korr. 1899, **36**, 26. J. W. Hinchley, J. S. C. I. 1900, **19**, 5; Photogram, 1900, **7**, 107; Brit. J. Phot. 1900, **44**, 119. A. V. Kenah, Brit. J. Phot. 1901, **48**, 39. H. Snowden Ward, Phot. J. 1900, **40**, 141; Photogram, 1900, **7**, 333. J. F. Sachse, Amer. Phil. Soc. Proc. 1896, **35**, 119. J. W. Swan, Eng. Mech. 1898, **67**, 119.

Joly also obtained the following patents: E.P. 7,743, 1893, photography in colors, abandoned; 13,196, 1894, ibid.; 6,214, 1895, ibid.; 19,388, 1895, the use of dyed silk fibers; 19,711, 1895, photographic plate or film, abandoned; 93, 1896, mounting of transparencies; 4,621, 1896, storing and viewing transparencies, abandoned; 7,671, 1896, ruling lines in fluid pigments, abandoned; 8,114, 1896, ink reservoir, abandoned; 8,441, 1896, mounting pen, abandoned; 9,920, 1896, ruling machine, abandoned; 13,554, 1896, color-sensitive surface; 18,097, 1896, ruling pen, abandoned; 11,612, 1897, color photography, abandoned; 14,101, 1897, producing pictures, abandoned; 17,632, 1897, changing box; Brit. J. Phot. 1898, **45**, 539; 17,900, 1897, ruling machine, abandoned; 30,863, 1897, printing, abandoned; 4,044, 1898, photography, abandoned; 7,971, 1898; Brit. J. Phot. 1899, **46**, 264, in this Joly suggested the placing of the line or pattern screen in transparent gelatin obliquely to the linear screen. The section of the gelatin lines being lens-shaped, would break up by refraction the sharpness of the color lines. The transparent linear screen might be produced by dichromate printing or by etching lines on glass. Cf. J. T. Cundall, Brit. J. Phot. 1900, **47**, Supp. 31. C. B. Howdill, ibid. Supp. 36; Phot. News, 1900, **44**, 285; Phot. J. 1901, **41**, 342.

2. E.P. 12,645, 1896; Brit. J. Phot. 1896, **43**, 522, 674; 1899, **46**, Supp. 96; 1900, **47**, 69; U.S.P. 561,686; 561,687, 1896; F.P. 220,326 and U.S.P. 561,685, these being grouped in the E.P. Phot. Mitt. 1892, **29**, 171; Bull. Soc. franç. Phot. 1895, **42**, 231; Sci. Amer. 1892, **66**, 241; Phot. Rund. 1896, **10**, 382; Mon. Phot. 1895; Anthony's Phot. Bull. 1900, **31**, 292; 1895, **26**, 73; Phot. News, 1895, **39**, 218; 1900, **44**, 825; Photogram, 1896, **3**, 147, 273; Brit. J. Almanac 1897, 828. Cf. H. Snowden Ward, Phot. J. 1900, **40**, 141; J. Soc. Arts, 1900, **49**, 132; Phot. Mitt. 1900, **32**, 483. E. Douglass Fawcett, Brit. J. Phot. 1901, **48**, 118, 140, 205. M. Forrest, ibid. 1900, **47**, Supp. 69; Anthony's Phot. Bull. 1900, **31**, 292; Prof. Amat. Phot. 1900, **5**, 267. A. V. Kenah, Brit. J. Phot. 1901, **48**, 36, 140, 383. J. S. Shearer, ibid. 367. R. Hitchcock, Internat. Annual, 1902, **14**, 183.

Other patents by McDonough are: E.P. 13,895, 1896; Brit. J. Phot. 1896, **43**, 551; U.S.P. 562,642, 1896; D.R.P. 93,799, balanced chromatic shutter; E.P. 20,417, 1898; U.S.P. 611,457; Belg.P. 138,267, 1898, for screen-plate prints on paper, granted to International Color Co. D. K. Tripp, who was connected with the McDonough Co. obtained E.P. 12,922; 15,017, 1901; F.P. 312,929 for machine for ruling linear plates; similar patents were granted to E. E. Flora, U.S.P. 676,943; 679,070. U.S.P. 688,080, Flora, was for a screen holder.

3. E.P. 10,749, 1895; Brit. J. Phot. 1895, **42**, 538; Photogram, 1896, **3**, 227; abst. Phot. Annual, 1897, 69; Phot. News, 1895, **39**, 250; U.S.P. 559,051.

4. U.S.P. 578,147; Process Photogram, 1897, **4**, 76.

5. E.P. 8,390, 1896; Phot. J. 1901, **41**, 265; Brit. J. Phot. 1897, **44**, 217; 1901, **48**, 252; abst. 1907, **54**, Col. Phot. Supp. **1**, 24; D.R.P. 96,773; Smithsonian Rept. 1901, 523.

Brasseur E.P. 21,209, 1904; Brit. J. Phot. 1905, **52**, 694; Belg.P. 186,874; F.P. 357,813; Phot. Coul. 1906, **1**, Supp. 7 patented a special holder for the screen-plate; in D.R.P. 219,821 a filter with adjustable sectors was patented; in E.P. 28,798, 1903; U.S.P. 749,159; D.R.P. 153,440 the use of screen-plates angled as regards the lines for stereoscopic work was patented, a plan that had been shown by Joly two years previously.

6. D.R.P. 221,231, 1907.

7. U.S.P. 648,784, 1900; 666,424, 1901.

8. D.R.P. 279,932, 1913; Jahrbuch, 1915, **29**, 145; abst. J. S. C. I. 1915, **34**, 453; Annual Repts. 1916, **1**, 305.

10. E.P. 5,597, 1892; Brit. J. Phot. 1899, **46**, Supp. 96; U.S.P. 471,186; 471,187; the former is for the plate and the latter for the process; abst. Brit. J. Phot. 1907, **54**, Col. Phot. Supp. **1**, 16.

11. Compt. rend. 1904, **138**, 1337; J. S. C. I. 1904, **23**, 680; "Résumé des Travaux" Lyons, 1906, 149; E.P. 22,988, 1904; Brit. J. Phot. 1904, **51**, 605; 1905, **52**, 10; abst. J. S. C. I. 1905, **24**, 104; F.P. 339,223, 1903; U.S.P. 822,532; Can.P. 101,923; D.R.P. 172,851; Hung.P. Nov. 11, 1904; Span.P. 34,972; Luxemburg P. 5,687; Russ.P. Nov. 14, 1904; also F.P. 333,266, 386,147; 393,296; 409,044; addit. 11,790; 11,856; 449,594; Belg.P. 180,390; Phot. Mitt. 1907, **44**, 2189, 351; Phot.

Rund. 1907, **21**, 180, 193, 205, 210; Phot. Ind. 1907, 782, 813, 823, 905; Phot. Woch. 1907, **33**, 26, 283, 301; Phot. Welt. 1907, **21**, 337, 346; Phot. Korr. 1904, **41**, 286; 1907, **54**, 337, 346; Wien. Freie Phot. Ztg. 1907, 75, 87; Der Amat. Phot. 1907, **7**, 277; Wien. Mitt. 1907, 270, 311; Das Atel. 1907, **14**, 108; Brit. J. Almanac, 1905, 823; Phot. Kunst. 1904, **3**, 337; Phot. J. 1904, **44**, 226; Brit. J. Phot. 1904, **51**, 605; Camera Craft, 1904, **8**, 212; Phot. Chron. 1904, **11**, 576; Bull. Soc. franç. Phot. 1907, **54**, 358.

Cf. E. Coustet, Photo-Gaz. 1906, **16**, 87; 1907, **17**, 101; Rev. Sci. 1907, (5), **8**, 237. W. Abney, Brit. J. Phot. 1907, **54**, 804; Phot. J. 1907, **47**, 351. C. Beck, J. Roy. Micro. Soc. 1907, 763; Nature, 1907, **77**, 188. H. Chevrier, Bull. Soc. franç. Phot. 1907, **54**, 477; Photo-Gaz. 1907, **18**, 21. C. H. Claudy, Bull. Phot. 1907, **1**, 347. V. Crémier, Photo-Gaz. 1907, **17**, 186. Anon. Brit. J. Phot. 1906, **53**, 190; 1907, **54**, 772, 822, 839, 918. F. R. Fraprie, Amer. Phot. 1907, **1**, 59. Anon. Phot. News, 1907, **53**, 304. H. Frederking, Dingl. Poly. 1907, **322**, 713. T. K. Grant, Phot. J. 1907, **47**, 395. A. Guebhard, Compt. rend. 1907, **145**, 792; Brit. J. Phot. 1907, **54**, 898; Bull. Soc. franç. Phot. 1907, **54**, 534. "C. J." Nature, 1907, **76**, 317. E. Wallon, Photo-Gaz. 1904, **14**, 205.

12. E.P. 25,718, 1904; Brit. J. Phot. 1905, **52**, 92; abst. J. S. C. I. 1905, **24**, 162; F.P. 339,223; addit. 3,891; 4,290, 1904; Can.P. 92,098.

13. F.P. 425,586, 1910; E.P. 8,153, 1911; Brit. J. Phot. 1911, **58**, 656; abst. C. A. 1911, **5**, 199; Belg.P. 234,405.

14. E.P. 9,100, 1906; Brit. J. Phot. 1906, **53**, 654; D.R.P. 182,099; U.S.P. 877,351; abst. J. S. C. I. 1906, **25**, 867; Phot. Ind. 1913, 1091; Phot. Chron. 1911, **18**, 186. Cf. D.R.P. 233,167, 1909; 288,597; abst. C. A. 1912, **6**, 1718; Belg.P. 180,390; 191,792. In F.P. 467,128, 1913; Brit. J. Phot. 1914, **61**, Col. Phot. Supp. **8**, 40. A. and L. Lumière patented the use of a complementary colored varnish to correct any defect of fulfillment of the first black condition. This could be applied between the elements and the emulsion, or on the back of the glass, or by staining the gelatin of the emulsion.

15. F.P. 416,700, 1909; Phot. Ind. 1911, 57; Jahrbuch, 1911, **25**, 373.

16. D.R.P. 228,597, 1908; Phot. Ind. 1911, 56; Jahrbuch, 1911, **25**, 376.

17. Von Hübl, Wien. Mitt. 1912, 161; Phot. Chron. 1916, **23**, 253; abst. C. A. 1912, **6**, 1716; 1917, **11**, 1093. This plate was actually made on Christensen's patent (see p. 502). Cf. J. H. Pledge, Brit. J. Phot. 1913, **60**, Col. Phot. Supp. **7**, 4.

18. E.P. 3,252, 1908; Brit. J. Phot. 1908, **55**, 796; D.R.P. 233,140; abst. J. S C. I. 1908, **27**, 1132; Chem. Ztg. Rep. 1911, 232; Phot. Chron. 1911, **18**, 429; Jahrbuch, 1912, **26**, 369; C. A 1912, **6**, 1718.

19. E.P. 11,147, 1909; Brit. J. Phot. 1909, **56**, 730; F.P. 399,320.

20. E.P. 15,775, 1911; Brit. J. Phot. 1912, **59**, 677; Brit. J. Almanac, 1913, 692; abst. J S. C. I. 1912, **31**, 844; C. A. 1913, **7**, 30; Jahrbuch, 1913, **27**, 299; Phot. Ind. 1912, 1689.

21. E.P. 6,279, 1911; Brit. J. Phot. 1912, **59**, 204; Jahrbuch, 1914, **28**, 224; Phot. Ind. 1913, 1398; abst. C. A. 1912, **6**, 2582; F.P. 406,147.

22. U S.P. 947,965, 1910.

23. W. J. Morton, U.S.P. 705,691, 1902.

24. E.P. 16,273, 1910; Brit. J. Phot. 1910, **57**, 824; Brit. J. Almanac, 1912, 655; D.R.P. 233,167; Jahrbuch, 1912, **26**, 368; 1914, **28**, 224; Phot Ind. 1913, 1908; Phot. Chron. 1911, **18**, 180, 429; Belg.P. 226,739.

25. E.P. 19,554, 1910; Brit. J. Phot. 1911, **58**, 386.

26. E.P. 18,750, 1908; Brit. J Phot. 1909, **56**, 145; abst. J. S. C. I. 1909, **28**, 359; C. A. 1911, **5**, 1564; D.R.P. 219,663, 1908; Wag. Jahresber. 1910, **11**, 534; U.S.P. 974,464; F.P. 394,918; 394,032; Phot. Ind. 1910; Jahrbuch, 1911, **25**, 220, 373; Phot. Chron 1910, **17**, 376, 474. For other Brasseur patents see F.P. 349,742; addit. 5,417; 355,139; 364,132; addit. 7,468; 373,376; 394,194; 466,120; Belg.P. 210,452; 211,031.

27. E.P. 20,909, 1908; D.R.P. 219,977; abst. J. S. C. I. 1909, **28**, 260; U.S.P 976,118; Jahrbuch, 1911, **25**, 220.

28. U.S.P. 1,175,224, 1916; abst. J S. C. I. 1916, **35**, 306; C. A. 1916, **10**, 1306; Jahrbuch, 1915, **29**, 146.

29. D.R.P. 293,004, 1914; Zts. ang. Chem. 1916, **29**, 386; C.A. 1917, **11**, 1372; J. S. C. I. 1916, **35**, 1083; Annual Repts. 1917, **2**, 503; Jahrbuch, 1915, **29**, 144.

30. U.S.P. 1,221,457, 1917.

31. U.S.P. 1,206,000, 1916; abst. J. S. C. I. 1917, **36**, 101; Annual Repts. 1917, **2**, 503; C. A. 1916, **10**, 124.

32. E.P. 137,502, 1919; Brit. J. Phot. 1920, **67**, 143, Col. Phot. Supp. **13**, 12;

Jahrbuch, 1915, **29**, 147; J. S. C. I. 1920, **39**, 1248A; C. A. 1920, **14**, 1268; F.P. 519,537; abst. Sci. Tech. Ind. Phot. 1921, **1**, 93; D.R.P. 353,759; U.S.P. 1,497,747; abst. C. A. 1924, **18**, 3011.

33. E.P. 16,313, 1909; Brit. J. Phot. 1910, **57**, 616.
34. E.P. 22,228, 1907; Brit. J. Phot. 1908, **55**, 872.
35. F.P. 411,247, 1910.
36. D.R.P. 283,551, 1913; addit. 291,575; Phot. Ind. 1915, 259; abst. C. A. 1916, **10**, 1912; Jahrbuch, 1915, **29**, 145; Austr.P. 73,699; Chem. Ztg. Rep. 1916, 180; Brit. J. Phot. 1916, **63**, Col. Phot. Supp. **10**, 48; Phot. Korr. 1916, **53**, 23.
37. Phot. Korr. 1916, **53**, 23; Phot. Ind. 1915, 610; Jahrbuch, 1915, **29**, 136.
38. E.P. 50, 1909; Brit. J. Phot. 1910, **57**, 69; Jahrbuch, 1910, **24**, 221.
39. F.P. 373,492, 1907.
40. F.P. 379,632, 1907.
41. D.R.P. 313,008; J. S. C. I. 1919, **38**, 878A; Annual Repts. 1920, **5**, 514.
42. D.R.P. 296,846, 1918; abst. Phot. Ind. 1919, 643; Jahrbuch, 1915, **29**, 143; Phot. Korr. 1920, **57**, 216.
43. D.R.P. 250,036, 1910; Chem. Ztg. Rep. 1912, 512; Jahrbuch, 1913, **27**, 300.
44. Phot. J. 1909, **49**, 225; Brit. J. Phot. 1909, **56**, Col. Phot. Supp. **3**, 23, 32; abst. Jahrbuch, 1909, **23**, 317; Photo-Rev. 1909, **21**, 138.
45. D.G.M. 708,149, 1920; Phot. Ind. 1920, 169.
46. D.G.M. 708,150, 1920.
Cf. Pinoy, F.P. 386,839. Repin, F.P. 388,478; addit. 9,639. Siefert, F.P. 390,533.
47. E.P. 21,210, 1904; Brit. J. Phot. 1905, **52**, 873; J. S. C. I. 1905, **24**, 1190; D.R.P. 179,378, 1904; Jahrbuch, 1906, **20**, 434; 1908, **22**, 612; Belg.P. 186,895; Phot. Chron. 1907, **16**, 358.
48. U.S.P. 802,471, 1905; applic date, 1901; D.R.P. 215,072, 1905; 222,504; Phot. Ind. 1908, 127; 1909, 138; 1910, 1187; E.P. 20,662, 1905; Brit. J. Phot. 1905, **52**, 1029; 1906, **53**, 454; 1907, **54**, 707, 710, 730. 748, 763, 783, 812, 928; Brit. J. Almanac, 1907, 849; 1906, 863; F.P. 358,746; 358,747; Phot. Rund. 1904, **14**, 94; Phot. J. 1908, **48**, 3; Photo-Rev. 1906, **18**, 57; Phot. Woch. 1906, **33**, 104; Penrose's Annual, 1907, **13**, 13; Der. Phot. 1907, **17**, 321; Jahrbuch, 1906, **20**, 451; 1908, **22**, 222, 406; 1909, **23**, 296, 314; 1910, **24**, 377; Phot. Chron. 1908, **15**, 88; Fortschritte d. Chem. Phys. 1910, **2**, 157; Belg.P. 187,634; Nature, 1907, **76**, 642.
Cf. G. Schweitzer, Photo-Rev. 1924, **36**, 72.
49. D.R.P. 225,004, 1907; Phot. Ind. 1910, 1187. In this patent the mordanting with acid and basic dyes is specifically claimed, whereas it is included in the other patents.
50. E.P. 19,652, 1906; Brit. J. Phot. 1907, **54**, 737; abst. Brit. J. Almanac, 1908, 707; Phot. Korr. 1908, **45**, 240; Jahrbuch, 1908, **22**, 228, 410; F.P. 426,498; Phot. Coul. 1908, **3**, 289. These plates were introduced commercially as the Thames plates. Cf. E. H. Corke, Brit. J. Phot. 1908, **55**, Supp. 92.
51. E.P. 4,208, 1910; Brit. J. Phot. 1911, **58**, 144; U.S.P. 1,085,727; Belg.P. 233,224.
52. E.P. 5,859, 1912; Brit. J. Phot. 1913, **60**, 105; Col. Phot. Supp. **7**, 13; Phot. Rund. 1913, **50**, 144; Phot. Korr. 1913, **50**, 220. Cf. E.P. 6,903, 1913; Brit. J. Phot. 1913, **60**, 786; abst. C. A. 1914, **8**, 2986. This was called the Leto plate, but was not introduced commercially.
53. E.P. 28,406, 1907; Brit. J. Phot. 1908, **55**, 589; Brit. J. Almanac, 1909, 640; Phot. Ind. 1908, 1198; Phot. Mitt. 1908, **45**, 231; Jahrbuch, 1909, **23**, 317; 1912, **26**, 266; Phot. Coul. 1908, **3**, 193; 1910, **5**, 174.
54. D.R.P. 216,610, 1907; Phot. Ind. 1909; Phot. Chron. 1910, **17**, 399,476; Jahrbuch, 1910, **24**, 205; Fortschritte d. Chem. Phys. 1910, **2**, 157; abst. Brit. J. Phot. 1910, **57**, Col. Phot. Supp. **4**, 16.
55. D.R.P. 220,154, 1907; addit. to above.
56. E.P. 20,384, 1907; Brit. J. Phot. 1908, **55**, 459; Brit. J. Almanac, 1909, 640.
57. Austr.P. Anm. 5,930, 1909; abst. Chem. Ztg. Rep. 1910, **34**, 212; Jahrbuch, 1910, **24**, 383.
58. U.S.P. 946,470; 1,292,347; E.P. 3,601, 1909; Brit. J. Phot. 1909, **56**, 936; Brit. J. Almanac. 1911, 617; Phot. Ind. 1910; Jahrbuch, 1910, **24**, 202; 1911, **25**, 220.
59. E.P. 23,812, 1907; Brit. J. Phot. 1908, **55**, 797.
60. E.P. 10,802, 1908; Brit. J. Phot. 1908, **55**, 702.
61. F.P. 358,250, 1905.
62. F.P. 393,557, 1907.
63. Belg.P. 204,455, 1907.
64. E.P. 50, 1909; Brit. J. Phot. 1910, **57**, 69.

65. D.R.P. 292,347, 1911; Jahrbuch, 1915, **29**, 146.
66. D.R.P. Anm. 14,564, IV, 57a.
67. Application May 8, 1899. Cf. K. Kieser, Phot. Ind. 1907, 1479; Jahrbuch, 1908, **22**, 262. A. Mebes, "Die Dreifarbenphotographie mit Farbrasterplatten," 1911, 15. E. J. Wall, Photographic Annual, 1910, 12. R. E. Liesegang, Jahrbuch, 1908, **22**, 147. E. Stenger, Phot. Chron. 1908; Brit. J. Phot. 1908, **55**, Col. Phot. Supp. **2**, 23.
68. Phot. Almanach, 1904, 122.
69. D.R.P. 167,232, 1904; Silbermann, **2**, 385; Phot. Coul. 1906, **1**, Supp. 5; 1907, **2**, 3; E.P. 19,202, 1905; F.P. 357,896, 1905; addit. 5,375; 6,534; 6,536; 6.537; Wag. Jahr. 1906, **52**, II, 467. Cf. F.P. 386,772; 409,367.
70. D.R.P. 167,613, 1904; Silbermann, **2**, 386; Wag. Jahr. 1906, **52**, II, 487; E.P. 1,938, 1906; Brit. J. Phot. 1906, **53**, 534; 1907, **54**, Col. Phot. Supp. **1**, 93; Brit. J. Almanac, 1909, 644; Phot. Coul. 1907, **2**, 3; Camera Craft, 1908, **15**, 109. Cf. Belg.P. 186,950; 187,720; 193,681; 193,682; 193,683, 1906. E. J. Wall, Phot. News, 1907, **52**, 231. H. Schmidt, Jahrbuch, 1908, **22**, 95. E. Stenger Brit. J. Phot. 1908, **55**, Col. Phot. Supp. **2**, 23; Phot. Chron. 1908, **15**, 87. In E.P. 58, 1907 it was proposed to make black and white screens by this method.
71. E.P. 495, 1907; Brit. J. Phot. 1908, **55**, 44; D.R.P. 190,560, 1905; Phot. Ind. 1907, 1488; Jahrbuch, 1908, **22**, 412, 591; D.R.P. 188,431; Phot. Ind. 1907, 1249. The German patents were granted to the Deutsche Raster-Gesellschaft, which was formed, it is believed, to work the Krayn patents. Swiss P. 42,903; F.P. 388,913.
The author received some of this film in 1907 to coat with emulsion, but it was found impossible, as it was rotten and split along the lines of the cementing material.
72. E.P. 2,213, 1908; Brit. J. Phot. 1908, **55**, 330; D.R.P. 193,463, 1905; Chem. Tech. Rep. 1908, 75; Jahrbuch, 1908, **22**, 411, 610; F.P. 405,924; Belg.P. 205,579; Jahrbuch, 1908, **22**, 412, 591. The Neue Photographische Gesellschaft introduced Krayn's films on the market; Phot. Ind. 1910, 1426. Cf. O. Mente, Phot. Rund. 1911, **21**, 9. V. Breuer, Kunst. 1911, 229. F.P. 380,134; 380,174; 380,198. P. Hanneke, Phot. Mitt. 1911, **48**, 8.
73. E.P. 25,730, 1907; Brit. J. Phot. 1908, **55**, 852.
74. D.R.P. 197,749, 1907; Brit. J. Phot. 1908, **55**, Col. Phot. Supp. **2**, 45; abst. Brit. J. Almanac, 1909, 645; Phot. Ind. 1908, 562; Jahrbuch, 1908, **22**, 413. Cf. F. Limmer, Phot. Rund. 1910, **20**, 297. E.P. 7,739, 1908; F.P. 395,164; Belg.P. 207,034; 201,549; 201,560; 201,588.
75. D.R.P. 218,324, 1908; Wag. Jahr. 1910, **56**, 553; Chem. Zentr. 1910, **34**, 232; Brit. J. Phot. 1909, **56**, Col. Phot. Supp. **3**, 8; Photo-Gaz. 1909, **20**, 36.
76. D.R.P. 223,819, 1908; abst. J. S. C. I. 1910, **29**, 977, 1410; Wag. Jahr. 1910, **56**, II, 538.
77. U.S.P. 1,081,484, 1913; applic. date 1909; E.P. 28,631, 1913; abst. Brit. J. Phot. 1915, **62**, 155; J. S. C. I. 1915, **34**, 303; Annual Repts. 1916, **1**, 305; Austr.P. 41,834; Jahrbuch, 1915, **29**, 142; F.P. 466,120.
78. U.S.P. 990,247, 1911; applic. date 1904; abst. C. A. 1911, **5**, 2225.
79. D.R.P. 263,819, 1912; E.P. 1,549, 1912; Brit. J. Phot. 1913, **60**, 145; F.P. 438,746; Jahrbuch, 1913, **27**, 551; Austr.P. 60,094; Swiss P. 59,910.
80. Phot. J. 1900, **40**, 141. According to a report of the meeting of the Photographic Club, London, Brit. J. Phot. 1899, **46**, 399, Ward himself suggested the superposition of the stained gelatins.
81. E.P. 6,881, 1906; Brit. J. Phot. 1906, **53**, 494; Brit. J. Almanac, 1907, 850; F.P. 364,493; U.S.P. 914,197; D.R.P. 200,089; 228,412; Jahrbuch, 1909, **23**, 319; Phot. Coul. 1907, **2**, Supp. 13, 17.
82. D.R.P. 197,610, 1906; Phot. Ind. 1908, 617; Jahrbuch, 1909, **23**, 319; Brit. J. Phot. 1908, **55**, Col. Phot. Supp. **2**, 45; abst. Brit. J. Almanac, 1909, 644.
83. E.P. 6,098, 1907; Brit. J. Phot. 1907, **54**, 829; Brit. J. Almanac, 1909, 639; Belg.P. 198,623; Can.P. 106,464; Phot. Ind. 1911, 1169; D.R.P. 236,481, 1906; Phot. Ind. 1913, 33; Jahrbuch, 1908, **22**, 229; 1912, **26**, 368; Phot. Chron. 1912, **19**, 39; F.P. 375,632; 393,249; Phot. Coul. 1907, **2**, Supp. 50.
84. E.P. 8,761, 1910; Brit. J. Phot. 1911, **58**, 597; abst. Brit. J. Almanac, 1912, 655; J. S. C. I. 1911, **30**, 924; F.P. 431,991; J. S. C. I. 1911, **30**, 1470.
85. F.P. 536,737, 1920; abst. Sci. Tech. Ind. Phot. 1922, **2**, 117.
86. U.S.P. 976,118, 1910.
87. U.S.P. 1,209,453, 1916.
88. F.P. 372,661, 1906; Phot. Coul. 1907, **2**, Supp. 9.

89. E.P. 22,138, 1895; Brit. J. Phot. 1896, **43**, 757; abst. 1897, **44**, 11; 1907, **54**, Col. Phot. Supp. **1**, 32; Brit. J. Almanac, 1898, 877; D.R.P. 88,204; Silbermann, **2**, 321.

90. E.P. 194, 1907; Brit. J. Phot. 1907, **54**, 696; Col. Phot. Supp. **1**, 37, 46; F.P. 387,828; Bull. Soc. franç. Phot. 1907, **54**, 221; 1909, **56**, 199; Photo-Rev. 1909, **21**, 114; abst. J. S. C. I. 1908, **27**, 877; Phot. Rund. 1909, **19**, 120; Phot. Chron. 1909, **16**, 227; 1910, **17**, 521; abst. C.A. 1909, **3**, 752, 1728; 1911, **5**, 41; U.S.P. 995,405; 1,005,644; D.R.P. 218,323; Phot. Ind. 1909, 178; 1910, 204, 1198; 1911, 1656; Phot. Korr. 1907, **44**, 500; Penrose's Annual, 1907, **13**, 33; Jahrbuch, 1908, **22**, 409; 1909, **23**, 150, 310; 1911, **25**, 574; 1912, **26**, 370; Phot. Coul. 1907, **2**, Supp. 10; 1909, **4**, 5. Cf. F.P. 362,004; 370,956; addit. 7,183; 8,306; 13,408; 381,487; 422,567; Phot. Coul. 1907, **2**, Supp. 8; Belg.P. 196,820; 1906. Cf. Bardorf, Phot. Welt. 1907, **21**, 147, 167.

91. E.P. 9,014, 1908; Brit. J. Phot. 1909, **56**, 425; Jahrbuch, 1910, **24**, 386; 1913, **27**, 296; Chem. Ztg. Rep. 1909, 484; Apollo, 1912, **18**, 158; Der Phot. 1912, **22**, 174.

92. E.P. 26,911, 1909; Brit. J. Phot. 1910, **57**, 838, Col. Phot. Supp. **4**, 77; 1911, **58**, Col. Phot. Supp. **5**, 31; F.P. 409,397; U.S.P. 1,055,189; D.R.P. 221,727; Kunst. 1911, 229; Jahrbuch, 1911, **25**, 293; abst. J. S. C. I. 1910, **29**, 720; C. A. 1911, **5**, 1028, 3766; Belg.P. 220,777. Cf. W. Scheffer, Brit. J. Phot. 1910, **57**, Col. Phot. Supp. **4**, 89. E. Stenger, Phot. Chron. 1910, **17**, 575. H. E. Blackman, Camera Craft, 1911, **18**, 369; Brit. J. Phot. 1911, **58**, Col. Phot. Supp. **5**, 67. H. Quentin, Bull. Soc. franç. Phot. 1911, **58**, 293. E. Valenta, Phot. Korr. 1911, **48**, 41; Brit. J. Phot. 1911, **58**, Col. Phot. Supp. **5**, 30.

93. D.R.P. 239,486, 1909; Belg.P. 214,364; U.S.P. 1,081,341; abst. C. A. 1914, **8**, 470; E.P. 23,138, 1910; Brit. J. Phot. 1911, **58**, 30; Brit. J. Almanac, 1912, 655; Wien. Mitt. 1912, 82; Jahrbuch, 1912, **26**, 263. Cf. F.P. 399,676; 421,199.

94. U.S.P. 1,069,039, 1913.

95. E.P. 11,698, 1908; Brit. J. Phot. 1909, **56**, 221; U.S.P. 1,003,720; D.R.P. 237,755; Austr.P. 43,679; Belg.P. 208,294; Swiss P. 43,193; Phot. Coul. 1909, **4**, 59; D. Phot. Ztg. 1908, **32**, 364; Wien. Mitt. 1909, 583; 1910, 178, 572; Jahrbuch, 1909, **23**, 173, 316; 1911, **25**, 211; abst. J. S. C. I. 1909, **28**, 1055; C. A. 1911, **5**, 3768. Introduced commercially as the Dufay plate.

96. E.P. 18,744, 1908; Brit. J. Phot. 1909, **56**, 786; abst. J. S. C. I. 1909, **28**, 1055; Wien. Mitt. 1910, 33; Jahrbuch, 1910, **24**, 201; Phot. Ind. 1910, No. 8; Phot. Coul. 1910, **5**, 31; Phot. Rund. 1918, **28**, 285.

97. F.P. 370,956; addit. 7,138; abst. J. S. C. I. 1912, **31**, 1008; 1913, **32**, 451; F.P. 388,616; addit. 10,541; 13,132; 13,775; 408,552; addit. 11,696; 11,854.

98. E.P. 15,027, 1912; Brit. J. Phot. 1913, **60**, 615; 1918, **65**, Col. Phot. Supp. **12**, 21; F.P. 442,881, 1911; addit. 19,753; U.S.P. 1,155,900; La Nature, 1917, 290; Sci. Abst. 1918, **21**, 58; J. S. C. I. 1916, **38**, 73; Annual Repts. 1916, **1**, 305; 1918, **3**, 462; Phot. Ind. 1911, 1688; Jahrbuch, 1913, **27**, 300; C. A. 1913, **7**, 27; Phot. Rund. 1918, **28**, 285. Cf. P. Tooth, Tech. u. Ind. 1919, 143; C. A. 1920, **14**, 1644. This was termed the Versicolor process.

99. E.P. 27,708, 1912; Brit. J. Phot. 1913, **60**, 939; D.R.P. 273,629; Phot. Ind. 1914, 683; Jahrbuch, 1915, **29**, 147; Belg.P. 246,916.

100. E.P. 21,739, 1908; Brit. J. Phot. 1909, **56**, 146; F.P. 395,165; D.R.P. 218,298; Phot. Chron. 1910, **17**, 533; Jahrbuch, 1910, **24**, 204; 1911, **25**, 376. Similar patents were granted to A. Lehner, U.S.P. 1,112,540; 1,112,541; 1914; abst. C. A. 1914, **8**, 3763.

101. D.R.P. 230,387, 1910; Phot. Ind. 1910, 263; E.P. 21,840, 1908; Brit. J. Phot. 1909, **56**, 426; Phot. Chron. 1911, **18**, 417; Jahrbuch, 1912, **26**, 67.

102. E.P. 20,111, 1908; Brit. J. Phot. 1908, **55**, Col. Phot. Supp. **2**, 57; 1909, **56**, 366; F.P. 393,296, 1907; Phot. Coul. 1908, **3**, 169; D.R.P. 207,750; U.S.P. 916,467; abst. J. S. C. I. 1909, **28**, 109, 544; Brit. J. Almanac, 1909, 541; Phot. Chron. 1909, **16**, 463; Jahrbuch, 1910, **24**, 387; Photo-Era, 1908, **21**, 196; Belg.P. 210,541; Phot. Korr. 1908, **45**, 372; Phot. Welt. 1909, **23**, 121.

103. E.P. 29,273, 1909; F.P. 386,147; Brit. J. Phot. 1910, **57**, 556; Brit. J. Almanac, 1911, 617; abst. J. S. C. I. 1910, **29**, 720; Jahrbuch, 1911, **25**, 556. Cf. E.P. 4,912, 1910; Brit. J. Phot. 1910, **57**, 556; addit. to above; also E.P. 5,377, 1910.

104. E.P. 9,929, 1914; Brit. J. Phot. 1915, **62**, 433; F.P. 476,228; addit. 19,917; 478,117; U.S.P. 1,161,731; 1,191,034; abst. J. S. C. I. 1915, **34**, 637; Annual Repts. 1916, **1**, 305; C. A. 1915, **9**, 2841; 1916, **10**, 2331; D.R.P. 326,710; 326,711; Phot. Ind. 1921, 17; Jahrbuch, 1915, **29**, 142.

105. E.P. 189,813, 1921; Brit. J. Phot. 1923, **70**, Col. Phot. Supp. **17**, 30; F.P.

554,912. In F.P. 557,972 a machine is patented for ruling the lines; in 27,765 addit. a modification of the machine is described; abst. Sci. Ind. Phot. 1924, **4**, 26. D.R.P. 392,749; Phot. Ind. 1924, 475. In F.P. 27,364 addit. to 554,912 the use of discontinuous, curved or sinuous lines is claimed.

106. F.P. 527,667, 1920; abst. Sci. Tech. Ind. Phot. 1922, **2**, 26.
107. D.R.P. 373,621, 1922.
108. D.R.P. 375,259; 375,260; 375,261, 1919; Phot. Ind. 1924, 103; Sci. Ind. Phot. 1924, **4**, 103.
109. E.P. 201,234, 1922; Brit. J. Phot. 1923, **70**, Col. Phot. Supp. **17**, 4; abst. Sci. Ind. Phot. 1924, **4**, 169; abst. Brit. J. Almanac, 1925, 312.
110. E.P. 19,388, 1895; abst. Brit. J. Phot. 1907, **54**, Col. Phot. Supp. **1**, 16; Process Photogram, 1896, **3**, 103; Brit. J. Almanac, 1897, 833.
111. E.P. 20,834, 1906; Brit. J. Phot. 1907, **54**, 603; Brit. J. Almanac, 1908, 706; F.P. 357,928; addit. 5,986; 9,464; abst. Brit. J. Phot. 1907, **54**, Col. Phot. Supp. **1**, 13; Belg.P. 194,565; Phot. Coul. 1907, **2**, Supp. 5.
112. Phot. Coul. 1907, **2**, 2; Brit. J. Phot. 1907, **54**, Col. Phot. Supp. **1**, 13; Phot. Ind. 1907, 179.
113. F.P. 391,785, 1907; abst. J. S. C. I. 1908, **27**, 1178.
114. D.R.P. 227,130, 1908; abst. J. S. C. I. 1910, **29**, 1410; Wag. Jahr. 1910, **56**, II, 539; Phot. Ind. 1910, 1659; Jahrbuch, 1911, **25**, 375.
115. D.R.P. 231,676, 1910; abst. Wag. Jahr. 1911, **57**, II, 510; C. A. 1912, **6**, 1717; Kunst. 1911, 156; Zeit. ang. Chem. 1911, **24**, 659; Phot. Chron. 1911, **18**, 402; Jahrbuch, 1912, **26**, 368.
116. F.P. 460,724, 1912.
117. U.S.P. 1,196,718, 1916; applic. 1908; abst. J. S. C. I. 1916, **35**, 1035; Annual Repts. 1917, **2**, 503; Jahrbuch, 1915, **29**, 147.
118. E.P. 139,871, 1919; Brit. J. Phot. 1920, **67**, 240.
119. Belg.P. 215,587, 1909.
120. Belg.P. 215,845, 1909.
121. Phot. Rund. 1910, **20**, 140.
122. E.P. 20,971, 1908; Brit. J. Phot. 1909, **56**, 269; Brit. J. Almanac, 1910, 598; U.S.P. 994,977; D.R.P. 224,465; Jahrbuch, 1910, **24**, 387; 1912, **26**, 373; 1913, **27**, 299; Phot. Coul. 1912, **7**, 73; Phot. Ind. 1910, 1033.
123. E.P. 21,007, 1908; Brit. J. Phot. 1909, **56**, 898; Brit. J. Almanac, 1911, 617; Wien. Mitt. 1910, 442; Jahrbuch, 1911, **25**, 210; Belg.P. 213,422.
124. E.P. 7,480, 1912; Brit. J. Phot. 1913, **60**, 255; Col. Phot. Supp. **6**, 53; D.R.P. 278,043; Dan.P. 1911; C. A. 1912, **8**, 2583; Phot. Coul. 1912, **7**, 73; Jahrbuch, 1913, **27**, 299.
125. E.P. 163,311, 1921; Brit. J. Phot. 1922, **69**, 525; abst. J. S. C. I. 1922, **41**, 729A; Amer. Phot. 1923, **17**, 184; Sci. Tech. Ind. Phot. 1922, **2**, 15; U.S.P. 1,486,635. Cf. E.P. 216,853, 1923; abst. C. A. 1925, **19**, 18; D.R.P. 403,590; F.P. 581,802; abst. Sci. Ind. Phot. 1925, **5**, 71.
126. E.P. 9,167, 1912; Brit. J. Phot. 1913, **60**, 367; D.R.P. 254,180, 1910; Phot. Ind. 1913, 1398; abst. Brit. J. Almanac, 1914, 693; Jahrbuch, 1913, **24**, 224; C. A. 1913, **7**, 3722; F.P. 454,839; Belg.P. 245,345.
127. U.S.P. 1,290,794, 1919; Jahrbuch, 1915, **29**, 143.
128. E.P. 154,150, 1920; Brit. J. Phot. 1921, **68**, 126; Col. Phot. Supp. **14**, 10; abst. Sci. Tech. Ind. Phot. 1921, **1**, 36; U.S.P. 1,440,373.
129. E.P. 158,670, 1919; Brit. J. Phot. 1921, **68**, 188; abst. Sci. Tech. Ind. Phot. 1921, **1**, 55; U.S.P. 1,440,373; Amer. Phot. 1923, **17**, 496; F.P. 526,297; Can.P. 230,613; Austral.P. 18,864.
130. E.P. 17,065, 1908; Brit. J. Phot. 1908, **55**, 873; U.S.P. 1,089,602; D.R.P. 354,317, 1907; Phot. Korr. 1912, **46**, 73; abst. C. A. 1912, **6**, 2583; 1914, **8**, 1551; J. S. C. I. 1908, **27**, 1178. Cf. F. Limmer, Brit. J. Phot. 1909, **56**, Col. Phot. Supp. **3**, 49; Zeit. ang. Chem. 1912, **22**, 14. W. Scheffer, Brit. J. Phot. Ind. 1911, 318; Photo-Rev. 1909, **21**, 138, 191. R. Adan, Bull. Soc. franç. Phot. 1909, **56**, 331.
131. D.R.P. 247,722, 1909; Phot. Ind. 1912, 991; Jahrbuch, 1909, **23**, 320; 1910, **24**, 383; D. Phot. Ztg. 1909, **33**, 624; abst. C. A. 1912, **6**, 2583.
132. E.P. 219, 1907; F.P. 376,062; D.R.P. 209,444; U.S.P. 885,066; Brit. J. Phot. 1907, **54**, 771; J. S. C. I. 1907, **26**, 1029; Chem. Ztg. Rep. 1909, **33**, 296.
133. E.P. 110,993, 1917; Brit. J. Phot. 1918, **65**, 9; abst. J. S. C. I. 1917, **38**, 1920; Annual Repts. 1917, **2**, 503; Jahrbuch, 1915, **29**, 151.
134. F.P. 525,151, 1920; abst. Sci. Tech. Ind. Phot. 1922, **2**, 23; Chim. Ind. 1922, **7**, 1170. In F.P. 540,343; abst. Sci. Tech. Ind. Phot. 1923, **3**, 15 this patent is to be applied to cine work.

135. F.P. 399,765, 1909; Jahrbuch, 1910, **24**, 614.
136. F.P. 477,173; addit. 20,019; abst. J. S. C. I. 1916, **35**, 617; Jahrbuch, 1915, **29**, 142; C. A. 1916, **10**, 2332.
137. D.R.P. 293,218, 1915.
138. E.P. 7,629, 1908; Brit. J. Phot. 1909, **56**, 49; J. S. C. I. 1909, **28**, 109.
139. F.P. 414,953, 1909; J. S. C. I. 1910, **29**, 1333; Phot. Ind. 1911, 56; Jahrbuch, 1911, **25**, 376.
140. E.P. 152,002, 1920; Abst. Bull. 1921, **7**, 126; J. S. C. I. 1923, **41**, 198A. Cf. F.P. 546,510; Sci. Tech. Ind. Phot. 1923, **3**, 81; E.P. 197,359; Brit. J. Phot. 1923, **70**, 513; J. S. C. I. 1923, **42**, 686A.
141. D.R.P. 261,161, 1912.
142. U.S.P. 1,429,430, 1922; Amer. Phot. 1923, **17**, 368.
143. D.G.M. 706,483, 1920; Phot. Ind. 1920, 141.
144. F.P. 446,688, 1911.
145. U.S.P. 1,439,035, 1922; Amer. Phot. 1923, **17**, 429.
146. D.R.P. 216,611, 1908.
147. U.S.P. 1,439,325, 1922; F.P. 559,945; abst. Sci. Ind. Phot. 1924, **4**, 70, 154; E.P. 211,994; Brit. J. Phot. 1924, **71**, Col. Phot. Supp. **18**, 19; D.R.P. 396,330; Phot. Ind. 1924, 1160; Brit. J. Almanac, 1925, 313.
148. E.P. 12,513, 1911; 12,050; 18,093, 1912; abst. Brit. J. Phot. 1913, **60**, 690; E.P. 4,998; 5,004; 7,355, 1912; abst. ibid. 255; U.S.P. 954,291; 954,292; 1,051,591; 1,093,134; 1,201,048; Can.P. 142,609; 142,907; 145,668; F.P. 536,810; Austr.P. 2,284; D.R.P. 225,545; 276,476; Jahrbuch, 1911, **25**, 633.
149. U.S.P. 1,476,874.
150. D.R.P. 382,575, 1922.
H. E. Lichtenstein, U.S.P. 1,275,573 patented a camera with fixed taking screen and plate holders with external spring.
151. D.R.P. 389,852.
152. E.P. 216,853, 1923; Brit. J. Phot. 1924, **71**, Col. Phot. Supp. **18**, 40, 48; J. S. C. I. 1924, **43**, B998; F.P. 581,802.
153. D.R.P. 406,706, 1924; Phot. Ind. 1925, 98.

CHAPTER XIX

SCREEN-PLATE PRACTICE

Hyper-sensitizing.—The spectral sensitiveness of the Autochrome plate does not extend practically beyond wave-length 6500, which is actually almost on the border line of the orange, therefore, the reproduction of very deep reds and purples is by no means satisfactory. J. Thovert[1] (p. 533), found that by bathing the plates in 1 :200,000 solution of pinachrom not only were better reds obtained, but that the plate was actually faster. The bath should be made alkaline, if there is any chance of the water being acid, but not more than about 3 drops of ammonia per liter should be used. Later, Thovert[2] recommended the same dye, but 1 : 1,000,000 with bathing for 5 minutes, then rapidly drying without washing. The water might be rendered alkaline as before, but ordinary tap water was better.

It is somewhat difficult to determine the exact composition of the compensating filter for such plates; but a predominating yellow tint in the pictures indicated too long an immersion in the sensitizing bath, or too high a temperature of the same. Predominating blue, on the other hand, was due to too short immersion; while a prevailing reddish-orange tint was caused by too long immersion or too strong a bath; excess of greens pointed to too weak a bath. For flashlight work Thovert recommended a 1 : 1,000,000 solution of erythrosin with 2 minutes bathing, then briefly rinsing and drying.

C. Simmen[3] also recommended the extra-sensitizing and found the best dyes were pinaverdol, pinachrom and pinacyanol; but the exact ratios could not be given. In some cases the best proportion of pinaverdol to pinacyanol is 8 : 1, in others 7 : 4. It is thus necessary to start with a mixture of pinaverdol 3 to pinacyanol 1 and to add more of the latter if the greens predominate, or of the former if the reds are too strong. He stated that working with an aqueous solution the plates do not keep so well and frequently stains were caused; the best bath was made with 30 per cent of alcohol. The solution was rendered distinctly alkaline with ammonia. The composition of the bath was:

Dye solution, 1 : 1,000 alc.	2 ccs.
Ammonia, 22° Bé.	1 ccs.
Ethyl alcohol, 90 per cent.	330 ccs.
Water	660 ccs.

The above quantity is sufficient for about 550 sq. ins. of plate surface. The plates should be bathed for 5 minutes, irrespective of temperature, and then dried without washing.

A. von Palocsay[4] recommended pinachrom, using:

Pinachrom, 1 : 1,000 alc........................ 8 ccs.
Absolute alcohol200 ccs.
Water ..800 ccs.

Time of bathing 2 minutes, and drying as rapidly as possible.

C. Adrien[5] found that although this method of bathing gave greater general speed, yet it did not increase the green sensitiveness sufficiently to give good rendering of the foliage of trees, etc., as pinachrom is not a sensitizer for green. Von Hübl[6] stated that by the use of the following bath, the sensitivity of the Autochrome plate might be increased five times. Three stock solutions were prepared:

A. Pinacyanol, 1 : 1,000 alc.................... 5 ccs.
 Ammonia 3 drops
 Alcohol, 90 per cent..................... 50 ccs.
 Water100 ccs.
B. Exactly the same as above but with
 Pinachrom, 1 : 1,000 alc.................... 2 ccs.
C. As above but with
 Pinaverdol, 1 : 1,000 alc.................... 2 ccs.

Instead of the pinachrom. The actual sensitizing bath was:

A solution 67 ccs.
B solution466 ccs.
C solution ..,...............................466 ccs.

Bathe for 5 minutes and dry in the dark without washing.[7]

F. Monpillard[8] pointed out that old hyper-sensitizing baths can not be made to give such good results by increasing the time of immersion. In old baths the greater part of the pinacyanol becomes inactive, and the plates are sensitized for yellow and green, but not for red. Therefore, a fresh solution should always be used, and as several plates can be bathed one after the other it should be then thrown away, for the bath may be made up some little time in advance. The time of immersion may vary within wide limits, but should never be less than 3 minutes. The degree of dilution may also be varied, but it is preferable to keep to that which experience has shown to be the best. A great dilution necessitates longer immersion, and it is as well to avoid this, as there may be pinholes in the gelatin emulsion through which the liquid may find its way into the screen coating, and cause stains. Experience has shown that provided the dilution and the time of immersion remain the same, the results obtained by hyper-sensitizing do not appreciably vary with differences of temperature.

M. Jové[9] stated that he had found a commercial preparation for hypersensitizing, which was very satisfactory before the war, would no longer work well, and this he ascribed to the better panchromatization of the Autochrome emulsion. He had, therefore, fallen back on Simmen's method, and by adjusting the formula as directed, the quality of the added sensitiveness could be varied according to the requirements. The basis

of such adjustment being that pinachrom sensitizes for yellow; pinaverdol for green and pinacyanol for red. E. Vallot made a nickel-plated tank, in which several plates might be immersed in the bath. The principal feature being that a stopcock was arranged to draw off the solution in 2 minutes, in which case capillary action practically left the plates dry when withdrawn. The difference in time of immersion of the top and bottom of the plate seemed to have no harmful effects.[10]

Ultra-Sensitizing Screen-Plates.—F. Monpillard deposited in 1913 a sealed paper describing this process with the Société Française de Photographie, but it was not opened till eight years later.[11] Treatment of the plates by this process would seem to increase the sensitiveness about thirty times; but unfortunately the plates have but poor keeping power, 36 hours being about the limit. Three stock solutions of dyes are required:

> A. Pinaverdol, 0.1 per cent in 90° alcohol.
> B. Pinachrom, 0.005 per cent in 90° alcohol.
> C. Pinacyanol, 0.005 per cent in 90° alcohol.

From these a concentrated solution D was made:

> A solution 100 ccs.
> B solution 100 ccs.
> C solution 47 ccs.

And a concentrated sensitizer E:

> D solution 400 ccs.
> Alcohol, 90° 600 ccs.

A further solution F, of silver chloride in ammonia is required:

> Silver chloride 0.2 g.
> Ammonia, 22° 8 ccs.
> Water .. 92 ccs.

The actual sensitizing solution was compounded of:

> E solution 100 ccs.
> F solution 100 ccs.
> Alcohol, 22.5° 800 ccs.

The plates should be bathed at a low temperature for 5 minutes, rapidly washed and dried by heat. It is important that the plates be developed as soon after exposure as possible. The silver chloride and solution F must be prepared in non-actinic light.

A. Ninck[12] utilizing the above method with Lumière's pantochrome as the sensitizing dye, recommended a 1 : 2,500 alcoholic solution of the dye and a 2 per cent solution of silver chloride in ammonia. This last was prepared by dissolving 3.2 g. silver nitrate in 64 ccs. distilled water, adding 1.3 ccs. pure hydrochloric acid, then adding ammonia solution 135 ccs. The actual sensitizing bath was:

> Dye solution 20 ccs.
> Silver chloride solution 6.6 ccs.
> Water .. 1000 ccs.

Time of bathing 5 minutes at 10 to 12° C., though increase of the temperature merely shortened the time of bathing. The plates were rapidly

whirled for 30 seconds and dried in a calcium chloride box; they were stated to keep in good condition for at least 10 days. The speed obtained was about half that by Monpillard's method. In a later communication[13] Ninck laid stress on the importance of keeping the quantity of ammonia below 0.6 per cent, and suggested the following modification of the bath:

Pantochrome, 1 : 2,500 alc. sol................ 20 ccs.
Silver chloride solution 5.3 ccs.
Water1000 ccs.

The increase of speed was found to be actually twenty-five times, and the plates kept for a month.

Ninck also stated[14] that Autochrome plates, even 17 years old, might be utilized by hyper-sensitizing. It was preferable, however, to destroy the fog first by 5 minutes immersion in the following:

Chromic acid 5 g.
Potassium bromide 10 g.
Water1000 ccs.

Then wash for 5 minutes and hyper-sensitize. Later[15] he stated that the sensitiveness of the plates varied with the silver chloride content of the solution, the dye ratio remaining the same. Using an Eder-Hecht wedge, the speeds were, taking that of the Autochrome plate as unity, with pantochrome alone 6; with 0.07 g. silver chloride per liter, it was 17; with 0.18 g., 23; with 0.2 g., 33; with 0.53 g., 40. This last is the maximum quantity that can be used as with increase the speed drops, for instance with 1.6 g. it fell to 17. With the maximum quantity the plates must be used at once as they will not keep; but it was possible to obtain at the beginning of April, with lens working at F 2.5, good results in 1/200 second.

Filling the Dark Slide.—As the light must pass through the screen elements before it reaches the emulsion, it is essential that the back of the plate be turned to the lens. Hence it is important that the glass be perfectly clean, otherwise any dirt or splash of emulsion will be reproduced as a patch of greater density in the positive, therefore, there will be less color. There is no difficulty in cleaning the backs of the plates, as after they have been placed in the slides, the glass can be readily polished with a clean dry cloth.

As the gelatin film of all screen-plates is extremely tender, great care must be exercised in placing them in the holders, and they are issued with a card in contact with the emulsion side, the purpose of which is to prevent damage to the film from the springs of the slide. This card is black on the side in contact with the emulsion.

R. Chaboseau[16] found that white card would do as well as black for backing up the plate, and although it did not reduce the time of exposure, it was without action in any way in producing fog or halation. L. Benoist[17] stated that he had found that a white glazed card reduced the exposure from 20 to 30 per cent, and in a later communication he gave very careful

measurements as to the diffusion of the light, and the consequent degradation of the sharpness, etc. He pointed out that the reason why Chaboseau found no reduction of exposure was due to the latter having used a matt surface, but that a glazed one gave different results.

The first test was two transparent plates laid side by side, one red and the other green; and these were photographed on one plate, one half being backed by a white and the other by a black card. All appreciable diffusion would thus be rendered visible in consequence of those rays reaching the backing from the test object being diffused to that part of the plate representing the greens of the test object. There would thus be produced by this, an analagous diffusion of green to red, a central band of greater or less width and more or less completely free from color. But the results when examined under a lens, showed a perfectly defined and clear line where the black and white cards joined. Nor was there any appreciable alteration of the colors. It was found on microscopic examination that the sharpness on both plates was the same up to the limit of the resolving power of the emulsion. Comparative side by side exposures proved that with the glazed card there was a reduction of exposure of about one-third. It was only necessary to slip the glazed card between the usual black one and the plate, but as the glaze was due to gelatin care should be taken that it was not damp.

It should be pointed out that R. Colson[19] stated that the use of a white card behind an ordinary plate reduced the exposure, and that the same emulsion coated on glass and paper was faster on the latter, due to the reflection of light from the white surface. The author tested this statement with very careful experiments by the Hurter and Driffield system, and could find no increase in speed, though there was a slight increase in fog.

H. Quentin[20] stated that there was no advantage in this method, and assuming that one had an orange-yellow color, which was formed of 25 green, 100 red and 0 violet, then if it was assumed that an additional 5 was added to these colors, the result would be green 30, red 100, as this was the maximum attainable, and violet 5, with the result that the color would be paler. G. Henry[21] and Comte de Dalmas raised the question of the diffusion of the light. Benoist[22] pointed out that the increase in exposure thus obtained would also increase the overexposure, and to this he ascribed the assumption that it was a case of diffusion fog.

The Compensating Filter.—The purpose of this is to so adjust the action of light on the sensitive emulsion that the colors shall be rendered with correct visual luminosity. Therefore, it must be accurately adjusted to the sensitiveness of the emulsion under the screen elements. The methods of making suitable filters have already been given when dealing with filters generally.

G. Eastman[23] patented the incorporation of the compensating filter in

the back or non-curling coating of a celluloid screen-plate, and if the original screen-plate was to be used as a positive by reversal in the usual way, the dye should be one that should be washed out or discharged in the operations of developing, etc.

The Focusing Screen.—As the sensitive surface of the screen-plate is turned away from the lens it is obvious that the matt surface of the focusing screen must also be reversed in the same way. If the thickness of the ground glass is exactly the same as that of the glass of the plate, there will be no trouble, but if it is not there may be slight diffusion with large aperture lenses. If, however, the image be focused with the filter in position, there is very little chance of this being of serious moment. If the filter be placed behind the lens after focusing, the ground glass need not be reversed, as in this position it automatically corrects the difference. The action of filters on the sharpness has already been dealt with under "Filters."

In order to avoid trouble and to enable the camera to be used for ordinary work as well, L. Schrambach[24] placed on the market a screen, which had a diagonal of clear glass, and on one side of that the glass surface was matted on the inside and on the other on the outside. Exactly the same idea was utilized by H. Renezeder[25] and a German patent[26] was also granted for this. F. J. Hargreaves[27] recommended, as a focusing screen, the use of an unexposed plate of the same make that is to be exposed. In this way the "grain" of the selecting screen was superposed, as it were, on the focused image, and the limitations imposed thereby were thus forced on one's attention whilst focusing. The bare screen will be found too transparent, and a coat of matt varnish or a very fine ground glass bound up in contact with the screen will be found an improvement. A better way was to fog an unused plate, develop, fix and bleach with mercuric chloride, as has been suggested for ordinary plates. A very dilute developer should be used and the plate fixed as soon as it is visibly darker by transmitted light. The whole operation can be done in daylight, if a dilute developer, such as rodinal, 1 : 100, be used. When the plate is dry it should be varnished, bound up with a cover glass, and mounted with its glass surface in register with the plate in the slide. As the plate thus used is one of those in actual use, absolute register is automatically obtained. It will be found that the colors appear slightly brighter on such a screen than on ground glass.

Exposure of the Plate.—As the emulsion coating of all screen-plates is extremely thin, it possesses but little latitude of exposure. The ill-effects of errors are more apparent than with ordinary black and white work, because one may have more or less complete falsification of the colors through such errors. The average observer is a far better judge of the correctness of colors than of a monochrome rendering of the same subject.

Numerous tables have been published by various workers[28] but they

are of little value as a rule, as they leave too much to the personal equation. The only satisfactory method of estimating exposures would seem to be by one of the exposure meters that actually measure the actinic power of the light by a chemical change or tinting of a sensitive paper. It has been suggested that for this work these photometric papers should be color-sensitized. But A. Watkins[29] stated that his first experiments with Auto-chrome plates, made on flowers and still-life indoors were successfully timed by taking the speed of the plate as 1 on the Watkins meter, that is to say, the exposure was the time taken by the paper to attain the standard tint. Later, outdoor exposures were found to need the speed being taken as 2, or in some cases as 3, otherwise the plates were overexposed. As regards the suggestion that the remedy for this discrepancy would be an orthochromatic meter paper, he pointed out that tests made by him in the past of color-sensitized paper alongside the standard brand had showed that the orthochromatic paper was slower hence it would be no better guide.

On trying a color filter over the actinometer it was found that the standard meter paper was relatively quicker under the Autochrome screen indoors than outdoors. So that if a screen be used over the meter, both in and out, it increases the defect. Watkins attributed the discrepancy: (1) to the difference between a print-out and a developed emulsion, and (2) to a breakdown of the general law that intensity and time are inter-changeable as regards chemical light effect. There is evidently a differ-ence in ratio between bright and feeble light on the Autochrome plates and the meter paper.

A. Peaucellier[30] suggested an exposure meter for screen-plate work, consisting of a small paraffin lamp behind a condenser, which gave a brightly illuminated field, against which the image of the object was jux-taposed through an aperture. Two wedges of smoked glass were inter-posed between the eye and the condenser till fields of equal luminosity were obtained. An index was then read off against a logarithmic slide rule, calibrated by experiment, for the exposure.

E. A. Bierman[31] adopted Lumière's standard of exposure, viz., 1 sec-ond at F 8 in good light with a normal subject. He found that the in-creased exposure for each reduction of the diaphragm worked out at $2\frac{1}{2}$ times, whatever the actinic strength of the light; that is to say, if at F 8 the exposure required was found to be 2 seconds, then at F 11 this would be 5 seconds and so on. The same rule also applied to actinometer values. If an actinometer light-test of 3 seconds indicated an exposure of 1 sec-ond, a test of 12 seconds would indicate an exposure of $6\frac{1}{4}$ seconds, in-stead of 4 as in ordinary practice. The subject values are also important. It seems hardly possible to obtain good Autochromes even of distant sub-jects with less exposure than half normal, and near subjects require double normal. For interiors, normal exposures for general views and double

for near objects practically cover the ground; very near objects, photographed to a relatively large scale, being considered on their merits, using the near position as a basis.

Development.—The first developer recommended by the makers of the Autochrome plates was the following:

A. Pyrogallol 30 g.
 Alcohol1000 ccs.
B. Potassium bromide 30 g.
 Ammonia 150 ccs.
 Distilled water 850 ccs.

For use mix A 10 parts, B 10 parts, water 100 parts. Duration of development, 2½ minutes at 15° C.

Subsequently[32] the following was recommended for correcting errors in exposure and difference of temperatures. Multiply the correct time, 2½ minutes at 15° C., by the following factors for the given temperatures:

10° C. multiply by 1.6
15° C. " " 1.0
20° C. " " 0.8
25° C. " " 0.6

For overexposure, modify the developer as follows:

Degree of overexposure	Developer	Time of development
4 to 8 times	Sol. A 20 ccs. Sol. B 5 ccs. Water to 100 ccs.	6½ minutes
8 to 15 times	Sol. A 20 ccs. Sol. B 3 ccs. Water to 100 ccs.	6½ minutes

For underexposure, modify as follows:

Degree of underexposure	Developer	Time of development
¼ to ½ correct	Sol. A 10 ccs. Sol. B 20 ccs. Water to 100 ccs.	6 minutes
less than ¼ correct	Sol. A 6 ccs. Sol. B 20 ccs. Water to 100 ccs.	6 minutes

For stand development the following was recommended:

Solution A 20 ccs.
Solution B 20 ccs.
Water1500 ccs.

This takes about half an hour and could be used for six plates.

Later[33] a still further modification was suggested, which did away with the alcohol, and gave a solution that had less tendency to oxidize in use:

A. Pyrogallol 30 g.
 Potassium bromide 30 g.
 Sodium bisulfite lye 20 drops
 Water to1000 ccs.
B. Sodium sulfite, anhydrous.............. 100 g.
 Ammonia, sp. gr. 0.920................. 150 ccs.
 Water to1000 ccs.

For use this stock solution should be diluted with three times its volume of water. The actual developer was:

Solution A 100 ccs.
Solution B, diluted 100 ccs.
Water 1000 ccs.

To compensate for errors in exposure and variations of temperature the following system was devised:

Have ready in a small graduate 45 ccs. of diluted ammonia solution B to be added wholly or partly to the bath during development, if necessary. As soon as the plate is in the dish, count the number of seconds from the moment of entering the developer until the appearance of the first outlines of the image. The sky, however, should not be taken into consideration. It is unnecessary to examine the plate until 20 seconds have elapsed, as whatever be the degree of exposure the first sign of the image will not be seen till 22 seconds have elapsed. The number of seconds before the appearance of the image is the guide to the further development of the plate, which should be carried out according to the following table:

Time of first appearance of image (not counting sky)	Quantity of ammonia, solution B, diluted to ¼ strength, to be added after image appears	Total time of development including time of appearance	
Seconds	Ccs.	Minutes	Seconds
22 to 24	None	2	—
25 to 27	2	2	15
28 to 30	8	2	30
31 to 35	15	2	30
36 to 41	20	2	30
42 to 48	25	2	30
49 to 55	30	2	45
56 to 64	35	3	—
65 to 75	40	4	—
over 75	45	5	—

The additional quantity of B solution must be added when the outlines begin to appear.

It will be seen by the above, for example, that when the image takes 28 seconds to appear 8 ccs. of ammonia solution B should be added and development continued until the expiration of 2 minutes 30 seconds from the time the plate was placed in the developer.

Von Hübl[34] strongly recommended pyrogallol as the developer, on account of its tanning action on the gelatin. P. S. Chataux[35] suggested immersion of the plate first in the pyro solution and after a few seconds the addition of a little of the ammonia, continuing this addition if the plate appeared to lag, so as to complete development in 2½ minutes. L. Cust[36] considered that there was far greater possibility of correcting expo-

sure errors with pyro-ammonia than with metol-hydroquinon, and also suggested a tentative method of adding the ammonia gradually.

The ready oxidation of pyrogallol is to some workers a great objection, and MM. Lumière[37] suggested the following as obviating this difficulty:

Metoquinon (Quinomet)...................... 4 g.
Sodium sulfite, anhydrous...................... 18 g.
Ammonia, sp. gr. 0.920........................ 6 ccs.
Potassium bromide............................1 g.
Water to....................................1000 ccs.

Time of development 2½ minutes at 18° C. for correct exposure. A more elastic developer, which should permit of correction of errors in exposure was later[38] given:

Metoquinon 15 g.
Sodium sulfite, anhydrous...................... 100 g.
Ammonia 32 ccs.
Potassium bromide........................... 6 g.
Water to....................................1000 ccs.

For use 5 parts of this stock solution should be mixed with 100 parts of water. For correction of exposure the following method was advised. Place in two separate graduates 15 and 45 ccs. respectively of the above stock solutions. Immerse the plate in the dilute solution, and count the number of seconds till the first appearance of the image, exclusive of the sky in landscape work. The total time of development was then determined according to the following table: Immediately the outlines are discernible, pour into the dish either 15 or 45 ccs., which ever may be necessary according to the table, continuing to count the seconds:

Appearance of outlines	Quantity of developer to add on first appearance of outlines	Total duration of development from first immersion of plate	
Seconds	Ccs.	Minutes	Seconds
12 to 14	15 ccs.	1	15
15 to 17	15 ccs.	1	45
18 to 21	15 ccs.	2	15
22 to 27	15 ccs.	3	—
28 to 33	15 ccs.	3	30
34 to 39	15 ccs.	4	30
Extreme 40 to 47	45 ccs.	3	—
Underexposure above 47	45 ccs.	4	—

The Lumière N. A. Co.[39] issued subsequent to April 1, 1909 the following instructions, which involve the use of two baths only:

Quinomet 4 g.
Sodium sulfite, anhydrous...................... 18 g.
Ammonia, sp. gr. 0.920........................ 6 ccs.
Potassium bromide........................... 1 g.
Water to....................................1000 ccs.

This was to be used for 2½ minutes at 18° C. for correct exposure. The reversing solution was:

Potassium permanganate	2 g.
Sulfuric acid	10 ccs.
Water	1000 ccs.

This should be allowed to act for 3 or 4 minutes, the plate washed for about half a minute in running water, and then redeveloped with the same developer. After 3 or 4 minutes, when the high lights are completely darkened, the plate should be washed for 3 or 4 minutes and dried, without fixing. If after redevelopment the plate lacked brilliancy, it might be intensified with the acid-silver method.

Lumière & Seyewetz[40] also suggested the following method of using their metoquinon developer, although it seems to have been primarily suggested to them by M. Meugniot. The method is based on the first appearance of the image in a very dilute developer, and then finishing development with a concentrated solution, the duration in the latter being equal to the time of appearance of the image. The more concentrated stock solution (see p. 519) is used and 10 parts diluted with 15 parts of water. The plate should be placed therein, and the number of seconds counted till the first appearance of the image. The dilute developer should then be poured away, the stronger applied and development continued for the same time as that of the action of the dilute. It was stated that by this method exposures from correct to 4 times correct gave excellent results. The metoquinon here mentioned is a patented compound of two molecules of hydroquinon with one molecule of metol.

In place of the somewhat expensive metoquinon, R. Namias[41] suggested the following:

Metol	4 g.
Hydroquinon	12 g.
Sodium sulfite, anhydrous	50 g.
Ammonia, sp. gr. 0.920	33 ccs.
Potassium bromide	6 g.
Water	1000 ccs.

This was found to act the same as Lumière's developer and gave great brilliancy.

A. B. Hitchins[42] recommended the following:

Metol	6.5 g.
Hydroquinon	2.10 g.
Sodium sulfite, anhydrous	40 g.
Potassium bromide	2.5 g.
Hypo	0.10 g.
Ammonia, sp. gr. 0.880	20 ccs.
Water	1000 ccs.

For use dilute with an equal volume of water. The small quantity of hypo caused the image to begin to reverse in this solution. Development should be carried on till the high lights or flesh tones just begin to show reversal,

when viewed against the light. An excellent developer was obtained by using, instead of the hypo, potassium ferrocyanide, not ferri—, equal to half the weight of the actual reducing agent, thus 4.3 g. in the above formula.

V. Crèmier[43] stated that a mixture of 10 g. of metol and 5 g. of hydroquinon gave as good results as metoquinon, and that for very brilliant pictures 7 and 8 g. respectively should be used. It should be noted that according to the molecular weights the ratios should be 10 hydroquinon and 22.36 metol. Crèmier,[44] C. Lelong,[45] E. Mayer,[46] G. Winter,[47] Mouton,[48] H. Bourèe,[49] J. Carteron[50] used metol-hydroquinon in two solutions, adding the ammonia only just before use. A. Watkins[51] strongly recommended time development, adjusted for varying temperatures. A. Brizet[52] suggested for subjects, that contained much green or grey and showed but little contrast, a developer of:

Metol	6 g.
Hydroquinon	4 g.
Sodium sulfite, anhydrous....................	40 g.
Potassium bromide.........................	0.24 g.
Hot Water................................	1000 ccs.

When cool add

Ammonia	13 ccs.

This contains a relatively large proportion of metol and hydroquinon, but it should be borne in mind that metoquinon is 30 per cent more active than a mixture of the two reducing agents. For use 40 parts of above were to be mixed with 80 parts water. This was stated not to fog plates and development could be prolonged to 6 minutes if necessary.

V. Crèmier[53] pointed out that chloranol, a combination of chlorhydroquinon and metol, introduced by MM. Lumière, acted more energetically than metoquinon, and it is more soluble in water. The formula recommended was:

Chloranol	15 g.
Sodium sulfite, anhydrous....................	100 g.
Potassium bromide.........................	6 g.
Hot water................................	1000 ccs.

When cool add

Ammonia	32 ccs.

For use 5 parts of this should be diluted with 100 parts water. Development takes rather longer and the results are more brilliant. J. Carteron[54] recommended the following method as giving good control of Autochrome plates. Three dishes were used side by side; in the first one was either of the following solutions, which destroyed the color-sensitiveness of the emulsion:

A. Potassium bromide.......................	10 g.
Acid sulfite lye...........................	20 ccs.
Water	1000 ccs.

Or

B. Potassium bromide........................ 10 g.
Boric acid............................... 50 g.
Water1000 ccs.

In the second dish was the developer and in the third the reversing solution. The plate was placed, in absolute darkness, in the first dish and left for 2 minutes; the dish should be covered and the red light turned on. The developer was the usual metoquinon diluted with eight times the quantity of water. The plate should be well rinsed after the desensitizing bath and immersed in the developer for 10 or 15 minutes, or till it appeared grey, then washed and immersed in the reversing bath. As soon as the negative image had entirely disappeared, the plate was rinsed for a minute, then redeveloped.

E. Cousin[55] advised soaking the plates in water before applying the developer, so as to soften the gelatin and enable it to act better on the lower layers of the emulsion, where the image actually lies; he stated that this method enabled plates to be developed without fog setting in. Apparently as one would expect almost any developer can be used, such as pyrocatechin, rodinal, amidol, pyro-metol, etc. C. Simmen[56] strongly recommended the acid amidol developer, his formula being:

Diaminophenol (amidol)..................... 6.6 g.
Sodium sulfite, anhydrous.................... 19 g.
Sodium bisulfite lye......................... 19 ccs.
Potassium bromide, 10 per cent sol..............19-33 ccs.
Water to...................................1000 ccs.

The bromide might be reduced, only enough being used to keep the whites clean. The great advantage of this developer was said to be that it begins to develop from the bottom of the film, where the most exposed grains lie.[57] The solution, as given above, will not keep, and therefore, it is better to make a stock solution of sulfite and add the amidol as wanted.

A committee of the Société Française de Photographie[58] reported that while acid amidol gave good results, the plates were less brilliant than when the Lumière pyro developer was used, and the latter was on the whole preferable. Amidol was strongly commended by G. Balagny,[59] H. D'Arcy Power,[60] A. Personnaz,[61] R. Espitallier[62] and others.

F. Dillaye[63] advised immersion of the plate in bromide and acid sulfite, followed by development with metoquinon. For developing Autochromes in the tropics, G. de Vies[64] recommended:

Pyrogallol 4 g.
Potassium bromide........................... 4 g.
Sodium sulfite, anhydrous.................... 20 g.
Acid sulfite lye............................. 1-2 drops
Ammonia 30 ccs.
Water1000 ccs.

The plate should be first treated with a 2.5 per cent solution of formaldehyde, and then rinsed for 10 seconds.

V. Crèmier[65] recommended for extreme brilliancy for projection:

Metol 7 g.
Hydroquinon 8 g.
Sodium sulfite, anhydrous..................... 100 g.
Ammonia, sp. gr. 0.923........................32 ccs.
Potassium bromide........................... 6 g.
Water1000 ccs.

This is also very suitable for plates that have been hyper-sensitized.

Subjects of extreme contrast are difficult to deal with, even with ordinary plates, which have a very much greater latitude than all screen-plates. Drake-Brockman[66] proposed the use of a preliminary bath of from 0.5 to 1.5 per cent of potassium dichromate, for times ranging from 1 to $2\frac{1}{2}$ minutes, prior to development, then washing for 2 minutes. This was also recommended, especially for photomicrography, by O. Lederer.[67] For extreme contrasts G. Balagny[68] advised the use of acid amidol, with the addition of sodium sulfite in small quantities at a time, according to the appearance of the image.

A. J. Woolway[69] recommended rodinal, 1 : 100, for 6 minutes at 15° C. This was also commended by E. Clifton,[70] H. D'Arcy Power,[71] and E. J. Steichen.[72] R. Namias[73] recommended glycin and sodium carbonate, without sulfite. A. Ebert[74] recommended edinol.

The Reversing Solution.—The purpose of this is to dissolve the primary image, and that first recommended by MM. Lumière was:

Potassium permanganate..................... 2 g.
Sulfuric acid, conc........................... 10 ccs.
Water1000 ccs.

First dissolve the permanganate, then add the acid slowly with constant stirring. The solution should be kept in the dark, and should not be used a second time. It should be allowed to act for 3 or 4 minutes.

Unfortunately some trouble was caused from this, and it was found better to keep it in two solutions[75] by dissolving the permanganate in half the water and the acid in the rest, and mix just before use. Stale solution is somewhat slow in action and may give rise to black specks, due to the precipitation of some insoluble manganese compound. This is particularly the case if the solutions have been kept in the light. To avoid this deposition H. D'Arcy Power[76] suggested immersing the plate face down. G. E. Rawlins[77] proposed the use of fresh solution, 5 to 10 per cent, of ammonium persulfate, followed by a weak bath of sodium bisulfite, about 3 per cent. The Comte de Dalmas[78] proposed the use of a dry reverser, which was specially useful on tour as it merely required dissolving in water to be ready for use. The formula was:

Potassium permanganate........................ 2 g.
Sodium bisulfate...............................50 g.

This quantity being sufficient for a liter.

G. Drake-Brockman[79] preferred the following:

Potassium dichromate........................ 5 g.
Sulfuric acid, conc........................... 10 ccs.
Water1000 ccs.

This was also commended by R. Namias.[80] The only disadvantage being that it requires rather longer washing for removal than the permanganate; but it can not give rise to black spots. F. Stephan[81] suggested a mixture of:

Potassium permanganate..................... 2 g.
Alum, saturated solution....................1000 ccs.

Which not only reversed, but hardened the gelatin; a subsequent bath of bisulfite was used.

R. Chaboseau[82] patented a mixture of permanganate 2, alkaline bisulfate 18, potash alum 15 parts, which was called "Inversol," and which was to be dissolved when required in a liter of water. R. Krügener[83] patented the same combination.

The Second Development.—After the primary image has been dissolved, and this should always be done in the darkroom, the plate must be washed to remove the last traces of the reversing solution. The makers state that this need only be for 30 to 40 seconds, but it is preferable to wash for at least a minute or two, and this can be carried out in white light.

The condition of the plate at this moment is that the primary image produced by the development of the silver halide grains, exposed in the camera, has been dissolved by the reversing solution. There is then left a gelatin film containing unexposed and undeveloped silver bromide, where the light did not act in the camera, plus those parts of the film, which have been freed from metallic silver, where the colors of the screen elements are visible. The silver salt thus unreduced is converted to metallic silver by exposing the plate to white light with subsequent development. For this second development, the makers recommended the use of:

Amidol 5 g.
Sodium sulfite, anhydrous................... 15 g.
Water1000 ccs.

Too close adherence to this formula is of no moment, in fact there is no reason why the solution used for the primary development should not be used, nor any particular solution that appeals to the operator. The only requirement would seem to be that the developer should not stain.

There is one point, on which little stress has been laid, but which is important, and that is one well known to every photographer. By extreme overexposure it is possible to convert the silver halides into such a condition that they will not give a vigorous image on development, due to reversal or solarization. It may, therefore, happen that too long expo-

sure, or too bright a light, may produce this condition, with the result that very little is reduced to silver, which should block out those screen elements which are not required to form the colored image; so that the result may appear pale from admixture of white light.

It is obvious that any actinic light may be used, arc, magnesium, electric or incandescent gas, etc., so that it is unnecessary to record all the details of particular exposures to particular lights that have been suggested by workers. J. Husnik[84] was of the opinion that the second time of development, as advised by the makers, which was about 2 minutes, was insufficient, and that it should be continued for at least 6 or 7 minutes, particularly in dull weather.

F. Torchon[85] warmly supported the use of 5 per cent solution of ammonium sulfide, instead of the second developer, and stated that the image was pure black. Subsequent intensification was unnecessary, the plates were extremely transparent, and the results obtained perfectly permanent. A. Damry[86] contended that the images, thus obtained, were weak and required intensification, and for this purpose proposed mercuric iodide in sulfite solution. Red stains were also found to be formed by Torchon's method; but R. Ceiller[87] pointed out that these were due to traces of manganese left in the film by the reversing solution, and that a bisulfite bath was a complete remedy. This method did not find general adoption in practice.

C. Gravier[88] proposed to treat the plate after reversal, with bisulfite solution and then to omit all further operations, merely washing and drying. This method, if sound, would eliminate five operations; but it is extremely doubtful whether the results are as good. Gravier claimed that the pictures were more brilliant; but as pointed out by the author[89] this is hardly correct. That there might be greater luminosity of the plate as a whole is obvious, as in the original method, in which the second development reduced the primarily unattacked silver salt, the final result was a colored image plus black silver, which stopped out the light where it was not wanted. In the Gravier method there was a colored image plus silver bromide, and the latter was neither colorless nor opaque. Therefore, there was added to the colored light passing through the screen elements, that transmitted through the silver salt, so that the colors were actually paled.

Intensification.—In order to render the black stopping-out silver grains quite opaque and free from any greenish tinge, and also to improve overexposed plates, it was recommended by the makers that intensification should be resorted to. Although this is not always requisite with correctly exposed plates, it will be found as a rule that there will be some improvement in the apparent brilliancy of the pictures.

The method first suggested was with nascent silver, for which the following solutions were required:

A. Pyrogallol 3 g.
 Citric acid............................. 3 g.
 Water1000 ccs.
B. Silver nitrate.......................... 5 g.
 Water 100 ccs.

For use add 10 parts of B to 100 parts of A, and immediately apply to the plate, and rock the dish till the intensification is sufficient. The mixed solution rapidly turns brownish-yellow and becomes cloudy. In the latter case it should be poured away, and freshly mixed solution applied if necessary. As the intensification is due to the precipitation of metallic silver, a perfectly clean dish must be used, otherwise the silver will deposit everywhere.

The duration of intensification should not be more than 30 seconds, and may be complete in less, and this is easily judged by examination by transmitted light. If the intensification is not complete in this time, the solution should be poured away, the plate well washed and a clearing bath of:

Acid permanganate solution................... 20 ccs.
Water1000 ccs.

Applied. This acid permanganate solution is merely the reversing solution. The plate should be again well washed and freshly intensified. Unfortunately the above solution of pyrogallol soon grows mouldy and then spoils. To remedy this, T. K. Grant[90] recommended the addition of 0.05 per cent of salicylic acid as preservative.

G. E. Brown[91] stated that the silver solution was apt to deposit metallic silver on standing, and that care should be taken not to disturb any precipitate, that might be in the bottle, or the small particles of silver might stick to the film.

Several substitutes were suggested for the above nascent silver bath; but with a little care there is very little more trouble with it than some of the other solutions recommended. F. Monpillard[92] preferred Monckhoven's potassio-silver cyanide intensifier. This gives excellent results, but the action must be very carefully watched, in order that the action does not proceed too far, and produce actual reduction of the lower densities, which is characteristic of this solution. This is the more likely to occur in consequence of the small quantity of gelatin used, as all solutions act much more quickly than on an ordinary plate.

R. Namias[93] suggested a variant of the cupric intensifier, as follows:

Cupric sulfate............................. 20 g.
Potassium bromide.......................... 20 g.
Hydrochloric acid.......................... 5 ccs.
Water1000 ccs.

As soon as the plate has completely bleached, it should be rapidly washed, then treated with a 5 per cent solution of silver nitrate, acidified with nitric acid, and when black enough it should be placed in a neutral permanganate

bath, washed and redeveloped with an amidol developer or treated with 5 per cent solution of sodium bisulfite.

E. J. Steichen[94] avoided intensification as far as possible, as he considered that this was the cause of the glaring colors so often seen in Autochromes. When required, he preferred the Agfa intensifier, which is a solution of mercuric sulfocyanide. A. David[95] had recourse to the chromium process, using:

Potassium dichromate....................... 20 g.
Hydrochloric acid...........................20 ccs.
Water1000 ccs.

The plate should be immersed in this for from 30 to 60 seconds, washed and immersed for not more than 30 seconds in a 3 per cent solution of bisulfite, so as to remove any yellow stain, and then redeveloped with an amidol developer.

"Anon"[96] suggested the use of lead ferricyanide. The plate was to be bleached in this, dipped for 15 seconds into a 2.5 per cent solution of hydrochloric acid, washed and blackened in a 2.7 per cent solution of sodium sulfide, again immersed in the acid bath, washed and dried. The permanence of the result is doubtful.

Fixing.—After intensification the plate should be washed for 30 seconds, then treated to a clearing bath of:

Potassium permanganate.................... 1 g.
Water1000 ccs.

For from 30 to 60 seconds, then washed for the same time and fixed in:

Sodium hyposulfite......................... 150 g.
Sodium bisulfite lye......................... 50 g.
Water1000 ccs.

And washed for 5 minutes. R. Namias considered this bath was too strong and very liable to dissolve the intensification and preferred a 3 per cent solution of hypo. Sometimes the above clearing bath causes brown stains, and he proposed[97] the use of a 0.2 per cent of oxalic acid after it. E. König[98] suggested for the same purpose a very dilute solution of sodium bisulfite, and this had the advantage that if it was not washed out, it would do no harm when the plate was placed in the hypo.

G. Müller[99] pointed out that one common failure was the practical disappearance of the image in the fixing bath, and the plate was usually given up for lost. But if physical intensification was resorted to, full intensity might be obtained, although it sometimes took a long time. Neuhauss' old formula was recommended:

Ammonium sulfocyanide.................... 24 g.
Silver nitrate............................. 4 g.
Sodium sulfite............................ 24 g.
Hypo 5 g.
Potassium bromide, 10 per cent sol........... 6 drops
Water100 ccs.

For use 6 ccs. should be added to 60 ccs. water and 2 ccs. of rodinal added. If the solution turns thick and muddy before the necessary intensification is obtained, it should be thrown away and fresh applied.

Varnishing the Plate.—In order to protect the somewhat delicate film, it is advisable to varnish it, and the makers of the plate recommended:

Gum dammar.............................. 200 g.
Benzol1000 ccs.

The plate must be thoroughly dry, and it is preferable to warm it before applying the varnish.

E. Valenta[100] recommended a 10 per cent solution of dammar in carbon tetrachloride or:

Gum dammar.............................. 20 g.
Manilla copal, powdered...................... 50 g.
Carbon tetrachloride........................1000 ccs.

As soon as the resins are dissolved, the mixture should be heated to the boiling point, and then filtered while hot. G. Le Roy[101] suggested:

Gum dammar.............................. 66 g.
Gum mastic................................. 66 g.
Carbon tetrachloride........................1000 ccs.

G. E. Brown and Welborne Piper[102] recommended celluloid dissolved in amyl acetate; but E. König[103] strongly advised against this or any varnish containing nitrocellulose, as the latter under the action of light gives off nitrous fumes, which would be apt to attack the dyes of the screen elements.

Failures.—The following is a list of possible failures and their remedies, details of which have been collected from various sources.

Frilling.—The early batches of the Autochrome plate were very prone to this trouble, due to some peculiarity in their manufacture; but the later ones show but little signs of this defect. The most satisfactory remedies seem to have been the reduction of the alcohol in the developer, varnishing or waxing the edges of the plate, and after reversal, binding the edges with a strip of adhesive plaster.

Black Spots.—These are unavoidable faults in the manufacture, and can be removed by touching them with the acid reversing solution, dipping into water and fixing. Or they may be touched with a very fine camel's hair brush, or the pointed end of a match with:

Potassium iodide............................ 1 g.
Iodine 1 g.
Water50 ccs.

And then fixing. They were apparently metallic silver, which was by this treatment, converted into silver iodide, which dissolved in the hypo.

Dark Brown or Blackish Patches.—These must not be confounded with the previous defect. They are much larger, more diffuse as to their edges, and more frequently make their appearance on those parts of the picture that should be colorless. They may be due to (a) incomplete

solution of the primary image, through too short action of the reversing solution; (b) to the reversing solution having been used too often, and thus having lost its solvent power; (c) according to the makers, to traces of undissolved silver remaining through small inequalities of the film thickness; (d) a precipitate of manganese dioxide from the second clearing solution; (e) to the developer not having been thoroughly washed out, thus reducing the intensifier. The remedies are (a) longer action of the reverser; (b) the use of freshly made reverser; (c) more complete action of the reverser; (d) the application of a solution of oxalic acid, or sodium bisulfite, which dissolve the manganese compound.

Peculiar patches are sometimes also caused by the back of the plates not being clean. Dirt here would naturally prevent access of light to the emulsion, which would not then be reduced to metallic silver, or not to so great an extent, by the first developer, and after reversal the second development would reduce the unaltered silver bromide. There is no remedy, or the very doubtful one of local reduction.

Green Spots.—These differ in character. Small spots are due (a) to minute holes in the insulating varnish, through which the solutions penetrate and dissolve out the dye, which thus spreads a little; (b) larger spots and lines are due to mechanical injury to the varnish through too great pressure of the springs of the plate holder; (c) to allowing the plate to remain wet too long after washing; this particularly shows at the edges. The remedies are (a) spot out with opaque color; (b) thicker cards and reduction of the pressure of the springs; (c) gently dab off moisture with a soft cloth; whirl the plate till dry, or put in a current of warm air.

White Spots.—Generally due to air-bells clinging to the film during the second development. These must not be removed with the finger, as the film is so tender, that it is almost certain to be ruptured. A small pledget of absorbent cotton, well wetted, should be lightly passed over the spot. If the plate is placed in the reversing solution in white light, traces of the developer may reduce unexposed silver bromide, which would then dissolve; or the light might cause slight printing-out of the silver bromide, when it would also be dissolved.

Blue Spots.—These, it has been stated have been occasionally met with, and are ascribed to the alcohol penetrating the varnish and dissolving the blue dye. This, however, is doubtful. If the image appears blue generally, with practically little other color, it may be due to the omission of the compensating filter, or if there is a general blue tinge, the plate is underexposed, or the filter has faded. Stray white light would also naturally produce the same effect, because it would penetrate the blue screen elements and cause more action thereunder than through the red and green, therefore the former would be more transparent in the positive.

Von Hübl[104] stated that the mosaic screen of the older plates had a decided pink tinge and, therefore, for correct rendering of the colors a

filter of certain density was required. The later plates show much less of this reddish tinge, and if the same filter be used, the action of the blue would be undercompensated, or in other words bluish pictures must be produced. This is a far more likely cause than the fading of the filter, which has a considerable stability to light.

If the plate appears too dark generally and the colors dull, it may be due to either underexposure, which tends to give excess blue, or the plate was insufficiently developed at first, or the developer was too cold. Both these would naturally cause less primary reduction, therefore, there would be more than the correct quantity of silver halide reduced after reversal. Insufficient action would also tend to produce this, but this would be more apparent in the high lights.

Overexposure produces pale colors with want of detail in the high lights, as there would be too much silver reduced at these points in the primary development, and thus too little after reversal. Too high a temperature of the developer, or too much ammonia, insufficient washing after the clearing bath will also cause the picture to appear too pale.

If the picture shows no color, the plate was probably placed the wrong way round in the dark slide, that is with the sensitive surface facing the lens. If the colors appear correct after the second development and become paler on fixing, the duration of the second development was insufficient, or the plate had not been exposed long enough to white light. Out of focus images may be caused by incorrect position of the focusing screen, focusing without the compensating filter in position, and with some lenses to alteration of the diaphragm after focusing.

If the silver intensifier is used too long, so that it becomes muddy, specks of metallic silver may be deposited on the film, or the whole film may appear yellowish. This may be cured by treatment with the neutral permanganate solution and fixing. A general rosy tinge is caused by too long washing after fixing, so that some of the green dye is dissolved.

Very frequently deep shadows show a distinct blue tinge, and H. Lehmann[105] ascribed this to the fact that with very low intensities of light, blue always develops before the other colors at the less refrangible end of the spectrum. Von Hübl[106] showed that this explanation was unsound, as a scale of greys was correctly reproduced by white illumination, both when exposed for a very long time to a poor light, and for a short time to a good light. He ascribed this fault to an incorrect compensating filter, and stated that many of those on the market were not of equal density.

G. A. Le Roy[107] suggested that when Autochromes were too bluish from underexposure, they should be immersed in a weak solution of the complementary color, such as Poirrier's orange II. Such baths must be used with care, and not allowed to act too long, or the remedy would be worse than the disease.

Viewing and Exhibiting Screen-Plates.—The full beauty of a

screen-plate picture can only be seen when the only light reaching the eye is that transmitted through the plate. This may obviously be attained by enclosing the plate in a box, with an eye-hole, and a diffusing screen of ground glass behind the picture. One method of showing these pictures has become very general, and that is to use a flat base containing a mirror, with side pieces of cloth to cut off side light and a ground glass screen at an angle of 45 degrees above the same with an aperture below to hold the screen-plate. The image is thus not viewed directly, but by reflection in the mirror. One advantage of this is that in consequence of the double reflection from the back and front surfaces of the mirror, the frequently troublesome clumping of the grains is almost entirely destroyed visually, as pointed out by F. Leiber.[108]

For lantern projection as brilliant and as white a light as possible is desirable, so too large a disk should not be shown, otherwise the picture loses much in brilliancy, because all screen-plates transmit but a comparatively small proportion of the incident light. There is, however, another point, which is still more important, and that is the enlargement of the screen elements. For if this be too great these become obtrusive, or the distance of the nearest spectators must be so great as to be of trouble in small halls.

For an object to be distinctly visible, it must subtend an angle of 1 minute of arc, which is about the angle subtended by 460 millimeters at a distance of 1925 meters, or 1 millimeter at 4.2 meters. It is easy to see, therefore, that one has merely to multiply the size of the original screen element by the degree of magnification to find the distance of visibility. With regular patterned screens, this is of course, a matter of simplicity; but with irregular screens, where one has clumping of the grains, it is not so easy to decide. As a matter of fact, it may be assumed that a 3 or 4 foot disk is as large as one can comfortably show, and much more brilliant results are obtained if the size is kept even below this, and the pictures shown by transparence, that is to say, the picture should be thrown on to a sheet of ground glass or tracing cloth from behind, so that the spectators see the pictures through the screen and not by reflected light.

H. Lehmann[109] proposed the use of an aluminum screen. Linen or calico should be well stretched on a frame and painted with:

Zinc oxide.....................................200 g.
Glycerol100 ccs.
Gelatin100 g.
Water ...900 ccs.

Soak the gelatin in the water and dissolve by heat. Grind the zinc oxide into a paste with the glycerol and a little water, add the gelatin solution, and apply while still hot to the cloth with a broad flat brush. When dry this remains supple and does not crack. It should then be painted over with gold-size or copal varnish, and whilst still tacky, silver bronze (alumi-

num powder) should be dusted over it, whilst in a flat position, and then allowed to dry. On standing up vertically excess of powder will fall off.

Zeiss, of Jena, introduced commercially screens of this type with a rippled surface, which enabled spectators at a wider angle to see the pictures. Lehmann gave the following table of the relative maximum brightness H, and the useful angle of diffusion W, that is the angle over which the metallic surface appears equally bright:

	H	W
Ordinary white paper	1.0	—
Matt aluminum, Zeiss	13.8	48
Canvas aluminum, Zeiss	7.8	61
Rippled aluminum, Zeiss	3.4	84
Aluminum in celluloid	3.4	71
Aluminum in rubber	2.9	56
Coarse ground glass, silvered on the matt side	1.6	96

The "rippled" screen was an aluminum screen to the surface of which a fine rib or ripple had been mechanically imparted.

Von Hübl[110] pointed out that if the pictures were projected in a square room, it follows from measurements that have been made, that one portion of the audience will see the projection in its full strength. Others will see the picture of only five times the brilliancy, and others still further removed from the center of the room will see it only twice the brightness, or even no brighter than in the ordinary way. While those far removed towards the sides, are at such disadvantage that they will see it of about half the brilliancy as projected in the usual way. It will thus be seen that only about 10 per cent of the audience can see the picture in its full brilliancy. While 50 per cent see it considerably better and the remainder not so well as in ordinary projection. In the case of the rippled screen, the conditions are more favorable; although the extreme brilliancy attained is only $3\frac{1}{2}$ times as great as with a white screen; 20 per cent of the audience are able to view it at full strength. In this case also, the brilliancy falls off as a more sideways observation is taken, until the brightness is only that of the ordinary screen.

Naturally the color of the light has considerable influence on the resultant impression, and details of the colored filters for projection will be found in the section dealing with filters.

The early issues of the Autochrome plate were of a much more tender nature, as regards the film, than the later ones, and showed a great tendency to crack in the lantern. As a remedy for this von Hübl[111] recommended bathing the plate in a 5 per cent solution of glycerol and drying without washing. But as glycerol is a sensitizer for some of the dyes, and caused them to fade, he later[112] suggested the addition of 5 per cent of cupric sulfate to the bath. The particular virtue of this addition is open to question, as the dyed elements are protected by an insulating varnish. H. E. Corke[113]

used the former method and found that the pictures gradually acquired a rosy tint, due probably to solution of the red dye by the glycerol, which would in time penetrate the varnish film; further the plates developed patches, that looked like bacillary growths.

A. D. Brixey[114] patented a projection screen, composed of a translucent light-diffusing screen for receiving the projected rays and a non-reflecting-reducing screen for transmitting the picture to the eyes of the audience. Practically it seems to have been a modification of the Autochrome plate, and the results were said to be shown in colors, although the projected picture seems to have been in black and white only.

1. Phot. Coul. 1909, **4**, 94; Brit. J. Phot. 1909, **56**, Col. Phot. Supp. **3**, 52; Brit. J. Almanac, 1910, 602; Jahrbuch, 1910, **24**, 170; Compt. rend. 1909, **148**, 36; Chem. Ztg. 1910, 91.
C. Adrien, Bull. Soc. franç. Phot. 1912, **58**, 400; abst. C. A. 1912, **6**, 837, used a 1 : 1,000,000 pinachrom bath.
2. Phot. Coul. 1911, **6**, 81; Bull. Soc. franç. Phot. 1911, **58**, 379, 383; Phot. Korr. 1911, **58**, 483; Wien. Mitt. 1911, 19; Brit. J. Phot. 1911, **58**, 47; Brit. J. Almanac, 1912, 660; Bull. Phot. 1912, **10**, 829.
3. Phot. Coul. 1910, **5**, 141; Bull. Soc. franç. Phot. 1910, **57**, 275; 1911, **58**, 382, 403; Photo-Gaz. 1910, **20**, 214; Brit. J. Phot. 1910, **57**, 65; 1912, **58**, Col. Phot. Supp. **6**, 17; Brit. J. Almanac, 1911, 618; 1913, 693; Jahrbuch, 1911, **25**, 200; Phot. Mitt. 1910, **47**, 292; Wien. Mitt. 1910, 443, 585; 1911, 11; abst. C. A. 1912, **6**, 837. Cf. F. Monpillard, Phot. Coul. 1912, **7**, 77; Brit. J. Phot. 1913, **60**, Col. Phot. Supp. **7**, 33; Brit. J. Almanac, 1914, 700. E. Vallot, Bull. Soc. franç. Phot. 1913, **60**, 360. L. Gimpel, Der Phot. 1913, **19**, 381. A. Personnaz, Phot. Coul. 1918, **3**, 163. E. Coustet, Rev. Sci. 1911, **49**, 239. V. Crèmier, Photo-Gaz. 1912, **22**, 171. T. K. Grant, Brit. J. Phot. 1912, **59**, Col. Phot. Supp. **6**, 36.
4. Wien. Mitt. 1911, 5; Phot. Korr. 1911, **48**, 483; Brit. J. Phot. 1911, **58**, 29; Brit. J. Almanac, 1912, 659; Jahrbuch, 1911, **25**, 199; abst. C. A. 1911, **5**, 3767.
5. Bull. Soc. franç. Phot. 1911, **58**, 400; Phot. Ind. 1912, 939; Jahrbuch, 1913, **27**, 296; Brit. J. Phot. 1911, **59**, Col. Phot. Supp. **6**, 12.
6. Wien. Mitt. 1913, 2, 33; Phot. Chron. 1913, **20**, 214; Phot. Ind. 1915, 689; abst. C. A. 1913, **7**, 1447; Phot. J. Amer. 1913, **50**, 437.
7. Photography, 1914, 49; Brit. J. Almanac, 1915, 522; Jahrbuch, 1915, **29**, 140. For descriptions of drying boxes see: H. G. Drake-Brockman, Brit. J. Phot. 1913, **59**, Col. Phot. Supp. **7**, 9; Brit. J. Almanac, 1914, 701. F. Monpillard, Bull. Soc. franç. Phot. 1914, **61**, 184; Brit. J. Phot. 1914, **61**, Col. Phot. Supp. **8**, 36.
8. Bull. Soc. franç. Phot. 1908, **55**, 349; 1912, **59**, 126; Brit. J. Phot. 1908, **55**, Col. Phot. Supp. **2**, 75; 1913, **60**, ibid. 7, 1, 13; Brit. J. Almanac, 1909, 649.
G. Denjean, F.P. 570,098 patented the use of varnish or waterproof cloth round the edges of screen-plates while hypersensitizing; abst. Sci. Ind. Phot. 1924, **4**, 185.
9. Bull. Soc. franç. Phot. 1921; Brit. J. Phot. 1921, **68**, Col. Phot. Supp. **14**, 4.
10. Bull. Soc. franç. Phot. 1914, **61**, 360, 389; abst. C. A. 1914, **8**, 1243; Phot. Korr. 1920, **57**, 275; Phot. Mitt. 1911, **48**, 369.
11. Bull. Soc. franç. Phot. 1922, **64**, 90, 130; Rev. Franç. Phot. 1922, 3, 90; Brit. J. Phot. 1922, **69**, 349; Col. Phot. Supp. **16**, 25, 27; Amer. Phot. 1922, **16**, 725; Brit. J. Almanac, 1923, 409.
It is interesting to note that W. H. Hyslop (see p. 250) used an ammoniacal solution of silver chloride with erythrosin in 1887.
12. Bull. Soc. franç. Phot. 1924, **65**, 345; abst. Rev. Franç. Phot. 1923, **4**, 302; 1924, **5**, 47; Sci. Ind. Phot. 1924, **4**, i, 12; Amer. Phot. 1924, **18**, 570. This process is not applicable to ordinary plates.
13. Bull. Soc. franç. Phot. 1924, **61**, 11, 48, 165; Brit. J. Phot. 1924, **71**, Col. Phot. Supp. **18**, 9, 15, 25, 32, 42, 48; Rev. Franç. Phot. 1924, **5**, 72, 96, 117, 189, 292; Phot. Ind. 1924, 553; Amer. Phot. 1924, **18**, 570; abst. Brit. J. Almanac, 1925, 314; Phot. Chron. 1924, **31**, 430; Bull. Soc. franç. Phot. 1924, **66**, 208; Photo-Rev. 1925, **37**, 64; Camera (Luzerne) 1925, **3**, 184; abst. C. A. 1925, **19**, 1230.
14. Bull. Soc. franç. Phot. 1924, **66**, 83, 92; Amer. Phot. 1924, **18**, 693; 1925,

19, 56; Rev. Franç. Phot. 1924, **5**, 127; Le Procédé, 1924, **26**, 92; Brit. J. Phot. 1925, **72**, Col. Phot. Supp. **19**, 9.

15. Bull. Soc. franç. Phot. 1924, **66**, 84, 168.

16. Phot. Coul. 1908, **3**, 243; Bull. Soc. franç. Phot. 1908, **45**, 349; Brit. J. Phot. 1908, **55**, Col. Phot. Supp. **2**, 75; abst. Brit. J. Almanac, 1909, 649; Photo-Era, 1913, **30**, 95.

17. Brit. J. Phot. 1911, **58**, Col. Phot. Supp. **5**, 5; Bull. Soc. franç. Phot. 1911, **58**, 229; Phot. Mitt. 1911, **48**, 269; abst. C. A. 1911, **5**, 65.

18. Brit. J. Phot. 1911, **58**, Col. Phot. Supp. **5**, 7, 65.

19. Bull. Soc. franç. Phot. 1897; Phot. Chron. 1897, **4**, 405; Jahrbuch, 1898, **12**, 381.

Sir D. Brewster suggested in 1850 the use of a white ground at the back of the old albumen plate, as increasing the sensitiveness, Brit. J. Phot. 1897, **44**, 567, 678.

20. Phot. Coul. 1911, **6**, 69.

21. Bull. Soc. franç. Phot. 1910, Nov.

22. Ibid. 1911, Feb.

23. U.S.P. 1,028,337, 1912.

On the use of compensating filters in general see: F. W. Painter, Brit. J. Phot. 1916, **63**, Col. Phot. Supp. **10**, 11. J. McIntosh, ibid. 1908, **55**, ibid, **2**, 88. A. Watkins, ibid. **2**, 96. Anon. ibid. 1909, **56**, 540. C. N. Bennett, ibid. 1910, **57**, ibid. **4**, 17. F. Monpillard, ibid. 1910, **57**, ibid. **4**, 32; Bull. Soc. franç. Phot. 1910, **52**, 103. K. Martin, Jahrbuch, 1913, **27**, 103. Anon. Amat. Phot. 1912, **56**, Supp. 3. E. B. Havelock, Brit. J. Phot. 1919, **66**, Col. Phot. Supp. **12**, 22; Camera Craft, 1919, **26**, 402. R. M. Fanstone, Brit. J. Phot. 1923, **70**, Col. Phot. Supp. **16**, 4, 31. F. R. Newens, ibid. 1923, **70**, ibid. **16**, 5.

24. Photo-Gaz. 1909, **11**, 19; Jahrbuch, 1911, **25**, 298.

25. Phot. Korr. 1910, **47**, 47; Jahrbuch, 1911, **25**, 226; Wien. Mitt. 1910, 142.

26. H. Francke, D.R.P. 228,468, 1910; Jahrbuch, 1911, **25**, 298; Phot. Ind. 1910, 53. Cf. Dorschky, D.G.M. 621,069.

27. Photography, 1914, 22; abst. Brit. J. Almanac, 1915, 523.

28. H. Reeb, Photo-Rev. 1908, **20**, 27; Bull. Soc. franç. Phot. 1907, **44**, 490. H. Bourée, Photo-Rev. 1909, **21**, 9. E. Ventujol, Rev. Franç. Phot. 1923, **4**, 163.

29. Brit. J. Phot. 1907, **54**, 874; Col. Phot. Supp. **1**, 82; abst. Brit. J. Almanac, 1909, 646. Cf. Brit. J. Phot. 1913, **60**, Col. Phot. Supp. **7**, 24, 28; ibid. 1914, **61**, ibid. **8**, 27. As to the H & D number of the autochrome plates, cf. E. J. Wall, ibid. 1907, **1**, 56.

30. Photo-Rev. 1908; Brit. J. Phot. 1908, **55**, Col. Phot. Supp. **2**, 27; abst. Brit. J. Almanac, 1909, 646.

31. Brit. J. Phot. 1915, **62**, Col. Phot. Supp. **9**, 2; abst. Brit. J. Almanac, 1916, 497; Amat. Phot. 1914, **60**, 56.

For further notes on exposure of Autochromes see: R. B. Domony, Brit. J. Phot. 1915, **62**, Col. Phot. Supp. **9**, 32; abst. Brit. J. Almanac, 1916, 498. E. Coustet, Photo-Gaz. 1908, **18**, 111; Brit. J. Phot. 1909, **56**, Col. Phot. Supp. **3**, 10. V. Crèmier, Photo-Gaz. 1909, **19**, 190; Brit. J. Phot. 1909, **56**, Col. Phot. Supp. **3**, 94. C. Litchfield, Brit. J. Phot. 1908, **55**, Col. Phot. Supp. **2**, 24. A. Personnaz, Bull. Soc. franç. Phot. 1908, **55**, 179, 308. A. Watkins, Brit. J. Phot. 1908, **55**, Col. Phot. Supp. **2**, 15, 73; Bull. Phot. 1908, **3**, 293; Photo-Era, 1909, **22**, 83. Houdaille, Bull. Soc. franç. Phot. 1909, **56**, 292; Brit. J. Phot. 1909, **56**, Col. Phot. Supp. **3**, 69. R. Bouldyre, ibid. 1910, **57**, ibid. **4**, 86. G. H. Parker, ibid. 72. L. Maleve, Bull. Phot. 1912, **10**, 578. Anon. Amat. Phot. 1912, **56**, Supp. 3. J. Cooper, Photo-Era, 1913, **31**, 80. H. M. Smitten, Camera Craft, 1913, **20**, 475; Brit. J. Phot. 1914, **61**, Col. Phot. Supp. **8**, 15. E. A. Barton, ibid. **8**, 24. A. Brizet, ibid. **8**, 19. S. H. Carr, ibid. 1914, **61**, ibid. **8**, 48; 1915, **62**, ibid. **9**, 4. H. M. Murdock, ibid. 40. E. Wenz, Bull. Soc. franç. Phot. 1914, **61**, 127. O. Lederer, Brit. J. Phot. 1910, **57**, Col. Phot. Supp. **4**, 33. M. Ferrars, Phot. Welt. 1908, **22**, 2, 3. C. W. Piper, Brit. J. Phot. 1915, **62**, Col. Phot. Supp. **8**, 31. R. M. Fanstone, ibid. 1919, **66**, ibid. **12**, 40; Camera Craft, 1920, **27**, 68. Anon. Brit. J. Phot. 1921, **68**, Col. Phot. Supp. **14**, 22. C. Schitz, Bull. Soc. franç. Phot. 1921, **61**, 22. H. W. Wright, Brit. J. Phot. 1921, **68**, Col. Phot. Supp. **14**, 12. J. Fouchet, Bull. Soc. franç. Phot. 1923, **65**, 19; Brit. J. Phot 1923, **70**, Col. Phot. Supp. **17**, 9. E. Ventujol, Brit. J. Phot. 1923, **70**, ibid. **17**, 33.

32. Brit. J. Phot. 1907, **54**, Col. Phot. Supp. **1**, 51, 65, 90; 1908, **55**, ibid. **2**, 44; 1917, **64**, ibid. **11**, 39; Phot. J. 1907, **47**, 421; Phot. Coul. 1907, **2**, 184; 1908,

3, 147; Photo-Rev. 1909, **21**, 85; Amer. Phot. 1908, **2**, 93; Bull. Soc. franç. Phot. 1907, **54**, 515.

33. Brit. J. Phot. 1908, **55**, Col. Phot. Supp. **2**, 44, 79; abst. Brit. J. Almanac, 1909, 649; Amer. Phot. 1908, **2**, 361; Jahrbuch, 1908, **22**, 179; Phot. Korr. 1908, **45**, 197. Cf. A. Löwy, Phot. Korr. 1909; Brit. J. Phot. 1909, **56**, 37. Von Hübl, Wien. Mitt. 1908, 298; Phot. Ind. 1909, 1342; Phot. Coul. 1908, **3**, 145; Bull. Soc. franç. Phot. 1909, **56**, 210, 449; Jahrbuch, 1909, **23**, 27.

34. Wien. Mitt. 1908, 296.

35. Photo-Rev. 1911, **23**, 138; Brit. J. Phot. 1911, **58**, Col. Phot. Supp. **5**, 43; Brit. J. Almanac, 1912, 656.

36. Brit. J. Phot. 1912, **59**, Col. Phot. Supp. **6**, 5; Brit. J. Almanac, 1913, 694.

37. Brit. J. Phot. 1909, **56**, Col. Phot. Supp. **3**, 67; Phot. Ind. 1909, 691.

38. Brit. J. Phot. 1909, **56**, Col. Phot. Supp. **3**, 26; Phot. Coul. 1909, **4**, 49, 125; Jahrbuch, 1909, **25**, 301; 1910, **24**, 176.

39. Brit. J. Phot. 1909, **56**, Col. Phot. Supp. **3**, 261; 1917, **64**, ibid. **11**, 39.

40. La Nature, 1919; Bull. Soc. franç. Phot. 1919, **66**, 341; Bull. Belge. 1920, 49; Phot. Chron. 1920, **27**, 190; Photo-Rev. 1920, **32**, 109; Brit. J. Phot. 1919, **66**, Col. Phot. Supp. **13**, 37; Brit. J. Almanac, 1920, 421; Camera Craft, 1919, **26**, 478. Cf. D. J. Sheehan, Amer. Annual Phot. 1915; Brit. J. Phot. 1915, **62**, Col. Phot. Supp. **9**, 15. Meugniot's paper appeared Bull. Soc. franç. Phot. 1919, **66**, 341.

41. Il Prog. Foto. 1911; Photo-Gaz. 1911, 138; Phot. Coul. 1911, **6**, 105; Brit. J. Phot. 1911, **58**, Col. Phot. Supp. **5**, 43; Jahrbuch, 1912, **26**, 257; 1915, **29**, 140. Cf. L. Planve, Photo-Rev. 1919, **31**, 154, 169.

42. Wilson's Phot. Mag. 1914, **51**, 15; Brit. J. Phot. 1914, **61**, Col. Phot. Supp. **8**, 22; D. Phot. Ztg. 1914, **38**, 225; Brit. J. Almanac, 1915, 524. Cf. E. Mayer, Wien. Mitt. 1910; Brit. J. Phot. 1910, **57**, Col. Phot. Supp. **4**, 43.

43. Photo-Rev. 1920, **32**, 26, 86; Phot. Rund. 1920, **30**, 278; Brit. J. Phot. 1920, **67**, Col. Phot. Supp. **13**, 31.

44. Photo-Rev. 1909, **21**, 74, 85.

45. Brit. J. Phot. 1909, **56**, 60; Phot. Coul. 1909, **4**, 117, 127; Photo-Rev. 1909, **21**, 54.

46. Wien. Mitt. 1910; Brit. J. Phot. 1910, **57**, 13.

47. Wien. Mitt. 1911; Brit. J. Phot. 1911, **58**, 13.

48. Phot. Coul. 1909, **4**, 157; Photo-Rev. 1909, **21**, 13.

49. Photo-Rev. 1910, **22**, 75; Phot. Ind. 1909, 380.

50. Photo-Rev. 1913; Jahrbuch, 1914, **28**, 227. L. Gimpel, Bull. Soc. franç. Phot. 1908, **45**, 317; Brit. J. Phot. 1908, **55**, Col. Phot. Supp. **2**, 61; abst. Brit. J. Almanac, 1909, 617, recommended the use of a phonograph in the dark room, which should call out the necessary operations at the required times.

51. Photography, 1908, 365; Brit. J. Phot. 1908, **55**, Col. Phot. Supp. **2**, 73; Brit. J. Almanac, 1909, 650.

52. Photo-Rev. 1914, **26**, 113; Brit. J. Phot. 1914, **61**, Col. Phot. Supp. **8**, 19; abst. Brit. J. Almanac, 1915, 524.

53. Photo-Rev. 1914, **26**, 113; Wien. Mitt. 1914, 433; Brit. J. Phot. 1914, **61**, Col. Phot. Supp. **8**, 26; abst. Brit. J. Almanac, 1915, 524; C. A. 1914, **8**, 3538.

54. Photo-Rev. 1913, **25**, 77; abst. Phot. J. Amer. 1913, **50**, 577. Cf. F. Dillaye, Bull. Soc. franç. Phot. 1912, **58**, 68; Brit. J. Phot. 1912, **59**, Col. Phot. Supp. **6**, 37; Les Nouveautés Phot. 1912, 115.

55. Bull. Soc. franç. Phot. 1911, **58**, 244.

56. Phot. Coul. 1908, **3**, 1. Brit. J. Phot. 1908, **55**, Col. Phot. Supp. **2**, 9; Brit. J. Almanac, 1909, 651; Photo-Rev. 1908, **20**, 59; Jahrbuch, 1908, **22**, 397; Phot. Korr. 1908, **54**, 271. Cf. C. A. Dowier, Brit. J. Phot. 1908, **55**, Col. Phot. Supp. **2**, 32.

57. This particular property of the amidol developer was announced by G. Balagny, Photo-Gaz. 1912, **22**, 146, and confirmed by F. Monpillard, Bull. Soc. franç. Phot. 1912, **59**, 289; Brit. J. Phot. 1912, **59**, 703. Cf. E. Cousin, Phot. Coul. 1913, **8**, 78.

58. Bull. Soc. franç. Phot. 1908, **55**, 159; Brit. J. Almanac, 1909, 651. Cf. Lumière and Seyewetz, Phot. Coul. 1908, **3**, 144; 1909, **4**, 105. C. P. Clerc, Brit. J. Phot. 1922, **69**, 16.

59. Bull. Soc. franç. Phot. 1908, **55**, 55; 1913, **60**, 50; Brit. J. Phot. 1913, **60**, Col. Phot. Supp. **7**, 6; Jahrbuch, 1913, **27**, 295.

60. Camera Craft, 1908, **12**, 205; Brit. J. Phot. 1909, **56**, Col. Phot. Supp. **3**, 5; Brit. J. Almanac, 1909, 652.

61. Photo-Rev. 1908, **20,** 159.
62. Photo-Rev. 1920, **32,** 22; Brit. J. Phot. 1921, **68,** Col. Phot. Supp. **15,** 8; Brit. J. Almanac, 1922, 429.
63. Bull. Belge, 1911, 379; Brit. J. Phot. 1912, **59,** Col. Phot. Supp. **7,** 37; Brit. J. Almanac, 1913, 700.
64. Photography, 1920, 236; abst. Brit. J. Almanac, 1921, 407.
65. Photo-Rev. 1920, **32,** 86; Brit. J. Phot. 1920, **67,** Col. Phot. Supp. **14,** 31; abst. Brit. J. Almanac, 1921, 407.
66. Brit. J. Phot. 1909, **58,** Col. Phot. Supp. **3,** 73; abst. Brit. J. Almanac, 1909, 652; Bull. Belge, 1909; Photo-Rev. 1909, **21,** 177; Photo-Gaz. 1910, **20,** 86; Les Nouveautés Phot. 1912, 102.
L. Vidal, Phot. J. 1903, **43,** 220 had recommended the use of a 1 per cent solution of potassium dichromate for regenerating old sensitized plates. J. Sterry, Phot. J. 1904, **44,** 50; Photography, 1904, 94 recommended the same treatment for controlling the gradations in bromide prints. F. Sforza, Brit. J. Phot. 1909, **56,** Col. Phot. Supp. **3,** 95 denied that this method was of any value.
67. Wien. Mitt. 1910, 121; Phot. Coul. 1910, **5,** 138.
R. J. F. Revel, Belg.P. 219,551, 1909, patented a dish for developing screen-plates in daylight. W. Ihrig, D.R.P. 352,164, 1921 patented a method of washing Autochrome plates by leaving them in the last solution and gradually adding water, and thus lowering the concentration in about a minute.
68. Bull. Soc. franç. Phot. 1912, **59,** 371; Brit. J. Phot. 1913, **60,** Col. Phot. Supp. **1,** 6; abst. Brit. J. Almanac, 1914, 652.
69. Photography, 1907, 450; abst. Brit. J. Almanac, 1909, 652.
70. Brit. J. Phot. 1908, **55,** 130.
71. Camera Craft, 1908, **12,** 215; Brit. J. Almanac, 1909, 652.
72. Camera Work, 1908; Brit. J. Phot. 1908, **56,** 300; Brit. J. Almanac, 1909, 654.
73. Penrose's Annual, 1909, **14,** 54.
74. Phot. Korr. 1907, **54,** 594; Jahrbuch, 1908, **22,** 396.
For further notes on developing Autochromes see: Anon. Brit. J. Phot. 1908, **55,** Col. Phot. Supp. **2,** 79. H. Drake-Brockman, ibid, 47, 80. F. Monpillard, ibid. 49. A. Lelong, ibid. 1909, **56,** ibid. **3,** 60. C. Gravier, ibid. 1908, **55,** ibid. **2,** 34; ibid. 1911, **58,** ibid. **5,** 2. T. H. Jones, ibid. 171. P. S. Chataux, ibid. 43. De Dalmas, ibid. 34; Bull. Soc. franç. Phot. 1911, **53,** 106; Phot. Mitt. 1911, **48,** 177. C. W. Evans, Brit. J. Phot. 1911, **58,** Col. Phot. Supp. **5,** 52. E. Coustet, ibid. 1912, **59,** ibid. **6,** 9. F. Mairot, ibid. 16. A. E. Morton, ibid, 1913, **60,** ibid. **7,** 17. Anon. Phot. Mitt. 1909, **46,** 121, 347. F. Dillaye, Les Nouveautés Phot. 1909, 117. H. D'Arcy Power, Camera Craft, 1908, **15,** 110, 215, 353. F. Monpillard, Bull. Soc. franç. Phot. 1908, **55,** 231. G. Mareschal, ibid. 289; Photo-Gaz. 1908, **18,** 152. H. Vinzl, Phot. Korr. 1916, **53,** 288. A. D. Williams, Camera Craft, 1916, **23,** 19; Brit. J. Phot. 1916, **63,** Col. Phot. Supp. **10,** 12. M. R. Espitallier, ibid. 1921, **68,** ibid. **14,** 8; Camera Craft, 1921, **28,** 95. E. K. Elmslie, Brit. J. Phot. 1922, **69,** Col. Phot. Supp. **15,** 28. T. W. Bartlett, ibid. 1923, **70,** ibid. **16,** 16. E. Müller, ibid. **16,** 8. C. Adrien, Rev. Franç. Phot. 1924, **5,** 316; Brit. J. Phot. 1925, **72,** Col. Phot. Supp. **19,** 3. A. Chapon, Rev. Franç. Phot. 1925, **6,** 33.
For description of tank for developing see A. Seyewetz, Brit. J. Phot. 1911, **58,** Col. Phot. Supp. **5,** 40.
75. Brit. J. Phot. 1907, **54,** 839; 1908, **55,** 465; abst. Brit. J. Almanac, 1909, 653. Cf. E. Stenger, Brit. J. Phot. 1913, **60,** Col. Phot. Supp. **7,** 35 for history of the reversal process.
76. Camera Craft, 1908, **12,** 215; Brit. J. Almanac, 1909, 653.
77. Brit. J. Phot. 1908, **56,** Col. Phot. Supp. **2,** 43; Brit. J. Almanac, 1909, 653; Photo-Era, 1908, **21,** 109; Jahrbuch, 1909, **23,** 302; Phot. Chron. 1908, **15,** 448; Phot. Coul. 1908, **3,** 168. R. Namias, Das Atel. 1907, **14,** 141 also recommended bisulfite for this purpose.
78. Bull. Soc. franç. Phot. 1909, **56,** 102; Brit. J. Phot. 1909, **56,** Col. Phot. Supp. **3,** 40; 1910, **57,** 91; Brit. J. Almanac, 1910, 602; Photo-Rev. 1909, **21,** 123; 1920, **32,** 142.
79. Brit. J. Phot. 1909, **56,** Col. Phot. Supp. **3,** 74. Cf. T. Mayer, Jahrbuch, 1912, **26,** 258. Bergeron, Brit. J. Phot. 1912, **59,** Col. Phot. Supp. **6,** 44.
80. Penrose's Annual, 1909, **14,** 54. Cf. Lüppo-Cramer, Brit. J. Phot. 1913, **60,** Col. Phot. Supp. **1,** 37; abst. Bull. Soc. franç. Phot. 1914, **61,** 171.
81. Photo-Rev. 1909, **21,** 159; Phot. Coul. 1909, **4,** 258; Jahrbuch, 1910,

24, 190. Cf. V. Crèmier, "La Photographie des Couleurs par les Plaques Autochromes," Paris, 1911, 51. R. Namias, Photo-Rev. 1908, **20,** 136; 1909, **21,** 159.

82. F.P. 392,528, 1908; Bull. Soc. franç. Phot. 1908, **55,** 349; Photo-Rev. 1908, **20,** 117, 127; Phot. Coul. 1908, **3,** 242.

83. D.R.P. 198,061, 1907.
R. John, U.S.P. 1,212,228 patented a dark room lantern, with an inclined safe-light and window, through which a strong white light might be obtained for the reversal of the screen-plate.

84. Phot. Korr. 1908, **44,** 50.

85. Photo-Rev. 1908, **20,** 30; Phot. Coul. 1908, **3,** 205; Brit. J. Phot. 1908, **55,** Col. Phot. Supp. **2,** 60, 72; Brit. J. Almanac, 1909, 657; Bull. Phot. 1908, **3,** 117; Photo-Era, 1908, **21,** 222. Cf. F. Lapeyre, Photo-Rev. 1908, **20,** 137. R. d'Hélicourt, ibid. This process did not give black but brownish-red images, which modified the color rendering somewhat disadvantageously.

86. Phot. Coul. 1908, **3,** 301; Brit. J. Phot. 1909, **56,** Col. Phot. Supp. **3,** 5; Brit. J. Almanac, 1910, 603.

87. Photo-Rev. 1908, **20,** 177.

88. Bull. Soc. franç. Phot. 1907; 1909, **56,** 411; Brit. J. Phot. 1907, **54,** Col. Phot. Supp. **1,** 93; Photo-Rev. 1907, **19,** 43, 91, 130; Penrose's Annual, 1910, **15,** 70; Phot. J. 1908, **48,** 172; Jahrbuch, 1908, **22,** 399. Cf. G. Mebes, Der Phot. 1907, **17,** 342. H. Hinterberger, Wien. Mitt. 1908, 129. E. Coustet, "La Photographie en Couleurs à Filtres Colorés," Paris, 1909, 64. C. Lelong, Phot. Coul. 1909, **4,** 118.

89. Phot. J. 1908, **48,** 172; Phot. News, 1907, **51,** 451; Phot. Ind. 1908, 96.

90. Brit. J. Phot. 1908, **55,** 896, Col. Phot. Supp. **2,** 96; Brit. J. Almanac, 1910, 603.

91. Brit. J. Phot. 1907, **54,** 839.

92. Bull. Soc. franç. Phot. 1908, **55,** 238. Cf. Anon. ibid. 76.

93. Penrose's Annual, 1909, **15,** 55.

94. Camera Work, 1908; Brit. J. Phot. 1908, **55,** 300.
Cf. R. M. Fanstone, ibid. 1920, **67,** Col. Phot. Supp. **18,** 44; 1921, **68,** ibid. **14,** 45.

95. Photo-Rev. 1912, **24,** 146; Brit. J. Phot. 1912, **59,** Col. Phot. Supp. **6,** 31, 44; Brit. J. Almanac, 1913, 702. Cf. R. M. Fanstone, ibid. 1921, **68,** ibid. **15,** 45; Brit. J. Almanac, 1923, 408.

96. Wien. Mitt. 1914; abst. C. A. 1914, **8,** 272. Cf. S. H. Carr, Brit. J. Phot. 1909, **56,** Col. Phot. Supp. **3,** 64; Chapman Jones, Knowledge, 1908, **5,** 104; Brit. J. Phot. 1908, **55,** Col. Phot. Supp. **2,** 46.

97. Penrose's Annual, 1909, **14,** 55. Cf. A. W. Goutcher, Brit. J. Phot. 1908, **55,** 227. L. Boucher, Photo-Gaz. 1912, **22,** 157.

98. "Die Autochromphotographie," 1908, 37.

99. Phot. Rund. 1909; Brit. J. Phot. 1909, **56,** Col. Phot. Supp. **3,** 40; Phot. Times, 1911, **43,** 93.

100. Phot. Korr. 1908, **44,** 29; Brit. J. Phot. 1908, **55,** Col. Phot. Supp. **2,** 20; Brit. J. Almanac, 1909, 657.

101. Bull. Soc. franç. Phot. 1907, **54,** 472; Brit. J. Phot. 1908, **55,** Col. Phot. Supp. **2,** 13; Brit. J. Almanac, 1909, 657.

102. Brit. J. Phot. 1907, **54,** 859; "Colour Photography with Autochrome Plates," 1907, 12. Cf. J. Szczepanik, Brit. J. Phot. 1909, **56,** Col. Phot. Supp. **3,** 48.

103. "Die Autochromphotographie," 1908, 38.
A. Carrara, Brit. J. Phot. 1924, **71,** Col. Phot. Supp. **18,** 41 suggested sealing the cover glass and screen-plate with Canada balsam in xylol.

104. Wien. Mitt. 1912, 97.
For further notes on failures see: F. Dillaye, Brit. J. Phot. 1908, **55,** 221. H. Drake-Brockman, ibid. 371; Col. Phot. Supp. **2,** 55, 95, 96. E. Shivas, ibid. 32. A. Stieglitz, ibid. 53. W. Bourke, ibid. 1909, **56,** 735. L. C. Leon, ibid. Col. Phot. Supp. **3,** 64. Anon. 76, 563, 735. W. Herschel, ibid. 1911, **58,** Col. Phot. Supp. **5,** 52, 55. C. E. Frank, ibid. 64. De Dalmas, ibid. 1912, **59,** Col. Phot. Supp. **6,** 36. Grange, ibid. 1913, **60,** ibid. **7,** 31. Anon. ibid. 44; Camera Craft, 1909, **16,** 29; Amat. Phot. 1911, **54,** 191, 265. De Dalmas, Bull. Soc. franç. Phot. 1912, **59,** 158. L. Gerard, ibid. 1913, **60,** 337. R. Namias, Phot. Rund. 1913, **50,** 47; Phot. Chron. 1913, **20,** 71. Von Schrott, Phot. Korr. 1913, **50,** 397; Bull. Soc. franç. Phot. 1914, **61,** 170. W. Kein, Phot. Rund. 1914, **51,** 17. R. M. Fanstone, Brit. J. Phot. 1921, **68,** Col. Phot. Supp. **15,** 5; Camera Craft, 1921, **28,** 271. L. M. Leventon, Brit. J. Phot. 1921, **68,** Col. Phot. Supp. **14,** 28. C. Schitz, Bull. Soc. franç. Phot. 1921, **63,** 22. A. Carrara, Brit. J. Phot. 1923, **70,** Col. Phot. Supp. **17,** 4. R. M. Fanstone, ibid. 1922, **69,** ibid. **16,** 17. E. Müller, ibid. 38.

105. Congress German Phys. Soc.; Brit. J. Phot. 1908, **55,** Col. Phot. Supp. **4, 11.**

106. Wien. Mitt. 1908, 142; Brit. J. Phot. 1909, **56,** Col. Phot. Supp. **3, 27.**

107. Bull. Soc. franç. Phot. 1908, **54,** 473; Brit. J. Phot. 1908, **55,** Col. Phot. Supp. **2, 11.**

108. Phot. Rund. 1910, **24,** 120.

Projection on to a translucent tracing cloth was recommended, Phot. Ind. 1910, 924. B. J. Falk, U.S.P. 1,152,156; E.P. 11,354, 1908 patented a mirror viewing frame.

109. Phot. Chron. 1909, **16,** 245,256; Brit. J. Phot. 1909, **56,** Col. Phot. Supp. **3,** 44; Jahrbuch, 1910, **24,** 192, 322.

110. Wien. Mitt. 1909, 205; Jahrbuch, 1910, **24,** 154; Brit. J. Phot. 1909, **56,** 47.

111. Wien. Mitt. 1909, 269. Cf. Brit. J. Phot. 1908, **55,** 445.

112. Wien. Mitt. 1909, 269, 276.

113. Phot. J. 1912, **52,** 341.

For stand for exhibiting screen-plates see: H. F. Perkins, Photo-Era, 1916, **36,** 103; Brit. J. Phot. 1916, **63,** Col. Phot. Supp. **10,** 13. Cf. Brit. J. Phot. 1914, **61,** Col. Phot. Supp. **8,** 35. P. Duchenne, D.R.P. 231,872, 1910 patented a frame for viewing transparencies, which took the form of a book, in one cover of which was an electric lamp and a mirror to reflect the light through the slide. Cf. P. Duchenne and F. Forbin, E.P. 15,347, 1910; Brit. J. Phot. 1911, **58,** 343. V. Letouzey, Bull. Soc. franç. Phot. 1909, **56,** 83. F. Dillaye, Les Nouveautés Phot. 1911, 113.

114. U.S.P. 1,204,401; F.P. 470,712; E.P. 8,805, 1914; Brit. J. Phot. 1915, **62, 26.** The patentee would enrich the English language by some new terms, for he calls the screen image a "repliture," the phenomenon is "repliturance" and the device a "repliturant."

On viewing Autochromes by artificial light see: R. Locquin, Photo-Rev. 1908, **20,** 81, 94; Brit. J. Phot. 1908, **55,** Col. Phot. Supp. **2,** 75. E. Marriage, ibid. 970; Camera Craft, 1909, **16,** 187. G. Massiot, Bull. Soc. franç. Phot. 1908, **55,** 207. Poulenc Frères, ibid. 487. De Dalmas, ibid. 1910, **57,** 398; Photo-Gaz. 1911, **21,** 187; Brit. J. Phot. 1911, **58,** Col. Phot. Supp. **5,** 7. W. Thorner, ibid. 1913, **60,** ibid. **7,** 32. R. M. Fanstone, ibid. 1922, **69,** ibid. **16,** 22. C. Adrien, Bull. Soc. franç. Phot. 1923, **65,** 114; Rev. Franç. Phot. 1925, **6,** 13. G. Massiot, ibid. 1922, **64,** 271. A. Polack, Bull. Soc. franç. Phot. 1925, **67,** 83.

For method of mounting Autochromes see: H. Chrevier, Bull. Soc. franç. Phot. 1908, **55,** 257. Poulenc Frères, ibid. 1909, **56,** 39. A. Palocsay, Phot. Korr. 1909, **46,** 569. H. C. Messer, Brit. J. Phot. 1912, **59,** Col. Phot. Supp. **6,** 54. G. Massiot, Bull. Soc. franç. Phot. 1914, **61,** 224; Brit. J. Phot. 1914, **61,** 40. A. and L. Lumière, Bull. Soc. franç. Phot. 1908, **55,** 486; Brit. J. Phot. 1909, **56,** Col. Phot. Supp. **3,** 8; ibid. 1910, **57,** ibid. **4,** 483 described a magazine viewing apparatus, called a chromodiascope. A. E. Morton, Brit. J. Phot. 1919, **66,** Col. Phot. Supp. **13,** 23 described a combined retouching and viewing stand. R. M. Fanstone, Brit. J. Phot. 1923, **70,** Col. Phot. Supp. **17,** 16. L. Lumière, Brit. J. Phot. 1924, **71,** Col. Phot. Supp. **18,** 21; Sci. Ind. Phot. 1924, **4,** 59, 108, described a projector for large Autochromes, using condensers as the objective. B. Grotta, Camera, 1924, **29,** 291. C. Adrien, Rev. Franç. Phot. 1925, **6,** 25, 65, 82, 91.

O. Bloch, Phot. J. 1925, **65,** 312, announced that J. Hetley & Co., 35 Soho Square, London, W. England, could supply a special copper blue glass, known as M F, which gave a spectral distribution like mean daylight, which was very suitable for viewing and exhibiting screen-plates.

PRINTING FROM SCREEN-PLATES

The comparative ease with which a color result can be obtained with screen-plates, and the obvious disadvantage that for every copy desired it is essential to make a fresh exposure, naturally led to attempts to duplicate them by copying or printing, but there are unfortunately several pitfalls.

C. E. K. Mees[1] (p. 562), put the matter in a very simple and easily grasped way and said: "consider the color-negative having lines of red, green and blue, and imagine this to have been exposed to green light, and developed, so that the green stripe is black; now print it on a similar film put over it at right angles, and consider the nine squares thus formed, first with regard to the negative, and then to the positive produced upon

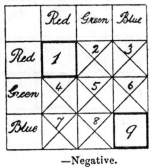 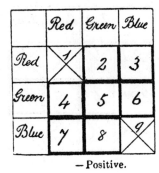

—Negative. —Positive.

Fig. 135.

development, Fig. 135. Square 1 is formed by the crossing of red through red, and will be transparent in the negative, forming a black in the positive. Square 2 is red through green, is black in the negative, and transparent in the positive. Square 3 is red on blue, black in the negative, transparent in the positive. Squares 4, 5, and 6 have the silver deposit on them, and give transparent squares in the positive. Square 7 is blue on red, black in the negative, and transparent in the positive. Square 8 is blue on green, black in the negative, and transparent in the positive. Square 9 is blue on blue, is transparent in the negative, and black in the positive. So that of our nine squares in the positive, seven are transparent, and instead of having only green, we have, to three greens, two reds and two blues; thus producing always faint colors degraded with greys. This result is easily confirmed by direct experiment, and however the squares be arranged, whether in lines or patterns of any particular shape, it must always happen that to three greens there will be two reds and two blues; or to one square of pure color there will be six squares making two whites.

539

"In order to avoid this difficulty we may develop our plate, and by some reversing process, either during development, or by after treatment, form a positive direct. But in this case, if we try to reproduce it, making another positive, we shall be met by another difficulty of the same type. Suppose, for instance, we consider the plate exposed to green and developed to a positive, then we shall get our red and blue stripes black, and our green transparent, giving us a satisfactory green positive. Printing as before, we have Fig. 136: 1, 2, 3 black in the first positive, giving black in the second. 4.—We have green on red, which gives us a black in our second positive. 5.—We have green on green, giving us one square green in our second positive. 6.—We have green on blue, giving us a black in our second positive. 7, 8 and 9 are all black. So that we shall have a green positive but of only one-third of the brilliancy of that from which we printed it, and there appears to be no method of reproducing our original positive, except by means of 'Uto' paper."

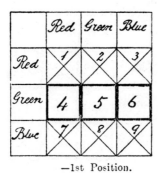
—1st Position.

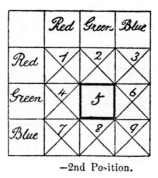
—2nd Position.

Fig. 136.

Mees' results were generally confirmed by Welborne Piper[2] but as he pointed out this trouble does not obtain with linear screens, such for instance, as the Warner-Powrie. His best results were obtained by copying irregular screen-plates, such as the Autochrome, in the camera, but there was even then some difficulty in obtaining sharp focus, and the color of the light transmitted through the plate had a tendency to give a general tint. The degradation of black in a positive is very obvious, and to get out the deep tints, reds especially, two to three times the exposure, necessary for a negative from a positive, seems to be required to give the best results. As regards color, a copy from a positive seemed to give the best rendering. The dilution with white or grey, that takes place when a positive is made from a negative, seems to involve an alteration of color that can be more or less compensated for by increasing the exposure. Probably the best results would be obtained from a somewhat thin original, but the want of focus, the presence of the added black, and the slight variations of color render the best copy available far inferior to an original Autochrome.

E. Stenger and F. Leiber[3] dealt with this subject in a very exhaustive manner, and although they came to the same conclusions as to the reproduction of irregular screens as Mees and Piper, yet they pointed out the possibilities of using linear screens and explain very clearly why they may be used. Their statements are theoretical, but were borne out in practice; but are unfortunately too voluminous to abstract, so that reference must be made to the original sources.

The makers of the Autochrome plate suggested[4] an ingenious arrangement for copying these plates, which is as useful as any and very simple. A rectangular wooden box *ABCD*, Fig. 137, about sixteen inches in length, light-proof, the interior stained black to prevent reflection, is provided at one end *AB* with an opening which is fitted with a special filter *E* for giving correct effects with magnesium. This opening is covered by a movable slide *V*. At the opposite end of the box is a frame *HI* in which is placed the positive to be duplicated *O* with its glass side towards the interior of the box, then the unexposed plate, the glass side in contact with the film of the positive, then the usual black card. The frame is then closed by means of the shutter *R*.

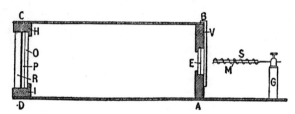

FIG. 137. Lumière Exposing Box.

A fixed support *G* carries a spiral of wire, fixed horizontally, in which is placed the magnesium ribbon *M* to be ignited; the wire merely giving the ribbon the requisite rigidity. The support is fixed at a certain distance from the end of the box, and in such manner that the magnesium ribbon is level with the center of the filter. The diameter of the wire should be from 0.3 to 0.4 mm. and the wire so arranged as to give one ring of the spiral to each centimeter of ribbon. The magnesium ribbon is cut to the desired length, an average of 4 to 8 inches of ribbon one-eighth of an inch wide, according to the density of the picture to be copied, then folded in the center and placed inside the wire spiral in a vertical position. If, for example, 16 centimeters of ribbon be used, this when folded is reduced to eight, and will correspond to eight rings of the spiral. These details must be observed in order to insure regular combustion of the magnesium, the degree of rapidity of the latter influencing the faithfulness of the result.

The support *G* is fixed in such a way that the extremity of the magnesium ribbon is in front of the filter and exactly in the center of the box. The shutter *V* being closed, the magnesium is ignited by means of a

spirit lamp, and the shutter immediately opened. When the magnesium is exhausted the plate is removed and developed as usual. The time of exposure, that is the length of ribbon is easily determined by a preliminary test. It should be as exact as possible to secure a good reproduction. Exposure must, of course, be conducted without any other light than the magnesium. Copper or brass wire should not be used, and the diameter of 0.3 mm. should be adhered to as closely as possible, being suitable for magnesium ribbon 3 mm. wide and 0.1 mm. thick. To make the spiral it will be found convenient to wind the wire on a round object of 3 to 4 mm. in diameter, in such a way that the rings are juxtaposed. The support is then withdrawn and the spiral slightly extended. When the magnesium has been inserted, it is again stretched until of the desired length, that is, until the rings of the spiral are 1 centimeter apart. Instead of the wooden box a camera of the same size may be used, the lens of which is replaced by the special yellow filter, and provided the plate holders are sufficiently deep to hold two plates.

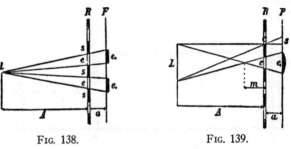

Fig. 138. Fig. 139.

Von Hübl[5] also dealt with the subject from a simple geometrical standpoint, which considerably facilitates the comprehension of the basis of printing. When an Autochrome plate is printed on to printing-out paper, so as to obtain a print in monochrome, the results are weak because practically the only light that affects the silver salts is that passing through the blue particles, therefore, the whole print is broken up into minute areas of white plus black. So that even the deepest shadows are represented by one-third black and two-thirds white, and the same difficulty is met with in reproducing on another screen-plate. The fact that such exposures can only be made by placing the film side of the original towards the glass side of the plate on which the copy is to be made, and is, therefore, about 2 mm. distant from the sensitive surface of the latter, is not of much account, as it is easy to obtain sharp copies. A camera can be tilted towards the sky, which must be covered by white clouds, and the lens set at infinity thus securing parallel light; but the difficulty of color rendering still comes into play. For if we suppose that the red consists in the original of 300 red and 600 black grains, then in reproducing only one-third of the red grains will fall on the red grains in the second film, and the result will be 100 red

to 800 black grains. A comparatively simple means of avoiding this trouble seems to be in sacrificing some sharpness of the second image, and by suitable choice of the unsharpness, the colors of the adjacent elements run into one another.

Let *R,* Fig. 138, be a transparent plate containing black areas *s,* which are projected by a small source of light on to a surface *F.* The elements in this case will be reproduced quite sharp, and so will the transparent spaces *e.* If, however, the source of light is not a point, but an extended surface, such as *L,* in Fig. 139, the transparent elements are enlarged to *e′,* and these are not of uniform illumination, the latter falling off towards the edges of each unit, as indicated by the shaded areas in Fig. 140. This will be readily understood as the center of *e′* receives the light from the whole of the light source, whilst towards the edges the illumination gradually falls off. The transparent element *e* is thus reproduced as an image

FIG. 140.

e′, which is larger and of vignetted outlines, its size depending on the size of the light-source, other things being equal. In other words, by suitably choosing the dimensions of the light-source, a color-screen picture may be reproduced with the introduction of unsharpness and enlargement of its color elements, and the disturbing want of homogeneity in the colors thus avoided. In Fig. 141 *R* shows a portion of a screen-plate, in which the blue and green elements are covered by silver and the red grains free, and the plate represents a red. If this portion of the picture is projected on to the surface *F,* under the conditions shown in the diagram, the red elements are enlarged three times to *r′, r′*; so that instead of appearing sharply defined against a black ground they are so enlarged that they join up. As a result of uneven illumination the whole surface is not even now of perfectly homogeneous character. In order to obtain this, the light-source must be larger still, and by so choosing it that the degree of en-

FIG. 141 (Page 543). FIG. 142.

largement is 4 times, the projected image will be of a homogeneous red color. Under these conditions the structure of all other colors is destroyed, and Fig. 142 shows how a homogeneous yellow can be reproduced from the green and red elements g and r.

In order to work out the exposure conditions under various circumstances, the numerical connection between the size of the elements in the projection, and the factors affecting the result must be known. From Fig. 139 the following equation is obtained:

$$\frac{L}{e_1} = \frac{A-m}{a-m} \quad and \quad \frac{e_1}{e} = \frac{a}{m}\frac{m}{m}$$

calling the ratio $\frac{e_1}{e}$ equal to v, that is, the degree of enlargement, then

$$v = \frac{a + Lm}{m} \quad and \ therefore \ m = \frac{a}{v\text{-}1}$$

Substituting this value for m in the equation, we get:

$$L = e\frac{A\ (v\text{-}1)\text{-}a}{a}$$

as a is very small in comparison with $A\ (v\text{-}1)$, it can be neglected and thus we obtain the simpler equation:

$$L = \frac{A\ (v\text{-}1)}{a}$$

This tells us what must be the size of the light-source to obtain an enlargement of the element e of 4 times in the projection; A being the distance from the light-source of the original, and a its distance from the sensitive surface. In general the degree of enlargement will be so chosen that $v = 4$. Thus to take the example of a Dufay plate, in which the value of e is 0.1 mm., the distance of the original from the sensitive film will be 2

mm., and assuming that the light is 400 mm. distant, then the size of the latter will be given by the equation:

$$1 = 0.1 \times \frac{3 \times 400}{2} = 60 \ mm.$$

It will be obvious that this process of enlarging the color units also affects the outlines of the objects in the picture. The point c in Fig. 139 thus appears as the line s, and the extent to which it is thus spread out

Fɪɢ. 143 (Page 546).

characterizes the degree of unsharpness in the copy. The figure shows that $\dfrac{L}{A} = \dfrac{s}{a}$, and thus the want of sharpness s equals $60 \times 2/400 = 0.3$

mm. In the case of the Autochrome e may be taken as 0.025, having regard to the fact that the film contains clumps of grains of the same color, although the diameter of each starch grain is 0.012 mm. If the glass side of the original lies upon the sensitive film, then a is 2 mm., and if the light-source be placed 500 mm. distant, then the size of the light-source L is given by the equation:

$$L = 0.025 \frac{3 \times 500}{2} = 18 \ mm.$$

and the unsharpness $s = 12 \dfrac{2.5}{500} = 0.06 \ mm.$

As shown by the equation a variety of results may be obtained with a light-source of given size by merely varying A and a, but on paying regard to the structure of the screen-plate, it will be seen that the actual size of L is very material to the process of copying because of parallax errors. As shown in Fig. 143, the screen-plate image consists of the mosaic multi-color screen R, the gelatin film G, containing the developed image s, and a transparent film separating the two and indicated in the diagram by i. Assuming that the blue elements are covered by the silver deposit s this area will appear yellow, the light-source being chosen of such size that an almost homogeneous yellow is formed on the surface F. But the rays of light are not entirely obstructed by the silver deposit on the blue areas, but pass obliquely to the surface F, so that a portion of them arrive on certain areas m in the diagram, forming white with the red and green which have passed through the screen; thus there is produced, not a degraded, but a whitish yellow on the surface F. The same parallax occurs with all colors, and the result, therefore, is less saturated or whitish colors. This defect is greater the more obliquely the light rays fall on the original plate, that is to say, it depends on the ratio $L : A$, and it increases towards the edges of the picture. It is necessary, therefore, to choose the light-source L as small as possible, and its distance A as large as possible. The distance between the two films is then given by the equation:

$$a = \frac{A}{L} e \ (v\text{-}1)$$

Von Hübl recommended that in practice a lens should be used in a camera with a circular aperture covered with ground glass and the picture to be copied and the sensitive plate placed in the dark slide, the glass side of the original being laid against the sensitive film, so that the distance between the two a is the thickness of the glass of the original, about 2 mm., the extension of the camera should be about 50 cm., and the size of the circular disk, admitting the light, can be adjusted to comply with the above rules. The camera should be pointed to an even white sky, or the ground glass may be illuminated by artificial light, and magnesium is the best. The results are much improved in the Lumière arrangement if the circular aperture be covered with ground glass and the usual yellow filter used. Instructions for making filters for artificial light work with screen-plates has been given under Filters.

E. Stenger and F. Leiber[6] suggested that it might be possible to print from screen-plates with leuco-bases of dyes, as they considered that no satisfactory method of reproduction was available. They suggested that it would be more convenient to use Autochrome negatives, in the complementary colors; the first advantage being that the black silver deposit would not produce degradation of the color, but a brightening of the pic-

tures. Assuming the complementary negative image, the printing process must fulfill the following requirements: behind the uncovered filter elements must be formed the complementary color; behind white, that is, behind the elements free from protecting silver deposit, there must be black, and behind the completely covered parts, there must be formed white. The pinachromy process (see p. 422), would seem to be the ideal, and it is conceivable that if paper were coated with three suitable leuco-bases, a correct color positive might be formed under the complementary negative. The question is what must be the color of the three leuco-bases. It is evident that they must stand at equal distances in the color circle, for whether subtractive or additive, they must be colorless when in small quantities. The color triad of most screen-plates is pure blue, yellow-green and vermilion, and the complementaries of these are yellow, bluish-red and blue-green.

H. Friese[7] suggested that in the reproduction of screen-plates the use of the ordinary filters should be done away with, and the plates themselves stained up, thus for red the plate should be stained green, for the blue an orange, and for the yellow a violet emulsion.

Pinatype Prints from Screen Plates.—L. Didier[8] suggested the following procedure for these, and although in connection with Autochromes, it is obviously applicable to all screen-plates. The screen-plate should be developed as usual, but not reversed, so that a negative in complementary colors is obtained. The positives used as print-plates should be obtained from the complementary negative image in the camera by green, red and blue light, using the normal tri-color filters with panchromatic plates for the red and green and an ordinary for the blue. When working with a camera for enlargement or reduction, the glass of the screen-plate must face the lens for the ordinary pinatype process. But for the modified method the glass should be turned from the lens, as in this case the transparencies themselves are used as print-plates. It is better to use a printing frame, and if a fixed distance and light-source be used, then any number of transparencies can be made, if the ratio of the filters is known. This ratio is not the same as for daylight; in the former case the exposure for the red filter is the least. The developer should, for preference, be hydroquinon, with a good dose of bromide, so as to work clean and give good density.

The transparencies have a certain grain, which is most pronounced in the case of the blue negative; but this is no disadvantage, and if the plates are fully or slightly overexposed, so as to suffer a little from halation, the image is practically converted into a continuous surface, and the grain is negligible in the finished print. As the screen-plates only give at their best, one-third of the color values of the original, it might be thought that the prints would appear flat and degraded. This, however, is not so, and the result is due to the scattering from the grains of the image, and to the

intensification produced by the action of the strong developer, and these help to fill up the interstices.

Other Processes.—A. Lelong[9] proposed a method of printing from screen-plates, which might be feasible, were it possible to find the proper dyes. A sheet of bromide paper was to be exposed to the camera image of the screen-plate, and so that practically the blue elements were those principally recorded. The paper should be developed with a reducing agent that tans the gelatin round the blue elements, and that round the green elements partly so, whilst close to the red is very slightly tanned; the blacks being quite soluble. After washing, development was to be again conducted with a very strong developer, that does not tan gelatin at all, such as amidol, so that the portions corresponding to the green and orange are completely developed. After washing all reduced silver was to be dissolved with acid permanganate, and then the paper taken out into daylight. The film has now portions, corresponding to the three colors, represented only by gelatin, insolubilized for the violet, partially so for the green and soft for the red. The blacks are soft, and still contain silver bromide. After drying, the film should be treated with a dye that penetrates only the insoluble gelatin, which corresponds to the violet, and slightly that for the greens. The color must be made insensitive to further operations. Development for a short time should then be carried out, so as to make the blacks insoluble, and after washing, a yellow dye applied that will only penetrate soft gelatin. This would strongly dye those parts corresponding to the reds, and to a less extent the partially insoluble portions of the greens, which will then be a pure green. Then a red dye is to be applied that only takes on soft gelatin, and it was said that a perfect reproduction of the original was obtained.

A. Carrara[10] was successful in making three-color carbons from Autochromes. The first thing was to obtain a satisfactory set of tri-color negatives, and these were made by contact as follows: the source of light was a one-filament Nernst lamp; the Autochrome was placed in an ordinary Lumière reproducing box (see p. 541), in contact with a Warren & Wainwright panchromatic plate. To the front of the box, after removal of its shutter and filter, was fitted a Thornton-Pickard studio shutter, which enabled accurate time exposures to be given. In front of the shutter was placed a set of sharp-cutting analysis filters, for Nernst light. Between the filters and light-source was interposed ground glass. The distance of the lamp filament from the face of the analysis filter was about 5 inches. An ordinary Autochrome required about 30 seconds exposure for the red; the green and blue filters each required about three times that exposure. The negatives were all developed in the same dish with a 1 : 22 rodinal solution, which gave a soft delicate negative; but if more vigor was required, the addition of a little bromide and slightly longer development would give it.

In the yellow-printing negative the granular structure was very marked, but this was of no importance, as it was not seen in the finished print. In the red-printing negative the structure was much less marked. The blue-printer was the one to give trouble, as here the structure was very noticeable and this was evident in the finished print. A softening of the structure generally was easily obtained by placing a piece of note paper in between the Autochrome film and the plate. And as a further aid to softening the structure of the blue printer, a thin sheet of celluloid should be inserted between the tissue and the negative when printing.

The Autotype tri-color tissues were used; sensitizing being effected with a quick drying sensitizer, and about 4 per cent solution for the red and 3 per cent for the yellow and blue. The baths should contain about 3 per cent of alcohol. The printing in the sun was timed by Watkin's steadfast meter tints, and the blue required $8\frac{1}{2}$ times the tint time; the red tissue 6 times and the yellow 5 times. Waxed celluloid was used as the temporary support, and as cementing medium a 5 per cent solution of gelatin, applied as cold as possible to the paper print, which should be laid flat on a sheet of opal glass, and the next print gently lowered on to it. Benzol was used to clean off the wax, after stripping from the celluloid, and immersion in alum solution hardened the cement.

S. H. Williams[11] suggested a process of printing by the use of a tri-color screen-plate, obtaining the constituent negatives by analysis filters therefrom, somewhat on the lines of Brasseur & Sampolo, with the use of a black and white line plate to block out the color lines other than that to form the negative. Raydex, stained gelatin or the Ozobrome process might be adopted, the latter being applied to bromide prints, which were inked up in the three colors and transferred to the final support.

E. A. Bierman[12] stated that he had obtained the most successful results in printing from screen-plates by the use of the box, shown in Fig. 144. This was lined with asbestos and then with thin litho aluminum ungrained. At one end were four diffusing screens *G1* to *G4* of ground glass, in front of which was a glass tank *T*, in which water or colored solutions were used. For instance, if the general tone of the plate were too yellow, a blue dye could be placed in the tank to correct this. The transparency was placed in front of this in a carrier, which might be of the revolving type, and should be movable so that the distance between the tank and plate can be varied, two or three inches being the normal distance. For illumination two arc lamps, indicated by * * were used. These should be as near to the sides and ends of the box as is safe without causing over-heating. The light is reflected from the metal lining of the box, and at every possible angle backwards and forwards until the whole interior is a mass of brilliant light of excellent copying power. This arrangement, and *A* is the asbestos and *M* the metal lining, was erected in front of and in line with

the camera, and the space between the lens and transparency covered with an opaque cloth.

R. Raymond[13] proposed that a sheet of mica or celluloid should be bound up with an Autochrome, so that it could not shift, and that it should then be sensitized with dichromated gelatin, dried and exposed to light behind a filter corresponding to one of the colors of the grains. It was then to be washed and inked up with a greasy ink. This operation was to

FIG. 144 (Page 549).

be repeated three times, and the result, it was said, would be a complete color record all except the blacks, and these were to be obtained by coating with silver emulsion, exposing, developing and reversing as in the original plate. The print was then to be stripped and bound up.

L. Gimpel[14] was successful in obliterating the structure of the screen elements in the reproduction of Autochromes by exposing two panchromatic plates with their films in contact, using a yellowish-green filter, as suggested by Monpillard (see p. 81). After development, the negatives, which were kept rather thin, were bound in contact and printed with the sharp one in contact with the sensitive surface.

Howard Farmer[15] in a paper read before the Congress of Applied Chemistry, said that the problem of reproducing screen-plates was the production of the negatives, in which the light acting through the elements of each color should make the same either entirely coalesce or gradate with their spreading with the tones of the image. The following had been tried for attaining this effect: 1. By irradiation in the gelatin film itself; 2. By interposing an air space, or transparent film between the screen-plate and the sensitive surface; 3. An intentional diffusion when copying in the camera; 4. An intentional to-and-fro or lateral movement of the plate, lens or screen-plate during exposure; 5. Imparting a vibratory motion to the copying camera or easel during exposure; 6. The use of a diffusing lens or glass; 7. Placing a thin glass plate between the screen-plate and image during exposure and slightly oscillating the same, this was suggested by W. Hibbert; 8. Placing a fine ruled screen in contact with the sensitive film; 10. A current of irregularly heated air passing in front of the lens.

H. Quentin[16] said that it would be of considerable assistance if the makers of bleach-out paper would issue three separate papers, so that each color could thus be isolated. Prints could then be made and superposed. J. V. Alteneder[17] suggested making the constituent negatives by copying in the camera. V. Crèmier[18] proposed making ordinary negatives with correct color rendering from screen-plates. H. D'Arcy Power[19] stated that he had obtained reproductions with correct color luminosities by making a negative carbon print from Autochromes and using this for printing; the duration of printing was about an hour in the sun. L. Gimpel[20] successfully made enlargements of screen-plates on others with an increase of two diameters. He found that Autochromes could be satisfactorily treated, using Omnicolor and Dioptichrome plates. Omnicolor plates could be copied on Autochrome and Dioptichrome plates, and Dioptichrome copied on the other two. The compensating filters had to be different for each combination. A. E. Morton[21] dealt with the reproduction of Autochromes on Paget screen-plates. He placed the former in the back frame of a large camera, a panchromatic plate in the plate holder with a Paget taking screen in contact therewith. Incandescent gas was used as the illuminant, with a special filter. Development was effected with amidol at 18° C. for 2 minutes.

Le Comte Hourst[22] proposed to make separation negatives from Autochromes by using panchromatic plates and Wratten's selective filters. At 18 inches from the plate he found 1½ inches of magnesium ribbon, 5 mm. wide, sufficient for the violet filter; 1⅛ inches for the green and 2 inches for the red. Celluloid, 0.1 to 0.24 mm. thick, coated with gelatin, was sensitized with 3 per cent solution of ammonium dichromate, and exposed through the back. After washing in cold water, the images were stained up with pinatype dyes. The films were then soaked first in cold water

and the temperature raised slowly to 46° C., which produced a relief. They were then immersed in 2 per cent glycerol and dried. At this stage the prints might be temporarily superposed to check the color rendering, and if satisfactory transferred to a weak bath of cupric sulfate to fix the colors. To superpose them a 10 per cent solution of glue was used at the lowest possible temperature that would keep it liquid. The first print should be immersed in the glue and transferred to well-glazed paper, lightly squeegeed, placed in a press and allowed to thoroughly dry. This print was then immersed in acetone, which dissolved the celluloid. The surface was then well washed with acetone and the other prints transferred in the same way, though the celluloid need not be removed from the top print, as it served as a protection.

Screen-Plate Printing Patents.—Naturally inventors turned their attention to this subject, and the following patents are those which refer directly to this work.

C. L. A. Brasseur and S. P. Sampolo[23] patented the use of a line screen in front of a sensitive plate in the camera, with a black and white line screen in front, thus blocking out all colors but one line, and monochromatic filters were used. The International Color-Photo Company[24] would print white celluloid, paper or the like, with straight, zig-zag or other lines or dots, coat with emulsion, and negatives taken with similar screens in the camera were placed in register with the patterned support, and a positive made. Printing surfaces for photomechanical work could also be made and impressions from these printed in black ink on paper with corresponding patterns. C. L. A. Brasseur[25] proposed to obliterate the ruling of the screen negative by first making a positive, then copying in the camera in contact with a black and white screen, as shown in Fig 145; *1* represents the original polychrome screen enlarged; *2* shows the normal spectrum photographed through it. The black and white screen is shown in *3* as covering all but the red line of the positive. Each line was thus exposed, the black and white screen being shifted for each exposure. Later Brasseur[26] proposed to partially rotate the black and white screen and the plate as a whole, first to one side and then to the other, around an axis parallel to the lines of the screen, so that the rays would impinge at corresponding angles. Those parts of the plate covered by the black lines would thus be exposed and the closing up of the elements effected. He also proposed[27] to use sharp-cutting filters for printing transparencies from screen-plates.

The Vereinigte Kunstseidefabriken[28] patented a process, and if line screens were used primarily, it was only possible to obtain prints by using a similar screen at a given angle, otherwise the well-known moiré made its appearance. In screens in which only one line was continuous and the others broken up into rectangles, there is also moiré, though less pronounced, unless the angle was about 45 degrees. This trouble was to be gotten over by making, in the latter case, another colored line unbroken.

The Deutsche Rastergesellschaft[29] would add zinc white to the colored celluloid, which was made into blocks and cut for screens. A complementary negative was to be printed on this.

R. Ruth[30] proposed to make a mosaic or other pattern on a gelatinized surface, which was then coated with panchromatic emulsion, exposed in the usual manner, and after development and fixing the whole picture and screen was stripped from the support, sensitized with dichromate, printed through the picture plus screen, then developed with hot water, which would give a negative image; a positive was made in the same way and

Fig. 145. Brasseur's E.P. 15,185, 1905.

transferred. R. Ruth and A. Schuller[31] considering that for viewing, the screens should be more transparent than for taking, would use two dyes, one of which could be washed out after the negative had been made. The screen and picture were to be stripped from the glass and transferred to paper, then washed to remove the soluble dye. Or bleaching dyes might be incorporated, such as the fulgides, and in this case, the picture was exposed to full sunlight till the fugitive dyes bleached out.

C. Rothgieszer[32] convinced of the difficulty of obtaining perfect register between a positive and the viewing screen, proposed to make the negative in the usual way, and to fasten permanently to the glass side of

the screen-plate used for the negative, a positive emulsion plate or film with the sensitive surface out, then to expose, develop and fix and destroy the negative.

E. Pal[33] proposed to use a screen-plate for positive work, in which the elements were red, yellow and blue. Fig. 146 shows his idea; *A* is the layer of elements and *N* the negative image, the elements *a, b, c,* being respectively orange-red, yellowish-green and violet. In *I* white is represented; in *II* an orange-red; in *III* a yellowish-green; in *IV* blue-violet,

Fig. 146. Pal's D.R.P. 251,623.

and in *V* no light or black. The positive is *P*, and the figuring represents the same fields, but the elements *a', b', c'* are red, yellow and blue; *B* is the support. Under each of the fields of the negative there appears two red elements, or rather two halves *a', a'* and a yellow and blue element *b'*, and *c'*, therefore, white was formed. The best arrangement of the elements is shown in *2,* and this had the advantage over lines or the usual checker board, and to attain this effect the screen was divided into parallel strips, and each strip into squares or parallelograms, which were colored

alternately in the three colors, and so that the colors were shifted half the breadth of one of the squares.

E. G. Caille[34] patented a process in which the negative image was obtained on a separate plate as usual and reversed. A screen was printed on paper, or white celluloid, in red, yellow and blue, so that a deep grey appearance was produced. The negative was printed on carbon tissue with white pigmented gelatin, or the negative was bleached with mercuric or cupric chloride and transferred to the paper. Or a silver image could be produced on the paper and bleached with the above salts. In a later patent[35] white celluloid was used, and subsequently[36] the shadows were deepened by a black key plate and the high lights heightened by a white one.

R. Krayn[37] proposed to make a compound screen-plate, one side of the support carrying a viewing screen, in which the colors gave grey. The positive was produced on this. The other side of the support carried the compensating filter, the elements of which registered with the corresponding ones of the viewing screen, and were so colored that in combination with the similarly colored elements of the viewing screen, they absorbed the complementary color, and the whole formed a taking screen. The coating of greasy colors, which covered those spots of a gelatin layer that were not to absorb any color in an aqueous solution, was formed as a congruent double print on a base preferably very thin and gelatined on both sides. The interspaces of one coat were then colored in the first ground color as compensating screen elements, and the interspaces of the coat of greasy color in the same as the viewing elements. Alternatively, screens might be made by first producing the compensating screen on the back of the support, and producing the viewing screen on the other side by a bleaching process, exposing through the screen already made. The support might be thin transparent material, such as paper, but sufficiently translucent to allow printing through the back. The viewing screen with the picture thereon might be detached and transferred to another support.

E. Lewy[38] proposed to utilize the differential action of hardened and soft gelatin for absorption of dyes. A black and white screen negative was obtained with a multi-color screen-plate as usual and a positive made therefrom on dichromated gelatin film, carrying screen elements, but in complementary colors to the taking screen. The exposed gelatin was squeegeed to gelatinized paper and by imbibition the dyes transferred. R. Beyer[39] also used the dichromate process, but made the original screen the carrier of the final positive. The plate consisted of a glass or other support coated successively with gelatin, the screen elements and a panchromatic emulsion. It was exposed and treated in the usual way and after drying the whole film stripped, and the layer constituting the screen element was sensitized with dichromate and exposed through the positive, then developed as a carbon print and applied to paper.

M. Obergassner[40] suggested to overcome the registration trouble by using coloring substances which were altered by acids or alkalis. For instance, a 25 per cent solution of litmus in gelatin; a similar strength of metanil yellow, the former being red in acid and blue in alkaline solutions, and the latter violet in acid and yellow in alkalis; for the green a mixture of acid green, light green Nos. 1 and 2, brilliant yellow and phenolphthalein, which is green in acid but red in the alkaline state. The colors being altered by treatment with acids or alkali. In a later patent[41] Obergassner proposed to add some transparent substance to the colloid of the color elements, which should form a lake or additional coloring matter. The substance cited is barium chloride, which is converted into the sulfate, to which dyes adhere. Or silver nitrate might be added and this converted into the iodide, which might be used as a mordant for basic dyes.

O. S. and H. K. Dawson[42] would build up the elements on the positive image. From a negative, made under a screen, a positive was obtained and after insulation with varnish, sensitized with a dichromated colloid, and this might be exposed between two matrix screens used for making the negative screen, or the matrices might be successively used to obtain the color elements on the positive, which could be sensitized with a colloid between each printing. The colors were to be obtained by using the selective action of dyes for hard and soft gelatin, for instance, by immersion of a printed colloid in a mixture of safranin, brilliant yellow and naphthol green. The most exposed parts would be colored green and the least exposed red. The third color might be applied in alcoholic solution to the support, which was to be celluloid.

J. H. Christensen[43] would produce positives from screen-plates, prepared according to E.P. 25,419, 1913 (see p. 397), with permeable films. Three papers, stained with complementary dyes, were to be brought into contact with a film containing developer, and exposed through the screen-plate by light complementary to the color of the dye in the paper. During exposure the developer acted upon the film and the dye diffused into the plate containing the developer.

J. E. Thornton[44] would coat paper with a screen pattern, either by a dichromated colloid, or using a silver emulsion, or printing from an intaglio roller or block. Any pattern might be used and the only requisite seems to have been that the mosaic pattern should be larger or smaller than those of the plates to be printed from. No information is given as to how registration was to be done. A subsequent patent[45] which is stated to be particularly suitable for cinematographic work, consists in superimposing on celluloid two, three or more absorbent layers, the individual colors being applied to each layer and then the whole coated with emulsion. This might be used for positive and negative work. Any grainy effect might be overcome by slightly altering or staggering the color elements in each

alternate picture. For the use of screen-plates for cinematography generally see page 602.

G. S. Whitfield[46] proposed to coat glass with a weakly colored screen, and then with emulsion, and to place the same in register with a color record, which might be either a negative or positive. Exposure was to be by white light through the record and the image reversed, if the original was a negative; or a process might be used that would give a positive direct from a positive. The screen and picture was then to be stripped and transferred to paper. In a later patent[47] paper with a light-sensitive emulsion was saturated with water till expanded to its fullest extent, and in this condition applied to the color record, exposed and immediately developed, fixed, washed and applied to the viewing screen by daylight, and permanently secured, while in its expanded state. The viewing screen was to be preferably on a temporary support and then stripped with the combined color record.

M. F. Ungerer[48] would make three negatives by using subtractive light filters and printing successively on one surface. A cyanotype print was to be made from the red-filter negative, varnished with lac varnish, coated with dichromated gelatin, printed under the blue negative and dyed up in aurophenin. A coat of colloid was then applied, another dichromate coat and this dyed up with erythrosin.

J. and E. Rheinberg[49] proposed to make multi-color prints by successive printings, in which the colors were only superposed in parts leaving a certain number of differently colored dots. Such prints were improved by causing adjacent dots to transfuse or merge so as to act on the subtractive principle. To obtain better gradation, the color print might be transferred in register to a black and white or monochrome positive.

H. Hess[50] would make the three constituent negatives by printing under the usual three filters, and from these make prints on dichromated colloid on celluloid, printing through the back. A cyanotype print might be used as a base and the other colors superposed as reliefs. F. E. Ives[51] would do away with the making of intermediate negatives by printing on to an emulsion in the usual way, then hardening the gelatin in situ with the silver with dichromate and dissolving off the soft gelatin, stain up and superimpose the red and yellow on a cyanotype print.

F. M. Warner[52] would make a monochrome positive from a negative screen-plate on panchromatic emulsion, by the use of "balanced conditions," that is to say, the emulsion must be equally sensitive to all colors, or a compensating filter must be used. The positive thus obtained was bound up with a screen-plate, and in preference with one of the linear type, such as the Warner-Powrie. R. L. Stinchfield[53] would utilize a two-color method but distribute the filter areas between two supports. Fig. 147 will enable the principle to be grasped, and *1* represents one of the elements with the sensitive coating broken away; *2* is a test chart; *3* repre-

sents a negative of the same through a red filter; *4* the same through a green filter; *5* is a face view of the green-lined element enlarged and *6* is the same of the red unit; *7* is an enlarged face view of a positive made on the green; *8* is a diagrammatic section of one of the sensitive elements with the opaque reflecting backing broken away. The support might be celluloid or glass with the elements spaced apart so as to leave clear spaces or windows through which the other colors were seen. M. C. Hopkins[54] would also use a process on similar lines.

F<small>IG</small>. 147. Stinchfield's U.S.P. 1,364,958 (Page 557).

J. Szczepanik[55] would coat a print-out emulsion on a mosaic, and then on top of this a panchromatic emulsion. The former would not be affected during the camera exposure, and was to be exposed through the negative, the primary image not being reversed. The negative was stripped off. S. Schapovaloff[56] devised a screen-plate in which the elements were stained so that part of the coloring matter was removable after exposure, the remainder giving the correct colors. After removal of the temporary color the support with the image might be attached to paper.

J. H. Smith[57] proposed to make prints by the bleach-out process and patented a special wing mirror printing frame. J. Szczepanik[58] stated that

for printing screen-plates on bleach-out paper the ordinary varnish was too soft and advised that the plate be coated with rubber, then collodion, cellulose acetate or hardened gelatin. A. Goedecke[59] patented the idea of clipping a screen-plate and sensitive plate together with paper clips on every side, which would serve as registration means after the plate was developed. J. H. Stevens[60] patented an apparatus for registering positives and viewing screens, in which one plate was firmly held and the other so that it could be shifted vertically and horizontally by levers.

The Société Anonyme la Photographie des Couleurs[61] would use a screen-plate with or without a compensating filter in the camera and transfer this negative to a support coated with dichromated colloid, provided with a similar patterned screen. Parts of the elements were protected from the developer and dissolved off. The positive elements might be made of colored resins and these fused by alcohol vapor. E. B. Wedmore[62] would make separate negatives and use the imbibition method for the prints, relying on the sideways diffusion of the dyes to obtain continuous tones.

A. Schwarz[63] proposed to use superimposed celluloid foils and cut across the block thus made, using the lines at right angles to those of the taking screen. O. S. Dawson and C. L. Finlay[64] would take a negative through a regular patterned separate screen and print on a screen-plate coated with an ordinary emulsion. The register for printing was obtained by viewing the negative in contact with the screen-plate in a weak light, printing being effected in a strong light. In registering with the negative complementary colors were seen. W. Kunz[65] proposed to take three-color separation negatives, and then to print on to screen-plates by the aid of mirrors, prisms or the like.

E. Cervenka[66] printed from negatives with a geometrical screen on to dichromated gelatin, carried by an identical screen, the picture then being immersed in stannous chloride or other decolorizer which would penetrate the unhardened colloid, and the result was transferred to paper. In an alternative method a second screen was made with bleach-out dyes and printed under the original. The same inventor[67] would use a linear or regular pattern screen as close as possible to a panchromatic plate and project a positive from a lined negative through a similar screen.

J. E. Thornton[68] patented a method in which a transparent support was coated with plain gelatin and the patterns mechanically printed with dyes that should soak through the colloid to the back. Or dyed grains of colloid might be scattered on a tacky surface. Sensitizing with dichromate followed and after printing, development like carbon. C. Courmont[69] proposed to obtain three monochrome prints and superpose. Later[70] he claimed the superposition of transparent tri-color images, obtained by any process, suitably cemented. H. Bruggemann[71] projected an enlarged image

of the subject on to a screen-plate in the dark room and then photographed this compound image. F. S. Soudet[72] proposed to make three separation positives and project in superposition.

The Société Anonyme la Photographie des Couleurs[73] patented the fusion of the colors by treating the support with a solvent for the vehicle. The same inventors[74] proposed to suppress the compensating filter by shading the different color elements with a neutral color. This plan was first suggested by du Hauron (see p. 455). Later they also would use[75] elements on paper complementary to those of the negative screen-plate. H. Hudson[76] would use non-reversed screen negatives and print in three successive dichromated-gum films, using color filters.

H. Pedersen[77] would make a mosaic screen on a transparent support with the elements dyed with colors soluble in alcohol, but insoluble in water. This was then coated with emulsion, containing a white pigment. After the usual operations the plate was treated with a bromoil or other hardening solution, fixed and developed with hot water and dried. Then a sheet of gelatin, impregnated with alcohol could be applied and the colors would diffuse through the variable thickness of the image into the gelatin, which was then stripped and applied to a black support. Precisely the same patent was granted to O. Fielitz.[78] M. Poulot[79] would use a mixture of gelatin, ferric chloride and tartaric acid coated on one side of a transparent paper, the other side being coated with a dichromated screen. G. Jousset[80] proposed to obtain negative and positive and paint with colors and then reproduce with a screen-plate.

L. Heck[81] would expose a panchromatic plate in contact with a screen-plate, then make three positives on glass and expose on dichromated fish glue and strip and transfer to paper. M. H. Poinsot[82] provided paper with red, yellow and blue elements, sensitized and exposed and then immersed in a bleaching bath, which acted through the insolubilized parts. The paper might be fixed to glass or metal for registration and a greasy line resist used to protect the colors. A Bueno[83] made three negatives from a screen-plate and from these reliefs. Three styluses were electrically moved over the reliefs, on the system of the pantograph, and traced the images on prepared paper.

K. Warga[84] proposed to obtain an ordinary black and white positive from a negative, taken without a filter, and stain the same yellow. And from the blue-filter and red-filter negatives, taken at the same time as the other, print-plates were made on dichromated gelatin, coated on a metal band, and the images inked up with greasy inks. They were then immersed in dye solutions and the dye images transferred to a yellow-stained positive. L. Dufay[85] proposed to use a regular geometrical screen for taking and a similar patterned screen on paper, with much fainter colors, coated with a positive emulsion. After a negative had been made on a panchromatic plate by the separate method, it was applied to the positive

paper so as to show complementary colors, and then the exposure made. Registration was rendered easy by using non-expansive translucent paper and by pins in the printing frame. It was also suggested to use deeper colored screens for transparency work and bleach the image with mercuric chloride.

G. S. Whitfield[86] patented the production of separate color constituent positives from screen mosaics by means of a masking key screen, which had a pattern in black or color to mask two of the color records of the screen negative. The taking screen had registering bands at the ends of the plate and superposed on the pattern-taking screen, which stopped one of the colors and transmitted the other two. The key-masking screen had at the ends a color pattern area the same as the pattern of the taking screen. This masking screen was registered correctly with the screen negative so that only a single color was seen. A. C. Eastman,[87] C. L. A. Brasseur[88] and Whitfield[89] also patented registering marks.

E. Boubnoff[90] patented the production of photomechanical prints by the use of negatives through linear screens, making a positive in relief, fixing the latter on a cylinder and using the relief as the control of a spray apparatus that applied color to paper. S. Schapavoloff[91] would dye the screen elements twice in the same color, one application being fixed and the other subsequently removable, thus utilizing the same idea as Ruth and Schuller (see p. 553), and Krayn (see p. 555). L Dufay[92] proposed to use a double-coated film, panchromatized and impregnated with a light-restraining dye, so as to prevent the light from penetrating from one side to the other, and then to print from a complementary colored negative, using selective filters. The third image might be obtained by any other process, such as imbibition. The same inventor[93] would print from screen-plates in the complementary colors. Prints were to be made on panchromatized film or bromide paper through selective filters and the images converted into red, yellow and blue for superposition. Or the images might be tanned with acidified solution of dichromate and bromide of potassium. When bleached, the print was inked up with its appropriate color, after being etched with glycerol and water, as in collotype. The images might be transferred to stone, zinc or copper and further treated for lithography, half-tone and photogravure.

MM. Lumière & Jougla[94] patented method of impregnation of a bleach-out paper, before exposure, with solutions of hypochlorites, hypobromites or hypoiodites with addition of chlorides, bromides or iodides of the alkaline or alkaline-earth metals. Thus a paper might be prepared with a mixture of erythrosin, anthracen and methylen blue, and be subsequently immersed in a solution of eau de Javelle. Among the hypochlorite compounds suitable for the process, were those of sodium, potassium, barium, strontium, magnesium, aluminum or zinc. The concentration was so chosen that in using sodium hypochlorite about 25 to 30 per cent of

available chlorine was obtained in the solution. The paper, after this treatment, was to be exposed whilst still damp under the colored original or Autochrome. The bleaching action took place readily and the print was fixed by destroying the sensitizer by a reducing agent, such as sodium sulfite, bisulfite or ammonia, or as alternative to the latter, the paper might be fumed with ammonia.

1. Brit. J. Phot. 1907, **54**, Col. Phot. Supp. **1**, 49; Phot. Coul. 1907, **2**, 149. Cf. Mees and Pledge, Brit. J. Phot. 1907, **54**, Col. Phot. Supp. **1**, 75.

2. Brit. J. Phot. 1907, **54**, Col. Phot. Supp. **1**, 81; Phot. Coul. 1907, **2**, 181. L. Gimpel, Bull. Soc. franç. Phot. 1908; Brit. J. Phot. **55**, Col. Phot. Supp. **2**, 61 confirmed Piper's conclusions. R. Child Bayley, Photography, 1907, 369; Brit. J. Phot. 1907, **54**, 831; Bull. Soc. franç. Phot. 1909, **56**, 325 stated that he had obtained duplicates that were as good as the originals. Cf. Anon. Brit. J. Phot. 1907, **54**, 858.

3. Zeits. Repro. 1908; Brit. J. Phot. 1908, **55**, Col. Phot. Supp. **2**, 30, 69. Cf. Von Hübl, ibid. 82, 93; Wien. Mitt. 1912, 609. W. Scheffer, Phot. Rund. 1908, **11**, 52. The form of the silver deposit depends on the angle at which one set of lines crosses the others. The areas are rectangular only when the crossing lines are at right angles. Phot. Chron. 1908, **15**, 193; Zeits. Repro. 1908; Brit. J. Phot. 1908, **55**, Col. Phot. Supp. **2**, 76; Das Atel. 1908, **15**, 18, 97, 107, 122; Jahrbuch, 1909, **23**, 315.

4. Rev. Trimestriélle, 1910, **13**, 24; Bull. Soc. franç. Phot. 1909, **51**, 457; Penrose's Annual, 1909, **15**, 149; Brit. J. Phot. 1910, **57**, Col. Phot. Supp. **4**, 1; Phot. Mitt. 1910, **47**, 22; Photographie, 1910, 17. Cf. A. Villain, Photo-Rev. 1910; Brit. J. Phot. 1910, **57**, Col. Phot. Supp. **4**, 27. L. Gimpel, Photo-Rev. 1908, **20**, 80. C. König, Brit. J. Phot. 1910, **57**, Col. Phot. Supp. **4**, 67. E. König, Phot. Korr. 1910, **47**, 115. G. Winter, Brit. J. Phot. 1910, **57**, Col. Phot. Supp. **4**, 75.

5. Wien. Mitt. 1910; Brit. J. Phot. 1910, **57**, Col. Phot. Supp. **4**, 59. Cf. Wien. Mitt. 1912, 609; Phot. Rund. 1913, **50**, 81.

6. Brit. J. Phot. 1908, **55**, Col. Phot. Supp. **2**, 34; Phot. Coul. 1908, **3**, 137, Das Atel. 1911, **18**, 96, 107, 122; abst. C. A. 1912, **6**, 459; Chem. Ztg. Rep. 1911, 132; Jahrbuch, 1912, **26**, 371. Cf. L. Didier (p. 423), as to the use of pinachromy for printing from screen-plates.

7. Phot. Korr. 1910, **47**, 584; Jahrbuch, 1911, **25**, 633. E. Cousin, Brit. J. Phot. 1913, **60**, 330; 1914, **61**, Col. Phot. Supp. **8**, 7; Phot. Mitt. 1913, **50**, 373 detailed experiments with arc lights.

8. Phot. Coul. 1908; Brit. J. Phot. 1908, **55**, Col. Phot. Supp. **2**, 35; 1910, **4**, 8. Cf. H. Bourée, Photo-Rev. 1909, **21**, 130. E. Grills, Brit. J. Phot. 1907, **54**, 764. On making enlarged negatives from Autochromes see Brit. J. Phot. 1913, **60**, Col. Phot. Supp. **7**, 44.

9. Brit. J. Phot. 1909, **56**, Col. Phot. Supp. **3**, 33; Phot. Coul. 1909, **4**, 29. Cf. J. V. Alteneder, Amer. Phot. Annual, 1911, **25**, 128; Brit. J. Phot. 1911, **58**, Col. Phot. Supp. **5**, 7. L. Gimpel, ibid. **5**, 53; Bull. Soc. franç. Phot. 1912, **26**, 121.

10. Brit. J. Phot. 1914, **61**, Col. Phot. Supp. **8**, 3, 10; ibid. 1918, **65**, ibid. **12**, 15; Camera Craft, 1914, **21**, 407; abst. C. A. 1914, **8**, 1923. Cf. F. Dillaye, Les Nouveautés Phot. 1910, 122. A. Le Mée, Brit. J. Phot. 1911, **58**, Col. Phot. Supp. **5**, 30.

11. Phot. J. 1919, **59**, 88; Brit. J. Phot. 1919, **66**, Col. Phot. Supp. **12**, 15, 18; Annual Repts. 1919, **4**, 512; Camera Craft, 1919, **26**, 201; Amat. Phot. 1919, **47**, 200, 359. Cf. E. Coustet, Brit. J. Phot. 1911, **58**, Col. Phot. Supp. **5**, 28. J. R. Fuller, Brit. J. Phot. 1924, **71**, Col. Phot. Supp. **18**, 2.

12. Penrose's Annual, 1916, **21**, 87; Brit. J. Phot. 1915, **62**, Col. Phot. Supp. **9**, 2; 1916, **63**, ibid. **10**, 4, 7. Cf. W. A. Heydecker, Bull. Soc. franç. Phot. 1914, **56**, 172.

13. Phot. Coul. 1908; Brit. J. Phot. 1908, **55**, 97.

14. Bull. Soc. franç. Phot. 1908, **50**, 317; 1923, **65**, 23; Amer. Phot. 1923, **17**, 495; Brit. J. Phot. 1908, **55**, Col. Phot. Supp. **2**, 61; 1910, **4**, 75; Photo-Gaz. 1908, **18**, 222.

15. Brit. J. Phot. 1909, **56**, Col. Phot. Supp. **3**, 71. Cf. Penrose's Annual, 1910, **15**, 161; 1911, **16**, 12; Brit. J. Phot. 1911, **58**, Col. Phot. Supp. **5**, 3.

16. Phot. Coul. 1909, **4**, 153; Brit. J. Phot. 1909, **56**, Col. Phot. Supp. **3**, 78.

17. Amer. Annual Phot. 1911; Brit. J. Phot. 1911, **58**, Col. Phot. Supp. **5,** 7.
18. Photo-Gaz. 1911; Brit. J. Phot. 1911, **58**, Col. Phot. Supp. **5,** 7.
19. Photography, 1908, 223.
20. Bull. Soc. franç. Phot. 1911; Phot. Mitt. 1911, **48**, 156; Photo-Rev. 1911; Brit. J. Phot. 1911, **58**, Col. Phot. Supp. **5**, 53; 1917, **64**, ibid. **11**, 48. Cf. A. Weimann, Phot. Mitt. 1911, **48**, 215. C. Fingerhuth, Phot. Rund. 1915, **52**, 81. As to using two plates in superposition see L. Gimpel, Bull. Soc. franç. Phot. 1923, **65**, 23.
21. Brit. J. Phot. 1913, **60**, Col. Phot. Supp. **7**, 45. Cf. A. Weimann, Phot. Mitt. 1911, **48**, 215.
Cf. Brit. J. Phot. 1914, **61**, Col. Phot. Supp. **8**, 29 as to reproducing by photo-engraving.
22. Brit. J. Phot. 1923, **70**, Col. Phot. Supp. **17**, 19; Amer. Phot. 1923, **17**, 48.
23. E.P. 8,390, 1896; abst. Brit. J. Phot. 1907, **54**, Col. Phot. Supp. **1**, 24; D.R.P. 96,773; Silbermann, **2**, 382; Bull. Soc. franç. Phot. 1898, **45**, 72; Mon. Sci. 1898; Phot. Chron. 1898, **5**, 181; Jahrbuch, 1899, **13**, 543; 1907, **21**, 129; U.S.P. 571,314; Phot. J. 1901, **41**, 266; Process Photogram, 1897, **4**, 192; Can.P. 50,898.
24. E.P. 20,417, 1898; Brit. J. Phot. 1899, **46**, 118; Brit. J. Almanac, 1900, 853; Jahrbuch, 1900, **14**, 564.
25. E.P. 15,185, 1905; Brit. J. Phot. 1906, **53**, 674; D.R.P. 174,964; Jahrbuch, 1907, **21**, 129, 585; Belg.P. 192,563; U.S.P. 897,815; Chem. Ztg. 1906, 348; Phot. Chron. 1907, **14**, 147; Phot. Coul. 1907, **2**, 73.
26. E.P. 716, 1907; Brit. J. Phot. 1907, **54**, 678; F.P. 373,376; D.R.P. 177,243, 1906; Phot. Chron. 1907, **14**, 238; Jahrbuch, 1907, **22**, 585; Austr.P. 31,034.
27. E.P. 4,932, 1907; 4,745, 1908; Brit. J. Phot. 1908, **55**, 243, 515; F.P. 367,834; D.R.P. 214,323; 219,821; U.S.P. 1,163,207; Belg.P. 198,227; 205,697; Jahrbuch, 1911, **25**, 373.
28. D.R.P. 221,916, 1908; U.S.P. 1,113,359, granted to A. Lehner.
29. D.R.P. 193,062, 1905; addit. 167,232; previous addit. 167,613; 188,431; 190,560.
30. D.R.P. 254,181, 1908; Austr.P. 8,344, 1909; U.S.P. 1,093,948; Jahrbuch, 1913, **27**, 302; Phot. Ind. 1912, 1810; F.P. 417,382; abst. C. A. 1914, **8**, 1924; E.P. 25,998, 1909; Brit. J. Phot. 1910, **57**, 899.
31. E.P. 22,451, 1912; Brit. J. Phot. 1913, **60**, 823; D.R.P. 228,597; 288,598, 1910; U.S.P. 1,091,443; 1,093,948; Zeits. ang. Chem. 1916, II, 41; F.P. 449,080; abst. C. A. 1914, **8**, 1711; Phot. J. Amer. 1913, **50**, 576; 1916, **53**, 79; Jahrbuch, 1915, **29**, 147; Belg.P. 249,309.
32. D.R.P. 190,349, 1906; Brit. J. Phot. 1907, **54**, Col. Phot. Supp. **1**, 4; abst. Brit. J. Almanac, 1909, 645; Phot. Chron. 1908, **15**, 147; Jahrbuch, 1908, **22**, 618.
33. D.R.P. 251,653, 1908; addit. 224,701; F.P. 410,602; 445,787; E.P. 1,234, 1910; Austr.P. Anm. 4,633; abst. J. S. C. I. 1909, **28**, 1064; 1910, **29**, 1410; Jahrbuch, 1910, **24**, 387; 1911, **29**, 375.
34. E.P. 15,050, 1908; Brit. J. Phot. 1909, **56**, 634; Brit. J. Almanac, 1910, 616; Belg.P. 228,228; F.P. 389,977; 445,787; abst. J. S. C. I. 1913, **32**, 1033; Wag. Jahr. 1912, II, 567; Jahrbuch, 1913, **27**, 300.
35. E.P. 19,601, 1910; Brit. J. Phot. 1911, **58**, 747; abst. C. A. 1912, **6**, 1408; Phot. J. Amer. 1913, **50**, 576; F.P. 463,062; abst. J. S. C. I. 1914, **36**, 440; 1915, **37**, 1118.
36. E.P. 15,935, 1912; Brit. J. Phot. 1913, **60**, 634; F.P. 445,787; Austr.P. 64,542.
37. E.P. 18,553, 1909; Belg.P. 218,393. Cf. E.P. 12,891, 1911.
38. D.R.P. 250,647, 1909; Jahrbuch, 1913, **27**, 548. Cf. C. Kriss, Austr.P. 42,687, 1909.
39. F.P. 409,323, 1909; abst. J. S. C. I. 1910, **29**, 720; Belg.P. 220,624.
40. E.P. 1,549, 1912; Brit. J. Phot. 1913, **60**, 145; F.P. 438,746; 533,157; Austr.P. 10,636, 1911; 60,094. Cf. E.P. 182,167, 1921; abst. J. S. C. I. 1922, **41**, 648A; D.R.P. 308,405; Phot. Ind. 1922, 676; Brit. J. Phot. 1922, **69**, 464; Col. Phot. Supp. **16**, 29; C. A. 1922, **16**, 4152; Belg.P. 242,038; Swiss P. 59,910; Dan.P. 34,380.
41. D.R.P. 362,106, 1918; addit. to 308,405; Phot. Ind. 1923, 277. In D.R.P. 354,389 Obergassner patented a method of granulating colloids, except soap, so that they will be free from bubbles, especially for color screens, by spraying the solutions by means of gases that are soluble in the colloid or its solvents.

42. E.P. 6,903, 1913; Brit. J. Phot. 1913, **60**, 786; D.R.P. 233,167; Austr.P. 54,475; 64,543; Jahrbuch, 1912, **26**, 36; 1915, **29**, 148; Zeits. ang. Chem. 1916, 41.

43. E.P. 13,260, 1914; Brit. J. Phot. 1915, **62**, 90; D.R.P. 289,629; 290,537; 306,206; Phot. Korr. 1916, **53**, 113; Jahrbuch, 1915, **29**, 163.

44. E.P. 13,711, 1914; Brit. J. Phot. 1915, **62**, 46; F.P. 478,928; abst. J. S. C. I. 1915, **34**, 818; Annual Repts. 1916, **1**, 307; U.S.P. 1,263,962; Jahrbuch, 1915, **29**, 147.

45. E.P. 14,145, 1912; Brit. J. Phot. 1915, **62**, 517.

46. E.P. 5,144, 1912; Brit. J. Phot. 1913, **60**, 290; Brit. J. Almanac, 1914, 695; Jahrbuch, 1913, **27**, 301; Phot. Rund. 1912, **22**, 302, 320.

47. E.P. 24,566, 1913; Brit. J. Phot. 1912, **59**, 669; 1913, 60, Col. Phot. Supp. **7**, 44; 1914, **61**, ibid. **8**, 20; 1915, **62**, 105; U.S.P. 1,144,575.

48. E.P. 17,979, 1913; Brit. J. Phot. 1914, **61**, 107; D.R.P. 286,630; U.S.P. 1,128,389; Phot. J. Amer. 1914, **51**, 233; F.P. 461,228; abst. C.A. 1915, **9**, 1014; 1916, **10**, 474; J. S. C. I. 1914, **36**, 222; Annual Repts. 1916, **1**, 306; Jahrbuch, 1915, **29**, 151; Belg.P. 259,207.

49. E.P. 22,938, 1913; Brit. J. Phot. 1914, **61**, 813; J. S. C. I. 1914, **33**, 116; Jahrbuch, 1915, **29**, 150; U.S.P. 1,191,034. In E.P. 22,764, 1914; Brit. J. Phot. 1915, **62**, 275; abst. J. S. C. I. 1915, **34**, 513, the same inventors claim incomplete transfusion or intermingling of the dyes or pigments as produced in the prior patent.

50. U.S.P. 1,225,246, 1917.

51. U.S.P. 1,247,116; Jahrbuch, 1915, **29**, 147.

52. U.S.P. 1,358,802; E.P. 175,373, 1920; Brit. J. Phot. 1922, **69**, 201; Col. Phot. Supp. **16**, 14; F.P. 527,293; abst. Sci. Tech. Ind. Phot. 1922, **2**, 25; C. A. 1922, **16**, 2086.

53. U.S.P. 1,364,958, 1921. In U.S.P. 1,364,959 the elements are claimed. Reference should be made to Bradshaw & Lyell's patent (see p. 605).

54. U.S.P. 1,460,673, 1923.

55. E.P. 6,098, 1907; Brit. J. Phot. 1907, **54**, 829; 1918, **65**, Col. Phot. Supp. **12**, 27; Brit. J. Almanac, 1909, 639.

56. E.P. 180,323, 1922; Brit. J. Phot. 1922, **69**, Col. Phot. Supp. **16**, 32; ibid. **18**, 3; Brit. J. Almanac, 1923, 407; 1925, 313; D.R.P. 369,404; abst. J. S. C. I. 1923, **42**, 631A; F.P. 550,442; Sci. Tech. Ind. Phot. 1923, **3**, 67.

57. E.P. 15,937, 1908; D.R.P. 207,499; F.P. 393,708; Brit. J. Phot. 1907, **54**, Col. Phot. Supp. **1**, 62; 1909, **56**, 676; Col. Phot. Supp. **3**, 2. Cf. H. E. Corke, ibid. 1909, **3**, 23. F. Limmer, Phot. Korr. 1912, **49**, 626; Jahrbuch, 1913, **27**, 306. The angling of the printing frame with the interposition of celluloid film was pointed out by Powrie, Phot. J. 1908, **48**, 3. Cf. Brasseur (p. 552).

58. Phot. Ind. 1909; Brit. J. Phot. 1909, **56**, Col. Phot. Supp. **3**, 48.

59. D.R.P. 212,364, 1908; Jahrbuch, 1908, **24**, 387.

60. E.P. 2,975, 1914; Brit. J. Phot. 1915, **62**, 105.

61. F.P. 416,135, 1910; E.P. 12,252, 1910; Brit. J. Phot. 1911, **58**, 460; Belg.P. 225,487; Swiss P. 53,091.

62. E.P. 21,684, 1907; Brit. J. Phot. 1908, **55**, 797; abst. Brit. J. Almanac, 1910, 616.

63. E.P. 28,614, 1907; Brit. J. Phot. 1908, **55**, 874.

64. E.P. 13,340, 1910; Brit. J. Phot. 1911, **58**, 559.

65. E.P. 110,964, 1916; Brit. J. Phot. 1917, **64**, 643; Can.P. 183,749; F.P. 484,012.

66. E.P. 109,054; F.P. 503,000; Can.P. 187,459, 1918; Brit. J. Phot. 1920, **67**, Col. Phot. Supp. **14**, 28, 36; Jahrbuch, 1915, **29**, 149; Norweg.P. 29,124; Swiss P. 80,704; Dan.P. 25,853; Can.P. 187,459.

67. F.P. 478,312, 1914.

68. E.P. 8,300, 1915; Brit. J. Phot. 1916, **63**, 587; Jahrbuch, 1915, **29**, 147; U.S.P. 1,263,962.

69. F.P. 421,419; addit. 13,840; 14,350; E.P. 16,201, 1911; Brit. J. Phot. 1912, **59**, 696.

70. F.P. 430,271, 1911.

71. D.R.P. 346,988, 1920.

72. F.P. 477,444, 1914.

73. Belg.P. 223,348, 1910.

74. Belg.P. 217,142, 1909.

75. Belg.P. 216,358, 1909.

76. U.S.P. 1,431,663, 1922; abst. C. A. 1922, **16**, 4152.

77. E.P. 121,776, 1917; Brit. J. Phot. 1919, **66**, 61; Col. Phot. Supp. **13**, 8; J. S. C. I. 1919, **38**, 118A; Jahrbuch, 1915, **29**, 150.

78. F.P. 515,067, 1917; abst. Sci. Tech. Ind. Phot. 1921, **1**, 60; D.R.P. 362,105.

79. F.P. 429,461, 1910.

80. F.P. 466,787, 1913.

81. F.P. 437,346, 1911.

82. F.P. 412,628, 1909.

83. F.P. 531,842, 1921; abst. Sci. Tech. Ind. Phot. 1922, **2**, 50; E.P. 176,777; Brit. J. Phot. 1923, **70**, Col. Phot. Supp. **17**, 34. In F.P. 576,893; addit. to above Bueno patented the use of a photo-electric cell with a stylus; D.R.P. 391,715; Camera (Luzerne) 1925, **3**, 129.

84. U.S.P. 1,420,673, 1922; F.P. 553,045; D.R.P. 403,395 granted to Pyrocolor Corp.

85. F.P. 520,784, 1917; abst. Sci. Tech. Ind. Phot. 1921, **1**, 95.

86. E.P. 167,793, 1920; Brit. J. Phot. 1921, **68**, Col. Phot. Supp. **15**, 41; J. S. C. I. 1921, **40**, 718A.

87. D.R.P. 103,311, 1896; Silbermann, **2**, 384.

88. D.R.P. 171,333, 1905; E.P. 12,793, 1906.

89. E.P. 18,900, 1912; Brit. J. Phot. 1913, **60**, 690; D.R.P. 326,712; Phot. Ind. 1921, 68.

90. E.P. 24,119, 1913; Brit. J. Phot. 1915, **62**, 59; U.S.P. 1,190,095; F.P. 474,096; D.R.P. 309,784; Jahrbuch, 1915, **29**, 152.

91. E.P. 180,323; D.R.P. 369,404; abst. J. S. C. I. 1924, **43**, B36.

92. F.P. 563,203; Génie Civ. 1923, **82**, 543; Chim. Ind. 1923, **10**, 613D; Sci. Ind. Phot. 1924, **4**, 99; E.P. 197,912; 208,564; abst. C. A. 1924, **18**, 1442; J. S. C. I. 1924, **43**, B538; Brit. J. Phot. 1924, **71**, Col. Phot. Supp. **18**, 16, 28; 1925, **72**, 79; ibid. **19**, 8; D.R.P. 405,154. Cf. Bidault des Chaumes, Gén. Civ. 1923, **82**, 543.

93. F.P. 560,220.

On the use of Autochromes in collotype see A. Albert, Jahrbuch, 1911, **25**, 103. For photomechanical work generally, J. Husnik, ibid. 1910, **24**, 34. For photolithography, see H. Eckstein, Zeits. Repro. 1911, **13**, 88. O. Mente, Phot. Rund. 1908, **18**, 58. V. Crèmier, Photo-Gaz. 1911; Phot. Chron. 1911, **18**, 451.

The following French patents apply to screen-plates: Soc. Anon. Mackenstein, 385,048 for development in daylight. Soc. Anon. Demaria, 385,152. Montandon, 419,583. Simon, 473,651; addit. 19,702. Eckhoff, 473,705. For printing frames for the same, Dufay 410,030. Vuillot, 415,051. For viewing instruments or frames, Brocq 395,238. Lumière 385,753; addit. 8,856; 9,612; 400,741. Gimpel, 425,533; addit. 15,398. Dubois, 438,742. Richard, 421,862.

R. B. Hutton, E.P. 2,746, 1908; Brit. J. Phot. 1909, **56**, 291 patented a dark slide combined with a developing dish, so that the screen-plates might be developed without removal from the same. C. L. A. Brasseur, D.R.P. 173,027, 1904 patented a plate holder by means of which an uneven glass plate could be pressed into contact with a screen-plate. Mackenstein, D.R.P. 225,647, 1908, patented a plate holder for screen-plates. O. S. Dawson and C. L. Finlay, E.P. 19,665, 1909 patented the use of screen-plates with isolating filters for the production of photomechanical printing surfaces. P. Ulysee, F.P. 502,078; addit. 23,780 proposed to use three selection negatives for making Autochromes.

94. D.R.P. 258,241, 1911; Phot. Ind. 1913, 661; Chem. Ztg. 1913, 276; Brit. J. Phot. 1913, **60**, Col. Phot. Supp. **7**, 24; abst. Brit. J. Almanac, 1914, 707; Jahrbuch, 1913, **27**, 305.

CHAPTER XXI

STEREOSCOPIC PICTURES WITH AUTOCHROMES

The use of the Autochrome or other screen-plate for stereoscopic work would seem to be a natural application, for then one would have the beauty of color added to the charm of relief. But there is always a great liability for the individual screen elements appearing far too prominent in the stereoscope.

In connection with this point the possible explanation is to be found in a paper by E. Grimsehl[1] (p. 572), and he pointed out that if an obliterated German 10 pfennig, red stamp is examined with both eyes through a magnifying glass of about four inches diameter, the obliteration appears to stand about 2 or 3 millimeters above the plane of the paper. This does not appear with a 5 pfennig, green stamp; the effect is due to the color of the stamp. It does not appear when a black letter is drawn on a piece of red paper, only when the letter is drawn in red on white, that is a fine network of red lines on white paper, and with a black design. It is especially noticeable with a wide-meshed net in those parts of the letter lying on the red lines, whereas those parts lying in-between on the white ground appear sunken in. If also a series of concentric circles are drawn alternately with green or blue, black, red, black, etc., ink without white interspaces, when viewed with binocular vision through a reading glass; the green will appear sunken in. The black circles appear also raised where their edges touch the red, and sunken in where they touch the green.

This phenonemon is due to the chromatic aberration which the rays experience as they pass through the edges of the glass. This, however, does not explain the following fact: if a large number of black, green and red dots are made on a sheet of white paper in irregular arrangement, about 2 millimeters apart, and if they be examined through a reading glass, the green dots appear in front, behind them are the black and further off still the red. On a black ground the visual appearance is reversed. In many three-color prints, made with a coarse screen, the three colors appear, when examined through a glass, in different planes, the red on top, then the yellow and finally the blue, each being 1 to 2 millimeters from each other. If two separate reading glasses are used, of about 12 centimeters focus, one for each eye, the effect is reversed. On looking through the center of the lenses, there is no stereoscopic effect, only when the edges are used. If the inner edges of the lenses are used the effect is reversed. With achromatic lenses no such effect is seen.

M. von Rohr[2] commenting on this, pointed out that Sir David

Brewster[3] had described the depth arrangement in 1848 and 1851. The explanation of the phenomenon is that actually each eye looks through a prism, the refractive angle of which is towards the temples of the observer. If any dark spot on a white ground is examined with one eye through a prism, held in the same way, the image will be seen displaced, and surrounded by colored fringes, as the result of the dispersion of the rays from the white ground, and a blue fringe lies on the nasal side and a red fringe on the temporal. If the spots on a dark ground be observed with the naked eye, the red spots will appear more distant than the blue ones, and this is due to the non-achromatism of the eye.

R. Luther[4] said that it is advisable to use long focus lenses for the stereoscope, so as to avoid as far as possible enlargement of the grain, and that longer focus lenses should be used in the camera, because while the exposure is made through the glass of a screen-plate, a stereoscopic picture is examined from the film side, and, therefore, towards the sides of the picture especially, parallax may come into play, and the portion of the picture which is actually red may appear of another color, due to the angle at which the colored element is looked at. Though it is actually an open question whether parallax comes into play with screen-plates, with which the emulsion is coated on the elements.

Luther gave such explicit directions for obtaining stereo Autochromes, that his remarks are given in extenso: Anyone who has prepared an Autochrome stereoscopic transparency must have asked himself the question, from which side, film or glass, should the stereogram be viewed? Should the picture be reversed as usual in stereoscopic work, or can the undivided plate be employed? These doubts arise from the fact that the Autochrome differs from the ordinary transparency. The plate is exposed through the glass and afterwards converted directly into a positive, a process which must be considered when using the plates for stereoscopy. Every beginner knows that in making an ordinary stereo transparency the picture taken with the left-hand lens must be viewed with the left eye, and vice versa. Nothing seems easier, therefore, than doing this with Autochromes made on a single plate.

Without cutting the plate, that is, without exchanging the right-hand and left-hand print, the pictures are brought into position by turning the plate longways. The right-hand print is then before the right eye, and the left-hand print before the left eye, and the glass side of the transparency is towards the observer. If such an Autochrome is observed in the ordinary stereoscope, solidity is seen, provided, of course, that the separation of the lenses is considerably greater than that of the taking lenses. Yet the effect is not stereoscopic, but pseudoscopic. In reality the more distant objects appear nearest, whilst those really nearest appear more remote. It is a curious fact that many people can not distinguish this pseudostereoscopy from the natural effect until the difference is pointed out to

them. This fact, however, teaches us that the uncut Autochrome should not be used even though the proper image appears before each eye. The separate images must be reversed in position, yet not in such a way that a left-hand print is brought before the right eye and vice versa. There is, therefore, nothing to do than cut the plate down the middle and to arrange the two plates with their film sides facing the observer, when the correct effect is obtained.

The rule may be very simply explained thus:—reverse the positions of the two pictures and view them from the film side. If the two are exchanged, but viewed from the glass side, the effect is stereoscopically correct, but in this case the original is seen reversed as regards right and left, just as one would see the picture in a mirror.

In order to understand the principles upon which this rule is based it may be well to consider the case of a very simple object of a diagrammatic kind. Let us assume that we are looking with both eyes at two points, one higher h and the other lower n. Let the higher one be further removed and more to the right than the lower, that is to say, the letter h is higher and further back. If a glass be held some distance from the eyes, the state of things is that shown in Fig. 148. If the left and right eye be alternately shut, it will be seen that for the left eye the lower point appears directly to the right under the higher point on the glass, whilst with the right eye the lower point is shifted to the left from the higher point, Fig. 150. The two images which which we should thus see on a glass plate have the arrangement shown in Fig. 149. The points in a finished stereoscopic print would be arranged in exactly this way in order to give the stereoscopic effect on observation with both eyes. Thus it will be seen that the image seen by the left eye can be distinguished

Fig. 150.

Fig. 148.

Fig. 149.

FIG. 151.

FIG. 152.

FIG. 153 (Page 570).

FIG. 154.

from the other by the fact that in it the two points are almost exactly perpendicularly one above the other.

Assuming now that the two points are to be obtained on an Autochrome print. In Fig. 151, in place of our eyes, we imagine two lenses O_l and O_r at suitable distances; behind is the plate, glass side to the lenses. If, after exposure, development and so on, the finished plate is placed in the same position as that which it occupied at exposure, the two pictures are seen, of course, upside down, but the right-hand one is behind the right-hand lens, and the left behind the left-hand lens, as shown in Fig. 152. If we turn the plate on its long axis, so that the glass is towards us, the pictures are upright and in the right position to correspond to the

arrangement of Fig. 153, but not with the desired arrangement of Fig. 149. In order to obtain this it is easy to see that the plate must be cut in half, and each plate turned separately on its vertical axis, when the arrangement of the points is correct and the film side of the plate is towards us.

The sizes of the plates commonly employed for stereoscopy are 12x16, 9x16 and 10x15 cm., and in the event of plates not being obtainable of this size, it is necessary to use two 9x12 plates or one 13x18; in either case the total breadth is 18 cm. If the finished transparency is to be viewed in an existing stereoscope, the separation of the distance in each picture must be made to suit that apparatus. The most simple way of using an existing stereoscope is by aid of a stereoscopic print, which gives a good effect without fatiguing the eyes.

A print should be chosen which contains distant objects, and in which such actually appear distant when viewed stereoscopically. The separation is then measured between two corresponding points of the distance, and may be called a. On the uncut Autochrome a measurement is likewise made of corresponding points in the distance, these corresponding to the separation of the lenses and being called b. These two data enable us to carry out the rule that from the whole breadth of the plate, 18 cm., a portion equal to 180-a-b, must be cut off. In other words, add the separation of distant objects in a good stereo print to that of the similar separation in the Autochrome and subtract the total from the full breadth of the plate, the remainder gives the amount that must be cut off. For example, the separation of a good print was 82 mm., the actual separation of the lenses was 66 mm., consequently the amount to be cut off was 180—82—66=32 mm., or 16 mm. from each plate. The total picture before trimming is in the condition shown diagrammatically in Fig. 153.

If the plate is cut down the middle and the pictures reversed, the separation of the distance will be 180—66=114, as shown in Fig. 153. But as the stereoscope requires a distance of 82 mm., a further amount equal to 114—8—2 must also be cut off, as indicated in the figure. Fig. 154 shows the finished plate. The trimming of the plate may, of course, be done before cutting down the middle, the portions to be trimmed off being situated at either end. From the formula 118-a-b, it follows that the best use is made of the plate the closer the value $a+b$ approaches 180. If, therefore, the camera, or the stereoscope, allows of the separation it is an advantage in making full use of the Autochrome plate. Should, however, the total of a and b be greater than 180, there is then no portion to be cut off; the component pictures are placed a little further apart after their positions have been reversed.

The grain of the screen-plate, which to the unaided eye, is fairly visible, is often enlarged to an unpleasant degree by the magnifying lenses of the stereoscope, which, when of a focal length of 100 to 150 mm., give about a double enlargement. It is, therefore, advisable as far as possible

to make use of the least degree of enlargement, that is to say, to choose lenses for the stereoscope of long focus, and in order to retain the geometrical truth of the stereoscopic effect, it is likewise advisable to choose a pair of lenses for the camera of 18 to 25 cm., in place of 9 to 15 cm., which are usually employed.

This choice of longer focal length for all the lenses has a further advantage, which is connected with the character of the screen-plate, and does not apply to ordinary slides. This lies in the fact that while the exposure is made through the glass, the transparency is viewed from the film side. The direction, therefore, in which oblique rays fall upon the elements and emulsion during exposure, does not correspond with that in which the rays pass through the film when observed in the stereoscope. In Fig. 155 an exaggerated representation is given of the marginal portion of a screen-plate transparency, in which oblique rays are falling on the plate. It is seen that the portion which appears actually red, may appear green to the eye. This difficulty is gotten over by looking at the positive through the glass but the picture is then reversed.

Fig. 155 (Page 575).

There is one point in connection with the cutting of screen-plates, and that is the very great possibility of the film splitting from the glass, if the latter be cut in the usual manner, that is to say with the diamond on the glass. The method of avoiding this was suggested by Garel.[5] Place the plate, film up on the table and with a sharp knife cut right through the film down to the glass, making two such incisions about one-eighth of an inch apart and equidistant from the medial line of the plate. To ensure the diamond cutting exactly between the two incisions, a cardboard gauge should be used, which can be easily made by drawing a line on a sheet of smooth card, equal in length to the base line of the plate. Near the center, at right angles to the base line of the plate, should be drawn two lines, the distance between them being equal to the cut of the diamond. This, as a rule, varies slightly, but it is extremely easy to find, by placing a foot rule, or straight edge, on the card drawing a pencil line as closely as possible

to the edge, and then without shifting the latter drawing the diamond, bearing rather heavily on it, down the card, when the cutting point will score the card. To cut the film then, it is only necessary to place the screenplate, face down on the card, so that the line corresponding to the cut of the diamond falls midway between the two incisions of the film. If the straight edge is then placed against the other line, which will be easily seen, if it be drawn longer than the plate, the diamond will cut the glass in the correct place.

Flashlight Work with Screen-Plates.—One of the first to utilize flashlight for screen-plates was B. J. Falk[6] although no details were published. F. Monpillard[7] described the work of Pavie and H. d'Osmond, the latter of whom had compounded a special mixture for use with Autochrome plates, the composition of which was not published. A. and L. Lumière and A. Seyewetz[8] although at first antagonistic or indifferent to its use, suggested a mixture of 2 parts of magnesium with 1 part of potassium perchlorate. The latter should be very carefully ground alone and passed through a sieve of 120 mesh, and then mixed with the magnesium, which should also be passed through the same sieve. The mixture should be effected with a feather on a card.

F. Novak[9] proposed a mixture of 1 part of anhydrous thorium nitrate and 2 parts of magnesium powder, and with the special filter (see p. 82), it was found that 15 g. of the powder at a distance of 2.5 meters, with a lens working at F 6.3, gave excellent results without any diffusing screen in front of the light. G. Krebs[10] patented the use of various compounds, typical being 1-2 parts alum, 1-2 parts magnesium, 6-8 parts nitrates and 2-3 parts sugar, dextrin or flour, to which was added sodium or calcium fluorides for a yellow light, copper fluoride for blue, barium fluoride for green and the lithium salt for red. In a later patent[11] mixtures of the salts could be used.

A. von Palocsay[12] made comparative experiments with various powders and found that the Lumière perchlorate was the most powerful, but gave the most smoke. D'Osmond's powder was rather noisy but vigorous, but the thorium nitrate mixture gave the best results. W. Weissermel[13] tried aluminum instead of magnesium with perchlorate with success, and found that about 10 g. was enough with a distance of 3 meters and lens working at F 6.

1. Phys. Zeits. 1908, 109; Jahrbuch, 1908, **22**, 355; Brit. J. Phot. 1908, **56**, 328; Phot. Coul. 1908, 3, 140.
2. Phys. Zeits. 1908, 201; Brit. J. Phot. 1908, **56**, 328. F. Kohlrausch stated that he had called attention to the same phenomenon produced by dispersion in Pogg. Annal. 1871, **143**, 144.
3. Trans. Roy. Soc. Arts Scot. 1851, 3, 270; Phil. Mag. 1852, (4), **3**, 31. Cf. von Rohr, "Die binokularen Instrumente," Berlin, 1907, 49; Phot. Coul. 1908, **3**, 141.
4. Phot. Rund. 1908, **18**, 522; Jahrbuch, 1909, 23, 299; Brit. J. Phot. 1908, **56**, Col. Phot. Supp. **2**, 85; Photographic Annual, 1910, 34; Photo-Rev. 1909, **21**, 188. Cf. Brit. J. Phot. 1909, 57, Col. Phot. Supp. 3, 59. L. Stockhammer, Photo-

Rev. 1909, **21**, 91; Phot. Coul. **4**, 52. H. Quentin, Phot. Coul. 1909, **4**, 128; Photo-Rev. 1909, **21**, 62. A. Payne, Brit. J. Phot. 1907, **54**, 784, 803.

5. Phot. Coul. 1909, **4**, 88; Brit. J. Phot. 1908, **58**, Col. Phot. Supp, **2**, 52. Cf. E. Estanave, Photo-Gaz. 1909, **19**, 130; Jahrbuch, 1910, **24**, 345; Phot. Ind. 1909, 409; Chem. Ztg. Rep. 1909, 296.

Demichel, F.P. 463,708, 1913 patented a mount for stereo Autochromes. Gavazzi, F.P. 462,042 patented a method of reproduction of screen-plates. L. Bouton and J. Feytaud, Compt. rend. 1910, **150**, 1424. C. W. Piper, Brit. J. Phot. 1910, **57**, Col. Phot. Supp. **4**, 12. C. Balmitgère, ibid. 1911, **5**, 22. L. Gimpel, Bull. Soc. franç. Phot. 1911, **58**, 211; 1921, **68**, 104; Brit. J. Phot. 1911, **58**, Col. Phot. Supp. **5**, 51 described the preparation of anaglyphs on Autochrome plates. C. Adrien, Bull. Soc. franç. Phot. 1921, **61**, 24; Brit. J. Phot. 1921, **68**, Col. Phot. Supp. **14**, 8; Camera Craft, 1921, **28**, 94.

6. Brit. J. Phot. 1909, **56**, Col. Phot. Supp. **3**, 16; ibid. 1911, **5**, 23.

7. Bull. Soc. franç. Phot. 1909; 1910, **57**, 103; Brit. J. Phot. **56**, Col. Phot. Supp. **3**, 51, 60; 1910, **4**, 25, 76; Photo-Gaz. **19**, 141. Cf. Brit. J. Phot. 1911, **58**, Col. Phot. Supp. **5**, 33.

8. Brit. J. Phot. 1910, **56**, Col. Phot. Supp. **4**, 70; Rev. gén. Chim. pur et appl. 1910, **13**, 284; Bull. Soc. franç. Phot. 1910, **57**, 285; Phot. Mitt. 1910, **47**, 324; Phot. Korr. 1910, **57**, 142; Phot. J. 1910, **50**, 314; abst. C. A. 1911, **5**, 36.

9. Jahrbuch, 1911, **25**, 190; Brit. J. Phot. 1911, **57**, Col. Phot. Supp. **5**, 68. Cf. A. Hamburger, ibid. 920, **13**, 3; Il Prog. Foto. 1920, **27**, 141.

10. D.R.P. 223,922, 1904; 226,598, 1908; F.P. 394,067; abst. C. A. 1911, **5**, 1564; Jahrbuch, 1892, **6**, 252.

11. D.R.P. 213,599, 1905.

The use of the earthy salts to obtain colored flashlights dates back to the very early days: Cf. J. Gaedicke and A. Miethe, D.R.P. 42,966, 1887; E.P. 7,035, 1887. E. J. Wall, Brit. J. Phot. 1921, **68**, 497.

12. Wien. Mitt. 1916, 25.

Cf. W. S. Hamburger, Amer. Phot. 1914, **8**, 514; Brit. J. Phot. 1914, **61**, Col. Phot. Supp. **8**, 34.

13. Phot. Rund. 1912, **22**, 58; Brit. J. Phot. 1912, **59**, Col. Phot. Supp. **6**, 18. Agfa, ibid. 31 also introduced a special lamp and powder, and stated that as a rule about 24 times the quantity of powder should be used as for black and white work.

` J. I. Crabtree, U.S.P. 1,240,027, 1916 patented a flashlight powder, which should give an illumination similar to that from a nitrogen Mazda lamp and would, therefore be useful in color photography. This was probably meant to be used with the Kodachrome process. Cf. E. J. Wall, Brit. J. Phot. 1907, **54**, Col. Phot. Supp. **1**, 50. On the use of colored carbons for arc lamps see E. J. Wall, Brit. J. Phot. 1908, **55**, Col. Phot. Supp. **2**, 55; Penrose's Annual, 1907, **13**, 97. J. Kjeldsen, E.P. 17,951, 1904; Brit. J. Phot. 1905, **52**, 131. A. Liebert, F.P. 374,927, 1907. On making Autochromes by enclosed arc light see Brit. J. Phot. 1909, **56**, 86. P. Thieme, Phot. Rund. 1912, **49**, 135. On the use of incandescent electric lamps for screen-plate work, G. Manjauze, Bull. Soc. franç. Phot. 1913, **60**, 203. W. Thieme, Phot. Rund. 1916, **53**, 196 on the use of colored flashlights. C. J. Belden, Brit. J. Phot. 1919, **66**, Col. Phot. Supp. **13**, 25; Camera, 1919, **23**, 246. C. Adrien, La Phot. 1925; Brit. J. Phot. 1925, **72**, Col. Phot. Supp. **19**, 17.

CHAPTER XXII

SUPPLEMENTARY NOTES ON SCREEN-PLATES

A few special notes on particular commercial or proposed plates have been collected in order to round out the matter.

The Warner-Powrie or Florence Plate.—It has always been a matter of regret to the author that this particular plate did not commercially materialize, as it possessed some advantages, particularly as regards printing from, not common to irregular or mosaic patterned plates. It was a linear plate (see p. 484), and the method of production of the lines was sufficiently ingenious to warrant dealing with at some length.

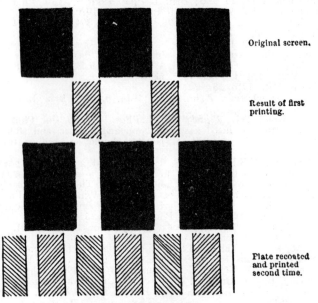

Original screen.

Result of first printing.

Plate recoated and printed second time.

Fig. 156.

A black and white matrix, with the black lines twice the width of the clear spaces was used, and after printing on dichromated colloid, the matrix was shifted till the already exposed and dyed up lines were covered and another exposure made and then the surface was recoated, the third exposure made through the back, the previously dyed lines playing the part of a negative and protecting the colloid over the already formed lines. This procedure will be more readily grasped by reproduction of a comment by A. J. Newton[1] (p. 579), though he dealt with the subject from the point of view of the formation of black and white screens:

"The lines being 600 and upwards to the inch, whereas the finest ruled

cross-line screens at present marketed are, I believe, 400 lines to the inch, it would at once occur to a photo-engraver to ask how Mr. Powrie obtained his original negative screen-plate of sufficient fineness. The reply is that Mr. Powrie makes black screens exactly like his color screens, and simply goes on reducing the lines and spaces until he obtains the fineness he wishes. He informed me that he commenced with quite a coarse screen ruled in the usual way, but with great accuracy, and from it he has made with ease screens of a fineness equal to 1,600 lines to the inch of perfect uniformity. The diagram, Fig. 156, shows quite clearly how this can be done by exposing and developing the plate, blackening these lines by a ferro-tannic process, and then recoating and replacing the plate in a different position. The second printing will give a screen of twice the fineness of the original, which is now replaced by the manufactured screen, and this is made to serve its fineness, and so on. I have handled black-line screens, both fine and coarse, made in this way, that for all practical purposes would serve as well as the ruled cross-line screen does for making half-tone blocks, and their cost should be enormously cheaper if, as asserted, one man, by means of a suitable printing machine, can make

Fig. 157.

dozens of them a day. Of course, any angle and any pattern of line can be produced in this way, and any width of ruling, any relationship of white space to black line."

It is obvious that there is some similarity with the method outlined by du Hauron (see p. 454), and in later experiments Powrie also utilized the former's idea of placing the matrix at right angles to the original direction of the screen lines, thus obtaining one continuous line with interposed rectangles of the other two colors. As regards the printing of these plates a similar ruled plate was used with the lines at right angles to the negative; but after making the first exposure, the printing frame was turned through a slight angle, so that the image of the line was projected not on top of the first exposure, but adjacent to it, as shown in Fig. 157, and then the frame turned through a similar small angle in the opposite direction, so that again the line was projected on the other side of the original line. Each line was in this way broken up into three lines, overlapping its neighbors on each side, the effect of which was to remove the white in the positive.[2]

The Omnicolore Plate.—This was the invention of du Hauron and Bercegol (see p. 492), and was introduced commercially[3] in 1907, and was made by a resist process.

E. Valenta[4] stated that the screen consisted of blue lines from 0.04 to 0.045 mm. width, with green and red rectangles of 0.06x0.07 and 0.05x0.06 mm. respectively, and as a whole the plate had a reddish or bluish tinge. By treatment with hot water some of the red dye was extracted and this had a yellowish-red fluorescence. Acetone dissolved the red and yellow dyes, and microscopically examined, the plate was seen to consist of a broad, bright blue line, and another narrow, dark blue one, and colorless spaces in the place of the red elements. The green was formed thus of a yellow and blue, and the red of a crimson and yellow. Soda lye destroyed the blue dye of the green fields, and the dark blue lines turned violet-brown. The dye of the dark blue lines was destroyed by ammonia, but was regenerated by acetic acid, while the blue dye of the green lines was not attacked. By treatment with hot alcohol the red and yellow dyes were removed, and there remained a system of parallel blue lines. The alcoholic solution was red and fluoresced yellowish-green; the red dye was precipitated by lead salts, pointing to the use of a fluorescein dye, which would not be conducive to light-stability. And it was found that the red and yellow dyes altered in sunlight, and the whole plate became more bluish.

The red elements were transparent from wave-length 5900 to the extreme red; the green transmitted from 4800 to 5900, and the blue from 4800 to the ultra-violet. The transmissions were sharper than with the Autochrome plate, and the compensating filter was lighter, yet the plate required three times the exposure of the Autochrome, due to the low sensitiveness of the emulsion. The color-sensitivity extended from B½C to b2/3F, with a distinct minimum at 4500 to 5000, and there were two maxima, so that probably an isocyanin was used. Du Hauron and Bercegol[5] gave some general data as to these plates, and stated that there were in every square millimeter about 72 orange-red units, 72 blue-violet, 72 green and 72 purple-violet units. The colors differed sensibly from those used in the Autochrome, the green being less yellow and the blue less violet.

The Dufay Plate.—The first plate, made according to the Dufay patents, was known as the "Diopticolor," and in that the screen was issued for separate use with panchromatic plates. Later the name "Dioptichrome" was adopted, and this plate was issued either coated with emulsion or for separate use[6] in which four colored elements were used. The principle of the screen was stated to be[7] the creation of a first group of two simple or primary colors, not complementary, which might be red and blue, or red and yellow, or yellow and blue. The superposition of a second group of colors exactly juxtaposed, the colors of which, unlike the first, should be exactly complementary to each other. One of these should be

that of the simple or primary color not entering into the composition of the first group. Thus on the first of, say red and blue, would be superimposed a yellow-violet group, and on the yellow-blue would be a red-green. On this system the inventor designed three different arrangements of four colors, each giving a filter chromatically correct and without any dark spaces.

The surface respectively occupied by the colors would be adjusted in such way that the general tone resulting from the first group should be complementary to the resultant of the second group. By this process the form of the units might be varied to any extent.

H. Quentin[8] stated that in the old form of plate, there were in a square millimeter, 5 green lines, 25 red and 25 blue squares; in the later plate there were in the same area 7 green lines, 35 red and 35 blue squares. The blue elements transmitted from 4500 to the ultra-violet, and was similar in color to the rapid screen blue of the Hoechst works. The green transmitted from 4500 to 5900, and was similar to solid green (Hoechst), with a faint transmission at 6500. The red had a sharp absorption, but transmitted a little blue at 4600. J. H. Pledge[9] stated that the width of the green lines averaged 0.09 mm., and the red and blue areas 0.11 mm. Whilst Mees and Pledge[10] stated that the green line was 0.06 mm. wide and the red areas 0.07x0.1 mm. and the blue areas 0.065x0.09 mm.

The Thames Plate.—This was produced under the Finlay patent, (see p. 485), and consisted of red and green circles with blue interstices[11] and was issued first as a separate screen, but later coated with emulsion. The details of construction have already been given. Later Dawson proposed the Leto plate, which so far as the author is aware, was never issued commercially.

The Krayn Screen Film.—This was produced under the Krayn patents (see p. 488). E. Stenger[12] stated that there were 7 lines to the millimeter. The colors of the lines were so adjusted that no compensating filter was required and the negatives were not reversed, but printed on to positive screen-film with a slightly different lining. These were said to be suitable for cinematographic work. But as Stenger pointed out the slight sensitiveness of the panchromatic emulsion would be an obstacle to such work, whilst yet another drawback lay in the linear ruling. As the cinematographic positive must be enlarged at least 80 to 100 times, each line would be 14 mm. in breadth and, therefore, plainly visible to the eye. Were it possible to make 20 lines per millimeter, the projected image would then have lines of 5 mm. width. Such thin films of celluloid would seem to be impracticable, whilst the above enlargement would not be sufficient in many cases, therefore, this process would not seem to be practical for color cinematography. It was also a question whether such thin bands would stand perforation, and a further question arose as to the breadth and height which the screen lines must have in order to avoid

parallax. F. Faupel answered this in saying that the thickness of the film should be at most one-half the width of the line. If the film contains twenty lines it will be 0.025 mm. thick. It is doubtful whether such sections can be made in celluloid. A cinematograph film should be at least 0.1 mm. thick, and if in such film the lines had a breadth of only 0.05 mm., there is bound to be great parallax. If a positive on an ordinary Krayn line screen be held up, the clear sky actually appears blue, but if it is viewed sideways it appears red or green.

F. Limmer[13] found that the lines were about 0.042 mm. broad, and the distances in between were 0.11 mm., and there were thus 216 units to the square millimeter. W. Scheffer[14] found that the thickness of the celluloid base was 0.013, the screen layer 0.005, the varnish 0.005 and the emulsion 0.020 mm. thick. Later a mosaic screen[15] was prepared and the final form seems to have been prepared with a greasy resist (see p. 493) in which mordants were used.[16]

The Agfa Screen-Plate.—The pre-war plate was stated to be prepared with gum arabic, or other colloid. Von Hübl[17] stated that the polygonal grains had a diameter of 0.01 to 0.02 mm., and this layer was insulated by a celluloid varnish of about the same thickness.

The latest form of this plate, issued since the war, would appear to be different. H. Naumann[18] stated that apparently it was made with gum arabic, or the like, stained and powdered and dusted on a tacky surface, and then rolled down. There are fine white lines between the grains but a filling is not necessary. The grains vary from 0.003 to 0.020 mm., there being about 7,000 per square millimeter. The color was stated to be about the same as the Autochrome, but the emulsion was faster, and the film more resistant to liquids and temperature changes. Several plates examined by the author had a very strong greenish tinge and quite unlike the Autochrome. W. Frerk[19] stated that the color elements now appear to be shellac, and it was an improvement on the pre-war plate as it was more waterproof. The compensating filter is now orange, instead of yellow of the earlier one, and the green-sensitiveness of the plate is higher than the red.

The Paget Plate.—This it is believed was the invention of C. Finlay and consists of square elements, the blue being 0.063 mm. with 0.085 mm. for the red and green. The ratio of the squares was stated by J. H. Pledge[20] to be roughly blue 8, green 7, red 7, there being two blue elements in the unit. The plate could be issued either as a separate screen, or coated with emulsion,[21] though it is issued as a separate screen. Von Hübl[22] stated that the panchromatic plates, furnished by the Paget Plate Co., appear to be sensitized with isocol or similar mixture, and that the relative red, green, violet sensitiveness was very similar to that of the Autochrome plate, and that, therefore, a compensating filter of almost the same composition could be used. He specifically recommended:

Filter yellow.................................... 0.5 g.
Acid rhodamin................................0.03 g.

Per square meter. The plates only require half the exposure of the Autochrome plates.

1. Brit. J. Phot. 1907, **54**, 730; Jahrbuch, 1908, **22**, 223.
Cf. W. Gamble, Brit. J. Phot. 1907, **54**, 748. E. J. Wall, ibid. 710; Phot. News, 1907, **52**, 329. J. H. Powrie, Penrose's Annual, 1907, **16**, 9; Amer. Phot. 1907, **1**, 186; Camera Craft, 1907, **14**, 503; Bull. Soc. franç. Phot. 1910, **57**, 386. F. Duncan, Brit. J. Phot. 1907, **54**, Col. Phot. Supp. **1**, 83. A. E. von Obermayer, Phot. Korr. 1907, **44**, 533; Jahrbuch, 1908, **22**, 223. Anon. Brit. J. Phot. 1907, **54**, 707, 788. L. W. Munro, Brit. J. Phot. **55**, Col. Phot. Supp. **2**, 8. J. G. Van Deventer, Nature, 1908, **78**, 376. E. H. Atkinson, Brit. J. Phot. 1907, **54**, 894.
2. C. E. K. Mees, J. Soc. Arts, 1908, **56**, 203; Brit. J. Phot. 1908, **54**, 708; ibid. 1910, **57**, Col. Phot. Supp. **4**, 47; Phot. Coul. 1907, **2**, 145. J. H. Powrie, Phot. J. 1908, **48**, 3.
Cf. E. Grills, Brit. J. Phot. 1907, **54**, 764 on the making of pinatype prints from these plates; Jahrbuch, 1908, **22**, 223, 406; Der Phot. 1907, **17**, 322; Phot. Ind. 1908, 127; Phot. Chron. 1908, **15**, 88. In the line and rectangle plate W. Scheffer, Phot. Ind. 1908, 380; Jahrbuch, 1909, **23**, 315; Brit. J. Phot. 1909, **56**, Col. Phot. Supp. **3**, 43; Bull. Soc. franç. Phot. 1910, **57**, 70; abst. C. A. 1910, **4**, 1851, stated that the red fields were 0.016x0.021 mm., the green 0.014x0.03 mm., and the blue 0.106x0.09. Cf. E. Stenger, Fortschritte Chem. Phys. 1910, **2**, 157; Jahrbuch, 1910, **24**, 377. J. H. Pledge, Brit. J. Phot. 1909, **56**, Col. Phot. Supp. **3**, 81.
3. Brit. J. Phot. 1907, **54**, Col. Phot. Supp. **1**, 37, 46; Phot. Coul. 1907; Bull. Soc. franç. Phot. 1907, **44**, 221, 500; 1909, **46**, 199; Jahrbuch, 1908, **22**, 410; Penrose's Annual, 1907, **13**, 33.
4. Jahrbuch, 1909, **23**, 150; "Die Photographie in natürlichen Farben," 153.
Cf. H. Hinterberger, Phot. Ind. 1910, 560; Phot. Mitt. 1911, **48**, 59; Jahrbuch, 1911, **25**, 158; D. Phot. Ztg. 1909, **33**, 623; Phot. Chron. 1909, **16**, 227. H. Quentin, Phot. Coul. 1910, **5**, 31, 53; Bull. Phot. 1909, **4**, 88; Sci. Amer. 1909, **67**, 359. C. E. K. Mees, Brit. J. Phot. 1908, **55**, Col. Phot. Supp. **4**, 10. W. Scheffer, ibid. 11, 18; Phot. Korr. 1909, **46**, 318, 482. For the maker's instructions see Brit. J. Phot. 1908, **55**, Col. Phot. Supp. **4**, 13, 42. For details of manufacture, Phot. Coul. 1909, **4**, 31, 63; Brit. J. Phot. 1909, **56**, 38. As to the fading of the colors, ibid. 1909, **56**, 96. On pinatype prints from the same L. Didier, Phot. Coul. 1910; Brit. J. Phot. 1910, **57**, Col. Phot. Supp. **4**, 8. Some alterations in the screen, H. Hinterberger, Phot. Ind. 1910, 560. O. Mente, Phot. Chron. 1907, **14**, 334. General notes: E. J. Wall, Phot. News, **52**, 329. E. Coustet, Rev. Sci. 1910, **48**, (1), 494; Photo-Gaz. 1910, **20**, 101. F. Dillaye, Les Nouveautés Phot. 1910, 125, 130. L. Dufay, Bull. Soc. franç. Phot. 1910, **52**, 177. Anon. Brit. J. Phot. 1910, **57**, 847; Col. Phot. Supp. **5**, 39. A. D. Ford, ibid. 88. P. Hanneke, Phot. Mitt. 1910, **47**, 257. Anon. Phot. Welt. 1910, **24**, 166. O. Schilling, ibid. 129. V. Crèmier, Brit. J. Phot. 1911, **58**, Col. Phot. Supp. **5**, 37. J. M. J. ibid. 64. H. E. Blackburn, Camera Craft, 1912, **19**, 215. Anon. Amat. Phot. 1912, **55**, 80. E. E. Fernau and J. M. Lohr, 8th Int. Congress Applied Chem. 1912, sec. 9, Photochemistry 137. F. Monpillard, Photo-Gaz. 1912, **22**, 190. W. J. Starr, Brit. J. Phot. 1912, **59**, Col. Phot. Supp. **6**, 10. Anon. La Nature, 1917, **45**, 292; Sci. Amer. Supp. 1918, **85**, 237; abst. Brit. J. Phot. 1918, **65**, Col. Phot. Supp. **12**, 20; Camera Craft, 1918, **25**, 415. L. P. Clerc, Brit. J. Phot. 1918, **69**, 414.
5. Photo-Rev. 1909, **21**, 177, 114.
6. Phot. Coul. 1908, **3**, 97; Brit. J. Phot. 1908, **55**, Col. Phot. Supp. **2**, 45, 51; Jahrbuch, 1908, **22**, 411; Photo-Rev. 1909, **21**, 98.
7. Phot. Coul. 1910, **5**, 31, 111; Brit. J. Phot. 1909, **56**, Col. Phot. Supp. **3**, 39; ibid. 1919, **12**, 4; Phot. Rund. 1910, **20**, 105; Wien. Mitt. 1910, 178.
8. Phot. Coul. 1910, **5**, 31. Cf. A. C. Braham, Brit. J. Phot. 1910, **57**, Col. Phot. Supp. **4**, 78.
9. Brit. J. Phot. 1909, **56**, Col. Phot. Supp. **3**, 32, 38, 42, 48, 81, 96. Cf. H. Hinterberger, Wien. Mitt. 1909, 583; 1910, **33**, 42, 572; 1912, 58; abst. C. A. 1912, **6**, 1235; Phot. Ind. 1910, 560; Phot. Mitt. 1909, **46**, 74; Jahrbuch, 1910, **24**, 201, 238; Phot. Welt. 1909, **23**, 49; Phot. Chron. 1911, **18**, 58, 130. C. Wolf-Czapek, Phot. Ind. 1910, 251, 1684; Wien. Mitt. 1909, 337. F. Limmer, Wien. Mitt. 1910, 178; Jahrbuch, 1911, **25**, 210. A. E. von Obermayer, Jahrbuch, 1909, **23**, 170.

10. Phot. J. 1910, **50**, 197, 350; Brit. J. Phot. 1910, **57**, 48. For general instructions for this plate see E. H. Corke, Brit. J. Phot. 1910, **57**, 433; Col. Phot. Supp. **4**, 57. V. Crèmier, Photo-Rev. 1911; Brit. J. Phot. 1911, **58**, Col. Phot. Supp. **5**, 37. W. J. Starr, Phot. Coul. 1912, **7**, 73; Brit. J. Phot. 1912, **59**, Col. Phot. Supp. **6**, 10.

11. Brit. J. Phot. 1908, **55**, 312; Col. Phot. Supp. **2**, 24, 72, 81, 89 with photomicrographs. Cf. E. H. Corke, ibid. 92,884; 1909, **56**, ibid. **3**, 23, 65. C. N. Bennett, ibid. **57**, 89. For general information, Anon. ibid. 48, 56, 66, 80, 111, 150, 170, 186, 258. Mees and Pledge, ibid. 1910, **57**, ibid. **4**, 47. C. S. Dawson and C. L. Finlay, ibid. 1908, **55**, ibid. **2**, 96; 1910, **57**, 42. E. Valenta, Phot. Korr. 1909, **46**, 32; "Die Photographie in natürlichen Farben," 1913, 157; Jahrbuch, 1908, **22**, 228; 1909, **23**, 313. C. Puttemans, Bull. Belge, 1909; Photo-Rev. 1909, **21**, 26. R. Child Bayley, Bull. Phot. 1909, **4**, 89. F. Dillaye, Les Nouveautés Phot. 1910, 127.

12. Das Atel. 1907, **14**, 124; Phot. Chron. 1908; Brit. J. Phot. 1908, **55**, Col. Phot. Supp. **2**, 23.

13. Wien. Mitt. 1910, 555; Jahrbuch, 1911, **25**, 216.

14. Phot. Ind. 1911; Jahrbuch, 1911, **25**, 216; Brit. J. Phot. 1920, **57**, Col. Phot. Supp. **4**, 89.

15. Mees and Pledge, loc. cit.

16. E. Valenta, Phot. Korr. 1911, **58**, 41; Brit. J. Phot. 1911, **58**, Col. Phot. Supp. **5**, 31; H. Hinterberger, Wien. Mitt. 1911, 13; W. Brenziger, Das Bild, 1911, 20; H. Quentin, Phot. Coul. 1910, **5**, 31; H. E. Blackburn, Brit. J. Phot. 1911, **58**, Col. Phot. Supp. **5**, 67.

17. Wien. Mitt. 1912, 161; Jahrbuch, 1912, **26**, 260; Phot. Rund. 1916, **26**, 37; Phot. Chron. 1916, **23**, 253; abst. C. A. 1917, **11**, 1093; Brit. J. Phot. 1913, **60**, Col. Phot. Supp. **7**, 4. Cf. A. Brooker Klugh, Amer. Phot. 1925, **19**, 42.

18. Zeits. wiss. Phot. 1923, **21**, 85; Phot. Ind. 1923, 165. Cf. J. H. Pledge, Brit. J. Phot. 1923, **70**, Col. Phot. Supp. **17**, 48; abst. Brit. J. Almanac, 1925, 318.

19. Camera, (Luzerne), 1923, **1**, 233; Photo-Börse, 1923, **5**, 127. Cf. R. Jacobsohn, ibid. 106. J. Blochmann, Phot. Rund. 1915, **53**, 74; 1916, **54**, 57, 61. A. Cobenzl, Phot. Korr. 1916, **53**, 323. J. Rheden, Camera, (Luzerne), 1924, **2**, 253; Photofreund, 1924, **4**, 283; Phot. Rund. 1925, **62**, 18. P. Thieme, Phot. Rund. 1916, **53**, 67. E. Valenta, Phot. Korr. 1916, **53**, 193; D.R.P. 224,456; 278,043. M. Perle, Bull. Soc. franç. Phot. 1923, **65**, 138, showed comparative exposures on Autochrome and Agfa plates, and the latter showed a predominance of green and in certain cases the great thickness of the insulating varnish over the screen elements caused parallax with oblique light, which falsified the colors; Brit. J. Phot. 1923, **70**, Col. Phot. Supp. **17**, 37. W. Tiem, Phot. Rund. 1924, **61**, 226; Amer. Phot. 1925, **19**, 520. H. Beck, Brit. J. Phot. 1924, **71**, Col. Phot. Supp. **18**, 22. R. von Arx, ibid. **18**, 30. Andresen Junr. Phot. Korr. 1924, **60**, 8. P. Vehl, Photofreund, 1925, **5**, 4; Brit. J. Phot. 1925, **72**, Col. Phot. Supp. **19**, 8, 11. E. Marriage, Amat. Phot. 1925, **59**, 267,293, puts the transparency of the commercial screen-plates as Autochrome 4, Agfa 7, Dioptichrome 12 and Paget 15.

20. Brit. J. Phot. 1913, **60**, Col. Phot. Supp. **7**, 32. Cf. R. Renger-Patzsch, Phot. Rund. 1913, **50**, 363; Phot. Chron. 1913, **20**, 613. A. Streissler, Phot. Welt. 1913, **27**, 67.

21. C. L. Finlay, Brit. J. Phot. 1912, **59**, Col. Phot. Supp. **6**, 42, 49; ibid. 1913, **60**, ibid. **7**, 15; Phot. J. 1913, **53**, 143; Jahrbuch, 1914, **28**, 230, 233. Cf. A. E. Morton, Brit. J. Phot. 1913, **60**, Col. Phot. Supp. **7**, 45. H. D'Arcy Power, ibid. 1914, **8**, 17. H. S. Young, ibid. 41. H. M. Burton, ibid. 1915, **9**, 9. F. W. Painter, ibid. 1916, **10**, 9. A. G. Eldridge, ibid. **10**, 12, 32. Expert, ibid. 1919, **12**, 12. R. M. Fanstone, ibid. 24, 44, 45; ibid. 1922, **15**, 5, 24; 1923, **16**, 28; 1924, **18**, 4, 20, 32; Camera Craft, 1919, **26**, 403. Anon. Brit. J. Phot. 1919, **66**, Col. Phot. Supp. **12**, 14. H. S. Rendall, ibid. 44. Anon. 1920, **13**, 15. R. W. Newens, ibid. 1921, **68**, 709, 724. Paget Prize Plate Co. ibid. 724. S. W. Rose, ibid. 361. W. H. Spiller, Photo-Era, 1915, **34**, 60, 113. W. Morris, Amer. Amat. Phot. 1917, **31**, 55. G. H. Rodman, Phot. J. 1916, **56**, 256; 1920, **60**, 200; Anon. Amat. Phot. 1920, **49**, 173. L. T. W., Work, 1920, **58**, 290. H. S. Watkins, Phot. J. 1921, **61**, 277; Brit. J. Phot. 1921, **68**, Col. Phot. Supp. **14**, 20. F. G. Tutton, ibid. 1923, **16**, 3.

22. Wien. Mitt. 1914, 21. Cf. G. S. Whitfield, Phot. J. 1913, **53**, 142; Brit. J. Phot. 1912, **59**, 366; 1920, ibid. Col. Phot. Supp. **13**, 15; Photo-Rev. 1914, **26**, 88. A. Carrara, Brit. J. Phot. 1923, **70**, Col. Phot. Supp. **17**, 41; abst. Brit. J. Almanac, 1925, 317. E. König, Phot. Rund. 1913, **50**, 277. J. W. Barker, Camera Craft, 1914, **21**, 408A. Breton, La Nature, 1914, **42**, 148. H. Calmels, Bull. Soc. franç.

Phot. 1914, **21**, 186. P. H., Phot. Rund. 1914, **50**, 124. F. J. Hargreaves, Camera Craft, 1914, **21**, 140. H. D'Arcy Power, ibid. 107, 193. P. Thieme, Phot. Rund. 1914, **51**, 65.
General notes on Autochromes will be found as follows: Brit. J. Phot.: F. M. Duncan, 1907, **54**, 834; 1908, **55**, Col. Phot. Supp. **2**, 1; 1909, **56**, ibid. **3**, 25. G. Courtellemont, 1908, **55**, ibid. **2**, 46. H. Edgson, ibid. **2**, 48. C. F. Emery, ibid. 48. Anon. ibid. 1907, **54**, 746; 1910, **57**, ibid. **4**, 87. E. J. Wall, ibid. **1**, 57; **2**, 55; 1914, **61**, ibid. **8**, 42, 4. T. K. Grant, 1908, **55**, 895. J. Husnik, 1908, **55**, ibid. **2**, 20. E. F. Law, 1908, **55**, ibid. **2**, 54. F. Monpillard, 1910, **57**, ibid. **4**, 10, 22; 1911, **59**, ibid. **5**, 11. W. Weissermel, 1910, **57**, ibid. **4**, 9. F. Leiber, 1911. **58**, ibid. **5**, 57. R. Namias, ibid. 38. J. McIntosh, 1908, **55**, ibid. **2**, 65. E. J. Steichen, 1908, **55**, 300. J. Szczepanik, ibid. **2**, 80. J. J. Ward, ibid. **8**. G. Mareschal, 1909, **57**, ibid. **3**, 88. G. Mueller, 1909, **56**, ibid. **3**, 40. Anon. ibid. **27**; 1910, ibid. **4**, 73; 1920, **67**, ibid. **15**, 28; 1921, ibid. **14**, 8, 24; 1907, **54**, ibid. **1**, 13; 1910, **57**, ibid. **4**, 70; 1914, **61**, ibid. **8**, 8, 38; 1923, **70**, ibid. **16**, 40, 44. Lumière N. A. Co. 1909, **56**, ibid. **3**, 26. V. Crèmier, 1911, **58**, ibid. **5**, 9. Comte de Dalmas, 1910, **57**, ibid. **4**, 32. F. D. Maisch, ibid 13. E. Mayer, ibid. 43. G. Winter, 1911, **58**, ibid. **5**, 13. L. Cust, 1912, **59**, ibid. **6**, 1, 5. G. S. G. ibid. 55. Coonor, 1913, **60**, ibid. **7**, 3. J. M. C. Grove, ibid. **4**. A. E. Morton, ibid. 25; 1914, **61**, ibid. **8**, 30, 47. F. Tobler, 1914, **61**, ibid. **8**, 16. W. Dearden, ibid. 32. H. F. Perkins, ibid. 31, 33; 1915, **62**, ibid. **11**, 22. V. Weidman, 1914, **61**, ibid. **8**, 27. A. Black, 1915, **62**, ibid. **9**, 36. F. Penrose, 1915, **62**, ibid. **11**, 27. S. H. Carr, ibid. 8, A. W. H. Weston, ibid. 21. N. Deisch, 1918, **65**, ibid. **12**, 30. T. W. Kilmer, ibid. 25. A. C. Austin, ibid. 13. W. Rounds, ibid. 22. B. Rundle, ibid. 41. M. Hervé, 1921, **68**, ibid. **14**, 16. J. B. Rimmer, 1920, **67**, ibid. **13**, 39. R. M. Fanstone, ibid. 7, 24, 29, 41; 1922, **68**, ibid. **15**, 28, 43; 1923, **69**, ibid. **16**, 12, 20; 1921. **68**, ibid. **14**, 17, 31. H. S. Watkins, 1921, **68**, ibid. **14**, 20. J. Lacroix, 1922, **69**, ibid. **15**, 48. H. Bourée, 1909, **56**, ibid. **3**, 22. C. N. Bennett, 1910. **57**, ibid. **4**, 66. R. Child Bayley, 1909, **56**, 89. H. E. Corke, 1910, **56**, 959. F. J. Lobley, 1912, **59**, ibid. **6**, 16. H. M. Burton, 1914, **61**, ibid. **8**, 37.
Phot. J.: F. M. Duncan, 1908, **48**, 172. H. T. Malby et al. 1909, **49**, 136. H. E. Corke, 1910, **50**, 4; 1912, **52**, 338. J. McIntosh, ibid. 320. F. Penrose, 1915, **55**, 215. H. S. Watkins, 1921, **61**, 277.
Bull. Soc. franç. Phot.: E. Wallon, 1907, **54**, 336; 1908, **55**, 381. G. Mareschal, 1909, **56**, 410. F. Monpillard, ibid. 404, 419; 1910, **57**, 239; 1925, **66**, 245. A. Personnaz, 1908; 1912, **59**, 58; Comte de Dalmas, 1910, **57**, 102. M. Hervé, 1920, **62**, 34. W. Scheffer, 1910, **52**, 70. A. Ninck, Bull. Soc. franç. Phot. 1924, **66**, 259; abst. Amer. Phot. 1925, **19**, 56, 167.
Photo-Gaz.: G. Martigny, 1907, **17**, 165. G. S. 1910, **20**, 177. V. Crèmier, 1910, **20**, 21; 1911, **21**, 11. E. Wallon, 1907, **17**, 221; 1908, **19**, 23. G. Mareschal, 1907, **17**, 121; 1909, **19**, 213. A. Personnaz, 1911, **21**, 107. L. Busy, 1912, **22**, 177. E. Coustet, 1908, **18**, 72.
Photo-Rev.: A. Personnaz, 1908, **20**, 148. H. Bourée, 1909, **21**, 9, 18, 55, 63, 71, 79. E. Trutat, 1907, **19**, 58, 66, 74, 89.
Phot. Chron.: Anon. 1907, **14**, 423. C. Wolf-Czapek, ibid. 447. E. Stenger, ibid. 499, 527, 543, 605; 1908, **15**, 9, 37, 137, 247, 259, 283, 360, 395, 432, 446, 569, 593, 617; 1909, **16**, 97, 104, 132, 182, 191, 207, 317. 325, 433, 469, 481, 577; 1910, **17**, 9, 259, 283, 331, 367, 515, 527; 1911, **18**, 25, 35, 46, 206, 264, 307, 315, 331. Florence, 1912, **19**, 165.
Phot. Korr.: C. Wolf-Czapek, 1907, **44**, 461. R. Krügener, ibid. 337. Anon. ibid. 434. J. Husnik, 1908, **45**, 49. E. Valenta, ibid. 24; 1909, **46**, 234. A. Cobenzl, 1913, **50**, 242.
Phot. Mitt.: W. Weissermel, 1910, **47**, 5. A. Seyewetz, 1909, **46**, 295, 309. P. Thieme, ibid. 81. V. Weidmann, 1914, **51**, 204. H. Hinterberger. 1908, **45**, 52.
Phot. Rund.; P. Thieme, 1920, **30**, 169. A. Berger, 1913, **50**, 357. F. Tobler. ibid. 297. E. Wychgram, ibid. 229. W. Weissermel, 1912, **49**, 58.
Jahrbuch: A. Guebhard, 1908, **22**, 164. K. Worel, ibid. 49. E. Valenta, ibid. 143. J. Husnik, ibid. 127. A. Saal, ibid. 1910, **24**, 212. A. Von Palocsay, ibid. 177; 1911, **25**, 194; 1912, **26**, 250. A. Albert, ibid. 1911, **25**, 103. E. Lederer, ibid. 680. Von Hübl, ibid. 267, 275.
Camera Craft: R. Child Bayley, 1908, **15**, 177. E. Gray, ibid. 132. H. D'Arcy Power, ibid. 20, 31, 229. F. M. Steadman, 1907, **14**, 395. A. E. Morton, 1913, **20**, 535. S. H. Carr, 1915, **22**, 204. N. Deisch, 1918, **25**, 244. M. Hervé, 1921, **28**, 202.
Amer. Annual Phot.: M. Toch, 1910, **24**, 245. H. O. Klein, ibid. 130. H. C.

Knowles, ibid. 38. H. D. Miller, 1909, **23**, 77. W. I. Starr, 1912, **26**, 228. D. J. Sheehan, 1914, **29**, 284. M. C. Rypinski, ibid. 116. A. E. Biermann, 1916, **30**, 170. W. Morris, 1917, **31**, 55. C. J. Belden, 1918, **32**, 88.

Bull. Phot.: C. H. Claudy, 1908, **3**, 105, 125, 145. R. Locquin, ibid. 259. G. A. Rockwood, ibid. 300. J. Bartlett, 1912, **11**, 373. Anon. ibid. 686.

Photo-Era: J. A. Burnham, 1910, **24**, 197. W. Downes, 1908, **20**, 41. M. Toch, 1909, **23**, 20. F. D. Maisch, ibid. 262; 1910, **24**, 8. A. H. Lewis, 1912, **28**, 10. R. Namias, 1914, **32**, 280. H. F. Perkins, ibid. 17. W. H. Spiller, 1915, **34**, 113. S. H. Carr, ibid. 216. T. W. Kilmer, 1917, **39**, 294. P. M. Riley, 1907, **19**, 307.

R. Krügener, Phot. Welt. 1907, **21**, 113, 131. E. Schwarzer, ibid. 1913, **27**, 161. Anon. Outlook, 1907, **87**, 238; Amat. Phot. 1920, **49**, 173; Phot. Mitt. 1909, **46**, 122. L. Brown, Trans. Roy. Soc. Arts, 1908, **18**, 154. J. Carpentier, Mem. Soc. Ing. Civ. 1908, **61**, 962. E. J. Wall. Phot. News, 1907, **52**, 63, 451; J. N. Laurvik, Internat. Studio, 1908, **34**, 21. E. F. Law, J. Iron and Steel Inst. 1908, **76**, 151. F. Dillaye, Les Nouveautés Phot. 1910, 109. M. Toch, Amer. Phot. 1909, **3**, 274. W. A. Schultess-Young, ibid. 1915, **9**, 668. J. B. Rimmer, 1920, **14**, 516. E. Stenger, Zeits. wiss. Phot. 1907, **5**, 372. B. McCord, Camera, 1914, **18**, 679. E. Baum, Phot. Kunst. 1915, **14**, 89. N. Deisch, Phot. J. Amer. 1917, **54**, 467. G. de Vies, Amat. Phot. 1920, **49**, 236. W. D. Wilcox, Amer. Alpine Club, 1920. E. Wychgram, Zeits. wiss. Micro. 1911, **28**, 174. O. Lederer, Wien. Mitt. 1911. Roulacroix, C. R. Soc. Biol. 1911, **69**, 659. E. Coustet, Rev. Sci. 1911, **49**, 239. H. S. Ward, Photographic Annual, 1909, 30. E. J. Wall, 1910, ibid. 9. A. Cobenzl, Phot. Kunst. 1912, **11**, 284. E. Roux-Parassac, La Photo pour Tous. 1925, **2**, 259, 279, 314, 351. C. Adrien, Rev. Franç. Phot. 1925, **6**, 137. F. Monpillard, Phot. Moderne, 1925, **3**, 35. H. O. Klein, New Phot. 1925, **2**, 152, 270.

CHAPTER XXIII

CINEMATOGRAPHY IN COLORS.
ADDITIVE PROCESSES

The basis of all cinematographic projection is persistence of vision. A picture formed on the retina persists for a brief period of time, and if a succeeding series of pictures is similarly formed with but small intervals of time between the formation of each picture, the result will be a composite, in which fundamental phases of movement are no longer visible or distinguishable.

This applies equally to color. If red is projected, and immediately afterwards green, and before the red has had time to fade from the retina, the green is virtually superimposed, the resultant color in the brain will be yellow. Nor are we conscious that the latter color is actually composed of red and green. Should blue-violet be added in the same way, the result is white. Obviously this process is an additive one, for we start with a black screen and add light to light.

The only disadvantage of this method is that after some time we become conscious of an irritation, which takes the form with some people of an intense frontal headache and eyestrain. From the practical point of view, it is clear that as there must be approximately the same number of pictures projected as in black and white, the consumption of film is threefold, in order to show the same total amount of subject. Further than that, as a rule a special form of projector is required and this obviously limits the use of this process.

Attempts have been made to produce each projected picture complete in itself in colors on the screen, and while this method produces less eyestrain, the apparatus necessary for projection is more complicated, and consequently more costly. There is the further disadvantage of having to keep the pictures in register all the time, which entails the watching of the screen by a competent operator, which again increases the cost beyond commercial limits.

Were it possible to obtain each picture in colors on the film itself, one would have the same amount of film used as in black and white, the eyestrain, or color bombardment, as it is called, would be eliminated. Numerous processes have been attempted or patented to this end, mostly by means of a two-color method.

We may, therefore, divide the subject into two main divisions: the additive and subtractive. The former is again divisible into projection by persistence of vision, and simultaneous projection. The former being defined as that in which each picture is projected in a single color. The

latter in which each picture is formed complete in colors on the screen. The subject has, therefore, been divided into these classes for treatment.

The Additive Method With Persistence of Vision.—The first suggestion for this process may justly be ascribed to Chas. Cros,[1] (p. 611) for he said: "Le phénakistoscope, remis en vogue dernièrement sous le nom *zoetrope,* me dispense de longues explications sur le synthèse successive. Les images élémentaires sont substituées rapidement les unes aux autres sous les regards et les impressions produites sur la rétine se confondent. On obtient ainsi la combinasion des trois couleurs pour tous les points de l'image résultante. Ce procédé s'applique aux projections sur ècran, aux positifs transparents, et aux positives à vue directe. Les instruments sont plus simples que le phénakistoscope, car il n'y a que trois figures élémentaires, au lieu de vingt ou trente. De pareils instruments sont très-faciles à imaginer et réaliser. J'en donnerai les dispositifs si on me les demande. Il est à peine besoin de dire que le principe de cette synthèse successive est experimentalement démontré par le disque tournant à secteurs colorés."

Anglicized: the phenakistoscope, revived lately under the name of the zoetrope, excuses me from long explanations on successive synthesis. The elementary images are rapidly substituted the one for the other in the eyes and the impressions produced on the retina recombine. This method is applicable for projection on a screen from transparent positives or from positives viewed direct. The instruments are more simple than the phenakistoscope, for there are only three elementary images, instead of twenty or thirty. Similar instruments are very easy to imagine and to realize. I will give the arrangements if anyone wants them. It is scarcely necessary to say that the principle of this successive synthesis is experimentally proved by the revolving disk of colored sectors.

Although Cros had not in mind in all probability motion pictures, yet the principle of persistence of vision in colors is clearly stated. This method has practically fallen into disuse, therefore, the notes thereon have been curtailed as far as possible.

The first patent that has been found was granted to H. Isensee[2] and he placed in front of the lens, both in taking and projection, a rotary shutter with three 120 degrees sectors in the usual colors. W. Friese-Greene[3] appears to have had some confused notion of a similar process, for he proposed to use a lens composed of three colored sectors, or a rotary color shutter or a ribbon shutter. The images were received on one plate, and it was claimed that a transparency from the negative thus obtained, showed colors when projected in the same way. The supposed results were, of course, an optical impossibility; but the patent is interesting because of the suggested shutters. B. S. Philbrook[4] had a somewhat similar idea, adopting, however, Cros' idea of the zoetrope. W. N. L. Davidson[5] would use a shutter with opaque sectors between the color

sectors, and proposed to equalize exposures by variable speed of the shutter or darkening the green and blue sectors.

H. L. Huet and A. Daubresse[6] employed a series of lenses mounted on a drum at axial distances equal to the interaxial separation of the successive pictures. There was also a film-carrying drum with a series of reflectors. This arrangement of lenses, and Wenham prisms were used, antedates some later patents. M. C. Hopkins[7] proposed an improvement on this by using two oppositely moving drums with reflectors and color filters.

C. M. Higgins[8] would use a series of fourteen lenses mounted on a sprocket chain, each lens being fitted with a colored diaphragm at the rear. The interesting point about this patent is that the inventor used a central aperture to admit white light: "the central apertures are of such size that the unobstructed light passing through the rest of the diaphragm will produce the desired actinic effect upon the sensitive surface of the film. The colored light alone is not sufficiently active chemically to produce the effect with sufficient speed for kinetographic work, and consequently the central aperture is provided to give the additional light necessary." This idea of adding white light was first suggested by J. W. Gifford (see p. 61), and has been used for cinematography by Raleigh and others. B. A. Brigden[9] also used the idea of multiple lenses.

J. Berthon and J. Gambs[10] used revolving sectors and[11] would also use mirrors, glasses or prisms interposed between the lens and film. The projecting filters were differentiated in color from the taking filters. Berthon, Gambs & Theurier[12] would project a successively taken positive simultaneously with two of the images through concentric shutters. H. Joly[13] when dealing with the positives for projection would do away with rotary shutters and color each positive itself, a device patented by many others. W. N. L. Davidson[14] proposed to use an endless band of celluloid, bearing the filters, thus doing away with the sector shutter. W. Friese-Greene[15] also proposed to use the endless band, in this case with three colors, whereas Davidson used two only. W. F. Vaughan[16] used an opaque band with the rotary color shutter.

O. Pfenninger[17] would do away with the opaque sectors and arrange the shutter in front of the film so that the color sectors overlapped one another at a particular period of their revolution, thus making a temporary safe-light when the film was moved. H. W. H. Palmer[18] proposed to use the sector shutter for the negative, but stain up the positive like Joly. E. Maurich[19] arranged the sector shutter for projection so that the colors followed one another in the order blue, yellow and red, with a longer dark break between the colors as a whole than between the individual colors, claiming better fusion. Viscount Tiverton and E. A. Merckel[20] proposed to use the dark interval both in taking and projection to obtain and show a second picture by another camera or projector. In taking this was said to give great increase in speed.

L. C. Van Riper[21] on the assumption that the red sensation lasts longer than the others, would project in the order red, green, red, blue for tricolor pictures and red, red, green for two-color. J. S. Higham[22] utilized the same idea. J. Campbell[23] patented the affixing of the appropriate color filter to each positive, or the color might be sprayed on or imbibed.[24] In conjunction with Thompson[25] stencils were to be used to protect one picture; or a quick-drying liquid,[26] such as collodion might be used. The same inventors[27] would apply colored celluloid or gelatin in the same way. A. J. Waggett[28] also used colored strips of celluloid. This idea was followed by C. J. Coleman.[29] Campbell & Thompson[30] suggested the application of colored gelatin or celluloid to panchromatic negative stock, and stripping after development, the exposure being through the base. L. Herzberg[31] patented the local coloring of the positive, also F. Royston.[32] W. B. Featherstone[33] would make the celluloid colored in the first instance and then coat with emulsion. J. Shaw and J. W. Berwick[34] proposed to use a resist of rubber to protect alternate pictures, or a continuous cloth with openings. L. F. Douglass[35] would also locally apply the colors or tone each image.

Campbell & Thompson[36] patented a shutter with a blue sector of 36 degrees with red and green sectors of 72 degrees. In a later patent[37] the angles were made variable. The same thing was patented by E. Zollinger and S. Mischonsiky.[38] F. W. Hochstetter[39] would provide a frame for the filters with reciprocating motion. In a modification[40] the filters were arranged on a swinging arm, and a box-like arrangement[41] was used. In another form[42] a drum with radial tubes. Another form[43] was a disk with spaced rectangular areas concentrically disposed, each carrying a plurality of color divisions. J. Shaw[44] would do away with color bombardment by alternating the colors, thus red, green, red, yellow, red, blue for taking the negatives; but the positives were projected through red and green only. Later[45] the colors were altered.

P. Richy[46] proposed what he called a three-color system in which two vertically juxtaposed lenses were used with violet and green sector shutters. Positives were printed in orange and black for one film and in black and orange for the other film and these two films were projected through the taking filters, and the result was said to be all colors. Boudreaux & Semat[47] would make a negative on panchromatic film, and color the positive by hand, then make negatives through filters from this and project positives through the same filters. A. Miethe[48] used a colored sector shutter and projected in the same way. He contended that the trouble of flicker would be overcome by using a triple-width film. Zoechrome and T. P. Middleton[49] patented a film that could be used for color or black and white. Exposures were made at the rate of 32 per second with a red, green and blue sector shutter alternating with yellow or white ones. The inventors seem to have had some peculiar notions, as the alternation of

the black and white with the color pictures was said to reduce fringing, and this was further reduced by throwing the color pictures slightly out of focus while printing. Various methods were suggested for printing.

The Silent Drama Syndicate[50] would use standard size film but reduce the pictures to half the usual width and take them alternately staggered, so that the center of one picture was level with the dividing line of two pictures of the next row. H. Dony[51] proposed to obtain the negatives in the usual way, then color the images in accordance with the filters or use a sector shutter and three or four images might be used in blue, yellow, red and yellow. The same inventor[52] would use a rotary shutter with red, yellow, green and yellow sectors, claiming better exposures. The same shutter could be used for projection.

H. May[53] proposed to take the negatives with equal color sectors, but project with sectors variable so as to agree with the sensibility of the eye to colors. C. Friese-Greene[54] described his process of two-color cinematography by the persistence method. A color sector filter was rotated behind the camera shutter, and the former had a white light aperture, thus utilizing the ideas of Raleigh, Kelley and others. Ordinary positives were produced and the colors applied to each positive, thus copying Joly, Campbell and others. A. Hnatek[55] used the persistence method with two objectives and projected each image twice, like Lee & Turner. R. B. Barcala[56] patented the usual tri-color sectors for taking and projecting. Pathé[57] patented a projector with the usual sectors and an additional shutter behind the gate. H. Blanc[58] proposed the normal sector for taking and projecting through red, yellow and blue, or the whole seven spectral colors might be used. The Lesjakplattenpackfabrik[59] patented color sectors before the gate.

Additive Simultaneous Projection.—F. M. Lee and E. R. Turner[60] although not claiming simultaneous projection, yet in their specification stated that "the positives of the various color sensations may be exhibited singly in rapid succession, or two or more of them may be superposed." And in projecting there was some sort of simultaneous superposition, which must, however, never have been actually sharp. Because the three negatives were taken in succession and not simultaneously, therefore, in any movement there must have been different phases recorded in successive pictures, so that actual superposition could not have been obtained. The familiar color sector shutter was used with opaque sectors in between. In projection although the same colors were used in the sectors, they were placed in different order in the three divisions. Three projecting objectives were used vertically superposed and three pictures simultaneously shown, each component being shown first through the top lens, then by the middle and lastly by the bottom lens. The shutter had colored concentric sectors, with narrow, opaque, radial sectors between each triad of filters. In the first triad the order of the colors from the periphery to the center

was red, blue-violet, green; in the second green, red and blue-violet and in the third blue-violet, green and red, therefore, it is clear that each constituent record passed behind each lens accompanied with its own filter.

B. Jumeaux and W. N. L. Davidson[61] proposed to use prisms in front of a single lens, in which case they were separated with their bases towards one another, or with three lenses, in which case the prisms were placed in front of the outer lenses; in the former case the separation of the prisms allowed the red rays to have direct access to the film. Davidson[62] pro-

FIG. 158. Davidson's E.P. 7,179, 1904.

FIG. 159. Pfenninger's E.P. 332, 1905.

posed an arrangement of mirrors, mainly for projection, though it was said that under favorable conditions the same might be used for the negatives. Fig. 158 requires little explanation, except that of *4*, and it was said that: "this arrangement gives color records from almost the same point of view unless very near objects are photographed." The same inventor[63] would use two prisms point to point behind the lens, thus avoiding the formation of double pictures. O. Pfenninger[64] would use non-achromatic

or achromatic prisms between the combinations of the lens, as shown in Fig. 159; the middle diagram showing the arrangement for two-color and the lower for three-color work; the planes of the images is shown by *h.* W. Friese-Greene[65] proposed to place a prism covering half the lens at the back, as shown in Fig. 160, in which the rays are coming from the left to the lens *c; d* being the prism, *e* a yellow-orange filter and *f* a blue-red one and *g* the focal plane of the lens. The picture taken direct would be sharp, but the other one would lie in a different plane and would be less sharp than with other prism forms, because of the greater dispersive power of the prism.

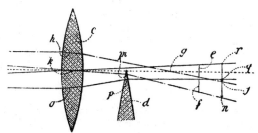

FIG. 160. Friese-Greene's E.P. 9,465, 1905.

FIG. 161. Jumeaux's E.P. 3,766, 1906.

R. Berthon and J. Gambs[66] proposed an arrangement of the sectors like Lee & Turner, with three vertically disposed lenses. B. Jumeaux[67] proposed to use two modified Wenham prisms, as shown in Fig. 161, in front of two side lenses *b* and *b,*[2] and these were adjustable so as to register on the screen. The filters were behind the lenses at *c,*[1] *d* and *c,*[2] the film passing at *f.* The disadvantage of this was that the angles between the two side lenses, and the optical paths of the rays were not equal, the images thus not being of the same size.

O. Pfenninger[68] utilized a mirror box in front of the lens (see p. 169). In a later patent[69] "prismoids" were used, which were modified Wenham prisms, with three vertically superposed lenses cut down as to

their diameters, as shown in Fig. 162. This system might be used for two or three-color and the prisms placed in front of or behind the lenses. R. Bjerregard and the Continental Films Co.[70] proposed to use mirrors or prisms to obtain the three images side by side, as shown in Fig. 163, and this system could be used for projection as well, when a concave lens was placed between the main condenser and the prism or lenses. Later[71]

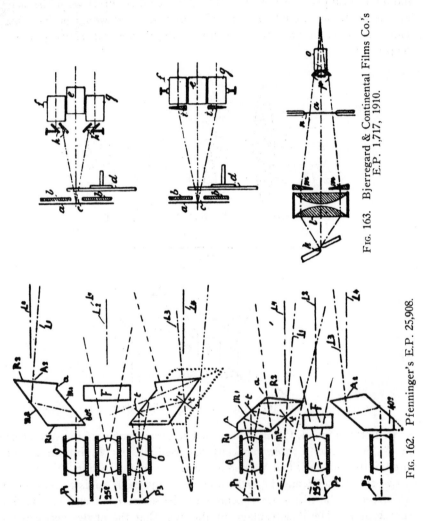

FIG. 163. Bjerregard & Continental Films Co.'s E.P. 1,717, 1910.

FIG. 162. Pfenninger's E.P. 25,908.

apochromatic prisms are claimed between the lenses and the screen and the use of a non-transparent black frame for each picture on the film, to obviate any color fringes on the screen. Zeiss[72] also patented a method of simultaneous projection in which each picture was surrounded by a black mask, photographically produced.

The Natural Color Moving Picture Co.[73] patented three lenses side by side; the side ones being fitted with adjustable total reflecting prisms, so that the reflected rays might be directed into line with the optical axis. The central lens might be placed at a slightly greater distance from the film than the side ones, thus equalizing the optical paths. T. D. Kelly[74] would use three projectors, the side ones being angled.

P. Ulysee[75] proposed to obtain on normal width film multiple images of small size and the scheme was further elaborated,[76] as shown in Fig. 164, in which *l* shows the normal film and *2* to *10* the modifications proposed; while *12* to *14* show the projection system and *15* to *19* the particular arrangement of the lenses. Later[77] a multiple lens or film was moved and four small images obtained on a standard area, the images being formed in space and projected by a single lens. A plurality of light-sources[78] such as a multi-carbon arc, or a single arc with multi-focal condensers consisting of decentered dioptric rings was used in conjunction with rotating color sectors. A modification[79] of this was one light-source with triple condensers with mirrors and prisms, or prisms only or parabolic reflectors with and without condensers. Continuous projection[80] was also patented.

O. Pfenninger and W. Agate[81] patented a two or three lens camera, with sawn-off lenses, with a bi-prism in front of the lenses; a rotary shutter with excentrically cut opaque sector in front. Filters might be inserted in the path of the beams and might be achromatic. F. E. Ives[82] also proposed to take two pictures in one picture space, either side by side or over one another, or to turn the pictures through an angle of 90 degrees, or turn each image through 90 degrees in opposite directions. Various prism systems are described for this purpose. Two colors were to be used, red and green, and the apparatus might be used for taking and projecting with simultaneous addition. R. M. Craig[83] used some very complicated prismatic devices and looping of the film, so that some pictures were taken on the front and some on the back.

L. Mauclaire, A. Garbarini and G. Gautier[84] proposed to take four negatives through filters and occupy the space of two normal pictures. Two of the colors were to be 120 degrees apart on the chromatic circle, while the third one, that should occupy the third 120 degree point, was split into two colors, which were complementaries to the first pair. Two superposed lenses were used with annular sector shutters, and the same system was used for projection. P. Ulysee[85] would use two groups of three lenses, one with fixed focus for distant objects and another with variable focus for near ones. A projector was disclosed with arrangement for showing both black and white and colored pictures.

J. Szczepanik[86] patented a complicated camera and projector for continuously moving film, which passed round a drum. W. Späth[87] would do away with filters altogether for projection by utilizing either two Nicol

prisms, or a Duboscq calcite prism and a Nicol, or two polarizing bundles of glass, with a double-refracting plate between. C. Zeiss[88] patented two projection machines coupled together with synchronously moving film, and the light was reflected from a moving octagonal drum with mirror and a collective system. A. Köhler[89] patented a projection system, in which two apertures were placed close to the condenser, in front of which was placed a collective system of lenses, composed of one large and two small ones; the image of the light-source being projected into the entrance pupil

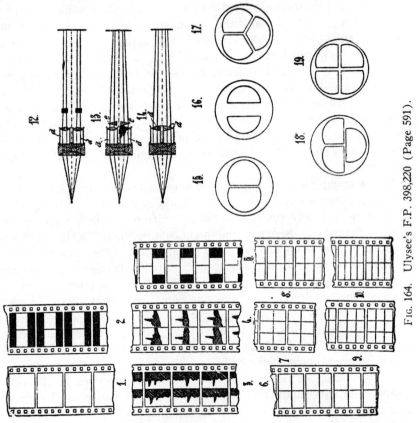

Fig. 164. Ulysee's F.P. 398,220 (Page 591).

of the small lenses. F. Bollmann[90] patented the use of three superposed projectors with rotary shutters.

W. Thorner[91] would use the filters on the lenses, mirrors or prisms in a projector with continuously moving film. B. A. Johnson[92] patented three lenses mounted side by side on the arc of a circle, so that their axes converged to a common focus. Filters were placed in front of or behind the lenses and changed synchronously with the film. The pictures were taken alternately right and left, for instance red and green, then green and

red. A. P. Plahn[93] used the old idea of Wenham prisms for the side pictures and a glass block to equalize the path of the central ray. F. Lenhold-Wyld[94] would obtain stereo color effects by simultaneous projection of two images on to a spherical mirror. It being claimed that the aberrations and distortions introduced by the mirror produced stereoscopic effects.

Boudreaux and Semat[95] projected films taken simultaneously or successively through filters, while a luminous beam of the complementary color was thrown on the screen. They also[96] treated positives so that the silver image became reflective, and transmitted and reflected light was used. They also[97] would take a negative on a panchromatic film and color the positive by hand and make the record negatives from this. Castel and Mazo[98] used a single light-source with triple condensers and lenses. Chaupe[99] patented tri-color pictures taken successively and projected through filters. Stefanik[100] used a reflecting telescope to form a parallel beam on three filters and three lenses; the size of the latter being adjusted to the chemical action of the rays. J. Sacré[101] used a series of six mirrors or prisms, inclined at angles to one another and placed in front of three lenses, superposed for taking and projecting.

P. Mortier[102] used simultaneous monochromes with centers on an oblique line, not contiguous, obtained with three lenses and dioptric blocks in front to obtain identical images. Projection was effected through a common condenser with trapezoidal facets and prisms of weak deviation. Later[103] the image was resolved into four monochromatic images, the effective rays recording each image passing through filters before reaching the film. The filters were arranged in pairs, the individual colors of each being complementary and equidistant on the chromatic circle. By this method four impressions, forming a tetrachromatic set, could be obtained on one film, either side by side or in vertical alinement, with or without stereoscopic relief. Gebay[104] used a single lens and three standard films, one arranged at right angles to the optic axis, the other two at each side parallel to the axis. Two rotary mirrors at right angles to one another, but at an angle of 45° to the optic axis projected the images in succession to the side films and allowed it to pass to the central film. The same arrangement could be used for projection with three arc lamps.

E. Sommavilla[105] patented a process in which yellow, green and blue filters were used to obtain the negatives. The yellow filter passed red and green, and the red record was made by printing through the yellow record positive and the green record negative. Additive projection was used. G. Casieri[106] would use two reflectors, the front one being transparent. The images being thus obtained from the same standpoint and through a complementary sector shutter. B. D. Underhill[107] would use a two-lens system, mounted side by side with prisms for throwing the images at an angle, so that the lenses were close together. A revolvable disk carried auxiliary lenses, which might be used to alter the focus of the principal

lens. L. Mauclaire and A. Breon[108] used the ordinary width film, but the color records were split into two series, though occupying the same picture space as the ordinary film. The red record occupied half one picture space and the blue-green the other half, while in the succeeding space the green occupied one-half and the violet-red the other.

L. Gaumont[109] patented two coupled projectors for showing black and white and color pictures, one common motor driving the two. Later[110] an operator was placed close to the screen and manipulated an electric drum, connected with the lenses to ensure accurate superposition. A solenoid[111] was also used. Later[112] a band of paper was perforated during the first run, thus serving to automatically adjust registration in subsequent shows. L. Mauclaire[113] would use vertically or horizontally juxtaposed lenses, the pictures being half the usual size. Projection was to be effected through an annular sector shutter, two of the elementary colors being used, while the third was split into two; the color sectors might be graded. T. A. Mills[114] also patented the taking of the negative through lenses of different foci, so that one large negative corresponded with two or three small ones, as in the Ulysee and Mauclaire patents. O. Fielitz[115] proposed to take blue and red pictures and blue and green simultaneously and project to form one image.

J. Shaw[116] patented a method in which the negative was taken through red, yellow, red, blue, red, green filters and printed two positives of each color record in sequence, in which the blue and green pairs were dyed green and the red pairs red. It was claimed that color fringing and color bombardment were much reduced. Later[117] the same sequence of filters was to be used for the negative and all the red records were to be printed on one side of double-coated stock, but doubled images for each picture, that is two positives from each of the same negative. S. Maximowitsch[118] proposed to reduce the too frequent rosy tinge of additive projection pictures by reducing the color depth of the filters to one-half, so that they formed white on the screen. T. A. Killman[10] used two truncated prisms with their apices in contact, placed in front between the gate and lens. A rotary annular sector shutter being used between the condensers and gates. M. Héraut[120] also used simultaneous projection, but the result was not very satisfactory, there being some fringing.

The Chromo-Filmgesellschaft[121] proposed to project two vertically juxtaposed pictures by means of mirrors or Wenham prisms placed behind the lenses, the two pictures being at a double-depth gate. Cinechrome Instruments, Ltd.,[122] patented projectors for simultaneous projection. A. Wilson[123] would obtain stereo effects in color by passing one film past two gates and taking negative pairs through red and green sector shutters. They were to be shown in the same way. F. B. Prinsen[124] arranged three lenses in trefoil pattern and projected with a similar arrangement. The images might be reflected by a 45° mirror, at right angles to the first, and

taken up by a second set of lenses. Or an aerial image might be formed and taken up by a second set of lenses.

A. Sauvé[125] patented a complicated projection system for still additive methods in which four reflectors and four lenses were used. B. Weinberg[126] patented twin positives synchronously projected by complementary lights and viewing through similar spectacles, which system was said to be useful for color work. H. A. Rogers[127] patented a form of mutoscope that could be used for viewing either black and white or natural color films. J. Henley[128] patented a stereoscopic system with occulting shutter, said to be applicable to color work. H. Shorrocks[129] used a shutter with masking strips, which might also comprise color screens, that could be turned into operative position, while the shutter was in motion, and when desired to change from black and white to color.

H. R. Evans[130] patented the staining of positives so that the colors were not in accord with the color sensations, but in any desired manner so as to obtain pleasing results. L. Horst[131] patented a three-apertured gate for showing three pictures simultaneously. F. W. Kent[132] patented the use of two shutters with sectors that could be regulated as to size and which were run at different speeds so as to give different exposures for different colors. C. Zeiss[133] patented a continuously moving film with a cube of glass interposed between the film and a ring of moving lenses. The light being split up into a spectrum, T. P. Middleton[134] used a projector in which two side by side lenses were used with one light source, the two beams being obtained from mirrors or split condensers. The K. & S. Syndicate[135] patented a color sector shutter for projectors.

Two-Color Processes.—Elsewhere have been recorded the facts as to the use of two-color processes for still work, and these methods have been applied to color cinematography It may seem somewhat curious to attempt to restrict the colors to only two, but as a matter of fact, the addition of the blue-violet records in ordinary color projection has mostly the effect of brightening up the colors and forming actual white, the true violets and deep blues. In all two-color processes, with normal filters at least, there are no true whites formed; but white is but a relative term, and the pale yellowish whites formed by the usual red and green filters appear white to the normal eye by contrast against the other colors.

Assuming that red and green are the colors used, the main difficulty is in the rendering of the violets and blues, if the filters are too deep in color, that is with restricted spectral transmission. On the other hand, if the transmission band of the green filter be widened too much all the colors will be paled by the addition of white.[136]

Another trouble with these processes is the preponderance of one of the constituent hues in the shadows, which is chiefly due to the emulsion, which gives a different characteristic curve for the red and green filters; the former having, as a rule, a much longer period of under exposure than

the green, therefore, giving a little more detail in the positive green.[137] The question as to the best filters for two-color work is dealt with under subtractive processes.

G. A. Smith[138] patented a two-color process with rotary shutters of red and green sectors, with opaque sectors between, relying on the persistence of vision. This was known as Kinemacolor and had for a short time quite a rage. But like most of the persistence methods the eye-strain was very marked. Actually the first two-color process was exhibited by B. Jumeaux and W. N. L. Davidson[139] in Paris in 1904, and at the Photographic Convention at Southampton, England, in 1906.

C. N. Bennett[140] proposed to use two vertically superposed lenses with rotary shutters, and although the inventor admitted the occurrence of parallax, he claimed an improvement because there would be precisely the same movement in the two successive pictures. J. Campbell and T. Thompson[141] used a rotary shutter in which opaque sectors of 90° each, and transparent filters ranging from green to violet-blue of 60° aperture, and from yellow to red of 120°. The particular virtue in grading the filters is not apparent, and precisely the same effect would be obtained if the whole of the sector were made of that color, which is the sum of the graded one. This matter is referred to later. The same inventors[142] would use separate cameras or projectors and angle them horizontally. Later[143] a shutter with variable sectors was patented. Still later[144] the transmissions of the filters were exactly defined, thus the blue included from 4200 to 5200, and the orange from 5400 to the red end, and these were separated by opaque sectors respectively of 90° and 135°. The positives were to be projected through screens of from 4000 to 5500 for the blue, and from 5800 to the red for the orange.

J. Campbell[145] patented the use of two vertically superposed lenses and annular sector shutters, with the red the outer annulus in one and the green the outer in the other, so that the red was exposed through the two lenses, and as the outer annulus was longer more exposure was given. Another variation by the same inventor[146] was to use a plurality of films with several lenses with annular shutters for each color. Projection was to be effected in the same way. Later[147] rotary shutters were used.

W. B. Featherstone[148] would use this principle of double exposure for each picture through two lenses and annular shutters. P. Ulysee[149] proposed to give four partial exposures to the same film area, at slightly different times. The same inventor[150] to save film, would cut down the size of the pictures, thus crowding two into the area of one normal. C. Raleigh[151] patented the marking of the negative film with a readily distinguishable mark, such as one perforation in each picture space, with a circular hole, so as to be able to differentiate the color record. C. Urban[152] and T. Royston[153] patented the same idea.

W. F. Fox, W. H. Hickey and Kinemacolor of America[154] patented a

two-color process in which a red sector was used, the other being white, so that one had the whole of the blue, violet and ultra-violet impressed. Projection was to be effected in the same way and it was stated that the colorless pictures appeared green, due to the fatigue of the eye!

H. R. Evans[155] patented a printer in which the light was automatically varied for the two colors. T. H. Blair[156] used a projector in which rotary shutters could be moved out of the axis to show black and white pictures. H. W. Joy[157] split the blue-green sector into two by an opaque sector, claiming better fusion of the colors. M. J. Wohl and R. Mayer[158] would use four colors for the negatives, but only two for projection. Red, orange-yellow, blue-green and blue-violet being the taking colors and for projection a combination of the first two and last two being used. In a later patent[159] four colors were claimed for projection. L. F. Douglass[160] would alter the angles of the sectors for those subjects, which had a predominance of green, and also for distance.

C. Raleigh and W. V. D. Kelley[161] had a somewhat confused color theory, according to which, each picture was to be recorded by two colors, that is to say for instance, by red and blue, and by green and red. The same method was to be used for projection and the inventors stated that purple and yellow light gave red, as the former cancelled the latter. In the same way blue-green and yellow gave green, because the blue cancelled the yellow. As a matter of fact mere tints would thus be formed, as a large amount of white light would be the result in each case. The same inventors[162] patented shutters that admitted white light, and claimed that this intensified the colors and leveled them up. Obviously the same result would be obtained by using very pale filters, the sum of the white light and the colors.

G. Remy[163] proposed a system in which the negatives were taken through red, peacock-blue, orange and blue-violet and in this order, while the positives were to be projected through red and blue-violet; these colors being said to be complementary. C. J. Coleman[164] patented a film with transverse stripes more sensitive for red than green. Various non-commercial methods were disclosed for making this film. E. H. Lysle[165] patented a combined camera and projector also applicable to color, with continuously moving film and an endless chain of twenty-two mirrors. V. L. Duhem[166] patented two spaced lenses and filters with gearing so that the pictures were taken in succession but with ten picture spaces between pairs.

L. A. Pineschi and S. V. Santon[167] also used a two-color method. R. Bjerregard and Continental Films Co.[168] used two or more lenses with prisms in the camera so that the negatives were taken simultaneously. The positives were also projected simultaneously, the central beam being lengthened by a negative lens, and prisms being used for the side pictures. F. W. Donisthorpe[169] patented a device for effecting optical rotation

through an angle of 90° of a pair of images, placed side by side with the horizontal lines of the objects parallel to the length of the film. In projection the images were also thus turned. A single erecting prism or a combination of three right-angled prisms or mirrors might be used. F. Weinstock[170] used two lenses side by side at stereoscopic separation, with mirrors and prisms to reflect the images simultaneously one above the other. Semat[171] would take stereo negatives side by side on single-width film, using filters for taking and projection.

F. Leiber[172] patented a system which was designed to obviate the defect of Kinemacolor in giving yellowish whites, and the procedure was apparently doubled with the shutters giving a tendency to blue in the resultant pictures. Four filters were used in pairs. The Continental Films Co. and R. Bjerregard[173] used a sector shutter with inserted white sector. C. Raleigh[174] used a rotating shutter with overlapping sectors. C. Schlochauer and E. Albert[175] patented a film in which one or more colored pictures were followed by one or more black and white ones.

W. B. Wescott[176] patented a camera with two gates spaced two picture areas apart, with automatic pressure frames and parallel guides for the film during exposure. A projector on the same lines[177] and for use with positives obtained from the negatives was also patented, and a printing machine was also[178] devised. J. Hunt[179] patented a projector for two-color films in which two gates spaced apart were used. A. Alessandri[180] proposed to obtain two images side by side in one normal picture area by horizontally juxtaposed lenses. A red filter was used for the one lens and blue and green filters for the other, and these were changed during the exposure. The two images were projected simultaneously after reflection in a system of prisms. N. H. Losey[181] used two stereoscopic films with red and green pictures side by side, the observers being provided with similar spectacles. The Ica Gesellschaft[182] patented a rotary shutter, which could be revolved on the shaft.

J. W. Berwick[183] proposed to use a rotating shutter with three or four apertures, two of which were filled with selective filters and the others merely fitted with iris diaphragms, which could be closed down. This was used in the camera, and the non-filter apertures gave a black and white picture, which was said to enhance the shadows. Either the additive or subtractive process might be used for the positives. L. Brown[184] would make pictures of the usual size but in staggered formation, so that the dividing line of one series came opposite the center of the others, the film being moved zig-zag fashion, thus all the series of one color would fall on one side of the film and the other color on the other.

Bi-Packs and Tri-Packs.—M. F. de Colombier[185] appears to have been the first to suggest the application of this system to cinematography, and like so many French patents it is a little indefinite in phraseology. Three films were employed representing the same view and perfectly

superposable. The positives were wholly colored, each having one of the fundamental colors or the complementaries, generally three, blue, red and yellow. The combination of the tints, more or less neutralized by the blacks and whites of the film, would give animated projections possessing their true colors. The three pictures were exactly superposed, either by apparatus having synchronous movement and automatic focusing, and superposed or separate projectors were used. And it was stated that it was possible to employ superposable films without preliminary coloring; it being sufficient to provide each projector with a different filter, yellow, blue and red. Another arrangement consisted in making reels of three or more films rolled up together, the impression of the image would then be simultaneous, the small thickness of the film base and its opacity being without action. It would be sufficient to color the films separately and place them in their first order so as to have a single trichromatic film; in this case an ordinary projector might be used. From this it is clear that the inventor had the idea of using a tri-pack for exposure; also he would use the additive as well as the subtractive processes.

G. Battistini[186] suggested two methods, the one shown in the upper diagram of Fig. 165, in which three films, *4, 5* and *6* were rolled up on a spool *3* and passed to spool *2*. Translucent or transparent emulsion might be used for the film nearest the lens in order to facilitate the transmission of the light. But the inventor stated that he had found this condition was not indispensable. For the selection of the colors, filters might be dispensed with by sensitizing each film for a given color, for instance, the front film for violet, the second for green and the third for orange. The arrangement of the films might be with the red-sensitive one in the middle. For two-colors, red and blue should be chosen, and in this case the front film was to be stained orange to act as a filter for the rear one. If a filter was required for the front film, it could be arranged near the lens. If two films were to be used it was preferable to arrange them emulsion to emulsion, they would thus be in the same focal plane. Positives from each negative were to be stained with the complementary color of the filter, and the three positives might be placed one behind the other in an ordinary projector, and in this case gelatin should be against gelatin. The above is taken from the amended specification, but in the original, the arrangement, shown in the lower diagram is given, and is thus described: in the case of three superposed films the celluloid constitutes a thickness sufficient to prevent accurate exposure of all three sensitive surfaces at the same time, and it is preferable to form two bands, one constituted by the superposition of two films, and the other by the third film, and to expose these two bands simultaneously in two machines as shown in *2*, where *7* and *8* represent two cameras of ordinary type, mounted on a base *13*, and operated simultaneously synchronously by a crank and the rod *10*, and universal joints *11, 11*. In one machine the band is made up of two

superposed films, the third being in the other machine, and a transparent mirror 9 arranged in front of the two machines so as to deflect some of the rays and thus form two identical images.

A somewhat similar arrangement was proposed by W. Buchanan-Taylor and others[187] and the camera contained a semi-transparent mirror to transmit and reflect the light to one film and also to the other two in contact. Suitable gearing at right angles synchronously actuated the films. The single film might be exposed through a red filter, and the other two through a blue filter, and a thin film of yellow gelatin might be interposed between them to make the green filter, or the yellow tint of the two films might be sufficient.

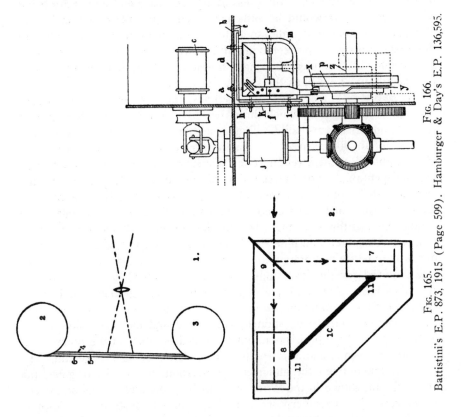

Fig. 166. Hamburger & Day's E.P. 136,595.

Fig. 165. Battistini's E.P. 873, 1915 (Page 599).

F. E. Ives[188] patented a bi-pack, using red and green positive colors. The front film was to be specially translucent and sensitized for green by an extremely dilute solution of erythrosin and ammonia. The rear film might be body-dyed, or a superficial red filter placed on the front film face; a yellow filter might be used over the lens. The films were to be kept in contact at the moment of exposure by pressure of a resilient pad against a block of glass. The inventor stated that he believed that the

front specially translucent film was new, but it will be seen that it was suggested by his anticipators above. The positives might be stained up in various ways. The inventor also stated that he considered that the use of the two films wound on one reel face to face to be novel, and that it was an important feature of his system, whereas this was previously employed by Buchanan-Taylor and Battistini. He claimed: "producing local intimate contact of the sensitized surfaces of the two strips by a resilient squeezing pressure at the rear thereof against a rigid transparent plate located behind the lens." But the resilient pressure dates back to 1856, for in Thornthwaite's "Guide to Photography," published by S. D. Humphrey, New York, 1856, page 20, it says: "but the double back (Fig. 27) is employed exclusively for sensitive paper; it consists of two frames hinged together at the bottom, and each having a mounted glass plate (g), inside and a moveable shutter outside. By this arrangement two pieces of prepared paper can be retained in a frame of no larger size than the ordinary single back, fitting the same size groove at the back of the camera. When used the glass plates should be nicely cleaned, and one piece of paper laid face downwards, upon one of the plates of glass; a piece of bibulous paper, the size of the sensitive paper, is then laid upon it, and the other sheet of sensitive paper placed, face upwards, upon the bibulous paper; that portion of the frame and glass which is not occupied by the papers is now turned upon them, and secured in its position by two or more fastenings at the sides. By this arrangement the papers are pressed perfectly flat against the two inner surfaces of the glass plates, etc." R. Krügener[189] had used a front plate of glass to keep films flat during exposure, in 1892. Le Prince also, in 1888,[190] also Marey.[191] Friese-Greene[192] stated: "to keep the film fast and steady whilst opposite the aperture it is passed between cushions or glass plates *15,* the back one of which is mounted on a spring arm."

A. Hamburger and W. E. L. Day[193] also patented a semi-dialyte method, and a plan view of the suggested camera is shown in Fig. 166, in which *c* and *j* are the driving sprockets for the films. Two films, sensitive respectively to blue and green, were to be arranged face to face to pass over *c* and the aperture plate *de,* and they received the image reflected from a refraction-reflection element or glass, interposed on the optical axis *fg.* The other film, which was to be red-sensitive, passed over the sprocket *j* past the aperture *k* in the gate *l,* in front of which was the red filter. The other details are merely for the operating mechanism. The patent is for the film-feeding mechanism, and no details are given as to the positives.

A. Gleichmar[194] patented a light-splitting mirror with the use of three films. The transmitted light affected the red-sensitive element, and the reflected light traversed a green filter and acted on the green and blue-sensitive films at the same exposure field. J. de Frenes[195] assumed that

the film was faster to green than red and proposed to cut down the exposure for the former and increase it for the latter, by giving a longer pause to the film in the latter area. F. Pramor[196] proposed to use three thin films rolled up on one spool, which were passed behind three slits, placed one above the other, containing the filters; each film being rolled up on a separate spool, as soon as it had passed a slit.

R. O. Humphrey and C. H. Friese-Greene[197] patented a method of obtaining negatives for two-color additive projection, in which a two-aperture shutter was used. One aperture being so arranged that white light with blue-green was passed and the other passing from yellow to red. The colors might be graded and it was claimed that there was less color fringing, and fuller exposure obtained. Obviously the reasoning here is weak and the admission of white light and the grading of the colors had been patented by Wohl & Mayer, Raleigh & Kelley.

W. Friese-Greene and Color Photography, Ltd.[198] would make negatives on a single sensitive surface by alternate exposures to white light and through a filter. This idea had already been patented by W. Friese-Greene,[199] who also patented[200] the idea of interposing a black section or picture space at intervals in the recurrent color pictures, for relieving eye-strain.

Screen-Plate Processes.—Were it possible to carry out this process practically, it would undoubtedly be the ideal, for each individual picture would be the carrier of its own appropriate colors, complete in every detail. The film could be run through any projector and one would have, possibly, nothing but the straight processes of black and white work, assuming that manufacturers could produce commercially the necessary negative and positive film stock. But there are one or two grave hindrances to its general adoption. In the first place, if we assume that the negative is to be obtained in the complementary colors, we shall have to print on to positive screen-film, and the difficulties have been pointed out in the section dealing with screen-plates generally. But there is the initial difficulty as to whether the negative film could be made sufficiently rapid for ordinary work. True, if we did not want to reverse the negative, this might be accomplished, and one can assume that the exposure would be no longer through the screen elements than through the normal filters. The practical application of extremely fine elements to long lengths of celluloid, however, is no mean task.

If we consider the size of the units, we must argue back from the enlarged screen-image, and in some theaters this is 20 ft. across, but if we accept a 15 ft. screen as the mean, we shall find that our screen elements must be quite small. As the actual projected picture is approximately 1 inch, the magnification becomes 180 times. W. Scheffer has shown (see p. 461), that the resolving power of the eye is of such an

order that it will see lines separate, if their period (twice their separating distance for lines of equal width to the spaces) is one-thousandth of their distance from the eye. Thus the screen unit must not be more than 2.54 mm. on the projection screen, and if the magnification is as stated above, we find that the actual size of the unit must be 0.015 mm.

Some inventors have been rash enough to put on paper at least, what they consider possible methods of using the screen-plate process. L. Vidal[201] suggested the use of the Joly screen for Edison's Kinetoscope. F. W. May and E. Judson[202] would utilize a transfer process, and paper was coated with dichromated gelatin, exposed to light and then after washing and calendering, the gelatin was rubbed over with wax in benzol and a second coat of plain gelatin and sugar applied, which was termed the "transfer." The colored elements might be applied in the form of lines or dots in a resist, and the dyes might be mordanted by ferric chloride. F. W. May[203] patented the production of a screen-plate or film, in which a resist of gelatin in lines was applied to a gelatin-coated support. The film was to be hardened and the color applied in the free spaces, then the surface treated with formaldehyde, ferric chloride or aluminum acetate. The resist was washed off and the process repeated for the other colors.

H. A. Dorten[204] would make his negative by the screen-plate process, make a positive from the same, project the picture and make three constituent negatives with successive pictures, or by separating each color record, then the positives could be made as usual and projected with a rotary shutter. In a later patent[205] the same inventor would make a color positive film by a screen process and then enlarge this about five diameters, copy through the usual filters on to three films three times the normal width, each picture being exposed by itself. Then from the negative thus obtained positives could be made as usual.

H. Workman[206] proposed to apply the screen elements to the positive film made from a screen negative, by mechanical means. Fig. 167 represents one of the various patterns that might be employed: *1* shows the arrangement of the camera with the lens *a*, *b* the film was fed in the usual way, and *c* is the gate, *d* the sectional color screen, "disposed therein so as to be in contact or nearly so with the front of the film." The positive was to be made from the negative thus obtained, and it is clear from the wording that the negative was merely a black and white one with the image broken up into the screen pattern. To the positive the color elements were now to be applied by mechanical impression, dyeing or a combination of both. It may as well be pointed out that in "nearly so" contact with a screen-plate is useless, as there can be no possible accurate pattern thus obtained. The negative taking screen is shown in *2, R, G, B* standing for the colors red, green and blue. The three printing surfaces are shown in *3, 4* and *5*. H. Tress[207] patented an aperture plate with

guides to keep a film in contact with a screen-plate fixed in the gate of the camera.

R. G. Bradshaw and J. C. Lyell[208] proposed to color both sides of the celluloid, then scrape away the colored surfaces so as to leave juxtaposed but not superposed points, lines or other areas. Green and red might be used, or green, red and violet and the substance of the celluloid itself might be colored. Then the lines or figures might be obtained by the aid of planes, scrapers or revolving circular cutters. As an alternative the

FIG. 167. Workman's E.P. 9,610, 1913 (Page 603).

base, after being colored or not, might be manufactured with raised figures, the raised parts being planed or scraped off to produce the same effect. Fig. 168 shows one form of the invention, *1* and *2* are perspective views of the film in section, showing a two-color film, *3* shows a three-color film; *a* is the film ready for scraping, and *b* one color and *c* the other. In *3* the stripes of red overlap the green *c* at the dotted lines *x* and *y* forming violet. It is presumably unnecessary to point out that this would form an additive film.

W. V. D. Kelley[209] patented a process, which, it was claimed, gave better and more uniform definition and which was applicable to two-, three- or more-color systems. Approximately half the area of the film subject was recorded without color filters, by the interposition between the film and lens of a black and white screen. The clear and opaque areas being approximately equal. The remainder of the exposure might be made through the usual filters over the entire area of the picture or only on the previously unexposed parts. It was claimed that this impression would be, for instance, of the red in the subject, and the color records

FIG. 168. Bradshaw & Lyell's E.P. 6,894, 1913.

would be fully recorded in the unexposed areas, and also there would be a further impression of color on the already exposed parts. There is a weak point in this argument, for if we assume that the primary exposure gave a latent density of 2, and this was further impressed by red light, sufficient to produce a latent density of 0.5, then the final density would be at this point 2.5, so that the positive would have less density there and the color would be diluted with white. One method of making the exposures was to use three shutters on the camera; the regular cut-off one, covering the change of film, and change of screen-film; a second shutter

carrying the line screen and a third the filter. The line screen frame would come into position at the film change and move intermittently, while the filter frame, in a two-color scheme, would move one-half revolution for each picture and might move continuously. In projection the ordinary shutter was used. Fig. 169 *1* represents a perspective view of one form of shutter, filter and screen arrangement; *A* is a rotary frame carrying the cut-off shutter *B;* *C* is a rotary filter frame carrying the filters *D* and *E* and the former was provided with a clear space *F* for each filter. The spaces *G* between the sections *D* and *E* and the clear section *F* constitute shutters, which permit the line screen to be shifted out of the optical path. The screen is represented in *2* by a slide *H* worked by *I; J, K* is the film which runs over the usual spools *L, L; M* is the lens. To reduce the action of the violet rays the clear portions might be colored yellow. In *3* the lines are circular to avoid blurring. In *4, 5, 6* other modifications are shown. Screens with 200 to 400 lines to the inch were suggested, but others might be used.

The same inventor[210] also proposed a screen unit process for double-coated film, which was exposed on both sides through a screen, but the lines exposed on the one side registered with the unexposed on the other, as shown greatly enlarged in *1*, Fig. 170. And *2* is a similar view, *9* being the celluloid and the small figures the exposed parts. The object is shown diagrammatically in *5*, consisting of two white sectors *W, W,* a red sector *R* and a green sector *G.* In *4* section *C,* the sectors are additively obtained in white by alternating bands of pure red-orange, *5* in *2*, and pure green-blue *8* in *2*. The section *R* in *C* consists of the print on the back of the green-blue negative colored red, modified by the green colored lines *8* on the front, which still additively gives the red print, even although the green lines overlap the red print, narrow bands of black occur. The green sector *G* was likewise reproduced by narrow bands of green alternating with black.

J. E. Thornton[211] after summarizing some of the known motion picture color systems, proposed to make a screen negative and claimed that it was possible to expose at the rate of sixteen pictures a second. Any pattern elements could be used, and from this negative the individual records were to be prepared. The patterns being obliterated as was done in Dorten's patent and screen-plate work generally. This was to be done by using black and white screens, like Brasseur and others, or by angling the light as in the Powrie, Smith and other methods.

F. Habere[212] would get over the graininess by enlarging the horizontal elements. S. Kolowrat and A. Nekut[213] pointed out that the grain of existing screen-plates was too coarse for cine work and proposed to centrifugally separate silver iodide from an emulsion, stain up in the three colors and re-emulsify in gelatin. The dyes were to be fixed with tannin and the silver salt dissolved. As it would not be possible to coat these grains

Fig. 170. Kelley's U.S.P. 1,337,775.

Fig. 169. Kelley's U.S.P. 1,322,794.

in a single layer, they were to be stained yellow, blue-green and crimson, so that by superposition the subtractive colors would be formed; although all screen-plates are of the additive class. The Deutsche Rastergesellschaft[214] proposed to obtain stereoscopic effects by using two-color screens and providing the spectators with suitable spectacles. The method of

making the screen was with a greasy resist, and the process was said to be applicable to cinematography.

J. T. Smith[215] considered the usual methods of making the patterns were all defective and proposed a compound one, in which a colloid resist was used to prevent the etching action of certain etching-coloring solutions on celluloid, which was to be the support. Stained fish-glue was applied in pattern to the base, then insolublized by dichromating and light or formaldehyde. The etching solution was preferably anilin with dyes dissolved in it. The process seems to have been a two-color one and after varnishing the emulsion was to be coated direct on the screen. A black and white monochrome picture was to be alternated with the colored ones. The same inventor[216] would also prepare the surface of celluloid by treatment with abrading powder, or liquid with solvent action, and apply the dye in solution of solvents of celluloid.

The Compagnie Générale Phonographes et Cinématographes[217] proposed to take a negative on a panchromatic film and color each picture on its positive and photograph the same through a tri-color screen. From the composite negative thus obtained, a positive was made and projected through a reduced line screen. W. G. Finnigan and R. A. Rodgers[218] proposed to expose a film in contact with a piece of ground glass. From the negative a film covered with minute particles in any pattern, coated with positive emulsion was used, and the result was said to be in natural colors!

I. Kitsee[219] proposed to make a template with transparent spaces equal to the opaque, and from this to make a master key of longitudinal lines the full width of the emulsion-coated base, by exposing to an arc lamp and then developing. From this a print was made on dichromated gelatin, containing a dye. The exposed parts would be hardened, whilst the unexposed would swell in water and the dye be discharged. The lines would also be raised up and the second color was to be applied by a roller. Later Kitsee[220] proposed to apply the elements by means of rollers or a spray, using Canada balsam, dissolved in alcohol and stained up, then to dye the interspaces with another color. The inventor lays stress on his discovery that an aqueous solution of a second dye will not stain up a resinous resist, and claims the use of one color miscible only in alcohol and the other only in water. Later[221] a template was to be made by reducing down by photographing squared paper, the alternate lines of the squares being filled up with ink. Apparently this was also a dichromated gelatin process. Another modification[222] was a resinous resist and the celluloid itself dyed up. While a modification of the formation of the elements was patented.[223]

R. Wellesley and T. M. Saunders[224] patented a method of transferring a color screen to a positive picture from a temporary celluloid support. The positive was to be passed through an adhesive-applying ap-

paratus, then pressed on the screen-film by rollers. The combined film was then passed over an illuminated inspection plate, on which the relative positions of the positive film and screen were adjusted by hand. The film was then treated with warm water plus acetic acid, so that the temporary support might be stripped off. B. Bock[225] proposed a screen-

Fig. 172.
Kelley & Dunning's U.S.P. 1,431,309
(Page 610).

Fig. 171.
O'Grady's U.S.P. 1,402,371 (Page 610).

film in which the elements of only two colors should occur in each picture, and these colors should change in successive pictures, so that in three succeeding pictures each color should occur twice.

F. T. O'Grady[226] would apply the filters to the surface of panchro negative stock in lines longitudinally of the base in the usual triad, of

from 1/1000 to 1/2000ths of an inch, and stagger the lines, as shown in Fig. 171, in which *R, G, B* represent the colors. The filter lines were to be removed by washing; the result being merely a linear negative in black and white, from which a positive was made as usual. This positive was then ruled with the necessary lines and it was claimed that marked sterescopic effect as well as colors was obtained. L. Herzberg[227] proposed to use colored threads pressed into celluloid. The Aktiengesellschaft f. Anilinfabrikation[228] patented the coating of celluloid with the elements by passing it through a liquid and forcing the elements into the latter and allowing them to deposit on the film.

W. V. D. Kelley and C. H. Dunning[229] proposed to use a line or regular screen for two, three or four colors. A symmetrical pattern screen, *7* in Fig. 172 was to be used, two colors only being here shown. The picture was taken through this screen, while above the picture-taking lens was arranged another one *3* fitted with a right-angled mirror or prism *4* above the base of which was placed a diffusing surface, such as ground glass; a filter *6* also being used. The negative film was pulled down two picture spaces at a time and the screen pattern impressed in alternate sequence with the pictures. It is stated that where the color-values were recorded correctly in the negative, regardless of the subdivisions of the spectrum used, that it was possible to reproduce them satisfactorily with but two projection colors. The positive film was preferably double-coated and the picture areas were all printed in successive areas on one side of the film, and the design or pattern on the other. And assuming that the filter *6* be greenish-blue, it is obvious that the red lines of the pattern will be clear in the negative and dense in the positive, and can then be dyed or toned red, while the alternate lines, which are dense in the negative and clear in the positive will be stained green. Thus would be formed an additive screen-film, capable of projection in any machine.

J. W. Flender[230] patented an extraordinary idea in which a negative was taken in the usual manner, and a positive made therefrom by exposing in contact with a black and white matrix screen and projecting this positive on to a screen, bearing a mosaic pattern. It was said that: "the resulting pictures will have depth and color tone, and will accurately show, either in black and white or in colors, the color values of the original settings." C. Dupuis[231] proposed to obtain either still or cinematographic pictures by a screen-plate, either on one or several plates or films, and then to print on to polished silver that had been superficially coated with silver subchloride, formed by electrolysis, as suggested by Becquerel for the Seebeck process. It was stated that the picture could be projected 175 times without alteration of the colors.

W. V. D. Kelley[232] would imprint the sensitive surface with lines by the action of light and then to issue the same so that the user might print his picture on the same mordant the lines after development, with suitable

colors. This was also claimed for double-coated film. F. T. O'Grady[233] would apply the filters to the emulsion as in his previous patent. In a subsequent patent[234] the negative was taken through a two-color rotating sector shutter and the positives printed through a line screen, all the one color records being printed first and the other record printed in accurate juxtaposition.

C. J. Coleman[235] would overcome the difficulty of ruling very fine lines by placing in front of the camera lens at a distance equal to about one-twentieth or more of the distance between the lens and the subject, a line screen. It was stated that by thus placing the screen "the resistance to and choking or decreasing of the volume of light passing through the lens is decreased very materially." The same arrangement was to be practically used in projection. L. Dufay[236] would dye one side of the celluloid blue and print resist lines thereon. An alcoholic red dye was then applied, which destroyed the blue exposed spaces. The resist was removed and a yellow dye applied which produced green and orange. A fresh series of resist lines were then printed at an angle to the first and a blue-violet dye applied, which destroyed the yellow in the unprotected parts. A four-color screen was thus produced.

L. F. Douglass[237] proposed to copy a series of black dots or figures on a positive film and dye-tone them red. Then sensitize the clear gelatin with a ferric salt, expose and develope with ferricyanide, forming a blue ground. The whole film was then stained yellow, so that the red became an orange-red and blue a blue-green. M. C. Hopkins[238] would obtain the constituent negatives in the ordinary way, make therefrom positives with linear screen of monochrome colors, thus following the patents of Bradshaw & Lyell and Kelley, that is with the color lines displaced as regards one another. S. Schapovaloff[239] patented a process applicable to a screen-film or one with superposed images, in which successive coatings were sensitized, and which might contain a white diffusive material.

The Aktiengesellschaft f. Anilinfabrikation[240] proposed to reproduce on a mosaic screen through the taking filters, three record positives, or the image additively projected in colors might be printed by the same method.

1. Les Mondes, Feb. 25, 1869. Subsequently published as a separate pamphlet, entitled: "Solution générale du Problème de la Photographie des Couleurs,' Paris, 1869.

2. D.R.P. 98,799, 1897; Silbermann, 2, 343; Brit. J. Phot. 1916, 63, Col. Phot. Supp. 9, 19; Jahrbuch, 1900, 14, 561; Phot. Rund. 1899, 13, 29.
C. F. Jenkins, Brit. J. Phot. 1900, 47, Supp. 4, also suggested color cinematography with red, yellow and blue filters. T. C. Porter, E.P. 12,921, 1897 patented alternate projection of the pictures with occulting shutter for the observers, for stereoscopy; the process might be used for color work.

3. E.P. 21,649, 1898; abst. Brit. J. Phot. 1899, 46, 729; 1907, 54, Col. Phot. Supp. 1, 47; Photogram, 1900, 7, 109.
For a lantern on similar lines see E.P. 13,883, 1900.

4. E.P. 10,611, 1907; Brit. J. Phot. 1908, 55, 598, 607; F.P. 377,374; Can.P. 108,152; Belg.P. 199,772; Phot. Coul. 1908, 3, 216.
R. Krayn, E.P. 10,000, 1900, void; Brit. J. Phot. 1900, 47, Supp. 96 also pro-

posed to mount the three positives with filters and pass them successively in front of an opening in a wheel. Cf. W. Bishop, Brit. J. Phot. 1892, **39**, 362.

5.ʼ E.P. 23,863, 1898; abst. Brit. J. Phot. 1900, **47**, Supp. 94; 1907, **54**, Col. Phot. Supp. **1**, 64; U.S.P. 676,532; D.R.P. 128,907; Silbermann, **2**, 343.

6. E.P. 7,035, 1900; abst. Brit. J. Phot. 1907, **54**, Col. Phot. Supp. **1**, 64.

7. U.S.P. 1,204,771; E.P. 16,201, 1913; F.P. 459,960.

8. U.S.P. 727,948, 1903.

9. U.S.P. 1,143,608; F.P. 472,002, 1914.

10. F.P. 364,369, 1906.

11. Addit. to above 6,193, 1906.

12. F.P. 375,110, 1907.

13. F.P. 381,494, 1906.

14. E.P. 453, 1908; Brit. J. Phot. 1909, **56**, 126. Patented also by H. R. Evans, F.P. 478,847, 1915, and R. Nuber, D.R.P. 338,182, 1920.

15. E.P. 11,791, 1908; Brit. J. Phot. 1909, **56**, 202; U.S.P. 937,367; Austr.P. 41,127; Phot. Ind. 1910, 561; Jahrbuch, 1911, **25**, 337.

16. E.P. 249, 1902.

17. E.P. 5,945, 1909; Brit. J. Phot. 1910, **57**, 407.

18. E.P. 9,912, 1909; Brit. J. Phot. 1910, **57**, 407.

19. D.R.P. 239,382, 1910; Phot. Ind. 1911, 1727; Jahrbuch, 1912, **26**, 241; F.P. 421,053; Austr.P. 53,257.

20. E.P. 24,161, 1912; Brit. J. Phot. 1914, **61**, 182. In E.P. 28,365, 1912, stereoscopic pictures were to be shown.

21. F.P. 456,344; Belg.P. 255,340; E.P. 8,063, 1913; Brit. J. Phot. 1914, **61**, 502; D.R.P. 281,362; U.S.P. 1,130,221.

In D.R.P. 285,558, 1913 the inventor proposed to equalize exposures by partly employing the color values of one picture in the next. In F.P. 456,343; E.P. 8,062, 1913 he used oscillating color reflectors for successive pictures.

22. E.P. 26,292, 1912; Brit. J. Phot. 1913, **60**, 730.

23. E.P. 21,261, 1911; Brit. J. Phot. 1912, **59**, 541; F.P. 448,488; U.S.P. 1,184,226; Jahrbuch, 1915, **29**, 158.

24. E.P. 2,704, 1914; Brit. J. Phot. 1915, **62**, 155.

25. E.P. 19,098, 1912.

26. E.P. 23,386, 1911; Brit. J. Phot. 1912, **59**, 202; abst. J. S. C. I. 1912, **31**, 258; U.S.P. 1,184,226; D.R.P. 270,551; Phot. Ind. 1914, 280; Jahrbuch, 1912, **26**, 240.

27. E.P. 23,499, 1911; abst. Brit. J. Phot. 1912, **59**, 885. In E.P. 7,477, 1912; Brit. J. Phot. 1913, **60**, 29 a machine was patented for applying the color film to the positives.

28. E.P. 23,221, 1911; abst. Brit. J. Phot. 1912, **59**, 835.

29. U.S.P. 1,293,040, 1919.

30. E.P. 23,499, 1911; Brit. J. Phot. 1912, **59**, 885.

31. E.P. 14,133, 1912; Brit. J. Phot. 1913, **60**, 558; D.G.M. 504,520.

32. F.P. 445,601, 1911.

33. U.S.P. 1,145,410, 1915. Cf. Pathé, F.P. 437,445, 1920.

34. U.S.P. 1,287,594, 1918; E.P. 131,478; Brit. J. Phot. 1920, **67**, 288; Col. Phot. Supp. **13**, 18; Jahrbuch, 1915, **29**, 159.

35. E.P. 117,864, 1918; Brit. J. Phot. 1919, **66**, 16; Col. Phot. Supp. **13**, 3; abst. J. S. C. I. 1918, **37**, 607a; U.S.P. 1,325,279; F.P. 487,306; Jahrbuch, 1915, **29**, 155.

36. E.P. 23,497, 1911; abst. Brit. J. Phot. 1912, **58**, 1000. Cf. W. H. Kunz, U.S.P. 1,175,961, 1916 for the same idea. Also A. Markus, D.G.M. 545,977.

37. E.P. 1,489, 1912; Brit. J. Phot. 1913, **60**, 500.

38. E.P. 26,976, 1912; Brit. J. Phot. 1913, **60**, 500; D.R.P. 274,710; U.S.P. 1,203,681.

39. U.S.P. 1,094,147; F.P. 471,082; E.P. 9,229, 1914. In U.S.P. 1,243,273 an endless linked chain carrying the filters is patented. Cf. A. G. Donnelly, U.S.P. 1,098,370.

40. U.S.P. 1,094,148; E.P. 9,230, 1914.

41. U.S.P. 1,115,538; E.P. 9,765, 1914; F.P. 471,290. Cf. Hochstetter and Pryce, U.S.P. 1,255,421.

42. U.S.P. 1,137,320; E.P. 9,764, 1914; Brit. J. Phot. 1915, **60**, 243; F.P. 471,289; 471,083 granted to P. M. Pierson and Hochstetter.

43. U.S.P. 1,301,265, 1919.

44. U.S.P. 1,289,940; E.P. 126,220, 1918; Brit. J. Phot. 1919, **66**, 386; Col. Phot. Supp. **12**, 26; F.P. 385,249; 513,802; abst. Sci. Tech. Ind. Phot. 1921, **1**, 53.

45. U.S.P. 1,300,887, 1919.

46. Photo-Rev. 1920, **32**, 11, 49.

I. Kitsee, U.S.P. 1,070,699 proposed to use incandescent lamps, with colored bulbs, and alternately light these.

47. F.P. 470,244, 1913. Cf. F.P. 467,609; 435,745.

C. A. Coppier, F.P. 527,145; addit. 24,045; 24,985, proposed to take objects in front of a black or white background, enlarge and paint the prints and then reduce down again to normal size.

48. Phot. Chron. 1904, **11**, 571.

49. E.P. 154,150, 1920; Brit. J. Phot. 1921, **68**, Col. Phot. Supp. **14**, 10; D.R.P. 352,649. Cf. T. H. Blair, U.S.P. 1,186,612, 1916.

50. F.P. 513,885, 1920.

51. F.P. 561,711; Sci. Ind. Phot. 1924, **4**, 83.

52. E.P. 202,271, 1922; Brit. J. Phot. 1924, **71**, 344.

53. F.P. 569,954, 1922; E.P. 200,292; abst. Sci. Ind. Phot. 1924, **4**, 153, 185. In D.R.P. 371,323, 1919 May patented an adjustable stand for the projector shutter.

54. Phot. J. 1924, **64**, 397.

C. Paraloni and G. Perron, F.P. 569,407; E.P. 219,957; abst. Sci. Ind. Phot. 1924, **4**, 184, patented the use of negatives of half the usual height, thus saving film. The positives were to be projected through a rotary sector shutter or with a two-color filter in the lens and prisms. Cf. Brit. J. Phot. 1921, **68**, Col. Phot. Supp. **15**, 4. L. Brown, U.S.P. 1,514,501, 1924, in this the images might be staggered.

55. Der Phot. 1923, **33**, 93.

56. E.P. 212,875; F.P. 571,003, 1923; abst. C. A. 1924, **18**, 2294; Sci. Ind. Phot. 1924, **4**, 198.

57. F.P. 537,445; E.P. 171,975.

58. F.P. 552,781.

59. D.R.P. 371,117; addit. to 328,192.

W. F. Fox, U.S.P. 1,166,120 also patented a projector for persistence of vision, which could be used for black and white. Cf. W. C. Vinten, E.P. 546, 1914.

For notes on Miethe's projector see: Brit. J. Phot. 1902, **49**, 281, 581; 1903, **50**, 102, 121, 828; Photo-Era, 1903, **10**, 138; Phot. Chron. 1903, **10**, 442, 445; 1904, **11**, 571; 1905, **12**, 9; Phot. Korr. 1904, **41**, 286; 1905, **42**, 21; Zeits. wiss. Phot. 1905, **3**, 40.

60. E.P. 6,202, 1899; abst. Brit. J. Phot. 1907, **54**, Col. Phot. Supp. **1**, 48; U.S.P. 645,477, 1900. Cf. C. Forch, "Der Kinematograph," 1913, 129. Hopwood and Foster, "Living Pictures," 1915, 262.

61. E.P. 3,729, 1903; Brit. J. Phot. 1907, **54**, Col. Phot. Supp. **1**, 88; F.P. 342,445.

62. E.P. 7,179, 1904; Brit. J. Phot. 1905, **52**, 254. No patent granted on this application. D.R.P. 162,049, 1903; Silbermann, **2**, 338.

63. E.P. 27,419, 1904.

64. E.P. 322, 1905; Brit. J. Phot. 1905, **52**, 1012.

65. E.P. 9,465, 1905; Brit. J. Phot. 1905, **52**, 213.

66. F.P. 369,092; addit. 7,480, 1907, this last deals with a positive from a successively taken negative projected through three lenses vertically juxtaposed, in conjunction with a rotating sector shutter, on to a positive from a negative taken without filters, this latter being run synchronously.

67. E.P. 3,766, 1906; Brit. J. Phot. 1907, **54**, 294; D.R.P. 198,196; Phot. Chron. 1908, **15**, 590; Jahrbuch, 1909, **23**, 235; U.S.P. 944,787. The same device was suggested in Brit. J. Phot. 1909, **56**, Col. Phot. Supp. **3**, 72; Jahrbuch, 1910, **24**, 340.

68. E.P. 25,908, 1906; Brit. J. Phot. 1907, **54**, 582.

69. E.P. 15,726, 1907; Brit. J. Phot. 1908, **55**, 590. In E.P. 2,538, 1913; Brit. J. Phot. 1914, **60**, 32; Jahrbuch, 1914, **28**, 521, three lenses vertically juxtaposed were used. Cf. F. Fissi, Penrose's Annual, 1912, **18**, 235.

70. E.P. 1,717, 1910; Brit. J. Phot. 1911, **58**, 145; F.P. 411,557; addit. 13,521; D.R.P. 231,526; 242,101. The concave lens is claimed in the additional F.P. and in E.P. 25,869, 1910; Brit. J. Phot. 1911, **58**, 920; D.R.P. 237,423; 234,775; Phot. Ind. 1911, **28**, 2122; Jahrbuch, 1911, **25**, 326; 1912, **26**, 242.

71. U.S.P. 1,130,702, 1915.

72. D.R.P. 276,870, 1913.

Cf. G. Griffith, U.S.P. 1,513,984, 1924; abst. Amer. Phot. 1925, **19**, 520.

73. E.P. 18,340, 1909; Brit. J. Phot. 1910, **57**, 518; U.S.P. 973,961; 963,962 granted to W. E. Oliver; Motography, 1911, **5**, 20. In a later patent E.P. 24,779, 1910; Brit. J. Phot. 1911, **58**, 899; Jahrbuch, 1912, **26**, 240, granted to Oliver, mirrors were used instead of prisms.

74. E.P. 29,596, 1912; Brit. J. Phot. 1913, **60**, 979.

75. F.P. 398,220, 1908; addit. 12,942; E.P. 17,872, 1910; Brit. J. Phot. 1911, **58**, 615; E.P. 672, 1914; Brit. J. Phot. 1915, **62**, 138; Belg.P. 252,280; 256,695.

76. E.P. 18,431, 1912; Brit. J. Phot. 1912, **59**, 330; F.P. 433,162.

77. E.P. 30,108, 1912; Brit. J. Phot. 1914, **61**, 143; F.P. 449,962.

78. E.P. 12,577, 1913; Brit. J. Phot. 1914, **61**, 616; F.P. 455,693.

79. F.P. 464,905, 1913.

80. F.P. 502,078, 1920.

81. E.P. 166,344, 1920; Brit. J. Phot. 1921, **68**, 539; abst. Sci. Tech. Ind. Phot. 1922, **2**, 39; F.P. 534,011. Cf. O. Pfenninger, Gaumont, Ulysee, Gergacsevics, Bjerregard, etc.

82. U.S.P. 1,262,954, 1918.

83. U.S.P. 1,247,646, 1917.

84. F.P. 487,501; E.P. 112,940, 1917; Can.P. 204,789.

85. F.P. 523,552, 1920; abst. Sci. Tech. Ind. Phot. 1922, **2**, 11.

86. E.P. 148,254; 155,764; U.S.P. 1,423,697, 1922. Cf. Kinotechnik, 1924, **6**, 293, 322; Sci. Ind. Phot. 1925, **5**, A, 19.

87. U.S.P. 1,430,765, 1922; Amer. Phot. 1923, **17**, 184; E.P. 196,778; Brit. J. Phot. 1923, **70**, Col. Phot. Supp. 17, 32; F.P. 554,755; Sci. Ind. Phot. 1924, **4**, 72; D.R.P. 371,201. Cf. D.R.P. 395,001.

88. D.G.M. 817,507; Phot. Ind. 1922, 702.

89. U.S.P. 1,428,103, 1922; Swiss P. 87,589. Cf. C. Zeiss, D.G.M. 558,541.

90. D.R.P. 187,199, 1905.

91. D.R.P. 267,500, 1912; E.P. 134,926.

In E.P. 216,518; Brit. J. Phot. 1924, **71**, Col. Phot. Supp. **18**, 42 Thorner proposed to use four colors projected by split condensers; F.P. 581,921.

92. F.P. 505,901; E.P. 134,926, 1918; Brit. J. Phot. 1920, **67**, 143; D.R.P. 352,631; U.S.P. 1,425,775.

93. F.P. 506,441; E.P. 134,842, 1918; Brit. J. Phot. 1920, **67**, Col. Phot. Supp. **13**, 46; U.S.P. 1,355,498; D.R.P. 340,569.

94. F.P. 506,097, 1920; U.S.P. 1,419,901.

95. F.P. 465,786, 1913.

96. F.P. 467,609, 1913.

97. F.P. 470,244, 1913.

98. F.P. 397,934, 1908.

99. F.P. 453,059, 1912.

100. F.P. 422,526, 1910.

101. F.P. 460,310, 1913.

102. F.P. 456,203; E.P. 8,035, 1914.

103. E.P. 6,565, 1913; Brit. J. Phot. 1914, **61**, 633.

104. F.P. 464,637, 1913.

105. D.R.P. 313,561; Phot. Ind. 1920, 139; Phot. Korr. 1920, **57**, 277; Jahrbuch, 1915, **29**, 164; F.P. 519,442; abst. Sci. Tech. Ind. Phot. 1921, 1, 93.

106. E.P. 147,767, 1920; Brit. J. Phot. 1921, **68**, 718; Col. Phot. Supp. **15**, 46; abst. Sci. Tech. Ind. Phot. 1921, 1, 8; F.P. 517,523.

107. U.S.P. 1,340,923, 1920.

108. E.P. 18,646, 1914; Brit. J. Phot. 1915, **62**, 690; F.P. 472,710; Belg.P. 253,190, 1913. In addit. 19,319 to above F.P. four colors were used, complementary to one another.

109. U.S.P. 1,385,912; Bull. Soc. franç. Phot. 1912, **54**, 370; abst. Sci. Tech. Ind. Phot. 1922, **2**, 52. Cf. U.S.P. 1,223,881.

110. F.P. 525,883, 527,132; abst. Sci. Tech Ind. Phot. 1922, **2**, 24.

111. Addit. 23,941, 1920 to above F.P. 525,883.

112. F.P. 533,812; abst. Sci. Tech. Ind. Phot. 1922, **2**, 77; U.S.P. 1,490,979 granted to G. Mareschal and H. Aschel.

113. U.S.P. 1,421,279; Belg.P. 259,342, 1913. Cf. Mauclaire, A. Breon and P. Randebel, F.P. 464,345; addit. 18,403; 465,496; 465,543; 466,827, 1913.

114. U.S.P. 1,407,875; E.P. 172,714, 1920; Brit. J. Phot. 1922, **69**, Col. Phot. Supp. **16**, 6; D.R.P. 350,188; Phot. Ind. 1922, 506; Sci. Tech. Ind. Phot. 1922, **2**, 79; F.P. 542,337.

115. D.R.P. 317,787, 1917.
116. U.S.P. 1,402,668; abst. Sci. Tech. Ind. Phot. 1923, **3**, 19.
117. U.S.P. 1,402,669, 1922.
118. D.R.P. 310,349, 1913; Phot. Ind. 1919, 140.
119. U.S.P. 1,413,591, 1922. Cf. U.S.P. 1,458,210.
120. Brit. J. Phot. 1921, **68**, 279; Sci. Tech. Ind. Phot. 1923, **3**, 76. Probably produced under the following F.P. A. H. Héraut, 526,602; 526,603; abst. Sci. Tech. Ind. Phot. 1922, **2**, 24; F.P. 528,889; abst. ibid. 1922, **2**, 38; Chim. Ind. 1922, **7**, 1170.
121. D.R.P. 375,513, 1922; F.P. 554,947; E.P. 195,630; Sci. Ind. Phot. 1924, **4**, 103. In a later patent D.R.P. 392,849, 1922; Phot. Ind. 1924, 612 the Wenham prisms were split into two right-angled prisms. Cf. D.R.P. 393,969; 393,970.
122. E.P. 206,003; 206,682, 1922; F.P. 572,020; abst. Sci. Ind. Phot. 1924, **4**, 187.
123. E.P. 197,409, 1922.
124. F.P. 561,175; E.P. 192,078, 1923; abst. Sci. Ind. Phot. 1924, **4**, 83.
125. E.P. 10,923, 1900.
126. F.P. 386,264, 1908.
127. E.P. 14,583; 14,584, 1914; U.S.P. 1.294,172.
128. E.P. 106,373, 1916; U.S.P. 1,284,673.
129. E.P. 121,751.
130. E.P. 11,514, 1914.
131. U.S.P. 1,437,895, 1922.
132. E.P. 17,483, 1912.
133. F.P. 559,431, 1922.
134. E.P. 27,675, 1909.
135. E.P. 204,378; F.P. 567,419; Brit. J. Phot. 1923, **70**, 692; abst. Sci. Ind. Phot. 1924, **4**, 148, 171.
136. See L. A. Jones, "Color Analyses of two component mixtures," Brit. J. Phot. 1915, **62**, Col. Phot. Supp. **9**, 11, 13.
137. It should be noted that the Kodak panchromatic negative stock (1921) is apparently coated first with a green-sensitive emulsion, and then with the red-sensitive. Obviously in the case of a very weak light, as in the shadows of a subject, the light might not have sufficient penetrative power to reach the underlying green-sensitive layer.
138. E.P. 26,671, 1906; J. Soc. Arts, 1908, **57**, 70; Brit. J. Phot. 1907, **54**, 642; 1908, **55**, 960; Photography, 1911, 377; Nature, 1909, **79**, 314; D.R.P. 200,128; F.P. 376,837; Jahrbuch, 1910, **24**, 337; Photo-Rev. 1909, **21**, 189; Phot. Rund. 1912, **26**, 159; Phot. Mitt. 1909, **46**, 120; Wien. Mitt. 1909, 322; U.S.P. 941,960; Penrose's Annual, 1909, **15**, 129; 1911, **17**, 161; 1912, **18**, 217; La Nature, 1912, 214. In 1915 this patent was annulled on the grounds that its claims were too broad, as all colors were said to be reproduced, and also on the ground of ambiguity; Brit. J. Phot. 1915, **62**, Col. Phot. Supp. **8**, 16; Jahrbuch, 1910, **24**, 31, 337. Cf. O. Pfenninger, Jahrbuch, 1910, **24**, 29.
139. E.P. 3,729, 1903. An opaque light screen was placed between and projecting from the faces of the prisms, and to guard against ghosts and double reflections the objects had to be posed against a black background, and the angle of the prisms had to be calculated for a given distance both for the camera and projector.
140. E.P. 1,642, 1911; Brit. J. Phot. 1911, **58**, 419; Bioscope, 1911, 860; Belg.P. 246,294; U.S.P. 1,217,391; Can.P. 147,445. In E.P. 1,900, 1912; Brit. J. Phot. 1912, **59**, 941; Jahrbuch, 1913, **27**, 145, the multiple shift principle was applied in projection. In E.P. 10,639, 1912; ibid. 1913, **60**, 426; Can.P. 150,316 spacing apart of the pictures by one or more spaces was proposed. In E.P. 26,173, 1912 Bennett patented a printer in which the negative and positive films were pulled down two or more picture spaces. And for color work when desired to differentiate between the pictures, the light might be cut down for one by the interposition of a grey glass, etc.
141. E.P. 24,645, 1911; Brit. J. Phot. 1912, **58**, 659; U.S.P. 1,278,302. Cf. E.P. 23,829, 1912; Brit. J. Phot. 1912, **59**, 862; Jahrbuch, 1914, **28**, 522.
142. E.P. 24,646, 1911; Brit. J. Phot. 1912, **59**, 925.
143. E.P. 89, 1912; ibid. 866.
144. E.P. 15,478, 1912; ibid. 1913, **60**, 166.

145. E.P. 2,786, 1913; ibid. 1914, **61**, 387. Another variation was patented in E.P. 2,787, 1913; ibid. 425.

146. E.P. 5,440, 1913; ibid. 1914, **61**, 142.

147. E.P. 8,144, 1913; ibid. 1914, **62**, 462.

148. U.S.P. 1,209,420, 1916; M. P. News, 1918, 2234.

149. E.P. 100,021, 1914; Brit. J. Phot. 1921, **68**, 600; Col. Phot. Supp. **15**, 40.

150. E.P. 18,451, 1912; Brit. J. Phot. 1913, **60**, 330; D.R.P. 259,136; abst. Phot. Ind. 1913, 806; Jahrbuch, 1914, **28**, 524; F.P. 433,162.

151. E.P. 21,271, 1912; Brit. J. Phot. 1913, **60**, 92; F.P. 448,546.

152. D.R.P. 263,817; Phot. Ind. 1913, 1499; E.P. 24,948, 1912; Brit. J. Phot. 1913, **60**, 997.

153. D.R.P. 244,943, 1911.

154. E.P. 636, 1914; Brit. J. Phot. 1914, **61**, 669; F.P. 470,834.

155. E.P. 14,270, 1914; Brit. J. Phot. 1915, **62**, 531; D.R.P. 321,550; U.S.P. 1,425,461; Can.P. 173,257.

156. U.S.P. 1,186,612, 1916.

157. U.S.P. 1,202,724; F.P. 480,530; E.P. 22,595, 1914; Brit. J. Phot. 1916, **63**, 87; F.P. 482,783; D.R.P. 380,361; Phot. Ind. 1924, 137. In E.P. 101,814, 1916 Joy patented a combination camera which could be used for black and white and colors by alteration of the path of the film. In U.S.P. 1,250,186 a combined projector for black and white and color was patented.

158. U.S.P. 1,211,904, 1917; Can.P. 161,771.

159. U.S.P. 1,279,065, 1918. Cf. U.S.P. 1,122,455; Can.P. 161,771 for the same thing granted to Kelley and Raleigh.

160. U.S.P. 1,325,280, 1919.

161. U.S.P. 1,133,730; Can.P. 185,187; E.P. 22,921, 1914; Brit. J. Phot. 1916, **63**, 319; 1917, **64**, Col. Phot. Supp. **11**, 14; ibid. **12**, 8; F.P. 477,728; Phot. Korr. 1918, **55**, 156; Phot. Ind. 1917, 617. Cf. U.S.P. 1,122,455, 1914 granted to Wohl and Mayer.

162. U.S.P. 1,216,493; 1,217,425; 1,278,211; 1,325,204; E.P. 14,225, 1915; Brit. J. Phot. 1915, **63**, 652; F.P. 479,921; D.R.P. 331,746; Phot. Ind. 1921, 373; Sci. Tech. Ind. Phot. 1921, **1**, 72; Can.P. 185,159.

163. Photo-Rev. 1919, **31**, 36.

164. U.S.P. 1,276,330, 1918. In U.S.P. 1,271,668 Coleman used alternate red and green-violet rotating sectors with the red sector larger than the other and the mechanism governing the movement of the film caused a longer dwell when the red was used. Cf. U.S.P. 1,271,667.

The use of transverse stripes of emulsion with different color-sensitiveness was also patented by E. Wolff, D.R.P. 371,449; Phot. Ind. 1924, 543, but the filter dyes were incorporated in the emulsion. In D.R.P. 390,232 the Radebeuler Maschinen-Fabrik A. Koebig patented a machine for coating film with transverse strips; a carriage with three tanks being moved across the film; Phot. Ind. 1924, 543.

165. U.S.P. 1,375,922, 1921.

166. U.S.P. 1,108,838, 1911.

167. Ital.P. 458,218, 1916.

168. E.P. 1,717, 1910; F.P. 411,557; addit. 13,521.

169. E.P. 102,280, 1916; Brit. J. Phot. 1917, **64**, 251; F.P. 484,116; U.S.P. 1,350,143. In a subsequent E.P. 210,823, 1922; F.P. 571,648; abst. Sci. Ind. Phot. 1925, **5**, 26 three mirrors were used for combining the images, one of them being split and capable of being tilted through small angles in two planes. Cf. D. C. L. Syndicate, D.R.P. 397,654.

170. F.P. 470,138, 1914.

171. F.P. 444,866, 1912.

172. D.R.P. 263,038, 1911; F.P. 448,557.

173. D.R.P. 242,101; Jahrbuch, 1911, **26**, 242; Phot. Ind. 1912, 122.

174. F.P. 443,315, 1912.

175. D.R.P. 225,438; Jahrbuch, 1911, **25**, 338; Phot. Ind. 1910, 1307.

176. U.S.P. 1,383,357, 1921; abst. Sci. Tech. Ind. Phot. 1922, **2**, 28. In U.S.P. 1,502,077; 1,502,078, 1924 lens fronts are patented, revolving so as to bring the lens opposite the finder.

177. U.S.P. 1,391,029, 1921.

178. U.S.P. 1,409,628; 1,417,005, 1922; abst. Sci. Tech. Ind. Phot. 1923, **3**, 84.

179. U.S.P. 1,404,773, 1922.

180. F.P. 526,870, 1920; abst. Sci. Tech. Ind. Phot. 1922, **2**, 25.

181. U.S.P. 1,291,954, 1919.
182. D.R.P. 259,931, 1912.
183. U.S.P. 1,321,705, 1919.
184. U.S.P. 1,344,616, 1920.
185. F.P. 395,981, 1908.
186. E.P. 873, 1915; Brit. J. Phot. 1915, **62,** 611; Ital.P. 456,137; F.P. 477,378; Jahrbuch, 1915, **29,** 157.
187. E.P. 12,469, 1914; Brit. J. Phot. 1915, **62, 612.**
188. U.S.P. 1,320,760, 1919.
189. E.P. 18,899, 1892.
190. Hopwood and Foster, "Living Pictures," 1915, 57.
191. Loc. cit. 77.
192. E.P. 22,928, 1896.
193. E.P. 136,595, 1918; U.S.P. 1,332,828; F.P. 506,418 is for a similar mechanism granted to Holam Ltd.; Chim. Ind. 1921, **5,** 564. Cf. C. Raleigh, F.P. 396,103.
194. D.R.P. 326,369; Austr.P. 5,859; Jahrbuch, 1915, **29,** 147; F.P. 509,333; Phot. Ind. 1920, 848.
195. E.P. 1,607, 1913; Brit. J. Phot. 1914, **61,** 308.
196. D.R.P. 229,136, 1907; Jahrbuch, 1911, **25,** 378; Chem. Ztg. Rep. 1907, 88; F.P. 415,276; Austr.P. 46,899.
197. E.P. 183,150, 1921; Brit. J. Phot. 1922, **69,** 607; Col. Phot. Supp. **16,** 39; ibid. **18,** 1, 16; Amer. Phot. 1923, 17, 185; J. S. C. I. 1922, **41,** 729A; F.P. 558,139; Austral.P. 9,844; abst. Brit. J. Almanac, 1925, 323; U.S.P. 1,513,322; D.R.P. 388,751; 388,700; Can.P. 239,131.
198. E.P. 165,826, 1919; Brit. J. Phot. 1921, **68,** 525; Col. Phot. Supp. **14,** 39; U.S.P. 1,383,460; F.P. 531,987; abst. Sci. Tech. Ind. Phot. 1922, **2,** 27; Brit. J. Almanac, 1924, 387.
199. E.P. 4,774, 1912; Brit. J. Phot. 1913, **60,** 255; Austr.P. 1,257, 1912; U.S.P. 1,155,056; Jahrbuch, 1913, **27,** 140.
200. E.P. 26,927, 1910; Brit. J. Phot. 1912, **59,** 220; F.P. 436,540; D.R.P. 365,707; Jahrbuch, 1912, **26,** 244.
E. Suess and F. Lejeune, D.R.P. 403,591 patented the obtaining of record negatives through filters absorbing about one-third of the spectrum, blueish-red, yellow and greenish-blue. Positives were to be projected so that the high lights were white and the shadows of that color complementary to the taking filter. Or black and white positives might be used and the screen illuminated with the complementary colors. Finzi, D.R.P. 395,001, 1922 would use polarized light for taking the negatives, obtained with quartz plates in the sectors of a rotary shutter.
201. Jahrbuch, 1895, **9,** 269.
202. E.P. 23,645, 1911; Brit. J. Phot. 1913, **60,** 443.
203. D.R.P. 351,763, 1921; abst. J. S. C. I. 1922, **41,** 729A; Amer. Phot. 1923, **17,** 185.
204. D.R.P. 271,882; 278,168; E.P. 15,098. 1913; Brit. J. Phot. 1914, **61,** 88; Austr.P. A, 5,570; F.P. 459,727; Belg.P. 257,987.
205. D.R.P. 278,168, 1913.
206. E.P. 9,610, 1913; Brit. J. Phot. 1914, **61,** 579. This patent carried two provisional specifications 9,610; 9,680.
207. E.P. 11,496, 1913; Brit. J. Phot. 1914, **61,** 482.
208. E.P. 6,894, 1913; Brit. J. Phot. 1913, **60,** 997; abst. C. A. 1915, **9,** 1723; D.R.P. 329,272; Phot. Ind. 1921, 190; Austr.P. 2,625; Jahrbuch, 1915, **29,** 143; U.S.P. 1,139,633; F.P. 459,612; Belg.P. 265,825. In E.P. 19,175, 1913; Brit. J. Phot. 1914, **61,** 699 a machine for making the film is described.
209. U.S.P. 1,322,794, 1919.
210. U.S.P. 1,337,775; F.P. 504,589; E.P. 129,638, 1918; Brit. J. Phot. 1920, 67, Col. Phot. Supp. **13,** 47; Jahrbuch, 1915, **29,** 158; D.R.P. 345,784.
211. E.P. 14,145, 1914; Brit. J. Phot. 1915, **62,** 517. Cf. E.P. 100,629; Brit. J. Phot. 1916, **63,** 587; U.S.P. 1,281,714; abst. C. A. 1919, **13,** 99; U.S.P. 1,360,156; 1,361,783; 1,435,759; 1,435,760. In U.S.P. 1,408,312; 1,408,313; 1,408,314; 1,408,315 various modifications of the methods of applying the colors by photomechanical processes are given. Cf. E.P. 5,100, 1915; 16,899, 1914; F.P. 481,357; E.P. 8,300, 1915; U.S.P. 1,288,753; Sci. Ind. Phot. 1924, **4,** 104; E.P. 213,647; 213,866; 214,934; 224,569; 224,570; 224,571; 224,572; 224,573; Brit. J. Phot. 1925, **72, 7,** 143; Col. Phot. Supp. **19,** 4, 10.
212. Austr.P. 140, 1914; Phot. Ind. 1914, 970.

213. Austr.P. 79,955, 1917; Jahrbuch, 1915, **29**, 144.
214. E.P. 12,891, 1911; Brit. J. Phot. 1912, **59**, 162.
215. E.P. 129,717; Brit. J. Phot. 1919, **66**, 712; Col. Phot. Supp. **12**, 46; F.P. 500,963; U.S.P. 1,390,252; D.R.P. 347,437; Jahrbuch, 1915, **29**, 143; Dan.P. 29,486.
216. E.P. 161,995, 1920; abst. Sci. Tech. Ind. Phot. 1922, **2**, 14.
217. F.P. 368,565, 1906; Phot. Coul. 1907, **2**, Supp. 20.
Cf. L. Sabourin, F.P. 582,252.
218. E.P. 138,396; Brit. J. Phot. 1920, **67**, 174; Jahrbuch, 1915, **29**, 150.
219. U.S.P. 1,383,819; abst. Sci. Tech. Ind. Phot. 1922, **2**, 28.
Cf. W. B. Bolton, Brit. J. Phot. 1891, **38**, 116.
220. U.S.P. 1,426,995; abst. J. S. C. I. 1922, **41**, 788A; Can.P. 219,898.
221. U.S.P. 1,426,996, 1922.
222. U.S.P. 1,446,049; 1,446,050, 1923; abst. C. A. 1923, **17**, 1388; J. S. C. I. 1923, **42**, 378A.
223. U.S.P. 1,449,417, 1923. In U.S.P. 1,477,880; E.P. 225,659; Brit. J. Phot. 1925, **72**, 125, Kitsee proposed to dye the celluloid and cut away the dyed surface mechanically in lines and redye the exposed parts. In U.S.P. 1,477,881; 1,477,882 the production of regular mosaics was claimed. U.S.P. 1,477,883; F.P. 572,827; abst. Sci. Ind. Phot. 1924, **4**, 16 is for machines for making the patterns.
224. E.P. 140,560; F.P. 522,418, 1920; abst. Sci. Tech. Ind. Phot. 1921, **1**, 103; D.R.P. 341,736; U.S.P. 1,441,615; Amer. Phot. 1923, **17**, 493; Can.P. 216,860.
225. D.R.P. 332,313; Phot. Ind. 1921, 373; abst. Sci. Tech. Ind. Phot. 1921, **1**, 80
226. U.S.P. 1,402,371; abst. Sci. Tech. Ind. Phot. 1922, **2**, 127.
227. D.R.P. 259,471, 1911.
228. D.R.P. 261,341, 1911.
229. U.S.P. 1,431,309, 1922; E.P. 205,941; Brit. J. Phot. 1923, **70**, Col. Phot. Supp. **17**, 3; ibid. **18**, 3; abst. Sci. Ind. Phot. 1924, **4**, 70, 186; Brit. J. Almanac, 1925, 320.
230. U.S.P. 1,458,410, 1923; abst. Sci. Ind. Phot. 1925, **5**, 28.
231. F.P. 395,506, 1908.
232. U.S.P. 1,465,643.
233. U.S.P. 1,465,053; abst. Sci. Ind. Phot. 1925, **5**, 52.
234. U.S.P. 1,465,054; abst. Sci. Ind. Phot. 1925, **5**, 52.
235. U.S.P. 1,271,667, 1918.
236. E.P. 217,557, 1923; Brit. J. Phot. 1924, **71**, Col. Phot. Supp. **18**, 40; 1925, **72**, **203**, Col. Phot. Supp. **19**, 16; Phot. Ind. 1924, 971; F.P. 579,300; abst. C. A. 1925, **19**, 218; D.R.P. 411, 612.
237. U.S.P. 1,504,465, 1924; abst. C. A. 1924, **18**, 3327.
238. U.S.P. 1,460,673, 1923; abst. Sci. Ind. Phot. 1925, **5**, 28.
239. E.P. 217,234, 1923; abst. C. A. 1925, **19**, 219; J. S. C. I. 1925, **44**, B28; F.P. 582,330; Sci. Ind. Phot. 1925, **5**, 67; D.R.P. 403,592.
M. J. Vinik, U.S.P. 1,218,342, 1917 patented a camera with revolving half sector shutter, which was stated to be adaptable for three-color cine films, and which could be used for the additive process.
240. F.P. 573,180, 1923; abst. Sci. Ind. Phot. 1925, **5**, 23.

DICHROMATE PRINTING. TWO FILMS. MULTI-WIDTH FILMS. SUBTRACTIVE PROCESSES

Dichromate Printing Processes.—Of all processes for the production of cinematograph positives, the slow printing with dichromated colloids would naturally seem to be the one that would least appeal to the practical worker. The disadvantages are, obviously the low sensitiveness of the colloid, the necessity of transfer, unless printing is effected through the support, the inevitable chances of distortion and want of register through contraction and expansion of the celluloid from the action of the warm water in developing, and the consequent necessity of perforating the positives after printing so as to ensure that the holes always fall in the correct position as regards the dividing line, otherwise the picture will creep up or down on the screen.

It may be interesting to record that the author was engaged in 1911 to test this method out, and whilst there was no difficulty in the practical performance, the results were too expensive to be able to compete with the ordinary silver print. Ordinary carbon tissue was slit to the required width and wound in contact with the negative, which was provided with a safe edge by painting the edges with nigrosin, dissolved in amyl acetate and acetone, on a rubber-covered drum, in spiral form as tightly as possible, then intimate contact was obtained by inflating the rubber cushion with air. Exposure, for experimental purposes, was effected to a series of Mazda lamps, though later mercury vapor lamps were installed, and direct sunlight was also used.

After exposure the tissue and the celluloid film, to which the picture was to be transferred, were passed through a long, narrow trough, containing acetone and water, and then squeegeed together, and wound on a drum with expansible sectors. The tissue was wound as tightly as possible with the sectors unexpanded, then the whole was immersed in warm water. As soon as the tissue expanded, the sectors of the drum were also expanded to take up the slack. The drum was then lifted from the water, the paper backing stripped off, the drum again lowered into the hot water and kept on the move till development was complete. Rinsing in cold water and an alum bath followed.

Perforation was then effected and this was a tedious job, as a special machine had to be used, so as to enable the punches, and only one pair of holes could be punched at once, to be watched, for the operator had to keep on shifting the punches till the perforations took the exact position

required with respect to the dividing line. Not more than 2000 feet could be punched on one machine in one day.

Later expansible drums were made on which the tissue and negative were automatically wound, between brass strips in spiral, and the expansion of the rubber-coated sectors was also automatically effected. Writing entirely from memory, the exposure to direct sunlight was about 5 minutes; to the Mazda lamps, and twelve were used in line, it was 25 minutes, and to one mercury vapor lamp 18 minutes; the drum carrying the negative and tissue was kept revolving all the time.

One and only one possible advantage of the process was the possibility of obtaining positives in any monochrome color; but even this, except for color photography, is minimized for we are not educated to admire pictures in every brilliant color. The actual cost, in consequence of the price of labor, was too high to make the process ever anything but an interesting laboratory one.

J. E. Thornton[1] (p. 635) proposed the use of dichromated colloids and the subsequent absorption of dyes by the hardened or unhardened gelatin; or the use of the powder process, the ordinary carbon or gum process. Alternating pictures were to be used, thus relying on the persistence of vision. In a later patent the trouble of printing from the back was stated to be overcome by using a colloid to which dye or color was added and printing with a negative, broken up into dot formation, as in the half-tone process, about 40,000 to the inch being recommended. An ordinary negative was obtained and from this the positive made and from this a half-tone dot negative produced.

Viscount Tiverton and F. A. Merckel[2] also used the carbon process and dyed up first in a minus-red, then coated with celluloid varnish. The back was then coated with dichromated gelatin and printed. The front of the film was recoated and this procedure gone through for the third color. F. R. Miller[3] proposed to coat celluloid with dichromated colloid, expose under a transparency, develop with water and stain up. Alcohol and acetic acid were added to the solutions so as to act on the celluloid itself. Mineral colors as well as organic dyes might be used. As an alternative the back of the negative might be coated with sensitive colloid.

E. Josephson[4] proposed to print positives by some photo-mechanical process, either in black and white or colors. G. Taussig[5] patented a method of coloring positives by squeegeeing into contact with a dye template, made by blocking out a negative or positive and staining up those parts from which the color was to be imbibed. H. Jerne[6] made photomechanical prints on well-clayed paper and transferred the impression to celluloid, the face of which was softened by a solvent, such as acetone. The printing surface might be fine-etched for printing in several colors. For taking the constituent negatives a camera with three separate lenses with three separate films was used.

Two Film Processes.—The use of wide films and also two separate films is naturally accompanied with the disadvantage of having to build special cameras and projectors, unless the positive be made by some subtractive process, and this probably accounts for the comparatively few patents to deal with. In the case of two films one has also the trouble of synchronous movement.

L. C. Egrot[7] would use two films, the one acted upon by the yellow and blue rays and the other by the red. For the former a rotary shutter was used, whilst for the latter the filter was fixed. In *1*, Fig. 173, is schematically shown the arrangement for actuating the two films X and X^1, whilst E represents the lens and the prism system by means of which the light-rays were split into two beams. The shutter is shown in *2, b* representing the blue and c the yellow, d and e were two wings which could be used to increase or decrease the apertures, according to the speed of the emulsion. It will be seen that f is a Swan cube and that the path of the rays is equal. The two negatives are shown in *3* and *4*, with the blue image x and the yellow y. The printing apparatus made a blank between the blue and yellow pictures, on which the red one was printed.

S. Procoudin-Gorsky and S. Maximowitsch[8] pointed out that by the additive persistence method with two or three colors, there was always great flicker, and to obviate this they proposed to use two films, one of which should bear all the red records and the other the green and violet alternating, and the positives were to be synchronously projected as a composite picture. The single picture strip might be the violet, while the red and green alternated. L. F. Douglass[9] proposed to use two or more films, run side by side, exposed through two lenses and the negative records were obtained with a blank space alternating, so that in printing, the negative of one could be printed in the blank space of the other. The exposures were made in succession. The projection was to be alternate through a rotary shutter.

The idea of alternate blanks was used by Aragao,[10] B. Weinberg.[11] Mazo and Tauleigne,[12] Boralleras,[13] G. Gartmann,[14] D'Halloy,[15] F. Oprescu,[16] C. H. Bandry,[17] and G. Kohn.[18]

L. M. Blaise[19] would use two half-lenses with reciprocating motion with one or two films in continuous motion. The Color Company[20] used a half-silvered mirror at 45 degrees, thus dividing the light beam and projecting two images on to two films.

Multi-Width Films.—W. B. Featherstone[21] proposed to use wide films so as to obtain the records in parallel or staggered. In order to avoid the use of separate filters the celluloid might be stained. The lenses moved with the film in order to obtain or project sharp pictures. Means were provided in the projector for obtaining coincidence of images, and in "order to increase the relief-like impression of the projected pictures and to improve the stereoscopic effect I provide," says the inventor,

"improved viewing devices for viewing the pictures through transparent elements, these elements being colored so as to transmit light of the primary colors, or a mixture of the primary colors."

E. J. Wall[22] suggested the use of double-width film, with the arrangement of all the records of one color on one width, and the other two alternating on the other. Mirrors or prisms or two lenses might be used, and the red and green alternate and the blue be continuous, or the reverse. The reasons that led the author to propose this system were the observations of P. G. Nutting, who stated[23] that "when light is thrown suddenly on the retina the visual impression lags somewhat behind the stimulus, and is quickly followed by a fatigue effect lagging behind the impression. In the steady state the luminous sensation is the resultant of an impression and a fatigue. If the illumination of the retina is suddenly cut off there is a certain persistence of vision in the after image. There are various phenomena resulting from impression lag, fatigue and persistence of vision, some of which are of great practical importance. With very low illuminations, the visual impression requires many seconds or even minutes to reach its full value; complete recovery of sensibility occurs in a similar interval. At ordinary intensities, however, the full sensation is attained in a few hundredths of a second. Direct determinations of the growth of the visual sensation (impression plus fatigue) with time were made by Broca and Sulzer[24] Working with red, green, blue and white light they found in every case an overshooting sensation of above its final value. With blue the maximum sensation was at least five times the final and occurred about $+ 0.07$ sec. after the initial exposure. Red and white overshoot to about double the final intensities after about 0.13 second. Green overshoots scarcely at all, indicating either very little fatigue or else a very slight lag of fatigue behind impression." In the specification the application of the colors to the celluloid or the gelatin is disclosed, either as solutions or in the form of stained gelatin or celluloid films.

C. P. Christensen[25] would use film of treble width, that is equal to the height of three pictures plus the perforations, and run it horizontally, not vertically, so that the pictures were recorded in this direction. S. Maximowitsch[26] also proposed to use double-width film, utilizing the author's idea of splitting up the records. Two monochrome positives, alternately tinted in complementary colors, yellowish-green and pinkish-violet were to be used for projection. H. Workman[27] also would use double- or treble-width films. T. A. Killman[28] suggested a sort of toy or home apparatus, taking wide films with the pictures running horizontally, but staggered, as were also the lenses, which were carried on the arc of a circle. E. Belin[29] used a triple-width film, a second objective with three mirrors in front inclined to one another, which threw the picture at an angle of 90 degrees to the optic axis. Boudreaux & Semat[30] patented an

apparatus for taking and projecting in black and white, the records being on triple-width film. The filters were thrown electrically in and out of the optical path, thus enabling color or black and white to be shown one after the other.

C. W. R. Campbell and F. G. Roberts[31] proposed to take or project two or more images simultaneously by means of an optical system, comprizing a small lens for each image, and a large correcting lens. Points on the principal axis of the small lenses in the plane of the film being conjugate with the same point on the principal axis of the large lens. The images were transversely arranged on a wide film, a single shutter, a negative lens for adjustable focusing and screens for color projection being provided. E. Leiber[32] used double-width film and the color records alternated, for instance yellow and blue, and green and red side by side, or yellow and green, and blue and red. The positives were shown in pairs. D. F. Comstock and Technicolor Motion Picture Corporation[33] patented a film of double-width, which was folded down its length, then perforated, printed through the support and treated so as to obtain reliefs, which were suitably dyed, then the two celluloid faces were cemented together.

Opaque Supports.—O. Fulton[34] proposed to use opaque bands of cloth, fabric or other material as the support for motion pictures. The same idea was patented by the Fultomatograph Syndicate Ltd., O. Fulton and T. T. Baker[35] and the pictures might be arranged in line or trefoil pattern. See also Brewster (p. 641).

H. Wolff[36] would do away with the expensive celluloid by using paper as the support, and by inversion of the negative image employ the original negative as the projecting positive. The paper was to be coated with an emulsion of about 0.01 mm. thickness, with a silver bromide content about three times that of the usual emulsion. After exposure and the usual development, the image was to be treated with acetic acid to destroy the absorbed developer then with acid permanganate or dichromate to dissolve the silver, again exposed to light and developed. F. de Mare[37] proposed to use metal ribbons as supports, a white surface being obtained by electro-plating, etc. Reflected light being used for projection. E. and C. Dupuis[38] patented the preparation of metallized paper by the deposition of a thin film of silver on a highly polished nickel cathode, covering the same with celluloid solution, then applying glazed paper, coated with gum-lac, submitting the paper to pressure and high temperature and stripping the paper which carried the silver with it. Boudreaux & Semat[39] would also so treat positives that the silver became reflective. Transmitted and reflected light was used for projection.

Glass Plates—The use of glass plates of circular form with the images arranged in spiral had already been suggested for black and white. H. W. H. Palmer[40] would apply this system to color photography, as shown in Fig. 174, in which *1* is the shutter, with unequal sized annular

FIG. 174. Palmer's E.P. 9,912, 1909 (Page 623).

FIG. 173. Egrot's F.P. 412,498 (Page 621).

sectors; in *2* the stained film used instead of the said shutter and in *3* the glass plate with its spiral series of pictures. It is almost needless to point out that unless the pictures were very small, or the plates very large, there would be very great limitations as to the length of the reels.

Subtractive Processes.—When one considers that cinematography in black and white was about twelve years old before the first color picture was shown, it will be seen that many of the moving picture theaters were already equipped with the necessary apparatus. Therefore, any process, such as simultaneous projection which requires a special machine, is severely handicapped commercially, and the alternate or persistence of vision methods had already become discredited. Therefore, the film of

the future will be one which carries each picture as a finished colored result. Many have been and are still striving towards this end, chiefly by the two-color methods, which obviously reduces the essential operations, and the results are in some cases fairly satisfactory.

First as to the filters to be used for the two-color process. G. A. Smith, (see p. 596) who was the first to apply two-colors to motion picture work commercially, used at first for taking the negatives, a red filter that could be matched by one composed of yellowish eosin 9.5 g., filter yellow 2 g. per liter of gelatin solution with approximately 7 ccs. per 100 qcm. The green filter was a very blue-green, that could be matched by rapid filter green 1 g., naphthol green 0.6 g., and filter yellow 0.3 g. For projecting the red filter could be duplicated by rose Bengal 6 g., filter yellow 3 g. But the taking filters were subjected later to some change. According to C. N. Bennett[41] the first filters, as above, were the Wratten & Wainwright regular tri-color red and green, but a special light pair were used for recording brilliant sky and sea effects. This red transmitted to about D ½ E, while the green was distinctly more bluish-green. Bennett said: "with these 'light' filters blues are rendered far brighter than before, as are also artificial greens, by virtue of their large blue-green content. Exposures are also very much shorter. On the other hand, grass and foliage green are reproduced in the resultant two-color image as a bronze brown. Upon my introduction to the theory of the process it was explained to me that this browning of natural greens when using the 'light' series filter set was due to the green content passed by the orange filter, but the explanation was fallacious; the true reason of the difficulty having to be sought in the swamping action of the additional greenish-blue rays passed by the green filter, as was speedily proven by experiment. The problem then remaining for solution was how to obtain a set of two-color filters as light as possible, so as to allow of very short exposures (a necessity in the Kinemacolor system of cinematography) and at the same time give renderings of foliage shades which were at least green and not brown. The solution was found to be in the employment of a small proportion of pure blue, or even blue-violet, light in the form of a restricted transmission band in the green filter wherewith to make the necessary records of blue objects, at the same time cutting out the offensive blue-green rays from little b to F½G or thereabout."

It is open to argument whether Bennett was right as to the swamping action of the additional blue-green and greenish-blue, as the emulsion is least sensitive to these colors, and the reflection spectrum from the average foliage is only 50 per cent of the incident light between E and F, which contains the above colors. And bearing in mind that the Kinemacolor pictures were additive and not subtractive on the screen, the bronzing of the greens would be due to insufficiency of action in the negative, which would mean greater density in the positive and consequent suppression of

the green projecting light, and this would cause the bronzing, which was due to excess red. Bennett's plan of admitting a blue band would probably result in better exposure, hence more density in the green negative and consequent greater transmission through the green positive. Possibly the excess of red was contributed to by the characteristic chlorophyll reflection band from B to C½D. The results obtained being comparable to those seen with Simler's erythroscope, though, of course, not so brilliant.

If we consider the matter from the point of view of projection we can possibly arrive at some sort of conclusion as to the best filters to use. In the first place one must recognize that some of the colors, such as the deep blues and violets, have to be sacrificed. These are not recorded in the negative and will, therefore, not be reproduced in the positives. But one must not assume that they will all be blacks, for as nearly all natural objects reflect some white light, this will act to some extent on both films. And, moreover, the blues reflect more or less of the green rays, and the violets more or less of the red. The consequence will be that these colors are not always shown as black.

One factor that is of some importance in the taking of the negatives is the question of exposure, and to clear this up one must take into preliminary consideration the actual method of obtaining the exposures. If these are in succession, as was the case in the original Kinemacolor process, it is clear that as the revolving shutter was composed of two colored sectors, variation of exposure could be obtained by varying the angles of the sectors, so that if the negative stock was not equally sensitive to both red and green, it was possible to compensate for this. If, on the other hand, and it is assumed that only one lens is used, the image is split up into two beams by mirrors or prisms, then the only method of equalization is that of altering the reflective power of the reflecting surface.

Of course, if the reflective surface is silver, that is a half-silvered surface, it is extremely easy to control the ratio of the reflected to the transmitted light by the use of a more or less dense deposit. If the reflective surface is composed of small elements, then varying the areas of these also gives the same effect. Equalization of exposure by varying the density of the filters is out of the question, as it is extremely difficult to do this without altering the absorptions, unless one adds black to one of the dyes, and this would be excluded assuming that the sensitive ratios of different batches of emulsion also varied. On the other hand, there is comparatively wide latitude in the variation of the relative color-sensitivity, because of the overlap of the filters, and the fact that we are not using pure spectral colors but natural objects, which usually reflect a considerable amount of white light.

Considering that the additive processes have been relegated to the dead and gone methods we may dismiss these very briefly by stating that the best projection filters are Nos. 25 and 44, issued by Wratten &

Wainright. We can thus confine our attention to subtractive work alone. For negative work the standard filters, recommended by the above firm, are their Nos. 22 or E 2, and 60, also known as P, and the transmissions of these is shown in Fig. 175. If these be placed on one chart, we shall see how much of the spectrum is passed by them and the amount of the overlap.

As a guide to the colors we may take Helmholtz's table of the distribution of the colors, as follows:

Red, A-C..........................wave-lengths 7600-6560
Orange C-C¾D.................wave-lengths 6560-6060
Golden-yellow, C¾D-D1/6E......wave-lengths 6060-5790
Yellow, D1/6E-D1/3E...........wave-lengths 5790-5680
Greenish-yellow, D1/3E-E........wave-lengths 5680-5270
Green, E-b.......................wave-lengths 5270-5180
Blue-green, b-F.................wave-lengths 5180-4860
Cyan blue, F-F1/3G.............wave-lengths 4860-4670
Indigo, F1/3G-G........wave-lengths 4670-4300
Violet, G-H.....................wave-lengths 4300-3970

From Fig. 176 it will be seen that the actual overlap for the above filters is from 6180 to 5580, so that we have some of the orange, the whole of the golden yellow and yellow, and about one-fourth of the greenish-yellow. Now it is important to bear in mind that it is the shadows of the negative that print, therefore all the blacks in the diagrams used, represent those parts of the positives in which colors will appear, and as it is usual to employ red and green as the printing colors, we must think of these blacks in these two terms. If we combine the above figures into one diagram, Fig. 176, and conventionally represent red and green, the subject may be a little clearer, and it will be seen that in the overlap we must have dyes that will in thin films pass these colors.

If we assume that we have to reproduce the spectrum as given by these filters, then obviously the printing colors should be antichromatic to the taking filters, and this applies to all two-color filters from the theoretical standpoint. If this applies to the spectrum, then it should also apply to natural objects. It may be thought at first sight that we cannot under the above circumstances obtain a pure yellow, whereas if the above two filters be superimposed, it will be seen at once that the transmitted color is yellow, though saddened by black, that is, of lowered luminosity. This statement applying to the light seen through the filters themselves superimposed; and the lighter the hue of each filter is made the brighter the yellow becomes, that is to say, the less black there is.

If we take two other filters, that were suggested for two-color work[42] Nos. 29, or F, and 44, or minus red 4, we shall find, that there is no overlap, in fact, from 6100 to 5850 is not recorded at all. This region is the golden yellow, and includes the D lines, and superimposing these filters in the same way, yellow is not formed. In another pair, Nos. 25, or the

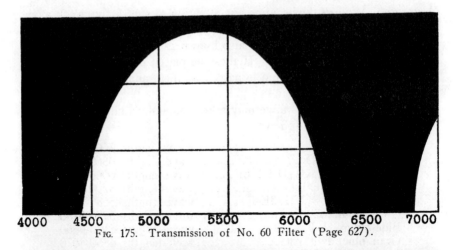

4000 4500 5000 5500 6000 6500 7000

Fɪɢ. 175. Transmission of No. 60 Filter (Page 627).

Fɪɢ. 175. Transmission of No. 22 Filter (Page 627).

Fɪɢ. 176. Overlap of Nos. 22 and 60 Filters (Page 627).

standard tri-color red A, and 58, or B 2, we have 5800 to 6400 over-lapping. This includes the golden yellow and 70 per cent of the orange. With Nos. 21, monobromofluorescein, and 45, or H, there is a small over-lap from 5400 to 5500, which is practically in the middle of the greenish-yellow.

The position of the overlap is important as regards the rendering of the yellows, which are next to white the most luminous colors, and the aim should be to include these as far as possible.

Assuming that the previous statement, as to the reproduction of the spectrum is correct, then the most obvious course is to use as printing colors those which shall be the sum of the absorption of each filter, that is to say, the red dye must match the colors absorbed by the green filter, and the green match the absorption of the red filter. One has to bear in mind, however, that the blues and deep violets are not recorded in the negatives at all, therefore, they can or must be ignored when dealing with the reproduction colors. The point is where should one locate the limits of color reproduction? On reference to the above table it will be seen that cyan blue ends at wave-length 4670, the limit of the indigo which is rela-tively a dark color. We may, therefore, assume that the whole of the spectrum from this point to the red end must be reproduced.

As we have assumed that the subtractive colors shall be anti-chromatic to the taking filters, we may limit the green to this particular point for the blue end, and set its limit at close to the middle of the orange, which is wave-length 6310. The sum of the spectral region between these two limits must be the color of the dye used for the green, or minus-red, record. Reference to Mees' "Atlas of Absorption Spectra" will show that acid green plus naphthol green is likely to be of value, for the former shows an absorption from about 6000, with a transmission band from 6500 to 7500, which can be cut out by the naphthol green. But at the blue end these two may transmit a little too far, so that the addition of a yellow, such as naphthol yellow S, may be required. It must be noted that we are limited to acid dyes, unless the silver image itself is to be dye-toned, when basic only must be used.

Treating the red end in the same way, we find that the limit of the yellow is 5270, but this might make the red too much of an orange, that is to say any deep reds in the picture would be rendered as scarlets, so that if we shift this point further towards the red, to about 5500, we shall find that the scarlet BB extra N or B, plus a yellow dye to cut out the blue transmission of both these dyes ought to be satisfactory. Or one might use rose Bengal, plus a yellow, for this has a very clean, sharp cut just about the point we want.

For those who like to have some standard to work to, other than the spectrum, it will probably be found that for the green dye, a mixture that will match Wratten & Wainwright's No. 52 filter, will be a good guide.

Or if this is too yellow, then 57 should be adopted. For the red, No. 23, E red, or 23 A, E red light, or as alternative No. 27 A, stage red light, can be used.

One can easily match these up by staining gelatinized glasses, varying the ratios of the dyes, till the desired shade is obtained when the films are dry, and they must be matched by artificial light.

Using the spectrum as a standard, it is only necessary to project it on to a white screen, and then match the color by a measured admixture of the dyes chosen. It will be noted that it is recommended to project the colors, and this is important as they are by no means the same when examined by daylight, and a mixture, correct by daylight, may look quite wrong when projected by the comparatively yellow arc. It would be possible to use a projected spectrum and the apparatus for this can be rigged up at very little cost, using a liquid cell prism, a few cheap spectacle lenses, and a slit made from a line ruled on a sheet of glass coated with black varnish. A short spectrum should be first obtained, three inches is quite long enough, and either the filter itself used, or a template cut so as to remove the colors absorbed by the filter. Then the remainder can be projected by a second lens into a color patch, which can be matched. One light only need be used, if the beam reflected from the front face of the prism be deflected on to the screen, side by side with the spectrum patch, by the aid of a mirror. The adoption of some such plan will save hours of rule-of-thumb work with positives, though probably the latter is the method usually adopted.

One of the commonest errors in subtractive pictures is the failure to obtain blacks, they being either a deep violet or red. The former is due to the transmission of the violet by the red dye, as too often a magenta type of transmission is used. While the redness is caused by the use of a green dye that transmits the deep red, and nearly all green dyes, with the exception of the naphthol greens, transmit a band, more or less bright, in the red. Frequently the violet can be eliminated by the use of a yellow dye, but modification of the green to absorb the red band is not possible by any addition, except that outlined above.

Naturally one must use dyes that are compatible, that is to say, that will not mutually precipitate. Their stability to light is of less moment, taking into consideration the short time they are actually exposed during projection. Another method of obtaining the desired result is to utilize the principle of the precipitation of basic by acid dyes, and one can first stain in an acid dye, and then pass the print through a basic dye of the modifying color, when the latter will be precipitated on the former. But this involves another operation, which should be avoided if possible, and the final dye compound may be less transparent than is desirable.

Occasionally a little trouble is met with in the differing absorption of the dyes, that is to say, if we are using a red and a yellow dye, the one

or the other may be absorbed faster than the other. This can be overcome by adjusting the ratios of the two, or frequently by the addition of some salt or acid, such as the citrates, borax or acetic acid, which will modify the tendency of the dye absorption. If a mixture of dyes be found to match the filter curves and on practical trial they are found to be satisfactory, they should be adhered to for all work. Variation of the ratio of the dyes to obtain particular effects is an easy way to court trouble.

One must take into account, of course, the exposure ratios with any pair of filters, and these with Nos. 29 and 44 are 20 : 4; for 25 and 58, 12 : 12, and for 22 and 60, 10 : 10, and with 21 and 45, 8 : 5. It is obvious that assuming equal sensitiveness to the red and green in the film used, variation of the reflector constants must be adopted, as already pointed out.

T. A. Mills[43] patented the production of a subtractive film, in which all the records were printed in sequence and bleached in a mixture of potassium ferricyanide and ammonia, thus converting the image into silver ferrocyanide, then alternately toning them with baths of acidulated ferric chloride, which gave the blue, and vanadium and copper, or vanadium and uranium for the red. Stencils might be used to protect alternate areas, or rotating disks or moving bands be used to apply alternate solutions. The toned pictures were treated with hyposulfite to remove the silver salt to render them more transparent. The film thus obtained could be coated on the back with an emulsion, or dichromated gelatin to which silver chloride had been added, or a printing-out emulsion could be used. The second impression was obtained on this sensitive surface with the records alternating so that a blue picture was behind an orange one. The process of making three-color pictures was also outlined, the use of the diachrome process, or the obtaining of reliefs by the peroxide etching or equivalent method, and the use of chromium or other mordant to assist in the fixation of the dyes to be used in these latter processes; also the dyeing up of hardened and unhardened gelatin.

F. W. Kent[44] proposed to obtain a relief by exposing a sensitive surface through the support. This might then be fixed or not, treated with a weak solution of dichromate with hydrochloric or hydrobromic acid, so as to induce local insolubility of the gelatin. The soluble portions were then removed by a strong solution of sodium dichromate, with or without the addition of acetic acid. The silver image was then dissolved, leaving a clear relief, which might be dyed up, the relief being first mordanted if required. The three films might be passed through the projector superposed in register, or lashed together by loose threads in the perforations, or might be cemented. The reliefs might be used for imbibition and for making printing moulds. The same inventor[45] would produce the positives on a waxed paper support, or metal, etc., and transfer in superposition either on the back or front of the celluloid.

T. P. Middleton[46] dealt with the printing of superposed pictures

from alternating records by a discriminative or selecting printing machine, in which optical printing was resorted to, that is to say, the production of the image by means of a lens, in contra-distinction to printing by contact; no particular methods of obtaining the colors are claimed. F. J. Norman[47] and others proposed to make two positives from the negatives and select one of them for the final support. The image was treated with a chromium, ferricyanide or cobalt salt to obtain the blue image. This was then coated with gelatin, sensitized with dichromate, exposed through the other positive and dyed with the complementary color. The process was applicable to three-color work, and the imbibition process was suggested for obtaining the three subtractive colors.

A remarkable coincidence occurs in the patents taken out by F. W. Donisthorpe[48] and W. F. Fox[49] as not only is the process the same, but in some cases the phraseology bears a resemblance. These processes may be summed up by saying that a positive from one color record negative is superposed on the negative of the other color record and a positive made from the two. The image thus obtained was toned a blue-green by means of vanadium, uranium or other compound, that will so harden the gelatin, where the toning takes place, that it will no longer absorb a dye solution. The positive thus obtained was then immersed in a bath of the complementary color, and the compound positive obtained bound up or otherwise combined with a black and white positive. Variations of the toning baths and procedure were given, but the main principle remains the same.

E. Sommavilla[50] also proposed to combine negatives and positives in a somewhat similar manner to the above. E. Sommerfeldt[51] patented the production of pictures by the use of two filters only. The positives from the same being stained up in the complementary colors; the third impression being obtained by a combination of the two negatives. E. Albert[52] had patented the combination of the three constituent negatives with a positive from a black key plate as a printing matrix. H. N. Hyde[53] also patented the superposition of negatives and positives to obtain correct color values.

S. J. Cox[54] proposed to print from one record negative and develop with a developer of non-tanning character, such as amidol or ferrous oxalate, the images being toned blue with ferrocyanide and fixed. The film was then sensitized with 5 per cent solution of dichromate, exposed under a positive in appropriate register, and the film, after washing, toned with pinatype red, or other suitable dye, which only takes on the unexposed gelatin. For three-color work the dyes should be mordanted with cupric sulfate, coated with another dichromated film, again printed and dyed up with a yellow dye of like character.

F. E. Ives[55] would adopt the same process almost, that is, toning the first positive with a ferrocyanide blue, then dichromating, exposing, wash-

ing, but would use eosin red, which was said to be mordanted by the chromium compound of the image. Or a black and white positive might be used instead of the second negative and a dye, such as fast red, which takes on the unexposed gelatin, or the second image might be obtained by an imbibition process. C. F. Jones[56] patented the use of two separate negatives, toning one blue, then sensitizing with dichromate solution containing a yellow dye and printing the second positive on to this film and staining up in the appropriate color.

It must not be supposed that in this sketch of the subtractive processes all are included here that can be rightly considered so; but only those not dealt with elsewhere, which will be found under various headings. For instance, many of the relief processes have been, or can be used, and various mordanting processes fall into the same category. Here, however, are grouped methods which it would seem could be best dealt with under this heading, the main idea of the patentees being to claim or produce subtractive cinematographic pictures.

W. V. D. Kelley[57] would tone the first image by the diachrome process to a green, then sensitize with dichromate and print from the positive of the second record and dye with a pinatype dye. H. Shorrocks[58] would adopt resists to protect one series of colored positives, and the others might be treated by the diachrome process, and after removal of the resist, immersed in a combined green and red toning mixture, consisting of ferricyanide, vanadium chloride and a ferric salt with ammonium chloride, sodium citrate and rhodamin. The iodized image absorbed the dye, while the hitherto protected images were toned green. S. M. Procoudin-Gorsky[59] proposed to obtain a negative with recurring sets of color records, then to print the minus-yellow constituents first, iodize and dye with auramin, which was mordanted with aluminum acetate and then fixed. The film was again coated with emulsion, exposed under the minus-red negative, again iodized and dyed with rhodamin, again recoated and the final image toned blue with a cyanotype mixture.

Cemented Films.—E. Witte[60] pointed out that with the additive process, special projection apparatus was required, and to obviate this he proposed to use multiple-film negative stock, which must be separable, and one carrier of which at least might be colored. Probably a species of film pack is meant. Subsequent registration was to be obtained by marks or perforations. The positives might be obtained by the carbon process, or by the conversion of the silver image into a colored one. The inventor then says: "After making the negative films they are brought together with the similarly or like prepared positive films, and these two films provided with corresponding letters or marks. Now the possibility is given without further trouble of bringing the separate positive bands into corresponding contact, and to convert them in a known manner into one colored image (possibly orange and blue), if a printing process has not been

selected which gives a colored impression without further treatment. The prepared film bands, which carry the individual constituent images, can now with the aid of the corresponding register marks, etc., be brought immediately into the correct mutual position, *if required with the use of an adhesive or cement.* The preparation of a three-layer film is obvious from the above description without further comment."

This is, so far as can be traced, the first suggestion for the cementing together of the individual colored constituent images to form a subtractive cinematograph film, capable of projection in any machine. The cementing of the three positives, however, whether for prints or transparencies, was well known at this time to those skilled in the art.[61]

J. E. Thornton[62] proposed to use extra thin celluloid, not more than 0.002 in. thick and produce the constituent images on triple-width film. The methods of obtaining the colored images might be by any process. The film was then to be slit and the images superposed and cemented together, thus producing a single subtractive picture, which might be run through any projector, as outlined and anticipated by Witte above. In this patent the inventor gives the printing colors as red, green and violet, thus obviously giving incorrect results. A machine was also patented[63] for developing, dyeing and assembling multiple-width positives. A further modification,[64] such as the Tauleigne-Mazo iodide process, or the absorption of dyes by hardened or unhardened gelatin, or the formation of reliefs, was patented. The obtaining of register by means of the perforations was also claimed. Later[65] the thin films were to be supported on an inextensible base, such as metal. M. and H. Nekut[66] also patented the use of a provisory support with subsequent superposition and stripping. In a later patent[67] Thornton claimed cementing the images or celluloid together. For the temporary support[68] a rough-surfaced paper coated with rubber might be used. The two-color images might be produced by any and every process that has ever been suggested or used.

F. E. Ives[69] proposed to make two separate negatives, one of them reversed, and positives from the same were toned in the proper colors and cemented face to face with gelatin or other cement, and the celluloid dissolved from one face with amyl acetate whilst wet. In another process[70] the first image of a tri-color picture was to be obtained by cyanotype toning a silver image. The gelatin was to be then sensitized with dichromate, the image stained up with eosin red, and the third image obtained by imbibition from a separate dyed relief. A method which had been in use for many years. The same inventor also patented[71] the use of what he called "dichroic" images. Positives were made as usual, but in making the green filter negative it was preferred "to admit to the sensitive film a slight amount of blue light, enough to give a pale or feeble effect," thus following Bennett's idea, as outlined for Kinemacolor. But the main idea seems to have been the mixture of dyes, for instance, fast red D in

conjunction with brilliant yellow for the red impression, it being claimed that the lighter tones were thus rendered yellow. The practice of the mixture of dyes to give this effect was common knowledge, and had been in use almost since the first subtractive pictures were made (see von Hübl, p. 443).

A. R. Lawshe[72] disclosed a method of cementing the celluloid base of two-color subtractive pictures so that the images would be on the outside. This patent is for a method of producing multi-colored pictures (see p. 334), and whilst it deals primarily with stills, its use for cinematography is specifically disclosed. This it is believed is the first instance of the pictures being cemented base to base.

A. Coppier[73] would produce films in colors by making enlargements, coloring the same and then assembling and copying. M. Holfert[74] patented the use of films which were each coated with the same positive emulsion. D. F. Comstock[75] patented the control of the gammas, or degree of contrasts, of the positives, by alteration of the color of the printing light. This principle was first suggested by Lemann[76] and had been in constant use for many years. W. Finnigan and R. A. Rodgers[77] would take the negatives with two films in contact with one another. The front one being an ordinary emulsion, and the rear a panchromatic, sensitized with a mixture of pinacyanol, pinaverdol and fuchsin. The positive from the rear negative was dyed blue-green, and that from the front one stained a pink-red. The two were to be "hermetically fastened together in any way that may be desired."

C. Raleigh[78] patented the reduction of the intensity of one colored image with regard to the other. H. Tappen[79] would dye the celluloid with a dye, that would not wash out, for positive work. The Technicolor Motion Picture Corporation[80] proposed to form subtractive films by cementing two thin films either face to face or back to back, with a temporary metal strip backing if desired. Or relief films on metal backings might be used for imbibition. Accurate registration was to be obtained by the perforations. A. P. Kennis[81] would print on to triple-width film, suitably color the positives by a photomechanical process, then slit the wide strip, which carried six rows of perforations and join up the ends as usual. W. Zorn[82] patented a process for the chemical treatment and coloring of films, in which the chemicals were brought into a pasty condition with a binding medium, and then applied to the film. T. A. Edison[83] would take ordinary black and white negatives, make a positive therefrom and block out the various colors, make a second negative from which the projecting positive was made. V. Casiraghi, L. Sabourin and V. Sabourin[84] patented the use of three films, exposed side by side through three lenses and cementing the constituent positives together.

1. E.P. 4.045, 1912; Brit. J. Phot. 1913, **61**, 232.
Many of Thornton's patents for dichromate processes have but indirect connection with color. See E.P. 3,384; 3,385; 4,043; 4,044; 4,164; 12,231; 14,433;

29,112; 29,113, 1912; 9,865, 1913; 14,901; 29,512; 29,513; 29,514; 29,515, 1914; 5,100, 1915; Brit. J. Phot. 1913, **60**, 231, 232, 292, 501; 1914, **61**, 109, 387; 1915, **62**, 499; 1916, **63**, 587; C. A. 1914, **8**, 1294; U.S.P. 1,158,587; 1,160,671; 1,169,096; 1,173,898; 1,173,899; 1,169,097; 1,213,037; 1,213,038; 1,233,447; F.P. 450,731; 451,015; 454,557; 456,776; addit. 17,842; 478,928; 478,986; 479,051; 459,122; 459,123; 459,124; Belg.P. 253,302; 253,340; 253,455; 256,742; 256,743; Chem. Ztg. 1916, **40**, 600; D.R.P. 288,548.

 2. E.P. 6,061, 1913; Brit. J. Phot. 1914, **61**, 329; U.S.P. 1,288,753; abst. J. S. C. I. 1919, **38**, 158A.

 3. U.S.P. 1,389,963; abst. Sci. Tech. Ind. Phot. 1922, **2**, 52.

 4. F.P. 538,026, 1921.

 5. U.S.P. 1,398,286, 1921.

 6. E.P. 6,292, 1914.

 7. F.P. 412,498, 1910.

 8. E.P. 29,586, 1910; Brit. J. Phot. 1911, **58**, 656; Bioscope, 1911, 341; F.P. 424,895.

 9. U.S.P. 1,313,587, 1919; Photo-Era, 1917, **36**, 143; M. P. News, 1918, 1333. Cf. U.S.P. 1,253,796.

 10. F.P. 401,180, 1908.

 11. E.P. 2,584, 1908.

 12. F.P. 431,967, 1910.

 13. E.P. 24,455, 1914.

 14. F.P. 532,396, 1920.

 15. F.P. 514,076, 1920.

 16. F.P. 534,807, 1921.

 17. F.P. 540,328, 1921.

 18. F.P. 562,217, 1922.

 19. E.P. 4,288, 1915; Brit. J. Phot. 1915, **62**, 548.

 20. F.P. 524,841, 1920; abst. Sci. Tech. Ind. Phot. 1922, **2**, 19. Hardy and Hardy, E.P. 2,136, 1914 also used two films with reciprocating shutter.

 21. E.P. 18,352, 1911; Brit. J. Phot. 1912, **59**, 733; Can.P. 162,507; F.P. 433,663; U.S.P. 1,127,382; 1,167,643; Jahrbuch, 1913, **27**, 145. The Natural Color M. P. Co. and W. Oliver also proposed to use triple-width films (see p. 591).

 22. E.P. 23,551, 1911; Brit. J. Phot. 1912, **59**, 904; Jahrbuch, 1913, **27**, 140.

 23. "Outlines of Applied Optics," Philadelphia, 1912, 132.

 24. Compt. rend. 1903, **137**, 977, 1046.

 25. E.P. 2,218, 1912; Brit. J. Phot. 1913, **59**, 789; Jahrbuch, 1913, **27**, 145, 345.

 26. E.P. 14,142, 1913; Brit. J. Phot. 1914, **61**, 290; F.P. 459,467; D.R.P. 229,007, granted to Gorsky and Maximowitsch; Jahrbuch, 1911, **25**, 693; Phot. Ind. 1911, 95. Cf. D.R.P. 310,348. For projector see F.P. 460,962; D.R.P. 310,349, 1913.

 27. U.S.P. 1,328,352; E.P. 100,717; Brit. J. Phot. 1916, **63**, 548; F.P. 481,792. For projectors for the same see E.P. 7,657; 7,658; 7,659, 1915; Brit. J. Phot. loc. cit.; F.P. 481,793; 481,794; 483,046; E.P. 14,722, 1915; ibid. 692; U.S.P. 1,284,587; 1,309,992.

 28. U.S.P. 1,324,122, 1919.

 29. F.P. 476,146, 1914.

 30. F.P. 469,943, 1913.

 31. E.P. 151,383.

 32. E.P. 21,623, 1912.

 33. E.P. 188,329; Brit. J. Phot. 1924, 71, Col. Phot. Supp. **18**, 27; F.P. 551,357; 557,750; abst. Sci. Tech. Ind. Phot. 1923, **3**, 162; Brit. J. Almanac, 1925, 322; Can.P. 246,810; 246,809. Cf. Gleichmar, p. 328 for folded films. J. A. Ball, Can.P. 246,799. L. T. Troland and J. A. Ball, Can.P. 246,787.

 34. E.P. 9,532, 1911; Brit. J. Phot. 1912, **59**, 619; Jahrbuch, 1913, **27**, 145.

 35. E.P. 8,207, 1912; ibid. 1913, **60**, 386.

 36. F.P. 451,678, 1912.

 37. E.P. 20,836, 1907.

 38. E.P. 23,688, 1910; Brit. J. Phot. 1911, **58**, 859. Cf. E.P. 19,028, 1909; ibid. 1910, **57**, 712.

 39. F.P. 467,609, 1913.

 40. E.P. 9,912, 1909; Brit. J. Phot. 1910, **57**, 407. Cf. E.P. 17,309, 1908; ibid. 1909, **56**, 689.

41. Brit. J. Phot. 1911, **58,** Col. Phot. Supp. **5,** 45.

42. "Wratten Light Filters," Rochester, 1916, 3rd edit. The alternative filters were not recommended in the 1920 edition.

43. E.P. 28,081, 1911; Brit. J. Phot. 1913, **60,** 329; F.P. 451,809; U.S.P. 1,172,621; Jahrbuch, 1915, **29,** 161; Belg.P. 251,842; Can.P. 150,954; D.R.P. 275,683; Austr.P.A. 10,241, 1912.
Mills and Kent, E.P. 626, 1912; Brit. J. Phot. 1913, **60,** 386 also patented a similar method, but there is no claim for a toning process.

44. E.P. 20,555, 1912; D.R.P. 327,439; 327,440; F.P. 466,472; 482,514; abst. Sci. Tech. Ind. Phot. 1921, **1,** 36. Cf. D.R.P. 389,538.

45. E.P. 20,556, 1912; Brit. J. Phot. 1913, **60,** 845; E.P. 29,616, 1912; ibid. 1914, **61,** 126; abst. J. S. C. I. 1914, **34,** 221; F.P. 531,529. In E.P. 12,091, 1915; Brit. J. Phot. 1916, **66,** 560; abst. C. A. 1919, **13,** 3,094; J. S. C. I. 1916, **36,** 1,035; Annual Repts. 1917, **2,** 501, the machine and method of waxing the support is dealt with. Cf. Phot. J. 1919, **59,** 42. Can.P. 212,713; 220,369; 159,408.

46. E.P. 16,353; 16,354, 1913; Brit. J. Phot. 1914, **61,** 715; F.P. 475,065. Cf. E.P. 9,044, 1914; ibid. 1915, **62,** 45; E.P. 9,043, 1914; ibid. 14.

47. E.P. 21,778, 1913; Brit. J. Phot. 1915, **62,** 90, granted to F. J. Norman, T. F. Dawes and W. Buchanan-Taylor; abst. C. A. 1915, **9,** 763; J. S. C. I. 1915, **35,** 199. An almost identical patent was granted to the same patentees E.P. 20,433, 1914; Brit. J. Phot. 1916, **63,** 117; abst. C. A. 1916, **10,** 861; J. S. C. I. 1916, **38,** 276; Annual Repts. 1916, **1,** 306; Jahrbuch, 1915, **29,** 169.

48. E.P. 7,368, 1913; Brit. J. Phot. 1914, **61,** 503; 1915, **62,** Col. Phot. Supp. **9,** 36; abst. C.A. 1914, **8,** 2,987; F.P. 470,176; D.R.P. 329,509; Phot. Ind. 1921, 205; U.S.P. 1,193,879; abst. J. S. C. I. 1914, **33,** 503; Sci. Tech. Ind. Phot. 1921, **1,** 55; Jahrbuch, 1915, **29,** 153. In E.P. 13,874, 1907; Brit. J. Phot. 1908, **55,** 29 Donisthorpe had patented the use of these same hardening baths.

49. E.P. 552, 1914 granted to W. F. Fox, W. H. Hickey and Kinemacolor Co. Cf. E.P. 8,728, 1914; 3,666, 1915; U.S.P. 1,166,121; 1,166,122; 1,166,123; 1,187,241; 1,187,422; 1,187,423; 1,207,527; 1,156,675; Belg.P. 264,041; 264,042; 266,862; F.P. 467,400; 478,011; 476,049; Can.P. 157,088; 159,986; 162,999; Brit. J. Phot. 1915, **62,** 13; Phot. Dealer, 1916, 324; M. P. News, 1918, **17,** 2,110, 2,170; abst. C. A. 1916, **10,** 2,076; J. S. C. I. 1914, **33,** 1,227 1916, **35,** 73; Jahrbuch, 1915, **29,** 154; D.R.P. 297,862; Phot. Ind. 1917, 379; Phot. Korr. 1917, **54,** 297; Chem. Ztg. Rep. 1917, 244.

50. D.R.P. 315,220, 1918; addit. 313,561.

51. D.R.P. 345,531, 1920.

52. D.R.P. 101,379; 116,538; Silbermann, **2,** 401; Jahrbuch, 1900, **14,** 681. Cf. Schelter and Giesecke, D.R.P. 152,799, 1901; Silbermann, **2,** 406.

53. U.S.P. 827,241, 1906. Cf. Pfenninger and Townsend, E.P. 26,608, 1910. J. A. H. Hatt, U.S.P. 1,518,426, 1924 also proposed to superpose negatives and positives to obtain better color rendering for photo-mechanical printing.

54. E.P. 15,648, 1914; Brit. J. Phot. 1915, **62,** 673; F.P. 479,130.

55. U.S.P. 1,170,540, 1916; F.P. 497,133; abst. J. S. C. I. 1916, **35,** 386; E.P. 9,951, 1915, void; Can.P. 168,200; 168,201; E.P. 119,854, 1917; Brit. J. Phot. 1919, **67,** 578; Col. Phot. Supp. **13,** 38. Cf. U.S.P. 1,278,667, 1918 in which a copper-toned image is combined with a blue-green one.

56. E.P. 105,380; Brit. J. Phot. 1917, **64,** 217; abst. J. S. C. I. 1917, **36,** 615; Annual Repts. 1917, **2,** 502; Austr.P. Anm. 1957; Phot. Ind. 1917, 291; Jahrbuch, 1915, **29,** 153; D.R.P. 349,944; Phot. Ind. 1922, 549; F.P. 481,533; Can.P. 172,822. In E.P. 170,932; F.P. 524,842; U.S.P. 1,416,645 a camera for making the negative.

57. U.S.P. 1,278,161; abst. J. S. C. I. 1918, **37,** 749A; Jahrbuch, 1915, **29,** 156.

58. E.P. 111,054; U.S.P. 1,303,506; abst. J. S. C. I. 1917, **36,** 1920; 1918, **38,** 479A; Jahrbuch, 1915, **29,** 155.

59. E.P. 168,100; Brit. J. Phot. 1921, **68,** 600; Col. Phot. Supp. **15,** 38; Phot. Ind. 1921, 277; Sci. Tech. Ind. Phot. 1922, **2,** 62; 1923, **3,** 100; D.R.P. 335,138; 362,107; Phot. Ind. 1921, 546; 1923, 180; F.P. 541,361; Can.P. 227,393. In E.P. 135,166; 135,171; Brit. J. Phot. 1921, **68,** 239; U.S.P. 1,412,089 the same inventor patented a symmetrical printer for colored films. E.P. 135,167, 1918 is for an electric time switch. Cf. Co. gén. d. Phon. Ciné. F.P. 412,517, 1910. L. Sabourin, F.P. 582,229.

60. D.R.P. 219,661, 1908; Jahrbuch, 1910, **24,** 339, 1911, **25,** 339.

61. It is unnecessary to give all the references to the cementing of constituent positives; but the following may be referred to: "La Triplice photographique et

l'Imprimerie," 1897, 252; E.P. 2,973, 1876 du Hauron. L. Vidal, F.P. 102,415, 1874. M. and H. M. Miley, U.S.P. 711,875. A. Gurtner, D.R.P. 146,149, 1902; E.P. 7,924, 1903. J. W. Bennetto, E.P. 28,920A, 1897. E. J. Wall, Brit. J. Phot. 1907, **54**, Col. Phot. Supp. **1**, 9; E. Grills, ibid. 17.

62. E.P. 26,786, 1911; Brit. J. Phot. 1913, **60**, Col. Phot. Supp. **7**, 29; U.S.P. 1,229,546; D.R.P. 328,849; Dan.P. 18,450; Jahrbuch, 1913, **27**, 142.

63. E.P. 12,229, 1912; Brit. J. Phot. 1913, **60**, 482; E.P. 12,231, 1912; ibid. 501; F.P. 459,122; 459,123; 459,124; U.S.P. 1,160,096; 1,169,098; D.R.P. 275,551; 287,176.

64. E.P. 26,827, 1912; Brit. J. Phot. 1913, **60**, 30; Jahrbuch, 1913, **27**, 142.

65. E.P. 26,828, 1912; ibid. 30; D.R.P. 275,320; F.P. 474,046 granted to Kino-Films Ltd.; Jahrbuch, 1913, **27**, 142.

66. Austr.P. A4,166, 1913.

67. E.P. 213,647, 1922; 213,866; abst. J. S. C. I. 1924, **43**, B538; Sci. Ind. Phot. 1925, **5**, 50. Cf. E.P. 213.866; 224.570; 224.571; 224,572; 224.573; 232,302; 230,965; 231,030; 231,058; 233,985; 233,989; 233,990; 233,991. F.P. 581,288; 582,276.

68. E.P. 214,934, 1922; abst. C. A. 1924, **18**, 3011; Brit. J. Phot. 1925, **72**, 7, Col. Phot. Supp. **19**, 4.

69. U.S.P. 1,248,864; abst. J. S. C. I. 1918, **37**, 75A.

70. U.S.P. 1,188,939, 1916.

71. U.S.P. 1,376,940; abst. Sci. Tech. Ind. Phot. 1922, **2**, 16.

72. E.P. 131,319, 1916; Brit. J. Phot. 1920, **67**, 144; Col. Phot. Supp. **13**, 11; U.S.P. 1,248,139.

73. F.P. 527,145; addit. 24,045; abst. Sci. Tech. Ind. Phot. 1922, **2**, 76; 1923, **3**, 82; E.P. 186,649.

74. D.R.P. 286,657, 1913; Phot. Ind. 1915, 621; Phot. Chron. 1917, **24**, 122; Jahrbuch, 1915, **29**, 169.

75. U.S.P. 1,283,087; E.P. 132,580; Brit. J. Phot. 1920, **67**, 84; Col. Phot. Supp. **13**, 5; abst. J. S. C. I. 1919, **38**, 234A; Annual Repts. 1919, **4**, 512; F.P. 491,616; Le Procédé, 1921, **23**, 35; D.R.P. 345,575.

76. Kreutzer's Zeits. f. Phot. 1861, **3**, 182; Handbuch, 1899, **4**, 104. Cf. W. E. Debenham, Brit. J. Phot. 1890, **37**, 516,542.

77. E.P. 140,349; Brit. J. Phot. 1920, **67**, 256; Jahrbuch, 1915, **29**, 157.

78. Belg.P. 247,248, 1912.

79. D. G. M. 398,455; Jahrbuch, 1910, **24**, 332.

80. E.P. 209,404, 1923; F.P. 575,211; D.R.P. 405,155; abst. Sci. Ind. Phot. 1925, **5**, 46; Brit. J. Phot. 1925, **72**, 265. Cf. Lawshe above.

81. U.S.P. 1,489,945, 1924. Cf. E. Etienne, F.P. 572,333; 572,334; Chim. Ind. 1925, **13**, 627.

82. D.R.P. 374,347, 1922.

83. U.S.P. 1,138,360, 1915.
The following patents deal with stencils or coloring machines; Neue Phot. Gesell. D.R.P. 245,468, 1910; abst. C. A. 1912, **6**, 2583; Zeits. ang. Chem. 1912, **25**, 1097. Itala-Film-Ing. Sciamengo and Pastrone, F.P. 435,082; 435,083, 1911; U.S.P. 1,036,730. Co. Gén. Phon. Ciné. E.P. 14,743, 1909; abst. Brit. J. Phot. 1910, **57**, 269; J. S. C. I. 1910, **29**, 517; Jahrbuch, 1910, **24**, 339; 194, **25**, 332; Belg.P. 199,714; F.P. 331,859; 413,141; 413,142; Can.P. 107,858; D.R.P. 227,683; Phot. Ind. 1910, 14. A. T. Saunders, U.S.P. 1,366,954; 1,317,825; F.P. 522,418; E.P. 156,612; Sci. Tech. Ind. Phot. 1921, **1**, 96, 103. A. Wyckoff and M. Handschiegel, U.S.P. 1.303,836; 1,303,837; E.P. 126,745, 1917; abst. J. S. C. I. 1919, **38**, 479A, granted to J. L. Lasky; Cf. U.S.P. 1,316,791; F.P. 498,793. Société des établissements Gaumont. U.S.P. 1,035,433; D.R.P. 207,830; F.P. 394,199; 394,236; 418,773; D.R.P. 231,531. Mery, F.P. 397,629. J. Jourjon, D.R.P. 252,103; F.P. 445,137. P. E. Stow, U.S.P. 1,130,645; 1,162,886; E.P. 27,793, 1912; Brit. J. Phot. 1914, **61**, 87; D.R.P. 321,553. W. Friese-Greene, E.P. 10,191, 1914. Cf. A. S. Cory, M. P. News 1917, 1038. N. Marceau, Can.P. 114,074, 1908. M. Vandal, E.P. 12,788, 1912; U.S.P. 1,226,282. G. Taussig. U.S.P. 1,396,791; 1,398,286. K. Geyer, D.R.P. 364,395. H. Joly, F.P. 383,074, 1906. Gillespie and Mackey, U.S.P. 1,342,803; F.P. 516,782. Pathé, F.P. 568,907; E.P. 130,603; 219,302. C. W. Mable, U.S.P. 1,230,714, 1917. Ivatts, U.S.P. 923,432. Wight, U.S.P. 949,558. Dick, U.S.P. 538,663. J. Campbell, U.S.P. 1,184,226. W. Zorn, D.R.P. 389,050. Cf. C. Forch, Kinotechnik 1921, **3**, 248,289; Rev. Franç. Phot. 1921, **2**, Supp. 84. Pathé Cinéma, E.P. 219,302, 1923. A. H. Herault, F.P. 528,889; addit. 28,942.

84. F.P. 578,246, 1924. Cf. F.P. 582,504.

CHAPTER XXV

DOUBLE-COATED STOCK

The use of double-coated stock, that is film coated on both sides with emulsion has become fairly general for subtractive processes, and it has been thought well, therefore, to devote a special section to the same.

E. Lewy[1] (p. 651) seems to have been the first to have actually used double-coated film for color photography, though as will be seen from the footnote, its use for black and white is both old and fairly wide. Lewy's patent is primarily for obtaining a polychrome positive, which could be printed from on bleach-out paper; yet it clearly defines this form of film. He said: "In the film support of the present invention three light-sensitive surfaces are so combined, that they may be developed without the necessity of their being completely separated from one another. The film support used in the invention, *a,* for instance a glass plate, has on one side a light-sensitive gelatin emulsion coating *b* and is so bound up with a film *c,* coated on both sides with light-sensitive emulsion,

FIG. 177. Lewy's D.R.P. 238,514

that the latter at *d* on one side of the support is glued on or otherwise fastened. The film supports folded together thus show three films. Each of the films is simultaneously stained as a filter for the surface lying thereunder." The illustration of the patent is shown in Fig. 177.

The next patent to interest us is one granted to T. A. Mills and F. W. Kent[2] and in the provisional specification the applicants state: "The film band for the positive is coated on both sides with an appropriate sensitive material, gelatino-bromide for example this being made of a rather full density and this film-band is laid for printing between the two original negative bands, so that these two negatives will correspond image for image and detail for detail. This combination is now passed through an appropriate sprocket mill or printing device and both sides are exposed to light either simultaneously or successively so as to impress one developable positive on each side of the medial band." F. W. Kent[3] patented a transfer process on somewhat the same lines as above and suggested that after sheets of paper had been combined back to back, that they should

639

be coated on both sides with sensitive material, and that the paper should be yellow or dark or non-actinic to prevent the light from one side penetrating through to the other.

Another interesting patent is one granted to the Société des Établissements Gaumont,[4] which whilst not for color photography, utilized double-coated film, and has some features valuable from the patent standpoint. The aim of the patent was the application of the anaglyphic principle to stereocinematography by the aid of a single film, printed on both sides in different colors. The film was to be coated on both sides with gelatin emulsion with a substratum or underlying film of an actinically opaque color. Or it might be coated with dichromated colloid on both sides. The images were to be obtained in complementary colors, red and green being cited in the patent. The positive was to be observed through colored glasses, thus giving the effect of relief, the principle being that of d'Almeida and du Hauron.

J. E. Thornton[5] followed Gaumont's method in a very striking manner, and the similarity between the two in the use of the "opaque or light-obstructing medium" between the sensitized layers is remarkable. It will be understood that "opaque" here means actinically opaque to the printing light, and not opaque like metal. The same inventor[6] again patented the same idea, but this time admitted the possibility of using a single negative film with recurring color records, instead of the two separate negatives of the previous patent. In a further patent[7] he proposed to make from an alternating color record, two or more separate negatives and to print them on double-coated positive film.

A. Hernandez-Mejia[8] also patented the use of double-coated film, and his first claim reads: "The improved process of making a colored photographic transparency, for projecting or viewing by direct or reflected light, which consists in simultaneously taking two negatives of the same subject, from the same view point, respectively through screens of complementary colors, one of said negatives being directionally reversed with respect to the other. Printing from one of said negatives upon one side of a single transparent positive film, sensitized on both sides, and from the other of said negatives upon the opposite side of said positive film, with the images in register, treating one side of the positive so that the image thereon will appear in one color, and treating the opposite side of said positive so that the corresponding image will appear in a complementary color." Under the name of "Colorgraph," this process was described by Hernandez-Mejia[9] and he stated at the end of his article: "The double-coated positive stock has arrived from Germany, so that the feasibility of this double coating is now commercially established."

W. F. Fox[10] assigned to the Natural Color Pictures Co., the use of double-coated pictures, which were produced by treating both sides with a mixture of uranium nitrate, ferricyanide and acid, then fixing. The film

might then be dried, one side protected by a waterproof varnish and the other side converted into a complementary green by treatment with a ferric salt. Or the second solution might be applied to the wet film by suitable rolling or brushing devices. W. F. Fox, W. H. Hickey and Kinemacolor Co.[11] also claimed the use of double-coated stock, but one of the pictures was in black and white, and the other side in colors only. Later Fox[12] proposed to use this form of positive stock, and the process is referred to under subtractive processes.

F. E. Ives[13] also adopted the use of it with copper mordant toning for one side and cyanotype toning for the other. I. Kitsee[14] would use dichromated gelatin dyed up prior to exposure and the complementary records were printed on the same through the necessary filters. That is to say, the red record was printed through a green screen and the green through a red. After exposure the soluble gelatin was washed away, the exposed parts retaining the color.

W. V. D. Kelley[15] also patented the use of double-coated positive stock, suggesting a spray for applying solutions and a protecting coat of celluloid varnish to one side while the other was being treated with dye solution. In a subsequent patent[16] the use of this stock with a four-color record negative was also claimed. Kelley also patented an additive process.[17] Double-coated stock was used and exposed through a screen of symmetrical pattern, such as lines, dots, etc. The screens for each side being displaced so that the exposed parts of the one side were opposite the unexposed parts of the other. The two-color negatives were then printed on opposite sides in registry and the film further treated as usual. The result being that on one side there were all the blue-green images, broken up into geometrical spaces of clear gelatin, and on the other side all the red images broken up in like manner. But the clear spaces on one side not being superimposed on those of the other, but juxtaposed, they all acted like small windows through which the images could be respectively seen, no matter from which side the picture was examined. The result optically was a two-color screen-plate positive with the color units on opposite sides of the support.

P. D. Brewster[18] would apply the double-coating principle to negative stock, and proposed to insert a stained medium between one emulsion layer and the base to prevent the colored light from penetrating through the support to the other side. One side was sensitized so that it would record one group of colors, for instance blue and green, and the other so that it would record the red and orange. After completion, the image on the front of the film, that nearest the lens, was to be toned blue-green and that on the back red or orange. From this colored negative, a positive was made on double-coated film, one side being coated with a perfectly transparent emulsion stained yellow, sensitive to blue and green, while the other side was sensitive to red. Modifications were suggested, such as

FIG. 178. Brewster's E.P. 1,073, 1915.

FIG. 179. Brewster's E.P. 2,463, 1915.

staining the celluloid itself. A further patent[19] is identical; in the former
the method is claimed and in the latter the film.

In Fig. 178 are shown various types of camera, patented by Brewster.[20]
In *1* a two-lens camera, in *2, 3,* and *5* one-lens cameras. In the case of *2*

the ratio of the light reflected to one film was determined by the distance the prism was set above or below the center of the lens. In *3* the face of the prism *26* was provided with linear reflecting surfaces, as in *4*. In *5* the surface of the prism *33* has recesses *36, 36* ground into its face, the light being reflected from those parts situated over the recesses, and the other part of the light passing through the cemented surfaces *37, 37*, as shown in *6*. Other forms of two-lens cameras are shown in *7, 8* and *9*. In the first case the lenses are vertically juxtaposed and in *8* the components are separated and mirrors used for dividing the beam; whilst in *9* prisms are used.

Abandoning the use of prisms as costly Brewster patented[21] a light-splitting device, which though invented for portraiture, was applicable for cinematography. The same inventor also patented[22] a special type of negative film. This consisted of two transparent supports *4, 6*, Fig. 179, with the color-sensitive emulsions *5, 7* with a spacer *8* and a separator between the two films, specially sensitized for red and green respectively, and they might be on the outside as in *1* or facing as in *2*. The two films and spacer might be attached in any desired manner as by lacing through the holes *19, 19*. The separator might be integral with the spacer and should be sufficiently opaque to prevent the passage of any light. The function of the spacer was to maintain a separation between the films equal to the thickness of a positive film. After the exposure the two films were separated and treated as usual, then reassembled. The positive film, coated on both sides, was placed between the two negatives and printed. The two films might be inseparably connected along one edge as at *19b* in *2* and *6*, in which case they might be held open during development, etc. The type of camera for this film is shown in *8*, and the passage of the light is sufficiently clear. The surface *23* of the prism *15*, was preferably provided with alternating clear bands *25* and silvered ones *24*, as shown in *9* and cemented with Canada balsam.

Modifications were also patented[23] and this requires but little enough comment. In Fig. 180 is shown the film in section in the upper diagram, with a type of optical system in which the film lies on the plane of the optic axis, the two images being obtained by the split and reflected rays. It was suggested that the original film might be converted into a positive by a reversal method and further negatives made from this. Also that in consequence of the non-parallelism of the condenser rays in projection and the thickness of the base the two images would not coincide and there would be fringing on the screen. Hence the inventor preferred "to have the two images exactly superposed or congruent at the center, but one progressively larger than the other to compensate, as it were, for the angularity of the rays, non-axial or extra-axial, used in projection." Consequently he proposed to have a lens in the camera of substantially the same focal length as that of the projecting system. This would obviously mean

a different negative for every theater, that did not possess a given throw, which is absurd commercially.

Brewster also patented[24] two special cameras with registering pins for two separate films at right angles to one another, so as to ensure accu-

FIG. 180. Brewster's U.S.P. 1,258,087 (Page 643).

rate register of the positive films with their respective negative images. In these patents there is also claimed the possibility of using a double-width film instead of the two separate ones. Special spacings of the perforations in the usual margins and the use of circular perforations in the center of the dividing space between consecutive pictures are also shown.

The Printing of Double-Coated Stock.—The usual method of making negatives for two-color work is, as will have been gathered, by alternate recurring color records, and to print these in series of all one color, one may use either a contact method or optical printing. In the former case one has to be very careful that the image on the one side does not penetrate through to the other. It is obvious also that there would have to be some special device by which the negative can be shifted two steps, while the positive film is shifted only one. Optical printing has also been resorted to, defining this as the production of an image on a sensitive surface from a matrix by the aid of a lens system. It is, therefore, differentiated from contact printing in which the sensitive surface is pressed into actual contact with the matrix. In this latter case there is a material image on a substantial support; whereas in optical printing, there is a real but aerial image formed on the sensitive surface; the actual negative, or positive, image being separated by an air space from the sensitive medium.

Optical printing is no new idea, as it has been employed from the very earliest days of photography, as in the making of lantern slides and enlargements. One has but to turn to Sutton & Dawson's "Dictionary of Photography," page 279, to find the following passage: "Printing Process. By 'Printing' is meant the reproducing a positive, in which the lights and shades are true to nature from a negative in which they are reversed. The operation, not being attended with the destruction of or injury to the negative, they may be repeated indefinitely, and therefore any number of prints may be taken from the same negative. There are two methods of printing; one consists in copying the negative by means of a lens, the other by pressing it upon a sensitive tablet in a pressure frame, and exposing to direct light. In both cases the light which produces the print is transmitted through the transparent parts of the negative and stopped by its ·opaque parts."[25]

Optical printing was also employed by H. Joly,[26] T. P. Middleton,[27] H. Dorten,[28] P. Ulysee.[29] C. N. Bennett[30] described a plate-titler as follows: "This is really a combination of printer and ordinary still view projection lantern. The original title laid out in white letters on a black velvet ground is first photographed upon a glass plate by means of a downward-pointing still view camera. The black letter photographic title transparency so obtained is then centered before the condenser of a projection lantern contained within the printing cabinet. By means of a suitable objective lens, also within the cabinet and situate between the title transparency and the printer gate, a sharp image of the title wording is thrown upon the threaded positive stock. Such a form of photographic printing is also known as "reduction titling" as in contradistinction to "contact," where the usual kinematograph negative is employed before the positive stock in the printer. With "reduction titling" it will be seen that only the single thickness of unprinted stock is threaded in the gate, the place of the negative film being taken up by the projected image of the title borne upon the transparency in the focus of the interior projection unit." O. Fulton[31] described optical printing for double-coated material.

Some patents, which have considerable bearing on the subject were granted to W. R. Schwab[32] and it is stated in the specification: "My present invention relates to improvements in photographic apparatus and more especially to the type adapted for the reproduction of books, records and other documents, and the primary object of the invention is to provide a simple, improved and more efficient apparatus of this type whereby accurate photographic reproductions may be made quickly upon oppositely sensitized surfaces such, for example, as a paper or film sensitized upon both or opposite sides, the exposure of both sensitized surfaces being produced by the use of a single lens which splits an object into two images of two objects upon the respective sensitized surfaces. In reproducing records or other matter contained in books, the objects upon the two open

pages of the book are projected through the lens and are properly cast upon the respective sensitized surfaces by the aid of mirrors or other suitable means for bending or directing the light rays. By using a single lens for the exposure of the two sensitized surfaces, not only is the construction and operation of the apparatus simplified, but more uniform results are obtainable."

FIG. 181. Brewster's U.S.P. 1,233,176.

Again in a later patent[33] it is stated: "The apparatus shown in the present instance is adapted to simultaneously expose both sides of a strip of paper or other appropriate material having sensitized surfaces on both sides thereof, the exposure of the two sides of the sensitized medium being effected through the single lens and by the aid of reflectors or equivalent means which divert the light rays from the lens to the opposite sides of the sensitive medium."

For printing on double-coated stock Brewster[34] devised various types of printers of which one is shown in Fig. 181. The film is fed through 5 in 3; 5a being the light source and the beam is split up by the device 7, 8, a prism with silvered bars, and thence to the mirrors 9, 10 to the positive film in the film-gate 11. The exposure of the positive film was controlled by rotary shutters 12, 13, one of which is separately shown, with cut-out quadrants. Another type of printer [35] is shown in Fig. 182, in which the negative 20, 20 is illuminated on each side by the lamps 29, 29, 29, 29, and the image is taken up by the prisms 28, 32, and transmitted by the lenses 2, 2, to the prisms 33, 34 and thence to the films 23, 24, 25.

W. V. D. Kelley and J. Mason[36] patented a printer in which registration of a negative with double-coated positive film was effected by sprocket pins, the one ensuring vertical and the other horizontal registration. Standard positive film was used and certain perforations of each positive picture area were exactly registered with corresponding ones of the negative picture area by pins tightly fitting the perforations from top to bottom in the one case, and from end to end in the other, so that any shrinkage, warping or distortion was taken up here. With standard perforated film this might be satisfactory, but to ensure perfect accuracy a pin on the opposite side was also used, this pin, which fitted opposite perforations of negative and positive stock tightly, had a loose fit from side to side, so that there was allowance for the shrunken negative to slide laterally under the control of the full-fitting pin on the other side. A subsequent patent[37] was for the positive film strip transparency thus produced.

Fig. 182. Brewster's U.S.P. 1,253,137.

J. G. Capstaff[38] would solve the difficulty of printing on both sides of the stock by so selecting the light rays that the absorbing action of the emulsion comes into play. He pointed out that the emulsion "as used on ordinary cinematograph film is somewhat yellow in color, is sensitive mainly to ultra-violet, violet, blue and green light, or in other words to light materially absorbed thereby, which comprises the shorter wavelengths. On the other hand, the opacity of the emulsion to light increases with the decrease in the wave-length of the light, so that light of short wave-length penetrates the emulsion to a less depth than light of a longer one. Accordingly, ultra-violet and violet lights do not pass through the sensitized layer on the ordinary positive film as readily as blue and green

lights. Then, since the emulsion is sensitive only to the green, blue, violet and ultra-violet, I eliminate the blue and green from the source of light and use only the extreme violet and ultra-violet rays." The essence of his invention is the use of the readily absorbed short wave-lengths for printing. But he discloses the possibility of the emulsion being stained, or its support, and the use of light which is thus absorbed and can not pass through to the second surface.

FIG. 183. Capstaff's U.S.P. 1,361,012.

Capstaff[39] also patented a projection printer, in which variations of the size of the images, that might possibly exist, could be compensated for, and in which the images were also projected on a screen, various prisms and lenses being claimed for the apparatus, some of which are shown in Fig. 183. Later[40] he described a projection printer for the registration of the images on opposite sides of double-coated stock. The International Moving Picture & Film Co.[41] patented a printing machine for registering alternately through two complementary colored screens, using a double printer with independent guides for the films.

S. Procoudin-Gorsky[42] proposed to print one of the constituent negatives on to ordinary positive film, convert the image into the complementary color, then recoat with a silver emulsion and print in registration the second image and repeat the operations for the third image. The same inventor described[43] a printer for cine color films having recurrent series of color records. All the pictures of one color were first printed by stepping the negative three pictures to each step of the positive film. J. R. Hunt[44] patented a machine for printing from negatives with alternately recurring records. The positive and negative films moved at the same rate of speed through different paths, so that the red records were printed at one gate upon alternate areas, and the green records at another gate, the lights being of different intensities. C. Paraloni and G. P. Perron[45] patented a projection printer in which the images were reproduced in smaller dimensions on one side of the middle line of the film, the other

Fig. 184. Brewster's U.S.P. 1,223,664 (Page 650).

color records being then similarly printed on the other side of the middle line. D. F. Comstock[46] patented a printer in which the images were obtained in register by optical printing.

Dyeing Up the Images.—The dyeing or staining up of the positive images on double-coated stock naturally requires rather more careful treatment than single-coated, as each image must be protected from the action of the dye that is required for the other surface. The use of resists, either in the form of templates or locally applied solutions, involves a multiplication of operations, which in the handling of long lengths of film stock becomes time-consuming and, therefore, adds to the cost. The use of machines for applying the colors by means of pads, etc., by pressure, necessitates carefully constructed mechanism, so that other methods have found favor with inventors.

Brewster[47] would use a long, narrow tank, Fig. 184, in which the film *2* runs face down over the liquid, being moved by the sprocketed wheels *21, 22,* and kept under a slight vacuum by means of the suction pipe shown above. Two tanks were used, each containing one of the dyes, and between them was placed a wash tank containing constantly renewed water, in which the film took a 180° turn, so that in the second tank the other face was presented to the other dye, which was either to be sprayed on or thrown by means of the revolving brushes, driven by a common drive.

J. G. Capstaff[48] used a long, narrow trough, provided with a plurality of parallel capillary rollers, which revolved in the dye and carried enough to stain up the positive image as the film passed over them; tension rolls between the dyeing rollers regulating the contact surface of the film with the dyeing rollers. An exhaustion box was also fitted which removed excess of dye from the surface of the film. The machine is shown in Fig. 185, and the film runs from right to left. It is unnecessary to enter more

Fig. 185. Capstaff's U.S.P. 1,351,834.

fully into the constructional details, as the operation is sufficiently clear from the diagram.

J. Mason[49] conceived the ingenious idea of treating one side of the film by floating it on the surface of a solution, thus taking advantage of the surface tension. It is obvious that this method does away with any inflatable drums or spraying methods and is extremely simple and effective in action. Besides that the necessary troughs being very long and narrow, in fact they need be but little more than the width of the film itself, space is much economized. J. I. Crabtree[50] patented the use of an inflatable drum, covered with rubber and behind which air or other fluid could be pumped after winding on of the film. This was practically the arrangement used by the author in 1911.

J. H. Christensen[51] patented a process in which the supports were stretched in a frame prior to exposure, thus preventing any contraction and expansion in the subsequent baths. A. Hamburger[52] described a

machine and frame for treating double-coated film positives so that the staining of the one side should not interfere with that of the other. L. T. Troland, J. A. Ball and J. M. Andrews[53] patented an apparatus for treating one side of the film, which is essentially a modification of Mason's idea. F. B. Thompson[54] patented a machine for the automatic development, fixing, toning, etc., of double-coated stock, in which both faces of the film were subjected to the action of the solutions with automatic arrangements to remove surplus moisture from the surface of the film and to obviate shrinkage. P. D. Brewster[55] patented a method of differential development of negatives, taken through red and green filters, so as to obtain equal gammas, and described a machine for the same, in which the film was treated for varying times for each side.

J. G. Capstaff and N. B. Green[56] patented a method of correcting the color or dye ratios on double-coated and stained positive pictures, by treatment of one or other with 1 per cent alcoholic solution of ammonia. The principle of reducing overstained positives by the use of an alkaline solution, such as borax or ammonia, was given by von Hübl[57] (see p. 444).

D. F. Comstock[58] patented a blower to remove superficial moisture from the surface of a film and a suction pad to withdraw any liquid in the perforations. W. V. D. Kelley[59] patented the use of double-coated stock printed from black and white negatives and dyeing up in complementary colors. This was essentially for titles, and by adjusting the colors pleasing results could be obtained. H. Friess[60] patented a machine for dyeing films, consisting of a number of troughs over which the film passed. Over each was a paddle wheel, which forced the film intermittently into the dye solution, the latter being kept in circulation.

1. D.R.P. 238,514, 1910; Zeits. ang. Chem. 1911, **24**, 1956; Chem. Ztg. Rep. 1912, 16; Jahrbuch, 1912, **26**, 359; abst. C. A. 1911, **5**, 40, 359.

Cf. The section on opaque supports also. As to the use of double-coated supports for black and white work see: J. Kirk, U.S.P. 136,439, 1873; Phot. News, 1873, **17**, 225; Phot. Korr. 1874, **11**, 6; Handbuch, 1897, **2**, II, 232. A. Hommel, E.P. 3,059, 1875; Phot. News, 1876, **20**, 308; Phot. Korr. 1876; Phot. Mitt. 1876, **13**, 54. "Amateur Canadian," Phot. News, 1873, **17**, 211, 322; Phot. Times, 1873, **3**, 103. L. Warnerke, E.P. 2,099, 1885; 2,662, 1887; Brit. J. Phot. 1885, **29**, 474; 1886, **33**, 213, 229; Brit. J. Almanac, 1886, 121; Phot. News, 1885, **29**, 474, 604; 1886, **30**, 25, 231, 261. A. Nowicki, Phot. News, 1888, **32**, 19. W. Friese-Greene, E.P. 13,377, 1885; 1,075, 1895; Can.P. 50,899, 1895; 51,412, 1896; D.R.P. 118,205; Silbermann, **2**, 86; Brit. J. Almanac, 1898, 878. T. C. Roche, U.S.P. 328,431, 1885; Can.P. 21,453, 1885. E. and H. Anthony, Can.P. 22,280, 1885. A. Schwarz, D.R.P. 149,799, 1902; Silbermann, 1, 165; E.P. 12,585, 1899; U.S.P. 656,751. Neue Phot. Gesellschaft, D.R.P. 95,197, 1896; Silbermann, 1, 181. H. Goodwin, U.S.P. 610,861, 1898; applic. 1887. Grieshaber, Phot. News, 1890, **34**, 352; Brit. J. Phot. 1890, **37**, 303. G. Rydill, E.P. 5,947, 1883. W. C. Renfrew and F. G. Wilcox, E.P. 2,675, 1913; D.R.P. 269,683, 1913. F. Largajolli, Austr.P. 70,651, 1915; abst. C. A. 1916, **10**, 124. A. C. McCloskey, U.S.P. 1,213,925; 1,265,464, 1918; abst. J. S. C. I. 1918, **37**, 486. A. L. Smith, E.P. 16,999, 1905; F.P. 369,043; abst. J. S. C. I. 1907, **26**, 67; D.R.P. 196,768; abst. Wag. Jahr. 1908, **54**, II, 496; Chem. Ztg. Rep, 1908, **32**, 228; J. S. C. I. 1906, **25**, 654. M. Levy, E.P. 10,098, 1897; Nature, 1897, **57**, 311; Brit. J. Phot. 1897, **44**, 539; Phot. Annual, 1898, 389; D.R.P. 106,576, 1897; Silbermann, 1, 87; Handbuch, 1905, 3, 595; Jahrbuch, 1898, **12**, 231. G. Seguy, Compt. rend. 1897, **125**, 602; Phot. Annual, 1898, 389. A. Edwards, E.P. 111,913, 1916; abst.

Brit. J. Phot. 1918, **65**, 216; J. S. C. I. 1918, **37**, 75A. S. Lacy and H. Fowler, E.P. 27,732, 1913; Brit. J. Phot. 1914, **61**, 669. F. de Mare, E.P. 24,225, 1907; D.R.P. 210,304. O. Fulton and W. Gillard, E.P. 11,219, 1903; F.P. 342,328; E.P. 6,018, 1904; Can.P. 90,029, 1904. A. Hernandez-Mejia, U.S.P. 1,282,829, 1918. The Rheinische Emulsionspapierfabrik, D.G.M. 681,586; Jahrbuch, 1912, **26**, 513. C. Rosier, E.P. 10,205, 1915; Brit. J. Phot. 1916, **63**, 210.

As to the use of emulsions superposed on the same side of the base see: Anon. Brit. J. Phot. 1876, 1893, **40**, 193, 306; 1895, **42**, 803, 818. W. B. Bolton, ibid. 813; Anthony's Phot. Bull., 1876, **7**, 338. J. T. Sandell, E.P. 21,381, 1891; D.R.P. 66,311; Silbermann, **1**, 87; Phot. Annual, 1892, 894; 1893, 85; Brit. J. Phot. 1892, **39**, 812; Cam. Club J. 1892, **6**, 188; Phot. Woch. 1892, **18**, 411; Jahrbuch, 1893, **17**, 193, 379; Phot. Korr. 1829. L. Smith, U.S.P. 746,594, 1903. R. Fischer, E.P. 15,054, 1912; abst. Brit. J. Phot. 1913, **60**, 366; C. A. 1913, **7**, 1,499. Sandell Film & Plate Co. E.P. 25,243, 1902; J. S. C. I. 1903, **22**, 1,148. W. H. Smalley, U.S.P. 723,054, 1903; abst. J. S. C. I. 1903, **22**, 511. A. Balconi, F.P. 466,996, 1914; abst. J. S. C. I. 1914, **36**, 845; Annual Repts. 1916, **1**, 302; Phot. Ind. 1914, 1,091. J. G. Capstaff, U.S.P. 1,303,635, 1919; abst. J. S. C. I. 1919, **38**, 513A; Annual Repts. 1919, **4**, 514; D.R.P. 314,571. C. P. Browning, U.S.P. 1,285,015, 1919; abst. J. S. C. I. 1919, **38**, 118A.

2. E.P. 8,626, 1912; abst. Brit. J. Phot. 1913, **60**, 386; Jahrbuch, 1914, **28**, 521; U.S.P. 1,172,621; Can.P. 159,408; F.P. 461,920; 466,470. Cf. E.P. 20,555, 1912.

3. E.P. 29,616, 1912; abst. Brit. J. Phot. 1914, **61**, 126; J.S.C.I. 1914, **33**, 221.

4. F.P. 420,163, 1909. Cf. C. Forch, "Die Kinematographie," 1913, 140.

5. E.P. 9,324, 1912; Brit. J. Phot. 1913, **60**, 482; U.S.P. 1,250,713, 1917; Belg.P. 257,556; 255,714; D.R.P. 372,910; Phot. Ind. 1923, 607; Jahrbuch, 1914, **28**, 521.

6. E.P. 14,340, 1912; Brit. J. Phot. 1913, **60**, 558; U.S.P. 1,245,882.

7. E.P. 24,534, 1912; Brit. J. Phot. 1913, **60**, 939; Jahrbuch, 1914, **28**, 522.

8. U.S.P. 1,174,144; M.P. News, 1913, Oct. 5. Cf. E. J. Wall, Phot. J. Amer. 1915, **52**, 510; Brit. J. Phot. 1912, **59**, 805; Col. Phot. Supp. **5**, 44; 1916, **63**, ibid. **9**, 22; Jahrbuch, 1913, **27**, 139.

9. Brit. J. Phot. 1912, **59**, 805.

10. E.P. 143,180; Brit. J. Phot. 1920, **67**, Col. Phot. Supp. **13**, 37; Jahrbuch, 1915, **29**, 156; Sci. Tech. Ind. Phot. 1921, **1**, 4; U.S.P. 1,256,675.

11. E.P. 8,728, 1914; U.S.P. 1,166,121; Can.P. 154,713.

12. U.S.P. 1,207,527; Can.P.154,712, 1914.

13. U.S.P. 1,278,668, 1918.

14. U.S.P. 1,298,514, 1919; Jahrbuch, 1915, **29**, 156.

15. U.S.P. 1,259,411; F.P. 539,936.

16. U.S.P. 1,278,162; E.P. appl. 17,002; abst. J. S. C. I. 1919, **38**, 520A; Jahrbuch, 1915, **29**, 156.

17. U.S.P. 1,337,775; E.P. 129,638; Brit. J. Phot. 1920, **67**, Col. Phot. Supp. **13**, 47; 1921, **14**, 18; F.P. 530,049; abst. Sci. Tech. Ind. Phot. 1922, **2**, 44; F.P. 504,580; 540,191.

18. E.P. 2,465, 1915; Brit. J. Phot. 1915, **62**, 386; F.P. 468,397; abst. J. S. C. I. 1914, **36**, 936; U.S.P. 1,145,968; abst. C. A. 1915, **9**, 2,039, 2,355; D.R.P. 305,571; Jahrbuch, 1915, **29**, 157.

19. U.S.P. 1,191,941; E.P. 3,435, 1914; Brit. J. Phot. 1915, **62**, 451; abst. C. A. 1916, **10**, 2,332; J. S. C. I. 1914, **33**, 986; Jahrbuch, 1915, **29**, 157. D.R.P. 305,571

20. E.P. 2,463, 1915; Brit. J. Phot. 1916, **63**, 159; F.P. 479,160; Can.P. 193,747; U.S.P. 1,208,739 is for the type of camera shown in 1, Fig. 178. U.S.P. 1,228,877 for camera 7. U.S.P. 1,253,136; 1,277,041 also for two-lens cameras of similar type; abst. J. S. C. I. 1916, **35**, 329; D.R.P. 333,095; abst. Sci. Tech. Ind. Phot. 1921, **1**, 96; Phot. Ind. 1921, 450; Phot. J. Amer. 1916, **53**, 272.

21. E.P. 1,073, 1915; Brit. J. Phot. 1916, **63**, 210; E.P. 100,082, 1915; ibid. 536; U.S.P. 1,253,138; abst. J. S. C. I. 1916, **35**, 329; F.P. 479,160. For figures see still cameras and chromoscopes, p. 134.

22. U.S.P. 1,222,925, 1917.

23. U.S.P. 1,258,087; 1,284,869; 1,508,916; Can.P. 193,747; D.R.P. 339,025; abst. C. A. 1924, **18**, 3557. In U.S.P. 1,308,538 the use of double-coated film with two-color images is claimed.

24. U.S.P. 1,359,024; 1,359,025, 1920; D.R.P. 386,918.

25. This work was published first in 1858; a second edition in 1867 and from this the passage quoted is taken.

26. F.P. 381,494, 1906.
27. E.P. 16,353; 16,354, 1913; F.P. 475,064.
28. D.R.P. 271,882, 1911; E.P. 15,098, 1913.
29. E.P. 672, 1914; U.S.P. 1,161,910.
30. "Handbook of Kinematography," 1913, 2nd edit. 84.
31. E.P. 5,025, 1910.
32. U.S.P. 1,003,300; E.P. 6,669, 1912; Brit. J. Phot. 1912, **59**, 677; D.R.P. 269,091.
33. U.S.P. 1,084,492, 1914; D.R.P. 388,699.
34. U.S.P. 1,233,176; F.P. 523,030; abst. Sci. Tech. Ind. Phot. 1922, **2**, **4**. Cf. W. Zorn, D.R.P. 387,885.
35. U.S.P. 1,253,137; E.P. 14,102, 1915; Brit. J. Phot. 1916, **63**, 335; F.P. 479,160. Cf. U.S.P. 1,267,844; E.P. 130,002, 1918.
36. U.S.P. 1,350,231; F.P. 502,622; E.P. 130,603; Brit. J. Phot. 1921, **68**, 512; abst. Sci. Tech. Ind. Phot. 1922, **2**, 27; D.R.P. 400,865.
Cf. Rotary Phot. Co. and von Madaler, E.P. 18,851, 1910. Casler, U.S.P. 731,282, 1903, patented registration by pins. The same system had been used by Bell & Howell in their cameras since 1907. Cf. U.S.P. 1,238,520. International Moving Picture & Film Co., F.P. 523,705, 1920; E.P. 148,463. A. Rateau, E.P. 5,026, 1897. W. V. D. Kelley, E.P. 193,363.
37. U.S.P. 1,350,023; 1,350,024, 1920.
38. U.S.P. 1,260,324, 1918.
39. U.S.P. 1,361,012; 1,478,599; E.P. 13,430, 1915; Brit. J. Phot. 1916, **63**, Col. Phot. Supp. **10**, 34; abst. J. S. C. I. 1916, **38**, 868, 907; Annual Repts. 1916, **1**, 304; Phot. Korr. 1915, **52**, 166; Phot. Ind. 1917, 397; Chem. Ztg. Rep. 1917, **41**, 244; 1919, **43**, 172; Jahrbuch, 1915, **29**, 155. Cf. Eastman Kodak Co., D.R.P. 312,752.
40. U.S.P. 1,394,504; abst. Sci. Tech. Ind. Phot. 1922, **2**, 79.
41. F.P. 523,705, 1920.
42. E.P. 135,161; U.S.P. 1,435,283; 1,443,012; D.R.P. 362,107, 1921; Phot. Korr. 1920, **57**, 231; Brit. J. Phot. 1919, **66**, Col. Phot. Supp. **8**, 44; 1920, ibid. 19; Jahrbuch, 1915, **29**, 161; Can.P. 215,991.
43. E.P. 135,171; F.P. 541,192, 1919.
44. U.S.P. 1,320,145, 1919; 1,323,767; F.P. 523,704; E.P. 148,464.
45. F.P. 509,617; E.P. 145,478; Brit. J. Phot. 1922, **69**, 127; Col. Phot. Supp. **16**, 10; abst. Sci. Tech. Ind. Phot. 1921, **1**, 12. The negatives for this were obtained under D.R.P. 358,661, 1920.
46. U.S.P. 1,390,983, 1921.
47. U.S.P. 1,223,664, 1917.
48. U.S.P. 1,351,834, 1920.
49. U.S.P. 1,348,029; D.R.P. 344,352; F.P. 517,577; abst. Sci. Tech. Ind. Phot. 1921, **1**, 80; E.P. 143,230; abst. J. S. C. I. 1921, **40**, 530A; Jahrbuch, 1915, **29**, 159.
50. U.S.P. 1,168,286; 1,225,929; E.P. 6,976, 1915; Brit. J. Phot. 1916, **63**, 58; D.R.P. 297,256; 297,802; Jahrbuch, 1915, **29**, 159.
51. E.P. 128,781; Brit. J. Phot. 1919, **66**, 652; Col. Phot. Supp. **12**, 43; D.R.P. 313,836; Phot. Ind. 1919, 644, 728; Jahrbuch, 1915, **29**, 162; U.S.P. 1,373,053; abst. Sci. Tech. Ind. Phot. 1921, **1**, 96.
52. E.P. 123,786; 123,787; U.S.P. 1,308,708; 1,308,709; 1,308,710; F.P. 495,274; Brit. J. Phot. 1919, **66**, Col. Phot. Supp. **13**, 13, 17; J. S. C. I. 1917, **38**, 304A; Annual Repts. 1919, **4**, 511; Jahrbuch, 1915, **29**, 156.
53. U.S.P. 1,435,764, 1922; F.P. 558,386; abst. Sci. Ind. Phot. 1924, **4**, 31; 1925, **5**, 49; E.P. 211,918; Brit. J. Phot. 1924, **71**, 418; D.R.P. 395,547.
54. U.S.P. 1,328,464, 1920.
55. U.S.P. 1,410,884, 1922.
56. U.S.P. 1,444,329, 1923.
57. "Die Dreifarbenphotographie," 1902, 138, 172.
58. U.S.P. 1,493,246, 1923.
59. U.S.P. 1,461,356, 1923.
60. D.R.P. 354,116.
For apparatus for coating both sides of film see C. Rosier, E.P. 10,205, 1915; Brit. J. Phot. 1916, **63**, 210. For a coloring machine see Hernandez-Mejia, U.S.P. 1,525,423, 1925.
The following articles deal with color cinematography generally: C. Wolf-Czapek, Phot. Korr. 1912, **49**, 436. W. Heyne, Phot. Rund., 1913, **50**, 22. E. König, ibid. 1913, **50**, 3. "Kine-Chromo," Brit. J. Phot. 1915, **62**, Col. Phot. Supp. **9**, 38.

E. J. Wall, ibid. 1916, **63**, ibid. **10**, 19, 22. C. Raleigh, ibid. 1922, **69**, ibid. **16**, 30, 35. C. B. De Mille, Amer. Phot. 1923, **17**, 14; Brit. J. Phot. 1923, **70**, Col. Phot. Supp. **17**, 7. E. J. Wall, Amer. Phot. 1923, **17**, 166; Brit. J. Phot, 1923, **70**, Col. Phot. Supp. **17**, 22. A. Gleichmar, Phot. Ind. 1921, 894. J. Szczepanik, Kinotech, 1924, **6**, 293, 322. O. Pfenninger, Jahrbuch, 1910, **24**, 29. A. Goderus, Bull. Belge, 1912, 215. G. Mareschal, Phot. Ind. 1912, 1712. Kinotech. 1925, 7, 61. P. Tietze, ibid. 129. Spanuth and R. Hornhold, ibid. 157.

CHAPTER XXVI

THE PRISMATIC DISPERSION AND
ALLIED PROCESSES

The Prismatic Dispersion Process.—In this method all color filters are done away with, and separation of the colors is effected by the dispersion of light by prisms. There are two distinct methods which differ widely from one another; in the one, the light is dispersed into a single spectrum and the three negatives obtained by the action of the three different regions. Positives from the negatives thus obtained are placed in the path of the spectral rays and recombined into a colored virtual image. In the second process, the light is split up into a great number of individual spectra, which are all formed side by side on a single negative plate; from this a positive can be made and viewed in the taking apparatus, or projected. One may possibly look upon this method as an optical screen-plate process. Both processes are comparatively simple to work, but the apparatus is costly and they are hardly applicable to general work or exhibition purposes.

The first suggestion as to the former of these processes was made by Chas. Cros[1] (p. 677) in 1869. He suggested that the color filters might be replaced by a prism, which should be turned for each exposure in such a way that in the first case, it would send into the camera only red rays; secondly, only the yellow rays and finally only the blue rays, or by taking simultaneously the three negatives by the three beams, resulting from the decomposition of the light emitted from or reflected by the subject, by the prism. A system of lenses was so placed as to group the rays proceeding from the subject. This compound beam would fall upon the prism, which would decompose it and spread it out into a spectrum, and three elementary lenses would receive respectively the red, yellow and blue rays and form three partial images on the sensitive surfaces. Perhaps it would be necessary to place before each objective a prism, which would compensate for the elongation of the images.

In dealing with the positives Cros is rather more explicit and said: "The synthesis by refraction gives one of the most elegant solutions of the problem. It is based on the following principles: the path of a simple colored ray, which traverses a succession of refractive media, is the same in two directions, that is to say, that the source of the ray and its focus may change places without the path varying. But if a compound ray, containing red, yellow and blue, passes through a prism, each of these rays will be projected at a different place. If then, from each of these places where these rays fall, one transmits rays of the same kind through

655

the prism under the same respective angles as those of their emergence, an identical compound ray is reconstituted. Whence follows the practical process :—three negatives are taken in the three regions of the simple rays of the spectrum. Positives are made from these negatives, either by transmitted or reflected light. To these three positives are supplied the uniform colors red, yellow and blue as they occur. The three proofs are placed back again in the places where they were obtained. In looking at them through the analysing prism they form one and the same image. The same effect is obtained on projecting the rays which pass through the prism on to a screen. In pursuit of this line of thought, a solution is found still more pure and simple, in which the use of all predetermined artificial colors disappears. This is the result of the following principle :— A ray of white light traverses a prism; the red, the yellow and the blue emerge at different angles. If one sends in the reverse direction, and at the same angle as that of the emergence of the red, a ray of white light, this ray is decomposed and all the red that it contains will take the direction of the first ray. Also the inverted white ray will give yellow and

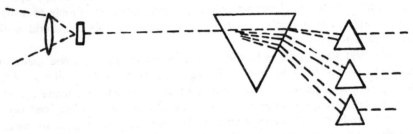

Fig. 186. Donisthorpe's Prismatic Dispersion System.

blue rays in the direction of the direct white pencil. Then the same apparatus, which serves to decompose the subject into three negatives, taken in the red, yellow and blue region of the spectrum, may be used, these negatives having been once obtained, to recompose them. It will be sufficient for this synthesis to replace the three clichés by their positives, noncolored, and to send through each of them the corresponding colored ray. Thus one will have the reproduction of a natural object, either direct in the eye or on a screen. This solution is remarkable in that the result does not depend on an artificially colored product. The colors are thus transformed under purely geometrical conditions and these conditions regenerate in turn the colors. The apparatus only renders in this way that which it receives."

Cros' idea seems to have lain dormant for many years, and to have received but little attention from experimenters. Wordsworth Donisthorpe[2] described a method of prismatic dispersion, which although faulty in detail, is essentially that given by Cros. He suggested the use of one large prism and three smaller ones, as shown in Fig. 186. The light rays were

to be parallelized and passed through the large prism and then the different colored regions separated by the small ones. Three negatives were to be thus obtained, from one of which a print was to be made in one

Fig. 187. Drac's E.P. 1,008, 1904 (Page 658).

color, then this sensitized for the other two. The "heliotype," or carbon, process was suggested as the most suitable. It is immaterial that Donisthorpe's arrangement of the prisms is erroneous, for the light rays

would be refracted towards the bases of the prisms, the essential idea is there.

K. J. Drac[3] utilized the Cros principle, and directly refers to his statements in his German patent. The method substantially consisted in the use of a prism, or set of prisms, by means of which the rays passing through an objective from an object, were split up by dispersion into a spectrum and deflected. The separate parts of the spectrum were then to be collected by means of lenses and directed through suitable lens systems on to sensitive plates. The scheme of the apparatus will be clear from the diagram, Fig. 187; an arrangement of prisms formed the central part, or "analyser," of a camera. In front of the prism was the lens, which rendered the principal beam parallel; behind the prisms *D, D, D* are the reconverting dioptric systems or rear objectives, which threw the colored beams on the plates, if necessary after enlargement. The com-

Fig. 188. Moelant's F.P. 442,766.

position and nature of the lens systems could be varied, since the conditions stated above and also the general conditions with regard to achromatism, aplanatism and anastigmatism could be fulfilled in various ways by known combinations of lenses. The camera could be used both for taking the negatives and reconstituting the image. The positives being adjusted in the positions of the three negatives and a complete picture would be projected on to a screen or into the eye. It was unnecessary to color the positives. Colorless positives exposed to white light produce an image exactly corresponding with the original in all shades of color, since only that color which acted on the negative from which the positive was obtained reaches the front lens. The rays not required were absorbed in the interior of the camera. In a later patent[4] Drac simplified the arrangements so that the number of prisms was reduced from four to two and also

direct-vision Wernicke prisms were used, which considerably reduced the bulk of the optical train.

L. Moelants[5] also patented a somewhat similar system, which, however, does not appear to be so simple as Drac's and is further handicapped in that a slit was used to obtain the spectrum, which would reduce the light to a minimum. The apparatus is shown in Fig. 188.

D. de Bruignac[6] obtained a French patent for a very similar method to Drac's and as outlined by Cros, that is on the principle of the path of the rays and conjugate foci. The apparatus was to consist of a lens giving an image of the subject, an optical system of great dispersion and a colored screen, transparent or otherwise, reproducing the spectral colors. Practically the dispersive system might be a prism placed in front of or behind a camera lens. The colored screen might be obtained, for example, by taking a white surface by Lippmann's interference process. The positives were, as in the other processes, to be placed in the planes of the negatives.

The Micro-Spectra Method of Dispersion.—This happy title was suggested by J. Rheinberg, and aptly describes the second class of dispersion processes.

FIG. 189. Lanchester's E.P. 16,548, 1895 (Page 660).

In 1895 F. M. Lanchester[7] applied for an English patent, the essence of which is as follows: a grating, consisting of opaque parallel bars and clear interspaces, the latter being narrower than the former, was to be placed between the object and the camera, provided with a lens to which was cemented a prism, or this latter might be placed between the combinations or behind the same, the axis of the prism being parallel to the bars of the grating. The dispersion must be such that the images of the grating form a series of spectra on the plate. A filter to give true luminosity values and to absorb the ultra-violet might be used. In landscape work, where the grating can not be conveniently arranged near the object,

a pinhole camera might be used or the lens considerably stopped down, to bring the grating and landscape into common focus on the plate. The apparatus might also be used to make interferential color photographs if the sensitive film were backed with a mercury mirror. The colored picture was reconstituted by placing a positive in the same plane that the negative originally occupied, the grating being illuminated by white light. Or a lamp and condenser might be placed behind the transparency and the image thrown on a screen. In another form the image was first projected on to the grating by a supplementary lens and condenser.

Lanchester gave the following rough sketch, Fig. 189, and explanation: let A be an objective producing the image not more than two inches in diameter in the plane M. Let G be a grating of 300 lines to the inch, situate in the plane M. The opaque inter-spaces of the grating to be twice the width of the clear spaces. Let B be a second objective, projecting an image of the plane M on the ground-glass screen S, with a magnification of two diameters. Let P be a narrow-angled prism, placed just in front of the grating, of such dispersive power that the spectra which it produces on the screen S just lie next to one another without overlapping. Provided the image at M were white (or, in other words, only white light fell upon the grating), then the effect of the above arrangement would be to cover an area of four diameters on the screen with a series of contiguous spectra, 150 per inch. To the unaided eye this surface would appear of a greyish white. In the diagram, part of the screen is shown covered with these spectra, of an exaggerated width. Now suppose for a moment that another grating of 150 lines per inch were laid over the screen, the lines being parallel to the spectra. Then each line of this grating would cover up the same portion of each successive spectrum and the whole field would appear to the eye of some uniform color. If, for example, the lines covered up the red portion of each spectrum, then the field would appear in the complementary color to red, viz., green. If the number of lines of the grating laid over the screen do not exactly correspond with the number of spectra, a comparatively quite long spectrum can be visually produced, because then the successive black lines do not block out exactly the same portions of spectra, but successive portions.

In a private letter to Rheinberg, who later took up this subject, Lanchester stated[8] that his apparatus consisted of a camera and a steel tubular frame, attached to its front, this frame carrying at its front end a silvered glass screen, with slits scratched through the silver, twenty to the inch; the slits forming about one-quarter of its area. The ratio of the reduction was 5:1, the screen being 15 inches square, and the plate 3¼ inches square. The angle of the prism was about 2 to 3 degrees; the pitch of the spectra on the plate was 100 per inch, which were sufficiently fine to fuse optically. The object of the silvered mirror was to reflect light to the subject, which had to be placed as near the screen as possible.

J. Rheinberg[9] suggested a method of like character, which he called the micro-spectra method of color photography; but made no actual experiments, and it was not till he had read of the results of Lippmann's and Cheron's work that he actually started practice of this process; but his suggestions practically covered the field.

G. Lippmann[10] apparently ignorant of previous suggestions, stated the reversibility of the path of the light-rays and then proposed to apply this to color photography as follows: instead of the single slit of a spectroscope, a series of slits very close together were to be used, being fine transparent lines of a ruled screen of 5 to the millimeter. This screen was to be placed in front of a photographic enlarger, that is, a box provided with a sensitive plate at one end, and carrying a converging lens at a plane about midway between its two ends. In front of the lens was to be placed a prism of small angle, with its edge parallel to the transparent lines of the screen. The image to be reproduced was projected on the screen, the sensitive plate exposed, developed and the positive therefrom put in the place of the sensitive plate. On illuminating the apparatus with white light an image was seen in colors. Each line of the screen acted as a slit of a spectroscope and, as the lines were not visible at the distance of distinct vision, the image appeared continuous. It was necessary that the prism be of an angle so small that each spectrum had a length less than the interspaces, otherwise the spectra would encroach on each other. It was also necessary that the positive occupied exactly the same place as the plate in exposure. Were the positive moved in its frame, the colors rapidly changed; if turned, colored moiré effects were obtained. Rapid commercial plates could be used and the exposure would be much shorter than for the interference process.

It might be possible to improve the process so as to avoid the use of an apparatus to observe the colors, and to make the plate sufficient in itself. For instance, suppose that a sensitive plate be placed in an ordinary camera, without a prism, but with the screen, and suppose that on a ruled screen, which might have 5 lines to the millimeter, there was superposed a grating of 500 lines to the millimeter; each luminous point thus projected on to the screen would then spread out as a spectrum, and could be photographed. On applying the screen, with its grating, to the developed positive, one would see the colors of the original if the eye could occupy the place of the lens.

P. E. B. Jourdain[11] stated that he had conceived in 1898 the idea of using diffraction for obtaining color photographs, and said: "It is well known that, when monochromatic light passes through a narrow slit in an opaque screen, it is diffracted, and if the diffracted light is received on a white screen, or viewed through a small telescope, a band of light of that color is seen and right and left of it a series of similar bands, gradually diminishing in brightness and separated by dark bands. The

O, O', lenses; M, single lenses; T, screen; C, C', C'', rack and pinions; R, R', hinges; P, prism; Pl, plate; L, L', micrometric screws; V, eye-hole.

Fig. 190. Cheron's F.P. 377,229.

breadth and closeness of these bands are functions of wave-length; the bands are narrower and nearer together the shorter the wave-length. If the screen is replaced by a photographic plate, there will be on development, bands of deposit whose breadth and closeness depend on the light used,—in other words position of particles in the film takes the place of the original color. Now, if a colored image is formed by a lens on a plate and a grating interposed a short distance in front of the plate, the image will be split up into minute bands corresponding to the wave-lengths at any point. In fact, new gratings whose rulings correspond to the colors at various points of the picture would apparently be formed. In this case the picture, placed in front of a biconvex lens illuminated by a narrow source of light and viewed in the proper position, would appear in natural colors."

In a later paper[12] Jourdain said: "If a slit be illuminated and photographed by a model 'prismatic camera,' the image on the sensitive plate would consist of one or more bands according as the slit was illuminated with monochromatic light or not, in fact, the same kind of effect would be obtained as that shown on the corona photographs obtained by Sir Norman Lockyer with his prismatic camera. It is easy to imagine that a positive from this banded negative, when backed with a screen colored or graduated like a spectrum, and viewed through the prism, could be so illuminated that the colors should be recombined and the eye should see the slit in its natural color. Of course, it is extremely doubtful whether such a process could be of any practical use, as obviously the object must be very narrow."

In March, 1906, Cheron[13] patented a method and his apparatus consisted of two separate cameras, in front the line screen, with a 1:5 ratio of transparent to opaque lines, the latter being about 0.2 mm. wide, was placed in the focal plane, and almost in contact with it a large field lens to condense the light on to a prism of 2.5 degrees, and the lenses of the second

camera. Subsequently Cheron devised another apparatus[14] in which he used a 10-inch focus lens to project the line screen on to the plate, Fig. 190, but the inordinate length of this apparatus—42 inches for a 2½-inch plate —made it extremely cumbersome.

M. Raymond[15] also described an apparatus, Fig. 191, consisting of a long camera with lens of large aperture, which formed an image a' b' on a screen T, of parallel horizontal lines, the opaque ones being twice the width of the transparent and a few fractions of a millimeter wide. The image was then formed, after leaving T, of bright and dark lines, the latter having the color of the object in front of L. This image a' b' was vertical and was transformed after passing through a second lens placed at twice its focus from the screen T into an image, which might be received on a ground glass at the end of the apparatus. If the prism P were placed in the path of the rays, and it was so chosen that its dispersion was equal to one of the transparent lines plus an opaque one, the image b' a'' would be the spectral image of a' b', the spectra being side by side and not overlapping, thanks to the opaque lines. Thus in Fig. 192

FIG. 191. Raymond's Prismatic Dispersion Apparatus.

the spectra d' e', f' g', h' i' correspond to the lines d e, f g, h i, and cover the image of the opaque lines. If the ground glass be replaced by a color-sensitive plate, it would be possible to photograph these spectra, and the exposure would only be about three times longer than in the ordinary way, and this would be due to the absorption by the opaque lines. Subsequently Raymond suggested a still simpler arrangement, which, however, falls into the next section.

F. Urban[16] proposed to first break up the image by means of a cross line or other screen, then pass it through a dispersing medium, such as a simple prism, a direct vision prism, combinations of prisms, small particles of color-diffusing material or a diffraction grating. This is obviously no more than a modification of the previous methods.

The most perfectly worked out system was that by J. and E. Rheinberg,[17] but it still remains more of a laboratory than a practical process. A specially computed direct-vision prism was used, which gave nearly a normal spectrum. The line screen had 500 lines to the inch with the clear

spaces three times as wide as the opaque. The image was split up into contiguous spectra on the plate and obviously only those colors acted that were in the subject. From the negative thus obtained, transparencies were made and viewed in the taking instrument. Reference should be made to the original paper for working details.

FIG. 194. Frauenfelder's U.S.P. 747,961.

FIG. 192. (Page 663).

FIG. 193. Dogilbert's Prismatic Dispersion System.

F. Dogilbert[18] suggested that sheets of celluloid could be moulded by pressure so as to form a multitude of prismatic surfaces, and on the plane side a panchromatic emulsion could be spread. Then on exposure of such a plate through the prismatically moulded surface, the color would be recorded by the diffraction and dispersion without any special arrange-

ment. After development and reversal of the image a plate should be obtained, reproducing the colors in their exact tints. The method of manufacture being very simple, the process could be applied to hand camera films and cinematography. The cutting of the forms *A* and *B*, Fig. 193, could be done by a tool on a dividing machine. In *A* the prisms might be blackened at the apex or not; in *B* biprisms were formed, and in *C* the formation is lenticular and non-achromatic.

This idea was completely anticipated by P. G. and L. R. Frauenfelder[19] the methods being sufficiently clear from the diagram, Fig. 194, to need no further explanation.

The Refraction Process.—Under this title, which has been coined by the author, are included those processes, which may be considered intermediate between the dispersion and diffraction methods which are purely optical. In the methods here considered, though color filters are used, they are placed in the diaphragm and not in contact with the sensitive surface. This division seems to be legitimate, as the refraction process is partly optical like the dispersion and diffraction methods and partly absorptive like the screen-plate processes.

The first suggestion, which outlined the use of colored diaphragms, was made by R. E. Liesegang[20] although primarily it deals with a linear screen method. He stated: "A modification of Joly's process is the use of a diaphragm with apertures, each of which is covered with a yellow, blue or red gelatin film. In order to explain the action of these diaphragms, it is necessary to bear in mind that each aperture of a cross-lined screen acts like a pinhole camera, that is to say it reproduces the diaphragm aperture exactly. When using a square stop the dots in the negative are square; with triangular stops three cornered, etc. If a diaphragm is used with several holes, the negative image with sufficient separation between the screen and the plate, has not the same number of holes as the screen, but as many more as there are holes in the diaphragm. Of the three component points of the half-tone negative, one will be produced by the blue, another by the red and the third by yellow light. In order to convert the negative thus obtained into its natural colors, a grained plate must be prepared with red, yellow and blue points, which must fit the positive made from the negative; also the transparency can be projected through the three colored diaphragm."

In the following year J. A. C. Branfill[21] said: "The plan I propose is to employ a diaphragm in the lens, with four openings suitably arranged, three of them covered with the primary colors, and the fourth left clear, each approximately proportioned in size to the respective exposures required. If a somewhat coarse half-tone screen be used, I should expect to find represented through each opening (at a certain distance) a group of dots, each of which would be rendered in accordance with the color of the original. In order to print on zinc, etc., from such a negative, it

would be necessary to block out, in each group (this would seem to be the most difficult part of the process, but I think it might be done), and the resulting plate would form one of the color blocks. Four blocks thus made would represent the three colors and a key, which might be printed in black or grey according to taste. This plan only requires one negative, and by correct registering, each dot would be separate from the next, unless strongly lighted, when it might overlap its neighbor at the edges."

W. Giesecke, of Leipzig, took out a German patent[22] which while really designated by the inventor as a linear process, is obviously a refraction method, or can be used as such. The specification is worthy of study as the theoretical considerations of the formation of the images is very complete, though marred by erroneous conception of the Joly screen-plate method and the effect of mixing colored lights.

Another patent embodying all the points of Giesecke's was taken out by J. Szczepanik,[23] this latter being applied for on April 12, and Giesecke's German patent on May 30, 1899. F. E. Ives also patented the same idea.[24] The exposure might be made simultaneously or simply by shifting an opaque line screen. The camera was preferably of fixed focus, and for focusing near objects a supplementary lens was interposed. J. de Lassus Saint-Genies[25] apparently ignorant of the work of others also brought forward as novel the use of the three-colored diaphragm.

E. R. Clarke[26] patented a three-color process, in which all three colors were first printed on one negative, one or more groups being then printed on separate plates by means of masks photographically made. In the diaphragm of the lens were three apertures, each covered by a filter. In front of the sensitive plate was placed a screen of fine apertures, each of which threw an image of the diaphragm apertures on the plate. The image was thus made up of three groups of dots representing the three primary colors. A mask was then made by placing another plate in the camera, and exposing through one of the apertures. From this negative, a positive was printed and before development, a printing from the tri-color negative superimposed. When developed a positive representing only one color was obtained. Colored films thus obtained might be super-imposed. M. Raymond[27] also suggested the use of this method, with one large prism of narrow angle, or a series of small prisms, superposed base on apex, the angle of the prisms being from 3 to 8 degrees.

Lenticular Supports.—Although the supposition may be erroneous, still one may be excused from attributing to Lippmann the germ of the following process, in which the support of the emulsion is formed into lenticular shapes. He had proposed[28] a film of celluloid or collodion, which before it had thoroughly set, should be impressed with a sort of honeycomb structure, so that it would be covered on both sides with small hemi-spherical forms. The spaces between these tiny lenses were to be filled with a black material, and each lens, of very wide angle, would form

a photograph of that which was before it on its own minute portion of sensitive film. Thousands of stereoscopic images would thus be formed side by side, each, slightly varying from the other. When, therefore, the film was examined by transmitted light, a series of juxtaposed images would be seen. The eye would see only a point of each image, but the sum of the points would be a complete image, as seen by the eye, owing to the extraordinary accommodation powers of the latter. The position of each point seen would vary naturally with the movement of the eye, and thus by gently shifting the plate a wonderful panoramic effect would be obtained. Given a structure as here outlined it is comparatively easy to imagine the coating of the rear surface with a panchromatic emulsion, and the splitting up of the image into the necessary minute pictures, so that the whole should form a complete color picture when viewed at a distance.

R. Berthon[29] patented the use of a lens diaphragm with three apertures, covered respectively with red, green and blue-violet filters, and a sensitive surface on a support, the other side of which was impressed with hemi-spherical, transparent, refractive protuberances, which acted like microscopic lenses. There would thus be formed on the sensitive surface images of the three-field diaphragm. Or the colored filters of the diaphragm might be apportioned into a series of microscopical parallel transparent portions, then the lenticular forms might take the shape of semicylindrical ridges. The opaque striations of the diaphragm must be inversely proportional to the lengths of the fundamental wave of each colored filter; thus their number must be such that their linear projection on the sensitive film gives at least sixteen lines per millimeter in the red, nineteen in the yellow-green and twenty in the blue-violet. A positive might be made from the negative thus obtained, or the latter might be reversed and the positive viewed through the lens, an image in colors would then be seen or it might be projected.

The essential feature of Berthon's patent was that the tri-color filter should be placed at such a distance in the cone of rays, that three elements were included from any point on the sensitive surface, which was supported on celluloid, and that side presented to the lens being impressed with semi-cylindrical lenses. It was pointed out that the tri-color screen could be replaced by a grating or juxtaposed prismatic elements. Fig. 195 shows the various methods suggested, from which it will be seen that not only circular but hexagonal forms were proposed, these latter having the advantage of giving no interspaces. Later[30] the curving of the lenticular surfaces into cylindrical or hemi-spherical lenses was claimed and also[31] prismatic surfaces.

A. Keller-Dorian[32] patented a method of making the lenticular supports by passing celluloid between a smooth-surfaced cylinder and an engraved one, or a plate could be used. Three forms of film are shown with refractive elements or objectives of square pyramidal form, of hemi-

spherical members, arranged in quincux and hexagonal pyramids. He also patented[33] the use of lenticular supports, and proposed[34] to fill in the interstices between the lenses with a black filling, which might also be

Fig. 196. Landry's U.S.P. 1,189,266 (Page 669).

Fig. 195. Berthon's E.P. 10,611, 1909 (Page 667).

produced[35] photographically by a preliminary exposure of the film with the aid of special annular diaphragms. Probably with the idea of printing from such films, the use of a shutter[36] combined with a between-lens one

is described, each color element being blocked out in turn. Subsequently[37] a total reflecting prism was placed behind the lens, and behind this a plane plate, and the interference of the two was said to obviate the use of color filters. The reflection device might be replaced by one having multiple layers of air, similar to that employed in the Lippmann interference spectrum. For making the cylinders for forming the lenticular elementary forms, the photogravure process was claimed,[38] starch grains being used as the resist. An exhibition of this lenticular system, which has been called the K. D. B. (*Keller-Dorian, Berthon*), was given in Paris[39] and was very highly spoken of.

Pathé Frères[40] patented a method of projecting lenticular films, in which filters were arranged not in the lens, but between the condenser and the film, the lenticular surface of the latter facing the condenser. Three prismatic elements, which might have a divergent cylindrical curvature, might be affixed to the plane face of the condenser. In a later patent[41] an improvement is disclosed, in which convergent cylindrical prismatic surfaces were used, which were adjustable. And a method is described of so adjusting them that each ray passed through its respective element. The use of lenticular surfaces[42] for a two-color stereoscopic process is outlined. Complementary colors were to be used and the results viewed through suitable spectacles.

L. Landry[43] patented a compromise between the purely prismatic and lenticular forms, as he suggested the splitting up of the light by means of prisms, with the use of a crimped support, as shown in Fig. 196. The prisms were staggered and immersed in a liquid, the mean refractive index of which was near that of the glass prisms, such as cinnamic ether. This has a very high dispersion, so that the yellowish-green rays IV had about the same co-efficient of refraction as the glass, whereas it differed considerably for the red and violet.

L. Tissier[44] proposed to eliminate the use of filters also in this process by the use of spectral dispersion, which might be obtained by prisms, non-achromatic lenses, diffraction screens or multiple prisms etc. In the case of the multiple prisms they are shown immersed in cinnamic ether. The use of a number of prisms, immersed in a liquid, was patented by Pathé Frères.[45]

M. Behrens[46] patented a method of producing lenticular supports by using a plastic film, or one that could be made so, and impressing depressions in the same by means of small spheres. The interstices were to be covered with an opaque coating, and the depressions filled up with a medium, the refractive index of which was so chosen that they would act as positive or negative lenses of the desired focal length. Gaumont[47] stated that when using K.D.B. films it was impossible to print by contact, as the elements formed a real diffraction grating. They, therefore, proposed to take separation negatives as usual, make three monochromes,

superpose by projection and obtain a negative in complementary colors and print from this on to lenticular film for projection.

The K.D.B. Société[48] patented the use of black separator papers, the front surface being in contact with the emulsion and provided with a protective coating; thus being somewhat on the lines of the Autochrome system. This was for amateur use of lenticular films. A camera[49] was also patented for obtaining stereoscopic pictures with lenticular film. In order to ensure even illumination the use of a telephoto lens[50] in reverse position was patented. To reduce the size[51] of the elements to the same order of magnitude as the definition of the usual projection lens, or less, the size of the elements should not exceed 0.04 millimeters. Such elements acted as pinholes and might be formed by hollowed engraved dies. Later[52] it was proposed to reduce the size of the elements, so that diffraction would have a preponderating effect in the formation of the images of the ocular disk. The elements numbered 500 per mm., and this number might be so selected that the diameter of each corresponded to the diffraction disk. In printing from lenticular films on to like film, the moiré or watered pattern might be removed[53] by embossing the elements by cylinders at a suitable angle relatively to each other. This angle might be 30, 90, 120, 210, 270 or 330 degrees, but preferably 90 degrees. The interposition of a collective lens[54] in close proximity to the film so as to make the rays, proceeding from the camera lens, strike the elements normally and to correct astigmatism and curvature of the field was patented. Minute cone-shaped figures, either arranged in quincux or hexagonal forms[55] on which the emulsion should be coated. These might be formed by rolling the film or applying a plastic substance. In lieu of lenticular elements the support[56] might be provided on that side opposite the emulsion with a series of minute perforations. The lenticular surface might be turned towards the condenser[57] or a negative lens be placed[58] between the film and the trichrome element.

The Diffraction Process.—This is an extremely beautiful use of the phenomenon of diffraction by gratings, but may be justly described as belonging rather to the laboratory, for practically the results can only be seen by one person at a time, or to very few, as the scale on which they can be thrown on a screen is limited by the great loss of light, common to the use of all gratings. It was devised by Professor R. W. Wood, of the University of Wisconsin.[59]

The theoretical basis of the system is comparatively simple. With diffraction gratings it is found that the greater the number of rulings per unit length, the greater the distance between the central white image and the spectra on each side. It is obvious then that one can so choose the number of rulings in three gratings that any three colors will fall on any given vertical, as shown in Fig. 197, in which S is the central white image, and I, II, III three spectra under one another. The vertical HH

passes through the fundamental red in I, through the fundamental green in II and through the blue-violet in III. If this vertical slice from all three spectra be combined in the eye, or on a screen, one must have white light, and by suppression of any slice or part of the same, color must be the result.

Wood used gratings with rulings of 2,000, 2,400 and 2,750 lines to the inch respectively,[60] the first being used for the red sensation, the second for the green and the third for the blue-violet. Copies of the original gratings were made on dichromated gelatin, to obviate fracture of the originals. Thin German plate was flowed over with:

Emulsion gelatin 40 g.
Water 1000 ccs.
Potassium dichromate, sat. sol............... 16–24 ccs.

Fig. 197.

The gelatin was soaked in the water, dissolved in a water bath and the dichromate added, and filtered while hot. The glass was then coated, allowed to drain for 10 seconds, placed on a leveling slab to set and dried in a dust-free place.

The grating was placed in contact with the dichromated film and exposed to sunlight for from 10 to 25 seconds, with parallel rays as far as possible; this can easily be effected by placing the plates at the bottom of a deep narrow box, or admitting the light through a hole in a shutter of a window. After exposure the plate was immersed in warm water at 35° C., till perfectly colorless, rinsed in distilled water and dried on edge. The chief difficulty in the manufacture of these gratings is to obtain uniformity of coating. This can be tested by placing the copy in front of a light and viewing through a small hole with one eye[61] when the surface should appear of uniform color throughout.

Three constituent positives are required from negatives taken through the usual trichromatic filters. A dichromated gelatin plate is placed in contact with the 2,000 line grating and above the grating the positive taken through the red filter. The exposure should now be made to parallel sunlight. Register marks must be affixed to the dichromated film or its support. Wood used an ink dot, this corresponding to some prominent object equally defined in each positive. After exposure, the grating and positive were removed, and the 2,500 grating and the positive from the green-filter negative accurately superimposed on the exposed plate. Another exposure was then made, and the operation repeated for the blue-violet grating and positive. The plate was then developed in warm water and dried.

Wood first imprinted all three gratings on one plate, but the difficulties of accurate superposition led him subsequently to print only the red and green positives on one plate and utilize a second plate for the blue-violet, reversing the positive, that is to say, placing the film side out, thus this last plate could be used as a cover glass for the two-grating picture.

The viewing apparatus consisted of a section of a large reading glass, with an eyehole, or preferably a narrow slit. As the spectra are formed on each side of the central white image, if the distance between the two spectra were so arranged as to coincide with the interpupillar distance of the eyes, it is obvious that one could obtain stereoscopic pictures by this process.

It was further pointed out that it was possible to produce these diffraction pictures directly in the camera on a single plate. For if a plate of fine grain were to be exposed in succession under red, green and blue filters, on the surface of which diffraction gratings had been ruled or photographed, the plate on development should appear as a colored positive, when examined in the viewing apparatus. The ordinary commercial plate has too coarse a grain, but it seems possible that a Lippmann emulsion might be satisfactory.

Fig. 198 shows Wood's illustration of his patent, and *1* is a diffraction grating of uniform grating space, in combination with a lens, the projection of the spectra being diagrammatically shown. In *2* is a similar view with the grating provided with varying and overlapping grating space; *3* shows the front view of the grating 1, *4* a front view of *2*. A diagrammatic view of a multi-colored object to be viewed is shown in *5*, and the distribution of the grating lines in the finished photograph of the same is shown in *6*, the viewing apparatus is in *7*.

T. Thorp[62] patented what he considered an improvement on Wood's process, in that he impressed the grating rulings on dichromated gelatin, or mounted a celluloid replica grating direct on the gelatin, then printed under the positive, removed the grating and developed the plate. All the

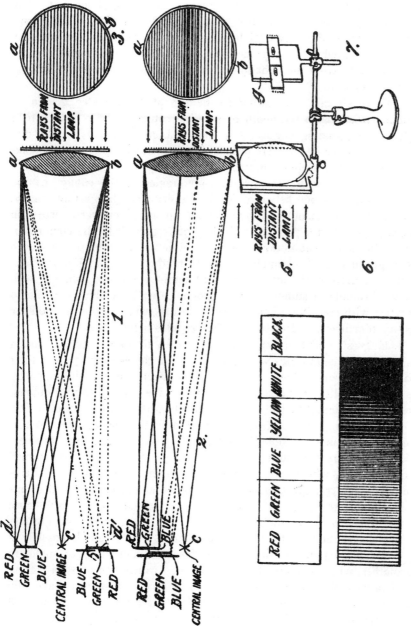

Fig. 198. Wood's E.P. 4,601, 1899.

pictures were prepared in the same way, but the subsequent gratings were imposed at an angle, preferably 10 degrees, to the ruling of the first. The three grating pictures were then superimposed and viewed in an apparatus, in which the source of light was incandescent gas, for instance, and mirrors placed on the surface of an ellipsoid of revolution, which reflected the light from the light-source through slits parallel to the rulings of the gratings.

F. E. Ives[63] said that owing to the use of dichromated gelatin or albumin, variations in the depth of printing could not be relied upon to produce corresponding variations in the apparent luminosity of the different tones of the image. He proposed to improve the process by breaking up the diffraction lines by making the exposure through a black and white line screen with the lines at right angles to the rulings of the grating. The distance between the line screen and the grating was so adjusted that the shadows thrown by the opaque lines were deepest in the center, and had a penumbra shading off regularly to the commencement of the next penumbral shadow. It was also claimed that a screen with a granular surface might be used; further that the interruptions might be secured by the incorporation of semi-transparent granules, such as silver bromide in sufficient coarse grain, either in a film to be placed in contact with the diffraction grating or incorporated within or upon the sensitive film itself, and dissolving the granules afterwards.

H. E. Ives[64] said that one of the fundamental defects of this process was that the three gratings were superposed on the assumption that their separate effects were added. But disturbing effects were produced, partly due to the inability of the gelatin surface to take several grating impressions without mutual blotting out and chiefly to the formation of a new compound grating. For if two gratings of different spacings were superposed, the spacings periodically got in and out of step, and this new periodic structure formed a new diffraction grating, which then formed its own spectra, which subtracted light from the original ones. Therefore, when the two gratings were superimposed, the eye, instead of receiving double the quantity of light, received much less. A still more serious defect was that the new spectra, due to the composite grating, fell in such positions as to produce false colors. That this is possible is proved by placing two gratings with different rulings, at right angles to one another, when two sets of spectra will be formed, one by each grating and parallel to its ruling and in addition a series of spectra diagonally disposed. If the gratings be now turned into the same straight line all the spectra turn, and the additional diagonally-spaced spectra take up positions between the spectra formed by the original gratings. So that while the eye may receive red from one grating and blue from another, one of the spectra formed by the combination of the two gratings may produce another color, such as green.

It is obvious from the above arguments that a method of combining the effects of the three gratings by some means, other than superposition would be advantageous. This can be done by some process in which the grating elements should be exactly formed in juxtaposed strips, as the color lines in a linear screen process. Some experiments had already been made by Wood with Joly pictures to prove the possibility of making screen-plates with very much finer lines than is possible by ruling. The method of procedure was the ruling of a special grating, consisting of several lines of one spacing, followed by several of another and then several of the third, repeated all across the plate. From this grating a print was made on the special line picture, which had been previously flowed with gelatin. This in turn was used to make gelatin copies. The practical disadvantages were the necessity of the special ruled grating, by no means an easy task, and the possibility of the Joly lines themselves forming spectra. H. E. Ives overcame all these difficulties[65] by using a black and white line screen of at least 200 lines to the inch, and with the opaque lines twice the width of the transparent and shifting this between each exposure.

Wood's viewing apparatus was simple and satisfactory, but the total light reaching the eye was obviously little. F. E. Ives[66] would improve matters by utilizing multiple slits, thus combining the light from two or more spectra. Some of these slits[67] were also to be made wider than others. Later[68] the light was so disposed that it passed twice through the diffraction photograph.

R. S. Clay[69] suggested a method of obtaining results in color, somewhat on the lines of Wood's process, utilizing the formation of Newton's rings formed between two plane surfaces inclined to one another at small angles. Thus if two plane surfaces are used, which meet along a line at O, Fig. 199, I, the light and dark lines, still called Newton's rings, will be straight and parallel to the line of contact through O. In this case the lines will be equidistant, that is $OA=AB=BC$, etc., and each is equal to $\frac{1}{2}\lambda OK/HK$, since again the distance apart of the surfaces increases by half a wave-length from one line to the next. A photograph of such a system formed by monochromatic light could evidently be used as a diffraction grating. The number of lines formed would depend on the purity of the light; the distance apart of the wave-length. The light transmitted or reflected by a colored object, being a mixture of light of a great range of wave-lengths, will only form a few, say ten, lines and will only form these close to the line of contact O. The fringes would be situated close to the surface producing them. Suppose now that a film of celluloid could be formed, consisting of a great number of tiny wedges, each just about wide enough to form ten lines, Fig. 199, II, and this was placed in contact with a glass plate, then even with ordinary colored light, fringes would be formed all along the surfaces of the wedges. The

distance apart of these fringes would depend for a given angle of the wedges, on the color of the light used. By semi-silvering the lower surface of the film and the adjacent surface of the glass plate, the fringes would be rendered much more distinct.

If the film so mounted were pressed against the surface of a sensitive

Fig. 199 (Page 675).

plate, the latter would on development be made into a diffraction grating, of which the ruling would be determined by the color of the light. In Fig. 199, III, B is the Canada balsam, C the celluloid and S the sensitive surface. The plate could be examined by slightly oblique light, and at a certain angle would appear colored with the light used. Lastly if such a film were placed in the camera in the usual way, a combined photograph and grating would be produced. This printed and viewed at a certain angle would appear in colors, similar to those produced by Wood's process. Provided, therefore, that the wedge film can be obtained, the production of colored pictures by its means would be perfectly simple; moreover, they could be multiplied in the same way.

Several methods suggest themselves for the production of the wedged film. For instance, Wood described[70] an "echelette," which he had made by ruling a soft metal with a carborundum crystal, which gave a series of parallel wedge-shaped grooves. A cast in celluloid of such a surface could be taken, the grooved surface of the celluloid might be semi-silvered, and then mounted grooved side down in Canada balsam on a sheet of glass previously semi-silvered. The thickness of the celluloid would

probably not be enough to matter much, though this is an open question. Instead of ruling the grooves in soft metal, they might be made by clamping together a bundle of thin glass or steel sheets, each about 1/1000 of an inch thick. The upper and the lower surfaces would then be polished and the whole inclined at a small angle, and the celluloid cast made from this surface.

1. "Solution générale du Problème de la Photographie des Couleurs," a reprint of the articles originally published in Les Mondes, February, 1869. Cf. E. J. Wall, Brit. J. Phot. 1912, **59**, Col. Phot. Supp. 6, 32.

2. Brit. J. Phot. 1875, **22**, 479.

3. E.P. 1,008, 1904; Brit. J. Phot. 1906, **53**, 21, 87; 1907, **54**, 87. F.P. 341,645; Phot. Coul. 1907, **2**, Supp. 7; D.R.P. 181,919; Can.P. 93,040.

4. E.P. 9,449, 1905; Brit. J. Phot. 1907, **54**, 111; U.S.P. 905,802; Belg.P. 175,130.

5. F.P. 442,776; D.R.P. 268,391; E.P. 9,313, 1912; Brit. J. Phot. 1913, **60**, 385; Belg.P. 235,823; 245,166; 245,167; 246,082; 246,083.

6. F.P. 369,357.

C. L. Legrand, Belg.P. also used a dispersion method with cylindrical lenses to correct the distortion of the images by mirrors.

7. E.P. 16,548, 1895; Brit. J. Phot. 1896, **43**; Supp. 63; 1904, **51**, 7; Brit. J. Almanac 1897, 829; Photogram, 1897, **7**, 91; Phot. Coul. 1907, **2**, Supp. 3.

8. Phot. J. 1912, **52**, 167.

9. Brit. J. Phot. 1904, **51**, 7; Brit. J. Almanac, 1905, 835; Nature, 1906, **75**, 153.

10. Compt. rend. 1906, **140**, 270; Brit. J. Phot. 1906, **53**, 644; Brit. J. Almanac 1907, 849.

11. Brit. J. Phot. 1899, **46**, 232.

12. Ibid. 262.

13. F.P. 364,526, 1906; Phot. Coul. 1906, **1**, 80; Brit. J. Phot. 1906, **53**, 675, 904; Bull. Soc. franç. Phot. 1906, **50**, 36; La Nature, 1906, **34**, 401.

14. Phot. Coul. 1907, **2**, 161; Brit. J. Phot. 1907, **54**, 675; 1908, **55**, Col. Phot. Supp. **2**, 3; F.P. 377,229.

15. Photo-Rev. 1907, **19**, 51; Brit. J. Phot. 1907, **54**, Col. Phot. Supp. 1, 5, 18.

16. E.P. 8,723, 1907; Brit. J. Phot. 1907, **54**, 869; F.P. 376,616; Belg.P. 199,391; Austr.P. 44,368.

17. Phot. J. 1912, **52**, 162; Brit. J. Phot. 1912, **59**, Col. Phot. Supp. 6, 19, 24, 28; Zeits. wiss. Phot. 1913, **12**, 373; Phot. Welt. 1913, **27**, 67; Phot. Coul. 1912, **6**, 97, 121, 145, 169; Phot. Korr. 1912, **48**, 623; Camera Craft, 1912, **19**, 277; Amat. Phot. 1912, **55**, 356.

18. Brit. J. Phot. 1911, **58**, Col. Phot. Supp. 5, 4; Jahrbuch, 1912, **26**, 373. Cf. J. Rheinberg, Brit. J. Phot. 1911, **58**, Col. Phot. Supp. 5, 24, 32.

19. U.S.P. 747,961, 1903; Brit. J. Phot. 1911, **58**, Col. Phot. Supp. 5, 16.

20. Phot. Archiv. 1896, **37**, 250; Jahrbuch, 1897, **11**, 487; Brit. J. Phot. 1896, **43**, 569.

21. Brit. J. Phot. 1897, **44**, 142.

22. D.R.P. 117,598, 1899; Silbermann, 2, 386.

23. E.P. 7,729, 1899; Brit. J. Phot. 1900, **47**, 329.

24. U.S.P. 648,748, 1900.

25. Phot. Coul. 1913, **7**, 149; Jahrbuch, 1915, **29**, 146; Brit. J. Phot. 1914, **61**, Col. Phot. Supp. 8, 18; F.P. 459,566.

26. E.P. 10,690, 1902.

27. Photo-Rev. 1907, **19**, 51; Brit. J. Phot. 1907, **54**, Col. Phot. Supp. 1, 19.

28. Compt. rend. 1908, **166**, 446; Brit. J. Phot. 1908, **55**, 192; Phot. News, 1908, **52**, 359; Phot. Chron. 1908, **15**, 525; Jahrbuch, 1909, **23**, 414; Phot. Coul. 1907, **2**, 121. Cf. A. Byk, Phys. Zeits. 1909, 326.

29. E.P. 10,611, 1909; Brit. J. Phot. 1910, **57**, 421; Col. Phot. Supp. **4**, 15; F.P. 399,762; addit. 11,286; 413,103; addit. 12,342; 430,600; addit. 14,438; 14,439; U.S.P. 992,151; D.R.P. 223,236; Phot. Coul. 1909, **4**, 244; Phot. Ind. 1910, 937.

30. F.P. 402,507, 1909.

31. F.P. 401,342, 1908.

32. F.P. 466,781; E.P. 24,698, 1914; Brit. J. Phot. 1916, **63**, 117; U.S.P. 1,214,552. Cf. E.P. 207,836, 1922; Brit. J. Phot. 1925, **72**, 65.

33. E.P. 7,540, 1915; Brit. J. Phot. 1916, **63**, 410; F.P. 472,419; U.S.P. 1,214,552.

34. F.P. 516,050, 1920.

35. F.P. 547,529; 547,530; E.P. 180,656, 1921; abst. Sci. Tech. Ind. Phot. 1923, **3**, 113.

36. F.P. 521,533; abst. Sci. Tech. Ind. Phot. 1921, **1**, 102; D.R.P. 359,408.

37. F.P. 523,336; abst. Sci. Tech. Ind. Phot. 1921, **1**, 68; 1922, **2**, 7; E.P. 158,511; Brit. J. Phot. 1921, **68**, 265; Col. Phot. Supp. **14**, 221; 1922, **69**, 265; Col. Phot. Supp. **16**, 20; U.S.P. 1,372,515; Can.P. 222,374; Jahrbuch, 1915, **29**, 142.

38. F.P. 548,435. Cf. F.P. 548,894; abst. Sci. Tech. Ind. Phot. 1923, **3**, 142, 143.

39. Sci. Tech. Ind. Phot. 1923, **3**, 12; Bull. Soc. franç. Phot. 1923, **65**, 26; Brit. J. Phot. 1923, **70**, Col. Phot. Supp. **17**, 10; Photo-Börse, 1923, **5**, 167; Brit. J. Almanac, 1924, 385.

40. E.P. 17,330, 1913; Void; F.P. 472,090, 1913.

41. E.P. 4,943, 1915; Brit. J. Phot. 1916, **63**, 175; F.P. 476,086.

42. F.P. 476,821, 1914; E.P. 6,878, 1915.

43. U.S.P. 1,189,266, 1916.

44. E.P. 24,276, 1914; Brit. J. Phot. 1916, **63**, 158; Can. P. 163,204; Jahrbuch, 1915, **29**, 142; Austr.P. 83,317.

45. D.R.P. 322,716, 1913.

46. D.R.P. 369,748, 1921; abst. Sci. Ind. Phot. 1924, **4**, 31.

47. F.P. 572,746, 1924; abst. Sci. Ind. Phot. 1924, **4**, 201.

48. F.P. 552,221; abst. Sci. Tech. Ind. Phot. 1923, **3**, 160.

49. F.P. 560,216.

50. F.P. 563,903; abst. Sci. Ind. Phot. 1924, **4**, 101.

51. E.P. 207,836, 1923; F.P. 571,096; abst. Sci. Ind. Phot. 1924, **4**, 198.

52. E.P. 207,837, 1923; F.P. 571,097; abst. Sci. Ind. Phot. 1924, **4**, 198.

53. E.P. 211,486; F.P. 566,432, 1922; 573,532, 1923; Bull. Soc. franç. Phot. 1923, **65**, 26; Brit. J. Phot. 1923, **70**, Col. Phot. Supp. **17**, 10; ibid. **18**, 28; 1925, **72**, 264, Col. Phot. Supp. **19**, 20; Sci. Ind. Phot. 1925, **5**, 23.

54. F.P. 572,550, 1924; abst. Sci. Ind. Phot. 1924, **4**, 200.

55. F.P. 572,929, 1924.

56. F.P. 572,788, 1923; abst. Sci. Ind. Phot. 1924, **4**, 201.

57. F.P. 573,399, 1923; abst. Sci. Ind. Phot. 1925, **5**, 23.

58. F.P. 573,508, 1923; abst. Sci. Ind. Phot. 1925, **5**, 23, 48.

For further patents, see F.P. 571,722; 573,400; 575,648; D.R.P. 401,146; 401,147.

59. E.P. 4,601, 1899; Brit. J. Phot. 1899, **46**, 229, 232, 357, 420; D.R.P. 140,-907; Silbermann, **2**, 388; Chem. Ztg. 1903, **27**, 488; Archiv. wiss. Phot. 1900, **1**, 184; U.S.P. 755,983; Phot. News, 1900, **44**, 120; J. Soc. Arts, 1900, **48**, 285; 1900, **49**, 116, 226,265; Nature, 1899, **46**, 229, 420; 1904, **70**, 614; Mon. Sci. 1905, **64**; J. S. C. I. 1904, **23**, 455; Phot. Mitt. 1900, **46**, 119; Jahrbuch, 1900, **14**, 558; 1901, **15**, 177; 1905, **19**, 213; 1907, **21**, 134; Rev. Sci. Phot. 1904, **1**; Phot. J. 1899, **39**, 259; 1905, **45**, 3; Photo-Rev. 1899, **11**, 29; Bull. Soc. franç. Phot. 1899, **45**, 267; Phot. Rund. 1901, 17; Brit. J. Almanac, 1901, 829; D. Phot. Ztg. 1899, **23**, 271; 1900, **24**, 39; Sci. Amer. Supp. 1899, **48**, 19,674; Phot. Korr. 1899, **36**, 432; Phot. Crlbl. 1899, **5**, 192; Der. Amat. Phot. 1899, **13**, 137; Rev. Phot. 1899, **11**, 184; Cosmos, 1899, **40**, 709; Vie Sci. 1899, **2**, 228; Phil. Mag. 1899 (5), **47**, 368; Photogram, 1899, **6**, 178; 1900, **7**, 105; Phot. Coul. 1906, **1**, 36; Science, 1899, **9**, 859. Cf. J. T. Cundall, Brit. J. Phot. 1900, **47**, Supp. 31. F. Loescher, Phot. Chron. 1900, **7**, 295. L. Pfaundler, Jahrbuch, 1901, **15**, 177.

60. It is obvious that the actual number of lines to the inch is variable within wide limits. The only condition to be fulfilled being that the ratio of the rulings in the three gratings shall be so chosen as to bring the fundamental colors on the same vertical. The distance of any color from the central white image is determined by the formula $\sin a = n\lambda/b$, in which λ is the wave-length, n the order of the spectrum, which is always in this case 1, and b the width of one ruling and the grating space. But it is clear that the finer the grating the greater the technical difficulties in registration, etc.

61. It is obvious that the grating must not be looked at direct, or one would see nothing but the central white image; it must be examined at a slight angle; or if the eyehole is kept constant, then the grating must be turned.

62. E.P. 11,466, 1899; Mem. Manchester Lit. Phil. Soc. 1900, **44**, 1; Photography, 1900, 514; Camera Obscura, 1900, **2**, 425; Photogram, 1900, **7**, 399; Brit. J. Phot. 1900, **47**, 327; Jahrbuch, 1901, **15**, 177; 1902, **16**, 229.

63. U.S.P. 666,423, 1901.
64. J. Frank. Inst. 1906, **161**, 439; U.S.P. 817,569, 1906; Brit. J. Phot. 1906, **53**, 609, 853; E.P. 6,825, 1906; Brit. J. Phot. 1907, **54**, 54, 89; Phys. Rev. 1906, **22**, 339; 1907, **24**, 103; Photo-Era, 1906, **17**, 285.
65. It must be understood that these records have no color and no structure, they are the ordinary positives in black and white, from the constituent negatives.
66. U.S.P. 839,853, 1907.
67. It is clear that the distance of the slits is dependent on the grating space, or the number of lines per inch. Ives used 2,000, 2,600 and 2,900.
68. U.S.P. 898,369, 1908.
69. Penrose's Annual, 1921, **23**, 33; Brit. J. Phot. 1921, **68**, Col. Phot. Supp. **14**, 9.
70. "Physical Optics," 1911, 227. Cf. T. E. Freshwater, Phot. J. 1905, **45**, 3.
The following articles deal with color photography generally:
Brit. J. Phot.:—J. B. Fowler, 1873, **20**, 488. A. A. C. Swinton, 1883, **30**, 776, 791. A. S. Herschel, 1886, **33**, 271. Anon. 1894, **41**, 65. T. Bedding, 1890, **37**, 4. E. J. Wall, 1894, **41**, 283, 406, 424, 454, 472; 1895, **42**, 474, 484; 1897, **44**, 476; 1898, **45**, 476, 808; 1904, **51**, 666, 684; 1906, **53**, 588; 1904, **51**, 321, 666, 684; 1906, **53**, 588. F. E. Ives, 1895, **42**, 103, 599; 1896, **43**, 674; 1898, **45**, Supp. 4. W. Hume, 1874, **21**, 135, 160; 1895, **42**, 25. J. S. Gibson, ibid. 345, 362. Anon. 1896, **43**, 642; 1897, **44**, 98. W. Herschel, ibid. Supp. 94; 1901, **48**, 439. W. Abney, 1897, **44**, Supp. 51; 1898, **45**, 218, Supp. 35; 1904, **51**, 63; 1890, **37**, 229; 1905, **52**, 975. Von Hübl, 1897, **44**, Supp. 12; 1898, **45**, 134, 167; 1899, **46**, 23. A. D. Pretzl, 1897, **44**, 293, 310, 822, 836. Saville Kent, 1899, **46**, 22. Anon. 1891, **38**, 273, 306; 1899, **46**, 262; 1903, **50**, 383; 1905, **52**, 723; 1906, **53**, 366, 391, 419, 438; 1907, **54**, 781, 918, Col. Phot. Supp. **1**, 19, 30; 1911, **58**, ibid. **5**, 10; 1914, **61**, ibid. **8**, 25; 1916, **63**, ibid. **10**, 17; 1918, **65**, ibid. **12**, 24, 37, 41, 42, 45, 47; 1917, **64**, 249; 1919, **66**, ibid. **13**, 22. J. Sanger-Shepherd, ibid. 1899, **46**, 583; Supp. 49. D. Barbieri, 1900, **47**, 474. P. E. B. Jourdain, 1898, **45**, 815. A. A. K. Tallent, 1898, **45**, 764. L. W. Munro, 1899, **46**, 213. T. T. Baker, 1903, **50**, 987; 1904, **51**, 707; 1905, **52**, 31. W. T. Wilkinson, 1916, **63**, Col. Phot. Supp. **10**, 26. A. Bosch, 1903, **50**, 828. H. Dalziel, 1903, **50**, 205. C. Kaiserling, ibid. 282. H. Farmer, 1905, **52**, 849, 868. E. Stenger, ibid. 710. F. C. Tilney, 1907, **54**, Col. Phot. Supp. **1**, 41; 1908, **55**, Col. Phot. Supp. **2**, 66. F. Boardman, 1906, **53**, 397. S. G. Yerbury, ibid. **78**, 106. C. L. A. Brasseur, 1907, **54**, 843. L. P. Clerc, 1907, **54**, Col. Phot. Supp. **1**, 29. W. Gill, ibid. 33. K. Worel, ibid. 36. F. H. Evans, 1910, **57**, Col. Phot. Supp. **4**, 96. H. F. Perkins, 1910, **57**, ibid. 40. W. A. Casson, ibid. 16. H. E. Ives, 1913, **60**, Col. Phot. Supp. **7**, 21, 26. A. Genthe, 1915, **62**, Col. Phot. Supp. **9**, 39. C. W. Piper, ibid. 4, 18, 26, 38, 41; 1917, **64**, ibid. **11**, 1, 9, 21, 29, 36, 40, 44. H. D'Arcy Power, 1916, **63**, ibid. **12**, 5; 1921, **68**, ibid. **15**, 24. S. G. Yerbury, 1919, **66**, ibid. **13**, 36. A. J. Bull, 1918, **65**, Col. Phot. Supp. **12**, 5. R. M. Fanstone, 1919, **66**, ibid. 41; 1921, **68**, ibid. 127. E. G. H. Lucas, 1919, **66**, ibid. **13**, 39. W. W. Davidson, ibid. 1920, **67**, ibid. **14**, 9. T. J. Offer, 1920, **67**, ibid. **14**, 2; 1922, **69**, ibid. **16**, 26. S. Procoudin-Gorsky, 1920, **67**, ibid. **13**, 19. J. Herzberg, 1922, **69**, ibid. **16**, 32. H. E. Rendall, 1922, **69**, ibid. **16**, 9; 1920, **67**, ibid. **13**, 45. F. J. Stoakley, 1922, **67**, ibid. **16**, 12. C. W. Piper, 1918, **65**, ibid. **14**, 17. T. J. Briant, 1917, **64**, ibid. **13**, 36, 40, 44. C. N. Bennett, 1921, **68**, ibid. **14**, 19. Chapman Jones, 1905, **52**, 13. A. Marshall, 1916, **63**, Col. Phot. Supp. **12**, 15. Bruno Meyer, 1894, **42**, 157, 187. H. D'Arcy Power, 1924, **71**, Col. Phot. Supp. **18**, 6, 10, 24. F. C. Tilney, ibid. **18**, 13. J. C. Warburg, ibid. **18**, 18, 29.
Phot. News:—R. W. Thomas, 1870, **14**, 606. J. Spiller, 1876, **20**, 344. J. Husnik, 1878, **22**, 123, 148; J. Sawyer, 1883, **27**, 349. A. A. C. Swinton, ibid. 805, 826. C. R. Woods, 1884, **28**, 405. A. S. Herschel, 1886, **30**, 283, 326. W. Abney, 1889, **33**, 9, 20, 69, 276, 348, 412, 429. F. E. Ives, 1895, **39**, 611. E. J. Wall, 1894, **38**, 394, 407; 1895, **39**, 13, 38; 1906, **50**, 388, 426,490. W. Abney, 1904, **44**, 81. J. B. Acres, 1891, **31**, 178. Anon. 1898, **42**, 838; 1906, **50**, 755. T. C. Day, 1906, **50**, 128.
J. Soc. Arts:—T. Bolas, 1897. W. Abney, 1888, **37**, 80, 90, 99, 113. H. T. Wood, 1897, **45**, 802. H. Dalziel, 1903, **51**, 292. E. Sanger-Shepherd, 1900, **48**, 758, 769, 781, 793.
Phot. J.:—G. Lindsay Johnson, 1902, **42**, 86. A. A. K. Tallent, 1898, **38**, 81. W. Abney, 1899, **39**, 291; 1905, **45**, 280. E. Sanger-Shepherd, ibid. 316. C. Grebe, ibid. 205. J. C. Warburg, 1923, **63**, 192. T. T. Baker, 1905, **45**, 24. A. J. Bull, 1918, **58**, 69. J. F. Shepherd, 1922, **62**, 373. D. Northall-Laurie, 1923, **63**, 48.
Photo-Rev.:—F. Monpillard, 1904, **16**, 66, 74. E. Forestier, ibid. 109. C. Fabry, ibid. **43**, 131, 141, 146. L. Wulff, 1899, **11**, 52.
Anthony's Phot. Bull.:—A. A. C. Swinton, 1888, **16**, 194, 226. L. Vidal, 1891,

22, 698, 725. J. S. Gibson, 1896, 27, 184. F. C. Lambert, 1897, 28, 108. J. Booth-royd, 1899, 30, 72.

Phot. Korr.:—H. Ott, 1879, 16, 365. Dawes, 1884, 21, 117. G. Pizzighelli, ibid. 121. V. Angerer, 1886, 23, 129. L. Schrank, 1887, 24, 53. J. M. Eder, 1889, 26, 264; 1890, 27, 264; 1897, 34, 229. H. W. Vogel, 1891, 28, 551. K. H. Broum, 1914, 51, 450. K. Sartori, 1904, 41, 224.

Sci. Amer.:—D. Gray, 1894, 70, 169. H. W. Vogel, Supp. 1879, 41, 260. Anon. Supp. 1881, 43, 3,439, 459. A. Bosch, 1903, 89, 185.

Nature:—J. Albert, 1877, 17, 92. G. Pim. 1884, 29, 470.

Jahrbuch:—E. Kuchinka, 1904, 18, 201. J. Husnik, 1905, 19, 222. L. Pfaundler, 1907, 21, 20; 1910, 24, 64. H. Schmidt, ibid. 10. E. J. Wall, 1914, 28, 127. K. Worel, 1911, 25, 3.

Bull. Soc. franç. Phot.:—F. Monpillard, 1898, 43, 409, 534; 1902, 47, 169; 1904, 49, 319. C. Gravier, 1902, 47, 132; 1903, 48, 221; 1911, 56, 411. R. Namias, 1905, 50, 44. C. Adrien, 1913, 56, 59.

Phot. Chron.:—A. Miethe, 1904, 11, 681. F. Hansen, 1905, 12, 418. H. Auer-bach, 1908, 15, 295, 323, 339, 347. H. Traut, 1908, 15, 49. Florence, 1901, 8, 349, 399, 519, 643; 1902, 9, 105, 205, 320, 437, 657; 1903, 10, 118, 275. F. Stolze, 1903, 10, 442; 1905, 12, 528, 541.

Internat. Annual Phot.:—G. Balfour, 1888, 1, 46. R. Hitchcock, 1901, 13, 107.

Amer. Annual Phot.:—H. D'Arcy Power, 1915, 30, 106. J. Lewisohn, 1917, 31, 182. C. Donaldson, 1915, 30, 78. M. Levy, 1904, 19, 235. W. H. Kunz, 1912, 26, 28. C. E. K. Mees, 1910, 24, 20. C. M. Carter, 1909, 23, 41. H. F. Perkins, 1910, 24, 102.

Photo-Era:—H. Leffmann, 1912, 28, 237. E. J. Wall, 1906, 17, 352; 1914, 33, 126, 171. L. Merillat. 1917, 38, 183. R. M. Fanstone, 1922, 48, 143. M. Gross, 1919, 42, 64. Anon. 1919, 43, 186. W. W. Davidson, 1920, 44, 80. W. Thiem, 1922, 49, 28, 85. F. H. Evans, 1911, 26, 119. Day-Baker, 1909, 10, 103.

Camera Craft:—C. W. Piper, 1916, 23, 29, 371; 1918, 25, 370. A. Miethe, 1902, 4, 199. F. M. Hilliard, 1912, 19, 21. H. J. Comley, 1910, 17, 261. S. G. Yerbury, 1910, 17, 315. H. D.'Arcy Power, 1903, 6, 240; 1908, 15, 311, 353; 1909, 16, 29, 73, 186, 321, 369. A. E. Talboys, 1903, 6, 109, 141, 192. Anon. 1919, 26, 399.

Phot. Kunst:—E. Sallwuerk, 1905, 4, 243. G. Walter, 1905, 5, 321. K. Worel, 400, 425. E. König, 1903, 2, 1. E. Stenger, 1905, 4, 161, 201, 323, 361; 1906, 5, 173.

Bull Phot.:—C. A. Gilchrist, 1909, 4, 379; 1910, 5, 8, 38. Anon. 1915, 17, 644, 675, 707, 739, 772; 1916, 18, 3, 35, 67, 132, 163, 209, 227, 259, 291.

Zeits. wiss. Phot.:—J. Precht, 1904, 2, 60, 407. E. Stenger, ibid. 410. B. Donath, 1903, 1, 94.

Photo-Gaz:—V. Crèmier, 1909, 20, 4. Anon. 1901, 11, 165, 189, 226. L. Loebel, 1905, 15, 55, 76, 96. G. Mareschal, ibid. 21.

Phot. Rund.:—P. Knoche, 1920, 57, 287. W. Thiem, ibid. 169. O. Fielitz, 1921, 58, 311, 329. A. Miethe, 1914, 51, 293.

H. W. Vogel, Phot. Mitt. 1890, 27, 24, 36. Wilson's Phot. Mag. 1890, 27, 488, 635. L. Doyen, Art. del Stampa, 1879, 8, 179. L. H. Friedberg, Technologist, 1909, 14, 137. A. N. Goldsmith, School of Mines Quarterly, 1909, 30, 130. W. J. Pope, Eng. 1915, 99, 304. L. Darling, Pop. Sci. Monthly, 1916, 89, 102. T. W. Corbin, Marvels of Science, 1917, 212. L. K. Hirshberg, Amer. Mag. Art. 1917, 8, 281. C. D. Hodgman, J. Cleveland Eng. Soc. 1917, 10, 127; Sci. Amer. Supp. 1917, 84, 399. G. Rigg, Met. Chem. Eng. 1914, 12, 30. O. N. Rood, Can. Mag. Sci. 1886, 14, 94. V. Angerer, J. Buchdr. 1887, 54, 81. Carey Lea, Eng. Mech. 1887, 45, 408. F. Graby, Cosmos, 1900, 42, 389. M. C. Rypinski, J. Soc. Ill. Eng. 1914, 9, 579; Sci. Amer. 1915, 79, 134. A. E. Woodhead, J. Soc. Dyers, 1914, 30, 78. G. L. Johnson, Phot. Times. 1902, 34, 547. W. J. Herschel, Annual Rept. Smithsonian Inst. 1902, 313. L. Dubois, Bull. Soc. Indust. Nord France, 1901, 29, 485. Anon. Rev. Tech. 1898, 10, 451. W. Abney, Proc. Roy. Inst. 1898, 15, 802. G. H. Nie-wenglowski, Smithsonian Annual Rept. 1898, 209. H. E. Ives, Eighth Inter. Con-gress. App. Chem., Sec. 9, 26, appendix, 447; J. Phys. Chem. 1913, 17, 41. J. Bordeaux, Rev. gén. 1909, 90, 905. C. Fabry, Bull. Soc. Sci. Ind. Marseille, 1908, 36, 7. Chapman Jones, Science Prog. 1908, 2, 349. R. Goldschmidt, Rev. Université Bruxelles, 1908, 13, 317; Bull. Soc. Chim. Belg. 1908, 22, 20. E. J. Steichen, Camera Work, 1908, No. 22, 13. T. W. Smillie, Smithsonian Annual Rept. 1908, 231. W. Saville Kent, J. Roy. Asiatic Soc. 1906, 18, 435. J. S. Plaskett, Trans. Roy. Can. Inst. 1902, 7, 371. G. Fritsch, Akad. Wiss. Berlin, 1904, Anhang 2. Chapman Jones, Nature, 1904, 70, 553, 578; Penrose's Annual, 1904. M. Maldinez. Soc. Emul. du Doubs, 1907 (7), 8, 177. W. Abney, Der Amat. Phot. 1898, 12, 88. W. H.

Idzerda, Phot. Ind. 1916, 335. S. Smeaton, Austral. Phot. J. 1902, 11, 89. P. Prieur, Phot. Franç. 1902, 14, 103, 143. W. J. Pope, Sci. Amer. Supp. 1915, 79, 38. A. J. Bull. ibid. 1918, 86, 69. E. J. Wall, Process Photogram. 1895, 2, 47; J. S. C. I. 1896, 15, 400. A. E. Talboys, Photogram, 1902, 10, 46, 116. T. Huson, ibid. 1899, 6, 41. A. Press, Pop. Sci. Monthly, 1917, 90, 254. Anon. Amer. Phot. 1914, 8, 358. W. Abney, J. S. C. I. 1901, 20, 1,060. C. F. Townsend, Camera, 1905, 8, 279. J. Thovert, Chim. Ind. 1922, 8, 312. Ochs. Camera (Luzerne), 1924, 2, 185. Spaulden, Phot. Mitt. 1892, 29, 202. A. and L. Lumière, St. Veronica, 1902, 5, 18. A. Nodon, Phot. Coul. 1907, 2, 138, 158. P. Van Duyse, Phot. Moderne, 1924, 2, 39, 52. T. Bedding, Brit. J. Almanac, 1899, 659. J. Plaskett, Trans. Can. Inst. 1902, 7, 371. G. Balfour, Anthony's Internat. Phot. Annual, 1888, 46. Anon. Phot. Rund. 1925, 62, 93. H. O. Klein, New Phot. 1925, 4, 114, 567, 592. F. Monpillard, Rev. Franç. Phot. 1925, 6, 100.

BIBLIOGRAPHY

ABNEY, W. DE W. The Colour Sensations in Terms of Luminosity. London, 1899.
The Scientific Requirements of Color Photography. London, 1897.
ACLAND, MISS. The Spectrum Plate—Theory; Practice; Result. London, 1900.
ARMIN, C. L. Der Gummidruck in natürlichen Farben. Vienna.
AUSTIN, A. C. Practical Half-tone and Tri-color Engraving. Buffalo, 1898.
BAYLEY, R. C. Photography in Colours. London, 1900; 2nd edit. 1904.
Color Photography (Autochrome). New York, 1907.
Real Colour Photography. London, 1907.
BECQUEREL, E. La Lumière, ses causes et ses Effets. 2 vols. Paris, 1867.
BERTHIER, A. Manuel de Photochromie interférentielle. Paris, 1895.
BERGET, A. Photograpie des Couleurs par le méthode interférentielle de
M. Lippmann. Paris, 1891; 2nd edit. 1901.
BLECHER, C. Lehrbuch der Reproduktionstechnik. Halle, 1908.
BOLAS, T. A. A. K. Tallent & E. Senior. A Handbook of Photography in Colours.
London, 1900.
BONACINI, C. La Fotografia ortocromatica. Milan, 1896.
La Fotografia dei Colori. Milan, 1897.
BOURÉE, H. Notes pratiques sur l'emploi des plaques Autochromes. Paris, 1909.
BROUM, K. Die Autotypie und der Dreifarbendruck. Halle, 1912.
BROWN, G. E. Color Photography. Photominiature No. 128. New York, 1913.
Practical Instructions in Color Photography. Photominiature, No. 147.
New York, 1916.
BROWN, G. E. AND WELBORNE PIPER. Colour Photography with the Lumière Auto-
chrome plate. London, 1907.
BRUNEL, G. La Photographie en Couleurs. Paris, 1899.
CAJAL, R. S. Fotografia de los Colores, Madrid, 1912.
CALMELS, H. AND L. P., CLERC. La Reproduction photographiques des Couleurs,
Paris, 1917.
CALMETTE, L. Lumière, Couleur et Photographie. Paris, 1893.
CHANOS, M. A. La Photographie des Radiations invisibles. Paris, 1917.
CLERC, L. P. La Photographie des Couleurs. Paris, 1899.
Les Reproductions polychromes photomechaniques. Paris, 1919.
The Ilford Manual of Process Work. London, 1924.
COUSTET, E. La Photographie en Couleurs sur plaques à filtres colorés. Paris, 1908.
CRÈMIER, V. La Photographie des Couleurs par les plaques Autochromes. Paris,
1911.
CROS, CHAS. Solution générale du Problèm de Photographie des Couleurs. Paris,
1869.
DAVANNE, A. Rapport sur les titres de M. Lippmann au Grand Prix de 12,000
francs. Paris, 1895.
DAVID, L. AND C. SCOLIK. Die orthoskiagraphische Photographie. Halle, 1900.
DILLAYE, F. Les Nouveautés photographique. Paris, 1894. Pp. 142-154.
La Photographie par Autochromes. Paris, 1908.
DONATH, B. Die Grundlagen der Farbenphotographie. Brunswick, 1906.
DROUIN, F. La Photographie des Couleurs. Paris, 1896.
DU HAURON, ALCIDE DUCOS. La Triplice photographique des Couleurs et l'Im-
primerie. Paris, 1899.
DU HAURON, L. DUCOS. Les Couleurs en Photographie. Solution du Problème.
Paris, 1869.
Les Couleurs en Photographie et, en particulier l'Héliochromie au charbon.
Paris, 1870.
L'Héliochromie. Decouvertes, constations et ameliorations importantes. Agen,
1874.
L'Héliochromie. Agen, 1874.
La Photographie indirecte des Couleurs. Paris, 1899.
L'Héliochromie. Méthode perfectionnée pour la formation et la superposition
des trois monochromes constitutifs des Héliochromies à la gelatine. Agen,
1875.

L'Héliochromie. Nouvelles recherches sur les négatifs héliochromiques; la rapidite trouvèe; le paysage et le portrait d'après nature. Agen, 1875.
Traité pratique de Photographie des Couleurs; système d'Héliochromie Louis Ducos du Hauron. Paris, 1878.
La Photographie des Couleurs de M. Louis Ducos du Hauron. Alger, 1888.
Photographie des Couleurs. Reproduction photomechanique des Couleurs en nombre illimité d'exemplaires. Alger, 1891.
DUGARDIN, L. Traité pratique de la Photographie des Couleurs. Paris, 1894.
DUMOULIN, E. Les Couleurs reproduite en Photographie. Paris, 1876; 2nd edit. 1894.
EDER, J. M. Chemical Effect of the Spectrum. London, 1883.
ERNAULT, A. La Photographie directe des Couleurs. Paris, 1895.
FALLOWFIELD, J. Autochrome Photography. London, 1909.
FITZSIMMONS, R. J. Color Photography with Autochrome plates. New York, 1916.
FRAPRIE, F. R. How to make prints in colors. Boston, 1916.
FRITSCH, G. Beiträge zur Farbenphotographie. Halle, 1903.
GAMBLE, W. BURT. Color Photography, a list of references in the New York Public Library. New York, 1924.
GAUMONT, L. Manuel de l'Autochromiste. Paris, 1908.
GODEFROY, L. Guide pratique pour reussir la photographie en Couleurs. Paris, 1921.
GOLDBERG, E. Farbenphotographie und Farbendruck. Leipzig, 1908.
GRABY, E. Photographie des Couleurs. St. Claude-sur-Bienne.
GRANGE, D. Pour faire une bonne Autochrome. Paris, 1914.
HÜBL, A. VON. Die Theorie und Praxis der Farbenphotographie mit Autochromplatten. Halle, 1908; 2nd edit. 1909.
Die photographischen Lichtfilter. Halle, 1910.
Die Lichtfilter. 2nd edit of above. Halle, 1922.
Die Dreifarbenphotographie. Halle, 1897; 2nd edit. 1902; 3rd edit. 1912; 4th edit, 1922.
Die orthochromatische Photographie. Halle, 1920.
HOFMANN, A. Die Praxis der Farbenphotographie. Wiesbaden, 1900.
Aufnahmeapparate für Farbenphotographie. Munich, 1901.
IVES, F. E. A new principle in Heliochromy. Philadelphia, 1889.
Handbook to the Photochromoscope. London, 1894.
Kromskop Color Photography. London, 1898; Philadelphia, 1900.
Isochromatic photography with chlorophyll. Philadelphia, 1886.
JAISER, A. Farbenphotographie in der Medizin. Stuttgart, 1914.
JANKU, J. B. Der Farbenstich als Vorlaufer des photographischen Farbendrucks. Halle, 1899.
JOHNSON, G. L. Photographic Optics. Color Photography. London, 1911.
Photography in Colours. London, 1911; 2nd edit. 1914; 3rd edit. 1917; 4th edit. 1922.
KIESER, K. Beiträge zur Chemie der optischen Sensibilisation von Silbersalzen. Freiburg, 1904.
KLEIN, H. O. Three-Colour Photography. London, 1915.
KÖNIG, E. Die Autochrom-Photographie und die verwandten Drei-Farbenraster Verfahren. Berlin, 1908; 2nd edit. 1912.
Die Farbenphotographie. Berlin, 1904; 2nd edit. 1906; 3rd edit. 1912; 4th edit. 1921.
KÖNIG, E. AND E. J. WALL. Natural-Color Photography. London, 1906.
KRONE, H. Ueber das Problem in natürlichen Farben zu photographieren. Dresden, 1894.
Die Darstellung der natürlichen Farben durch Photographie. Weimar, 1894.
LEHMANN, H. Beiträge zur Theorie und Praxis der direkten Farbenphotographie mittels stehender Lichtwellen nach Lippmann's Methoden. Freiburg, 1906.
LENZ, T. Die Farbenphotographie. Brunswick, 1897.
LIESEGANG, R. E. Die Heliochromie; das Problem der Photographie natürlichen Farben, eine Zustammenstellung der hierauf bezüglichen Arbeiten von Becquerel, Niepce und Poitevin. Düsseldorf, 1884.
LIMMER, F. Das Ausbleichverfahren. Halle, 1911.
Bleach-out Process and Uto-color Paper. Paris, 1912.
MARTIN, L. C. AND W. GAMBLE. Colour and methods of reproduction. London, 1923.
MATHET, L. Etude theorique et pratique sur les procédés isochromatique ou orthochromatiques. Paris, 1890.
Guide pratique pour l'emploi des surfaces orthochromatiques. Paris, 1891.

MEBES, A. Farbenphotographie mit Farbrasterplatten. Bunzlau, 1911.
 Farbenphotographie mittels eine Aufnahme, 1909.
MEES, C. E. K. Color Photography. Nos. 128, 183 Photominiature. New York, 1921.
MIETHE, A. Dreifarbenphotographie nach der Natur. Halle, 1904.
NAMIAS, R. I Processi modierne par la Fotografia dei Colori. Milan, 1911.
 La Fotografia in Colori. 4th edit. of above. Milan, 1921.
NATURAL COLOUR PHOTO CO. Natural Colour Photographs, Dublin.
NAUDET, G. La Photographie des Couleurs. Paris, 1899.
NEUHAUSS, R. Die Farbenphotographie nach Lippmann's Verfahren. Halle, 1898.
NIEWENGLOWSKI, G. H. AND A. ERNAULT. Les Couleurs et la Photographie. Paris,
 1895.
 La Photographie directe des Couleurs par le Procédé de M. G. Lippmann,
 Paris, 1895.
NIEWENGLOWSKI, G. H. Les Progrès de la Photographie des Couleurs. Paris, 1899.
QUENTIN, H. Comment on obtient une photographe en couleurs. Paris.
 Notes pratiques sur l'orthochromatisme. Paris, 1900.
REG, O. (pseudonym of O. Pfenninger). Bye-paths in Colour Photography.
 London, 1921; New York, 1924.
ROUX, V. Photographie isochromatique. Paris, 1887.
RUCKERT, C. La Photographie des Couleurs. Paris, 1900.
SANTINI, E. N. Les Couleurs réelles en photographie. Paris, 1898.
SCHEFFER, A. Manuel pratique de photographie des couleurs par les plaques Auto-
 chromes. Paris, 1909.
SCHEIDEMANTEL, H. Nicola Perscheid's Photographie in natürlichen Farben.
 Leipzig, 1904.
SCHMIDT, F. Farbenphotographie. Leipzig, 1912.
 Meesterwerken der kleuren-photographie. Leyden, 1912.
SCHNEIDER, J. Die Photographie in Natürfarben. Leipzig.
SMITH, A. E. Colour Photography. London, 1900.
SOLGRAM COLOR PHOTO CO. The Solgram, 1905.
STUDIO, THE. Special Number, 1908.
THOVERT, J. Photographie des Couleurs. Paris, 1924.
TRANCHANT, L. La Photographie des Couleurs simplefiée. Paris, 1903.
TRAUBE, A. AND H. AUERBACH. Photographie und Farbenphotographie. Berlin, 1920.
TURPAIN, A. Conferences Scientifiques. Fasc. V. Paris, 1924.
VALENTA, E. Die Photographie in natürlichen Farben. Halle, 1894; 2nd edit, 1912.
VECINO, J. Estudio teorico-practico de la Fotografia en Colores. Madrid, 1908.
VIDAL, L. Photographie des Couleurs. Paris, 1897.
 Traite pratique de Photochromie. Paris, 1903.
 Manuel pratique d'orthochromatisme. Paris, 1891.
 La Photographie des Couleurs par impressions pigmentaires superposés. Paris,
 1893.
 La Photographie en relief et en creux. Paris, 1892.
 Photographie des Couleurs et Projections Polychromes. Paris, 1893.
 Méthode graphique automatique pour la synthèse des couleurs. Paris, 1894.
 Procédé de Projection Polychromes à l'aide de diapositifs non colorés. Paris,
 1892.
VOGEL, W. H. Die Photographie farbiger Gegenstände in richtigen Tonverhältnissen.
 Berlin, 1885.
 La Photographie des objets colorés avec leurs valeurs réelle. Paris, 1887.
WALL, E. J. Practical Color Photography. Boston, 1922.
WALLACE, R. J. Color Photography. No. 38 Photominiature, New York, 1902.
WALLON, E. La photographie des couleurs et les plaques Autochromes. Paris, 1907.
WIENER, O. Ueber Farbenphotographie. Leipzig, 1909.
ZANDER, C. G. Photochromatic Printing. Leicester, 1896.
ZENKER, W. Lehrbuch der Photochromie. Berlin, 1868; reprint, Brunswick, 1900.

ADDENDA

A few patents that have appeared while this work was in preparation and other notes, supplementary to those already given, are here included.

CHAPTER I

THE THEORETICAL PRINTING INKS (p. 26)

L. P. Clerc[1] (p. 700) defined the ideal inks as a yellow absorbing the whole of the blue-violet and transmitting all the green and red rays; its hue, comparable with that of the spectrum yellow between 5,695 and 5,700, is best represented by a solution of naphthol yellow. The red or pink ink should completely absorb the green and transmit the whole of the red and blue, a color which does not exist in the spectrum, but is fairly represented by solutions of rhodamin S or erythrosin, neither being, however, sufficiently blue. The blue-green ink should absorb the whole of the red and transmit completely the blue-green. The hue of this is comparable with that comprising from 4,880 to 4,885, and is approximately represented by solutions of solid green bluish or carmin blue, both of which, however, transmit undue proportions of the extreme red.

Clerc gives the following table of the limits of the separation filters of various authorities:

	Blue	Green	Red
Newton & Bull, 1904	4,100-5,000	4,600-6,000	5,800
Mees, 1909	4,100-5,100	4,800-6,000	5,800
Wallace, 1909	4,100-5,000	4,900-4,950	5,875
Von Hübl, 1912 (normal filters)	4,100-4,950	4,850-5,900	5,800
Von Hübl, 1912 (modified filters)	4,100-4,950	4,650-5,850	5,800

CHAPTER I

FOUR-COLOR PRINTING (p. 37)

A. E. Bawtree[2] has adopted a four-color process, based on his theory, which was primarily enunciated by Edridge-Green, that yellow is a primary color and not compounded from red and green. He postulates a chromatic circle, divided into eight sectors with the following colors: violet, blue, green, lemon, yellow, orange and magenta. The printing inks must be complementary to the taking filters. The present three-color

process is faulty according to his views, as the green filter yields an image which is too strong towards the yellows and too feeble towards the blues, hence the well-known veiling of the greens in printing by magenta, and also the lack of strength in the violets. The red filter similarly throws too much blue into the yellow parts, but to avoid this a true red filter is not used, but one between orange and red. But even so this co-operates with the green filter in yielding blues which are too feeble. The printer attempts to correct this by using too strong and too violet a blue ink, with the result that he upsets all other parts of the picture and has to resort to fine etching. The filters for this new method are defined as magenta, blue, lemon and orange. The inks as lemon, orange, magenta and blue. The inks and filters being respectively complementary to one another. It is further stated that the exact hue of the filters depends somewhat upon the commercial inks available, but they have been standardized for one particular make of inks. Bawtree admits that the process does not cure all existing difficulties, but the methods of fine etching and retouching are much simpler and more easily learnt than those of the present three- or four-color systems.

CHAPTER III

STILL CAMERAS AND CHROMOSCOPES (p. 140)

A. Miethe[3] stated that next to the gray scale, photographed side by side with the object, a properly constructed chromoscope was the best

Fig. 200.

means for judging as to the correctness of the constituent images for three-color printing. Although the colors, as they appear in the

chromoscope, are not directly comparable with those obtained later with superposed printing, yet with a little experience a correct reproduction of the colors both in the high lights and shadows in this instrument gives good results in subsequent printing. Zink's chromoscope may be used for this purpose, only naturally it must be made of suitable size with suitable filters. Ives' chromoscope can not be used, as spectroscopic examination of the filters at once proves that they do not correspond to the theoretical requirements. With correct arrangement the red filter must transmit from 7,800 to 6,000 or at the most 5,900. The green filter should be transparent from 5,900 to 5,100, and the violet from 5,050 to the ultra-violet. The violet filter may also advantageously transmit a small quantity of red light from 7,800 to 6,900. The filters must be made with stained gelatin.

In the arrangement of the filters care must be taken to avoid double reflections. The backs of the mirrors, therefore, must be coated so that the reflected light is absorbed by the filters. Miethe suggested three arrangements, as shown in Fig. 200. In the first arrangement F' was the red filter, F'' the violet and F''' a colorless one. In the second arrangement F' was the green filter, F'' the violet and F''' colorless. R' was a purple-violet coated reflector transmitting from 7,800 to 6,000 and 5,050 to 4,000; R'' being red transmitting like the red filter, R''' being colorless. In the third arrangement F' was a violet filter, F'' a green and F''' colorless. R' being a yellow-coated reflector, transmitting from 7,800 to 5,100; R'' a red, transmitting like the red filter and R''' colorless.

(p. 145)

The Jos-Pe Farbenphoto Gesellschaft G.m.b.H[4] patented plate holders constructed of metal so that they could be simultaneously moved to and from the lens in an octagonal camera. This was presumably for use with the mirror system, p. 690.

CHAPTER V

OPTICAL DATA (p. 203)

P. Rudolph[5] adopted the use of three mirrors, Fig. 201, directly behind the lens, so that the angle of field is great and three images exactly congruent to one another. The device consists of three inner mirrors, a, a, a of the core, enclosed at a given distance by the three outer mirrors b, b, b, parallel to the same. The three smaller mirrors being arranged in the form of a right-angular straight prism truncated at 45 degrees with regard to the edge. The apex of truncation lying in the axis of the objective and to which each mirror is inclined at 45 degrees. To equalize the exposures the effective areas of the mirrors might be varied.

A. B. Crow and E. J. Dunn[6] patented a "divertor" for obtaining two-, three- or four-color images with one lens, Fig. 202. In *1 a a′* represents the front combination of a doublet lens, *b b′* the back combination; *d d′* are diaphragms, placed as close as possible to the prisms *e e′*, so as to insure equal illumination of the images; *j j′* are the filters close behind the prism combinations *e f, e′ f′*. The image, instead of coming to a focus at *v* is split into two or more at *k k′*. In *2* is shown the front view of the arrangement of prisms for two-color work; in *3* that for three-color and *4* that for four-color work. The dotted circles in each case representing the lens and

Fig. 201. Rudolph's E.P. 230,686.

f, f¹, f², f³ the filters. The meeting plane or point of the prisms being placed on the optical axis. Formulas are given for achromatizing the prisms.

The Jos-Pe Farbenphoto Gesellschaft G.m.b.H[7] patented a mirror arrangement, Fig. 203. The mirrors *1, 2, 3* being arranged with free spaces between their edges; *1* and *2* are in the same plane being joined at one end, while *3* crosses them, preferably at right angles, and their planes may be at right angles to the lens axis. The position of the mirrors with respect to the lens axis is shown in *4*. When the mirrors are placed with the

plane of intersection vertical and the focusing screens are placed extra-focally for infinity, *5, 6, 7* represent the dispersion figures on the ground glasses. Coarse focusing is effected by shifting the ground glasses and fine focusing by moving the lens or one of its combinations.

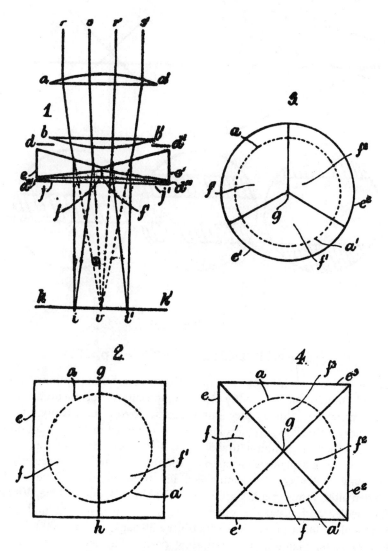

FIG. 202. CROW & DUNN'S, E.P. 228,207.

K. Dobrosky[8] also patented a three-sided reflecting solid body behind the lens. One edge of the prism or body being parallel to the plane of the plate while the other two are parallel to two other plates.

FIG. 203. JOS-PE E.P. 229,250.

CHAPTER IX

DESENSITIZING PLATES (p. 303)

Desensitizing continues to attract considerable attention. Lüppo-Cramer[9] pointed out that many dyes, though interesting theoretically, are of little practical value as they cause intense fog or stain badly. Others, like pinacryptol yellow, are decolorized and rendered ineffective by sulfites. Fogging action is common to both sensitizers and desensitizers and is, therefore, an independent property. Some dyes fog by mere bathing, others only by drying in the emulsion. The following desensitize and fog: methylen blue, Janus green, Capri blue, Nile blue 2B, cyanin blue, Victoria, Bindschedler and malachite greens. This last dye, methyl and crystal violets and brilliant green desensitize very strongly in 1:10,000, but also fog very rapid plates though not slow ones. The leuco-bases of these last dyes do not desensitize in 1:20,000, but actually increase the sensitivity. This is considered a proof of the oxidation theory of desensitizers.

Von Hübl[10] reported that methylen blue 1:200,000 reduced the sensitivity of an extra-rapid plate to one-hundredth of its original value, which is a greater effect than is produced by the same concentration of

any other dye, except the new pinacryptol green Th. The heavy fog, produced by methylen blue alone, was prevented by the addition of acridin yellow, provided the concentration of the blue was not increased or development too prolonged. Pinacryptol yellow can reduce the sensitivity to one five-hundredth of the original and so is fifty times more effective than the methylen blue-acridin yellow mixture.

A. E. Amor[11] reported as to the effect of various dyes, using a metol-hydroquinon developer at 18°C., with fast films. These were totally immersed during development, thus excluding any chance of aerial fog. When the films were treated for 5 minutes, prior to development, with a 1 : 1,000,000 dye bath, then rinsed for 5 minutes there was an increased fog, thus on the untreated film the fog was 0.12, with pinacryptol green 0.16, with safranin 0.15. When the desensitizer was added to the developer in a strength of 1 : 1,000,000 there was a notable reduction of fog, and this was not bettered when the dye strength was increased ten times. The following readings were obtained:

Untreated film0.12	Chrysoidin0.10
Phenosafranin0.05	Methylen blue0.15
Pinacryptol green	...0.06	Auramin0.11
Basic scarlet N0.09	Acridin yellow0.11

The mixture recommended by the Pathé laboratory, see p. 302, gave fog densities between 0.10 and 0.15, but the strengths of the dyes were much less than recommended. The greater the initial fog the more marked the action of the dyes. In all cases there was very little staining of the gelatin and this was completely removed by a few minutes washing.

Lüppo-Cramer[12] considered that the protective action of acridin yellow and other dyes in desensitizing as comparative to that of quinolin and glycin reds in sensitizing with cyanin. From the theoretical standpoint this is important. Methylen blue can not be used with plenty of light because it is destroyed by the developer, thus does not give any protection during development. But the methylen blue-acridin yellow mixture is very effective, reducing the sensitivity 98.8 per cent. The analagous rhodulin blue mixtures reduce the sensitivity 75 per cent; but rhodulin violet-acridin yellow is no more effective than safranin, requiring also longer immersion of the plates. This also applies to rhodulin G, which is quite as energetic as safranin and does not require the addition of a protective dye.

J. Rheden[13] reported on the action of pinacryptol green as a desensitizer for Agfa screen-plates, used as a preliminary bath 1 : 100,000. There was distinctly less fog and no appreciable falsification of the color rendering. Examination of many other pictures made on the same plates, but with stronger baths, also showed no ill-effects as regards the colors. Even with the above-named dilution a ruby light could be used for examination of the screen-plate during development.

CHAPTER XI

SUBTRACTIVE PROCESSES—I, CARBON PROCESS

(p. 337)

W. Wadhams, A. Ziehm, H. A. Sonderman and P. Woithe[14] patented a modification of the dichromate sensitizer, which is stated to give great speed in printing. One formula is:

Potassium dichromate	30 g.
Magnesium chloride	10 g.
Sodium acid phosphate	5 g.
Water	1000 ccs.

Gelatinized surfaces should be immersed in this for about 2 minutes at a temperature not exceeding 18°C. and dried. The exposure is stated to be reduced to about 1 second under an ordinary negative. An alternative solution is:

Anilin hydrochloride	2 g.
Sodium acid phosphate	5 g.
Magnesium chloride	10 g.
Water	1000 ccs.

Dissolve and add:

Potassium dichromate	30 g.

This is to be used as the former and allows a print to be obtained in one-fourth second. The exposed surface should be treated with hot water at 45°C., to which ammonia or borax may be added. The colorless reliefs thus obtained may be stained up.

CHAPTER XII

SUBTRACTIVE PROCESSES II. DEVELOPED RELIEFS (p. 355)

Lüppo-Cramer[15] definitely pointed out the restraining action of sulfites on the tanning of gelatin and the formation of reliefs by the oxidation products of developing agents, and said: "the relief, the whole tanning action, is strongest when one completely omits the sulfite in developing. It is obvious from this, that the oxidation products of adurol exert a tanning action on the gelatin which is nullified or even prevented from occuring by more or less sulfite. . . . The same tanning action of their oxidation products is shown by paraminophenol and metol, and with these substances also the tanning is prevented by the sulfite."

It would seem that no valid claim can be made for anchoring the hardened image or protuberances directly to the support, as precisely the same effect was obtained by Donisthorpe[16] and by Payne[17] who disclosed the use of his process for line as well as half-tone blocks, that is for a continuous image. This was then hardened with dichromate and alum and developed to form a relief. Schumacher[18] also presumably anchored an image, hardened by development with pyrogallol, to metal plates. Kent[19] also produced a hardened image by exposure through the support with relief formation with hot water.

J. G. Capstaff[20] patented a method of obtaining relief images on both sides of double-coated film, or single relief images on ordinary film. The images were printed in the usual way, developed with metol or other developer which exerts no tanning action on the gelatin. After washing, and without fixation, the unaffected silver salts were to be exposed to white light and developed with a tanning developer. The film was then to be treated with hot water when the primary image with its contiguous soluble gelatin would be washed away. The metallic silver of the second image may be removed by a reducer. In lieu of the second light-exposure, the unaffected silver salt might be developed with pyrogallol and caustic alkali, or other developer that reduces silver bromide without exposure to light. In order to obtain a positive relief the primary image must be a negative.

CHAPTER XIII

SUBTRACTIVE PROCESSES III. MORDANTING

(p. 385)

L. Preiss[21] would make the three separation negatives through filters each transmitting one-third of the spectrum. Silver positives were then to be made and the images converted into metallic ferrocyanides, such as copper, then dye-toned with basic dyes. The copper bath should, for preference, contain less than half the usual amount of salts and more ferrocyanide than copper. The individual prints were then to be superposed and cemented with alkaline silicate solution with some gum. Apparently the constituent images were in the first place on celluloid and stripped by treatment with amyl acetate, etc. Paper, ivory, celluloid, etc., may be the final support.

E. Grünwald[22] patented the superposition of constituent color records produced on stripping development papers and superposing while wet.

CHAPTER XIV

SUBTRACTIVE PROCESSES IV. TONING, ETC.

(p. 404)

The Kelley Color Laboratory[23] claimed a process in which two complementary color-record images are formed in the same colloid layer, one image being printed first, developed and toned, the layer then cleared by treatment with a bath containing ammonium bromide and potassium dichromate, and the second image then printed on the unaffected silver salt, developed and toned. In an example, the first image is printed on the layer through its transparent support from a blue-green record negative, developed for 3 minutes with amidol, toned in a bath of vanadium oxalate, ferric ammonium oxalate, oxalic acid and potassium ferrocyanide. The layer is then to be cleared with ammonium dichromate and bromide. After washing and drying, the second image is printed on the front of the layer from a red record negative, developed for 3 minutes with amidol, fixed in hypo, toned in uranium nitrate, potassium oxalate, hydrochloric acid and ferrocyanide and finally fixed.

THE KODACHROME PROCESS CHEMISTRY

(p. 413)

J. H. Venn[24] in a preliminary note dealing with the chemical actions involved in the bleaching of silver images with bromoil solutions, that is mixtures of cupric and dichromate salts, points out that E. Mayer[25] quotes P. R. von Schrott as authority for the following equations:

$$2Cu_2Br_2 + Ag_2 = 2AgBr + Cu_2Br_2$$

The cuprous bromide reduces the dichromate thus:

$$3Cu_2Br_2 + 6CrO_3 = 3CuBr_2 + 3CuCrO_4 + Cr_2O_3.CrO_3$$

But this latter equation does not seem justified.

A well-washed, bleached and tanned print, on treatment with ammonia gives a blue solution. This shows that the green residual image, obtained by bleaching and tanning in a neutral solution, is to some extent a copper compound. Chromate is present but not to the extent shown by the above formula. On treatment of a bleached print with an acid solution of sulfuretted hydrogen the original image developed up in brown copper sulfide; chromium being incapable of forming a sulfide in aqueous solution, is removed by the acid. Rosenfeld[26] studied the reactions of cuprous chloride and potassium chromate and obtained a green precipitate, to which he gave the formula $CrO_3.Cr_2O_3, 6CuO + 9H_2O$, which on heating

left a residue corresponding to $3Cr_2O_3 . 12CuO$; but his figures are unconvincing, yet they do suggest that basic copper compounds are formed.

Venn proved experimentally that the dichromates acted in a somewhat similar manner to the chromates with cuprous halides. He suggested the following equation as possibly correct:

$$3CuCl_2 + K_2Cr_2O_7 + 7H_2O = 2KCl + 2CuCl_2 + 4Cu(OH)_2 + 2Cr(OH)_3$$

It is finally suggested that unless some sort of physical protection of the copper hydroxide by the chromium hydroxide occurs, due to absorption or similar phenomena, there is some chemical combination.

CHAPTER XV

SUBTRACTIVE PROCESSES V. DICHROMATE-GUM PROCESS (p. 425)

R. Hiecke[27] described some experiments in making enlargements with gum-dichromate. The light source was a 12 ampere arc lamp, with 4 inch condenser and anastigmat lens working at F:5 of 7 inch focus. The three constituent negatives were clean and somewhat hard. The paper was first sized with chrome-alum-gelatin, the sensitive coating was a mixture of 1 part of 60 per cent solution of gum arabic and 2 parts of 10 per cent solution of potassium dichromate.

The exposure required for each of the three colors was about 20 minutes. But as only few of the lightest gradations were obtained in the prints, at least six exposures, each of 20 minutes were finally given, with a second coating for each color. It was found, however, that by means of supplementary lighting, approximately one-third of the luminosity of the bare glass of the negative, that better results were obtained with abbreviation of the exposures, these being 15 minutes for the red and yellow and 10 minutes for the blue impression.

It was also found that by allowing the sensitized pigmented gum solution to stand for 70 hours in the dark it gained about three times its original sensitiveness.

The supplementary exposure was obtained with two incandescent lamps of 35 c.p. at 100 volts, which, however, were over-run at 110 volts, giving 75 c.p. The two lamps were placed one on each side of the easel at a distance of 18 inches, and to increase their action a semi-cylindrical reflector of white paper was placed behind each.

The sensitive coating must not be dried by heat but with a fan, but after development and washing the enlargement should be thoroughly dried by heat to enable it to stand the application of the subsequent coats with the brushes. Development was best effected with a rose spray.

Under the title of Resinopigmentypy R. Namias[28] patented a modification of the powder process. Gelatinized paper, sensitized with ammonium dichromate and dried, was exposed under a transparency. Then treated with water at a suitable temperature in which the unexposed parts absorbed water, becoming tacky. A powder pigment, brushed over such a surface, will adhere to the swelled places. The special pigments must be impervious to water, such as natural resins or bituminous substances, for instance, dragon's blood or asphalt. Or fused resins may be used, like resin, shellac or gum dammar. A typical mixture being: resin 100, gum dammar 100, stearic acid 2 parts, melted at a moderate heat and 80 parts of finely ground lampblack added. Or a resin may be dissolved in alkali with the addition of an alkaline stearate and pigment and precipitated by addition of an acid or alum. Any dichromate stain may be removed by treatment of the dried print with sodium bisulfite, or the wet image with ammonia. This process is applicable to three-color work. A silver image may also be the foundation print by the use of a bromoil or Carbro hardener, though this presents somewhat greater difficulties.

E. Buri[29] also patented a modification very much on the same lines as Namias, the sole difference being apparently the addition of wax to the color powders. The wax or resin may be dissolved and the treated mass dried and powdered. Organic dyes or mineral colors, such as ultramarine, peat or lycopodium, charcoal, etc., may be used. Dichromated gelatinized paper was to be exposed under a positive and swollen in warm water, partly dried and dusted with the powder. The color penetrates into the swelled gelatin, avoiding those parts hardened by light. Images with strong contrasts may be obtained by applying the powder to negative prints produced by the oil or bromoil processes. The powders may also be applied to copper plates.

CHAPTER XX

PRINTING FROM SCREEN-PLATES (p. 552)

L. P. Clerc[30] pointed out that in the reproduction of screen-plates, such as the Autochrome, especially for photomechanical work, the results obtained in making separation negatives by the use of an ordinary set of tri-color filters are usually unsatisfactory, since the defects of the two successive separations are added. It is preferable to utilize the separation already effected on the screen-plate by using filters which completely absorb two of the colors, while transmitting the third. The transmissions of the filters must be narrower than those of the screen units, and entirely comprised within them, or should at any rate present a very marked maximum transparency towards the center of the transmission range of

the screen elements. The average of many measurements of Autochrome plates gives the following as the mean transmissions of the elementary filters and the maximum transparency of the same:

Elementary filters	Blue	Green	Red
Limits of transmission...	4,000-5,050	4,900-5,800	beyond 5,700
Maximum transparency ..	4,650	5,250	6,200

To sort out the three images Clerc suggests that the filters should transmit 4,200 to 4,800 for the blue; 5,100 to 5,700 for the green and beyond 5,900 for the red. These limits can be obtained by the Ilford Micro 2 + Micro 6 (blue), Spectrum green + Micro 4 (green) and Micro 5 + Micro red 7 (red).

The Wratten & Wainwright screen-plate analysis filters are No. 29 or F, passing beyond 6,000 with maximum transparency at 6,500 for the red; No. 50 or L, passing from 4,000 to 4,900 with maximum transparency at 4,600 for the blue and No. 61 or N passing 4,900 to 6,000 with maximum transparency at 5,300 for the green.

R. J. Cajal[31] proposed to coat glass or other support by means of a whirler with a thin film of dichromated albumin or gelatin. When partly dry this film should be lightly brushed over with the usual green, red-dish-orange and blue-violet colors. The ratios being so chosen that the first black condition is fulfilled. The colors must be insoluble in water. Asphalt might also be used as the sensitive medium. Light pressure with a hard substance would imbed the particles in the substratum.

The plate was to be then exposed under the screen-plate picture to insolubilize the coating and developed in the case of gelatin with warm water, cold being used for albumin, and benzol for asphalt, using a soft brush or swab of absorbent cotton to remove the colored grains not anchored to the support by the exposure. The result would be a positive whether viewed by reflected or transmitted light. The whites would be formed by the additive synthesis of the grains and blacks by backing up the glass with black paper.

The main difficulty here would be the panchromatization of the dichromated carrier. Experiments to this end with the isocyanins were without result. Some improvement was obtained by printing through analysis filters, thus much prolonging the duration of insolation for the red and green. The color rendering was by no means perfect and Cajal suggested that filaments or sheets cut on the microtome might be used as color elements. The sensitive material might be coated on celluloid and exposed through the back, development being carried out as usual. The colors should be treated with cupric sulfate before this operation to fix them.

CHAPTER XXIII

CINEMATOGRAPHY IN COLORS. ADDITIVE PROCESSES (p. 595)

J. Szczepanik[32] patented an additive process in which an anterior divergent lens was placed in front of a system of positive lenses arranged on an endless chain. The combinations of the divergent lens were so separated that the point of intersection of the rays fell in the object, thus they emerge in a parallel condition and are taken up by the posterior lenses. Parallax is thus reduced to a minimum. The same system may be modified for projection.

A. C. Macbeth[33] patented an additive process in which the red and green records were taken side by side in one normal picture space. Projection was to be effected by a simultaneous method by the aid of two shutters, revolving in opposite directions, between the positive films and the condensers. The peripheries of the shutters being provided with radial slots, separated by opaque bars equal in width to the slots. The slots of one shutter being in alinement with the bars of the other, so that the pictures are to be projected in alternate strips of red and green. A bi-prism between the film and projecting objective causing deflection of the individual images. Extending across a plurality of the shutter slots may be a blue glass, or like material, to rectify color effects.

C. H. Friese-Greene[34] patented a method of additive cinematography in which a rotating shutter was used. One sector was red and the other consisted of a white light, a yellow or an opaque sector, the latter being adjustable, so as to cut out more or less yellow. It is stated that the white light sector may include a relatively small proportion of spectral blue, provided that such addition will not appreciably affect the predomination of the red color of the filter, or a small blue sector might be used. This is stated to give better rendering of foliage and the finer gradations of color with good definition in the distance, even when the latter is wrapped in mist. The positives were to be stained in red and green. It may be pointed out that if a white light sector be used it would necessarily include some of the blue. White light in addition to colored was used by Gifford, p. 61; Zoechrome & Midddleton, p. 586; Fox, p. 596; Raleigh & Kelley and others.

W. F. Fox[35] patented an additive persistence method, in which a shutter with 180 degree sectors of red and green was to be used and revolved one and one-half times for each picture, the result being that the red record negative would be exposed through the red sector twice and the green sector once, and the green record twice through the green sector and once through the red sector. The positives were to be shown

through the usual rotating color shutter. It is claimed that a projection speed more nearly that of black and white is thus obtained, with less flicker and less color fringing. Why the same results could not be obtained by using taking filters which would be the sum of the light transmitted by this system is not obvious, nor how it is to reduce fringing. Steinheil Söhne[36] would take the constituent records diagonally on normal width film, with the longer side occupying half the normal width and the first small picture of the triad falling side by side with the last of the previous triad.

L. Held[37] patented a process in which the alternate exposures were made and positives printed from the same and stained with the taking filter colors. In a subsequent patent[38] stereoscopic images were to be taken with a shifting mirror and projected in the same way. L. Brun[39] proposed to obtain and project stereo views in colors by the additive process, using a mirror at an angle of 45 degrees to one side of the lens, which reflected the objects to a rotating shutter with one sector clear and the other silvered glass, this latter projecting one of the images to the film, while the other image was obtained direct through the clear sector of the shutter.

J. Leyde[40] patented the projection of alternate complementary red and green pictures onto a screen illuminated by bluish light. The red and green should form yellow, which mixed with the blue illumination to form white. A. F. P. Carchereux[41] proposed to use two or three gates under one another so as to show two or three pictures at once. W. A. Alder & E. L. Syndicate, Ltd.,[42] patented a method of additive projection, in which successive color records, uniformly and alternately stained with red and green, were to be projected by the Leitz-Mechau[43] projector with continuously moving film.

CHAPTER XXIV

CINE SUBTRACTIVE PROCESSES (p. 635)

A. Oschmann[44] proposed to take stereo pictures and strip the positive films and superpose, after printing in complementary colors to the taking filters. For cine work one of the negatives might be taken without a filter, or only a yellow correcting filter. A positive might be printed from this and superposed with a negative image taken through a color filter.

CHAPTER XXV

DOUBLE-COATED STOCK (p. 649)

J. A. Ball & E. A. Weaver[45] patented an optical printing machine for double-coated stock or separate films to be subsequently cemented. Registration of the images is to be obtained by optical superposition of the separate color records and with the perforations as registered bases. Color screens may be inserted in the path of the active light to vary the gammas of the positives and various prisms used for superposition of the images.

1. "Ilford Manual of Process Work," 1924, 191.
2. Penrose's Annual, 1925, **30**, 44; Caxton Mag. 1925, **27**, 148.
3. Jahrbuch, 1901, **15**, 461.
4. F.P. 585,707; D.R.P. 410,992.
5. E.P. 230,686; Brit. J. Phot. 1925, **72**, 340; Col. Phot. Supp. **19**, 24.
6. E.P. 228,207; Brit. J. Phot. 1925, **72**, 264; Col. Phot. Supp. **19**, 20.
7. F.P. 585,706; E.P. 229,250; Brit. J. Phot. 1925, **72**, Col. Phot. Supp. **19**, 20; Phot. Chron. 1925, **32**, 133, 228; Phot. Rund. 1925, **62**, 140.
8. D.R.P. 412,086.
9. Phot. Ind. 1925, **26**, 56; abst. C. A. 1925, **19**, 1384; Phot. Korr. 1925, **61**, 4.
10. Phot. Ind. 1925, **14**, 432; abst. C. A. 1925, **19**, 1384; Phot. Korr. 1925, **61**, 4; abst. C. A. 1925, **19**, 1543; Phot. Rund. 1925, **62**, 71, 198.
11. Brit. J. Phot. 1925, **72**, 183; abst. Sci. Ind. Phot. 1925, **5**, 85.
12. Phot. Ind. 1925, **187**, 432, 458; abst. Sci. Ind. Phot. 1925, **5**, 85. Cf. Johannes, Phot. pour Tous, 1925, 335.
13. Phot. Rund. 1925, **62**, 18, 71; Brit. J. Phot. 1925, **72**, Col. Phot. Supp. **19**, 19.
14. E.P. 228,377, 1924.
15. Jahrbuch, 1901, **15**, 44.
16. U.S.P. 923,030, 1909.
17. E.P. 28,415, 1907.
18. U.S.P. 1,042,827, 1912.
19. E.P. 20,555, 1912.
20. U.S.P. 1,525,766, 1925; abst. J.S.C.I. 1925, **44**, B300.
 Koppmann, D.R.P. 309,193, 1916, (see p. 355) and the Aktien-Gesellschaft f. Anilinfabrikation, U.S.P. 1,453,258, (see p. 355), used precisely the same processes for single films. F. Hausleiter, D.R.P. 236,276, 1909; Jahrbuch, 1911, **24**, 589; Handbuch, 1917, **4**, II, 354 also suggested the same method for printing on metal and called the process Direktotypie.
21. D.R.P. 406,707; 406,708; abst. Amer. Phot. 1925, **19**, 421. There is no novelty in this at all. It is usual to use such filters and the lowering of the strength of the toning bath salts was patented by Traube, see p. 370.
22. D.R.P. 412,199.
23. E.P. 228,887; abst. Brit. J. Phot. 1925, **72**, Col. Phot. Supp. **19**, 20.
24. Brit. J. Phot. 1925, **72**, 119.
25. "Bromoil Printing & Transfer," translation by F. R. Fraprie, 1923, 32.
26. Ber. 1879, **12**, 954.
27. Phot. Korr. 1906, **43**, 170; Phot. Woch. 1906, **52**, 224; Brit. J. Phot. 1906, **53**, 305.
28. E.P. 205,092, 1922; Brit. J. Phot. 1925, **72**, 220; Amer. Phot. 1924, **18**, 310; Sci. Ind. Phot. 1924, **4**, 171; Rev. Franç. Phot. 1925, **6**, 129, 142.
29. E.P. 228,187, 1924; abst. Amer. Phot. 1924, **18**, 692; Das Atel. 1925, **32**, 34. Cf. O. Mente, Phot. Chron. 1925, **32**, 133.
30. "Ilford Manual of Process Work," 1924, 193.
31. La Fot. 1904, Oct.; "La Fotografia de los Colores," 1912, 299.

32. F.P. 580,937; Abst. Amer. Phot. 1925, **19,** 421; Photo-Börse, 1925, **7,** 105, 144; Phot. Ind. 1925, **380,** 395; Sci. Ind. Phot. 1925, **5,** 19; Kinotechnik, 1924, **6,** 293, 322. Cf. M. Tietz, Kinotechnik, 1925, **7,** 131; abst. Sci. Ind. Phot. 1925, **5, 48.** Spanuth & R. Hohnhold, Kinotechnik, 1925, **7,** 157; D.R.P. 411, 025.

33. U.S.P. 1,540,352.

34. E.P. 233,129; Brit. J. Phot. 1925, **72,** 340; Col. Phot. Supp. **19, 23.**

35. U.S.P. 1,540,323.

36. D.R.P. 408,274.

37. D.R.P. 409,164.

38. D.R.P. 410,032.

39. F.P. 586,075, 1924.

40. E.P. 230,387, 1924; Brit. J. Phot. 1925, **72,** 312. In F.P. 587,774 a machine for applying colors, dissolved in acetone and amyl acetate, to the celluloid at the back of the pictures is patented. Cf. Suess & Lejeune, p. 617.

41. F.P. 588,820.

42. E.P. 152,347. Specification 117,864 is officially referred to.

43. E.P. 232,285, 1924.

44. F.P. 573,248; addit. 28,359, 1924.

45. U.S.P. 1,541,315, 1925.

LIST OF PERIODICALS AND ABBREVIATIONS

Abridged Scientific Publications from the Kodak Research Laboratory.

Abst. Bull.Abstract Bulletin of the Kodak Research
 Laboratory.
abst.abstracted in.
Akad. Wiss. Berlin................Sitzungsberichte der königlich Preussischen
 Akademie der Wissenschaften zu Berlin.
Amat. Phot.The Amateur Photographer.
Amer. Acad. Sci.American Academy of Science.
Amer. Alpine ClubJournal of the American Alpine Club.
Amer. Annual Phot.American Annual of Photography.
Amer. J. Pharm.American Journal of Pharmacy.
Amer. J. Phot.American Journal of Photography.
Amer. Mag. ArtAmerican Magazine of Art.
Amer. Phot.American Photography.
Amer. Photo-EngraverAmerican Photo-Engraver.
Amer. PrinterAmerican Printer.
American Textile.
Ann. Chim. Phys.Annales de Chimie et de Physique.
Ann. d. Phys.Annalen der Physik.
Ann. Phys. Chem.Annalen der Physik und Chemie.
Annuaire gén. Internat. Phot.Annuaire générale Internationale de Photo-
 graphie.
Ann. Rept. Smithsonian Inst.Annual Report of the Smithsonian Institution.
Annual ReportsAnnual Reports of Applied Chemistry.
Anthony's Phot. Bull.Anthony's Photographic Bulletin.
Arch. f. Pharm.Archiv für Pharmacie.
Astrophys. J.Astrophysical Journal.
Austral. P.Australian Patent.
Austral. Phot. J.Australian Photographic Journal.
Austr.P.Austrian Patent.
Bayer. Gew. Bl.Bayerische Gewerbeblatt.
Beibl. Ann. Phys. Chem.Annalen der Physik und Chemie Beiblätter.
BeiträgeBeiträge zur Photochemie und Spektralanalyse,
 Eder und Valenta.
Belg.P.Belgian Patent.
Ber.Berichte der Deutschen chemische Gesell-
 schaft.
Ber. Berlin Akad.Berichte Berlinsche Akademie.
Ber. MonatsberBerlin Monatsberichte.
Biochem. Zeits.Biochemische Zeitschrift.
Bioscope.
Brit. J. AlmanacBritish Journal Photographic Almanac.
Brit. J. Phot.British Journal of Photography.
Bull. Assoc. gén. d. Chimistes del'
 Industrie textileBulletin de l'Association générale des Chim-
 istes de l'Industrie textile.
Bull. BelgeBulletin de l'Association Belge de Photographie
Bull. Bureau Standards............Bulletin of the Bureau of Standards.
Bull. Congres Phot.Bulletin de la Congres de Photographie.
Bull. d'Enc.Bulletin d'Encouragement.
Bull. Nord. Franc.Bulletin de la Société photographiques du
 Nord de la France.
Bull. Phot.Bulletin of Photography.
Bull. Photo-ClubBulletin du Photo-Club.
Bull. Soc. Chim. Belge............Bulletin de la Société chimique de Belgique.
Bull. Soc. Chim. Franc............Bulletin de la Société chimique de France.
Bull. Soc. Fot. Ital.Bulletino Societa Fotografia Italiano.

Bull. Soc. franç. Phot.............Bulletin de la Société Française de Photographie.

Bull. Soc. Havraise Phot..........,Bulletin de la Société Havraise de Photographie.

Bull. Soc. Ind. Marseille...........Bulletin de la Société Industrielle de Marseille.

Bull. Soc. Indust. Nord France..... Bulletin de la Société Industrielle de Nord France.

C. A.Chemical Abstracts.

Camera (Luzerne)

CameraCamera, U. S. A.

Camera Obscura.

Camera Work.

Can. Mag. Sci.,...............Canadian Magazine of Science.

Can.P.,Canadian Patent.

Chem. Crtlbl.Chemisches Centralblatt.

Chem. NewsChemical News.

Chem. Tech. Rep.Chemische-Technische Reportorium.

Chem. Zentr.Chemisches Zentralblatt.

Chem. Ztg.Chemiker-Zeitung.

Chem. Ztg. Rep.Chemiker-Zeitung Repertorium.

Chim. Ind.Chimie et Industrie.

Club Phot.The Club Photographer.

Collegium.

Color Trade J.Color Trade Journal.

Col. Phot. Supp.Colour Photography Supplement (to British Journal of Photography, monthly).

Compt. rend.Comptes rendus hebdomadaires des Sciences de l'Académie des Sciences.

C. R. Soc. Biol.Comptes rendus des Seances et Memoires de la Société de Biologie, Paris.

Congres d. Societes Savantes........Congres des Société Savantes de l'Académie des Sciences.

Congress German Phys. Soc.Congress of the German Physical Society.

Congres Internat. Chim. applic......Congres Internationale de Chimie appliquée.

Conquest.

Cosmos.

Dan.P.Danish Patent.

Das Atel.Das Atelier des Photographen.

Das Schulhaus.

Denkschr. Akad. Wiss. Wien.......Denkschrift der Kaiserlichen Akademie der Wissenschaften, Wien.

Der Amat. Phot.Der Amateur Photographe.

Der Phot.Der Photographie.

D. Camera-AlmanachDeutsche Camera-Almanach.

D. Industrie Ztg.Deutsche Industriezeitung.

D. Phot. Ztg.Deutsche Photographen-Zeitung.

D. R. G. M.Deutsches Reichs Gebrauchs-Muster.

D.R.P.German Patent.

Dingl. Poly.,Dingler's Polytechnische Journal.

E.P.English Patent.

Edin. Trans.Transactions of the Royal Society of Edinburgh.

Eighth Inter. Congress Appl. Chem..Reports of the Eighth International Congress of Applied Chemistry.

Eng. Mech.English Mechanic.

F.P.French Patent.

Fabre, Traité Encycl.Traité encyclopedique de Photographie by Chas. Fabre.

Fortschritte Gebiete Röntgentechnik..Fortschritte aus dem Gebiet der Röntgentechnik.

GazettaGazetta Chicima Italiana.

HandbuchEder's Handbuch der Photographie.

Handbuch d. Physiol. Optik........Handbuch der physiologische Optik.

Horn's Phot. J.Horn's photographisches Journal.

Hung.P.Hungarian Patent.
Il Corr. foto.Il Corriere Fotografico.
Il Prog. Foto.Il Progresso Fotografico.
Internat. AnnualAnthony's International Annual of Photography.
Ital.P.Italian Patent.
Jahresber.Jahresbericht der Chemie.
Jahr. Chem.Jahresbericht der Chemie.
Jahrbuch.Eder's Jahrbuch der Photographie und Reproduktionstechnik.
Jahrbuch f. phot. Kunst.Jahrbuch für photographische Kunst.
Japan J. Phys.Japan Journal of Physics.
Jap.P.Japanese Patent.
J. Amer. Chem. Soc................Journal of the American Chemical Society.
J. Buchdr.Journal für Buchdrucke-Kunst.
J. Cleveland Eng. Soc.Journal of the Cleveland Engineering Society.
J. C. S.Journal of the Chemical Society (English).
J. C. S. Annual Repts.............Journal of the Chemical Society, Annual Reports.
J. Cam. Club..............Journal of the Camera Club (English).
J. Frank. Inst.Journal of the Franklin Institute.
J. f. Gasbel.Journal für Gasbeleuchtung.
J. Ind. Eng. Chem.Journal of Industrial and Engineering Chemistry.
J. Iron & Steel Inst.Journal of the Iron and Steel Institute.
J. Opt. Soc. Amer.Journal of the Optical Society of America.
J. Phot. Soc. India................Journal of the Photographic Society of India.
J. Phys.Journal de Physique.
J. Phys. Chem.Journal of Physical Chemistry.
J. Physiol.Journal of Physiology.
J. prakt. Chem.Journal für praktische Chemie.
J. Roy. Asiatic Soc.Journal of the Royal Asiatic Society.
J. Russ. Phys. Chem. Soc.Journal of the Russian Physical Chemical Society.
J. Soc. ArtsJournal of the Society of Arts.
J. S. C. I.Journal of the Society of Chemical Industry.
J. Soc. Dyers & Col.Journal of the Society of Dyers and Colourists.
J. Soc. Ill. Eng.Journal of the Society of Illuminating Engineers.
J. Wash. Acad. Sci.Journal of Washington Academy of Science.
KK. Akad. Wiss. Wien.KK. Akademie der Wissenschaften Wien.
KinotechnikDie Kinotechnik.
Klimsch's JahrbuchKlimsch's Jahrbuch für Reproduktionstechnik.
Knowledge.
Kolloid-Zeits.Kolloid-Zeitschrift.
Kreutzer's Zeits. Phot.Kreutzer's Zeitschrift für Photographie.
Künst.Künstoffe.
L'Année Scientifique.
La Blanchère, Rep. encycl. Phot.....Repèrtoire encyclopedique de Photographie.
L'Industrie Textile.
La Lumière.
La Nature.
La Phot.La Photographie.
La Phot. Franç.La Photographie Française.
Le Gers.
La Photogramme.
Le Procédé.
Les Mondes.
Les Nouveautés Phot.Les Nouveautés Photographiques.
Les Progres Photographique.
Liebig's Ann.Liebig's Annalen.
Liesegang's Phot. AlmanachLiesegang's photographischer Almanach.

Lux.
Luxemburg P.Luxemburg Patent.
M. P. NewsMotion Picture News.
Manchester Lit. Phil. Soc.Memoirs of the Manchester Literary and Philosophical Society.
Mem. Coll. Sci. Kyoto. Imp. Univ....Memoirs of the College of Science, Kyoto Imperial University.
Mem. Soc. Ing. Civ.Memoires de la Société Ingineurs civiles.
Mem.d Savants etrangers de l'Académie des SciencesMemoires des Savants etrangers de l'Académie des Sciences.
Met. Chem. Eng.Metallurgical & Chemical Engineering.
Mining & Scientific Press.
Mitt. Maler.Technische Mitteilungen für Malerei.
Mitt. Oesterr.-Techn. Versuchamstes.Mitteilung des Oesterreiches-Technische Versuchamstes.
Monats. Chem.Monatshefte der Chemie.
Mon. d. l. TeintureMoniteur de la Teinture.
Mon. Ind. Belge.Moniteur de L'Industrie Belge.
Mon. Phot.Moniteur de la Photographie.
Mon. Sci.Moniteur Scientifique.
Motography.
Monthly Notices.
Nature.
Neues Erfind.Neues Erfindungen.
Oesterr. Chem. Ztg.Oesterreichische Chemiker-Zeitung.
Oesterr.-Ungarischen Buchdruckztg..Oesterreichische-Ungarischen Buchdruckerzeitung.
Optician.
Outlook.
Paris-Photographe.
Penrose's AnnualPenrose's Pictorial Annual. The Process Yearbook.
Phila. Phot.The Philadelphia Photographer.
Phil. Trans.Philosophical Transactions of the Royal Society of London.
Photogram.
Photographic Annual.
PhotographieLa Photographie.
Phot. Abst.Photographic Abstracts.
Phot. AnnualPhotography Annual.
Phot. Archiv.Photographisches Archiv.
Photo-Börse.
Phot. Chron.Photographische Chronik.
Phot. Coul.La Photographie des Couleurs.
Phot. Centrbl.Photographisches Centralblatt.
Photo-Era.
Phot. Franç.La Photographie Française.
Photofreund.
Photo-Gaz.Photo-Gazette.
Phot. Ind.Photographische Industrie.
Phot. J.The Photographic Journal.
Phot. J. Amer.Photographic Journal of America.
Phot. Korr.Photographische Korrespondenz.
Phot. KunstPhotographische Kunst.
Photo-Miniature.
Phot. Mitt.Photographische Mitteilungen.
Phot. ModernePhotographie Moderne.
Phot. MotivenschatzPhotographisches Motivenschatz.
Phot. Nachr.Photographische Nachrichten.
Phot. NewsPhotographic News.
Phot. NotesPhotographic Notes.
Photo-Pratique.
Phot. QuarterlyPhotographic Quarterly.
Photo-Rev.Photo-Revue.

46

Phot. Rund.Photographische Rundschau.
Phot. TimesPhotographic Times.
Phot. WeltPhotographische Welt.
Phot. Woch.Photographisches Wochenblatt.
Photo-Woche.
Phot. WorkPhotographic Work.
Photography.
Pogg. Annal......................Poggendorff's Annalen der Physik und Chemie.
Popular Astronomy.
Pop. Sci. MonthlyPopular Science Monthly.
Pract. Phot.The Practical Photographer. (U. S. A.)
Proc. Amer. Acad.Proceedings of the American Academy of
 Arts & Sciences.
Proc. Roy. Inst.Proceedings of the Royal Institution of Lon-
 don.
Proc. Roy. Soc.Proceedings of the Royal Society of London.
Process Eng. MonthlyProcess Engraver's Monthly.
Process Photogram.
Prometheus.
Phys. Gesell. VerhandlungenPhysikalische Gesellschaft Verhandlungen.
Phys. Rev.The Physical Review.
Phys. Zeits.Physikalische Zeitschrift.
Rend. Acad. Sci. TorinoRendeconti dell'Academia delle Scienze, Torino.
Report Brit. Assoc.Reports of the British Association.
Résumé d. TravauxRésumé des Travaux, publiées par MM. A. &
 L. Lumière.
Rev. d. Matières ColorantesRevue générale des Matières Colorantes.
Rev. d'OptiqueRevue d'Optique.
Rev. d. Phot.Revue de Photographie.
Rev. Gén.Revue générale des Sciences pure et appliquées.
Rev. gén. Chim. pur. appl.Revue générale de Chimie pure et appliquée.
Rev. gén. Sci.Revue générale des Sciences.
Rev. Phot.Revue de Photographie.
Rev. Sci. Phot.Revue des Sciences Photographiques.
Rev. Tech.Revue Technique.
Rec. Trav. Chim.Recueil des Travaux chimiques du Pays-Bas.
Rev. TrimestriélleRevue Trimestriélle.
Rev. Université BruxellesRevue de l'Université de Bruxelles.
Rivista Intern. Illus.Rivista Internationale Illustrata.
Russ.P.Russian Patent.
St. Louis Phot.The St. Louis Photographer.
St. Veronica.
School of Mines Quarterly.
Schriften d. Vereines z. Verbreitung
 KentnisseSchriften des Vereines zur Verbreitung Kent-
 nisse.
Science.
Sci. Amer.Scientific American.
Sci. Amer. Supp.Scientific American Supplement.
Sci. Ind. Phot.Science et Industries Photographiques.
Science Prog.Science Progress.
Sci. Tech. Ind. Phot.Sciences, Technique, et Industrie Photogra-
 phiques.
Schweitzer Phot.-Ztg.Schweitzer Photographen-Zeitung.
SilbermannFortschritte auf dem Gebiete der Photo- und
 Chemigraphischen Reproduktionsverfahren,
 1877-1906, by H. Silbermann, Leipzig, 1907.
Soc. de Biol.Bulletin de la Société de Biologie.
Soc. franç. Phys.Société française de Physique.
Soc. Ind. MulhouseBulletin de la Société industriélle de Mulhouse.
Span.P.Spanish Patent.
Stolze's Phot. NotizenkalenderStolze's Photographischen Notizenkalender.
Swiss.P.Swiss Patent.
Technologist.
Tech. u. Ind.Technik und Industrie.

Textile Colourist.
Trans. Faraday Soc.Transactions of the Faraday Society.
Trans. Roy. Can. Inst.Transactions of the Royal Canadian Institute.
Trans. Roy. Soc. Arts. Scot.Transactions of the Royal Society of Arts, Scotland.
Trans. Roy. Soc. DublinTransactions of the Royal Society of Dublin.
Trans. Roy. Soc. Edin.Transactions of the Royal Society of Edinburgh.
U.S.P.United States Patent.
Vie Sci.Vie Scientifique.
Vogel's HandbuchVogel's Handbuch der Photographie.
Wag. Jahresber., Wagner's Jahresberichte.
Wied. Annal.Wiedemann's Annalen.
Wien. Freie Phot. Ztg.Wiener Freie Photographen-Zeitung.
Wien. klinische Wochenschr.Wiener klinische Wochenschrift.
Wien. Mitt.Wiener Mitteilungen.
Wien. Phot. BlattWiener Photographisches Blatt.
Wien. Sitzber.Sitzungsberichte der Wiener Akademie der Wissenschaften.
Wilson's Phot. Mag. Wilson's Photographic Magazine.
Wiss. Ind.Wissenschaft und Industrie.
Zts. ang. Chem.Zeitschrift für angewandte Chemie.
Zeits. Chem. Ind. KolloideZeitschrift für Chemie und Industrie der Kolloide.
Zeits. f. Instrument.Zeitschrift für Instrumentekunde.
Zeits. Repro.Zeitschrift für Reproduktionstechnik.
Zeits. wiss. Phot.Zeitschrift für wissenschaftliche Photographie.

INDEX TO PATENT NUMBERS

INDEX TO PROPER NAMES

GENERAL INDEX

733